ARTS & HUMANITIES
Through the Eras

ARTS & HUMANITIES
Through the Eras

The Age of the Baroque
and Enlightenment
1600–1800

Philip M. Soergel, Editor

THOMSON
GALE

Detroit • New York • San Francisco • San Diego • New Haven, Conn. • Waterville, Maine • London • Munich

Arts and Humanities Through The Eras: The Age of the Baroque and Enlightenment (1600–1800)

Philip M. Soergel

Project Editor
Rebecca Parks

Editorial
Danielle Behr, Andrew Claps, Pamela A. Dear, Jason Everett, Dwayne Hayes, Rachel J. Kain, Ralph G. Zerbonia

Editorial Support Services
Mark Springer

Indexing Services
Barbara Koch

Imaging and Multimedia
Randy Bassett, Mary K. Grimes, Lezlie Light, Michael Logusz, Kelly A. Quin

Rights and Acquisitions
Margaret Chamberlain, Shalice Shah-Caldwell

Product Design
Michelle DiMercurio

Composition and Electronic Prepress
Evi Seoud

Manufacturing
Wendy Blurton

LIBRARY OF CONGRESS CATALOGING-IN-PUBLICATION DATA

Arts and humanities through the eras.
 p. cm.
 Includes bibliographical references and index.
 ISBN 0-7876-5695-X (set hardcover : alk. paper) —
 ISBN 0-7876-5696-8 (Renaissance Europe : alk. paper) —
 ISBN 0-7876-5697-6 (Age of Baroque : alk. paper) —
 ISBN 0-7876-5698-4 (Ancient Egypt : alk. paper) —
 ISBN 0-7876-5699-2 (Ancient Greece : alk. paper) —
 ISBN 0-7876-5700-X (Medieval Europe : alk. paper)
 1. Arts—History. 2. Civilization—History.

NX440.A787 2004
700'.9—dc22
 2004010243

This title is also available as an e-book.
ISBN 0-7876-9384-7 (set)
Contact your Thomson Gale sales representative for ordering information.

Printed in the United States of America
10 9 8 7 6 5 4 3

CONTENTS

ABOUT THE BOOK

SEEING HISTORY FROM A DIFFERENT ANGLE. An education in history involves more than facts concerning the rise and fall of kings, the conquest of lands, and the major battles fought between nations. While these events are pivotal to the study of any time period, the cultural aspects are of equal value in understanding the development of societies. Various forms of literature, the philosophical ideas developed, and even the type of clothes worn in a particular era provide important clues about the values of a society, and when these arts and humanities are studied in conjunction with political and historical events a more complete picture of that society is revealed. This inter-disciplinary approach to studying history is at the heart of the *Arts and Humanities Through the Eras* project. Patterned in its organization after the successful *American Decades, American Eras,* and *World Eras* products, this reference work aims to expose the reader to an in-depth perspective on a particular era in history through the study of nine different arts and humanities topics:

- Architecture and Design
- Dance
- Fashion
- Literature
- Music
- Philosophy
- Religion
- Theater
- Visual Arts

Although treated in separate chapters, the connections between these topics are highlighted both in the text and through the use of "See Also" references to give the reader a broad perspective on the culture of the time period. Readers can learn about the impact of religion on literature; explore the close relationships between dance, music, and theater; and see parallel movements in architecture and visual arts. The development of each of these fields is discussed within the context of important historical events so that the reader can see history from a different angle. This angle is unique to this reference work. Most history books about a particular time period only give a passing glance to the arts and humanities in an effort to give the broadest historical treatment possible. Those reference books that do cover the arts and humanities tend to cover only one of them, generally across multiple time periods, making it difficult to draw connections between disciplines and limiting the perspective of the discipline's impact on a specific era. In *Arts and Humanities Through the Eras* each of the nine disciplines is given substantial treatment in individual chapters, and the focus on one era ensures that the analysis will be thorough.

AUDIENCE AND ORGANIZATION. *Arts and Humanities Through the Eras* is designed to meet the needs of both the beginning and the advanced history student. The material is written by subject experts and covers a vast array of concepts and masterworks, yet these concepts are built "from the ground up" so that a reader with little or no background in history can follow them. Technical terms and other definitions appear both in the

text and in the glossary, and the background of historical events is also provided. The organization of the volume facilitates learning at all levels by presenting information in a variety of ways. Each chapter is organized according to the following structure:

- Chronology covering the important events in that discipline during that era

- Brief overview of the development of that discipline at the time

- Topics that highlight the movements, schools of thought, and masterworks that characterize the discipline during that era

- Biographies of significant people in that discipline

- Documentary sources contemporary to the time period

This structure facilitates comparative analysis, both between disciplines and also between volumes of *Arts and Humanities Through the Eras*, each of which covers a different era. In addition, readers can access additional research opportunities by looking at the "Further References" and "Media and Online Sources" that appear at the back of the volume. While every effort was made to include only those online sources that are connected to institutions such as museums and universities, the web-sites are subject to change and may become obsolete in the future.

PRIMARY DOCUMENTS AND ILLUSTRATIONS. In an effort to provide the most in-depth perspective possible, *Arts and Humanities Through the Eras* also includes numerous primary documents from the time period, offering a first-hand account of the culture from the people who lived in it. Letters, poems, essays, epitaphs, and songs are just some of the multitude of document types included in this volume, all of which illuminate some aspect of the discipline being discussed. The text is further enhanced by 150 illustrations, maps, and line drawings that bring a visual dimension to the learning experience.

CONTACT INFORMATION. The editors welcome your comments and suggestions for enhancing and improving *Arts and Humanities Through the Eras*. Please mail comments or suggestions to:

The Editor
Arts and Humanities Through the Eras
Thomson Gale
27500 Drake Rd.
Farmington Hills, MI 48331-3535
Phone: (800) 347-4253

CONTRIBUTORS

Andrew E. Barnes received the Ph.D. in history from Princeton University in history in 1983. He taught at Carnegie-Mellon University for a number of years before accepting his current position at Arizona State University in Tempe in 1995. His books include *The Social Dimension of Piety* (Paulist Press, 1994) and *Social History and Issues in Human Consciousness* (NYU, 1989) with Peter Stearns. He has published many articles on the religious history of early-modern France, and has more recently turned to examine European missionizing efforts in nineteenth- and twentieth-century Africa. Currently, he is completing a history of Western missions in Nigeria, where he served as a senior Fulbright lecturer during 1992–1993.

Ann E. Moyer received the Ph.D. in history from the University of Michigan in 1987, and taught at the University of Chicago and the University of California, Santa Barbara, before accepting her current position at the University of Pennsylvania. Moyer was also a member of the Institute for Advanced Study in Princeton from 1994–1996, and has held numerous fellowships. Her scholarship focuses on the intellectual history of the later Italian Renaissance. She has published widely on the place of music in humanism and is now researching the birth of the social sciences in the period. Her books include *Musica Scientia: Musical Scholarship in the Italian Renaissance* (Cornell, 1992); *The Philosopher's Game* (Michigan, 2001); and a translation of Raffaele Brandolini's *On Music and Poetry* (*Medieval and Renaissance Texts and Studies*, Vol. 323). Originally trained as a musician, Moyer continues to read widely in the history and musicology of Western music.

Philip M. Soergel, Editor, received the Ph.D. in history from the University of Michigan in 1988, and has been a member of the Department of History at Arizona State University since 1989. There he is responsible for teaching courses on the Renaissance, the Reformation, and early-modern Europe. From 1993–1995, he was a member of the Institute for Advanced Study in Princeton, and he has also held fellowships from the Friedrich Ebert and Woodrow Wilson foundations, the American Philosophical Society, and the National Endowment for the Humanities. He has twice served as a visiting professor at the University of Bielefeld in Germany. Professor Soergel's research interests lie in the history of the Protestant and Catholic Reformations, particularly in their use of miracles as propaganda. His books include *Wondrous in His Saints: Counter-Reformation Propaganda in Bavaria* (California, 1993); the forthcoming *Miracles and the Protestant Imagination*; and the Renaissance volume in Thomson-Gale's *Arts and Humanities Through the Eras* series.

ERA OVERVIEW

ONE PERIOD, MANY DESCRIPTIONS. The seventeenth and eighteenth centuries have long been described as the culmination of the "early-modern world," a designation that calls attention to the period's role in forming the institutions, economies, and societies that we associate with the modern West. The rise of science and technology, the birth of industrial capitalism, and the appearance of new political theories that eventually inspired the French and American Revolutionaries were just a few of the many important developments in the years that anticipated the consumer-oriented, mass democracies of nineteenth- and twentieth-century Europe. At the same time the early-modern period was a curious amalgam of the old and the new, and for this reason historians have coined numerous terms and phrases in the hopes of describing its many conflicting features. Many scholars have long referred to both the seventeenth and eighteenth centuries as "Europe of the Old Regime," a phrase that draws attention to the widespread religious intolerance, economic inequities, aristocratic dominance, and political absolutism that were realities in the period. The challenge of finding a suitable terminology to describe these centuries has also led historians to separate the seventeenth century from the eighteenth that followed it. The earlier century, for example, has often been treated in ways that call attention to its many religious conflicts, its authoritarian political systems, and the generally dismal tenor of life. It has been described, for instance, as the Age of Absolutism, the Age of Religious Wars, or the Age of Confessions. Some historians have treated this same period as the "Crisis of the Seventeenth Century," or a time that was

"in search of stability." In more poetic terms, too, it has even been dubbed the "Iron Century." The eighteenth century, though, generally fares considerably better in such summations, for it has most often been called the "Age of Reason," or the "Century of Light." The fundamental disparity of these terms points to an underlying fact about the two centuries. Although many common threads link them, both periods have their own distinctive character, but a character that is hard to sum up in the description of a few words. This book primarily treats artistic and intellectual developments in these two centuries, and consequently the text engages in discussion of political, social, and economic changes only when they are necessary to illuminate cultural developments. Consequently, we have avoided those labels that call attention to political, religious, or social issues in the period, and have instead decided to opt for the title, "The Age of Baroque and Enlightenment," a title that calls attention to the two pervasive cultural movements of the age, movements that had far-reaching effects on intellectual life and the arts.

THE ORIGINS OF THE BAROQUE. Like the term "Gothic," the word "Baroque" was originally a pejorative term used to condemn the arts of seventeenth- and early eighteenth-century Europe. The word may derive from a Portuguese word *barroco* that had long been used to describe pearls that were rough and heavily encrusted with sediment. Or its origins might lie in the Italian *baroco*, a term that referred to a thorny problem in logic. Its use can be first traced to the 1730s, when it began to be used almost simultaneously to describe both music

and architecture that were heavily ornamented or overly complex. In the first century and a half after the word "Baroque" entered into European languages, it was universally applied in a negative way, a term of derision that attacked the prevalence of ornate decoration in the seventeenth and early eighteenth centuries. The origins of these judgments lay in the new spirit of neoclassicism, a more restrained movement in art and architecture that began to flourish in the mid-eighteenth century. It was not until 1888 that the art historian Heinrich Wölfflin rehabilitated the word "Baroque," treating the art and architecture of these years not as a period of decline and tasteless ornamentation, but as an age with many dynamic and positive attributes. In his *Renaissance and Baroque* he described the elements of the Baroque style. Importantly, he showed that the Baroque was not a debased or degraded form of High Renaissance art, as many had long imagined it, but was instead the product of a new aesthetic sensibility that was daring and creative. The chief elements of this Baroque style, Wölfflin argued, derived from an underlying spirit of creativity, a *Zeitgeist*, meaning literally a "spirit of the age," that had shaped the arts in Baroque Europe as definitely as a Gothic or Renaissance spirit had molded those of the periods that preceded it. Since the late nineteenth century, historians have generally discarded arguments like Wölfflin's that make use of the concept of a *Zeitgeist*, an amorphous spirit that could be said to pervade and shape artistic production in a period. Instead they have searched for the causes of an era's style in the social, cultural, and political realities of that time. But while the notion of a Baroque *Zeitgeist* may now be discredited, Wölfflin's work has continued to be important since it helped to sanction the notion of the Baroque era as a discrete time period in Europe's cultural life. Since the late nineteenth century, in other words, the notion of a Baroque era that flourished in Europe between 1600 and 1750 has only rarely been called into question, and historians have come to speak of art, architecture, and music in this period as displaying both great variety and certain common underlying characteristics.

RISE OF THE BAROQUE STYLE IN THE VISUAL ARTS AND ARCHITECTURE. In art and architecture the rise of the Baroque style can be traced to the city of Rome, and to forces that were at work there around 1600. One of the most important sources of inspiration for sponsoring this new style in the visual arts and architecture was the Catholic Reformation and its search for an art that might provide a clear and forceful statement of religious truth and at the same time stir the emotions of the faithful. Although Baroque artists were often

united in their aims of fulfilling these demands, the directions their creativity took them were still extremely varied. In Roman painting, the Baroque embraced the classical naturalism of figures like Annibale Carracci, the gritty realism of Michelangelo da Caravaggio, and the sweeping and swirling complexities of Pietro da Cortona. Somewhat later in Northern Europe, the divergent paths of the visual arts similarly produced the monumentally dramatic paintings of Rubens, and the quiet intimacy and inwardness of Rembrandt and other Dutch painters. In architecture, too, the developing style admitted both the more classically inspired works of Gianlorenzo Bernini alongside the tempestuous and willful designs of Francesco Borromini. Despites such disparities, certain common features can be seen in the new architectural monuments of the age. These included a new sense of movement in buildings, a flow that was created through curved lines and spaces that frequently invited admirers to walk around these structures. Baroque buildings were often created on a massive scale that was intended to awe the viewer; yet despite their size, a coherent unity was achieved in the best of these structures by massing many complex decorative elements to grant them a sense of dramatic climax. This new architectural language was often imposing, larger than life, and it came to be preferred by many seventeenth-century kings and princes since it gave expression to their pretensions and desires to exercise absolute authority over their states. Yet as Baroque architecture made its way from Italy to Northern Europe it also developed numerous regional variations, and frequently encountered resistance from native forces that resisted its attractions. In France, an enduring classicism inherited from the Renaissance—exemplified in Louis XIV's Palace of Versailles and other famous monuments he built in Paris around the time—discouraged the adoption of many elements of Italian Baroque style. In Catholic Germany and Austria, the Baroque style was accepted late, in large part because of the widespread devastation that occurred in the region as a result of the Thirty Years' War (1618–1648). When those troubles receded, though, the Baroque was enthusiastically accepted, particularly in Catholic central Europe, where it was often molded into a fanciful and exuberant style that frequently outdid in ornament earlier Roman monuments. Although Protestant states in Germany eventually adopted Baroque architecture for palaces and some churches, England and the Netherlands—countries heavily influenced by sixteenth-century Calvinism and the rise of a new commercial ethic—proved relatively resistant to the new style's imposing monumentality. Despite a few efforts to imitate the new Baroque fashion, a Palladian-influenced classicism adopted at the

end of the Renaissance persisted in England and the Netherlands, and an enduring faithfulness to this style eventually provided a welcoming atmosphere for the more restrained neoclassical architecture that emerged in the mid-eighteenth century. Thus the very multiplicity of architectural styles that co-existed in Baroque-era Europe points up a critical fact of the age: the increasingly diverse and heterogeneous character of the continent's various regions and national cultures. If the enormous, human-dwarfing palace of Schönbrunn just outside Vienna is a typical embodiment of Baroque Catholic absolutism, the new Town Hall of seventeenth-century Protestant Amsterdam displays an entirely different aesthetic, but an aesthetic that was nevertheless an equally important component of the Baroque era. Fashioned on a human scale and built for a society that prized commerce, republican government, and comfort as its everyday values, Amsterdam's Town Hall seems today to invite participation in public life, while the enormous spaces of Schönbrunn and Versailles at the same time express a desire to overawe the subject. By the later seventeenth century the increasingly divergent paths that religious, social, and economic changes had produced in Europe were making such contrasts between absolutist states and the new commercial and urbanized societies of places like Amsterdam, with its large class of middle-class merchants, more obvious.

THE BAROQUE IN MUSIC. In music, the production of the first operas in Florence around 1600, and somewhat later in other Italian cities, has similarly been seen as a "defining moment" in fashioning Baroque music. In contrast to the polyphonic music popular in the late Renaissance in which many musical lines were simultaneously sung or played, the new operas, cantatas, and oratorios of the emerging Baroque style often favored the solo voice. Baroque music was influenced by the Renaissance past all the same. Opera, one of the most popular of the Baroque arts, arose from the attempt of late-Renaissance humanists to recreate the dramatic intensity and power of ancient tragedies, which these scholars believed had been entirely sung. The rise of the new art at the end of the Renaissance also helped to sponsor the use of the *basso continuo*, or "figured bass" style of composition, an innovation that became one of the defining features of Baroque music. In this technique a composer wrote out the melody line and the lowest note of the accompanying bass. Through notated figures entered above the bass tone, the accompanying ensemble, keyboard, or lute player, derived the other notes that accompanied the melody in chords. This use of basso continuo first flourished in opera, but soon it was almost

universally adapted in the ensemble instrumental music of the Baroque era. And although operas began primarily as an elite pastime in Italy's courts, they soon escaped from those rarefied circles to become one of the era's most popular urban entertainments. New commercial opera houses appeared, first in Italy, but relatively quickly in northern Europe. But just as was the case in the visual arts and architecture, not every country was seduced by the new Italian medium. England resisted Italian opera until very late, although attempts were made by native composers like Henry Purcell to nourish the development of a native form. Somewhat later, Georg Frideric Handel presented successful Italian operas in London, but after laboring for more than twenty years to establish the art form as a permanent force on the city's scene, he gave up. London's rise to become one of the world's great capitals of the art was to be postponed until the nineteenth and twentieth centuries. In France, Italian opera was similarly resisted, despite the attempts of Louis XIV's Italian-born minister Cardinal Mazarin to nourish its development in the 1650s. With his death in 1661, Italian opera withered on the vine in France, until another Italian-born but French-influenced composer, Jean-Baptiste Lully, fashioned a native French form of the art in the 1670s that was widely admired at court. This new French form eventually spread to other parts of Europe, where it competed against Italian opera, although it was never successful in overtaking the latter. In most places, particularly in central Europe, Italian opera remained the clear leader throughout the eighteenth century, so much so that Mozart and other late eighteenth-century composers continued to write more works in Italian than in their native languages.

OTHER MUSICAL FORMS. Opera was perhaps the most quintessentially Baroque form of music since, like the era's architecture, it satisfied a taste for imposing, monumental drama, and in its fondness for spectacular arias it nourished the age's fascination with complex patterns of ornamentation and elaboration At the same time, the musical genres and styles of the Baroque were as varied as those evidenced in architecture and the visual arts. Great regional and national variations developed in Baroque-era music, most notably between the patterns of music composed and in the performance practices used in Italy and in France. But everywhere, native schools of musical composition and performance flourished, so much so that the performance practices of northern Germany were often very different from those of the south and from Austria. While operas, oratorios, and cantatas satisfied the taste for vocal music that made use of tuneful, ornamented melodies, the old polyphonic

music of the Renaissance did not die out. The polyphonic tradition, sometimes called the "old style" (*stile antiche*), persisted, and inspired some of the greatest musical writing of the age, including the fugues and polyphonic chorales of Johann Sebastian Bach, works that might be seen as the finest expression, and in many ways the culmination, of the lingering tradition of Renaissance polyphony. In music the Baroque era thus saw the persistence of the old, as well as the rise of the new, and it was these two factors working in tandem that inspired the great vitality of the art in this age.

THE LITERARY BAROQUE. While scholars have long seen certain parallels between the visual arts, architecture, and music of the era between 1600 and 1750, it remains considerably more difficult to classify European literature of this period as "Baroque." In literature, the expansion and stylistic developments of the national languages continued apace in the seventeenth century. In most places, the triumph of native literature over the neo-Latin poetry and prose of the later Renaissance had already been assured by 1600. At the same time the styles and rhetoric that flourished in England, France, Germany, Italy, and Spain were so various and divergent that a common classification of them as "Baroque" often seems meaningless. In every country the seventeenth century saw the vigorous publication of devotional texts as well as newer forms of secular verse, fiction, and journalism; the steady increase in these secular genres continued in the eighteenth century. While some attempts have been made to classify certain writers of the era—figures like Martin von Opitz in Germany, Giambattista Marino in Italy, or John Donne in England—as "Baroque poets," the lack of a common thread of style that was shared by these figures, and between them and other writers of the era, has discouraged the effort to establish a notion of a European "Baroque literature." In France, classicism, an effort to establish clear and distinct rules for the writing of prose and poetry based upon the models of the ancients, dominated many authors' styles. In England, the later seventeenth century saw the appearance of the Augustan style, a clear, lucid, and relatively unadorned form of expression that continued to flourish throughout most of the eighteenth century. Thus the dynamics of literary production in much of Europe ran counter to the Baroque aesthetic sensibility, with its fondness for ornamentation, drama, and complexity.

THE ROLE OF SCIENCE. The façades of Baroque palaces or churches may have presented to their viewers a vision of a secure, unchanging, and assured worldview, yet behind such structures, profound forces of change were transforming life and thought in early-modern Europe all the same. The great questions of the age asked philosophers and intellectuals to harmonize the received wisdom of Christianity and ancient learning with the newer insights derived from the developing Scientific Revolution. Copernicanism, with its powerful model of a sun-centered universe, was just one of the many challenges that the new science posed to Western thinkers in the seventeenth century. The rise of the new discipline often proceeded in fits and starts. Copernican theory, for instance, found its first great exponent in the figure of Galileo Galilei, who fashioned proofs for the sun-centered solar system through the revolutionary act of experimentation: he peered through the lens of a telescope. But the astronomer's condemnation by the Inquisition in 1633 stunted the acceptance of Copernicanism for almost another two generations. When Isaac Newton returned to the problem, and provided a set of proofs for the laws of gravity and centrifugal motion in his *Principia* (1687), the heliocentric theory came rather quickly to be favored in intellectual circles throughout Europe. Newton, like Galileo before him, saw no contest between his Christian beliefs and his bold new portrait of a universe held together by a balance of opposing, mechanistic forces. But those that followed him were soon to see the cracks that Newton's brave, new world was revealing in the traditional, Christianized view of the cosmos. For the first time in European history, it had become possible to envision the world as a product of purely automatic forces rather than as a system held together by the efforts of a beneficent deity. Could this new view of the physical universe be harmonized with the long-standing Christian notion that the earth and the stars had been fashioned for the purpose of enacting a human drama of sin and redemption? This and similar questions prompted philosophers and religious thinkers to reassess the traditional Christian worldview. And in turn, these questions inspired the development of new religious movements like Deism, which taught that God could be known through His works in nature, and that although he had fashioned the universe's system, He had now left humankind to enjoy and manage His Creation. For most of the eighteenth century most philosophers and intellectuals still tried to find ways to harmonize Christianity with the new scientific discoveries, although science had now, for the first time in human history, opened up the possibility of atheism as an intellectually respectable option to religious belief. Although denying the existence of God remained a minority position among intellectuals throughout the eighteenth century, the new mechanical view of the universe nourished a secular spirit all the same, a spirit in which the traditional

structures, doctrines, and religious practices of Europe's churches could seem increasingly irrelevant to the educated. As a result, society and politics now were examined in many cases without the traditional lenses of Christian theology. It is no coincidence that the age that saw the publication of Newton's *Principia* also produced John Locke's powerful new vision of politics freed from traditional Christian moral considerations. Instead of concentrating on the state of human nature as wickedly depraved by sin, Locke expressed a newfound faith in the fundamental goodness of the individual, in the virtues of human freedom, and in the values of hard work—ideas that placed him, despite his professed Christian orthodoxy, firmly in opposition to the traditional church. His views concerning human psychology and of the politics human beings might produce in a society where greater freedom could flourish were very different from those that had long been nourished by the Christian notion of Original Sin, a force that theologians had persistently argued doomed all efforts to improve society. Locke's ideas proved to be every bit as revolutionary as Newton's, although he was just one of the first of a number of figures that championed the new notion of human perfectibility.

CHANGING NATURE OF EIGHTEENTH-CENTURY SOCIETY. Yet other changes underway in eighteenth-century society stretched far beyond the confines of circles of philosophers and scientists like Newton and Locke, and these transformations helped to create an audience for the developing ideas of the Enlightenment, the great European-wide intellectual movement that aimed at the reform of society along the lines promoted by human reason. Throughout the eighteenth century Europe's economy continued the rapid expansion that had begun in the final quarter of the seventeenth, and although this growth occurred unevenly across the Continent, it produced rapid urbanization almost everywhere. Vast numbers of the poor were to be found in the swelling cities of the era, but Europe's commercial success and its incipient industrialization was creating a larger middle class than ever before, many of whom lived off invested capital and thus possessed significant leisure to pursue their interests. Alongside the new pleasure gardens, variety theaters, and other amusements that Europe's cities now had on offer, reading and the intellectual discussions it fostered played a greater role in urban society than ever before. In this new urban landscape the coffeehouse was one of the most universally popular features, particularly among those who possessed leisure to enjoy reading and discussion. Informed men poured into the new coffeehouses, where they gathered to read the latest news and commentary upon the issues of the day, and to discuss their ideas while they smoked tobacco and drank Europe's newest exotic beverage import. In London, Paris, and other cities throughout the continent, journals and newspapers appealed to this new social set and the traffic in ideas—witnessed in the rise of journalism as a profession—had now become a commodity in an increasingly consumer-oriented age. These transformations left their imprint on the literature of the period. The emergence of new groups of "middle class" readers, for instance, forged an audience for the ideas of Enlightenment thinkers, the great public intellectuals of the day, even as they nourished a new taste for the everyday concerns of the "bourgeois" dramas and novels of the period. The rise of this audience also influenced the fashions and art of the era, helping to sponsor the popularity of Neoclassical domestic architecture, interior design, decorative arts, and clothes that expressed the developing sensibilities of the age for clarity, restraint, and a relief from the authoritarian formalism of the Baroque age.

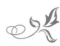

CHRONOLOGY OF WORLD EVENTS

By Philip M. Soergel

1598 In France, Henri IV promulgates the Edict of Nantes, a decree granting French Calvinists or Huguenots a limited degree of religious toleration.

Philip II, who ruled over vast territories in the New and Old Worlds, dies in Spain.

1600 The British East India Company is chartered to undertake trade with the Far East.

In Japan, the shogun Tokugawa Ieyasu defeats Itshida Mtsunari at the Battle of Sekigahara, preparing the way three years later for the rise of his own Tokugawa Shogunate, the beginning of the so-called Edo period in Japanese history.

1602 The Dutch East India Company is established in the Netherlands, with six offices in the country's major trading cities.

The English explorer Bartholomew Gosnold is the first European to discover Cape Cod in North America.

The English explorer James Lancaster sails into Achin harbor with the English East India Company's fleet on the island of Sumatra.

1603 In England, Elizabeth I dies and is succeeded by James VI of Scotland. A mem-

ber of the Stuart dynasty, he will rule England as James I.

The first performance of Kabuki theater occurs in Japan.

In the Ottoman Empire, Ahmed I succeeds Mehmed III. Ahmed will conduct unsuccessful campaigns in Eastern Europe, and eventually retire to a life of pleasure, a path that will prove detrimental to the empire's presence on the international scene.

1604 Guru Arjan sets down the Sikh religion's scriptures.

French settlers establish their first successful colony at Acadia in North America, as well as a settlement in Guiana on the northern coast of South America.

The Spanish explorer Luis Vaez de Torres becomes the first European to sail through the Torres Strait, the gulf of water that separates modern New Guinea from Australia.

1605 In England, the Gunpowder Plot is uncovered. This alleged Catholic plan aimed to blow up the Houses of Parliament in Westminster when the king and members were present. Anti-Catholic sentiment

grows in England as a result of the foiled plot.

Polish troops occupy Moscow. For the next seven years, Poland will try to determine the course of events in Russia.

1606 The Treaty of Zsitva-Torok ends the war between the Ottoman Empire and the Austrian Habsburgs.

1607 The Jamestown settlement is established in Virginia. Although the first years of the colony will be difficult, the settlement will manage to survive.

England's Popham Colony is established in what is present-day Maine; it fails after one year.

1608 The first telescope is invented by Hans Lippershey, a maker of lenses from the Netherlands.

The first official representative of the English crown arrives at Surat, in the western Indian territory of Gujarat.

Samuel Champlain founds Quebec, the oldest still-existing European settlement in North America.

1609 The Italian astronomer Galileo performs the first observations of the revolution of the planets with the aid of a telescope.

The English explorer Henry Hudson is the first European to sail into Delaware Bay.

1610 The Jesuit missionary Matteo Ricci dies in China, after having translated many ancient European classics into Chinese.

In France, the Catholic fanatic Ravaillac assassinates Henri IV, hoping to set off a reaction against the crown's policy of toleration of the Protestant Huguenots. Instead, Henri's wife, Marie de' Medici, assumes power as regent, and France's state successfully weathers this crisis.

1611 In Japan, the Emperor Go-Yozei abdicates in favor of Go-Mizunoo. During Go-

Yozei's reign, the first presses using movable type were brought to the country.

The Authorized Version of the Bible, popularly known as the King's James Version, appears in England.

1612 In Russia, the gentry rebel against Polish rule, touching off a civil war that will end one year later with the election of Michael Romanov as czar. He will establish the Romanov dynasty that will endure until the 1917 Revolution.

1614 The Native American Pocahontas marries the Virginia settler John Rolfe, establishing a generation-long peace between English settlers and natives in the colony.

In France, the Estates General, the country's parliament, meets for the last time until the onset of the Revolution in 1789. In the coming decades, France's kings will successfully establish their absolute authority over the political life of the country.

1615 The Japanese shogun issues the Boku Shohatto, a code of conduct aimed at regulating the behavior of the country's aristocrats.

1616 Nurhachi becomes leader of the Manchus and begins a series of invasions into China; within five years, he will control much of the northeastern part of the country.

1618 The Thirty Years' War begins in Central Europe. The conflict is produced by the still lingering religious controversies of the Reformation and Counter-Reformation, and the devastation that the war brings will soon lay waste to much of Germany.

Aurangzeb, last of India's great Mogul emperors, assumes the throne. His reign will be noteworthy for its intolerance of Hinduism.

1619 In colonial Virginia, the House of Burgesses, colonial North America's first representative assembly, meets for the first time.

The first slaves appear in England's New World colonies.

England establishes its first colonial outpost in India.

1620 The Pilgrims establish Plymouth Colony in North America. By the end of the first winter, almost half of all the English settlers there will have died.

Protestant defeat at the Battle of White Mountain outside Prague paves the way for the re-catholicization of Bohemia by the Habsburgs.

1622 One-third of all English settlers are killed in the "Jamestown Massacre" in Virginia.

The French explorer Étienne Brûlé is the first European to visit Lake Superior.

1623 Murat IV is installed as the Ottoman emperor following a palace coup that displaces Osman II. In the early years of his reign, his mother will dominate government, but in 1630, Murat will seize control and begin a campaign against governmental corruption.

England establishes a colony on the Caribbean island of St. Kitts.

In Baghdad, the Turkish tribe of the Safavids regains control of the city and surrounding region.

1624 The Dutch establish a trading colony on the island of Taiwan at Kaohsiung.

1625 The Dutch trading center of "New Amsterdam" is chartered on the site of the future city of New York.

1626 Spain establishes a trading colony on the island of Taiwan.

1628 Salem Colony is founded north of what is the modern city of Boston. One year later, the Massachusetts Bay Colony will found the city of Boston.

In England, William Harvey publishes his findings confirming the circulation of blood.

1629 Woman performers are banned from the Kabuki theater in Japan on moral grounds.

1632 In India, the Mogul Emperor Shahjahan begins the construction of the Taj Mahal as a memorial to his deceased wife, Mumtaz Mahal.

The Caribbean islands of Antiqua and Barbuda are first colonized by the English.

1633 Galileo is forced to recant his support for the heliocentric theory of Nicholas Copernicus after an inquiry conducted by the Inquisition.

Ethiopian leader Negus Fasilidas expels foreign missionaries from that African country.

1634 In France, the first meetings of the French Academy, an institution organized by Cardinal Richelieu with the intentions of standardizing literary French, are held in Paris.

King Ladislaus IV of Poland defeats the Russian army at the Battle of Smolensk.

The first English settlers arrive in the new colony of Maryland under the leadership of Lord Baltimore.

1635 The Caribbean islands of Guadaloupe and Martinique are first settled by the French.

1636 The Puritans establish Harvard College at Cambridge near Boston.

1637 France sends its first missionaries to the Ivory Coast in Africa.

1638 The Ottoman Emperor Murat IV captures Baghdad from the Safavids; as a result of the treaty concluding these hostilities the boundaries between Iran and the Ottoman Empire (modern Turkey) are firmly fixed.

Spanish explorer Pedro Texeira sails up the Amazon River and travels as far as Quito, Ecuador.

English sailors shipwrecked in Central America found the settlement of Belize.

The first settlers arrive in New Sweden, the modern state of Delaware.

The Dutch found a trading colony on the island of Mauritius in the Indian Ocean.

1639 The Japanese shogunate closes the borders of the country to all outsiders, the most extreme measure taken yet to protect Japan from Western missionaries and traders. Only the Dutch are allowed to remain in the country.

In Scotland, Archbishop William Laud's plans to establish an episcopal governmental structure over the Church of Scotland precipitate the Bishop's War.

Russian forces cross the Urals, continuing their campaign of conquest to the Pacific Ocean at Okhotsk.

The colony of Connecticut adopts its first written constitution.

1640 The Ottoman Emperor Murat IV dies and is succeeded by his brother Ibrahim the Mad. Ibrahim suffers from depression and is overshadowed by his mother for a time. Eventually he rallies, though, to conduct unsuccessful wars against the Republic of Venice.

The first book is printed in colonial North America at Cambridge, Massachusetts.

In England, Charles I calls the "Short Parliament," a meeting that lasts only a month. After realizing the dire state of his finances, though, he reconvenes Parliament in the same year. This "Long Parliament" will eventually sit for almost two decades, and its members will sentence the king to his death in 1649.

1641 Dutch traders establish a colony at Dejima in Japan.

In the same year, Dutch forces also seize the colony of Malacca in modern Malysia from Portugal.

1642 The Dutch explorer Abel Tasman and his crew are the first Europeans to see the islands of New Zealand and Tasmania.

In France, Blaise Pascal invents the "Pascaline," history's first adding machine.

French settlers found the city of Montreal in Canada.

1644 In China, the Manchus overthrow the Ming Dynasty and establish the new Qing lineage, a government that will make major colonial expansions into Central Asia.

In Japan, Miyamoto Musashi, one of Japan's greatest samurai swordsman, dies. In the year proceeding his death, Musashi retired and lived as a hermit, writing the classic text, *The Book of Five Rings*, a meditation on his career and philosophy.

1645 The Chinese rebel Li Zicheng dies, either from assassination or suicide. Li Zicheng led a rebellion that helped to bring down the Ming Dynasty, but with the rise of the Manchus to power, his forces were defeated.

The Maunder Minimum, a solar phenomenon later discovered by the astronomer E.W. Maunder, begins. During the seventy years following 1645, sunspots became extremely rare, depressing the world's temperature even further during this time in the "Mini-Ice Age," the coldest period in recorded history that lasted from the fifteenth to the early eighteenth century.

In England, Parliament outlaws use of the Book of Common Prayer in the country's national church.

1648 The Peace of Westphalia is signed in Münster, Germany, bringing to a close the Thirty Years' War. The terms of the Peace recognize Calvinism as a legal religion, but uphold the principle that Germany's territorial rulers may define the religion of their subjects. The separate Treaty of Münster signed at the same time by the Netherlands and Spain finally recognizes Dutch independence and ends 80 years of war between the two powers.

In Paris, the Fronde, a rebellion waged by French nobles and prominent urban fac-

tions, begins. Although the movement is eventually suppressed, it will color the young king Louis XIV's attitudes toward the aristocracy.

Mehmed IV ascends the throne as Ottoman Sultan. During his reign, he will concentrate most of his efforts on hunting.

In Paris, the rebellion of the Fronde begins among the nobility and members of the city's Parlement or representative body. The rebellion will last for almost five years, and will, on one occasion, force the king and his family to leave the city.

1649 In England, Stuart King Charles I is executed by Parliament. In the years that follow, the country will be ruled by a Puritan Commonwealth, over which the Protector Oliver Cromwell will eventually assert forceful control.

1651 The English political theorist Thomas Hobbes publishes his *Leviathan,* a work that supports a strong ruler as an antidote to the aggressive nature of humankind.

The English scientist William Harvey lays the foundations for modern embryology through his *Essays on the Generation of Animals.*

The Battle of Beresteczko is fought in the Ukraine between native forces and the Poles. It is perhaps the largest battle ever waged in the seventeenth century. Although the Poles are massively outmanned by Ukranian forces, they manage to win when the Ukrainian's allies, the Tatars, abandon the battlefield.

1652 The Dutch East India Company establishes a center for resupplying their ships near the Cape of Good Hope in southern Africa.

The English colony of Rhode Island becomes the first in North America to outlaw slavery.

The first Anglo-Dutch War begins between England and the Netherlands when

Parliament passes measures outlawing the importation of goods into the country except in ships that are English-owned. This trade dispute precipitates tensions between the Dutch and English that will worsen over the coming decades.

Young boy performers are banned from the Kabuki theater in Japan on moral grounds. From this point onward, this form of theater will become male-dominated and will develop into a highly stylized and artificial form of drama.

1654 The rebel Bohdan Chmielnicki leads a revolt against Polish forces in Ukraine. To assure their territory's security, the revolt's leaders sign a treaty with Moscow that will eventually lead to their region's annexation into the Russian Empire.

1655 Emperor Go Sai ascends the throne in Japan.

New Sweden (modern Delaware) is seized by Dutch forces.

1656 Masuria, a region in modern northeastern Poland, is laid waste by marauding hordes of Poles and Tatars. This attack is one of the worst blows during the "Deluge," a period of troubles in Poland in which the country came to be devastated by a series of external invasions. As a result, the region's population declined by as much as a third.

1660 The "Long Parliament" is disbanded in England and the Stuart heir Charles II is restored to the throne.

1661 King Charles II of England marries Catherine Braganza of Portugal. As part of Catherine's dowry, she brings the colonies of Bombay and Tangiers, which become English colonies.

The Dutch abandon their colony on Taiwan, after the Qing dynasty invade the island.

1662 Charles II founds the Royal Society in England; this institution will be a major

force in popularizing the Scientific Revolution among the country's intellectuals.

In China, Emperor K'ang Hsi assumes the throne at the age of eight. The fourth in the line of Manchu emperors, he will eventually become a great statesman, scholar, and warrior.

1663 Queen Nzinga of Ndongo and Matamba, territories in southwestern Africa, dies. During her long life, she had attempted to limit the depredations of the slave trade in her lands by negotiating treaties with the Portuguese, converting to Christianity, and, when necessary, conducting skillful military campaigns against the traders.

1664 The Netherlands surrenders New Amsterdam (modern New York) as well as other New World colonies to the English.

1665 The last outbreak of the plague in Western Europe strikes London. One year later, much of the city will be destroyed by the Great Fire.

Portuguese forces kill King Garcia II of the African state of Kongo (modern Angola), ending that country's independence.

1667 Poland gives up control of Smolensk, Kiev, and Ukraine to Muscovy. From this date forward, these possessions will become integral parts of the Russian empire.

1668 The English East India Company takes control of the port of Bombay in India.

1669 In India, the Mogul Emperor Aurangzeb bans Hinduism and burns several temples, inciting a rebellion.

Famine in the northeastern Indian state of Bengal claims as many as three million lives.

1670 King Charles II charters the Hudson Bay Company to undertake trade with native Americans in Canada in all those regions where the rivers flowed into the great bay.

England assumes control over the island of Jamaica in the Caribbean.

1672 Forces of Louis XIV's France invade the United Dutch Provinces, touching off the "Dutch War."

The future Peter the Great, czar of Russia, is born.

Charles II issues the Royal Declaration of Indulgence in England, granting toleration to Catholics and Protestant Dissenters. The measure is opposed by Parliament, and the king is eventually forced to negate it.

Simon Dezhnev, a Russian cosack and explorer who was the first to navigate the Bering Strait, dies.

1673 In Japan, the Kabuki actor Sannjuro Ichikawa invents the Arigato style, which features the central character of masculine, superhuman war god.

Father Marquette and Louis Joliet explore the Mississippi River in North America.

The Mitsui family founds a banking and trading house in Japan.

1674 Jan Sobieski is elected to serve as King John III of Poland after having waged successful battles against the Ottoman Empire.

Father Marquette founds a mission on the banks of Lake Michigan at the site of the future city of Chicago.

1676 The Danish Astronomer Ole Romer conducts the first measurements of the speed of light.

Feodor III becomes czar of Russia. Sickly and childless, he will rule for the next six years largely from his bed.

1677 In England, Elias Ashmole makes a gift of manuscripts and books to the University of Oxford that will become the Ashmolean Library, one of the world's great research institutions.

The Dutch scientist Anton van Leuwenhoek observes human sperm under a microscope for the first time.

1679 In North America, the French priest Louis Hennepin discovers Niagara Falls while sailing on the Great Lakes.

The French inventor Denis Papin creates the first "pressure cooker," a discovery that will be useful as later European scientists try to capture the power of steam.

1680 King Sivaji, ruler of the Maratha kingdom in western India, dies after a life spent conducting wars against the Mogul rulers of the subcontinent.

The first Portuguese governor is appointed to control the trading colony of Macau in China.

1681 Charles II gives a grant of land to William Penn to develop as a colony; it will later become known as Pennsylvania, "Penn's Woods."

France seizes the city of Strasbourg in Germany.

1682 The Palace of Versailles outside Paris is officially named the home of France's government.

Peter the Great and his brother Ivan V become co-rulers of Russia.

Ihara Saikaku publishes *The Life of An Amorous Man*, a work that initiates a new genre of fiction that treats the concerns of commoners.

1683 The city of Vienna is besieged by an enormous force of the Ottoman Empire. Three months later, the siege is broken when reinforcing Polish, German, and Austrian troops arrive, and sent the Ottoman forces packing. The victory marks a turning point in the war, as Austria begins to repel the Turks from Eastern Europe.

1684 After the assassination of his chief minister, Hotta Masatoshi, the Shogun Sunayoshi's government flounders. Sunayoshi's impractical pronouncements and laws create grave hardships for the Japanese people.

China grants the English East India Company the right to establish a trading colony at Canton.

1685 Louis XIV of France revokes his country's Edict of Nantes, forcing Protestant subjects to convert to Catholicism or go into exile.

In Germany, a change of succession in the Rhineland Palatinate forces the conversion of this important territory from Calvinism to Catholicism. Just as in France, many German Calvinists will immigrate over the coming years to northern Germany, England, and North America.

1687 Isaac Newton's *Principia* appears. It explains the concepts of gravity and centrifugal force, thus resolving the controversy that has long raged about Copernicus' heliocentric theory.

The French explorer Robert La Salle is killed by his own men while searching for the source of the Mississippi River in North America.

1688 The Catholic James II is forced from the English throne; one year later, Parliament will call his daughter Mary and her husband William from Holland to serve as co-regents in the so-called Glorious Revolution.

Louis XIV declares war on Holland and invades the Holy Roman Empire, hoping to conquer the Rhineland for France.

The one-time pirate turned English explorer William Dampier is the first European to discover Christmas Island in the Pacific.

In Japan, the Genroku Era, a period of great achievement in the arts and popular culture, begins.

1690 The Battle of the Boyne occurs in Ireland between supporters of James II, the deposed Stuart King, and his son-in-law, William III, who is now king of England.

The Ottoman sultan Suleiman II is killed in battle against Habsburg forces while trying to retake Hungary.

1692 In colonial Massachusetts, the Salem Witch Trials begin, a generation after such persecutions have stopped in Europe.

1693 The College of William and Mary, the second English institution of higher education to be established in North America, is founded at Williamsburg in Virginia.

The Ottoman emperor Mehmed IV dies. He was responsible for waging a number of costly, and ultimately unsuccessful, campaigns to extend Ottoman authority into Eastern Europe and the Eastern Mediterranean.

The Academy of Hard-Working Fellows, an organization dedicated to scientific study, is founded in Slovenia.

1695 Mustafa II becomes the sultan of the Ottoman Empire, beginning an eight-year reign that will end in his being deposed by his brother.

1696 Peter the Great becomes the sole czar of Russia following the death of his brother, and co-regent Ivan V. Peter will embark on an ambitious plan of Westernization.

John III of Poland dies after a generally successful reign in which he helped to reclaim some of the country's former glory through military successes.

1697 The Ottoman emperor Mustafa II attempts to turn back the advance of the Austrian Habsburgs in Eastern Europe by trying to recapture Hungary. Two years later, he recognizes defeat when he cedes control over both Hungary and Transylvania to Austria.

Spain conquers Tayassal, the last independent native state in Central America.

1698 In Russia, Peter the Great imposes a tax on men who wear beards.

The English inventor Thomas Savery patents a steam engine capable of pumping water out of mines.

Prince Constantin Brâncoveanu of Moldavia and Wallachia names the city of Bucarest his capital in what is now modern Romania.

Arabs wrest control of the city of Mombasa, in what is now southeast Kenya, from the Portuguese.

1699 The first French settlement is founded on the Mississippi River in North America at Biloxi.

The Treaty of Karlowitz concludes hostilities between Austrian and Ottoman forces, bringing to an end Ottoman incursions into Eastern Europe.

In India, the tenth Sikh master, Guru Gobind Singh, establishes the rite of Amrit, a baptism for followers of the religion, a radical sect that practices complete social equality among its members.

After a gruesome 33-month siege, the Portuguese Fort Jesus at Mombasa is surrendered to the Sultan of Oman. Within the next two years, the Portuguese presence on the east coast of Africa will disappear.

1700 The Great Northern War breaks out when Russia, Denmark, Poland, and Saxony declare war and invade Sweden. In the Battle of Narva in the same year, King Charles XII of Sweden will defeat the forces of Peter the Great of Russia.

1701 The death of the Spanish king Charles II without an heir touches off the War of the Spanish Succession. One of the first truly international wars in which trade and merchant interests come to dominate, it eventually involves most major European powers, and is fought, not only in Europe, but in the North American colonies, too.

The French colony of Detroit is founded in what is modern-day Michigan.

The Hanoverian Queen Anne succeeds to the throne of England, and Parliament passes the Act of Succession stipulated that the English monarch must be a Protestant.

Yale College is founded at New Haven, Connecticut.

1702 In Japan, 47 ronin, samurai warriors, commit suicide after avenging the unjustified ritual suicide forced upon their leader. The event will come to sum up the epitome of the samurai's code of bushido or loyalty.

1703 In Russia, Peter the Great founds the city of St. Petersburg; his ambitions are to open up Russian life and culture to influences from Western Europe, and the city will eventually become one of the most beautiful in European Russia.

In the Ottoman Empire, Ahmed III rises to power following the abdication of his brother, Mustafa. Ahmed cultivates good relations with England as a counter to the encircling threat that he feels from Russia.

1704 Native Americans invade the settlement of Deerfield, Massachusetts, killing its inhabitants.

In Japan, the Genroku Era, known for the brilliance of its popular culture, draws to a close.

The British Duke of Marlborough wins the battle of Blenheim and seizes the Rock of Gibraltar from the Spanish.

1705 The British astronomer William Halley predicts the return of the famous comet that has since that time born his name.

1706 The American patriot and revolutionary Benjamin Franklin is born in Boston.

The great philosopher Pierre Bayle, who was a source of inspiration for the subsequent Enlightenment, dies in exile from France at Rotterdam.

1707 The Act of Union joins Scotland and England into the United Kingdom.

1708 In the Polish province of Masuria as much as one third of the population die in an outbreak of the bubonic plague.

The city of Kandahar in modern Afghanistan is conquered by the Afghan leader Mir Wais.

In China, Jesuit missionaries complete the first accurate map of the country.

1709 Czar Peter the Great of Russia defeats Sweden at the Battle of Poltava, bringing the Scandinavian country's period of international greatness to an end.

1712 Peter the Great moves his capital to his newly created city of St. Petersburg.

1713 The Treaty of Utrecht ends the War of the Spanish Succession and the legitimacy of the Bourbon monarchy in Spain is upheld. Spain cedes the Netherlands to the control of the Austrian Habsburgs, while several New World colonies of France in Canada are transferred to Great Britain.

1714 The Elector of Hanover ascends to the English throne as George I; during much of the Hanoverian period that follows the Whig party will control English Parliament, and will continue to advocate a thoroughly constitutional monarchy.

Chikamatsu Monzaemon, known as Japan's Shakespeare, dies.

France receives the island of Mauritius in the Indian Ocean from the Dutch.

1715 King Louis XIV of France dies, ending a 72-year reign. He is succeeded by his grandson Louis XV. Philippe d'Orléans, the boy's uncle, serves as regent for the five-year old king.

The future Peter II, the grandson of Peter the Great, is born in Russia.

1716 The first dictionary of the Han form of the Chinese language appears under the

title, *The Kangxi Dictionary*; it is named for the Qing Emperor Kangxi.

In Japan, the Kyoho reforms begin. These measures are designed to make the shogunate more financially responsible by accommodating commercial enterprises within a traditional Confucian ethic.

1717 Portuguese colonists began to settle near the modern city of Montevideo in Uruguay.

The future Marie-Theresa of Austria is born.

1718 The Treaty of Passarowitz is signed between Austria, Venice, and the Ottoman Empire. Venice loses certain possessions in the eastern Mediterranean, while Turkey cedes parts of Bosnia and Serbia to Austria.

In London, James Puckle receives a patent for the first machine gun.

Blackbeard the pirate is killed in a naval battle with the English off the coast of colonial Virginia.

1719 In England, the South Sea Company's stock climbs to new unprecedented heights. The company has been charged with developing trade with South America, and the price of its stock rises to hitherto unheard of heights. Within a few years, though, the South Sea bubble will have burst, and its shares will be worthless.

In Paris, the Scottish financier John Law develops a similarly popular scheme for the development of the Mississippi territories. Law succeeds in enriching a number of Parisian aristocrats and members of the bourgeoisie before the city's investors sour on the plan.

1722 Hyder Ali, an Islamic warrior who will prove to be the most successful challenger of British authority in India, is born.

The French settlers begin to colonize Mauritius.

1724 The Treaty of Constantinople partitions Turkey, with Russia and the Ottoman Empire dividing the territory.

1725 The first reported case of a European scalping Indians is recorded in the New Hampshire colony in North America.

1726 Spain establishes the city of Montevideo in Uruguay in an effort to discourage Portuegese settlers from colonizing the region.

1727 The Hanoverian King George I dies and is succeeded by his son, George II, who will rule until 1760.

The Czarina Catherine I dies in Russia.

The first coffee plantation is founded in Brazil.

1729 Portuguese forces briefly occupy the city of Mombasa again before losing it to Arab forces.

Diamonds are discovered in Brazil.

1730 In Turkey, Mahmud I becomes sultan of the Ottoman Empire. His reign, which will last until 1754, will be marked by frequent wars with Russia over Persia.

1732 James Oglethorpe establishes the colony of George in colonial North America with the intention of providing refuge to debtors.

1734 After a long siege Russian troops succeed in taking possession of the port of Danzig on the Baltic.

In colonial North America, the Great Awakening, a religious revival that had begun the previous year in the town of Northampton, Massachusetts, is spreading through the colonies.

Frederick Augustus II, the Elector of Saxony, is named King of Poland with the support of Russian and Austrian troops that are in attendance.

1735 Nadir Shah, the advisor to the Persian Safavid ruler, defeats forces of the Otto-

man Empire and captures Tiflis, modern Tbilisi, in Georgia.

1736 Nadir Shah deposes the last of the Safavid rulers of Iran and installs himself as shah.

The properties of rubber are discovered in Peru.

1739 Nadir Shah of Iran invades India, capturing Delhi and Lahore and carting off vast treasures from the country. In the years that follow he extends Iran's boundaries to their largest extent. The Great Northern War breaks out when Russia, Denmark, Poland, and Saxony declare war and invade Sweden. In the Battle of Narva in the same year, King Charles XII of Sweden will defeat the forces of Peter the Great of Russia.

1740 The War of the Austrian Succession begins when Maria Theresa becomes Empress of Austria. King Frederick II, refusing to recognize her claim to the throne, seizes Silesia, thus precipitating the eight-year war between Austria and Prussia. Within a year, all of Europe's most important powers will become involved in the conflict.

1743 The English King George II defeats French forces at the Battle of Dettingen, a crucial engagement in the War of the Austrian Succession.

1745 Francis I is elected Holy Roman Emperor through the offices of his wife, the Empress Maria Theresa of Austria.

British forces of King George II defeat the French on Cape Breton Island and seize Fort Louisbourg. It will be returned to France at the conclusion of the War of the Austrian Succession in exchange for holdings France seized in Madras, India.

1746 The brutal battle of Culloden ends the Jacobite Rebellions in Scotland. In the years that follow, England begins repressive measures to suppress the clan system in the Scottish highlands.

In colonial North America, the College of New Jersey is founded by Presbyterians.

It will eventually become known as Princeton University.

The Mazrui dynasty at Mombasa, in what is now modern Kenya, establishes its independence from the Sultan of Oman.

1748 The Treaty of Aix-le-Chapelle concludes the War of the Austrian Succession. The provisions recognize Maria Theresa's right to her Austrian lands, but she is forced to cede certain Italian territories. Prussia is allowed to retain Silesia.

1753 French settlers begin to move into the Ohio River Valley in North America. Their presence will help to produce the French and Indian War that begins one year later.

1755 A massive earthquake strikes Lisbon, Portugal.

In North America, General Braddock is unsuccessful in wresting Fort Duquesne near present-day Pittsburgh from the French.

A massive smallpox epidemic in southern Africa almost completely obliterates the Khoisan people.

1756 The Seven Years' War breaks out and eventually gives births to two alliances: Prussia, England, and Hanover waged war against France, Sweden, Russia, and Austria. It is sometimes called the first "world war," because it is fought extensively in Europe's colonial outposts as well as on the continent.

The Nawab of Bengal seizes Calcutta from the British East India Company and imprisons 146 people in an airless room. By the next morning, most are said to be dead. The exploitation of the story throughout the English-speaking world is used in the coming years to portray Indians as base and tyrannical.

Wolfgang Amadeus Mozart is born in Salzburg, Austria.

1757 Robert Clive commands forces of the British East India Company to victory

over Nawab of Bengal at the Battle of Plassey.

Frederick the Great of Prussia defeats French and Austrian forces at the Battle of Rossbach during the Seven Years' War that pits Austria and France against Prussia and England.

1759 The British General Wolfe captures the French Canadian cities of Montreal and Quebec during the French and Indian War. Later in the same year, he and his French adversary, General Montcalm, will die as a result of wounds they received in battle.

The first life insurance company is established in Philadelphia in North America.

1760 King George III begins a sixty-year reign in England with decisive victories over the French and Austrians in the Seven Years' War.

1761 The British capture Pondicherry in India from the French, continuing their rise to power in the subcontinent.

1762 The Empress Go-Sakuramachi rises to power in Japan. She will be the last empress to rule in the country, abdicating in favor of her nephew in 1771.

In Russia, the German-born Catherine the Great assumes control of the government; although her reign will be marked by notorious sexual scandals, it will see the unprecedented flowering of Russian learning and culture as well.

1766 Britain's Parliament repeals the Stamp Act in the American colonies, after colonists, incited in part by Benjamin Franklin's propaganda against the act, protest and "tar and feather" the Crown's officials.

Burmese forces invade the Ayutthaya kingdom in modern Thailand, laying waste to its capital.

The Treaty of Paris cedes all of French Canada to Great Britain, a development that will permanently cripple the country's efforts to colonize in North America.

1767 Catherine the Great convenes the Legislation Commission in Russia to reform the country's legal codes.

1768 Captain Cook sets sails for the South Pacific, eventually exploring New Zealand and parts of Australia.

1769 A massive famine wreaks devastation on the population of the Indian state of Bengal.

1770 British troops kill five American colonists in the Boston Massacre, an event that will enflame already brittle relationships between England and Massachusetts settlers.

Marie-Antoinette of Austria marries the Dauphin Louis, the heir to the throne of France, at Versailles.

Captain James Cook lays claim to eastern Australia as a colony for the British.

1771 The Swedish pharmacist Karl Wilhelm Scheele discovers oxygen. His discovery is confirmed three years later by another experiment conducted by Joseph Priestley in England.

1773 A rebellion of cossacks in the Russian army is brutally suppressed.

The British Parliament passes the Tea Act, granting the East India Company the exclusive right to export tea to the North American colonies, a measure that soon irritates colonists.

The Mamluk Sultan Ali Bey, who successfully challenged the power of the Ottoman Turks and who established his own sultanate in Egypt for a time, dies in Cairo after losing his power.

1774 The First Continental Congress is convened at Philadelphia to discuss worsening relations with Great Britain.

The British East India Company appoints Warren Hastings the first Governor General of India.

Peasant revolts break out in many parts of Russia and, as the revolutionaries

march toward Moscow, they are brutally crushed by government troops.

1776 The Declaration of Independence is signed by the Continental Congress in Philadelphia; in the next few months open warfare breaks out in the colonies.

The Spanish Franciscan Father Palou founds a mission at what will later become San Francisco, California.

The British economist Adam Smith publishes his *The Wealth of Nations*, a work arguing against government intervention in the economy.

1778 The English explorer Captain James Cook explores several of the Hawaiian Islands, naming them the Sandwich Islands.

In France, the Enlightenment thinker Voltaire dies.

1779 The world's first iron bridge is constructed across the Severn River in England.

Boer settlers clash with the Xhosa in what is today South Africa.

1780 Francis Scott Key, who will grow up to write the words to the "Star-Spangled Banner," is born.

Empress Maria Theresa dies in Austria and is succeeded by her son Joseph II, who desires to reform Austrian society along the lines advocated by Enlightenment thinkers.

1781 Los Angeles is founded as "El Pueblo de Nuestra Senora La Reina de Los Angeles de Porciuncula (City of the Queen of the Angels) by 44 Spanish settlers.

General Cornwallis surrenders his English forces after the Battle of Yorktown in Virginia.

1783 The Treaty of Versailles draws an end to hostilities between the British and Americans. Britain recognizes the independence of its thirteen colonies, and many European countries soon grant diplomatic recognition.

Russia annexes the Crimea and begins to develop a major port there at Sevastopol. One year later the Ottoman Turks will recognize Russian sovereignty in the region.

1784 American patriot Benjamin Franklin invents bifocals.

In Japan, a famine rages that may produce as many as 300,000 deaths.

Revolution in Transylvania prompts the Austrian emperor Joseph II to suspend the Hungarian constitution in the region.

Ann Lee, a leader in the American Shaker movement, dies.

In England, John Wesley draws up a charter for Methodist churches.

1785 The United States adopts the dollar as its monetary unit, becoming the first state to use a decimal coinage in history.

In France, the exposing of the Affair of the Necklace, a scheme hatched by several con men and women, tarnishes the reputation of Queen Marie-Antoinette.

1787 Delegates meet at Philadelphia to fashion a new constitution for the United States.

Catherine the Great of Russia declares war on the Ottoman Empire.

1788 The British name New South Wales a penal colony and begin deportations of convicted felons there.

The English King George III suffers from one of two bouts with insanity brought on by porphyria, an enzymatic disorder. The second will begin in 1811 and last until his death in 1820.

Fire ravages the French settlement of New Orleans, destroying more than 850 buildings.

1789 The storming of the Bastille begins a militant phase of the French Revolution in Paris.

1790 The National Assembly of France passes the Civil Constitution of the Clergy, abolishing centuries-old clerical privileges and tax exemptions and subjecting priests, monks, and nuns to the same laws as lay people. When thousands of the clergy refuse to swear allegiance to the national government in the years that follow, many are persecuted and even executed.

1791 The United States Mint is established.

Wolfgang Amadeus Mozart dies in Vienna.

The Metric System is developed in France and replaces the medieval systems of weights and measures long used in the country.

1792 Russia is rebuffed when it tries to establish trade relations with Japan.

1793 The radical Jacobins unleash the Reign of Terror against "counter-revolutionaries" in Paris.

King Louis XVI is sentenced to death by a one-vote majority in the National Convention. The deciding vote is cast by the aristocrat, Philippe d'Orléans, now known as the revolutionary Philippe d'Egalité, Philip Equality. Ten months later, Louis' wife and France's queen, Marie-Antoinette, will follow her husband to the guillotine.

1794 Eli Whitney receives a United States patent for his invention of the cotton gin.

In France, Maximilien Robespierre falls from grace as a leader of the revolution. After inspiring the executions of 17,000 Frenchmen and women during the terror, he himself is put to death.

1795 Conservatives in the National Convention seize control over the course of developments in the Revolution in France; eventually, they establish the government of the Directorate, which brings a retreat from the bloodletting of previous years.

Russia, Austria, and Prussia partition Poland and annex its territories into their own states.

British forces seize the Cape Colony in Africa from the Dutch.

The Scottish explorer Mungo Park sets out to discover the source of the Niger River in Africa.

1799 Napoleon Bonaparte effectively stages a coup against the French government of the Directorate. As a result, he will eventually rise over the coming years to the position of Emperor of the French.

The fourth Qing Emperor Qianlong dies in China three years after abdicating in favor of his son.

chapter one

1

ARCHITECTURE AND DESIGN

Philip M. Soergel

IMPORTANT EVENTS
in Architecture and Design

1603 Carlo Maderno's influential façade for the Church of Santa Susanna is completed at Rome.

1606 Work begins on the façade of St. Peter's Basilica at Rome along designs completed by Carlo Maderno.

1622 Inigo Jones's Banqueting House is finished in Whitehall, London. The severe Palladianism of the building will continue to influence London's Baroque architecture in the seventeenth and eighteenth centuries.

1631 Construction begins at Venice on the Church of Santa Maria della Salute, designed by Baldassare Longhena.

1635 Work commences on François Mansart's designs for the Orléans Wing at the Château of Blois in France.

1638 Francesco Borromini designs his innovative Church of San Carlo alle Quatro Fontane, or St. Charles of the Four Fountains.

1640 Inigo Jones's recently completed Queens House at Greenwich sets a new standard for classical architecture in England.

1642 Work begins on the Church of Sant'Ivo della Sapienza at Rome, designed by Francesco Borromini.

1652 Gianlorenzo Bernini's Cornaro Chapel is completed in the Church of Santa Maria della Vittoria in Rome.

1653 The Church of Sant'Agnese is begun in the Piazza Navona in Rome, according to the designs of Francesco Borromini.

1656 Work begins on Gianlorenzo Bernini's designs for the Colonnade of St. Peter's at the Vatican. When completed, the massive space this structure encloses will be capable of accommodating crowds of hundreds of thousands of people.

1657 Nicholas Fouquet, a commoner who rose to serve as finance minister to King Louis XIV, commences construction of his lavish Château of Vaux-le-Vicomte.

1663 The Church of the Theatines, a structure heavily influenced by the Roman Baroque, is begun in the city of Munich in Germany.

1666 The Great Fire destroys most of the city of London, the core of the ancient medieval city. During the coming decades Sir Christopher Wren and other English architects will design many churches and public buildings for an ambitious plan of rebuilding.

1667 Guarino Guarini's completes his designs for the Chapel of the Holy Shroud within the Cathedral of Turin, and building commences. The work will include an intricate and imaginative interlacing of arches that create an imaginative web.

 Work begins on a new classically-inspired façade, designed by Claude Perrault and Louis Le Vau, for the Palace of the Louvre in Paris.

1669 King Louis XIV decides to move his court from Paris to his hunting lodge at Versailles. Work begins on transforming this humble structure into the grandest palace in Europe.

1675 Building commences on the new Cathedral of St. Paul's in London. When completed in 1710, it will be the largest church in England and one of the largest in Europe.

1676 In Paris, construction of the Church of the Invalids begins on the grounds of a military hospital. The church will be completed according to designs set down by Jules Hardouin-Mansart, and its gilded

dome will be a recognizable landmark on the Parisian cityscape for centuries to follow.

1679 Construction begins on Guarini's lavish façade for the Palazzo Carignano at Turin.

1687 Louis XIV begins construction on the Grand Trianon, a weekend retreat constructed to replace a small porcelain decorated pavilion on the grounds of the Palace of Versailles. The new palace is designed by Jules Hardouin-Mansart.

c. 1700 The taste for elegant palaces that imitate the design of the Château of Versailles, begins to spread throughout Europe.

1702 Construction begins on Jakob Prandtauer's imposing designs for the Benedictine Abbey of Melk in Austria.

1705 The Neoclassical Greenwich Hospital, designed by Sir Christopher Wren, is completed in England.

Work commences on John Vanbrugh's plans for the Baroque Blenheim Palace near Woodstock in England.

c. 1710 The Rococo architect Daniel Pöppelmann designs Baroque structures for the electors of Saxony's capital at Dresden.

1716 Johann Bernhard Fischer von Erlach designs the Karlskirche or Charles Church at Vienna.

1719 In Würzburg, capital of an important German diocese, Balthasar Neumann designs a new lavish residence for the town's bishops.

1722 The Upper Palace of the Belvedere is begun at Vienna according to the plans of Johann Lukas von Hildebrandt. The garden will be one of the most sumptuous in Europe.

1725 The Spanish Steps are completed in Rome, an attractive promenade that connects major thoroughfares in the city and links the Church of Trinità dei Monti with the Piazza di Spagna. The Steps are designed and their construction supervised by the architect Francesco de Sanctis.

1726 James Gibbs' classical Church of St. Martin's-in-the-Fields is completed in what later becomes known as Trafalgar Square in London.

1733 In Munich, the architect Egid Quirin Asam begins construction on the Church of St. John Nepomuk. Asam and his brother pay for the structure, which will eventually be completed in the highly ornate style of the Rococo.

1736 Filippo Juvara, designer of a number of innovative and elegant buildings in and around the Italian city of Turin, dies.

1738 Archeological excavations of the ancient Greek city of Herculaneum commence in southern Italy. Excavations will follow at Paestum and Pompei, ancient towns in the same region and will foster a fashion for a purer classicism throughout Europe.

1739 James Gibbs designs the circular, domed Radcliffe Library at Oxford University.

1743 The Frauenkirche or Church of Our Lady is completed in Dresden, one of the grandest Rococo churches in Europe and one of the largest Protestant structures on the continent.

1745 At Potsdam outside Berlin the building of the Rococo pleasure palace, Sansouci (meaning "without a care"), begins on the grounds of the Prussian king's principal country palace.

1752 The fantastically ornate and elegant Cuvilliés Theater is completed for the kings of Bavaria in Munich. After this date the fashion for the ornate and fantastically decorated Rococo style will begin to fade in favor of greater naturalism and classical detail.

1757 The building of the Panthéon begins at Paris according to designs set down by Germain Soufflot. The church is intended

to commemorate King Louis XV's recovery from serious illness, but will eventually become a shrine to the great thinkers, artists, and authors of France.

1762 Robert Adam designs a series of classical rooms for Syon House outside London that will have great impact on interior design throughout Europe and America.

The Trevi Fountain is finished in the city of Rome.

1763 The Place Louis XV is laid out in Paris according to designs of Ange-Jacques Gabriel. The site will eventually become the Place de la Concorde which will serve as the place of execution of many French aristocrats and priests during the French Revolution.

1768 Louis XV begins building a small retreat, the Petit Trianon, on the ground of Versailles for his mistress, Madame du Pompadour. Eventually, the relaxed atmosphere the small structure affords will make it one of Queen Marie-Antoinette's favorite retreats.

c. 1780 The English taste for the "picturesque" in garden designs has become popular throughout Europe, prompting a new fashion for seemingly naturalistic garden settings with architectural focal points. In reality, these more casual surroundings are intricately planned and executed by European designers.

1789 The naturalistic but grand English Garden is laid out in Munich. When completed in the early nineteenth century, the massive park will include elements of Neoclassical and oriental architecture and will provide a space that mimics the countryside within the city.

Work begins on the classical Brandenburg Gate in Berlin.

OVERVIEW
of Architecture and Design

RELIGIOUS RENEWAL. The rise of the Baroque style in architecture had intricate connections to the religious dilemmas and problems of sixteenth- and seventeenth-century Europe. Few great projects of church construction had been undertaken in sixteenth-century Europe, the one notable exception being the reconstruction of St. Peter's Basilica in Rome. Chronic money shortages as well as the religious controversies of the sixteenth century diverted the attentions of the Papacy and other high-ranking officials of the church away from many of the grand projects begun during the High Renaissance. As the seventeenth century approached, however, a revival of spirit became evident in the Roman Catholic Church. This Catholic Reformation saw the foundation of many new religious orders like the Jesuits, Theatines, and Capuchins, who worked for religious renewal. During the half-century following 1570, these groups led a dramatic resurgence in Catholic piety. The new orders demanded religious architecture that focused worshippers' attentions on the sacraments and key elements of Catholic worship, that appealed to the senses, and that was an enhancement to parishioners' religious lives. One of the first churches to reflect these new spiritual values was the Gesù, the home church of the new Jesuit order in Rome. Although its interior decoration did not initially make use of the techniques that Baroque designers developed, its physical layout mirrored the style of church construction that became common during the seventeenth and eighteenth centuries. This structure's enormous size and massive barrel vault provided broad expanses of wall and ceiling space on which painters presented images that celebrated and defended Catholic truth. Inside the Gesù the focus of worshippers was drawn to the High Altar and the pulpit, the two sources of religious authority Catholic Reformers promoted as vital to the faith. As a number of new churches appeared on the Roman horizon around 1600, many made use of this plan's coherent and unified design. These structures were even more ornate and imposing than their original source of inspiration.

ELEMENTS OF THE BAROQUE STYLE. Whereas High Renaissance architects favored rational and intellectually conceived spaces, the architects of the early Baroque violated many canons of classicism. They placed broken pediments as frames for windows and doorways, a departure from the classically-inspired canons of the Renaissance. Similarly, other decorative elements they used on their façades and in their interiors stepped outside the traditional canons of Renaissance classical design. Baroque architects also massed their decorative elements to create dramatic focal points and an impression of climax in their buildings. This attempt to harness a worshipper's gaze often began at a church's door and continued along the path that led to the church's altar. From the very start, the Baroque presented Europeans with a variety of faces. Imaginative designers like Francesco Borromini and Guarino Guarini relied on complex geometrical patterns in their structures, patterns that were more imaginative and complex than the static and serene symmetries of High Renaissance design. Their bold works inspired departures from classicism in many parts of Europe, and at the same time they were rejected in other regions as being too radical. A second face of the Italian Baroque was evident in the more conservative works of figures like Carlo Maderno and Gianlorenzo Bernini. In Rome, these architects created grand interiors that awed the city's many pilgrims with symbols of the Roman Catholic Church's power. Maderno, Bernini, and other Baroque designers also set themselves to the task of transforming Rome's cityscape. They laid out impressive squares and broad avenues, and created monuments and fountains that provided Rome with attractive focal points. Their emphasis on grand urban planning and design had numerous imitators in Northern Europe as Baroque design became an international style favored throughout the continent.

RISE OF ABSOLUTISM. Features of the political landscape of seventeenth-century Europe also favored the rise of the Baroque. The seventeenth-century witnessed a dramatic increase in the power of kings and princes over their subjects. The new theories of absolutism stressed that a king was the sole source of political authority in his realm, as monarchs in France, England, Spain, and in scores of smaller principalities throughout the continent grew anxious to assert their authority over their subjects and to wrest power from their nobilities. Often the elaborate pretensions of seventeenth-century kings to power were more illusory than real, yet in a large and prosperous country like France, the rise of a more centralized state with power focused in the hands of the king and his ministers is undeniable.

In this climate, one in which kings and princes were desirous to present an image of their muscle, Baroque architecture provided an important visual language for a monarch's self-representation. The most dramatic example of the ways in which the Baroque enhanced the power and reputation of a king was the Palace of Versailles outside Paris. Originally built as a hunting lodge, this modest structure had grown to become the very centerpiece of royal government by the late seventeenth century, an expensive stage for the spectacles of royal power. An elaborate protocol and etiquette governed every aspect of the nobility's lives at Versailles and many flocked there to be near the king. An unwieldy formality prevailed, not only in social life, but also in the grand architectural spaces that Louis's designers built in the palace and its gardens. Versailles' reputation for formality and grand monumentality spread quickly throughout Europe, as scores of smaller and less powerful courts throughout the continent imitated its style.

THE IMPORTANCE OF CITIES. While the designs of country and suburban palaces celebrated the rituals of state and court, the Baroque period also witnessed an unprecedented growth in Europe's cities. Many of the fastest growing cities were located in the northwestern part of the continent, particularly in the Netherlands, where rapidly expanding commerce and colonial ventures quickly transformed the region into the most urbanized part of Europe. Both London and Paris witnessed dramatic growth, as did many of Spain's cities at the time, but the most advanced of the many urban renewal and expansion projects undertaken in the seventeenth century occurred in Amsterdam, the population of which increased fourfold during the seventeenth century to top 200,000 by 1700. In support of the town council's decision to open up new areas for settlement in 1612, workers dug three grand canals to provision the city, and residential and commercial quarters were separated from other parts of the town dedicated to crafts and industry. While other cities emulated Amsterdam's careful planning, fast-growing towns like London and Paris took a more random approach. In these cities new, planned squares, filled with attractive brick and stone edifices, gradually replaced the half-timbered, wooden houses that had long been the primary feature of the urban landscape. One catalyst for change in London was the city's Great Fire in 1666 that destroyed the vast majority of the city's houses and churches. Sir Christopher Wren's ambitious plans to rebuild London as a city of broad streets and classical buildings could not be achieved. The expense of his designs, as well as long-standing traditions and laws guarding private property, ensured that most

of London continued to be a tangled web of dark streets and alleyways. Despite its lack of planning, London's late seventeenth-century growth was enormous. By 1700, it had emerged as Europe's largest metropolis.

THE ROCOCO. With the death of Louis XIV in 1715, a new decorative style, eventually called the Rococo, began to dramatically change the houses of nobles and the wealthy in France. Long judged a merely decorative and sometimes even corrupt period in the history of art and architecture, the Rococo's history has more recently been re-assessed. The movement arose at a time of rapid change in Western history. The tastes of Louis XIV's age had long shown a propensity, on the one hand, for a symmetrical, austere, and commanding classicism, and on the other, for interior spaces created to serve the rituals of France's secular religion of royalty. In the years immediately following the monarch's death many noble families returned to Paris from Versailles to build townhouses or to redecorate their ancient homes within the city. New fashions for extensive but delicate gilt ornamentation and for elaborately sculpted plaster were two of the most distinctive elements of the early Rococo. Designers of the period produced some of the first cabinets, small drawing rooms that were spaces of relative privacy in a world that to this point had provided little opportunity for intimate gatherings. The rise of the Rococo proceeded apace with the development of salons in France, gatherings of elites and intellectuals that eventually became a major vehicle for the dissemination of Enlightenment thinking. The Rococo opened up new vistas, then, in providing spaces that were suitable for the elevated discussions that occurred within the small galleries and drawing rooms of eighteenth-century Paris. As the movement traveled beyond France, its influence spread to interior design and decoration elsewhere in Europe, but most particularly in Germany and Austria. Here Rococo designers like François Cuvilliés, a French emigré, and native architects like Dominikus Zimmermann and Johann Michael Fischer unlocked more of the movement's architectural potentials. In a series of works created during the 1730s and 1740s these figures created striking spaces, less angular and hard-edged than those of the Baroque, into which they poured an exuberant, even festive wealth of ornamentation. The culmination of their efforts bore fruit in a number of churches long recognized in Germany as *Gesamtkunstwerke,* masterworks that combined architecture, painting, sculpture, and other decorative arts so that their creative fusion was greater than their constituent parts.

NEOCLASSICISM AND ROMANTICISM. During the mid-eighteenth century new waves of interest in the

architecture of ancient Rome and Greece attracted the attention of Europe's most sophisticated designers and patrons. In Italy, archeological excavations were uncovering a more historically accurate picture of the architecture of the ancient world. A key figure in this revival was the Italian designer, Giovanni Battista Piranesi, who throughout his career did much to promote antique architecture. His etchings of Roman and Greek monuments demonstrated an understanding of the ways in which ancient peoples had built their structures, and Piranesi's strikingly beautiful, yet idealized vision of ancient architecture captured the imagination of patrons and architects alike to spark the neoclassical movement in the mid-eighteenth century. This movement also fit neatly with the ideas of Enlightenment philosophers, and their advocacy of a new social order based around principles of human freedom. These thinkers perceived the virtues of the ancient Roman Republic or the Greek polis as an antidote to the corruption and decadence they saw around them. Not surprisingly, too, many Enlightenment philosophers celebrated England as the greatest political culture of the age, sensing in its limited monarchy a model for political reforms that should be adopted throughout Europe. Neoclassicism found a ready home in this island country, where an early eighteenth-century revival of Palladian classicism began to give way to the more austere vision of neoclassicists after 1750. In France, the movement likewise mingled with the pre-existing taste for classical architecture, producing the designs of figures like Soufflot and Gabriel, which were notable for their great restraint in ornament and decoration. Neoclassicism, though, was just one of a series of revival styles that became popular throughout Europe, as new waves of fashion attempted to recreate the architectural visions of previous ages. Gothic architecture, too, witnessed a surge in popularity. The romantic impulses of the period can perhaps nowhere be more brilliantly witnessed than in the garden and landscape architecture of the later eighteenth century. A new fashion for naturalistic English gardens spread quickly throughout Europe, as designers and patrons desired to emulate the freedom and seemingly unplanned character of the English country landscape. At the same time they poured into these spaces artificial lakes and rapids, Chinese pavilions, ancient ruins, Gothic chapels, and other structures that provided "picturesque" focal points for connoisseurs as they moved through their gardens. Ironically, the fashion for the English garden revealed some of the underlying contradictions and ironies of the age, as eighteenth-century men and women enjoyed spaces that were models of both human freedom and restraint.

FROM BAROQUE TO CLASSICISM. European design during the seventeenth and eighteenth centuries continually drew from the great designers of the Renaissance as well as new innovations in form and aesthetics pioneered by the great contemporary figures of the age. Successive waves of classicism gradually revived a more historically accurate picture of the architecture of previous ages. At the end of the eighteenth century innovations in design championed a new informality that departed from the formalistic architecture that had prevailed throughout much of the Continent since the early seventeenth century. The underlying impulses of this movement were consonant with the waves of dramatic change that convulsed Europe following the outbreak of the French Revolution in 1789.

TOPICS
in Architecture and Design

THE RENAISSANCE INHERITANCE AND CATHOLIC RENEWAL

TERMS. In Italy, architecture and urban planning began to move in a grander direction in the years around 1600. Since the eighteenth century this style has been known as the "Baroque," a word that comes to us from the Portuguese *baroco*. Originally, this term referred to pearls that were rough and heavily encrusted with sediment. When the neoclassicists of the eighteenth century adopted the word to describe the architecture of the period that preceded their own, they did so to criticize the imposing grandeur and often heavily ornamented style that had been popular throughout Europe in the seventeenth and early eighteenth centuries. They found this style decadent and corrupt; in its place, they longed to develop a purer classicism with simpler and more harmonious features. The label the neoclassicists applied to the period stuck, although today it retains little of its negative connotations. While the word "Baroque" still sometimes disapprovingly suggests an art, architecture, or literature that is overly complex, stylized, or contrived, modern historians of art and architecture have come to realize that the designs of the seventeenth and eighteenth centuries possessed considerable variety and vitality. Today, in other words, the architecture of the Baroque has been restored to its important place in the history of Western culture, and the designs of the architects and urban planners of this period have come to be valued on their own terms as well

as for their important role in shaping modern notions about cities and urban planning.

ORIGINS OF BAROQUE ARCHITECTURE. In sixteenth-century Italy, two important styles of building—High Renaissance classicism and the more willful and artful designs of later Renaissance Mannerism—rose to prominence. High Renaissance classicism first began to emerge in Milan, Florence, and Rome in the late fifteenth and early sixteenth centuries, and its design elements had been articulated most forcefully in the works of Donato Bramante (1444–1514). Bramante's design principles stressed restraint in ornament, harmonious proportions derived from an intellectually conceived program, and monumental scale. The period of the High Renaissance was short, lasting only for about three decades following 1490. While these years saw the construction of a number of important structures in northern and central Italy, political and financial realities frequently dogged High Renaissance projects, as did issues of sheer technical complexity and scale. Many of the great designs of the period were too large to be completed without armies of laborers and artisans, and, given the political, financial, and religious instabilities of the time, their sponsors soon shelved or abandoned them even before they moved beyond their initial stages. The largest and most important of building projects undertaken at the time were in and around Rome. At the beginning of his pontificate, Pope Julius II (r. 1503–1513) signaled his determination to transform Rome into a grand capital of all Christendom. During the Middle Ages the city had grown into a tangled web of dark, winding streets filled with mud huts and brick tenements. Julius wanted to redesign Rome, to transform it into a city of squares, impressive churches, and imposing public buildings that made use of developing architectural ideas. While few of his projects fulfilled his lofty vision, he set the agenda that would dominate architecture in Rome for the century that followed by demolishing the ancient St. Peter's Basilica, a structure that had stood since the fourth century on the Vatican Hill outside the city. He chose Bramante to serve as the chief designer for the church's rebuilding, and although neither figure lived to see the project carried forward beyond its initial stages, Bramante and Julius fixed the scale and proportions of the church by constructing four great piers to support its planned dome. In the century that followed, the greatest architects of the age, including Michelangelo, Carlo Maderno, and Gianlorenzo Bernini, perfected and enhanced Bramante's plans. At times, political realities, religious crises, financial problems, and sheer technical complexity stalled the project. And in an indirect way, the construction of the new St. Peter's Basilica even contributed to the rise of the Protestant Reformation, since Julius's successor, the Medici Pope Leo X (r. 1513–1521), resorted to corrupt and unscrupulous sales of indulgences in order to carry on construction of the new building. The marketing of these indulgences prompted Martin Luther to attack the church in his famous *Ninety-Five Theses,* one of the documents that precipitated the rise of religious controversies throughout Europe. Those disputes, as well as the Sack of Rome at the hands of German armies in 1527, cooled for a time the artistic and architectural ambitions of those within the church's capital. Despite the controversial nature of the project and the problems that stalled its completion, the construction of the building dominated architectural achievements in Rome until the mid-seventeenth century.

MANNERIST COMPLEXITIES. In the relatively brief period of the High Renaissance, designers like Bramante favored a language of restrained and imposing classicism and they planned buildings and urban squares that might have impressed their viewers by their austere noble proportions and sheer monumental scale. As the High Renaissance began to fade, a new fashion for buildings that were less classical in spirit developed. Historians call this style "Mannerism" and the word has long been used to refer to developments both in architecture and the visual arts. Many Mannerist artists followed the lead of the willful and highly personal style that Michelangelo developed during his middle age. During the 1510s and 1520s, he had spent much of his time working for the Medici family in Florence, designing the family's mausoleum in the Church of San Lorenzo in that city, as well as the Laurentian Library at the same site. While his architecture in this period made use of classical design elements, the artist played imaginatively with these features to create spaces that made use of repetition and a seemingly strange juxtaposition of objects. Michelangelo later rejected his own highly personal style when he became overseer of the construction of the new St. Peter's in the mid-sixteenth century. At this time his designs returned to the more thoroughly classical style of the High Renaissance. Yet his works in and around Florence inspired a taste for Mannerist design continued by architects like Giorgio Vasari, Giulio Romano, and Bartolommeo Ammanati. These figures continued to violate the norms of High Renaissance classicism in favor of designs that were elegant, willful, and often artificial. In contrast to the severity and monumentality of the High Renaissance, these Mannerist architects favored the repetition of purely decorative elements and played

a PRIMARY SOURCE *document*

CHARLES BORROMEO ON CHURCH DESIGN

INTRODUCTION: The influence of St. Charles Borromeo, a leading figure in spreading the doctrines of the Catholic Reformation, touched almost every area of religious life in Catholic Europe during the later sixteenth and seventeenth centuries. His advice to architects—that they abandon the central style of church construction much favored in the Renaissance—was not always heeded. But the seventeenth century did return to favor the traditional Latin cross he recommended. Among the most notable of the many churches that were to be finished in the shape of a Latin cross was St. Peter's Basilica in Rome, where the Renaissance plans for a central style structure were abandoned to fit with the increasingly conservative tastes of Catholic Reformers.

There are a great many different designs, and the bishop will have to consult a competent architect to select the form wisely in accordance with the nature of the site and the dimensions of the building. Nevertheless, the cruciform plan is preferable for such an edifice, since it can be traced back almost to apostolic times, as is plainly seen in the buildings of the major holy basilicas of Rome. As far as round edifices are concerned, the type of plan was used for pagan temples and is less customary among Christian people.

Every church, therefore, and especially the one whose structure needs an imposing appearance, ought to be built in the form of a cross; of this form there are many variations; the oblong form is frequently used, the others are less usual. We ought to preserve, therefore, wherever possible, that form which resembles an oblong or Latin cross in construction of cathedral, collegiate or parochial churches.

This cruciform type of church, whether it will have only one nave, or three or five naves as they say, can consist not only of manifold proportions and designs but also again of this one feature, that is beyond the entrance to the high chapel, on two more chapels built on either side, which extended like two arms ought to project to the whole of their length beyond the width of the church and should be fairly prominent externally in proportions to the general architecture of the church.

The architect should see that in the religious decoration of the façade, according to the proportions of the ecclesiastical structure and the size of the edifice, not only that nothing profane be seen, but also that only that which is suitable to the sanctity of the place be represented in as splendid a manner as the means at his disposal will afford.

SOURCE: Evelyn Carole Voelker, "Charles Borromeo's Instructiones Fabricae et Supellectilis Ecclesiasticae, 1577. A Translation with Commentary and Analysis" (Ph.D. diss., University of Syracuse, 1977): 51–52 and 63; in *Baroque and Rococo: Art and Culture.* Ed. Vernon Hyde Minor (London: Laurence King, 1999): 78.

with the language of classical architecture, remolding it to create new and unexpected features that appeared on their façades and in their interiors. While the High Renaissance style never completely died out in Italy, Mannerism came to compete against it, particularly in Florence and other Central Italian towns. Both styles—Mannerism and High Renaissance classicism—became a wellspring of inspiration to later Baroque architects as they created a number of new buildings in Rome at the end of the sixteenth century.

ROME RESURGENT. Elements of Baroque style first began in the many churches under construction in Rome during the late sixteenth and early seventeenth centuries. Following Rome's Sack in 1527, few great churches had been built in the city, a result not only of the depression that the attack caused, but also of the Protestant Reformation, which had criticized the costly outlays on church building that had occurred in the later Middle Ages. Toward the end of the century, though, a broad and ever-deepening movement within Catholicism gathered

strength. Known as the Catholic Reformation, this movement matured in Italy sooner than in other parts of the continent, in part because of the peninsula's central position within Roman Catholicism. The Catholic Reformation inspired a number of new religious orders, groups like the Jesuits, Theatines, Capuchins, and the female order of teaching nuns known as the Ursulines. These groups dedicated themselves to renewal in the church, and as they became officially recognized, many began to build new churches in Rome to commemorate their newly acquired status as official orders within Catholicism. As they set up institutions elsewhere in Italy and throughout Europe, groups like the Jesuits also commissioned scores of new churches throughout the continent. The stimulus that the new orders thus gave to church construction soon inspired elites in Rome and in Catholic cities throughout the continent to patronize church building projects, too. As a result, many medieval and Renaissance churches came to be rebuilt or remodeled in the new style, one that favored

a PRIMARY SOURCE *document*

THE PRINCE OF DESIGNERS

INTRODUCTION: Gianlorenzo Bernini ruled over the artistic life of Rome for much of the seventeenth century. A figure similar to the great Renaissance men of the fifteenth and sixteenth centuries, he was simultaneously a sculptor, painter, architect, musician, and dramatist. His artistic vision, while more conservative than Filippo Borromini's, mingled exquisite craftsmanship with a new dynamism that had not been characteristic of the Renaissance. Like Michelangelo and Raphael, the scope of Bernini's achievements was widely recognized during his lifetime. Shortly after the artist's death, Filippo Baldinucci published a biography from sources that Bernini himself had compiled while living. Baldinucci's work continually stressed that the designer's star had never fallen from favor in seventeenth-century Rome. In truth, the architect's undertakings at St. Peter's were widely credited during his lifetime with weakening the integrity of Michelangelo's grand dome, and for a short while, Bernini did fall afoul of the papacy. Of the many creative figures active in seventeenth-century Rome, though, his influence over the Baroque style was incomparable.

The sun had not yet set upon the day which was the first of Cardinal Chigi in the Highest Pontificate, when he summoned Bernini to him. With expressions of affectionate regard, he encouraged Bernini to undertake the great and lofty plans that he, the Pope, had conceived of for the greater embellishment of the Temple of God, the glory of the pontifical office, and the decoration of Rome.

This was the beginning of a new and still greater confidence that during this entire pontificate was never to be ended. The Pope wished Bernini with him every day mingling with the number of learned men he gathered around his table after dinner. His Holiness used to say that he was astonished in these discussions how Bernini, alone, was able to grasp by sheer intelligence what the others scarcely grasped after long study.

The Pope named him his own architect and the architect of the Papal Chamber, a thing which had never before happened to Bernini because each former pope had had his own family architect on whom he wished to confer the post. This practice was not observed by popes after Alexander VII because of the respect they had for Bernini's singular ability, so that he retained the office as long as he lived.

… Bernini, with a monthly provision of 260 *scudi* from the Pope, began to build the Portico of St. Peter, which in due time he completed. For the plan of this magnificent building he determined to make use of an oval form, deviating in this from the plan of Michelangelo. This was done in order to bring it nearer to the Vatican Palace and thus to obstruct less the view of the Piazza from that part of the palace built by Sixtus V with the wing connecting with the Scala Regia. The Scala Regia is also a wonderful work of Bernini and the most difficult he ever executed, for it required him to support on piles the Scala Regia and the Paolina Chapel, which lay directly over the stairs, and also to make the walls of both rest on the vault of the stairs. Furthermore, he knew how to bring by means of a charming perspective of steps, columns, architraves, cornices, and arches, the width of the beginning of the stairway most beautifully into harmony with the narrowness at its end. Bernini used to say that this stairway was the least bad thing he had done, when one considered what the stairway looked like before. The supporting of these walls was the boldest thing he had ever attempted, and if, before he applied himself to the task, he had read that another had done it, he would not have believed it.

SOURCE: Filippo Baldinucci, "The Life of Cavalier Giovanni Lorenzo Bernini," (1682) in *Michelangelo and the Mannerists; The Baroque and the Eighteenth Century.* Vol. II of *A Documentary History of Art.* Ed. Elizabeth G. Holt (Englewood Cliffs, N.J.: Prentice Hall, 1957): 117–119.

elaborate adornment, display, and imaginative new shapes and decorative elements. Through this style, architects aimed to impress worshippers with an image of the church as a powerful celestial and earthly institution—to capture the imagination, in other words, and lift a worshiper's mind towards Heaven. Much Baroque church architecture was thus monumental in spirit, and even when the scale of religious architecture was small, architects aimed to create spaces that might inspire and awe viewers.

CATHOLIC REFORM. The developing ethos of the Catholic Reformation also stressed the importance of the sacraments—particularly the Eucharist—as central

elements of Catholic life. The movement embraced effective preaching as an important goal of the priesthood, while at the same time teaching that an individual's participation in the process of working out salvation was necessary. Catholic reformers vehemently rejected one of the central tenets of Protestant teaching—that salvation was a free gift of God's grace—and instead taught that a diligent participation in the life of the church as well as frequent good works paved the road to Heaven. Architects tried to give visual expression to these teachings as well. One of the first places that the effects of Catholic reform can be seen is in the Gesù, the home church of

the Jesuit Order in Rome. Il Gesù was a massive, barrel-vaulted church completed in the city during the later sixteenth century, and later Baroque designers imitated many of its design features. The church's plan provided for broad expanses of ceiling and wall space, ideal surfaces on which seventeenth-century painters and sculptors could celebrate the richness and variety of the church's history and its teachings. At the same time the sight lines of Il Gesù led inexorably to the church's choir, the place in which the Eucharist was commemorated at the High Altar. The complex of side aisle chapels that had long existed in many medieval structures was thus downplayed at the Gesù and in the many buildings that imitated its plan. Instead the attention of worshippers who visited these places was focused on the altar and the pulpit, the sites from which the sacraments and preaching issued. Following the example of the Gesù, early Baroque architects labored to lend drama and a climactic force to their creations. Many of their constructions frequently suggested movement, underscored by the massing of decorative details at a church's door and along the path to the structure's culminating altar. Thus in contrast to the serene and often static character of High and Late Renaissance buildings, Baroque architecture was, from its very inception, dynamic—an architecture, in other words, that embraced movement.

INFLUENCE ON THE CITYSCAPE. As Rome revived from the flagging morale with which it had been afflicted in the mid-sixteenth century, the city began a host of new grand public works projects. These projects began under the reign of the "building" pope, Sixtus V (1585–1590). The enthusiasm with which Sixtus approached the reconstruction of Rome encouraged the church's major officials as well as Rome's noble families to pursue new projects as well. This program of rebuilding intensified after 1600, as one of Sixtus's successors, Pope Paul V (r. 1605–1621), brought new sources of water to the capital by restoring the ancient Roman aqueducts that had once supplied the city. Rome now had a guaranteed, sufficient supply of water that lasted for a century. To celebrate the achievement in providing fresh water, Paul began to build a series of new fountains throughout the city to call attention to this achievement. Thus he helped to create one of the most attractive features of modern Rome: its many fountains set within attractive city squares. Paul commissioned plans for many new churches to minister to the throngs of pilgrims returning to Rome at the time. His architects planned broad avenues to link the city's major pilgrimage churches, and they set ancient artifacts like obelisks as focal points within squares throughout the city. In the years following Paul's pontificate, the resurgence evident in Rome did not diminish. Instead, by the mid-seventeenth century Rome gained even more construction sites. As a result, it became a city populated with an almost incomprehensible number of jewels of Baroque architecture. These monuments included many new and remodeled churches, impressive private palaces, civic buildings, and new quarters for the church's bureaucracies. In this process of expansion and refurbishment, Rome emerged as a model for other European capitals, and rulers throughout the continent soon evidenced a desire to imitate elements of the city's revitalization.

SOURCES

Andrew Hopkins, *Italian Architecture: From Michelangelo to Borromini* (London: Thames and Hudson, 2002).

Pamela M. Jones and Thomas Worcester, eds., *From Rome to Eternity: Catholicism and the Arts in Italy, ca. 1550–1650* (Leiden, Netherlands: E. J. Brill, 2002).

Wolfgang Lotz, *Architecture in Italy, 1500–1600* (New Haven, Conn.: Yale University Press, 1996).

Peter Murray, *The Architecture of the Italian Renaissance* (London: Thames and Hudson, 1986).

Rudolf Wittkower, *Art and Architecture in Italy, 1600–1750* (New Haven, Conn: Yale University Press, 1999).

SEE ALSO *Visual Arts: The Renaissance Legacy; Religion: Catholic Culture in the Age of the Baroque*

THE RISE OF THE BAROQUE STYLE IN ITALY

QUALITIES OF ROMAN BAROQUE. The buildings constructed as a result of the Baroque architectural revival displayed both great variety as well as certain common traits. The first architect to express many of the features of the new style was Carlo Maderno (1556–1629). In the façade he designed for the Church of Santa Susanna in Rome (1597–1603), he imitated many of the design elements from the earlier Jesuit Church of the Gesù, while giving these a completely new interpretation. Both structures were two-stories high, decorated with a profusion of columns or pilasters, and were crowned with central pediments. Maderno, however, massed his decorative detailing on the façade of Santa Susanna in such a way as to accentuate the central door of the church. He set the sides of the façade back to make the doorway to the church appear to protrude outwards, a welcoming effect to worshippers as they approached the structure. To enhance this impression, Maderno used double columns on both sides of the

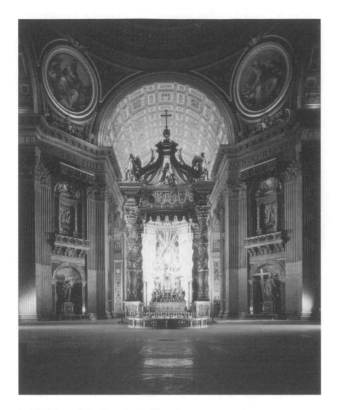

Baldachino of St. Peter's Basilica, Rome. © DAVID LEES/CORBIS.

door while placing single rounded columns at the central bay's sides and barely visible squared pilasters at the façade's corners. In the earlier Church of il Gesù, the designer had finished the structure with a rounded arch that contained within it a triangular-shaped pediment, an awkward device that Maderno avoided at Santa Susanna. Instead he crowned the building with a simple gabled pediment, and he repeated this triangular shape above the door as well. These details made the structure's sight lines all seem to converge on the church's portal. Maderno's designs for Santa Susanna's façade included a wealth of decorative detailing, yet curiously this ornamentation never seems to be out of control. Rather, these decorative elements appear to enhance the critical design features of the structure. This search for ways to mass ornament and decoration to create dramatic effects and to suggest movement soon became a central quest of other Baroque architects working in the city.

ST. PETER'S. Even before he completed the façade for Santa Susanna, Maderno became chief architect for St. Peter's, a position that had been held by the sixteenth-century cultural giants Donato Bramante and Michelangelo Buonarroti. Bramante had originally designed the church in the shape of a Greek cross, that is, as a structure in which the four radiating arms were of equal length. His plans intended to crown the Vatican hill, the

site of St. Peter's martyrdom and tomb, with a monumental domed temple that was thoroughly classical in spirit. Subsequent architects abandoned many features of his designs, although Michelangelo revived and reinstated the crucial features of Bramante's plans. Workers finished the construction of the dome during the pontificate of Sixtus V. Michelangelo's designs, while reinstating the spirit of Bramante's original plans, also treated the dome and the church like a gigantic sculptural mass. Today this feature of his work can only be appreciated from the rear, that is, from the Vatican Gardens, a place that few tourists ever see. The masking of his achievement occurred for several reasons, all of which served the demands of the Catholic Reformation that was underway during the seventeenth century. Although the construction of St. Peter's was well advanced by the time of Maderno's appointment in 1605, Pope Paul V (r. 1605–1621) was anxious to cover all the ground at the site that had originally lain within the ancient basilica, and thus he commissioned the architect to extend the church's nave. In this way the shape of the church conformed to the more traditional pattern of a Latin cross, a style recommended by influential reformers like St. Charles Borromeo. This considerable expansion, however, was incompatible with Michelangelo's immense dome, since it obliterated views as worshippers approached the church toward its main entrances. The resulting compromise, however, increased the scale of the church to truly monumental proportions and made St. Peter's undoubtedly the largest church in Christendom for many centuries to come. In the façade he designed for the building, Maderno again massed design elements, as at Santa Susanna, to make the center doorway the focal point and he emphasized the entrance again with a triangular pediment. But the addition of an upper story to the façade was another departure from the original plans set down by sixteenth-century architects, and one again that was not in keeping with the spirit of the original plans. It further obliterated views of the massive dome. Religious rituals like papal blessings, though, necessitated a *loggia,* or gallery, from which the pope might appear before the crowds who gathered in the square below, and so Maderno obliged by adding an upper story onto his façade. His plans also called for two bell towers to flank the façade at both ends, structures that might have relieved the horizontal emphasis of the structure as it stands today. These towers, though, were not immediately built. Somewhat later, Gianlorenzo Bernini, one of Maderno's successors at the site, commenced their construction, although he extended their height even further. When the first of the bell towers was built, its foundations soon proved inadequate. Fearing that it

might collapse, Bernini had the tower torn down, and the project was soon completely abandoned. Thus, since the seventeenth century the façade of St. Peter's has stood as a compromise, one that, although imposing and grand, is not completely in keeping with its original plans. If the exterior of St. Peter's presents a not altogether satisfying appearance, Maderno's interior decoration remains an unsurpassed example of Baroque ornamentation. With the extension of the church, the architect faced the task of decorating a vast expanse of vaulting overhead as well as the massive columns and piers that supported the structure. In the additions he designed for the church, Maderno opened up broad vistas from his nave by using enormous arches. These arches provided views into the side aisles, which he decorated with broken pediments set atop columns of richly colored marble. To deal with the enormous expanse of vaulted ceiling, Maderno designed an elegant pattern of gilded coffering. Later architects at St. Peter's added to his decoration. Most notable among these additions were those of Gianlorenzo Bernini, who guided the design team that completed the massive bronze and gilt *baldachino,* a canopy that soars almost 140 feet over the church's high altar. Bernini also paneled the columns of the church's main aisle in richly colored marbles, and he placed many sculptures as decorative elements throughout the church. Yet the dominant decorative spirit within St. Peter's is Maderno's, and the use he made there of richly colored marbles mingled with much gilded ornamentation had numerous imitators in other architects of the period.

SOURCES

Anthony Blunt, *Roman Baroque* (London: Pallas Athene Arts, 2001).

Howard Hibbard, *Carlo Maderno and Roman Architecture, 1580–1630* (London: Zwemmer, 1971).

Paolo Porteghesi, *Roma Barocca: The History of an Architectonic Culture.* Trans. Barbara La Penta (Boston: MIT Press, 1970).

Donato Ugi, *Carlo Maderno. Architetto Ticinese a Roma* (Lugano, Italy: Banco di Roma per la Svizzera, 1957).

SEE ALSO *Religion: Catholic Culture in the Age of the Baroque; Visual Arts: Elements of the Baroque Style*

THE ACHIEVEMENTS OF GIANLORENZO BERNINI

DOMINATED SEVENTEENTH-CENTURY ART. While Maderno's designs proved to be influential in shaping the direction of the Baroque style, it was Gianlorenzo Bernini who dominated artistic and architectural developments in Rome for much of the seventeenth century. Bernini was in many ways similar to the great "universal men" of the Renaissance. An accomplished sculptor, architect, and painter, he also wrote for the theater and composed music. By his mid-twenties he had produced a string of sculptural masterpieces, and was beginning to undertake architectural commissions for Pope Urban VIII (r. 1623–1644). These included the famous baldachino and sculptural decorations for St. Peter's as well as a series of tombs for Roman notables, and a large number of stunning fountains located throughout the city. A student of urban design, Bernini's sculptural fountains ennobled many Roman squares and gave the city numerous attractive focal points. In this way he achieved one of the visions that Renaissance designers had longed for: the creation of handsome monuments set in attractive public squares where city dwellers might meet and congregate.

ST. PETER'S COURTYARD. While Bernini decorated the city as a grand canvas, his most important architectural achievement was the courtyard he created in front of St. Peter's Basilica, an enormous public space capable of holding crowds of hundreds of thousands of people, yet made inviting by its enveloping colonnades. He ingenuously designed the shape of these structures to hide less attractive buildings within the papal complex. Unlike many more highly decorated colonnades at the time, Bernini's design was far simpler, calling for four rows of simple Doric columns progressing out from the basilica, first in a straight line and then bowing to form a circular shape. In all, there are 300 columns in this massive structure. They enclose a square with two large circular fountains at the sides and an Egyptian obelisk in the center. Atop the colonnade's simple, unbroken entablature Bernini placed a large number of statues of the saints of the church. While massive and severely unadorned, the colonnade nevertheless suggests the "arms of mother church," Bernini's own phrase to describe the space he wished to create.

PARISIAN INTERLUDE. As a result of achievements on this truly massive scale, King Louis XIV recruited the architect to plan his remodeling of the medieval and Renaissance palace of the Louvre in Paris. A jumble of conflicting wings and buildings had collected at this site from the Middle Ages onward, and Louis initially believed that Bernini was the architect who might bring order out of this architectural chaos. When he first arrived in Paris, he pronounced the Louvre beyond redemption, and argued that it should be torn down. Over time, though, he became convinced that the façade of

the enormous palace might be rebuilt to give the structure unity and coherence. One of his designs for the structure was highly imaginative and included a curved façade, although Bernini eventually altered that design to reflect the more severe and classical tastes of the king and court. While he participated in the ceremony to lay the new foundation stone for the remodeling of the palace, his plans were rejected immediately after his departure from Paris. Back in Rome after only five months abroad, Bernini continued to sculpt, to design, and to supervise many projects until his death at the age of eighty. He remains one of the most prolific artists of the seventeenth century, and as an architect he was especially important for his grand contributions to urban planning and design. His plans for buildings are fewer in number than other great architects of the day and included only three small church projects built in Rome. Yet these structures demonstrated imaginative uses of the more fluid shapes Baroque architects championed at the time.

SOURCES

Massimo Birindelli, *Piazza San Pietro* (Rome: Laterza, 1981).

Irving Lavin, ed., *Gianlorenzo Bernini: New Aspects of His Life and Art* (University Park, Pa.: Pennsylvania State University Press, 1985).

Torgil Magnuson, *Rome in the Age of Bernini* (Atlantic Highlands, N.J.: Humanities Press, 1982).

Charles Scribner III, *Gianlorenzo Bernini* (New York: H. N. Abrams, 1991).

SEE ALSO *Visual Arts: Sculpture in Italy*

THE TEMPESTUOUS AND FANCIFUL BAROQUE

BORROMINI. An altogether more tempestuous spirit and highly imaginative genius animated the architectural visions of Francesco Borromini (1599–1667), the architect of a number of churches in and around Rome in the mid-seventeenth century. Unlike the amiable Bernini, Borromini was a loner who was quick to take offense and who eventually ended his life in suicide. While his competitor Bernini reveled in interiors filled with opulent displays of gold, colored marbles, and sculpture, Borromini's designs usually called for stark white, highlighted only by touches of gilt. Into these spaces he poured strange symmetries, curving walls and entablatures, and concave pediments—in short, shapes that had never been seen before in such close juxtaposition. Trained as a sculptor like Michelangelo and Bernini, he obsessed over small details in his designs,

treating buildings as if they were sculptural forms. His plans almost always reveal his sophisticated knowledge of geometry. One of the best examples of his unusual architecture is the small Church of San Carlo alle Quattro Fontane, a structure in which Borromini used many intersecting elliptical shapes. Inside, these shapes give the viewer the impression that the church is alive because of the constantly shifting dynamic flow of its curved lines. A more mature and larger work resulted from Borromini's designs for the Church of Sant'Ivo, a domed structure unlike any built up to this time in Europe. Borromini built the church at the end of a long courtyard for a school that later became the University of Rome; from the outside, the structure's dome and cupola appear as if they were a *ziggurat,* an ancient stepped pyramid dating from Mesopotamian times. These designs had become known in Europe during the sixteenth century, but only Borromini ventured to make such bold use of this shape. The footprint of the church is in the form of a six-pointed star, although, inside, Borromini's alterations to this shape quickly become apparent. Rather than ending in the angular shapes of a triangle, three alternating points of the star are rounded into semicircular niches, a motif repeated even more forcefully in the dome above. Thus, as one stands inside the church in any direction the shapes constantly oscillate against each other, and the form that is behind one is exactly the opposite of that which is in front. This highly intellectual architecture had many admirers, particularly in a seventeenth-century world fascinated by the properties of mathematics and geometry. Yet Borromini's works also evidenced a playful and unexpected side, too. In the Church of Sant Agnese he designed in the Piazza Navona in Rome, the architect made the façade appear as if it was a traditional church with side aisles and a nave. He strengthened this illusion by the placement of towers at both ends of the façade. Once inside, however, the viewer finds that the shape of the church is an ellipse that runs parallel, rather than perpendicular, to the square outside. The façade at Sant'Agnese, too, manages to complete Michelangelo's vision for unobstructed views of a church's dome. Flanked by its corner towers, the dome of the church soars above and is framed by high towers, thus accomplishing what the papacy's revisions in the design of St. Peter's destroyed at the great basilica. Here, as in most of his structures, Borromini also played with the traditional language of architecture to create a space notable for its decorative imaginativeness as well as its undeniable beauty. While he was not the only Italian Baroque architect to have a profound effect in Northern Europe, his works were especially revered in Germany and Austria, and knowledge of his achievements even-

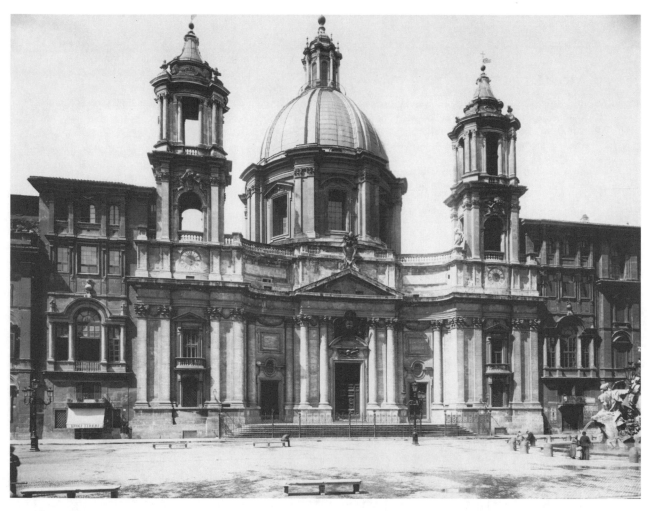

The façade of the Church of S. Agnese, Rome. ALINARI-ART REFERENCE/ART RESOURCE, NY. REPRODUCED BY PERMISSION.

tually inspired a climate of experimentation and innovation in these regions.

RICCHINO AND LONGHENA. The development of a dynamic Baroque architecture soon occurred in other places throughout Italy. At roughly the same time that Bernini and Borromini began their careers in Rome, several figures—working primarily in Venice and Milan—began employing design techniques similar to those taking shape in Rome. At Milan, Francesco Maria Ricchino (1583–1658) experimented with combinations of rectangles and octagons within the Church of San Giuseppe. Designed in the early seventeenth century, the structure broke away from reigning conventions to include a central-style interior composed of two octagons. The resulting structure bore great resemblance to the curving, undulating lines that Borromini developed at roughly the same time in Rome. Ricchino, once dubbed "the most imaginative" of seventeenth-century Baroque architects, inspired a native school of Baroque architec-

ture in Milan that developed roughly contemporaneous with the more familiar and famous Roman style. Slightly later in Venice, the designer Baldassare Longhena (1598–1658) made similar experiments with the Baroque style in the Church of Santa Maria delle Salute, a structure prominently placed at the end of the city's Grand Canal. Begun in 1631, the church was intended to commemorate the cessation of a recent outbreak of the plague in the city. The building was constructed in the central style, that is, it radiated outward as an octagon from a single point at its center, a form of construction generally disfavored by ecclesiastical leaders at the time. Inside, the interior was fairly typical of churches built at the time, yet on its exterior Longhena massed 125 decorative sculptures, rounded volutes, or scroll-shaped decorations, that served as buttresses, and other ornamental elements so that the entire structure took on the effect of a gigantic sculptural confection. It remains one of the most fanciful churches on the Venetian scene to

a PRIMARY SOURCE *document*

VILE ARCHITECTURE

INTRODUCTION: The imaginative spaces and shapes of Italian Baroque architecture did not please everyone. Writing in 1672, the Roman art historian Giovanni Pietro Bellori attacked the newfangled ideas of seventeenth-century architects, ideas that deformed the noble artistic synthesis accomplished by the ancients and recreated by High Renaissance masters. Bellori dedicated his work to Louis XIV's chief minister Colbert, who actively supported classicism in that country by encouraging the king to found the Royal Academy in 1671.

As for architecture, we say that the architect ought to conceive a noble *Idea* and to establish an understanding that may serve him as law and reason; since his inventions will consist of order, arrangement, measure, and eurythmy of whole and parts. But in respect to the decoration and ornaments of the orders, he may be certain to find the *Idea* established and based on the examples of the ancients, who as a result of long study established this art, the Greeks gave it its scope and best proportions, which are confirmed by the most learned centuries and by the consensus of a succession of learned men, and which became the laws of an admirable *Idea* and a final beauty. This beauty, being one only in each species, cannot be altered without being destroyed. Hence those who with novelty transform it, regrettably deform it; for ugliness stands close to beauty, as the vices touch the virtues. Such an evil we observe unfortunately at the fall of the Roman Empire, with which all the good Arts decayed, and architecture more than any other; the barbarous builders disdained the models and the *Ideas* of the Greeks and Romans and the most beautiful monuments of antiquity, and for many centuries frantically erected so many and such various fantastic phantasies of orders that they rendered it monstrous with the ugliest disorder. Bramante, Raphael, Baldassare [Peruzzi], Giulio Romano, and finally Michelangelo labored to restore it from its heroic ruins to its former *Idea* and look, by selecting the most elegant forms of the antique edifices.

But today instead of receiving thanks these very wise men like the ancients are ungratefully vilified, almost as if, without genius and without inventions, they had copied one from the other. On the other hand, everyone gets in his head, all by himself, a new *Idea* and travesty of architecture in his own mode, and displays it in public squares and upon the façades: they certainly are men void of any knowledge that belongs to the architect, whose name they assume in vain. So much so that they madly deform buildings and even towns and monuments with angles, breaks and distortions of lines; they tear apart bases, capitals, and columns by the introduction of bric-a-brac of stucco, scraps, and disproportions; and this while Vitruvius condemns similar novelties and puts before us the best examples.

SOURCE: Giovanni Pietro Bellori in *Michelangelo and the Mannerists; The Baroque and the Eighteenth Century*. Vol. II of *A Documentary History of Art*. Ed. Elizabeth G. Holt (Englewood Cliffs, N.J.: Prentice Hall, 1958): 104–105.

this day, providing the city with one of its most unforgettable and dramatic views, and one that is strategically placed in an important crossroads at the city's center. It is, in other words, an effective, grand note of drama and whimsy at Venice's core.

GUARINO GUARINI. In a somewhat different vein the architecture of Guarino Guarini (1624–1683) made use of elements drawn from Borromini, although he deployed these to a completely different effect. A member of the Catholic reform order of the Theatines, Guarini spent his youth in Rome, where he became aware of the experiments with new forms and styles being conducted by Maderno, Borromini, and Bernini. As he came to maturity, he became one of the great traveling architects of the seventeenth century, designing buildings in Sicily, Paris, and at Lisbon, as well as completing from a distance designs for churches at Munich and Prague. Later he moved to Turin, where he planned many buildings, most of which unfortunately have been destroyed since that time. A few examples of his work do survive, however. Although in some regards his use of curved shapes and unusual juxtapositions of geometric figures was similar to Borromini's and shows his influence, Guarini became even more obsessed with geometric patterns in his work. Much of this inspiration he derived from the knowledge he acquired of Islamic architecture while working in Sicily and Spain. In addition, late Gothic or Flamboyant architecture with its highly decorative vaulting provided another source of inspiration. In the designs for two domes he created in Turin, for example, he made use of intricate webs of triangles. For the Chapel of the Holy Shroud in Turin's cathedral, Guarini created a complex pattern of ever-shifting hexagons that move up the dome and frame its culminating *oculus*, a window which is in itself made up of a kaleidoscope of circles, semi-circles, and triangles. This pattern refracts and throws the light that enters the chapel in a way no less spectacular than in the greatest of Gothic cathedrals.

Guarini's creations were, above all, intellectual exercises in the deployment of geometric figures to create spaces that strike their observers as suave, elegant, and highly intellectual. In their wealth of decorative ornamentation and flamboyant detailing, Guarini's works anticipate the elegance of the Rococo style of the eighteenth century.

DIFFUSION OF THE BAROQUE STYLE BEYOND ITALY. Through the travels of figures like Gianlorenzo Bernini and Guarino Guarini, the accomplishments of Italian seventeenth-century design came to be known throughout continental Europe. The popularity of engraved architectural etchings and theoretical treatises written by Italians also spread knowledge of the innovations underway in the peninsula, as did the travels of European designers in Italy, too. Throughout the continent, many of the features of Italian design inspired similar experiments with space, ornament, and monumental scale. The Baroque, as it developed elsewhere in Europe, was not just slavishly copied or imitated from Italian examples. The breakthroughs of figures like Bernini and Borromini were instead assimilated to varying degrees within native styles. One of the chief accomplishments of Roman Baroque architects in the first half of the seventeenth century had been to create a dynamic architecture that suggested movement—movement bolder than the passive, static, and intellectualized spaces favored by the designers of the High Renaissance and Mannerist periods. Baroque buildings invited viewers to enjoy their complexities from multiple angles. The asymmetrical lines and the curving spaces of their interiors demanded that viewers walk about these structures to explore the many facets of their interiors. All of these elements, though, were carefully calculated to produce a climactic impression, an impression that often bespoke of power and authority. In the many churches that sprouted on the cityscapes of Rome and other Italian cities, this element of power had been carefully harnessed to support the resurgence of religion underway as a result of the Catholic Reformation. Elsewhere, the use of the new dynamic and monumental techniques of Baroque architecture found their way into an almost innumerable number of urban palaces, country villas and châteaux, as well as churches and civic buildings. For their abilities to command the environment and to suggest control, buildings constructed in the Baroque fashion quickly became the preferred style for seventeenth-century kings and princes desiring to present an image that coincided with their absolutist political rhetoric and theories.

SOURCES

Anthony Blunt, ed., *Borromini* (Cambridge, Mass.: Harvard University, 1979).

Joseph Connors, *Borromini and the Roman Oratory* (Cambridge, Mass.: MIT Press, 1980).

Frederick Hartt, *Art. A History of Painting, Sculpture, Architecture*. 3rd ed. (New York: H. N. Abrams, Inc., 1989)

J. S. Held and D. Posner, *Seventeenth and Eighteenth Century Art* (Englewood Cliffs, N.J.: Prentice Hall, 1971).

Andrew Hopkins, *Santa Maria della Salute: Art and Ceremony in Baroque Venice* (Cambridge, England: Cambridge University Press, 2000).

H. A. Meek, *Guarino Guarini and His Architecture* (New Haven, Conn.: Yale University Press, 1988).

Paolo Porteghesi, *The Rome of Borromini*. Trans. Barbara La Penta (New York: G. Braziller, 1968; Englewood Cliffs, N.J.: Prentice Hall, 1971).

ARCHITECTURE IN FRANCE IN THE SEVENTEENTH CENTURY

A CENTURY OF GREATNESS. The later sixteenth century had been a time of great troubles in France, with religious and civil wars threatening on many occasions to tear the country apart. The accession of Henri IV (r. 1589–1610) paved a way for an era of greater peace and stability. Henri's conversion to Catholicism in 1593, and the granting of a limited degree of religious toleration to French Protestants through the Edict of Nantes (1598) were both controversial measures at the time. Yet both royal actions provided a foundation for France's relative domestic peace and stability in the seventeenth century. Although Henri IV was to die the victim of an assassin's dagger in 1610, France weathered this crisis and did not return to the chaotic civil conflict of the kind that had raged in the sixteenth century. As a result, the seventeenth century saw a period of unprecedented growth in royal power and authority, a growth reflected in the architecture of the period. The new political goals and ideology of the age have frequently been called absolutism, meaning that the king was the sole source of political authority in the realm. In practical terms, this meant that seventeenth-century French kings aimed to strengthen their power by reforming the government's finances and administration, by weakening the local control of the country's nobles, and by enlarging French territory and the country's role on the international scene through military engagements. The emerging Baroque style in architecture provided an ideal way in which to express the enhanced power of France's royal government, and for much of the seventeenth century it was the city of Paris that benefited architecturally from the wealth and resources that France's new stability afforded. In Paris, the seventeenth-century French monarchy

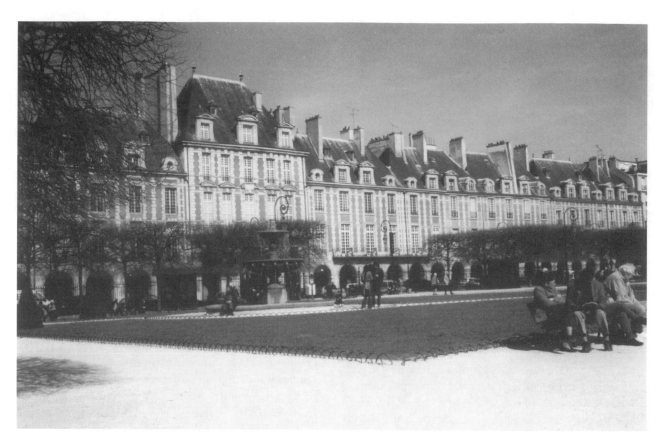

Place des Vosges, Paris. PHILIP M. SOERGEL.

supported a number of new projects that made use of the developing tenets of Baroque design. At the same time the Baroque in Paris re-interpreted the dramatically imaginative and irregular spaces Italian designers favored so that monuments built in Paris during the seventeenth century displayed a more severely classical, if no less monumental imprint.

PARIS IN THE SEVENTEENTH CENTURY. In 1600 Paris was one of continental Europe's largest cities. Although the developments that most tourists associate today with Paris—the city of attractive squares, public monuments, and grand boulevards—were largely creations of the nineteenth century, Paris was still one of Europe's fastest growing seventeenth-century cities, and one that was beginning to be shaped by the techniques of urban planning. At the time, new districts and suburbs were continually being opened up for settlement, and many projects undertaken in these areas anticipated, if on a smaller scale, the grand Paris of modern times. A growing willingness, too, to attack and surmount the problems that nature presented is evident in many of the projects undertaken during the Baroque period. Two districts—the Marais and the Île Saint-Louis—show the appetite that existed for land for development close to

the heart of the city. Though they were less-than-ideal sites, their proximity to the medieval core of Paris made them prime locations for townhouses for the city's nobles and wealthy burghers. The Marais—meaning literally "swamp" or "marshland"—lay directly east of Paris's early medieval walls. During the Middle Ages, the Knights Templar and several other religious orders had drained the area of its swamps, and set up religious houses in the district. Eventually, the area was brought within the town's walls, and Paris's Jews were allowed to settle there. In the fourteenth century, two royal residences were built at the north and south edges of the district, making the Marais a center of artistic and cultural life in the later Middle Ages. By the late sixteenth century, though, much of the Marais was still susceptible to flooding, and its previous medieval and Renaissance glory had languished as the court had again taken up residence in the Louvre. Henri IV decided to reinvigorate the area, and he devised a plan to construct Paris's first purpose-built square, the Place Royale, later known as the Place des Vosges. Plans for the area had already been set down during the time of Catherine de' Medici in the 1560s but, given the turbulence of the later sixteenth century in France, they had not been

a PRIMARY SOURCE *document*

A ROYAL BUILDER

INTRODUCTION: During the early years of Louis XIV's reign the king was constantly involved with new architectural projects as a way of enhancing his own kingly status. Later, the king decided to shower most of his attentions on the Palace of Versailles. But in the years just after he emerged from his minority, he concentrated more on quantity than quality.

However, the young king had not as yet made any definite choice of his favourite place. He was building, enlarging and making alternations nearly everywhere, even in Paris which he had never liked since the Fronde. It was his firm belief that glory and reputation were also to be gained by magnificent buildings. In January 1664 he made his Intendant of Finance, Jean-Baptiste Colbert, Superintendent of Buildings as well. But as early as 1661, he had already acquired the unrivalled team of men who had built Vaux for Fouquet: Le Nôtre, Le Vau, Lebrun, the 'engineers' of the waterworks and even the orange trees. Very soon he had repairs, enlargements and new buildings going on practically everywhere: at Fontainebleau, Vincennes, Chambord and Saint-Germain with its marvellous terrace. With the Pope's permission he brought Bernini from Rome to complete the Louvre in the Italian style but then changed his mind and chose Claude Perrault

whose colonnade was begun in 1667. Also in Paris, the *portes* Saint-Denis and Saint-Martin, the Collège Mazarin, the Observatory and the Invalides were gradually taking shape. Versailles to begin with had been turned from a hunting lodge into a park and pleasure gardens. Groves, a labyrinth, grottos, a lake and waterways, the first ornamental and allegorical statues, the first fleets of boats and the first menageries were all designed by Le Nôtre. The house itself was scarcely touched. Le Vau, who wanted to pull it down, was obliged to be satisfied with padding it out a little while one of the earliest follies in the shape of a Chinese pavilion, the porcelain Trianon, was built at a little distance. In 1670, much against Colbert's wishes, Louis decided to move in. In 1671 it was decided to transform the neighbouring hamlet into a royal town. But Le Vau was dead, leaving countless plans behind him, and others were to build the Versailles of the king's mature years. Le Nôtre, too, redesigned his park.

Like Colbert and the learned Chapelain, Louis considered that buildings alone were not enough for his glory. All the arts, letters and sciences must come together, as in the time of Augustus, to glorify his person and his reign, and all naturally, in perfect order and obedience.

SOURCE: Pierre Goubert, *Louis XIV and Twenty Million Frenchmen.* Trans. Anne Carter (New York: Random House, 1970): 80–81.

undertaken. In 1603, Henri began to sell plots to buyers who agreed to construct their houses along the predetermined designs for the site. The result produced one of Europe's most dignified and attractive city squares, a site that has changed little since the seventeenth century. The houses of the Place des Vosges were constructed from stucco and brick. Facing inward toward the square, the buildings were united by a single continuous colonnaded arcade with the projecting stories of the houses that lay above providing shelter from the elements. On both sides of the square, two taller and larger houses were reserved for the king's and queen's use, while the other houses cannot be distinguished from one another, except by looking at the lines of the mansard, or steeply pitched, roofs. Elaborate festivities commemorated the inauguration of the site in 1612, and the square quickly became a favorite for nobles and wealthy burghers who served the court. By the mid-seventeenth century, Henri IV's foresight had reinvigorated the Marais as the center of Parisian life and culture. In the mid- to late century one of its more famous residents was Madame de Sevigné,

a noblewoman and author of a voluminous correspondence with her daughter, one of the most revealing records of upper-class French life at the time.

THE ÎLE SAINT-LOUIS. Only a few years after the death of Henri IV, his wife, the regent Marie de' Medici, undertook a similarly ambitious project on a long-neglected island adjacent to the Marais in the Seine. At the time, the island was known as the Île Notre Dame, since it had once belonged to the canons of Notre Dame and lay directly beside the city's cathedral on the Île de la Cité, the heart of medieval Paris. The Île Notre Dame had long served as pasture land and a place where Paris's washerwomen beat clothes on the river shores. The island's dubious notoriety had also been sustained by its venerable status as a dueling ground. Low lying, the area was regularly subjected to flooding, and a channel dug through it in the fourteenth century cut one side of it off from the other. It was, in fact, a poor site for a residential quarter, although the aplomb with which these problems were solved suggests some of the ingenuity and determination with which Baroque architects and urban

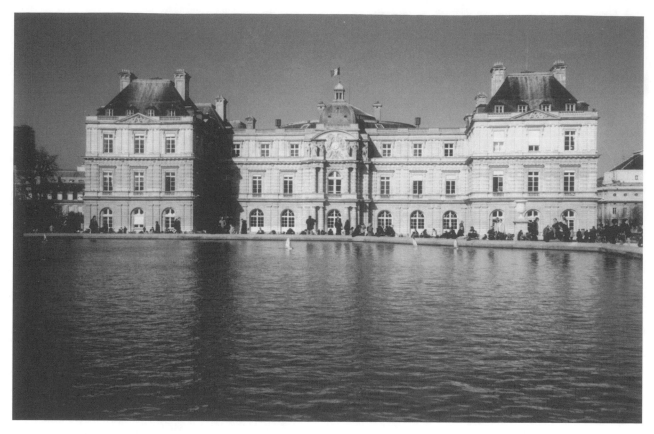

Exterior view of the Luxemburg Palace, Paris. PHILIP M. SOERGEL.

planners aimed to conquer nature. In 1614, the crown awarded the island to a partnership consisting of several military engineers and financiers hired to supervise the filling in of the channel and its development as a residential quarter. The group's finances were always shaky, and a portion of those who had bought land on the island eventually took over the project's control, ensuring that, by 1650, the channel between the two parts of the island had been filled in and that a series of quays 32 feet high now kept the river at bay. On this safe surface above the Seine, grand rows of townhouses began to take shape, while a bridge conveniently connected the island with the Marais that lay to the north. On this small site—less than 120,000 square feet—towering townhouses became an undeniable testimony to Paris's wealth and the seventeenth-century's will to surmount nature. The arrangement of these houses, too, points to a changing sensibility among Paris's upper class about the River Seine, a changing sensibility that has defined Parisian life since the seventeenth century. For centuries, the river's role in Paris had been either lamentable or utilitarian. On the one hand, the Seine had been a highway for provisioning the city; on the other, it had been an ever present cause of misfortunes made palpable in perpet-

ual dampness, flooding, and disease. Now on the safe promontory that the island's quays provided, the prominent designers Le Vau, Mansart, and Le Brun built elegant houses for the city's wealthy that looked outwards toward the river. Nature, tamed in the way it had been in the middle of the Seine, now served as an enhancement to real estate.

OTHER PARISIAN VENTURES. Attentions similar to those showered on the development of the Marais and the Île Saint-Louis focused elsewhere throughout the city of Paris in the seventeenth century. During the reign of Louis XIII (r. 1610–1643) many of these projects continued along the lines of the Mannerist style that had been popular in late sixteenth-century France, including the construction of the Luxemburg Palace (b. 1615), just outside the Latin Quarter on the Left Bank of the Seine. The palace became home to the Queen Mother Marie de' Medici. Its style, however, was largely traditional and there was as yet little of the elegant garden that eventually so enhanced the palace's rather small scale. Another project of Louis XIII's reign imitated the style of early Baroque newly ascending to popularity in Rome: the construction of the Chapel of the Sorbonne, the university's church designed by the architect Jacques Lemercier and

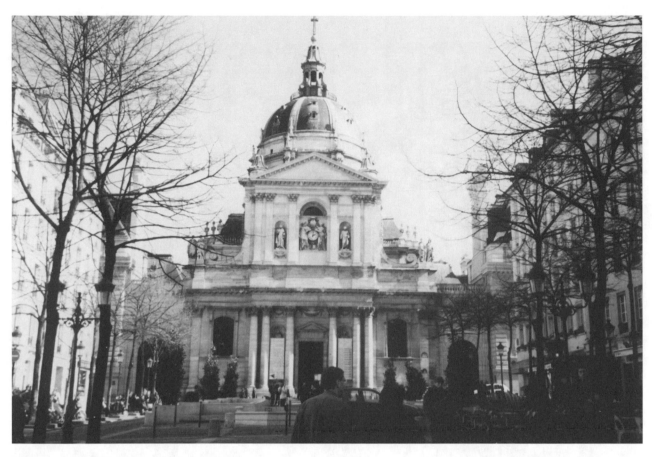

Chapel of the Sorbonne, Paris. PHILIP M. SOERGEL.

begun in 1635. This domed structure largely copied the Church of San Carlo ai Catinari, completed in Rome in 1620. Cardinal Richelieu, Louis' powerful minister, ensured that this building could be properly seen from its street angle by demolishing a group of medieval buildings that had stood on the site. In flavor, though, the building remains a conservative imitation of the grand Italian style, and nowhere in Paris does one find the kind of daring uses of dramatic and unusual shapes and spaces like those that prevailed in the architecture of Borromini and Guarini in Italy. Instead, the native French Baroque architects of the time looked conservatively to late Renaissance models or to those of the early Baroque, rather than to more innovative designs. Although more conservative in spirit, the buildings of the period nevertheless embraced a monumental scale similar to those being constructed in Italy at the time. Examples of this monumentality can be seen in the new additions and remodeling undertaken at the Palace of the Louvre. This grand structure, the largest urban palace in Europe, was almost continually in a state of repair, refurbishment, and remodeling until the nineteenth century. Renaissance alterations at the site had included the destruction

of the medieval tower of the original castle, and the construction of two new wings according to designs set down by Pierre Lescot. These structures were the first truly Renaissance designs in the city of Paris. Slightly later in the sixteenth century, Catherine de' Medici took up residence in the Louvre and began to construct a second enormous building, the Palace of the Tuileries, to the west of the original Louvre complex. Although a mob eventually burnt down that palace during the Revolt of the Paris Commune in 1871, a long Gallery constructed during the reign of Henri IV joined both the Tuileries and Louvre together. Louis XIII and Louis XIV continued to add to the palace, with Louis XIII beginning the construction of the massive *Cour Carrée*, the square courtyard that was four times larger than the original internal courtyard of the Renaissance palace. This enormous project consumed the efforts of the architect Jacque LeMercier for many years before finally being completed under the direction of Louis Le Vau. By the 1660s, and the reign of Louis XIV, the only major project left at the Louvre included the construction of a new façade for the palace's East Wing, an important part of the entire venture since it faced eastward toward the city of Paris.

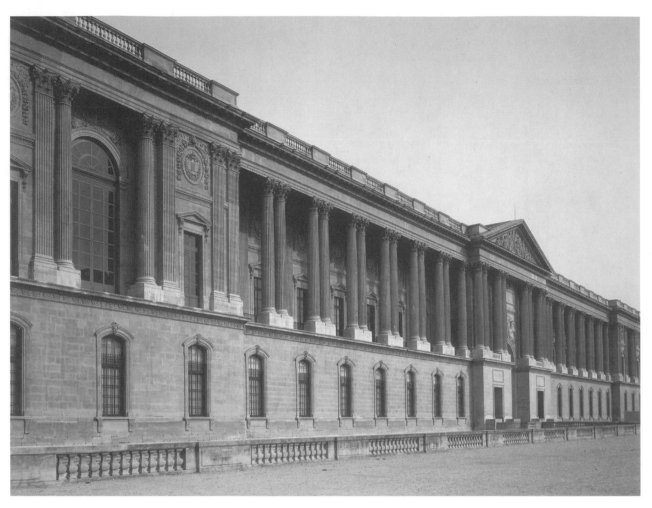

East façade, Palace of the Louvre, Paris. GIRAUDON/ART RESOURCE, NY.

To complete this project, Louis first imported the Roman architect Bernini, who drew several plans for the site—plans that, if they had been undertaken, might have completely altered the Renaissance appearance of the structure. Not entirely convinced of the wisdom of Bernini's designs, the king's ministers solicited plans from French designers, too, and soon after Bernini's return to Rome, the king selected designs drawn up by the architect Louis Le Vau and Claude Perrault, a physician, scientist, and scholar, as well as a writer on architectural theory.

THE FOUNDATIONS OF FRENCH CLASSICISM. The project for the East Wing of the Louvre was of major significance in setting design standards that prevailed in public buildings in France for much of the rest of the seventeenth and eighteenth centuries. While massive in its proportions, the façade's arcade of paired columns rising above a story of simple arched windows suggests a thorough knowledge of Roman temple architecture. The only break in the entablature running across the entire façade is in the single pediment that stands in the center, while at both ends of the structure simple pavilions with three windows, the center one arched in a Palladian manner, complete the structure. The serene and majestic face of the building became a premiere example of French "good taste" in construction. Shortly after the building's completion in 1670, Louis XIV's minister, Colbert, made the bold move of establishing the Royal Academy of Architecture in France, an academic body charged with meeting regularly to discuss and set the canons for public buildings. This body rejected the extravagantly ornamental forms favored by architects like Guarini and Borromini, and instead insisted that the canons of French architecture that had prevailed since the Renaissance should be safeguarded. Usually, the body supported "French restraint" in building as superior to Italian Baroque innovations. In particular, the academy rejected broken pediments and other Italian innovations, and instead insisted on the use of a harmonious and rationally understandable classicism inspired by Antiquity.

THE BEAUTIFUL AND THE UGLY

INTRODUCTION: The Duc de Saint-Simon (1675–1755) was one of the most trenchant observers of the court life of Louis XIV's reign. In his *Memoirs*, which fill more than 25 thick volumes, he commented on almost every aspect of the life of the nobility, often calling attention to the way that squalor existed side-by-side at court with imposing grandeur. His comments here attack Louis' poor choice of Versailles' site, the violence the king wreaked on nature in his gardens, and the bad taste on display everywhere at the château.

He liked splendour, magnificence, and profusion in everything: you pleased him if you shone through the brilliancy of your houses, your clothes, your table, your equipages.

As for the King himself, nobody ever approached his magnificence. His buildings, who could number them? At the same time, who was there who did not deplore the pride, the caprice, the bad taste seen in them? St. Germains, a lovely spot, with a marvellous view, rich forest, terraces, gardens, and water he abandoned for Versailles; the dullest and most ungrateful of all places, without prospect, without wood, without water, without soil; for the ground is all shifting sand or swamp, the air accordingly bad.

But he liked to subjugate nature by art and money. He built at Versailles, on, on, without any general design, the beautiful and the ugly, the vast and the mean, all jumbled together. His own apartments and those of the Queen, are inconvenient to the last degree, dull, close, stinking. The gardens astonish by their magnificence, but cause regret by their bad taste. You are introduced to the freshness of the shade only by a vast torrid zone, at the end of which there is nothing for you but to mount or descend; and with the hill, which is very short, terminate the gardens. The violence everywhere done to nature repels and wearies us despite ourselves. The abundance of water, forced up and gathered together from all parts, is rendered green, thick, muddy; it disseminates humidity, unhealthy and evident; and an odour still more so.

SOURCE: Duc de Saint-Simon, *Memoirs*, in *Louis XIV*. Ed. H. G. Judge (London: Longmans, 1965): 48.

It generally supported the use of the steep French, or mansard, roof as generally well adapted to the country's northern climate. In addition, the French Academy's influence penetrated into the building industry itself, as it became a body charged with establishing standards for construction and for the materials used in buildings as well as for stipulating correct building practices.

FROM VAUX-LE-VICOMTE TO VERSAILLES. The foundation of the Royal Academy of Architecture in Paris established the canons of French classicism as normative in public building projects undertaken in the country during the seventeenth and eighteenth centuries. At the same time, the construction of private residences and country châteaux displayed considerable variety as well as a taste for extravagance. One of the most significant of the many country retreats built in this period was the Château of Vaux-le-Vicomte, constructed for Louis XIV's chief minister of finance, Nicholas Fouquet. This massive project, perhaps the most comprehensively successful of the many French country châteaux completed in the sixteenth and seventeenth centuries, was a collaborative project undertaken by the architect Louis Le Vau, the interior designer Charles Le Brun, and the garden designer André Le Nôtre. Although Vaux-le-Vicomte's extravagance eventually spelled disaster for Fouquet, the structure was important in that it was one of the first highly successful integrations of outdoor landscaping, architecture, and interior design. Seen from its gardens, Vaux embodies many qualities of elegance, particularly its domed central salon adapted from Italian Baroque architecture of the period. Less exuberant than similar palaces constructed in Italy at the time, the structure and its gardens, nevertheless, were the envy of French nobles at the time. Shortly after completing the structure in 1661, its owner, Fouquet, entertained the king and the court at a lavish celebration, which included impressive fireworks and even a specially commissioned comedy written by Molière. Even before the king arrived, however, Fouquet's undoing had been planned. Convinced that Foquet had long embezzled from the royal treasury, Louis accepted his minister's hospitality before imprisoning Fouquet for life two weeks later. The king seized Fouquet's pride, the Château at Vaux-le-Vicomte, as well as his other possessions. The extravagant displays that he had seen while in Vaux-le-Vicomte steeled Louis' resolve to punish the extravagant upstart. While at Vaux, though, Louis was so impressed with the quality of the château's garden, its interior decoration, and façades that he recruited the team of designers—Le Vau, Le Brun, and Le Nôtre—to join his service. Within a few years, these three collaborated on the greatest project of the age: the Palace of Versailles.

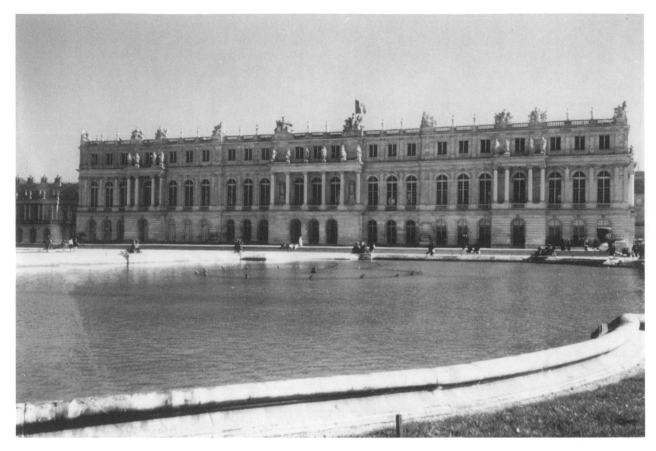

Garden Façade, Palace of Versailles. PHILIP M. SOERGEL.

A ROYAL HUNTING LODGE. The building that became known as the wonder of the age, Versailles, began as a simple hunting lodge, constructed for the pleasure of Louis XIV's father in 1624. Its rise to prominence as the seat of the French monarchy began in the 1660s for a variety of reasons, not least of which was the restiveness of the country's nobility, which had recently been evidenced in the *Fronde* of 1648–1653. This series of rebellions of French nobles and parlementarians occurred in and around the city of Paris during Louis XIV's minority. Since he had acceded to the throne when he was only five years old, Louis' government had been largely presided over by his mother, Anne of Austria, and her chief minister, the Italian Cardinal Mazarin. Their actions to strengthen the power of the crown and set royal finances on a firmer footing angered the Parlement of Paris, which rose up in revolt in 1548 and 1549. Slightly later, a faction of nobles rebelled, too, raising an army against the crown and succeeding in driving the king, the Queen Regent, and Cardinal Mazarin from Paris. For a time the city fell under blockade, but the successful quashing of the rebellion actually enhanced royal authority. Although Louis had been only ten years

old when these disturbances began, he never seemed to forget his humiliation at the hands of the country's nobles, and his later decision to move his government to Versailles, away from the Parisian nobles, was in large part inspired by the embarrassment of the fronde. With the death of his chief minister Mazarin in 1661, Louis resolved to rule alone, and, particularly, to bring into submission the French nobility. When he first began to visit his father's small hunting lodge at Versailles in the 1660s, though, Louis considered it no more than a place of diversion. To make the site more suitable to royal entertainment, the king enlisted Le Nôtre to design lavish gardens there for court festivities. A few years later, in 1668, Louis decided to extend the small château that stood at the site, adding three large wings constructed from stone rather than the original brick and stucco. With these additions, he completely dwarfed the rather modest structure that had originally stood at the site. In truth, Versailles was always a poor choice for the construction of Louis' ambitious designs. The land was marshy and had to be extensively drained. An inadequate supply of fresh water meant that a complex system of pumps had to be built to bring water miles from the

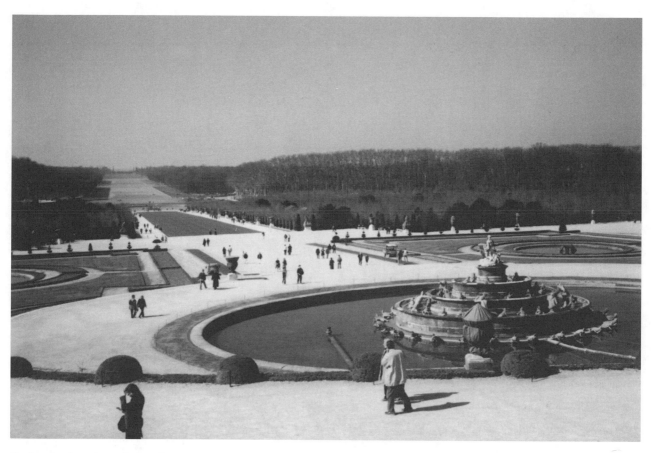

Gardens at the Palace of Versailles. PHILIP M. SOERGEL.

Seine to the château in order to feed its 1,400 fountains as well as its enormous canal. The palace that Louis built had an unyielding symmetry and logic, and this made Versailles a cold and drafty place, where opposing windows and cold marble floors produced many a chill and pain in the joints. Equally unwieldy was the complex and highly contrived court etiquette that developed for the courtiers who attended the king there. Every move of the court and the king had to be choreographed according to an unbending etiquette that lasted long after Louis had died. The king intended these intense displays of court ritual to tame his nobles, to make them into obedient subjects. Curiously, perhaps the only one that Louis showed deference to at Versailles was his father: he carefully preserved his father's original hunting lodge as the core of the château, continuing to build around it for the rest of his life, even though its style was greatly at odds with the Italianate palace that sprang up around it.

THE SEAT OF GOVERNMENT. The Roman Baroque style of the period heavily influenced the interiors of this palace, although in subsequent alterations, parts of Versailles took on a more classical flavor. The huge structure and its surrounding gardens always remained a hodge-

podge of conflicting elements and styles, yet they all curiously adhered to each other by virtue of the palace's overwhelming grandeur and scale. At the center of this structure there was one constant: the king's bedroom, where his rising and going to bed became one of the central rituals of the state. At the height of the society Louis created there, more than 10,000 courtiers were often in attendance at court. During the late seventeenth century, Versailles was almost constantly under construction. Within a decade of the major expansions begun in 1668, a second set of alterations began, this time with the purpose of moving the court and royal government permanently to Versailles. Thus, between 1677 and the transfer of government to Versailles in 1682 a small city sprang up around the palace to serve the king and his courtiers. The king's architect, Jules Hardouin-Mansart supervised this second expansion, which included two gigantic wings built at the north and south of the structure. These radiated off at perpendicular angles from the U-shaped block that now stood at the center, and they brought the total width of the palace's front façade to more than 600 yards. Seen from this angle, Versailles remains a not-altogether pleasing construction, although one that

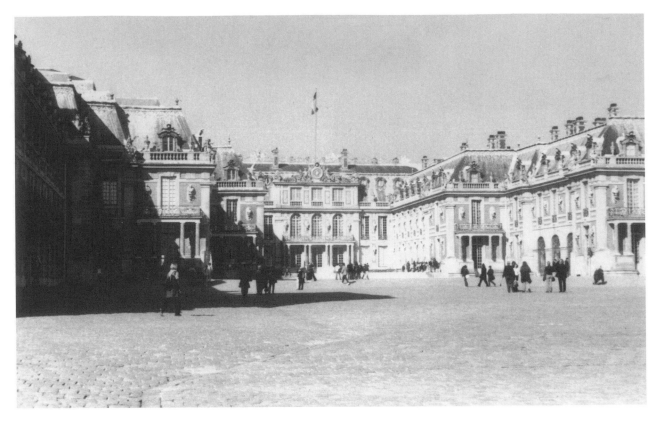

Exterior view of the Marble Court, Palace of Versailles, France. **PHILIP M. SOERGEL.**

nevertheless continues to amaze and confound visitors by its sheer size. It is from the gardens, however, where the palace's design clearly shines. The geometric patterns created by the gardens' many walks and broad avenues and the placement of the fountains and more than 4,000 pieces of sculpture combine to make the palace's enormous garden façade appear strikingly beautiful, even delicate, against the sky. As in the palace proper, the central placement of the king's bedroom and the daily path of the sun from east to west were the major principles around which the gardens were organized. Known as the "Sun King," Louis ensured that this motif of the sun recurred in many other places at Versailles.

OTHER CONSTRUCTIONS. As Louis and his court settled in Versailles as a permanent residence in the 1680s, even the king began to tire of the elaborate protocol and uncomfortable spaces of his creation. In 1687, he commissioned his chief architect, Jules Hardouin-Mansart, to build a smaller palace at the far edges of Versailles' garden, where a small village known as Trianon had once stood. This "Marble Trianon" replaced a small Chinese pavilion constructed at the site in the 1670s. Louis intended the Grand Trianon, as it later became known, to be a private retreat, where he might bring ladies from the court for private suppers. The gardens

were more informal and the scale of the small palace less forbidding than the great château. Unlike the many-storied creation of Versailles, the Trianon had a single story of family bedrooms and drawing rooms. When completed, the palace had two large wings separated by a marble colonnade. As Louis mended his wayward marital habits later in life, the Trianon took on more the nature of a family house in which the king, his children, and wife might escape the pressures of court life. In these later years the king also constructed Versailles' sumptuous royal chapel, an oval two-storied construction where the king heard Mass from the balcony above. The lines of this high building can be seen today towering above the town façade of Versailles, and even at the time of its construction the chapel was criticized for destroying the view of the palace from the front courtyard. Inside, however, was one of Hardouin-Mansart's most beautiful and restrained creations. Below, a colonnade of Roman-style arches are decorated with simple, yet elegant reliefs, while, above, on the second-story balcony, plain white Corinthian columns support a broad entablature that runs around the structure's oval shape. Simple arched windows emit a striking light into the chapel, whose ceiling is decorated with gilt and murals. The royal chapel was the first freestanding church to be built upon the

Church of the Invalids (Les Invalides), Paris. PHILIP M. SOERGEL.

grounds at Versailles, although five smaller chapels had preceded it. It was completed only in 1710, five years before the king's death. Its light and airy spaces reflect the developing tastes that made Rococo architecture so widely popular among nobles and wealthy city dwellers in France in the early eighteenth century. Still, the overwhelming feeling that the chapel presents is of a restrained classicism, one that since the mid-seventeenth century French architects had been anxious to develop as a native style. Louis reputedly built the structure to satisfy his second wife, the commoner Madame de Maintenon, whose piety was well recognized at the time, and who helped wean Louis away from his self-indulgent nature. Nevertheless, the structure is fully consonant with the aims of Versailles, which were, in large part, to create spaces befitting of a monarch with grand pretensions and a love for the adulation of his subjects. The daily hearing of Mass that occurred within the space was in and of itself one of Versailles' most important rituals.

ASSESSMENT. Even in his own day, Louis XIV's Versailles was often criticized as a palatial stable, and it was attacked for its bad taste and lack of comforts. Yet despite the frequent aesthetic judgments that have been made against the structure from the seventeenth century onward, it is difficult to overestimate Versailles' influence on the palace architecture of Europe during the early eighteenth century. In Germany and central Europe, in particular, where scores of territorial princes competed against one another for political advantage and glory, Versailles came to be widely imitated. A host of smaller Versailles, in other words, soon popped up on the European landscape. The widespread emulation of the French model involved more than just creating public spaces and gardens that imitated Versailles, for courtly taste adopted the elaborate etiquette and rituals that prevailed in the French palace, too. Versailles, in other words, embodied the absolutist and courtly aspirations of the age.

PARISIAN DEVELOPMENTS. The king's and court's move to Versailles, some fifteen miles southwest of the center of Paris, consumed an inordinate amount of France's state treasury at the time. As a result, few great architectural projects could be completed in France's largest city in the later seventeenth century, although there were several important exceptions. In 1670, Louis founded the Hospital of the Invalids, a home for France's war veterans. Over the years, this complex grew in the

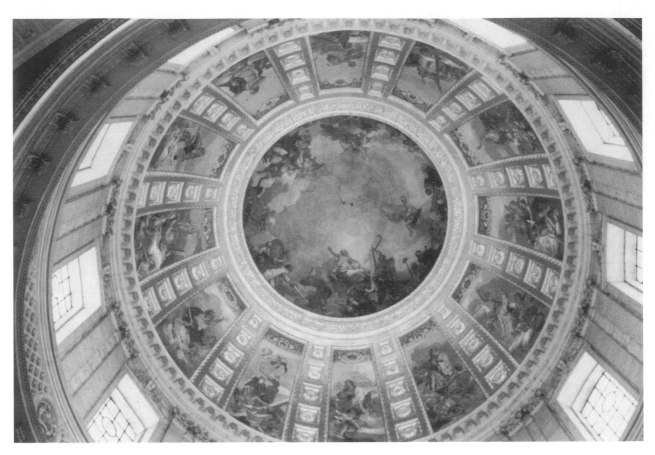

Interior view of the dome of the Church of the Invalids (Les Invalides), Paris. **PHILIP M. SOERGEL.**

western part of the city to accommodate more than 4,000 veterans. A handsome addition to the complex was the construction of its massive, domed church, designed by Jules Hardouin-Mansart and begun in 1687. At Les Invalides, as it has long been known, Hardouin-Mansart used a design detail, the cut-off ceiling, adopted from the repertory of his uncle François Mansart. In the interior of the high dome, in other words, he included an inner dome that was much lower than the external structure, yet cut off at the top to allow views to the much higher structure above. The result creates an impression of soaring height and a dramatic vista from the floor of the church below. The exterior of this structure, too, makes use of the severe classicism that French designers favored at the time. The project of Les Invalides, taken up in the west of Paris and on the Left rather than the Right Bank of the Seine, also signaled an important shift in the city's population. As the court congregated more and more outside the city at Versailles, the wealthy and cultivated elites that remained began to move from the Marais and other districts on the edge of Paris' medieval core westward, particularly into the regions around St. Germain-des-Pres, an ancient abbey that had

once stood on the western fringes of the city. At the end of the seventeenth century the area began to be filled with handsome townhouses. Further south of the heart of medieval and Renaissance Paris, new suburbs began to spring up on the Left Bank, too. This shift in residential development in the city continued throughout the eighteenth and nineteenth centuries, making the Left Bank one of the most desirable locations for residences in the city, while leaving the former residential areas of the Right Bank open more and more to commercial development. One final important project begun during the late seventeenth century was the construction of the Place Vendôme, under the direction of the royal architect Hardouin-Mansart. This planned square stood at the time on the Right Bank north and west of the Louvre, in an as yet little settled area. The square had been planned as early as 1685 to accommodate a group of public buildings, but the project stalled because of lack of funds. Eventually, Hardouin-Mansart laid out the square and began to build a series of classical façades, but a royal shortage of funds forced the king to sell the entire project to the city of Paris. At this point, the project languished until the 1720s, when the French king's

Scottish financier, John Law, succeeded in precipitating a real-estate boom in and around the square through the skillful sale of stock in its development. From Law's time, the classically inspired square has managed to remain one of the most stylish areas of Paris.

SOURCES

Anthony Blunt, *Art and Architecture in France, 1500–1700* (New Haven, Conn.: Yale University Press, 1999).

J. S. Held and D. Posner, *Seventeenth and Eighteenth Century Art* (Englewood Cliffs, N.J.: Prentice Hall, 1971).

F. Hartt, *Art. A History of Painting, Sculpture, Architecture*, 3rd ed. (New York: H. N. Abrams, Inc., 1989).

Vernon Hyde Minor, *Baroque and Rococo. Art and Culture* (London: Laurence King Publishing, 1999).

DIFFERENT DIRECTIONS IN ENGLAND

MODEST MEANS. In comparison to France, England had always been a relatively poor country, where the rituals of court and government had long been celebrated on a far more economical scale. The country's population—about four million in 1600—was only one quarter of that of France. Although the grandeur of the Tudor court might appear considerable to modern observers, Elizabeth I (r. 1558–1603) was notoriously tight-fisted by the standards of her era. With the accession of James I (r. 1603–1625) and the rise of the Stuart dynasty upon her death, greater luxury and opulence did come into fashion in the circles that surrounded the crown. Still James' wealth was considerably more limited than that of the French king. He may have desired to present an elegant face to the outside world, and he did try to do so, but the shortage of funds was an endemic problem and one that always threatened the monarch's efforts to create architectural monuments on a grand scale. Still, in the years of his reign several important projects, designed mostly by the talented architect Inigo Jones, laid the foundation for English classicism, a style that was persistently revived over the following two centuries and molded to fit the changing tastes of the time. Jones's style was considerably more restrained than the Italian Baroque and less monumental in scale than the French classicism of the time. He imitated many elements of the sixteenth-century architecture of the northern Italian, Andrea Palladio (1508–1580). During his long career Palladio had created a number of important public buildings and country villas, as well as several influential churches in the Venetian Republic. His ideas for a relatively unadorned architecture that nevertheless made use of elegant, often sinuous lines had been communicated in Northern Europe through the publication of his important architectural treatises. Nowhere, however, did these ideas take root more forcefully and pervasively than in England.

INIGO JONES. Born in 1573 in London, Jones had few of the advantages of the great gentlemen architects that came after him in England. Despite his humble situation as the son of a clothmaker, he managed to travel to the continent in 1603, his visit perhaps financed by a nobleman. Somewhat later he returned again to Italy where he made a detailed study of ancient Roman architecture. Largely self-taught, he rose in the court circles of Stuart England, and together with Ben Jonson he staged some of the most elaborate court masques of the early seventeenth century. These entertainments required great skill in staging as well as a thorough knowledge of design. Under both James I and his successor Charles I, Inigo Jones received a number of commissions for large-scale houses and he began work on the Queen's House in Greenwich outside London during 1616. Slightly later, Jones received the commission for the Banqueting House in Whitehall. Both structures survive and demonstrate the architect's thorough mastery of Palladian design principles. They are two of the first buildings to integrate the High Renaissance style in England, although by the standards of the time they might have looked rather severe and small in scale to continental observers. The Queen's House—intended for James I's wife, Anne of Denmark—was built on the grounds of the royal palace at Greenwich, although that larger palace has since been destroyed. Jones ingeniously devised the Queen's House to provide a bridge over a local road that cut the royal park in two. To solve this problem he built an H-shaped structure with two wings joined at the upper story by a bridge (the crossbar in the H). Later this design feature was covered up when the road was redirected and the center portion filled in. The ground floor of the structure was constructed from rusticated stone, with simple squared pediments as the only decoration above the windows. On the second floor, Jones used smoother masonry, yet repeated the same simple windows. A balustrade finished the structure. The entire mood of the Queen's House is somber, yet elegant, and thoroughly Palladian in its elements. The appearance of the Banqueting House, by contrast, is less severe, and the structure makes use of a greater range of decorative details. Although its interior is a single block, the structure appears from the street as a three-story structure with a rusticated ground floor. The first floor that rises above has alternating circular and triangular-pedimented windows and its columns are of the Ionic order, while on the floor

a PRIMARY SOURCE *document*

THE THREE PRINCIPLES OF MAGNIFICENT BUILDING

INTRODUCTION: The art and architectural theorists of the Baroque era frequently engaged in heated disputes about the precise style that was most aesthetically pleasing to the eye. French theorists, in particular, were anxious to weigh their own developing architectural traditions against those of the Italians, very often finding their own classicism superior to the innovation and experimentation of southern European designers. In England and the Netherlands, the shape of much writing about architecture was decidedly more practical. Rather than treating aesthetics, Balthazar Gerbier (1592?–1667), a Flemish architect and diplomat who settled in London in 1617, showed his readers how to garner the maximum architectural effect economically. Gerbier's *A Brief Discourse Concerning the Three Principles of Magnificent Building* set out solidity, conveniency (or convenience), and ornament as the chief principles that should govern a patron's choices in building. In a highly practical vein Gerbier also informed his readers about the best possible building practices to use, and he showed them how to safeguard themselves from the tricks of cost-cutting artisans and laborers. In this passage he treats the proper mixture of mortar to make cement.

The Romans are very curious in their tempering of mortar, and in the laying it as thin as they possibly can to prevent the sinking and bending of their walls, which the laying of their mortar too thick doth cause; and experience doth show, that when some walls are taken down in England, half of the substance is sand and dust.

The Romans (as likewise the Greeks before them) did not make use of their lime at the same time it was flaked, but for six months' time did suffer it to putrify, and so putrified composed a cement which joined with stone (or brick) made an inseparable union, and such work as I have seen iron tools break on the old mortars of the amphitheaters at Verona and Rome.

Their manner of preparing lime is to lay it in cisterns, the one higher than the other, that the water (after it has been so stirred as it is well mixed and thoroughly liquid) may drain from one cistern to the other, and after six months' time (the lime having evacuated its putrefaction) remains purified, and then they mix two parts lime with one part of sand, and makes that strong and perfect mortar, which if practiced in England, would make a wondrous strong union, especially if the clay makers did bend the clay as it ought to be, the English clay being better than the Italian, nay the best in the world.

They are very careful in making large and deep foundations, and to let the walls raised on the foundations rest and settle a good while before they proceed to the second story.

Some of our carpenters have learned to lay boards loose for a time, the Italians and other nations are not sparing therein. They nail them as if for good and all, but rip or take them up again, to fit them for the second time.

As I said before, no building is begun before a mature resolve on [decision is made based upon] a model of the entire design; the builder having made choice of his surveyor, and committed to him all the care and guidance of the work, never changeth on the various opinions of other men, for they are unlimited, because every man's conceits are answerable to his profession and particular occasion.

A sovereign or any other landlord is then guided by natural principles, as well as by his own resolve, taken on a long considered model, because they know by experience how sudden changes are able to cause monstrous effects.

SOURCE: Sir Balthazar Gerbier, *A Brief Discourse Concerning the Three Principles of Magnificent Building: Solidity, Conveniency, and Ornament* (London: n.p., 1664): 19–22. Text modernized by Philip M. Soergel.

above Jones used the Corinthian order and squared pedimented windows. To finish the structure, he created a decorative garland frieze and a simple balustrade. At the time of the building's construction in London in the early 1620s, nothing this classical in spirit had ever been seen before on the streets of England's capital. While Jones received many commissions during his long career, none of his subsequent work ever matched the influence of these two projects, although one of his most important achievements was his design of Covent Garden in London beginning in 1631. This was, like the Place des

Vosges in Paris and several earlier examples in Italy, a purpose-built square, the first in London. It derived many of its features from the earlier Parisian example. It was to be followed in the later seventeenth and eighteenth centuries by many other handsome squares, most of them built in the western part of the city. In those years, Jones's architectural examples also inspired a string of designers who were even more accomplished in applying Palladian classicism to the English environment.

REBUILDING LONDON. The greatest of Baroque English architects was Sir Christopher Wren (1632–1723),

a PRIMARY SOURCE *document*

IN PRAISE OF ST. PAUL'S

INTRODUCTION: In 1677 the massive rebuilding of St. Paul's Cathedral was just getting underway following the building's devastation in the Great Fire of 1666. The following poem, published in London, celebrated the effort to rebuild the church, an effort it compared to the great architectural achievements of the ancients and of the Roman Renaissance. Something of the excitement that the unprecedented building produced on the London scene can be gleaned from the poem's elaborate rhetorical flourishes.

What Miracle of Art will grow from hence,
And challenge through the World a Parallel,
When the bare Model only for Expense,
And real Value does so far excel?

But something more Majestic than even this
May we with solid reason expect,
Where to the Work, a *C H A R L E S* auspicious is:
A help so great can have no small effect.

Hereafter, how will every Generation
Bless that dear name, when from Records they know
This City's Beauty, Glory of the Nation,
To th' pious greatness of his soul they owe.

Nor shall Posterity forget the least
Of those, who such a Monument shall raise;
For when from their surviving Work they rest,
Eternal Fame shall mention their due Praise.

What did I say———only, eternal Fame?
Better Records are to such merit given;
Angels shall write with their own quills, each name
In the everlasting Registers of Heaven.

While in the front of those deserving men,
As the Conductor of this beauteous Frame,
Stands *England's Archimedes,* Learned *Wren,*
Who builds in *Paul's* a Trophy to his Name.

Earth's Cabinet of Rarities, famed *Rome,*
Shall now no more alone possess what's rare;
Since *British* Architecture dares presume
To vie with the most celebrated there.

Britain, who, though perhaps, the last she be
To imitate what's great in Foreign Parts,
Yet when she that hath done, we always see
Th' Inventors she excels in their own Arts.

Ah happy Englishmen! if we could know
Our happiness, and our too active fears
Of being wretched, did not make us so!
What cause of grief, other than this appears?

France, and the neighboring *Europe,* flame in War,
Seeking by Arms each others rest t' invade;
But while they burn and bleed, we only, are
Rich in an envied peace, and Foreign Trade.

While there, nor Church, nor Sanctuary can
Shield the rich Merchant from the armed rout,
Nor Virgin from the Lust of furious man.
Our Island one Asylum seems, throughout

Sacred and Civil Structures there decrease,
And while to Arms their lofty heads submit,
We are employed in the best Works of Peace,
And erect Temples to the God of it.

Rise noblest Work, rise above Envy's eye,
Never in thy own Ruins more to lie,
Till the whole world finds but one obsequy.

Rise to that noted height that Spain, and France,
Nay, Italy, may by their confluence
To our North Wonder, thy great Name advance.

And, what's to Protestants of better sense,
Make them confess our English Church expense,
And Beauty, equals their Magnificence.

SOURCE: James Wright, *Ecclesia Restaurata: A Votive Poem to the Rebuilding of St. Paul's Cathedral* (London: Henry Brome, 1677): 4–6. Text modernized by Philip M. Soergel.

a figure who left a major imprint on London after the city's catastrophic fire of 1666. Wren was the son of an eminent clergyman who eventually became the Dean of Windsor, the site of England's largest royal castle. Thus, the young Wren moved in powerful circles from an early age; his playmates were members of the royal family, and by virtue of his superior education, he matured into something of a Renaissance man. He attended Wadham College, Oxford, at the age of sixteen, where he worked under a brilliant anatomist and conducted some of the first experiments in the use of opiates as anesthesia. When he completed the Master of Arts degree, he received a prestigious fellowship to All Souls College, also at Oxford, a position he held for the next twenty years and which allowed him to pursue his research interests in astronomy. While still a fellow, he also accepted an academic appointment at Gresham College in London, where he gave regular lectures in Latin and English. While in London, he and a close friend founded the Royal Society for the Promotion of Natural Knowledge,

Chapel and cloisters of Emmanuel College, Cambridge, designed by Sir Christopher Wren and built in 1677. © PHILIPPA LEWIS/CORBIS.

the institution that remained England's premiere national academy for scientific research. Appointed to a prestigious professorship at Oxford in 1661, Wren began to dabble in architecture after his uncle, the bishop of Ely, asked him to design a chapel for Pembroke College, Cambridge. Several small commissions followed, but his rise to prominence began soon after the Great Fire of 1666 destroyed more than two-thirds of the City of London, including the medieval core. Within a few weeks of this catastrophe, Wren presented the king with comprehensive plans for rebuilding London. As a result of Wren's travels in Europe, he longed to remake London into a city filled with monuments in the French classical and Italian Renaissance styles. The king and court admired his plans, but decided they were too costly to ever be completed. Wren wanted to demolish much of what was left in London and fill the rebuilt city with grand avenues and broad squares. Charles II instead appointed him to the post of Surveyor General, a position he held for half a century. Like Paris, London had outgrown its medieval core by the seventeenth century, although the area destroyed in the fire had been the center of commerce and of civic and religious life. Eighty-nine

of London's almost 100 churches had been destroyed in the fire. Wren's plans for rebuilding included designs for only 51 churches. Thus, his architectural renewal had a long-lasting effect on the city's spiritual life, since his design resulted in an ambitious, but very controversial program of parish consolidation. Today, only a portion of the handsome churches Wren created survive; many were lost in bombing raids during the Second World War while others have been destroyed by terrorist attacks since the 1970s. Still, enough of Wren's achievement survives to point to the vibrancy of his architectural style, as well as its ready adaptability to many different kinds of circumstances.

WREN'S STYLE. The architect's crowning achievement was his plan for the rebuilding of St. Paul's Cathedral, a structure that imitates the massive proportions of the Baroque, yet in most respects owes much to the High Renaissance designers Bramante and Palladio. Initial plans had called merely for the repair of the surviving Gothic church at the site. Wren soon realized that the destruction was too considerable to be repaired, and so he planned a central-style church to be constructed in the form of a Greek cross. The canons of St. Paul's, however,

reacted bitterly to the design as impractical for the demands of worship. Wren responded by adopting the more traditional Latin cross as the basic shape. The final structure demonstrated his encyclopedic knowledge of the major buildings constructed during the previous century in continental Europe. While much of the flavor of the building derives from the High Renaissance, the building's dramatic sense of energy seems more a feature of the Baroque. This emphasis on drama can be seen in the two-storied portico that Wren designed for the building's west façade. Here he grouped paired columns together, as in Perrault and Le Vau's east wing of the Louvre. As at that structure, he included a central pediment as a culmination point, although he placed this pediment between two bell towers that borrowed from the Roman architect Borromini's plans for the Church of Sant' Agnese in Rome. The dome that rises to be seen through this portico is more than 35 stories high, and its design again shows much indebtedness to continental models, especially to those pioneered by Michelangelo and Bramante. The dome's drum is encircled with a colonnade in the manner of Bramante's High Renaissance Tempietto at Rome (constructed in 1502), while the shape of the structure that rises above it is pure Michelangelo. In short, the building long appeared to many observers as the perfect integration of many Renaissance and Baroque design elements, and for this reason it influenced many other structures in Britain and throughout the English-speaking world. It was the only truly monumental Protestant church to be constructed in Northern Europe during the seventeenth century, although, inside, some of the weaknesses of the union between Protestant theology and monumental church architecture become apparent. Queen Victoria, for instance, dubbed the interior dreary, and many have agreed. In comparison with similar Catholic churches of this magnitude, the absence of gilt and of decoration—rejected by Protestants as too ostentatious and wasteful—makes the interior appear severe. These problems became accentuated over the decades, since the inferior-quality stone of the massive building required that the church interior be painted to hide its flaws. Rather quickly over time, the pristine white walls of the church grew gray with soot, a grime that is only now beginning to be removed by a painstaking process of restoration. Still, the details of Wren's interior show a faithful integration of the Corinthian order as well as other classical design elements. In the long Gothic space of the church, though, these elements prove to be inadequate to sustain the visual interest of most viewers.

OTHER PROJECTS. There are a number of other masterpieces among the fifty other churches that Sir

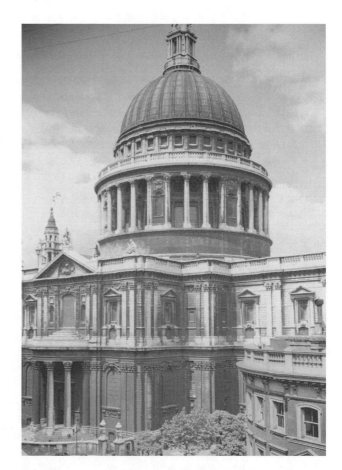

Dome of St. Paul's Cathedral, London. © BETTMANN/CORBIS.

Christopher Wren created to replace those burned in the London fire of 1666. At St. Mary Le Bow, for instance, Wren used the church's pre-existing foundation, as he often did in the rush to complete these structures. Since these medieval foundations were of varying height and width, he sometimes imaginatively deployed these irregular spaces in his creations. At Mary Le Bow, he designed his first great steeple, which again made use of the medieval belfry's foundations. Palladian-arched windows adorn the first upper level of the belfry, which is decorated with classical pilasters. Above a round, colonnaded temple, similar to Bramante's famous Tempietto in Rome, supports a smaller second colonnaded structure from which rises a final obelisk as a steeple. Wren's fertile mixing of Renaissance, Baroque, and classical elements as in the Church of St. Mary Le Bow, was for many years one of the most distinctive features of the London skyline. Before the advent of the twentieth-century glass and steel skyscraper, the forest of steeples with which Wren endowed London was one of the city's most recognizable elements. These steeples, too, were widely copied wherever English settlers moved, finding their way into the town squares of villages throughout

North America and in places as distant as Australia and New Zealand.

SOURCES

Kerry Downes, *English Baroque Architecture* (London: Zwemmer, 1966).

John Harris, *The Palladians* (New York: Rizzoli International Publications, 1982).

Joseph M. Levine, *Between the Ancients and the Moderns: Baroque Culture in Restoration England* (New Haven, Conn.: Yale University Press, 1999).

Christian N. Schulz, *Baroque Architecture* (New York: Rizzoli International Publications, 1986).

Rudolf Wittkower, *Palladio and English Palladians.* Compiled by Margot Wittkower (London: Thames and Hudson, 1974).

CLASSICISM AND CITY PLANNING IN THE NETHERLANDS

RESTRAINED GRANDEUR. As in England, a severe classicism free from a great deal of ornamentation was typical of most Dutch architecture in the seventeenth century. As a trading empire, the country's merchants were in frequent contact with the world that lay beyond their canals, dikes, and interior seas. Dutch traders and architects were frequent visitors to Italy, France, and England, although they generally shunned the elaborately ornamented spaces of the Roman Baroque as well as the severe grandeur of the court culture of nearer Versailles. During this Golden Age in the country's history, a fondness for classical design, much of it influenced by the relative severity of figures like Inigo Jones and Andrea Palladio, prevailed. The country's ethos—shaped by Calvinism and the sixteenth-century fight for independence from Catholic Spain—meant that the seventeenth century was not a great age in Dutch history for the construction of churches. As a rule, Dutch Protestants merely took over Catholic churches from the later Middle Ages, often whitewashing over the structure's murals and removing their sculptures. As population increased in the country's cities during the seventeenth century, new churches, often built in a style known today as "Dutch Palladianism," were constructed, but Calvinism, with its radical distaste for religious art and decoration, assured that many of these structures had only simple interiors. Dutch artists of the time like Vermeer and Saenredam documented the severe interiors that were common in the country's churches. Cleansed of their "idolatrous" religious art, these structures presented a severe face, with simple white walls and austere but massive spaces as their defining characteristics. Often the only ornamental elements that survived in these churches were their Gothic vaulting or their more modern carved and handsome pulpits, this later feature suggesting the primary importance given to the scriptures, the Word of God, in the new reformed faith.

DOMESTIC ARCHITECTURE. By contrast, the Dutch displayed a more decorative taste in their civic buildings and houses, drawing on a repertory of Palladian decorating elements on the handsome exteriors of these structures. In the seventeenth century most Dutch houses were built from brick, rather than stone, although stone façades tended to increase as Dutch prosperity climbed during the century. Unlike Italy, where merchant princes had long built great urban palaces, Dutch houses were considerably more modest. Large tenement buildings that housed several families were also uncommon. Instead, the Dutch house was a place in which a single family or extended family lived. Most were quite small and were built in a way similar to modern "row houses." In Amsterdam and other cities near the water, they faced onto a canal, the main arteries for commercial deliveries at the time. They were usually about 25 to 30 feet wide and four to six stories high with decorated gables that faced toward the street or canal. This design allowed the maximum number of merchants access to a city's thoroughfares, but it also shaped and limited the domestic spaces inside. Most houses were only one or two rooms wide, although they were considerably deeper, stretching back from the street or canal. The Dutch house of the time was often used for both business and domestic pursuits, with cellars and attics functioning as commercial storehouses. Great families sometimes joined two or more of these smaller houses into a single space. Grand mansions built over several city lots were not as common in the Netherlands as they later became, although Amsterdam did acquire quite a number of these structures in the later seventeenth century.

CITY PLANNING. Between 1600 and 1700, Amsterdam's population increased fourfold. Although its growth was the most dramatic in the region, rapid increase was the rule in most parts of the country. The Dutch's success in their sixteenth-century war of independence against the Habsburgs had left the country free to develop as a commercial center. To the south in Flanders and France, and to the east in Central Europe, religious repression continued to be the rule through most of the seventeenth century. In the Netherlands, by contrast, relative tolerance became the rule. Although the law officially prohibited Catholicism and some other religions, in practice Dutch local officials permitted a

considerable degree of religious freedom. As a result, Jewish settlers from throughout Europe streamed into the country, as did Mennonites, Anabaptists, French Huguenots, Catholics from Flanders, Germany, and France, and even Orthodox Christians from Greece and the Near East. The Netherlands had long been a country that was exceptional by European standards; much of its land was low-lying, large parts of it were even below sea level, and for centuries, the country had been claiming territory from the water through the skillful draining of marshes and the construction of dikes. This tradition of public engineering continued in the seventeenth century, yet at the same time a new method of urban planning was taking shape in the country's cities. To accommodate the influx of new settlers in Amsterdam, the town council devised the Three Canals Plan in 1612 to increase the city's size and manage its growth. In essence, the plan expanded the town walls to enclose four times more space than they had previously, and called for three new canals to provide merchants and artisans with an outlet to the sea. Tough new restrictions drew a distinction between areas where "noisy" industries and crafts might be pursued and other parts of the town intended for residences and quieter commercial transactions. They divided the undeveloped land with mathematical precision into lots that were each 25 feet wide, and carved the new water thoroughfares with geometric regularity so that all roads led inexorably to the town's center. Handsome townhouses soon appeared in the new quarters, with prominent families streaming into these districts to take advantage of the relative peace and quiet. They decorated the new town walls with impressive gates at the major entrances and exits to the city, and along this string of walls, massive new fortifications protected the city from attack. Thus, in comparison to the relatively piecemeal plans for urban development then in use in London and Paris at the time, the Dutch model of urban planning was notable for its thoroughness and rationality.

PUBLIC ARCHITECTURE. During the Baroque period, Dutch burghers, that is city dwellers, continued to build imposing town halls, a tradition that stretched back through the Renaissance to the later Middle Ages. Of the many civic projects undertaken during the Netherlands' seventeenth-century Golden Age, the greatest was the construction of a new town hall in Amsterdam to replace an older medieval building that had served this purpose. When the burghers of the city began this project in 1648, they had merely desired to expand their pre-existing civic offices. In the initial phases of remodeling, however, the medieval structure at the site burnt

down. Thus Jacob van Campen, the new building's architect, had a blank slate with which to work. The structure that he created survives today as an imposing testimony to the wealth of the time. The hall covered an entire city block, almost 300 feet wide and more than 230 feet deep. Above a ground floor, Campen designed two high-ceilinged stories, so that the entire structure, minus its enormous cupola, soared to a height of more than 100 feet. The central portion of this building projected outward towards the surrounding square and culminated in a pediment. Inside, an enormous Great Hall made use of the full potential of the building's grand height. Like Inigo Jones' Banqueting Hall in early seventeenth-century London, this hall was a single monumental block of space, one of the largest public halls built during the Baroque. While it employed more restraint in its decoration than the exuberant ostentation typical of Italian buildings at the time, the massive scale of the structure makes it a building of undeniable grandeur.

HIDDEN CHURCHES. Another feature of seventeenth-century Dutch life presents a curious adaptation to the continuing religious controversies of the period. While the Netherlands was an island of relative religious toleration in the seventeenth-century world, the law still officially forbade the practice of Catholicism. As a result, large numbers of "private" churches sprang up in the country's cities, usually accommodated in the attics of townhouses. The degree of toleration granted to these institutions fluctuated over time and from place to place, although in most places bribes and even a system of fines meant that Catholics enjoyed relative freedom to practice in these private churches. Many of Holland's secret churches spanned the attics of several houses, and their artistic decoration was often quite flamboyant. The nobles, wealthy merchants, and foreign Catholic traders who patronized these institutions saw to it that these private chapels had elaborate murals, frescoes, and gilt ornament similar to the ostentation common in the continent's leading Baroque churches. In spite of their status as a subculture within the predominantly Calvinist cities of the region, the number of these secret churches was often considerable. Amsterdam had about twenty, Leiden eight. The potency of the Baroque interiors that survive from this period demonstrate the appeal that this style had for Catholics who existed in a state of relative isolation from the broader world of Roman religion.

SOURCES

Julius S. Held and D. Posner, *Seventeenth and Eighteenth Century Art* (Englewood Cliffs, N.J.: Prentice Hall, 1971).

W. Kuyper, *Dutch Classicist Architecture* (Delft, Netherlands: Delft University Press, 1980).

Vernon Hyde Minor, *Baroque and Rococo. Art and Culture* (London: Laurence King Publishing, 1999).

THE BAROQUE IN CENTRAL EUROPE

WARFARE AND EXTERNAL THREATS. In comparison to the relative peace and stability of the Netherlands, the seventeenth century in Central and Eastern Europe was a time of great tribulation. Religious disputes marred the first half of the century, as the Thirty Years' War (1618–1648) raged in much of Central Europe. This great conflict involved almost every major European power, although Germany and parts of Bohemia were its primary battlegrounds. The Thirty Years' War produced widespread poverty, famine, and disease, and resulted in the depopulation of large areas of the countryside. As internal religious strife receded in Germany, the region began a slow process of recovery. To the east, however, in the Habsburg lands of Austria and Hungary, a renewed threat to security arose in the later seventeenth century. During the 1660s, the Ottoman Empire reinforced its positions in Hungary and renewed its drive up the Danube into Austria, laying siege to Vienna in 1683. Eventually, the Habsburgs succeeded in expelling Ottoman forces from their homelands, but not without expending considerable financial and military resources. As a result of these protracted religious crises and external threats, fewer great architectural projects were undertaken in the region than in Italy or Western Europe during the seventeenth century. As stability returned, though, the way was paved for an enormous building boom throughout Central and Eastern Europe.

THE BEGINNINGS OF REVIVAL. While the warfare that had afflicted much of Germany and Central Europe left the economies of many areas depressed, devastation also brought new opportunities for renewal and rebuilding. In 1622, for example, the town of Mannheim in southwestern Germany had been destroyed as a result of the conflicts of the Thirty Years' War. It was soon rebuilt, although French forces destroyed it yet again in 1689. As the local prince prepared to reconstruct his capital, he adopted a comprehensive plan influenced by the ideas of Baroque architects and town planners. His new city included broad avenues, handsome squares, harmonious buildings, and a grid system for its streets that was similar to that which was later to be adopted in New York City. During the Second World War, most of the town was destroyed in bombing raids, only to be rebuilt again largely in a functional modern style. Even now, though, Mannheim's street system largely continues to

adhere to the original Baroque grid pattern laid out in the late seventeenth century. Very few modern observers find the overall effect of the town as it now stands satisfying when compared against the city of handsome squares and palaces that existed for more than two centuries as a monument to the intelligence and sophistication of Baroque planners. At the same time, it is important to note that the ideas of those designers reflected certain notions about power, and Baroque architecture has often rightly been treated as a tool of seventeenth- and eighteenth-century rulers anxious to establish greater authority over their subjects. At Mannheim, these intentions produced relatively happy results. Elsewhere in Central Europe the Baroque became a tool for establishing cultural and religious uniformity with mixed results. In the wake of the Thirty Years' War, the Austrian Habsburgs established hegemony over the Czech citizens of Prague. Since the fifteenth century the inhabitants of the city had provided a safe haven for many reform movements critical of the Roman church. As the Habsburg dynasty moved to establish its authority over the city, they labored as well to re-establish Roman Catholicism as the sole religion in the region. Habsburg church and state authorities remodeled Prague's churches, transforming the town's once spare and severe Protestant-styled churches into models of Baroque display and ornamentation. Authorities expelled those townspeople who continued to practice Protestantism and seized their properties, often selling their houses for a fraction of their worth to new German-speaking settlers. This plan of resettlement thus paved the way for large portions of Prague to be rebuilt in the new ornate fashions of the Baroque. Thus in Prague the Baroque became synonymous in the minds of native Czech inhabitants with the establishment of Austrian political hegemony and Catholic religious authority.

CHURCHES. Where affections for Roman Catholicism ran deeper in Central and Eastern Europe, they soon gave birth to an unprecedented boom in the construction of new churches and religious institutions. In Italy, the rise of the Baroque had been accompanied by the construction of scores of new religious edifices, testimonies to the renewal of a spirit of self-assurance typical of the Catholic Reformation. In Central Europe, the conclusion of the Thirty Years' War similarly left Catholic rulers and their subjects re-invigorated. As the economy revived and stability returned, numerous church building projects were begun. While the more ornate and imaginative styles pioneered in Rome and Northern Italy had begun to spread in Central Europe quite early, the trials of the Thirty Years' War had stalled

THE
Sacred Landscape

The period following the conclusion of the Thirty Years' War was followed by an unprecedented construction and remodeling boom in Catholic churches throughout southern Germany and Austria. Inspections of local churches in the wake of the conflict made obvious the deficiencies in church architecture. But the boom in remodeling and reconstruction arose from a surge in the people's piety, since many of these projects were initially financed by a broad segment of the Catholic population. As this surge in popular religiosity intensified, the Catholic elite also supported many projects aimed to beautify churches throughout the countryside after 1700.

Many churches needed new furnishings in the aftermath of the Thirty Years' War. All the visitations conducted in the 1650s, and even the 1660s, focused on the need to use resources to replace utensils, pictures, and statues lost and stolen during the war. The recovery from the war was followed by a wave of redecorating and redesigning which began in the last two decades of the seventeenth century.

In many ways, developments inside churches and chapels mirrored the development of the sacral landscape itself. As the number of churches and sacred sites increased after 1650, so too did the number of altars, the quantity and quality of furnishings, the number of statues and paintings, and the general density of decorations in the churches. The effect of denser furnishings was also to provide a greater variety of settings for religious practice.

The Catholic population, church patrons, and secular authorities all supported the adornment of churches. The driving force appears to have been the village community, especially in the late seventeenth century. In 1669 the *Gemeinde* [community council] of Schönau in the Black Forest rebuilt the interior of the chapel at Schönenbuch, removing St. Blasien as the patron and replacing him with St. John the Baptist, probably to the displeasure of the local lord, the Abbey of St. Blasien. In 1683 the *Gemeinde* of Mindersdorf asked its parsimonious lords, the Teutonic Knights in Mainau, for help in paying for new bells for the parish church. The Knights were never enthusiastic about such expenditures and the Mindersdorfer had to engage in the typical long process of appeal, especially to the bishop, to try to squeeze some money out of the parish patron. Such disputes had been the pattern since the sixteenth century, and probably before. While parish patrons often had some obligation to pay for the upkeep of parish church, village communities frequently were the only ones willing to pay for the decoration of chapels.

Beginning around 1700, however, many parish patrons, especially the monasteries, became active, and even enthusiastic, about decorating village churches and chapels. Not surprisingly, of course, abbots and abbesses preferred dramatic projects such as the construction of the new shrines at Steinhausen and Birnau. At the same time, however, the constant need to refurbish parish churches and local chapels provided further opportunities to patronize the arts. Although ecclesiastic patrons always sought to avoid new financial obligations, in the eighteenth century they often responded positively to requests for new decorations. The cooperation between villagers and church institutions reflects the unity of rural Catholicism, as well as the desire for self-promotion and religious representation that characterized the world of the Catholic elite.

SOURCE: Marc Forster, *Catholic Revival in the Age of the Baroque* (Cambridge: Cambridge University Press, 2001): 78–79.

the fashion's general acceptance. In 1614, for instance, the archbishops of Passau had begun the reconstruction of their Cathedral at Salzburg along plans set down by early Italian Baroque designers. Undertaken to replace a basilica that had been destroyed by fire at the end of the sixteenth century, the town's new Baroque-styled Cathedral was consecrated in 1628. As warfare worsened in the region, the style of Salzburg's new Cathedral was not to be immediately imitated. In the second half of the seventeenth century, though, many Catholic patrons, bishops, and monasteries began to rebuild their churches in the grand Baroque style and the Baroque architectural language. At its very core, the elaborate and sumptuous interiors of the Baroque church were a counterattack on Protestant sensibilities, which stressed restraint and a relatively unadorned style as most befitting to Christian worship. As the Baroque spread in Central Europe, it demonstrated considerable variety, although certain constants continued to recur in most of the movement's churches. As in Italy, a taste for dramatic spaces developed in which all parts of the structure were subordinate to the greater goal of achieving a climactic impression. Rich ornamentation and gilt, curved shapes, broken pediments, and other elements that were not strictly classical in origin prevailed. In place of the relatively restrained vocabulary of decoration that was present in England, the Netherlands, and Protestant Germany, the Italian and native architects who practiced in Central Europe

frequently created spaces that were colorful and enlivened by a festive spirit. Their free flowing, dramatic shapes owe a great deal to the innovative designs of figures like Guarini and Borromini, and generally the Baroque architecture of the region derived more inspiration from Italian rather than French examples.

MAJOR PROJECTS. Among the most important church monuments of the early Baroque in Central Europe were the new Cathedral at Passau (begun after a fire destroyed the existing structure in 1662), the Church of the Theatine Order in Munich (begun in 1663), and the Cathedral at Fulda (begun in 1704). Great Baroque churches multiplied even more profusely throughout Central Europe during the first half of the eighteenth century. The numbers of new projects undertaken at the time still manages to astound modern visitors to the region. In the century that followed 1650, almost all of the Catholic parish churches in southern Germany, Austria, and Switzerland were either rebuilt or redecorated in the Baroque style. As a result of this architectural renewal, central features of the Catholic Reformation's teachings—particularly of the Jesuits and other counter-reforming orders—were given architectural expression. Since the mid-sixteenth century these orders had argued that religious worship should take place within sacred spaces that captivated the human imagination and prepared the soul for union with God in the sacraments. Visibly, the Baroque churches of Central Europe attempted to achieve this aim with spaces that merged architecture, painting, and all the visual and decorative arts in ways that inspired the soul to undertake the pursuit of Christian perfection.

PILGRIMAGE CHURCHES. Another popular feature of the church architecture of the age was the construction of both great and small pilgrimage churches. During the sixteenth century, Protestants had attacked the medieval custom of making pilgrimages to the graves, relics, and religious images long associated with the saints. In the later seventeenth century this custom experienced a renewal in the Catholic regions of Central Europe, eventually becoming an important element of the religious identity of the period. During the later seventeenth and early eighteenth centuries, hundreds of pilgrimage churches were consequently erected or remodeled throughout Central Europe. Many of these places were quite small, but the greatest often had monasteries attached to them, and their pilgrimages became significant sources of income to the surrounding economy. In southern Germany, Vierzehnheiligen, the Wieskirche, and Altötting were among the largest pilgrimage centers. At each, masterpieces of Baroque architecture were created to deepen the piety of the pilgrims who visited these sites. Similar great churches were constructed in Austria in places like Maria Zell and Maria Plain and in Switzerland at Einsiedeln. These pilgrimage churches often provided large interior spaces and imposing central squares at which the faithful might congregate for religious rituals and worship. Notes of charm and whimsy were also present in the hundreds of edifices constructed at the time. In 1716, the Benedictine monks of Weltenburg Abbey, a site located along a narrow, cliff-bound stretch of the Danube River in Bavaria, commissioned the famous architects, Cosmas and Aegidius Asam, to remodel their church in the Baroque style. The Asam brothers created a fantastic interior that presented pilgrims with the illusion of being caught up in the heavens. The visual techniques of the building even extended to the confessional boxes, which were sculpted out of plaster to appear as if they were clouds. This playful note recurred in many places in southern Germany during the Baroque period, and as the stylistic movement endured, architects made use of a great range of decorative sophistication and creativity.

PALACES AND CITIES. As greater stability returned to the region, numerous country villas and palaces also began to be constructed in the Baroque style throughout Central Europe. If Baroque church architecture was popular primarily in Catholic regions as a counterattack on Protestant sensibilities, both Protestant and Catholic rulers proved to be enthusiastic builders of palaces in the Baroque style. The political realities of Central Europe bred a climate ripe for the construction of innumerable palaces and country retreats. For centuries, the political heart of the region had been the Holy Roman Empire, a multi-lingual, multicultural, but nevertheless weak confederation of about 350 separate principalities, free cities, and territories ruled by officials of the Roman Catholic Church. During the sixteenth and seventeenth centuries, political disintegration had made the empire into ever more of a fictional power, as the largest territories became more like autonomous states and the emperor ever more an honorific figurehead. By the later seventeenth century any pretensions of his power to rule over this unwieldy set of states had largely been destroyed, especially by the specter of the internecine destruction that had raged during the Thirty Years' War. In the now largely independent territories that made up the Holy Roman Empire, rulers increasingly adopted the trappings of absolutist rule, ignoring or disbanding the representative assemblies that had long served to limit their power. At the same time, these princes became anxious to surround themselves with the kinds of sumptuous displays and ostentation that were common in far wealthier

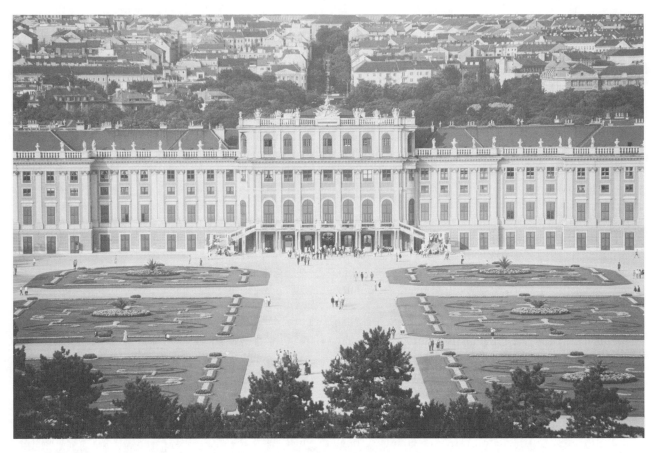

Schönbrunn Palace, Vienna. © DAVE BARTRUFF.

and more powerful states like France. Scores of grand palaces, hunting lodges, and country villas thus sprang up on the landscape as an enduring testimony to this political reality. When compared against the standard of late seventeenth-century Versailles, many of these structures were quite modest, although given the large number of territories in the region, Central Europe today is populated with a far larger number of Baroque monuments than other continental regions. What is equally remarkable about the Baroque style here is the ambitious plans it inspired to remake many of the region's cities. As imposing country palaces and urban residences for the nobility grew in popularity, however, other minor noble families and wealthy merchants imitated the style, and thus the fashion for imposing Baroque buildings soon spread to influence the appearance of entire towns. Prague, Salzburg, Vienna, and Passau managed largely to preserve much of their Baroque core against the devastation of the Second World War. Other not-so-fortunate cities such as Warsaw, Dresden, and Berlin had to reconstruct many of their monuments. Even the depredations of World War II, which destroyed the majority of the historical centers of these towns, have proven insuf-

ficient since then to erase the imprint Baroque designers left on these places. In Warsaw, the Baroque core of the city was lovingly reconstructed over a number of years following its destruction in World War II. In Berlin and Dresden, the campaign to restore the monuments of the Baroque continues even in contemporary times, and the absence of many major buildings from the Baroque era is still felt by many people in these cities as a palpable loss. Perhaps in no place except Rome, then, has the Baroque style's effects on urban life continued to cast such a long shadow as in Central Europe.

AUSTRIAN ARCHITECTS. The numerous monuments produced in Germany, Austria, Bohemia, and Poland resulted from a talented group of designers who came on the scene rather quickly after 1700. While Italian and French architects were imported to design some of these structures, native designers produced most of them. In Austria the most important architects included Johann Fischer von Erlach (1656–1723), Jakob Prandtauer (1658–1726), and Johann Lukas von Hildebrandt (1668–1743). Von Erlach even received a minor noble title from the Habsburg emperor for his efforts to beautify Vienna and to create stunning palaces for the

royal family and nobility. His major commissions included the massive *Karlskirche* in Vienna, a structure that was a charming, but rather unusual mixture of architectural design elements that ranged across periods from Antiquity to the Baroque. Another important set of structures Fischer von Erlach created was the complex of buildings at the Belvedere Gardens on the outskirts of Vienna. He undertook these commissions for Prince Eugene of Savoy, a war hero from Austria's campaigns against the Turks, and the charming summer palaces and garden architecture that von Erlach created there were often imitated in later years. By contrast, the most important works that Jakob Prandtauer undertook were several imperial abbeys built along the Danube River. Among these, the lofty grandeur of Cloister Melk is the most impressive, sitting as it does perched high on a dramatic outcropping of rocks above the river. Prandtauer adapted his plans for Melk—which included a series of ceremonial rooms intended for imperial visits—to other powerful churches and religious institutions in the region. The grandest project of the age, though, proved to be the continual construction and rebuilding of the Schönbrunn Palace outside Vienna. A country house had been located at this site since the fourteenth century and had been remodeled in 1548. Toward the end of the sixteenth century, the estate came into Habsburg possession and the family began to rebuild it to serve as a retreat and hunting lodge. A grander structure was built at this place, in what are now suburbs of Vienna, in the mid-seventeenth century, although Turkish forces destroyed that structure in the siege of the city that took place in 1683. By 1700, the Habsburgs had reconstructed much of the building on an even more monumental scale, although the extensive plans made for the site by the architect Johann Fischer von Erlach were never undertaken in their entirety because they were too costly. Finally, in 1742, the family decided to extend the palace once more, destroying parts of the von Erlach design in the process. Over the next five years the building expanded at such a rate as to be the equivalent of the Versailles. During the Empress Maria Theresa's long reign, it eventually became the center of government, an enormous structure whose more than 1,400 rooms rivaled the French palace. While Maria Theresa's most important residence, it was only one of an impressive collection of palaces, villas, and country retreats that the monarchy used at the time.

GERMAN DESIGNERS. Similar patterns of profligate ostentation were also the rule among the greatest German princes of the age. Throughout this region an even larger number of Baroque architects practiced their

trade. The country's major Baroque designers included Georg Bähr (1666–1738), Daniel Pöppelmann (1662–1736), Georg Wenzeslaus von Knobelsdorff (1699–1759), Andreas Schlüter (1659(?)–1759), and Balthasar Neumann (1687–1743). Bähr, Pöppelmann, and von Knobelsdorff were all active in Dresden during the first half of the eighteenth century, where they served the ambitions of the electors of Saxony, who were anxious to transform their capital into a model of Baroque elegance. It was during this period that Dresden began its rise to prominence as an artistic center that eventually earned the town the reputation for being the "Florence on the Elbe." One of the most unusual projects begun during this time was the building of the *Frauenkirche*, or the Church of Our Lady, a massive domed structure that once stood at the center of the city, and which is presently being rebuilt with a painstaking attention to detail. Although Dresden was Lutheran, and Lutheran church architecture usually avoided sumptuous display, Georg Bähr created an enormous structure with a grand interior. By contrast, most of the monuments that Daniel Pöppelmann left behind were of a secular nature. For many years he reigned as the chief architect in and around the city, where he produced such famous landmarks as the Zwinger Palace, a masterpiece of the high Baroque and Rococo style. As Dresden developed into a town of incomparable Baroque elegance, the designers Andreas Schlüter and Georg Wenzeslaus von Knobelsdorff transformed the Hohenzollern capital Berlin and its surrounding countryside with the design of similar monumental creations. Von Knobelsdorff is chiefly responsible for the Hohenzollern dynasty's masterpiece, the Palace of Sansouci, a pleasure villa constructed at Potsdam, Berlin's suburban counterpart to Versailles and Schönbrunn. To construct this and other monuments in and around Potsdam, an entire population of stoneworkers and artisans had to be settled in the town. The enormous façade of the Palace of Sansouci, a pleasure structure more than 300 meters long, recalled the Grand Trianon in the gardens of Versailles, although by the time of its construction its confectionary of decorative details and greater plasticity of line and form had departed far from the relative restraint of the French example. Numerous Baroque buildings were also under construction in the city of Berlin at the time, and those that survived the Second World War suggest the elegance of the Baroque city. Major features of Berlin's cityscape that date from this period included Von Knobelsdorff's designs for the Opera as well as many of the other impressive monuments that lined the city's elegant core avenue *Unter den Linden*. To the south, in Catholic Bavaria, the Wittelsbach rulers continually remodeled

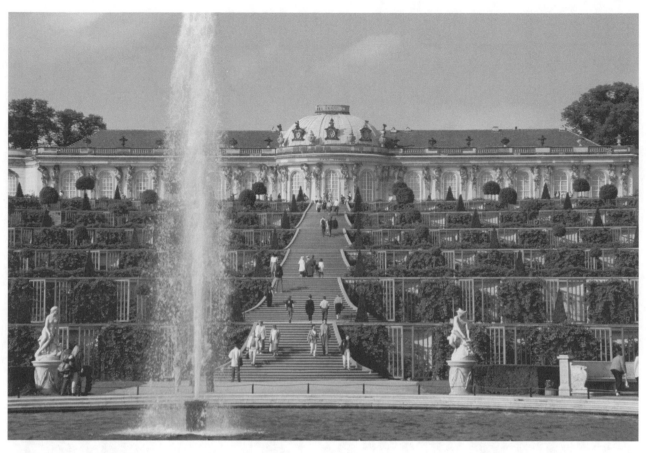

Palace of Sansouci, Potsdam, Germany. © BOB KRIST/CORBIS.

their Munich palace, the Residence, and created broad and handsome squares to beautify the city. Outside the city at Nymphenburg and Schleissheim they created a series of country retreats, some on a smaller scale than Versailles, Sansouci, or Schönbrunn, while others like the New Palace at Schleissheim were said to rival these creations. This brief snapshot of major Baroque palaces cannot begin to suggest the scores of even smaller projects undertaken throughout Germany at the time. While minor nobles might not hope to compete in grandeur with the Wittelsbachs, Habsburgs, and Hohenzollern, most princes equipped with even modest resources tried to surround themselves with the elegant and ornate trappings of Baroque structures. Perhaps the greatest architectural figure of the German Baroque was Johann Balthasar Neumann, a designer who worked for many years in southern Germany, primarily in the diocesan capital of Würzburg. There he built a number of structures, including his masterpiece, the Residence, an urban palace for the town's prince bishops, which contained the largest and most sumptuous staircase ever built during the period. Although the palace itself was not the grandest of Germany's Baroque creations, the

entire complex is, nevertheless, one of the era's most attractive and completely realized. Its appealing qualities arise from its integration of new French design and decorative elements drawn from the developing Rococo movement with a thorough understanding of the massive and monumental possibilities of the Italian Baroque. Neumann's career opened up new vistas in the Baroque in Germany, and in his relatively long career he produced many buildings notable for their sinuous, undulating lines and their dramatic uses of light. These spaces seem to breathe, and as a consequence they reflect an appealing organic dynamism. Among his best works was the pilgrimage church of Vierzehnheiligen (constructed between 1743 and 1772), although Neumann created a number of handsome churches throughout southern Germany. He was also notable for his urban planning efforts at Würzburg, efforts that helped to transform the city into one of the more completely harmonious Baroque cities in the empire. As in his buildings, Neumann planned broad and curving streets and squares, and he created a number of ingenious regulations that encouraged building in the ornamented Baroque style. At his behest, for example, the town granted tax ex-

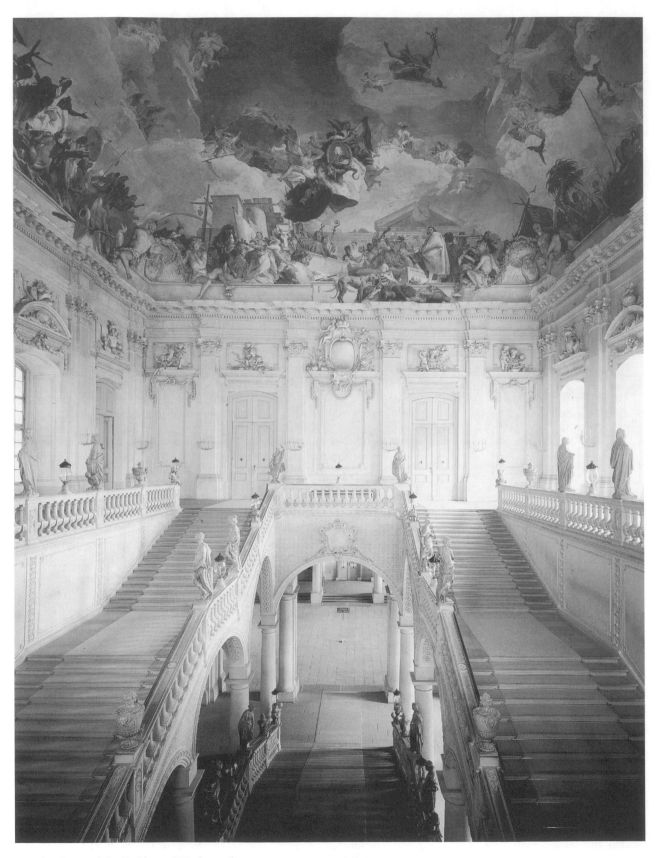

Grand staircase of the Residence, Würzburg, Germany. **THE ART ARCHIVE/DAGLI ORTI.**

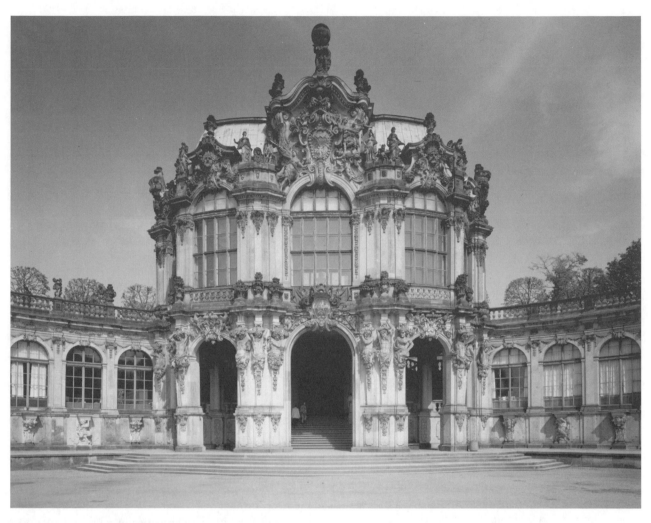

Zwinger Palace, Dresden, Germany. © **MASSIMO LISTRI/CORBIS.**

emptions of twelve years to anyone who added a Baroque façade to their house or business. Measures like these also contributed to Neumann's own trade, and in his years at Würzburg he obliged the town's burghers with a number of buildings.

BAROQUE VARIETY AND UNITY. As it left Italy, the Baroque style came to be invigorated by national traditions and to be molded to the religious and political demands of the states of Northern Europe. Great variety characterized the national styles of architecture, with England and the Netherlands generally avoiding the sumptuous and ornate decorative dimensions of the movement in favor of a more restrained classical vocabulary. In France, a grander and more ornate form of that same classicism continued to hold sway throughout most of the seventeenth century, particularly in the public buildings constructed in and around Paris. In Central Europe, though, the plastic forms and decorative impulses of the Baroque that had first developed in

Italy came to full fruition, producing monuments that astounded their viewers with their complexity, free-flowing lines, and festive spirit. One feature, though, that was shared by architects in all regions of Europe in the seventeenth and early eighteenth centuries was a new attention to details of urban planning, as purpose-built squares, broader avenues, and handsome public buildings came to be prized as expressions of a civic ethos as well as the state's power to accomplish change on the urban landscape. If Baroque architects and their patrons thus dedicated themselves to the task of making over many European towns and cities, they were also no less determined to create elaborate pleasure palaces and retreats set in idyllic, yet highly formalized gardens on the outskirts of Europe's growing cities. This tension between ideal visions of rural and urban existence was one of the defining characteristics of the age, and continued to endure long after the Baroque style had faded in favor of new influences.

SOURCES

J. S. Held and D. Posner, *Seventeenth and Eighteenth Century Art* (Englewood Cliffs, N.J.: Prentice Hall, 1971).

Nicolas Powell, *From Baroque to Rococo: An Introduction to Austrian and German Architecture, 1580–1790* (London: Faber, 1959).

Christian N. Schulz, *Late Baroque and Rococo Architecture* (New York: Rizzoli International Publications, 1980).

Jeffrey Chipps Smith, *Sensuous Worship: Jesuits and the Art of the Early Catholic Reformation in Germany* (Princeton, N.J.: Princeton University Press, 2002).

THE ROCOCO IN THE EIGHTEENTH CENTURY

FRENCH ORIGINS. In the years immediately following the death of King Louis XIV, design in France began to take on an entirely new feeling. On the one hand, public buildings continued to be constructed using the classically influenced designs that French architects and royal patrons had favored since the early seventeenth century. On the other, domestic spaces quickly became more elegant. This style is known in English by the Italian word that described it, "Rococo," although the French word *rocaille* had the same meaning. It referred to "rockwork," or plaster sculpted to appear as if it was stone. Since the sixteenth century, these techniques had been employed to create fanciful grottoes from stucco in the gardens of palaces and country villas. Around 1700, though, *rocaille* techniques began to move indoors, and French plasterers made extensive use of the techniques in palaces and townhouses. *Rocaille* now referred to delicate scrolling patterns of stucco in swirls and arabesques, designs that were reproduced over and over again on walls, ceilings, and wood paneling during the first half of the eighteenth century. These patterns first appeared at Versailles and in other royal residences around 1700, and in a decade or two, *rocaille* became fashionable in the decoration of homes in Paris.

DEVELOPMENT OF THE ROCOCO. The fashion for plaster decoration sculpted in the new fanciful shapes that *rocaille* techniques offered was just one of several changes in taste and fashion that occurred in France soon after the death of King Louis XIV in 1715. As one of the movement's most important decorative devices, the term *rocaille* summed up the entire decorative impulses of the age. Outside of France, this period in architectural and decorative design has been referred to by its Italian equivalent *rococo* since the eighteenth century. The rise of the new style reveals a rather sudden shift in aesthetic values, a shift inspired by important changes underway in French elite society. The vast interior spaces of the seventeenth-century Palace of Versailles had favored dark and sonorous colors and the use of paneling crafted from dramatic polychromed marbles. The palette of the Rococo was altogether lighter, favoring white or ivory walls decorated with low-lying reliefs trimmed with gilt. Subtle shades of pastels figured prominently in the paintings that were hung in these rooms, or which were executed as frescoes on the walls. A fashion for mirrors intensified the bright light in these spaces, also. In sum, the feeling of a Rococo interior was considerably gayer and less forbidding than that of seventeenth-century spaces. The scale of these rooms, too, was often smaller, given more to quiet, intimate gatherings than the formal reception areas of the earlier period.

PARIS. It was in Paris that these new fashions took hold most quickly, and there the new elements of interior design decorated many salons in the mid-eighteenth century. The development of the Rococo came at a time when Paris regained an important status in the early years of Louis XV's reign. In the years between 1715 and 1722, the young king centered his government, not at Versailles, but in France's largest city, as the regent, Philippe d'Orléans, preferred the town to the country. This brief re-establishment of government in Paris did much to stimulate a flurry of interior decoration and building, as nobles who had taken up residence in Louis XIV's seat of power at Versailles returned to the capital to be closer to the court. Instead of the elaborate angular and symmetrical formality of Louis XIV's age, the Rococo designers of Paris in these years produced rooms that were models of restrained and decorative delicacy. Much of this elegance, though, could not be seen by the general public since the façades of many fine townhouses built at the time continued to use the classical forms that had been popular in Paris since the seventeenth century. The Rococo fashion was an almost exclusively upper-class phenomenon, one that by 1735 had become the reigning style of interior decoration. In that year, Germain Boffrand created two striking rooms in the interior of the Hôtel de Soubise in Paris: the Oval Salon and the Salon of the Princess. These spaces survive today and demonstrate many of the central features of the style as it moved to a high point of development. In place of the angular symmetry that had prevailed during the time of Louis XIV, Boffrand's rooms feature a creative and curving asymmetry. Delicate, low relief ornament cover the walls, yet these surfaces are not nearly so heavily encrusted with decoration as the Baroque interiors that preceded them. Instead great patches of white show through Boffrand's scheme of elaborate swirling, gilt patterns. Through the repetition of vertical lines used throughout

SHIFTING Family Values

With the death of Louis XIV in 1715 and the removal of the court to Paris during Philippe d'Orléans' regency ... the building of magnificent but nonetheless discreet town houses or *hôtels* in Paris announced a shift in the values of French domestic architecture. This shift, in turn, opened up opportunities of painters to represent these interiors in ways that took advantage of the social meanings of greater intimacy and familiarity.

Before the bottom fell out of his fiscal schemes, John Law (1671–1729), a Scottish monetary reformer in the employ of Philippe d'Orléans, helped to earn many Parisians instant wealth, which sent them on buying sprees the like of which had not previously been set outside of the royal family. Philippe had hoped to reduce the enormous public debt incurred during the later years of the reign of Louis XIV, and initially Law's plans worked. He supervised the founding of a bank that would issue notes, replacing scarce gold and silver currency, and paper money was issued in large quantities. Before the paper currency lost most of its value, Law's strategy had a significant impact on building activity in Paris. Suddenly, it seemed, many had the means to build or renovate existing structures, and furnish them with paintings, marble busts, and the beautiful cabinetry, sofas and chairs produced by the craftsmen who had once been in the employ of Louis XIV.

Jacques-François Blondel (1705–1774), Louis XV's architect, became a spokesman for how domestic architecture should look and function in eighteenth-century France. Blondel claimed to be a follower of Vitruvius, the first-century Roman architect and theorist, in endorsing what Blondel called "commodity, firmness, and delight." The idea of commodity means not just the useful and convenient, but also the commodious or comfortable. Although a building should hold true to sturdy traditions of architecture ("firmness") and display the aesthetics of the age ("delight"), it must also be comfortable. Comfort was hardly a quality sought by Louis XIV and his architects. Nor, as we have seen, was it of primary importance to the prosperous salon society of early to mid-eighteenth-century Paris.

Blondel understood that the French nobility needed homes that would have a grand room for ceremonial purposes, a reception room that was smaller yet still public, and private *appartements* for the members of the family. The Rococo *hôtel* was constructed for a family, a husband, wife, and children. Domestic servants were kept in separate rooms (often above the low-ceilinged bedrooms) or in their own apartments. Therefore, the private spaces—even the salon, which was both a reception room and a place for banquets—were built on a scale that would easily accommodate but not overwhelm the nuclear (rather than extended) family and their occasional guests.

SOURCE: Vernon Hyde Minor, *Baroque and Rococo. Art and Culture* (London: Laurence King Publishing, 1999): 342–343.

these spaces the designer called attention to these rooms' high, decorative ceilings, even as he used windows to catch and refract the light off the many gilt surfaces. The result produced a jewel box effect. While Boffrand's rooms still rank among the greatest achievements of the fashion, numerous upper-class townhouses in Paris and throughout France were being remodeled as tastes changed. While most of these spaces were not nearly so elaborate as those at the Hôtel de Soubise, typical Rococo rooms came to be paneled with wood painted white or ivory and decorated with the typical patterns of gilded plaster. Elaborate stucco decoration also figured prominently, with many plaster decorative reliefs being used prominently at the boundary between ceilings and walls.

THE ROCOCO CONQUERS VERSAILLES. Even at Versailles, a palace once filled with imposing and dark interiors, the royal family remodeled many rooms to fit with the changing fashion. In the years after 1722, Louis XV reestablished government in the seventeenth-century palace, although by the 1730s he had grown tired of the forbidding decoration of many of Versailles' rooms. In 1735, Louis XV decided to redesign his private apartments within the palace. He chose the lighter Rococo fashion to replace the dark decoration that had previously filled these rooms, and he divided his apartments into several smaller cabinets that included a bedchamber, clock room, private office, and bathroom, eschewing the elaborate bedchamber of his great-grandfather, Louis XIV. But once his new accommodations were completed, Louis XV did not return to that uncomfortable bedchamber. He favored instead the smaller scale of his new, more private surroundings. The king thus evidenced the same desire for intimate settings as did the elites of Paris and other French cities.

SALONS. The rise of the Rococo style of decoration coincided with the development of the salon as an institution of French culture. In the first half of the eighteenth century these cultured meetings of elites and intellectuals became increasingly important in the social life of Paris. While the salon eventually played a key role in

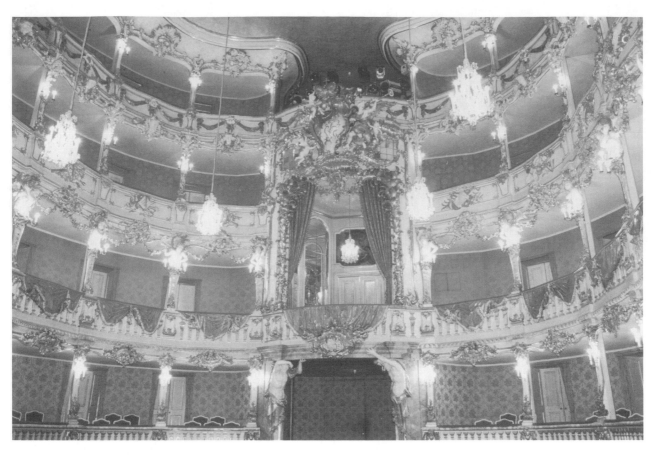

Interior of the Residence Theater, Munich. © ADAM WOOLFITT/CORBIS.

the rise of the Enlightenment and later of the French Revolution, it was, at its base, a place where large groups of cultivated individuals who prized wit and speech, the social graces, and connoisseurship of art and music could gather. By 1750, a large city like Paris had about 800 salons that met regularly to discuss issues of civic, philosophical, or artistic importance. The craze for decoration in the Rococo, then, was one consequence of the emergence of these salons, as wealthy families competed against one another to create spaces worthy of the lofty discussions that occurred within their homes. In these new social groups members of the nobility mingled alongside merchants and students in the new private spaces that Rococo architecture offered. Women often presided over the discussions that took place in these salons, a sign of the rising status they acquired at the time as leaders of intellectual discussion as well as arbiters of domestic taste and consumption. The undeniably feminine character of much of the Rococo derived in large part from the new role that wealthy women played as consumers of art and the refined accessories of domestic living. The movement's designs also embraced a taste for the foreign, even as they made use of motifs that were rustic and surprisingly mundane. For exotic inspiration, designers turned to the Near and Far East, adopting decorative details from elements of Chinese and Arabic design. At other times they reached out to idealize rural life, filling their rooms with scenes of landscapes, hunts, or country life. Fabric printed with these scenes became popular at the time, much of which had still to be imported into France from other countries at mid-century. To avoid squandering the country's resources, Louis XV chartered a royal factory for producing the popular cloth in 1762 at Jouy-en-Josas, a small village near Versailles. The village name contributed to the modern term "Toile du Jouy" or just merely "toile" to indicate a kind of fabric filled with narrative scenes of daily life.

THE STYLE SPREADS. The primarily decorative dimension that the Rococo took in France is undeniable. As a result, architectural historians have long debated whether the Rococo merits any consideration as an "architectural" period at all. Outside France, though, the Rococo developed a more pronounced architectural dimension, particularly in Germany and Austria. By contrast, the style was unpopular in England, where except for a small number of rooms decorated in this fashion,

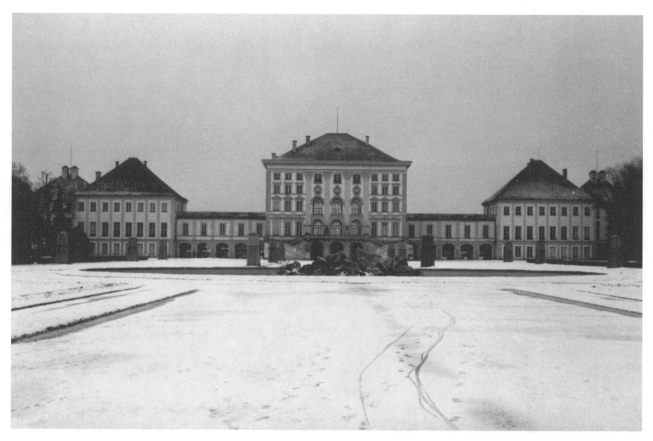

Schloss Nymphenburg in Munich, Germany. **PHILIP M. SOERGEL.**

the Rococo's influence remained limited. In Rome, architects and designers remained impervious to the fashion's popularity and continued to produce buildings and monuments that used the grand, imposing proportions of the Baroque. Elsewhere in Italy, small pockets of Rococo-influenced architecture were to be found, most notably in the capital of the duchy of Savoy, Turin, and in Naples, Italy's largest city at the time. Thus of all the places to which the Rococo traveled outside France, it was in Central Europe, particularly in Germany and Austria, where the movement produced its greatest landmarks. In that region, the Rococo developed, not just as an interior fashion, but as an architectural phenomenon as well. A key figure in encouraging the popularity of the style in this region was François de Cuvilliés (1695–1768), a French-speaking designer whose family originally hailed from Flanders. Cuvilliés came to work in the city of Munich through an extraordinary set of circumstances. In 1711, he became a court dwarf in the service of the Bavarian duke Maximilian II Emmanuel while that prince served out a term of exile from his native country. Several years later, Cuvilliés returned with the duke to Munich, where he eventually received an education in the court. By 1720, the duke's official

designer was schooling him in architecture. He soon left for Paris, where he stayed for five years to finish his studies. Thus Cuvilliés was a student in Paris during the early years of Rococo's rise to popularity among aristocrats and the wealthy. When he returned to Munich in 1725, he attained a position of prominence among the many accomplished designers practicing in southern Germany at the time. During his long career his most celebrated accomplishments included a series of pleasure villas constructed for the Bavarian dukes in the gardens of the Nymphenburg Palace outside Munich, rooms designed in the suburban palace at Schleissheim, and the Residence Theater in Munich. This last structure, carefully rebuilt after its devastation in the Second World War, is known affectionately today in Munich merely as the "Cuvilliés." The theater is ornate and decorative in the extreme since the architect relied on ornamental features to make obvious the distinctions between the various levels of aristocrats who visited the theater. He massed the greatest decorative details, for instance, on the ducal box and first balcony that surrounded it, which was reserved for the highest levels of society. In the balconies above, these decorations diminished with each level. While his design was highly decorative, Cuvilliés

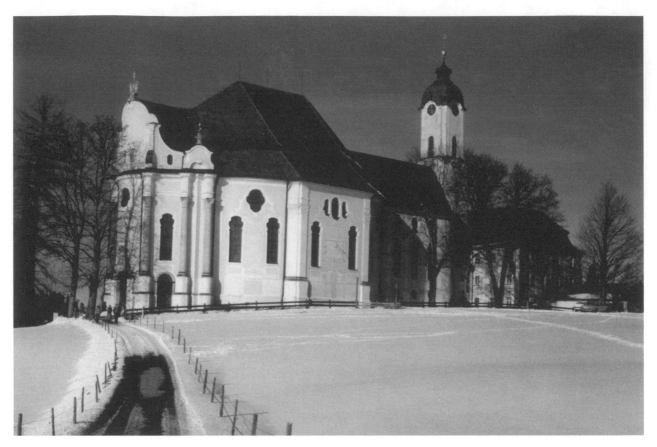

Church of the Wies, Germany. **PHILIP M. SOERGEL.**

was an astute student of theatrical design and provided a space that was an excellent venue for good drama. It continues even now to serve its original purpose as home to many theatrical productions in Munich.

CUVILLIÉS' INFLUENCE. As a student, Cuvilliés had acquired a firsthand knowledge of the ways in which Parisian plasterers produced their stunning *rocaille* effects. In the years that he served as court architect in Munich, his influence ensured that these techniques became a fixture of architecture in Bavaria and southern Germany. By mid-century designers used the new skills to stunning effect in their creation of buildings that appear like sculptural masses constructed out of the fluid shapes that *rocaille* techniques afforded. At this time, architects in southern Germany also made use of the Rococo's possibilities for creating churches that were brilliantly filled with light. Thus, the Rococo in the region developed into far more than a fashion for domestic interior design. Throughout Central Europe, many buildings originally begun in the Baroque style, like the Zwinger Palace in Dresden or the Residence in Würzburg, acquired Rococo detailing. The Rococo achieved its most pronounced developments as an inde-

pendent architectural movement, however, in Bavaria and the German south.

MAJOR DESIGNERS. The use of light, the creation of festive interiors, and the predominance of sinuous lines encrusted with ornament were central features of the new style, and these played a particularly dynamic role in the works of Germany's two most accomplished Rococo designers: Dominikus Zimmermann (1685–1766) and Johann Michael Fischer (1712–1766). Zimmermann's greatest work is his Church of the Wies (meaning "meadow"), outside of the village of Steingaden in the Bavarian Alps. Begun in 1743 for a nearby monastery, this church housed a miraculous image of the flagellation of Christ, to which a pilgrimage had developed. Zimmermann developed the nave of the church as an elongated oval supported by eight columns that melded into the structure's ceiling in a riot of encrusted decoration. The Corinthian columns of some of these supports take on the effect of jewelry, sculpted as they are out of plaster and decorated with touches of gilt. Above, in the space where a cornice or entablature might normally separate the walls of the church from the ceiling, Zimmermann created a fluid space decorated with stucco and gilt

encrustations so that it is difficult for the eye to tell where the walls end and the ceiling begins. Light floods into the space through the broad and elongated windows. The sinuous treatment of lines continues in the exterior, where the architect used long, flowing detailing to set off the windows. Modest, refined decoration also seems to drip from the building's pilasters and upper surfaces.

OTTOBEUREN. Like Zimmermann, Johann Michael Fischer already had a reputation as an accomplished architect when he began to create spaces using the Rococo style. He had designed a number of Catholic churches in Bavaria and throughout southern Germany since the late 1720s. In his mature work, though, he began to adapt the new style to a series of monastic churches he created during the 1740s. The largest and most famous of these was Ottobeuren in the small town of the same name in the German southwest. Previous architects had already established the monumental size of this structure and they had fixed its shape as a Greek cross. Fischer revolutionized their design by building two huge towers on the church's exterior and setting a convex central portion between them. These two towers frame the elaborately decorated gable that runs above the central entrance to the church. Columns set on both sides of the entrance further enhance the strongly vertical lines of the exterior. Inside, Fischer made the most of the Greek cross space by setting huge windows in the enormous walls and allowing light to fill the structure. The central piers that support that structure's main dome are decorated with colored faux marble pilasters so that they appear even larger than they really are. Throughout the interior Fischer left broad patches of walls, spaces later decorated with paintings by Johann and Franz Zeiler and sculptures by Johann Joseph Christian. These decorative elements skillfully enhanced the monumental lines developed by Fischer in the structure. As a result, Ottobeuren stands as one of the premier monuments of the German Rococo, an archetype for what Germans have long called a *Gesamtkunstwerk*, a masterpiece in which the imaginative fusion of all the arts work toward a single, greater goal.

IMPLICATIONS OF THE ROCOCO. Great works of Rococo architecture like the Wies or the monastic church at Ottobeuren seem today to sum up the imaginative possibilities as well as the limitations of Rococo as an architectural and stylistic movement. In these structures, decoration combined with skillful architectural design to create works of incomparable beauty and greatness. In the hands of lesser lights, though, the fashion for encrustation led to many considerably less imaginative spaces. Fashion had sustained the rise of the Rococo since its beginnings in early eighteenth-century Paris. As the

second half of the eighteenth century approached, and as Rococo design moved to its final stage of ornate elaboration, fashions just as quickly began to change. In the second half of the eighteenth century Neoclassical spaces, often serene and severe, revolutionized domestic, church, and public architecture throughout Europe just as quickly as the Rococo had changed fashions in the first half of the century.

SOURCES

Anthony Blunt, ed., *Baroque and Rococo: Architecture and Decoration* (New York: Icon Editions, 1982).

Julius S. Held and D. Posner, *Seventeenth and Eighteenth Century Art* (Englewood Cliffs, N.J.: Prentice Hall, 1971).

Vernon Hyde Minor, *Baroque and Rococo. Art and Culture* (London: Laurence King, 1999).

Katie Scott, *The Rococo Interior: Decoration and Social Spaces in Early Eighteenth-Century Paris* (New Haven, Conn.: Yale University Press, 1995).

SEE ALSO *Visual Arts: The Rococo*

THE DEVELOPMENT OF NEOCLASSICISM

REACTION AGAINST THE ROCOCO. Even as fanciful patterns of Rococo decoration and architectural creation achieved great popularity in many wealthy circles throughout Europe, people began to react negatively toward the style. By 1750, many architects and patrons viewed the movement as corrupt and decadent, and began to embrace a broad, Neoclassical revival in place of the Rococo. The forces that inspired Neoclassicism arose from numerous intellectual, economic, and social sources. By the second half of the eighteenth century, though, a rising fascination with Antiquity is undeniable throughout Europe. One force that helped to create this fascination was the phenomenon of the Grand Tour, a circuit that intellectuals and wealthy cultivated men and women often made through Europe's main capitals. The Grand Tour was particularly popular among English elites, and during the eighteenth century it became an event that was seen as necessary to complete one's education. Many people published accounts of their tours, and as later cultural pilgrims imitated the tours of others who had gone before, the Grand Tour became increasingly formalized as a social convention. Of course, elites from throughout Europe had long visited the continent's major capitals, and since the Renaissance they had been especially anxious to make the journey to Italy. Whereas earlier generations of intellectuals had frequently wanted

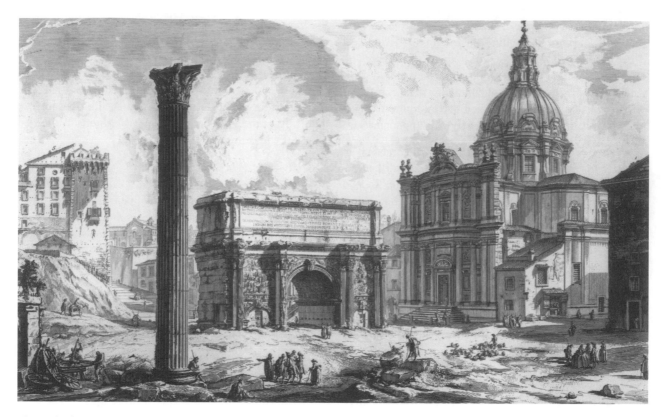

The Arch of Septimus Severus by Giovanni Battista Piranesi, an example of the eighteenth-century Neoclassical fascination with antiquity. **LIBRARY OF CONGRESS.**

to witness firsthand the cultural achievements of Renaissance humanists and artists, however, refined society in the eighteenth century desired to see firsthand the power and austere beauty of the ancient ruins in Rome as well as other antique sites. For many, the city of Rome was the high point and often the culmination of the Grand Tour for its wealth of ancient monuments. Literary and historical works that celebrated the achievements of Antiquity had whetted tourists' appetites for these sights. In the English-speaking world the greatest of these works was Edward Gibbon's *The Decline and Fall of the Roman Empire*, first published in 1788; but, as elsewhere in Europe, Gibbon's superb statement of eighteenth-century classical history had long been preceded by a number of other works that treated life in the ancient world. At its foundation, this fascination with all things classical arose from a deeply felt desire to imitate the cultural greatness of Rome and Greece.

STUDY OF ANTIQUITY. One important result of this fascination was the rise of archeology as a new discipline at the time. As a result of scholarly attention, the artifacts and buildings of the ancient world were subjected to a new, more detailed examination. A key figure in popularizing the achievements of ancient builders was

Giovanni Battista Piranesi (1720–1778). During a forty-year career spent mostly in Rome, he fostered close contacts with many European architects and patrons who visited the city. Piranesi acquired an unparalleled understanding of ancient architecture through the studies he undertook at archeological digs in Italy, and he spread this knowledge through a series of skilled and undeniably beautiful etchings of ancient monuments. Later in his career he also shaped the course of European architecture by publishing a series of polemical works that advocated an eclectic and practical adoption of ancient designs. Piranesi's voluminous and archeologically informed knowledge of the ancient world placed him in a uniquely powerful position to influence the Neoclassical revival. In his written works, for instance, he argued that ancient design had been practical, adopting influences and practices from throughout the Mediterranean to fit the changing needs and circumstances of people. Such arguments shifted the terms of the debates that had long raged about ancient architecture. Piranesi rejected long-standing questions about whether the architecture of the Greeks had been superior to that of the Romans. Instead he celebrated the ancient monuments that existed in Italy from the time of the Etruscans as practical and well suited

to the needs of each culture's own time. Implicit within this defense of classical architecture, though, was a criticism of the highly ornamental and decorative styles of building that flourished in many places in Europe at the time. In this way his writings and etchings undermined the popularity of Baroque and Rococo styles of ornamentation. Fascinated by the images he presented of historically accurate ancient buildings, patrons and designers began to emulate the simpler, less adorned styles of Antiquity.

NEOCLASSICISM IN FRANCE. During the high tide of the Rococo's popularity in Paris, townhouses and public buildings in the city had continued to be constructed with restrained façades, and many of the elements of these structures had their origins in the classicism of the Renaissance. In the later years of Louis XV's reign, an increased severity and gravity became the rule in many of the royal projects undertaken in Paris as the new, more historically informed Neoclassicism spread through Europe. The reigning architects of the second half of the eighteenth century were Germain Soufflot (1713–1780) and Ange-Jacques Gabriel (1698–1782). Soufflot was originally from Lyons, France's second largest city, where he designed a number of country houses and public buildings before moving to Paris in the 1750s. In 1755, work began on his designs for the Church of Ste.-Geneviéve (now known as the Panthéon), although numerous problems plagued this church's completion and the structure remained unfinished until 1790. This building commemorated Louis XV's recovery from an illness after he made a vow to the saint. Constructed on a hill overlooking the Left Bank of the Seine, the church commands the site by virtue of its enormous classical dome. The structure's classicizing tendencies bear greater resemblance to the architecture of the High Renaissance than they do to the exuberant and more decorative style of the seventeenth-century French Baroque. Throughout the church Soufflot deployed the sophistication he had acquired in classical design while a student in Rome. The exterior and interior surfaces of the church are largely unadorned and its porticos might have appeared on public buildings constructed in the Roman forum. By contrast, Ange-Jacques Gabriel (1698–1782) was a French-trained architect who became the palace architect at Versailles. During his tenure he completed many works of reorganization at the château for Louis XV, a monarch obsessed with achieving greater privacy in the mammoth spaces of the palace. While constantly involved in projects of remodeling at Versailles, Fontainebleau, and other royal residences, Gabriel also designed several buildings that were notable for their use of the new, more

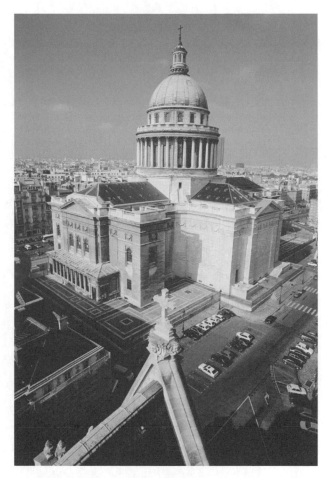

The Panthéon, Paris. © SETBOUN/CORBIS.

severe Neoclassicism. In Paris, Gabriel designed two new public buildings that faced the Place Louis XV (now the Place de la Concorde), then just west of the Tuileries Palace. While consonant with the façades that had been constructed for the nearby Louvre in the seventeenth century, Gabriel included details more in keeping with ancient than Baroque architecture. His colonnades, for instance, are comprised of rows of single, rather than paired columns, and the culminating pavilions of these buildings are each crowned with a pediment, rather than the elongated and solitary structure that stretched over the east façade of the Louvre.

PETIT TRIANON. At about the same time Gabriel was completing plans for the buildings of the Place Louis XV, he was also creating his great masterpiece, the Petit Trianon at Versailles. He built this small retreat on the fringes of the garden of the Grand Trianon, the much larger haven that Louis XIV had built to escape Versaille's formality. This was one of the most notable buildings of the eighteenth century because its scale and layout very much resembled that of modern houses. In this relatively

a PRIMARY SOURCE *document*

AT HOME WITH THE QUEEN

INTRODUCTION: The fashion for intimate interiors in the first half of the eighteenth century gave rise in later years to an intensified demand for small, private spaces that provided a focus for family life. Many members of the royal family and the court rejected life at Versailles in favor of newer and smaller-scaled residences. These houses were nevertheless decorated with sumptuous interiors, but at the same time they offered natural gardens and interiors constructed on a human scale. In the later years of her short reign as queen of France, Marie-Antoinette all but abandoned the great Palace of Versailles, and instead took up residence with her children in the Petit Trianon at the far reaches of the château's gardens. The queen's isolation attracted great controversy as rumors circulated that orgiastic parties occurred there. After the queen's execution, Madame Campan, a member of her aristocratic inner circle, tried to put to rest these rumors by reminiscing in her memoirs about Marie-Antoinette's intensely private family life in the small spaces of the Petit Trianon.

The king, always attentive to the comfort of his family, gave Mesdames, his aunts the use of Château de Bellevue, and afterwards purchased the Princess de Guéménée's house at the entrance to Paris for Elisabeth [Louis XVI's sister]. The Comtesse de Provence bought a small house at Montreuil; Monsieur already had Brunoy; the Comtesse d'Artois built Bagatelle; Versailles became, in the estimation of all the royal family, the least agreeable of residences. They only fancied themselves at home in the plainest houses, surrounded by English gardens, where they better enjoyed the beauties of nature. The taste for cascades and statues was entirely past.

The Queen occasionally remained a whole month at Petit Trianon, and had established there all the ways of life in a château. She entered the sitting-room without driving the ladies from their pianoforte or embroidery. The gentlemen continued their billiards or backgammon without suffering her presence to interrupt them. There was but little room in the small Château of Trianon. Madame Elisabeth accompanied the Queen there, but the ladies of honour and ladies of the palace had no establishment at Trianon. When invited by the Queen, they came from Versailles to dinner. The King and Princes came regularly to sup. A white gown, a gauze kerchief, and a straw hat were the uniform dress of the Princesses. Examining all the manufactories of the hamlet, seeing the cows milked, and fishing in the lake delighted the Queen; and every year she showed increased aversion to the pompous excursions to Marly [a country retreat originally built by Louis XIV].

SOURCE: Jeanne Louise Henriette Campan, *Mémoires of Madam Campan*. Vol. 1 (Paris and Boston: Grolier Society, 1890): 266–268.

small house, Gabriel improved upon the Rococo's techniques for providing families with greater privacy. Built as a hideaway for the king and his mistress Madame de Pompadour, the building's small scale and perfection of decoration made it a fitting tribute to Pompadour, who avidly supported the Neoclassical style's development in France. With her banishment from court and the death of Louis XV, the property became a favorite retreat of Queen Marie-Antoinette, who found the structure's informality more attractive than the vast and cold spaces of nearby Versailles. The queen likely admired the structure because its use of space was completely different than most of the royal residences of the time. In his design Gabriel combined all the functions and spaces necessary for a nuclear family to live in relative quiet and seclusion. On the ground floor he located the kitchens and other facilities necessary to support the family, who lived above. On that upper story the bedchambers and bathrooms were segregated to one side, while the more sober drawing and dining rooms were found at the opposite end. All rooms offered attractive vistas into the gardens below. Relying on this logic of seclusion and privacy, a logic that had now intensified even from the time of Rococo interiors, Gabriel created a space that Marie-Antoinette prized because it afforded her the opportunity to control how much access visitors had to her inner sanctum. The house, for instance, was too small to provide accommodations for her ladies-in-waiting, who had to return to their rooms in nearby Versailles at the end of their visits with her.

NEOCLASSICISM IN ENGLAND. While Italian and French contributions to the classical revival were considerable, it was in England that the new style developed most decidedly. During the course of the eighteenth century, England exercised a powerful influence over intellectual life and fashions throughout Europe. The country acquired a role similar to that which France had played in the seventeenth century. In continental Europe the philosophers of the Enlightenment celebrated the genius of English constitutional government, seeing in it a system that provided greater freedom and that consequently fostered human ingenuity and creativity. Under the

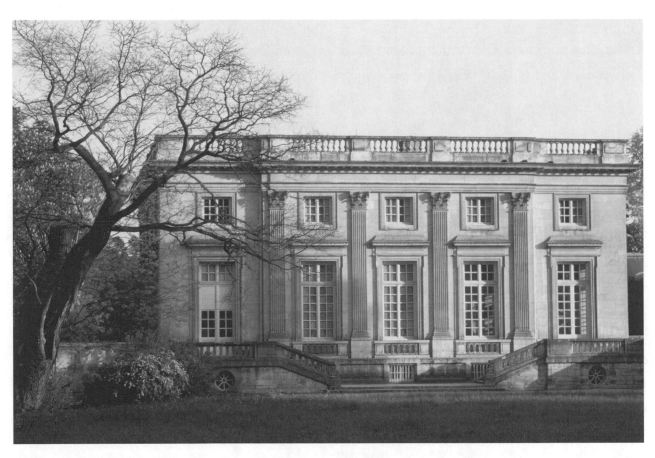

The Petit Trianon villa north of the Palace of Versailles gardens. © **ADAM WOOLFITT/CORBIS.**

Hanoverian kings, limited monarchs who came to England from Germany, the country entered an era of undeniable prosperity. London became Europe's largest city, and England's trade contacts stretched to the furthest reaches of the globe. Although the groundwork for these transformations had been laid in the sixteenth and seventeenth centuries, rapid growth and change characterized the eighteenth century. The period became known for its many cultural achievements. In art, literature, and architecture, it is often called England's Augustan Age, a term that calls attention to the undeniable greatness of works produced at this time, but also to their self-conscious emulation of ancient Rome.

CLASSICAL INFLUENCES. England offered one of Europe's most receptive climates for the development of Neoclassicism for a variety of reasons. Its Baroque architecture, crafted by figures like Christopher Wren and John Vanbrugh, had included many important classical elements, while the suave elegance of the Rococo had made few inroads into English palaces and houses. Thus, as English designers tried to recapture an archeologically correct classicism in the second half of the eighteenth century they had less ground to cover than many of their

continental counterparts. The country's economic growth created a ready class of consumers, aristocrats, gentlemen farmers, merchants, and—as the century progressed—new industrialists who were anxious to surround themselves with stylish buildings. The most visible testimonies to England's economic expansion at the time were in the countryside and in London. In rural England a boom in the construction of country homes hit soon after 1700. As new fortunes multiplied, and as older money became enriched by investment in the new ventures the age offered, England became a land filled with hundreds of country estates. At the same time, London acquired ever more the character of a metropolis. During the early eighteenth century, a characteristic pattern of development emerged in the city, particularly on its western fringes. In Piccadilly, Mayfair, Marylebone, and other once outlying suburbs, handsome new squares filled in with rows of attractive and harmonious Georgian townhouses became a noted feature. In this regard the aristocratic architect Robert Boyle, the third earl of Burlington, did much to impress a Palladian identity on the city in the eighteenth century. Born in 1694, he made his Grand Tour in 1714, returning home with over 870 pieces of luggage filled

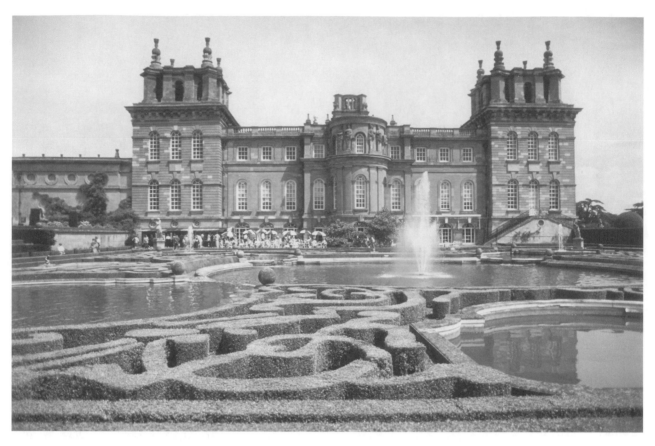

Blenheim Palace in Oxfordshire, England. © ROYALTY-FREE/CORBIS.

with Roman antiquities, drawings from the hands of Palladio, and other souvenirs of his journey. While in northern Italy, the grace of Palladian architecture captivated him, and back in London he decided to use the style in the construction of Burlington House in affluent Piccadilly. In the years that followed, he trained himself as an architect, acquiring a following among the country's aristocracy. He constructed his own country seat at Chiswick House, just outside London, during the 1720s, and made use of Palladio's own famous plans for the Villa Rotonda, near Vicenza in northern Italy. He crowned the simple, yet cubicle mass with a dome, and the structure did much to popularize Palladian architecture among English aristocrats. Elements of its design were frequently copied in the English-speaking world, most notably by Thomas Jefferson who used the designs of both Villa Rotonda and Chiswick House to inform his Monticello on the American frontier. Burlington's architecture, like that of James Gibbs and other architects then active on the scene in London, was important in establishing a taste for classicism. Although the buildings produced in this first wave of Palladian classicism were not highly original, they had the great advantage of creating undeniably attractive public thoroughfares and squares. The Palladian Revival of the early eighteenth century also laid the groundwork for the more thoroughly classical architecture that became popular throughout Britain in the second half of the century.

CHANGE IN DIRECTION. The significance of the changes in English architecture during the eighteenth century can be gauged by comparing the monuments constructed around 1700 with those built just a few decades later. Blenheim Palace, begun in 1705, was the largest Baroque house ever built in England. This enormous structure at Woodstock just outside Oxford was constructed at great taxpayer expense to honor the Duke of Marlborough, John Churchill, for his recent military victories. Blenheim was to be both a country seat for Marlborough and a national monument at the same time that was worthy of the country's growing international reputation. Unfortunately, the public purse was not able to withstand the weight of Marlborough's ambition, requiring the duke to underwrite the building's completion. When Blenheim was finally finished, the building and its courtyards stretched over seven acres and the cost had reached almost £300,000, an astonishing figure at a

Engraving of Sir John Vanbrugh. CORBIS-BETTMANN. REPRODUCED BY PERMISSION.

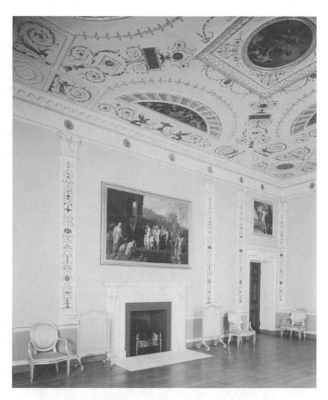

Lansdowne Room, designed by Robert Adam. © PHILADELPHIA MUSEUM OF ART/CORBIS.

time when most English families survived on less than £100 per year. Designed by the Baroque architect John Vanbrugh, Blenheim's exteriors and interiors made use of classical elements, but there is scarcely anything "classical" about the palace's feel. The massive facade, almost 500 feet wide, can scarcely be taken in in a single view. Its enormous colonnades dwarf the human form, and reveal the typically Baroque tendency to overawe viewers. In scale, Blenheim is similar to the great country palaces of the Habsburgs and the Bavarian Wittelsbachs, but its effect offers little of the charm of those palatial country retreats. It is a monument to ambition, both national and personal, and its Baroque, stage-like settings disregard all thoughts of attractive scale or comfort. Even at the time that Blenheim Palace was being completed in the 1720s, its era was already passing, and the designs seemed to the practicing architects at the time to be passé. Few of Blenheim's features found imitation in the decades that followed. Instead, the Palladian revival fueled the construction of more modest structures, built on a human scale, that, like their French Rococo counterparts, did much to offer families and their guests intimate spaces for domestic life and entertaining. The interiors of these structures might have seemed severe and unadorned to continental European visitors at the time, yet their undeniable elegance continues to captivate even today. The Palladian style's quick rise to popularity, too, is evident in the ways in which it was quickly adapted to transform, not only London and the English countryside, but growing towns like Philadelphia, New York, Edinburgh, and Dublin.

ROBERT ADAM. While Palladian-styled homes continued to be popular in England and the colonies, new waves of a more historically accurate Neoclassicism swept through the English-speaking world after 1750. Key figures in establishing the popularity of this style were Robert Adam (1728–1792) and William Chambers (1723–1796), the two greatest British architects of the later eighteenth century. Adam was a Scot who made his Grand Tour in 1754 and on his return set up shop as an architect in London. A cosmopolitanite, he was in touch with the best French and Italian architects of his day, and he applied his firsthand knowledge of the excavations underway in Italy to interiors and exteriors he created in England. When his younger brother James completed his Grand Tour in 1763, he joined his brother's firm in London, and the two established a successful partnership, catering to aristocratic and wealthy British clients. His remodelings and interior design work

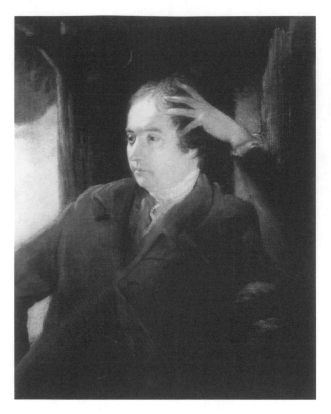

Portrait of Sir William Chambers. **PUBLIC DOMAIN.**

Portrait of Robert Adam. **THE LIBRARY OF CONGRESS.**

undertaken in country houses was particularly noteworthy, and in these he brilliantly used color and a chaste decoration. One of his masterpieces was a series of rooms he remodeled in Syon House, just outside London. The entrance hall he constructed there demonstrated his understanding of how Roman houses might have looked. He set about this space a series of brilliant copies of ancient sculptures. In fact, Adam's interiors were notable for their great restraint, while those of ancient Rome had been filled with decoration. Yet Adam's austerity captured the imagination of the age, and it was the vision that many continued to associate with Antiquity, a vision of spare white walls and reserved decoration. Although William Chambers (1723–1796) came from a Scottish family, he grew up in England and completed his Tour in 1749–1750. On that circuit he first undertook studies in Paris before moving on to Rome, where he came in contact with Giovanni Battista Piranesi. For a time he seems even to have lived in the Italian architect's studio. He set himself up in business in London just a few years before Adam, and soon received commissions from the crown. During the 1760s Chambers and Adam became the sole two architects within the Office of Works, the English body charged with completing commissions for the king. From this vantage point, both Chambers and Adam held an unusual degree of influence over building

in England, not only for the government, but for wealthy aristocrats and merchants also. Like Adam, Chambers's remodeling work and designs for new London townhouses and country villas were widely popular among aristocrats and the wealthy. An important theorist, he edited *Vitruvius Brittanicus*, a mostly Palladian architectural handbook that had served as a textbook for the first wave of English classical designers of the early century. Chambers set down the plans for Kew Gardens, a pleasure garden popular with Londoners in the late eighteenth century, and for Somerset House, a classically inspired building purposely built to house various public records' offices. The structure still stands today as a repository and spans a large space between the River Thames and the Strand. Chambers's structures, like Adam's, were notable for their great restraint and severity of detailing.

SOURCES

Wend von Kalnein, *Architecture in France in the Eighteenth Century.* Trans. David Britt (New Haven, Conn.: Yale University Press, 1996).

Antoine Picon, *French Architects and Engineers in the Age of Enlightenment.* Trans. Martin Thom (New York: Cambridge University Press, 1992).

John Summerson, *Architecture in England, 1530–1830* (Harmondsworth, England: Penguin, 1991).

SEE ALSO *Visual Arts: Neoclassicism*

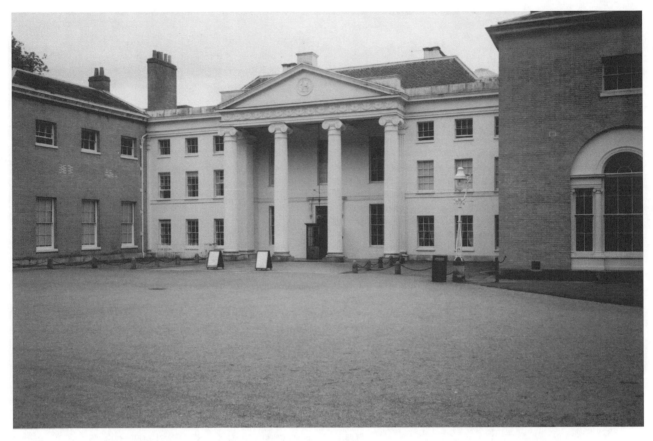

Kenwood House, Hampstead Heath, London. **PHILIP M. SOERGEL.**

REVIVALS AND ROMANTICISM

NOSTALGIA AND THE FASHION FOR THE EXOTIC.
Even as Neoclassicism continued to increase in popularity in England, France, Italy, and other parts of the continent, a new wave of romantic architecture appeared. As a movement, Romanticism arose from sources of sentiment similar to those of Neoclassicism. Its appeal lay, in part, in a longing, even nostalgia, for times that were simpler and more virtuous. Much the same impulse had fueled the revival of classical architecture in England and many parts of continental Europe, as designers, patrons, and intellectuals had sensed that a world of austere and elegant simplicity was to be found in Antiquity. Research into the precise nature of classical art and architecture since the eighteenth century has shown that many of the ideas of these Neoclassicists were incorrect. The pristine white, unadorned spaces present in many eighteenth-century Neoclassical designs were not an accurate reflection of antique tastes. Ancient buildings, in fact, had been decorated with a riot of color and ornament. Yet the affection that many Neoclassicists felt for the world of Antiquity was inspired all the same by a sense of the

vigor and simplicity they felt had been present in the ancient world. This same longing to reproduce the visual qualities of past, more virtuous ages fueled a revival of Gothic architecture in Europe from the early 1740s. One of the most notable of the many Gothic houses constructed in England at the time was Horace Walpole's Strawberry Hill, which he began outside London in Middlesex in 1748. Walpole was the son of Britain's longest-serving prime minister, a writer, and an amateur authority on numerous subjects, including medieval chivalry. In order to complete this rambling, fanciful structure, he required help from some architects, who supplemented his designs. The craze for Gothic spaces was widespread enough to produce at least one textbook in English that informed readers how they might build their own house in this style. In Germany, too, architectural manuals of the time almost always debated the question of the relative merits of medieval and ancient architecture. Like Neoclassical structures, the taste for the Gothic was not always historically correct, with elements of the era's churches being freely adapted onto homes whose scale was far grander than those of the Middle Ages.

a PRIMARY SOURCE *document*

THE CHINESE FASHION

INTRODUCTION: William Chambers was one of the great architects of the neoclassical revival in England. He and Robert Adam served together for many years as royal architects, and both designed a large number of neoclassical townhouses and country estates. The taste for classical design did not prevent the architects of the time from indulging a fashion for other more exotic structures. Many neoclassical designers also produced buildings in the Chinese and Gothic styles. In 1757, Chambers published in both French and English his *Designs for Chinese Buildings, Furniture, Dresses, Machines, and Utensils.* The work was of major importance in sustaining the popularity of things Chinese throughout Europe. Although Chambers was quick to point out the inferiority of Chinese architecture when compared to European antiquity, he nevertheless recommended the Chinese style as a way of adding visual interest to large houses and gardens. His emphasis on the way in which Chinese architecture might add picturesque interest to a large garden was a typical feature of late eighteenth-century design.

These which I now offer to the publick are done from sketches and measures taken by me at Canton some years ago, chiefly to satisfy my own curiosity. It was not my design to publish them; nor would they now appear, were it not in compliance with the desire of several lovers of the arts, who thought them worthy the perusal of the publick, and that they might be of use in putting a stop to the extravagancies that daily appear under the name of Chinese, though most of them are mere inventions, the rest copies from lame representations found on porcelain and paper-hangings.

Whatever is really Chinese has at least the merit of being original: these people seldom or never copy or imitate the inventions of other nations. All our most authentick relations agree in this point, and observe that their form of government, language, character, dress, and almost every other particular belonging to them, have continued without change for thousands of years; but their architecture has this farther advantage that there is a remarkable affinity between it and that of the antients, which is the more surprising as there is not the least probability that the one was borrowed from the other.

In both the antique and Chinese architecture the general form of almost every composition has a tendency to the pyramidal figure: In both, columns are employed for support; and in both, these columns have diminution and bases, some of which bear a near resemblance to each other; fretwork, so common in the building of the antients, is likewise very frequent in those of the Chinese … There is likewise a great affinity between the antient utensils and those of the Chinese; both being composed of similar parts combined in the same manner.

Though I am publishing a work of Chinese Architecture, let it not be suspected that my intention is to promote a taste so much inferiour to the antique, and so very unfit for our climate: but a particular so interesting as the architecture of one of the most extraordinary nations in the universe cannot be a matter of indifference to a true lover of the arts, and an architect should by no means be ignorant of so singular a stile of building: at least the knowledge is curious, and on particular occasions may likewise be useful; as he may sometimes be obliged to make Chinese compositions, and at others it may be judicious in him to do so. For though, generally speaking, Chinese architecture does not suit European purposes; yet in extensive parks and gardens, where a great variety of scenes are required, or in immense palaces, containing a numerous series of apartments, I do not see the impropriety of finishing some of the inferiour ones in the Chinese taste. Variety is always delightful; and novelty, attending with nothing inconsistent or disagreeable, sometimes takes place of beauty.

SOURCE: Sir William Chambers, *Designs of Chinese Buildings, Furniture, Dresses, Machines, and Utensils* (London: 1757) in *Michelangelo and the Mannerists; The Baroque and the Eighteenth Century.* Vol. II of *A Documentary History of Art.* Ed. Elizabeth G. Holt (Englewood Cliffs, N.J.: Prentice Hall, 1958): 295–296.

ENGLISH GARDENS. Another sign of the eighteenth century's yearning for simplicity can be seen in garden architecture. By the second half of the century the grounds that surrounded many country houses throughout Europe were being remodeled to take account of a new fashion for natural settings. In many places these more relaxed spaces became known as "English gardens." The primary feature of an English garden was a bucolic, easy flow of brooks, forests, and meadows, rather than the hard edges of clipped hedges and fountains. The taste for gardens constructed in an English style revealed the spread of Enlightenment ideas, which celebrated England's constitution at the time as the most natural, free, and virtuous in Europe. The English garden, eighteenth-century philosophers told their readers, was a cultural embodiment of the country's genius, for in its confines nature was not tortured and made to conform to human artifice, but allowed to proceed on its own course. The English Garden in Munich, laid out in 1789 by the American-born physicist Benjamin

Le Hameau (The Hamlet). © **ADAM WOOLFITT/CORBIS**.

Thomson, is the largest and most famous of these many landscapes. Thomson's political views—he supported the Crown during the American Revolution—forced his emigration to Europe, where he practiced a number of professions in the years that followed. At Munich, his plans for the English Garden made use of an enormous space, a block almost one and a half miles square. Into it, he poured streams with rapids, meadows, Chinese pavilions and antique temples to create a pleasurable space on the city's outskirts. Although not quite the naturalistic setting that philosophers had intended, the garden survives today as one of Munich's most treasured spaces.

THE PICTURESQUE. The English Garden in Munich reveals a great deal of the underlying irony of the late eighteenth century's attitudes toward nature and design. On the one hand, nature was believed to function best when allowed to follow its own course. Nature was most appealing when it was unadorned, spare, and untouched by human artifice. On the other hand, patrons and designers could not escape the human tendency to embellish. As at Munich, gardens constructed after the new English taste were often decorated with numerous pavilions designed to appear as buildings from other cultures

and eras. Carefully placed Greek, Roman, and Gothic ruins gave the landscape the appearance, not of a natural setting, but of having long been settled and tamed by human inhabitants. Chinese and Japanese tearooms, too, were set down in these gardens at places where they might add maximum effect, while streams, rapids, and lakes were carefully sculpted to appear as if they were not the product of the human hand. While seemingly embracing nature as virtuous, then, the eighteenth-century English Garden was one of the most highly artificial of constructions. Sustaining its popularity was a new fashion for spaces that were "picturesque," a word that was, in fact, coined at the time to describe this phenomenon of carefully constructing gardens in a naturalistic way with vistas that offered a maximum of visual interest. Along a trek laid out by a garden's designers, the landscape presented to connoisseurs numerous views that appeared as if they might have been painted. During the 1770s and 1780s the French queen Marie-Antoinette created one of the most notable of these gardens around the Petit Trianon at Versailles. The walks that led through the garden included focal points of grottoes, a Belvedere, a Tempe of Love, and eventually a medieval French hamlet. This last addition was begun in 1783 and completed two years later to include a village of

twelve farmhouses and outbuildings, carefully constructed to appear as if they were of a venerable age. The artifice of Marie-Antoinette's *Hameau* was complete, including as it did real flocks of sheep, herds of cattle, a pond and fishery, and a group of seeming peasants who were imported to live there. The central focal point of this village was the Queen's cottage, a structure that appeared from the outside as a substantial peasant's house, but which indoors was decorated with the extreme refinement typical of aristocratic houses of the time. Here Marie-Antoinette fled the cares of court to indulge her taste for a simpler, less artificial life. Ironically, this *Hameau* was perhaps the eighteenth-century's most man-made illusion, and the queen had little time to enjoy it. Its completion in 1785 came only several years before the beginning of the French Revolution that eventually toppled the monarchy.

CONCLUSION. During the eighteenth century new architectural movements swept across Europe as the tastes of architects and patrons began to change. Although late Baroque and Rococo styles continued to survive in some places, new waves of Neoclassicism and other revival styles vied for the attention of designers and their patrons. The Neoclassical revival that began in Europe at mid-century made use of new insights drawn from archeological excavations in Italy. This Neoclassicism developed most vigorously in those countries in which a strongly classical bent to design had been most evident during the Baroque era. In England, for instance, Neoclassicism followed a widespread Palladian revival that had already begun to transform the appearance of London and other British cities in the early eighteenth century. In France, the long-standing taste for classically inspired façades provided a foundation on which the taste for the more thoroughly ancient elements of Soufflot's and Gabriel's designs developed. Central Europe proved more resistant to the new stylistic tendencies and the Rococo tended to survive longer there than in the West. In Munich, Berlin, Vienna, and other capitals in the region, new churches, private houses, and public monuments began to appear in the Neoclassical style during the later decades of the century. Neoclassicism expressed the longing of the eighteenth century to escape the confines of contemporary history and to foster a more virtuous society, something to which the great upheavals of the French Revolution aspired as well. The histories and literary works of the age celebrated Rome and Greece for the vigor of their cultural achievements as well as for the austerity and elegant economy of their artistic vision. New revival styles throughout the eighteenth century also made use of similar feelings of nostalgia for bygone eras. A taste for the exotic, an affection that had long been embraced by Baroque and Rococo designers, persisted in the continued popularity of structures that made use of elements of Eastern and Near Eastern design. In both England and the continent, Gothic Revival style appeared at around the same time as Neoclassicism, and its rise demonstrates the importance that Romantic sentiments and longings had on the architectural scene at the end of the eighteenth century. Perhaps nowhere is the influence of this Romanticism more evident than in the gardens of the later century that consisted of Chinese pagodas, ancient temples, and Roman and Gothic ruins set within a landscape that appeared as if it had been untouched by human hands. At the same time a careful progression of "picturesque" views provided a backdrop for the musings of those who made their way through these highly artificial, yet seemingly natural spaces. Thus while the eighteenth century desired to escape its history, and to rewrite its culture in a way that abandoned the Baroque tendency toward elaborate adornment, human artifice returned nevertheless to produce designs that were no less artificial than those of the ages that had come before.

SOURCES

Kenneth Clark, *The Gothic Revival* (Middlesex, England: Penguin Books, 1964).

Brian Fothergill, *The Strawberry Hill Set: Horace Walpole and His Circle* (London: Faber, 1983).

J. S. Held and D. Posner, *Seventeenth and Eighteenth Century Art* (Englewood Cliffs, N.J.: Prentice Hall, 1971).

Nikolaus Pevsner, ed., *The Picturesque Garden and its Influence Outside the British Isles* (Washington: Dumbarton Oaks, 1977).

David Watkin, *The English Vision: The Picturesque in Architecture, Landscape, and Garden Design* (New York: Harper and Row, 1982).

Dora Wiebenson, *The Picturesque Garden in France* (Princeton, N.J.: Princeton University Press, 1978).

SIGNIFICANT PEOPLE
in Architecture and Design

ROBERT ADAM

1728–1792

Interior Designer
Architect

SCOTTISH UPBRINGING. Robert Adam, the man who revolutionized English classical design in the course of the eighteenth century, was born into a family of educated Scots in Edinburgh in 1728. Adam's father was also a successful architect, and the young Adam mastered the skills of this trade early in life, joining his father's firm for a time in the years immediately after he finished university. When his father died in 1748, Adam continued the practice with his brother John, and together they undertook many successful commissions throughout Scotland. These included buildings constructed in the then-popular Gothic Revival style as well as forts and other military fortifications intended to quell recent uprisings in the country. With his fortune strengthened, Adam embarked on his Grand Tour in 1754, making a circuit similar to other cultivated British gentlemen of the age. His journey lasted four years, a large portion of which he spent in Italy. In Rome, he came into contact with the discoveries that were being made about ancient architecture from excavations underway in Pompeii and Herculaneum, the ill-fated towns destroyed by the eruption of Mt. Vesuvius in 79 C.E. In 1758, Adam returned to Britain from his journeys and settled in London, where he soon became a fashionable designer of interiors and structures for the English aristocracy and gentry.

CHANGING TASTES. Commissions came slowly at first for Adam in London, although his business quickly improved with his election to the Royal Academy in 1761 and his selection, together with his rival William Chambers, to serve as co-architect of the King's Works. By 1763, his practice was successful enough to accommodate his two brothers, who joined the firm in London. During the years between his arrival in the capital and 1765, Adam mastered the Neoclassical style, and in his later life he seldom designed buildings in the Gothic Revival style that he had practiced in his youth. One of his chief achievements from the early years in London was the completion of the remodeling of Syon House, a Tudor-era convent located outside London. Over the previous generations, this building had been remodeled to increase its comfort as a private house. Adam, however, cleared away many of the previous additions, and in their place designed classical rooms notable for their severity and restraint. He laid out these spaces in an unusual configuration of patterns drawn from his knowledge of Roman baths, and he made use of dramatic contrasts of color. The impressive designs he realized at Syon House earned him great acclaim and Adam received many new commissions for remodeling and new structures at the end of the 1760s. Chief among the many country houses he designed at this time were Osterley

Park in Middlesex, and Kenwood House, a brilliant little gem of Neoclassical architecture located on Hampstead Heath on the fringes of London. Osterley Park was a pre-existing Tudor house that Adam redesigned to fit with the Neoclassical fashion. To do so, he built a dramatic classical portico around the structure's courtyard, raising the vertical lines of the house to a new, more dramatic height and decorating the rooms with a series of motifs drawn from Antiquity. These included coffered Roman ceilings, apses, pilasters, and even ancient grotesques. One of the most distinctive elements of his remodeling at Osterley Park was his inclusion of an Etruscan dressing room. The Roman architect Piranesi had done much to popularize the style of the ancient Etruscans—the civilization that had preceded the Roman Empire in Italy—and Adam's use of the style is among the finest eighteenth-century adaptations to survive. At Kenwood House, he created a small-scale classical country house that made use of new techniques in the execution of stucco. He decorated the garden façade of this structure with pilasters crafted from a recently discovered technology that allowed for greater delicacy of execution. The vaulted library of Kenwood has often been hailed as one of Adam's most beautiful creations. With its gentle palette of blue offset by white columns and touches of gilt, it manages to achieve a delicacy and sophistication unknown to the age except in its finest porcelains.

OTHER COMMISSIONS. Even as Adam left his imprint on the country landscape of Britain, he was busy remodeling and redesigning urban houses in London. His commissions for these projects rose quickly around 1770, and a number of examples of the innovations that he made in interior design still survive in London. London houses presented a special challenge to an architect. Instead of the vast spaces that many country houses afforded, the typical London townhouse sat on a narrow lot and stretched back from the street. The grand entertaining that became increasingly common during the London season in the eighteenth century demanded interiors that were handsome and well proportioned. Adam's created spaces were models of refined elegance in these houses, relying on attenuated lines to grant his drawing rooms a feeling of greater spaciousness when expansion was impossible. Besides his work for the king, Adam also undertook the design of many public-planning projects, laying out squares in London and other British cities. His innovative plans for the expansion of the town of Bath, a major resort city at the time, were not to be followed, nor was a proposal that he presented for the reconstruction of the Portuguese capital of Lisbon following the city's destruction in a devastating earthquake

in 1755. Adam generated the majority of his revenues from residential projects, a sign of the increasing importance that the eighteenth century accorded domestic architecture.

IMPACT. As one of the king's directors of the Royal Works, Adam had special responsibility over royal projects in Scotland. In addition to his success in England, the architect continued to produce numerous designs for houses and urban projects in Scotland. Most notably, his influence can be seen today in the city of Edinburgh, where Adam designed many structures and decorated many interiors in the New Town, Edinburgh's massive eighteenth-century expansion project. Adam was also an important figure because of his methods of creating architectural designs. Like a modern architectural firm, his London practice employed numerous draftsmen and assistants who executed ideas set down by Adam and his brothers. In this way the Adam style proved to be easily reproducible and adaptable to many different architectural situations. The architect's firm also played the role of a general contractor, as Adam and his associates kept employed a regular group of craftsman who were familiar with his work and were thus able to execute the office's plans quickly and with a minimum of retooling. In all these ways, Adam modernized the practice of construction in eighteenth-century England and he set patterns for architectural practice that persisted in the English-speaking world until modern times.

SOURCES

Geoffrey Beard, *The Work of Robert Adam* (New York: Arco, 1978).

Eileen Harris, *Robert Adam. The Genius of His Interiors* (New Haven, Conn.: Yale University Press, 2001).

Damie Stillman, *English Neoclassical Architecture*, 2 vols. (London: A. Zwemmer, 1988).

FRANCESCO BORROMINI

1599–1667

Architect

A TEMPESTUOUS SPIRIT. Born Francesco Castelli, this northern Italian eventually took his mother's name Borromini to distinguish himself from the many other members of his family who were active throughout Italy in the building trades. As a child he served an apprenticeship as a mason in Milan before moving to Rome in 1619 when he was twenty. Through family connections he succeeded in being hired onto the largest project in the city at the time, the construction of the mammoth façade of St. Peter's Basilica, which had been designed by his relative Carlo Maderno. Given to frequent bouts of melancholy, the mason Borromini spent much of his free time in mastering the art of drawing, and he appears to have copied many of the works of Michelangelo in his efforts to improve his ability as an artist. His work paid off when, within a few years of his arrival in Rome, his qualifications as a draftsman had resulted in his promotion from mason to an architect working in Maderno's office at the Vatican. During the 1620s one of the projects in which he participated was Bernini's construction of the massive Baldachino, or canopy, to cover the High Altar of the church. His participation in this and other major work underway at St. Peter's assured his rise to prominence, and he was asked to collaborate on a number of other projects being built around Rome at the time.

INDEPENDENT COMMISSIONS. Borromini's first independently produced design was for a monastery and church for the Trinitarian Order in Rome. This early masterpiece, the Church of San Carlo alle Quattro Fontane (or St. Charles of the Four Fountains), was notable for several reasons. The Trinitarian order was one of the poorer religious groups to take up residence in Rome during the renewed spiritual fervor of the Catholic Reformation, and they had few funds to build an impressive complex. Working within these constraints, Borromini nevertheless provided the order with a structure that made a noble impression on seventeenth-century Rome. It was also a highly unconventional structure. To this day, architectural scholars continue to debate the sources for Borromini's unusual design, which seems to make use of the superimpositions of the forms of a cross, an oval, and an octagon into the same small space. Into this tightly-defined area, Borromini poured decorative shapes of semi-circular apses, ovals, and columns, combined in such a way to present an impression of dramatic expansion and contraction. In the years that followed, he built upon the initial breakthroughs that he had at San Carlo to create a number of structures notable for their violations of classical architectural design principles. In this process he created a dramatically new and powerful kind of design that continued to stir controversy throughout the Baroque period. While his works were emulated in Rome, and his style eventually melded to the conventions of Roman Baroque, his architecture was alternately admired or rejected in other parts of Europe. In England, France, and the Netherlands, architects utilized little of Borromini's style, while in Central Europe and Spain, his influence was widespread.

ST. IVO AND ST. AGNESE. The highly geometric use of space that Borromini developed in his mature creations is brilliantly displayed at St. Ivo, a church built to serve

as the chapel for a school that eventually became the University of Rome. An unusually shaped leftover space had been reserved for the structure, and Borromini turned what might have been an artistic deficit into a great asset. He filled the space with one of the most unusual domes ever seen in Rome at the time. Unlike the domes in fashion since the High Renaissance, the structure that the architect designed to crown this church did not rest on a drum, but rested instead on the unusually shaped structure of the building itself. The sources of inspiration for his design continue to be debated, but in effect the building's floor plan resembles a six pointed star, three points of which have been cut off and the remaining alternating angles transformed into concave semi-circles. In any direction the viewer faces inside the structure, he or she sees a shape that is exactly the opposite of that which is behind. In this way one must look up to the dome above, where the pattern is repeated, to understand the plan in all its complexity. Borromini followed the undeniably strange, but nevertheless beautiful construction of St. Ivo with a series of commissions undertaken for the popes, including the Church of Sant' Agnese in the Piazza Navona. Great difficulties plagued this last project, which was undertaken initially to serve as a family mausoleum for the reigning pope. By the time the architect arrived at the site, ten feet of the church's foundations had already been built. Borromini developed an ambitious and complex design, the most innovative parts of which were rejected by his papal patron. The church as it now stands, though, continues to present a series of imaginative solutions to the problems that arose from its small site. Here, too, Borromini managed to present Rome with a smaller version of what Michelangelo had intended with his designs for St. Peter's. Flanked on either side by two towers and a concave façade, his dome manages to soar above the church and to be seen. At St. Peter's, by contrast, the expansions that the papacy demanded in the structure's original size obscured Michelangelo's grand dome to those who approached its main entrance.

LATER DIFFICULTIES. Borromini's unusually complex ideas as well as his temperament eventually resulted in his dismissal from the project at Sant' Agnese. Other commissions followed, but the architect's designs were always controversial. Widely admired in his youth for his good looks and refined manners, Borromini grew more introverted and melancholic as he matured. In his final years he was said to have preferred his own solitude to the company of friends and associates. He grew suspicious and withdrawn, although he continued to have many advocates who passionately defended his art in his final years and even after his suicide. Largely self-taught, he managed to acquire more than a passing familiarity with philosophical and theological problems, and he appears to have been a disciple of the Roman Stoic philosopher Seneca. His library included more than 1,000 books, a truly enormous collection for a man of his income and schooling. Yet, like Michelangelo and Caravaggio, his status as a commoner often left him ill at ease in the great social circles in which he traveled. In the generations following his death his imaginative architectural solutions to design problems allowed his reputation to soar in some quarters, even as his violation of the classical tenets of design continued to condemn his vision to attacks and criticism. Since the late nineteenth century scholarship has universally tended to revere the enormity of Borromini's imagination.

SOURCES

Anthony Blunt, *Francesco Borromini* (Cambridge, Mass.: Harvard University Press, 1979).

Rudolf Wittkower, *Art and Architecture in Italy, 1600–1750* (Harmondsworth, England: Penguin, 1980).

FRANÇOIS DE CUVILLIÉS

1695–1768

Architect
Interior Designer

EARLY LIFE. Born at Hainault near Brussels in 1695, François de Cuvilliés entered into the service of Duke Maximilian II Emmanuel of Bavaria as a court dwarf when he was eleven. At the time, the duke was in exile from his duchy, but when he returned to Munich in 1714, he brought Cuvilliés with him. Over the years that followed, Maximilian looked after his servant's education, apprenticing him eventually to serve as a draftsman to his court architect. With Maximilian's financial support, Cuvilliés left Munich for Paris in 1720, and during the next four years he completed his architectural studies there. At the time that Cuvilliés was a student in the city, the early Rococo style was becoming fashionable in France. The young architect studied under Jean François Blondel, one of the most important of the early French Rococo designers. In Paris, he also studied the techniques of French *rocaille* or "rockwork" plaster, and on his return to Bavaria he began to use them in his architectural creations. His first project was at the Wittelsbach's country palace, *Schloss Schleissheim*. Pleased with his creativity, Duke Maximilian granted Cuvilliés a position within his court architect's office. Somewhat later, under Maximilian's successor, Carl

Albert, Cuvilliés began to receive a series of more important commissions.

MATURE STYLE. In Cuvilliés' greatest works he outshined the merely decorative conventions of Rococo style and surpassed the many competent designers who practiced in the style in France. Some of his work has been destroyed since the eighteenth century, but two of the greatest of his creations—the Amalienburg in the gardens of Schloss Nymphenburg and the Residence Theater in Munich—survive. The Amalienburg was a small pleasure villa built between 1734 and 1739. From the outside the structure appears as a model of courtly refinement. Once inside, though, its extreme ornateness becomes quickly evident. Like many Rococo structures, the rapidly floating and swirling spaces of stuccowork at the boundary between the ceilings and walls make it difficult to tell where one ends and the other begins. While filled with decorative detailing, the relatively limited palette of pale colors provides a sophisticated, rather than merely ornate, air to the rooms. The Residence Theater in Munich is, by contrast, a riot of sumptuous ornament. Built in 1751–1752, the palette of bright red, gold, and white has splashes of ornament to demarcate the social hierarchy of the nobles and courtiers who attended the productions staged there. The Wittelsbach box and the balconies that surround it have the most decoration, while on the levels above simpler ornamentation becomes the rule. While ornate in the extreme, Cuvilliés' theater was also a very practical environment in which to perform plays, and it was adaptable to other uses as well. The theater was originally equipped with a mechanism that allowed the sloping floor of its auditorium to be lowered into a flat position so that court balls could be held there. Of the many theaters built during the Baroque and Rococo periods, it remains one of the favored spots for the performance of period dramas and operas.

INFLUENCE ON DESIGN. The Amalienburg and Residence Theater are only two of the many structures that Cuvilliés worked on during his long career in Bavaria. In 1740, his patron at the time, Duke Carl Albert, rose to the office of Holy Roman Emperor, and at that time the architect received the largely honorific title of "Imperial Architect." While the empire was largely a fictional power by this time, Cuvilliés' position close to its heart still won him many commissions outside Bavaria. These included plans for numerous additions to Schloss Wilhelmstal near Kassel, the country palace Seraing for the bishop of Liége in modern Belgium, and a palace for the aristocratic Fugger family. In addition, he completed plans for the Residence at Würzburg as well as an urban plan for the city of Dresden, which acquired its delicate late Baroque and Rococo character at the time. The architect was also an enthusiastic collaborator, and during his career he worked with Johann Baptist Zimmerman and other southern German architects, helping to spread knowledge of the decorative techniques he had acquired while a student in Paris. In 1738, Cuvilliés began another project that firmly established his influence among other architects practicing throughout Europe. In that year he began to produce a series of bound engravings illustrating the proper ways to ornament and decorate buildings and furniture. When completed in 1755, this project totalled 55 books of engravings published in three separate series. These works had wide circulation throughout the continent, and even influenced later Rococo decoration as well as the construction of furniture. Cabinetmakers, for instance, enthusiastically studied Cuvilliés' designs for inspiration as they created sophisticated works for their aristocratic clients.

SOURCES

Hermann Bauer, *Rocaille. Zur Herkunft und zum Wesen eines Ornament-Motivs* (Berlin: De Gruyter, 1962).

Wolfgang Braunfels, *François de Cuvilliés* (Munich: Süddeutscher Verlag, 1986).

LOUIS XIV

1638–1715

King of France

A FIVE-YEAR-OLD KING. Born the only child of King Louis XIII and Anne of Austria, Louis succeeded to the throne when he was only five years old. He spent his early years, then, in a long period of regency in which his mother and Cardinal Mazarin wielded power in France. The experience of the *Fronde*, a series of rebellions staged by members of the Parlement of Paris and French nobles that occurred between 1648 and 1653, left a lasting impression on the king. At one point in these disturbances Louis and his mother had to flee the capital, an insult that the king never forgot and that continued to color his relationships with many members of the nobility years later. In 1661, Louis finally assumed his royal powers, and shortly thereafter, his confidante and chief minister Cardinal Mazarin died. As a result, the king took his royal duties more seriously. The key features of his policies as they developed in the following years aimed to focus all political authority in France firmly in the hands of the king and his ministers, to assault the lingering power of the nobility and local assemblies throughout France, and to accrue glory for

the state through wars waged against other powers in Europe. The legacy of Louis XIV's reign thus established royal authority on a firmer footing than it had been previously, even as it bred financial and administrative corruption and other problems that lingered long after Louis' death.

ART AND ARCHITECTURE. The visual arts and building were also key to the king's plans to enlarge royal power. Over the course of Louis' reign the arts played a central role in the monarch's efforts at self-promotion, even as his lavish commissions and expenditures on art, jewelry, and buildings became increasingly symptomatic of the king's tendency toward indulgence. In the prosperous years of the 1660s and 1670s, Louis managed to satisfy both his tastes for lavish consumption and display and his appetite for foreign wars. As the seventeenth century drew to a close, however, the increasing military burdens that Louis' international intrigues placed on France required the king to curb his expenditures on art and building. The lion's share of Louis' great architectural achievements thus date from the first half of his reign, the period of France's greatest prosperity. During these years royal bureaucracy defined and executed Louis' commissions. A series of ministers, including Jean-Baptiste Colbert and later the architect Jules Hardouin-Mansart, held the position of Superintendent of Fortifications, Art, and Royal Manufactories, the chief post entrusted with supervising all aspects of the king's commissions of furniture, tapestries, buildings, and forts. Two other positions, the King's First Artist and the King's First Architect, were entrusted with defining a suitable style for the monarch's consumption, while within the royal household a number of other posts oversaw entertainment and supervised the running of Louis' various palaces. Beyond these institutions concentrated in the monarch's household, the Royal Academy of Painting and Sculpture and the Royal Academy of Architecture defined the training of artists as well as the theory of art and architecture that prevailed during the king's long reign. These heavily encrusted layers of bureaucracy and royal administration make it difficult to discern the precise contours of Louis XIV's own artistic and architectural tastes. His mother and Cardinal Mazarin, formative influences on the young monarch, were sophisticated admirers of art, but the king sometimes confided in his ministers later in life that the press of royal duties had prevented him from becoming a true connoisseur. The styles favored in the court in the commissioning of buildings and the visual arts demonstrated an undeniable propensity for projects that were sumptuous and served the monarch's grand pretensions.

MAJOR ARCHITECTURAL PROJECTS. The early period of Louis' reign saw most of the king's efforts as a builder concentrated in the city of Paris. Chief among the projects undertaken at the time was the completion of the remodeling of the Palace of the Louvre, a project that had preoccupied many French kings since the early sixteenth century. Francis I, a great connoisseur of art and architecture, had originally desired to transform this defensive fortress that lay outside Paris' walls into a stylish palace, and the work on this transformation had continued for much of the sixteenth and early seventeenth centuries. In the reign of Louis XIII much had been done to bring a sense of order to the tangled web of confused wings that Francis, Catherine de' Medici, and Henri IV had built at the site, and the project of constructing the huge palace continued during the early years of Louis XIV's reign. The culmination of this work consisted in the commissioning of the East Wing, the structure's most important façade, since it faced toward the city of Paris. While Louis XIV's ministers originally imported the accomplished Italian architect Bernini to guide the project, they eventually decided to follow a native design apparently set down by Claude Perrault and Louis Le Vau, figures later key in the establishment of the Royal Academy of Architecture. The style chosen for the work, a severe but monumental classicism, defined French public buildings over the course of the century that followed.

VERSAILLES. The most imposing project that the king undertook continually throughout his reign was the construction of the new royal palace at Versailles. As at the Louvre, Louis followed the time-honored principle among French kings of adding on to an existing structure—in this case, a hunting lodge his father had built at this site about twelve miles southwest of Paris. During the 1660s Louis began to concentrate more of his architectural attentions at this palace, an area that was always unsuitable for the construction of a grand country estate due to the marshy land and lack of a secure source of water. To solve the latter problem, Louis' architects designed a complex set of machinery to pump water from the Seine, which lay miles away, to feed Versailles' gardens and palace. In the 1660s the designer Le Nôtre began to expand the gardens to meet Louis' demands for a place suitable for staging royal spectacles, while the royal architect, Louis Le Vau, greatly expanded the small hunting lodge beginning in 1668. Le Vau added three new wings to surround the original building, although the character of Versaille's original hunting lodge—constructed from brick, stucco, and stone—was carefully preserved at the center. The expansion of

the gardens continued throughout the late seventeenth century, and one of the key elements there was the construction of the Grand Canal, an enormous reservoir, the perimeter of which is more than four miles long. Here mock sea battles and entertainments were sometimes staged. Beginning in 1678, another round of additions greatly expanded the palace to provide sufficient housing for royal ministers and government officials. In 1682, Louis transferred his government to the site, making Versailles his official residence, a role it served for the monarchy almost continually until the French Revolution. In embracing this site outside Paris Louis aimed to exercise greater control over his fractious nobility. To entice noble courtiers to take up residence at his splendid new court, he awarded freedom from bankruptcy prosecution to those who lived at Versailles, sparking a building boom in the small town. Such plans, though, enticed only about 3,000 of France's 200,000 nobles to live there. Still, all roads to the government—to the awarding of contracts and key positions in the government—more and more led to the palace. Nobles who desired preferment from the crown increasingly had to journey to Versailles. The system of etiquette and protocol that developed in this highly artificial court also played a key role in taming the once rebellious French nobility.

INFLUENCE OF VERSAILLES. Although it was just one of many royal residences that Louis maintained during his long reign, Versailles became a potent symbol of absolute monarchy in the seventeenth century. Kings and princes throughout Europe often tried to imitate the palace's elaborate courtly etiquette and imposing grandeur. Comfort was of little importance in the grand palaces that became increasingly common in Europe during the Baroque period, and Versailles was perhaps one of the most forbidding and draughty of the many architectural creations of the age. Its scale, too, meant that the royal family and courtiers who took up residence there spent a great deal of their lives in a palace that was continually under construction. But while hardly approaching modern standards of comfort, the château still manages to astound its visitors with the grand pretensions of its builder.

SOURCES

Robert W. Berger, *Versailles: The Château of Louis XIV* (University Park, Pa.: Pennsylvania State University Press, 1985).

Guy Walton, *Louis XIV's Versaille* (Harmondsworth, Enlgand: Penguin, 1986).

Andrew Zega, *The Palaces of the Sun King* (New York: Rizzoli International, 2002).

CHRISTOPHER WREN

1632–1723

Architect
Scientist

A CULTIVATED UPBRINGING. At an early age Christopher Wren moved in elevated social circles. When the young Wren was still a boy, his father became the Dean of Windsor. Windsor was the site of England's largest royal castle, and the young Wren had royal playmates there. He attended Westminster School in London for five years, and then was tutored privately before entering Wadham College, Oxford. At Wadham, Wren's interests focused on the sciences, and he conducted some of the first experiments that used opiates as anesthesia. By 1651, he had graduated with a Master's degree and he received an appointment as a Fellow of All Souls College, also at Oxford. This position allowed him to pursue his research interests in astronomy and the physical sciences with relative freedom. In 1657, Wren accepted a post as a professor of astronomy at Gresham College, London, and in 1660, he and some close associates founded the Royal Society, an institution that survives in Britain today as the most important organ of scientific research in the country.

THE TURN TO ARCHITECTURE. Christopher Wren was a brilliant mathematician and astronomer, who in his own day was considered the greatest scientist in England, although the somewhat later accomplishments of John Newton have tended to obscure the scientific reputation of Wren. In 1663, Wren began to dabble in architecture when his uncle, the bishop of Ely, asked him to design a new chapel for Pembroke College, Cambridge. When he finished that project two years later, Wren departed England for Paris, where he stayed for nine months. Wren had timed his visit to France to make contact with Gianlorenzo Bernini, who was in Paris at the time working on designs for the Louvre. He also made the acquaintance of Mansart, the most successful French designer of the day, and he studied the classically influenced buildings of Paris. Wren did not travel in continental Europe beyond Paris, and the voluminous knowledge that he acquired of Italian Renaissance and Baroque architecture came largely secondhand from engravings. His reading and short sojourn in Paris, though, evidently equipped him for the profession that he adopted in the wake of London's Great Fire of 1666.

RESHAPING LONDON. On 2 September, a great conflagration began in the medieval center of London.

Before the fire was extinguished several days later more than 430 acres and 13,000 houses had been devastated. Sensing the opportunity for rebuilding the city on a grander and safer footing, Christopher Wren set himself to the task of fashioning a plan for London's rebuilding. The substantial reputation he had already earned from his scientific endeavors meant that he had the ear of King Charles II, who admired Wren's plans, but who did not have the money to finance them. Instead of pursuing such a grandiose rebuilding of the city—a rebuilding which might have required the king and government to wage war on the venerable English concept of private property—Charles appointed Wren to serve as Surveyor General of the King's Works. From this vantage point, the budding architect left an indelible imprint on the public buildings of London. Eighty-nine churches had been destroyed in the city's fire; Wren's plan included designs for reconstructing only 51 of these structures. The first four of these buildings were hastily rebuilt following the blaze, but the remaining churches were more carefully reconstructed with designs that Wren and his assistant Robert Hooke crafted. Wren did not lavish the same degree of attention on every church in Central London. Some, like St. Mary Le Bow and St. Clement Danes, are clearly superior designs, but the indelible imprint of his style remains fixed in the characteristic steeples that he crafted for the group as a whole. Before the advent of the modern skyscraper, Wren's forest of London church steeples was one of the most distinguishable features of the cityscape. Besides the wealth of imaginative decorative detailing that the architect included on his church exteriors, his plans for these churches were handsome and highly practical. As the son of a clergyman and a family that long had ties to the Anglican Church, Wren well understood the necessities of space for providing a suitable environment for Protestant worship. In a position paper he shared with the government concerning his plans for rebuilding, Wren made it clear that a church must always be laid out with suitable sight lines and acoustical features that allowed worshippers to see and hear the service. Galleries and balconies skillfully placed above the side aisles of the main floor amplified the seating capacities of his constructions. Characteristically, his structures were usually outfitted with clear glass windows, making a bright light shining upon white or off-white walls one of their defining attributes. Many of the church sites in Central London had been small and irregularly shaped, hemmed in by other plots of private property. In these confined spaces Wren often used the pre-existing medieval foundations of the church to create classically inspired spaces. His amazing inventiveness solved many thorny architectural problems, yet the demands of providing a suitable space for worship were a constant feature his designs tried to address.

ST. PAUL'S CATHEDRAL. Wren's undeniable masterpiece was his plan for the reconstruction of St. Paul's Cathedral, a project that proceeded slowly and engendered some controversy. Initially, the plan had called only for repairing the medieval Gothic church that had stood at this site, but as the project went forward it soon became evident that a completely new structure was needed. Disagreements with the cathedral's canons about the church's precise shape further delayed the rebuilding, as did a shortage of funds. By the time the project went forward, Wren had been forced to make a number of concessions. He had longed to rebuild St. Paul's as a central-style church in the manner of Bramante's and Michelangelo's High Renaissance designs. But just as the papacy and its officials at Rome had altered these plans to the shape of a Latin cross, the diocese of London resisted such design innovations. Wren conceded and rebuilt the structure with the shape it had in the Middle Ages. While traditional in this respect, Wren brilliantly demonstrated his knowledge of both Renaissance and Baroque architecture on the church's exterior. For his massive dome, he found inspiration in Bramante's 1502 Tempietto at Rome. The entrance façade of the church quoted from the recently completed East Wing of the Palace of the Louvre in Paris, while the towers that flanked the central portico came from Borromini's plans for the Church of Sant' Agnese in Rome. Inside, the church may not be as successful a creation as St. Peter's in Rome, but its underlying design elements fit with Wren's philosophy of providing a space suitable to the spare and relatively austere demands of Protestant services. Although the London skyscrapers that now surround it dwarf St. Paul's, it remains perhaps the most noble and appealing building ever to have been constructed in the city. The cathedral, together with Wren's other handsome London churches, established a taste for classical architecture in England that long outlived the great seventeenth-century scientist and architect.

SOURCES

Ronald D. Gray, *Christopher Wren and St. Paul's Cathedral* (Cambridge, England: Cambridge University Press, 1979).

Joseph M. Levine, *Between the Ancients and the Moderns: Baroque Culture in Restoration England* (New Haven, Conn.: Yale University Press, 1999).

Jeffery Paul, *The City Churches of Sir Christopher Wren* (London: Hambledon Press, 1986).

DOCUMENTARY SOURCES
in Architecture and Design

Germain Boffrand, *Livre d'architecture* (1745)—A work of architectural theory written after its author had become a key figure in the Royal Academy of France. While Boffrand had been one of the foremost designers of Rococo interiors, he eventually rejected the style and instead argued that nobility of form, common sense, and simplicity of design should be the key determinants in designing space. His defense of these concepts thus exercised a formative influence on the Neoclassical revival in France.

Colen Campbell, *Vitruvius Brittanicus* (1715)—A multivolume collection of engraved illustrations of classically influenced architecture built in England since the sixteenth century. Campbell was the editor of this hugely successful publishing venture, and his influential introduction to the first volume attacked the overly ornate Baroque style and instead advocated greater simplicity in building based upon the early seventeenth-century Palladianism of Inigo Jones.

Paul de Fréart, *Diary of the Cavaliere Bernini's Visit to France* (1665)—A diary account written by Paul de Fréart relating the details of the Roman Baroque architect's five-month visit to Paris during 1665. Louis XIV appointed de Fréart as an aide to the artist while he lived in France. The work provides a view onto the world of high stakes architectural creation at the height of the Baroque.

Guarino Guarini, *Archittetura civile* (1737)—This collection of the great Italian architect's theoretical writings was collected and published years after his death. It shows the architect's concern with elaborate decorative vaulting techniques and sets out his theory that great buildings must, above all, appeal to the senses.

William Halfpenny, *The Country Gentlemen's Pocket Companion* (1752)—One of 22 practical architectural manuals written by this author in the mid-eighteenth century. It included plans for building houses and garden structures and showed its readers how to make architecture an expression of gentlemanly "good taste." Halfpenny also treated the subject of siting buildings in the landscape so that they took advantage of vistas and other natural features. His other works treated subjects as diverse as the building of structures in the Gothic style as well as the proper way to construct a Chinese pagoda. Taken as a group, Halfpenny's widely distributed "how-to" books inspired the fashion for "picturesque" gardens and structures that became a prevailing fashion in the English architecture of the later eighteenth century. His works were also particularly important in the American colonies where their practical, no-nonsense instructions fed the fashion for neoclassicism.

Louis XIV, *The Way to Present the Gardens of Versailles* (1689–1705)—A manuscript written by the great French king himself in six different editions over a period of sixteen years. Louis constantly revised the work to take account of his ongoing building in Versailles' park, although his guide continually advised how best to approach the various monuments, fountains, and sculptures that lay in the great gardens of the palace complex. Thus, Louis' guide provides an unparalleled introduction to the Sun King's own aims in laying out his grand gardens.

Andrea Palladio, *Four Books on Architecture* (1570)—This definitive statement of the Renaissance architect's theories and style continued to be avidly read throughout the Baroque period. It was also translated into other European languages and laid the foundation for the Neoclassical revival of the eighteenth century.

Claude Perrault, *Ordonnance for the Five Kinds of Columns after the Ancients* (1688)—This guide to the five architectural orders of Antiquity was particularly important in establishing the canons of French classicism in the late seventeenth and early eighteenth centuries. The author, a physician, was a major figure in the establishment of the Royal Academy in France, and has long been credited as the driving force behind the creation of the classical façade for the East Wing of the Louvre.

Duc de Saint-Simon, *Memoires* (1691–1755)—These voluminous journals and reminiscences of daily life in Versailles and among the French nobility provided an unparalleled account of court life and a window on the greatest palace of the age. The duke also freely offered his opinions concerning the lavish display and bad taste he sensed was rampant in Louis XIV's court.

DANCE

Philip M. Soergel

IMPORTANT EVENTS
in Dance

1600 Fabritio Caroso's *The Nobility of Ladies* is printed at Venice. The work treats the rules dancers must master for success on the ballroom floor and includes a number of choreographies for popular dances of the day. It will be re-issued in a second edition in 1605.

The marriage of King Henri IV to Marie de Medici is celebrated at Florence. As part of the festivities an opera is performed with a series of interludes or *intermedi* mounted between the acts. These intermedi require more than 100 performers and 1,000 men to control the elaborate stage machinery. Dance figures prominently throughout the production.

1602 Cesare Negri publishes the second of his dance manuals at Venice entitled *The Grace of Love*. Negri's work will be republished two years later in a new edition and, with Caroso's *The Nobility of Ladies*, will dominate ballroom dancing styles in courtly societies in Italy and elsewhere in Europe for the first third of the seventeenth century.

1605 Ben Jonson's *The Masque of Blackness* is performed in London at court. The work is the first to be produced through Jonson's partnership with the architect Inigo Jones. Over the next 25 years the two will produce almost thirty such productions, making use of imaginative scenery, dance, music, and poetry grouped loosely around a theme.

1610 King Henri IV is assassinated in Paris and his nine-year-old son, Louis XIII, assumes the throne under the regency of his mother, Marie de Medici. During Louis' long reign he will expand the crown's patronage of the *ballet de cour*, a form of spectacle performed at court that mixed dance, music, and poetry around a loose theme. The *ballets* are staged and performed by members of the court and the king and queen. Royal patronage of the late-Renaissance form will continue during the first half of Louis' son and successor's reign.

1617 Ben Jonson introduces the continental custom of performing an *antimasque* as an interlude in his court masques. In contrast to the elevated themes that were common to the English masques, the anti-masques were notable for their burlesque humor and their improvised dances which were performed by professional troupes of comedians and dancers, usually before the masque's conclusion.

1623 François de Lauze's *Apology for Dance* is printed in France, heralding the development of a new style. The work includes instructions for new steps as well as movements of the upper body. It also is the first dance manual to include a description of the *plié* and *elevé*, two stretching exercises used to this day that also became important elements of Baroque dance.

1634 King Charles I of England demands that the Inns of Court produce the masque entitled "The Triumph of Peace" at a cost of £21,000. Hundreds of musicians and dancers participate.

c. 1635 The *courante* and *sarabande* reign as two of the most popular courtly dances of the mid-seventeenth century.

1640 In Spain, Juan de Esquivel Navarro's *Sober Discourse on the Art of Dancing* is published. Like de Lauze's earlier treatise, it outlines a greater range of movements that will become popular in the social and professional dancing of the Baroque period.

1650 Pierre Beauchamp, an accomplished dancer, is appointed to supervise dances and the *ballets de cour* performed in the royal court of France. Beauchamp is credited with creating the five classic positions used in ballet, although he may have only codified existing practices of his day.

1651 John Playford publishes *The English Dancing Master* in England. The work will become important in spreading knowledge of English country dances throughout Europe, particularly in France, where country dancing known as *contredanses* will become the fashion by the end of the century.

1653 Louis XIV appoints Jean-Baptiste Lully as his court composer. One of Lully's chief duties will be to compose music for the many *ballets de cour* performed in the French court.

1660 Charles II is restored as king of England; French dancers begin to make their way to England to perform professionally for the court.

1661 The Royal Academy of Dance is founded in France. Like other French academies, this institution will establish standards that will aid in the professionalization of dance as an art form.

1668 The Royal Academy of Music, later to become known merely as the Opera, is founded in France. This institution will have widespread influence on the development of French music, opera, and ballet.

1670 King Louis XIV gives up dancing in court spectacles and productions. During the coming decades his refusal to participate in the French *ballets de cour* inadvertently aids the rise of professionally performed ballets at court.

Molière's play *The Bourgeois Gentleman* is first performed for the king at Versailles. Like many of the dramatist's plays written around this time, the plot makes frequent use of dance.

1672 The first professional ballet dance troupe, led by Pierre Beauchamp, is founded at Paris. The troupe will perform at the Opera in the city and for the king at Versailles.

1681 The first women dancers join the ballet troupe of the Opera in Paris and dance in Lully's production of the *Triumph of Love*.

1687 The death of the influential court composer Jean-Baptiste Lully allows dancers and choreographers greater independence from opera in the French theater. In place of dance's former use as a mere *divertisement* or diversion inserted between the acts of opera, new opera ballets, or merely "ballets" for short, quickly begin to be performed. The plots of these ballets are still revealed via singing, but the trend is to an ever greater dominance of dance in the production.

1688 The *Marriage of the Great Cathos* is performed at Versailles. André Philidor wrote the music and Jean Favier choreographed the work's dance. Although within the traditional genre of *ballets de cour*, the work displayed a heightened intermingling of dance, plot, and music.

1697 André Lorin's *Book of Country Dances Presented to the King* appears in France. Lorin's work is the first to include schematic diagrams of how the different figures should be created on the ballroom floor.

1700 Raoul-Auger Feuillet publishes his *Choreography*. The work is the first to make use of a system of notation for laying down the various steps used in a dance. Because of its clear method of presenting the various dances it outlines, it is enthusiastically received throughout Europe and translated into English, Spanish, and Italian, thus helping to spread knowledge of French practices throughout eighteenth-century Europe.

1704 The Opera's ballet troupe in Paris numbers 21 members, including ten women and eleven men.

1706 John Weaver translates Feuillet's *Choreography* from French into English, publishing it in the same year as *Orchesography*. In its English edition it will become one of the most widely distributed books on dance of the eighteenth century. Weaver's translation will subsequently be re-translated into German in 1717.

c. 1710 In England, the dance choreographies of Mister Isaac are popular among members of the court. These dances are printed in short, easy-to-understand versions that make use of the new practices of dance notation.

1713 A school for training adult dancers is founded at the Opera in Paris.

1717 John Weaver's choreographed pantomime *The Loves of Mars and Venus* is first performed in London. During the coming decades Weaver will experiment with *ballet d'action*, ballets without words in which the story is entirely told through dance and mimed gestures.

1720 The young King Louis XV dances in a *ballet de cour* staged at court. This will be the last time that the king and amateur members of the court perform in one of these spectacles. By this time, theatrical dances at court have become increasingly the preserve of professionals.

1725 Pierre Rameau's *The Dancing Master* is published in France. The work describes a number of steps and is one of the greatest sources of information on eighteenth-century dance. In a second book published around the same time Rameau tries to improve upon the system of dance notation first pioneered by Feuillet around 1700.

1728 John Essex translates Pierre Rameau's *The Dancing Master* into English.

1734 The French ballerina and choreographer Marie Sallé performs a radically new version of the ancient legend of Pygmalion at London. Sallé chooses to dance without the traditionally confining corset used by women and without the masks that dancers commonly donned at the time.

c. 1735 The minuet reigns as the most popular courtly dance of the mid-eighteenth century. It is a couple's dance performed to music written in triple time. In various altered forms the dance will survive into the twentieth century.

1748 The important dance theorist Pierre Rameau dies in France.

c. 1750 In France, the Royal Opera's dance troupe now numbers eighteen men and twenty-four women professionals.

The operas of the composer Jean-Philippe Rameau grant a heightened importance to ballet, and the dances inserted into these works often rival the sung drama for dramatic effect.

1753 The dance master Jean-Georges Noverre arrives in Paris and displeases audiences there with his unconventional productions of pantomime ballets. He moves on to Stuttgart in Germany, where he develops new *ballets d'action* in a more conducive atmosphere.

1754 Louis de Cohusac publishes his *Ancient and Modern Dance* in France. The work advocates greater dramatic expressiveness, and its impact is to be felt in many new works of dance drama that appear in the coming years.

1758 Gasparo Angiolini is appointed to direct the ballet at Vienna. During his tenure he will produce many *ballets d'action* (dance dramas that reenact a story line) in imitation of the dances of the ancient Greeks.

c. 1760 In court circles in France a new fondness for country dances performed in squares develops. The fashion will eventually supersede the popularity of the elaborate and complex couple's dances that had been popular in the first half of the century.

1763 The Opera burns in Paris and will not be reopened for seven years. The company performs in the meantime in the Tuileries Palace nearby.

Jean-Georges Noverre experiences a great success at Stuttgart with the production of *Medée et Jason*. The work will be widely performed throughout Europe.

1767 Jean-Georges Noverre assumes the position of court ballet master at Vienna. His duties include the supervision of dance in Vienna's two court theaters. There he stages a number of successful works of *ballet d'action*.

1770 The Paris Opera re-opens with a performance of Rameau's 1749 work, *Zoroastre*. In the coming years newer forms of *ballets d'action* will gain greater popularity in this important theater, an institution that by this time had become one of the most staid in Europe. A number of other theaters flourish in Paris at the same time that make vivid use of the new narrative dance styles.

1776 Jean-Georges Noverre receives the position of dance master at the Paris Opera. His experimental *ballets d'action* will fail to please Parisians, forcing his resignation a few years later.

1779 In Paris a ballet school is founded at the Opera for the training of children in dance techniques.

1781 Fire breaks out in the Paris Opera at the Palais Royale during a ballet production. Disaster is narrowly averted. In the same year the Opera moves to new quarters in a specially built theater. Far from the center of town, the poor roads leading to it will mean that audiences dwindle during periods of poor weather.

1789 Revolutionary crowds force the closure of the Opera on 12 July, two days before the storming of the Bastille.

1790 Louis XVI's financial difficulties cause him to abandon his patronage of the Opera in Paris. Administration of the institution is handed over to the city of Paris.

1792 Ballet productions at the Paris Opera reflect the new revolutionary sentiments of the Parisian populace. Many aristocratic patrons of dance have by now fled the country or will soon be executed.

1793 Financial necessity and the Revolution in France force Jean-Georges Noverre to spend two seasons working as a choreographer in London. His productions are warmly received.

A number of dancers and choreographers in France fall under suspicion in the new Revolutionary order. Their ties to the aristocrats of the Old Regime often mark them as counter-revolutionaries.

OVERVIEW
of Dance

INHERITANCE. By the beginning of the Baroque era considerable development had already occurred in the art of dance throughout Europe, and dance was both a form of social entertainment and an art that was widely used to accompany theatrical productions. The staging of balls was a common diversion at European courts and among the wealthy societies of the Continent's cities. At the same time dance played a vital role in the many spectacles that were staged at Renaissance courts. During the sixteenth century these festivities had grown ever more complex, and kings and princes had come to hire an increasing number of professionals to dance and perform acrobatics in them. In larger courts dance masters were frequently hired to stage these spectacles, and the fifteenth and sixteenth centuries had produced a number of new manuals of dance theory. While much of the information contained in these treatises was practical in nature, Renaissance dance theorists also searched through the corpus of antique writers in search of ideas to support their art's rising status. From Aristotle, they acquired the notion that graceful deportment and the measured, careful performance of steps were a representation of the Golden Mean; moderation in one's outward appearance, in other words, played a vital role in demonstrating one's virtue and one's mastery of the body. The rise of Platonism as a philosophy during the later Renaissance also left its mark on dance during the sixteenth century. Since Plato's philosophy taught that a higher realm of ideals governed the human mind as well as life on earth, dance was re-interpreted at this time as an expression of the movements of planets and of the celestial harmony that prevailed in the Heavens. A key component of Renaissance Platonism's ideas toward dance celebrated the art as a "school for love," seeing in the ideal motions of couples on the dance floor an experience that might teach men and women the arts of refined and compatible living.

TOWARD THE BAROQUE. No immediate changes in dance theory or in dances themselves are evident in the period around 1600 as styles in art and architecture in Europe began to change from those of the late Renaissance to the early Baroque. Dance continued to play the role that it had for the previous two centuries in courtly entertainment and spectacles, although the rise of the opera in the last decades of the sixteenth century was to be a decisive development for the subsequent transformation in dance that occurred during the seventeenth century. The Opera, a form of art that mixed sung recitatives with arias, had originally begun to emerge out of the discussions of the Florentine Camerata in the 1570s. The members of this group desired to revive the performance practices and theatrical genres that had existed in ancient Greece. From their studies of the ancient dramatists, they discovered that ancient tragedies and other dramatic forms had been delivered in a declamatory style of chant, and the new art of recitative, in which singers proclaimed their texts on rising and falling notes, was an attempt to recapture this lost art. Musical theorists of the time, too, came to realize that ancient tragedy had mixed dance, song, and other forms of music, and so in the developing operas of early Baroque Italy, dance eventually played a vital role. Another venue for theatrical dance in both Renaissance and Baroque Italy was the *intermedio*, an interlude that occurred between the various acts in a comedy or tragedy. The performance of songs and elaborate dances was a common feature of these *intermedi*. By the late sixteenth and early seventeenth centuries, scores of performers were necessary to stage the most sophisticated of these diversionary entertainments in Italian court productions. In France, England, and elsewhere in Europe similar types of dance entertainments had appeared in the sixteenth century, and many of these were, as in Italy, also touched by the new scholarship of the Renaissance and the early Baroque. In late sixteenth-century France, for example, the *ballets de cour,* an elaborate type of royal entertainment, appeared that mixed song, dance, poetry, and pantomime together, while in England the masques, a form of court pageant introduced by the Tudor monarch Henry VIII, underwent a dramatic expansion and elaboration under the new Stuart kings. Both the masques and the *ballets de cour* treated loose themes or myths that served to link the various dances, songs, and tableaux together, but they were not usually integrated dramas that presented a single plot or story line. Rather loose ties and motifs served to bring together the hours of dancing and songs that these productions presented. Masques and *ballets de cour,* too, were ephemeral productions, that is, they were performed once to satisfy a desire for spectacle and entertainment. Once staged, they were not revived, although music and dances from one

production were sometimes adapted to later productions. The performers in these theatricals, too, were largely drawn from the members of the court, although professional dancers and acrobats sometimes were hired to augment their participation. In France, the Bourbon kings Henry IV, Louis XIII, and Louis XIV danced in these spectacles, usually performing in the concluding ballet that drew the evening's entertainment to a close. While the Puritans were largely to outlaw masques in England during the period of the Commonwealth (1640–1660), the *ballets de cour* survived in France, and had become by the late seventeenth century a popular art form in royal circles.

IDEALS OF GRACE. Baroque forms of *intermedi,* masques, and *ballets de cour* made use of the popular social dances of the day, including forms like the *sarabande, courante, passepied,* and in their later forms the popular minuet. While new dances were created for these productions that were performed by solo dancers as well as couples, the dance masters who created these special dances did so using a repertory of steps that was well known to the amateur performers who participated in them. In France and England, masques and *ballets de cour* had originally been staged in large halls rather than on a proscenium stage. Thus the emphasis of those who choreographed was on creating elaborate figural compositions. Dancers frequently moved through a series of steps that inscribed certain signs and symbols on the dance floor. In France, bleachers placed around the room allowed those who watched the performance to read these signs and to relate them to the evening's overarching themes. The dances of the Baroque were also performed in clothing that greatly restricted and reduced the possibilities of free movement. The emphasis of choreographers and dancers was thus on refined footwork, while the upper body was kept largely stationary and highly controlled. This idea of deportment was considered a fundamental social grace, and courtiers who were not able to master the refined movements of the dance floor faced ostracism and mockery.

THE AGE OF LOUIS XIV. During the later seventeenth century France emerged as the dominant absolutist monarchy in Europe, and trends at its court of Versailles were widely copied and imitated throughout Europe. In these years the country proved to be the major source of inspiration for new dance forms, as well. An example of the country's fertility in the arena of dance can be seen in the rise of the *contredanse* throughout Europe. Originally, these "country dances" had been performed in England. By the mid-seventeenth century the French aristocracy's appetite for new kinds of dance brought them into French ballrooms where French tastes refined the simple square dance into an elegant expression of cultivated living. Reinterpreted through the lens of French culture, then, the contredanse spread throughout Europe, becoming by 1700 one of the most popular forms of dance throughout the Continent. Another example of France's influence on European patterns of dancing can be seen in the foundation of the Royal Academy of Dance and the Royal Academy of Music, both of which were founded in the second half of the seventeenth century. The absolutist ambitions of Louis XIV affected many areas of life and arts in seventeenth-century France. Louis and his ministers, for instance, divided up all the arts—visual, plastic, dramatic, and literary—into new academies that were charged with setting standards in their various disciplines and with training those who were gifted in a particular art form. The Royal Academy of Dance was founded in 1661, and its thirteen professional dance masters trained dancers and produced ballets for the entertainment of the court. Its role came increasingly to be subsumed into the Royal Academy of Music, an institution founded in 1672 and placed under the direction of the court composer Jean-Baptiste Lully (1632–1687). The Royal Academy of Music soon became known merely as the Opera, the chief institution in France for staging this art form. By this time Lully had already collaborated with many dramatists to produce music for comedy-ballets and other light productions that mixed song, dance, and drama. During the later years of his life, though, Lully satisfied the growing tastes of the king and his circle for more serious and elevated entertainments. In a series of thirteen tragedies he produced before his death, Lully forged a union between music, dance, and song that was hailed by contemporaries as a brilliant expression of French culture. These productions made frequent use of complex ballets, and to stage them the Opera formed a professional troupe of dancers. While membership was originally open only to men, women soon joined the troupe's ranks. In the decades after Lully's death, his operas as well as new productions in his mold continued to be staged by the company. The rising popularity of ballet in these productions meant that more and more time had to be devoted to dance in the operas of the early eighteenth century. In many cases the ballets that punctuated the evening were joined only by the loosest ties to the main operatic dramas' plots, but in the hands of figures like Jean-Philippe Rameau (1683–1764) the union of dance and song achieved a great degree of artistic finesse and unity.

PROFESSIONALISM SPREADS. The successful development of a courtly operatic theater and ballet in Paris

soon was imitated elsewhere in Europe. During the eighteenth century Vienna, Stockholm, Dresden, Warsaw, St. Petersburg, and Berlin were just a few of the many European cities in which similar institutions emerged. The foundation of a city opera company at Hamburg in 1679 was another important development. This opera company was paid for and administered by the town's government, rather than by a royal court. While Hamburg became a force in North Germany for the development of opera and dance, other towns did not immediately follow suit and imitate Hamburg's example. Opera and ballet remained in much of northern Europe a phenomenon largely nourished and paid for by monarchs and aristocrats. In the course of their development the new operas formed professional ballet troupes, which were invigorated with the French examples of Lully, but also by trends in Italy. There, a different pattern of adaptation had arisen between the tastes for opera and ballet. During the eighteenth century dance masters from Italy and France toured Europe and accepted posts in the new institutions. The rising affection for professional dance can be seen in the steadily increasing numbers of performers that were hired in many opera houses. To stage the diversionary ballets that were increasingly used in operatic productions, many opera houses founded schools which, like the Paris Opera's academy, existed to ensure a steady stream of talent. Great dancers achieved celebrity throughout Europe, and the cultivated urban audiences closely followed their careers. In France, the prima ballerinas Madame de Camargo and Marie Sallé became fashion trendsetters, responsible for new styles in hair, shoes, and hats.

DEVELOPMENT OF BALLETS D'ACTION. Dancing also acquired an increasing theoretical sophistication. Figures like Camargo and Sallé mingled with the most prominent thinkers of the Enlightenment, and new dance authors like Jean-Georges Noverre and Gasparo Angiolini considered the deeper meanings of dance and the aesthetics that should govern its performance. Noverre and Angiolini responded to the criticisms that French Enlightenment thinkers made of the contemporary art. In the mid-eighteenth century, for instance, the French *philosophes* frequently observed that contemporary dance was badly in need of reform. Figures like Voltaire and Diderot observed that the art had degraded into nothing more than a form of gymnastic athleticism. To remedy this situation, dance masters like Noverre and Angiolini insisted that dance had great dramatic force and that it should be merged with pantomime to produce new narrative ballets, works that soon became known as *ballets d'action*. By the 1750s and 1760s the

centers for much of this innovation in dance had moved from France eastward into Germany and Austria, where the opera ballets at Stuttgart and Vienna were producing some of the most daring forms of the new pantomime ballets. Although these departures were originally resisted at the Paris Opera, even that venerable company began to produce works in the new genre by the 1770s. In this way ballet acquired a new force and independence by virtue of its abilities to narrate stories and to lend these stories even greater emotional depth than might have been possible with words.

THE FRENCH REVOLUTION. The political upheavals and transformations that began in France in 1789 had far-reaching effects on the practice of both opera and ballet. Throughout Europe, opera had long been an art form that had flourished in close connection to the hereditary aristocracy and royal governments. In the fiscal crisis that had preceded the rise of the Revolution in France, King Louis XVI was forced at first to scale back his support for the Paris Opera and its ballet, and then, eventually to curtail his expenditures on the company altogether. The ballet was transferred to the control of the city of Paris, but the popularity of the company's productions continued to ensure its survival. In the course of the French Revolution, too, political leaders sensed in the ballet a force of support and promotion for their republican pretensions. As the new government solidified its hold over Paris and the country, many new festivals were proclaimed and celebrated with the commissioning of ballets and elaborate celebratory dances. Performed to the strains of revolutionary hymns, these productions ensured professional dancers of a new audience, as opera and ballet were cut off from their patronage links to the now increasingly proscribed nobility. The relatively new form of *ballet d'action* also provided a ready medium with which to praise the democratic principles of the political movement. In this way ballet was assured of a continued audience, despite the enormous political upheavals that occurred in France and throughout Europe at the end of the eighteenth century.

TOPICS
in Dance

SOCIAL DANCE IN THE BAROQUE

RENAISSANCE INHERITANCE. No immediate change in styles of dance or in attitudes to the art are perceptible between the late Renaissance and the early Baroque

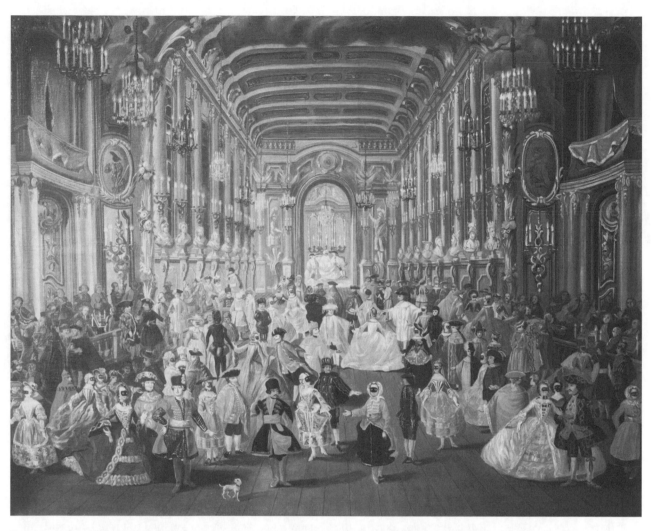

Engraving of a masked ball held at the Court Theater in Bonn, Germany, in the eighteenth century. Such entertainments were popular in court society throughout the Baroque period. © ARCHIVO ICONOGRAFICO, S.A./CORBIS.

periods. The seventeenth century inherited from the Renaissance a widespread perception of dance as a necessary social grace, a sign of distinction that accomplished men and women needed to master to participate in society. During the fifteenth and sixteenth centuries Europe's first works of dance theory had appeared. While these treatises outlined the necessary steps and skills that a good dancer had to master, they also reached back to Antiquity in search of theories that might support dance's general popularity in courtly society. In Aristotle, Europe's dance theorists had located part of the rationality for dance's aesthetic appeal, arguing that the art displayed the mind's ability to subject the body to its disciplines. The popularity of Platonic thought during the later Renaissance also left its marks on artistic theory, as dance came to be treated in many literary works, conduct manuals, and aesthetic treatises as an expression of the concept of Platonic ideals. The philosophy of Plato taught that a higher, heavenly realm of universal concepts or ideals governed life on earth, and thus dance represented in the works of its most vigorous advocates, an expression of the harmony that prevailed in a higher realm. In his poem, "Orchestra," first published in 1594, the English author Sir John Davies celebrated dance for its ability to express the well-ordered relationships that prevailed in the heavens, and Davies saw in the highly choreographed revolutions of the planets the origins of human dance. His extravagant praise of dance as "love's proper exercise" found many echoes in the world of the late Renaissance and the Baroque. Dance was a motif found in the plays of Shakespeare and other writers and was often used to express the ideals of sociability, civility, and love. Similarly, dance figured prominently in the many conduct manuals of the age. These recommended the art as a necessary accompaniment to courtship, seeing in the ideal movements of the dance floor skills that might teach the art of love.

a PRIMARY SOURCE *document*

EMBARRASSED BEFORE THE KING

INTRODUCTION: Louis de Rouvroy, the Duke of Saint Simon (1675–1755), wrote one of the most voluminous memoirs of life at the court of Versailles, totaling sixteen large volumes in its modern edition. In the following excerpt he describes the embarrassment that occurred when a young nobleman was not up to the challenge of dancing at a court ball.

On Shrove Tuesday, there was a grand toilette of the Duchesse de Chartres, to which the King and all the Court came; and in the evening a grand ball, similar to that which had just taken place, except that the new Duchesse de Chartres was led out by the Duc de Bourgogne. Everyone wore the same dress, and had the same partner as before.

I cannot pass over in silence a very ridiculous adventure which occurred at both of these balls. A son of Montbron, no more made to dance at Court than his father was to be chevalier of the order (to which, however, he was promoted in 1688), was among the company. He had been asked if he danced well; and he had replied with a confidence which made every one hope that the contrary was the case. Every one was satisfied. From the very first bow, he became confused, and he lost step at once. He tried to divert attention from his mistake by affected attitudes, and carrying his arms high; but this made him only more ridiculous, and excited bursts of laughter, which, in despite of the respect due to the person of the King (who likewise had great difficulty to hinder himself from laughing), degenerated at length into regular hooting. On the morrow, instead of flying the Court or holding his tongue, he excused himself by saying that the presence of the King had disconcerted him; and promised marvels for the ball which was to follow. He was one of my friends, and I felt for him, I should even have warned him against a second attempt, if the very indifferent success I had met with had not made me fear that my advice would be taken in ill part. As soon as he began to dance at the second ball, those who were near stood up, those who were far off climbed wherever they could get a sight; and the shouts of laughter were mingled with clapping of hands. Every one, even the King himself, laughed heartily, and most of us quite loud, so that I do not think any one was ever treated so before. Montbron disappeared immediately afterwards, and did not show himself again for a long time. It was a pity he exposed himself to this defeat, for he was an honourable and brave man.

SOURCE: Louis de Rouvroy, *The Memoirs of the Duke of Saint Simon on the Reign of Louis XIV and the Regency.* Vol 1. Trans. Bayle St. John (Philadelphia: Gebbie and Co., 1890): 19–20.

IMPORTANT SOCIAL SKILL. For nobles and the wealthy in Europe's cities, dancing was thus an essential social skill and the mastery of the most popular social dances of the day was necessary for participation in elite society. In his voluminous memoirs of life in the court of Versailles, for example, the Duc de Saint Simon related the story of a provincial noble who was so unfamiliar with the dances of court that he was jeered off the dance floor. Dance was so important in noble circles that the great aristocratic households of Europe frequently employed dance masters to teach the young members of the household these skills. These masters also coached adults in new dances, even as they choreographed dances for special occasions. Dance masters often fulfilled a variety of other roles in royal and noble households, too. They planned spectacles, designed stage sets and interiors, and they sometimes taught horseback riding, gymnastics, and deportment. Europe's most successful dance masters wrote texts on their art, and the second half of the sixteenth century saw a number of these appear that continued to dominate dancing styles during the decades of the early Baroque. In the mid-seventeenth century new patterns of dancing helped to produce another spate of new dance manuals published in Italy, France, Spain, and England. In this way knowledge of new steps and dances popular in one part of Europe was able to spread rather quickly throughout the continent. Travelers, too, carried knowledge of the latest dance fashions, so that despite regional variations, the patterns of social dancing practiced in Europe's courts and "high societies" was relatively homogenous by the seventeenth century. In the continent's cities, dance schools were another avenue that disseminated knowledge of the art, and these trained the sons and daughters of successful merchants, men of commerce, and bankers in the latest steps. In Catholic Europe, the Jesuit schools also provided instruction in dancing to their male students, since dance was thought to be an essential skill for courtship. In England and other places in which the rigorous Christian doctrines of Calvinism held sway, moralists and preachers attacked dancing, and in some places dancing was officially prohibited. Yet even during the years of the Puritan Commonwealth in England (1649–1660), dancing instruction continued in the country's elite public schools.

PATTERNS OF SOCIAL DANCING. While many dances were common throughout Europe, there was still great variety in the kinds of dances that were performed. Dances, in other words, existed to express all kinds of emotional states and for all tastes and occasions. A ball opened with a number of dignified processional dances, including *pavans* and *branles*. A series of couples dances usually followed in which only one couple at a time danced. Rank governed the progression of these dances, with the highest-ranking members present dancing before those of lesser status. For most of the seventeenth century the most popular of these couples dances was the *courante*, but toward the end of the century, the minuet began to supplant its popularity. Other dances popular at the time included the *bourrée, gavotte,* and *passepied.* In all these dances the emphasis was on sprightly, yet contained and disciplined footwork and on the repetition of rigorously defined steps with subtle modulations. Generally, seventeenth-century dances kept the upper body rigid and erect and the arms and hands remained contained, their movements stylized. Besides the dignified character of dances like the minuet and courante, a number of more theatrical and dramatic dances were performed. These included the *sarabande, chaconne,* and *gigue* (in English known as the jig), dances that had an air of exoticism about them. The sarabande, for instance, was believed to have been a dance alternately of South American or Saracen Turkish origins, and was originally wildly energetic. While it grew more staid and dignified as it entered aristocratic society, the rhythmic schemes of its music still featured lively syncopated motifs that were frequently repeated. In addition to these standard dances performed in elite societies throughout most of Europe, balls often featured special dances that were choreographed for the occasion. These specially created dances were often intended to display the skill of a single couple and they were consequently highly complex, calling for sophisticated amateurs to memorize a number of steps and their progression in the days and weeks that preceded a ball.

DANCE MUSIC. The dances of aristocratic society in seventeenth-century Europe were largely international in flavor, although subject to regional variations. Greater variety characterized the music played to accompany dances throughout Europe. In France, violins and violin variants were most often used at balls, the most famous French ensemble being the "24 Violins of the King," an ensemble of strings employed at court to entertain at royal balls. In Italy, collections of dance music published for the lute were particularly popular, while in Spain the guitar often predominated. Dancing masters often doubled as violinists, lutists, and guitar players, and if a great deal of music has survived from the period, it must also be remembered that much of the dance music intended to accompany balls was heavily improvised and has consequently not survived. Of that which survives, numerous printed collections of dance music exist for solo instruments, and vocal pieces, too, sometimes accompanied dancing, although far less frequently than instrumental music. Dance suites—that is, instrumental music composed for small ensembles that recreated the rhythms familiar to social dancers—became enormously popular throughout the seventeenth century, and survive from every European region. The music recorded in this way, however, was intended primarily to be heard and did not accompany balls.

RISE OF FRENCH STYLE. As in other areas of cultural life, the example of French aristocratic and court society came to dominate the dancing practices of much of Europe during the course of the seventeenth century. This taste for French dancing was particularly strong in the second half of the century, as Versailles became a model for courtly practices almost everywhere in Europe. One consequence of this dominance was the rise and spread of "country dances," forms of figure dancing that were originally English in origin but which were transformed by French taste into the *contredanses* that became popular in Europe around 1700. In the 1650s, the English dancing master John Playford began to publish a series of short books entitled *The English Dancing Master* that informed their readers about how to perform "country dances." In style, these dances were amazingly simple, their repertory consisting of no more than a few steps. Their appeal rather consisted in the intricate figures that four or more couples made on the dance floor as they progressed through the country dance's figures. As knowledge of these dances spread to France, they had an enthusiastic reception in elite societies, but were soon transformed by French taste for more intricate and refined footwork. From the foothold that country dancing gained in France, however, the style soon spread throughout Europe, producing regional variations of "country dancing" almost everywhere on the continent. In one of the ironies of cultural history, Marie-Antoinette, for instance, brought to the French court of Versailles an Austrian version of "country dancing" that flourished in her native Vienna in the second half of the eighteenth century. This style, though, owed its origins to the taste for country dancing that French culture had helped to plant throughout Europe at the end of the seventeenth century.

DANCING REVIVES AT COURT

INTRODUCTION: In 1683, King Louis XIV's wife died, and in the period of mourning after her death the king fell under the spell of Madame de Montespan, originally a governess to members of the royal household. Over time, her strict, uncompromising moral influence resulted in a decline in dancing at court. While great balls continued to occur on state occasions, the incessant round of dances and masquerades that had been common at court in previous decades was curtailed. By the 1690s the young duchess Charlotte Elizabeth, wife of Louis's nephew, had captivated the king, and he allowed a greater degree of frivolity for her amusement. In one of her letters she happily described a recent masked ball that occurred at Marly, a small royal retreat not far from Versailles.

I must tell you about the masked ball at Marly. On Thursday the King and all the rest of us had supper at nine o'clock, and afterwards we went to the ball, which began at ten o'clock. At eleven o'clock the masks arrived. We saw a lady as tall and broad as a tower enter the ballroom. It was the Duc de Valentinois, son of Monsieur de Monaco, who is very tall. This lady had a cloak which fell right to her feet. When she reached the middle of the room, she opened her mantle and out sprang figures from Italian comedies. Harlequin, Scaramouche, Polichinello, the Doctor, Brighella, and a peasant, who all began to dance very well. Monsieur de Brionne was Harlequin, the Comte d'Ayen, Scaramouche, my son, Polichinello, the Duc de Bourgogne was the Doctor, La Vallière was Brighella, and Prince Camille was the peasant …

The Dauphin arrived with another party, all very quaintly dressed, and they changed their costumes three or four times. This band consisted of the Princesse de Conti, Mademoiselle de Lislebonne, Madame de Chatillon,

and the Duc de Villeroy. The Duc d'Anjou and the Duc de Berri and their households composed the third group of masks; the Duchesse de Bourgogne and her ladies the fourth; and Madame de Chartres, Madame la Duchesse, Mademoiselle d'Armagnac, the Duchesse de Villeroy, Mademoiselle de Tourbes, who is a daughter of the Marechal d'Estrées, and Mademoiselle de Melun, the fifth. The ball lasted until a quarter to two o'clock … On Friday all the ladies were elegantly attired in dressing-gowns. The Duchesse de Bourgogne wore a beautiful fancy costume, being gaily dressed up in Spanish fashion with a little cap … Madame de Mongon was dressed in ancient fashion, Madame d'Ayen in a costume such as goddesses wear in plays. The Comtesse d'Estrées was dressed in ancient French style and Madame Dangeau in ancient German style. At half-past seven or eight o'clock masks came and danced the opening scene of an opera with guitars. These were my son, the Comte d'Ayen, Prince Camille, and La Vallière in ridiculous men's clothes; the Dauphin, Monsieur d'Antin, and Monsieur de Brionne as ladies, with dressing gowns, head-dresses, shawls, and towers of yellow hair much higher than are usually worn. These three gentlemen are almost as tall as each other. They wore quite small black and red masks with patches, and they danced with high kicking steps. D'Antin exerted himself so violently that he bumped in Monsieur de Brionne, who fell on his behind at the Queen of England's feet. You can imagine what a shout of laughter there was. Shortly afterwards, my favourite, the Duc de Berri, went to disguise himself as "Baron de la Crasse" and came back and performed a very comical dance by himself.

SOURCE: Gertrude S. Stevenson, ed. and trans., *Letters of Madame*, in *Dance and Music of Court and Theater. Selected Writings of Wendy Hilton* by Wendy Hilton (Stuyvesant, N.Y.: Pendragon Press, 1996): 17–18.

FOLK DANCE. Although historians have long supposed that many of the courtly dances performed in European courts derived from folk dances, the popular origins of ballroom forms cannot be established given the surviving documents. It is, nevertheless, logical to conclude that many dances popular in seventeenth-century Europe had origins in the customs of village life and of urban societies. The precise nature and extent to which folk dancing served to invigorate the elite ballroom, though, may always be a matter of conjecture. Many of the best-documented dances of the seventeenth century had, even then, legendary associations, associations that cannot be documented and that may mask their true historical origins. The French dance known as

the *passepied*, for instance, was believed to derive from the folk dances of Brittany; the *bourrée*, another dance popular in cultivated ballrooms, was thought to come from the peasant dances of the Auvergne, a region of southern France. The origins of some dances are better known. During the sixteenth century a dance known as the *sarabande* became controversial in Spanish cities. Notable for its overt sexuality, the sarabande had by the early seventeenth century found its way into ballrooms everywhere throughout Europe. Originally seen as wild and licentious, its performance grew far more staid, and it became one of the standards of masked balls in the first half of the seventeenth century. While Protestant and Catholic moralists sometimes turned a disapproving

eye on dancing generally, they usually reserved their greatest criticisms for folk dances practiced in the countryside. Moralists condemned the tight embraces of these dances, as well as the occasions for dance themselves, as events that led to immorality and fornication. During the seventeenth century religious attempts to reform the morality of village life persisted in many parts of Europe. At this time Calvinist divines were usually among the most vigorous in condemning the dances of rural societies as well as those of the urban poor and middling classes. While Calvinists were widely recognized for their uncompromising attitudes toward dance, Catholic and Protestant divines could and did react vigorously to folk dancing in particular times and places.

SOURCES

Joan Cass, *Dancing Through History* (Englewood Cliffs, N.J.: Prentice Hall, 1993).

Mark Franko, *Dance as Text: Ideologies of the Baroque Body* (Cambridge, England: Cambridge University Press, 1993).

Rebecca Harris-Warrick and Carol G. Marsh, *Musical Theatre at the Court of Louis XIV* (Cambridge, England: Cambridge University Press, 1994).

Skiles Howard, *The Politics of Courtly Dancing in Early Modern England* (Amherst, Mass.: University of Massachusetts Press, 1988).

Karl Heinz Taubert, *Höfische Tänze: ihre Geschichte und Choreographie* (Mainz, Germany: Schott, 1968).

SEE ALSO *Music: Origins and Elements of the Baroque Style; Theater: The Commercial Theater in Early Seventeenth-Century England*

DANCE IN COURT SPECTACLE

INTERMEDI AND THE BALLETS DE COUR. Besides dance's role as a cultivated social pastime, the art had long played a role in the theatrical spectacles staged by kings and princes as well. In Italy, elaborately choreographed dances formed the heart of the many *intermedi*, or short interludes, that were staged between the acts of dramas and operas. In France, dance played a central role in royal fêtes and spectacles, and in the staging of *ballets de cours*. This form of courtly entertainment had appeared at the end of the sixteenth century, and it differed from the royal fêtes still popular at the time by virtue of its adoption of a more unified plot line. The *ballet de cour* made use of a printed libretto that was circulated among the audience, and its long performances included songs, musical interludes, dances, and poetry that treated a mythological theme or story. Its primary purpose was to glorify the figure of the monarch, but at the same time, the *ballets de cour* also made use of the knowledge recently unearthed by Renaissance humanism concerning ancient dance, music, and poetry. Like the Italian opera with its accompanying intermedi, these French productions mixed dance, music, and poetry in an attempt to recreate the theater of the ancient world, but most particularly of the Greeks. In both the Italian and French forms popular at the time, however, spectacle predominated, and productions made use of lavish costumes and sets as well as the most sophisticated stage machinery available in the period. In 1600 at Florence, for example, an opera was staged to mark the wedding of King Henri IV of France to Marie de Medici. In between the staging of the musical drama, a series of impressive intermedi or interludes diverted the attention of the audience while scene and costume changes were being made in the central drama. More than 100 dancers were required to produce these diversions, but a force of 1,000 stagehands was necessary to run the elaborate stage machinery necessary to raise and lower the stage, position the scenery, and man the many illusionary devices used in the productions. In France, the massive staging of the *ballets de cours* relied on similarly vast quantities of dancers, stagehands, and machinery to present spectacles that glorified the monarch.

MASQUES. The English equivalent of the French *ballet de cour* or the Italian intermedi was the masque. The origins of the masques stretched back to the time of Henry VIII, who, in 1512, had staged the first of these productions at court in imitation of continental entertainments popular at the time. Native traditions of wearing masks and of mumming, an early form of pantomime, also merged into English masques as well. Throughout the Tudor period masques increased in popularity and complexity at court, and they were usually staged with their disguised participants presenting a series of dances and pantomimes in the banqueting hall of royal palaces. The Stuart king, James I, who ascended to England's throne in 1603, was a great admirer of the masques, and he stepped up the support the royal court gave to these productions. Inigo Jones's famous Banqueting House, which still stands in London's Whitehall section today, was constructed in part to provide a suitably grand venue in which to perform the masques. While in the earlier Tudor period masques had been performed with scenery that was wheeled into these halls atop carts, the Stuart masque came to be staged more and more on a fixed stage. The most lavish productions were presented as royal entertainments, although the Inns of Court in London, the guild of lawyers active in

a PRIMARY SOURCE document

THE MASQUE OF QUEENES

INTRODUCTION: Steadily increasing complexity and rising costs characterized the masques staged at the Elizabethan and Stuart courts. Under James I and Charles I, the theatrical partnership of Ben Jonson and Inigo Jones produced almost thirty of these productions. The third in this fruitful collaboration, *The Masque of Queenes,* was staged for the court in 1609. It included an anti-masque, a kind of bizarre or grotesque theatrical that preceded the masque proper. This custom of staging anti-masques had recently come to England from the Continent. Jonson's prologue to the printed version of the masque suggests some of the sumptuousness of the staging and costuming. Productions like this typically were augmented with several hours of dancing as well, making the event a long and imposing affair.

It increasing, now, to the third time of my being used in these Services to her *Majesty's* personal Presentations, with the *Ladies* whom she pleases to honor; it was my first and special regard, to see that the nobility of the Invention should be answerable to the dignity of their Persons. For which reason I chose the Argument to be, *A celebration of honorable and true Fame,* bred out of Virtue: observing that Rule (a) of the best Artist, to suffer no object of delight to pass without his mixture of Profit and Example. And because her *Majesty* (best knowing, that a principal part of life, in these *Spectacles,* lay in their variety) had commanded me to think on some *Dance,* or *Show,* that might precede hers, and have the place of a foil or false *Masque*: I was careful to decline, not only

from others, but mine own Steps in that kind, since the (b) last Year, I had an *Anti-masque* of Boys: and therefore now, devised, that twelve Women, in the habit of *Hags,* or *Witches,* sustaining the Persons of *Ignorance, Suspicion, Credulity, &c.* the Opposites to good *Fame,* should fill that part; not as a *Masque,* but a *Spectacle* of strangeness, producing multiplicity of Gesture, and not unaptly sorting with the current, and whole fall of the Device.

His *Majesty,* then, being set, and the whole Company in full expectation, the part of the *Scene* which first presented itself, was an ugly *Hell*: which flaming beneath, smoked unto the top of the Roof. And in respect all *evils* are, *Morally,* said to come from *Hell*; as also from that observation of *Torrentius* upon *Horace* his *Canidia,* ... These Witches, with a kind of hollow and infernal Music, came forth from thence. First one, then two, and three, and more, till their number increased to Eleven; all differently attired: some with Rats on their Head; some on their Shoulders; others with Ointment Pots at their Girdles; all with Spindles, Timbrels, Rattles, or other *beneficial* Instruments, making a confused noise, with strange Gestures. The Device of their Attire was Master *Jones* his, with the Invention, and *Architecture* of the whole *Scene,* and *Machine.* Only, I prescribed them their *Properties* of Vipers, Snakes, Bones, Herbs, Roots, and other Ensigns of their *Magic,* out of the Authority of ancient and late Writers, wherein the Faults are mine, if there be any found; and for that cause I confessed them.

SOURCE: Ben Jonson, *The Masque of Queenes.* (London: n.p., 1609). Text modernized by Philip M. Soergel.

the capital, also staged their own masques in the first half of the seventeenth century.

MASQUES OF JONSON AND JONES. The most refined of all seventeenth-century English masques were those produced by the theatrical team of Ben Jonson and the stage designer and architect Inigo Jones. Jones's and Jonson's partnership lasted almost 25 years, during which they produced almost thirty productions. Eventually, though, the two fell out, and while Jones continued to produce masques for the Stuart court, Jonson no longer lent his hand to the staging of these productions. While their co-operation lasted, the two provided a steady stream of entertainment for King James I (r. 1603–1625) and Charles I (r. 1625–1648). The Jonson-Jones masques did a great deal to develop the tastes in England for continental patterns of staging and production. The architect Jones, for example, adopted the elaborate style of staging typical of French and Italian

spectacles of the time, while Jonson eventually adopted the continental custom of interspersing scenes of anti-masques—that is, scenes of grotesque humor and ribaldry—alongside the more elevated themes of the masque proper. The heart of the masque was, as in the Italian intermedi or the French *ballet de cour,* the series of dances that either loosely or more forcefully conveyed the theatrical's chosen text or story line. In Ben Jonson's hands, the masque's poetic underpinnings may have been elevated to a point of high art, but in most of these spectacles the high point was always the series of dances that were generally peppered throughout the productions. Sometimes these series of dances lasted more than four or five hours. In contrast to the couple's dances that were popular in court society, the dances of the masques—as those of the French fêtes or *ballets de cour*—were figure dances. In the complex choreographies they created for these productions dancing masters created geometric fig-

ures, letters, and other symbols by skillfully arranging dancers, and these figured creations helped to convey some of the underlying themes and messages of the masque proper. Sophisticated amateur dancers within the court performed most of these dances, a fact that frequently elicited criticisms from English Puritan divines of the day. At the same time as masques grew more sophisticated, and as the comedy and ribaldry of antimasques became ever more fixed within the masque structure itself, professional athletes, gymnasts, comedians, and dancers participated in these productions. The use of professional performers was just one factor that caused an enormous increase in the cost of masques in early seventeenth-century England. The importation of elaborate stage machinery and the steadily rising costs of costuming the many participants in these productions were two other factors that contributed to these increases as well. By the mid-century these costs were often enormous and produced a growing chorus of criticism. At that time William Prynne, a Puritan lawyer, published his *Histriomatrix,* a work condemning the licentiousness and sumptuous display of Charles I's court entertainments. Charles responded quickly and fiercely. He required the Inns of Court, the association of lawyers in London, to stage a production of the masque *The Triumph of Peace* to demonstrate their allegiance to the crown. The production lasted for hours and was preceded by an equally long procession through London's streets. More than 100 musicians and an almost equal number of dancers performed in the spectacle, which cost the prodigious sum of £21,000, the equivalent of more than several million pounds today. These costs had to be borne by the Inns of Court. In this way Charles used the masques as a political tool to quash opposition, but it was a policy that soon backfired on him.

PURITAN SUPPRESSION OF THE MASQUES. There can be little doubt that the princely sums expended on the masques was one factor that aided in their suppression during England's Puritan Commonwealth (1649–1660). Yet Puritan distaste for these productions ran deeper than just a mere distaste for sumptuous display and profligate waste. The Puritans opposed dancing and the theater as well, and so the masque stood condemned on multiple grounds. With the execution of King Charles I in 1649, the court masque ceased to exist, although during the period of the Commonwealth masque-like productions continued to be mounted throughout England, most notably in the country's secondary schools where the masque was still considered a suitable vehicle for teaching knowledge of classical mythology and literature. In London and other towns, some of the techniques of staging masques survived in new plays that were termed "moral representations." With the Restoration of the monarchy that occurred in 1660, the court masque was not revived, and the techniques of staging and dance that these theatricals had once nourished came increasingly to be accommodated as dramatic interludes within plays and operas.

SOURCES

Joan Cass, *Dancing Through History* (Englewood Cliffs, N.J.: Prentice Hall, 1993).

Mark Franko, *Dance as Text: Ideologies of the Baroque Body* (Cambridge, England: Cambridge University Press, 1993).

Skiles Howard, *The Politics of Courtly Dancing in Early Modern England* (Amherst, Mass.: University of Massachusetts Press, 1988).

Karl Heinz Taubert, *Höfische Tänze: ihre Geschichte und Choreographie* (Mainz, Germany: Schott, 1968).

SEE ALSO *Theater: Court Spectacle in Stuart England*

THE RISE OF THE BALLET IN FRANCE

TRENDS. Several undeniable trends are evident in the history of dance in seventeenth- and early eighteenth-century France. First, dances performed in the theater became increasingly the preserve of professional dancers and, second, dance began to acquire enhanced status as an art form on par with poetry, music, and drama. At the same time, the modern institution of the ballet emerged in close connection with the opera. Ballet troupes, for example, were most often connected to opera houses, and ballets played a key role within the action of operas or as a diversionary entertainment within theatrical and musical productions. This pattern developed in Paris at the end of the seventeenth century as the ballet's rise to prominence as an art form occurred in close connection with the city's main opera house. In 1672, Louis XIV chartered the Royal Academy of Music, a production company that throughout its long history came to be known most frequently merely as the Opera, since its operatic productions were a primary source of its revenue and fame. Within a few years the king also gave the Academy's director, the composer Jean-Baptiste Lully, the use of a theater in the Palais Royale, a popular theatrical and commercial development near the Louvre. For most of the Old Regime—that is, until the French Revolution's onset in 1789—the Opera remained at this location. During its

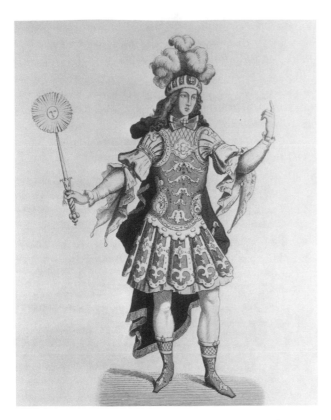

Engraving of Louis XIV, the "Sun King," in a ballet outfit. © **BETTMANN/CORBIS.**

PROFESSIONAL DANCERS. Another impetus to the development of the Opera's professional dance troupe was Louis XIV's retirement from dancing after 1670. The king had long been an avid dancer, and had regularly performed in the many *ballets de cour* that were mounted at the French court. As he matured, Louis gave up the art, and his courtiers followed suit. Professionals were thus needed to mount the extravagant theatricals that were still popular at court. The early history of the Opera's ballet company suggests that many of its dancers performed both in musical productions in Paris and for the king and his court at Versailles. The dancers who performed in the troupe were initially all men, and they also performed for the king at the court and some choreographed productions staged elsewhere. Women entered the troupe quite early. The first female performer, Madame de Lafontaine (1655–1738), appeared at the Opera in 1681 in a production of Lully's opera *The Triumph of Love*. As amateur performers, women had long been active in court productions, although they had usually appeared in scenes with other women, or they had relied on masques to hide their true identities. Madame Lafontaine's appearance thus set an important historical precedent, and female dancers soon made inroads into the troupe. By 1704, men were still dancing many female roles in the productions of the troupe, although women were now employed in the company in roughly equal numbers. Within a decade, their numbers had surpassed male dancers, and the Opera emerged as the site for a ballet and singing school. In this early stage of its history the Paris Opera's ballet school seems to have cultivated technical proficiency in its dancers rather than dramatic skills. In the course of the eighteenth century, however, the theatrical and dramatic demands of ballets rose, necessitating the training of performers with a greater acting sense. Several key developments in the late seventeenth century aided in dance's rise to the status of a profession in France. The standardization of the system of five dancing positions may have only served to fix with greater accuracy what had already become standard practice among dancers, but as ballet acquired a greater precision, it also developed an increasing sophistication in its notational systems. Dance notation allowed for a progression of precise steps to be charted out, showing their progression across the floor, so that each time a dance was performed it was executed in a roughly similar way. Dances that were written down in this way were more long-lasting than those that were taught by a dancing master or choreographer to his students for each new circumstance. In this way the impact of a choreographer's work was more permanent, and dances that were performed in one place could also be reproduced else-

first fifty years of existence, the Opera premiered more than 100 productions, despite chronic bouts of financial instability and a space that was less-than-ideal for the performance of opera or the ballet. Because of the lavishness of its productions, tickets to the Opera cost twice what they did in other contemporary theaters in Paris. Dance figured prominently in most of the operas staged there, and Lully soon founded a permanent dance troupe within the opera to support his grand musical creations. The first director of this troupe was Pierre Beauchamp, an accomplished dancer and choreographer, who came to have an enormous influence upon the development of professional dance throughout Europe. He served as personal dance instructor to Louis XIV, and in his work with the Opera he codified the five positions that are still used by ballet dancers to this day. He also developed a system for notating dances, although Raoul-Auger Feuillet later revised his system. Beauchamp's tenure at the Opera began in 1680 and ended at Lully's death in 1687. He continued to choreograph dances, particularly for the Jesuit colleges in France. In his role as a director of the Académie Royale de Danse (the Royal Academy of Dance), he also came to have a profound impact on professional dance in France.

a PRIMARY SOURCE *document*

THE IMPORTANCE OF DANCING

INTRODUCTION: In the 1660s and early 1670s the great French playwright Moliére collaborated with the composer Jean-Baptiste Lully to produce a series of comedy-ballets that mixed dancing, text, and song. The greatest of these was *The Bourgeois Gentleman* or sometimes called in English *The Shopkeeper Turned Gentleman*, a play that treated a humble man's rise to social distinction. In this scene from near the beginning of the play, the shopkeeper, Mr. Jourdain, announces his intentions to employ a fencing master and a professor of philosophy to teach him the skills necessary for life in society. His music and dance masters assure him that dance and music are all that he needs, because in these two arts is hidden all the secrets of the world.

Mr. Jourdain: I will learn it, then; but I hardly know how I shall find time for it; for, besides the fencing master who teaches me, I have engaged a professor of philosophy, who is to begin this morning.

Music Master: Philosophy is something, no doubt; but music, Sir, music. ...

Dancing Master: Music and dancing, Sir; in music and dancing we have all that we need.

Music Master: There is nothing so useful in a state as music.

Dancing Master: There is nothing so necessary to men as dancing.

Music Master: Without music no kingdom can exist.

Dancing Master: Without dancing a man can do nothing.

Music Master: All the disorders, all the wars that happen in the world, are caused by nothing but the want of music.

Dancing Master: All the sorrows and troubles of mankind, all the fatal misfortunes which fill the pages of history, the blunders of statesmen, the failures of great captains, all these come from the want of a knowledge of dancing.

Mr. Jourdain: How is that?

Music Master: Does not war arise from a want of concord between them?

Mr. Jourdain: True.

Music Master: And if all men learnt music, would not this be the means of keeping them in better harmony, and of seeing universal peace reign in the world?

Mr. Jourdain: You are quite right.

Dancing Master: When a man has committed some fault, either in the management of his family affairs, or in the government of a state, or in the command of an army, do we not say, "So-and-so has made a false step in such an affair"?

Mr. Jourdain: Yes, we do say so.

Dancing Master: And from whence can proceed the false step if it is not from ignorance of the art of dancing?

Mr. Jourdain: This is true, and you are both right.

Dancing Master: This will give you an idea of the excellence and importance of dancing and music.

Mr. Jourdain: I understand it now.

SOURCE: Moliére, *The Shopkeeper Turned Gentleman*, Act I, Scene II, in *The Dramatic Works of Moliére*. Trans. Charles Wall (London: G. Bell and Sons, 1900–1901).

where through the circulation of manuscripts and printed dance notations.

NOTATIONAL SYSTEMS. The first dance notational systems to provide diagrams of how specific dances were to be performed appeared in France around 1700. In 1697 André Lorin published his *Book of Country Dances Presented to the King*, a work that helped to feed the popularity of the English country dance among the French aristocracy. In it, he included a series of sketches that showed precisely how the country dances' figures were to be performed. At around the same time Raoul-Auger Feuillet developed a slightly different system that pro-

vided for a greater specificity of detail. His notation, in other words, showed how dancers were to place their arms and feet and how the specific movements corresponded to the music. Like Lorin, Feuillet deployed his method in printed works that codified country dances. At the same time, his notational system seems to have been readily adopted at the Paris Opera, since a number of dances survive from this era that were set down using his system. These dances combined many different steps in elaborate patterns, although at this time, the men and women who danced these steps usually did so in unison. The energetic leaps and bounds typical of the

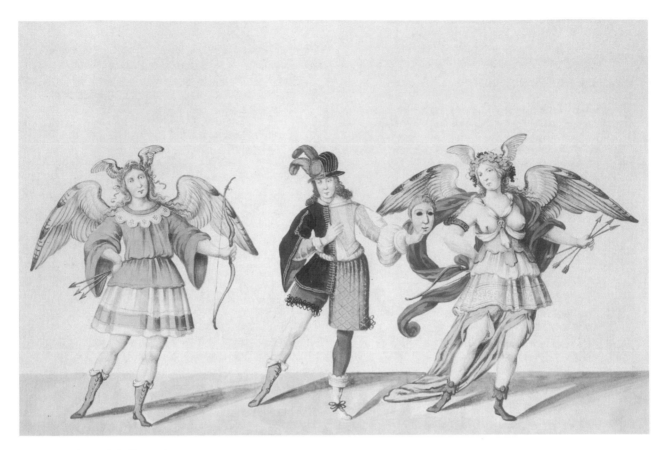

Engraving of French ballet performers. MARY EVANS/EXPLORER/DEVAUX.

contemporary ballet were largely impossible in this early era of the art's development. Heavy costumes, heeled shoes, masks, and other paraphernalia limited the movements of dancers. Dancing on toe-point, a readily recognizable attribute of the modern ballet, was largely impossible, although some steps were performed on partial toes. Instead the emphasis in the theatrical ballets was on elaborate and ornate patterned movements. These dances were often quite difficult for men and women performers alike, but the greatest demonstrations of technical proficiency were usually reserved for the solo dances of male, rather than female, performers.

BALLET AS AN ACCOMPANIMENT TO OPERA. The operas of Jean-Baptiste Lully dominated the musical life of late seventeenth-century Paris and of the royal court at Versailles. Lully had a long history of using dance in his musical productions. During the 1660s he cooperated with France's great comic playwright, Molière, to produce a series of "comedy-ballets" in which dances were interspersed between the spoken scenes of the drama. The last and greatest of these was *The Bourgeois Gentleman*, which was produced in 1670. His greatest achievements, though, were in the production of operas

known as *tragédies en musique,* or lyric tragedies. These works became especially popular with the king in the later years of Louis XIV's reign, as he adopted a new serious moral tone. Between 1673 and his death in 1687, Lully composed thirteen of these tragic operas, all of which show careful attention to the integration of dance into the drama's action. He apparently worked quite closely with his librettist, Phillippe Quinault, to ensure that dance was an accompaniment and enhancement to the sung drama. Although dance was still considered a *divertissement,* a diversion to the main plot of his operas, Lully's operas were long remembered after his death as a particularly "French" art form, in part because of their persistent attempts to integrate dance, poetry, music, and singing into a greater whole. Even in the eighteenth century great choreographers anxious to develop the ballet as an independent medium looked to the operas of Lully for support in their efforts, and French writers treating aesthetics were also quick to point to the composer's art as an expression of the country's genius. Still, the connection between dance and drama upon which he relied was largely implicit, and was consonant with much of the artistic theory of his time. In the works of artistic theoreticians of the late seventeenth century, dance was

extolled for its ability to represent through mimed gestures what might have been represented in words. There was little sympathy, in other words, for the views that were to develop later in the eighteenth and nineteenth centuries that dancing's representation might in certain situations *exceed* by virtue of its appeal to the emotions and senses the power of spoken words.

BALLET IN OPERA AFTER LULLY.

Lully's example in the operatic world remained influential long after his death in 1687, although changes began to occur soon after that time in the use of dance within the opera house. By the end of the century Houdar de Lamotte and André Campra had created a new kind of performance known as the opera-ballet that granted a greater importance to dance. In these productions singing still conveyed the essentials of the story line, although the role of dancing was expanded beyond a mere diversion and brought into the central flow of the opera's story line. Many new production experiments occurred in Paris around this time, producing works that were termed "heroic ballets" or "ballet comedies," all of which expanded the roles given to dancers. Thus dance escaped the longstanding role that it had played in the *divertissements* between scenes and acts, and mixed with the action of the drama proper. One of the most popular examples of this new style of production was André Campra's *The Venetian Feast* (*Les fêtes venetiennes*) of 1710, a work that was frequently revived in the first quarter of the eighteenth century. Like most of the new operas produced around this time, *The Venetian Feast* had several self-contained acts that were grouped around a central theme, in this case the foibles and complications of love. Dancers entered into the action by playing the roles of gypsies, clowns, gamblers, and gondoliers in the exotic setting of the city of the lagoons. Like most operas of this kind, the singing conveyed the drama, but dancers took a greatly expanded role. This was also the case in the many tragedies that were produced during the early eighteenth century. Lully's tragic works had by this time become an esteemed part of the French operatic canon. His operas were continually revived in the eighteenth century, but their productions were packed over time with more and more ballets. Other composers created music for these dances, or music was adapted from other Lully compositions. These pieces accompanied the numerous new dance interludes that were injected into these venerable operas. The steadily increasing role that dance played in these operas contributed to the expansion of the Opera's troupe in the first half of the century. While the troupe had consisted of about twenty men and women in 1700, its ranks had risen to more than thirty by 1738 and to 42 in 1750.

DANCE MOVES TOWARD DRAMA.

As dance became an important force within the opera, a tension soon developed between the demands of technical brilliance and dramatic representation. In a private performance staged for aristocrats in 1714, two accomplished dancers from the Paris Opera first performed the concluding scene of a tragedy by Corneille completely in pantomime. In France, this experiment was not imitated for many years, although developments underway in England staged by the accomplished dance master and teacher John Weaver eventually influenced French ballet as well as dance troupes elsewhere in Europe. In 1703 Weaver produced a short dance work, *The Tavern Bilkers,* entirely in pantomime. He continued these experiments in dramatic dance, staging a pantomime ballet in 1717 at the Drury Lane theater near Covent Garden entitled *The Loves of Mars, Venus, and Vulcan.* Until Enlightenment sensibilities began to transform the French theater in the mid-eighteenth century, however, these innovations were not immediately imitated in France. In the operas of the composer Jean-Philippe Rameau, Lully's successor as the dean of French music in the early eighteenth century, *divertissement* dances did sometimes take on a more complete role as miniature dramas within the structure of an opera. Rameau's 1736 opera *The Gallant Indies* (*Les indes galantes*) included a concluding divertissement that was actually a small, completely self-contained ballet, consisting of its own narrative that was conveyed through the use of dance and pantomime. Rameau's willingness to grant dance a greater role in some of his operatic productions seems, in part, to have derived from his partnership with Louis de Cahusac, the librettist he used for several of his operas. In 1754, Cahusac published a work on the history and theory of dance that aimed to promote the art's ability to express a greater range of emotions. Although Rameau was open to the greater integration of dance into his operatic narratives, most of the uses to which he deployed dance in his production still remained within the conservative mold of the Opera at the time. He did not, in other words, rely on dance to convey central details of plot or story line.

PROFESSIONAL DANCE ELSEWHERE IN PARIS.

More imaginative and theatrical uses of dance to depict narratives occurred at other theaters in the city of Paris during the early eighteenth century. The Opéra-Comique (literally "Comic Opera"), a Parisian company formed of vaudevillian entertainers in 1714, performed pantomime ballets as early as the 1720s. Catering to a popular rather than elite audience, the origins of the "comic operas" this company produced lay in the *commedia dell'arte,* fair entertainments, and other forms of

a PRIMARY SOURCE document

ATHLETICS, NOT DANCE

INTRODUCTION: The system of training athletic dancers who were virtuosi of their craft was very much alive at the Paris Opera in 1750. While the many ballets staged and interwoven through operas at the time had great appeal to many in the audience, they were attacked by Enlightenment *philosophes*. In an entry he wrote for the *Encyclopédie* Baron Grimm likened the contemporary practice of ballet within the Opera to a school in which mediocre students of athletics performed their moves in front of a crowd.

The best dancers, however, are reserved to show off as soloists of pas de deux; for important moments, they form pas de trois, quatre or cinq or six, after which the corps du ballet had stopped moving in order to make way for the masters to regroup, and finish the ballet. For all of these different divertissements, the composer furnishes chaconnes, loures, sarabands, minuets, passepieds, gavottes, rigaudons and contradances. If once in a while there is a moment of action, or a dramatic idea, it is a pas de deux or trois that executes it and then the corps du ballet immediately begins its insipid dances. The only real difference between one ballet and another is the way the tailor costumes the ballet, whether it be in yellow, white, green, red, following the principles and etiquette of fashion. Thus the ballet in French opera is only an academy of dance, where in public view, mediocre people exercise, make figures break apart and reform into groups and where the great dancers show us their most difficult moves by making noble, gracious and wise positions or poses.

SOURCE: Baron Grimm, "Poème Lyrique," *Encyclopèdie*, in *Dance in the Shadow of the Guillotine*. Trans. Judith Chazin-Bennahum (Carbondale, Ill.: Southern Illinois University Press, 1988): 16.

IMPLICATIONS. During the later seventeenth and early eighteenth centuries a greater range of ballet forms began to appear in connection with the performance of operas in Paris. New notational systems as well as the codification of ballet positions provided the foundation upon which ballet developed as an art form performed by professional dancers. The center of much of this transformation lay in the Royal Academy of Music, the institution that fondly became known in Parisian aristocratic and upper-class societies as the Opera. While the Opera granted dance a new importance as a diversionary entertainment within musical dramas, it proved resistant to the development of completely independent forms of ballet. The limits of the Opera's championship of dance as an art form able to convey narrative drama were demonstrated in its revivals of the popular operas of Lully as well as the productions of Rameau in the early and mid-eighteenth century. At the same time new forms of narrative pantomime ballet flourished in more popular venues in the city. These more popular forms told a story, and eventually the tendency to narrate an event or incident combined with the steps and techniques used in the more refined opera ballet to provide the foundation around which the modern ballet was to coalesce.

SOURCES

James R. Anthony, "The French Opera-Ballet in the Early Eighteenth Century: Problems of Definition and Classification," *Journal of the American Musicological Society XVIII* (1965): 197–206.

———, *French Baroque Music: from Beaujoyeulx to Rameau* (New York: Norton, 1978).

Sarah McCleave, ed., *Dance and Music in French Baroque Theatre: Sources and Interpretations* (London: IAMS, 1998).

Spire Pitou, *The Paris Opéra: An Encyclopedia of Operas, Ballets, Composers, and Performers.* 2 vols. (Westport, Conn.: Greenwood Press, 1983–1985).

THE BALLET ELSEWHERE IN EUROPE

ITALY. Dance was a vital component in the operas produced in Italy in the seventeenth century. In Venice, the home of Italy's first professional opera house, professional productions featured dance from the mid-seventeenth century on. The relationship between these ballets and the plot of the opera was usually loose, however, with composers and librettists devoting far less attention to creating situations in their works in which dances might arise out of the plot. The typical Venetian opera of the seventeenth century featured three acts, and dances were usually concentrated at the end of the first

street theater that had been widely enjoyed throughout Europe since the Renaissance. Not all the productions that this troupe performed were comedies by any means, but the forms of drama, dancing, and music that the group cultivated had a broader appeal than the classically-inspired tragedies performed at the Opera at the same time. Another similar group active around the same time, the Comédie-Italienne, produced more than fifty pantomime ballets from 1738 until it merged with the Opéra-Comique in 1757.

OF MIMES AND PANTOMIMES

INTRODUCTION: The English dance master John Weaver envisioned the revival of ancient pantomime as a way to reinvigorate the eighteenth-century ballet. In his *Essay towards an History of Dancing* (1712) he treated the subject of the pantomime, outlining its adaptability to modern dance.

After the Romans, by the introduction of the Asiatic luxury with the conquest of that country, had sunk into effeminacy and lost all the manly taste of the great arts as well as arms, the stage (which too often in its ruin has forerun that of the country) sunk into ridiculous representations, so that the poet's part grew the least considerable of it. The pompous passage of a Triumph, rope dance, and twenty other foolish amusements, carried away the people's affections and took up the representation, so that the admirable effects of tragedy and the agreeable diversions of comedy were lost in noise and show. Then arose a new set of men called mimes and pantomimes to restore that imitation without words which was lost among them. The stupidity of the people was not moved with the conception that in a manner confounds credibility, yet the testimonies of eyewitnesses are too strong to suffer us to doubt of the matter of fact, but the accounts are so strange, that they almost exceed the belief of our times, where nothing like it is performed by any of our French pretenders to dancing. Nay, even some of our best actors are so little acquainted with this mimicry, or imitation, that they appear insipid and dull to any spectator who has any notion of the characters which they represent.

The mimes and pantomimes, though dancers, had their names from acting, that is, from imitation; copying all the force of the passions merely by the motions of the body to that degree as to draw tears from the audience at their representations. It is true that with the Dancing, the music sung a sort of opera's or songs on the same subject, which the dancer performed, yet what was chiefly minded, and carried away the esteem and applause of the audience, was the action of the pantomimes when they performed without the help of music, vocal or instrumental.

The actions and gestures of these mimes and pantomimes, though adapted to the pleasure of the spectator, were never thought a general qualification fit for persons of quality, or gentlemen, from thence to derive a graceful motion, mien, or handsome assurance in conversation. It is true that many of the Roman young nobility were very fond of them and attempted to learn their art till there was a law made that no pantomime should enter a patrician's house. It is likewise true that Augustus Caesar gave Laberus, though a mimick, a golden ring, which used to be the honorary present of soldiers that had served their country in the war, as we gather from Pliny and others …

The pantomimes, as I said before, were imitators of all things, as the name imports, and performed all by gesture, and the action of hands, legs, and feet, without making use of the tongue in uttering their thoughts, and in this performance the hands and fingers were much made use of, and expressed perhaps a large share of the performance. Aristotle says that they imitated by number alone without harmony, for they imitated the manners, passions and actions by the numerous variety of gesticulation.

SOURCE: John Weaver, *An Essay Towards an History of Dancing* (London: Jacob Tonson, 1712): 118–121. Text modernized by Philip M. Soergel.

and second of these divisions. A key figure in shaping the character of these dances in Venice was Giovanni Battista Balbi, an impresario (much like a modern producer) who designed productions in Venice and choreographed their dances between 1636 and 1657. Balbi played a key role in the spread of Italian opera throughout Europe. Anne of Austria, the mother of King Louis XIV, summoned him to Paris in the 1640s, where he staged several productions that had a great impact on French ballet and opera. In the dances that he staged at Venice, he gave certain kinds of roles to dancers to perform. Many Italian operas of the time adopted pastoral themes, meaning that a procession of forest nymphs and shepherds frequently appeared on the stage—roles that dancers might easily perform. Balbi's productions, in particular, made use of exotic characters and even incorporated live animals into their fanciful productions. He also staged fantastic dream sequences as dances as well. Other roles commonly given to dancers in Balbi's time included demons and soldiers. While tragedy dominated many of the Paris Opera's productions, comedy played a greater role in Italian opera. Many roles for clowns, buffoons, and jesters were worked into productions—roles that were also ideal for dancers. As a new art form, the opera in Italy underwent rapid development in the course of the seventeenth century. While dances and ballets frequently peppered many of the productions of the mid- and late-seventeenth century, the

reforms fostered by the Arcadian Academy at Rome after 1695 tended to relegate dancing more and more to the intervals between acts. The Arcadian theorists wanted to eliminate much of the comic buffoonery that existed in the Italian operas of their day, and instead introduce serious or pastoral themes that treated Arcadian figures and heroes, in imitation of the earliest operas that had been performed around 1600. Under the influence of these reforms, ballet began to be used in many Italian operas at the turn of the eighteenth century like a French *divertissement.* Dances, in other words, became diversionary entertainments staged between the scenes of the opera. Few documentary sources survive from the Italian theaters of the seventeenth century. Unlike France where systems of notation developed to record the precise steps used in dances, Italian choreographers did not develop a system to set down their creations. Scattered accounts of dances are all that survive to provide us with a glimpse of many of the Italian opera's ballets. These suggest that the ballet in Italy was a vehicle for demonstrating greater gymnastic ability and athletic prowess than in the relatively refined forms that flourished in Paris at the same time.

ENGLAND. The Restoration of the Stuart Monarchy in England in 1660 played a vital role in the history of dance in that country. Charles II (r. 1660–1685) was a great lover of the theater, and a steady stream of French dancers, theatrical producers, and choreographers traveled to England in search of employment in the wake of his return to the throne. One of these was Robert Cambert, a French composer who is often credited as being one of the "fathers" of French opera. Cambert came to England in 1673 to serve as music master in the household of Louise de Queroualle, a French noblewoman who was also the Duchess of Portsmouth. Louis XIV had arranged his appointment there, and at the time the Duchess was the Stuart king Charles II's favorite mistress. Cambert established a Royal Academy of Music similar to the French institution that was just beginning to take shape in Paris at the time, but the fledgling institution soon failed. England, in contrast to France and many other European countries, remained without a royal opera house until the twentieth century, though operas were frequently staged in the many professional theaters there. Cambert's work in England—especially his staging of two of his operas, *Ariane* and *Pomone*—helped to establish a taste for French opera in the country as well as for French dancing. Several other imported entertainments followed as well. During the last quarter of the century French ballet thus came to mix with native traditions in England, especially with the tradition

of the masque. The result produced a new short-lived genre known as "semi-opera," the most famous of which was Henry Purcell's *The Fairy Queen* of 1692. These productions made use of the ballet practices common to the French operas of Jean-Baptiste Lully, while drawing on traditions of production that had been common in the Stuart Masques and other theatricals. Even as opera began to flourish as a site for ballet in England, dancing acquired a greater role in the professional theater of the period as diversionary entertainments between the acts of drama. The presence of a number of prominent, professional English dancers in London around 1700 reveals the rising appetite of Britons for professional ballets of a type similar to those that were already flourishing in France and Italy. Among these figures, the choreographer and dancer John Weaver was the most prominent. Weaver translated Feuillet's *Chorégraphie*, publishing it as *Orchesography* in 1706. His work in this vein did a great deal to establish Feuillet's system of notation in England and to spread patterns of French ballet in the country. Hester Santlow Booth, one of the first female professional dancers in England, was also a fixture of the theatrical life of the period. She debuted at the Drury Lane Theater near Covent Garden in 1706, and until her retirement in 1733 she continued to dance in many theatrical productions, particularly those choreographed by John Weaver.

ELSEWHERE IN NORTHERN EUROPE. The popularity of French and Italian forms of dancing spread to many other parts of Central and Northern Europe in the later years of the seventeenth century. After suffering great devastation during the Thirty Years' War, Central Europe's theatrical and musical traditions began to revive in the later seventeenth century. At Hamburg, Germany's first public opera house was opened in 1678, and a little more than a decade later, in 1689, Lully's *Acis and Galatée* was staged there. The fashion for the French-style ballet soon developed in the town's productions, and the choreographers at work there derived much of their inspiration from Lully's uses of dance. Austria was the second great center of opera production in seventeenth-century Central Europe. The Habsburg Emperor Leopold I first began to support the production of these "musical dramas" as early as the 1650s, staging a number of Italian productions at his court in Vienna, while in mountainous Innsbruck, a Venetian-styled opera house was first constructed in 1654, the first such theater to exist north of the Alps. Under Habsburg patronage, the opera flourished for a time in both towns, although Vienna's dominance in the Austrian operatic world emerged largely as a result of Habsburg patronage. Similar court operas de-

veloped around this time in Munich, Dresden, and Hannover, while in Scandinavia, Stockholm became home to a vigorous tradition of opera and ballet performance.

SOURCES

Irene Alm, "'Four Corners of the Earth': Exoticism in XVII Venetian Opera," in *Musica Franca: Essays in Honor of Frank D'Accone*. Eds. Irene Alm, et al. (Stuvesant, N.Y.: Pendragon Press, 1996): 233–57.

Susan Leigh Foster, *Choreography and Narrative. Ballet's Staging of Story and Desire* (Bloomington, Ind.: Indiana University Press, 1996).

Donald. J. Grout, *A Short History of Opera* (New York: Columbia University Press, 1988).

A. Macaulay, "The First British Ballerina: Hester Santlow c. 1690–1773," *Dancing Times* xxxi (1990–91): 248–50.

Sarah McCleave, ed., *Dance and Music in French Baroque Theatre: Sources and Interpretations* (London: IAMS, 1998).

E. Rosand, *Opera in Seventeenth Century Venice: The Creation of a Genre* (Berkeley, Calif.: University of California Press, 1991).

SOCIAL DANCE IN THE EIGHTEENTH CENTURY

FRENCH DOMINANCE. At the beginning of the eighteenth century French patterns of social dances remained common in the courts and elite societies of continental Europe. The stately minuet was the dominant couple's dance practiced at this time; its measured and careful use of the body was believed to reflect one's grace and deportment. At the same time, the straightforward patterns of French *contredanses* or "country dances" also had a general appeal throughout cultivated circles. Knowledge of these dances had spread quickly throughout Europe in the later seventeenth century through the publication of dance manuals, as well as the adoption of Feuillet's system of notation for dances. Dance also remained a vital social skill, practiced by nobles and the wealthy throughout the continent. As the eighteenth century progressed, though, a rising standard of living and increased numbers of leisure hours for many in Europe's burgeoning cities meant that middling ranks of people began to learn the steps that previously had been confined to elite circles. Dance halls began to appear in Europe's cities, while theaters and opera houses held "masked balls" as popular forms of entertainment. The general popularity of dancing can also be seen by the rise of many forms of classical music in the period that were closely modeled on the dances of the seventeenth and eighteenth centuries. The eighteenth century saw spread of the practice of subscription concerts, paid performances to which middle- and upper-class men and women bought advance tickets. In the symphonies, string quartets, concertos, and other compositions that were played at these events dance rhythms and music figured prominently. In the typical Viennese symphony that appeared at this time, exemplified in the great works of figures like Franz Josef Haydn or Wolfgang Amadeus Mozart, the minuet appeared as the third movement, while *rondos,* another popular form of dance music at the time, frequently figured prominently in many works' concluding movements. Dance's influence thus pervaded many other cultural spheres outside the European ballroom.

NEW FORMS. As the century progressed, new kinds of dances became popular throughout Europe. The popularity of the contredanse continued everywhere and evolved into altered and more complex forms. Originally English in origin, the contredanse had been transformed in the second half of the seventeenth century by its widespread acceptance in French aristocratic society. Like many French cultural products, its new, more refined features spread back to England as well as into central and southern Europe. In Austria and Germany, it was embraced enthusiastically, and many new variant forms developed. By the second half of the seventeenth century, for example, the *contredanse allemande* or "German country dance" had become the rage in Paris, its popularity spread, in part, by the Seven Years' War (1756–1763). During this conflict, the dance manual writers of the period noted, French troops had become familiar with the German forms, which included difficult patterns of hand holding and under-the-arm passes. The new form thus came to France's capital where it was enthusiastically adopted. Another force that helped to popularize the *contredanse allemande* was the marriage of Marie-Antoinette to Louis XVI. The country dances of Austria thus came to be danced at Versailles and in other aristocratic circles as a homage to Marie-Antoinette's native country. Most of the contredanses were written in double meter (that is, 2/4, 4/4, or 6/8 time). Toward the middle of the eighteenth century, though, three new dances spread quickly throughout Europe that were set to triple meter (3/4 time). The three were known as the *Dreher, Schleifer,* and *Ländler,* and were all of southern German and Austrian origins. In contrast to the stately dances that had developed as a result of the spread of French courtly practices, these new forms were rapid dances in which couples whirled about each other. The Ländler, for example, was increasingly known after 1780 by a new name, the *Waltzer,* the German word for

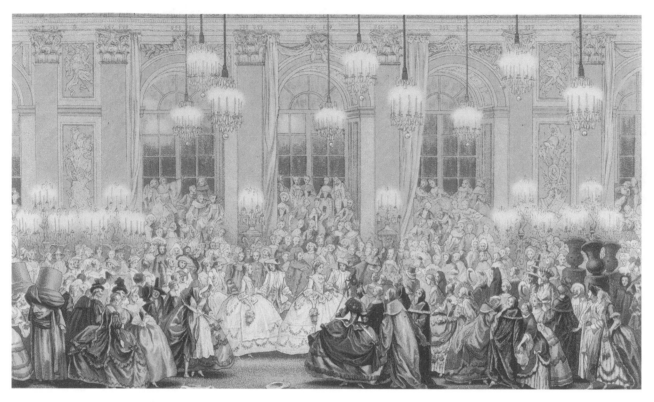

A masked ball at the Palace of Versailles around 1720. **THE ART ARCHIVE**.

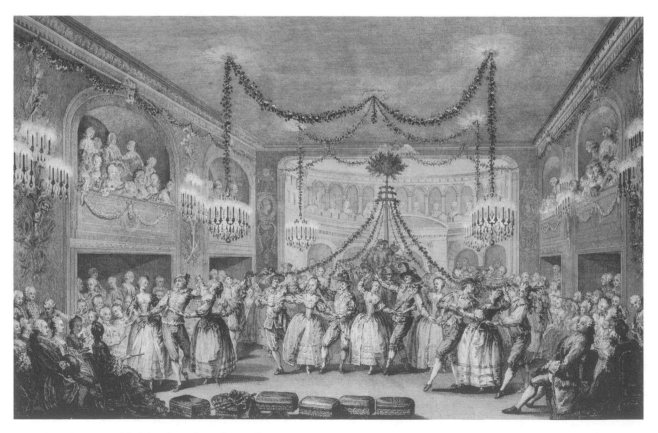

Engraving of a May Ball held at the Palace of Versailles in 1762. **THE ART ARCHIVE/BIBLIOTHÈQUE DES ARTS DÉCORATIFS PARIS/DAGLI ORTI.**

a PRIMARY SOURCE document

HIJINKS AT A BALL

INTRODUCTION: The great eighteenth-century lover Giacomo Casanova (1725–1798) began his life as a cleric, but was soon expelled from his monastery for his lewd conduct. The following excerpt from his journals shows the revelry that often occurred at balls. Masquerading was a common custom of the time, and men and women sometimes wore each other's clothing as an amusement. In trying to switch clothes with the young Juliette, Casanova hoped he might obtain her sexual favors. He was disappointed, but the event only caused him to refine his dance and seductive techniques in the period after his rebuff.

While the after-supper minuets were being danced Juliette took me apart, and said, "Take me to your bedroom; I have just got an amusing idea."

My room was on the third story; I shewed her the way. The moment we entered she bolted the door, much to my surprise. "I wish you," she said, "to dress me up in your ecclesiastical clothes, and I will disguise you as a woman with my own things. We will go down and dance together. Come, let us first dress our hair."

Feeling sure of something pleasant to come, and delighted with such an unusual adventure, I lose no time in arranging her hair, and I let her afterwards dress mine. She applies rouge and a few beauty spots to my face; I humour her in everything, and to prove her satisfaction, she gives me with the best of grace a very loving kiss, on condition that I do not ask for anything else. ...

I place upon my bed a shirt, an abbé's neckband, a pair of drawers, black silk stockings—in fact, a complete fit-out. Coming near the bed, Juliette drops her skirt, and cleverly gets into the drawers, which were not a bad fit, but when she comes to the breeches there is some difficulty; the waistband is too narrow, and the only remedy is to rip it behind or to cut it, if necessary. I undertake to make everything right, and, as I sit on the foot of my bed, she places herself in front of me, with her back towards me. I begin my work, but she thinks that I want to

see too much, that I am not skilful enough, and that my fingers wander in unnecessary places; she gets fidgety, leaves me, tears the breeches, and manages in her own way. Then I help her to put her shoes on, and I pass the shirt over her head, but as I am disposing the ruffle and the neck-band, she complains of my hands being too curious; and in truth, her bosom was rather scanty. She calls me a knave and rascal, but I take no notice of her. ...

Our disguise being complete, we went together to the dancing-hall, where the enthusiastic applause of the guests soon restored our good temper. Everybody gave me credit for a piece of fortune which I had not enjoyed, but I was not ill-pleased with the rumour, and went on dancing with the false abbé, who was only too charming. Juliette treated me so well during the night that I construed her manners towards me into some sort of repentance, and I almost regretted what had taken place between us; it was a momentary weakness for which I was sorely punished.

At the end of the quadrille all the men thought they had a right to take liberties with the abbé, and I became myself rather free with the young girls, who would have been afraid of exposing themselves to ridicule had they offered any opposition to my caresses.

M. Querini was foolish enough to enquire from me whether I had kept on my breeches, and as I answered that I had been compelled to lend them to Juliette, he looked very unhappy, sat down in a corner of the room, and refused to dance.

Every one of the guests soon remarked that I had on a woman's chemise, and nobody entertained a doubt of the sacrifice having been consummated, with the exception of Nanette and Marton, who could not imagine the possibility of my being unfaithful to them. Juliette perceived that she had been guilty of great imprudence, but it was too late to remedy the evil.

SOURCE: Giacomo Casanova, *The Complete Memoirs of Jacques Casanova de Seingalt, 1725–1798.* Vol. 1. Trans. Arthur Machen (1894; reprint, New York: G. P. Putnam and Sons, 1959): 124–127.

turning around or twirling. The medical wisdom of the later eighteenth century rejected such dances as unhealthy since they might cause dizziness and disorientation, and moralists, too, decried these fashions as suspect. Yet the popularity of these straightforward, energetic forms persisted, and by the end of the century the waltz, as it had now become known, had emerged as a popular dance almost everywhere in Europe.

OTHER FORMS. While many common dances were performed in Europe's cities and aristocratic courts, regional dances continued to play an important role in the social life of many areas. In Central and Eastern Europe, the *polonaise* was a processional dance of Polish origin. By the mid-eighteenth century it was danced throughout the German-speaking world as well. Another Polish dance, the *mazurka,* was just beginning to spread

through Central Europe at the end of the eighteenth century. In Austria and Hungary, the *verbunko,* a dance of gypsy origin, came to be performed in the region's cities after 1765. In Spain, two new dances—the *fandango* and *seguidilla*—gained popularity before spreading to other European regions. At the same time, composers of the eighteenth century frequently inserted Turkish-styled dances into their operas. Both the choreographies and music for these pieces were widely Europeanized, although certain steps marked them as exotic. Few social dances seem to survive that made use of this idiom, and the Turkish style seems to have flourished more in the theater than in the ballroom.

SOURCES

Mark Franko, *Dance as Text: Ideologies of the Baroque Body* (Cambridge, England: Cambridge University Press, 1993).

Wendy Hilton, *Dance and Music of Court and Theater* (Stuvesant, N.Y.: Pendragon Press, 1997).

THE ENLIGHTENMENT AND BALLET

PHILOSOPHICAL UNDERPINNINGS. The movement known as the Enlightenment had an ever-deepening effect on theatrical dance during the course of the eighteenth century. Throughout the eighteenth century the thinkers of this broad, international movement argued that ancient superstitions and outmoded customs should be eliminated, and that reason should play a major role in reforming society. Their works were particularly important for all forms of literature and theater at the time because in France the leaders of the movement known as *philosophes* devoted special attention to the arts. In 1751, one of the greatest Enlightenment projects, the publication of the *Encylopédie,* began in Paris. This project was directed by the philosophes Denis Diderot (1713–1784) and Jean le Rond d'Albert (1717–1783). The two commissioned other like-minded progressive social figures to write the 72,000 entries contained in their project. Although the work was not completed for more than twenty years, its 28 volumes were released as they were compiled, and many of the subjects treated in it touched upon themes in music, dance, and the theater. With articles by such luminaries as Voltaire, Rousseau, and many other French philosophes, the *Encylopédie* profoundly influenced the ideas and tastes of educated French men and women in the second half of the eighteenth century. In their entries on dance and ballet as well as those on the theater generally, the philosophes supported the development of art forms that gave meaningful expression to hu-

a PRIMARY SOURCE *document*

CRITICISM OF DANCE

INTRODUCTION: In France the Enlightenment thinkers criticized the conventions of the ballet of their time. The *philosophes* who shaped public opinion argued that the dances that were practiced in the opera ballets of the day did not serve to further the plot, but were instead mere gymnastics inserted to demonstrate the prowess of certain dancers. These sentiments were circulated widely in France and Europe through the publication of the *Encylopédie,* a massive compendium of Enlightenment thinking that commenced publication in 1751. Diderot was one of the editors of this project, and a few years after it began, he himself criticized contemporary ballet in a play he wrote entitled *The Natural Son.* In the Introduction to the printed version he made this lament about the dance of his day.

The dance? The dance still awaits a man of genius; because one seldom finds it used as a genre of imitation, the dance one sees is terrible everywhere. The dance should be to pantomime as poetry is to prose, or more precisely as natural speech is to song. It is a measured pantomime.

I would like someone to tell me what all these dances performed today represent—the minuet, the passe-pied, the rigaudon, the allemande, the sarabande—where one follows a traced path. This dancer performs with an infinite grace; I see in each movement his facility, his grace, and his nobility, but what does he imitate? This is not the art of song, but the art of jumping.

A dance is a poem. This poem must have its own way of representing itself. It is an imitation presented in movements, that depends upon the cooperation of the poet, the painter, the composer, and the art of pantomime. The dance has its own subject which can be divided into acts and scenes. Each scene has a recitative improvised or obligatory, and its ariette.

SOURCE: Denis Diderot, "Entretiens sur 'Le Fils Naturel,'" in *Diderot's Writings on Theatre.* Ed. F. C. Green (Cambridge: Cambridge University Press, 1936): 97–98. Translated and reprinted in Susan Leigh Foster, *Choreography and Narrative. Ballet's Staging of Story and Desire* (Bloomington, Ind.: Indiana University Press, 1996): 17–18.

man thoughts, ideas, and feelings, and they disregarded merely decorative or ornamental forms of art. The aesthetic ideas of their movement generally advocated greater

naturalism in place of the contrived sophistication and majesty that had been such an important feature of Baroque aesthetics. The ideas of Enlightenment thinkers came to fruition in the second half of the eighteenth century in the emergence of new forms of ballet that attempted to convey meaning, drama, and the human emotions, eventually giving birth to a new genre known as the *ballet d'action,* a dance containing an entire integrated story line. The rise of the new form soon met resistance, although Enlightenment arbiters of tastes like the philosophes weighed in mightily on the side of these new art forms. In his play *Le fils naturel* (*The Natural Son*) (1756), the philosophe Diderot had decried the current state of ballet in his country, a state he argued derived from the inability of dancers to understand that theirs was an imitative, and not merely decorative, art. Dance, he observed, should play a role similar to poetry as an art form that heightened the expression of the human emotions. To do so, Diderot and other Enlighteners argued it should adopt the techniques of traditional pantomime and jettison the elaborate trappings customary in the Baroque theater. By the 1770s the taste of Europe's urban audiences shifted in favor of this position, and new danced dramas became a fixture in many European capitals.

NEW DIRECTIONS. At the same time, powerful changes were also underway in the day-to-day world of the ballet. As the art form achieved a new maturity, great new stars emerged whose careers and performances were avidly followed by the audiences of the day. As a result the quickly developing art form also began to acquire a greater independence from its long tutelage to opera. A new technical finesse emerged among the dancers of the eighteenth century, a development that was often at odds with the Enlightenment's advocacy of greater naturalism and sophisticated uses of drama. These competing demands—brilliance in execution and dramatic representation—often warred against each other, and the greatest French ballet performers and choreographers of the period sometimes left Paris in search of environments that were more amenable to their own artistic ideas. In this way the innovations and achievements of the French theater in the realm of dance came to be established in many of the opera houses of Europe.

RISE OF BALLET STARS. The late seventeenth and early eighteenth centuries had produced a number of notable dancers, but their careers and reputations were soon eclipsed by many new stars. Louis Dupré (1697–1774), a dancer who first debuted at the Paris Opera in 1714, continued to perform there until his sixties. In 1743, he became director of the Opera's school, and in this position he trained many of the great dancers

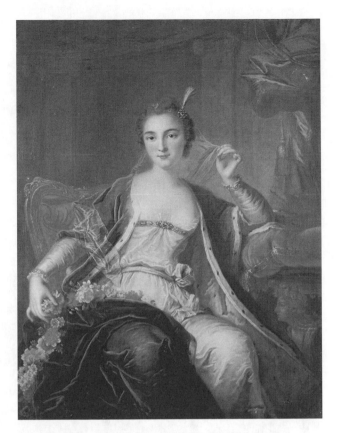

Portrait of the ballerina Marie Sallé. THE BRIDGEMAN ART LIBRARY.

of the later eighteenth century. Dupré was responsible for expanding the virtuosity of performance, and his gracefulness and physique were widely admired. Two ballerinas of the period, Marie-Anne Cupis de Camargo (1710–1770; Paris Opera debut 1726) and Marie Sallé (1707–1756; Paris Opera debut 1727) were noteworthy for expanding the repertoire of steps and leaps practiced by women and for reforming the conventions that governed female performance. Camargo was apparently the first ballerina to practice two leaps, the *pas battu* and the *entrechat,* previously reserved for men, an achievement that caused the philosophe Voltaire to observe that she was the "first woman to dance like a man." She was also the first woman ballerina to dance in slippers rather than heeled shoes, and she shortened the length of her skirt so that she could perform more difficult steps. Such departures earned Camargo both censure and adulation, although the path that she blazed was one that many prima ballerinas followed in the next decades. In contrast to Camargo's athleticism, Marie Sallé's dancing was noteworthy for its great subtlety and refinement. She, too, was something of a reformer and a renegade, however, and her agility engendered jealousy in the Paris Ballet. Although she was a student at the Paris Opera

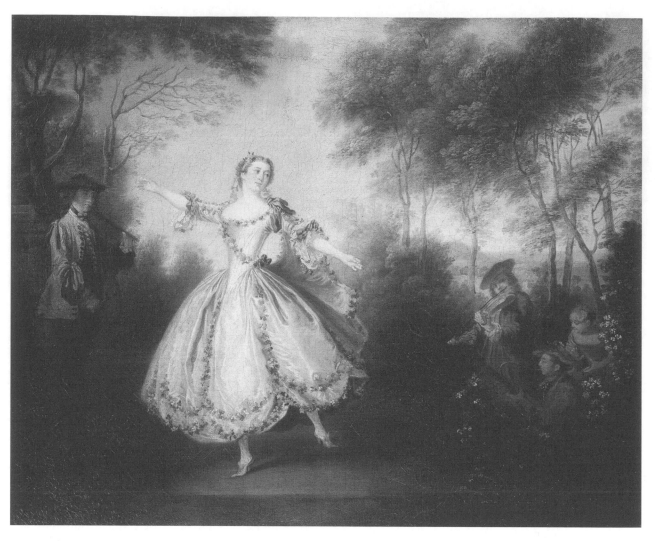

Portrait of the ballerina Marie Camargo. THE ART ARCHIVE/MUSÉE DES BEAUX ARTS NANTES/DAGLI ORTI.

for a number of years, she did not make her debut as a star until she was twenty. In the intervening years, she divided her time between performing in London and Paris, first appearing in the English capital in a performance of *Love's Last Shift* in 1725. The performance that she staged there in 1734 of *Pygmalion* was also notable for its revolutionary costuming and great naturalness. Sallé discarded the cumbersome costumes and masks that ballerinas had worn to this point, and instead appeared with her hair let down and in a simple muslin shift. The performance was recognized for its innovative appeal from the start, and her production of *Pygmalion* ran for several months. Sallé's learning, ingenuity, and intellect also distinguished her among the dancers of her day; she was one of the first great ballerinas to associate with men and women of letters. In this way her own art and that of ballet writ large figured as topics discussed in the brilliant French salon culture of the period.

DIFFERENTIATION OF STYLES. Like opera, which developed several different kinds of genres that were suitable to performers who specialized in particular kinds of roles, ballet's dance styles became increasingly delineated and differentiated in the course of the eighteenth century according to three distinct dancing styles: grotesque or comic, noble or serious, and *demi-caractère* (the counterpart of character roles in acting). While many of the burgeoning caste of professional performers danced all three kinds of roles, some began to specialize in one of these particular forms; as time progressed, the ballet schools in France came to identify dancers for one of these three kinds of genres based upon their physique. Louis Dupré, for instance, was recognized for his great ability in dancing noble roles, although he still performed as other kinds of characters. As the eighteenth century progressed, many more dancers came to specialize in comic, grotesque, or character roles to feed the French

audience's rising appetite for virtuosity and technical brilliance.

NOVERRE. Perhaps the most influential performer and choreographer of the entire eighteenth century was Jean-Georges Noverre (1727–1810), a reformer who was controversial in his own day but who helped to transform the character of ballet in the second half of the eighteenth century. Noverre was born in Paris and trained at the Opera's ballet school under Louis Dupré. In his long life Noverre became an iconoclast, dedicated to destroying what he felt were outmoded and antiquated forms of the ballet. He was also a crusader for a new type of art, helping to create a new genre of dramatic dances known as the *ballet d'action*, works that are similar to the "classical" ballets of the nineteenth century by virtue of their enactment of a story. Noverre, in other words, took up the Enlightenment's call to create new forms of ballet that conveyed greater meaning and emotional depth. While he did not create the genre of *ballet d'action* single-handedly, he was so vital to its development that he has long been accorded the title "Father of the Ballet." For inspiration, Noverre turned to the pantomime ballets that had been performed in London and Paris with increasing frequency in the first half of the eighteenth century, particularly those of the English dance master John Weaver. The ideas of Louis Cahusac—another advocate for the inclusion of greater drama within ballets—were important, as well. Noverre also admired the many pantomime ballets that had been performed at the Comédie-Italienne in Paris between 1738 and 1756. Noverre fused these elements together in his works, and in a long and varied career he attempted to establish a philosophical underpinning to the *ballet d'action* that was consonant with the Enlightenment's demands for a more meaningful art. He was both a dancer and choreographer, and at times he worked in Paris, London, Stuttgart, Vienna, Milan, and Lyons. While he often produced the typical dance *divertissements* used in operas of the day, his passion was for the *ballet d'action*, the first of which he staged in Lyons in 1751. This work, a pantomime ballet, was not enthusiastically received, and Noverre moved to Stuttgart, a less staid environment, a few years later. At the same time, he published *Letters on Dance*, a work that advocated his dramatic theories and showed the influence of Enlightenment thinking as well. Its widespread circulation established him as the foremost dance theorist of the day and as an important writer more generally on the subject of aesthetics. In the *Letters* Noverre argued that dancers should abandon the elaborate costumes and trappings that hid their expressions from the audience, and that they should become adept, not only

Portrait of Jean-Georges Noverre. BRIDGEMAN ART LIBRARY.

at the repertoire of steps that comprised their art, but in the skills of pantomime that might allow them to convey the human emotions and to tell a story. In the early 1760s he brought these ideas to bear while at the Paris Opera, but they were resisted, and Noverre left again for more congenial appointments elsewhere in Europe. Over time, his call for a more naturalistic art that was able to convey drama and emotional content was heard in the French capital as it was in many places during the second half of the eighteenth century. In Paris, the Opera's ballet eventually adopted principles more closely akin to those of Noverre, and in 1776, he was recalled there to choreograph productions once again.

VIENNA. While Paris had long been the cradle of the ballet's development, Noverre's career shows that new centers of dance were emerging as important sites for innovation during the mid- and later eighteenth century. Besides Stuttgart, the site for some of Noverre's most innovative productions, Vienna was also home to a flourishing dance culture in the 1750s and 1760s. At the same time that Noverre was advocating the development of a more meaningful form of ballet, the Italian dancer and choreographer Gaspero Angiolini (1731–1803) was also conducting experiments in *ballets d'action* in Austria. At Vienna, Angiolini staged a number of ballets in the city in partnership with Christoph Willibald von Gluck,

Vienna's then-reigning court composer. In contrast to Noverre's calls for greater naturalism and for an art that was consonant with the emerging philosophies of the Enlightenment, Angiolini intended to revive the dance of Antiquity, hoping to stage complete dramas upon the principles that had been set down by the ancient Greeks. Like Noverre, Angiolini also produced diversionary entertainments to be inserted within operas and dramas, but his true allegiance was to dramatic forms of dance. He staged a number of *ballets d'action* on pastoral and mythological themes. One of his most daring productions was *Don Juan*, a work that provided great dramatic force since it ended with the central character being carried off to the torments of Hell at the ballet's conclusion. In this production Gluck's music suggested the terror that gripped Don Juan at this climactic moment. Gluck was a natural partner for Angiolini's ambitions since he had recently come to produce a series of "reform operas," works that aimed to present a broader range of human emotions and which attempted to integrate musical forms of expression more closely to the texts being sung. In his collaboration with Angiolini, then, Gluck provided music that augmented and heightened the danced pantomimes that conveyed a story. This new sophistication in creating a fusion between music and dancing suggested to the Viennese audience some of the possibilities that lay within the emerging *ballet d'action*'s integration of the two art forms. Elsewhere in Europe the music for the new pantomime ballets was usually adopted from pre-existing pieces that did not fit so closely with the choice of dramatic story line, and the results were not always as appealing to audiences. While both Noverre and Angiolini labored to establish the new tenets of the *ballet d'action*, the two shared a number of differences. In contrast to Noverre's difficult and challenging intellectualism, Angiolini's ideas about the new art form were more straightforward and less complex. As a result, the two waged a long and sometimes bitter rivalry, but in tandem their efforts helped establish the new dramatic ballets within many key European dance centers of the day.

SOURCES

Susan Leigh Foster, *Choreography and Narrative. Ballet's Staging of Story and Desire* (Bloomington, Ind.: Indiana University Press, 1996).

Ivor Guest, *Le Ballet de l'Opera de Paris* (Paris: Théâtre national de l'Opera, 1976).

——, *The Ballet of the Enlightenment* (London: Dance Books, 1996).

J. C. Manfred Krüger, *Noverre und das Ballet d'action* (Emdstetten, Germany: Lechte, 1963).

Deryck Lynham, *Chevalier Noverre, Father of Modern Ballet* (London: Sylvan Press, 1950).

Artur Michel, *Ballet d'action before Noverre* (New York: W.P., 1947).

SEE ALSO *Philosophy: The Enlightenment in France*

BALLET IN AN AGE OF REVOLUTION

DESTRUCTION AND CHANGE. The onset of Revolution in France in 1789 produced profound changes in the production of all the arts. Both opera and ballet had flourished in Paris in tandem with the Opera, a royal institution that had long been nourished by the court's patronage. As the Revolution approached, bankruptcy loomed as the only way out of an engulfing royal financial crisis. In the first few years of the Revolution the special privileges of the clergy and nobility as well as many of the ancient prerogatives of the monarch were abolished in a series of progressively tightening measures directed at all forms of ancient privilege. At first, a new constitutional monarchy was fashioned, but King Louis XVI's attempt to escape from France with his queen in June of 1791 turned the tide of opinion against such an option, leading to the abolishment of the monarchy and the establishment of a new republican government. As a result of these swiftly moving events, Louis XVI's patronage of the arts at first rapidly diminished as he was forced to cut costs to fit with his dramatically straitened circumstances, and then dried up altogether. As the new republican government moved to establish its control over all elements of the state, a pervasive Reign of Terror ensued in which anyone suspected of monarchical sympathies might fall prey to persecution and execution. Many of the institutions that had long nourished ballet and opera thus faced great trials during the Terror, since their longstanding ties to aristocratic society marked them as bastions of privilege. An older musical and dramatic culture, sustained by aristocratic sensibilities, quickly disappeared in Paris and other French cities, and the political leaders of the Revolution advocated art that might express the democratic principles and revolutionary ideals that lay at the heart of their movement. Such principles were aptly suited to the rising form of the *ballet d'action*, since its narrative dances provided one way of presenting stories that fit neatly with the new revolutionary impulses. While ballet did not disappear as a diversion within the operas of the time, its place as an independent art form became firmly established by the end of the eighteenth century in Paris as the revolutionary government embraced it to defend republicanism.

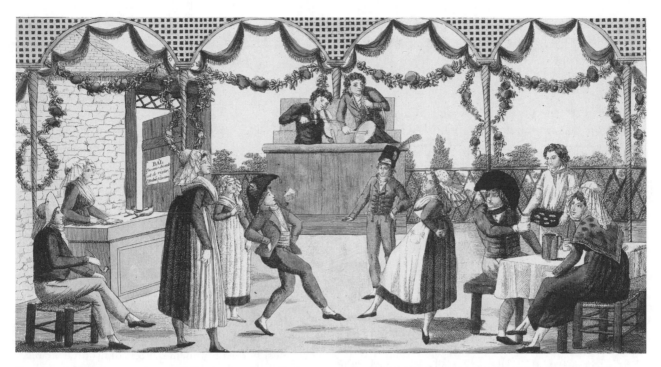

Engraving of the Summer dance held in the French revolutionary month of Thermidor in the late eighteenth century. **THE ART ARCHIVE/MUSÉE CARNAVALET PARIS/DAGLI ORTI.**

CHANGES IN BALLET. Despite the monumental changes that were occurring in French society at the time, the Paris Opera continued to flourish in the tumult of Revolution. As aristocrats disappeared from the ranks of its audience, new spectators appeared from among the middle classes. While financial shortfalls were typical at the institution during the early days of Revolution, they subsided somewhat after the city of Paris assumed its control. At first, the ballets and operas staged there continued in much the same pattern as they had over the previous two decades. Many ballets, in other words, were performed that relied on ancient mythological or heroic themes. As the fervor of republican sentiment grew in Paris in the years after 1790 and the Revolution grew more radical, the commune—that is, the city's own municipal government—demanded that the company stage new revolutionary dance dramas. The Opera's ballet performers were also enlisted to dance in productions held in other Parisian theaters. During the Reign of Terror between 1792 and 1794, the revolutionary government commissioned many new ballets and dances to mark key events in the Revolution. The establishment of the Civil Constitution of the Clergy and the execution of King Louis XVI were two events that were celebrated with the staging of elaborate dances. Dance dramas commemorated important events in the Revolution's history, but they also marked some of the momentous changes that the revolutionary assembly attempted to implement in France. The Worship of the Supreme Being, a state-sanctioned deistic religion opposed to traditional Christianity, became mandatory throughout France in May 1794. Within a month a massive festival was mounted to commemorate the new change, and an elaborate series of dances that involved hundreds of participants was staged in the open air. Dance commemorated the Revolution even as the Paris Commune and the national assembly's Committee of Public Safety exerted a tightening grip on the kinds of operas, ballets, and plays that were performed in the city. The Committee of Public Safety, for example, decreed that from henceforth no aristocrats should figure as characters in any theatrical productions. In this way art conformed to revolutionary demands, and the Committee dispatched police officials and soldiers to supervise ballet and operatic productions. These years of the Terror were particularly difficult for many artists, especially ballet dancers and opera singers who had long enjoyed the patronage and largesse of the nobility. A number of key French dancers left France during this period, many taking up residence and performing in London at the time. Jean-Georges Noverre, Auguste Vestris, and Jean Dauberval were just a few of the many Parisian dancers who took refuge in England. For those who stayed in France, participation in the new revolutionary ballets, with their story lines that defended liberty and republican government, provided one way of averting the

regime's suspicions and avoiding imprisonment and the guillotine. In the heightened atmosphere of persecution that revolutionary demands produced, there was consequently no shortage of volunteers to dance in the Revolution's ballet spectacles.

GROWTH OF TROUPES. Despite fiscal crises and revolutionary upheaval, the ballet flourished in Paris during the years of the Revolution. Old patronage networks that had been supported by the aristocracy had disappeared, but dance's new role as a promoter of republican ideals at festivals guaranteed its lavish support even while the new regime faced chronic shortages of funds and supplies. Elsewhere in Europe, the final decades of the eighteenth century were times of great expansion in ballet troupes as well. In Italy, most major opera houses employed around forty dancers at this time, while in distant Stockholm their ranks numbered around seventy. By 1770, the Paris Opera's own troupe had risen to more than ninety performers, and although the chronic fiscal crisis of the 1780s may have caused these numbers to shrink somewhat, the elaborate spectacles staged with professional dancers from the Opera point to its continuing vitality. By the end of the eighteenth century, the purpose of these urban troupes was in most places twofold; the ballet troupes of the time still performed *divertissements*, entr'actes, and concluding ballets within operas as they had done for almost two centuries, but they also performed pantomime ballets or *ballets d'action*. Ballet's long apprenticeship to opera had not completely ended by the year 1800, but the art form had achieved a striking degree of independence during the course of the previous century. One sign of this new reality, and a harbinger of even greater innovations to come, occurred at the very end of the eighteenth century as the Italian dancer and choreographer Salvatore Vigano instituted drastic reforms in costuming and footwear to the dance troupe at the Venetian Opera. Vigano introduced light and loose-fitting Neoclassical dress, and he required his dancers to wear either sandals or slippers. His emancipation of dancers from much of the elegant trappings in which eighteenth-century aristocratic society had long placed them opened up the way for the striking innovations in dance technique that occurred in the nineteenth century.

SOURCES

Judith Chazin-Bennahum, *Dance in the Shadow of the Guillotine* (Carbondale, Ill: Southern Illinois University, 1988).

Susan Leigh Foster, *Choreography and Narrative. Ballet's Staging of Story and Desire* (Bloomington, Ind.: Indiana University Press, 1996).

Ivor Guest, *The Ballet of the Enlightenment* (London: Dance Books, 1996).

SEE ALSO *Theater: The Rise of Revolutionary Sentiment in France and Its Impact on the Theater*

SIGNIFICANT PEOPLE
in Dance

GASPARO ANGIOLINI
1731–1803

Dancer
Choreographer

BEGINNINGS. Gasparo Angiolini was born at Florence and began his career as a dancer at Lucca in 1747. Like most of the prominent dancers of his time, he made his debut when he was just a teenager, and his early success brought him soon to Venice, the home of Italy's oldest opera house. He performed there during several seasons, but in his early career he was also associated with the ballets at Spoleto, Turin, and again at Lucca. By his early twenties he had risen through the ranks of these companies and was recognized as a choreographer. After a brief stint in Rome, he made his way to Vienna, where he danced with Maria Teresa Fogliazzi. At the time the notorious eighteenth-century lover Casanova was pursuing Fogliazzi, but Angiolini successfully won her hand in marriage. Following successes in Vienna the two returned to Italy, where they were the lead dancers at Turin. When Franz Hilverding, ballet master of the French theater in Vienna, left to direct the Tsar's ballet in Russia, Angiolini replaced him. Despite several early setbacks, the most productive and creative part of his career soon began in the Austrian capital.

BALLET D'ACTION. Angiolini's rise to fame in Vienna coincided with the development of the new genre of dance known as the *ballet d'action*, danced dramas in which performers used gestures and pantomime to convey a story. The first productions that he staged for the Viennese opera were largely traditional diversionary pieces common to the time. In 1761, though, the French theater in Vienna hired an assistant who took over these tasks, and Angiolini was now free to devote himself to the creation of major dance dramas. In two of these, *Don Juan* and *Sémiramis*, the ballet master tried to apply ancient ideas about dance and pantomime. At this early stage in his development as a producer of dance dramas,

Angiolini collaborated with Willibald Christoph von Gluck, the Viennese court composer whose music and operas set new standards for dramatic and expressive powers. Later Angiolini was to write much of the music for his ballets himself, but his early production of *Don Juan*—a theme already highly familiar to the Viennese audience—was noteworthy for its dramatic conclusion. Audiences found the final scene in which Don Juan was carried off to Hell to be a revelation. It showed how dance's power might be combined with music to create a heightened sense of urgency and drama, a sense more profound than in a mere spoken drama. The collaboration with Gluck was a happy one, although Angiolini always preferred his latter ballets in which he had complete control over music, dance, and story line.

MOVE TO ST. PETERSBURG. In 1765 the Habsburg emperor died, and a long period of mourning began throughout Austria. Typically during these periods all theaters were closed, and so Angiolini faced a protracted period of unemployment. Around this time his predecessor in Vienna, Hilverding, left his position in St. Petersburg, and Angiolini replaced him. His time in Russia saw the creation of new ballets as well as the staging of ones that he had already pioneered in Vienna. After leaving Russia a few years later, he worked in Venice, Padua, and Milan. It was in this last city that Angiolini wrote his *Gasparo Angiolini's Letter to Mr. Noverre Concerning the Ballet Pantomime*, actually a pamphlet that attacked Noverre for his claims of originality in staging *ballets d'action*. Angiolini demonstrated that the artistic genre had been first developed by his own predecessor, Franz Hilverding, at Vienna. Angiolini also criticized Noverre for an insufficient attention to technique as well as a relative ignorance of music. The rivalry proved long lasting, although the two were by this time among the most prominent ballet masters in Europe. In 1774, they swapped posts. Angiolini took Noverre's position at Vienna, and Noverre assumed the Italian's at Milan. Other trips to St. Petersburg followed, where Angiolini staged productions and became involved with the city's developing ballet school. By 1780, though, Angiolini had returned to Milan, and his base of operation remained in the city for the rest of his life.

HIGH POINT AND RETIREMENT. Between 1780 and 1782, Angiolini's career achieved its high point while he was at work staging ballets for La Scala, the opera in Milan. By this time the choreographer was composing all of his own music. While he was widely hailed at the time for his compositional powers, the few scattered scores that survive show that Angiolini was a composer with considerable deficits. His lively staging, with elaborate machinery and sumptuous costumes, was notable among the many grand productions of the later eighteenth century. The master's importance, though, continues to be recognized in his revival of pantomime techniques and his advocacy of danced dramas. While Angiolini sometimes wrote dance theory, he was not as lively an author as Jean-Georges Noverre, and thus his relative modern obscurity can be credited to his less certain rhetorical powers.

SOURCES

Bruce Allan Brown, *Gluck and the French Theatre in Vienna* (Oxford: Clarendon Press, 1990).

Ivor Guest, *The Ballet of the Enlightenment* (London: Dance Books, 1996).

Marian H. Winter, *The Pre-Romantic Ballet* (London: Pittman Publishing, 1974).

MARIE-ANN DE CUPIS DE CAMARGO
1710–1771
Ballerina

BEGINNINGS. One of two great prima ballerinas in mid-eighteenth-century France, Marie-Ann de Cupis de Camargo was born at Brussels to a family of mixed Franco-Flemish and Spanish heritage. In her youth she studied with Francoise Prevost, the greatest ballerina in Paris at the time, and in 1720, she was engaged at the Brussels ballet. Her Paris debut occurred in a production of *Les caractères de la danse* in 1726, and her performance was so brilliant that it excited the jealousy of her teacher, who refused to work with her anymore. She next studied with Blondy and Dumoulin, two other masters of the time. Between the time of her debut and retirement in 1751, she performed in almost eighty ballets in Paris. A fierce rivalry developed between Marie Camargo and Marie Sallé, the other great ballerina of the period. Voltaire, the greatest philosophe of the age, noted that Camargo's style was quick and brilliant, while Sallé's was more lyrical and expressive. Camargo's technical facility was apparently enormous, and she was the first woman to perform several demanding leaps, including the *cabriole, pas battu,* and *entrechats*—steps that had previously been reserved for men. Madame Camargo has also long been credited with establishing the ballerina's normative position with feet pointed at a 90 degree angle to the body. Eventually, she shortened her skirts, an innovation that allowed her to perform even more demanding footwork, and which opened up new technical arenas for ballerinas who followed.

SOCIAL ACCEPTANCE. Throughout her career her performances were often associated with the operas of Jean-Baptiste Lully, the late seventeenth-century composer who had largely fixed the canons of the genre in France. As revivals of these works were mounted, however, additional dances were added to the productions to show off the skills of dancers like Camargo and Sallé. In one production a male dancer failed to appear on cue, and Camargo scored a great success by dancing in his place a fantastically improvised ballet. Camargo's prowess on the theatrical stage allowed her admittance into some of the most cultured spheres of mid-eighteenth-century Parisian society. She became a darling of the "salon" set, and her hairstyles, shoes, and hats were widely copied by upper-class Parisian women. French chefs of the period named a number of dishes after her, including such delicacies as Soufflé à la Camargo and Filet de Boeuf Camargo. Prominent French artists painted her portrait on several occasions, and her reputation survived long after her death. During the nineteenth century, for example, two operas were written about her life, and in 1930, the Camargo Society of London, a dancing troupe, was named after her. Despite her widespread fame—a fame achieved after just a few years of performing in the Paris Opera—Camargo retired in 1734 to become the mistress of the Count of Clermont. Seven years later, though, she returned to Paris and continued to perform in the Opera ballet until 1751, at which time the king granted her a state pension for the remainder of her life. Besides her long-term association with Clermont, she did not marry.

SIGNIFICANCE. Like her rival Sallé, Camargo's career opened up new possibilities for ballerinas who followed her. A trailblazer in the realm of technique, Camargo's dancing set a new standard of technical excellence. During the Baroque, rising standards of performance in both the opera and the ballet helped to create an audience that avidly followed and tracked the best singers and dancers of the day. The split in opinion that occurred in Paris over the relative merits of Camargo and Sallé was typical of the tenor of the times, as audiences devoted the kind of attention to these celebrities that modern people do to sports stars and popular musicians.

SOURCES

Maureen Needham Costonis, *The New Grove Dictionary of Music and Musicians.* Eds. S. Sadie and J. Tyrell (London: Macmillan, 2001).

Parmenia Migel, *The Ballerinas from the Court of Louis XIV to Pavlova* (New York: Macmillan, 1972).

JEAN-GEORGES NOVERRE
1727–1810

Dancer
Choreographer

EARLY TRAVELS. Born the son of a Swiss soldier and a Parisian woman, Jean-Georges Noverre, the man who was destined to transform the ballet, studied dance in Paris from an early age. At first a student of the noted master Marcel, he later studied with Louis Dupré, at the time the first dancer in the Paris Opera's troupe. He made his debut with the Opera ballet around 1743 in a production that Dupré directed of the burlesque ballet *Le Coq de Village* (The Village Rooster). In the same year he danced for the royal court at the Palace of Fontainebleau, outside Paris. In these early years of his career he came in contact with the great naturalism of the female dancer Marie Sallé as well as with the expressive music of Jean-Philippe Rameau. These two influences left their mark on Noverre's career as he labored to develop ballet as a form of drama. In the years that followed his Paris debut, Noverre left Paris for Berlin, where he performed in a number of productions. By 1747, he was back in France, where he may have taken a short post in the city of Marseilles before moving on to Strasbourg.

EARLY BALLETS. In Strasbourg in 1749, Noverre made the acquaintance of the actress and dancer Marie-Louise Saveur, whom he married. A year later, he was called to dance at Lyons, France's second-largest city, where he partnered with Marie Camargo, France's great female dance virtuoso. In 1751, he staged his first pantomime ballet there, a production of *The Judgment of Paris*. In his subsequent engagements as choreographer and dancer in the next few years at Strasbourg and Paris he did not continue to stage pantomime ballets, but instead confined his work to more traditional ballets filled with complex figural patterns and the virtuosic displays typical of the time. His productions were noteworthy, however, for their complex stage scenery and costuming. Because of his failure to garner a permanent position at the Paris Opera, Noverre left France for London in 1755. Here he worked with the prominent man of letters and impresario David Garrick at the Drury Lane Theater near Covent Garden. At the time, relations between France and England had turned sour, and an upswell in anti-French sentiment condemned Noverre's production of *The Chinese Feast* to failure. The crowds who attended this production even erupted in a riot after one performance. Unable to earn a living in England, Noverre returned to Lyons, where he began to work on his book, *Letters on Dance and Ballet.* Published in 1759, the book

was an immediate success and it did a great deal to enhance his reputation throughout Europe.

LETTERS ON DANCE. Noverre's letters on dance developed ideas that France's Enlightenment thinkers were promoting about the nature of the arts. The *philosophes*, as they were known, stressed that art was far more than a mere adornment or ornament to life. The arts possessed the power to ennoble humankind by presenting to the race an image of beauty as well as the range of human emotions. The thinking of the Enlighteners stressed the ability of the various arts to convey ideas, thoughts, and feelings in ways that were unfettered by courtly conventions and elaborate rules. Around the time that Noverre was writing his book on dance, the famous Enlightenment dramatist and encyclopedist Diderot produced his play *The Natural Son*. In that work he decried the merely decorative and ornamental nature of the ballet in his time, and he expressed the fervent hope that a master might come along who could show the art a way out of its decadence. It was Noverre who took on this task in his *Letters*, and in the remainder of his career he devoted himself to transforming the ballet into a dramatic, rather than merely athletic, art.

MOVE TO STUTTGART. While France's Enlightenment thinkers and literati found his *Letters on Dance* a compelling work, Noverre's colleagues in French opera houses were not won over. After working at the Opera for only a short time as a choreographer, he made his way to the court of the Württemberg dukes at Stuttgart, which was then home to a more experimental dance culture than in either Paris or Lyons. Here he produced about twenty ballets before the company he directed was disbanded in 1767. At that time he secured his most important position—ballet master to the Habsburgs at Vienna—where he staged almost forty ballets in eight years. His productivity in Vienna was enormous, and his most important ballets date from this period. The resources of the Habsburg imperial court were considerable, and their musical culture was among the finest in Europe. Noverre staged his ballets to music by Gluck and several other Viennese masters, including Josef Starzer and Franz Aspelmayr. As a result of these performances, his reputation as a choreographer spread throughout Europe. Despite rivalries with other dance masters—most notably the Italian Gasparo Angiolini—and brief periods of unemployment, Noverre continued to be in demand as a choreographer throughout the continent for most of the rest of his life. In 1776, for example, he finally achieved the position he had long desired as balletmaster at the Paris Opera. Although he remained in this position until 1781, the Parisian audience was not receptive to his artistic vision, and he accepted a semi-retirement from the company in 1779. Many complained of his choices of themes as well as his refusal to stage ballets that were a part of a larger opera. Noverre, ever convinced of the cause of his art, took some of his productions to London, and over the course of the following years, he staged ballets and *divertissements* in England and Lyons. He retired, but in the 1790s the inflation of the French Revolution forced him to return to choreography. At the height of the Terror he fled to London and produced a number of productions; when his fortunes improved, he returned to France, where he spent the rest of his life in retirement.

INFLUENCE. Noverre's artistic ideas contained in his *Letters on Dance and Ballet* were undeniably his most important contribution to the theory and practice of dance. He advocated an art freed from the merely ornamental and subjected to new dramatic discipline and emotional expression. Many other ballet masters of the period openly advocated reforms similar to those of Noverre, and some of their own innovations preceded this French master's. Noverre's widely published book, however, established a place for its author in posterity, so that he has long been wrongly credited with single-handedly transforming the ballet into a form of dramatic art. Noverre's own theatrical career was checkered with many failures and a few successes. The high point of his activity occurred in Vienna during the late 1760s and 1770s. After this time, the choreographer never matched the success he had experienced in this environment, although his intellectual influence on dance persisted by virtue of his widely read *Letters*.

SOURCES

Ivor Guest, *The Ballet of the Enlightenment* (London: Dance Books, 1996).

Deryck Lynham, *The Chevalier Noverre: Father of Modern Ballet* (London: Sylvan Press, 1980).

Pierre Tugal, *Jean-Georges Noverre, der grosse Reformator des Balletts* (Berlin: Henschel, 1959).

Marian H. Winter, *The Pre-Romantic Ballet* (London: Pittman Publishing, 1974).

GAETANO VESTRIS

1729–1808

Dancer
Choreographer

A DISTINGUISHED FAMILY. Gaetano Vestris was born into a family notable for its dancers and musicians.

His elder sister Teresa Vestris (1726–1808) was a prominent dancer at the Paris Opera during the 1750s, before becoming a courtesan. Gaetano's younger brother Angiolo also became a dancer, performing in Paris and then later in Stuttgart in the pantomime ballets that Jean-Georges Noverre produced there. In total, nine members of the family were connected with the Opera in Paris or distinguished themselves in the field of dance or music during the eighteenth and nineteenth centuries. Thus like the Bach family, who provided church and court musicians for the German principalities throughout the eighteenth century, the Vestris family was a major force on the Parisian musical and dance scene. Gaetano himself trained at the Paris Opera and performed there between 1749 and 1780. His career thus coincided with the rise of the *ballet d'action*, and he became the leading dancer of the mid-century. After retiring from performance, he continued to teach in Paris, training the male dancers who carried forward French innovations in ballet into the nineteenth century. Thus like Louis Dupré, who dominated dance in Paris in the first half of the eighteenth century, Vestris's long career assured his influence over professional dance for years following his death.

TRADITION AND INNOVATION. The Vestris family had emigrated from Florence to France around 1740, and certain members seemed already to be well acquainted with Italian traditions of miming. The daughter Teresa was the first to make her way as a ballerina, performing in the Esterhazy Ballet in Hungary before moving on to Dresden and her later Paris debut. In Paris, she used her influence to obtain for her brothers Gaetano and Angiolo instruction at the Opera's school. As a student there, Gaetano studied with Louis Dupré, the greatest dancer and teacher of the first half of the eighteenth century. He acquired the traditional skills necessary to a ballet performer of the time. These included a ready athleticism, knowledge and mastery of all the steps and leaps that formed the ballet's vocabulary of movements, and a thorough understanding of how these were to be combined with the musical forms that had since Lully's time accompanied the opera ballet in France.

CHOREOGRAPHER. Although Vestris's training had been largely traditional, he performed in the new pantomime ballets that became popular after 1750. In addition, as a teacher and choreographer he adapted himself to the changes in technique that were quickly transforming the ballet. His tenure as ballet master at Paris coincided with a bleak period in the institution's history, and historical assessments have not always been kind to his choreography. Vestris tried to strike a balance in the

works that he created for the Opera between the new and the old. While his productions have sometimes been discounted as too traditional, it must be remembered that this was a low period in many ways in the Opera's history. In 1763, the Opera's theater in the Palais Royale burned down, and for seven years, the company was temporarily located in the Tuileries Palace nearby. A new theater reopened at the same site north and east of the Louvre in 1770, but it was as cramped and inadequate as the one it had replaced. When it was damaged in a fire in 1781, plans were made to house the Opera and ballet in new, grander surroundings. Besides the problems of space at the time, artistic differences about the direction the Opera's dances should take were numerous. In creating new ballets, then, Vestris appears to have tried to strike a compromising chord, a chord that seemed to please few. In these years, though, he continued to dance and impress audiences with his athletic prowess, developing a reputation as the best living exemplar of the "noble style" in French dancing. By the early 1770s, Gaetano was in his early forties, and he sometimes deferred performing to allow his son, Auguste, to dance his roles. Auguste was even more definite about adopting the reforms that were circulating in the dance world of his day. While previous dancers had sometimes given up the masks and elaborate costuming to perform more complex roles, Auguste abandoned them completely. He was thus able to perform with such freedom of movement and to execute such a range of steps that the longstanding custom of decking dancers out in an array of trappings soon disappeared. Around 1780, both Gaetano Vestris and his son Auguste undertook a tour to London, where their ballets caused a sensation. Both Vestris's returned to Paris in triumph, and at his retirement from dancing a few years later in 1782, Gaetano was celebrated as a French national hero. He received a state pension as a result of his distinguished career.

TROUBLES IN THE REVOLUTION. Like many other dancers who had flourished in the aristocratic society of eighteenth-century France, Gaetano Vestris's fortunes fell on hard times during the early years of the French Revolution. As a result of the fiscal crisis, the new republican government cut off his state pension, and for a time, Vestris fell under suspicion of monarchical sentiments. He traveled again to London, where he became ballet master to the King's Theatre. In 1793, though, he returned to Paris, and the republican government restored his pension to him. During the 1790s his son, Auguste Vestris, as well as several of the students that Gaetano had trained, continued to dominate ballet performance in Paris.

SOURCES

Susan Leigh Foster, *Choreography and Narrative. Ballet's Staging of Story and Desire* (Bloomington, Ind.: Indiana University Press, 1996).

Ivor Guest, *Le Ballet de l'Opera de Paris* (Paris: Théâtre national de l'Opera, 1976).

———, *The Ballet of the Enlightenment* (London: Dance Books, 1996).

Spire Pitou, *The Paris Opéra: An Encyclopedia of Operas, Ballets, Composers, and Performers.* 2 vols. (Westport, Conn.: Greenwood Press, 1983–1985).

Marian H. Winter, *Pre-Romantic Ballet* (London: Pitman Publishing, 1974).

JOHN WEAVER

1673–1760

Dance Master

DANCER AND WRITER. England's great early eighteenth-century dancer was born the son of a dance master, and attended school at Shrewsbury for a time before settling in Oxford with his father. There his father ran a studio of dance, and John Weaver picked up his techniques there before heading to London around 1700 to make his way as a theatrical dancer. In 1703, Weaver staged his first ballet, *The Tavern Bilkers.* Somewhat later, the dancer was to praise his early production as the first "Entertainment that appeared on the English stage, where the Representation and Story was carried on by Dancing, Action and Motion only." Scant information survives about the production, so it is difficult to tell whether *The Tavern Bilkers* was actually England's first pantomime ballet. Weaver must have been an accomplished dancer and choreographer even at this date, because Mister Isaac, the greatest dance master in London at the time, soon befriended him. Under his encouragement, Weaver translated Feuillet's *Choreography,* an important French dance manual of the time. He published his version as *Orchesography* in 1706. Around the same time he also published six of Mister Isaac's dances, which he set down using the new Beauchamp-Feuillet style of notation.

THEORY. Sometime around 1707 or 1708, Weaver returned to Shrewsbury, where he settled with his family. The town served as his home base for the rest of his life, although he did return to London on several occasions to stage productions. Back in his childhood home, Weaver soon devoted himself to dance history and theory. Under the prodding of the dramatist and man of letters Sir Richard Steele, the dance master began to write a history of dance. This work of scholarship, *An Essay Towards a History of Dancing* (1712), treated at great length the development of dance in Antiquity, but concluded that a new kind of art needed to flourish in contemporary times. Weaver supported dance that would display human manners and emotions and convey a story line. Thus his work anticipated the great achievements of pantomime ballet and *ballets d'action* that were to follow in the mid- and later eighteenth century. In 1717, he returned to London where he was engaged to produce the pantomime ballet, *The Loves of Mars and Venus,* at the Drury Lane Theater, the site where many of eighteenth-century London's experiments in dance were produced. Weaver styled his *Loves* as a work made in "imitation of the pantomimes of the ancient Greeks and Romans," and his attempt to revive these ancient arts fit neatly with much of the eighteenth-century Neoclassical spirit in Britain. While Weaver was generally admiring of ancient practices, his own pantomimes did not slavishly imitate antique art. In his theoretical writings on Greek and Roman pantomime, he stressed that the ancients had used a single actor to portray many different characters. By contrast, Weaver himself relied on many professional dancers to stage his production of the *Loves.*

SUCCESSES. Weaver followed the success of his first pantomime ballet with another work, *Orpheus and Eurydice.* Around this time he began to study the anatomy of the human body with a special emphasis on how the musculature supported movement. In 1721 he published a work entitled *Mechanical and Anatomical Lectures upon Dancing,* the first study of the science of human movement. Two other pantomime ballets were to follow: the first, *Perseus and Andromeda,* was staged at Drury Lane in 1728, while the final work, *The Judgment of Paris,* was performed during 1733. In this last work, Weaver included much pantomime, but he also reintegrated songs and music into his drama, a return to some of the conventions of ballet that remained in force at the time. After the *Judgment of Paris,* Weaver did not return to produce ballets in London. He remained at Shrewsbury, where he continued to serve as a dance master.

IMPORTANCE. Although Weaver was a visionary in the field of dance, his ideas were not to be taken up by subsequent masters for several decades. When these new experiments in dramatic ballet arose, they appeared in the court theaters of the German- and French-speaking world, rather than in Weaver's England. In his own time, his productions were noteworthy but not widely successful. Neither were they widely imitated because the impresarios of the period concentrated their attentions on other works that were more commercially viable.

Lacking the rich budget of a court theater, where subsidies made experimentation possible, Weaver's vision of pantomime ballet largely withered on the vine. His literary importance as a commentator on dance and as a force that helped to establish Feuillet notation throughout Europe has ensured the survival of his reputation in posterity.

SOURCES

I. K. Fletcher, S. J. Cohen, and R. Lonsdale, eds., *Famed for Dance: Essays on the Theory and Practice of Theatrical Dancing in England, 1660–1740* (New York: Books for Libraries, 1980).

Susan Leigh Foster, *Choreography and Narrative. Ballet's Staging of Story and Desire* (Bloomington, Ind.: Indiana University Press, 1996).

Richard Ralph, *The Life and Works of John Weaver* (New York: Dance Horizons, 1988).

Marian H. Winter, *Pre-Romantic Ballet* (London: Pitman Publishing, 1974).

DOCUMENTARY SOURCES
in Dance

John Essex, trans., *The Dancing Master* (1728)—This translation of Pierre Rameau's dance treatise provided performers in England with knowledge of the latest trends in French dance. Rameau was one of the most important theorists of dance in eighteenth-century France. He explained the precise placement of hands and feet besides cataloguing an enormous number of steps.

Jean-Georges Noverre, *Letters on Dancing and Ballets* (1754)—One of the most influential dancing treatises of all time, this collection of observations on dance reinterpreted the art form according to the theories of the Enlightenment. Noverre stressed that dance must strive to be a representation of the human emotions, that it should adapt a greater naturalism, and that it should abandon the cumbersome costumes and masks typical of the day. Noverre's theories, which attacked the mere technical virtuosity of many contemporary dancers, were controversial, but eventually prevailed in the ballet.

John Playford, *The English Dancing Master* (1651)—This collection of English country dances was widely available in the later seventeenth century. Through Playford, knowledge of country dances spread to France, where these figure dances were refined and made into an essential part of the ballroom repertoire of the later seventeenth and eighteenth centuries.

John Weaver, trans., *Orchesography* (1706)—This famous translation of Feuillet's *Choreography* spread knowledge of French dance notational techniques in England. It also established fashion for many French trends. Weaver's translation went through several editions, and was, in turn, re-translated into German, helping to spread knowledge throughout Europe of the Feuillet system.

John Weaver, ed., *A Collection of Ball-Dances Performed at Court* (1706)—The Stuart kings' dancing master, Mister Isaac (1640–1720), originally compiled this collection of ballroom dances. It provides unparalleled information about the precise kinds of steps that were performed in the English ballroom around 1700. Weaver, the most prominent English choreographer of the early eighteenth century, edited it and oversaw its publication.

chapter three

FASHION

Philip M. Soergel

IMPORTANT EVENTS
in Fashion

c. 1600 In Spain, a fondness for somber colors and restrained but opulent decoration reigns. Elsewhere in Europe these elements of Spanish design often meld with native traditions to produce imaginative, but sometimes distorted and bizarre regional variations.

1603 Elizabeth I of England dies. As part of the inventory taken of her goods, scores of opulent dresses are noted in her private collection, most of which come into the possession of her successor James I's wife, Anne of Denmark.

1604 A bill is introduced in the English Parliament that abolishes all sumptuary laws in the country. When James I tries repeatedly to proclaim sumptuary legislation himself, his measures are struck down by Parliament.

c. 1620 The dominance of Spanish fashions begins to fade in court societies throughout Europe.

The popularity of *ruffs*, starched collars pleated into elaborate folds, wanes in Northern Europe.

c. 1625 Dutch fashions become popular in urban and court circles. The Dutch favor less restrictive styles that are more comfortable, as well as garments made of wool. Their clothes are often richly decorated with lace.

1630 Men's hairstyles showcase long locks that are artfully arranged.

1642 Marie de' Medici, once queen of France and one of the most fashionable women in Europe, dies impoverished and exiled from her adopted country.

1643 Louis XIV assumes the throne in France as a five-year-old child. As an adult, the king will dominate men's style in aristocratic societies throughout Europe.

c. 1660 French fashion begins to become popular at courts throughout Europe.

c. 1665 The *justaucorps*, a long outer coat that stretches to the knees, begins to be worn at the French court atop a shorter waistcoat and britches. In tandem, this three-piece wardrobe will govern men's styles in much of Europe over the next century and will form the basis for the modern "three-piece" suit.

c. 1670 Wigs become popular as a hairstyle for men, as Louis XIV in France and Charles II in England don the new fake hair.

1682 The Palace of Versailles becomes the official home of the French court and the center of state government. During his years at the château, Louis XIV makes the ceremony of his rising and dressing, known as the levée, into a grand centerpiece of Versailles' system of etiquette, requiring more than 100 noblemen to attend the king at this ceremonial dressing.

1683 Jean-Baptiste Colbert, Louis XIV's powerful chief minister, dies. During the previous decades Colbert has followed the economic policies of mercantilism, establishing France's preeminence in certain key industries, including the making of lace and other fine fabrics necessary to clothing.

c. 1700 In England, the popularity of male wigs, or *perukes*, reaches its high point. Different professions and types of gentlemen begin to wear wigs that distinguish their stations in life, and the taste for these hairpieces gives rise to fashions that are fanciful and increasingly artificial.

1709 Louis XIV suffers disastrous defeats in international wars. The resulting financial weakness in France prompts the court to pursue a new austerity in dress.

1715 In France, King Louis XIV dies and is succeeded by his young great grandson, Louis XV. Because Louis XV is a minor, his uncle Philippe, the Duke of Orléans, rules, and, during this period known as the Regency, a new more opulent and lighter style in dress and interior decoration flourishes.

c. 1730 The *robe à la française* becomes one of the most popular styles of fashion for women throughout Europe. The gown is fashioned on women's negligées and fits tight at the bodice, but allows contrasting or identical underskirts to show through, artfully arranged over a series of hoops or paniers so that they fall into bell shapes.

1746 Madame de Pompadour becomes the official court mistress of Louis XV. During the years in which she fills this position, Pompadour establish many styles in France and throughout Europe, including *pompoms*—a play on Pompadour's name—which are an arrangement of fur or feather balls that are placed atop or at the side of women's heads.

c. 1750 The popularity of the elegant Rococo style in France helps to inspire fashions in dress that are made up of elaborate flounces and ruffles.

1760 Louis XV purchases several factories and merges them into a single company that is charged with the responsibility of producing high-quality cottons for the French domestic market. Its popular printed cottons become known as toile du Jouy after the company's location at Jouy near Versailles, and the fabrics featuring exotic motifs or scenes of everyday life are used for everything from ladies' dresses to upholstery.

1764 Madame de Pompadour, King Louis XV's mistress and a fashion trendsetter throughout Europe, dies.

c. 1770 The production of affordable cottons in English factories helps to inspire the popularity of new fashions crafted from these materials throughout Europe.

1774 Louis XVI begins his reign as the king of France, during which his queen, Marie-Antoinette, will set new standards in lavish dress. As the French Revolution approaches, the queen and her court adopt the more free-flowing and informal styles popular in England at the time.

1775 In Paris, the fashion book, *Monument of the Physical and Moral Costume at the End of the Eighteenth Century*, is published for the first time. The work accurately reflects French aristocratic styles of the period and spawns imitators, including the first fashion magazines.

1778 The Parisian publishers Jean Esnaut and Michel Rapilly commence distribution of their *Gallerie des modes et costumes français* (Gallery of French Style and Costumes), which are collections of fashion plates intended to keep consumers up to date on the latest styles.

1783 Elisabeth Vigée-Lebrun, a middle-class French portrait painter, produces a portrait of Queen Marie-Antoinette wearing a chemise, a simple dress of white muslin gathered at the neck with a drawstring and tied at the waist with a sash. The style is an important departure for a French queen, whose style of dress has long been dictated by unbending court etiquette, and is controversial at court, even while reflecting the growing popularity of English informal styles among the aristocracy in France.

1785 The first fashion magazine is published in Paris under the title *Les Cabinet des modes* (The Cabinet of Style). It will soon change its name to *Le Magasin du modes nouvelles françaises et anglaises* (The Magazine of New French and English Styles) to take account of the widespread popularity of more informal English fashions in France.

1786 The Affair of the Necklace captivates French society. This court intrigue, involving the alleged sale of an ostentatious diamond necklace to Queen Marie-Antoinette, becomes an occasion for attacking the court's lavish consumption.

1789 The royal prison of the Bastille is stormed in Paris. In the wake of this event the government requires citizens to wear revolutionary cockades on their hats or lapels, which are emblems constructed of ribbons of white, red, and blue.

1793 The *Sans Culottes* (meaning "without britches") come to the forefront of the Revolution as a powerful working-class group supporting the radical Jacobin cause in the French Revolution. The movement is comprised of small Parisian shopkeepers, artisans, and poor workers, who wear trousers rather than the knee britches, thereby popularizing the wearing of trousers among those dedicated to the cause of revolutionary democracy in France.

1795 The government of the Directory is set up in France and begins to restore order to the country following the Reign of Terror. During the several years of the Directory's rule, Neoclassical women's fashions will become the rage in Paris and other French cities and will eventually spread throughout Europe. These fashions, at once feminine, practical, and relatively inexpensive, mark the end to the costly aristocratic opulence of the eighteenth century.

OVERVIEW
of Fashion

FASHION: THE PRESERVE OF THE ARISTOCRACY.
For most of the seventeenth and eighteenth centuries participation in the world of fashion was limited to wealthy aristocrats who lived in royal courts. While wealthy merchants and members of the gentry sometimes imitated the clothing worn by nobles, very few were able to dress in the lavish way that the nobility did. Even if they could have afforded the expense of such clothing, the vast majority of the European population could not have worn the luxurious styles due to long-standing moral prohibitions against lavish consumption as well as sumptuary laws (laws that forbade certain kinds of consumption and tried to limit the amount that people spent on their clothing). England was the first country to do away with sumptuary laws; the English Parliament repealed all sumptuary legislation in 1604 because of a legal wrangle with the Stuart King James I (r. 1603–1625). Although there were numerous subsequent attempts to enact new sumptuary laws in England, the ongoing competition between Crown and Parliament meant that prohibitions against certain kind of dress disappeared in England far earlier than elsewhere in Europe. The absence of written laws did not lead to widespread consumption of extravagant clothing, however, as the popularity of Puritanism as a religious creed discouraged lavish consumption of clothing. While large segments of the population shunned luxurious dress, high-ranking members of the nobility continued to wear extravagant costumes. Elsewhere in Europe, the austere teachings of many Protestant and Catholic religious groups and the persistence of sumptuary laws similarly discouraged extravagant consumption among broad sectors of the population. Usually, though, items that were prohibited to be worn by the populace at large were freely permitted to many members of the nobility. In this way clothing served as one of the most visible and potent markers of social status.

THE SHIFTING STYLES OF THE SEVENTEENTH CENTURY. Despite long-standing religious and economic prohibitions condemning the world of style, fashions changed nonetheless, albeit only every three to four decades during the seventeenth century. Every major European capital and royal court was filled with a cadre of elites that possessed the resources to indulge changing tastes. Around 1600, the reigning fashion throughout Europe favored styles that were originally Spanish in origin, with ruffs (high starched and pleated collars), farthingales (hooped contraptions that extended the line of women's hips, often to enormous widths), and capes being among the most popular items adopted from the repertoire of sixteenth-century Spanish dress. Spanish clothing had usually been rather austere, with Spanish aristocrats favoring exquisite tailoring and subdued colors instead of opulent display. As these fashions were adopted throughout Europe in the later sixteenth and early seventeenth centuries, they were often distorted by local tastes. The farthingale, the hoop-like contraption on which women of the time arranged their skirts, was one case in point. Originally an early sixteenth-century Spanish style, it was avidly adopted in courtly societies throughout northern Europe, and in this process its contours became greatly exaggerated. By the early seventeenth century farthingales sometimes reached a width of four feet before beginning to shrink and, by 1620, disappearing altogether. The ruff presented a similar case in point. A relatively restrained Spanish item of dress in the sixteenth century, it was avidly adopted in many places by 1600 and taken to new extremes of width and complexity before fading into fashion oblivion by the end of the first quarter of the new century. Both the love of Spanish style and the tendency to exaggerate these innovations present us with two tendencies that were often to be repeated in the world of European fashion during the Baroque period. First, aristocratic and wealthy Europeans from throughout the continent often found inspiration for their clothing in the patterns of dress favored in the then-dominant power. As Spain declined in the first quarter of the seventeenth century, the rise of the Dutch Republic with its trading empire throughout Europe provided a new and ready source of emulation. In the second half of the eighteenth century, the torch of European fashion passed to France, where the absolutist system set up by King Louis XIV created the raw materials of an industry that was to dominate European style even into modern times. The rise of England as Europe's dominant eighteenth-century power brought with it a new host of styles that were avidly imitated throughout Europe and which came to be adopted, refined, and exploited by the fashion industry in France.

A TENDENCY TOWARD DISTORTION. The second tendency that European fashions exemplified throughout the early-modern period was a tendency to exaggerate

innovations, often to a point at which styles became highly contorted and even bizarre. Here the wig presents a case in point. Hairpieces had been used in the Renaissance to make women's tresses fuller, despite long-standing Christian prohibitions against the custom. In the second half of the seventeenth-century wigs gradually became a prized item of male dress, particularly after King Louis XIV began to wear them to compensate for his receding hairline. From France, the fashion for wigs spread throughout continental Europe and to England, and by the early eighteenth century male wigs had become increasingly artificial. Now the wig was not just a compensation for the middle-age loss of hair, but a fashion accessory very much like a woman's hat. Male coiffures sometimes rose to incredible heights, and male wigs that were powdered silver, pink, blue, or lavender became all the rage. By 1750, though, this trend had largely spent itself, and men in England and France began to renounce the wig altogether. Similar trends are notable in women's fashions. Elaborately coifed hair and wigs rose to enormous heights and hips were widened to great widths with paniers throughout the first half of the eighteenth century before these styles faded. Fashion extremes inevitably bred reactions, with the rise of simpler styles that renounced previous trends sustaining fashion's continuous changes and innovations.

ROCOCO AND REACTION. During the eighteenth century rising wealth produced new previously unheard-of levels of consumption in almost every corner of Europe. Long-standing state and religious prohibitions against lavish consumption relaxed, producing styles of undeniable opulence and display. Nowhere were the forces of this new consumerism more evident than in France, where the austerity of the later years of Louis XIV's reign gave way by the mid-eighteenth century to an era of unprecedented aristocratic extravagance. This world of French Rococo fashion continues in many people's minds to conjure up an image of eighteenth-century style. Elaborate women's dresses that consumed scores of yards of costly taffetas, brocades, and other luxury fabrics and exquisitely embroidered men's outfits were two of the hallmarks of the age. The extravagance of these costumes was still well beyond the reach of all but a tiny minority of French men and women. Yet even though the middle and lower classes lagged behind aristocratic standards of consumption, new standards in style were being set across the social spectrum. As the eighteenth century matured, the inspiration for new clothing styles came, not only from French aristocratic society, but from England. Britain stood at the vanguard of the economic developments that were transforming eighteenth-century Europe, and by 1750, taste in the English-speaking world

had come to be dominated by a new middle-class sensibility that prized utility, practicality, and understatement, in contrast to the Rococo fashions popular elsewhere in Europe. From Philadelphia to Edinburgh and London to Dublin, members of the English-speaking world were developing styles notable for their ready adaptability to all sorts of occupations and ways of living. For men, the frock coat combined with the vest or waistcoat and britches to become the uniform of shopkeepers, merchants, gentlemen, and even the aristocracy. For women, undeniably feminine yet simple and elegant dresses constructed of cotton and muslin provided an alternative to the increasingly artificial fashions that emanated from aristocratic France. The new sensibilities of the Enlightenment, the great international philosophical movement that argued for an extension of human liberty and the triumph of reason, accelerated the acceptance of English fashions throughout Europe. The fashion for things "English" came in many places to be adopted as a way of showing one's support for the greater liberty that many Europeans sensed lay in the English way of life. By the 1770s and 1780s, the more informal English styles had made significant inroads throughout Europe, and even in France, where they were initially resisted, they had begun to replace the aristocratic artifice of Rococo dress. By the early 1780s, even France's queen Marie Antoinette had begun to adopt English styles as day wear, helping to popularize these fashions. Adopted by the French middle and upper classes, many English styles were to survive and to persist throughout Europe in the nineteenth century.

THE FRENCH REVOLUTION. Clothing had long played a critical role in early-modern Europe as a marker of social status, and thus with the coming of the French Revolution in 1789, political changes soon came to be reflected in dress as well. In the years that followed the outbreak of the Revolution, middle- and upper-class clothing in France continued to reflect the taste for English designs that had flourished in Europe during the 1770s and 1780s. The Revolution, in fact, intensified the commitment to English styles, particularly among the French middle classes. English patterns of dress symbolized more than ever before one's attachment to the principles of the Enlightenment and to the cause of political liberty. By the early 1790s the leaders of the French Revolution were denouncing the highly artificial and opulent clothing worn by the aristocracy during the Old Regime as a detestable symbol of privilege as well as a form of despotism over the body. Women's corsets, hoops, and tight-fitting bodices became symbols of the dangers of royal absolutism for, as Revolutionary leaders cautioned, these styles constricted the body's movements even as absolute monarchs limited their subjects' politi-

cal freedoms. At the same time, the leaders of the Revolution feared luxury and stylish indulgence, and they urged citizens to adopt ways of dressing that were practical and comfortable, and which made use of economical, monochromatic fabrics. During the high tide of revolutionary sentiments, though, other more radical groups agitated for even more extreme changes in society, and they relied on their clothing to make statements about their support for democratic reforms and the abolition of all social privileges based upon rank, birth, or office. As a result, certain items of dress quickly became highly charged symbols of one's support for, or rejection of, Revolutionary principles. During the first months of the Revolution the revolutionary cockade (an emblem constructed of red, white, and blue) had become an obligatory item of dress in Paris. But clothing fashioned from combinations of red, white, and blue persisted in the early years of the Revolution to express one's support for political change. Soon groups like the *Sans Culottes*, with their outfits consisting of long trousers, tri-colored vests, and the *bonnet rouge* or "red cap," were impressing their demands for greater reform on French society, partly by wearing clothes that were of lower-class origin. The abolition of all sumptuary laws in France in 1793 also marked a key change. During the reigns of the Bourbon monarchs Louis XV and Louis XVI, these laws had rarely been enforced, but now the Revolution embraced the freedom of men and women to choose their dress based upon their own personal preferences. Many used this freedom to experiment with new styles, and by the end of the eighteenth century, a world of fashion was emerging in which semi-annual changes in clothes were avidly followed by large groups of the population. These frequent changes in dress were now tracked and broadcasted throughout the European world through fashion magazines that were printed weekly and bi-weekly. Thus the political changes of the French Revolution helped to give birth to the world of fashion that most modern people recognize, a world in which changes in dress are frequent and occur throughout a far broader portion of the populace than in the aristocratic societies of the Old Regime.

TOPICS
in Fashion

THE REGULATION OF CONSUMPTION

THE LONG TRADITION. In both medieval and early-modern Europe a web of laws tightly controlled clothing and the consumption of luxury goods. As a

body, these sumptuary regulations—laws intended to control dress and extravagant feasting and celebrations—were one of the largest and most universal sets of regulations in European states, although the specifics of restrictions differed greatly from place to place and over time. Generally, though, sumptuary law fell into two broad categories. First, city and state officials tried to limit the amounts their subjects spent on clothing by stipulating that certain garments might not contain more than a certain amount of fabric, lace, or trim, or by limiting the total sum that might be spent on any one garment. These types of regulations were often very specific, and as such, they were consequently subject to many attempts to circumvent their intentions. In sixteenth- and seventeenth-century Italy, for instance, restrictions on the amount of cloth a woman's skirt might contain fed the popularity of *chopines*, which were large stilt-like shoes whose platform soles at times reached heights of twelve to eighteen inches. Perched on these lofty pedestals, late-Renaissance women required more cloth in their dresses so that their skirts reached the ground, another demand of propriety. Thus, as in this case, new fashions often bred a continued outpouring of restrictions, as Italian governments legislated against the chopines even as they had once turned to consider the widths of women's skirts. The second broad type of sumptuary legislation aimed to confine the consumption of certain expensive items of dress to members of the aristocracy. These measures were particularly widespread in the kingdoms of Western Europe. In France and England, for instance, the consumption of costly furs like ermine or of rare feathers was generally reserved only to those who were of noble birth. In this way clothing styles tended to buttress the established social order, to serve as marks of social distinction, and to encourage attempts to get around the regulations. Restrictions of one kind against consumption, then, tended to inspire attempts to control consumption with ever more specific laws, as state and city officials constantly labored to defend against what they perceived were attempts to flout their authority. In most countries, though, the punishments meted out to those who violated sumptuary legislation were comparatively mild when compared against those reserved for theft and other crimes. A system of fines was most frequently used to compel those who violated the laws to comply.

MORAL AND ECONOMIC INCENTIVES. The tradition of controlling and limiting consumption in Western Europe stretched back into the early Middle Ages and even had its precedents in Antiquity. The high tide of sumptuary legislation in Europe, though, occurred

between the fourteenth and early eighteenth centuries at a time when Western industry, commerce, and society were all growing more diverse, and when industry presented consumers with more choices of rich cloth than ever before. At the beginning of this period, problems related to overpopulation, famine, and the Black Death of 1347–1351 winnowed away at Europe's population. Subsequent recurrences of the plague and outbreaks of other epidemics meant that by 1450 there were forty percent fewer people in the continent than there had been in 1300. It was not until about 1620 that the European population again reached its pre-plague levels. In every European region, this massive decrease in population produced long-term inflation, as labor became a commodity that was relatively dearer than previously. Inflation, in turn, made it more difficult for young couples to marry, since the cost of establishing a household was now considerably greater than before. The first rise in the adoption of new sumptuary laws that occurred during the fourteenth and fifteenth centuries responded to these realities, as town officials in Italy and elsewhere in Europe tried to limit consumption—particularly of expensive clothing—as a way of keeping household costs low. From the first, these heightened efforts were sanctioned and supported by the religious orders of the day, and the Franciscans and Dominicans, in particular, rode to a high tide of popularity by condemning the wasteful vanities of contemporary society. Women's dress figured most prominently in the sermons of these friars, and fashion was, it was generally agreed, primarily a woman's problem. These judgments were not merely a form of clerical misogyny directed against women, but arose from the peculiar facts that surrounded clothing in both the late-medieval and early-modern world. Cloth was an expensive but necessary commodity, and the establishment of any new household required enormous supplies of linens, bolts of fabric, and other supplies. In Renaissance Italy, the surviving marriage contracts show that families were often incredibly attentive to the precise needs of their children, and the families of prospective brides and grooms competed against each other to display their ability to provide for their offspring. In the weeks immediately before and after a marriage took place, brides and grooms exchanged a series of gifts, the most important of which were the dowry payment made from the bride's father to the prospective husband and the *trousseau*, or women's clothes given by the groom to the prospective bride. The dowry payment substituted for a woman's share in her father's inheritance, and although it was not equal to the sum that a son received when his father died, it was nevertheless a substantial share of a family's wealth. As fewer young men and

women were able to marry in the period between the late fourteenth and sixteenth centuries, the cost of dowries steadily rose to encourage young men to contract marriages. Yet the rising costs of dowries brought with it other attendant problems, as the other marriage gifts that couples exchanged before their wedding—particularly the trousseau—also rose in magnificence alongside the increase in dowries. In Florence and other cities it became customary for prospective husbands to spend as much as a third of the sum that they received in a woman's dowry to shower their future wives with a trousseau and other rich gifts before the marriage. It was these customs—customs over which women had little control—that tended to identify fashion and consumption as primarily a problem generated by women.

PSYCHOLOGY OF LIMITED WEALTH. In modern times our own economic assumptions have come to differ radically from those of the late-medieval and early-modern world. In the modern world consumer purchasing is taken to be a sign of the health of any economy, and consumer spending is almost universally interpreted as a positive good that aids everyone's economic well-being. The purchase of clothing, luxury household goods, and other consumables is tracked in modern economies as a key indicator of economic health, since it reveals the disposable income that people possess at a given moment. In the late-medieval and early-modern world, by contrast, the total wealth of any society was believed to be scarce and limited, and was linked in the minds of political theorists and the state's officials to the supply of gold and silver coinage that existed within a country. This psychology of limited wealth gave rise to the many efforts of sixteenth- and seventeenth-century kings and princes to limit imports and to foster national industries that might discourage consumption of goods made abroad. While cloth and the other raw materials required in items of dress were produced everywhere in Europe, key centers of luxury production were located in Italy and in the Low Countries (modern Holland and Belgium). The flavor of much economic regulation at the time was protectionist, encouraging products that were produced domestically while discouraging the consumption of luxury items. Since many of the luxurious silks, taffetas, and expensive trims that decorated Baroque dress came from relatively few areas throughout the Continent, the efforts to limit consumption were often motivated by attempts to prevent imports. Paradoxically, these efforts often stimulated demand, making lace, golden cloth, and other fabulously expensive items have all the allure of forbidden fruit. These contradictions were observed even at the

time; the late sixteenth-century philosopher and essayist Michel de Montaigne pointed out that prohibitions against the wearing of velvet and gold braid did little more than "give prestige to these things and ... increase everyone's desire to enjoy them" Then, as now, attempts to prohibit certain items of clothing produced unexpected results, often encouraging the very same perceived vices as the regulation was intended to curtail.

INCREASING IMPORTANCE OF ECONOMIC ARGUMENTS IN SUMPTUARY RESTRICTIONS. If medieval Franciscans and Dominicans had labored to destroy the taste for frills and lace, Calvinists and French Jansenists took up the attack on luxury as a vice in the seventeenth century. Christian morality remained an important feature of sumptuary restrictions at the time, but economic arguments were increasingly being used to justify these regulations. The seventeenth century saw a rash of new sumptuary laws throughout Europe, except in England. By this time the market economy and the trade in cloth and other items of apparel was a significant force in the economy of almost every European region. This rising tide of commercialism, though, was not greeted with universal enthusiasm, and almost everywhere kings and princes responded with a host of regulations designed to keep demand for certain luxurious items in check. Gradually, the old Christian moral arguments used to condemn waste in clothing became less important. In Continental Europe, dress codes now functioned to reinforce social hierarchy, and regulations became minutely concerned with outlining just what items of dress were permitted to each social class. The dominant economic theory of the seventeenth century—mercantilism—pointed to the development of a notion of a "national economy," and protectionist arguments about defending a country's money supply now assumed a greater importance in defending sumptuary law than traditional Christian moral arguments condemning extravagance. The aim of most laws enacted at the time was to prevent imports, rather than to enforce a sober moral vision. By the eighteenth century the increasing penetration of the cloth industry and market economies throughout Europe, and a shift in economic arguments toward new theories that celebrated consumption, was to make the old order of controlling luxury increasingly difficult to maintain. In almost every country throughout Europe sumptuary restrictions gradually disappeared, or their enforcement was relaxed at this time, a recognition of the vital role that consumption now played in the economic household.

ENGLAND. In England, by contrast, sumptuary law disappeared a century earlier than in other parts of Europe. The country's controls on clothing were abolished in 1604 when Parliament repealed the previous royal proclamations of Elizabeth I. During her reign the queen had frequently pronounced sumptuary proclamations that, like their French counterparts, attempted to enforce a vision of social hierarchy by limiting certain items of luxurious dress to members of the nobility or other high-ranking classes in society. The Stuart King James I who succeeded Elizabeth in 1603 wished to continue to legislate his subjects' clothing in this way, too, but in the later sixteenth and early seventeenth centuries, legislation enacted through royal proclamations had grown increasingly controversial in England. The English Parliament attempted to protect its prerogatives as the legislative power within the state by arguing that all regulation should originate under its supervision. In England, sumptuary legislation thus floundered on the disputes between Crown and Parliament that became increasingly common in the first half of the seventeenth century. Numerous new attempts to regulate dress at this time ultimately failed because of the constant wrangling that occurred between king and Parliament concerning the nature of their own powers and prerogatives. As these disputes came increasingly to take on the nature of a religious crisis between Puritanism and Anglicanism, disputes bristled in the country about clothing and the excesses of contemporary dress. The Puritans, in fact, supported a sober and restrained style, in contrast to the aristocratic Cavalier party that stood behind the Crown. Puritan settlers took the traditional regulations of sumptuary law to New England, where a host of restrictions on dress appeared in the seventeenth century. Yet in England itself restrictions on clothing disappeared, not because they were unpopular in and of themselves, but because of disagreements about how they should be formulated and enacted in the English state.

SOURCES

Frances Elizabeth Baldwin, *Sumptuary Legislation and Personal Regulation in England* (Baltimore, Md.: Johns Hopkins University Press, 1926).

Diane Owen Hughes, "Sumptuary Laws and Social Relations in Renaissance Italy," in *Disputes and Settlements,* Ed. John Bossy. (Cambridge, England: Cambridge University Press, 1983).

Alan Hunt, *Governance of the Consuming Passions: A History of Sumptuary Law* (New York: St. Martin's Press, 1996).

Catherine K. Killerby, *Sumptuary Law in Italy, 1200–1500* (Oxford: Clarendon Press, 2002).

FASHION TRENDS IN THE EARLY SEVENTEENTH CENTURY

SPANISH DOMINANCE. During the later sixteenth and early seventeenth centuries, the styles of Spain dominated throughout Europe. In the long reign of Philip II (r. 1556–1598) the country was undoubtedly the most powerful in the continent, enriched as it was through its New World colonies and vast European holdings. Despite financial and military setbacks in the second half of the sixteenth century, Spain dominated European affairs, and its manners and clothing were widely imitated by aristocrats and wealthy city people from Austria and Hungary in Central Europe to the Netherlands and France in the west. While Spanish style achieved a general acceptance throughout much of Europe in the later sixteenth century, its influence did not persist past the end of the first quarter of the seventeenth. Thus the great age of Spanish fashion in Europe coincided roughly with the period of the country's international prominence. After 1620, Spain's defeats in wars against its rebellious subjects in the Netherlands and its disastrous involvements in the religious and political intrigues of the Thirty Years' War in Central Europe left the country impoverished and in an increasingly weakened state on the international scene. Yet in the years that Spain's dominance over European affairs persisted, Europe's aristocrats and merchants tended to conform to the styles of the Spanish court and its royal officials, who came to be widely admired throughout Europe for the elegance yet severity of their deportment and the somber dignity of their clothing.

ELEMENTS OF SPANISH STYLE. In discussing the influence of Spain at this point in European fashion, a distinction must first be made between the styles of Spain itself and the ways in which they were interpreted and refashioned elsewhere in Europe. Spanish clothing was widely known and respected in Europe around 1600 for the skill displayed in its tailoring and the magnificence of its materials. Wealthy and aristocratic Spaniards favored dark and somber colors that set off their jewels and other elements of decorative trim. Elsewhere in Europe, the restraint evident in Spanish fashion was frequently jettisoned, and helped to inspire fashions that were more purely decorative. Indeed the period between 1580 and 1620 saw some of the most elaborate costumes appear in court societies throughout Europe, and these were notable for their exaggerated lines and sheer artifice. During the sixteenth century several Spanish innovations in dress had spread throughout Europe, including the farthingale, the cape, and the ruff. The far-

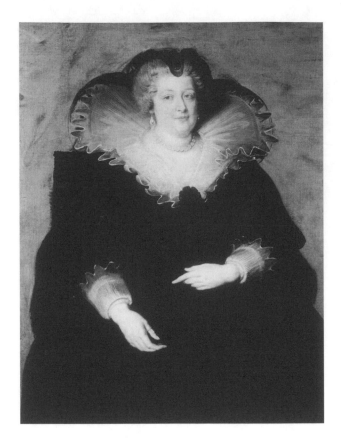

Portrait of Marie de' Medici, Queen of France by Peter Paul Rubens. © FRANCIS G. MAYER/CORBIS.

thingale was known in Spanish as the *verdugado*, and had first appeared as an element of women's dress in the country around 1500. The farthingale was a stiffened underskirt frequently outfitted with wood or whalebone hoops that made a woman's skirt stand out and fall into a cone-shaped pattern. Elsewhere in Europe this pattern inspired considerable innovations, as in France where farthingales appeared in the second half of the sixteenth century that were constructed in a simple drum rather than cone shape. By the end of the sixteenth century such skirts had often become very wide, as can be seen in many of the late portraits of the English Queen Elizabeth. To accentuate the lines of these English farthingales, it became common to tie a bum roll around a woman's waist so that the skirt stood out even further from the farthingale's structure. The ruff was a second popular Spanish style of the late sixteenth and seventeenth centuries and one that, like the farthingale, was open to an almost infinite variety of elaboration and reinterpretation. In Spain, these fashions for the neck were actually quite restrained, but with the introduction of starch throughout Europe in the later sixteenth century, they became quite large and complex everywhere else. The craze for the ruff's elaborate sculpted ripples and

cartwheel patterns reached its high point in the early years of the seventeenth century, but its popularity faded by about 1620. By contrast, the taste for cloaks or Spanish capes proved to be more enduring. The fashion for these loose-fitting outer garments had spread throughout Europe in the second half of the sixteenth century, and had showed considerable variety in length and cut. Cloaks were worn over both shoulders or artfully draped over just one. In Spain, capes had usually been constructed out of heavy and dignified cloth, but elsewhere in Europe, they, like other elements of Spanish dress, became elaborately decorated. The cloak had a perennial appeal as well. It persisted as a man's style throughout Europe for much of the seventeenth century, but was replaced in the 1670s by the French *justaucorps*, a long-fitted jacket worn over a shorter vest. In the eighteenth century, though, capes made a comeback, particularly as an element of evening attire.

CHARACTER OF THE SPANISH STYLE. Like much of the clothing of the later Renaissance, the Spanish styles of the late sixteenth and early seventeenth centuries that were popular among wealthy and aristocratic Europeans were notably complex, elaborate, and uncomfortable. The act of dressing itself was a complicated task for the wealthy, and the aid of servants was frequently necessary to apply many layers of clothing. In contrast to the modern world in which Westerners usually wear only under and outer garments, early-modern Europeans wore many separate items of dress that combined to create a complete ensemble. Women's outfits consisted of a farthingale, petticoats, corset, outer skirts, a bodice, sleeves, a stomacher (a decorative V- or U-shaped garment that was worn over the bodice), a ruff, and from time to time, other elements like the cape or the bum roll. Men's garments were also multi-layered, and consisted of stockings, hose or britches for each leg, undershirts, an outer doublet, a ruff, and a cape. Both men and women often wore corsets. In the period mind, beauty was not natural, but an achievement of human art. Clothing may have covered the human form, in other words, but it also attempted to improve upon it, changing the contours of the hips, the torso, and so on, so that the figure took on shapes that were not natural, but highly contrived and decorative. After 1620, many of these more artificial elements of style softened somewhat before fashions grew even more formal and contrived in the court dress of the later seventeenth century.

SOURCES

Max von Boehn, *Modes and Manners*. 4 vols. Trans. Joan Joshua (Philadelphia: J. B. Lippincott Company, 1932–1936).

James Laver, ed., *Costume of the Western World*. vol. 3, *Fashions of the Renaissance* (New York: Harper and Brothers, 1951).

Olga Sronková, *Fashions Through the Centuries: Renaissance, Baroque, and Rococo*. Trans. Till Gottheimer (London: Spring Books, 1959).

THE RISE OF THE NETHERLANDS

A VICTORIOUS REBELLION. Since the 1560s the counties of the Low Countries (modern Belgium and Holland) had been waging a war of independence against Spain. To protect Spanish authority in the region, Philip II had fortified his positions in the region that is today Belgium. At Antwerp, he had created a bastion of Spanish and Catholic authority, and the religious intolerance that became customary there eventually resulted in the migration of many Protestants and Jews from the southern Netherlands into the free counties of the north. The largest of the counties that comprised the United Dutch Provinces was Calvinist Holland, where the revolt against Spanish authority produced a burgeoning population and an increase in trade. In Amsterdam, the policies of relative religious tolerance fueled the economy's swift development during the seventeenth century, while at Antwerp to the south, trade and commerce stagnated. In this period, the southern Netherlands remained a center of elite learning and culture, while Holland became the center of a thriving trade empire. In this way Dutch influence spread throughout Europe through the region's many trading contacts with other important financial centers on the Continent.

CHARACTER OF DUTCH CULTURE AND COSTUME. Although a hereditary nobility existed in the United Dutch Provinces, the character of life throughout the region was shaped by its cities, where merchant and commercial activity dominated. The Dutch church was Calvinist, and despite the presence of numerous religious minorities in the region's cities, Calvinism shaped the ethos of the country. In dress, religious convictions came to be expressed in a fondness for dark colors and a less ornate and decorated style. In this regard Dutch clothing came paradoxically to imitate the somber fashions of Spain that had been prevalent in that country during the previous centuries. These styles had generally grown more elaborate and ornate as they had been accepted elsewhere in Europe, but now the rise of Dutch influence throughout Northern Europe in particular promoted an increasingly conservative and less artificial style. In contrast to the clothing worn in the previous generation, the fashions Dutch traders and merchants favored were less constricting and confining and more

comfortable. Corsets, farthingales, and other examples of late sixteenth- and early seventeenth-century artifice were now abandoned in favor of outfits that granted their wearers greater freedom.

DECORATION. Two of the most characteristic decorative items of the time were the ruff and lace. Lace, the product of an industry that had thrived in the Netherlands since the Middle Ages, was almost always confined in Dutch fashions to the wrists and neck. During the seventeenth century Dutch traders conducted a busy trade in lace, which was primarily woven by peasant and poor city women in the towns of Flanders in the southern Netherlands. In contrast to the strongly geometric patterns of the later Middle Ages and the sixteenth century, this Belgian lace became increasingly ornate after 1600, first incorporating floral patterns into its designs and then elaborate, running scrollwork patterns by the mid-seventeenth century. Somewhat later, small freestanding ornaments came to be inserted into the open weave of the fabric at regular intervals. The techniques used to produce these highly prized designs relied on a combination of methods that were both native to the region and which were imported from Italy. During the Middle Ages Belgian lacemakers had developed their art by weaving together threads from scores of bobbins assembled on a frame with hundreds of pins rising from its surface. The character of this work was fine, but angular in its orientation since the threads were woven around numerous pegs. In Venice and other Italian centers of lace weaving, producers had long relied on the needle to create designs that were more freely flowing. By the seventeenth century Belgian lace weavers had developed ways of combining both types of art, thus producing work that was highly prized throughout Europe for its great delicacy and imaginative designs. The trade in lace thus became a major source of revenue, as the bolts of fabric from the towns of the Southern Netherlands constituted major imports in England, France, and elsewhere on the continent. At the same time, the trim was notoriously expensive, and prompted efforts to copy the work. In France, for example, King Louis XIV's chief minister Colbert imported Venetian weavers and issued a royal grant to underwrite the establishment of a state industry in lace weaving in 1665. At Alençon, Rheims, and a number of other centers of production throughout France, he charged weavers with copying the most intricate patterns of Belgian and Venetian weavers, while at the same time prohibiting the import of any more of the trim. His efforts gradually bore fruit; by the end of the seventeenth century, lace produced in France—particularly at Alençon—had acquired a repu-

tation comparable to its Italian and Flemish sources of inspiration. Colbert's successful protectionist efforts to establish a native French industry were not duplicated elsewhere in Europe, where lace production failed to get off the ground as little more than a homespun pastime until the nineteenth century allowed for its production by machine looms. To stem the tide of Dutch lace imports, most states tried to limit demand for the finery. In this regard the restriction placed upon lace consumption in the mid-seventeenth century by the Puritan officials of the Massachusetts Bay Colony was typical: lace was forbidden to all but the wealthiest members of society. In this way its cachet as a sign of social distinction only rose in most people's estimation.

WOOL. Since the Middle Ages the traders of the Netherlands had been actively engaged in the marketing of woolen cloth, and the commerce in this valuable commodity had helped to transform the European landscape. Wool from England and Spain had long been the most coveted form of the material throughout Europe, and the increased demand for fabric necessitated that more and more arable land in these regions be given over to the raising of sheep in the fifteenth and sixteenth centuries. In England, wool was a vital part of the economy and had spawned a number of acts of enclosure in the country's parliament. In these laws the previously common lands of many towns and villages were turned over to producers, and the bitter controversies that these dispossessions caused was still a bitter memory in the country during the seventeenth century. The Puritan settlers who came to colonial North America, for instance, desired to protect the common lands of their villages in part because of their memories of the depredations that the wool industry had worked on England during the previous generations. The Dutch continued to trade in wool throughout the seventeenth century, yet at the same time the country's traders began to tailor their own clothing from the fabric, an innovation in a world where the wealthy had long favored silks and velvet. To this time, woolen cloth had been used for garments primarily by the lower classes who wove their own homespun or purchased cheap grades of the cloth. In wealthy urban and aristocratic circles, wool's use had been largely confined to stockings, undergarments, hats, and felt slippers. Yet wool was an imminently practical fabric, especially the worsted wools that became popular at the end of the Middle Ages. This new type of woolen cloth, named for the sheep-raising village of Worstead in Norfolk, England, was woven from the shearings of long-haired sheep and combed to produce a soft fabric that was surprisingly waterproof, resistant to wrinkling, and immensely

durable. The taste that Dutch merchants helped to inspire for garments fashioned from worsteds persisted into the eighteenth century before linens and eventually cottons surpassed their popularity. The new fashion for woolen garments also sustained the production of woolen cloth in England, the United Dutch Provinces' most active trading partner in the seventeenth century. By 1700 as much as two-thirds of the value of all British exports may have derived from the woolen industry, and outer clothing fashioned from wool had become a venerable staple in the wardrobes of Europeans.

LOCKS, LACE, AND LEATHER. Dutch elements of style spread easily through Europe because of the commercial contacts of this small but important trading region. The freer-flowing garments the Dutch favored were soon imitated throughout much of Northern Europe. Like the Spanish style that had preceded its rise, Dutch style was popular largely because of its ready adaptability to different circumstances. On the one hand, Dutch clothing styles provided a practical form of day wear for merchants, bankers, and other members of the urban middle classes in Northern European cities. The emphasis on a new informality and on comfort, as opposed to artifice, was enthusiastically embraced in Europe's cities, and the clothes that were favored there came to be relatively unadorned, even severe. Among aristocrats, though, elements of Dutch style continued to combine with a fondness for decoration, giving rise to courtly ways of dressing that favored generous amounts of lace and other trim by the mid-seventeenth century. By the 1630s, aristocratic dress in much of Europe had produced a style with a notable fondness for "locks, lace, and leather." This way of dressing can be seen in the many portraits of King Charles I of England and his Cavalier supporters, many of which were completed by the great Flemish artist Anthony Van Dyck in the 1630s. In one of these, *Charles I From Three Different Angles* (1636), the king's two profiles and frontal view are depicted sporting the elaborately curled long hair and lace collars that were then the aristocratic fashion of the day. Another portrait from the same year, *Charles I at the Hunt* shows all the elements then in vogue in noblemen's fashions, including a rakishly worn felt hat, an outer jacket or doublet worn over a lace shirt, and knee-length britches that met leather boots. The effect that such costumes produced was refined and elegant while at the same time allowing for greater comfort and freedom of movement than the fashions of the later Renaissance. In this way, then, the elements of Dutch style came to be combined with aristocratic tastes for luxurious opulence, and the fashions of the Netherlands, like those of Spain

before them, came to be transformed in ways that were very different from their original source.

SOURCES

James Laver, ed., *Costume of the Western World* (New York: Harper Brothers, 1931).

Olga Sronková, *Fashions Through the Centuries* (London: Spring Books, 1959).

Doreen Yarwood, *English Costume* (New York: Scribner's, 1956).

THE AGE OF LOUIS XIV

FRENCH CIVILIZATION. During the long reign of Louis XIV (1643–1715) France dominated affairs throughout Europe. Louis XIV assumed the throne when he was only five years old, and instability, revolt, and other troubles plagued his early years as king. During his minority his mother, Anne of Austria, and his chief minister Cardinal Mazarin dominated royal policy and administration. In the years following Mazarin's death in 1661, though, Louis came into his own, announcing his intentions to rule without the aid of his ministers. Over the next half century he devoted himself to his own glorification and that of France as the most powerful state in Europe. Although he planned to rule alone, Louis nevertheless relied on a series of ministers to place his stamp on royal policy and administration. The first years of his independence were notable for rising standards of luxury at court, increased patronage of the arts, and a consequent brilliant flowering of French high culture. In such figures as Jean-Baptiste Molière (1623–1673) and Jean Racine (1639–1699) in the theater and Jean-Baptiste Lully (1632–1687) in the musical world, French taste set the standards for Europe. While influencing the rest of the continent, French arts and learning were, in turn, affected by the absolutist political doctrines practiced by the king and his chief ministers. Music, literature, painting, and architecture all flowed from the royal academies that Louis XIV founded, or which he expanded. These institutions controlled the production of works of art and the training of those artists who worked at court. They promoted tenets of design that were frequently raised to the level of rules that were inflexible and bound French artists to emulate classical principles. At the same time, the crafts and industrial production served as tools of royal government, as Louis XIV and his most influential minister Colbert nourished native French industries. The reigning economic theory of the age was mercantilism, a philosophy that linked a nation's wealth to its money supply and which tried to foster

a PRIMARY SOURCE *document*

OF THE FINEST GOLD

INTRODUCTION: Madame de Sévigné was one of the great letter writers of the seventeenth century. Most of the beautiful correspondence she wrote was sent to her daughter, Madame de Grignan, a noblewoman who lived away from Paris and the court. Her mother kept her informed on many things, including the latest fashions and fabrics available in the capital. In this excerpt she describes how the latest style of "transparents" was introduced into court society through a gift made to Madame de Montespan, Louis XIV's then-reigning mistress.

So here I am. I dined with the good Bagnols and found Mme de Coulanges in that lovely room full of sunshine, where I have seen you so often, nearly as brilliant as the sun. The poor convalescent welcomed me warmly. She wants to write a few words to you,—it may be some news from the other world that you will be very glad to know. She told me about the transparents. Have you heard about transparents? They are complete dresses of the finest gold and azure brocade you could ever see and over them transparent black dresses, either of fine English lace or chenille velvet on gauze, like that winter lace you have seen. That is what transparent is, a black garment, and one all of gold or silver or any colour you like. That is today's fashion. Thus attired they had a dance on St Hubert's day, a dance that lasted half an hour, for nobody would dance. The King pushed Mme d'Heudicourt into it

by main force … Monsieur le Prince wrote from Chantilly to the ladies that their transparents would be a thousand times nicer if they would wear them on their lovely bare skin; I doubt whether they would look any better …

M. de Langlée has given Mme de Montespan a dress of gold on gold, all embroidered with gold, all eged with gold, and on top of that a sort of gold pile stitched with gold mixed with a certain gold, which makes the most divine stuff ever imagined. The fairies have secretly devised this work; no living soul knew anything about it. The way of delivering it was as mysterious as its making. Mme de Montespan's dressmaker brought her the dress she had ordered. He had made the bodice to ridiculous measurements, hence cries and complaints as you can imagine. The dressmaker said, all of a tremble, "Madame, as time presses, see whether this other dress might possibly suit you instead." The dress is displayed, "Oh, what a lovely thing! What material! Has it come from heaven? There is nothing like it in the world." The bodice is tried on; it is a picture. The King arrives; the dressmaker says, "Madame, it is made for you." It is realized that it must be a present but who can have given it? "Langlée," said the King. "It must be Langlée," said Mme de Montespan, "nobody else can have imagined such magnificence." "It's Langlée, it's Langlée," everyone repeats. The echoes are all in agreement and say, "It's Langlée!" So I, my dear, so as to be in the fashion, say, "It's Langlée."

SOURCE: Madame de Sévigné, *Selected Letters*. Trans. Leonard Tancock (Harmondsworth, England: Penguin, 1982): 214–215.

exports while limiting imports as a drain on national resources. The rise of mercantilist theory points to the importance of a "national economy" in seventeenth-century Europe. Louis XIV's ministers and officials carefully developed native industries in the production of lace, fabric, jewelry, and other consumables that might compete successfully against items that had long been imported from elsewhere in Europe. Although other centers of design and production continued to be important in seventeenth- and eighteenth-century Europe, the royal industries that Louis founded influenced styles throughout the continent, a testimony to the success of the royal policies that the king and his ministers practiced. By 1700, the idea of fashion in Europe was increasingly synonymous with the trends set by the French court and by wealthy aristocrats and members of the bourgeoisie who lived in and around Paris. As a result of these developments Paris emerged as the center of European fashions, a role that it has continued to play until contemporary times.

ZENITH AND DECLINE OF LOUIS XIV'S POWER. The centralized and absolutist policies of Louis XIV meant that the royal government in France dominated and controlled the country's economy and industries. At first, particularly under the leadership of Louis XIV's powerful minister Jean-Baptiste Colbert (1619–1683), these economic policies produced brilliant results. Later, in less capable hands, many of France's state industries underwent a period of stagnation before being renewed under Louis XV in the mid-eighteenth century. By the 1680s, though, most elements of Louis XIV's regulation of the French economy were in place. The state supervised everything from lace making to road building. At the same time Louis' grand pretensions and, in particular, his penchant for waging costly international wars intended to foster French preeminence meant that his state always rested on feet of clay. His desire to control his subjects' religious beliefs and economic activity proved increasingly problematic as well. In 1685, the king revoked the Edict of Nantes. Since 1598, the terms of this

royal edict had guaranteed a degree of religious toleration to French Huguenots, Protestants who held to the ideas of John Calvin. Under the influence of his pious second wife, the commoner Madame de Maintenon, the king's attitudes toward divergent religious ideas had grown increasingly inflexible. In the years following the Revocation, French Huguenots were forced to convert to Catholicism or leave the country. The migration of Huguenots to England, Germany, Holland, and colonial America proved detrimental to France's economic life, since many of them were important artisans and commercial figures. Yet the Revocation of the Edict of Nantes was only one of many measures that pointed to an increasingly rigid and high-handed royal administration. With the death of his chief minister Jean-Baptiste Colbert in 1683, Louis had been forced to rely on figures that were considerably less adept and who drew him into costly international wars. By the final years of his reign the advances that French industry and commerce had made paled in comparison to a mounting royal debt, corruption in public life, and an increasingly unpopular, yet nevertheless ambitious and grand, royal court. Although the king had been idolized and glorified throughout much of his life as the very epicenter of French life and culture, he ended his days as a widely unpopular figure.

CHARACTER OF COURT LIFE. Despite the long-term trends of Louis' reign, it is difficult to overestimate the importance that France's court life exercised on the imagination of Europeans during the seventeenth and eighteenth centuries. During his reign France's royal court became the major force in setting styles and fashions throughout European aristocratic society as nobles from throughout the continent imitated the elaborate etiquette that was practiced in France and adopted innovations in art and dress that had been pioneered in and around Paris. The stage on which many of these trends were set throughout Louis' reign was Versailles, the magnificent royal château that was located just outside Paris. During the 1660s Louis had begun to shower his attentions on this former royal hunting retreat, using it as a place for hunts, celebrations, and spectacles. In 1678, the king decided to expand the palace to truly grand proportions, and in 1682, he moved his government permanently there. At Versailles every element of daily life and court ceremonial was carefully choreographed and governed according to a formidable set of rules. These tactics were in large part a response to the series of rebellions known as the *fronde* that had occurred in and around Paris in 1648 and 1653. At one point in these revolts the underage king and his mother, Anne of Austria, had been forced to flee the capital and had even hid

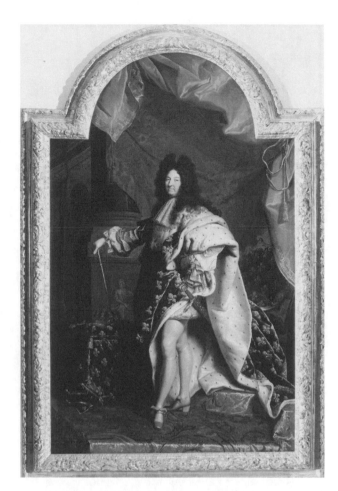

Portrait of Louis XIV, king of France. © ARTE & IMMAGINI SRL/CORBIS.

out for a time in a stable to avoid the angry crowds and rebellious aristocrats of Paris. To insure that he was never again subjected to such humiliation, Louis defined life in his court circle in ways that domesticated his nobles, transforming them into decorous but powerless courtiers. As was everything else in the life of the court, dress came to be dominated and defined by the figure of Louis XIV and his family. Certain costumes were prescribed for certain occasions, and among the small noble faction that surrounded the king during his reign, expenditures on clothing were truly profligate, often reaching standards of expenditure that were more than 100 times those of simple shopkeepers and artisans in the city of Paris. The number of aristocrats that attended the king at Versailles was relatively small, however, and the Parisian nobles who rarely attended court functions were far less lavish in their expenditures on clothing. Despite being confined to a relatively small portion of the aristocracy, the brilliant patterns of consumption at Versailles prompted criticism of the French nobility and aristocracy in general.

a PRIMARY SOURCE *document*

GRAND PREPARATION FOR A ROYAL WEDDING

INTRODUCTION: The Duc de Saint-Simon was one of the most brilliant diarists of Louis XIV's and Louis XV's court. In the following entry he recounts the preparations for Louis XIV's grandson, the Duke of Bourgogne's marriage to Princess Marie Adelaide of Savoy. The marriage occurred in 1697 during the period of austerity encouraged by the king's pious second wife, Madame de Maintenon. Despite the financial problems of the latter years of his reign, Louis decided to celebrate the marriage with great fanfare, causing everyone at court to try to outdo each other in the clothes they purchased for the wedding. Saint-Simon relates that there were scarcely enough tailors and workmen to finish the outfits, and one noblewoman even resorted to kidnapping workers from another job. The Duc de Saint-Simon and his wife ended up spending 20,000 *livres* on their outfits alone, enough to have fed many peasant families for several years.

The King continued to be delighted with the princess, who fully merited his affection by her extraordinary precociousness, her charm, intelligence, and response to his advances. He determined to lose no time after her twelfth birthday, which fell on 7 December, a Saturday, before celebrating the wedding. He let it be known that he would like the Court to be resplendent and himself ordered some fine clothes, although for years past he had dressed with the utmost simplicity. That was enough for everyone, excepting priests and lawyers, to disregard their purses, or even their rank. There was hot competition in splendour and originality, with scarcely enough gold and silver lace to go round and the merchants' booths emptied in a very few days; in a word, unbridled extravagance reigned throughout the Court and Paris, for crowds went to watch the great spectacle. The thing was carried to such a pitch that the King regretted ever having made the suggestion, saying that he failed to understand how husbands could be so foolish as to ruin themselves for their wives' clothes, or, he might have added, for their own. But he had slacked the reins; there was no time to remedy matters, and I almost believe that he was glad of it, for he loved rich materials and ingenious craftsmanship, and greatly enjoyed seeing all the fine clothes, praising the most magnificent and the best contrived. He had made his little protest on principle, but was enchanted to find that no one had heeded him.

This was not the last time that he so acted. He passionately loved to see every kind of splendour at his Court, especially on State occasions, and anyone who had listened to his protests would have found themselves sadly out of favour. Indeed, amidst so much folly there was no chance for prudence; many different costumes were needed, and Mme de Saint-Simon and I spent twenty thousand *livres* between us. There was a dearth of tailors and dressmakers to make up the fine garments. Mme la Duchesse took it into her head to send archers to kidnap those working for the Duc de Rohan, but the King learned of it and was not pleased; he made her return them immediately. It is worth noting that the Duc de Rohan was a man whom he actively disliked and never scrupled to pretend otherwise. He did something else that was particularly chivalrous, and showed how much he wished everyone to be smart. He personally selected a design for some embroidery to give to the princess. The embroiderer said that he would put everything else on one side so as to finish it. The King would not allow that; he told him most explicitly to finish all that he had on hand, and only then work on his order, and he added that if it were not finished in time the princess would do without it.

SOURCE: Louis de Rouvroy, the Duc de Saint-Simon, *Memoirs: A Shortened Version.* Vol I. Trans. Lucy Norton (London: Prion Books ltd., 1999): 96–97.

COURT DRESS. As he did in most other areas of court life, Louis XIV established rules and standards for the dress of his courtiers. Royal directives concerning clothing were quite specific. For instance, at each of the royal palaces and retreats that the court visited a different kind of court costume was prescribed. At the small palace of the Trianon at the far edges of the gardens of Versailles, men were expected to wear red embroidered with gold, while at the royal hunting lodge of Rambouillet, those who accompanied the king on hunts had to don blue outfits made of heavy fabric that were again embroidered in gold. As in most royal courts, the ceremony of presentation was an occasion that demanded a different kind of finery from the other balls, ceremonies, and festivities the court celebrated. No one might expect to move about in the court circles that surrounded the king without being formally presented to Louis XIV and the queen. For these ceremonies, women were expected to wear a dress with a tight-fitting bodice supported by a whalebone corset. Their dresses were required to have a long train and an opulent skirt, while the neckline had to be oval shaped and their sleeves short and decorated with profusions of lace. Most women's dresses on this occasion were made out of black cloth to underscore the solemnity of meeting the king and queen, although women who were in mourning sometimes wore white to emphasize the difference between their own personal tragedies and the public ritual of presentation. Men's

a PRIMARY SOURCE *document*

CLOTHING QUEEN MARIE-ANTOINETTE

INTRODUCTION: At Versailles, an unbending court etiquette defined almost every aspect of daily life. In the years following the French Revolution, Madame Campan, one of Marie-Antoinette's closest ladies in waiting, published her memoirs and described the often tiresome round of activities at court that were prescribed by royal protocol. Her description of the process of dressing the queen each day runs many pages, from which this excerpt describing the choosing of the queen's clothes is drawn.

The tirewoman had under her order a principal under-tirewoman, charged with the care and preservation of all the Queen's dresses; two women to fold and press such articles as required it; two valets, and a porter of the wardrobe. The latter brought every morning into the Queen's apartments baskets covered with taffety, containing all that she was to wear during the day, and large cloths of green taffety covering the robes and the full dresses. The valet of the wardrobe on duty presented every morning a large book to the first *femme de chambre*, containing patterns of the gowns, full dresses, undresses, etc. Every pattern was marked, to show to which sort it belonged. The first *femme de chambre* presented this book to the Queen on her awaking, with a pincushion; her Majesty stuck pins in those articles which she chose for the day,—one for the dress, one for the afternoon undress, and one for the full evening dress for card or supper parties in the private apartments. The book was then taken back to the wardrobe, and all that was wanted for the day was soon after brought in in large taffety wrappers. The wardrobe woman, who had the care of the linen, in her turn brought in a covered basket containing two or three chemises and handkerchiefs. The morning basket was called *prêt du jour*. In the evening she brought in one containing the nightgown and night-cap, and the stockings for the next morning; this basket was called *prêt de la nuit*. They were in the department of the lady of honour, the tirewoman having nothing to do with the linen. Nothing was put in order or taken care of by the Queen's women. As soon as the toilet was over, the valets and porter belonging to the wardrobe were called in, and they carried all away in a heap, in the taffety wrappers, to the tirewoman's wardrobe, where all were folded up again, hung up, examined, and cleaned with so much regularity and care that even the cast-off clothes scarcely looked as if they had been worn. The tirewoman's wardrobe consisted of three large rooms surrounded with closets, some furnished with drawers and others with shelves; there were also large tables in each of these rooms, on which the gowns and dresses were spread out and folded up.

For the winter the Queen had generally twelve full dresses, twelve undresses called fancy dresses, and twelve rich hoop petticoats for the card and supper parties in the smaller apartments.

She had as many for the summer; those for the spring served likewise for the autumn. All these dresses were discarded at the end of each season, unless, indeed, she retained some that she particularly liked. I am not speaking of muslin or cambric gowns, or others of the same kind—they were lately introduced; but such as these were not renewed at each returning season, they were kept several years. The chief women were charged with the care and examination of the diamonds; this important duty was formerly confided to the tirewoman, but for many years had been included in the business of the first *femmes de chambre*.

SOURCE: Madame Campan, *Memoirs of the Court of Marie Antoinette, Queen of France.* (Boston: Grolier Society, 1890): 156–158.

dress was even more highly prescribed on these occasions, although it was not as costly as women's. For men, the ceremony of presentation stretched over three days. On the first day, men were presented to the king in an elegantly embroidered *justaucorps*—a close-fitting, long coat that covered a man's britches and often had highly decorated long sleeves. This style had developed around 1670, and the justaucorps was usually worn over an interior vestcoat. These three pieces—justaucorps, vestcoat, and britches—formed the basis for the modern three-piece men's suit, but at the time the rise of this new fashion replaced a taste for elaborate britches known as *rheingraves* that had a wide leg and were decorated with elaborate lace flounces. With the new fashion for the justaucorps, French legwear gradually grew more restrained, and ornament came to be concentrated on the outer coat. On the second day of a man's presentation at court, he was expected to undertake a hunt with the king during which he had to wear a vest and britches of red cloth and an outer coat of grey cloth. Finally, on the third day, men were presented to the king's family, and were expected to wear another outfit that was less grand than that of the initial presentation to the king.

DRESS AT OTHER COURT OCCASIONS. Court life demanded specialized clothing for a number of occasions. Besides royal hunts and ceremonies of presentation,

Illustration of eighteenth-century English gentlemen's dress. **BETTMANN/CORBIS**.

life in Louis XIV's court witnessed a steady progression of banquets, balls, diplomatic receptions, and theatrical and operatic performances that required sumptuous clothing. The ceremonies of the king's and queen's rising—known as the *levée*—and of their *coucher*—that is, their retiring in the evenings—also became central features of Versailles' daily schedule. Daily mass, too, was another occasion that called for finery. During the seventeenth century the cost of clothing a courtier for these occasions rose to new, unprecedented heights, but even this level of expenditure was to be vastly outdone by the excesses of the eighteenth century that followed. Dress and gambling were the two greatest expenses of those several thousand nobles who attended the king at Versailles. For courtiers, a typical day in the life of Versailles began with the levée. Louis XIV divided his ceremony of waking up and dressing into two parts, which became known as the petit levée and the grand levée. At the petit levée the king was washed, shaved, and dressed by his most trusted courtiers, and he said his daily prayers before being presented to a larger circle in the grand levée that followed. About 100 nobles attended these events each day, and it became a great honor to be asked to assist the king on these occasions. Daily mass, the hunt,

and a tour through the gardens were other events that filled the day, but it was in the evening that court festivities really got underway. Beginning about six o'clock courtiers were entertained with plays, operas, several suppers, a ball, and gambling that stretched deep into the early morning hours. During all this time only members of the royal family were allowed to sit down; nobles who broke with this key rule of etiquette were dismissed from court. After catching a short nap in the early morning hours, the aristocrats who attended the king were expected to be elegantly dressed and coifed again to begin the new day by eight the next morning. This daily round of decorous, often frivolous activities was known to have physically, morally, and financially exhausted many nobles. Some fled court life rather than take part in the endless cycle. But for those who preferred royal offices and who desired to be at the center of power conforming to Versailles' routines was a necessary evil in obtaining the king's favor. At the same time the monotonous hum of royal social activity was not always constant. By the late seventeenth and early eighteenth centuries, increasingly bleak financial realities, the king's growing piety, as well as his advancing age meant that the cycle of Versailles' social events grew more subdued. Still, taking part in the

rituals of state within the palace proved even then to be a daunting and expensive affair. While minor innovations were made in court dress during the seventeenth and eighteenth centuries, the patterns that Louis XIV stipulated for both men and women persisted until the French Revolution in 1789. The Revolution swept away such patterns of dress and abolished the royal court, although the restoration of the monarchy in the nineteenth century brought with it new prescriptions for court attire. By contrast in England, court apparel came to be defined and influenced in large part by French examples in the eighteenth century, but these patterns of dress at court presentations were amazingly long-lived. Until the 1950s, those presented to the English king and queen were required to dress with many elements of clothing that had largely been set down in the 1700s.

SOURCES

Madeleine Delpierre, *Dress in France in the Eighteenth Century* (New Haven, Conn.: Yale University Press, 1997).

Alan Hunt, *Governance of the Consuming Passions. A History of Sumptuary Law* (London: Macmillan, 1996).

Daniel Roche, *The Culture of Clothing* (Cambridge, England: Cambridge University Press, 1994).

FASHION BEYOND THE COURT

CLOTHING SOCIETY AT LARGE. The fashions of the court of Versailles are among the best known in Europe during the seventeenth century, in large part because of the wealth of testimony that has been left behind in art and documents of the period. Outside these exalted circles, though, consumption of clothing was considerably less grand, even among those nobles who did not frequent Versailles or who went there only occasionally. Cloth was an expensive commodity, although it was one of the most universally produced items throughout Europe. For most of the seventeenth and eighteenth centuries the production of cloth was not mechanized as it was in the wake of the Industrial Revolution, but produced through a series of steps that have been described as a "putting out" system. Historians have described these techniques of production as "proto-Industrialization." In this system cloth merchants known as mercers, rather than entrepreneurs or investors, parceled out various parts of the production process to families. Raw wool was purchased and then given over in succession to carders, spinners, and dyers, who prepared the thread for weaving. Once the cloth had been produced by various categories of weavers, the fabric was again turned over to others who were responsible for finishing it and return-

ing it to the great cloth merchants who sold it. While these techniques provided for certain economies of scale that had been lacking in ancient and medieval methods of production, cloth was still an expensive commodity. Thus one of the most obvious distinctions in the early-modern world between rich and poor was in the amounts of fabric their clothes consumed. Female servants, by and large, did not wear floor-length skirts, but ones that reached only to the mid-calves or ankles. Male shopkeepers and workers did not wear the elegant embroidered justaucorps tailored from silk and other expensive fabrics, but instead wore chemises or shirts, vests, and jackets constructed of far less expensive cloth. Even a comparatively wealthy bourgeois woman did not waste fabric in trains and elaborate skirts that were common among the wealthiest aristocrats.

HOUSEHOLD INVENTORIES IN PARIS. Another picture of consumption patterns can be gleaned from the inventories compiled of household goods at death. These inventories were undertaken in order to levy inheritance taxes, and so some families may have eluded taxation by giving away part of the deceased's wardrobe before the inspector arrived. Still in a great city like Paris a number of these documents survive and their profusion has allowed historians to gauge consumption patterns in the city around 1700. At this time about three percent of the city's half million people were members of the nobility. Great diversity characterized these aristocrats, and many divided their time between the city, their country estates, and Versailles. Those with modest incomes consumed clothing in ways that were little different from prosperous artisans and merchants. But in wealth and splendor the value of the aristocracy's clothing as a group far outstripped even that of the wealthiest merchants in the capital, although the Parisian nobility, as opposed to those who resided at Versailles on a full-time basis, spent comparatively little of their wealth on clothes and jewels. Studies of the death inventories reveal that the average Parisian noble wardrobe, together with its jewels, was valued at around five to six percent of the family's total wealth. At the same time, the deep social divisions that existed in early-modern society become evident when the values of the wealthiest of the nobility's wardrobes are compared against those of modest workers and shopkeepers. The greatest noble families spent as much as 200-300 times more to clothe and adorn themselves as workers with modest incomes did. Thus sumptuous wealth and extravagant consumption existed side-by-side in Paris with relative economy, even privation. The consumption habits of Parisian aristocrats stand out in even greater relief when it is remembered that studies of death

inventories fail to take account of the substantial portion of the population who were vagrants and paupers, and thus were not subjected to inheritance tax. No group in the city was thus able to compete in splendor with the nobility, and although Parisian aristocrats may have been considerably more modest in purchasing clothes than those who surrounded the king on a daily basis, their standard of wealth vastly surpassed any other group in the city.

CLOTHING OF THE URBAN WORKING CLASSES.

The clothing of those who worked for a living in Europe's largest cities—artisans, shopkeepers, and day laborers—still showed great variety, and even the better off and poorer members of the working classes often tried to emulate, albeit on a far more modest scale, the clothes of wealthy aristocrats. Female domestic servants sometimes received the castoff clothing of their mistresses, which served as partial payment for their labor. These women sometimes remade these clothes to suit their own circumstances, reusing the vast quantities of material that had once been consumed in trains and elaborate skirts to fashion new garments. Like those men and women who served as tailors, milliners, and in the other industries related to the aristocratic clothing trade, the servants of the wealthy were often far better dressed than the poor day laborers or those in the humblest trades. Yet even at the bottom of the social spectrum, the poorest of French working women who were known as *grisettes* displayed a concern about their clothes. The term *grisette* had its origins in the simple gray woolen cloth out of which these women's dresses were usually cut. In literature of the eighteenth and nineteenth centuries grisettes were frequently charged with having exaggerated romantic sensibilities, for falling prey to unscrupulous men, and for sliding into the world of prostitution that existed just below their class. At the same time grisettes, it was often observed, had a single outfit reserved, much like modern "Sunday best," for special occasions. While these outfits were usually made from materials that were far cheaper than the clothes of upper-class women, they often imitated the kinds of fashions worn in aristocratic circles. Such outfits provided a release from the drab functionality of everyday dress. The grisette's custom of wearing these outfits at public events on holidays and special occasions points to the increasing importance that clothing had in the eighteenth-century world as a marker of social distinction for all urban people. A poor working-class woman, anxious to better her social circumstances, saw clothing as an avenue to advancement, and as she dressed for public events after the working day, she aimed to project an image of higher social standing to attract suitors. At the same time, her efforts marked her, in the minds of those from higher classes, as an upstart, and spawned criticism and ostracism.

THE CLOTHING INDUSTRY. At almost all layers of society, clothing was in constant circulation. Jackets, shirts, and linens were passed on as prized possessions to sons and daughters. Clothes were also used to settle bills with merchants, as part of the annual pay given to servants, or they were frequently sold or exchanged with secondhand dealers once they had outlived their usefulness. Even the wealthiest aristocrats often rented the outfits and jewels they required to attend court functions or to be seen at fashionable weddings and other social events. At Versailles and other royal palaces, the dictates of Louis XIV allowed all Frenchmen free entrance, provided they possessed the required hats and clothes. Such decrees stimulated the growth of rental merchants, who established themselves at the gates of Versailles and other royal palaces to rent the required dress to those who wished to gain entrance. In Paris, by contrast, more than a third of the population may have been employed in all facets of the clothing industry, that is, from the finishing and sale of cloth to the making of fashion accessories like wigs. At the apex of the Parisian clothing industry stood the mercers (purveyors of fabric), drapers, tailors, and wigmakers, many of whom set up shops in the area around the Palais Royal in the center of the city and in other fashionable quarters in town. Tailoring was a profession that required a great deal of training, and consequently tailors commanded large fees for the production of their made-to-order clothing. Beneath the shops of the greatest tailors, milliners, and wigmakers, though, was a diverse network of cheaper clothiers, secondhand dealers, and other producers. Cobblers, fan-makers, glovemakers, milliners, and furriers were just a few of the many professions that made up the clothing industry, although many of the city's population consumed clothes that were bought secondhand, or that were cheaply made at home or by seamstresses, rather than by the artisan tailors who catered to the wealthy.

THE RISE OF LINEN. One change during the seventeenth and eighteenth centuries that made a big impact on consumption habits was the increasing use of linen. Linen, a fine cloth made of threads woven from flax, had been in use to dress beds and to produce underwear for the wealthiest Europeans since the Middle Ages. After 1700, however, linen's use grew enormously throughout society, and the linen industry emerged as an important part of the European fashion world. Linen became a sign of social distinction as well as a marker of

a PRIMARY SOURCE document

A THEFT OF FINE LINEN

INTRODUCTION: As he matured, the French Enlightenment thinker Jean-Jacques Rousseau came to realize the futility of trying to keep up with contemporary styles. He gave up all attempts to emulate the wealthy bourgeoisie and aristocracy, with their frequently changing clothing patterns and instead practiced a relative economy. Of all the elements needed by a gentlemen in the eighteenth century, clean linen was one of the most important, and despite Rousseau's relative economy, he continued to keep a wardrobe that contained 42 linen shirts. One Christmas Eve, though, his collection was stolen, and thus Rousseau was deprived of the last element of a gentleman's wardrobe.

However austere my sumptuary reform might be, I did not at first extend it to my linen, which was fine and in great quantity, the remainder of my stock when at Venice, and to which I was particularly attached. I had made it so much an object of cleanliness, that it became one of luxury, which was rather expensive. Some person, however, did me the favor to deliver me from this servitude. On Christmas Eve, whilst the women-folk were at vespers, and I was at the spiritual concert, the door of a garret, in which all our linen was hung up after being washed, was broken open. Everything was stolen; and amongst other things, forty-two of my shirts, of very fine linen, and which were the principal part of my stock. By the manner in which the neighbors described a man whom they had seen come out of the hotel with several parcels whilst we were all absent, Thérèsa and myself suspected her brother, whom we knew to be a worthless man. The mother strongly endeavored to remove this suspicion, but so many circumstances concurred to prove it to be well founded, that, notwithstanding all she could say, our opinions remained still the same: I dared not make a strict search for fear of finding more than I wished to do. The brother never returned to the place where I lived, and, at length, was no more heard of by any of us. I was much grieved Thérèsa and myself should be connected with such a family, and I exhorted her more than ever to shake off so dangerous a yoke. This adventure cured me of my inclination for fine linen, and since that time all I have had has been very common, and more suitable to the rest of my dress.

SOURCE: Jean-Jacques Rousseau, *The Confessions of Jean-Jacques Rousseau*. Trans. William Conyngham Mallory (New York: Tudor Publishing, 1928): 561–562.

one's personal standards of cleanliness. If eighteenth-century Europeans still did not change their linen undershirts, chemises, and underwear every day as most modern people do, it was important in urban society to present an image of freshly starched collars, sleeves, and wristbands. Dirty linen became increasingly synonymous with slovenly behavior and sexual disorder. Armies of laundresses were needed to care for the sheets, shirts, napkins, and tablecloths of urban households, and in the countryside, thousands of linen weavers churned out various levels of finery in the cloth. In his *Confessions* the French Enlightenment philosopher Jean-Jacques Rousseau (1712–1778) related his misfortune in suffering the theft of his linen shirts one Christmas Eve. While the family was at religious observances, someone stole 42 of the garments from the philosopher's home. By this time in the philosopher's life, he wrote, he had already come to realize the vanity of style, and the theft freed him from his last remaining tie to middle-class respectability. Although Rousseau's comments were, in part, a condemnation of the reigning fashion for linen, many Europeans seem to have shared his youthful consumption habits, and with the spread of industrialized production techniques in the later eighteenth century, the fashion for linen became even more deeply entrenched into European society.

THIEVERY. Jean-Jacques Rousseau's experience with his linen demonstrates another trend that was common to the age: theft of clothing. Since clothing was a necessary, yet expensive commodity it was subject to frequent theft. In fact, one recurring literary motif of seventeenth- and eighteenth-century literature portrayed the sellers of used clothing—a key industry in all European cities—as dealers of stolen goods. In reality, the evidence suggests that these poor shopkeepers and peddlers were generally honest business people whose activities were well supervised by the police. In Paris, most used-clothing sellers were women, and, in fact, during the seventeenth and eighteenth centuries they seemed to have played a key role in identifying to the police groups of criminals who were stealing clothes and trading in them on a black market. In Paris, the trial records from the eighteenth century reveal a steadily increasing number of complaints of clothing thievery. This type of theft seems to have been practiced mostly in Paris' poorer quarters, as the poor robbed the poor. Yet in the later decades of the century, the victims of many of these thefts came from the wealthy aristocracy and bourgeoisie

of the city; evidently thieves were becoming more brazen and selective in the choice of items that they stole. This evidence thus points to the importance that new standards of consumerism were producing in a country like France, as even the poor desired to possess and trade in the items prized by upper-class society.

DRESS BEYOND THE CITY. Although the clothing styles worn in the continent's cities are better documented than those of the surrounding countryside, the vast majority of Europeans in the eighteenth century were peasants who were relatively unaffected by the fashions generated in urban society. In some regions the percentage of people that lived on the land was more than eighty or ninety percent of the total population. While in some areas close to large cities country men and women emulated some dimensions of the urban world, much of Europe still lived in relative isolation from those styles. It is consequently inappropriate to use the words "fashion" or "style" to describe the clothing worn by the large and diverse class of Europe's peasants. The wealthiest members of this class certainly possessed resources comparable to artisans and tradespeople in the cities. Yet almost everywhere, most peasants were relatively unconcerned with emulating the styles they saw when they brought their wares to urban markets. The clothes these men and women wore were most influenced by necessity, and their patterns of dressing changed only very slowly over time. The fabric used for peasant clothes were homespun or cheaply purchased woolens, linens, and sometimes even cloth woven from hemp, the raw material for rope. Although there was considerable regional variation in the clothes that peasant men and women wore, common items of dress were nevertheless shared across much of the European peasantry. Costly dyes used in urban clothes were not common in the fabrics used in peasants' outfits. Instead, men's clothing were most often brown, grey, and black, while women's outfits expanded on these basics with occasional flares of blue, yellow, and red. The shoe, an invention of the late fifteenth century, was common in the countryside, although in many parts of Europe peasants continued to wear wooden clogs or wooden soled leather footwear known in French as *sabots*. Peasant women did not wear corsets or *paniers*, the elaborate hoop contraptions used to extend the line of a woman's hips. Instead, an almost universal outfit consisted of a calf- or shin-length skirt gathered at the waist. Over the top of this garment, women wore an apron that sometimes included a bib that covered their fitted undershirts and bodices. Lace caps were a common form of headgear, while scarves were often worn around the shoulders, the ends of which were sometimes tucked into the bodice. Almost everywhere, men wore a form of britches and a vestcoat overtop a linen, wool, or cotton shirt. Generally, decoration and embellishment were spare on peasants' clothes, a sign of these garments' function as a creation of necessity, rather than of style.

SOURCES

Madeleine Delpierre, *Dress in France in the Eighteenth Century* (New Haven, Conn.: Yale University Press, 1997).

Alan Hunt, *Governance of the Consuming Passions. A History of Sumptuary Law* (London: Macmillan, 1996).

Daniel Roche, *The Culture of Clothing* (Cambridge, England: Cambridge University Press, 1994).

THE HIGH TIDE OF FRENCH FASHION

FRENCH INFLUENCE ON EUROPE. During the second half of the seventeenth century France had emerged as the pre-eminent state in Europe under the rule of Louis XIV. Although the king's reign was plagued with problems, particularly in the years after 1700, France's hold over the cultural imagination of Europe in the eighteenth century remained strong. During the eighteenth century, Paris, one of Europe's true metropolitan cities, continued to be the center of the fashion industry. Parisian fashions were avidly followed elsewhere in Europe, and the dress of the eighteenth century acquired a feature that it has possessed until present times: its frequent changeability and constant alteration to suit stylish society's sense of the times. It was not until the later years of the eighteenth century that the notion of an "annual fashion season" really took off and became a feature of urban societies throughout Europe. But throughout the century the forces that made fashion an infinitely alterable landscape—subject to subtle modulations of whims, fancy, and tastes each season—were gathering steam in Paris. In the early years of the eighteenth century, French fashion dolls outfitted in the latest examples of court and city dresses were sent out from Paris to merchants and royal courts throughout Europe. These dolls were displayed in shop windows and kept women abreast of the latest trends in France. Later in the century, the fashion magazine replaced these dolls, performing much the same task of keeping women up to date on changes in style. The fashion magazine thus provided a cheaper and more convenient way to inform women of the latest changes in taste, and allowed for the circulation of fashion knowledge among an even broader range of society. Through these marketing innovations France secured a position in the world of European dress that it continues to hold even in contemporary times.

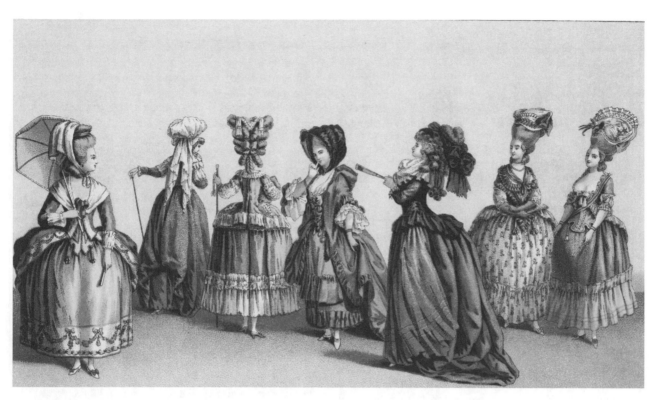

Mid-eighteenth-century women's fashions. BETTMANN/CORBIS.

NEW LIGHTER AND MORE DECORATIVE STYLES.
The French fashions that eventually conquered Europe were not the elaborate and imposing ceremonial dress typical of Louis XIV's Versailles, but a new sort of clothing that reflected the changing tastes of the eighteenth century. In the years following the death of Louis XIV, the tastes of wealthy Parisians began to change rather quickly. The new king, Louis XV, was the great-grandson of the Sun King, and when he acceded to the throne he was only five years old. His uncle Philippe, the Duke of Orléans, served as his regent. In the later years of Louis XIV's reign, the king's increasingly rigid piety and France's involvement in costly and draining international wars had given a tone of gravity to the times. Although the French state was heavily indebted at the time of Louis XIV's death, the Regent Philippe favored styles and fashions that were lighter and less grave than those of Louis XIV's era. Despite France's problems, the early years of Louis XV's reign were notable for the appearance of a new "Regency Style," a style actively supported by the Duke of Orléans. Philippe moved France's government from Versailles back to Paris, where a glittering aristocratic society was just beginning to develop the salons and other social institutions that were to discuss the ideas of the Enlightenment. In the houses of the wealthiest Parisian nobles a new fashion emerged

for rooms that were filled with light and with splashes of gold. The art used to fill these spaces suggested scenes of everyday enjoyment, that is, of popular pastimes undertaken in parks, at fairs, or in the countryside. New fabrics made use of patterns inspired by Chinese or Arabic designs that gave an exotically foreign taste to the interiors of the time. Thus the Regency fashions that flourished in France during the later 1710s and 1720s laid the foundations for the elegant, yet light and sprightly features of Rococo style that by the mid-eighteenth century defined upper-class tastes.

THE TRIUMPH OF THE ROCOCO AT COURT. Although these new standards of taste were rather quickly adopted in Paris, the dress of the court was at first barely touched by them. The prescriptions of Louis XIV on dress in court circles continued to be respected, particularly at formal state occasions. But by the 1730s and 1740s the winds of change in clothing styles were having their effect even there. Although Louis XV moved the government back to Versailles and relied on the elaborately formal etiquette of his great-grandfather's time, he carved out a private world for himself, his mistresses, and family in the grand palace that reflected the lighter, less serious tastes of the era. In the 1730s he redecorated an apartment of private rooms in the palace in the new less ponderous fashions of the day. He relaxed the ob-

a PRIMARY SOURCE *document*

A MORNING GOWN

INTRODUCTION: Eighteenth-century men and women of fashion were avid consumers, and men were every bit as well informed about the latest fashions for women as their female counterparts. In the following excerpt from Samuel Richardson's novel, *Clarissa*, the male character Lovelace describes the attire of his love in the most minute detail

Thou hast heard me also describe the wavy ringlets of her shining hair, needing neither art nor powder; of itself an ornament, defying all other ornaments; wantoning in and about a neck that is beautiful beyond description.

Her head-dress was a Brussels-lace mob, peculiarly adapted to the charming air and turn of her features. A sky-blue ribband illustrated that. —But altho' the weather was somewhat sharp, she had not on either hat or hood; for, besides that she loves to use herself hardily (by which means, and by a temperance truly exemplary, she is allowed to have given high health and vigour to an originally tender constitution), she seems to have intended to shew me, that she was determin'd not to stand to her appointment. O Jack! that such a sweet girl should be a rogue!

Her morning-gown was a pale primrose-colour'd paduasoy: The cuffs and robings curiously embroider'd by the fingers of this ever-charming Arachne, in a running pattern of violets, and their leaves; the light in the flowers silver; gold in the leaves. A pair of diamond snaps in her ears. A white handkerchief, wrought by the same inimitable fingers, concealed—O Belford! what still more inimitable beauties did it not conceal! —And I saw, all the way we rode, the bounding heart; by its throbbing motions I saw it! dancing beneath the charming umbrage.

Her ruffles were the same as her mob. Her apron a flower'd lawn. Her coat white satten, quilted: Blue satten her shoes, braided with the same colour, without lace; for what need has the prettiest foot in the world of ornament? Neat buckles in them: And on her charming arms a pair of black velvet glove-like muffs, of her own invention; for she makes and gives fashions as she pleases. Her hands, velvet of themselves, thus uncover'd, the freer to be grasp'd by those of her adorer.

I have told thee what were *my* transports, when the undrawn bolt presented to me my long-expected goddess. —Her emotions were more sweetly feminine, after the first moments; for then the fire of her starry eyes began to sink into a less-dazzling languor. She trembled: Nor knew she how to support the agitations of a heart she had never found so ungovernable. She was even fainting, when I clasp'd her in my supporting arms. What a precious moment That! How near, how sweetly near, the throbbing partners!

By her dress, I saw, as I observ'd before, how unprepar'd she was for a journey; and not doubting her intention once more to disappoint me, I would have drawn her after me. Then began a contention the most vehement that ever I had with lady. It would pain thy friendly heart to be told the infinite trouble I had with her. I begg'd, I pray'd; on my knees I begg'd and pray'd her, yet in vain, to answer her own appointment: And had I not happily provided for such a struggle, knowing whom I had to deal with, I had certainly failed in my design; and as certainly would have accompanied her in, without thee and thy brethren: And who knows what might have been the consequence?

SOURCE: Samuel Richardson, *Clarissa*. Vol. III. (1748; reprint, Stratford Upon Avon: Basil Blackwell Oxford, 1930): 28–29.

servance of sumptuary regulations in France, helping to sponsor an era of magnificent display and seeming abundance. During his long reign, women at court and in Paris's wealthy aristocratic circles played a new role as arbiters of fashion. The expenditures of aristocratic women on clothing were by this time about twice that of men, and the greatest women of Louis XV's court—including his most powerful and enduring mistress, Madame de Pompadour—defined the fashions of the era, giving rise to an era of Rococo indulgence and opulence that now seems in most modern people's minds to be synonymous with the style of the entire eighteenth century.

ROCOCO WOMEN'S FASHIONS. The chief innovation of the period in women's dress was the garment that became known throughout Europe as the *robe à la française*, a gown that was worn over a bodice decorated with a stomacher (a decorative V- or U-shaped garment) and outfitted with hoops or paniers that supported its skirt. The gown was parted in the middle to form a V-shaped opening that allowed contrasting or identical underskirts to show through, thus creating an impression of an abundance of cloth and material. In the 1740s, these styles were often decorated with a profusion of bows, lace, elaborate braidwork patterns, or embroidery, and the sleeves of the gown were cut to make elaborate flounces at the elbows that were usually decorated with lace. While trains were common in the early years of the *robe à la française*'s appearance, they tended to be ever more re-

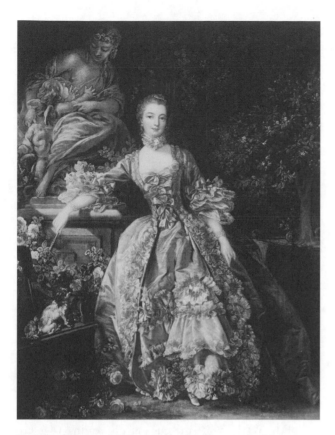

Portrait of Madame de Pompadour wearing a robe à la française. HISTORICAL PICTURE ARCHIVE/CORBIS.

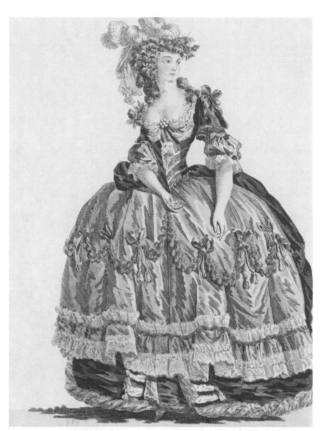

Eighteenth-century French court gown. © HISTORICAL PICTURE ARCHIVE/CORBIS.

stricted to court circles, where the train was an obligatory element of dress. During the 1740s and 1750s the hoops or paniers of these skirts grew progressively wider. The fashion soon became popular among wealthy and aristocratic women almost everywhere in Europe, spawning regional variations. In England and Scotland, for example, women had abandoned the broad hoops typical of French gowns of this type by the 1750s, and instead favored only small side hoops at the hips or no hoops at all. The resulting innovation made their skirts trail elegantly behind them on the ground as they walked. The *robe à la française* became one of the most popular upper-class fashions throughout Europe, and it reflected the reigning taste for costly silks, brocades, and floral patterned fine cloth of the day. Many of the fabrics used in these costly creations also reflected the taste for Chinese and Arabic motifs, and during the 1760s and 1770s, the rising popularity of cotton meant that the garment came to be made out of this fabric as well. At court, more elaborate dresses constructed of taffeta, brocade, and other expensive fabrics remained the rule, but cotton offered the advantage of quicker production times, and thus a cheaper price tag, bringing the elegance of the *robe à la française* into the reach of a broader number of women in society. Many of the new

cotton fabrics used at this time for dresses were printed, rather than woven from colored thread, thus greatly simplifying their production. Of all the cotton manufactories that turned out cloth used in these elaborate aristocratic fashions the most famous was the French factory at Jouy, near Versailles, an institution that gave its name to the *toile du Jouy* fabric popular in the second half of the eighteenth century. Louis XV had acquired this industry in 1760 at the instigation of his one-time mistress Madame de Pompadour. For many years, Madame de Pompadour and her circle at Versailles had disregarded royal regulations against the wearing of richly printed fabrics, fabrics long acquired from foreign sources. Pompadour's daring fashion innovations were thus a force that encouraged Louis XV in his plans to found a national industry for the production of printed cloth. The Jouy factory turned out a succession of prints that were filled with exotic Chinese, Arabic, and Indian motifs as well as scenes of everyday life. Since their appearance, these prints have become known in most European languages merely as *toile*. The influence of the fabric stretched throughout Europe and the many high-quality cotton prints produced there were avidly copied elsewhere.

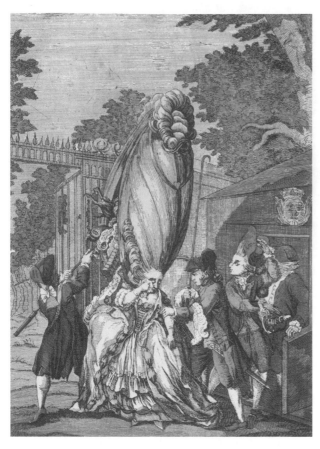

Eighteenth-century French caricature showing a woman weighed down by her wig. BETTMANN/CORBIS.

MEN'S WEAR IN THE MID-EIGHTEENTH CENTURY. For most of the eighteenth century the three-piece ensemble that included a justaucorps, vestcoat, and britches remained the dominant pattern of male dress in French aristocratic society and came to be adopted throughout many parts of Europe. This style had first appeared during the late 1660s at Versailles and in Paris, and it continued to be elaborated upon in the eighteenth century. By 1700, the justaucorps worn at court occasions had become increasingly tight fitting, and was now embroidered at its front opening with gold and silver thread or with lace made from these precious metals. Floral patterns eventually gave way on the justaucorps to more restrained patterns of embellishment, while the interior vestcoat tended to become ever more elaborate in its decoration. It was not uncommon for the decoration on these jackets and vestcoats to cost a great deal more than the velvets, silks, and taffetas out of which they were constructed. The colors used in the most elaborate of these male costumes in the first half of the eighteenth century now appear quite garish to modern eyes. Such dress, though, was worn in the evening, when the glow of candlelight softened the ef-

fect and refracted the light brilliantly off the bright metal surfaces and precious gemstones that were used to decorate the buttons. In England and the Dutch Republic, patterns of male dressing were far more restrained than in France or Germany. The Protestant ethos of these countries made the elaborate display typical of Continental dress seem too opulent for daily wear. English men were said to prefer browns, dark grays, blacks, and blues, and although aristocratic men donned costumes for ceremonial occasions at court that were almost as grand as those of their Continental counterparts, men's costumes were, on the whole, restrained in England when compared to France. Men generally avoided a great profusion of decoration on the clothes they wore on the streets of London or Amsterdam. In contrast to the many different kinds of women's dresses that were popular throughout Europe and the many variations that existed in women's wear for different occasions, men's fashions were relatively standardized in much of Western Europe by the eighteenth century. The three pieces that comprised men's primary wardrobe—britches, vestcoat, and justaucorps—were common to men of affairs and commerce almost everywhere, and were only distinguished by the wealth of their fabrics and decoration.

THE WIG. While the custom of wearing wigs had been common in the ancient world, it had generally died out in medieval Europe where religious leaders taught that false hair was a sinful indulgence. During the sixteenth century, though, the elaborate styles of hair worn in Renaissance cities saw the popularity of hairpieces grow among women. Queen Elizabeth had more than eighty of these to dress her hair in the elaborate hairdos of the period, while her cousin, the ill-fated Mary Queen of Scots, was also known for her great quantities of false hair. During the seventeenth century wigs had first become common as menswear at the French court of Louis XIII (r. 1610–1643). For the first years of his reign, his son and successor Louis XIV avoided wearing wigs since he was generally proud of his full head of hair. Still the custom grew among Louis's courtiers, many of whom relied on wigs to imitate the young king. The years of the mid-seventeenth century saw wigs make their way into the fashions of the age, since the tastes of the era favored long male locks that were elaborately dressed into curls. When Louis XIV began to go bald around 1670, he, too, succumbed to the fashion for wearing wigs, and false hair among French men became all the rage. King Charles II and his court established the practice in later seventeenth-century England, and by 1700, the wig was required menswear in English cities, reaching the zenith of its popularity in the first few years of the new century. As wigs became a common fashion accessory for men, their shapes

and forms altered. Originally intended to serve as a replacement for men's hair, the wig functioned more and more like an element of fashion. The colors favored grew increasingly fantastic, first evidencing a flair for grey and white, later for such colors as pink, blue, and lavender. In England and elsewhere in Europe, the styles of wigs men wore also reflected their station in life, with men of the law generally favoring a different kind of *peruke*, as they were then known, than merchants or country gentlemen. Although wigs continued to be worn by men after the first two decades of the eighteenth century, they were gradually confined more and more to ceremonial occasions and to circles of the nobility. Women, by contrast, retained a fondness for false hair much longer than men, although even among women a new fashion for more naturalistic hairstyles developed in the last decades of the eighteenth century. During the Rococo period, women's hairstyles frequently grew to enormous heights. Women's wigs were sometimes outfitted with replicas of model ships, dressed with turbans in imitation of Arabic styles, or with pompoms constructed of fur and feathers (a style inspired by Louis XV's mistress Madame de Pompadour), and with other excesses that were frequently mocked and caricatured even at the time. Urban legends grew about women whose wigs had harbored nests of vermin, and the doors of carriages grew higher to accommodate the styles. Stories of court women who had to hold their heads outside carriages to avoid spoiling their hairdos were common. These styles came to a high tide of popularity in the 1760s and 1770s before beginning to wane. In the years that followed, a taste for more naturalistic, less artificial hair fashions grew, so that by the 1780s women in portraits were seen sporting rather simple lace caps or restrained hats placed atop free-flowing, seemingly natural hair.

SOURCES

Millia Davenport, *The Book of Costume* (New York: Crown Publishers, 1948).

Madeleine Delpierre, *Dress in France in the Eighteenth Century* (New Haven, Conn.: Yale University Press, 1997).

Aileen Ribeiro, *Dress in Eighteenth-Century Europe, 1715–1789* (London: B. T. Batsford Ltd., 1984).

SEE ALSO *Architecture: The Rococo in the Eighteenth Century*

REACTION TO THE ROCOCO

CHANGING TASTES. During the 1770s fashion began to change in Europe rather quickly. By this time the

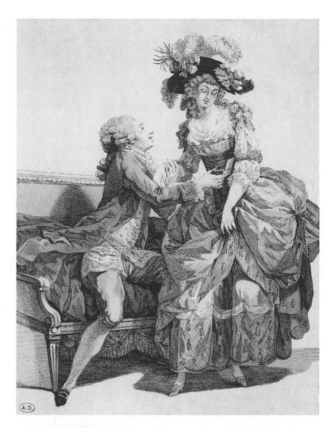

Engraving after a painting by Louis Joseph Watteau showing fashionable French dress around 1785. THE ART ARCHIVE/ BIBLIOTHÈQUE DES ARTS DÉCORATIFS PARIS/DAGLI ORTI.

tendency toward opulent decoration and to fanciful and fantastic clothing seemed to many to have been spent. While richly decorated women's dresses and men's suits remained popular in some court circles for a time, new and simpler styles first began to appear in England and then to spread to Continental Europe. English fashions, although profoundly influenced by the French throughout the eighteenth century, had long evidenced a fondness for simpler and less artificial lines than those popular in France. French innovations, such as the use of elaborate paniers or hoop skirts, had been widely popular in the country among women, but had given rise to native innovations. By the 1750s, English women began to abandon the paniers altogether or merely to favor hip pads that widened this area of the body. They also began to wear dresses in which the cloth was gathered and elegantly arranged to flow toward a woman's back. The reigning fashion common among upper class and aristocratic women in England became known throughout Europe as a *robe à la anglaise,* or "English robe." It was simpler than its more elaborate French counterpart, but no less feminine. Where the *robe à la française* had been open at the front to reveal a woman's corset, bodice, and

a PRIMARY SOURCE document

KEEPING ABREAST OF STYLE

INTRODUCTION: Before the advent of fashion magazines at the very end of the eighteenth century, much knowledge about the latest trends circulated in the letters that aristocratic and wealthy women wrote each other. The following excerpts from Betsy Sheridan, an English gentlewoman, were written to her sister, who lived in provincial Dublin to try to keep her abreast of the latest changes in fashion.

1785. Tunbridge Wells.—Now for Article of fashions. I like your habit very much. I hope you wear no powder, all who have fine hair go without and if you have not quite enough 'tis but buying a few curls. ... My Habit tis what they call Pitch colour—a sort of blackist green not beautiful but the most stilish now worn. Dark blues are very general—indeed all dark colours are fashionable. Cambric frills and white waistcoat. Rather large yellow buttons.

Washing gown of all kinds are the ton. ... As a Dress gown I have brought down a Robe à la Turque—violet colour—the peticoat and vest white–Tiffany, gauze and pale yellow ribbons—with that a sash and buckle under the Robe. Gauze gowns and clear muslin gowns are very much worn in full dress. ... Miss Belsay has taken a particular fancy to every article of dress she has seen me wear and frequently applys for patterns, this I most readily comply with.

1786. London—However you may tell her as a friend gradually to reduce her Stuffing as Rumps are quite out in France and are decreasing here but can not be quite given up till the weather grows warmer. The handkerchiefs are not so much puff'd out ... the hair loose—curls without pins and the toupée as if it was curled and a comb run thro' it. Aprons very general, chiefly tucked. Most fashionable collours dark green, pale straw collour, and a very bright purple.

1788. Hats are also worn, like riding hats. The Hair universally dress'd very loose in small curls. ... As to gowns—all kinds—Chemises, Round gowns, with flounce or not. Great coats made very open before to shew the peticoat. ... I must add to my chapter of Fashions that fur Muffs (very large) and Tippets are universal.

1789. Wednesday they all sup here and there is to be quite a crowd so I make up a new dyed sattin Gown for the occasion. We are to have the Prince, Duke of York, Mrs. Fitzherbert, all the fine people. ... We are all busy making our gowns and aprons for tomorrow Evening so I must leave off.

SOURCE: Betsy Sheridan, *Letter from Sheridan's Sister to her Sister in Dublin*, in *The Cut of Women's Clothes, 1600–1930.* Ed. Norah Waugh (New York: Theatre Arts Books, 1968): 125–126.

petticoats, the English version fit more snugly, and was all of one piece. The classic formulation of such robes was far simpler than the elaborate concoctions that had been popular in France during the height of the Rococo period. Typically, a *robe à la anglaise*'s skirts were gathered at the back and allowed to fall in folds. A colored sash often held these folds in place and was worn high, just below the bust line. A new fondness for cotton muslins and for dresses made from white cloth and other lighter colors as well as the new cotton fabrics replaced the once great affection for expensive taffetas, silks, velvets, and brocades. English women also began to wear simple fichus—that is, scarves made of transparent material—around their shoulders, one of the defining elements of the "English style." The new fashion spread quickly among aristocratic woman in Continental Europe, although France at first resisted the greater naturalism of these dresses. Despite the resistance offered by members of the French court and aristocracy, these fashions had begun to make inroads there by the 1770s.

IMPACT OF THE ENLIGHTENMENT. The new styles of the era were, in part, inspired by the impact of Enlightenment thinking in Europe. In France, one of the most important literary vehicles for conveying the new values of this movement was the *Encyclopédie*, a massive, multi-volume project begun by the French Enlightenment thinkers Denis Diderot (1713–1784) and Jean D'Alembert (1713–1787). Published in 28 separate volumes during the years between 1751 and 1772, the *Encyclopédie* was not widely read by all French men and women, although it was avidly consumed by the upper echelons of society. The enormous work did not convey a single point of view, but Diderot and D'Alembert enlisted authors whose opinions often fit closely with their own. Fashion was one subject touched upon in hundreds of entries, with the *Encyclopédie* offering opinions on the history and usage of scores of items of clothing as well as giving advice generally on elements of good taste, manners, and etiquette. As the primary guiding spirits behind this enterprise, Diderot and D'Alembert championed the cause of social utility in clothing, customs,

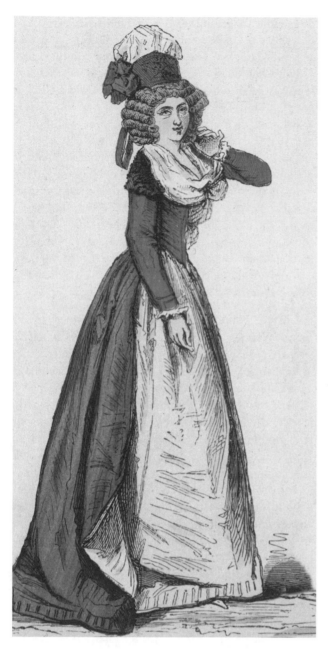

Late eighteenth-century women's fashions. LEONARD DE SELVA/CORBIS.

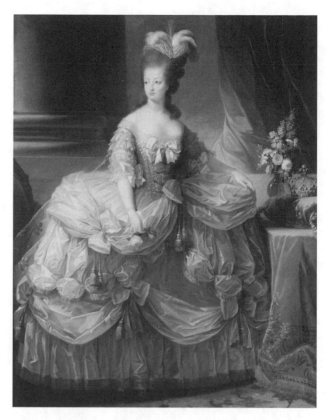

Portrait of Marie-Antoinette, Queen of France by Elisabeth Vigée-LeBrun. THE ART ARCHIVE/MUSÉE DU CHÂTEAU DE VERSAILLES/DAGLI ORTI.

and consumption. They believed, in other words, that society's customs and even its clothing should be judged according to whether they were truly useful. Thus in contrast to the guiding spirit of opulence and decoration that had prevailed in the Rococo style, the Enlightenment championed an aesthetic that stressed naturalness over artificiality. Of course, the ideas of philosophical thinkers like Diderot and those he enlisted to write for the *Encyclopédie* did not immediately shape the clothes that were worn in aristocratic society. But the criticism of the artificiality of the eighteenth-century style laid the foundation for a new taste that cultivated greater simplicity and utility over mere decorativeness.

THE SPREAD OF ENGLISH TASTES. For much of the eighteenth century, close contacts between England and France had invigorated the world of fashion in both countries. While English aristocrats and wealthy Londoners generally avoided the extremes of opulence of the French Rococo style, they had nevertheless adapted those fashions to their own purposes, and both men and women of the upper classes had kept abreast of the changes in style that emanated from Paris. At the English royal court the styles of prescribed dress closely resembled those worn at Versailles and in other French royal palaces by the mid-eighteenth century. Yet in their great rural estates, England's aristocrats generally favored clothes that were more rustic and natural than those worn by the wealthiest French nobles of the period. The fondness for hunting and other outdoor pursuits gave rise to the creation of the riding habit, a close-fitting coat and britches worn by both men and women. These rustic fashions, the Baroque equivalent of modern "sportswear," were constructed of simpler, more practical fabrics like wool and cotton than the

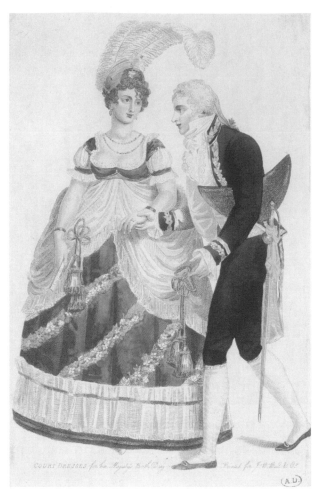

Court dress worn for the queen's birthday in England, 1798.
© GIANNI DAGLI ORTI/CORBIS.

the simple yet feminine style in French society. These dresses were usually modeled on the chemise and were sewn in a simple cylindrical tube shape. Equipped with a drawstring at the neck, they were worn gathered at the waist with a sash. Thus in place of the artifice of hoops, trains, and ruffled sleeves that had long served to delineate members of the court, the queen and members of the French aristocracy sided with the cause of English informality. Marie Antoinette and members of her circle indulged their affection for these comfortable styles at the queen's retreat, the Petit Trianon, a small palace at the edge of the grounds of the Versailles, much to the consternation of many of the traditionalists at court. When the party returned to the royal chateau to participate in the grand receptions of state, though, the tradition of court dress with its rigid and unbending rules continued to hold sway at Versailles.

MEN'S DRESS. The increasing divide between French elegance and English informality and practicality were perhaps even more notable in men's dress than in women's. In France, men in the 1770s continued to wear elaborately trimmed outer and vest coats that were tailored to show off rich fabrics of silk and other costly fabrics. By the 1780s, though, English styles were present among members of the aristocracy and wealthy bourgeoisie in France. By this time, the more informal and comfortable frock coat had become the norm of middle class and aristocratic dress in England as both day and evening wear. The frock coat had originally been an element of hunting clothing worn by gentlemen and aristocrats in the countryside. Throughout the eighteenth century its cut had grown simpler, and in place of elaborate cuffs and side pleats, English men favored garments that were elegantly tailored, yet devoid of decoration. By 1750 the fashion for the frock coat had spread almost everywhere in the English speaking world and was common attire for men of commerce and political affairs, country gentry, and even New World colonists. In England, the combination of frock coat, waistcoat, and britches was worn everywhere except at court, and the elaborately cuffed sleeves had disappeared in favor of simple slits at the wrists. Decorated side pleats had also been replaced by a short skirt on the jacket that was held in place by slightly stiffening the fabric. The most common element of design in the frock coats of the time was their relatively small, turned-down collars. Instead of the elaborate lace flounces that had once been worn under these garments, English men now favored undecorated linen shirts and a shorter waistcoat that was of a complementary but lighter color from the dark fabrics usually used to tailor the frock coat. Simple tan britches

sumptuous silks, taffetas, and velvets worn by the French upper classes at the time. Although these styles were initially resisted in France, they had begun to make inroads there in the 1770s, and by the following decade were widely popular among the country's aristocrats. In the years immediately preceding the French Revolution, Queen Marie-Antoinette and members of her circle at court often indulged their love of English informality by choosing dresses that reflected the more natural and comfortable styles preferred in Britain. In 1783, the queen allowed one of her favorite portraitists, Elisabeth Vigée-LeBrun, to paint her wearing this kind of dress. When the portrait was displayed that year at the Royal Academy's annual salon, it caused a great controversy; members of Parisian society complained that the queen had allowed herself to be painted in nothing more than a chemise, the equivalent of the modern slip. Vigée-LeBrun's picture was soon withdrawn from the exhibition, but the furor that it caused helped to popularize

completed the outfit. In keeping with this more informal fashion, men wore their hair naturally or lightly powdered, and the wig soon fell out of use altogether except by members of certain professions and among domestic servants, particularly footmen. While French men resisted these styles for several decades, they had gained a foothold amongst the aristocracy and wealthy bourgeoisie by 1780, and in the years that followed the frock coat and britches became even more popular. Emulation of English dress was stimulated by the dictates of fashion, but at the same time the fondness for things "English" represented an important triumph of Enlightenment thinking in France. For most of the eighteenth century, Enlightenment thinkers like Voltaire, Diderot, and Rousseau had celebrated the customs and mores of the island country for their modernity and freedom. Now, as the French Revolution approached, English styles became one way in which France's aristocrats and bourgeoisie expressed their fondness for the concept of greater liberty.

THE FASHION PRESS. The taste for the new informal styles that emanated from England was fed throughout Europe by the increased production of fashion plates: engravings of men and women dressed in the most stylish clothing of the day. By the 1770s fashion plates had begun to replace the dressed mannequin dolls that had long been sent out annually from the major dress and tailoring shops in Paris to courts and shops throughout Europe. The custom of illustrating clothing in engravings had long existed, although not until the later eighteenth century did publishers and designers begin to exploit the possibilities of the press for satisfying an appetite for news of the fashionable world. During the sixteenth century German engravers and printers began to publish large collections of engravings known as *Trachtenbücher*, or "costume books." The purpose of these volumes had been to illustrate the various types of dress worn by members of society's different orders and professions. As the custom of producing these costume books spread throughout Europe, these books served by and large to satisfy an anthropological interest. Costume books, for instance, had often informed their readers of the kinds of clothing that were worn in societies throughout the world, satisfying an innate human curiosity about the exotic customs and manners of other peoples. In the later decades of the eighteenth century French artists, designers, and printers began to sense the commercial possibilities that lay within the medium. They now used it to satisfy readers' desires to learn about the latest styles worn by the country's aristocracy. In 1775, one of the most brilliant and beautiful of all the

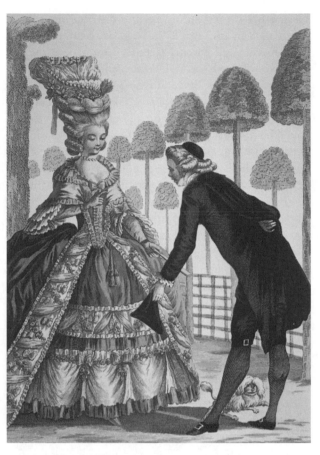

French fashion plate from 1778, showing a couple promenading through the Palais-Royale, Paris. **THE GRANGER COLLECTION.**

costume books appeared under the title *Le Monument du costume physique et moral de la fin du dix-huitième siècle* (Monument of the Physical and Moral Costume at the End of the Eighteenth Century). The accomplished artist Jean-Michel Moreau (1741–1814) drew many of the designs for the plates that illustrated the work, while the novelist Restif de la Bretonne (1734–1806) wrote the accompanying text. Today, the work's illustrations continue to be widely admired, and their influence on fashion journalism has long been recognized. In capturing the styles and dress of the period, Moreau and the other artists who contributed to the series did not pose men and women lifelessly, but instead, like modern photojournalists, they showed a young man and woman of fashion going about their social duties on the Parisian scene. The work's prints thus captured its imaginary characters in the fashionable world in settings that were by and large natural.

FASHION MAGAZINES. In the years that followed the success of the *Monument* other printers in Paris responded by commissioning series of fashion engravings

from other prominent artists and distributing them in small collections. By 1778, two Parisian publishers, Jean Esnaut and Michel Rapilly, commenced the distribution of their *Gallerie des modes et costumes français* (Gallery of French Style and Costumes). Over the next decade Esnaut and Rapilly produced some seventy different collections of fashion plates that they released every few months. Each collection contained six colored engravings of costumes currently being worn on the Parisian scene. The popularity of the *Gallery* prompted many leading artists of the day to draw illustrations for these collections and thus high art and popular tastes for style combined to make the new fashion plates an immediate success. The *Gallery's* appeal soon prompted other imitators, and by the later 1780s France had a number of regularly published fashion magazines or journals. The first of these, *Les Cabinet des modes* (The Cabinet of Style) commenced publication in 1785, but soon changed its name to *Le Magasin du modes nouvelles françaises et anglaises* (The Magazine of New French and English Styles) one year later to take account of the widespread popularity of more informal English dress. The periodical appeared every two weeks, complete with several fashion plates and articles that informed readers about the latest changes in dress. Despite the aristocratic tone of the magazine, publication continued even during the first years of the French Revolution, and in 1790, the journal became known merely as *Le Journal de la mode et la goût* (The Journal of Style and Taste). When the *Journal* ceased publication in 1793, other fashion magazines continued to proliferate on the scene, some appearing at intervals as often as every five days. By this time styles began to change so quickly that Paris's new ranks of fashion journalists and illustrators faced a serious challenge in keeping up with the pace of style.

SOURCES

Madeleine Delpierre, *Dress in France in the Eighteenth Century* (New Haven, Conn.: Yale University Press, 1997).

Doris Langley Moore, *Fashion Through Fashion Plates, 1770–1970* (London: Ward Lock, 1971).

Aileen Ribeiro, *Dress in Eighteenth-Century Europe, 1715–1789* (London: B. T. Batsford, Ltd., 1984).

Daniel Roche, *The Culture of Clothing* (Cambridge, England: Cambridge University Press, 1994).

Cynthia L. White, *Women's Magazines, 1693–1968* (London: Joseph, 1970).

SEE ALSO *Architecture: The Development of Neoclassicism*

FASHION DURING THE FRENCH REVOLUTION

UPHEAVAL. The years following the Revolution in France in 1789 brought massive upheaval and changes in French society, which, in turn, produced profound changes in dress and fashion. Clothing had long served in France as one of the most visible markers of social privilege and aristocratic status, so it is hardly surprising, then, that fashion was deeply affected by the course of revolutionary changes. The royal court's dress had long been prescribed by an unbending etiquette that had originally been fashioned by Louis XIV, author of the absolutist system of government that had transformed the country into Europe's greatest seventeenth-century power. During the eighteenth century this system had grown increasingly unwieldy, corrupt, and outmoded, and the privileges of aristocracy and the court seemed in the eyes of many to be an evil that needed to be rooted out if the country was to move forward. In the first years of the Revolution many aristocrats and wealthy French bourgeoisie agreed with this conclusion, and the initial phases of political change in the Revolution were marked by relative unanimity concerning the abolition of ancient noble privileges, clerical status, and distinctions of rank. A swiftly changing political scene, however, marked the clergy, the aristocracy, and those who served them as forces of counter-revolution among those who advocated more radical changes in government and society. During the Reign of Terror that began in 1792, thousands of French nobles, priests, and those who sympathized with them were guillotined. In the midst of these troubles, clothing played an important symbolic function, as men and women relied upon it to express their political convictions; dress became alternately a way to support or to condemn revolutionary change. The aristocratic fashions of the eighteenth century were seen as an evil that needed to be suppressed, and the Revolution moved to condemn those elements of dress that embodied traditional aristocratic society. Expensive silks, taffetas, velvets, and other costly elements of clothing were prohibited as France's new government tried to dictate a new order in which fraternity, rather than privilege, might be realized.

CLOTHING AS SYMBOLS. From the earliest days of the Revolution elements of dress played a vital role in the political movement's identity. In the wake of the Storming of the Bastille on 14 July 1789, the government of the city of Paris decreed that all citizens in the capital must wear a tricolor cockade, a round emblem constructed of ribbons displaying the city's colors of red and blue as well as the monarchy's standard white. Even

a PRIMARY SOURCE *document*

THE POLITICS OF COLOR

INTRODUCTION: In early-modern Europe clothing played a vital role in identifying the status of particular groups in society. With the coming of the French Revolution the symbolic role of clothing continued, and men and women relied on their outfits to make statements about their support or rejection of the principles of the era. Color became a particularly important vehicle for showing one's political sympathy. In the following excerpt from *The Secret Memoirs of Princess Lamballe*, the editor, Catherine Hyde, the Marquise de Gouvion Broglie describes problems she had with an outfit she wore to the Opera, as well as the surly attitude of French soldiers when she refused to show she was wearing the revolutionary tricolor—red, white, and blue. The writer was an Englishwoman, married to a French nobleman, and part of the inner circle that surrounded Queen Marie-Antoinette.

The reader will not, I trust, be dissatisfied at reposing for a moment from the sad story of the Princesse de Lamballe to hear some ridiculous circumstances which occurred to me individually; and which, though they form no part of the history, are sufficiently illustrative of the temper of the times.

I had been sent to England to put some letters into the post office for the Prince de Conde, and had just returned. The fashion then in England was a black dress, Spanish hat, and yellow satin lining, with three ostrich feathers forming the Prince of Wales's crest, and bearing his inscription, "*Ich dien*, I serve." (This crest and motto date as far back, I believe, as the time of Edward, the Black Prince.) I also brought with me a white satin cloak, trimmed with white fur.

In this dress, I went to the French opera. Scarcely was I seated in the box, when I heard shouts of, "En bas les couleurs de d'empereur! En bas!"

I was very busy talking to a person in the box, and, having been accustomed to hear and see partial riots in the pit, I paid no attention; never dreaming that my poor hat and feathers, and cloak, were the cause of the commotion, till an officer in the national guard very politely knocked at the door of the box, and told me I must either take them off or leave the theatre.

There is nothing I more dislike than being thought particular, or disposed to attract attention by dress. The moment, therefore, I found myself thus unintentionally the object of a whole theatre's disturbance, in the first impulse of indignation, I impetuously caught off the cloak and hat, and flung them into the pit, at the very faces of the rioters.

The theatre instantly rang with applause. The obnoxious articles were carefully folded up and taken to the officer of the guard, who, when I left the box, at the end of the opera, brought them to me and offered to assist me in putting them on; but I refused them with true cavalier-like loftiness, and entered my carriage without either hat or cloak.

There were many of the audience collected round the carriage at the time, who, witnessing my rejection of the insulted colours, again loudly cheered me; but insisted on the officer's placing the hat and cloak in the carriage, which drove off amidst the most violent acclamations.

Another day, as I was going to walk in the Tuileries (which I generally did after riding on horseback), the guards crossed their bayonets at the gate and forbade my entering. I asked them why. They told me no one was allowed to walk there without the national ribbon.

Now, I always had one of these national ribbons about me, from the time they were first worn; but I kept it in the inside of my riding-habit; and on that day, in particular, my supply was unusually ample, for I had on a new riding-habit, the petticoat of which was so very long and heavy that I bought a large quantity to tie round my waist, and fasten up the dress, to prevent it from falling about my feet.

However, I was determined to plague the guards for their impudence. My English beau, who was as pale as death, and knew I had the ribbon, kept pinching my arm, and whispering, "Show it, show it; zounds, madame, show it! We shall be sent to prison! show it! show it!" But I took care to keep my interrupters in parley till a sufficient mob was collected, and then I produced my colours.

The soldiers were consequently most gloriously hissed, and would have been maltreated by the mob, and sent to the guard-house by their officer, but for my intercession; on which I was again applauded all through the gardens as La Brave Anglaise. But my, beau declared he would never go out with me again: unless I wore the ribbon on the outside of my hat, which I never did and never would do.

SOURCE: Catherine Hyde, Marquise de Gouvion Broglie in *The Secret Memoirs of Princess Lamballe* by Marie Thérèse Louise de Savoie Carignan, Princesse de Lamballe. (Washington, D.C.: M. Walter Dunne, 1901): 219–221.

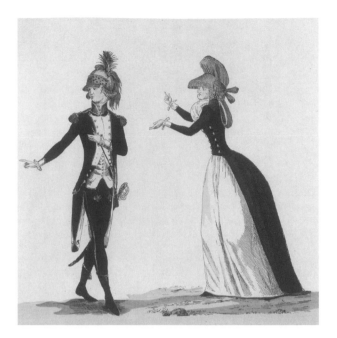

Patriotic men's and women's dress of the French Revolution. **THE ART ARCHIVE.**

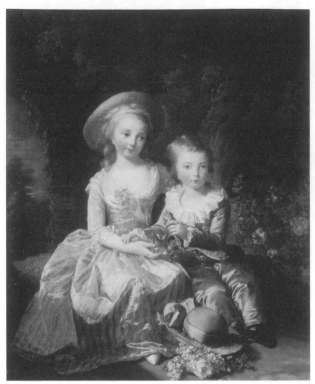

Portrait of the Dauphin Louis Joseph and his sister Thérèse by Elisabeth Vigée-LeBrun. **THE ART ARCHIVE/MUSÉE DU CHÂTEAU DE VERSAILLES/DAGLI ORTI.**

Louis XVI bowed to this pressure, and when he was reconciled to the city of Paris following the famous attack on the royal prison of the Bastille, he and his family donned the revolutionary cockade to demonstrate their support for political change. The demand that Parisians wear the cockade of red, white, and blue became an immediately popular symbol of support for the Revolution, and spawned new fashions for clothing in the tricolor. Women wore skirts made from tri-colored fabrics or shoes with buckles of revolutionary cockades; men wore red coats, white stockings, and blue britches to express their support for political change. Yet not all Parisians bowed to such fashions, and those who supported the upholding of tradition, aristocratic privilege, and monarchical power sometimes wore pure white, the color of the Bourbon monarchy. In the highly charged political atmosphere of the early 1790s, however, such acts of defiance could result in arrest and persecution, so most Parisians accommodated themselves to the new requirements. The sudden changes in fashion also deeply affected the clothing industry in Paris. Many of those who had served aristocratic society in previous decades now found themselves without customers, as nobles and wealthy Parisians fled the city. Rose Bertin, once a prominent milliner and a designer of the queen's dresses, even supported herself by selling cockades and other concoctions sporting the revolutionary colors. Bertin and other members of the town's clothing trade now indulged revolutionary tastes to make ends meet.

IN SEARCH OF A NEW STYLE. While the color of clothing and of accessories like the cockade played an important symbolic role in the early years of the Revolution, no immediate change in the style or cut of clothes occurred at this time. Instead most members of the bourgeoisie (the French middle and upper-middle classes) as well as many aristocrats that initially supported the Revolution instead wore the English informal fashions that had begun to gain popularity in France during the 1770s and 1780s. In place of the taffetas, velvets, and silks that were now prohibited as symbols of the old order and of aristocratic privilege, women's dresses were made of cotton and linen, usually all of a single color, and men's frock coats and britches were constructed of wool, and their shirts of linen and cotton. The triumph of the new style can be vividly seen in many of the portraits that Jacques-Louis David (1748–1825), France's great Neoclassical painter, and other revolutionary-era artists completed during the early years of the new order. In his 1795 portrait of his brother-in-law, Pierre Sériziat, David painted the sitter as if he was an English country gentleman, complete with tan britches, a dark outer coat, and a vest and shirt of white. To complete the allusion to the "English style," the artist showed his brother-in-

law sporting a top hat and riding crop. A similar affection for the standards of English informality can be seen in the painting that David completed of his sister, Madame Sériziat, in the same year. The artist showed the subject clad in the chemise, the simple tube-like dress gathered at the neck with a drawstring and here tied with a green sash at the waist. Instead of the elaborate coiffures typical of the world of the pre-revolutionary Old Regime, Madame Sériziat is shown with natural hair placed under a lace cap and a simple, yet elegant straw hat decorated again with green ribbon and bows. The child at her side wears much the same outfit. It was such dress that came to be increasingly the norm among those members of the bourgeoisie who supported the Revolution's changes, as the course of fashion came even to be debated in the new national academies and societies of the time. During 1793 and 1794, the Société Popular et Républicane des Arts, the institution that replaced France's Royal Academy of Arts, debated the question of clothing in a revolutionary age. David, one of its most prominent members, took part in these discussions, which lasted over four months, and his portraits of his sister and brother-in-law were presented at the institution's salon in 1795, in part to demonstrate the society's prescriptions for the reform of fashion. In its deliberations the Société concluded that clothing should be hygienic, should not advertise its wearer's rank or status, and should allow for free movement of the body. In particular, the institution enjoined women not to contort their bodies into shapes through the wearing of corsets, paniers, or other devices, since these were styles that flourished under political despotism and which had largely restricted women's freedom to move. The body should not be concealed or contorted by clothes, but rather enhanced by it. Thus in searching for ways to realize these dictates, French fashion adopted the English style, a form of dress that ironically had been embraced in the 1770s and 1780s by the French aristocracy. These fashions now expressed the Revolution's longing for freedom.

OTHER VOICES. As the reigning artist of his day, Jacques-Louis David tried to steer a path of moderation through the increasingly turbulent political world of Revolutionary fashion. Appointed minister of arts by the government in 1794, David received a commission to design the uniforms to be worn by France's judges, municipal officials, and civil servants, a controversial duty at a time when radicals within the Revolution were advocating for the abolition of any distinction of rank or privilege. The uniforms that David designed for the new order thus tried to take account of the need for the French state's civil servants to be distinguished from one another, while at the same time stressing their equality before the law. Despite his best efforts, David's decisions were controversial, and by the mid-1790s, dress and fashion had emerged as important ways for French men and women to express their political viewpoints. During the height of the Reign of Terror—that is during the dismal years between 1792 and 1794 when many thousands were put to death for "counter-revolutionary" sentiments —groups like the *Sans Culottes* advocated for a more complete reform of French government and society. The *Sans Culottes* (meaning "without britches") were drawn largely from the ranks of Parisian shopkeepers, artisans, and poor workers in the city, groups that had long worn trousers rather than the stylish knee britches of aristocratic and bourgeois society. The group's uniform consisted of long trousers, a short-skirted coat known as the *carmagnole*, a tri-colored vest, and a *bonnet rouge* (or "red cap"), and their clothing became synonymous with their agitation for radical democratic reforms. This trend towards the politicization of clothing met a counter-trend in the mid-1790s, however, as greater peace and stability returned to France under the government of the Directory; groups of male *incroyables* (literally "unbelievables") and female *merveilleuses* ("the marvels") appeared on the Parisian scene whose clothing mocked the trends of the previous years. The female *merveilleuses* displayed daring amounts of cleavage or wore sheer dresses that exposed large portions of their legs underneath the sheerest of fabrics. Their dress thus mocked the Revolution's dictates that women's clothes should provide for greater freedom of movement by carrying them to a logical conclusion. The *incroyables*, by contrast, were dandies that distorted the new fashions the Revolution had helped sponsor, poking fun at the taste for English informality by sporting elaborately grand lapels, striped trousers, and bizarre "dog-eared" hairstyles. While the Revolution had hoped to found a new society in which all social distinctions of dress were outlawed, the *incroyables* and *merveilleuses* hoped for a time in which men and women might distinguish themselves purely for the imaginativeness of their clothing. Although their presence on the Parisian scene was relatively brief, both groups pointed to the emergence of a new consumer culture of fashion, one that now stretched far beyond the confines of aristocratic society, and which would in the following generations encompass an ever-larger portion of the European world. In the daring innovations of *incroyables* and *merveilleuses* we can see the genesis of the infinitely changeable and swiftly altering modern world of fashion. Since that time cosmopolitan Europeans have struggled to keep up with that world's seasonal dictates.

SOURCES

Aileen Ribeiro, *Fashion in the French Revolution* (London: B. T. Batsford Ltd., 1988).

———, *The Art of Dress: Fashion in England and France, 1750–1820* (New Haven, Conn.: Yale University Press, 1995).

Jean Starobinski, *Revolution in Fashion: European Clothing, 1715-1815* (New York: Abbeville Press, 1989).

SIGNIFICANT PEOPLE
in Fashion

MARIE-JEANNE BÉCU DU BARRY
1743–1793

Royal Mistress

A SHOP GIRL. The last of King Louis XV's notorious mistresses, the Countess du Barry, was born into a poor family and received a convent education before becoming a worker in a Parisian dress shop. There she developed her sense of style and came to the attention of a nobleman from Gascony, the Count du Barry. She soon became his lover and began to circulate in Parisian society, serving in turn as mistress to a number of French noblemen. Eventually she came to the notice of King Louis XV and became his lover in 1768. Since the death of Madame de Pompadour in 1764, Louis had not appointed any mistress to the office of *maitresse en titre*, the court honor reserved for the mistress of the king. Marie-Jeanne Bécu was a commoner, and one from an unusually low social background. To secure her rise at Versailles, the Count of Barry arranged a marriage of convenience between her and his brother, and with the noble title that she thus attained, du Barry was soon appointed *maitresse en titre*. In this position du Barry wielded tremendous influence with the king, although she rarely dabbled in politics. Shortly after coming to court she was drawn into a court intrigue that brought down one of the king's most powerful ministers. The results proved disastrous, and du Barry confined her interests ever more to patronizing the arts. She was particularly interested in the development of the art of porcelain manufacturing in France, and encouraged the king to invest in the industry, then located at Sèvres, not far from Versailles. A generous patron of the arts, she allowed her portrait to be painted on many occasions, and commissioned artwork for her country house at Louveciennes from the greatest artists of the day. The chateau at Louveciennes was a gift from Louis XV, but du Barry set about decorating it in the reigning French fashions of the mid-eighteenth century, asking the court architect Anges-Jacques Gabriel to remodel it, and later the French designer Claude Nicholas Ledoux to build a pleasure pavilion there similar to the Petit Trianon at Versailles. Ledoux's pavilion became one of the first important monuments of the Neoclassical style in France.

INDIFFERENCE TO FASHION. Madame du Barry influenced French fashions during her relatively brief reign as the king's mistress primarily through indifference. In contrast to Pompadour, du Barry was little concerned about her appearance. Her dresses were relatively simple and her hairstyles less artificial and contrived than those of other women of the court, and thus du Barry helped, perhaps unwittingly, to strengthen the tendency toward greater informality at Versailles. In the years after 1770, the king's mistress was drawn into intrigues and disagreements with the Dauphine Marie-Antoinette, the future queen of France. Although Louis XV continued to support her in her role as *maitresse en titre*, she was soon banished from the court at his death in 1774. For two years she was forced to live in a convent before being given her freedom. She returned to her estates at Louveciennes and lived quietly there until the outbreak of the Revolution in 1789. At the height of the Reign of Terror du Barry made several trips to London apparently to bring funds to French nobles who had fled there. Eventually she was imprisoned as a counter-revolutionary and guillotined in December of 1793. Less benevolent and popular than Madame de Pompadour, Louis XV's longest-reigning mistress, du Barry became a symbol of the corruption of Old Regime aristocratic society during the Revolution. In that society itself, though, she had long been viewed by many aristocrats as a *parvenu*, a lower class upstart. That she was a woman of undeniable taste, though, has long been established by the scope of her collections and patronage of the arts. Her influence on the world of fashion in France was also felt in her favoring of styles that were less contrived and more naturalistic than those common during the height of the Rococo period.

SOURCES

André Castelot, *Madame du Barry* (Paris: Perrin, 1989).

Joan Haslip, *Madame du Barry: The Wages of Beauty* (London: Weidenfeld and Nicolson, 1991).

Jacques de Saint-Victor, *Madame du Barry: un nom de scandale* (Paris: Perrin, 2002).

Agnes de Stoeckl, *The Mistress of Versailles: Life of Madame du Barry* (London: J. Murray, 1966).

JOSEPHINE BONAPARTE

1763–1814

Empress of France
Socialite

COLONIAL UPBRINGING. The woman who was destined to become Empress of the French spent her early life and adolescence on the French island of Martinique in the Caribbean. Her father was from a poor aristocratic family, and he served there in the navy. When she was sixteen Josephine married Alexandre, the Viscount of Beauharnais, and moved to Paris, where she stayed for several years. Her husband was pretentious and often offended by Josephine's colonial manners. As a result, he did not present her at court, and despite the fact that the couple had two children, they were soon separated. Josephine returned to her island home of Martinique only to be driven back to Paris by a slave revolt in 1790. Conditions in Paris were not much better as the city was then in the throes of Revolution. Now older and more mature, she became a fixture of high society parties, but faced a threat in 1794 when her husband Beauharnais was executed as a counter-revolutionary. She survived a harrowing imprisonment and continued her rise to the top of the fashionable world of Revolutionary France. After her husband's death she faced financial crises, although she managed to gain a modicum of economic stability through her associations with men as well as several business dealings. Around this time she met Napoleon Bonaparte, then a rising officer in the French army. Almost immediately he was smitten with her, although she long remained indifferent to him. Sensing that the match might be advantageous, though, Josephine agreed to marry him in a civil ceremony in 1796.

FASHIONABLE SOCIETY. Although now married to Napoleon, Josephine continued her climb in Parisian high society. In the early years of their marriage Bonaparte was often away from the capital, and although he frequently wrote to his wife, she rarely answered his letters. She was widely rumored to have had a number of affairs in these years, and by 1798 Bonaparte was considering divorcing her. Her family convinced him to remain married to her, and he returned to Paris and paid off the large debts she had accumulated. In the next few years Bonaparte's rise to power and eventually to the office of emperor of the French drew the couple closer together. In 1804, they renewed their wedding vows, but this time in a religious, rather than civil ceremony. Initially, Josephine relied on her husband's position and her newfound status as empress to make favorable matches for her two children in European noble houses. But her extravagant consumption of clothing, art, and furniture continued to be a sore spot, as was her inability to bear children, and by 1810, Bonaparte had their union dissolved. He was able to have their marriage annulled since no priest had officially presided at their 1804 religious marriage. Josephine was given a pension and retired to her country house at Malmaison. There she continued to entertain French high society on a grand scale, paid for by the funds she received from her former husband. When Bonaparte was forced to abdicate a few years later, she was protected by the Czar of Russia, although she died not long afterward, having reigned for almost two decades over Parisian society at a turbulent point in its history.

FASHION AND ARTISTIC PATRONAGE. Josephine was certainly not a woman of formidable intellectual powers. Throughout her life she labored to overcome her provincial upbringing, and in this she was largely successful. She possessed a single-minded determination to succeed in high society, and her sense of taste in clothing and art was an undeniable ally in the achievement of her goals. She was also widely admired for her good nature. In art, her patronage was particularly vital to the development of the Empire style, a fashion that was notable for its classical elements, which in many ways continued the direction of Classicism that had been popular during the last years of the Old Regime. Her fashion sense in the choice of clothes was recognized to be impeccable, and Josephine wore the Neoclassical fashions that were just beginning to become the rage in late 1790s Paris. Like Marie Antoinette before her, she had a fondness for the chemise, the white or light-colored dresses modeled on nightshirts and undergarments that were usually made out of simple muslin or cotton. In contrast to the chemises that had been popular in France in the years immediately preceding the Revolution, Josephine wore the style with a high waist, helping to establish the fashion that since her day has become known as the "empire" waistline.

SOURCES

Evangeline Bruce, *Napoleon and Josephine: An Improbable Marriage* (New York: Scribner, 1995).

Eleanor P. DeLorme, *Joséphine: Napoléon's Incomparable Empress* (New York: H. N. Abrams, 2002).

Nina Epton, *Josephine: The Empress and Her Children* (New York: Norton, 1976).

Carolly Erickson, *Josephine: A Life of the Empress* (New York: St. Martin's Press, 2000).

FRANÇOISE D'AUBIGNÉ MAINTENON
1635–1719

Royal Mistress

AN UNFORTUNATE EARLY LIFE. Born while her father was in debtor's prison, the early life of Françoise d'Aubigné Maintenon was filled with trials. Following her father's release in 1645, the family emigrated to a French possession in the Caribbean, where her father planned to take up a position as a royal governor. They discovered the post was unavailable upon their arrival, however, and so her father returned to France; his death there left his family abandoned in the West Indies. The young Françoise returned to France and was entrusted to the care of an aunt with whom she lived for several years. When she was sixteen, her aunt sent her to live with the author Paul Scarron, and a few years later the couple married, despite a 25-year age difference. Françoise seems to have had little attraction for her husband, although she did care for him until his death in 1660.

MAINTENON'S RISE AT COURT. The death of her husband left Françoise penniless, and so she entered a convent, although she continued to direct her deceased husband's salon, an important group of highly literate men and women on the Parisian scene during the later seventeenth century. Through the ministrations of members of the salon, she eventually received a pension from Anne of Austria, the king's mother. In 1668, she began to care for and educate the bastard children of her friend, the royal mistress Madame de Montespan. Since King Louis XIV had fathered Montespan's children, he valued Françoise's discretion and rewarded her financially. In 1675, he gave her the noble title Marquise de Maintenon, and she became a lady-in-waiting to the Dauphine, the wife of the heir apparent of France. As a result, she ceased to serve as governess to the royal bastards, and instead embarked upon a career in court society. As her estimation rose in the king's eyes, she faced the jealousy of her former friend, Madame de Montespan, and she may have eventually supplanted her as the royal mistress. When the queen died in 1683, Louis may have secretly married Maintenon in the same year, although this marriage may not have taken place until 1697. Maintenon was never named "Queen of France" because of her first marriage, common birth, and the deference that Louis XIV continued to show to his first wife and their children. Yet as the consort of the reigning king, she exerted a powerful influence over the life of the court. Intensely pious, she began to steer Louis away from the life of indulgence and frivolity that he had led to this point. In place of the many lavish court entertainments that had been mounted in the previous decades, Maintenon favored quieter pursuits. And in general she was responsible for toning down the lavish excesses of fashion and dress that had flourished in Versailles and other royal palaces in the previous generation. Her portrait by Pierre Mignard suggests the fervent piety that she tried to instill in members of the royal family and at court, and as she aged, the images of Maintenon suggest the increasing gravity of her dress. In these years, too, she also took up her occupation as a teacher yet again, patronizing a local orphanage and sometimes teaching the orphans that lived there. In 1715 at the death of her husband Louis XIV, she retired to the convent of Saint Cyr, the institution that controlled the school she had long supported, and spent the remaining few years of her life in seclusion, mourning the death of her husband. Maintenon was not a woman of fashion. Her deep piety marked a very different strain of behavior from that which was then in fashion when she came to power at the French court. Through her religious zeal, she exerted a significant influence over the fashion of her times, weaning the French court away for a time from the lavish extravagances of the early years of Louis XIV's reign.

SOURCES

André Castelot, *Madame de Maintenon: La reine sècrete* (Paris: Perrin, 1996).

Jean Paul Desprat, *Madame de Maintenon, 1635–1719* (Paris: Perrin, 2003).

Charlotte Franken Haldane, *Madame de Maintenon. Uncrowned Queen of France* (Indianapolis, Ind.: Bobbs, Merrill, 1970).

Julien Gulfi, *Madame de Maintenon, 1635–1719* (Lyon: L'Hermés, 1986).

MARIE-ANTOINETTE
1755–1793

Queen of France

DESTINED FOR GREATNESS. The woman destined to become the queen of France was born the eleventh child of the Holy Roman Emperor and Maria Theresa of Austria. Indulged as a child, she had few of the skills necessary to serve as a queen when she wed the future Louis XVI in 1770. Poorly educated and brought up in the royal palaces of Austria where court etiquette was generally relaxed and informal, she was unprepared for the severe and unbending world of Versailles. When she arrived at the royal palace in 1770, she was initially admired for her great beauty, but in the months and years that followed she was drawn into court intrigues and be-

came the subject of gossip. Her marriage, too, was initially unsuccessful since a physical infirmity prevented her husband Louis from consummating the match for several years before he submitted to surgery to correct the problem. Spurned in these early years in France by her husband, she carved out a life of gay frivolity at court. These years, too, were marked by feuds with Madame du Barry, Louis XV's last mistress and the head of a powerful court party that generally disliked the Austrian princess. When her husband succeeded his grandfather as king in 1774, Marie-Antoinette was to see Madame du Barry and many of her party exiled from Versailles.

GROWING RESPECT. During the 1770s respect for Marie-Antoinette grew, both at court and in France generally. As queen, she curtailed her attendance at balls and parties and concentrated more on her duties as wife of the head of state. In the decade before the outbreak of the French Revolution, she bore the king four children, but a daughter died in childbirth, and her sons suffered from a genetic disability that proved to be crippling. Since her arrival in France, Marie-Antoinette had chafed under the unyielding rituals of Versailles. A daughter of Austria, she had grown up in a very different kind of world from that of France's courtly etiquette. When she had arrived at the borders of France as a young girl, she was, as all queens were, ceremonially stripped of her clothes and redressed in the official outfit of the French court. During her years as a princess at Versailles, her dress and demeanor were determined by the standards that Louis XIV had established, and which were by and large upheld by Louis XV. Thus as she rose to become queen, Marie-Antoinette wished to exert greater determination over her clothes and manners. Ladies in waiting had long dressed the queen in clothes selected by the royal entourage. Dressing the queen had traditionally been one of Versailles' most important daily events, with attendance at these ceremonies one of the markers of where one stood in the court's measures of status. Marie-Antoinette largely abandoned such practices, allowing the celebration of such rituals only on important ceremonial occasions. Instead each day she had her ladies in waiting and maids bring her catalogues of the royal wardrobe and she stuck pins beside the items of dress she wished to wear that day. Such departures from custom angered some in the court, although a devoted following of confidantes surrounded the queen. Widely recognized as good-hearted and loyal, she was at the same time attacked for being impetuous and arbitrary. As her relationship with her husband matured, Louis XVI granted her use of the Petit Trianon, the small and very private palace at the edge of the Gardens of Versailles.

Here she entertained her closest friends and led a more informal life. These private entertainments at the Trianon became a subject of court gossip, and slanders of the queen were not uncommon in the Parisian press even in the early years of her reign. She had the reputation of being a profligate spender, although her expenditures, while enormous, were not unusual when compared against other members of the royal family. Her departures from courtly etiquette, such as her decision to meet with her dressmaker, jeweler, and other royal suppliers personally, generated attacks, too. But although she was often criticized during the 1780s for her wanton sexuality, Marie-Antoinette seems only to have entertained one serious infatuation in her short life, that is, for the Swedish nobleman Count Axel von Fersen. The two may have had a sexual relationship, but they nourished a spiritual affection for one another that lasted through Marie-Antoinette's life.

A VICTIM OF FASHION. Given her penchant for informality, Marie-Antoinette was drawn to the English styles of clothing that were in the 1780s beginning to be popular in France. In 1783, she allowed her favorite portrait painter, Elisabeth Vigée-Lebrun, to paint her in a simple white dress similar to those popular in England at the time. The portrait was displayed at that year's annual Salon of the Royal Academy of Arts. The furor that it caused resulted in the removal of the painting from the exhibition, and Marie-Antoinette's decision to allow herself to be painted without the customary court dress was widely attacked as imprudent. Criticism of the queen grew in the following years, particularly as a result of the Affair of the Necklace of 1785–1786. During this scandal the queen was charged with having secretly purchased an enormously expensive diamond necklace through the intermediary of the Cardinal de Rohan, an important prince of the church, with whom she was also alleged to have had a sexual affair. Although the accusations were completely false and the Affair of the Necklace was, in fact, a plot organized to defraud the monarchy of the jewelry's purchase price, the charges made against Marie-Antoinette as a result of the affair seemed credible to many French people. The queen's long-standing reputation for extravagance caused her to be labeled in the popular press as "Madame Deficit," and in the years that followed, despite her efforts, she continued to be widely vilified.

DURING THE REVOLUTION. During the Revolution Marie-Antoinette's relationship with her husband deepened, and in the tumultuous changes that occurred following 1789, she frequently counseled him to stand firm against demands for reform. Her participation in the

failed plot to escape Paris during 1791 as well as her correspondence with those who opposed the Revolution brought her under increasing suspicion, and she was confined to prison, at first with Louis XVI and other members of her family. Later she was placed in solitary confinement for a period of ten months before her trial commenced on 14 October 1793. She was guillotined two days following her sentence, wearing a simple white dress very far removed from the elaborate courtly dress she had worn for much of her life as queen.

SOURCES

André Castelor, *Queen of France. A Biography of Marie Antoinette* (New York: Harper and Row, 1957).

Antonia Fraser, *Marie Antoinette* (London: Weidenfeld and Nicolson, 2001).

Munro Price, *The Fall of the French Monarchy* (London: Macmillan, 2002).

JEANNE-ANTOINETTE POISSON POMPADOUR

1721–1764

Royal Mistress

TRAINED FOR A CULTIVATED LIFE. The girl that was to mature into France's most important eighteenth-century royal mistress, Jean-Antoinette Poisson, grew up the daughter of a financier, at the time a profession notorious for its shady business dealings. Her father was exiled from France for a time when the young Jean-Antoinette was only four years old for taking part in a shady venture, but once he recovered his position he brought his daughter up to take her place in Parisian society. Interested even at this early age in art and literature, she associated with such important literary figures as Voltaire before she married Normant d'Etioles. She soon had a daughter with d'Etioles, but also felt herself increasingly drawn toward court circles at Versailles. In 1744, when Louis XV's mistress died, she came to the king's attention. She was soon established at court as the *maitresse en titre*, that is, the official royal mistress. She separated legally from her husband and received the title Marquise de Pompadour from the king. For the next twenty years, her influence shaped Versailles' society.

THE KING'S SECRETARY. Judgments about Madame de Pompadour's role in government have fluctuated since the eighteenth century. During the nineteenth century, for example, many historians judged her a wicked and cunning figure who dominated her lover, Louis XV. French historians, in particular, were anxious to treat the Bourbon monarchs of the eighteenth century as weak, dissolute, and corrupt figures in order to justify the Revolution that occurred after 1789. More recent reassessments of Louis XV and Madame de Pompadour have shown that the king was a far abler monarch than once assumed. Shy and retiring, he acted through his mistress Madame de Pompadour, but she did not form royal policy. Instead the king decided on matters of state and acted through the more dynamic Pompadour, who was often able to win over many French nobles to the king's position. As royal mistress she became the king's private secretary. At first she was installed in a few small rooms high in the Palace of Versailles, but she soon set about ingratiating herself to members of the royal family and even to the king's wife, Marie-Antoinette. In this way her influence grew, and she eventually moved to grander lodgings within the chateau. By this time, Louis XV had moved on to other mistresses, although the connection between the two remained close until Pompadour's death in 1764. During the later years of her life she became an essential fixture in the court, influencing the awarding of royal contracts, offices, and favors.

FASHION AND ARTISTIC PATRONAGE. Madame de Pompadour was a woman of impeccable artistic tastes with a keen eye for fashion. At the time in which she rose to influence over court society, royal sumptuary regulation was still in force, although Louis XV's enforcement of these laws was lax. In her choice of fabrics and other items of dress Pompadour frequently violated sumptuary law and encouraged other members of the court to do the same. Her dresses were among the most luxurious ever crafted in the eighteenth century, and she sat frequently for portraitists to record them. For many years she was the most important figure of fashion in France, giving rise to the style of high-piled hair that still today bears the name "Pompadour." She also inspired the wearing of "pompoms," ball-like concoctions of feathers that were worn atop the head in place of hats. Her influence also reinvigorated France's cloth industry. In the late seventeenth and early eighteenth centuries the fabric industry in France had entered on hard times, and Pompadour used her influence with the king to re-establish production throughout the country. Printed fabrics, rich brocades, and other elegant cloth had been prohibited, in part, because these fabrics often needed to be imported from abroad. Madame de Pompadour thus encouraged Louis XV to buy royal manufactories for the production of these luxury cloths, the most famous of which was the industrial centered at Jouy near Versailles. The printed fabrics that were produced there became known as *toile du Jouy* and were widely prized throughout France. Their

exotic motifs with design elements drawn from Chinese or Arabic art as well as their scenes of everyday life were imitated throughout Europe. Pompadour also used her influence with the king to have her brother named director of the king's works, and together with the king and her brother, she promoted the classical style prized in France in the mid-eighteenth century. Under her influence, the small palace of the Petit Trianon was begun at Versailles, and her brother also laid out the Place Louis XV, now known as the Place de la Concorde in Paris. A noble design, its regal and austere lines became the backdrop for the execution of thousands of French men and women in the Revolution, in what was ironically, a grand repudiation of the culture of aristocratic privilege upon which Madame de Pompadour had risen.

LATER YEARS. Although her literary and artistic patronage was largely successful, the king's favorite mistress dabbled more and more in politics in her later years, eventually to disastrous effect. Her party at court supported France's involvement in the Seven Years' War, a conflict that resulted in the loss of many of France's colonial possessions. In the wake of the war, powerful figures at court blamed Pompadour for the king's policy decisions, and the final years of her life were thus spent in relative seclusion in her apartments in Versailles. She contracted an illness, most likely lung cancer, and died in 1764 at the age of 42. Despite the relative cloud that had hung over her at the time of her death, the king mourned the passing of his favorite mistress and she was lauded by literary figures and French thinkers of the time as a force of kindness and justice at Versailles.

SOURCES

Margaret Crosland, *Madame de Pompadour: Sex, Culture, and the Power Game* (London: Sutton, 2000).

Madame du Hausset, *The Private Memoirs of Louis XV* (London: Nichols, 1895).

Nancy Mitford, *Madame de Pompadour* (New York: Harper and Row, 1968).

DOCUMENTARY SOURCES
in Fashion

Jeanne-Louise-Henriette de Campan, *Memoirs of Madame Campan* (1823)—The author of this collection of reminiscences long served as a member of Queen Marie-Antoinette's private circle. Her memoirs provide an unparalleled insight into the court and the world of aristocratic fashion during the final years of the Old Regime.

Louis de Rouvroy, Duke of Saint-Simon, *Memoirs* (1691–1723)—This extraordinary collection of reminiscences is particularly insightful about the world of fashion and style in the time of Louis XIV. Saint-Simon's work is also one of the greatest personal journals of the early-modern age.

Marie de Rabutin Chantal, Marquise de Sévigné, *Letters of Madame de Sévigné* (c. 1660–1696)—This collection of more than 1,500 letters was written by one of the greatest female writers of the age. Madame de Sévigné kept her correspondents up-to-date on the latest happenings in French aristocratic society, sometimes informing them about shifts in fashion.

Restif de la Bretonne, *Monument du costume physique et moral de la fin du dix-huitième siècle* (Monument of Physical and Moral Costume at the End of the Eighteenth Century; 1775)—This exquisite collection of fashion plates shows the progress of a young Parisian dandy and his female companion through the activities of daily life in Old Regime France. The *Monument* was a highly influential work in establishing the canons of fashion journalism.

Betsy Sheridan, *Letters and Journal* (1784–1790)—This collection of diary entries and letters was written by Betsy Sheridan, a member of a prominent Anglo-Irish family. Mrs. Sheridan kept her correspondents up-to-date on the latest changes in fashion emanating from London and Paris.

chapter four

LITERATURE

Philip M. Soergel

IMPORTANT EVENTS
in Literature

1599 Edmund Spenser, author of *The Faerie Queene*—an heroic work praising Protestantism and an ideal of chaste marriage—dies. The poet's brilliance will continue to produce many admirers and imitators during the early Stuart period.

1605 In Spain, Miguel de Cervantes finishes his masterpiece, the picaresque novel *Don Quixote*.

François de Malherbe is appointed court poet in France. His disciplined use of twelve-syllable Alexandrian verse will help to establish its popularity among seventeenth-century French writers.

Shakespeare publishes his *Sonnets* in London, a collection of poetry that will continue to inspire writers for centuries to come.

1611 In England, the Authorized Version of the Bible appears. Over the coming decades, the work will come to have a great impact on the development of the English language and its literature, and will become known affectionately as the "King James' Version" among English-speaking Protestants.

John Donne publishes his *Anniversaries* in London, the only collection of his accomplished poems that is to appear in print during his lifetime.

1614 Sir Walter Raleigh completes his epic *History of the World*, a work that has taken him seven years to finish while a prisoner in the Tower of London on false charges of treason to James I's government.

1616 William Shakespeare dies at his home in Stratford-Upon-Avon, England.

Miguel de Cervantes, the great Spanish novelist and dramatist, dies in Spain.

Ben Jonson is named Poet Laureate of England.

1617 Theodore-Agrippa d'Aubigné completes his satirical novel *The Adventures of the Baron de Faeneste* in France. Once a supporter of the French king Henri IV, d'Aubigné will soon become an opponent of his son Louis XIII's government and will be persecuted as a result.

1620 Thomas Campion, a great Elizabethan poet and lyricist, dies in England.

1623 Jakob Böhme completes *The Great Mystery*, a work that makes use of late-medieval and sixteenth-century German mystical writings and which will help to establish the religious movement of Pietism later in the century. Böhme's mysterious prose will also inspire many seventeenth-century German authors in search of a style in which to compose their vernacular works.

1624 Martin Opitz publishes his *Book of German Poetics*, a work that aims to create a cultivated German style through imitation of the rhetorical works of the later Italian Renaissance. This and other works by the accomplished author will have an enormous impact on German writers of the later seventeenth and early eighteenth centuries.

1627 Honoré d'Urfé completes his *L'Astrée*, a pastoral work inspired by the conventions of late sixteenth-century Italian literature.

1639 The great German poet Martin Opitz dies.

1649 In January, King Charles I of England is executed after a parliamentary trial, initiating the period of the Puritan Commonwealth. Over the coming decade literary enterprises in England will be very

much shaped by the country's dominant Puritan reformers.

1655 Cyrano de Bergerac, an accomplished master of French Baroque prose, dies after a brilliant career as a political and scientific literary figure.

1656 In France, the last of Blaise Pascal's *Provincial Letters* are published. These satirical works poke fun at the Jesuits, particularly at their legalistic notions about morality, and become widely imitated works, helping to shape the French prose of the age.

1659 In France, Paul Scarron completes *The Comic Novel.* The work is daring for the time because it pokes fun at heroic literary traditions.

1660 Charles II is restored to the throne in England, sparking a bold new literature of dissent from oppressed Puritans. Supporters of the crown will also produce a number of brilliant works over the next 25 years of Charles' reign, an era that becomes known as the Restoration.

In London, the man of affairs, Samuel Pepys, begins keeping his famous diary, a work that provides unparalleled insight into Restoration-era events and manners as well as considerable psychological insight into the author's own character.

1665 The publication of François de la Rochefoucauld's *Maxims* commences a distinguished lineage of French works that consider virtue in a genre of writing that debates the merits and makeup of the "honest man."

1667 John Milton's *Paradise Lost,* an epic poem of redemption, is first published. The still-extant contract of Milton's negotiations with his printer is the first such English document to survive from the period.

1669 Hans Jacob Christoffel von Grimmelshausen completes his masterpiece, *The Adventures of Simplicissimus,* in Germany.

1670 Blaise Pascal's *Pensées* or *Thoughts* are published posthumously for the first time in France. These reminiscences and short reflections are noted for the beauty and eloquence of the prose, as well as their revelation of the author's belief in justification by faith, a position that he could not articulate publicly while living.

1677 Aphra Behn, Restoration England's first professional female playwright, completes her popular play *The Rover,* a work that helps to establish her career as a successful literary figure on the London scene. Until her death in 1689, she will be one of the most prolific dramatists and poets on the English scene.

1678 John Bunyan writes *Pilgrim's Progress,* his masterful statement of his Puritan beliefs and a work that will continue to serve as a source of literary invention and creativity in England over the coming centuries.

Madame de La Fayette completes *The Princess of Cleves* in France. From the hand of one of the two great female literary figures of seventeenth-century France, the work is notable for its understated yet beautiful style.

1681 Richard Baxter publishes his *Breviate of the Life of Margaret Baxter,* one of the great seventeenth-century spiritual biographies, which treats the life of his wife and provides a depth of psychological insight into the world of marriage and family life of the time.

1688 Aphra Behn's *Oroonoko* is published in London; the work relies on the author's own experiences while a visitor in the Caribbean. It is noteworthy for its frank sexuality as well as its championship of the nobility of native peoples.

The "Battle between the Ancients and Moderns" begins in France with the publication of Charles Perrault's *Parallels of the Ancients and Moderns.* Over the next two decades French writers will debate the relative superiority of ancient versus modern literature, and eventually writers from

other parts of the continent, including England, will enter into the debate.

1694 George Fox's autobiographical *Journal* is first published at London. The work tells of the Quaker's persecution at the hands of intolerant state authorities as well as his quest for God; it is among the most important seventeenth-century spiritual autobiographies.

1700 John Dryden completes his *Fables, Ancient and Modern* in the year of his death. The work is a collection of translations of ancient and medieval fables and ranks among as one of his most important literary creations.

1704 The Anglo-Irish writer Jonathan Swift's *Battle of the Books* defends those who have argued that modern literature is not the equal of the ancients.

1711 Alexander Pope publishes his "Essay on Criticism," a poem that attempts to create harmony among supporters of ancient and modern literature. The work establishes its author as one of the brilliant literary figures of early eighteenth-century England.

Joseph Addison founds *The Spectator,* an important literary magazine on the London scene.

1715 Alain-René Lesage's picaresque novel, *History of Gils Bas,* is first published in France.

1716 Lady Mary Worthley Montagu publishes her *Court Poems,* a collection of works redolent with references to the ancients. The author's status as a member of the English aristocracy and as a figure of great erudition helps to establish her as a literary force in England.

1719 Daniel Defoe's *Robinson Crusoe* is first published. It will rank as one of the great adventure stories of the century.

1721 The Baron de Montesquieu finishes his *Persian Letters,* one of the first great works of the French Enlightenment. The work

argues for tolerance and the acceptance of pluralistic opinions in society.

1722 Defoe publishes *The History and Misfortunes of the Famous Moll Flanders,* a work that will have an important influence on the development of the eighteenth-century novel.

1726 Jonathan Swift's political satire *Gulliver's Travels* appears in London.

The French playwright and literary figure Voltaire begins a two-year exile in London. His residency there will inspire the *Philosophical Letters* he publishes in 1734, a work that praises the greater liberty of English society as compared to that of contemporary France.

1731 Antoine-François Prevost's novel *Manon Lescaut* appears in Paris. The work's tragic heroine will continue to inspire dramatic and musical creation over the next 150 years.

1740 Samuel Richardson's *Pamela,* often cited as the first true English novel, is published at London.

1749 Henry Fielding's masterpiece *Tom Jones* is printed. The work is a novel written as a comic epic and quickly becomes one of the most admired pieces of English fiction of the day.

1751 Denis Diderot commences the massive project of the *Encylopédie* in Paris. When completed some two decades later, the work's many volumes will treat numerous issues in contemporary aesthetics and literature.

1755 Samuel Johnson's *A Dictionary of the English Language* is first published in London, the most comprehensive dictionary of the language to this time.

1759 Voltaire's satirical *Candide* is first published. The work's savage mockery pokes fun at the philosophical optimism of the German philosopher Leibniz and argues

instead that human beings must shape their own destiny and mold society to suit the demands of freedom.

1761 Jean-Jacques Rousseau completes *Julie, or the New Héloïse*, a story that makes use of the medieval incident of Abelard and Heloise's ill-fated romance but which is set in the world of eighteenth-century France. The work's partially autobiographical strains initially cause its author some embarrassment.

1765 Samuel Johnson edits and publishes *The Works of William Shakespeare*. His attention to Shakespeare's works is only one sign of a growing sense among contemporary literary figures of the formative role of the bard's works on English literature and the theater.

1766 Oliver Goldsmith's masterpiece *The Vicar of Wakefield*, a work of gentle humor that treats the life of an impoverished clergyman, is printed in London. It will become one of the most successful of later eighteenth-century British novels.

1776 Edward Gibbon's massive work, *A History of the Decline and Fall of the Roman Empire*, appears. Its anticlerical strains credit Rome's late antique troubles with the rise of Christianity.

1777 Johann Wolfgang von Goethe's *The Sorrows of Young Werther* helps to establish the *Sturm und Drang* ("Storm and Stress") movement among writers in Germany. The work's vivid portrayal of the psychological torments attendant upon unrequited love make it a best-selling work in the generation that follows, both at home in Germany and also abroad.

1782 In France, Pierre Choderlos de Laclos's *Les liaisons dangeureuses* (Dangerous Liaisons) paints a picture of aristocratic sexual depravity and decadence that quickly makes it a best-seller.

1791 The Marquise de Sade's *Justine* is published. The work's cruel imagery will help to establish the term "sadism" in modern European languages.

OVERVIEW
of Literature

**THE SEVENTEENTH CENTURY: AN AGE OF GE-
NIUS.** It is difficult to summarize the achievements of
European literature in the Baroque and classical eras, be-
cause they are at one and the same time enormous and
yet enormously varied. From the benefit of hindsight,
though, the years following 1600 witnessed some fun-
damental changes that were to shape the greatest litera-
ture of the age. The examples of Italy, long the
inspiration for the Renaissance's greatest literary inno-
vations, declined in importance as a source of emulation
for Europeans in the Baroque era. Although great liter-
ature continued to be produced in Italy, much of the ef-
forts of Italian authors in the seventeenth and eighteenth
centuries found an outlet in new artistic forms like the
opera, where authors were kept busily employed writing
libretti for the country's insatiable appetites for musical
dramas. The years around 1600 were for Spain a Golden
Age, and in the decades that followed one Renaissance
form of literature popular in that country, the picaresque
novel, came to be widely read and imitated throughout
Europe. Although Spain's dominance over European
fashion was profound in the early seventeenth century,
it proved to be short-lived. By the 1640s the country's
costly involvements in international wars—much of it
motivated by the zeal to re-impose Catholic uniformity
on Europe—had led to bankruptcy and a retreat from
the international scene. By the second half of the seven-
teenth century, Spain's artistic and literary influence in
Europe was decidedly on the wane. In a larger sense,
though, the country's involvement in religious contro-
versies was symptomatic of the era, and in the seven-
teenth century many European authors became involved
in the working out of religious and moral dilemmas that
the sixteenth-century Reformation and Counter-Refor-
mation had produced. In every country in Northern Eu-
rope, religious debates produced a flood of tracts and
pamphlets, as well as more enduring poetry and prose
that spoke to the doctrinal dilemmas of the age. In Eng-
land, the controversies between Puritans and Anglicans
produced the great but enigmatic poetry and devotional
texts of figures like the Anglican John Donne and the
highly entertaining sermons of the Puritan Jeremy Tay-
lor. In France, the dispute between Jansenists and Jesuits
was similarly creative, inspiring a flood of devotional
works by which each side tried to sway readers to the
rectitude of their position. Among the great literary
products this competition produced was Blaise Pascal's
immortal *Provincial Letters* (1757), a work that satirically
and successfully mocked the legalistic hairsplitting of the
Jesuits, and which by virtue of the brilliance of the prose
it presented, survived to influence later generations of
writers. In Germany, a similar dynamic is evident. Al-
though most of the writers that contributed to the coun-
try's first "national" literature were Protestants, German
presses continued to churn out a host of devotional and
polemical literature that spoke to the religious sensibili-
ties of the age.

THE IMPACT OF DRAMA. Literary endeavor was
only rarely a life's work in seventeenth-century Europe.
The great works that survive from the period were not
written in pursuit of royalties, as in the modern world,
but rather to present an author's point of view, to en-
tertain, or to satisfy the demands of aristocratic patrons.
Many who wrote in the period did not publish their
works; their literary creations, in other words, often cir-
culated among friends and associates in manuscript form.
Often, it was only after an author's death that editions
of his or her major works were printed. The stipulations
of copyright were just beginning to be worked out in the
period, and as a result, publishing a successful work of
poetry or prose did not assure one's fortunes. Still, the
press was steadily becoming a medium for presenting
one's ideas and literary accomplishments, but it never-
theless competed against the far more important role that
the theater had as a source of support for authors. In
England, Spain, and somewhat later in France, the the-
ater was the most lucrative way in which authors might
employ their talents. Writing for the stage offered
authors the possibility of benefiting from a popular pro-
duction, since in most cases theatrical companies divided
the profits from a successful play with their writers. Such
a situation was well suited to provide a career path for
men of relatively humble status to ascend the social lad-
der. In seventeenth-century London, for instance,
William Shakespeare was just one of several successful
playwrights who sprang from modest origins. Later in
the century, the largely "self-taught" Puritan John Bun-
yan used his literary talents to promote his dissenting
views and as a significant source of income. But while
the seventeenth century presents numerous cases of such

seemingly "self-made" men, literary achievement continued to be strongly linked to social class and the educational benefits it often provided. In both France and England, seventeenth-century royal courts supported many "literary wits," figures that often made their way in these enclaves by virtue of their connections and the ability to write a passable verse. From the Renaissance, Europe's cultured courts had inherited a high sense of the mission of the poet, and court life offered a number of occasions that called for the poet's skills to lend literary immortality, depth, and grandeur to its rituals.

NATIONAL STYLES AND ANCIENTS AND MODERNS. Another feature of the age left its mark on the developing national literatures of the period: the debates over the rhetoric and style that was best suited to a particular language. By the seventeenth century most of Europe's various languages already possessed centuries of literary usage. During the Renaissance, however, the revival of a pure style of classical Latin, known as Neo-Latin, had enriched Europeans' knowledge of the subtle and complex skills that ancient rhetoric offered. In France, England, and many parts of Europe the reception of humanism—the learning promoted by the Italian Renaissance—had spurred new debates concerning the style and rhetoric that was best suited, not only to Latin writing, but to that in the native, or vernacular language. These debates persisted in the seventeenth century, but they soon expanded, providing the foundation for the establishment of the French Academy in 1634, and the various literary societies that were common throughout Central Europe. England lacked such organized institutions, yet at the same time, the crown's persistent appointment of poet laureates, and its support of literary circles at court, tended all the same to sanction certain kinds of rhetoric and style above others. In France, the discussions of the French Academy, as well as certain literary salons in and around Paris, played a profound role in shaping seventeenth-century French Classicism, a severe yet grand style of writing that was most brilliantly displayed in the verse tragedies of Corneille and Racine, but which left a more general impact on the poetry and prose of the period, too. In Germany, the many literary societies that emulated the country's "Fruit-Bringing Society" led to a literary ferment that failed to produce a single all-encompassing style, but which led to considerable discussion and creativity. Toward the end of the seventeenth century in England, it was the clear and lucid prose and poetry of John Dryden and his circle that predominated among intellectuals throughout the country. This form of expression, often referred to as "Augustan," was notable for its lucid, formal, and relatively unadorned style, and it persisted into the eighteenth century. Considerations about style inevitably led to questions about the relative superiority of contemporary literature when compared against the testimony of the "ancients." Bristling debates often erupted in early-modern states between those who argued that the poetry and prose of ancient Greece and Rome was the only suitable model for emulation, and those who argued that contemporary literary efforts might match and even surpass the culture of Antiquity. This debate, a part of the intellectual landscape of Europe since the early Renaissance, continued to erupt episodically in early-modern Europe. One of its last episodes occurred in France at the end of the seventeenth century within the developing French Academy, and the dispute between French authors soon spread to England and other parts of Europe. In this late embodiment of the debate, many figures argued that literatures and languages evolved and changed over time, and that the literature of the present had been enlarged by the steady accretions that had occurred over the ages. Although such insights did little to quiet the contemporary disputes between "ancients" and "moderns," they provided a bridge to the developing ideas of the Enlightenment. In the eighteenth century that followed, many literary figures advanced new theories for the criticism of literature, and in this way the long-standing tutelage of the ancients that had often been such an important force in fashioning writer's works tended to become less and less important.

MULTIPLICATION OF GENRES. Despite efforts to develop consistent national styles, Europe's rhetoricians never succeeded in establishing a single, unified literary vision. Indeed, as relative peace and prosperity emerged in Europe at the end of the seventeenth century, a host of new genres of literature became popular. Early forms of the novel—a prolonged, largely invented world of literary fiction—soon became popular in almost all parts of the continent. Spiritual autobiographies, a genre as old as St. Augustine's fifth-century *Confessions*, became popular reading, and diary and letter writing expanded steadily as well. Both the changing views of the natural world promoted by the Scientific Revolution and of the political order expounded in the works of philosophers like John Locke also produced a flood of new kinds of social commentary and criticism, as writers turned to examine their societies along lines promoted by the seemingly "scientific" models of the age. And finally, a new kind of literary endeavor, journalism, had steadily matured in the course of the seventeenth century. By 1700, it was poised to play an increasingly important role in

politics and in the establishing of literary tastes and trends. It was in London, Europe's largest eighteenth-century city, where the forces that sustained this new varied literary marketplace can be seen first exerting their pressures on the public world. Although the city's presses had been tightly controlled during the seventeenth century by the Stuart kings, the laws upholding the traditional organs of censorship lapsed in England in 1695, and were not renewed. In the years that followed, London's Fleet Street became home to Europe's most vigorous center of journalism, and the development of the city's newspapers fed a popular appetite for knowledge of recent events and for commentary on the course of politics. Many of the figures that took advantage of the new commercial possibilities the press offered still continued to fall afoul of British law. Daniel Defoe, for instance, was imprisoned on several occasions for the fiery tracts he printed attacking government policies. But the profits to be made in journalism were too attractive for many to pass up, and the daring that the city's newspaper men often evidenced soon made it difficult for Parliament and the Crown to contain the vigorous debate London's new journalistic culture inspired.

RISE OF THE NOVEL. One of the most distinctive literary genres that emerged from this new culture of information was the eighteenth-century novel, a form of fiction that was in many ways distinct from the older forms of the novel that had circulated in seventeenth-century Europe. Those seventeenth-century forms had often been *romans à clef*, in which classical stories had been peopled with prominent characters drawn from contemporary life. The popularity of this thinly-veiled form of satirical examination had, in fact, been sustained by a category of aristocratic readers anxious to see how far an author might go in holding up a mirror to present circumstances. Another form, the picaresque novel that had originally appeared in sixteenth-century Spain, had featured lowborn heroes and had followed these characters through a series of exploits and adventures in which they exposed the hypocrisy and venality of aristocratic society. But in early eighteenth-century England, the journalist Daniel Defoe pioneered a new category of seemingly realistic fiction in his *Robinson Crusoe, Moll Flanders*, and *Roxana*. To construct these realistic stories about life in exotic circumstances, Defoe drew upon older genres, including the spiritual autobiographies and confessional narratives that had been popular in later seventeenth-century England. At the same time, he relied upon a new taste for eroticism and a curiosity about "how the other half lived" to create a genre of fiction that steadily grew in popularity. His initial experimen-

tations with the genre laid the groundwork for the great novels of Samuel Richardson and Henry Fielding at mid-century, works that had a deep influence, not only in England, but also throughout Europe. As the new form of realistic or, as it is sometimes called, "bourgeois" fiction made its way through the European continent, it often gave voice to the disputes and dilemmas of the Enlightenment. In this process, the novel was raised from a once "light" and even disreputable form of fiction, into an elevated vehicle for discussing the great moral and philosophical problems of the age, a development that paved the way for the great age of Romantic nineteenth-century fiction that was to follow.

TOPICS
in Literature

ENGLISH LITERATURE IN THE EARLY SEVENTEENTH CENTURY

A CENTURY OF GREATNESS. At the beginning of the sixteenth century as the New Learning of the Renaissance made inroads into England, few signs were present of the enormous flowering that was soon to occur in the country's language and literature. For much of the later Middle Ages, England had remained one of Europe's more isolated backwaters, and its language, although raised to a level of high art in the late-medieval works of Chaucer and other authors, was still quite different from the rich and malleable literary forms that were to be deployed by Shakespeare and his Elizabethan contemporaries. During the course of the sixteenth century the world of international politics as well as the circumstances of religion helped to propel England into the ranks of important European powers. If the country's status flagged distinctly behind Habsburg Spain, Elizabeth I still managed to challenge that power by besting the Spanish Armada in 1588, as well as her rival Philip II. And while English power on the international scene may not have approached that of France under the Valois and Bourbon monarchies, the Elizabethan age still witnessed relative peace and security at the same time as France, the Netherlands, and other parts of Europe were suffering religious wars. During this era of relative stability England's theater and its literature witnessed unprecedented development, development that continued in the years following Elizabeth's death in 1603 despite the worsening political and religious climate in the country. The Elizabethan era witnessed the plays of Christo-

pher Marlowe (1564–1593), William Shakespeare (1564–1616), Thomas Kyd (1558–1594), and a distinguished lineage of lesser lights that cultivated a broad audience for the theater in England. It witnessed the creation of *The Faerie Queene* of Edmund Spenser (c. 1552–1599) and the works of a number of poets of high achievement. The period also nourished the development of many poets and playwrights, like Ben Jonson (1572–1637), whose careers lay more in the Stuart age that followed it, than in the reign of Elizabeth I. And although the accession of James I, the Stuart king of Scotland, to the English throne in 1603 brought an end to the relative domestic tranquility of Elizabeth's later years, there was no sudden decrease in the outpouring of literature in the early seventeenth century. The reign of James I, for example, continued to be an era of uninterrupted and steady achievement, even if disputes over religion soon bubbled up and combined with angry debates over the respective rights and prerogatives of Parliament and the Crown. The first signs of the new tensions occurred soon after the arrival of James I (r. 1603–1625) in England. As James journeyed from Scotland to London he was presented with the Millenary Petition, a series of requests for greater reforms in the Church of England, from English Puritans. Yet in the conference he convened to consider these requests at Hampton Court Palace several months later, the king rejected most of these demands, thus laying the foundations for the beginning of an alienation between the king and his Puritan subjects that grew worse over time. The unearthing of the Gunpowder Plot in 1605, an abortive plan allegedly masterminded by Catholics to blow up the Houses of Parliament in Westminster, brought determined persecution of the country's Catholic minority, too. In the years that followed, James and his son and successor Charles I (r. 1625–1649) wrangled persistently with the country's ruling elites, insisting upon, but never effectively establishing, their ability to levy taxes without parliamentary consent and to rule like Continental absolutist monarchs. Despite these troubles—troubles that ultimately led to the outbreak of the English Civil Wars of the 1640s and to Charles I's execution in 1649—the early Stuart period was a time of continued literary achievement. These accomplishments can be seen in the vitality of the London stage as well as in the poetry and prose of the era.

THE AUTHORIZED VERSION OF THE BIBLE. One distinctive note of relative unanimity in the otherwise troubled waters of religion and politics in the early Stuart era involved the preparation and acceptance of a new translation of the Bible into English, a work that was completed with the publication of the so-called Authorized Version of 1611. This text, long known in North America merely as the King James Version, was the culmination of efforts the king had sanctioned at the Hampton Court Conference of 1604, the body of church and political figures convened to consider the Puritans' Millenary Petition, as well as other issues in the Church of England. The resulting text became perhaps the single-most important work of English prose, helping to establish a cadence and metaphorical sensibility that made deep inroads into the literature of the seventeenth and eighteenth centuries and which persisted in the centuries beyond. Although Puritans had supported the idea of a new English Bible, James I soon granted the program his enthusiastic aid. To complete this enormous task, 54 translators were eventually asked to serve on six different translation teams, two centered in London and another two each at the universities of Cambridge and Oxford. Each team compiled its translations and then subsequently submitted them to a central oversight committee for approval. In completing their work, the translators of the Authorized Version did not create an entirely new translation, but instead relied on many of the earlier English Bibles published in the sixteenth century. They consulted, in other words, the "Bishops' Bible," an edition of the book that had been first printed for England's churches in 1568, and which was subsequently made compulsory throughout the Church of England. At the same time they relied on the so-called Geneva Bible of 1560, a work very much favored by Puritans because of the explicit Calvinist-inspired commentary that ran alongside the text. Two other sources were the somewhat earlier translations of Miles Coverdale, as well as that of William Tyndale. Tyndale's early sixteenth-century translation, while incomplete, showed great erudition in its rendering of the text into English, and its influence continued to be decisive in many cases in the Authorized Version, although the Genevan Bible's influence was also vital. Royal edict expressly forbade the translators from including any of the Genevan version's Calvinist commentary, a sign that James, like Elizabeth before him, intended to steer the Church of England on a middle course between more radical forms of Protestantism and Catholicism.

SUCCESS OF THE KING JAMES BIBLE. The resulting text may not have pleased all quarters in the embattled Church of England when it appeared in 1611, and many Puritan congregations continued to rely on the Geneva Bible for years to come. But the translation pleased enough of the fractious Church of England that it soon became the common version of the Bible in the

country's churches. Although titled an "Authorized Version," no royal edict ever required its usage. Still, it became the accepted version of the Bible, not only in England, but in Scotland as well, a country with a very different kind of reformed church and an English language very different from the southern portion of the island. In this way King James's version provided important ties of continuity between these various parts of the English-speaking world, and as England became a colonial power, the text was carried to the far corners of the world. In this process it helped to forge a common literary heritage among peoples that might otherwise have been vastly separated by linguistic differences. And although the Authorized Version eventually was replaced in the nineteenth and twentieth centuries by a series of revisions, it continued to define the ways in which most English-speaking peoples perceive the Bible as a sacred text. For this reason, the King James version continues to be embraced even now as the authoritative translation of the Bible by many conservative Protestant sects in England, America, and throughout the world.

RELIGIOUS LITERATURE AND SERMONS. If the King James version of the Bible struck a chord of unusual unanimity in the divided England of the early seventeenth century, other disputes of the era concerning religion soon became the stuff from which new literary forms were crafted. The seventeenth-century English church produced an enormous outpouring of printed sermons and devotional literature, written both by Puritans of all stripes and by Anglicans committed to its middle path between Catholicism and Protestantism. To publish a printed book in Elizabethan and Stuart England, the state required that texts be submitted to the Stationer's Guild, a medieval institution charged since the mid-sixteenth century with the task of administering an apparatus of inspection and censorship. Of course, authors and printers sometimes printed works without submitting them to these official channels, but the penalties for refusing to do so were great. In 1620, half of all works recorded in the Stationers' Guild's records were religious in nature, and this portion consisted of polemical tracts defending one's doctrine or point of view about reforms in the church, devotional books, and sermons. One issue that divided Puritans from committed Anglicans—that is, avid supporters of the Church of England's settlement—centered on the preaching of sermons. For many Puritan divines, preaching was an obligation that was to be conducted extemporaneously so that the minister might reveal the Word of God through the inspiration of the Holy Spirit. Printed prayers, like those of the church's *Book of Common Prayer*, as well as the

written sermons used by committed Church of England ministers, assaulted the sensibilities of determined Puritans, since they seemed an attempt to hem in and limit the very power of the Word of God and the Holy Spirit. Committed Puritans who relied on an extemporaneous delivery in church, though, were often careful to record their words following their sermons and to prepare printed editions of their texts. The competition between Anglicans and Puritans, moreover, sustained a constant outpouring of devotional works as both Puritans and committed Anglicans aimed to convince readers of the correctness of their respective positions concerning the church and the Christian life. On the Puritan side, men like Richard Baxter (1615–1691) composed fine devotional texts, best-sellers like his *The Saint's Everlasting Rest* (1650), which were consumed in numerous editions. And while Puritan churchmen like Baxter attacked supporters of the Church of England as promoters of an arid, spiritless formalism, the evidence suggests that they were not such easy targets.

ANGLICAN DEVOTIONAL LITERATURE. Throughout the seventeenth century committed Anglicans produced a steady flow of religious and devotional literature that aimed to inspire "holiness" among readers. The Anglican attitude toward Christian piety, although quite different from the highly defined and often theologically sophisticated and systematic treatments of Puritan divines, was no less firmly Christian in its outlook. Committed Anglicans sought to present images of the Christian life and its cycle of sin, forgiveness, death, and resurrection in ways that stirred the faithful to repentance and amendment of their lives. In the hands of its most urgent supporters, men like Archbishop William Laud (1573–1645) who became an enthusiastic persecutor of Puritans in the reign of Charles I, such calls to holiness earned for Anglicanism an enduring image of intolerance. Yet the Church of England also nourished many authors in the early seventeenth century that ably defended its positions, and who created an enduring literature of religious devotion that has continued to elicit admiration across the centuries. Among these figures, the works of Jeremy Taylor (1613–1667), Henry Vaughan (1621–1695), and Thomas Traherne (1637–1674) provided majestic, yet profound defenses of the principles of Anglicanism at a troubled point in the church's history. Although these figures' works are rarely read today outside the ranks of literary specialists, the period also produced John Donne (1573–1631) and George Herbert (1593–1633), who are still considered as authors and poets of the first rank, and who used their eloquence to defend the Anglican settlement. Donne has long had

a perennial appeal, in part, because his works encapsulated the religious and philosophical dilemmas of his age in ways that elevated these concerns into timeless meditations on the human spirit and its discontents.

DONNE. The circumstances of Donne's life were redolent with the disputes and controversies that the Reformation continued to inspire in late sixteenth- and early seventeenth-century England. Born into a prominent Catholic family, he was schooled at home by Catholic teachers before entering Oxford and perhaps somewhat later Cambridge. Prevented from taking a degree because of his Catholicism, he seems to have traveled for a time throughout Europe before renouncing his faith and becoming a member of the Church of England in 1593. His religious zeal in these early years, though, was overshadowed by a taste for adventure, and in the late 1590s Donne even sailed on several voyages with the adventurer Sir Walter Raleigh. He participated in the sack Raleigh's forces staged of Cadiz harbor in Spain in 1596 and he traveled the following year with the same force to the Azores in search of Spanish booty. Returning home from these adventures, he began to rise in the world of politics as a private secretary to Sir Thomas Egerton, an important man of state affairs in Elizabethan England. Eventually, he was elected to Parliament through Egerton's graces, but in 1601 a disastrous secret marriage to Ann More, Egerton's wife's niece, cut short his political career. He was imprisoned for a time, and spent the years that followed trying unsuccessfully to rehabilitate his reputation. His clandestine, unsanctioned marriage made him unsuited for public political life, and for almost fifteen years he and his wife lived off the patronage of friends and associates. Eventually, James I suggested he undertake a career in the church rather than in public affairs, and in 1615 he was ordained a priest and received a clerical appointment from the king. James forced Cambridge University to grant Donne a Doctor of Divinity degree, and with these credentials in hand, he began to acquire a series of positions in the church in London. Eventually, he rose to become dean of St. Paul's cathedral, and in that capacity he became one of the most influential preachers of the seventeenth century. His style both in his poetry—which he wrote almost exclusively for private amusement rather than public consumption—and in his sermons was notable for abandoning the "soft, melting phrases" preferred by Elizabethan authors. In place of that elegant and light style, Donne preferred a dramatic, deeply intellectual language that was often filled with forceful turns of phrase that lamented and yet gloried in the death and resurrection of the human spirit. As a preacher, his abilities to create metaphors

Engraving of John Donne. CORBIS-BETTMANN/NEWSPHOTOS, INC. REPRODUCED BY PERMISSION.

and turn phrases that encapsulated the spiritual dilemmas of the era earned him an enormous following among Londoners, and at the same time exemplified the possibilities that might exist in Anglican piety. For generations, the intensely intellectual, philosophical, and metaphysical cast of Donne's writing has been summed up in his *Devotions upon Emergent Occasions* (1624), the author's own considerable reflections on his sickness and attendant death. That work, filled with an astute understanding of the many shades of fear and longing that attend approaching death, includes the immortal refrains "No man is an island" and "never send to know for whom the bell tolls, it tolls for thee." Yet in the body of poetry and sermons that Donne left behind, and which was edited and published by his son after his death, the author's works present a diverse range of prose and poetry, much of it difficult to understand, yet rewarding to those that have tried to plumb its considerable intellectual range and depth. Donne's example soon inspired a number of poets and authors that followed.

THE METAPHYSICAL POETS. In the late eighteenth century Samuel Johnson coined the phrase "metaphysical poets" to describe John Donne and a school of

poets that had imitated that poet's difficult, yet forceful style. Others had already noted a "metaphysical" strain in Donne's work and in the poetry of early seventeenth-century England, a strain that had become less popular during the Restoration era of the later century, as authors had come to favor a clearer, less mysterious style. In truth, none of the figures that have been described as "metaphysical poets" in the early seventeenth century—including George Herbert (1593–1633), Richard Crashaw, (1613–1649), and Henry Vaughan (1621–1695), among others—were properly concerned with the subject of metaphysics, at that time a branch of natural philosophy that treated the underlying or hidden properties of things observed in the natural world. Nor do many of the poets sometimes connected to this so-called Metaphysical School seem to share much, beyond the use of certain literary conceits and a taste for ironic and often highly paradoxical treatments of their subjects. Yet the notion of an early seventeenth-century group of Metaphysical poets has endured, in part, because of the serious, religious themes treated in many of these figures' works—themes that differed dramatically from the secular, often worldly poetry written at the time by a group equally long identified as the "Cavaliers." In the works of the foremost practitioners of the "metaphysical style"—Donne, Herbert, Crashaw, and Vaughan—certain underlying structural similarities do seem to exist. One of these similarities is in their frequent recourse to emblematic modes of expression. Emblems were symbolic pictures that often contained a motto. They had first appeared in the Renaissance as a popular pastime, and books of emblems had figured prominently in courtly and aristocratic culture since at least the early sixteenth century. In Baldassare Castiglione's classic work, *The Book of the Courtier* (1528), for instance, the cultivated circle whose conversations are recorded in the work spend their evenings unraveling the mysteries encapsulated in emblems. In the decades that followed, emblems appeared throughout Europe on many elements of material culture. Artists inserted them into fresco cycles, or they became popular symbols incised onto jewelry. Sometimes they were even reproduced on dinnerware, so that cultivated, humanistically educated men and women might decode their meanings between the courses at banquets. Even as they grew more popular, though, the sensibilities that surrounded their consumption underwent changes—changes that were, in part, sponsored by St. Ignatius of Loyola's *Spiritual Exercises* and other sixteenth-century works that advocated a thorough and disciplined contemplation on visual stimuli in the "mind's eye" to enhance one's personal meditations. Emblems, once the preserve of a cultivated society anxious to demonstrate its knowledge of iconography and literary traditions, now came to circulate in books that were prized by devout Catholics, Puritans, and Anglicans alike as an aid to religious devotion. In books of emblems the emblem itself now came to be represented with three components: a motto that encapsulated the emblem's meaning, a symbolic picture that represented it, and a poem that commented upon its deeper significances. Works like these were self-consciously difficult, and they called upon the viewer's senses to decode the hidden underlying meanings that lay in the emblem's symbolic language. They both required and rewarded those who used their wits and erudition to unlock their many encoded significances. This same highly visual and symbolic sense is to be found in the difficult poems of Donne and his friend, George Herbert, and it also played a role in Herbert's admirers, Richard Crashaw and Henry Vaughan. While the concerns of these so-called "metaphysical poets" differed, and their style was extremely varied, there were thus certain common links in their works that were rooted in the devotional climate of their age.

THE CAVALIERS. Different sensibilities of style and content can be seen in a second, albeit equally artificial group of poets from the early Stuart period who have by long tradition been identified as the Cavaliers. Generally, this term was applied to all those who supported Charles I during the Civil Wars of the 1640s. Yet in literature it has long been granted to the poetry of figures like Thomas Carew (1594/1595–1640), Richard Lovelace (1618–1657/1658), Sir John Suckling (1609–1642), Robert Herrick (1591–1674), and Edmund Waller (1606–1687). The first three of these figures were courtiers in Charles I's circle, and did not live to see the Restoration of the monarchy under Charles II. Edmund Waller and Robert Herrick, by contrast, lived through the Civil Wars and came to see their fortunes rise again during the Restoration. Thomas Carew, the elder statesman of the group, served Charles I in the Bishops' War of 1639, an engagement precipitated by the Crown's disastrous plan to establish bishops in Presbyterian Scotland. One year later, Carew's career as a royalist was cut short by death, perhaps occasioned by the exertions of his military endeavors. In contrast to the seriousness and high moral tone observed in many of the "metaphysicals," Carew's poems were altogether lighter and less problematic, and like other Cavalier poets, they often reveal an easy attitude toward sex and morality. Although he wrote a poem in praise of John Donne, his own style seems to have owed more to the witticisms of Ben Jonson, an English Renaissance poet and dramatist, than to

a PRIMARY SOURCE *document*

FOR WHOM THE BELL TOLLS

INTRODUCTION: The great poet John Donne was also recognized as one of the most accomplished preachers of seventeenth-century England. His sermons often dealt with the mysteries of death, suffering, and Christian redemption. In contrast to the doctrinally tinged messages of Puritans at the same time, Donne and other Anglicans attempted to stir their audiences to repentance and holiness of life through presenting powerful images, as he does in this famous passage from his *Devotions Upon Emergent Occasions*, texts that were originally delivered in his office as Dean of St. Paul's Cathedral in London.

PERCHANCE he for whom this bell tolls may be so ill, as that he knows not it tolls for him; and perchance I may think myself so much better than I am, as that they who are about me, and see my state, may have caused it to toll for me, and I know not that. The church is Catholic, universal, so are all her actions; all that she does belongs to all. When she baptizes a child, that action concerns me; for that child is thereby connected to that body which is my head too, and ingrafted into that body whereof I am a member. And when she buries a man, that action concerns me: all mankind is of one author, and is one volume; when one man dies, one chapter is not torn out of the book, but translated into a better language; and every chapter must be so translated; God employs several translators; some pieces are translated by age, some by sickness, some by war, some by justice; but God's hand is in every translation, and his hand shall bind up all our scat-

tered leaves again for that library where every book shall lie open to one another. As therefore the bell that rings to a sermon calls not upon the preacher only, but upon the congregation to come, so this bell calls us all; but how much more me, who am brought so near the door by this sickness. There was a contention as far as a suit (in which both piety and dignity, religion and estimation, were mingled), which of the religious orders should ring to prayers first in the morning; and it was determined, that they should ring first that rose earliest. If we understand aright the dignity of this bell that tolls for our evening prayer, we would be glad to make it ours by rising early, in that application, that it might be ours as well as his, whose indeed it is. The bell doth toll for him that thinks it doth; and though it intermit again, yet from that minute that that occasion wrought upon him, he is united to God. Who casts not up his eye to the sun when it rises? but who takes off his eye from a comet when that breaks out? Who bends not his ear to any bell which upon any occasion rings? but who can remove it from that bell which is passing a piece of himself out of this world?

No man is an island, entire of itself; every man is a piece of the continent, a part of the main. If a clod be washed away by the sea, Europe is the less, as well as if a promontory were, as well as if a manor of thy friend's or of thine own were: any man's death diminishes me, because I am involved in mankind, and therefore never send to know for whom the bells tolls; it tolls for thee.

SOURCE: John Donne, *Devotions Upon Emergent Occasions* (London: Thomas Jones, 1624): 410–416. Spelling modernized by Philip Soergel.

the serious moral tone promoted at the time by Anglican holiness. Above all the members in the group, he seems to have been an excellent literary craftsman with an often-meticulous attention to detail in his poems, a quality for which another Cavalier, Sir John Suckling, criticized him as if he were a pedant. Of the remaining figures, Edmund Waller was long among the most admired, and his poems continued to elicit admiration from critics throughout the seventeenth and eighteenth centuries. The great John Dryden (1631–1700) credited Waller's poetry with ushering in England's "Augustan Age," and among the specific qualities that he admired in it was a great "sweetness." Today, the sophisticated simplicity of his works continues to be much admired, although unfortunately only among specialists in English literature; Waller has long since ceased to be a household name. Born to a wealthy family, he increased his fortune by several skillful marriages, and when he en-

tered Parliament in the 1620s, he was originally a member of the opposition. During the 1630s, he switched sides to become a royalist, but when he led an unsuccessful plot to seize London from Puritan forces in 1643, he was banished for a time from the country before being reconciled to the Puritan Commonwealth and rising to prominence again under Charles II after 1660. By contrast, Robert Herrick was the only member of the "Cavaliers" that never served at court. Granted a rural living in the Church of England as a reward for military service to the Crown, he lived out his days away from London, in considerably quieter circumstances—that is, as a country parson in a remote corner of Devon in the southwest of England. Although he originally detested the countryside, he came to admire the rural folkways of his parishioners, in part, because he abhorred the ways in which Puritans were attempting to suppress country people's traditional customs. His works were like all of

those of the so-called Cavalier group: witty, graceful, sophisticated, and laced with a touch of "devil-may-care."

MILTON AND THE PURITAN COMMONWEALTH.
The execution of Charles I by Parliament in January of 1649 signaled a sudden end to the Cavaliers' musings, and although certain poets like Waller and Herrick continued to write in this vein following the restoration of the monarchy, the decisive Puritan victory quieted such voices for a time. During the Puritan Commonwealth, many Royalist supporters were forced to flee England before returning, or like Herrick, to exist on the gifts of their friends before taking up the life they had enjoyed during the war. During the Puritan Commonwealth devotional works, religious polemics, and sensational prophecies continued to pour from England's presses, although there was little market in the heated religious climate of the 1650s for the kind of gracious and elegant poetry once championed by Cavalier society. One of the figures that continued to fuel the anxious political debates of the period was John Milton (1608–1674), who early in life had trained to be a Puritan minister, but until the 1640s had spent much of his time studying and perfecting his skills as a poet. During the Civil Wars Milton first became embroiled in the battle between Puritans and Royalists when he published a number of pamphlets attacking the episcopacy. With the establishment of the Commonwealth, he continued his activities as a propagandist for the Puritan cause, although he also served as a secretary to the Council of State. Increasingly blind, he nevertheless continued to support the cause, publishing one tract so vehement in defending the Puritan cause that it was burnt in ceremonial bonfires in several French cities. As the Commonwealth began to flounder in the months following the death of its Lord Protector, Oliver Cromwell, Milton tried to rally support for the increasingly unpopular government, again by serving as a pamphleteer. With the restoration of the monarchy in 1660, though, he was forced into hiding, eventually arrested, and after a short imprisonment, he was fined and released. His political career now in ruins, Milton retired to his home in London where he began to write his masterpieces, *Paradise Lost* (1667) and *Paradise Regained* (1671). Both works still rank among some of the most challenging reading in the English language, filled as they are with a complex syntax, abstruse vocabulary, numerous difficult classical allusions, and a complicated epic style. Despite their Puritan religious orthodoxy, the two monumental poems present Milton's breadth of learning and the complexities of his opinion. In *Paradise Lost* the author tells the story of man's fall from grace in the Garden of Eden, and presents one of the most sympathetic portraits of Satan ever recorded in the Western tradition. Milton treats him in the manner of a tragic hero, whose fatal flaw lies in the perversions of sin. Although the story of the Fall recorded in Genesis was well known to Milton's readers, and had long been given a host of literary treatments, the poems still manage to possess considerable originality and breadth of imagination. It is for this reason that their author has long been lauded as the English poet whose powers rank second only to William Shakespeare. Yet the crowning achievements of Milton's career as a literary figure were intricately embroiled in the harsh political realities of the seventeenth-century state. Had it not been for Milton's banishment from public life because of his complicity in the Puritan Commonwealth, his great life work might never have been completed.

SOURCES

R. Barbour, *Literature and Religious Culture in Seventeenth-Century England* (Cambridge: Cambridge University Press, 2002).

J. Carey, *John Donne: Life, Mind and Art* (New York: Oxford University Press, 1981).

S. Fish, *Surprised by Sin: The Reader in Paradise Lost* (Cambridge, Mass.: Harvard University Press, 1998).

F. Kermode, *John Donne* (London: Longman, 1957; reprinted 1971).

S. Lehmberg, *Cathedrals Under Siege: Cathedrals in English Society, 1600–1700* (University Park, Pa.: Pennsylvania State University Press, 1996).

A. Nicolson, *God's Secretaries: The Making of the King James Bible* (New York: Harper Collins, 2003).

G. Parfitt, *English Poetry of the Seventeenth Century* (London: Longman, 1985).

G. Parry, *Seventeenth-Century Poetry: The Social Context* (London: Hutchinson, 1985).

H. Vendler, *The Poetry of George Herbert* (Cambridge, Mass.: Harvard University Press, 1975).

SEE ALSO *Religion: The English Civil Wars*

FRENCH LITERATURE IN THE SEVENTEENTH CENTURY

INCREASING REFINEMENT. In France, the beginning of the seventeenth century marked a distinctive break from the legacy of warfare and domestic religious violence that had punctuated the concluding forty years of the sixteenth century. To achieve this respite, Henri IV had converted from Protestantism to Catholicism in 1595, and three years later he promulgated the Edict of

Engraving of Paris in 1607. © BETTMANN/CORBIS.

Nantes, the royal decree that granted a limited religious toleration to the country's Huguenots (French Protestants). Religious controversy did not disappear from France's internal politics. In 1610, Henri was assassinated by a Catholic religious zealot, but the peace that he fashioned proved to be longstanding, lasting until Louis XIV revoked the edict in 1685, and forced French Protestants either to convert to Catholicism or to emigrate from the country. In the roughly three generations between these two dates, the distinctive patterns of French absolutism came to influence society and culture throughout the country. During these years royal patronage of the arts was organized around academies, the descendants of which have often persisted in France until modern times. Literary culture was greatly affected by the foundation of the *Académie Française*, an institution that Cardinal Richelieu organized in the 1630s to establish standards of usage and rhetoric in the language. It soon became a powerful organ for shaping literary French and the drama in the country, yet its rise to

prominence had been prepared by an increasing refinement of rhetoric championed at court and among learned elites in France from the late sixteenth century.

D'URFÉ AND MALHERBE. In the works of Honoré D'Urfé (1567–1625) and François de Malherbe (1555–1628) this quest for an elegant style can be seen. D'Urfé was from southern France, near Lyons, where his family's château had long served as a center of elite culture and learning. In his youth, Honoré received a humanist-influenced education from the Jesuits, and after living through the dismal years of the Wars of Religion, he devoted his energies to the composition of a monumental work of pastoral fiction, *L'Astrée*. The pastoral was a literary tradition that had become increasingly popular in Spain and Italy in the later Renaissance; it often treated the conversations and innocent activities of shepherds and shepherdesses and was usually set in a beautiful and idyllic environment. The pastoral form inspired paintings, poetry, and prose, and works like this were also among the first texts to be set to music in early

operas. In his search for a new style, D'Urfé came to be affected by these earlier usages of the pastoral, although he greatly expanded the scope of his fiction to encompass an enormous length and presentation of detail. His title derived from the ancient goddess of justice, Astraea, who, mythology taught, was the last of all the deities to abandon earth at the conclusion of the Golden Age. In writing his work, D'Urfé chose this figure to underscore the return to peace, prosperity, and justice he and other French aristocrats hoped might follow Henri IV's Edict of Nantes. *L'Astrée* was published in five separate volumes in the years between 1607 and 1627; eventually it grew to be a 5,000-page epic. Although his plot was often artificial, his elegant style and psychological insight hinted at the great literary resurgence that was soon to begin in France. At the same time, *L'Astrée* did not inspire other pastoral works, although its influence could be seen in a new longing for a sophisticated and beautiful style. François de Malherbe was one of the most important French authors to satisfy this growing desire, through his many classically inspired poems. Malherbe was a provincial, a native of Normandy, who eventually rose to become Henri IV's resident poet. Fueled with a powerful sense of what was correct in language, as well as a desire to purge courtly writing and conversation of colloquialism and dialect, Malherbe's own poems were widely imitated by members of the court and by Parisian educated society. He gathered around him a group of disciples, and imparted to them his personal vision of how French poetry should be written. In the year before his death he published an edition of his poetry, *Collection of the Most Beautiful Verses of Messieurs de Malherbe*, that made his teaching evident to his readers. His works would scarcely be called great art today, but they did rely on a vastly simplified vocabulary that was austere and classically inspired, even as he used the metrical Alexandrine verse, which consisted of a line of twelve syllables. Prompted by Malherbe's influence, other authors began to adopt Alexandrine verse, and it soon became the dominant form for French poetry used in the country's many seventeenth-century dramatic tragedies. Malherbe demonstrated the possibilities that reposed in this verse style; prompted by the forceful example of his advocacy of his own art, he helped to establish a grand and austere literary classicism.

FRENCH ACADEMY. Malherbe died before the foundation of the French Academy in 1634. Conceived by Richelieu, the academy was charged with the task of standardizing literary French. Soon after its foundation, though, its members were drawn into a controversy over Pierre Corneille's *Le Cid.* Richelieu and others had found the play morally troubling, although audiences admired Corneille's elevated verse. In an effort to put the controversy to rest, Richelieu referred the play to the members of the *Académie Française*, who agreed with Richelieu that the play's plot was wanting, even though they argued that it was filled with much good poetry. This was one of the few times, though, that the academy intervened in a matter of taste or moral judgment. Its charge was instead to work for the standardization of the French language, and to this end it began work on a comprehensive dictionary of the French language that was finally published in 1694. The number of scholars and literary figures who gained admittance into the French Academy was soon limited to forty members, who became known as "the immortals." Quite a large percentage of these figures also wrote literary criticism and theory in the course of the seventeenth century, much of which supported the development of French classicism. Claude Favre de Vaugelas (1585–1650), for instance, wrote an important text, *Remarks on the French Language* (1647), which recorded the forms of French used in aristocratic and polite societies. Vaugelas had understood that the forms of spoken and written languages changed over time as a reaction to changing circumstances. Yet Cardinal Richelieu and the most conservative members of the French Academy desired to establish an unchanging style, and so the observance of Vaugelas' rules could, in the hands of mediocre stylists, lead to much slavish imitation. Vaugelas' work, in other words, soon became known as the "bible of usage." Two other works produced by members of the Academy were also influential in supporting the rise of French literary classicism: the *Poétique* (Poetics) of La Mesnardière (1639) and Abbé d'Aubignac's *Pratique du théâtre* (Practice of Theater; 1657). Both advocated the use of classical forms and verse, but their influence was generally superseded by that of Jean Chapelain (1595–1674), a member of the Academy who played much the same role that Malherbe had in the first quarter of the seventeenth century. It was Chapelain who was asked to write the Academy's equivocating pronouncements about Corneille's play *Le Cid.* But generally, Chapelain played the role of literary arbiter in court circles from the 1630s onward, much as Malherbe had done a generation earlier. More accepting of deviations from his own rules than Malherbe, Chapelain nevertheless constructed many theories that were fundamental in the development of classicism. He promoted these views in articles, short tracts, and through his voluminous correspondence. Under the influence of Louis XIV's chief minister Jean-Baptiste Colbert, Chapelain was eventually entrusted with naming those French authors that should be honored with royal

pensions, and in the practice of his office he engendered significant hatred from many literary figures. His own verse was far from magnificent, but as a literary arbiter he had few equals in mid-seventeenth-century France.

THE NOVEL. The elevated discussions of the Academy and its attempts to foster an austere classicism in French literature did not, at the same time, dampen enthusiasm for creative fiction. French readers of the mid-century evidenced a pronounced taste for novels, and the variety of texts that the country's authors produced is remarkable. Like D'Urfé's *L'Astrée*, many works of French fiction at the time were long and complex, but in the course of the seventeenth century they evidenced a preference for ancient rather than pastoral themes, or for comic, picaresque subjects. Among the many novelists the country produced at the time, Madeleine de Scudéry (1607–1701) was among the most widely read. Scudéry was the younger sister of a prominent French dramatist, who moved to Paris when she was quite young and soon captivated the city's most prominent literary salon, the circle surrounding the figure of the Marquise de Rambouillet. When Scudéry was 35, she published her first novel, *Ibrahim or the Illustrious Bassa* (1642). Other contributions followed, and her novels often grew to enormous lengths. Scudéry was a master of the genre of the roman à clef, a form in which the ancient characters that are depicted are in reality thinly-disguised references to men of affairs and prominent socialites in one's own day. Part of the excitement that reposed in Scudéry's fictions thus rested on the attempt to unearth or decode just who was being depicted as whom, and while many members of French polite society admired her work, she was criticized by others at the same time. By contrast, Cyrano de Bergerac's two novels, *A Comic History of the States and Empires of the Moon* and *A Comic History of the States and Empires of the Sun* were only published after his death. They tell of imaginary journeys to the moon and sun, and anticipate the quite later development of science fiction. Their purpose was to poke fun at religion and de Bergerac's contemporaries' reliance on traditional wisdom, rather than the insights offered by the new science. In place of such conservatism, de Bergerac advocated a kind of freewheeling materialism, a philosophy that he had derived from his own study of mathematics and the libertine or anti-absolutist political theory of the age. Where de Bergerac's works were literally set in another world, those of Paul Scarron (1610–1660) were very much located in contemporary, this-worldly circumstances. Scarron was a major figure in the French theater of the time, producing a series of comedies that were popular before the arrival of Cor-

neille, Molière, and Racine on the Paris scene. In his three-volume *The Comic Novel* (1651–1659) Scarron parodied the lives of the members of a theatrical troupe in a way that was very much influenced by the picaresque novel tradition of sixteenth-century Spain. Those works' central characters were often vagrants or members of society's downtrodden, and authors used the form to spin fantastic webs of adventure. Scarron's comic works reveal a lighter side of French seventeenth-century literature than that being written by the elegant arbiters of taste in the French Academy. His wife, Françoise d'Aubigné, also played a major role in the aristocratic world of the seventeenth century, eventually becoming in the years following her husband's death the king's mistress and then secret wife. This position placed the pious Madame de Maintenon, as she became known at court, in a unique vantage point to influence the king's tastes in drama and literature.

THE HONEST MAN. Another genre of French literature that played an increasingly important role in the second half of the century treated the qualities men should display to participate in the life of court and aristocratic society generally. These works examining the "honest man" became particularly vital in the years following the Fronde, a series of revolts of nobles and Parisian councillors that had erupted in the years between 1648 and 1653. Eventually, these rebellions were brutally repressed, but not without producing significant fear among those in the royal government. At the time at which they began, the young king Louis XIV was only five years old. During the course of these disturbances Louis and his mother, Anne of Austria, were forced to flee the capital. In their exile from Paris, they even slept in a stable, and so the Fronde's disturbances left a life-long impression on the king. In the years that followed, Louis XIV and his officials worked to domesticate the French nobility, eventually building the palace of Versailles and developing an intricate courtly etiquette that became a powerful means of disarming the class. They also sought to redirect the once bellicose spirit of the old French "nobility of the sword," those who descended from the medieval warrior nobles of the Middle Ages. Louis' government, in other words, championed an aristocratic ideal based on the concept of service to the king, rather than the demonstration of military prowess. In this regard the new genre of works about the qualities of the "honest man" reflects these changing realities. Works that treated the qualities of the "honest man" usually celebrated the virtues that were prized in the new "nobility of the robe," those who from the sixteenth century had received their noble titles as a reward for serving the king.

a PRIMARY SOURCE *document*

A THINKING REED

INTRODUCTION: Blaise Pascal was one of France's great seventeenth-century literary stylists. An heir to the tradition of Montaigne, he nevertheless found that author's moral relativism troubling, even as he realized that the ideas of the developing Scientific Revolution represented a real challenge to traditional Christianity. Pascal spoke as an insider; he was a brilliant mathematician and helped to develop many of the mathematical techniques upon which later scientific thinkers relied. Always sickly, he underwent a "second birth" in 1654, and thereafter resolved to dedicate himself to the propagation of religious belief. In this regard he came to defend the positions of the Jansenists, France's Augustinian religious party, in his famous *Provincial Letters*, satires of the Jesuits that were filled with a biting wit that soon made these works bestsellers. They came to have a profound effect on literary French in the later seventeenth century. His *Pensées* were a record of his deepest thoughts. Maintained throughout his life, they were published by his admirers after his death. They reveal one of the keenest and most discriminating minds in the Western tradition and a limpid and elegant literary style.

What is the Ego?

Suppose a man puts himself at a window to see those who pass by. If I pass by, can I say that he placed himself there to see me? No; for he does not think of me in particular. But does he who loves someone on account of beauty really love that person? No; for the small-pox,

which will kill beauty without killing the person, will cause him to love her no more.

And if one loves me for my judgment, memory, he does not love *me*, for I can lose these qualities without losing myself. Where then is this Ego, if it be neither in the body nor in the soul? And how love the body or the soul, except for these qualities which do not constitute *me*, since they are perishable? For it is impossible and would be unjust to love the soul of a person in the abstract and whatever qualities might be therein. We never then love a person, but only qualities.

Let us, then, jeer no more at those who are honoured on account of rank and office; for we love a person only on account of borrowed qualities....

Man is but a reed, the most feeble thing in nature, but he is a thinking reed. The entire universe need not arm itself to crush him. A vapour, a drop of water suffices to kill him. But, if the universe were to crush him, man would still be more noble than that which killed him, because he knows that he dies and the advantage which the universe has over him; the universe knows nothing of this.

All our dignity consists, then, in thought. By it we must elevate ourselves, and not by space and time which we cannot fill. Let us endeavour, then, to think well; this is the principle of morality.

SOURCE: Blaise Pascal, *Pensées*. Trans. W. F. Trotter (New York: Collier, 1910): 112–113, 120.

The honest man was expected, like the behaviors recommended in earlier Renaissance conduct books, to master the arts of fine living, good conversation, and social refinement. François de La Rochefoucauld (1613–1680) was one of the earlier figures that wrote a book in this vein. He had been a leader in the Fronde, but in the years that followed its disastrous conclusion, he devoted himself to a literary career, eventually publishing in 1665 his famous *Maximes*, which were short epigrams on matters of morality and truth. In these writings he celebrated self-preservation and self-interest as the only true source for moral action. Less suspicious and distrustful attitudes are to be found in other authors that turned to these themes, including Antoine Gombaud's *On True Honesty*, which celebrated the cult of "honest living" with its refinement and social graces as the true "art of living." In a similar vein one of the most famous of those who helped to define the "honest man" was Charles Saint-Évremond (1613/1614–1703). Like the sixteenth-century essayist

Montaigne, Saint-Évremond's counsels included an emphasis on epicurean enjoyment of the good things the world had to offer, even as he similarly pleaded for religious toleration.

LA FAYETTE AND SÉVIGNÉ. Two of the greatest prose masters of seventeenth-century French were women: Madame de La Fayette (1634–1693) and Madame de Sévigné (1626–1696). Both were aristocrats who were prominent in the salon life of later seventeenth-century Paris. Madame de La Fayette was a friend of the noble François de la Rochefoucauld, and together the two of them formed a literary circle that encouraged a restrained and commanding classical style. La Fayette became an author, and her masterpiece, *The Princess of Cleves* (1678), was first published anonymously. It is generally recognized as the finest French historical novel of the time. Set in the mid-sixteenth century, its plot revolves around the efforts of a young aristocratic wife

to suppress her passion for another man. The illicit couple's love remains unrequited, a fact that provided La Fayette with a springboard for examining the passions and their psychological effects, a central preoccupation of many of the French authors of the age. By contrast, Madame de Sévigné did not devote her efforts to the writing of fiction. Instead she compiled a voluminous correspondence that is one of the remarkable literary artifacts of the age. A member of fashionable Parisian society for most of her life, she became an astute letter writer after her beloved daughter's marriage. In the years following their separation the two exchanged almost 1,700 letters. They are generally informal and newsy, but they show a keen and discerning mind that was aware of all the best literary canons of the day. Although they are not formal in the manner of much Baroque state and diplomatic correspondence, they were nevertheless carefully crafted with a fine eye and ear for eliciting the best responses of those that read them. Above all, they show modern readers a letter writer who must also have been an astute conversationalist since, much like the conventions of salon speech, they ramble elegantly from one topic to another.

RELIGIOUS WRITING. In the final decades of the seventeenth century, new moral influences at Versailles' court led to a resurgence of religious and moralistic writing. Indeed much of French writing in the seventeenth century had been religious in tone, as elsewhere in Europe. The seventeenth century had opened with the great devotional works of François de Sales (1567–1622) and others who argued for a reform in the church and the amendment of individual lives. At mid-century the controversies between Jesuits and Jansenists had resulted in a steady outpouring of polemical tracts and satirical works like Blaise Pascal's famous *Provincial Letters.* Yet after 1680 a change in the tone in the literary circles surrounding King Louis XIV is also evident. In these years the king increasingly fell under the influence of his mistress, and later wife, Madame de Maintenon, an uncompromising moralist long credited with encouraging Louis to revoke the Edict of Nantes and to take other actions to uphold French Catholicism. At court, once gay theatrical comedies disappeared in favor of the new serious and "morally uplifting" operas of Jean-Baptiste Lully. Balls and other festivities disappeared, and many at court dedicated themselves to the devotional life. Among the great writers who took up this charge to moral perfection, Jacques-Bénigne Bossuet (1627–1704) had perhaps the broadest influence. Eventually, he rose to become a bishop, but in his mid-life he was also one of the ablest preachers in France, and in the years he

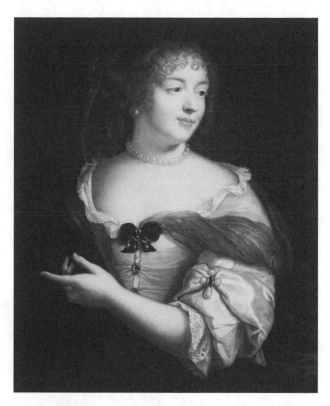

Portrait of Madame de Sévigné (1662) by Claude Lefebvre. © **ARCHIVO ICONOGRAFICO, S.A./CORBIS.**

spent preaching in Paris, he exercised a hold over his audience's imaginations similar to that of the great John Donne in England. In his later years as an important churchman, Bossuet intervened in a number of controversies, a fact that has often continued to mar his reputation. In his literary works, though, he produced a body of work that has consistently been lauded for its elevated style and good taste.

ANCIENTS AND MODERNS. At the end of the seventeenth century one debate that began in and around the French Academy was to spread far beyond France's borders. Disputes similar to this seventeenth-century battle between the "ancients" and the "moderns" had occurred throughout Europe since the Renaissance, with literary figures and critics weighing the relative merits of "contemporary" or "modern" literature when judged against the testimony of Antiquity. In France the debate that flared up on these themes at the end of the seventeenth century—the so-called "Quarrel of the Ancients and Moderns"—did not produce any decisive victory for either side. In this controversy, figures like Nicolas Boileau (1636–1711) supported imitation of the works of ancient authors as the only true path to sure and certain literary excellence. To these essentially conservative sentiments, Charles Perrault (1628–1703)

answered with his *Parallels of the Ancients and Moderns* (1688–1697), a work that assured its readers that as human history progressed the mind of man expanded and grew. Thus Perrault argued contemporary literature might even surpass that of the ancient world. These two entries in the battle encouraged incessant pamphleteering by other French literary figures. One consequence of this otherwise pointless intellectual battle was important for the future. In downplaying the received canons of ancient literature, Perrault and his party provided an idea that was to be fruitfully expanded upon by eighteenth-century Enlightenment authors: their notion of progress and the steady expansion of the human mind. Thus this dispute over the relative merits of ancients and moderns helped to prepare the way for the Enlightenment's rich and innovative literary climate, a climate that argued that works written on contemporary, realistic and even "middle-class" themes might be as morally instructive and purposeful as the elevated concerns of ancient mythology and poetry.

SOURCES

C. K. Abraham, *Enfin Malherbe: The Influence of Malherbe on French Lyric Prosody, 1605–1674* (Lexington, Ky.: University Press of Kentucky, 1971).

Joan DeJean, *Libertine Strategies: Freedom and the Novel in Seventeenth-Century France* (Columbus: Ohio State University Press, 1981).

Maurice Lever, *Le roman français au XVIIe siècle* (Paris: Presses Universitaires de France, 1981).

Carolyn Lougee, *Le Paradis des Femmes: Women, Salons, and Social Stratification in Seventeenth-Century France* (Princeton, N.J.: Princeton University Press, 1976).

H. J. Martin, *Livres, pouvoirs et société à Paris au XVIIe siècle (1598–1701)* (Geneva: Droz, 1969).

F. Warnke, *Versions of Baroque* (New Haven, Conn.: Yale University Press, 1972).

R. Winegarten, *French Lyric Poetry in the Age of Malherbe* (Manchester, England: Manchester University Press, 1954).

SEE ALSO *Theater: Neoclassicism in Seventeenth-Century Paris*

BAROQUE LITERATURE IN GERMANY

POLITICAL AND RELIGIOUS CONFLICT. Unlike France and England, which were unified states ruled by monarchs, Germany remained a loose confederation of more than 300 semi-autonomous states in the early-modern era. The Reformation and Counter-Reformation had cut deep fissures into the political system of the re-gion during the sixteenth century, and controversies over religion persisted in the early seventeenth century. Both Protestants and Catholics longed for a day in which a single, unitary faith might be reestablished in the country, and the tensions that competition between these confessions produced eventually boiled over in the dismal conflict known as the Thirty Years' War (1618–1648). That clash, waged in several major stages during its seemingly unending history, ultimately did little to resolve the longstanding problems that had made religion the central issue in German society since the 1520s. At its conclusion, Calvinism, once an illegal religion in the country, was permitted, but the principle *cujus regio, eiuis religio* or "he who rules, his religion," was upheld, leaving the rulers of Germany's individual states free to determine the religions of their subjects. The war thus helped to confirm the political disunity of the Germanies until the nineteenth century, and its legal formulations enhanced the tendency already present in politics for territorial rulers to become more and more like absolutist princes. In the generations following its conclusion, many German rulers looked westward toward France, and the cultural brilliance of Versailles provided a consistent source for their emulation. At the same time the outcome of the Thirty Years' War also strengthened the positions of the largest states in the empire—Austria, Brandenburg, the Rhineland Palatinate, Baden-Württemberg, and Bavaria—over and against the smaller ones. Although the number of Germany's independent territories remained large throughout the period, the individual policies of many states now came to be overshadowed by the political aims and maneuvers of the most powerful territories in the region, a situation that anticipated the great dominance that Prussia and Austria achieved in German politics during the eighteenth century. In England, these religious tensions, and eventual civil war, had done little to dampen the development of vigorous literary debates. So, too, in Germany, the seventeenth century produced a wealth of new religious literature, poetry, and fiction. But while some of these writings spoke to the dismal political and religious realities of the period, others were relatively unaffected by the problems of the age. And despite the Thirty Years' War's devastations, Germany's national literature continued to develop apace throughout the century.

GERMAN LANGUAGE. Against the backdrop of political squabbling, Germany's language was also undergoing many significant changes. Linguistic diversity had always been a major fact of German life, with many different dialects being spoken throughout the country. At the end of the Middle Ages, several attempts had been

made to foster a more unified written language, first at the court of Charles IV in Prague during the so-called "Golden Age" in the mid-fourteenth century, and later under the Habsburg emperors of the fifteenth and early sixteenth centuries, when a chancery or legal form of the language had been developed and its use pioneered throughout the country. These literary forms of German were distinctly different from the modes of expression that the country's sixteenth-century religious reformers and religious pamphleteers used in the Reformation, even as the Middle English of Chaucer is distinctly foreign when compared against the language used in Elizabethan times. The quest for a common literary form of German continued throughout the sixteenth century, but it came increasingly to be dominated, not by the flow of religious polemic, but by the course of discussion in the country's universities. By the end of the sixteenth century Germany's intellectuals continued to be trained in Latin-speaking universities, although the Latin they used had itself undergone great transformations in the course of the sixteenth century. Throughout the Middle Ages the Latin used in the church and universities had been transformed, so that by 1400 it had become a distinctly different language from that which had been spoken and written in ancient Rome. In the course of the fifteenth century, Italian humanists had revived the language's ancient grammatical structures and style, and this Neo-Latin eventually spread throughout Europe. In the sixteenth century great Neo-Latin stylists like Desiderius Erasmus and Michel de Montaigne were able to speak and write a form of the language that mirrored the ancient language, and their efforts were widely imitated among later sixteenth- and early seventeenth-century intellectuals. In Germany, those who received a university education continued to produce poetry and prose in Latin, rather than in their native languages in the seventeenth century. Yet their very experiments with the study of Neo-Latin helped to enrich the usages and style of German. As many began to compose in their native tongue, they decried the paucity of vocabulary and literary devices to convey their subtle arguments. And so, in the course of the seventeenth century, Germany's greatest literary figures set themselves to the task of developing a native literary mode of expression that could rival the sophistication they sensed existed in the Neo-Latin idiom.

THE "FRUIT-BRINGING" SOCIETY. The "Fruit-Bringing" Society (in German, *Fruchtbringende Gesellschaft*) was perhaps the most important of the many experiments in which German authors tried to create a literary form of German equal to that of other languages, particularly Neo-Latin. Founded in 1617 under the patronage of Prince Ludwig of Anhalt-Köthen, its aim was to imitate the great academies that had been founded in Florence and other Renaissance centers in the century and half before. Its membership was distinctly aristocratic from the first, and its purpose had several interrelated aims. First, the "Fruit-Bringing" Society desired to cultivate an elegant literary form of German that would make use of the best rhetorical skills. Beyond this, its members longed to purify their language of usages that were not Germanic in origin and to create a pattern of verse writing that was appropriate to the sound and syntax of their language. The efforts of the "Fruit-Bringing" Society were soon aided by the publication of the poems of Martin Opitz, the first great literary figure of the German Baroque era. In 1624, Opitz published his *Book of German Poetry*, a work that established standards that were to persist in German verse writing over the coming century. Opitz's poems demonstrated the great clarity that could be achieved in German poetry that relied on clear rhyme schemes. He recommended, for instance, the Alexandrine or twelve-syllable line for the writing of epics and the use of iambic pentameter for sonnets. But his work also included examples of how the best poems of writers in other languages might be successfully rendered into German, and this part of his focus soon inspired poets to undertake a host of new translations. Opitz also recommended the office of the poet to his readers as one of "divine" significance. Poetry, he argued, derived from divine inspiration, and thus it contained within its lines an encoded or "hidden" theology. It was the poet's task, therefore, not merely to represent reality, but to present an image of what might or should be. The poet, in other words, should make the beautiful appear even more so, even as he castigated ugliness in terms more grotesque than it was in actuality. For his own efforts in the art, the German emperor named him Poet Laureate in 1625, and two years later, raised Opitz and his descendants to noble status. In 1629, he was named a member of the "Fruit-Bringing Society," but by this time numerous other "literary societies" were already forming in Germany's major cities. Usually composed of members of the aristocracy, these societies pursued the same end as the original "Fruit-Bringing Society": to foster an elegant German literary style that would be the equal of other languages. In the years that followed, numerous poets throughout the German-speaking world took up the task that Martin Opitz had set down for them. They eagerly translated prose and poetic works from other languages into German, even as they experimented with applying the insights that they attained from these endeavors to fashioning a new literary idiom.

THE BAROQUE STYLE MATURES. The impact of Opitz and Germany's new literary societies did not produce a single unified style in the later seventeenth century, but instead a multiplicity of paths that points to the essential creativity of the period. Generally, the forces that led to the development of a "High Baroque" literary style, though, were Protestant, and were most in evidence in the Lutheran cities of the country. One stylistic direction was taken by the Protestants Georg Philipp Harsdörffer (1607–1658), Philipp von Zesen (1619–1689), and Andreas Gryphius (1616–1664). Harsdörffer was a native Nuremberger who traveled widely throughout Europe in his youth and eventually joined the "Fruit-Bringing Society." In 1644, he helped to write the *Pegnitz Pastoral*, a collection of poems intended to inaugurate the new "Order of the Flowers on the Pegnitz," the "Pegnitz" being the river that runs through the center of Nuremberg. That society came to be an important literary force in the second half of the seventeenth century. The fondness for an elaborate musical style was also echoed in the literary society, "The German-Minded Brotherhood," that Philipp von Zesen founded in 1643 at Hamburg. Unusual for his time, Zesen was able to support himself solely through his poetry and other literary activities. He translated French works and wrote *The Adriatic Rosemund*, one of the first great novels in the German language to deal with the theme of love and the role of religious differences in keeping a couple apart, soon to be a perennial theme. Like Martin Opitz, Philipp von Zesen was eventually raised to noble status for these efforts. The final figure, Andreas Gryphius, is today recognized as one of the greatest literary figures in the history of the German language. Unlike Zesen or Harsdörffer, Gryphius grew up in relative isolation from the great literary societies of the day. He was a Lutheran who was born in the east in Silesia; after studying in the Netherlands, he eventually became an attorney. Although his verse shares the same tendency toward literary flower as Zesen and Harsdörffer, it rises above the merely decorative through its persistent lament about harsh fortune. Gryphius's life was spent in the regions that were devastated by the Thirty Years' War, and in his poetry he continually expresses sentiments and themes that speak to its destruction. All life is transitory, filled with vanity. Human existence is governed by an unalterable fate, to which the only appropriate human response is to remain steadfast and courageous and to hold onto one's faith. Constancy and fortitude, two popular Baroque themes that were often personified as goddesses, constantly recur in Gryphius' somber works.

GRIMMELSHAUSEN. By the second half of the seventeenth century, Germany's vigorous literary climate, with its numerous literary societies, had produced not only a number of native poets, but many translations of prose works from French, Italian, and Spanish. One figure that was affected by this literary resurgence was Hans Jakob Christoffel von Grimmelshausen (c. 1621–1678), an author that had an almost "larger-than-life" existence. Grimmelshausen was an outsider on the literary scene. He was not an aristocrat or a university-educated wit in the manner of many of those that participated in Germany's new literary societies. He grew up in humbler circumstances, and his literary endeavors were not recognized until centuries later because he published his greatest work, the novel *The Adventures of Simplicissimus* (1688–1689), anonymously. It was not until the nineteenth century that his authorship was firmly established. Born a Lutheran, he was captured at the age of fourteen in the conflicts of the Thirty Years' War. Later he served in the Catholic forces of the imperial army before becoming a caretaker for a noble. In that capacity he ran an inn, sold horses, and was even a tax collector. When it came to light that he had embezzled funds, he was forced from these positions. Later he became an assistant to a physician, helping to manage his interests, before returning to tavern keeping and even becoming a bailiff in his final years. At this time, too, he converted from Lutheranism to Catholicism. Through all these constant shifts in profession, Grimmelshausen had continued to write, and he had published several satires in the late 1650s. His great masterpiece, though, was *The Adventures of Simplicissimus*, a work that was widely translated and became a best-seller in many parts of Europe. *Simplicissimus* is modeled on the Spanish picaresque novels of the sixteenth and early seventeenth centuries. The central character of the same name is, as in those earlier works, a lowborn child who becomes a vagrant through the chaos unleashed by the Thirty Years' War. The work was filled with coarse, black humor as well as an eye for creating memorable characters. Of the many works written in seventeenth-century Germany, it is the only prose work that is still widely read today, a testimony to the universality of its author's vision and his critique of the barbarities of war.

BÖHME. Perhaps the most influential writer of the seventeenth century in Germany was unaffected by the great debates over the direction that the language's style should take. Jakob Böhme (1575–1624), a Lutheran, had, like Andreas Gryphius, been born in the eastern empire, near the town of Görlitz. In 1594 or 1595, Böhme moved to Görlitz where he became a shoemaker,

a PRIMARY SOURCE document

COMMUNION WITH GOD

INTRODUCTION: The works of the German mystic Jakob Böhme (1575–1624) attracted numerous adherents, not only in Germany, but throughout Europe. They came to have a perennial appeal among German authors because of the way in which they described the soul's relationship with God. Their influence spread, too, far beyond Germany, where they came to influence later seventeenth-century religious writers like the Quaker George Fox. In Germany, too, the ideas of Böhme also influenced the literary monuments of Pietism, the great religious movement within Lutheranism that tried to deepen ordinary Christians' internal faith. Pietism came to shape the course of religious developments in eighteenth-century Germany, but, through its numerous educational institutions, it also nourished a disproportionate number of the country's authors.

When Man will go about Repentance, and with his prayers turn to God, before he begins to pray, he must consider his own mind, that it is wholly and altogether turned away from God, that it is become faithless to God, that it is only bent upon this temporal, frail, and earthly life, bearing no sincere love towards God and his neighbor, and also that it wholly lusts and walks contrary to the commandments of God, seeking itself only, in the temporal and transitory lusts of the flesh.

Secondly, he must consider that all this is an enmity against God, which Satan hath raised and stirred up in him, by his deceit in our first parents, for which abomination's sake we die the death and must undergo corruption with our bodies.

Thirdly, he must consider the three horrible chains wherewith our soul is fast bound during the time of this earthly life: the first is the severe anger of God, the abyss, and dark world, which is the center and creaturely life of the soul. The second, is the desire of the devil against the soul, whereby he continually sifts and tempts it, and without intermission strives to throw it from the truth of God into vanity, viz. into pride, covetousness, envy and anger,

and with his desire blows up and kindles those evil properties in the soul, whereby the will of the soul turns away from God and enters into [it]self. The third and most hurtful chain, wherewith the poor soul is tied, is the corrupt and altogether vain, earthly and mortal flesh and blood, full of evil desires and inclinations. …

Fourthly, he must earnestly consider that wrathful death waits upon him every hour and moment, and will lay hold on him in his sins, in his garment of a swine keeper, and throw him into the pit of hell, as a forsworn person and breaker of faith, who ought to be kept in the dark dungeon of death to the judgment of God.

Fifthly, he must consider the earnest and severe judgment of God, where he shall be presented living with his abominations before the judgment; and all those whom he hath here offended and injured with words and works, and caused to do evil …

Sixthly, he must consider that the ungodly loses his noble image (God having created him for his Image) and [becomes] instead like a deformed monster, like a hellish worm or ugly beast, wherein he is God's enemy and against heaven and all holy Angels and men, and that his communion is forever with the devil's and hellish worms in the horrible darkness.

Seventhly, he must earnestly consider the eternal punishment and torment of the damned, that in eternal horror they shall suffer torments in their abominations, which they have committed here, and may never see the land of the saints in all eternity, nor get any ease or refreshment …

All this, man must earnestly and seriously consider, and remember that God that created him in such a fair and glorious image, in his own likeness in which he himself will dwell that he hath created him in his praise for man's own eternal joy and glory, viz., that he might dwell with the holy Angels, and children of God in great joy, power, and glory …

SOURCE: Jakob Böhme, *The Way to Christ* (London: H. Blunden, 1647): 1–5. Spelling modernized by Philip Soergel.

and in the months that followed his arrival he had a profound religious conversion experience, an experience prompted by the local preacher. He later reported that in the space of a few minutes he had received certainty of his salvation. These mystical experiences did not prompt a great outpouring of devotional prose at first. He produced a few minor tracts broadcasting his mystical insights, but Böhme was largely unschooled, and so he set himself to studying the "major" authors of the

Christian tradition, the mystics of the German past, as well as certain sixteenth-century authors like the physician Paracelsus, whose ideas tended toward the abstruse and metaphysical. Shortly before his death, Böhme published the results of his studies in a number of works that seems to have consumed all his efforts during the last five years of his life. He may have been aided in these efforts by the gifts of friends that freed him from his occupation as a cobbler. But between 1619 and 1624 he

produced thirty tracts and books that were to have a profound effect on the generations that followed. Böhme's theology promoted God as a great abyss, a profound nothingness that was, at the same time, the ground of all being. Out of these depths, a creative force struggles to be set free, but as it does great problems arise in the world because of the human spirit's opposition to the divinity. Böhme himself claimed to be a prophet, and during his own life he attracted a following. In the decades following his death, his ideas traveled, inspiring groups of "Boehmites" in the Netherlands and other German regions. His ideas were also read in England where they affected the Quakers, even as they also were avidly read and studied by the Lutheran Pietists in the later seventeenth century in Germany. Later, Immanuel Kant and Georg William Friedrich Hegel also read his works and incorporated some of his psychological insights into their philosophies. Thereafter, the deeply mystical strains of his ideas continued to return to influence later German thinkers, among them Friedrich Nietzsche and Karl Schopenhauer.

SOURCES

I. M. Battafarano, ed., *Georg Philipp Harsdörffer* (Berne, Switzerland: P. Lang, 1991).

H. Bekker, *Andreas Gryphius; Poet between Two Epochs* (Berne, Switzerland: P. Lang, 1973).

G. Hoffmeister, ed., *German Baroque Literature: The European Perspective* (New York: Ungar, 1983).

K. Negus, *Grimmelshausen* (New York: Twayne, 1974).

K. F. Otto Jr., ed., *A Companion to the Works of Grimmelshausen* (Rochester, N.Y.: Camden House, 2003).

B. L. Spahr, *Andreas Gryphius: A Modern Perspective* (Camden, S.C.: Camden House, 1993).

J. J. Stoudt, *Jakob Boehme: His Life and Thought* (New York: Seabury, 1968).

F. van Ingen, *Philipp von Zesen* (Stuttgart, Germany: J. B. Metzler, 1970).

RESTORATION LITERATURE IN ENGLAND

THE CAVALIERS' RESURGENCE. The reestablishment of the monarchy that occurred in 1660 had profound implications for English literature. In the years following the execution of Charles I many of the figures that had surrounded the royal court had been forced into exile or hiding, but with the restoration of the throne to Charles' son, Charles II, royal and aristocratic patronage networks were quickly revived. The new king hoped to follow a tolerant path, although the Cavalier party

that soon dominated Parliament clearly had other plans. In the first few years of Charles' reign, the passage of a series of draconian measures—measures that eventually became known as the Clarendon Code—subjected Puritans, Presbyterians, and other English dissenters to a steady barrage of persecution, a reality that led to the great literary inventions of John Bunyan, George Fox, and other dissenting authors. At the same time, the royal court quickly moved to revive the theater in London, and although the plays that were performed there in the quarter century of Charles' reign were staged before audiences considerably smaller than those of the Elizabethan and early Stuart era, the Restoration stage still managed to produce a number of playwrights of considerable merit. Like the Cavalier poets that had preceded the Civil Wars, these playwrights expressed a propensity for light themes. Few of the playwrights that had been active in the early Stuart period survived to write for the stage under Charles II. The great dramatists of the period—men like William Davenant, John Dryden, William Congreve, Sir John Vanbrugh, and the woman Aphra Behn—now entertained London's aristocratic and wealthy merchant society with a steady stream of "comedy of manners," works that poked fun at the foibles and conventions of aristocratic society. Many of the figures that wrote for the stage were also poets and authors of considerable merit, although since the late seventeenth century the reputation of the Restoration stage for sexual license and ribaldry has tended to overshadow their non-dramatic writing. While poetry continued to be a popular genre, the later Stuart period also saw the first emergence of a number of new genres that became even more important in the eighteenth century that followed. During the Restoration period the first newspapers emerged in London and other English cities, and although their circulation was initially quite small, they eventually provided a source of employment for many writers in the years following 1700 as political journalism became an increasingly important part of London's literary scene. A deepening interest in history, biography, and autobiography can also be seen in the period, both in the printing of new works and in the keeping of numerous private journals. The most famous of these, Samuel Pepys' *Diary*, dating from the 1660s, provides an unparalleled view on the London scene. Finally, fictional works began in this era to attract the attentions both of authors and readers. The word "novel," in fact, began to appear to describe works treating forbidden romances and intrigues. By the end of the seventeenth century the expanding audiences for such fictions prepared the way for the great works of Daniel Defoe, Samuel Richardson, Henry Fielding, and

a PRIMARY SOURCE *document*

FROM HARMONY TO HARMONY

INTRODUCTION: John Dryden, the greatest English poet of the Restoration era, fulfilled a number of roles in an England living through a tumultuous period. He was a literary critic, a translator, and the nation's Poet Laureate. His poems were often intended to be consumed publicly, as this ode for St. Cecilia's Day. St. Cecilia was the patron saint of music, and the following poem that Dryden crafted to celebrate her annual feast was set to music at the time by the Italian composer, Giovanni Baptista Draghi. In the eighteenth century, Georg Frideric Handel returned to the text, giving it an immortal musical setting. The poem displays Dryden's sense of good taste and style, as well as the assured, sometimes monumental flourishes that were typical of the great poetry of England's Augustan Age. It also demonstrates the enduring fascination of European culture with the notion that musical harmony underlay all the relationships in the universe.

From harmony, from heavenly harmony,
This universal frame began;
When nature underneath a heap
of jarring atoms lay,
And could not heave her head,
The tuneful voice was heard from high,
'Arise, ye more than dead!'
Then cold, and hot, and moist, and dry,
In order to their stations leap,
And Music's power obey,
From harmony to harmony, from heavenly harmony,
This universal frame began:
From harmony to harmony
Through all the compass of the notes it ran,
The diapason closing full in Man.

What passion cannot Music raise and quell?
When Jubal struck the chorded shell,
His listening brethren stood around,
And, wondering, on their faces fell
To worship that celestial sound:
Less than a God they thought there could not dwell
Within the hollow of that shell,
That spoke so sweetly, and so well.
What passion cannot Music raise and quell?

The trumpet's loud clangour
Excites us to arms,

With shrill notes of anger,
And mortal alarms.
The double double double beat
Of the thundering drum
Cries Hark! the foes come;
Charge, charge, 'tis too late to retreat!

The soft complaining flute,
in dying notes, discovers
The woes of hopeless lovers,
Whose dirge is whisper'd by the warbling lute.

Sharp violins proclaim
Their jealous pangs and desperation,
Fury, frantic indignation,
Depths of pains, and height of passion,
For the fair, disdainful dame.

But O, what art can teach,
What human voice can reach
The sacred organ's praise?
Notes inspiring holy love,
Notes that wing their heavenly ways
To mend the choirs above.

Orpheus could lead the savage race;
And trees unrooted left their place,
Sequacious of the lyre:
But bright Cecilia rais'd the wonder higher:
When to her organ vocal breath was given,
An angel heard, and straight appear'd
Mistaking Earth for Heaven.

Grand Chorus.

As from the power of sacred lays
The spheres began to move,
And sung the great Creator's praise
To all the Blest above;
So when the last and dreadful hour
This crumbling pageant shall devour,
The trumpet shall be heard on high,
The dead shall live, the living die,
And Music shall untune the sky!

SOURCE: John Dryden, "A Song for St. Cecilia's Day," (1687), reprinted in M. H. Abrams, ed., *The Norton Anthology of English Literature* (New York: Norton, 1993), 1827–1829. Arthur Quiller-Couch, ed. 1919. The Oxford Book of English Verse: 1250–1900.

many others that entertained eighteenth-century readers. In all these ways, then, the Restoration era displays the development of a progressively more diverse literary marketplace.

JOHN DRYDEN. The greatest literary figure of the Restoration was John Dryden (1631–1700), an author who is largely recognized today on the basis of his plays and poetry. In his own time, though, Dryden exercised

a significant influence over many different styles of writing in late seventeenth-century England. He was initially a playwright, but he soon circulated in high political circles and received several positions in Charles II's court, work that took him in his mid-career away from writing for the theater. In 1668, Charles named Dryden England's Poet Laureate and the following year, Royal Historian. In these years of courtly activity, he continued to write, but he concentrated his efforts on literary criticism, and his works on aesthetics helped to define the English tastes of the age. Around 1680, Dryden also became embroiled in politics, and he wrote a number of polemics in the years that followed for the emerging Tory party. In these years the Tories were coalescing as a distinct group that opposed the plans of some in Parliament to exclude James, the Catholic brother of King Charles II, from the succession. At Charles' death in 1685, James did succeed to the throne for a time, and Dryden's career continued to flourish. But the king's expulsion from the country in 1688 and the calling of his daughter Mary and her husband William from Holland to serve as monarchs in 1689 discredited him. A few years earlier, Dryden himself had converted to Catholicism, and as a result of the change in monarchs, he now lost his court offices. To support himself, he returned to write for the stage, producing some of his finest work in the years after the Glorious Revolution. Eventually, though, he tired of writing for the theater, and in the final years of his life he devoted himself to translating a number of small works from Latin into English. He also translated Vergil, Chaucer, and Boccaccio into the English of his day. His great crowning achievement of these years was the publication of his *Fables Ancient and Modern* (1700), which was completed and published in the year of his death. Dryden's translations were not scholarly in the modern sense, but were instead quite freely executed. They amplified and exaggerated certain elements of the original texts he rendered to fit with his own and contemporary tastes, a defining feature of Dryden's own aesthetics and those of his time. During his career as a playwright, for example, the author had made frequent use of plays and plots drawn from the Elizabethan and early Stuart periods. His adaptation of these plays was never slavishly devoted to the original, but was intended to amplify certain important elements he felt were undeveloped in an earlier author's dramatic portrayal. So, too, in his translations Dryden intended to pay homage to his sources by rendering older stories to fit the tastes and idiom of contemporary times. These later works of translation were, in fact, quite popular and they helped to define knowledge of many about classical texts in the eighteenth century that followed.

RESTORATION STYLE. The changes evident in Dryden's own poetic and prose style were in many ways emblematic of those that English style generally was undergoing in the Restoration era. In contrast to the early Stuart era, which had favored a literary style that was complex and artful, Dryden's poetry and prose became altogether plainer and seemingly artless. He worked throughout his career to perfect a style of poetry suitable for public consumption. In his plays there is little of the kind of introspective quality typical of the greatest works of Shakespeare. Instead he concentrated on creating a grand and noble form of expression that seemed to make use of the best elements of Latin style, transferring them into the idiom of English. His prose was easy to read, clear, and logical and seems even today to reflect human speech. This lack of artifice was actually a highly studied quality and a notable feature of the "Augustan Age" of literature that his own poetry, prose, and works of criticism helped to inspire. In his dramas can be witnessed this same persistent change from an early dramatic language that was grand but somewhat artificial to greater naturalness and lucidity. As the first English writer to devote significant attention to writing literary criticism, he helped to fashion a new climate that took literary production seriously. Through his efforts, writing became an endeavor that was subjected to the same kind of scrutiny that was being directed at politics and the natural world at the time.

JOHN BUNYAN. Dryden's life and poetry had been fashioned by the political demands of the Restoration era, and except for two notable poems that praised the authority of the church as a public good, he did not verge into the private devotional realms that had proven so fruitful a source of literary invention for Anglicans and Puritans in the early Stuart era. As England's Poet Laureate for much of the Restoration era, he prudently avoided such tempestuous waters. Yet elsewhere the continuing controversies of religion were still producing great literary works. Among the many devotional writers of the later Stuart era, John Bunyan (1628–1688) was to cast a long shadow over English readers. His great masterpiece *Pilgrim's Progress* continued to be seen as obligatory reading until the late nineteenth century, and only fell out of fashion in the twentieth. An allegory, it is filled with an enormous number of motifs, motifs like "Vanity Fair" and the "Slough of Despond," that were long alluded to by later writers. Bunyan himself was largely unschooled, a status that he tended to wear as a badge of honor. He was from a small village in Bedfordshire, and served in his youth in the Parliamentary armies. When he returned to his village following the war, he seems to have undergone a conversion experi-

a PRIMARY SOURCE *document*

GRACE ABOUNDING

INTRODUCTION: Seventeenth-century religious figures came to write numerous autobiographies. Of the many texts like this printed in England, John Bunyan's own account of his quest for certainty of his salvation, *Grace Abounding to the Chief of Sinners*, was one of the most influential. It came, in time, not only to inspire other religious writers, but novelists like Daniel Defoe and Samuel Richardson who treated far more secular themes. Written in the first person, it is a tempestuous document, filled with many twists and turns, as Bunyan alternately received some assurance and consolation, and then would be cast down with doubt. Modern people often assumed that seventeenth-century Puritans like Bunyan were often charged with a profound sense that they were part of the elect, and as a result that they dedicated themselves to demonstrating the fruits of their election. Bunyan's text, though, shows us that doubt and a deep sense of personal unworthiness was often a result of the Puritans' espousal of John Calvin's doctrine of election. The following passage forms the conclusion of Bunyan's *Grace Abounding to the Chief of Sinners*.

1. Of all the temptations that ever I met with in my life, to question the being of God, and the truth of His gospel, is the worst, and the worst to be borne; when this temptation comes, it takes away my girdle from me, and removeth the foundations from under me. Oh, I have often thought of that word, "Have your loins girt about with truth"; and of that, "When the foundations are destroyed, what can the righteous do?"

2. Sometimes, when, after sin committed, I have looked for sore chastisement from the hand of God, the very next that I have had from Him hath been the discovery of His grace. Sometimes, when I have been comforted, I have called myself a fool for my so sinking under trouble. And then, again, when I have been cast down, I thought I was not wise to give such way to comfort. With such strength and weight have both these been upon me.

3. I have wondered much at this one thing, that though God doth visit my soul with never so blessed a discovery of Himself, yet I have found again, that such hours have attended me afterwards, that I have been in my spirit so filled with darkness, that I could not so much as once conceive what that God and that comfort was with which I have been refreshed.

4. I have sometimes seen more in a line of the Bible than I could well tell how to stand under, and yet at another time the whole Bible hath been to me as dry as a stick; or rather, my heart hath been so dead and dry unto it, that I could not conceive the least dram of refreshment, though I have looked it all over.

5. Of all tears, they are the best that are made by the blood of Christ; and of all joy, that is the sweetest that is mixed with mourning over Christ. Oh! it is a goodly thing to be on our knees, with Christ in our arms, before God. I hope I know something of these things.

6. I find to this day seven abominations in my heart: (1) Inclinings to unbelief. (2) Suddenly to forget the love and mercy that Christ manifesteth. (3) A leaning to the works of the law. (4) Wanderings and coldness in prayer. (5) To forget to watch for that I pray for. (6) Apt to murmur because I have no more, and yet ready to abuse what I have. (7) I can do none of those things which God commands me, but my corruptions will thrust in themselves, "When I would do good, evil is present with me."

7. These things I continually see and feel, and am afflicted and oppressed with; yet the wisdom of God doth order them for my good. (1) They make me abhor myself. (2) They keep me from trusting my heart. (3) They convince me of the insufficiency of all inherent righteousness. (4) They show me the necessity of flying to Jesus. (5) They press me to pray unto God. (6) They show me the need I have to watch and be sober. (7) And provoke me to look to God, through Christ, to help me, and carry me through this world. Amen.

SOURCE: John Bunyan, *Grace Abounding to the Chief of Sinners* (London: George Larkin, 1666): 94.

ence, and at the beginning of the Restoration era he was arrested for preaching publicly without license. For the next twelve years, he was imprisoned at Bedford, where he devoted his time alternately to writing and to making lace to support his family. During his prison years, he wrote and published *Grace Abounding to the Chief of Sinners* (1666), his own spiritual autobiography that told of the gradual certainty he had received of his own salvation as well as several other minor works.

PILGRIM'S PROGRESS. Released from prison under a general amnesty given by Charles II to religious dissenters in 1672, Bunyan quickly became a popular preacher in Bedford, where he was appointed pastor of the local non-conformist church. He was briefly imprisoned again in 1676 for six months, but in 1678 he published his *Pilgrim's Progress*, a work that became an immediate success. It was reprinted ten times in the decade following its first publication, and the work

helped grant its author a national reputation. From this point forward he had many contacts throughout England, and he continued to be a successful author until his death in 1688. To modern readers, *Pilgrim's Progress* cannot but help to seem artificial and contrived, since allegory is a literary genre little used in contemporary times. Yet for those who attempt to plumb the depths of Bunyan's work, it can yield considerable psychological insight. The story relates the journey of Christian and his friends Hopeful and Faithful as they wend their way to the Celestial City. Along the way they suffer numerous setbacks, not only from the reprobate and damned, but from those that seem on the surface to be fellow travelers, that is, members of the Calvinist "elect." Yet despite these enormous trials, the pilgrims arrive at their final destination, and along the way they have been freed of doubt and their other earthly burdens. In this way Bunyan's work dealt in a poetic fashion with one of the key dilemmas implicit in Calvinist and Puritan thought: how certainty of salvation could be combined with the doctrines of predestination and election. Even at a time when Puritanism had, by and large, been discredited as a political creed, Bunyan's work soon became a devotional classic, and in 1680 he wrote a sequel, *The Life and Death of Mr. Badman*, a work that relates the dismal alternative, that is, the condemnation and ultimate damnation that falls on one who is not a member of the elect. It was not nearly as successful as its predecessor, although it does present a vivid portrayal of evil. In the later years of his life, the author continued to write, and a number of unpublished manuscripts were found in his possession at his death in 1688, a few months before the Catholic King James II was deposed. These were published posthumously in a folio edition in 1690, but the breadth and depth of Bunyan's opus came to be overshadowed in the years that followed by his two chief masterworks, *Pilgrim's Progress* and *Grace Abounding to the Chief of Sinners*.

SPIRITUAL AUTOBIOGRAPHY AND DIARY WRITING. Bunyan's popular spiritual autobiography, *Grace Abounding* was only one of many such texts to appear in the later seventeenth century. Among other similar works that appeared at the time the *Journal* of George Fox (1624–1691) was also a particularly influential text. In this work, this early Quaker recorded his successful spiritual quest for certainty of salvation and he narrated the early history of his persecuted movement. Although not published until 1694, Fox's fashioning of his narrative shows that as a religious leader he was well aware of the value of autobiography for developing his movement. It also reveals a carefully calibrated history of the move-

ment to elicit the maximum degree of admiration for the Quakers from his readers. In it, Fox alleged that he and other Quakers had been committed to the principles of peace and pacifism from their earliest days, when, in reality, these teachings did not become central to the movement until the early Restoration years. The work's influence helped to establish an identity for later Quakers, but it also inspired a host of imitations. From Fox to the *Journals* of John Wesley in the late eighteenth century, English writers presented their deepest, most inward thoughts to their readers and to volunteer the circumstances surrounding their religious conversions to satisfy their audience's taste for devotional narratives. In a very real sense, such accounts played a similar role in Protestant England to the lives of the saints that were read in other Catholic regions of Europe. But not all the lives and autobiographies that appeared in the period were religious in nature. Diary writing generally was a popular pastime, and not every journal that was kept at the time reveals a spiritual nature as tender as that of Bunyan or Fox. One of the most extraordinary of the England's diarists to record their life experiences at this time was Samuel Pepys (1633–1703), who kept daily records of the events of his life in Restoration London during the 1660s. Aptly described as one of the "best bedside" books in the English language, Pepys' diary totals over six hefty volumes in its modern edition. It is never boring reading, filled as it is with recollections of the smallest details of living in a major European city at this pivotal point in history. Pepys frequently records his distaste with the lax ethical standards evidenced by Charles II and his court, but he was alternately fascinated and repulsed by their behavior. Capable of overlooking moral failings in those he found possessed of fundamental goodness, Pepys found the lazy and the dull-witted detestable. At the same time, he was a disciplined ascetic, devoted to his business, who liked to kick up his heels almost every night and enjoy London's pubs and theaters. His record of life in an extraordinary decade of royal renewal remains one of the greatest journals ever written in the English language, even as it continues to provide historians with an indispensable mine of facts. Some of its descriptions, like its recounting of the devastation wrought by the Great Fire of London in 1666, have long provided insight into one of the most crucial events in London's history. Like the Duc de Saint-Simon's roughly contemporaneous records of life in the Palace of Versailles, it is one of the great testimonies to the tenor of seventeenth-century life, the product of a society that realized that its own thoughts and feelings about the great events that were being witnessed at the

a PRIMARY SOURCE *document*

A VAST AND CHARMING WORLD

INTRODUCTION: Aphra Behn's *Oroonoko*, a short work of fiction partially derived from the time its author spent in the colony of Surinam, contains many charming passages of description. They seem more worthy of a travel book than a work treating the inhuman excesses of the slave trade. In one of these passages Behn treats the beauty and exoticism of her surroundings. Her remarks are one of the first occurrences in Western literature of what has remained a perennial theme among Northern European authors until the present time: the tantalizing effect of the tropics.

My stay was to be short in that country; because my father died at sea, and never arrived to possess the honor designed him (which was Lieutenant-General of six and thirty islands, besides the Continent of Surinam) nor the advantages he hoped to reap by them: so that though we were obliged to continue on our voyage, we did not intend to stay upon the place. Though, in a word, I must say thus much of it; that certainly had his late Majesty, of sacred memory, but seen and known what a vast and charming world he had been master of in that continent, he would never have parted so easily with it to the Dutch. 'Tis a continent whose vast extent was never yet known, and may contain more noble earth than all the universe beside; for, they say, it reaches from east to west one way as far as China, and another to Peru: it affords all things both for beauty and use; 'tis there eternal spring, always the very months of April, May, and June; the shades are perpetual, the trees bearing at once all degrees of leaves and fruit, from blooming buds to ripe autumn: groves of oranges, lemons, citrons, figs, nutmegs, and noble aromatics continually bearing their fragrancies. The trees appearing all like nosegays adorned with flowers of different kinds; some are all white, some purple, some scarlet, some blue, some yellow; bearing at the same time ripe fruit, and blooming young, or producing every day new. The very wood of all these trees has an intrinsic value above common timber; for they are, when cut, of different colors, glorious to behold, and bear a price considerable, to inlay withal. Besides this, they yield rich balm and gums; so that we make our candles of such an aromatic substance as does not only give a sufficient light, but, as they burn, they cast their perfumes all about. Cedar is the common firing, and all the houses are built with it. The very meat we eat, when set on the table, if it be native, I mean of the country, perfumes the whole room; especially a little beast called an armadillo, a thing which I can liken to nothing so well as a rhinoceros; 'tis all in white armor, so jointed that it moves as well in it as if it had nothing on: this beast is about the bigness of a pig of six weeks old. But it were endless to give an account of all the divers wonderful and strange things that country affords, and which we took a very great delight to go in search of; though those adventures are oftentimes fatal, and at least dangerous: but while we had Caesar in our company on these designs, we feared no harm, nor suffered any.

As soon as I came into the country, the best house in it was presented me, called St. John's Hill. It stood on a vast rock of white marble, at the foot of which the river ran a vast depth down, and not to be descended on that side; the little waves, still dashing and washing the foot of this rock, made the softest murmurs and purlings in the world; and the opposite bank was adorned with such vast quantities of different flowers eternally blowing, and every day and hour new, fenced behind 'em with lofty trees of a thousand rare forms and colors, that the prospect was the most ravishing that sands can create. On the edge of this white rock, towards the river, was a walk or grove of orange- and lemon-trees, about half the length of the Mall here; flowery and fruit-bearing branches met at the top, and hindered the sun, whose rays are very fierce there, from entering a beam into the grove; and the cool air that came from the river made it not only fit to entertain people in, at all the hottest hours of the day, but refreshed the sweet blossoms, and made it always sweet and charming; and sure, the whole globe of the world cannot show so delightful a place as this grove was. Not all the gardens of boasted Italy can produce a shade to outvie this, which nature had joined with art to render so exceeding fine; and 'tis a marvel to see how such vast trees, as big as English oaks, could take footing on so solid a rock, and in so little earth as covered that rock: but all things by nature there are rare, delightful, and wonderful.

SOURCE: Aphra Behn, *Oroonoko, or the Royal Slave* (London: Will Canning, 1688): 148–154. Spelling modernized by Philip Soergel.

time might one day come to be prized by those who followed.

THE ROLE OF FICTION. Another feature of the late seventeenth-century literary world points to the steadily multiplying genres that captivated the age: its fascination for fictions, fictions that alleged to be true. In the eighteenth century this appetite for fiction gave rise to the novel, a long narrative that recounted a completely imagined universe that was avidly consumed by the reading public. Seventeenth-century fictions were often

considerably humbler in their aims. One of the most interesting examples that survives from the period is Aphra Behn's *Oroonoko*, a tragic tale set in the Caribbean colony of Surinam. Behn was notably the first woman in England to support herself through writing for the theater, but her background and education remain a matter of mystery today. Certainly, like Bunyan, she did not have access to the world of high intellectual ideas like contemporary graduates of the universities at Cambridge and Oxford did. But the plays and tales she spun were not without literary merit, and not without knowledge of the world. Like Shakespeare, she seems to have been largely self-taught. She could read and apparently speak French, and her plays were sophisticated enough to keep cultivated London society entertained. But it was in her *Oroonoko*, a seemingly autobiographical tale that appears to relate her own experiences as a traveler in 1660s Surinam, that her skills as an impassioned storyteller shines. *Oroonoko* is not a great work of fiction, although its frequently overwrought descriptions of an enslaved African prince and his beautiful lover and bride Imoinda do manage to elicit a degree of pathos in its readers. The work is filled with echoes of other discourses that fascinated Europeans in the centuries that followed. The African slave prince is celebrated in ways that seem to anticipate Jean-Jacques Rousseau's "noble savage," one of the most important literary motifs of the Enlightenment. In truth, however, Behn's depiction is largely drawn from ancient Roman literary narratives, something again that points to the broad reading that she must have accomplished before stepping onto the London scene in the late seventeenth century. In *Oroonoko* Behn also presents one of the first images of northern European society transfixed by the climate and flora of the southern climates, a theme that has continued to play a role in European literature until contemporary times. Behn's readership may not have been prepared for the elaborate and lengthy novels that were to entertain eighteenth-century English society, but clearly a taste was developing in this world for stories that appeared to present a faithful view of the world, but which nevertheless carried their readers away into alternative times and places. Behn's *Oroonoko* was, in other words, an early example of "literary escapism."

THE GLORIOUS REVOLUTION AND ITS IMPACT ON THE LITERARY WORLD. A frank, frequently overt sexuality was one of the hallmarks, not only of Behn's fictional world, but of the Restoration era in which her fictions appeared. In the disputes that occurred over the English succession during the 1680s, the underlying tensions that had existed in society between a worldly and seemingly amoral court and a country that still possessed many Puritan values continued to seethe just below the surface of society. In the Glorious Revolution of 1688, the English Parliament effectively dismissed the last of the Stuart kings, the Catholic James II, and invited his daughter Mary and her husband William of Orange to assume the roles of dual monarchs. Sensing that the sources of discontent with the later Stuarts ran deeper than just issues about religious toleration or confessional allegiances, Mary and her co-regent soon exerted a conservative influence over the London stage and the capital's literary world. In this new age the sexual license that had flourished in the London theater and in the fictions of figures like Behn came rather quickly to appear old-fashioned, out-of-synch with the new tenor of the times. Yet the austere, grand rhetoric and English style that had been crafted for the Restoration era by such astute stylists as Dryden and other luminaries of the later Stuart era lived on, and in the eighteenth century they produced a brilliant age of prose fiction.

SOURCES

J. S. Bennett, *Reviving Liberty: Radical Christian Humanism in Milton's Great Poems* (Cambridge, Mass.: Harvard University Press, 1989).

H. Blamires, *Milton's Creation: A Guide through "Paradise Lost"* (London: Methuen, 1971).

M. Duffy, *The Passionate Shepherdess* (London: Methuen, 1989).

P. Hammond, *John Dryden: A Literary Life* (Houndmills, Basingstoke, England: Macmillan, 1991).

D. Hopkins, *John Dryden* (Cambridge: Cambridge University Press, 1986).

V. Newey, *'Pilgrim's Progress': Critical and Historical Views* (Totowa, N.J.: Barnes and Noble, 1980).

J. A. Winn, *John Dryden and His World* (New Haven, Conn.: Yale University Press, 1987).

ENGLISH LITERATURE IN THE EARLY EIGHTEENTH CENTURY

CHANGING ATTITUDES. At the end of the seventeenth century changes in attitudes in England began to pave the way for the development of political journalism on the one hand and for the rise of the novel-reading society of the eighteenth century on the other. The forces that produced these changes were interrelated, but complex. In the final quarter of the seventeenth century Isaac Newton and other leaders of the Scientific Revolution pioneered the notion of a mechanical universe that was governed by unalterable laws

and which was held together by the attraction and repulsion of gravity. In the writings of political philosophers like John Locke (1632–1704), this notion of a world governed by fundamental natural laws and by the balance of opposing forces within the commonwealth soon influenced political philosophy. Through his many writings on politics, Locke explored issues concerning good and bad government, trying to unlock the keys that produced the greatest happiness, prosperity, and liberty in states. Although Locke had been born into a Puritan family, his works displayed little of the distrust for human nature that had long been characteristic of the Calvinist tradition. Instead he argued that the mind was at birth a *tabula rasa*, a blank slate upon which good and bad experiences left their residue. His political writings which argued for limited government and a degree of religious toleration for dissenting Protestants came to be an important force in the Glorious Revolution of 1688, that bloodless political transformation that deposed King James II and replaced him with the co-regents William and Mary. Locke's works continued to be avidly read throughout the eighteenth century, and their arguments for limited government were avidly discussed by numerous political philosophers, not only in England, but in Continental Europe and the American colonies. The defenses that Locke fashioned for governments that protected citizens' property rights and their individual freedoms inspired the philosophies of the European Enlightenment, a movement that aimed to institute an "Age of Reason." And in America much of Locke's political philosophy came to be reflected in the Declaration of Independence and the Constitution. In England, the ideas of Newton, Locke, and other early Enlightenment thinkers soon produced great political ferment and discussion, leading to the rise of a society that hungered for newspapers and journalistic commentary, an industry that provided an outlet for some of the most creative minds of the period.

THE RISE OF JOURNALISM. London's first newspaper had appeared in the 1660s in tandem with the Restoration of the Stuart monarchy, but that paper, the *Gazette*, had functioned largely as a government organ of information. Parliament's passage of the Licensing Act in 1662 prohibited all publishing unless texts were submitted for licensing before being printed, a provision that, in fact, militated against the development of other newspapers because by the time that a journal might have wended its way through a maze of censors, its news would have been old. In 1695 the Licensing Act lapsed, and there was generally little will in Parliament to renew its provisions because, by this time, the Stationer's Guild that controlled the licensing process was widely seen as corrupt. It notoriously used its privileges merely to wrest as much money in fees as it could from printers and authors. But while the practice of licensing texts disappeared in England, government censorship did not. In the years that followed, the English government continued to subject the press to restrictions, but through different means. It often prosecuted those that published offending texts through the law of Seditious Libel. This change helps to explain the great flowering of political journalism and the English press generally that occurred in London in the years after 1700. Unlike the earlier licensing requirements, prosecutions for Seditious Libel occurred only after an author and printer had published an offending text. In the days, even months before government forces mobilized to punish offenders, thousands of texts could be profitably sold. Thus both printers and authors began to take their chances, testing the limits of the system, and often profitably making use of the very fact that an author's previous works had been banned. Such was the case with Daniel Defoe (1660–1731), the most famous of eighteenth-century journalists who prospered under the new system. Defoe had already achieved considerable success on the London scene by poking fun both at religious dissenters who occasionally conformed to the Church of England's laws so that they might hold government offices and at High Church Anglicans, who vigorously argued that strong measures be taken to punish dissenters. In 1702, he stepped a bit too far, though, in the direction of mocking the High Church party. In December of that year he published a satirical tract, *The Shortest Way with Dissenters*, a work that appeared to many to be an actual pamphlet written by a High Church Anglican. Defoe argued that the best way to deal with dissenters was to hang them all. Some of his language appeared to draw upon the works of Henry Sacheverell, then the ruling bishop of Oxford and a noted extremist in defense of the Church of England's prerogatives. A furor soon erupted; some argued that the tract was, in fact, genuine, while others recognized it as a satire and tried to unearth who had written it. When the author's identity came to light, his opponents cried for blood for having "put one over on his readers," and a summons was issued for Defoe's arrest. By this time, though, Defoe had already gone into hiding, although he was later caught, tried, and convicted, and on three occasions he was pilloried before regaining his freedom. For a time, his personal finances lay in ruin as a result of his political misfortunes.

MULTIPLICATION OF NEWSPAPERS. Defoe's case reveals the great dangers that lay in London's develop-

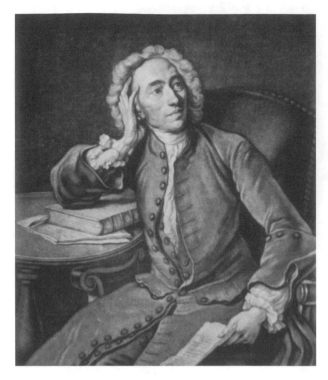

Engraving of Alexander Pope. THE LIBRARY OF CONGRESS.

ing world of political journalism. Just as writing for the theater could be dangerous in Elizabethan or early Stuart times, the annals of eighteenth-century journalism are filled with cases of those who, like Defoe, fell afoul of the law. But while these decisive punishments sometimes made journalists personally more cautious in the years after they had occurred, they did little to discourage others from following in their footsteps. England's developing political journalism could be a lucrative career. The early eighteenth century was a time of relative political instability in the country, with frequent changes in government during the reign of Queen Anne (1702–1714), and the political disputes of these years consequently created a market for news about politics. Other celebrated cases similar to Defoe's also nourished a market for newspapers, political tracts, and commentary on contemporary developments. Where London had a handful of newspapers in 1700, this number continued to grow in the first half of the century, and many new journals came to be centered in the city's Fleet Street, long the heart of English newspaper publication. With the establishment of regular coach services up and down the length of Britain in the early eighteenth century, London newspapers came also to be transported to far-flung points of the island, inspiring the foundation of journals and papers in other provincial cities that reprinted the "news" recently arrived from the capital together with information about local events. In London,

the vigorous climate of political journalism nourished some of the greatest writers of the age. Among the many distinguished authors who wrote for London's newspapers and journals were the poet Alexander Pope (1688–1744); the churchman and satirist Jonathan Swift (1667–1745); and the playwright and poet John Gay (1685–1732).

ALEXANDER POPE. Although he suffered great physical and emotional hardships throughout his life, Alexander Pope was able to rise above these challenges to become, like John Dryden, the defining poet of his age. Born to mature Catholic parents, he grew up in London before his family moved to Hammersmith, then a village west of the city. His father had been a wealthy merchant of linen, who was forced to retire from his profession by the passage of anti-Catholic laws during the Glorious Revolution of 1688. Despite that deprivation, the family remained prosperous, and when Pope was just twelve his father purchased an imposing estate and land in the forests outside London. Although he attended a school open to Catholic boys for a time, he was soon expelled for writing a satirical verse about another student, and priests provided much of his subsequent education. When he was still a child, Pope developed an infection of the bone that left him crippled in adulthood. As a result, he never grew past the height of four feet, six inches, and much of his life was spent wracked with pain. Eventually, he needed to wear braces in order to stand upright. Both his debility and his Catholicism became defining features of his character, with his life assuming the character of an almost heroic struggle to achieve recognition. During the 1710s, Pope spent some time writing for the London journal, *The Spectator*, a literary magazine that was edited by the great essayists Sir Richard Steele and Joseph Addison. Unlike the other London periodicals of the day, *The Spectator* generally steered clear of partisan politics, although its outlook was seen by many as mildly Whig—that is, favoring the authority of Parliament over the monarch. The journal was fashioned as if it was written by a fictional society known as the "Spectator Club," and in this format those who contributed poetry or prose to the periodical were free to write on any subject they chose, so long as they made their contributions fit with the fiction. From the time of the publication of these early pieces, Pope acquired the reputation for being the greatest English poet of his day, the heir to Dryden. Although he spoke on political issues from time to time, he was more concerned with developing a theory of aesthetics in his poetry and essays. Ugly things repulsed Pope, and he was consequently a lover of all the arts, visual as well as literary. He was

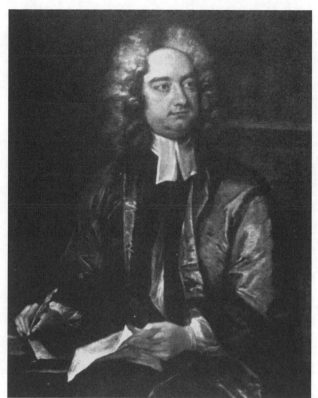

Portrait of Jonathan Swift. THE LIBRARY OF CONGRESS.

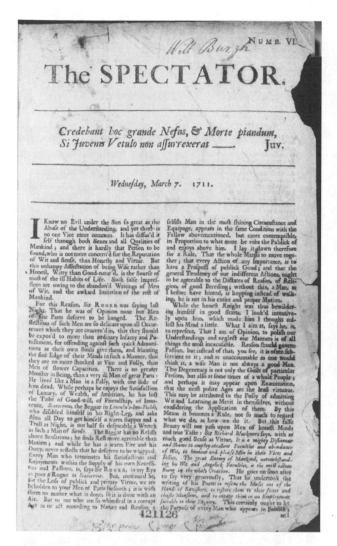

The Spectator, one of London's most popular eighteenth-century periodicals. SPECIAL COLLECTIONS LIBRARY, UNIVERSITY OF MICHIGAN. REPRODUCED BY PERMISSION.

not only a practicing poet, but a capable amateur painter as well. His published works promoted the idea that the poet's mission was to inspire his audience with an ideal of what might be accomplished in an orderly, well-run society that prized beauty. As a consequence of these aesthetic ideals, Pope was a harsh taskmaster over his own writing; he frequently subjected his poems to revision, thus there are variant versions of many of the poems.

SWIFT. Similar formalistic sensibilities are to be found in the life of Jonathan Swift, a satirist and poet who was for a time a close associate of Pope and Defoe. The three were members of the Scriblerus Club, a group of Tory wits that met in London during 1713 and 1714. These meetings left their imprint on the style of many of those involved in them. Biting satire came to be one of the common stocks in trade of those that were asso-

ciated with the Scriblerus Club, although Swift had honed his skills in this regard long before that venture. Born and raised as an Anglo-Irishman, he was educated at Trinity College in Dublin for a time, but was a haphazard student. Eventually, he received a "special degree" and became a tutor in the household of the Surrey gentleman, Sir William Temple. He took an M.A. from Oxford in 1692, and accepted a position in the Irish Protestant church near Belfast, but he soon returned to Temple's service when he became disenchanted with the grinding poverty of his situation. In Temple's service he began to write satire and literary criticism, including *A Tale of a Tub* and *The Battle of the Books.* This last work entered into the then common debate in England and France about the relative merits of ancient versus modern literature. Prudently, Swift sided with his patron, Sir William Temple, who had defended the ancients over the efforts of contemporaries. *A Tale of a Tub,* by contrast, was a biting satire that mocked recent corruptions in religious practices in the figures of three brothers who represent Catholics, Protestants, and Anglicans. Each figure dramatically misreads their father's will, a device that stands for the Bible. In this way Swift relied on a fable to condemn in a lively and exuberant fashion the recent errors of all the Christian faiths. But while Swift could

admit that his own Anglican tradition had sometimes erred, he continued throughout his life to evidence the religious views of a Tory—he always supported a High Church policy. He believed that the Church of England should continue to enjoy a privileged position among all the religious institutions of the country, and that laws against dissenters and Catholics should be upheld. In his political leanings, though, Swift often favored the Parliamentary dominance championed by the Whigs. The accession of the German Hanoverian king George I (r. 1714–1727), though, meant that the Tories were soon thrown from power, and because of his religious leanings and his participation in the Scriblerus Club, Swift never again wielded political influence. Instead he became a member of the loyal opposition, writing pamphlets that criticized the Whigs' corrupt exercise of power under George I and George II, and perfecting the art of political satire to the highest level it was perhaps ever to achieve. Among the works that he published in these later years of his life, two in particular stand out for their brilliance: *Gulliver's Travels*, which was published anonymously in 1726; and *A Modest Proposal*. The by-now familiar plot and charming narrative that Swift spins in *Gulliver's Travels* has long obscured the work's biting political attack on the Whig Party and its indictment of many British institutions of his day, including the Royal Society. In *A Modest Proposal* Swift continued to batter the government through a satirical tract that alleged to be a kind of government paper outlining a plan to raise Irish children for food. Although Swift continued to have a wide readership during his lifetime, the ribaldry and frank sexuality that is present in many of his works, including *Gulliver's Travels*, meant that they increasingly fell out of favor. As he aged, too, Swift was often accused of insanity, adding to the flagging popularity of his works. By the Victorian era, his great masterpiece, *Gulliver's Travels*, had been transformed in heavily sanitized editions into a classic intended to be read, not by adults, but by children. In this way knowledge of the topical political commentary Swift had inserted into the work fell out of English readers' view, and the work became merely a good yarn of adventure.

SOURCES

P. R. Backscheider, *Daniel Defoe: His Life* (Baltimore, Md.: Johns Hopkins University Press, 1989).

D. D. Blond and W. R. McLeod, *Newsletters to Newspapers: Eighteenth-Century Journalism* (Morgantown, W. Va.: West Virginia University Press, 1977).

P. Earle, *The World of Defoe* (New York: Athenaeum, 1977).

D. Fairer, *Pope's Imagination* (Manchester, England: Manchester University Press, 1984).

I. Higgins, *Swift's Politics: A Study in Disaffection* (Cambridge: Cambridge University Press, 1994).

THE ORIGINS OF THE NOVEL IN ENGLAND

NEW GENRE, NEW TIMES. The relatively rapid rise of the novel as a popular reading form in eighteenth-century England has long elicited interest from historians and literary critics. Of course, these were not by any measures the first "fictions" to enjoy a wide readership, but the eighteenth-century novel came to be distinguished from its forbearers—works like Aphra Behn's *Oroonoko*—both by its length and its efforts to create an entirely imagined universe. Its development as a modern literary form occurred in the relatively brief space of two generations, the years, that is, between 1720 and 1780. Its development points to many changes in eighteenth-century society, including increasing disposable income among the middle classes to spend on books and greater leisure time in which to enjoy them. Its appearance, too, points to the increasingly secular spirit of eighteenth-century society, as readers exchanged the devotional literature of the past for fictions, fictions that the Christian moralists of the age often condemned as morally suspect and light-headed. Since many of those that consumed the new novels were women, too, the rise of this literary form also reveals rising educational standards during the period. The novel was an undeniably secular form of entertainment when compared against the devotional works and spiritual biographies and autobiographies that had been popular in the seventeenth century. But while secular in its outlook, the ways in which eighteenth-century authors crafted their stories were not devoid of moral or religious purposes. Eighteenth-century England was still a country very much shaped by its Puritan past, and in the novel's plots authors often told stories about downtrodden women and libertine men, tales that had just enough of a whiff of danger about them to titillate, and yet reinforce traditional values.

DEFOE. Historians and literary critics have often identified a series of three works that Daniel Defoe (1660–1731) published in the years around 1720 as decisive in fashioning the English novel: *The Life and Surprising Adventures of Robinson Crusoe* (1719), *The History and Misfortunes of the Famous Moll Flanders* (1722), and *The Fortunate Mistress, or Roxana* (1724). Defoe came to this fictional form late in life, and he did not create these works out of entirely new cloth. Before completing his *Robinson Crusoe*, for instance, he had already written

a PRIMARY SOURCE *document*

A SCHOOL FOR PICKPOCKETS

INTRODUCTION: Daniel Defoe's early novels made use of the first-person narrative derived, in large part, from his familiarity with Puritan spiritual autobiographies. In this passage from his *The History and Misfortunes of the Famous Moll Flanders*, the dark heroine describes the way in which she came to be a pickpocket on London's streets.

Some time after this, as I was at work, and very melancholy, she begins to ask me what the matter was, as she was used to do. I told her my heart was heavy; I had little work, and nothing to live on, and knew not what course to take. She laughed, and told me I must go out again and try my fortune; it might be that I might meet with another piece of plate. 'O mother!' says I, 'that is a trade I have no skill in, and if I should be taken I am undone at once.' Says she, 'I could help you to a School-Mistress that shall make you as dexterous as herself.' I trembled at that proposal, for hitherto I had had no confederates, nor any acquaintance among that tribe. But she conquered all my modesty, and all my fears; and in a little time, by the help of this confederate, I grew as impudent a thief, and as dexterous as ever Moll Cutpurse was, though, if fame does not belie her, not half so handsome.

The comrade she helped me to dealt in three sorts of craft, viz. shoplifting, stealing of shop-books and pocket-books, and taking off gold watches from the ladies' sides; and this last she did so dexterously that no woman ever arrived to the performance of that art so as to do it like her. I liked the first and the last of these things very well, and I attended her some time in the practice, just as a deputy attends a midwife, without any pay.

At length she put me to practice. She had shown me her art, and I had several times unhooked a watch from her own side with great dexterity. At last she showed me a prize, and this was a young lady big with child, who had a charming watch. The thing was to be done as she came out of church. She goes on one side of the lady, and pretends, just as she came to the steps, to fall, and fell against the lady with so much violence as put her into a great fright, and both cried out terribly. In the very moment that she jostled the lady, I had hold of the watch, and holding it the right way, the start she gave drew the hook out, and she never felt it. I made off immediately, and left my schoolmistress to come out of her pretended fright gradually, and the lady too; and presently the watch was missed. 'Ay,' says my comrade, 'then it was those rogues that thrust me down, I warrant ye; I wonder the gentlewoman did not miss her watch before, then we might have taken them.'

She humour'd the thing so well that nobody suspected her, and I was got home a full hour before her. This was my first adventure in company. The watch was indeed a very fine one, and had a great many trinkets about it, and my governess allowed us £20 for it, of which I had half. And thus I was entered a complete thief, hardened to the pitch above all the reflections of conscience or modesty, and to a degree which I must acknowledge I never thought possible in me.

SOURCE: Daniel Defoe, *The Fortunes and Misfortunes of the Famous Moll Flanders* (London: 1722; New York: Quality Paperback, 1996): 222–223.

more than 400 other works of political commentary, fiction, and satire. These three works were consequently only a miniscule output of their author's entire body of work. His tremendous production is the result of his creation of the literary equivalent of a cottage industry. Like Peter Paul Rubens, the seventeenth-century painter who presided over an enormous studio that churned out many paintings under his name, Defoe seems to have employed "ghost" writers, including his two sons, in order to complete the massive amounts of prose he was called upon to write for newspapers, journals, and the press in the 1710s and 1720s. In the years between 1709 and 1714, he developed his skills as a propagandist for the Tory Party, then the ruling faction in Parliament. As Queen Anne's death approached, many Tories supported a return to Stuart rather than Hanoverian rule, but with the accession of the German George I (r. 1714–1727) to serve as England's monarch, these plans were quickly discredited. Defoe and some of his associates now were persecuted for their role in popularizing the Tory program in print. Defoe was convicted of Seditious Libel, and in the months that followed he seems to have become a kind of literary spy for the Whigs, who paid him to continue to work for Tory publications so that he might "tone down" the rhetoric they used against the new Hanoverian government. By 1715, Defoe was editing one Tory newspaper while simultaneously producing another that was Whig in its orientation. For these efforts he was widely attacked, but he was enormously successful all the same. He made annually around 1,200 pounds from his journalism alone, a sum that was about 25 times the average wage of a shopkeeper or artisan in

the country. Because of his acerbic wit, his texts were assured of a wide audience, and he was paid handsomely for them, but as a result, he also dabbled in other business deals, and in these he failed to show the same skill as in his journalism so that by the end of his life his finances were in shambles.

CASTAWAYS AND CRIMINALS. Defoe's skill in developing a market for his fiction can be seen in his *Adventures of Robinson Crusoe*, as well as in *Moll Flanders* and *Roxana*. In truth, it must be admitted that Defoe was not really trying to develop these texts as "novels"; they were extensions of his long-term use of satire and of the "pretend narratives" he had long written to make points in his journalism. A central concern of Defoe's political writings had been his criticism of public corruption and of the private morality evidenced by men of affairs in the political world of his time. In *The Life and Surprising Adventures of Robinson Crusoe* the author continued to speak to these issues, while nevertheless constructing an entirely fictionalized world. The sources for such an imaginative approach were many. Defoe appears to have modeled his story on the "real-life" adventures of Alexander Selkirk, a Scottish sailor who had been rescued from shipwreck and who had returned to Britain in 1709. But Defoe also relied on a number of travel narratives, history, diaries, works of political philosophy, and theology as well. The most important genre that inspired his narrative, however, was the Puritan confession or spiritual autobiography. Chief among the many works that left its residue in *Robinson Crusoe* was John Bunyan's *Grace Abounding to the Chief of Sinners*, a text that he was well familiar with as a result of his Presbyterian upbringing. The tale that he spins subsequently transposes the theme that Bunyan and other Puritan devotional writers had often treated: the attempt of the individual to achieve salvation in a hostile environment. Defoe imagined this hostile environment, not as "worldly" Restoration England or corrupt Hanoverian Britain, but rather as a desert island. The central character, Crusoe, is abandoned there as a direct result of his defiance of his parents' wishes and his embarking on a life of adventure, a plot derived from the story of the disobedience of Adam and Eve and the Fall of Man. The tale is thus filled with a high moral purpose, but also has the appeal of an adventure story. A similar combination of moral commentary and adventure are to be found in Defoe's two other masterpieces, *The History and Misfortunes of Moll Flanders* and *The Fortunate Mistress, or Roxana*, although both these stories are highly tinged with eroticism as well. In *Moll Flanders*, Defoe relied on the by-then conventional narrative of personal religious conversion. The central character, Moll Flanders—a name that was then redolent of prostitution—is born to a thief in prison and is eventually forced to survive on her wits as a fallen woman. Through a series of alternate fortunes and misfortunes, she eventually is able to put her shady past behind her, and she announces at the end of the work her intentions to live a new, morally upright life. To this point, though, the highly ironic cast in which Defoe has cast Moll's adventures leads the reader to conclude that perhaps she will not be so penitent as she claims.

LIFE AMONG THE GREAT AND GOOD. In *Roxana*, Defoe continued in a similar vein, although instead of setting his tale in the lower reaches of London society, he recounted the adventures of a great Restoration-era courtesan who circulates in high society. For its middle-class readers, part of the appeal of *Roxana* lay in its attack on aristocratic decadence and lasciviousness, qualities that they saw as standing in marked contrast to the thrift and hard work of English commercial society. The central character is forced to survive on the largesse of her lovers following her husband's abandonment and her subsequent bankruptcy. The narrative recounts Roxana's attempts to store up enough treasure through her subsequent line of distinguished paramours so that she may never be subjected to such embarrassments again. But in a way that was new, Defoe also describes Roxana's growing psychological turmoil and her eventual mental breakdown as a consequence of her constant realization that the path on which she has embarked leads only to personal damnation. Where Moll Flanders is eventually redeemed, or at least seems to be redeemed, from her life of crime, Roxana's criminal use of sex ultimately destroys her. Both works are extraordinary texts that can be profitably subjected to a number of different readings. On the one hand, they appear to uphold a traditional Christian morality, but they do so in a way that plays on the sexually voyeuristic appetites of readers. In both books, outright sexual perversions play a central role in the plot. In one of her misfortunes, for instance, Moll Flanders falls unwittingly into a marriage and incest with her brother. Roxana presents her maid Amy to sleep with her own lover so that she might give him a son, an incident that recalls the story of Sarah and Hagar in Genesis 16. Like her husband who has abandoned her, Roxana, in turn, abandons her own numerous children, and at one point even overexerts herself in hopes that she might miscarry. In these and other ways, both stories present a great deal of social commentary about the role that English law and society play in fostering such feminine crimes. Free

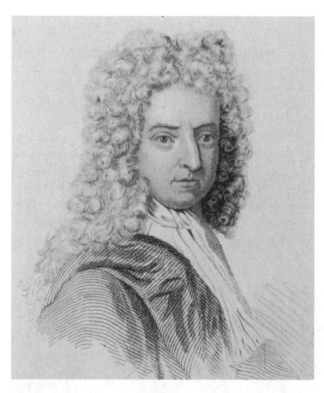

Portrait of Daniel Defoe. THE LIBRARY OF CONGRESS.

women, Defoe decries at points in both narratives, are enslaved by laws that dissolve their status into their husbands when they marry. English society, rather than educating its daughters in useful occupations that might provide them income to survive, instead schools them to make use of their sexuality. Prostitution is, Defoe argues, the logical consequence of the economic and social realities of the day, a daring statement at a time when moralists continued to insist that it arose strictly from personal sinfulness. Yet Defoe also keenly realized that his audience was fascinated by the ideas of Locke and other early Enlightenment thinkers that saw crime, not as the consequence of a primordial mark of Cain, but as the outcome of societies that were badly organized. In this way he developed his novels as exercises in social commentary. Although it must be admitted at the same time that these books' "high" moral aims were frequently at odds with their hints of the pornographic and the merely prurient.

SOURCES

Daniel Defoe, *The Fortunate Mistress, or Roxana* (London: T. Warner, 1724).

————, *The Fortunes and Misfortunes of the Famous Moll Flanders* (New York: Norton, [1973]).

————, *The Life and Surprising Adventures of Robinson Crusoe* (London: Constable, [1925]).

C. H. Flynn, *The Body in Swift and Defoe* (Cambridge: Cambridge University Press, 1990).

C. McIntosh, *The Evolution of English Prose, 1700–1800* (Cambridge: Cambridge University Press, 1998).

I. Watt, *Myths of Modern Individualism* (Cambridge: Cambridge University Press, 1996).

THE NOVEL AND MID-EIGHTEENTH-CENTURY ENGLISH LITERATURE

RICHARDSON. Although the autobiographical style that Defoe had used in his early novels continued to be used throughout the eighteenth century, a number of other authors soon expanded the repertory of techniques that could be called upon to structure the novel. Among these, Samuel Richardson (1689–1761) was the most influential in fashioning a mature novel style that was soon to be imitated by a number of writers. His career was unusual for a writer. Born into relatively humble circumstances, he was educated for the clergy before becoming a printer's apprentice out of financial necessity. In the years that followed he became a successful printer in his own right, and eventually turned to writing as a pastime. His first novel, *Pamela* (1740), appeared when he was already 51. Rather than relying on the autobiographical narrative that Daniel Defoe had popularized, *Pamela* is written in the form of a correspondence between its main characters. Richardson's own voice serves as the editor who compiles and arranges these letters, filling his audience in on the details that they need to know to understand their exchanges. Like Defoe, he structured his work to be both an entertaining diversion and a morally instructive tale, but although it was soon a hugely popular success, not everyone was so convinced that its themes were uplifting. The central character, Pamela, is a maid who rises to marry her master. Some criticized such a plot as seeming to sanction class commingling to its readers, while others found some of the novel's episodes—including one in which one character watches Pamela undress—immoral. In the years that followed, numerous parodies, including the almost equally famous *Shamela* (1741) of Henry Fielding, appeared from English presses. Richardson took the criticisms of his work to heart, and a few years later he completed his masterpiece, *Clarissa*, a work that was published in two halves during 1747 and 1748. The themes of this work were darker, and the book today retains the curious distinction of being the longest novel ever written in the English language. The novel recounts the trials of a young heiress at the hands of an immoral aristocrat, Lovelace, who eventually succeeds in seizing the woman,

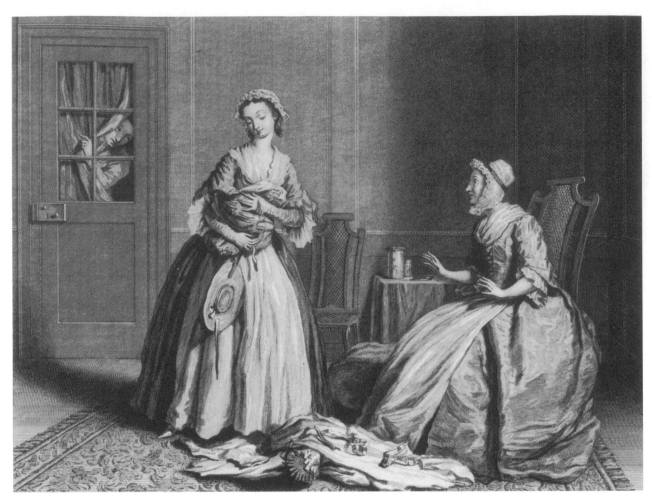

Illustration of the characters Pamela and Mrs. Jervis from Samuel Richardson's *Pamela*. HISTORICAL PICTURE ARCHIVE/CORBIS.

drugging her, and raping her in a brothel. Following the rape, Clarissa resolves to die, and the remainder of the story deals with the way in which she makes her funeral preparations. The story itself was not remarkable. Richardson apparently pieced together a tale from plots and themes that had been popular in English literature since the Restoration, even as he also relied on the works of a number of female writers that were popular in the early eighteenth century, including Penelope Aubin, Eliza Haywood, and Mary Delarivière Manley. Yet while its story was not extraordinary, the psychological insight that Richardson brought to this material, and the pathos with which he treated it, soon made it a sensation. Even before the novel had been completely published, a number of literary luminaries in England began to write to the author to plead that Clarissa's life be spared. The work established Richardson's reputation as a fictional writer of the highest rank, and his works and their epistolary style were widely copied. Eventually, his influence helped to establish a new genre known as the sentimen-

tal novel, which explored the emotions and their effects on characters.

FIELDING. The career of Henry Fielding followed a course different from that of the artisan Richardson. Born into a gentry family, he had grown up in an apparently well-off household, although there had been tensions about money which were exacerbated by his father's poor management of the family's resources. His mother had married for love, and her own family always found the match with Fielding's father inappropriate. Despite these troubles Henry Fielding received the best education possible. He attended the prestigious public school Eton before going off to study at the University of Leyden in Holland. In his twenties Fielding enjoyed a successful career writing for the London stage, but like many playwrights he faced a crisis when the government passed the Stage Licensing Act in 1737, a measure designed to censor and contain the theater, which had recently grown as a vehicle for expressing discontent. The Licensing Act prohibited drama in all venues in London

that lacked a royal patent, effectively placing a damper on the capital's great theater scene. As a result, Fielding saw the commercial possibilities that the stage offered dry up rather quickly. To continue to earn a living, he studied the law and eventually entered the bar. Although he was successful in his new career and eventually rose to the rank of judge, he continued to write, anonymously publishing his *Shamela*, a spoof on Richardson's *Pamela* as early as 1741. In that work Richardson's virtuous Pamela is transformed into the social-climbing servant Shamela who tricks her master, Mr. Booby, into marrying her. In 1742 Fielding wrote his first novel, *Joseph Andrews*, a work that continues where his spoof *Shamela* left off. Shamela is now the hopeless snob, Mrs. Booby, and Joseph Andrews is her lowborn brother. The novel opens with a hilarious scene of seduction in which Joseph refuses to surrender his virginity outside the bounds of marriage, and the resulting comic spectacle that Fielding relates ranks among one of the most entertaining in eighteenth-century English fiction. Fielding's skills as a storyteller continued to grow, and in 1749 he produced his great masterpiece, *The History of Tom Jones, A Foundling*. This rollicking story in which Jones makes his way in the world through a series of mishaps and romances is lighthearted and often erotic, but not without an infusion of moral purpose. At the novel's conclusion, the hero renounces his wayward past, marries, and settles down into a more prudent life. *Tom Jones*, in contrast to the darker *Clarissa* of Richardson, is a work of high comedy, but together the two stories rank as the finest novels of the period.

OTHER NOVELISTS. Although Fielding and Richardson were by far the greatest fictional authors of the period, the vogue for the novel inspired a host of other writers. By the second half of the eighteenth century, the novel had gradually replaced the theater as a source of literary innovation and entertainment for many English men and women. The commercial possibilities this kind of publication offered were great, for even in London and other provincial centers with a theater, an author still wrote for a relatively limited audience. Yet the readership for English novels might exist anywhere where English was spoken, thus providing an almost limitless audience for writers, who now became expert in appealing to their readers, and who made use of the financial possibilities that authorship offered. Although there were many great, near-great, and mediocre writers who wrote novels during this time, the works of Tobias Smollett and Laurence Sterne deserve special mention. In his many novels, Tobias Smollett (1721–1771) evidenced a taste for portraying characters that were amus-

Drawing of Henry Fielding. **THE LIBRARY OF CONGRESS.**

ingly exaggerated and grotesque. His tales were told in the first person and were greatly influenced by the picaresque tradition that had first developed in sixteenth- and seventeenth-century Spain. In those novels the central character was often lowborn and survives by his wits rather than hard work. Smollett made use of this tradition of characterization, but he modulated it to suit the current taste of English readers for a fiction that was realistic. The resulting mix of colorful characters, satire, and often righteous social commentary can best be seen in Smollett's novels *The Adventures of Roderick Random* (1748); *The Adventures of Peregrine Pickle* (1751); and perhaps his best novel, *The Expedition of Humphry Clinker* (1771). By contrast, a considerably more somber spirit hangs over the great creation of Laurence Sterne (1713–1768), *Tristram Shandy*, which was published in nine volumes during the years 1759–1767. Sterne's novel was a self-consciously experimental one, and its tone grows darker in its later volumes, a fact that has often led literary critics to question whether its author's approaching death occasioned this change. The novel is innovative because its narrator, Mr. Yorick, spends little time telling his readers about his own life and instead devotes himself to discussing his family and surroundings. Sterne was very much influenced by John Locke and his notions about human psychology, particularly

a PRIMARY SOURCE document

THE GRAND LOTTERY OF TIME

INTRODUCTION: At the beginning of the second book of his *The History of Tom Jones*, the author Henry Fielding gave the following apology for his method of narration. He calls attention to the differences between his own methods of writing a personal history of a life, and the methods of historians. The passage illustrates the charming, rambling style of the mid-eighteenth-century English novel. But more importantly, it hints at some of the essential freedom that its authors felt lay in the new form, a literary genre that was unfettered by the rules and conventions of older styles of writing. As he observes, as he himself is one of the founders of a new genre, he can do as he pleases.

THO' we have properly enough entitled this our work, a history, and not a life, nor an apology for a life, as is more in fashion; yet we intend in it rather to pursue the method of those writers, who profess to disclose the revolutions of countries, than to imitate the painful and voluminous historian, who, to preserve the regularity of his series, thinks himself obliged to fill up as much paper with the detail of months and years in which nothing remarkable happened, as he employs upon those notable eras when the greatest scenes have been transacted on the human stage. …

Now it is our purpose, in the ensuing pages, to pursue a contrary method. When any extraordinary scene presents itself (as we trust will often be the case), we shall spare no pains nor paper to open it at large to our reader; but if whole years should pass without producing anything worthy his notice, we shall not be afraid of a chasm in our history; but shall hasten on to matters of consequence, and leave such periods of time totally unobserved.

These are indeed to be considered as blanks in the grand lottery of time. We therefore, who are the registers of that lottery, shall imitate those sagacious persons who deal in that which is drawn at Guildhall, and who never trouble the public with the many blanks they dispose of; but when a great prize happens to be drawn, the newspapers are presently filled with it, and the world is sure to be informed at whose office it was sold: indeed, commonly two or three different offices lay claim to the honour of having disposed of it; by which, I suppose, the adventurers are given to understand that certain brokers are in the secrets of Fortune, and indeed of her cabinet council.

My reader then is not to be surprised, if, in the course of this work, he shall find some chapters very short, and others altogether as long; some that contain only the time of a single day, and others that comprise years; in a word, if my history sometimes seems to stand still, and sometimes to fly. For all which I shall not look on myself as accountable to any court of critical jurisdiction whatever: for as I am, in reality, the founder of a new province of writing, so I am at liberty to make what laws I please therein. And these laws, my readers, whom I consider as my subjects, are bound to believe in and to obey; with which that they may readily and cheerfully comply, I do hereby assure them that I shall principally regard their ease and advantage in all such institutions, for I do not, like a *jure divino* tyrant, imagine that they are my slaves, or my commodity. I am, indeed, set over them for their own good only, and was created for their use, and not they for mine. Nor do I doubt, while I make their interest the great rule of my writings, they will unanimously concur in supporting my dignity, and in rendering me all the honour I shall deserve or desire.

SOURCE: Henry Fielding, *The History of Tom Jones* (London: 1749; reprint New York: Modern Library, 2002): 75–78.

the idea that the mind was a "blank slate" upon which experience left its residue. In *Tristram Shandy*, then, he self-consciously attempted to develop these psychological insights by creating one of the first truly in-depth character studies in the English novel. The result is a stunning tour de force in literary experimentation, perhaps unequalled until the novels of James Joyce and Virginia Woolf in the twentieth century.

SAMUEL JOHNSON. While novels continued to attract the attention of English readers as one of the fashions of the age, the greatest literary personality of the eighteenth century was not a novelist, but a literary critic and poet. Samuel Johnson (1709–1784), known affectionately as Dr. Johnson to generations of English readers, began life in humble surroundings in a Midlands town before embarking on a remarkable life. He attended Oxford for only little more than a year, where the depth of his learning in the Classics impressed his tutors. He became a teacher at a grammar school, but left soon afterward when he found the environment stifling. Eventually he married well, and with his wife's money he set up his own school. One of his students, David Garrick, was destined to become the greatest actor in eighteenth-century England, but Johnson's school failed, and he and his pupil departed for London in 1737. Soon, he was

writing for the *Gentlemen's Magazine*, a popular literary and political journal. Although he was prolific and achieved some successes, his first decade in London was difficult. He did not, despite the aid of Alexander Pope, attract patrons, and he struggled to establish a reputation. In these years he formulated his plans for a comprehensive dictionary of the English language, a work that was begun in the late 1740s and published in its first edition in 1755. Johnson's *Dictionary of the English Language* was not the first such reference work to appear in England, although it was the most comprehensive to date. It provided its readers with etymologies, definitions, and examples of how words had been at different points in the history of the language. It quickly became an indispensable source of information for writers and educated society, and it was also a source of significant pride to its author, who reminded his friends that he had compiled his dictionary in only nine years, while a similar reference work for French had required a team of writers forty years to complete. In 1750, Johnson had begun writing for *The Rambler*, and his columns in that periodical as well as *The Adventurer* had already brought him significant acclaim. He began in 1756 to serve as editor of the *Literary Magazine*, and in that capacity his critical reviews helped shape literary tastes. Around this time, he also turned his attention to the works of William Shakespeare, planning and then in 1765 publishing the first critical edition of the bard's opus. Even before that great publication, the government had awarded him with an annual pension, which freed him from the necessity of his journalistic endeavors. In the same year of the first publication of his Shakespeare edition, he received an honorary doctorate from Trinity College in Dublin, a degree that was followed a decade later by another from Oxford.

A FORCE WITH WHICH TO BE RECKONED. Besides his literary endeavors, Johnson was famous for the role that he played in establishing The Club, an organization that he and his friend, the painter Sir Joshua Reynolds, formed in 1764. Nine members drawn from the world of politics, literature, and the arts were among the founding members of this organization, which quickly became an important force on the London scene in the later eighteenth century. Eventually, it became known as The Literary Club and it provided a significant outlet for Johnson's personable nature. His house in the center of London near Chancery Lane also became a significant social and literary hub, and in the years following his wife's death Johnson frequently invited literary men and women to stay with him there. Some in these later years of his life saw Johnson as a kind of literary dictator, who could establish or discredit the career of a budding author in a phrase or two. Yet he was a perceptive critic and was widely regarded for the common sense and good judgment that he exercised when commenting upon other authors' works. Johnson's life, his interest in everything from the Latin Classics to manufacturing processes, points to the increasingly outward-looking culture of metropolitan London in the Georgian era. Johnson arrived in London at a time when it was already the largest city in Europe, a great metropolis that attracted traders and literary figures from across the continent. Yet in those years, despite the city's precocious journalistic culture and its heated printed debates, London lacked the equivalent of the sophisticated salons that played such an important role in the diffusion of the ideas of the Enlightenment in France. Johnson's influence over the literary society of the later eighteenth century helped to develop similar centers of refined discussion throughout London society, as debating the relative literary merits of contemporary authors' works became increasingly a pastime of the city's cultivated society.

SOURCES

J. G. Basker, *Tobias Smollet, Critic and Journalist* (Newark, Del.: University of Delaware Press, 1988).

A. H. Cash, *Laurence Stern: The Early and Middle Years* (London: Methuen, 1975).

———, *Laurence Stern: The Later Years* (London: Methuen, 1986).

T. Eagleton, *The Rape of Clarissa* (Oxford: Oxford University Press, 1982).

I. Grundy, *Samuel Johnson and the Scale of Greatness* (Leicester, England: Leicester University Press, 1986).

J. Harris, *Samuel Richardson* (Cambridge: Cambridge University Press, 1987).

N. Hudson, *Samuel Johnson and Eighteenth-Century Thought* (Oxford: Oxford University Press, 1988).

C. Rawson, *Henry Fielding and the Augustan Ideal Under Stress* (London: Routledge and Kegan Paul, 1972).

P. Rogers, *Samuel Johnson* (Oxford: Oxford University Press, 1993).

W. Sale, *Samuel Richardson: Master Printer* (Ithaca, N.Y.: Cornell University Press, 1950).

I. Watt, *The Rise of the Novel: Studies in Defoe, Richardson, Fielding* (Harmondsworth, England: Penguin, 1957).

FRENCH LITERATURE DURING THE ENLIGHTENMENT

PRECURSORS. As in other parts of Europe, the Enlightenment in France had been preceded by the publication of a number of works that were critical of the

Roman Catholic Church, traditional Christianity, and received wisdom in general. Although the French court had come to be affected powerfully by a renewed sense of piety in the last quarter of the seventeenth century, these years had also seen the publication of a number of works that were to be widely read in the eighteenth century, and to form the basis for the Enlightenment's attempts to establish an "Age of Reason." Newton's ideas of a world held together by the opposing forces of gravity and John Locke's teachings concerning the necessity of liberty in civil societies came to be almost as important in eighteenth-century France as they were in England and America. Yet France also produced its own scientists and political theorists in this period, intellectuals that challenged the wisdom of past ages. Among these, Bernard le Bovier de Fontenelle (1657–1757) and Pierre Bayle (1647–1706) were two of the most important thinkers of the years around 1700, and their ideas formed one of the foundations of the Enlightenment in France as it gathered strength in the years following Louis XIV's death in 1715. Fontenelle was a scientist and a productive author who tried to make the implications of the latest scientific experiments available to a more general readership. He published widely on all kinds of topics, from the Classics to political theory and science, eventually winning a place for himself among the immortals of the French Academy. His most influential work, *A Plurality of Worlds* (1688), promoted the notion of the Copernican heliocentric or sun-centered universe. Although Copernicus had advanced this notion as early as 1543, and Galileo had elaborated upon his theory in the early seventeenth century, the Catholic Church's condemnation of the notion of a sun-centered universe had helped to dampen its rise to prominence, even among intellectuals in France in the later seventeenth century. Much of Fontenelle's scientific theorizing in the *Plurality of Worlds* was clearly wrong, and was soon disproven by the publication of Isaac Newton's *Principia* in 1689. Yet Fontenelle wrote vigorously and convincingly for the Copernican theory, and helped as a result to establish its acceptance in the country's intellectual society. Pierre Bayle, by contrast, singled out the entire edifice of Roman Catholicism for his most vigorous attacks. A Protestant, he was forced to emigrate from France as a result of Louis XIV's revocation of the Edict of Nantes in 1685, which had previously granted a degree of toleration to France's Protestant population. Bayle helped to establish the tradition of French writers publishing in exile that was to play an important role in the eighteenth century. His and his successors' works were often printed in London, Amsterdam, or in Switzerland before being smuggled into France, where they were avidly read by French intellectuals. In his works Bayle attacked the fanaticism of the traditional Catholic Church, but he was at the same time critical of the developing rationalistic strains of thought found in many European thinkers. His works were important, especially his *Historical and Critical Dictionary* (1697), because they celebrated toleration and championed a society of pluralistic views. His vision was not realized in late seventeenth- or early eighteenth-century France, although the thinkers of the Enlightenment were to champion many of the same causes that Bayle had.

MONTESQUIEU. The concerns that Bayle and Fontenelle had expressed soon were taken up by many others, including the Baron de Montesquieu (1689–1755), the first great thinker the French Enlightenment produced. Montesquieu entrusted his business interests to his wife, who was an astute manager, so that he could devote himself to study, writing, and his position in the Parlement of Bordeaux, an important court and administrative institution. In 1721, Montesquieu's first great work, *The Persian Letters*, appeared and soon prompted considerable debate. It was styled as a series of letters written between two Persian travelers during a visit to France. It mocked French civilization and customs by holding them up to the lens of supposed outsiders. In these letters Montesquieu ranged far and wide, and no one in France seems to have escaped the penetrating gaze of his considerable intelligence. The work attacked the absolutist system of government set up by Louis XIV, the Catholic Church, and all the country's social classes. In its allegorical portrait of a race of Troglodytes, it set forth a cogent discussion of Thomas Hobbes' seventeenth-century notion of the state of nature. Fueled by his success in prompting intellectual ferment, Montesquieu soon left his provincial home in Bordeaux and made his way to Paris, where he circulated in high court circles. In these years in Paris, he came into contact with several English aristocrats, and from his discussions with them, he, like other Enlightenment figures, came to admire the flexibility and greater freedom of England's political system. Eventually, he traveled to England to witness firsthand the country's government at work. In the years following his return to France, Montesquieu began his great classic, *The Spirit of the Laws*, a work that was largely complete by 1743, but not published until 1748, when he had deliberated over his arguments for a number of years and considerably refined them. In its final printed form it was almost 1,100 pages long. The originality of Montesquieu's vision as a political theorist can be seen in the ways in which he takes up subjects that were common among political writers at the time.

Instead of insisting, as past theorists had, that governments should be divided for purposes of examination into aristocracies, monarchies, and democracies, Montesquieu instead treated the spirit that he believed produced each kind of political system. Republics, he argued, arose from a spirit of human virtue; monarchies from a spirit of honor; while despotisms were the product of fear. A second feature of the work proved to be of major importance in the later political history of France and the United States: Montesquieu's notion of the separation of powers. He argued that it was not enough for a government merely to separate functions, but that the legislative, judicial, and administrative duties in a state should be confided to completely separate groups that acted autonomously of each other. In this way his political theory anticipated the political innovations of the U.S. Constitution and the French Revolution. Although Montesquieu shied away from controversy, the implications of his work were widely recognized and attacked at the time. In the Sorbonne, Paris' distinguished university, they were condemned, and the French clergy widely attacked his conclusions as well. In 1751, his *Spirit of the Laws* was placed on the Catholic Index of Prohibited Books.

VOLTAIRE. The greatest author of the French Enlightenment was François-Marie Arouet (1694–1774), who was always known by his pen name Voltaire. He began his career as a secretary before turning to writing, although troubles soon plagued his career. For his early plays, tragedies in the tradition of Pierre Corneille and Jean Racine, he was pronounced the great successor to seventeenth-century classicism. But when he fell afoul of members of the court, he was banished for a time from France. In these years he lived in London and came to admire the greater liberty of English life. When he returned to France, he published his reminiscences of his time among the English as *The Philosophical Letters* (1734), a work filled with keen insights and irony about the differences between French and English societies. In religious matters, Voltaire always professed to be a deist, that is, a follower of the naturalistic religion that had been popular in England among some intellectuals at the end of the seventeenth century. His criticisms of French life, manners, and religion eventually made his life in Paris uncomfortable and, turning his back on France, he traveled for a time to Prussia, where he was offered a position in the court of Frederick II. There intrigues followed him, and eventually he left Germany, only to be captured and imprisoned for a time by Frederick's forces before regaining his liberty. The remainder of his life he spent in Switzerland and at a château he owned on the French border at Ferney. Controversies continued even there, although Voltaire established a salon wherever he went that frequently was sought out by the best minds of Europe at the time. He was also an avid correspondent who kept in touch with many other Enlightenment figures. Besides his plays, Voltaire's greatest literary achievement was his short fictional satire, *Candide* (1759), a work that viciously attacked the philosophical optimism of Gottfried Wilhelm von Leibniz, an early German Enlightenment thinker. Leibniz had taught that nature showed a gradual evolution and improvement towards the most perfect forms. Voltaire, by contrast, argued that such complacency was a fundamentally wrong-headed attitude toward the world. Life presented everyone with sheer random events as well as inexplicable evils that every human being should strive to correct. The characters in his *Candide* start with an essentially optimistic view of the world, a view from which they are soon disenchanted by the stunning series of tribulations they experience. The work presented Voltaire's alternative to Leibniz's philosophical optimism. In it, he argued that human society could be changed for the better, but only if, as in the work's conclusion, everyone tended to "cultivating their garden."

DIDEROT AND THE ENCYCLOPÉDIE. Voltaire's fame spread far and wide throughout eighteenth-century Europe, in large part because of his popular plays but also because of his voluminous correspondence and his literary works. Denis Diderot (1713–1784) did not enjoy such an exalted reputation among France's Enlightenment philosophers and authors, but he came nevertheless to exert a significant influence over literary and artistic tastes in the country in the second half of the eighteenth century, primarily through his role as editor of the *Encyclopédie*. Diderot's publisher had intended this project to be merely a translation of the *Cyclopaedia* written by Ephraim Chambers and published in England in 1728. In his capacity as editor, though, Diderot soon vastly expanded the work, and together with his co-editor, Jean Le Rond d'Alembert (1717–1783), the pair made the publication into a major organ for promoting the ideals of the Enlightenment. The radical character of some of its articles, which were solicited from like-minded figures, soon led the government to censor parts of the publication. Despite such efforts and the work's 25-year production schedule, the *Encyclopédie* was eventually completed, a significant work that helped to establish many of the new teachings about art, literature, and politics among its broad, cultivated readership in France and Europe.

THE FRENCH NOVEL. While political philosophy and works of social and literary criticism attracted some

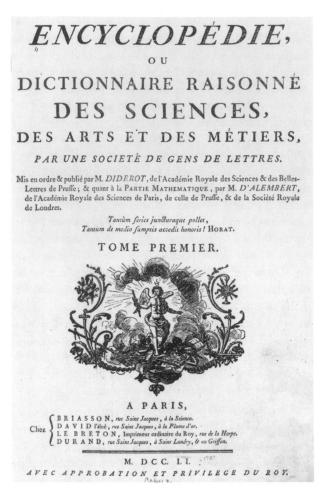

Title page of the *Encyclopédie*, the major Enlightenment reference work edited by Denis Diderot. **THE LIBRARY OF CONGRESS.**

of the finest minds of the French Enlightenment, the period was also a great one in the development of the novel. An important genre of *roman de moeurs* or "moralistic novels" developed throughout the period. In this regard, the works of Alain René Lesage (1667–1747) were widely influential. After producing several works that were influenced by Spanish novel traditions, Lesage began to publish his *Histoire de Gil Blas de Santillane* (The Adventures of Gil Blas of Santillane) in 1715. When the final installment was completed in 1735, it was a work unlike any other written to that time in French. The story followed its hero, Gil Blas, through a series of positions as a valet. Unlike the picaresque novels of Spain, the story is less tragic and brooding. It tells of Blas' adventures, crimes, and amours, before recounting his marriage and retirement from a life of exploits. More tragic, but no less popular was *Histoire du chevalier des Grieux et de Manon Lescaut* (History of the Knight des Grieux and of Manon Lescaut), the best known of the novels of the Abbé Prévost (1697–1763). It tells the story of a no-

bleman who falls in love with a courtesan. As a result, he falls into a seamy life to support his passion. In this widely read novel, realism combines with the taste for romance. The result produces a work that stood far above most of the novels written at the time. The tale follows the couple's fateful romance to its final destination, colonial Louisiana, where Manon dies. The overwrought but realistic description of her death was irresistible fare for operatic and ballet composers, as it was for eighteenth-century readers. Several composers relied on the story in the nineteenth century for operas and ballets. In contrast to Prévost's hard-edged realism, the novelist and playwright Pierre Marivaux (1688–1763) preferred plots that allowed him ample room to explore human psychology and his characters' thoughts. His two most accomplished works in this strain were *The Life of Marianne*, published between 1731 and 1741, and *The Fortunate Peasant*, published between 1734 and 1735. In both works Marivaux showed that he was a master of analyzing feelings and their effects on the human character. His works are now seen as anticipating the popular "novels of sentiment" that became common in both England and France in the second half of the eighteenth century.

RISING LITERARY QUALITY. Despite its great popularity, novels were considered slightly disreputable forms of literature in France—that is, until some of the country's greatest authors began to write them. Although they had long been consumed in France's elite society, fiction generally was associated in the elite mind with the lower classes and country folk. During the seventeenth and eighteenth centuries thousands of cheap fictions were sold in France's villages through *colporteurs*, itinerant peddlers who carried with them everything from bows to buttons to escapist fiction. The figures of the colporteurs, immortalized in François Boucher's eighteenth-century painting *The Galant Colporteur*, had helped to create a whiff of disreputability for the novel in French high society, even though the evidence suggests that many in high society read these texts. But the traditional concerns of French classicism, with its efforts to create a national literature that was immortal and timeless, continued to discourage efforts to see the novel as a literary form that might rise to the status of high art. In the later eighteenth century, though, this situation changed rather quickly. In the articles he wrote for the *Encyclopédie*, for example, Denis Diderot celebrated realistic bourgeois fiction as a vehicle for inculcating moral values, and he pointed to the English novelist Samuel Richardson's *Clarissa* as an appropriate source for authors to emulate. Diderot eventually tried his hand at writing such an "elevated" novel, but the resulting product, *Jacques, the Fatalist*, did not appear in print un-

a PRIMARY SOURCE *document*

AN END TO MISERY

INTRODUCTION: The Abbé Prévost, a clergyman, was also one of France's most successful eighteenth-century novelists. His *Manon Lescaut* (1731), a sentimental and overwrought piece of fiction, was widely popular in its day. It tells the story of a young aristocrat who takes up with a courtesan, to disastrous effect. Both he and his lover are eventually destroyed by their passion, although her death on the Louisiana frontier is certainly the grimmer punishment. In the following passage, Prévost plays upon his readers' desire for sentiment. The work's influence on other arts was longstanding, perhaps because of this death scene, which was widely depicted in several nineteenth-century operas and plays.

We had thus tranquilly passed the night. I had fondly imagined that my beloved mistress was in a profound sleep, and I hardly dared to breathe lest I should disturb her. As day broke, I observed that her hands were cold and trembling; I pressed them to my bosom in the hope of restoring animation. This movement roused her attention, and making an effort to grasp my hand, she said, in a feeble voice, that she thought her last moments had arrived.

I, at first, took this for a passing weakness, or the ordinary language of distress; and I answered with the usual consolations that love prompted. But her incessant sighs, her silence, and inattention to my enquiries, the convulsed grasp of her hands, in which she retained mine, soon convinced me that the crowning end of all my miseries was approaching.

Do not now expect me to attempt a description of my feelings, or to repeat her dying expressions. I lost her—I received the purest assurances of her love even at the very instant that her spirit fled. I have not nerve to say more upon this fatal and disastrous event.

My spirit was not destined to accompany Manon's. Doubtless, Heaven did not as yet consider me sufficiently punished, and therefore ordained that I should continue to drag on a languid and joyless existence. I willingly renounced every hope of leading a happy one.

I remained for twenty-four hours without taking my lips from the still beauteous countenance and hands of my adored Manon. My intention was to await my own death in that position; but at the beginning of the second day, I reflected that, after I was gone, she must of necessity become the prey of wild beasts. I then determined to bury her, and wait my own doom upon her grave. I was already, indeed, so near my end from the combined effect of long fasting and grief, that it was with the greatest difficulty I could support myself standing. I was obliged to have recourse to the liquors which I had brought with me, and these restored sufficient strength to enable me to set about my last sad office. From the sandy nature of the soil there was little trouble in opening the ground. I broke my sword and used it for the purpose; but my bare hands were of greater service. I dug a deep grave, and there deposited the idol of my heart, after having wrapt around her my clothes to prevent the sand from touching her. I kissed her ten thousand times with all the ardour of the most glowing love, before I laid her in this melancholy bed. I sat for some time upon the bank intently gazing on her, and could not command fortitude enough to close the grave over her. At length, feeling that my strength was giving way, and apprehensive of its being entirely exhausted before the completion of my task, I committed to the earth all that it had ever contained most perfect and peerless. I then lay myself with my face down upon the grave, and closing my eyes with the determination never again to open them, I invoked the mercy of Heaven, and ardently prayed for death.

SOURCE: Abbé Prévost, *History of Manon Lescaut and of the Chevalier des Grieux* (Paris and New York: Société des Beaux Arts, 1915): 186–187.

til 1796. A generation earlier, Jean-Jacques Rousseau (1712–1778), perhaps the greatest political and social theorist of the Enlightenment, had already taken up Diderot's call for a morally uplifting fiction. He was the first French philosopher to embrace the novel form as a serious vehicle for treating moral and philosophical issues. But he would not be the last. Until modern times, the novel in France has retained a centrality in philosophical discussions that it lacks in many other cultures. The great twentieth-century philosophers, Albert Camus and Jean-Paul Sartre, for example, continued to write novels, as their Enlightenment and nineteenth-century

forebears had. Rousseau's *Julie, or the New Heloise* (1762) stands at the beginning of this trend. Today, it hardly appears as a great work of art. It is long, overly sentimental, and often dry, but eighteenth-century readers loved it all the same. They seemed to have found in the work a precise description of a world they recognized, combined with a moral commentary they thought was appealing. Rousseau himself seems to have labored over *Julie*, working on the novel for about five years before its publication. The subject he chose was modeled after the medieval romance between Abelard and Heloise, an event that ended tragically with Abelard's castration and

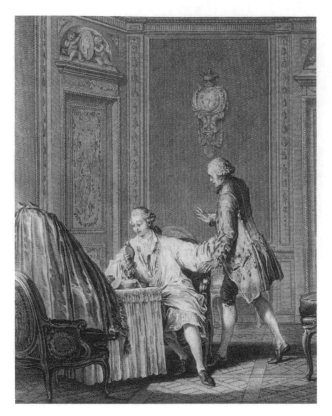

Illustration to Pierre Choderlos de Laclos's *Les Liaisons dangereuses*. GIANNI DAGLI ORTI/CORBIS.

both lovers' entrance into convents. In Rousseau's updated retelling of the story, Julie instead dies, but before she does, she composes a letter to her lover that asks him to accept her death and their unresolved passion. The novel thus set up an interesting interplay between erotic attachment, sexual desire, and its ultimate renunciation in death. The effect of this ending galvanized Rousseau's reputation as a novelist of the highest merit, particularly among his female readers. In this work, Rousseau had intended to accomplish for the French novel what Samuel Richardson had done for the English genre through his *Clarissa*. In the wake of his *Julie*, Rousseau was barraged with letters from his fans, particularly his female fans, a testimony to the way in which he modulated his storytelling to the sentiments of his time.

LATER EIGHTEENTH-CENTURY NOVELS. Two other novelists produced works in the later eighteenth century that stirred similar emotions, and which continued to experiment with ways of presenting moral and intellectual dilemmas to their readers. In 1782, Pierre Choderlos de Laclos' *Les liaisons dangereuses* (Dangerous Liaisons) caused an excitement similar to Rousseau's *Julie*. The work has stood the test of time better than the earlier philosopher's fiction, and it remains an extraordinary

piece of literature today. In fashioning his story Choderlos de Laclos (1741–1803) was also influenced by Samuel Richardson's *Clarissa*, a tale of a corrupt aristocrat who brutally rapes the heroine when she refuses to submit to his will. By contrast, the central story line of *Les liaisons dangereuses* involves, not a rape, but the gradual, entirely calculated seduction of a virtuous woman, who proves unable to resist the protestations of love of the anti-hero, Valmont. In the end it is the wicked Valmont who is consumed by his deceit, although the transforming experience of love that he undergoes with his heroine redeems him, so that even in his death he is restored to a state of moral goodness. But before this sublime transformation occurs, the work's complex plot twists reveal love among the "high and mighty" as nothing more than a cynical game, untouched by true passion, a diversionary amusement shaped by the desire for possessions and reputation. Choderlos de Laclos' brutal and contemptuous portrait of the dissolution of French high society remains unparalleled for its descriptions of aristocratic decadence. Its publication seven years before the outbreak of the French Revolution, when mounting criticism of France's idle aristocrats was steadily rising, helps to explain the sensation it caused, but the work transcends the problems of its own era and is one of the great Western depictions of hypocrisy and trickery. Evil of a different kind is also to be found in the works of the last great French novelist of the eighteenth century, the Marquis de Sade (1740–1814). His descriptions of sexual pleasure mingled with pain, particularly in his *Justine*, helped coin the word "sadism." The work is a "black novel," recounting the lives of two sisters, Justine and Juliette, the first virtuous, the second wicked. The religious Justine sees good in everyone, but is taken in by a libertine who gains her trust before subjecting her to his perversions. Like Rousseau's *Julie* and Choderlos de Laclos' *Les liaisons dangereuses*, the story line is also shaped by a reading of Richardson's *Clarissa* and the many "novels of sentiment" popular in late eighteenth-century Europe. The themes that Sade developed here—sexual desire, misplaced trust, and depraved wickedness—had frequently been treated in many other works, but certainly not with the degree of candor or overt sexuality as in Sade's fictions. The perversions he related in *Justine* as well as in many of the other writings he undertook while imprisoned for his own sexual deviations were, in large part, drawn from his own repertory of experiences.

SOURCES

J. P. Bertaud, *Choderlos de Laclos* (Paris: Fayard, 2003).

P. V. Conroy, *Jean Jacques Rousseau* (London: Twayne, 1998).

F. Du Plessix Gray, *At Home with the Marquis de Sade* (New York: Simon and Schuster, 1998).

H. Mason, *Voltaire: Optimism Demolished* (New York: Twayne, 1992).

A. Niderst, *Fontenelle* (Paris: Plon, 1991).

S. Werner, *The Comic Philosophes: Montesquieu, Voltaire, Diderot, Sade* (Birmingham, Ala.: Summa Publications, 2002).

R. Whelan, *The Anatomy of Superstition: A Study of the Historical Theory and Practice of Pierre Bayle* (Oxford: Voltaire Foundation, 1989).

SEE ALSO *Philosophy: The Enlightenment in France; Theater: The French Enlightenment and Drama*

THE ENLIGHTENMENT IN GERMANY

CHANGING TIMES. In the seventeenth century German literature had often reflected the troubled religious landscape of the age, and the literary landscape was profoundly affected by the disputes of the era. In those years Protestant writers like Andreas Gryphius and Hans Jakob Christoffel von Grimmelshausen had been largely responsible for the creation of a national literature in Germany, a literature which, despite touches of humor and the picaresque, had often concentrated on creating new modes of expression for a language that authors desired to endow with the grandeur of classical rhetoric. Great variety had characterized the verse poetry and prose produced in this era, as many writers had experimented with new rhetorical forms and genres, a literary innovation that Germany's budding "literary societies" supported. Yet the tenor of much of the underlying moral, religious, and philosophical foundations of this literature had remained conservative. While religion continued to be a central preoccupation of German life in the early eighteenth century, new pious movements led in directions different from the highly theological and doctrinal spirit of the Reformation and Counter-Reformation. At the end of the seventeenth century, the German Pietists had supported the development of a new spirit within Lutheranism. Leaders of this movement—men like Philipp Jakob Spener and August Hermann Francke—advocated a religion that spoke to the heart rather than the mind. While Lutheran Pietism remained intensely orthodox in the theology that it espoused, it nevertheless supported a practical spirit, evidenced in the foundation of orphanages and schools as well as the formations of "circles" of lay people that met regularly for prayer and study. As its influence spread in the eighteenth century, Pietism affected many Protestant countries in Northern Europe, eventually helping to inspire the growth of Wesleyanism in England and the Americas. It also fostered the expansion of literacy through the foundations of hundreds of schools, particularly in northern Germany where its influences were most widely felt. Pietism also came to be an intensely literary movement, with its major leaders and advocates frequently publishing devotional works, spiritual autobiographies, and journals similar to those that were common in England and other European regions. Among the literary monuments of the movement Johann Philip Arndt's *True Christianity* (1610), an early work later claimed by the Pietists as one of their sources of inspiration, and Philipp Jakob Spener's *Pia Desideria* (Pious Desires; 1675) became important texts of the movement, and were much emulated by later writers. Francke's influence, too, was notable in his foundation at Halle of a scriptural study institute that trained many in the techniques of Pietist biblical study and commentary. But the movement's impact on the ideas of the eighteenth century was profound, stretching throughout Protestant Europe, and eventually coming even to influence many Catholic devotional writers as well.

LEIBNIZ. While Pietism supported a "heart-felt" devotion rather than a hard-edged doctrinal religion, its teachings were nevertheless firmly located within the traditions of Lutheran orthodoxy fostered by the Reformation. Other sources of disaffection, though, were just beginning to appear in Germany around 1700, sources that eventually questioned the traditional role that Christianity had played in the country's public life. These forces can be seen at work in the career and writing of Gottfried Wilhelm Leibniz (1646–1716), a figure that had been born into a devout Lutheran family. Leibniz's lifelong pursuit of a philosophical alternative to Christianity eventually called that edifice of belief into question. When he entered the University of Leipzig in 1661 as a law student, he soon became familiar with the entire range of scientific thinkers that were producing a reassessment of European ideas at the time, including Galileo, Thomas Hobbes, René Descartes, and Francis Bacon. In the years that followed, Leibniz developed an intensely metaphysical philosophy that attempted to harmonize this new learning with his own hunger for truth. Eventually, this quest resulted in a strikingly original philosophy. Leibniz spent the early part of his career without employment, although he eventually won positions at court. Of the many positions he filled, one as the librarian of the Duke August Library in Wolfenbüttel was particularly important. Wolfenbüttel was home to one of Europe's most distinguished library collections, and there Leibniz was able to read widely, indulging his in-

terests, which ranged across philosophy, the Classics, mathematics, history, and even physics and mechanics. From his tenure at Wolfenbüttel throughout the eighteenth century that followed, the position of librarian at this venerable institution was persistently awarded to some of Germany's greatest literary figures. Eventually, the puzzling philosophy that Leibniz developed based upon his broad reading and his concept of monads, which were independent things he thought composed the real world, proved to be a significant intellectual riddle to untangle. But his lifelong search for philosophical truth, a truth that was independent of the received wisdom of traditional religion, inspired other major German thinkers in the Enlightenment. For these reasons, he has often been dubbed the "Father" of the German Enlightenment.

IMPACT OF ENGLISH LITERATURE. Leibniz had envisioned a world free from the constraints of traditional Christian theology, and although his ideas attracted adherents among other philosophers and authors in eighteenth-century Germany, they were controversial all the same. Additional ferment and inspiration for new German literary forms also appeared in the eighteenth century from English literary works that came to be known in the country from the early eighteenth century onward. In these years German intellectuals avidly read the writings of Daniel Defoe, Joseph Addison, Jonathan Swift, and a number of others. The trend continued throughout the eighteenth century. Later German writers were highly influenced by the works of Samuel Richardson and the literary criticism of Samuel Johnson and others that issued from England in the mid-eighteenth century. The political writings of the French and British Enlightenment were another source of inspiration. Translations of many of these works were produced in Germany relatively quickly, making English fiction and European political writings accessible to many in German society. Among the figures that attempted to apply the insights that they had culled from English Augustan literature, Johann Christoph Gottsched (1700–1766) and Friedrich Gottlieb Klopstock (1724–1803) were particularly important in fashioning new literary forms, both in the theater and in poetry. At Leipzig, Gottsched worked to establish new canons in the theater of his day, and he helped to formulate rules for judging the quality and content of literature. His rules were highly restrictive, but in the circle that he founded in the city, the discussion of them nevertheless produced a creative movement in the history of the country's drama and literature. His followers, for instance, were quick to fashion new, less restrictive canons and to do so, they studied and imitated the works of John Milton and other English writers. Klopstock was one of these writers and he made his greatest mark on German literature through his poem, *The Messias*, which was published between 1749 and 1773. When the first three cantos of that work appeared in 1749, they caused great excitement. They were modeled on Milton's *Paradise Lost*, and like that earlier text relied on unrhymed hexameter for their structure. Emotionally sophisticated, they helped to establish their author as one of the leading poets of his age.

LESSING. Perhaps the greatest literary figure of the mid-century in Germany was Gotthold Ephraim von Lessing (1729–1781), a critic of considerable powers who also wrote drama, prose, and poetry. In 1770, he accepted the same position that Leibniz had two generations earlier as librarian at Wolfenbüttel. But even before this period, he had amassed a reputation as a literary artist of significant innovation. In his plays Lessing helped to develop a "middle-class" drama that spoke to the concerns of Germany's increasingly bourgeois urban society. He produced a number of sparkling comedies before his writing took a more overtly philosophical tone. His work, in other words, came to celebrate the search for rational truth and for a tolerant society, unhindered by religious fanaticism that was typical of many Enlightenment authors. These dimensions of his work eventually spurred controversy. His dramatic poem, *Nathan the Wise* (1779), which intimated that three great world religions—Islam, Christianity, and Judaism—were essentially similar in their ethics, sparked controversy. His pleas for tolerance, particularly of Germany's Jews, were also unusual for their time. But despite criticism of his work, particularly its downplaying of traditional Christian truth, Lessing remained until his death fundamentally assured in his faith in humanity and its ability to perfect itself.

GOETHE. A more tempestuous note is to be found in the life, career, and writing of Johann Wolfgang von Goethe (1749–1832), one of the founders of the "Sturm und Drang" literary style. The values of the "Sturm und Drang" (meaning literally "Storm and Stress") movement fascinated many authors in the final third of the eighteenth century. Writers who adopted this style abandoned the influence of Augustan-era England, with its imperturbable and graciously elegant lyric poetry and prose, and they searched instead for an idiom that was altogether more turbulent, emotional, and personal. Similar movements also influenced the visual arts and music at this time in Germany, helping to provide a bridge between the Classicism that was generally favored in the mid- and later eighteenth century and the Ro-

a PRIMARY SOURCE *document*

THE UNITY OF RELIGIONS

INTRODUCTION: Gotthold Ephraim Lessing's dramatic poem, *Nathan the Wise* prompted controversy when it first appeared in 1779. It was a verse drama, intended to be read or staged, and its action was set in Jerusalem of the twelfth-century Crusades. It narrated a series of exchanges between Christians, Muslims, and Jews. In the following excerpt of dialogue between Nathan, the Christian, and Saladin, the Muslim, can be seen part of the reason for the controversy. Nathan's parable relates the way in which three world religions—Judaism, Christianity, and Islam—proceeded as a gift from God. The parable upheld Lessing's teaching that the ethical importance of each of these sets of teachings was essentially similar, and fit with the Enlightenment's championship of tolerance. The piece shows how the Enlightenment's values of religious tolerance came to shape literary texts, even in conservative Germany, where Pietism and the generally strong support that the state granted to the region's state churches tended to uphold the importance of traditional Christianity.

Nathan: There lived a man in a far Eastern clime
 In hoar antiquity, who from the hand
 Of his most dear beloved received a ring
 Of priceless estimate. An opal 'twas
 Which spilt a hundred lovely radiances
 And had a magic power, that whoso wore it,
 Trusting therein, found grace with God and
 man.
 What wonder therefore that this man o' the
 East
 Let it not from his finger, and took pains
 To keep it to his household for all time.
 Thus he bequeathed the jewel to the son
 Of all his sons he loved best, and provided
 That he in turn bequeath it to the son
 What was to him the dearest; evermore
 The best-beloved, without respect of birth,
 By right o' the ring alone should be the head,
 The house's prince. You understand me,
 Sultan.

Saladin: I understand: continue!

Nathan: Well this ring,
 From son to son descending, came at last
 Unto a father of three sons, who all
 To him, all three, were dutiful alike,
 And whom, all three, in natural consequence,
 He loved alike. Only from time to time
 Now this; now that one; now the third, as each
 Might be alone with him, the other twain
 Not sharing his o'erflowing heart, appeared
 Worthiest the ring; and then, piously weak,
 He promised it to each. And so things went
 Long as they could. But dying hour drawn near
 Brought the good father to perplexity,
 It pained him, the two sons, trusting his word,
 Should thus be wounded. What was he to do?
 Quickly he sends for an artificer,
 To make him on the model of his ring
 Two others, bidding spare no cost nor pains
 To make them in all points identical;
 And this the artist did. When they are brought
 Even the father scarcely can distinguish
 His pattern-ring. So, full of joy, he calls
 His sons, and each one to him separately;
 And gives to each son separately his blessing,

Saladin: I hear, I hear—Only
 bring you the tale
 to speedy end. Is't done?

Nathan: The tale is finished.
 For what still follows, any man may guess.
 Scarce was the father dead, but each one
 comes
 And shows his ring and each one claims to be
 True prince o' the house. Vainly they search,
 strive, argue,
 The true ring was not proved or provable—
 Almost as hard to prove as to us now
 What the true creed is.

SOURCE: Gotthold Ephraim Lessing, *Laocoön, Nathan the Wise, and Minna von Barnhelm.* Trans. W. A. Steel (London: J. M. Dent, 1930): 166–167.

mantic Movement that developed around 1800. Goethe was one of the last great universal geniuses that European society was to produce. He was interested in every dimension of human experience and the natural world, and he became a poet, art critic, naturalist, educational reformer, philosopher, playwright, and novelist. His writings rank even today as among the greatest achievements of world literature. His scientific studies, in fact, fill a fourteen-volume edition, and to this must be added an enormous amount of other writings, all composed in one of the most thoroughly fluent and engaging prose styles imaginable. His life straddled the great literary achievements of the eighteenth and nineteenth centuries, and in his consistent development, Goethe proved ever capable of reacting to changing times and changing questions. Born into the German middle class, he consis-

tently praised bourgeois culture for its production of history's greatest cultural embodiments. Educated in the sophisticated atmosphere of eighteenth-century Leipzig, he left Germany in 1765 on what was intended to be a grand tour. Stopping in Strasbourg, he wanted to study law for a time before going on to Paris and other European cities. In Strasbourg, though, he was so captivated by the sight of the city's Gothic cathedral that he came to realize the poverty of Leipzig's culture of sophistication. From this time he devoted himself to promoting the integrity of the "Gothic ideal." In Strasbourg, he also made contact with Johann Gottfried von Herder (1744–1803), one of Germany's foremost poets. His discussions with Herder convinced him of the poet's great role in expressing emotions and fashioning a primitive language that spoke to the human soul. From this point, his poetry, prose, and dramas thus began to acquire the characteristic mix of emotions, strains, and pressure typical of the *Sturm und Drang*. Goethe had not created this style, but he was its most famous proponent, even as he later experimented with other literary movements. As a *Sturm und Drang* writer, though, his most significant achievement was the publication of his novel, *The Sorrows of Young Werther* (1774), a work that in many people's minds became emblematic of the values of the entire *Sturm und Drang* movement, and which exerted a powerful influence over the development of literary Romanticism. The contents of *Werther*, the story of a young man's unrequited love for a woman who is promised to another, was partially autobiographical. Yet Goethe fashioned his retelling of the tale in such a way as to elicit great pathos and enormous response from his readers. The tale's tragic ending—young artistic Werther commits suicide as a victim of his love—spoke to readers who had to this point been schooled in the belief that art should mirror high ideals and present a larger-than-life heroism. Goethe showed them that the emotions might be a powerful barrier to achieving such a vision. His story thus played on the wellsprings of emotion that lay just beneath the imperturbable classical veneer of eighteenth-century middle-class and aristocratic societies. The novel produced an immediate sensation, not only in Germany, but throughout Europe, where it became one of the great literary success stories of the later eighteenth century. Its plot and style were widely imitated, and its popularity persisted into the nineteenth century, when it was dramatized, made the subject of ballets, and set to music in several operas.

IMPLICATIONS. In Goethe's *Sorrows of Young Werther* can be seen many of the forces that were shaping European literature as the eighteenth century drew to a close. Throughout the seventeenth and eighteenth centuries, European writers had experimented with various literary forms and genres to give expression to their underlying religious, moral, and philosophical beliefs. In the seventeenth century, these attempts had produced great spiritual autobiographies and personal narratives, in which the Christian dramas of the Fall of humanity and its eventual redemption had been given a highly personal, individualistic cast. Poets like John Milton in England and Andreas Gryphius in Germany had similarly devoted themselves to relating the traditional concerns of the classical and Christian worldviews in ways that spoke to their generations of readers. Such works had greatly expanded the literary possibilities of the French, German, and English languages. In France, they had produced a great age of drama, poetry, and prose, in which the greatest writers of the period had developed a distinctly classical idiom. In Germany, such efforts resulted in the emergence of a forceful, varied, yet florid prose and poetic style. And in England, the literary Baroque of figures like John Donne and Milton, with their emphasis on encapsulating difficult meanings, gradually gave way to an Augustan form of expression, notable in John Dryden and others for its detached beauty. In the decades that followed 1700, the quest to present philosophical truths and for a literature that represented the changing realities of the time had begun to produce a fundamental shift, evidenced in the writings of many eighteenth-century authors. Now prose fiction and philosophical writing gave expression to many of the new ideas of the developing Enlightenment. That movement was the recognized heir to the mechanistic views of the universe promoted by Isaac Newton, the theories of natural law and psychology of John Locke, and the questioning and inquisitive spirit of figures like Pierre Bayle, Gottfried Wilhelm von Leibniz, and Bernard le Bovier de Fontenelle. As the Enlightenment endeavored to reform society into one based on the tenets of human reason, authors searched for new literary modes of expression that might give voice to the concerns of their age. Although the novels of Daniel Defoe or Samuel Richardson still continued to be profoundly affected by traditional Christian moral concerns, they were prized, not only in England, but also throughout Europe for the way in which they gave expression to the concerns of an expanding and urban "middle class" society. In *Moll Flanders*, for instance, Defoe presented to his readers a seemingly realistic portrait of life without the middle-class comforts of Augustan London. And in his *Clarissa*, Richardson warned his readers of the enormous powers of the emotions,

helping to inspire a genre of "sentimental" novels in his native England, but also in France and Germany. The quest for a realistic fiction that might embody and examine the emotions and problems that accrued from living in the new civil societies of the age persisted throughout the later eighteenth century. Yet in Goethe and in the troubled spirit of his hero, Werther, can be seen at the same time the very same forces that eventually shattered the eighteenth-century confidence in human reason and its ability to perfect society. With Goethe, European readers were faced with a fundamentally new paradigm, a paradigm that led to the great Romantic literary experiments that fascinated nineteenth-century Europe.

SOURCES

S. P. Atkins, *The Testament of Werther in Poetry and Drama* (Cambridge, Mass.: Harvard University Press, 1949).

R. Critchfield and W. Koepke, *Eighteenth-Century German Authors and Their Aesthetic Theories* (Camden, S.C.: Camden House, 1988).

K. S. Guthke, *Gotthold Ephraim Lessing* (Stuttgart, Germany: Metzler, 1979).

W. Lefèvre, *Between Leibniz, Newton, and Kant: Philosophy and Science in the Eighteenth Century* (Dordrecht, Germany: Kluwer, 2001).

G. Lukács, *Goethe and His Age* (New York: Grosset and Dunlap, 1969).

SEE ALSO *Philosophy: The Enlightenment Elsewhere in Europe; Religion: Pietism*

SIGNIFICANT PEOPLE
in Literature

DANIEL DEFOE

1660–1731

Journalist
Novelist

FROM A DISSENTING FAMILY. In his relatively long life, Daniel Defoe had an enormous influence on journalism and the early English novel. He had been born Daniel Foe in rather humble circles. His father was a London butcher, and although he was fairly prosperous, his status as a dissenter prevented his son from attending university. He was sent instead to a school for nonconformists, those who refused to conform to the rites of the Anglican Church. He seems to have intended to follow a career as a minister, but by 23 he was married and working as a hosier. By this time, he had already traveled extensively in Continental Europe. In the constitutional controversies that developed in England in the 1680s, Defoe supported the Glorious Revolution settlement, and eventually he joined William III's army as it approached London. His career as a writer, though, did not begin until his late thirties when he published *An Essay upon Projects* (1697). It was followed by *The True-Born Englishman* in 1701, a satire that poked fun at those who argued that the English monarch had necessarily to be born an Englishman. In this same year Defoe courageously stood up to Parliament on the day after it had imprisoned five English gentlemen for presenting a petition demanding greater defense preparations for the impending likelihood of a European war. Angered by Parliament's high-handedness, Defoe wrote his *Legion's Memorial* and marched into the House of Commons where he presented it to the leadership. It reminded them that Parliament had no more right to imprison Englishmen for speaking their minds than a king did. Defoe's document produced its desired effect when the petitioners were soon released.

CAREER AS A JOURNALIST. Such political engagements emboldened Defoe, and in 1702 he published a tract, *The Shortest Way with Dissenters*, that mocked the Tory position against Nonconformists. In it, he humorously poked fun at "High Churchmen," those who argued that the best path to take with Dissenters was to uphold laws that limited their freedom. The text of Defoe's tract alleged to have been written by one such High Churchman, and argued that all dissenters should be put to death. For a time, some believed that the tract was genuine, but when it was discovered to be a forgery Defoe's printer was imprisoned and Defoe himself was forced into hiding. Eventually caught, his punishment included a heavy fine, imprisonment, and three sessions in the pillory. During his imprisonment, however, Defoe wrote his *Hymn to the Pillory*, which was sold to those who identified with his plight. In the years that followed, Defoe became more cautious in attacking the government, although he fell afoul of the law again in 1712 for several pamphlets he published, and again in 1715 when he was convicted of libelling an English aristocrat.

LITERARY ACHIEVEMENTS. Despite his checkered career as a journalist, Defoe was an extremely gifted writer. Throughout his lifetime he produced at least 250 books, tracts, pamphlets, and journals. Many were writ-

ten anonymously or under pseudonyms, such as his publication of *The Prophecies of Isaac Bickerstaff*, a series of works that began to appear in 1619. During the reign of Queen Anne (1702–1714), he alone wrote and edited his *Review*, a popular political journal of the day. It appeared at first as a weekly, but by the end of the queen's reign, it was being published three times each week. Despite his legal troubles, Defoe continued to produce the work, even while imprisoned. For these efforts, Defoe earned enormous sums of money, although his poor business sense resulted in much of his fortune being squandered on misconceived projects. Although his work as a journalist brought him fame, he is today best remembered for the series of three early English novels he published between 1719 and 1724: *Robinson Crusoe* (1719), *Moll Flanders* (1722), and *Roxana* (1724). This kind of fiction was a significant departure for Defoe, who had spent much of his life penning political journalism. Yet Defoe had often published under pseudonyms and crafted fake narratives in his attempts to damn the political programs of his opponents. In his later fictional works, he relied on these skills, but also on his knowledge of the seventeenth-century spiritual autobiography and confessional narrative, works like John Bunyan's *Grace Abounding to the Chief of Sinners*. Defoe argued that his fictions had highly moral purposes, but at the same time they seemed to satisfy the salacious and prurient interests of their audience. Although the content of *Robinson Crusoe* is rather tame, *Moll Flanders* takes its readers on a tour through London's seamiest sections, and along the way records a number of sexual crimes, including incest. *Roxana*, by contrast, is set in high society, but the lazy and indolent high society of England's Restoration period, and it reveals Defoe's distaste for the lascivious excesses of the later Stuart years. In all three works Defoe combined his enormous skills as a storyteller with his ability to catalogue and describe realities in ways that were fascinating to his readers. His fictions, in other words, benefited from the same curiosity that his journalistic career had. For these reasons, he is often called the "Father of the English Novel."

SOURCES

P. R. Backscheider, *Daniel Defoe: His Life* (Baltimore, Md.: Johns Hopkins University Press, 1989).

I. A. Bell, *Defoe's Fiction* (Totowa, N.J.: Barnes and Noble, 1985).

P. N. Furbank, *The Canonisation of Daniel Defoe* (New Haven, Conn.: Yale University Press, 1988).

J. J. Richetti, *Daniel Defoe* (Boston, Mass.: Twayne, 1987).

J. Sutherland, *Defoe* (London: Longmans, Green, 1956).

JOHN DONNE
1572–1631

Poet
Priest

CATHOLIC UPBRINGING. Of all the forces that shaped the life and writing of John Donne, his Catholic upbringing was certainly the most important. His family traced their origins back to Wales, although his father was a successful ironmonger in London, who died when the young John was still a baby. Donne's mother married a Catholic physician, and the family saw that Catholic tutors initially schooled the young boy at home. When he was eleven, he entered Hertford Hall at Oxford University, an institution that Catholics often attended at the time. Later, he may have also attended Cambridge, although his Catholicism prevented him from receiving a degree. In the years following his education, Donne played the "man about town" on the London scene. He was not known for leading a wild and dissolute life, but instead for being a careful dresser who enjoyed the company of prominent London ladies. In these years he studied law at the Inns of Court, the medieval guild charged with representing clients in the royal courts and the center of legal education in the English capital. In 1593, he renounced his Catholicism not, as some formerly claimed, in a calculated maneuver to receive important professional positions, but after careful study of the differences between the teachings of Catholicism and Anglicanism. He continued to remain at odds with some groups in the Church of England; he was never drawn toward Puritanism, but instead envisioned Anglicanism's benefits as consisting of a compromise between the hard-edged doctrinal religions of radical Protestants and Catholics.

ADVENTURE AND AN UNFORTUNATE MARRIAGE. In the mid-1590s, Donne embarked on a short period of adventure in the company of Sir Walter Raleigh and his "Sea Dogs." In the years following the defeat of the Spanish Armada in 1588, these sailors continued their efforts to discourage Spanish trade by conducting raids against the country's ports and trading outposts. Donne accompanied Raleigh on at least two missions, first to storm the port of Cadiz in Spain in 1596, and one year later to track down Spanish galleons laden with New World gold in the Azores. He soon retired from these exploits and, returning to London, he accepted a position as a secretary to Sir Thomas Egerton, an important royal official. In 1601, Egerton saw to it that Donne was elected to Parliament from a district he controlled in the north of England. Donne's patron became displeased

with his young charge, however, when he discovered that Donne had secretly married his wife's niece, Ann More. For contracting the illegal marriage (More had been a minor), Egerton had Donne imprisoned for a time. Eventually, he was released, and although the union with More survived, he was politically disgraced. During the years that followed, he continually tried to rehabilitate himself, but was always unsuccessful. He and More survived on the gifts and patronage of friends. Finally, in 1615, Donne took a suggestion of King James I to heart and he entered the church. James also saw to it that Cambridge University awarded Donne his degree, and he gave him a position as a chaplain. In the years that followed, Donne also received other appointments in the Church of England, eventually rising to serve as dean of the Cathedral of St. Paul's in London, one of the most important ecclesiastical positions in the English capital. In this capacity, Donne became one of the country's most famous preachers and he helped to establish a following for his particular brand of Anglican spirituality. That religion was opposed to what it perceived as "doctrinal hairsplitting" among the Puritans; churchmen like Donne instead promoted an ideal of Christian holiness. They counseled their audiences to search their lives to unearth sins, amend their paths, and concentrate their attentions on the great Christian drama of redemption.

WORKS. Donne had been a poet since his earliest years on the London scene, and in the period of his disgrace he had written works for his patrons. He did not publish these, apparently preferring to remain aloof from the public world of poetry that was at the time dominated by figures like William Shakespeare, Ben Jonson, and other playwrights anxious to turn a profit. In his years as dean of the St. Paul's Cathedral, he continued to write poetry, and at his death his son John collected and published his works. Even before his death, his style was credited with producing changes in English poetry. In contrast to the melodic lines favored by poets of the Elizabethan years, Donne's verse was recognized for its forceful style that bristled with intellectual insights. His poems were difficult to understand, yet filled with rewarding conceits and metaphors for those that struggled to excavate their meanings. In this regard they have remained a significant source of inspiration for later writers of English, although works like his *Holy Sonnets* (1609–1611) still prove vexing to literary critics. These works were undertaken during a period of illness. Like most of Donne's greatest literary endeavors, they display a fascination with death and the life that lies beyond the grave. In his popular sermons delivered at St. Paul's he continued to call his audience to meditate on these themes. One of his greatest literary achievements were the *Devotions Upon Emergent Occasions* he published in 1624. That book contains his celebrated Meditation XVII, where Donne develops his famous observations on the themes "No man is an island" and "never send to know for whom the bell tolls, it tolls for thee." Such rhetoric was a significant force in attracting greater devotion to the Church of England on London's scene in the 1620s, although the country's religious divisions grew wider in the years following Donne's death in 1631. His reputation as a poet and a devotional writer continued to be considerable, although by the eighteenth century critics like Samuel Johnson had less regard for the puzzling and quixotic nature of his poetry. Johnson identified Donne as the source of inspiration for a school of "metaphysical poets" in early seventeenth-century England. Although modern literary critics have come to discount this notion of a school, they have continued to see Donne's influence as important in fashioning one direction followed by other early Stuart poets and writers of prose.

SOURCES

R. C. Bald, *John Donne: A Life* (New York: Oxford University Press, 1970).

P. Brewer, *Doctrine and Devotion in Seventeenth-Century Poetry: Studies in Donne, Herbert, Crashaw, and Vaughan* (Rochester, N.Y.: Brewer, 2000).

J. Carey, *John Donne: Life, Mind and Art* (New York: Oxford University Press, 1981).

F. Kermode, ed., *The Poems of John Donne* (Cambridge: Cambridge University Press, 1968).

P. Milward, *A Commentary on the Holy Sonnets of John Donne* (London: Dance Books, 1996).

HANS JACOB CHRISTOFFEL VON GRIMMELSHAUSEN

c. 1621–1676

Novelist

EARLY YEARS. Hans Jacob Christoffel von Grimmelshausen's early life coincided with one of Germany's most dismal epics: the Thirty Years' War. He was born to Protestant parents, but as a child he was kidnapped by invading armies and impressed into service in one of the armies that was then making its way through the country. Later, he joined the Catholic forces of the emperor before serving as an assistant to Count Reinhard von Schauenberg. When the war finally concluded, Schauenberg's family gave him a position as a caretaker on their lands. In turn, he served the family as a tax collector, innkeeper, and bailiff. When it came to light that he had

been stealing from them, though, the Schauenbergs quickly dismissed him. In the next few years, Grimmelshausen became an assistant to a physician, and he also found work as a tavern keeper and again as a bailiff. Even while he was a soldier in the imperial army, though, Grimmelshausen had begun to write. In 1658 and 1660, he published his first works, two short satirical texts, but his fame rests ultimately on his great masterpiece, *The Adventures of Simplicissimus*, the first part of which appeared in 1668. It was followed by a second part and a continuation entitled *Courage, the Adventuress* one year later. It was an immediate success, one of the first best-selling pieces of fiction to appear in the German language. It brought Grimmelshausen no fame, however, since it was published anonymously, and his authorship was not established definitively until the nineteenth century.

BLACK HUMOR. Unlike Germany's great seventeenth-century poets, Grimmelshausen had not benefited from a university education. While he was largely unfamiliar with the structures of Neo-Latin rhetoric, he still managed to spin a considerable yarn of adventure. His work is the product of a great deal of reading, particularly in the picaresque novel tradition that had developed in late sixteenth-century Spain. His hero, Simplicissimus, is a vagrant, a naive peasant that passes from one unfortunate incident to the next. In the world that Grimmelshausen creates, soldiers routinely torture, maim, and murder civilians, and although Germany's peasants often strike back, they generally are unable to stop the carnage. Many of the gruesome accounts that Grimmelshausen related were apparently autobiographical; the account of Simplicissimus's capture by forces that had plundered his village is just one of the many examples of the parallels between this fictional world and real life. While the events he relates are gruesome and often obscene, the moral of the story was no less troubling: the only solution to humankind's cruelties lay in renunciation of the world. Simplicissimus becomes, at the conclusion of the tale, a hermit, but along the way to this transformation, his actions have confounded the mighty and embarrassed the learned. *The Adventures of Simplicissimus* is one of the best examples of the cross fertilization that occurred between literary genres in early-modern Europe. Its inspiration was to be found in the picaresque novels of Renaissance Spain, yet transposed into a new literary environment, Grimmelshausen was able to transform that form into high art, filled with hilarity and rich observation.

IMPLICATIONS. Much of the literature that survives from the seventeenth century is religious in nature. In poetics, German writers began at this time to experiment with new ways of forging lyrics that made use of the sound possibilities of the German language. In these efforts they searched through the classics and adapted the Neo-Latin rhetoric that had fascinated sixteenth-century authors. In so doing, they found new ways of elevating their language into a flexible mode of expression. The world of Hans Jakob Christoffel von Grimmelshausen, however, lay far from the elevated literary societies anxious to raise the literary standard in German. Like Shakespeare, Grimmelshausen sprang from humbler roots, although his broad reading and his life experiences marked him as someone who had a message to impart. Although great poetry and religious works appeared in Germany's cataclysmic seventeenth century, Grimmelshausen's *The Adventures of Simplicissimus* is today the only work that still claims a general readership from the period. Its greatness and continuing appeal arises, in large part, from the universal nature of its author's observations on human nature and its shortcomings. In this regard, its appeal spoke to the developing "bourgeois" society in Germany's societies, and although he had few imitators in the seventeenth century Grimmelshausen's work continued to produce imitators in the eighteenth- and nineteenth-century worlds.

SOURCES

H. J. C. von Grimmelshausen, *Simplicissimus*. Trans. M. Mitchell (Sawtry, England: Dedelus, 1999).

A. Menhennet, *Grimmelshausen the Storyteller: A Study of the "Simplician" Novels* (Camden, S.C.: Camden House, 1997).

G. Rörbach, *Figur und Charakter; Strukturuntersuchungen an Grimmelshausens Simplicissimus* (Bonn, Germany: Bouvier, 1959).

SAMUEL RICHARDSON

1689–1761

Printer
Novelist

EARLY YEARS. As a novelist, Samuel Richardson was catapulted to celebrity in England when he was already in his fifties. From the publication of *Pamela* in 1740, until his death 21 years later, his activities are widely known. Considerably less information is available concerning the earlier years of his life. It is known that he was born in rural Derby, although his family was from London. His father was a joiner, and soon returned with his family to the capital. The young Richardson apparently received little schooling, although he seems to have

been a voracious reader as a child. Although his parents might have preferred to send him into the church, they did not have the resources to tend to his education, and Richardson was apprenticed to a printer in London when he was seventeen. He completed his apprenticeship and was enrolled in the Stationer's Company, the guild of London printers, in 1715. By 1721, he had begun his own business, having married the daughter of his one-time employer. Like most London printers in the era, he produced a vast array of publications, printing books, journals, handbills, and other kinds of material for those who were willing to pay his fees. He seems soon, however, to have become a prominent member of the capital's printing establishment. In 1723, for instance, he became the printer entrusted with producing the *True Briton*, a Tory publication. A few years later he became an officer in the Stationer's Company.

A STRING OF TRAGEDIES. Although these were years of professional advancement, they were marked by great personal tragedies. In the years between his marriage in 1721 and the early 1730s, he lost all six of his children as well as his wife, a fact that he credited later in life with producing a tendency toward nervous disorders. In 1733, Richardson's tide of bad luck apparently turned, however; he remarried, this time to another printer's daughter, and the couple had four girls that survived. In the same year as his second marriage, Richardson printed his first book, *The Apprentice's Vade Mecum*, a conduct book. In these years his prosperity grew, largely because he won several lucrative government printing contracts. He purchased a country house just outside London, and seems to have had more leisure time. As a result, he began to write more in the later years of the 1730s. One project, which he began in 1739, was his first novel, *Pamela*. Most of the novels written in England to this time had made use of the autobiographical first-person narrative pioneered by Daniel Defoe around 1720. Richardson abandoned this form, which had been based on seventeenth-century spiritual autobiographies and confessions, and in *Pamela* he pioneered the "epistolary style," in which the action is told through a series of letters. Richardson was drawn to this form, in part, by some of his printer friends who had recommended that he write on the problems of daily life. Out of these experiments, he began to compose a series of letters that he eventually published as *Letters to Particular Friends*. But at the same time as he was composing these works, he also began to experiment with using letters to tell a story. When he turned to write *Pamela* in earnest, it took him only a matter of months to complete the enormous book. The story tells of a serving maid who preserves her virtue despite the advances of a young nobleman in the house in which she is employed. As a result of her basic goodness, she is rewarded at the end of the novel by her advantageous marriage. The admiration the work inspired was almost instantaneous. From throughout Britain readers praised its celebration of sexual virtue. But soon more critical appraisals of the novel attacked its implications, particularly its celebration of marriage across the classes. Within a short time, Henry Fielding, for instance, satirized the story in his *Shamela*, a work that transformed the heroine *Pamela* into a snob and upstart anxious to make her way up the social ladder.

CLARISSA. In the years that followed, Richardson took the criticisms voiced against his *Pamela* to heart, and attempted to fashion a second novel that would be unassailable on moral grounds. The result was *Clarissa*, the longest novel ever to appear in the English language. The first two volumes of the work appeared in 1747 and were a critical success. In the months that followed, Richardson was barraged by correspondents anxious to know the conclusion of his work. Some, who sensed that the plot was drifting toward the heroine Clarissa's ultimate death, even pleaded with Richardson to spare her life. In 1748, Richardson published the final five volumes of the work. The completed novel told a tale of aristocratic trickery and deceit in which the despicable yet attractive Lovelace doggedly pursues Clarissa. Eventually, he lures her to a London bawdy house, where he drugs her and brutally rapes her. As a result, Clarissa resolves to die and makes elaborate preparations for her funeral. The work produced widespread admiration, although some criticized the tale's amorality. In the decades that followed, though, it inspired a string of "sentimental novels," with plots fashioned on Richardson's, with its emphasis on the powerful effect that the emotions might have on the human psyche. It was soon translated into Dutch, French, and German, and in these countries it also inspired many subsequent works. During the years that followed the publication of *Clarissa*, Richardson continued to write, publishing *Sir Charles Grandison* in 1753 and 1754. While the work was successful, it also inspired criticism because of its length and boring plot. A year later he also produced *A Collection of the Moral and Instructive Sentiments ... in the Histories of Pamela, Clarissa, and Sir Charles Grandison*; in this work he attempted to distill the moral wisdom that he believed his works contained. In the later years of his life, Richardson continued to edit his works, and he was something of a fixture in London's literary scene, becoming a close associate in these years of Samuel Johnson and other luminaries in the capital's worlds of art and literature. His chief achievement, though, remains his *Clarissa*, a work that is not without flaws, but which

established a form for the English novel that allowed writers to develop characters and psychological portraits in a grand fashion.

SOURCES

E. B. Brophy, *Samuel Richardson* (Boston, Mass.: Twayne, 1987).

J. Harris, *Samuel Richardson* (Cambridge: Cambridge University Press, 1987).

M. Kinkead-Weekes, *Samuel Richardson, Dramatic Novelist* (Ithaca, N.Y.: Cornell University Press, 1973).

C. Wolff, *Samuel Richardson and the Eighteenth-Century Puritan Character* (Hamden, Conn.: Archon Books, 1972).

MARIE DE RABUTIN-CHANTAL SÉVIGNÉ

1626–1696

Letter Writer

A PRIVILEGED LIFE. Marie de Rabutin-Chantal, otherwise known to history as Madame de Sévigné, was born into an old Burgundian noble family. Orphaned at six years old, she was raised by her uncle, Philippe de Coulanges. Tutored rather than schooled, like other aristocratic girls of her time, she had a string of impressive teachers, including Jean Chapelain, one of the founding members of the French Academy. At the age of eighteen she was married to Henri de Sévigné, who introduced her to court society as well as to a prominent literary circle in Paris that met in the Hôtel de Rambouillet. The Hôtel was the home of Catherine de Vivonne, a French noblewoman, who in 1610 had first been introduced to the French court of Henri IV. Disgusted by the roughhewn manners she saw on display in the royal circle, Catherine de Vivonne, the Marquise of Rambouillet, had built her own lavish townhouse in Paris not far from the Louvre. There she continued to hold court in the mid-seventeenth century. The values of the women who circulated in this society prized "preciosity," a word that since the seventeenth century has come to have a negative connotation. At that time, however, Rambouillet and her circle used it to imply grace and refinement. The novelist Madeleine de Scudéry was a member of the Rambouillet literary circle, as were other prominent writers of the time. The group also left its mark on the young Madame de Sévigné, and her later vigorous correspondence owed much to her exposure to Rambouillet's circle.

MARITAL PROBLEMS AND WIDOWHOOD. Although he was from a respected noble family, Henri de Sévigné squandered his wife's money, and in 1651 he died as a result of an injury sustained in a duel. The couple had two children, whom Madame de Sévigné continued to raise, while also participating in society in and around Paris. A number of French noblemen courted her in the first years of her widowhood, although Sévigné decided not to remarry. While leading an active social life, she was also devoted to her children, but especially so to her daughter, Françoise Marguerite. When her daughter married in 1669, she left Paris to accompany her husband, a royal official, to Provence. The resulting loneliness prompted Sévigné to become one of history's most avid correspondents. Over the next years she exchanged almost 1,700 letters with her daughter, most of which were written in the first decade following their separation. In 1677, Sévigné took a lease on the Hôtel Carnavalet, a townhouse in the Marais district of Paris, and she remained there until her death. That house, now a museum of French domestic life, became one center of Parisian society, as Sévigné entertained her female friends there: the aristocratic novelist Madame de La Fayette, Madame de la Rochefoucauld, and Madame de Pomponne. In these years, Louis XIV's court was increasingly abandoning Paris for other royal châteaux in the countryside. At first, the king took up residence at St. Germain, but in the 1670s he expanded Versailles from a humble hunting lodge into a great palace, eventually making it the seat of his government in 1682. The retreat of the royal court from Paris produced great changes in the city's high society, generating an antagonism that persisted between Paris and the royal court until the outbreak of the French Revolution in 1789. Although Madame de Sévigné longed to circulate in the rarefied air of Louis' circle in these years, she only rarely did so. One of Madame's cousins had been imprisoned for a time in the Bastille, and her own friendships with those critical of the government marked her as inappropriate for life at Versailles. At two times in her life, though, Madame de Sévigné stepped out of the shell imposed upon her by familial and friendly connections. When her daughter came out in society, she was invited to the court's balls, and her mother was allowed to attend. Later, Louis XIV came under the influence of Sévigné's old friend, Madame de Maintenon, and she was invited on one occasion to a special court theatrical performance and allowed to sit with the king and his party. Otherwise, her life was lived out largely absent from the great court dramas being enacted at Versailles. Sévigné had a pious disposition that had been shaped by seventeenth-century Jansenism, and when she faced death, her friend the Count de Grignan observed that she did so with "dignity and submission."

IMPORTANCE. Unlike some other female members of the French nobility of the time, Madame de Sévigné never published literary works, although she circulated in a highly literate society and was acquainted with the best authors of the age. The chief testimony to her mind and her style is her letters, which are an extraordinary documentary history, not only of her life as a mother and socialite, but also of her considerable skills as a literary stylist. Her letters reveal her sunny disposition, and are punctuated by frequent notes of humor and wit. Unlike the rule-bound French classical prose and poetry of the age, Sévigné was a natural writer, without artifice or the heavy burdens of rules. Her correspondence consequently reads like a modern document, as fresh today as it was in the seventeenth century.

SOURCES

A. Bernet, *Madame de Sévigné, Mère passion* (Paris: Perrin, 1996).

C. M. Howard, *Les fortunes de Madame de Sévigné au XVIIème et au XVIIIème siècles* (Tübingen, France: G. Narr, 1982).

F. Mossiker, *Madame de Sévigné* (New York: Knopf, 1983).

DOCUMENTARY SOURCES
in Literature

John Bunyan, *Grace Abounding to the Chief of Sinners* (1666)—Written while its author was imprisoned for preaching without a license, this spiritual autobiography was tremendously influential among seventeenth-century Puritans, and in the eighteenth century it helped to inspire the early English novel.

Pierre Choderlos de Laclos, *Les liaison dangereuses* (Dangerous Liaisons; 1782)—This epistolary novel recounting corruption and sexual gamesmanship among the high and mighty fed pre-revolutionary France's taste for tales about aristocratic decadence.

Daniel Defoe, *Moll Flanders* (1722)—Often cited as one of the first novels, this text spins a rollicking good yarn about an eighteenth-century foundling turned prostitute and her many adventures.

John Donne, *Devotions upon Emergent Occasions* (1624)—These exhortations and meditations upon death show the English author at his finest. Together with his *Divine Poems* (1601–1615), they are a testimony to the strength of the Anglican tradition of spirituality in the seventeenth century and its impact on the English language.

Henry Fielding, *Tom Jones* (1749)—This masterpiece of the early novel combines epic, romance, and comedy into an inimitable brew of good fun.

Johann Wolfgang von Goethe, *The Sorrows of Young Werther* (1774)—This tale of unrequited love and its suicidal consequences caused a sensation when it was published. It is the best example of the German *Sturm und Drang* style.

Hans Jacob Christoffel von Grimmelshausen, *The Adventures of Simplicissimus* (1668)—Written in the picaresque novel form that had first been developed in sixteenth-century Spain, this early German novel provides insight into the conditions in the country during the Thirty Years' War. It was a widely successful book in its day, and still ranks as one of the chief contributions of fiction in the seventeenth century.

Gotthold Wilhelm Ephraim von Lessing, *Nathan the Wise* (1779)—Written as a dramatic poem, this work recounts the dealings of Christians, Muslims, and Jews in twelfth-century Palestine. Its argument—that the ethical teachings of these three world religions are similar—produced great controversy.

John Milton, *Paradise Lost* (1667)—This epic poem about the Creation, Temptation, and Fall of the human race is challenging, but rewards its readers with some of the finest religious lyric in the English language.

Blaise Pascal, *Provincial Letters* (1656)—Written to defend his fellow Jansenists from the charge of religious heresy, this set of satirical letters had a widespread impact on the fashioning of literary French in the seventeenth century.

Samuel Richardson, *Clarissa* (1747–1748)—The second of this author's epistolary novels, it ranks as one of the great literary achievements of the eighteenth century. Its tragic story of a woman who is wronged and resolves to die was an immediate success.

Madame de Sevigné, *Letters* (1671–1696)—This collection of extraordinary letters provides unparalleled insight into French aristocratic life during the later seventeenth century. Most of her letters were written to her daughter, and reveal the terrible loneliness she suffered when separated by the girl's marriage.

Voltaire, *Candide* (1759)—On its surface this adventure story seems pure fun, but underneath its amusing exterior it is a condemnation of the philosophical optimism of the Enlightenment.

5

MUSIC

Ann E. Moyer and Philip M. Soergel

IMPORTANT EVENTS
in Music

1598 *Dafne*, one of the first operas, is performed at Florence.

Landgrave Moritz of Hessen-Kassel hears 14-year-old Heinrich Schütz (1585–1672) sing at his family's inn and brings him to Kassel for training, thus beginning the musical career of one of Germany's greatest Baroque composers.

1605 Italian composer Claudio Monteverdi publishes his *Fifth Book of Madrigals.* In the introduction he distinguishes the older musical styles of writing for voices in counterpoint as the "first practice"; the "second practice," in which the text dominates and sets the rules for the music, marks the new style of Baroque music.

1608 The organist and composer Girolamo Frescobaldi, a native of Ferrara, is named organist of the Cappella Giulia of St. Peter's Basilica in Rome.

Claudio Monteverdi is appointed director of music at San Marco in Venice.

1618 The Thirty Years' War begins in the Holy Roman Empire. This extended era of violence hampers the development of musical culture in Central Europe and disrupts the lives and careers of a number of musicians and composers.

1621 Jan Pieterszoon Sweelinck, noted Dutch organist and composer of fantasias, dies in Amsterdam.

1627 Scholar Marin Mersenne (1588–1648) publishes his *Treatise on Universal Harmony* in Paris, advancing the study of music theory and acoustics.

1637 A Roman opera troupe brings opera to Venice and introduces public performances with *Andromeda* by Benedetto Ferrari (librettist) and Francesco Manelli (composer) at the Teatro San Cassiano, which the audience paid to attend.

The North German organist and composer Dieterich Buxtehude is born.

1640 Composer Pietro della Valle refers to one of his musical works composed for the Chiesa Nuova in Rome as an "oratorio," the first known use of the name for this important genre.

c. 1644 Antonio Stradivari, one of the world's greatest violin makers, is born into a family of instrument makers in Cremona, Italy.

1646 Jean-Baptiste Lully moves from Florence to Paris, soon to rise to pre-eminence in French music.

1653 Louis XIV of France performs in the court ballet, *Ballet de la Nuit*, as the Rising Sun; he praises and supports both music and ballet.

1672 Jean-Baptiste Lully becomes director of the Royal Academy of Music, with exclusive rights over operatic production in France.

c. 1680 The first examples appear of a new form of composition for orchestral groups. The concerto will usually showcase a solo instrumentalist against an orchestral accompaniment.

1681 Violinist and composer Arcangelo Corelli publishes his first set of trio sonatas, among the great chamber works of the era.

The composer Georg Philipp Telemann is born in Magdeburg, Germany.

c. 1683 John Blow (1648–1708), teacher to English composer Henry Purcell, writes *Venus and Adonis,* a variation on the tradition of

mounting "masques" in aristocratic society in England. The work is conceived very much like an opera, one of few such English works of the era.

1685 Composer Johann Sebastian Bach is born in Eisenach, Germany.

Messiah composer George Frideric Handel is born in Halle, Germany.

Italian composer Domenico Scarlatti is born in Naples.

1692 Henry Purcell writes his most famous ode for St. Cecilia's Day, *Hail, Bright Cecilia.*

1693 The composer Francois Couperin (1668–1733) is appointed organist to King Louis XIV of France.

Johann Adolf Hasse, the great composer of Italian-style opera seria, is born near Hamburg, Germany.

1700 Poet and theologian Erdmann Neumeister (1671–1756) introduces a type of religious poetry to be set to music, calling it a cantata.

1702 George Philipp Telemann founds Leipzig's Collegium Musicum.

1703 *Four Seasons* composer Antonio Vivaldi begins his tenure at the Pio Ospedale della Pietà in Venice, an orphanage for girls whose regular concerts inspired many of his compositions. He will remain there until his death in 1740.

1709 Italian composer Giuseppe Torelli (1658–1709) publishes a set of violin concertos that use the three-movement form that will become standard among eighteenth-century composers.

1710 Musical instrument maker Johann Christoph Denner of Nuremberg lists for sale a new variation on an old instrument, the clarinet.

1711 Italian archaeologist Scipione Maffei publishes a description of the Florentine

Bartolomeo Cristofori's new invention, now known as the piano.

1714 The elector of Hanover, Handel's patron, is crowned George I of England.

1717 Handel writes his *Water Music* suites for a procession by barge of George I on the River Thames.

1720 Farinelli (Carlo Broschi), the great Italian castrato singer, makes his debut in Naples at age fifteen in a performance of Porpora's *Angelica e Medoro*, with libretto by Pietro Metastasio.

1722 French operatist Jean-Philippe Rameau publishes his first work of music theory, *Treatise on Harmony,* in which he presents his theories of harmony and chord progression.

The famous German composer Johann Sebastian Bach publishes Book I of *The Well-Tempered Keyboard.*

Johann Mattheson begins publishing *Critica Musica,* the first German periodical on music.

1723 Johann Sebastian Bach moves to the Thomaskirche in Leipzig, with the task of supervising the school, rehearsing the choirs, and producing compositions.

1725 Austrian composer Johann Joseph Fux (1660–1741) publishes his *Gradus ad Parnassum,* which becomes a highly influential manual of composition in general and counterpoint in particular.

Antonio Vivaldi writes his set of concertos now called *The Four Seasons.*

1728 *The Beggar's Opera,* a ballad opera by John Gay (1685–1732), is performed in London. Its success leads to continued innovation in the English theater, while at the same time making French and Italian operas less popular.

1733 Italian operatist Giovanni Battista Pergolesi's intermezzo, *La Serva Padrona,* is first performed in Naples.

1738 John Sebastian Bach's son, Carl Philipp Emanuel Bach, moves to the court of crown prince Frederick of Prussia in Berlin.

1740 Frederick II or Frederick the Great is crowned king of Prussia.

1741 Johann Stamitz (1717–1757), composer and violinist, is appointed to the Palatine Court at Mannheim. Under his leadership, the court will become a showpiece for orchestral music throughout Europe.

1742 Handel's *Messiah* is performed for the first time at Easter in Dublin.

1749 Carlo Goldoni (1707–1793), the Italian playwright and librettist, begins his collaboration with composer Baldassare Galuppi that will lead to major changes in Italian *opera buffa*.

1750 Johann Sebastian Bach dies in Leipzig.

1751 Denis Diderot and Jean Le Rond d'Alembert publish the first volume of the *Encyclopédie*, a work that will be of major importance in defining aesthetics and style in the second half of the eighteenth century.

1752 Johann Joachim Quantz (1697–1773) publishes his treatise, *On Playing the Flute.*

1756 Prodigious composer Wolfgang Amadeus Mozart is born.

1762 Gluck's innovative opera *Orphée et Euridice* is performed in Paris.

Carl Philipp Emanuel Bach publishes the complete version of his *Essay on the True Art of Playing Keyboard Instruments.*

Johann Christian Bach (1735–1782) moves to London.

1776 English music historian Charles Burney publishes *A General History of Music.*

Sir John Hawkins publishes *A General History of the Science and Practice of Music.*

1778 La Scala Opera House opens in Milan. It will become one of the most important venues for premiering Italian operas.

1782 Composer and theorist Heinrich Christoph Koch (1749–1816) publishes the first part of his treatise, *Introductory Essay on Composition.*

1786 *The Marriage of Figaro,* with music by Wolfgang Amadeus Mozart and libretto by Lorenzo Da Ponte, is first performed in Vienna.

1789 The French Revolution begins. The Revolution will destroy patronage networks that nourished musical culture throughout the Baroque era.

1791 Mozart dies in Vienna.

Josef Haydn begins his first London symphonies. They will soon be celebrated at their premiere in England's capitals as one of the great achievements of symphonic music.

OVERVIEW
of Music

A PERIOD OF GREATNESS. During the seventeenth and eighteenth centuries European music underwent a series of dramatic changes. The beginnings of these transformations can be traced to a climate of experimentation that appeared in the later Renaissance, a time in which humanist intellectuals and musicians desired to revive the emotional power and force that they sensed had existed in the music of Antiquity. The experiments in new musical styles these figures helped to inspire produced the phenomenon of modern "classical" music—a repertory of serious works that are studied by well-trained musicians and which continue to be played before audiences. Opera and the tradition of public concert-going both trace their origins to the seventeenth and eighteenth centuries. The modern orchestra—a collection of diverse, but complementary families of instruments—underwent a long period of maturation in these years as well. The development of the orchestra inspired new creativity in the writing of instrumental music, producing musical forms like the symphony and the concerto. Other instrumental ensembles, like the string quartet, nourished the development of smaller and more intimate forms of chamber music, forms that continue to have many admirers today. When modern listeners enjoy the music of the seventeenth and eighteenth centuries, they find a sound that at once seems more familiar to them than the music of the Middle Ages or the Renaissance. The sense that this era's music is at once more "modern" than that of earlier periods derives from the fact that much of the music written in this time has similar harmonic structures and uses a system of tonality or keys that continues to be dominant in Western music in the contemporary world. But the modern ear also feels at home in the world of the seventeenth and eighteenth centuries because of the musical forms that composers used in these years to organize their compositions. These diverse musical genres—which stretched from the popular *aria da capo* form used in the opera to the stately and sophisticated outlines of the late eighteenth-century symphony—have continued to inspire music written in the last two centuries. Many of these forms provide Western classical music with its enduring appeal, an appeal that stems from this music's ready intelligibility, intellectual sophistication, and harmonic and inventive beauty.

ORIGINS OF THE BAROQUE. The forces that first produced a distinctive Baroque style began to appear in Italy in the years around 1600. The elements of the Baroque sound developed from the experiments of composers, musicians, and men of letters, many of whom were deeply affected by the culture of Renaissance humanism and its love of classical Antiquity. In Florence and other Italian cities groups of performers and intellectuals pioneered ways in which contemporary music might shape the human emotions, a power these figures realized had frequently been celebrated in ancient authors. Their experiments soon gave birth to a new musical style that became known as a "new" or "second" musical practice, in opposition to music of the "first practice"—music that derived from older Renaissance conventions. Music of this "second practice" was monodic; it consisted of a single melodic line set against a complementary accompaniment (often called the thorough bass or a basso continuo) that did not compete with the words that performers sung, but rather enhanced the emotional expression of the chosen text. During the seventeenth and eighteenth centuries music of this "second practice" continued to co-exist alongside older Renaissance traditions. Thus the term "Baroque music" generally refers to music from around 1600 until about 1750 that stemmed from either of these two practices. The "first practice," or the established tradition of Renaissance music, was mainly polyphonic in nature. A composition was made up of several musical lines or voices that sounded simultaneously but moved independently; with each line fairly similar in its importance to the overall sound of the composition. These voices would come together harmonically at key points in the work, called a cadence. The art of writing in this style was called counterpoint, since the composer's task involved placing one note against another. Contrapuntal style continued to develop during the Baroque era and it remained important well into the nineteenth century. At the same time, music of the "second practice" took vocal music as its standard. Inventors of this "second practice" helped to shape the early opera, an art form whose appearance around 1600 has often been said to mark the beginning of the Baroque period.

THE RISE OF OPERA. The form that we know today as opera first began to coalesce out of the experiments of late Renaissance musicians and composers to emulate

the power of ancient music and drama. The first operas were staged in Florence in the years around 1600, but soon the genre spread to other cities, including Mantua and Rome. At first an elite form of courtly entertainment, the opera soon began to acquire many admirers outside the narrow confines of aristocratic society. In 1637, the first public theater for the performance of opera was founded at Venice, and within a few years the city had become home to a number of opera theaters. Like the courtly entertainments of the previous generations, these new public opera houses staged productions that included a healthy dose of spectacle. Lavish production standards, costly stage machinery, and other elements common to the theatrical world of the time soon found their way into the overheated commercial atmosphere of Italy's public opera houses, and helped to sustain opera's rising popularity. To make their performances pay, the troupes that performed in these houses often took their productions on tour, helping to establish a taste for opera in many Italian cities, and by the mid-seventeenth century, in many places in Northern Europe as well. Opera was at once the quintessential example of Baroque musical tastes. It elevated vocal music by supporting new high standards of solo performance and it expressed the Baroque age's preoccupation with emotional states and with music's power to shape one's internal spiritual experience. But as it traveled to new places in Europe, opera often acquired regional features. In France, for instance, Italian opera was initially resisted. But soon, Jean-Baptiste Lully, an Italian by birth but French in his tastes, adapted the form for French courtly audiences. To satisfy his audiences, he included a healthy dose of ballet in his works and relied on texts that fit with the country's elevated dramatic traditions. As opera spread elsewhere in Europe, other regional variations developed, but by the eighteenth century, the art form was still dominated by Italian customs and traditions. Although not the source of every musical innovation of the Baroque period, the world of opera supplied the Baroque musical world with many of its popular musical forms and conventions. In France, the dance suites and ballets that accompanied operas helped to fix the confines and conventions of Baroque instrumental musical forms like the suite and the French overture. In Italy, the *sinfonia*, an overture form consisting of parts that were played fast, then slow, and then fast, left its mark on the early development of the symphony. The writing for the human voice that opera pioneered also affected music written for instruments, as composers of music for the violin, flute, and other solo instruments frequently adapted the conventions of vocal music from the operatic world to instrumental forms. They drew on popular operatic forms like the *air*, or aria, to give shape to compositions written for woodwinds and strings.

RHETORICAL SENSIBILITY. Whatever its geographic origin, a great deal of Baroque music shared a rhetorical sensibility. Music of this period often displayed certain common traits of expression that were based originally in speech and drama. For many musicians and theorists throughout the Baroque period, vocal music was the highest expression of art. When many composers purported to write music in general it is often clear that in fact they had vocal music in mind. They agreed that a good musical setting for a text was one that respected the character of the language; that matched musical accents with those of the words; that followed the language's natural cadence; and that amplified the emotional content of the idea being expressed. Instrumental music of the Baroque era often shows a similar sensibility, with musical phrases constructed in ways reminiscent of verbal ones and voices that answered one another in a conversational sort of way. While speech was a very important model in Baroque music, other human activities were significant as well, most notably dance. Dance was such a central feature to much of court life, especially in France, that the patterns and rhythms of the dances of this era found their way into far more music than was ever intended for actual dancing.

COMPOSERS AND AUDIENCE. While the opera house represented a new commercial venue for musical performance, many of the settings in which Baroque music was performed remained unchanged from previous centuries. Churches, for example, were important sites for hearing major new compositions. The choirmaster or organist at a major church was a position of prominence and importance for a composer, and the hiring for these positions was very competitive. Johann Sebastian Bach and many other composers held church positions that required them to serve not only as composer but also as organist, choir director, and even schoolmaster. The confessional differences established during the Reformation remained in place, so that the religious music in Calvinist regions (where organ music itself might be frowned upon) differed distinctly from Catholic areas that kept Latin masses. Lutheran regions developed and kept their own traditions of hymn singing as well. Other sorts of performances, however, differed little between religious factions, such as court music. Major nobles, inspired especially by the examples of prominent royal patrons like Louis XIV of France (r. 1643–1715) or Frederick the Great of Prussia (r. 1740–1786), kept composers in full-time residence at their courts along with staffs of musicians. Given the increasingly high levels of

education and social standing among composers of the era, many came to chafe under the restrictions of this kind of employment. Often court musicians were treated little better than domestic servants. When Johann Sebastian Bach tried to leave one court position he held early in his career to take another, his employer responded by having him jailed for a month. Similar cases of high-handed and arbitrary treatment of musicians by noble patrons abound in the annals of the age. The most successful composers—men like George Frideric Handel, Josef Haydn, and Wolfgang Amadeus Mozart—found ways of gradually freeing themselves from the restrictions of their court positions. At the same time, court employment provided composers with both a secure salary and a high profile, and these positions continued to be highly sought after by musicians throughout the period. Other commercial venues besides the opera house were just beginning to appear for musicians during the eighteenth century. The selling of subscriptions to concerts of instrumental music, a practice that first appeared in London at the end of the seventeenth century, soon spread to more and more European cities in the course of the eighteenth. But for most performers, playing in an orchestral ensemble for public performances did not provide a steady source of income, as it does for many of the best musicians in the modern world. By contrast, much music was still performed by amateurs, and amateur musicianship, in fact, seems to have expanded dramatically during the Baroque era. This change provided a steady source of income for Europe's best composers. As Europe's ranks of amateur musicians swelled throughout the era, astute composers like Antonio Vivaldi, Handel, and Georg Philipp Telemann produced a steady stream of works that were intended, not only for students learning to sing or play instruments, but for amateurs who performed at home for themselves and their friends. An ever-expanding music publishing industry supported this appetite for music intended for amateur performers, even as it helped to spread knowledge throughout the continent of the latest changes in styles and innovations in musical genres and to sustain many composers.

THE AGE OF GREAT COMPOSERS. By the early eighteenth century, the various styles, genres, and career paths of the Baroque era were all clearly established, and in the course of the decades that followed, a number of composers rose to prominence that became masters of all the existing styles and forms of composition. George Frideric Handel (1685–1759), who moved from Germany to England, established himself as a fixture in the musical landscape of his adopted country. He serves as

one of the most famous examples of the ways in which the great Baroque composers practiced their art. He is best known as a vocal composer, with a long list of notable operas, oratorios, anthems, and other vocal works large and small to his name; he also excelled as an instrumental composer. His works included various compositions for the new combination of strings and winds that was taking shape in the development of the orchestra. His contemporary, Johann Sebastian Bach (1685–1750), enjoyed a distinguished reputation during his life, but an even greater one some time after his death. He too wrote vocal music, at times producing a cantata each week. But he also produced music in nearly every form that was common in the period, with the notable exception of opera. Yet Handel and Bach are only two of the most famous examples of great Baroque virtuosi. In Italy, Antonio Vivaldi, known in his own day as the "red priest," produced some 500 concertos during his lifetime, as well as a cavalcade of highly successful operas, and works for the church, the keyboard, and small instrumental ensembles. Baroque audiences and patrons demanded a constant stream of "new" music, and the sheer output of Europe's composers in this era still manages to astound even musical specialists of the period. To satisfy the demands of musical commerce and patronage, composers were expected to work quickly, sometimes to produce an entire opera or oratorio in the space of only a few weeks. Certainly given these conditions not all music of the era was of a high standard, yet numerous great masterpieces continue to survive from these years in the modern repertory.

CHANGES IN THE MID-EIGHTEENTH CENTURY. In mid-eighteenth century Italy, and somewhat later in Northern Europe, new tastes began to produce changes in musical styles. Increasingly, composers began to experiment with both old and new idioms in ways that led to subtle or dramatic changes in music. At this time, for instance, Johann Sebastian Bach devoted significant attention to reviving the older musical practices of strict counterpoint. Although his attention in his later works to these traditional features of Baroque music has often been treated as a sign of his "old-fashioned" nature, the innovations and insights that he brought to these older styles was, in fact, one sign of the changing tastes of the mid-eighteenth century. By 1750, these changes meant that the Baroque period had largely drawn to a close. In the years that followed, Europe's composers split off in a number of distinctly different directions. Some developed a courtly style, a musical language that became truly international after 1750, and which has often been called the "Galant Style." This new way of composing

compositions emphasized elegance and a light touch, and found a ready entrance into many aristocratic circles where Rococo fashions in architecture and the visual arts were also popular at the time. Other composers, like Bach's accomplished son, Carl Philipp Emanuel Bach, developed a "Sensitive Style" that was intended to evoke a range of human emotions. Still others grew interested in the abilities of orchestral groups to produce a wide range of variations in loudness and softness (dynamic range) as well as tone color. The court of Mannheim in the German southwest became widely known in this era for its famous orchestra. Mannheim was one important center that favored music that made use of the new broad range of dynamic contrasts the orchestra now offered, and although it was a relatively small court, the compositions of its many accomplished composers exerted a significant influence over musical tastes throughout Europe. The features described by modern scholars as "classical" that soon appeared in this period also found appeal with many composer of the age. This classical style favored careful melodic lines, broken-chord bass (in opposition to the longstanding Baroque use of basso continuo) and attention to balance and symmetry in musical composition. Josef Haydn (1732–1809), after experimenting with the Galant and Sensitive styles, adopted this musical language, and his massive output of compositions created new standards of elegance, balance, and proportion in the music of the later eighteenth century. His efforts also helped to establish the symphony as one of the dominant musical forms of the age. The way that Haydn led was soon elaborated upon and perfected in the works of Mozart, who brought the Classicism of the later eighteenth century to its highest point of expression. Hadyn, Mozart, and the other composers who favored this "Viennese Classicism," as it has since become known, helped to forge a new international musical language that became accepted in many parts of Europe in the final years of the century.

END OF AN ERA. The equipoise (a state of equilibrium) that is brilliantly displayed in the great symphonies and concertos of the late eighteenth century, though, was to prove short-lived. Political and social changes touched off by the French Revolution after 1789 left their marks on the musical culture of the late eighteenth-century, disrupting in many parts of Europe the patronage of the nobility that had long been a significant spur to musical creativity. In Vienna and other European musical centers many composers began to experiment with new sounds and styles. These trends can be seen in the works that composers such as Ludwig van Beethoven wrote during the 1790s. Schooled for a time by Haydn,

Beethoven soon broke free from the classical musical language of the age to exploit a great range of sounds and effects that the orchestra and the now popular piano offered. In contrast to the composers of the Baroque era, Beethoven's career also displays a key change in musical sensibilities at the very end of the eighteenth century. For generations, vocal music had been the standard by which music in Europe had been judged, and vocal music had served as a continual source of inspiration for many forms of instrumental music. Although figures like Beethoven wrote vocal music, it was their instrumental compositions that exerted a powerful hold over the imagination of the developing Romantic audience. The increasing importance of instrumental music arose from new ways of thinking about art, ways that held that human emotions could be best represented in music that was free from the longstanding tie to words and the human voice. Music, these new sensibilities taught, represented a realm of pure abstraction, a realm that might evoke the world of the spirit more effectively than poetic texts and the performance of a singer. The appearance of these ideas, and the forceful examples of composers like Beethoven who exploited them, helped to dissolve the classical era's aesthetic and to produce yet another major change in Europe's musical style around 1800.

TOPICS
in Music

ORIGINS AND ELEMENTS OF THE BAROQUE STYLE

DATING THE BAROQUE. In music, the period of the Baroque has long been dated between 1600 and 1750, chronological boundaries that are arbitrary, but nevertheless useful in conceiving of the changes that occurred in Western music in the early-modern world. At the beginning of this period, new models of composition began to appear in Italy that were informed by the experiments of composers like Claudio Monteverdi (1567–1643), Jacopo Peri (1561–1633), and Giulio Caccini (1555–1618) as well as by the discoveries of Renaissance humanists concerning the drama and music of the ancient world. These innovations produced new harmonic structures, compositional techniques, and genres like opera. While music informed by earlier Renaissance models persisted throughout Europe, the innovations of the early Baroque also spread outward from Italy. As these new styles were studied and accepted

elsewhere in Europe, the new Baroque styles of composition and performance mixed with native traditions, producing regional variations that were very different from Italian models. Thus two characteristics are at once notable when considering the history of music during the Baroque. First, Europe's musical languages became increasingly differentiated along national and regional lines during the Baroque years. Second, the music that was consumed by aristocratic and urban elites was transformed by the development of new musical genres, new instruments, and new performance practices. It was during these years that many new musical forms appeared, forms that European composers have continued to rely upon until the present. In vocal music, the rise of opera was also accompanied by the appearance of the oratorio and the cantata. Developments in instrumental music were no less innovative. New musical genres like the sonata, the suite, and the concerto have their origins in the Baroque, as do instruments like the oboe, the violin, and the transverse flute. During these years many of the customs of modern performance developed as well. At the beginning of the period, much of music was still firmly under the control and patronage of the church and the aristocracy. Religious music remained vital throughout the seventeenth and eighteenth centuries, as did aristocratic patronage for musical composition and performance. At the same time the rise of opera houses in the early Baroque and the emergence of the subscription concert at the very end of the period provided new venues for performance, venues in which Europe's growing class of bourgeoisie were able to indulge their tastes for music. Domestic performances by amateurs were important throughout the era, and traditions of amateur musicianship became even more important over time.

THE RENAISSANCE AND THE REVIVAL OF ANCIENT MUSIC. Many of the Baroque period's features emerged as a result of a climate of experimentation that can be traced to Italy in the late sixteenth and early seventeenth centuries. This new climate of innovation owed a great deal to the intellectual life of the later Renaissance and to its steadily intensifying search to understand Antiquity. During the years after 1550 musical theorists and historians working in several Italian cities had become increasingly fascinated with examining ancient writings on music in order to revive some of its performance practices. From the texts of ancient authors like Plato and Quintilian, Renaissance intellectuals understood the high regard in which the ancients held music. The art was credited with possessing the power to transform the soul and to shape the human emotions, and many legends contained in ancient texts granted music an enor-

mous ability to perform feats of transformation on the human personality. An oft-quoted legend, for instance, credited one of Alexander the Great's important victories to the effects of a stirring tune played right before battle. As they reflected on the music of their own age, many later Renaissance thinkers judged their own art wanting since they found it had little power to shape the emotions in the ways in which the ancient art had done. The efforts that soon developed to recreate ancient music, though, were always piecemeal and incomplete, since no actual compositions had survived from Greece or Rome. While Renaissance artists were able to examine the many artifacts that survived from the ancient world, no such reliable body of evidence survived as a guide for composers interested in recreating ancient music. Knowledge of the tuning systems, instruments, and ancient musical modes was similarly fragmentary. Thus as they tried to recreate ancient sounds, most composers of the time were forced to adapt the incomplete knowledge that they had of antique music to forms that already existed in their own day. In this way the expanding, but nevertheless imperfect knowledge that intellectuals possessed of the ancient art shaped the performance practices and compositional styles of the later Renaissance and early Baroque. It was in Florence, a city in which a number of musicians and men of letters studied ancient Greek musical treatises, where the attempt to understand the role music had played in ancient drama developed most decisively. There a picture began to emerge in the later sixteenth century of a musical tradition that was very different from that of the sixteenth-century world.

FLORENCE AND EARLY OPERA. The development of opera best demonstrates the transition between Renaissance and Baroque music. The Florentines who studied musical drama in Antiquity became interested in creating their own dramas in ways that recalled, without attempting directly to copy, the features they had come to admire in ancient Greek drama. Key figures in this group were the Florentine aristocrats Count Giovanni de Bardi (1534–1612) and Jacopo Corsi (1561–1602), both humanist-trained intellectuals who were close to the court of the Medici Grand Dukes, Florence's ruling family. Bardi patronized a number of musicians, and his house was often filled with scholars. Later the cultivated circle Bardi helped to create at Florence was to become known as the Camerata, although at the time in which its discussions occurred the group was an informal one that deliberated upon a broad range of issues, including music, drama, literature, and even astrology, a popular fascination of Renaissance intellectuals. During the 1570s the discussion of the Bardi group were enriched

through Vincenzo Galilei's correspondence with Girolamo Mei (1519–1594), then Italy's greatest authority on ancient Greek music. From this correspondence, Florence's intellectuals derived much of their theories about ancient music and the ways in which it had been used in Greek drama. The conclusions that they drew from this scholarship helped to inform, not just the practices of the early opera, but Baroque music generally. Florence's theorists argued that the lines of ancient drama had been sung and not simply spoken, and that the choruses of these works had included dance or stylized movements that accompanied the sung lines. In addition, they realized that unlike the polyphonic music that was so popular in their own day, ancient Greek music had been monodic—that is, Greek music had used only a single melodic line. Thus the Florentines introduced a new style of singing that they called *stile recitativo* or "recitative style." In this style, the singer sang a line made up of standard musical pitches, but in a very simple melodic line intended to imitate the inflections and rhythms of speech. A bass line and a few simple chords accompanied the singer.

EXPERIMENTS IN EARLY OPERA. Following several small-scale attempts to perfect the new art of recitative as a vehicle for setting poetry to music, Jacopo Corsi commissioned an entire drama in the style, *Dafne*, which was performed in Corsi's palace in 1598. Corsi, a generation younger than Bardi, had recently risen to a position of prominence in Florence's musical world, and as one of the city's most important patrons, he desired to use his position, not just to discuss musical theory, but also to put into practice some of the insights gained from recent scholarship on ancient Greek drama and music. He was himself a composer, but his influence proved to be most lasting through the patronage he gave to other musicians and composers as well as his efforts to encourage Florence's Medici dukes to support the development of a new kind of musical drama. Among those he supported were Jacopo Peri (1561–1633) and Giulio Caccini (1551–1618). Peri was a singer and composer who wrote the music for *Dafne* in 1598, the work that has long been called the "first opera." Caccini, on the other hand, was also a composer who helped to spread knowledge throughout Italy of the basso continuo style of accompaniment through his popular collections of printed songs. Through Corsi's encouragement several other sung dramas were also staged in Florence in the years immediately preceding 1600, some in his own house, but most in the Medici family residence, the Pitti Palace. Many of these first efforts in the developing genre of opera took their story lines from ancient dramas, myths,

and historical events. The story of Orpheus, whose singing was said to charm wild animals and his efforts to rescue his beloved Eurydice from the underworld, was one popular subject. Chief among these path-breaking treatments of the myth was Claudio Monteverdi's *Orfeo* in 1607, which was first performed in Mantua, and is often revived today. The theme of Orpheus fit with one of the chief aims of musical theorists and composers of the time: their efforts to revive ancient music's power to speak to and influence the emotions, a key aim that was also to be shared by many Baroque composers. These early operatic experiments were, by and large, paid for by Italy's nobles and performed before their courts. The Medici court in Florence proved to be among the most avid supporters of the new art, but aristocratic households at Mantua and Rome were also important centers of early opera production. In this early period of opera's development the art form was largely an expensive entertainment mounted in these courtly households to impress guests. Elaborate sets, lavish costumes, special effects, and a generally high level of theatricality and spectacle soon became hallmarks of the early operatic productions.

MONTEVERDI AND THE "SECOND PRACTICE." Even as opera was continuing to develop as a new musical genre in the years around 1600, new compositional techniques were transforming vocal music and its relationship to the text. Claudio Monteverdi (1567–1643) was chief among the figures that contributed to this new climate of innovation. Monteverdi was one of the greatest musicians of the late Renaissance in Italy, but he also made important contributions to the new Baroque style. As a consequence, it has long proved difficult to classify this visionary artist. Whether he is best considered as a composer of the late Renaissance or of the early Baroque continues to be debated today, although it is clear that Monteverdi made major contributions to the music of both periods. Monteverdi and those who championed his new compositional techniques wanted to focus the listener's attention clearly on the singer's words and the feelings they expressed. To do this, they simplified the style of composition, and helped to codify the new techniques that were developing at the time. They minimized counterpoint and wrote instead a single musical line for the singer, along with a bass line and enough notes in between to accompany the voice but not compete with it. Often they wrote out only the bass or lowest part of this accompaniment, and simply indicated with numbers the harmonies above that line for the accompanists to add as they saw fit; they began to call this practice "figured bass." Since this bass line also ran continuously

a PRIMARY SOURCE *document*

IN DEFENSE OF NEW MUSIC

INTRODUCTION: The violinist Marco Scacchi was born in Viterbo around 1600, and by 1621, had been appointed as a musician in the court at Warsaw. Today, he is best known for his defense of new music, which he published as *A Brief Discourse on New Music* (1649). In it, he compares the explorations made by the new musicians to those of Christopher Columbus's exploration of the New World. While remembered today largely for his role in this controversy, Scacchi was a remarkably original musical theorist as well.

Let them say, pray, if Columbus had not sought with his intellect to pass the Pillars of Hercules through navigation, would he have discovered a New World? And yet, it is known to all, that when he put forward his sublime thought with demonstrative reasons he was thought mad, and all this arose because those to whom he reported his undertaking did not yet have the capacity for that which he was demonstrating, and yet in the present century the human race owes him so great a debt as a New World is worth. So now I say of the modern music, that if someone had proposed to our predecessors how one can operate the art of music in a manner different from that which they taught us, they would have deemed him a man of little knowledge. But this cannot be denied in the present age, for the hearing judges it as that from which music has received, and daily receives, greater perfection. Wherefore I say that just as Columbus made apparent in his field that which the first inventors of navigation were not able to investigate, so our modern music makes heard today that which our first masters did not hear, and still less was it granted them to investigate

that which modern musicians have discovered to express the oration. …

The old music consists of one practice only, and almost one same style of using the consonances and dissonances. But the modern consists of two practices and three styles, that is, the style of the church, of the chamber and of the theatre. Of the practices, the first is *Ut Harmonia sit Domina orationis* ['that the harmony is the mistress of the oration'], and the second, *ut Oratio sit Domina harmoniae* ['that the oration is the mistress of the harmony' …]. And each of these three styles contains within itself very great variations, novelties and inventions of not ordinary consideration. And it must be noted that the moderns understand this new music—in terms of style and of using the consonances and dissonances differently from the first practice—to be that which turns on the perfection of the *melodia* [the combination of oration, harmony and rhythm], and for this reason it is called second practice, different from the first, prompted by these words of Plato: *Nonne est Musica, quae circa perfectionern melodiae versatur?* [*Gorgias* 449D … 'Is it not music which turns on the perfection of the *melodia*?']. Wherefore modern compositions are defended to the satisfaction of the reason and of the sense: to the satisfaction of the reason because it relies on the consonances and dissonances [as defined by] mathematics, and on the command of the oration, principle mistress of the art, considered in the perfection of the *melodia*, as Plato teaches us in the [f. 12v] third book of the Republic [39D] and therefore is called second practice; and to the satisfaction of the sense, because of the mixture of oration commanding rhythm and harmony subservient to it.

SOURCE: Marco Scacchi, "Breve discorso sopra la musica moderna," in *Polemics on the 'Musica Moderna.'* Trans. Tim Carter (1649; reprint, Kraków: Musica Iagellonica, 1993): 37, 59–60.

throughout the piece, it was also described by many as "basso continuo," or "thorough bass." In order to express emotion, these composers were willing to let their works move through harmonies usually considered jarring, if that seemed to them to help express the line of text they were setting to music. In an early publication of a book of madrigals in 1605, Monteverdi referred to this style of composing as a new practice, or a "second practice." Two years later, his brother and fellow musician Giulio Cesare Monteverdi (1573–1630), explained in print that in this new practice, the text is mistress of the harmony. Other composers soon followed suit, continuing to develop this new practice. The new style then spread gradually across Europe. Other regions strove to hire Italian musicians, and Italian styles, composers, and

performers dominated Europe in the Baroque era that followed. It is the birth of the new or "second practice," that is seen as the starting point of the Baroque era.

THE "FIRST PRACTICE" SURVIVES. While music written in the "second practice" gained in popularity throughout the seventeenth century, older Renaissance styles of composing also continued to exist side-by-side with the new methods. This older style, or the "first practice" that was continuous with Renaissance musical practice, was contrapuntal, with a number of distinct lines or voices sounding together at the same time. It continued to look back to the great composers of the middle sixteenth century for inspiration, especially to the writings of the Roman composer Pierluigi Palestrina (1525/6–1594) because of his skill at making these

independent voices blend well together. Throughout the Baroque era composers continued to write complex works of counterpoint, works that require and reward careful listening. Thus this "first practice" needs to be understood as a central part of Baroque music. Perhaps the most noted advocate of this older style of composition was Johann Sebastian Bach (1685–1750), who wrote many works of counterpoint toward the end of the Baroque era. Counterpoint was an essential musical language to many composers of the seventeenth and eighteenth centuries, and it even outlived the Baroque. The tradition of the "first practice" survived even into the nineteenth century when figures like Ludwig van Beethoven and Felix Mendelssohn studied techniques of counterpoint and used them in their composing. The "first practice" was so fundamental to the music of the Baroque era that musical theorists of the later Baroque eventually abandoned the distinction that had once seemed essential between music composed in the "first" or "second" practices. Instead they classified compositions according to the setting and environment in which the music was to be performed. Hence, music was sorted into categories such as church music, chamber music, and theater music.

HARMONIES MAJOR AND MINOR. Whether written in the new style or the old, the first practice or the second, music in the Baroque era came more and more to use major and minor keys, rather than the system of modes used in earlier music. A key uses an eight-note scale (do-re-mi-fa-sol-la-ti-do). "Do" is the "home" note; the fourth and fifth steps (fa and sol) also help give shape to the piece. Harmonies are built using triads, or chords of three notes, made up of notes that are a fifth and a third above the foundation notes. Major scales differ from minor ones especially by the pitch used for "mi." This system of scales and triads is still in use today, so Baroque music sounds more familiar to modern listeners than does the music of earlier times. Music written in modes, by contrast, may seem foreign to modern ears. The ways that instruments were tuned, especially keyboard instruments, also helped to determine which keys sound best. A number of tuning systems came to be used throughout Europe during the Baroque period. Some favored the use of a few keys, such as G and C; music played in those keys would sound better in tune than if it were played with our modern tuning systems, but music in other keys would sound worse. One of these tuning systems was called "well tempering," which allowed a keyboard to play in a wide range of keys. Johann Sebastian Bach, who was very interested in the construction and tuning of keyboard instruments of all types,

wrote a set of pieces, called *The Well-Tempered Clavier.* The work included pieces in all 24 keys used in composition and thus brilliantly showed off the advantages of the new tuning system.

IMPLICATIONS OF THESE CHANGES. By the mid-seventeenth century the innovations of Italian composers like Monteverdi had begun to forge a distinctive Baroque sound characterized by the basso continuo, monody (music consisting of a single melodic line), and the use of harmonic keys. These innovations had developed, in large part, as a result of the late Renaissance's fascination with ancient drama and the attempt to recover the emotional power that scholars, composers, and musicians felt reposed in ancient music. At the same time the contrapuntal techniques of the Renaissance continued to survive throughout Europe in the seventeenth and eighteenth centuries, and were to inform much composition in the Baroque. The persistence of both styles proved to be one of the enduring characteristics of music throughout the period.

SOURCES

Howard Mayer Brown, "Opera, Origins," in *The New Grove Dictionary of Music and Musicians.* Eds. S. Sadie and J. Tyrrell. (London: Macmillan, 2001).

Claude V. Palisca, *Baroque Music.* 3rd ed. (Englewood Cliffs, N.J.: Prentice Hall, 1991).

David Schulenberg, *Music of the Baroque* (New York; Oxford: Oxford University Press, 2001).

SEE ALSO *Dance: Social Dance in the Baroque; Visual Arts: The Renaissance Legacy; Visual Arts: Elements of the Baroque Style*

PERFORMERS, PERFORMANCES, AND AUDIENCES

COMPOSERS AND PERFORMERS. During the Baroque era Europeans heard music in a number of types of settings, and the music they heard might be produced by a number of different kinds of people. While unwritten popular or folk music existed in abundance, the formal music of the period, which includes most of the musical compositions that survive, was written down by a composer, who was generally not the same person who performed the music. Most composers and professional performers came from one level or another of the middling classes; many of them received specialized training in music at schools known as conservatories. Further, many professional musicians came from families of musicians who passed on their trade. The descendants of

Johann Sebastian Bach provide us with one of the most prolific examples of a family in which many members made their livelihoods from serving as court and church musicians. The Bach family, by the birth of Johann Sebastian Bach, had already produced more than a dozen family members who pursued careers as professional musicians. Johann Sebastian Bach's own children kept this legacy alive, and their descendants continued to work as performers and composers into the nineteenth century. Fathers might train both sons and daughters for a life in musical service, as the Mozart family demonstrated. While women faced greater obstacles to pursuing a life as a professional musician, the church did provide employment for many female musicians. Often female vocalists were married to organists and composers, and they sometimes served in churches or at courts alongside their husbands. Both composers and performers might hold any of a number of types of positions during their career, including simply doing freelance work for a single performance. If they held a long-term position, they were often employed by people of higher social status. That is, musicians would be part of the staff of a court headed by a noble family, or they might be members of the staff of a major church. Therefore, Baroque composers wrote most of their major works because that work was commissioned by their employers for a special occasion, and not simply because the composer felt creative, as one might expect of artistic production today. Operas, for instance, were highly commercial works, composed under contract in a great hurry. The modern world is full of recorded music, so it is worth remembering that every performance of any kind during the Baroque era required a human presence. Thus paid musicians were present at more public and social occasions than is now the case; and those who wanted to listen to music in their private leisure time hired musicians if they were very wealthy, attended particular performances such as religious services or the theater, or produced the music themselves, perhaps with friends.

MUSIC AT COURT. During the seventeenth century, political developments in continental Europe heightened the power of the central ruler in many European states, and centralized authority in royal courts. The model for many of these centralizations of power was the French court of Louis XIV (r. 1643–1715). His opulent court, founded at Versailles outside Paris, served as an ideal by the late seventeenth century and was imitated by many princely courts throughout Europe. These courts were often important sources of employment for musicians in those regions where cities were relatively few and small, particularly in Central Europe. In Germany, for example,

a rich musical life developed throughout the countryside as princes and nobles competed against each other to develop court cultures that displayed their wealth and taste. Entering into the service of a prince as a court musician or a *Kapellmeister* ("Chapel Master") provided relative security. This last category of employment frequently included many duties, such as overseeing the prince's chapel choir and instrumental musicians, composing music for both sacred and secular occasions, and providing entertainment at court functions. Such positions usually provided a salary, a residence, and other allowances for one's upkeep. While some nobles and princes had little interest in music, many others had extensive musical educations. Some were very skilled amateur performers and composers who often tended to their court musical establishments with particular care. The small court of Cöthen in central Germany is a good example of the ways in which court orchestras sometimes grew. Cöthen was a relatively modest court by German standards that had no court musicians until 1707, when its young Prince Leopold convinced his mother, then the regent, to appoint three professionals. As Leopold matured and traveled throughout Europe in the years that followed, he gained a musical education; when he returned home in 1714, Leopold took over the reins of Cöthen's government. He used his newfound power to found an orchestra that had eighteen musicians by 1716. In these years Leopold took advantage of the disbanding of the court orchestra at Berlin, inviting its *Kapellmeister* and many of its musicians to take positions in his newly expanded musical establishment. In 1717, this director resigned, and Leopold appointed Johann Sebastian Bach as his new *Kapellmeister*. At Cöthen, the young composer flourished for more than four years in an environment in which performance quality and the ensemble's professionalism were both of a high standard. He was expected to provide music for Leopold's church services and court entertainments, and he seems to have developed a close relationship with his amateur employer. He even accompanied the prince with a small ensemble on a trip to the spa town of Carlsbad. Yet the circumstances that surrounded Bach's departure from Cöthen also reveal a darker dimension of court musical life. In 1721, Leopold married his cousin, Friderica, who had little interest in music, and in the months following the wedding the prince's ardor for his musical establishment waned. Soon Johann Sebastian Bach left Cöthen for another, more attractive position. While employment as a *Kapellmeister* was generally secure, it was still subject to the vagaries of a princely patron's tastes, his continuing devotion, and the health of his purse.

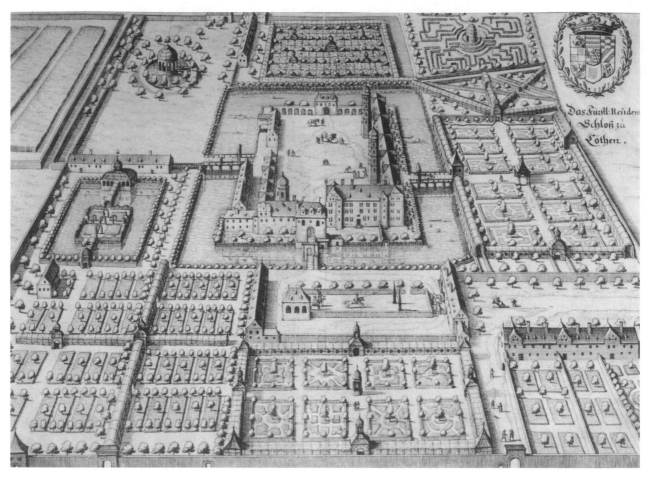

View of Cöthen, where Johann Sebastian Bach held a position as court music director. **THE ART ARCHIVE/BACH HOUSE, EISENACH/DAGLI ORTI.**

THE CHURCH. The Church was also another venerable source of employment for professional musicians and composers in the Baroque world. Music was common in all the churches of seventeenth- and eighteenth-century Europe, although the Protestant Reformation had affected the use of music, producing very different kinds of musical forms in Protestant Europe than those that flourished in Catholic countries. By the seventeenth century the kind of music that was heard in churches varied according to religious confessions. In Catholic churches priests regularly chanted the mass and other liturgical services. Catholics might hear an organ as part of religious services, and on special occasions, more elaborate performances with choirs and other instruments. Lutherans kept the basic order of the traditional mass in the local language in their churches, adding hymns or chorales sung by the whole congregation and led by a choir. The scope of Lutheran service music was often quite impressive, and in the largest churches of Germany, organs and other instruments often accompanied the singing of choir and

congregation. By contrast, the religious reforms of Calvinists generally downplayed ritual and shunned too great a reliance on religious music in church services. Calvinists focused instead on psalms sung to simple tunes that kept attention on the text. Yet even though religious considerations continued to shape the music that was performed in church, neither a noble interested in hiring a musician for his court chapel, nor a city church making an appointment to one of its important musical positions, typically hired only those who shared their religious beliefs. A Protestant noble might well hire a Catholic composer or vice versa, but the composer would write music to suit the religious observance of his patron rather than himself. Thus the seventeenth and eighteenth centuries present us with numerous examples of Catholic composers who created music intended for performance in Protestant churches, as well as the reverse. For example George Frideric Handel (1685–1759) had a position early in his career as organist at the Calvinist cathedral in Halle, although he was a Lutheran. A few years later he moved to

a PRIMARY SOURCE document

THE COMPOSER AS SCHOOLMASTER

INTRODUCTION: The career of a composer might include a number of different types of gainful employment, including organist, choirmaster, and courtier. Each kind of position brought unique advantages and unique burdens. When Johann Sebastian Bach accepted his position at the Thomasschule in Leipzig, he undertook responsibility not only for rehearsing the choirs and composing music for them to sing, but also many other tasks particular to the running of a school. Here is the agreement Bach signed, accepting his new responsibilities.

Their worships, the Council of this town of Leipzig, having accepted me to be Cantor of the School of St. Thomas, they have required of me an agreement as to certain points, namely:

1. That I should set a bright and good example to the boys by a sober and secluded life, attend school, diligently and faithfully instruct the boys.

2. And bring the music in the two chief churches of this town into good repute to the best of my ability.

3. Show all respect and obedience to their worships the Council, and defend and promote their honor and reputation to the utmost, and in all places; also, if a member of the Council requires the boys for a musical performance, unhesitatingly to obey, and besides this, never allow them to travel into the country for funerals or weddings without the foreknowledge and consent of the burgomaster in office, and the governors of the school.

4. Give due obedience to the inspectors and governors of the school in all they command in the name of the Worshipful Council.

5. Admit no boys into the school who have not already the elements of music or who have no aptitude for being instructed therein, nor without the knowledge and leave of the inspectors and governors.

6. To the end that the churches may not be at unnecessary expense I should diligently instruct the boys not merely in vocal but in instrumental music.

7. To the end that good order may prevail in those churches I should so arrange the music that it may not last too long, and also in such wise as that it may not be operatic, but incite the hearers to devotion.

8. Supply good scholars to the New Church.

9. Treat the boys kindly and considerately, or, if they will not obey, punish such in moderation or report them to the authority.

10. Faithfully carry out instruction in the school and whatever else it is my duty to do.

11. And what I am unable to teach myself I am to cause to be taught by some other competent person without cost or help from their worships the Council, or from the school.

12. That I should not quit the town without leave from the burgomaster in office.

13. Should follow the funeral processions with the boys, as is customary, as often as possible.

14. And take no office under the University without the consent of their worships.

And to all this I hereby pledge myself, and faithfully to fulfill all this as is here set down, under pain of losing my place if I act against it, in witness of which I have signed this duplicate bond, and sealed it with my seal.

Johann Sebastian Bach
Given in Leipzig, May 5, 1723

SOURCE: Philipp Spitta, *Johann Sebastian Bach*. Trans. C. Bell and J. A. Fuller-Maitland, III (London, 1885): 301–302.

Rome and wrote oratorios for Catholic performances there; whereas in England, where he spent most of his professional career, Handel wrote oratorios and other works to be presented in Anglican churches.

AMATEUR MUSICIANSHIP. The music most people heard in their own homes was music that they produced themselves. The ability to sing or to play for oneself and one's friends had long been seen as a mark of a lady or a gentleman. Many musical instruments were quite expensive, such as the lute or keyboard instruments, so owning one was a mark of some prosperity. A few of Europe's greatest political leaders, such as Frederick the Great of Prussia (r. 1740–1786), were well known for their devotion to music. Though Frederick could and did hire professional performers and composers, he became a skilled performer and gave concerts at court for his own enjoyment, just as the youthful King Louis XIV of France had once publicly showed off his skills as a dancer in ballets. One undeniable trend throughout the seventeenth and eighteenth centuries was the rise of musicianship among the middle classes. In these decades

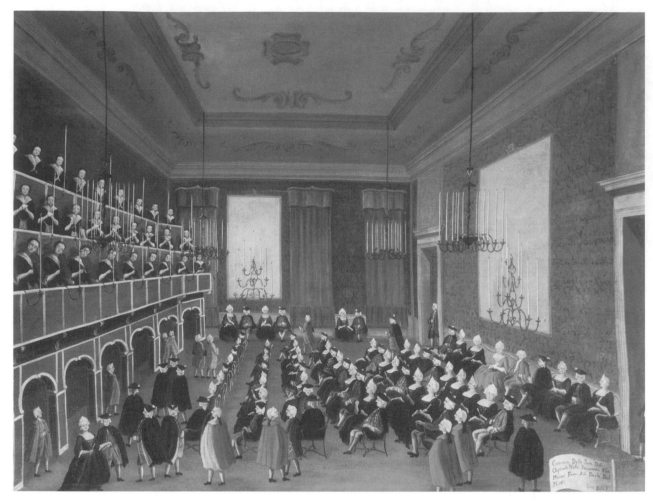

Engraving of a choir of orphans. ARCHIVO ICONOGRAFICO, S.A./CORBIS.

more and more middle-class people studied and played music as a leisure pursuit, enough that their love for it led to the use of the term "amateur." Printed music added to the expense of amateur musicianship, but thanks to advances in printing technology, it became less expensive during this era. More people could afford to buy sheet music of the latest works of popular composers, and perform them at home for themselves and with friends. Composers sometimes wrote smaller works with this amateur market in mind, and music publishers made some of their money this way as well. Johann Sebastian Bach wrote a number of works intended for sophisticated amateurs to perform on keyboard instruments as well as the lute, one of the most common instruments in European households. Similarly, Joseph Haydn (1732–1809) continued this tradition in the later eighteenth century, publishing reams of works for keyboard and small ensembles that could be performed both in great houses and in the more modest confines of middlc-class homes.

PAID PERFORMANCES. Although amateur musicianship points to the rise of an increasingly educated and discriminating musical public, the Baroque era also saw the development of the system that we know today of public performances before paying audiences. This innovation stood in contrast to the private performances that were organized at courts before audiences of invited guests. During the early decades of the opera's development, works had by and large been commissioned by noble patrons and had been performed in the palaces of Italy's princes and aristocrats. By the mid-seventeenth century, though, commercial opera halls had begun to appear. The first of these new venues, the Teatro S. Cassiano, was founded in Venice in 1637 to perform musical spectacles before paying patrons. At the time of its founding, the Teatro S. Cassiano was a risky venture, but one that soon paid handsome dividends for the entrepreneurs who invested in the scheme. By the early 1640s eight professional productions were being performed in the house each year.

Such opera halls soon were built in other parts of Europe, first in France, and then in the German-speaking world. Outside Italy, though, many of these institutions could not flourish commercially without princely support, and although these halls were open to a paying public, they generally had a wealthy clientele. One exception to this trend, however, was the Theater am Gänsemarkt in Hamburg. Unlike the royal opera houses of Paris, Vienna, or Stockholm, the Hamburg theater was founded as a commercial venture by a group of local citizens that desired to promote the writing of operas in German, an innovation at a time when most of the operas performed in the German-speaking world were composed in Italian. By 1700, operas performed before paying audiences were an established feature of the musical life of many large European cities. In the next decades, paid public performances of instrumental music appeared in many European cities as well. London seems to have been in the vanguard of those eighteenth-century cities that developed a vigorous concert-going tradition. At the end of the seventeenth century a number of amateur musical societies in the English capital began to offer concerts before paying audiences, and by the early eighteenth century the best of these groups were selling weekly subscriptions. The price of these subscription tickets was high in order to attract an exclusive crowd. Within a few years the most successful of these groups had taken up residence in concert halls, where they performed throughout the season. George Frideric Handel proved to be one major force on the development of these ensembles, and his sense of his audience's expectations helped to raise the professional standards of these concerts. Performing in one of London's instrumental ensembles was still not a full-time occupation, as it is in the modern symphony orchestra. But these new public performances provided professional musicians with a way to augment their income. Pleasing the public, not only a few noble patrons, thus became important to the careers of more and more musicians. Although London's concert scene was among the most precocious in Europe, public performances and concert halls were by the mid-eighteenth century becoming a fixture in many European cities.

SOURCES

Lorenzo Bianconi, *Music in the Seventeenth Century*. Trans. David Bryant (Cambridge: Cambridge University Press, 1987).

Lorenzo Bianconi and Giorgio Pestelli, *Opera Production and Its Resources*. Trans. Lydia G. Cochrane (Chicago; London: University of Chicago Press, 1998).

Ellen Rosand, *Opera in Seventeenth-Century Venice: The Creation of a Genre* (Berkeley; Oxford: University of California Press, 1991).

David Schulenberg, *Music of the Baroque* (New York; Oxford: Oxford University Press, 2001).

ITALIAN OPERA IN THE SEVENTEENTH CENTURY

ORIGINS AND DEVELOPMENT. The musical dramas known as "operas" today trace their origins to the experiments concerned with recreating the drama of the ancients that occurred in Florence in the late sixteenth century as well as to older forms of *intermedi* and *intermezzi*—musical interludes that were performed as short works between the acts of comedies and dramas or within other larger musical entertainments. By the final years of the sixteenth century, these kinds of works were themselves becoming the center of theatrical performances, and they quickly became a new staple of lavish entertainment and spectacle. Florence was the site of the first "opera" performance in 1598, but similar musical dramas were being staged in Rome and Mantua within a few years. Several stages have been observed in the history of seventeenth-century Italian opera. In the earliest period between 1600 and 1635, opera remained the preserve of Italian court nobility, and it flourished in the cultivated humanists circles that were common in the great aristocratic households throughout the peninsula. A new phase began in 1637, however, with the founding of Venice's Teatro S. Cassiano, the first public opera house that catered to an urban clientele. At this time opera was referred to as *dramma per musica*, or "drama in music." By 1650, the new opera house styles of productions common at Venice had become increasingly common elsewhere in Italy, and the art form spread north to France and other cultural centers throughout Europe in the decades that immediately followed. During these years opera became increasingly laden with lavish spectacle, and regional centers of production began to display many tendencies adapted from their own local theatrical traditions. Finally, as the seventeenth century came to a close, a reforming impulse began to affect the genre. These reforms emanated from France and the Arcadian Academy of Rome and they advocated greater purity and simplicity in the genre, an elimination of comedy and spectacle, and a concentration on ancient myths and pastoral themes. Despite the intentions of French composers like Jean-Baptiste Lully or the Italian Arcadian reformers, opera remained a popular form of entertainment, and the taste for lavish productions never

completely disappeared from the genre. This brief snapshot, though, does not suggest the wealth of creativity that existed in the genre in seventeenth-century Italy as a new and enduring art form appeared within the brief space of a generation or two. To understand the great range of operatic productions that existed in seventeenth-century Italy, we must consider some of the most important milestones in operatic production.

MONTEVERDI'S OPERAS. In 1607, Claudio Monteverdi's *Orfeo* had set a new standard for operatic production. For his subject Monteverdi and his librettist Alessandro Striggio had chosen the ancient myth of Orpheus, the god who was able to shape the outcome of history through his musical powers. Monteverdi's earliest opera did not break completely from the tradition of staged *intermedi* that were still popular in his day. These musical interludes had long been staged between the acts of Italian dramas or they had been inserted into court spectacles intended for the entertainment of honored guests. But in his *Orfeo* Monteverdi made use of the new types of music that were to become increasingly important to composers of operas and instrumental music during the Baroque era. His work was composed of a mixture of recitative, arias, choruses, and instrumental music, and the drama was preceded by a prologue that made use of a toccata theme played by the orchestra's trumpets, an innovation that laid the foundation for the overtures that were later to become common at the beginning of operas. In contrast to the virtuosic skill that was necessary to perform many arias written later in the seventeenth and eighteenth centuries, the arias of Monteverdi's *Orfeo* relatively simple, conceived in much the same way that Giulio Caccini had advocated in his *Le nuove musiche*. In *Orfeo* Monteverdi's arias make modest demands upon the singer, and they present the poetic text in a relatively simple and straightforward way. The composer conceived of his arias as songs that set to music in a verse style each of the strophes or stanzas of the poetic text. Each stanza of the aria was preceded by a *ritornello*, a refrain or instrumental passage played by the orchestra. The composer quickly followed the success of this work with another production, *Arianna*, in 1608, a work that was even more widely admired at the time than *Orfeo*. Unfortunately, only small portions of *Arianna*'s music have survived, and thus, *Orfeo* came over time to be the more influential composition. Published in its entirety in 1610, it was widely studied by Italian composers in the first decades of the seventeenth century and helped to shape many later productions. For his part, Monteverdi continued to write operas for another 35 years, most of them based on antique themes, legends, and ancient historical incidents. In 1642, though, he produced another definitive masterpiece, *L'incoronazione di Poppea* (The Coronation of Poppea). Written when the composer was 75 years old, the work brilliantly displayed the maturation of Monteverdi's style. It treated a famous incident in ancient history: the success of the aggressive Poppea in supplanting Nero's wife Octavia and her subsequent rise to become empress of Rome. Throughout the work Monteverdi relied on recitative to propel the action forward, but he also made use of musical imagery to draw his characters. The ancient Roman philosopher Seneca, Nero's tutor, is portrayed using musical lines that are calmer and serene, while Nero himself is portrayed as a nervous soprano. At the time his character was played by a *castrato*, an adult male singer that had been castrated before reaching sexual maturity. Monteverdi's use of the castrato was thus an early instance of a practice that was to become increasingly popular in the later Baroque operas of Italy. Throughout *The Coronation of Poppea* Monteverdi succeeded in rendering the brilliant libretto that the poet Gian Francesco Busenello had written for the work into a seamless dramatic spectacle. *The Coronation of Poppea* thus helped to establish a new standard for the integration of music and text, although few of the later Italian composers of the later seventeenth century were to approach its masterful blending of drama and music.

FROM COURT TO THEATER. By the time Monteverdi's *The Coronation of Poppea* was performed in Venice, opera had already begun to emerge from its early history as a humanistic court entertainment nurtured in Italian courts. The earliest operas had often been lavish and expensive spectacles performed before invited guests or at the marriage festivities of important nobles. In 1637, however, the patrician Tron family in Venice experimented with allowing a Roman troupe of operatic performers to mount a production in a theater they owned in the city. The performances were staged before a paying audience, and the success of this and other productions soon convinced other theater owners in Venice to convert their theaters into opera houses. By the early 1640s, Venice had four theaters that regularly performed operas during the six-week season surrounding Carnival. The number of opera houses in the city continued to grow, and by the end of the century musical drama had become a big business in Venice. To mount these productions, the families that owned the city's theaters often approached a new category of showman known as the impresario who was charged with gathering the singing talent and the stage-design know-how to pull off such complex productions. At other times the family theaters

entered into commercial ventures with troupes that rented their facilities, staging a season of operas there. As Venice's commercial opera grew in importance, the complexity of orchestrations, costuming, and staging rose. In the early years of the 1640s, productions had often been relatively cheaply produced, and had had few of the expensive stage sets and theatrical machinery that had been common in the court operas of the previous decades. Claudio Monteverdi had written three operas for the Venetian houses during the years immediately preceding his death in 1643, and these works, together with those of his student Francesco Cavalli (1602–1676) helped to establish the conventions of later seventeenth-century Venetian productions. Between 1639 and 1669, Cavalli wrote more than forty operas for the city's theaters; the most successful of these works was his *Giasone* (Jason), which was first performed in 1649. The work was typical of many of the commercial operas of the period. It included many subplots, lavish staging, the frequent use of dance, and scenes of comic relief set amidst a story that was of a generally serious moral tone. Cavalli's chief competitor in writing for the Venetian operatic scene was Piero Antonio Cesti (1623–1669), who wrote more than 100 operas in his brief life, only a small portion of which have survived.

TRANSFORMATIONS ON THE VENETIAN STAGE. As the competition heated up between the city's opera houses, lavish spectacle and the intermingling of comic and serious elements that Cavalli and Cesti displayed in their works became increasingly common. The quality of singing also became more important to audiences, and operas now filled up with arias that were written to showcase performers' talents. In contrast to the relatively straightforward songs that had been inserted into the art form in the early years, the aria now emerged as a central focal point of the genre. They grew longer and more complex, and eventually reflected the taste for the *da capo* style, (a form that used the musical scheme "ABA"). As these changes were occurring, critics of the Venetian stage attacked the reliance on improbable plot twists and the intermingling of comic and tragic impulses in these productions, elements that seem to have been widely popular. In the final quarter of the seventeenth century two events transformed the operatic stage in Venice. First, in 1674 one of the city's houses, the Teatro S. Moisè, slashed its ticket prices, forcing other theaters in the city to follow suit. This move dramatically expanded yet again the audience for opera in the city, while at the same time, placing most of the theaters on a tighter shoestring that limited the money available for spectacle and opulence. At about the same time, Venice's Grimani

family opened a new theater, the Teatro Grimano a San Giovannia Grisostomo, that charged high ticket prices in exchange for operas with lavish production standards. Thus as the seventeenth century drew to a close, Venice's opera houses had become divided into two classes: those that served a broad popular audience and a small minority of houses that catered to the expensive tastes of the city's patricians and wealthy merchants.

OPERA SPREADS. As Venetian opera emerged as an important force on the Italian cultural landscape, its customs and production methods spread first throughout Italy and then beyond the peninsula to Northern Europe. A key element in the diffusion of Venetian opera to other regions was the touring companies that impresarios gathered to perform operas in various cities throughout Italy. Of these early producers Benedetto Ferrari (c. 1603–1681) was instrumental in setting a standard that later impresarios followed. Ferrari himself was a librettist, composer, and musician, who had mounted the first opera productions with a touring troupe at Venice in 1637. During the 1640s he toured with a company that made major stops in Bologna, Modena, Genoa, and Milan, and a decade later he staged the first operatic productions before the imperial court in the Holy Roman Empire. By this time touring companies had already established a foothold for opera in Naples, then a territory that was a Spanish possession, and by 1651, the popularity of the genre there had given birth to an opera house similar to those of Venice in the city. By the end of the seventeenth century Naples was Italy's second capital of opera production. In France, the first productions of the new Italian operas occurred in the years between 1644 and 1652, and the familiarity of the audience with the new Italian innovations soon gave birth to attempts to produce a native art form that was independent of southern examples. Elsewhere the new art form penetrated European regions unevenly. Spain and England remained relatively untouched by the new Italian genre during the seventeenth century, while in Germany, Italian opera inspired a genre that imitated Italian forms for almost a century. As opera established a permanent commercial presence in Venice, throughout Italy, and somewhat later throughout Europe in the years of the mid-seventeenth century, the artistic possibilities of the genre expanded opera's range of dramatic expressiveness and artistic techniques.

ARCADIAN REFORMS. Still, not everyone approved of the lavish taste for spectacle and the confused mixture of plots and subplots that sometimes found their way onto the new opera stages of Europe. During the last quarter of the seventeenth century, critics at Venice and from throughout Europe began to attack as absurd the

crowd-pleasing productions that had grown increasingly common in previous decades. The foundation of the Teatro Grimano a San Giovanni Grisostomo at Venice in 1677 was one development that pointed to the increasing impatience of elites with the popular confections they believed were all too common in the city's opera house. The theater's express purpose had been to elevate production standards in the city and to appeal to a more educated clientele. In France, initial experimentation with the production of *dramma per musica* soon gave way to criticism and spawned an attempt to create an operatic style more in keeping with the traditions of the country's drama. These criticisms did not go unnoticed throughout Italy, and in 1690 the foundation of the Arcadian Academy at Rome aimed to reform the country's poetry and drama. In its efforts, the Arcadian Academy imitated the Académie Française that had been founded by Louis XIII's prime minister, Cardinal Richelieu, in 1634. Richelieu's organization had served to establish stylistic canons for the reform of French drama along classical lines. Similarly, the Arcadian reformers advocated a return to classical restraint in opera and drama and they encouraged librettists to make use of pastoral themes and heroic tales from Antiquity. While not all writers of text for the opera championed the movement's aims, the Academy had a broad influence on the operatic world in Italy in the several decades following 1690. A number of librettists, including Apostolo Zeno and Pietro Metastasio, began to produce texts for operas along the lines advocated by the Arcadian reformers. The effect of these reforms eventually shaped the *opera seria*, or serious opera, of the eighteenth century. Alessandro Scarlatti (1660–1725) and Giovanni Bononcini (1670–1747) were among the most important composers of the early eighteenth century to set this new style of classical poetry to music. Thus while the reforms of the Arcadian Academy had not succeeded in transforming opera into a more restrained and coherent art form by the end of the seventeenth century, the forces were gathering strength for an important reform of opera in the eighteenth century.

SOURCES

Lorenzo Bianconi and Giorgio Pestelli, *Opera Production and Its Resources*. Trans. Lydia G. Cochrane (Chicago; London: University of Chicago Press, 1998).

Roger Parker, *The Oxford History of Opera* (Oxford: Oxford University Press, 1996).

Stanley Sadie, ed., *History of Opera* (Basingstoke, England: Macmillan, 1989).

———, ed., *The New Grove Dictionary of Opera* (London: Macmillan, 1992).

OPERA IN FRANCE

FROM ITALY TO FRANCE. During the first half of the seventeenth century conditions in France improved after the violence that had been widespread in the country during the French Wars of Religion (1562–1698). A tentative stability returned to the country, and the state's economy and its political and cultural institutions revived. Under the control of powerful ministers like Cardinal Richelieu, Cardinal Mazarin, and Jean Baptiste Colbert, France's royal government played a key role in administering the country's economy and in shaping developments in the arts. Cardinal Richelieu (1585–1642) had been a particularly vigorous supporter of the development of French drama, but his successor Cardinal Mazarin was Italian-born and nourished Italian art forms at the French court, a controversial policy that did little to endear him to many of the French nobility. Between 1645 and his death in 1661, he commissioned Italian troupes to stage a number of operas at the French court. Mazarin had been named chief minister of France just before the death of Louis XIII in 1643, and during the long minority of Louis XIV (r. 1643–1715) he played a vital role in shaping French state policies. Mazarin raised money for his elaborate productions of Italian operas by means of new taxes, and this did little to promote a love of Italian opera among the French. During the series of rebellions known as the Fronde, Mazarin's support of Italian opera was widely criticized in Paris as one cause of the state's fiscal weakness, and for a time, the Cardinal, the Queen Mother, and Louis XIV were forced from the capital into exile. Mazarin's Italian artists, including many who had participated in the operas staged at court, were also threatened with imprisonment, and many fled Paris. Eventually, Mazarin succeeded in quelling the Fronde, and as he returned to a position of security, he continued to nourish the development of opera in Paris. Yet while his efforts to support the new art form continued until his death in 1661, they were always controversial. While some admired the music of the new Italian art form, many rejected it because its conventions ran counter to the styles of performances that were then fashionable in the French aristocratic society. The French court already enjoyed drama, particularly elevated tragedies of the kind that Pierre Corneille (1606–1684) was writing at the time. A popular song form of this era in French court production was the *air de cour*. These airs were written in verses or strophes, and used a lute or another instrument as accompaniment. *Airs de cour* figured commonly in France's most elaborate court entertainment, the *ballet de cour*, a lavish spectacle that mixed dancing, poetry, and music to present loose narratives

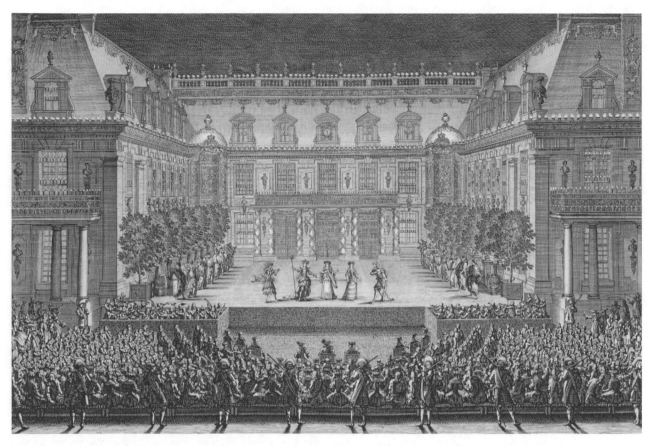

A performance of Jean-Baptiste Lully's *Alceste* held at the Marble Court at the Palace of Versailles in 1674. THE ART ARCHIVE/
BIBLIOTHÈQUE DES ARTS DÉCORATIFS PARIS/DAGLI ORTI.

drawn from antique legends and myth. These ballets featured elaborate costumes and sets that made use of the most up-to-date theatrical machinery of the time. Their music and choreography was highly developed by the early years of Louis XIV's reign, and the king himself and many of his nobles danced in these productions. Louis XIV grew up to be an excellent dancer, and he enjoyed his roles on stage. His title of the "Sun King" developed, in fact, from the role he played as Apollo, the Sun God, in the 1653 production of the *Ballet de la nuit* (The Ballet of the Night).

CHARACTERISTICS OF THE EARLY OPERA IN FRANCE. Since the late sixteenth century ballet had been a central preoccupation of the French court, and so it is not surprising to see that the earliest productions of Italian operas Mazarin patronized included a more notable role for dancing than had been the case in Italy. Three-act Italian operas were stretched to five to make room for generous interludes of dancing between the acts. In his efforts to try to nourish the development of the genre in Paris, Mazarin also imported several set designers and theatrical architects, and he spent enormous sums on

stage machinery to produce spectacles he hoped might capture the imagination of the French court. As his power grew during the 1650s, he spent ever more lavishly on his efforts to promote Italian opera in France. Shortly before his death in 1661, Mazarin secured the services of Francesco Cavalli, then Venice's greatest composer of operas, to write an opera to commemorate the marriage of Louis XIV to the Spanish princess. Cavalli came to Paris for two years, and Mazarin brought the Italian stage designer Gaspare Vigarini to Paris to build an elaborate theatre with the most up-to-date stage machinery. But neither the theater nor Cavalli's opera was completed in time to celebrate the king's marriage. Another of Cavalli's Venetian operas was substituted at the last minute, and was performed in a makeshift hall in the Palace of the Louvre. When two years later both the new theater and Cavalli's commission, *Ercole amante*, were completed, Cardinal Mazarin was already dead, and little interest seems to have existed in the production of the work. *Ercole* was staged nonetheless because enormous sums had already been laid out for its production. Performed in Cardinal Mazarin's vast new theater, the Italians complained that Vigarini's stage machinery had

Drawing of Jean-Baptiste Lully. THE LIBRARY OF CONGRESS.

a PRIMARY SOURCE *document*

LULLY'S CAUTION

INTRODUCTION: Jean-Baptiste Lully was one of the most prolific composers of the seventeenth century. His many operas defined the art long after his death, with later composers often defending their creations by recourse to Lully's example. In this excerpt from Sir John Hawkins *A General History of the Science of Music* (1776), the author related this comic anecdote about Lully, theatrical to the very end, and the fate of one of his creations.

A story is related of a conversation between Lully and his confessor in his last illness, which proves the archness of the one, and the folly of the other, to this purpose: for some years before the accident that occasioned his illness, Lully had been closely engaged in composing for the opera; the priest took occasion from hence to insinuate, that unless, as a testimony of his sincere repentance for all the errors of his past life he would throw the last of his compositions into the fire, he must expect no absolution. Lully at first would have excused himself, but after some opposition he acquiesced; and pointing to a drawer wherein the draft of *Achilles and Polixene* lay, it was taken out and burnt, and the confessor went away satisfied. Lully grew better, and was thought to be out of danger. One of the young princes, who loved Lully and his works, came to see him; and "What, Baptiste," says he to him, "have you thrown your opera into the fire? You were a fool for giving credit thus to a dreaming Jansenist, and burning good music." "Hush, hush, my Lord," answered Lully in a whisper, "I knew very well what I was about, I have a fair copy of it." Unhappily this ill-timed pleasure was followed by a relapse.

SOURCE: Sir John Hawkins, *A General History of the Science and Practice of Music*. Vol. 2. (1776; reprint, with an introduction by Charles Cudworth, New York: Dover, 1963): 648.

been tampered with, while the audience found the theater's acoustics wanting and were unable to hear the music. The focal point of the lavish production was its ballets, staged by Jean-Baptiste Lully, a rising star in the French court. Together with Cavalli's musical drama, the production of *Ercole amante* lasted more than six hours, and those who commented upon it at the time focused more attention on the work's dances than they did on its drama. The work thus proved to be the last of the Italian operas staged in France. Francesco Cavalli returned to Italy, resolved never more to write for the theater, a resolution he soon broke upon his return to Venice. In Paris, the experience seems, too, to have soured French composers from any more experiments with the genre. It would not be for another decade that the king's composer and musical superintendent, Jean-Baptiste Lully (1632–1687) turned to compose opera, and although an Italian by birth, Lully was to mold the original Italian art form to suit French tastes.

LULLY'S OPERA. Although Lully had originally been born and raised in Italy, he had come to France early in life to serve as a dancer and violinist in the home of a relative of the king. Lully had been forced to flee Paris in 1652 during the Fronde, but when he returned his reputation grew, and he was soon given a position at court. During the 1650s he choreographed and wrote music for the *ballets de cour* and on occasion even danced beside the king. By 1661, he had been appointed super-intendent of the court's music and a court composer. Other honors followed, but in the years immediately following Mazarin's death and the ill-fated productions of Cavalli's operas at Paris, Lully dedicated himself largely to providing light entertainments for the court. Until 1671, he collaborated with the great French playwright Molière on a number of comedy ballets, a French genre that mixed dialogue, dance, and song. In 1672, Lully purchased a royal monopoly to produce operas in Paris, and he founded the Royal Academy of Music, an

institution that became known over the next century merely as the Opera, and which until the French Revolution possessed the sole right to produce French operas in Paris. Over the next fifteen years, Lully produced a series of beautiful operas that molded the Italian form to native French traditions of drama, music, and dance. His works came at a time when the tone of the French court was growing more serious, as Louis XIX abandoned his youthful frivolity under the influence of his pious second wife, Madame de Maintenon. Lully developed a style of recitative that adapted its Italian features to the traditions of French theater and drama. His solo songs resembled the airs de cour that had been popular in the ballets de cours. His operas featured ornate costumes, sets, and stage machinery, as well as many ballets and other dances. Most of them told stories based on mythological subjects, as can be seen in the titles of such works as *Proserpine*, *Psyché*, and *Alceste*. Others were based on medieval and Renaissance courtly romances, such as *Roland* and *Amadis*. They used a five-act format, a style derived from Aristotle's discussion of the ideal dramatic form. In contrast to the many plots and subplots typical of Italian *dramma per musica* of the time, Lully chose his librettos carefully, favoring works by the accomplished French poet Philippe Quinault. The productions he mounted were tragedies that conformed to the French canons of dramatic performance outlined in the laws of the unities. These rules were derived from sixteenth-century French humanist interpretations of Aristotle and had been established as canonical in the spoken tragedies favored by the Académie Française since the 1630s. These rules stipulated that all action in a drama should be confined to treating a single plot that occurred in one place and time. Like French tragedies of the seventeenth century, Lully's operas were thus conceived of as edifying and morally uplifting dramas, although many of their heroes referred in some way to Louis XIV, and thus served a role as royal propaganda. Lully also developed the form for the overture that introduced and began the opera. By the time of his death in 1687, the great composer's considerable operatic production had left France with a set of works that was largely to be considered "canonical" over the course of the next hundred years.

FRENCH OPERA AFTER LULLY. Lully's monopoly on opera production during his lifetime kept rivals at bay, and kept Paris as France's operatic center. After his death, several composers carried on Lully's traditions. Chief among his immediate successors was Marc-Antoine Charpentier (1643–1704), a composer who slipped into a centuries-long obscurity soon after his death. Charpentier's works have recently been revived, studied, and

Engraving of Jean-Philippe Rameau. © CORBIS.

performed. His *Medée* has now been restored to its rightful place as a masterpiece of the French genre. Influenced by Lully's pattern of composition, Charpentier's *Medée* and two other operas he wrote for the Royal Academy have been seen as having their own individual voice, and providing a rich font of compositional invention. As in Lully's time, most of the plots of French opera still came from Greco-Roman Antiquity, though some were based on tales from medieval or contemporary literature and the Bible. In their emphasis on classical themes and on the avoidance of subplots, Lully and his successors' works influenced the Arcadian reforms that were underway in Italy in the years around 1700. Those efforts, centered in the Arcadian Academy of Rome, argued for a reform of Italian opera to remove subplots, comedy, and other crowd-pleasing innovations that aesthetic theorists judged were not in keeping with the serious moral tone they argued should pervade the genre. Although many French operas of the late seventeenth and early eighteenth centuries displayed a fondness for tragic stories, elaborate dance and ballet were more frequently incorporated into these productions than elsewhere in Europe. At the same time other dramatic musical genres persisted, and like Lully's famous early collaborations with the playwright Molière in the production of comédie-ballets, later French composers wrote many

MUSIC AS A SCIENCE

INTRODUCTION: Jean-Philippe Rameau first rose to prominence on the musical scene in France as a musical theorist, before becoming the country's greatest composer since Jean-Baptiste Lully. His operas were widely hailed as the successor to Lully's late seventeenth-century masterpieces. In his musical theory Rameau continued to outline principles that had been discussed since the Renaissance: music's foundation as the science of sound and its relationship to mathematics. The arguments built upon these principles led to his reputation as one of the most influential music theorists in the Western tradition.

However much progress music may have made until our time, it appears that the more sensitive the ear has become to the marvelous effects of this art, the less inquisitive the mind has been about its true principles. One might say that reason has lost its rights while experience has acquired a certain authority.

The surviving writings of the Ancients show us clearly that reason alone enabled them to discover most of the properties of music. Although experience still obliges us to accept the greater part of their rules, we neglect today all the advantages to be derived from the use of reason in favor of purely practical experience.

Even if experience can enlighten us concerning the different properties of music, it alone cannot lead us to discover the principle behind these properties with the precision appropriate to reason. Conclusions drawn from experience are often false, or at least leave us with doubts that only reason can dispel. How, for example, could we prove that our music is more perfect than that of the Ancients, since it no longer appears to produce the same effects they attributed to theirs? Should we answer that the more things become familiar the less they cause surprise, and that the admiration which they can originally inspire degenerates imperceptibly as we accustom ourselves to them, until what we admired becomes at last merely diverting? This would at best imply the equality of our music and not its superiority. But if through the exposition of an evident principle, from which we then draw just and certain conclusions, we can show that our music has attained the last degree of perfection and that the Ancients were far from this perfection, ... we shall know where we stand. We shall better appreciate the force of the preceding claim. Knowing thus the scope of the art, we shall devote ourselves to it more willingly. Persons of taste and outstanding ability in this field will no longer fear a lack of the knowledge necessary for success. In short, the light of reason, dispelling the doubts into which experience can plunge us at any moment, will be the most certain guarantee of success that we can expect in this art.

If modern musicians (i.e., since Zarlino) had attempted to justify their practices, as did the Ancients, they would certainly have put an end to prejudices [of others] unfavor-

works that combined singing, dancing, costumes, and a plot, but with lighter themes. These works, known as opéra-ballets and comédie-ballets, persisted throughout the eighteenth century.

JEAN-PHILIPPE RAMEAU. While a number of competent composers continued to write for the Parisian Opera in the generation or two after Lully's death, none attracted the attention or controversy that Jean-Philippe Rameau (1683–1764) did. Rameau reinvigorated the French tradition of opera and his works helped to sustain its popularity until the later eighteenth century. The composer began writing for the stage relatively late in life, after he had already had a successful career as a music theorist. Despite his late start, he left behind an enormous opus of works in many different genres. While Lully's works for the operatic stage had been largely tragedies, and had eventually discarded all comic elements, Rameau wrote tragedies, lyric comedies, operatic ballets, and heroic pastoral dramas. His works made use of some of the by-now canonical traditions of Lully—that is, they combined brilliant poetry and delicately created recitative with dance and choruses. But Rameau employed a broader range of themes than Lully, and his work reveals a generally lighter dramatic touch. He also adopted the most popular Italian innovations of the late seventeenth and early eighteenth centuries to the French stage. Among those influences he derived from Italian opera was the use of the da capo style of aria—that is, one in which the aria followed an "ABA" organization scheme. In other regards, too, Rameau tried to blend the best of new Italian opera with French style, and he fashioned carefully composed recitatives and arias that conveyed the character's emotions. French audiences cared greatly about their opera and operatic traditions, and not everyone approved of Rameau's innovations. These included a larger and more diverse orchestra; bold, new harmonies and dissonances; expressive rhythms; and richer orchestrations than those of the generally restrained operas of Lully and his followers. A whole party of critics declared itself supporters of Lully, and rejected Rameau's new works as

able to them; this might even have led them to give up those prejudices with which they themselves are still obsessed and of which they have great difficulty ridding themselves. Experience is too kind to them. It seduces them, so to speak, making them neglect to study the beauties which it enables them to discover daily. Their knowledge, then, is theirs alone; they do not have the gift of communicating it. Because they do not perceive this at all, they are often more astonished that others do not understand them than they are at their own inability to make themselves understood. This reproach is a bit strong, I admit, but I set it forth, deserving it perhaps myself despite all my efforts. In any case, I wish this reproach could produce on others the effect that it has had on me. It is chiefly to restore the noble emulation that once flourished that I have ventured to share with the public my new researches in an art to which I have sought to give all its natural simplicity; the mind may thus understand its properties as easily as the ear perceives them.

No one man can exhaust material as profound as this. It is almost inevitable that he will forget something, despite all his pains; but at least his new discoveries, added to those which have already appeared on the same subject, represent so many more paths cleared for those able to go further.

Music is a science which should have definite rules; these rules should be drawn from an evident principle;

and this principle cannot really be known to us without the aid of mathematics. Notwithstanding all the experience I may have acquired in music from being associated with it for so long, I must confess that only with the aid of mathematics did my ideas become clear and did light replace a certain obscurity of which I was unaware before. Though I did not know how to distinguish the principle from the rules, the principle soon offered itself to me in a manner convincing in its simplicity. I then recognized that the consequences it revealed constituted so many rules following from this principle. The true sense of these rules, their proper application, their relationships, their sequence (the simplest always introducing the less simple, and so on by degrees), and finally the choice of terms: all this, I say, of which I was ignorant before, developed in my mind with clarity and precision. I could not help thinking that it would be desirable (as someone said to me one day while I was applauding the perfection of our modern music) for the knowledge of musicians of this century to equal the beauties of their compositions. It is not enough to feel the effects of a science or an art. One must also conceptualize these effects in order to render them intelligible. That is the end to which I have principally applied myself in the body of this work, which I have divided into four books.

SOURCE: Jean-Philippe Rameau, *Treatise on Harmony.* Trans. Philip Gossett (New York: Dover, 1971): xxxiii–xxxv.

discordant, sentimental, and emotionally overwrought. Others praised Rameau and his new, thoughtful writing. Still others criticized any and all efforts to bring Italian styles into French music, arguing that French styles were far superior and could only be damaged by foreign imports. In this way French opera remained an arena both for great entertainment and for serious commentary and criticism about the very concept of cultural identity in France throughout the eighteenth century.

SOURCES

James R. Anthony, *French Baroque Music: From Beaujoyeulx to Rameau* (London: Batsford, 1978).

James R. Anthony, et al, eds., *French Baroque Masters: Lully, Charpentier, Lalande, Couperin, Rameau* (London: Macmillan, 1986).

Charles William Dill, *Monstrous Opera: Rameau and the Tragic Tradition* (Princeton: Princeton University Press, 1998).

Donald Jay Grout, *A Short History of Opera,* 2nd ed. (New York: Columbia University Press, 1965).

Michael F. Robinson, *Opera Before Mozart* (London: Hutchinson, 1978).

SEE ALSO *Dance: The Rise of the Ballet in France*

OPERA IN THE EARLY EIGHTEENTH-CENTURY WORLD

EXPANSION. Perhaps the most notable feature of opera in the eighteenth century was its rapid spread throughout the European world. In the course of the seventeenth century, opera had been a performance phenomenon in Italy, in France, and in about twenty courts and cities throughout Central Europe. During the eighteenth century, opera houses were founded in some fifty additional cities and courts. Opera spread to the far corners of Europe, with new houses appearing in Spain, Portugal, Scandinavia, England, and Moscow. The expansion, though, was most pronounced in Central Europe, particularly in the Holy Roman Empire, a

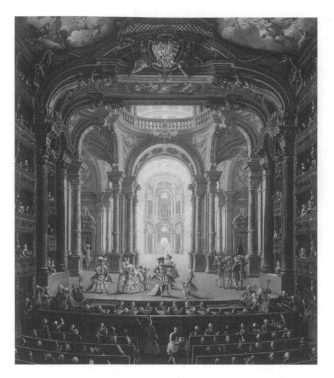

Interior of the Teatro Regio in Turin, Italy, on the night of its inauguration. This theater was one of the many new opera houses founded in the eighteenth century. ART RESOURCE.

region of the continent that had long been divided into many small states. Here rulers of both large and small territories found in opera an appealing art form to compete for cultural glory. As the eighteenth century progressed, the operatic world in Central Europe adapted itself to the demands of the Enlightenment, the great international philosophical movement that championed human reason and the abandonment of the fanaticism and superstition of the European past. Works that glorified the principles of this philosophical movement came to be performed in many of the new houses. At the same time the operatic world of the eighteenth century was extremely varied, and many of the new houses were court theaters that were heavily subsidized by princes. In these venues works with traditional themes drawn from Antiquity, legend, and history were performed alongside lighter fare that offered a more purely entertaining value.

ITALIAN OPERA IN CENTRAL EUROPE. Although some of the theaters imitated the French styles of production pioneered by Lully, the opera houses in Central Europe, by and large, followed Italian examples. Italian impresarios brought their productions to the cities and courts of the region, and composers and librettists from the peninsula were lured to Vienna, Berlin, and Dresden with long-term contracts. In the century and a

half following 1650, the German-speaking lands of the region provided a steady source of employment for Italian composers and musicians. During the seventeenth century Antonio Cesti (1623–1669), Antonio Draghi (c. 1635–1700), Marc'Antonio Ziani (1653–1715), and Antonio Bertali (1605–1669) were just a few of the Italians who found permanent employment at Vienna's court opera house. In the eighteenth century Antonio Caldara (1670–1736) and the now famous Antonio Salieri (1750–1825) were just a few of the many figures that carried on the Italian tradition in the German-speaking world at this time. Vienna was by no means unusual, and for most of the seventeenth and early eighteenth centuries operas written by native German speakers were a rarity. As the eighteenth century progressed, more German-born composers began writing operas, although many of these figures were trained to do so in Italy. While there were occasional attempts to compose operas in German, most artists chose librettos that were written in Italian. One exception to this rule, however, was Hamburg's Theater am Gänsemarkt, a theater founded by members of Hamburg's merchant and commercial classes in 1678 with the express purpose of nurturing operas in German. Many of the works performed there, nevertheless, made use of librettos that had been translated from Italian. Hamburg's Theater did have a major impact on the training of German composers to write opera, and it counted George Frideric Handel among the distinguished ranks of German artists who had written works for its stage.

VARIETY OF OPERA HOUSES. Great variety characterized the conditions of European opera houses in the eighteenth century, and a range of houses, from the modest to the luxuriant and palatial, was a fact of the age. The major houses of Venice and Naples sat at the apex of this world, as well as the great court theaters of Vienna, Paris, Berlin, and Dresden. These court operas were generally unable to survive without generous financial support from their royal patrons. Beneath these great theaters were a number of smaller court theaters and commercial houses. This last category was a thoroughly commercial affair charged by its investors with making a profit. These commercial theaters consequently economized on many productions, staging operas with scenery and costumes that were considerably more modest than those produced in the great houses of Venice, Naples, and Vienna. Theaters like this often shared productions with other houses, and scenery, costumes, and singers were carted around to perform a work in many different locations. Generally, the eighteenth-century season was made up of far more "new" operas than it was of re-

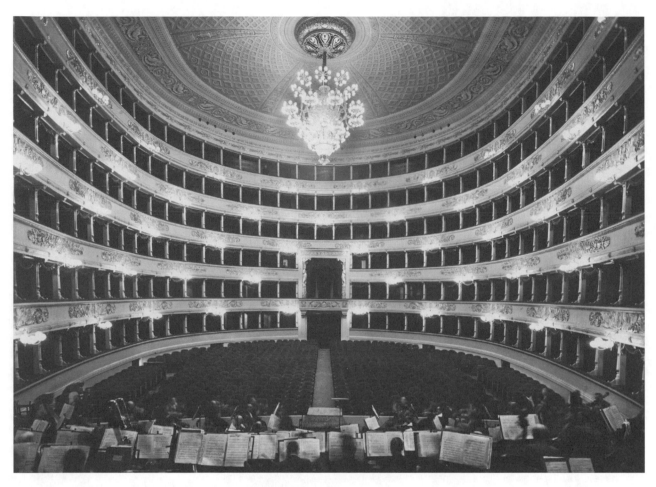

Interior of La Scala opera house in Milan, Italy. © BETTMANN/CORBIS.

vivals of older works, since the idea of an operatic repertory had not yet developed at this time and audiences craved novelty. Only in France were the operas of Jean-Baptiste Lully systematically revived from generation to generation. It was far more normal throughout the rest of Europe for an opera to be written for a season, to be performed several times, and after being repeated a season or two later, to be largely forgotten. This fact of eighteenth-century production continues even now to lure modern performers and opera directors into musical archives in search of the discarded gems of the eighteenth century.

ITALIAN DOMINANCE. Many of the singers, composers, and librettists who worked in Europe's opera houses first mastered their craft in the two great centers of Italian opera of the time: Venice and Naples. Venice's rise to leadership in the operatic world had begun already in the 1640s, and the city continued to shape operatic tastes well into the eighteenth century. By that time, though, Naples was not far behind as a discriminating center of new productions, and in the course of the eighteenth century it would, in most connoisseurs'

minds, surpass Venice for its innovation. Operas written and performed in these Italian cities began to develop standard features. Not content with hearing a simple basso continuo supporting much of the recitatives, audiences began to expect to hear more from the orchestra during the course of an evening. The musical entertainment, in fact, became the center of attention, far more so than the plots of the stories themselves, which might on their own seem far fetched. In both cities people flocked to hear star soloists, and to hear them sing arias written especially to show off their star qualities. Traveling troupes often carried Italian opera, especially those from Venice and Naples, to the rest of Europe. These tours nourished the composition of Italian operas in places far beyond the peninsula in the course of the eighteenth century. At this time many European courts and urban opera houses began hiring Italian composers and librettists to remain in residence and write operas and librettos for them; thus, before long, an "Italian opera" might well be written anywhere in Europe. In planning a production, an impresario looked first, if he could, for

a PRIMARY SOURCE *document*

RUSHED COMPOSITIONS

INTRODUCTION: In modern times composers have often labored over their operatic productions for years before allowing the public to see a glimpse of their works. This was not the case in the Baroque world, where operas were produced quickly to satisfy an almost insatiable appetite for the art form. The librettist Carlo Goldoni provides us this glimpse on how Antonio Vivaldi worked as he describes an incident in which the great Venetian composer had him re-write the entire text of an aria while he waited.

That year, for the Ascension opera, the composer was the priest Vivaldi. … This most famous violinist, this man famous for his sonatas, especially for those known as the *Four Seasons,* also composed operas; and although the really knowledgeable people say that he was weak on counterpoint and that he handled his basses badly, he made the parts sound well, and most of the time his operas were successful.

…Vivaldi was very concerned to find a poet who would arrange, or disarrange, the play to his taste, by adapting, more or less, several arias that his pupil had sung on other occasions; since I was the person to whom this task fell, I introduced myself to the composer on the orders of the *cavaliere padrone* [Grimani]. He received me quite coldly. He took me for a beginner and he was quite right; and not finding me very well up in the business of mutilating plays, one could see that he very much wanted to send me packing.

He [Vivaldi] knew the success my *Belisario* had had, he knew how successful my *intermezzi* had been; but the

adaptation of a play was something that he regarded as difficult, and which required a special talent, according to him. I then remembered those rules that had driven me mad in Milan when my *Amalasunta* was read, and I too wanted to leave; but my situation and the fear of making a bad impression on His Excellency Grimani, as well as the hope of being given the direction of the magnificent theatre of S. Giovanni Grisostomo *[sic],* induced me to feign and almost to ask [him] to try me out. He looked at me with a compassionate smile and took up a little book:

"Here," he said, "is the play that has to be adapted, Apostolo Zeno's *Griselda*. The work is very fine. The part for the prima donna could not be better. But certain changes are necessary … If Your Lordship knew the rules … Useless. You cannot know them. Here, for example, after this tender scene, there is a cantabile aria. But since Signora Anna does not … does not … like this sort of aria (in other words she was incapable of singing it), one needs here an action aria … that reveals passion, but not pathos, and is not cantabile."

"I understand," I replied. "I will endeavour to satisfy you. Give me the libretto."

"But I need it for myself," replied Vivaldi. "When will you return it?"

"Immediately," I replied. "Give me a sheet of paper and a pen."

"What! Your Lordship imagines that an opera aria is like an intermezzo aria!"

SOURCE: Carlo Goldoni, *Commedie,* Vol. 13, (1761), in Alan Kendall, *Vivaldi*. (London: Chappell, 1978): 77–79.

his main singers. Then he would seek out a good libretto, perhaps one that had done well in another city—one that was well known elsewhere, and hence was in demand. Many musical scores belonged to the individual composer or impresario who first wrote or produced it and hence could not easily be copied so often a new one would be written on the spot by a local composer, using a pre-existing libretto. One of the most accomplished libretto writers of the eighteenth century was Pietro Metastasio (1698–1782), who worked for more than fifty years in Vienna at the Hapsburg court opera. He tried to construct believable plots that were instructive as well as entertaining, and that conformed to the best principles of good drama. As much in demand as his libretti were, it was nonetheless common practice to edit them as local producers saw fit, adding or dropping

arias, cutting a recitative here or adding one there, as seemed appropriate to the local production. The search for new material meant that many composers frequently scrambled to satisfy the demands of the companies for which they worked. Tales abound of composers left to work through the night, beset with demands from singers and impresario alike, finishing the music at the very last minute. Handel, for example, wrote the entire opera *Tamerlano* in less than three weeks in 1724. According to legend, Wolfgang Amadeus Mozart did not complete the overture for his masterpiece *Don Giovanni* until the night before its first performance. In this overheated world, often governed by commercial demands and a taste for new stories set in lush and sometimes exotic surroundings, many composers frequently reused material from one opera to the next. The greatest stars of the

opera world were itinerant, moving about the continent from place to place to make the most of the financial possibilities their skills offered. Singers were also expected to embellish the lines of a composer's arias in order to show off their technique and musical personality. Thus an older aria, or its melodies, might have a very different effect when reused in a new production and sung by a different singer.

RISING TECHNICAL DEMANDS. During the eighteenth century schools that specialized in training operatic singers appeared in Venice, Naples, and other Italian cities. Specialized training over many years was becoming increasingly necessary to support the technical demands that composers now made on singers; singers seem happily to have risen to these challenges in order to win adulation from their audiences. In Italy, a major preoccupation of technical training often involved the teaching of the methods that later became known as *bel canto*, or "beautiful singing." In the years since the eighteenth century considerable dispute has raged among singers and music historians about the precise techniques that Italian singing teachers used in the eighteenth century. The evidence suggests that they spent a great deal of time perfecting a singer's *legato*—the ability to sing a passage in a perfectly smooth manner. Attention was also directed at the initial stages of instruction to the singer's ability to produce the *messa di voce*—a sustained tone that began softly and then built to a crescendo before diminishing once again. This exercise built incredible strength and self-control. In subsequent stages greater attention was concentrated on the upper registers, and the voice was expected to be kept light and agile so that it could perform brilliantly in coloratura passages—in the many florid embellishments of trills, roulades, cadences, and other vocal embellishments by which singers showed off their abilities on the opera stage. This training and its techniques were well suited to the opera houses of the period, which were generally small and intimate. Even the largest European houses, for instance, rarely accommodated more than about 800–900 patrons. Projecting the singing voice in these small spaces was not as much of a problem to eighteenth-century singers as it would become later. By the mid-nineteenth century, as opera houses were quickly doubling or tripling in size and orchestras were swelling to include an hitherto undreamed of number of instruments, new kinds of techniques became popular to ensure that a singer's voice carried throughout the hall.

BRILLIANT CAREERS. Both men and women were expected to master the cornerstones of Italian singing methods, and the commentators of the period frequently reserved their most exuberant praise for male sopranos,

that is, the castrati that were fixtures of the Italian opera world of the time. Of these figures, no one ever surpassed, by virtue of technique or achievements, the great Neapolitan male soprano Carlo Broschi (1705–1782), who was widely known as Farinelli. Accounts of Farinelli's art suggest the great technical prowess that Italian eighteenth-century methods ensured. The German composer Johann Joachim Quantz (1697–1773), who had personally heard him, left one of the best accounts of his technique. Quantz stressed that Farinelli's voice was perfectly modulated, able to execute the most technically difficult passages, and highly agile throughout the entire range of his voice. In the early stages of his career, Quantz observed, the singer's range extended already from the A below middle-C to the D above high-C. Later, Farinelli acquired even lower tones, but was able to continue to reach the high notes with complete surety. Because of his enormous range, composers typically provided him with different kinds of arias in the operas in which he starred. One was almost always written in the range of a contralto, while several others showed off his abilities in the higher registers of a coloratura soprano. Farinelli, and other castrati singers like him, became European-wide sensations. In the years following his Neapolitan debut, the singer toured Italy extensively before conquering the continent and then eventually making his London debut in 1734 in the company of George Frideric Handel's chief rival, Nicola Porpora (1686–1786), Farinelli's former teacher. Although Handel had negotiated with the artist, he had, much to his chagrin, been unsuccessful in securing Farinelli's services, and in the three-year period in which Farinelli sang for Porpora, the singer helped to establish the company of Handel's rival as a major competitor on the London scene. In 1737, the English capital's love affair with the male soprano came to an abrupt end. Farinelli broke his contract and fled to Spain, where he accepted a position as a singer in the royal household. Having heard of his amazing vocal qualities, the Spanish queen sought the singer's services as a way of treating the severe depression of her husband, King Philip V. As a condition of his contract at the Spanish court, Farinelli had to sing a number of arias to the king each night before he went to bed, a duty the castrato executed faithfully for the nine years before Philip's death in 1746. For these and other services to the crown, Farinelli was knighted, and when he retired from Spain to his hometown of Bologna in 1759, he continued to live a comfortable existence for the rest of his life. In these years he received visits and letters from Europe's greatest composers and political figures, including Wolfgang Amadeus Mozart, Christoph Willibald von Gluck, and the Austrian emperor Franz Joseph.

a PRIMARY SOURCE *document*

THE OPERA SCENE IN NAPLES

INTRODUCTION: Like many other eighteenth-century Englishmen, Samuel Sharp took the Grand Tour, a long circuit through Europe's major cultural capitals that usually culminated in Italy. His tour occurred in 1765 and 1766, and when he returned to England he published the letters he had sent home along the way. This excerpt from one of them describes the various opera houses at Naples and their performances.

Naples, Nov. 1765

Sir,

A stranger, upon his arrival in so large and celebrated a city as Naples, generally makes the publick spectacles his first pursuit. These consist of the King's Theatre, where the serious Opera is performed, and of two smaller theatres, called Teatro Nuovo, and the Teatro dei Fiorentini, where they exhibit burlettas [i.e. comic operas] only. There is also a little dirty kind of a play-house, where they perform a comedy every night, though the Drama has so little encouragement at Naples, that their comedies are seldom frequented by any of the gentry.

The King's Theatre, upon the first view, is, perhaps, almost as remarkable an object as any a man sees in his travels: I not only speak from my own feeling, but the declaration of every foreigner here. The amazing extent of the stage, with the prodigious circumference of the boxes, and height of the ceiling, produce a marvellous effect on the mind, for a few moments; but the instant the Opera opens, a spectator laments this striking sight. He immediately perceives this structure does not gratify the ear, how much soever it may the eye. The voices are drowned in this immensity of space, and even the orchestra itself, though a numerous band, lies under a disadvantage: It is true, some of the first singers may be heard, yet, upon the whole, it must be admitted, that the house is better contrived to see, than to hear an Opera.

There are some who contend, that the singers might be very well heard if the audience was more silent; but it is so much the fashion at Naples, and, indeed, through all Italy, to consider the Opera as a place of rendezvous and visiting that they do not seem in the least to attend to the musick, but laugh and talk through the whole performance, without any restraint; and, it may be imagined, that an assembly of so many hundreds conversing together so loudly, must entirely cover the voices of the singers.

Notwithstanding the amazing noisiness of the audience, during the whole performance of the Opera, the moment the dances begin, there is a universal silence, which continues so long as the dances continue. Witty people, therefore, never fail to tell me, the Neapolitans go to see, not to hear, an Opera. A stranger, who has a little compassion in his breast, feels for the poor singers, who are treated with so much indifference and contempt: He almost wonders that they can submit to so gross an affront; and I find, by their own confession, that however accustomed they be to it, the mortification is always dreadful, and they are eager to declare how happy they are when they sing in a country where more attention is paid to their talents.

The Neapolitan quality rarely dine or sup with one another, and many of them hardly ever visit, but at the Opera; on this account they seldom absent themselves, though the Opera be played three nights successively, and it be the same Opera, without any change, during ten or twelve weeks. It is customary for Gentlemen to run about from box to box, betwixt the acts, and even in the midst of the performance; but the Ladies, after they are seated, never quit their box the whole evening. It is the fashion to make appointments for such and such nights. A Lady receives visitors in her box one night, and they remain with her the whole Opera; another night she returns the visit in the same manner. In the intervals of the acts, principally betwixt the first and second, the proprietor of the box regales her company with iced fruits and sweet meats.

Besides the indulgence of a loud conversation, they sometimes form themselves into card parties; but, I believe, this custom does not prevail so much at present as it did formerly, for I have never seen more than two or three boxes so occupied in the same night.

SOURCE: Samuel Sharp, *Letters from Italy.* 3rd ed. (London, 1767): 77–79, 82–84, 92–93, in *Music in the Western World: A History in Documents.* Eds. Piero Weiss and Richard Taruskin (New York: Schirmer, 1984): 231–234.

FIERCE COMPETITION. In a world in which technical brilliance was prized over the opera's ability to dramatize, changes were sure to occur in the character of the opera. By the eighteenth century operas were filling up with arias, and singers were known to fight in rehearsals about who among them had the best ones.

The best singers were able to demand that composers and librettists re-write works to improve their parts. As these singers traveled around Europe, they often brought with them "suitcase arias," works that they had performed in other productions and which had often been written personally for them by a composer to show

off their special talents. The most powerful singers were able to bargain to have these arias inserted into a production in a new city, a practice that conflicted greatly with a composer's vision of how his work should unfold since arias that often had little to do with the dramatic needs of one production came to be interpolated into a work with very different intentions. In the late eighteenth century Wolfgang Amadeus Mozart satirized these operatic conventions and poked fun at the backbiting, competition, and intrigue that existed in the backstage world of the opera, a world that he knew only too well. At one hilarious point in his one-act opera, *Der Schauspieldirektor* (The Impresario) two of the theater's female singers engage in an hysterical dispute over which of them is the theater's "prima donna" or "first singer." Mozart's brilliant satire summed up his impatience with opera's star system and its egos, but the historical evidence of the time suggests that the situation that he mocked was only too real. At the same time, the world of fierce competition that undeniably existed in the theaters of eighteenth-century Europe provided one source of entertainment for the committed opera fan. Following the personalities of the operatic stage was, then, even as it is now, a preoccupation of those who loved the art form.

ARIA DA CAPO AND OPERA SERIA. By the mid-eighteenth century the aria had increasingly become a vehicle for singers anxious to demonstrate their skills. In many cases, particularly in the serious operas that experts began in the later eighteenth century to term *opera seria*, these arias were written in the da capo format, that is, with an organizational scheme of "ABA." At the opening of the aria, in other words, a performer sang a theme (the A section). This theme was usually repeated before the singer presented a second theme (the B section) and then returned to repeat the first section, usually twice, before a final cadence or series of cadenzas drew the work to a conclusion. The phrase "da capo," meaning "from the head" or "from the top," referred to the recapitulation or repeating of the theme that occurred at the aria's conclusion. There were other types of organizational schemes used in the arias of the day. Some arias, notably the cavata or its shorter variation, the cavatina, were written in the form "AB," rather than "ABA," meaning that they lacked a final recapitulation. But the rise of the da capo form to popularity and obligatory use in opera seria or "serious opera" had become one of the conventions of the genre by the mid-eighteenth century. The opera seria was, in fact, a form that had experienced a long gestation. Its origins lay in the realities of the operatic world of Venice and other Italian cities at the end of the seventeenth century. Dis-

Portrait of Carlo Broschi or Farinelli, one of the eighteenth century's most famous castrati. © ARCHIVO ICONOGRAFICO, S.A./CORBIS.

pleased with the crowd-pleasing spectacles that had become common in Venice's houses, the patrician Grimani family had founded the Teatro S. Giovanni Grisostomo in 1677 to cater to an elite clientele that craved works with high standards of production and literary and dramatic values. Within a few years, the writings of the members of the Arcadian Academy at Rome insisted that Italian opera needed to be rescued from the spectacle and comic burlesque into which much of the genre had fallen. Like Jean-Baptiste Lully and other French composers of the day, these Italian figures were concerned that opera be preserved as a tragic dramatic genre that would treat themes drawn from ancient myths, tales about heroes, and pastoral subjects. Many of the ideas of the Arcadian reforms were put into practice at the Grimanis' Teatro S. Giovanni Grisostomo before they spread elsewhere in the operatic world. By 1720, the opera seria was firmly ensconced as a genre in many Italian opera houses. Soon it spread throughout Europe, where by virtue of its elevated themes, it became particularly popular in the great court theaters. Here stories about ancient heroes or gods could be either subtly or overtly modulated to praise the enlightened but despotic princes of the age. In the libretti for

these dramas, cultivated poets like Pietro Metastasio frequently concentrated on the internal emotional turmoil of the central characters. Arias written in the da capo format provided one readily adaptable way to dramatize the torment that a work's hero or heroine experienced, with the middle B section providing a dramatic contrast to the enveloping A theme. Still, producing an opera seria, a form that was composed of numerous arias, required considerable skill on the part of a composer. It was common in the course of an evening of opera seria for performers to move through 25 arias on the path to the work's resolution or tragic ending. And so composers developed many variations on the form and relied upon it in tandem with other types of arias. At the same time the da capo form of aria was also favored by singers, many of whom dramatically embellished the A theme's recapitulation, and who relied on these works' concluding cadenzas to display their vocal firepower.

OPERA BUFFA. The most serious operas had serious subjects, mainly stories from myth and history. Yet by the eighteenth century, the opera-going public was broad enough that many audiences preferred light entertainment to enlightening and uplifting tales. Thus while librettists such as Metastasio succeeded in making "opera seria" a genuinely grand and serious matter, others helped fill a niche for lighter fare. If serious opera had its literary champion in the great poet Metastasio, the Italian comic dramatist Carlo Goldoni (1707–1793) proved to be a shaping force in the history of lighter operas throughout Europe. Goldoni wrote both for the spoken stage and the opera house, producing eighty libretti for light operas that were widely set to music in the eighteenth century. Feeling that Italian comedy had fallen into decline through the stock improvisations of contemporary *commedia dell'arte* performers, Goldoni labored to rescue the genre. But if opera seria largely served as a commentary on the internal world of personal emotions, the libretti that Goldoni crafted for comic operas commented on problems that were inherently social in nature. His plots were classic comedies of manners that included generous helpings of cases of mistaken identity, mismatched lovers, and rival suitors, all with an edge of moral purpose in that they parodied the social conventions of the age. If Goldoni made a major impact on the genre of opera buffa's lyricism, it was Giovanni Battista Pergolesi (1710–1736) who helped to shape much of this eighteenth-century genre's musical conventions. This short-lived composer wrote two works that have long been accepted as among the first comic operas, *Lo frate 'nnamorato* (The Brother in

Love), first produced at Naples in 1732; and *La Serva padrona* (The Maid as Mistress), staged one year later in the same city. Both works became tremendously successful, although the second enjoyed a particularly long life and was widely imitated throughout Europe. In truth, *La Serva padrona* was not an opera at all, but a light entertainment or intermezzo that had been commissioned to be staged during the intermission of one of the composer's opera seria. In the years following Pergolesi's death, both the libretto and music for *La Serva padrona* were performed in more than sixty opera houses throughout Europe. In Paris in the years after 1752, the work's staging by a troupe of Italian *buffo* performers— that is, comic singers or "buffoons"—excited controversy, producing ranks of admirers and detractors that commented upon its light farce in newspapers and short tracts. Thereafter, its French champions began to use the work's musical and poetic conventions to fashion shorter kinds of *opéras comique* (comic operas). Elsewhere in Europe, Pergolesi's light confection inspired the works that became known as opera buffa. The form proved to be beloved and particularly long-lived, as nineteenth-century composers like Gaetano Donizetti (1797–1848) and Giochino Rossini (1792–1868) continued to satisfy audience's cravings for this light fare well into the nineteenth century.

SOURCES

David R. B. Kimbell, *Italian Opera* (Cambridge, England: Cambridge University Press, 1991).

Roger Parker, *The Oxford History of Opera* (Oxford: Oxford University Press, 1996).

Ellen Rosand, *Opera in Seventeenth-Century Venice: The Creation of a Genre* (Berkeley, Calif.: University of California Press, 1991).

Stanley Sadie, ed., *The New Grove Dictionary of Opera* (London: Macmillan, 1992).

ORATORIO AND CANTATA

THE RISE OF THE ORATORIO. The oratorio rose to prominence as a genre of religious vocal music performed outside of churches; the name came from houses of prayer built for devotional groups in Rome, in which these early works were performed. An oratorio is dramatic like an opera, and the form developed at nearly the same time as opera. One of the very earliest musical dramas, Emilio de' Cavalieri's *Rappresentatione di Anima et di Corpo* in 1600, seems in many ways as much like an oratorio as an opera. An oratorio's story line is normally religious, while that of opera normally is not. Another

difference is the absence of acting; the singers in an oratorio do not act out their parts on a stage, so they do not usually use costumes or sets. Rather, they simply stand and sing, as do the rest of the chorus, and a narrator describes the action. Oratorios began to serve as substitutes for opera during Lent in Italian cities. Opera seemed too flamboyant for the penitential season; the religious subject matter of oratorios seemed more appropriate, yet audiences could still enjoy attending a performance that featured musical styles similar to opera. Giacomo Carissimi (1605–1704) was an important early composer of oratorios in Rome, helping to establish the genre's characteristic features. Like operas, oratorios relied on a mixture of recitative, arias, and choruses, with recitative usually being used to narrate events and arias to highlight particularly important parts of the biblical stories on which the libretti were based. Choruses were usually more prominent in Carissimi's oratorios than in operas, and such was true of the genre as it continued to develop in the later seventeenth and eighteenth centuries. Oratorios relied on all the musical styles popular in Italy at the time, but as the form spread to France and composers like Marc-Antoine Charpentier (1643–1704) began to write them, they used styles developed from French opera as well. By the later seventeenth century, the German-speaking regions of Central Europe were adding the oratorio to their own long-standing traditions of presenting religious plays during Holy Week and Easter as well as at Christmas and other religious holidays. The oratorio became a particularly important form of music in Protestant as well as Catholic regions of the Holy Roman Empire, and Hamburg, a Lutheran city in northern Germany, became an especially important center for oratorios.

HANDEL AND THE ENGLISH ORATORIO. Thanks to the presence of the German composer George Frideric Handel (1685–1759), the oratorio also became a popular form of religious music in eighteenth-century England. Handel had worked in Hamburg when he was a young composer and in 1707 he had traveled to Rome. Although he was a Lutheran, he had composed two oratorios there in the Catholic style between 1707 and 1708. Returning to northern Europe in 1710, Handel spent most of the next thirty years as a composer of operas, musical dramas, and other choral works for the city's churches and royal court. In these years he made only sporadic efforts to develop the composition of oratorios for English audiences. Toward the end of the 1730s Handel returned to the form, and he eventually developed it into a new genre that differed significantly from its Italian or continental European sources of in-

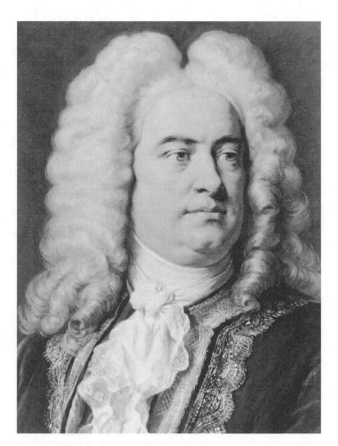

George Frideric Handel. © BETTMANN/CORBIS. REPRODUCED BY PERMISSION.

spiration. In 1741, he presented two of his works in the genre, *Samson* and his great masterpiece *Messiah*, at concerts in Dublin. They were enormous successes, and were soon performed in London. Although the *Messiah* is the most widely known of these works, it was also the most atypical of Handel's oratorio compositions because it relies on a libretto that is not dramatic. There are, in other words, no major events that are narrated in the work. Instead Handel chose a text for the *Messiah* that had been arranged by Charles Jennens from the Old Testament prophets and certain passages in the English Book of Common Prayer. The manner in which the work presents its message—that Jesus Christ is the fulfillment of Old Testament prophecy—was a departure from many of the oratorios of the past. The work does not, in other words, concentrate on the activities of Jesus' life or on his Passion, but on the way in which his mission fulfilled the promises of the Old Testament. Despite this subtle and essentially non-dramatic approach, Handel's *Messiah* still manages to treat the important events of Christ's ministry through allusions to those events in the words of the Old Testament Prophets. In Handel's other English oratorios, his approach was more fundamentally

dramatic—that is, he served to narrate a biblical story—and his works were, like their Italian counterparts, essentially substitutes for operas. They adopt as their subjects incidents from the Old Testament and the books of the Apocrypha, which their librettists gave a theatrical cast that was often influenced by their understanding of Greek drama. Most of Handel's seventeen oratorios are preceded by an overture that is usually written in the French style. In this form a lively fugue usually follows a stately introduction. One of the most distinctive and beloved features of Handel's oratorios is their choruses, which display considerable vitality and variety. Some, like the famous "Hallelujah Chorus" from the *Messiah*, are conceived as mixtures of massive and strong chords with generous doses of counterpoint. Some are conceived of as fugues; others are influenced by the long-standing traditions of madrigal and motet writing, and are complex exercises in polyphony. And still others present a melody set against simple, and sometimes even haunting, harmonies. Handel's example helped to establish a distinctively English form of oratorio that persisted in the country throughout the eighteenth and nineteenth centuries.

THE CANTATA. The cantata was also developed in Rome and spread from there to the rest of Europe. Like the oratorio, it was sung but not staged, but it used any sort of theme and any number of voices, from one to many; for example, a secular cantata for two voices might use a man and a woman and have a romantic theme. A cantata also resembled an opera in that it combined arias with sections of recitative, and might in fact seem rather like a scene from an opera that simply stood on its own. Cantatas also became very popular in German Protestant regions as church music, particularly within the Lutheran Church. These sacred cantatas, or chorale cantatas, were often built around a familiar hymn or chorale. References might be made to the chorale throughout the cantata, and the chorus sang it at the conclusion in its traditional four-part harmony. The demand for cantatas from composers, many of whom served as church organists, was particularly great during the years of the late seventeenth and early eighteenth centuries, and enormous numbers of cantatas were written at this time. Georg Philipp Telemann (1686–1767), for example, seems to have written as many as 1,700 cantatas during his life, of which 1,400 survive today in printed and handwritten versions. Telemann was atypical, but his output illustrates the almost insatiable appetite for cantatas in the Lutheran church during the first half of the eighteenth century. Many of Telemann's cantatas were composed while he was musical director of the court of Saxe-Eisenach, and in the cities

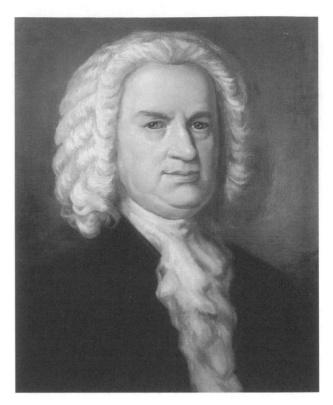

Portrait of Johann Sebastian Bach. **ARCHIVO ICONOGRAFICO, S.A./CORBIS.**

of Frankfurt and Hamburg. It was a common requirement of these positions that composers like Telemann regularly compose a new cycle of cantatas for the church year, which were then revived and performed at later dates. These cycles demanded at least sixty independent compositions for the weeks of the year, and the other feasts that were commemorated with music in the church. During Telemann's time in Eisenach, he was expected to finish a cycle of cantatas and church music for the city's churches once every two years. In Frankfurt, the town demanded that he produce a new cycle every three years. But in Hamburg, where the composer spent the years between 1721 and his death in 1767, he was expected to provide two cantatas for each Sunday as well as a concluding chorus or aria for the service. Despite this punishing schedule, a schedule that was also crowded with the demands of directing the city's opera and its choral school, Telemann proved more than able to produce the necessary music. During these years he also managed to write 35 operas and other works for the city's theater and to take on commissions for occasional music for Hamburg's wealthy citizens and nobles elsewhere in Germany. Telemann, who was ever open to the commercial possibilities his talents offered, was able in Hamburg to publish several of his cantata cycles, a rel-

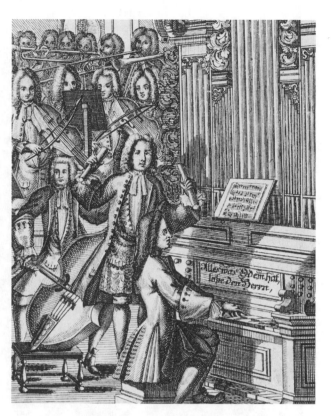

St. Thomas Church in Leipzig, where Johann Sebastian Bach was musical director. © RICHARD KLUNE/CORBIS.

A concert in Germany around 1730. THE ART ARCHIVE/SOCIETY OF THE FRIENDS OF MUSIC VIENNA/DAGLI ORTI.

ative novelty at the time. The composer's cantatas were widely performed throughout the Lutheran churches of Germany, and by the second half of the eighteenth century, they were among the most commonly sung works in the German Lutheran church.

THE CANTATAS OF JOHANN SEBASTIAN BACH. While he did not outdo Telemann in quantity, the cantatas of Johann Sebastian Bach rank among the most widely revered composition of the Baroque period. The great German composer wrote cantatas throughout his entire life in every court and church position in which he served. Bach's cantatas used both sacred and secular texts, although far fewer of his secular cantatas have survived than his sacred ones. Of the works written for the celebration of Sunday and holiday services, it is estimated that forty percent have not survived. Like other composers of the day, Bach reused much material, sometimes adapting melodies and arias composed from his early days in Weimar and Cöthen to the needs of his position in Leipzig. It was in this last city where Bach spent the greater part of his creative career. His position as organist of the St. Thomas Church in Leipzig and city musical director was one of the most respected musical positions in Germany, and in it, Bach was expected to provide new music for the choirs of the city's major churches.

At the small Calvinist court of Cöthen where Bach had been immediately before beginning his tenure in Leipzig, the role of service music in the court chapel had been relatively limited. As Bach began his tenure in the new position in 1723, he evidenced enormous ambitions to develop a new kind of sacred music for the celebration of weekly services. During his first year at Leipzig he completed a cycle for the liturgical year consisting of sixty cantatas. Given the press of time and his other duties as music master at St. Thomas's boarding school, Bach was forced in these early years to rely heavily on compositions he had already written in other positions. Despite these pressures, the first cycle that he composed in 1723–1724 includes an enormous amount of new material, and was conceived of as a "double" cycle—that is, it included two cantatas for each Sunday, one for before and one for after the sermon. He followed this first series of cantatas with a second cycle written in 1724–1725, a third between 1725–1727, and a fourth between 1728–1729. A fifth cycle was likely written over many years during the 1730s, although only fragments of these cantatas survive. Unlike the cantatas written in Central Europe to this time, Bach's works were truly innovative and designed with an intellectual program that was coherent and readily intelligible. He relied on

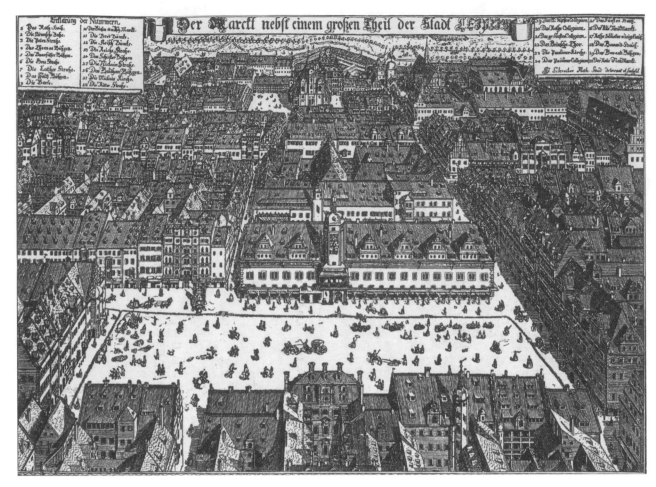

Engraving of eighteenth-century Leipzig. **BETTMANN/CORBIS**.

similar organizational schemes in many of these works, often alternating choruses with recitatives followed by arias and in many cases including a French overture to precede the entire work. In the earliest Leipzig works he relied upon texts of previously developed cycles that included a large amount of sacred poetry. Later he relied more firmly on the biblical texts from the lectionary of the particular Sunday. Many of the Leipzig cantatas, too, can be distinguished by opening movements, which are often conceived in a grand and stately style with rich orchestral accompaniment. These works, too, often conclude with a chorale or hymn sung by the entire choir. In his Leipzig years, Bach also wrote cantatas on secular themes and subjects, although the press of his church obligations there meant that he produced fewer of these kinds of works in this position than he had at earlier times in his career. Of the secular cantatas written during this period one of the most famous is his "Coffee Cantata," a comical work about a girl who loved drinking coffee. As in Bach's other works, the "Coffee Cantata" displays a wealth of fertile invention.

SOURCES

Denis Arnold, *The Oratorio in Venice* (London: Royal Musical Association, 1986).

Anthony Lewis and Nigel Fortune, eds., *Opera and Church Music, 1630–1750* (London: Oxford University Press, 1975).

David Schulenberg, *Music of the Baroque* (New York; Oxford: Oxford University Press, 2001).

Howard E. Smither, *A History of the Oratorio* (Chapel Hill, N.C.: University of North Carolina Press, 1979).

K. Marie Stolba, *The Development of Western Music: A History* (Boston: McGraw Hill, 1998).

SEE ALSO *Religion: Protestant Culture in the Seventeenth Century*

BAROQUE INSTRUMENTS

IDIOMATIC COMPOSITION. Baroque composers often wrote music for particular instruments, taking into

account their special sounds and qualities—that is, their tonal and harmonic possibilities, their distinctive voice, and range of pitches—to produce works that often have been described as "idiomatic." Composers became increasingly prescriptive about the instruments upon which their music should be played. Hence, the music of the Baroque era differed fundamentally from the medieval and Renaissance periods that had preceded it. In those earlier eras the choice of particular instruments had largely been left up to musicians themselves, who were free to choose from all the available possibilities to perform a particular piece. Many Baroque composers, by contrast, became especially famous for their writing for specific instruments. Domenico Scarlatti (1685–1757), for example, was widely known for his compositions for the harpsichord. Scarlatti himself was a virtuoso keyboard player, and his published works for the harpsichord became widely used exercises for students. These works showed off the full range of tonal possibilities and effects that could be gleaned from the best playing on the instrument, and they influenced many later composers' works for the harpsichord. What Scarlatti helped to accomplish for the harpsichord, Dietrich Buxtehude (1637–1707) and Johann Sebastian Bach (1685–1750) came to do for the pipe organ, creating works that have remained since their time among the most brilliant and accomplished compositions for that instrument. Numerous examples might be cited of new repertory that came into being during the Baroque, which was written for the specific abilities woodwind and string instruments now offered.

KEYBOARD INSTRUMENTS. By the seventeenth century composers had a number of different kinds of keyboard instruments to choose from when they wrote their works, and each of these had its own distinctive characteristics. The chief keyboard instruments of the Baroque were the organ, harpsichord, clavichord, and at the end of the period, the pianoforte. Although the organ is played by virtue of a keyboard, its sounds are produced by wind rushing through pipes. Among keyboard instruments it is unique in its ability to sustain a particular tone so long as the organist holds down a particular key. The organ can also make a wide variety of sounds, depending upon the construction of its pipes. Baroque organs steadily grew in size and complexity and they came to offer the possibility of playing an independent musical line with the feet on a pedalboard. Use of the pedals was particularly advanced in the Baroque period in northern Germany, and this region of Europe had developed a number of organ virtuosi, including Buxtehude and Bach, by the early eighteenth century. Often

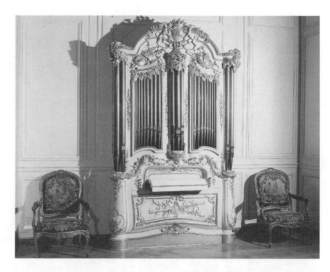

Organ in the apartments of Madame Adelaide in the Palace of Versailles. THE ART ARCHIVE/DAGLI ORTI.

a town's pipe organ was, like its clock or glockenspiel, a matter of intense pride, and the instrument was added onto, remodeled, and modernized to fit the changing tastes of the era. Figures like Bach supplemented their incomes by evaluating the organs of other churches, and suggesting to town and parish councils ways in which the instrument might be improved. Massive pipe organs, though, were hardly household instruments, although smaller scaled units were sometimes found in wealthy homes and the palaces of the nobility. By and large, the chief domestic keyboard instruments of the era were the clavichord and harpsichord, which produced their sounds by striking or plucking strings. Musicians and composers often used the clavichord, considerably smaller and less expensive than the harpsichord, as a practice instrument. It is a difficult instrument to play since it requires strength and dexterity of hand, and produces a much quieter sound than a modern piano. Later Baroque musicians often relied upon it to build technical strengths that they could then apply to harpsichord and pianoforte playing. Unlike the harpsichord, the instrument provided a considerable dynamic range, and when struck vigorously it produced a much louder tone. Few Baroque composers, though, exploited the instrument's strengths, with the exception of Carl Philipp Emanuel Bach (1714–1788), one of Johann Sebastian's sons, who wrote a number of works for the clavichord in the later eighteenth century. The harpsichord was more popular with composers, and since the mid-seventeenth century this instrument had been undergoing constant technical innovations. At that time the harpsichord had become popular as an instrument for solo performance and for accompanying singers. It was favored in part because its

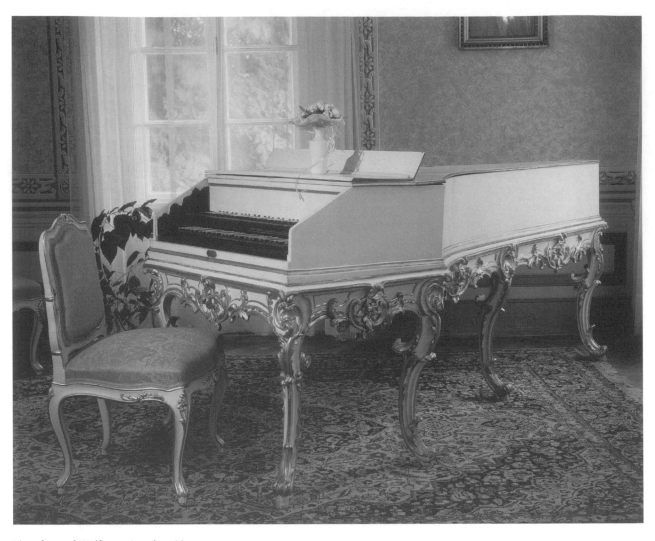

Pianoforte of Wolfgang Amadeus Mozart. © ARCHIVO ICONOGRAFICO, S.A./CORBIS.

sound was not unlike that of the lute, which in both the Renaissance and early Baroque periods was the most common domestic instrument in use throughout Europe. Like the lute, many keys could be struck on the harpsichord simultaneously to play chords, and for this reason the instrument played a key role in many of the orchestras and ensembles of the Baroque era. The harpsichord, like the organ, provided a ready source of continuous accompaniment to other instruments. It was also widely used in the theaters of the time as the instrument favored to accompany operatic recitatives. By the mid-eighteenth century, however, its limited dynamic range—that is, its inability to play loud and soft—meant that it was to become increasingly replaced by the fortepiano once such dynamic range became a prominent feature of composition and performance. A relative newcomer among the keyboard instruments of Europe, the fortepiano was invented in the early years of the eighteenth century.

Rather than its strings being plucked, they were struck by hammers, and a player was thus able to produce great dynamic contrasts. It was for this reason that that instrument was originally known as the *clavicembalo col piano e forte*, or a "loud and soft harpsichord." Few Baroque-era composers explicitly stipulated the pianoforte's use in their compositions, since its popularity did not gain ground until the second half of the eighteenth century.

STRING INSTRUMENTS. The violin, along with its related stringed instruments played with bows, rose to great prominence during the Baroque era, in part because its sound has so much in common with the human voice, and composers of the era valued vocal singing highly. Some composers became especially well known as composers for the violin and other stringed instruments, such as Arcangelo Corelli (1653–1713) and Antonio Vivaldi (1678–1741). The violin had begun to appear in Europe

in the fifteenth century, about the same time as the family of instruments known as viols had developed. Violins were distinguished from viols by the fact that they were held at the chin, while the viols were usually held in the lap or between the legs. While both viols and violins persisted throughout the Baroque period, members of the viol family like the viola da gamba were generally unable to compete with violins in dynamic range, and by the mid-eighteenth century they had begun to fade in popularity. Today the violin family consists of the violin, the slightly larger and lower-pitched viola, the cello, and the double bass. While these instruments are related to those of the Baroque period, violins differed regionally in Europe during the era, and there was considerable change and development over time in construction techniques throughout the period. Most pieces written for string ensembles concentrated on lines written for the violin and the viola. The undeniable rise in the violin's popularity in the seventeenth century can be seen in the appearance of a number of centers of violin production throughout Europe. By the early seventeenth century the Italian towns of Cremona and Brescia were already famous for their violins, and Cremona was eventually to produce the two makers, Antonio Stradivarius (c. 1644–1737) and Giuseppe Guarneri (1698–1744), by which quality standards have been judged in modern times. In the seventeenth and eighteenth centuries, however, many other makers and regions were known for the quality of their violins. The instruments of Jacob Stainer (1617–1683), a producer from the Tyrol in Austria, were widely admired throughout Europe, as were those produced at Mirecourt and Paris in France. Regional variations in musical composition and practices tended more and more to produce differences in the style of violin playing throughout Europe. By the end of the seventeenth century, for example, there was a recognizable "French style" of violin playing that was characterized by greater control over bowing and precision in rhythm and the use of ornamentations, a style that derived from the use of the violin in France to accompany operas and ballets and in the playing of the French overtures. By contrast, the Italian style of composition for the violin concentrated on showing off a player's virtuosity through brilliant passages of ornaments, runs, and trills.

WOODWINDS. Wind instruments had a variety of uses. Some, like horns and trumpets, were often used outdoors for fanfares, processions, hunting, and military occasions. They were more often used in groups, and seldom served as solo instruments. On the other hand, some woodwinds became so popular that instrument makers helped adapt and change them in order to make them better solo instruments, though woodwinds continued to serve in ensemble performances as well. By the later seventeenth century, the flute and the oboe had begun to compete with the violin as solo instruments that could be as expressive as a singer. During the Baroque period flutes were produced in two different varieties: the recorder and the transverse flute. Recorders are played by blowing air through a hole in their end, while the transverse flute is held sideways. Until about 1740, composers wrote music for both instruments, although after this date the transverse flute came to be favored almost everywhere. Instrument makers worked to extend their range of pitch, similar to the changes in the era's keyboard instruments; they also sought to improve the quality of sound throughout that range, so that the new baroque flutes and oboes could play two octaves and more. The king of Prussia, Frederick II (the Great; r. 1740–1786) was known for his excellent skills in playing the flute. In 1740, Frederick invited the noted flautist and composer Johann Joachim Quantz to Prussia to serve as his court composer. Quantz supplied a generous outpouring of compositions making use of the transverse flute, Frederick's own instrument. He was also a noted flute maker, and he produced a number of flutes for the king and for use in the royal household. A number of other eighteenth-century composers wrote works for solo flute or oboe, such as sonatas, much as they wrote for the violin, among them Carl Philipp Emanuel Bach (who worked for Frederick the Great for a number of years) and Georg Philipp Telemann. As the concerto form developed in the later Baroque and classical eras, the flute and the oboe moved into solo roles here as well, to be joined at the end of the century by the newest woodwind, the clarinet. The clarinet has a similar pitch range to the flute and oboe, but both its particular sound and its great dynamic range made it appealing to composers in the later eighteenth century, and it soon became a standard musical instrument both for ensembles and for solo performance.

SOURCES

Gerald Abraham, ed., *Concert Music (1630–1750)* (Oxford: Oxford University Press, 1986).

Philip Bate, *The Oboe: an Outline of Its History, Development and Construction* (London: E. Benn, 1975).

David D. Boyden, ed., *Violin Family* (London: Macmillan, 1989).

Rachel Brown, *The Early Flute: a Practical Guide* (Cambridge, England: Cambridge University Press, 2002).

Donald Jay Grout and Claude V. Palisca, *A History of Western Music.* 6th ed. (New York; London: W. W. Norton, 1996).

Bruce Haynes, *The Eloquent Oboe: a History of the Hautboy, 1640–1760* (Oxford: Oxford University Press, 2001).

Claude V. Palisca, *Baroque Music.* 3rd ed. (Englewood Cliffs, N.J.: Prentice Hall, 1991).

BAROQUE KEYBOARD MUSIC

A MUSIC FOR PROFESSIONALS. For much of the Baroque period keyboard instruments like the organ and harpsichord were the preserve of professional musicians. Organs and harpsichords were expensive instruments that were not readily available to many amateurs. The organ was, by and large, an instrument used in churches, while the harpsichord, although sometimes present in the homes of wealthy merchants and city dwellers, figured most prominently in the musical establishments of Europe's courts. Most often, professional keyboard players served as church organists, although some were also employed at court as harpsichordists. In these roles professional keyboard players were expected to accompany singers, other instruments, small ensembles and orchestras, as well as choirs and congregations. These tasks required the keyboard player to be able to improvise chords and basso continuo accompaniment and to be able to provide improvised interludes and preludes during the services of the church. Training on the keyboard thus stressed thorough knowledge of the basso continuo, improvisational techniques, and counterpoint. Printed music for the keyboard was extremely expensive in the Baroque era, more expensive than other kinds of published music since the multiple lines of keyboard music had to be printed by relying on an expensive engraving technique. As a result, most keyboard players kept a personal library of handwritten musical manuscripts that they added to throughout their lives. Many of these pieces they had composed themselves as exercises in improvisational and contrapuntal techniques. Although the keyboard music, particularly the organ music, of the Baroque today ranks as one of the period's most readily recognizable sounds, solo music written for the harpsichord or the organ was rarely performed during the period in public. The thousands of toccatas, fugues, preludes, and inventions that survive were more an intellectual kind of music intended to train organists and harpsichordists in the skills that were necessary for them in their professional capacities.

ITALIAN KEYBOARD TRADITIONS AND THE ART OF THE FUGUE. During the early seventeenth century several forms of keyboard music appeared in Italy that influenced the compositions of later Baroque composers for these instruments. Chief among those who concentrated on writing for the keyboard was Girolamo Frescobaldi (1583–1643), who served as organist at St. Peter's Basilica in Rome after 1600. Frescobaldi was to have almost as great an impact on writing for the organ and other keyboard instruments in the later Baroque period as Claudio Monteverdi did on the era's vocal music. Like Monteverdi, though, Frescobaldi's compositions remained an amalgam of older Renaissance styles with those of the developing Baroque. He wrote many works for keyboard soloists that were intended to sound like improvisations and which also included stylistic elements of late-Renaissance polyphony. These include fantasias, toccatas, and variations, or, as Frescobaldi termed them, "partitas." All three of these forms had precedents in earlier Renaissance music, although Frescobaldi's genius opened up new horizons in their use. The word "toccata" comes from the Italian for "touch," and works of this sort had developed in the sixteenth century to display a performer's virtuosity on the lute or at the keyboard. It became common, in part through Frescobaldi's published works for the organ, to pair these free, seemingly improvised pieces with a contrasting one in which the counterpoint was carefully worked out following strict rules. Frescobaldi used many terms to describe these contrapuntal movements, although in English they have come to be known as "fugues," since the great German composers, including Johann Sebastian Bach, used that term to describe them. Thus in many later Baroque organ works we find a number of two-part works with names like "prelude and fugue," or "passacaglia and fugue." A fugue was a polyphonic work written in counterpoint that followed very strict rules. It had a set number of voices (often two, three, or four) and was based on a piece of melody called a theme. One voice began by playing through the theme; then, one by one, the new voices entered by stating the same theme while the others continued in counterpoint. Composers played with the theme in fugues by speeding it up, slowing it down, turning it upside down or backwards, putting it in one voice or another, and fitting the other voices with care, until the voices all come together in the conclusion. Listening to a fugue, like writing one, is something of a game and a challenge. Johann Sebastian Bach, one of the greatest composers of organ music in the Western tradition, excelled in their production, and he wrote fugues to be played on the organ and the harpsichord. Later in life, he also composed his instructional book, *The Art of the Fugue*, which developed the arts of counterpoint and polyphony to a very high level of intellectualism. In that work Bach explored the tonal possibilities the fugue form had to offer, including forms that had two and three themes and counter-fugues in which the themes gradually diminished and disappeared.

a PRIMARY SOURCE *document*

ON THE GLORIES AND LIMITS OF THE KEYBOARD

INTRODUCTION: The development of many new instruments in the eighteenth century resulted in an increasing number of texts that treated proper performance techniques as well as the limitations and benefits that these new technologies opened up. C. P. E. Bach, the most illustrious of Johann Sebastian's sons, provided this treatment of the limitations and advantages of the keyboard instruments of his own time.

Keyboard instruments have many merits, but are beset by just as many difficulties. Were it necessary, their excellence would be easy to prove, for in them are combined all the individual features of many other instruments. Full harmony, which requires three, four, or more other instruments, can be expressed by the keyboard alone. And there are many similar advantages. At the same time, who is not aware of the many demands that are made upon it; how it is considered insufficient for the keyboardist merely to discharge the normal task of every executant, namely, to play in accordance with the rules of good performance compositions written for his instrument? How, beyond this, he must be able to improvise fantasias in all styles, to work out extemporaneously any requested setting after the strictest rules of harmony and melody; how he must be at home in all keys and transpose instantly and faultlessly; and play everything at sight whether designed for his instrument or not; how he must have at his com-

mand a comprehensive knowledge of thorough bass which he must play with discrimination, often departing from the notation, sometimes in many voices, again in few, strictly as well as in the galant manner, from both excessive and insufficient symbols, or unfigured and incorrectly figured basses; how he must often extract this thorough bass from large scores with unfigured or even pausing basses (when other voices serve as harmonic fundament) and with it reinforce the ensemble; and who knows how many other things? All this must be done competently, often on an unfamiliar instrument which has not been tested to determine whether it is good or bad, whether it is playable or not, in which latter case extenuation is but rarely granted. On the contrary, it can be expected that, normally, improvisations will be solicited without anyone's being concerned whether the performer is in the proper mood, and if he is not, without any effort being made to create or maintain the proper disposition by providing a good instrument.

Notwithstanding these demands, the keyboard has always found its admirers, as well it might. Its difficulties are not enough to discourage the study of an instrument whose superior charms are ample compensation for attendant time and trouble. Moreover, not all amateurs feel obliged to fulfill all of the requirements. They satisfy as many of them as they care to or as their innate talents permit.

SOURCE: Carl Philipp Emanuel Bach, *Essay on the True Art of Playing Keyboard Instruments.* Trans. William J. Mitchell (New York: W. W. Norton, 1949): 27–29.

FRENCH KEYBOARD MUSIC. In France, the tradition of organ building was well developed by the later seventeenth century, and inspired a distinctive school of organ composition in which compositions for the instrument were often inserted into the celebration of the mass. In contrast to the organs of Italy that featured a clear and smooth sound, French organs were generally larger and outfitted with a wide variety of pipes, many of which imitated the distinctive possibilities and colors of the woodwinds. As a result, French composers for the organ like Nicholas Lebègue (1631–1702) and Nicolas de Grigny (1672–1703) made use of these rich possibilities in the music they composed for the mass. A far larger repertory of French harpsichord music survives, however, from the seventeenth and eighteenth centuries. Much of this music was based upon the dances that were used in French courtly society and the theater, and by the early eighteenth century, the popularity of this kind of music had produced a distinctively French form, the

dance suite, a set of dances that was played on the harpsichord in a specific order. In the years that followed, France produced two composers of genius in the field of harpsichord music: François Couperin (1668–1733) and Jean-Philippe Rameau (1683–1764). Today Couperin is sometimes compared to the great nineteenth-century composer and pianist Frédéric Chopin. The comparison is meant to draw attention to the ways in which both figures understood their instrument and its possibilities. Although Couperin wrote both for the organ and the harpsichord, his pieces for the latter instrument show a distinctive mastery of the harpsichord's special tonal possibilities. Many of the pieces that he wrote for the instrument are short dances, their rhythms and melodies reminiscent of the gigues, courantes, and sarabandes that were played in French ballrooms at the time. Despite their small scale and relatively short duration, the composer still manages to endow these pieces with an appealing complexity that draws the listeners' ears to their

constantly changing subtle melodies, rhythmic schemes, and rich harmonies. Jean-Philippe Rameau, a musical theorist, became a successful composer of operas and ballets in his middle age, but also wrote music for the harpsichord throughout his life. Like Couperin, he made use of the organizational scheme of the dance suite, but his works were characterized by greater virtuosity. He drew inspiration from the brilliant passagework that was popular in the Italian music of the time. Rapid scales, arpeggios, and leaps characterize the most adventurous of Rameau's works for the harpsichord, devices that might have shocked the more restrained Couperin. He was credited with introducing a technique for rapid hand-crossing at the keyboard, a technique that since then has become known as "Rameau hand-crossing." While many of his pieces are extremely difficult and filled with brilliantly complex passages, Rameau was no less careful than Couperin to notate precisely all the embellishments that players of his pieces should make. Thus as most French composers of the time, neither musician left to chance or the musicians' taste their piece's ornamentation. This tendency of French music stood in marked contrast to the Italian music of the period, in which singers and players were both given considerable freedom to improvise and ornament their musical performances as they saw fit.

THEME AND VARIATION. A final musical form, theme and variation, played an important role in the keyboard music of the Baroque period. The theme itself consisted of a melody and accompanying bass line; sometimes the melody was that of a well-known song. The work began with a single rendition of the theme and was then followed by any number of sections that altered it, sometimes ingenuously "hiding" the melody in the bass or another voice so that a listener was forced to "hunt" for it. Each section consisted of a repetition or statement of the theme, but with modifications that kept the theme's basic structure while showing off the skills and talents of both composer and performer. While variations on themes had played an important role in demonstrating musical virtuosity since the sixteenth century, eighteenth-century composers in particular reveled in the form. Of the innumerable examples of this genre that were produced at the time, one of the most famous is Johann Sebastian Bach's "Goldberg Variations," which the composer published in 1741 after visiting with his former student Johann Gottlieb Goldberg, court harpsichordist at Dresden. Like many of his compositions, Bach's "Goldberg Variations" are conceived of as a massive intellectual project and are arranged according to several different organizational schemes. By contrast, the harpsichord theme and variations of George Frideric

Handel, written when the composer was young, display a considerably more playful side. Theme and variation, a form that could alternately be serious or mischievous, survived long after Bach's time. Carl Philipp Emanuel Bach, Franz Josef Haydn, and Wolfgang Amadeus Mozart were just a few of the many composers of the classical era that continued to write variations in the later eighteenth century.

SOURCES

Claude V. Palisca, *Baroque Music*. 3rd ed. (Englewood Cliffs, N.J.: Prentice Hall, 1991).

David Schulenberg, *Music of the Baroque* (New York; Oxford: Oxford University Press, 2001).

K. Marie Stolba, *The Development of Western Music: A History* (Boston: McGraw Hill, 1998).

BAROQUE MUSIC FOR INSTRUMENTAL ENSEMBLES

DEVELOPMENT OF THE ORCHESTRA. The Baroque era saw the survival of older ideas about the constitution of ensembles alongside newer departures. In France and Italy, the groups of players commonly used to accompany court dances at the beginning of the seventeenth century were string bands; that is, they were composed of groups of violins and viols at different pitches. This notion of a consort, inherited from the Renaissance, continued to be popular throughout much of Europe well into the eighteenth century, but it co-existed alongside newer kinds of ensembles, ensembles that, like the modern orchestra, were composed of families of several different kinds of instruments. In France, the number of performers in the *Violins du Roi* ("Violins of the King"), a court ensemble used to accompany dances and ballets, was fixed at 24 by 1618; this string band continued to perform at royal events until it was abolished in 1761. In the later seventeenth century the French composer, Jean-Baptiste Lully, relied on these professionals to provide accompaniment when his operas and ballets were performed at court. When he required a particularly large sound to produce dramatic effects, such as in his overtures, Lully augmented the 24 members of the *Violins du Roi* with the eighteen members of the king's *Petite Bande*, another string consort in the royal household. The result produced a 42-member orchestra, an extraordinarily large ensemble by seventeenth-century standards. The sonority of Lully's experiments with a large string consort, as well as the discipline and uniform performance practices of his players, were much admired by visitors to Paris, and helped to popularize the growth of larger string en-

sembles in other parts of Europe. Nowhere, though, did such string bands grow to more than about two-dozen members during the later seventeenth century. In the German courts of Central Europe, the much smaller resources of the region's principalities meant that courtly string ensembles often had only four to six members. Rarely were more than twelve string players employed in the largest aristocratic households of the region. Vivaldi's instrumental ensembles in early eighteenth-century Venice might number between 20 to 24 strings, and included a harpsichord charged with playing the continuo, that is the chords and harmonies that underlay and supported the melodies and other lines played by the strings. While Vivaldi's ensemble was fairly typical of that used in many early Baroque "orchestras," other sounds were tempting composers to add new families of instruments to their performance ensembles. In this way, many late seventeenth and early eighteenth-century performing ensembles were beginning to acquire more of the features of a modern orchestra. Already in the 1660s, the French composer Lully was sometimes augmenting the large string ensemble used to accompany his operas and court spectacles with other kinds of instruments, including woodwinds, brass, and even timpani players recruited from the king's cavalry. At first, Lully employed these players using the rationale of Renaissance consort playing. Woodwinds and horns, in other words, were integrated into court productions, but they played their parts separately at times different from when the strings played. By 1674, though, the composer had begun to integrate these instrumental voices more thoroughly into the overtures and other incidental music of his operas. Still, in deference to his singers, Lully continued to use only string accompaniment during the action of the opera, so as not to overpower the performers, and these players usually plucked their instruments rather than bowing them. Visitors to Paris were impressed by the sounds that Lully's larger orchestra produced, and in the years following his experiments, larger and more varied ensembles began to appear in many cities throughout Europe.

EARLY EIGHTEENTH-CENTURY DEVELOPMENTS. By the mid-eighteenth century the development of mixed ensembles, ensembles that a modern ear would recognize as being similar to an orchestra, had already become popular in many places throughout Europe. At this time the growth of large ensemble playing was most advanced in Italy and France, although the custom of combining numerous families of contrasting instruments was quickly becoming popular in German-speaking Europe as well as in England. These new ensembles included strings, but also flutes, recorders, oboes, horns, and bassoons, and a new novelty, the "double bass;" although the latter was initially used primarily as a curiosity; it has since gained an essential place in the musical literature of the orchestra since the eighteenth century. The rise of these new small orchestras soon came to have many implications, both in performance practice and repertory. Unlike the older Renaissance system of using consorts of similar instruments that performed separately, the new orchestras were integrated organizations in which the individual families of instruments sat together and each had their own leader. To balance the sound produced in the halls in which they performed, violins were usually divided and stationed on both sides of the group, with violas, cellos, and basses taking their seats in their respective sections. Two oboe players were common in most of these ensembles, and since the oboes did not usually play simultaneously with the flutes, many orchestras included players who were proficient in both instruments and could thus take on double roles. Bassoon, horns, and a harpsichordist who played the continuo were also obligatory features of the new Baroque orchestras; timpani and trumpets were also used, although not as frequently. This orchestral makeup was particularly popular by the mid-eighteenth century in the presentation of operas written in Italian, and it became increasingly common for composers to orchestrate instrumental music with it in mind. The development of such a large and diverse group of players also heightened the importance of the conductor, and a new emphasis on discipline and high performance standards emerged in these ensembles. The range of sound that these groups were capable of producing also inspired a flood of compositions that took advantage of the possibilities of sound and volume that such large groups offered. For inspiration for these works, composers turned both to older forms of suites and overtures and to newer genres of concertos and sonatas. Thus during the period in which the modern orchestra was experiencing its long gestation, a creative ferment was also occurring as composers and conductors experimented with ways to make best use of the new sound possibilities their enlarged ensembles offered.

FRENCH OVERTURE AND ITALIAN SINFONIA. The origins of the French overture, a popular Baroque orchestral form, lay in the ballets and operas of Jean-Baptiste Lully and other French composers active in the mid-seventeenth century. Lully had largely fixed the canons of this form by 1660, having adapted older kinds of entrance music to serve as a prologue for several of his ballets and operas. In these works he first set out a stately theme with tempos that were slow, even grave. Contemporaries described this aspect of the overtures as "majestic" or "heroic." Another feature of the first section included the use of dotted rhythms, that is, rhythms

in which longer "dotted" notes are set against a much shorter note or a succession of short notes. A fast section, reminiscent of a fugue, followed this stately first part. Usually, these themes were introduced quickly, and sometimes the composer abandoned the fugue to return in the second section to music that was more homophonic, that is, in which the ensemble's various melodies more or less move at the same pace and to the same effect. Often a brief restatement of the first part's theme was recurred in a cadence at the very end of the overture as a way of drawing the entire piece to conclusion. In the years following 1660, the style was widely adopted in France by most composers as the obligatory form for fashioning a musical prologue to ballets and operas. It quickly spread throughout Europe, becoming particularly fashionable in Germany. George Frideric Handel often made use of it in his operas, as did Bach who used it as the form for overtures for many of his orchestral suites. In the early eighteenth century, a new Italian form of overture, the sinfonia, was increasingly competing against the popularity of the French overture. In a sinfonia, a fast section was followed by a slow one before another rapid section concluded the overture. This form of prologue became particularly popular in eighteenth-century Italian operas, and gradually eclipsed the once-widespread popularity of the French overture. By the 1740s far fewer French overtures were being written than sinfonias, although late eighteenth-century composers sometimes revived its use. As late as 1791, Wolfgang Amadeus Mozart wrote the overture to his famous opera *Die Zauberflöte* using the form of the French overture.

THE SUITE. Many Baroque composers wrote works in several genres that were made up of multiple sections, each one like a separate composition, that were intended to be performed together at one sitting, one after the next. One example can be seen in the many dance suites that were often constructed out of individual movements, each of which made use of the rhythms and characteristics of the ballroom dances popular at the time. During the Baroque period, hundreds of such dance suites were written for solo instruments such as the lute or harpsichord, for smaller ensembles, and for the larger orchestral groups that were becoming popular. The form and length of each dance, or movement, in a suite depended on the steps of the original dance itself. Suites such as these had already begun to appear during the late Renaissance, and had often followed a specific order. By the middle and later Baroque era, a dance suite often contained a standard set of dances: allemande, courante, sarabande, and gigue. An allemande is duple, and moderate in pace, while a minuet is in three. A courante uses triple time and is livelier. Sarabandes are slower and more

sensual, allowing for more development of a melodic line. A gigue is lively. Also common in dance suites was the rondeau; a rondeau has a basic tune to which it returns several times after an intervening passage, rather like the chorus to a song. Gavottes, chaconnes, minuets, and branles were also dances that often figured in the suites. Handel's *Water Music* and *Music for the Royal Fireworks* are two still-famous compositions that make use of the dance suite form. The *Water Music* was written for a royal barge trip up the Thames River in the summer of 1717, and was first performed on the water by fifty musicians traveling in a barge alongside the king. By contrast, the *Music for the Royal Fireworks* represents a late Baroque elaboration of the original idea of the dance suite, and it includes one of the most brilliant French overtures of the Baroque repertory. In this piece, Handel elaborated upon the earlier form to include a kind of battling duet between the ensemble's trumpets. The premiere version of Handel's *Fireworks* music was originally scored for a woodwind band and was later revised to downplay wind instruments and include a role for strings. Even the revised form in which the music is heard today is noteworthy for the many brilliant, high passages that it includes for trumpets.

THE SONATA. Both the sonata and the concerto are forms whose importance lasted far beyond the Baroque era. They were both Italian forms introduced into both secular and religious music in the early seventeenth century. Originally, both terms were used as simple names for instrumental music, but eventually they developed into very specific forms. Early Baroque sonatas and concertos were scored for a basso continuo (a harpsichord or another instrument that played the bass line) and one or more instruments. These early examples relied on any compositional form for the individual movements. Such descriptions are indeed vague, but the original meaning of the word "sonata" (from "sounded") referred simply to any piece of music that was written for instruments, rather than performed by singers. Thus early Baroque compositions given the name "sonata" might have nearly any form. Before long, however, composers also began to use the term to describe groups of pieces of varying tempos like the popular dance suites of the time. As the sonata became more popular, it gradually acquired a standard shape so that by the eighteenth century, it was a group of three pieces, or movements—two faster ones with a slower movement in the middle. All sonatas, though, continued to be written for instruments. An amazing variety of instrumental pairings flourished in the sonatas of the early eighteenth century. Particularly popular was the trio sonata, which included independent melodic lines for two high-voiced instruments like the

violin set against the bass lines of a continuo, which might be played by a harpsichord or more than one lower pitched instrument. For most of the seventeenth century sonatas were written primarily by Italian composers, many of who became aware of the commercial possibilities that existed in their publication. Antonio Vivaldi (1678–1741) and Tomasso Albinoni (1671–1751) were two of the Italians composers that continued this tradition into the eighteenth century. By that time, however, the sonata had been avidly adopted and imitated by Austrian and German composers and the genre was also becoming increasingly popular in France, a region that had initially resisted it. Thousands of sonatas were now published or circulated in manuscript form, and the genre was one of the most common staples of the instrumental music of the period. In the classical period after 1750, the term "sonata form" also appeared to describe a specific movement, usually the first movement, within a symphony or concerto. At the same time instrumental sonatas for one or more instruments retained their popularity, surviving as an important form of chamber music into the nineteenth and twentieth centuries.

THE CONCERTO. A similar line of development can also be seen in the history of the Baroque concerto, a term that was initially used in a vague and indistinct way, but which eventually described a standardized musical genre. The phrase from the first referred to a concert of instruments together. Many Baroque concertos, especially later ones, consisted of three movements, like sonatas, although the concerto became a standard form only later during the classical and Romantic periods. In a given movement, passages featuring solo performers or groups of performers alternated with those scored for the ensemble. Concertos were often performed at courts, where large numbers of musicians could be kept on staff, and they became prominent during the later Baroque era. Antonio Vivaldi was perhaps the single greatest force in popularizing the concerto format in the early eighteenth century. He wrote more than 500 of them; they circulated throughout Europe, and their popularity helped to standardize many of the conventions of the genre in the eighteenth century. Like other Italian musical forms of the period, Vivaldi's concertos placed great emphasis on brilliant passagework that showed off a player's virtuosity. The composer also developed the already existing tendency of Italian composers to insert a *ritornello*—that is, a repeating refrain into his movements—so that the soloist and ensemble appear as if they are speaking back and forth to one another. Almost half of Vivaldi's enormous output of concertos was written for the violin; he wrote most of the others for the cello, flute, oboe, and bassoon. A number of these works were written as double concertos, that is, for two solo instruments with similar sounds. While Baroque concertos, like those of Vivaldi, increasingly highlighted the virtuosity and distinctive musical idiom of a particular instrument, another less popular form of concerto, the concerto grosso (meaning, "great concerto"), still remained popular. In these compositions the playing of a large group of instrumentalists was contrasted against passages of a small ensemble. Arcangelo Corelli (1653–1713) had developed this form in the seventeenth century, and both George Frideric Handel and Johann Sebastian Bach made use of it in the eighteenth century. Bach's *Brandenburg Concertos*, presented to the Margrave of Brandenburg in 1721 in hopes of attaining a position in his court, are perhaps the greatest surviving example of the concerto grosso from the Baroque.

SOURCES

Gerald Abraham, ed., *Concert Music (1630–1750)* (Oxford: Oxford University Press, 1986).

Nicholas Anderson, *Baroque Music: From Monteverdi to Handel* (London: Thames & Hudson, 1994).

Claude V. Palisca, *Baroque Music*. 3rd ed. (Englewood Cliffs, N.J.: Prentice Hall, 1991).

David Schulenberg, *Music of the Baroque* (New York; Oxford: Oxford University Press, 2001).

K. Marie Stolba, *The Development of Western Music: A History* (Boston: McGraw Hill, 1998).

MUSIC DURING THE ROCOCO

CHANGING TASTES. In the years following the death of Louis XIV, new fashions among the French aristocracy emerged. In architecture and the visual arts, a new appetite for lighter, less ponderous spaces and interiors soon became evident in the years of the French Regency (1715–1723), and continued to spread during the later epoch known as the Rococo. A new emphasis on privacy and intimacy and on refined social graces came to be embodied in the development of salons, which were cultivated meetings of intellectuals, in Paris and other French cities. In these circles distaste grew for elaborate late Baroque styles, including the period's interior design, art, architecture, and even its music, theater, and opera, now criticized as contrived and pompous. To many listeners, the elaborate counterpoint of late Baroque music, its intricate passagework, and rich ornamentation seemed increasingly outmoded. In several important musical centers new styles of musical composition began to emerge in the mid-seventeenth century. These new movements

a PRIMARY SOURCE document

THE APPEAL TO THE SENTIMENTS

INTRODUCTION: The vocalist Johann Mattheson (1681–1764) was something of a child prodigy. He composed his first music at age nine and became a widely hailed soprano in the opera at Hamburg by the time he was fifteen. As an adult, he wrote *The Complete Chapel Master*, a guide to the musical profession that was highly prized among German performers and composers. His consideration of the ways in which music appeals to the senses contributed to a discussion that had occurred in the West since antiquity: the role that music might play in altering the emotions and creating more virtuous human beings.

The most important and outstanding part of the science of sound is the part that examines the effects of well-disposed sounds on the emotions and the soul. This, as may be readily seen, is material that is as far-reaching as it is useful. To the musical practitioner it is of even more importance than to the theoretician, despite its primary concern with observation. Of much assistance here is the doctrine of the temperaments and emotions, concerning which Descartes is particularly worthy of study, since he has done much in music. This doctrine teaches us to make a distinction between the minds of the listeners and the sounding forces that have an effect on them.

What the passions are, how many there are, how they may be moved, whether they should be eliminated or admitted and cultivated, appear to be questions belonging to the field of the philosopher rather than the musician. The latter must know, however, that the sentiments are the true material of virtue, and that virtue is nought but a well-ordered and wisely moderate sentiment. Those affects, on the other hand, which are our strongest ones, are not the best and should lie clipped or held by the reins. This is an aspect of morality which the musician must master in order to represent virtue and evil with his music and to arouse in the listener love for the former and hatred for the latter. For it is the true purpose of music to be, above all else, a moral lesson.

Those who are learned in the natural sciences know how our emotions function physically, as it were. It would be advantageous to the composer to have a little knowledge of this subject. Since, for example, joy is an expansion of our vital spirits, it follows sensibly and naturally that this affect is best expressed by large and expanded intervals. Sadness, on the other hand, is a contraction of those same subtle parts of our bodies. It is, therefore, easy to see that the narrowest intervals are the most suitable. Love is a diffusion of the spirits. Thus, to express this passion in composing, it is best to use intervals of that nature. Hope is an elevation of the spirit; despair, on the other hand, a casting down of the same. These are subjects that can well be represented by sound, especially when other circumstances (tempo in particular) contribute their share. In such a manner one can term a concrete picture of all the emotions and try to compose accordingly.

Pride, haughtiness, arrogance, etc., all have their respective proper musical color as well. Here the composer relies primarily on boldness and pompousness, he thus has the opportunity to write all sorts of fine-sounding musical figures that demand special seriousness and bombastic movement. They must never be too quick or tailing, but always ascending. The opposite of this sentiment lies in humility, patience, etc., treated in music by abject-sounding passages without anything that might be elevating. The latter passions, however, agree with the former in that none of them allow for humor and playfulness.

Music, although its main purpose is to please and to be graceful, must sometimes provide dissonances and harsh-sounding passages. To some extent and with the suitable means, it must provide not only unpleasant and disagreeable things, but even frightening and horrible ones. The spirit occasionally derives some peculiar pleasure even from these.

SOURCE: Johann Mattheson, *Der volkommene Capellmeister* (1739), in *Music in the Western World: A History in Documents.* Ed. Piero Weiss and Richard Taruskin (New York: Schirmer, 1984): 217–218.

were both international and regional in nature. Many new styles emanated from Italy before being adopted elsewhere in the courts and chief musical centers of the continent. Elsewhere, particularly in northern Germany, other new patterns of composition emerged that held a more limited regional appeal and which were different from the prevailing Italian tastes of the age. The sum of all these new stylistic movements eventually led to the abandonment of many of the Baroque era's compositional techniques and laid the groundwork for the emergence of the classical style that dominated musical composition in the later eighteenth century.

THE GALANT STYLE. The name for one of the new styles that captivated eighteenth-century composers and audiences alike, *style gallant*, is French, although many of its original sources of inspiration derived from Italian composers of the mid-eighteenth century. It became one of the most international of musical languages in Europe at the end of the Baroque period. As it was used in France at the time, the word *galant* implied a fashionable atten-

tion to current trends and the ways of court societies. A galant man was someone who was well aware of contemporary aristocratic fashions, who knew how to dress well, and how to act in civilized society. Composers who adopted this new suave and urbane style abandoned the complex counterpoint and chromatic harmonies of the high and later Baroque era in favor of clear melodies with an accompanying bass, elegant phrasing, graceful ornamentation, and small musical turns of wit and charm. These figures also tried to combine the undeniable melodic interest that was to be found in Italian musical styles of the time with the restrained elegance of French ones. Because of its lightness and charm, the new style was particularly suited to secular music, and as a result its greatest development was in the operas and instrumental music of the mid-eighteenth century. Giovanni Battista Pergolesi (1710–1736) was among those who provided a source of inspiration for those composers who wished to write in the new Galant Style. Although he died very young, Pergolesi's comic one-act opera, *La Serva padrona*, produced in Naples in 1733, was frequently restaged throughout Europe during the rest of the eighteenth century. A brief work, it was often mounted as an intermission entertainment, and its simpler but polished musical textures helped to establish a taste for elegant melodic arias in the opera world. In instrumental music, the taste for refined yet less complex works also had an immediate appeal in many musical circles, where the works of Johann Sebastian Bach and other late Baroque composers was now seen as overly complex and "unnatural." It is interesting to note, though, that the fashion for the far simpler and less virtuosic compositions of the Galant Style appeared at a time when amateur musicianship was increasing dramatically throughout Europe. The works of the new style appealed to this audience, in part, because of their relatively light performance demands and their straightforward use of melody.

GEORG PHILIPP TELEMANN. One of the most fertile exponents of the new Galant Style was Georg Philipp Telemann (1681–1767), who was considered by many in his day to be the greatest living German composer. A contemporary of Bach and Handel, his music was often considered more appealing and accessible in the eighteenth century than works by his now more famous competitors. Telemann, like Antonio Vivaldi, ranked among the most prolific of all Baroque composers. During a relatively long life, Telemann composed scores of instrumental works, three dozen operas, more than one hundred orchestral suites, another hundred concertos, and more than 1,500 sacred cantatas and pieces of religious music. Telemann was not a virtuoso performer like Handel and Bach. Yet he

exerted considerable influence over musical tastes in Germany and beyond, particularly after his appointment as musical director in the city of Hamburg. That appointment offered him the opportunity to direct the city's opera, one of the most important in the country at the time. Telemann also wrote much of his music for the expanding amateur market, selling his publications of relatively simple and readily performable instrumental and ensemble music through subscriptions. The evidence of these editions shows his steadily increasing reputation throughout Europe. When in 1733, the composer made available his *Musique de Table* (in German, *Tafelmusik*; English: *Table Music*), more than a fourth of all subscriptions were bought by musicians outside Germany. The best of the composer's many works manage to capture the changing tastes of the age and at times display his considerable skills as a composer; many more were competent works that appealed briefly to the fashions of his time. In 1737, Telemann made a journey to Paris, where he stayed for eight months and came in contact with the developing musical tastes of the Galant Style. In the years following his return to Hamburg he produced a number of works that helped to popularize the Galant fashion in German-speaking Europe and elsewhere. These included his six Paris string quartets, published in 1738 and sold by subscription. Unlike the highly structured and developed genre of the string quartet of the later eighteenth century, these works were perceived much like the instrumental suites popular throughout the Baroque era, although they were written for a smaller ensemble. Yet to this longstanding genre, Telemann brought a new sense of rhythmic invention and a gaiety and grace derived from his Parisian experiences as well as livelier strains of melodic invention from his knowledge of Italian operatic and instrumental writing of the period. Like music of the Baroque period, Telemann's quartets show a persistent attempt to appeal to the emotions and to manipulate listeners' moods. Yet it is interesting to note that he became increasingly definite about the precise moods that these Galant pieces were to evoke. Each piece commences with a description of the emotion that its playing should evoke, including such terms as "gay," "graceful," and "distraught."

THE SENSITIVE STYLE. In the decade following Telemann's forays into the Galant idiom, many northern German composers experimented with the style, eventually producing a regional variation that was to have an important impact on the development of later instrumental and vocal music. These composers wanted to make the Galant Style even more emotionally expressive. They believed that a good composition should express a constant change of mood; its emotions should flicker like

The composer Christoph Willibald von Gluck at the Spinet.
© FRANCIS G. MAYER/CORBIS.

a candle whose flame is pushed by breezes one way, then another. They wrote the melodies of their compositions in short phrases full of nuance, and were especially interested in varying the loudness and softness, or dynamics, of a performance. This variant of the Galant Style became known as the *empfindsamer Stil* or "Sensitive Style." Among its greatest exponents was Carl Philipp Emanuel Bach (1714–1788), the great Johann Sebastian's second son. Emanuel Bach, as he was widely known, was one of four of Bach's sons who became composers, and all of these experimented with the new Galant Style. Emanuel's works, though, were particularly important to the development of later eighteenth-century chamber music and the symphony, the most distinctive contribution of the classical period to orchestral music. Much of Emanuel Bach's career was spent working at the court of Frederick the Great of Prussia, where he was little appreciated and severely underpaid. In 1767, when his godfather Georg Philipp Telemann died in Hamburg, Emanuel replaced him in the important position of musical director of the city. Here he spent the last years of his life, and developed a distinctive musical language that was to have an important effect on other composers of the time. Carl Philipp Emanuel Bach notated his compositions with particular care, using dynamic indicators like "p" and "pp" (piano and pianissimo, or soft and

softer) or "f" and "ff" (forte and fortissimo, loud and louder) that were only just making an appearance in music composition and publishing at the time. In so doing, he helped to establish dynamic markings as an important tool of the composer's trade. His works abandoned the complex contrapuntal techniques that his father had favored. His father is said to have supported these developments, recommending the works of certain Galant composers to him as appropriate sources for him to emulate. At the same time Emanuel Bach's works made use of the complex and expressive harmonies and rhythmic sophistication that earlier Baroque composers had developed. His opus remains a highly personal expression of the forces that were available to composers as the Baroque was fading in favor of new, less intricate musical forms of expression.

STURM UND DRANG. In the years after 1750, new literary movements in Germany, Austria, and other regions of Europe began to favor dramatic expressions of emotion, both on stage and in fiction. This movement was to become known in the German-speaking world as *Sturm und Drang*, or "Storm and Stress." Artists, particularly writers, began to see these tumultuous emotional states as a necessary precursor to creativity. The developing sensibilities of the movement were to come to full flower in the nineteenth-century Romantic movement, which embraced the notion that little great artistic creation occurred without suffering. The German literary figures that embraced *Sturm und Drang* drew their ideas from many Enlightenment philosophers, particularly Jean-Jacques Rousseau (1712–1788) and his new celebration of nature as the basis for artistic creation. They also were avid readers of Denis Diderot (1712–1784) and his *Encylopédie*. The articles of that voluminous work offered literary, musical, and artistic criticism on an incredibly broad range of subjects, and although it did not present a single point of view, many of its aesthetic critics attacked Baroque standards of taste as outmoded, contrived, and artificial. Of all the *Sturm und Drang* authors who were active in the German-speaking world, no one surpassed the creativity and influence of Johann Wolfgang von Goethe over the movement's aesthetics. Two of his works—his play *Götz von Berchlichingen* in 1773, and his novel *Die Leiden des jungen Werthers* (The Sorrows of Young Werther) in 1774—featured heroic figures that suffered great torment. In the case of *Werther*, the hero ends up committing suicide because of his unrequited love for a married woman. Goethe's novel was to have a profound and lasting impact on German culture; it continued to be read by many nineteenth-century Romantics, and to inspire theatrical and operatic adaptations.

Around the same time that Goethe's important *Sturm und Drang* works were appearing, composers sought to do similar things with music. The first signs of this *Sturm und Drang* musical style can be seen in the operas and ballets of the period, where composer's like Christoph Willibald von Gluck (1714–1787) created works that aimed to observe the effects of a broad range of emotional states. Gluck's ballet *Don Juan*, first performed at Vienna in 1761, inspired many late eighteenth-century imitations. The work's spectacular and horrific conclusion served as one source for Mozart's famous finale to his opera *Don Giovanni* in 1787. Quick, dramatic changes; use of percussion; unaccompanied, emotional lines for singers; and rapid dynamic contrasts appear in the operatic productions inspired by *Sturm und Drang* as well. Composers in all the new styles that were becoming popular at the time thus preferred musical instruments that could articulate these phrases, and especially produce the dynamic contrasts, that their music demanded. In the realm of purely instrumental music, music for larger groups of players added or subtracted players as needed for a passage. Many composers became at this time very interested in the piano, or as they called it then, the fortepiano or pianoforte, because of its dynamic range. Of the many composers that experimented with these new concerns with volume and contrast, Josef Haydn (1732–1809) has been seen as one who developed a distinctive style that has often been called "Sturm und Drang." Elements in his symphonic and vocal compositions in the years between 1768 and 1772, in particular, point to the influence of the literary and theatrical movement upon his works at this time.

SOURCES

Donald Jay Grout and Claude V. Palisca, *A History of Western Music*. 6th ed. (New York; London: W. W. Norton, 1996).

Daniel Heartz, *Music in European Capitals: The Galant Style, 1720–1780* (New York: W. W. Norton, 2003).

David Schulenberg, *Music of the Baroque* (New York; Oxford: Oxford University Press, 2001).

K. Marie Stolba, *The Development of Western Music: A History* (Boston: McGraw Hill, 1998).

THE REFORM OF OPERA

THE RISING STATUS OF THE COMPOSER. The experiments with new dramatically expressive kinds of music that the Galant and Sensitive styles fostered, and which were also found in the *Sturm und Drang*'s movement's influence upon music, soon had an important effect on the operatic world of the eighteenth century.

Opera was the place in which drama and the emotions had long found one of their most profound platforms for expression, and during the seventeenth and eighteenth centuries, a distinguished lineage of brilliant composers, including Jean-Baptiste Lully, Jean-Philippe Rameau, and George Frideric Handel, had developed the form in ways that heightened music's ability to give dramatic expression to the subtlest shades of human emotion. In the century after 1650, though, few operas were performed in precisely the ways their composers had originally envisioned them. Opera was a business that, by and large, served audience tastes. Lully and the Arcadian reformers of Italy had envisioned forms of opera in the late seventeenth century that might rise to the level of the art of tragic antique plays. But the operatic world was driven by financial forces and by impresarios and singers who often were at odds with such elite ideals. Even in the serious operas of the period, artistic unity had frequently been sacrificed to singers' demands to display their virtuosity before adoring crowds. Arias piled on top of one another in performances so that the various members of a cast might have a chance to show off their particular skills. After each, torrents of applause or, in more unfortunate circumstances, boos rained down upon the singers on the stage, thus suspending the action, often for long intervals before the drama could proceed once again. In this increasingly heated and competitive climate, singers traveled with their own arias, which they demanded be frequently inserted into the action of the particular piece they were performing in, often injuring a work's story line. By the 1760s, some composers had grown increasingly impatient with such conventions, and they now longed to create an art that would have greater dramatic integrity. By the end of the century the effects of a gifted lineage of artists transformed opera, weaning it away from its once common performance practices and creating a new genre that might stand beside the theater for the quality of drama it offered. The effect of these transformations was to raise the status of composers as the defining figure in an opera's creation. This process was long, and continued after 1800 as singers and impresarios battled to see that their ideas and contributions played a role on the operatic stage. But in the operas of figures like Christoph Willibald Gluck and Wolfgang Amadeus Mozart, the groundwork was being laid for a distinctly modern conception of opera as a creation of a solitary musical genius, a creation that makes visible the composer's artistic vision.

THE "REFORM" OPERAS OF GLUCK. The forces that were to revolutionize opera in the later eighteenth and early nineteenth centuries first became evident to contemporaries in the "reform" operas of Christoph

a PRIMARY SOURCE document

GLUCK: AN INTIMATE PORTRAIT OF A COMPOSER

INTRODUCTION: The accomplished English musician and composer, Charles Burney, is best known today for his *General History of Music*, a work that provides invaluable insight into the performance practices and customs of musicians and composers of the time. His account of an encounter with the German-Bohemian composer, Christoph Willibald von Gluck (1714–1787) in Gluck's household at Vienna gives us an unparalleled glimpse into the life of one of the greatest musicians of the eighteenth century.

He is very well housed there; has a pretty garden, and a great number of neat, and elegantly furnished rooms. He has no children; madame Gluck, and his niece, who lives with him, came to receive us at the door, as well as the veteran composer himself. He is much pitted with small-pox, and very coarse in figure and look, but was soon got into good humour; and he talked, sung, and played, madame Thun observed, more than ever she knew him at any one time.

He began, upon a very bad harpsichord, by accompanying his niece, who is but thirteen years old, in two of the capital scenes of his own famous opera of *Alceste*. She has a powerful and well-toned voice, and sung with infinite taste, feeling, expression, and even execution. After these two scenes from *Alceste*, she sung several others, by different composers, and in different styles, particularly by Traetta. ... When she had done, her uncle was prevailed upon to sing himself; and, with as little voice as possible, he contrived to entertain, and even delight the company, in a very high degree; for, with the richness of accompaniment, the energy and vehemence of his manner in the *Allegros*, and his judicious expression in the slow movements, he so well compensated for the want of voice that it was a defect which was soon entirely forgotten.

He was so good-humoured as to perform almost his whole opera *Alceste*; many admirable things in a still later opera of his, called *Paride ed Elena*; and in a French opera, from Racine's *Ipfhigeni*, which he has just composed. This last, though he had not as yet committed a note of it to paper, was so well digested in his head, and his retention is so wonderful, that he sung it nearly from the beginning to the end, with as much readiness as if he had a fair score before him.

His invention is, I believe, unequalled by any other composer who now lives, or has ever existed, particularly in dramatic painting, and theatrical effects. He studies a poem a long time before he thinks of setting it. He considers well the relation which each part bears to the whole; the general cast of each character, and aspires more at satisfying the mind, than flattering the ear. This is not only being a friend to poetry, but a poet himself; and if he had language sufficient, of any other kind than that of sound, in which to express his ideas, I am certain he would be a great poet: as it is, music, in his hands, is a most copious, nervous, elegant, and expressive language. It seldom happens that a single air of his operas can be taken out of its niche, and sung singly, with much effect; the whole is a chain, of which a detached single link is but of small importance.

If it be possible for the partizans of *old French music* to hear any other than that of Lulli and Rameau, with pleasure, it must be M. Gluck's *Iphigenie*, in which he has so far accommodated himself to the national taste, style, and language, as frequently to imitate and adopt them. The chief obstacles to his fame, perhaps, among his contracted judges, but which will be most acceptable to others, is that there is frequently *melody*, and always *measure*, in his music, though set to *French words*, and for a *serious French opera*.

SOURCE: Charles Burney, *An Eighteenth-Century Musical Tour in Central Europe and the Netherlands, Dr. Burney's Musical Tours in Europe.* Vol. 2. Ed. Percy A. Scholes (Westport, Conn.: Greenwood, 1959): 90–91.

Willibald von Gluck. Gluck's ideas for the reform of the genre were hardly revolutionary, since many Italian dramatists, librettists, and composers in the decades before Gluck began to stage his productions in Vienna had advocated similar reforms. Rather Gluck was the first to display the potential that might exist in an operatic art form in which drama and music were more closely integrated. One key figure in shaping Gluck's ideas had been Pietro Metastasio, the accomplished librettist and poet who had long been a fixture of the Viennese court theater. Metastasio's librettos, written mostly for the opera seria productions popular in that city from the mid-eighteenth century onward, had employed elevated verse and had displayed their author's unusually keen dramatic sense. In the hands of impresarios, singers, and composers, though, his dramatic vision had often been subverted to take account of the realities of the opera house and its audiences. Metastasio had criticized these tendencies, arguing that the opera was filling up with arias that were little more than "symphonies for voices." Ironically, the poet's vision for an opera that might have greater dramatic unity was shared by his great enemy,

a PRIMARY SOURCE document

THE STUNTED DEVELOPMENT OF ENGLISH MUSIC

INTRODUCTION: In the seventeenth and eighteenth centuries music experts recognized that there were great differences in national styles of composition and performance. At the beginning of the Baroque, Italy's dominance in musical composition was widely recognized. Toward the end of the seventeenth century, though, a distinctive French style was evidenced in the patterns of composers like Jean-Baptiste Lully, and this style spread throughout the continent to compete with Italian dominance. Before the twentieth century the achievements of English composers were comparatively slight, although the short-lived Henry Purcell did a great deal to foster a taste for new musical compositions at the end of the seventeenth century. In his famous *General History of Music* (1789) the eighteenth-century music historian Charles Burney outlined the history of early Baroque music in England, placing special emphasis on Purcell. Like other commentators Burney was careful to relate English style to continental models, and he laid part of the blame for England's failure to produce a vigorous climate of musical composition on the short lives of its composers.

Indeed, Music was manifestly on the decline, in England, during the seventeenth century, till it was revived and invigorated by Purcell, whose genius, though less cultivated and polished, was equal to that of the greatest masters on the continent. And though his dramatic style and recitative were formed in a great measure on French models, there is a latent power and force in his expression of English words, whatever be the subject, that will make an unprejudiced native of this island feel, more than all the elegance, grace, and refinement of modern Music less happily applied, can do. And this pleasure is communicated to us, not by the symmetry or rhythm of modern melody, but by his having fortified, lengthened, and tuned, the true accents of our mother-tongue: those notes of passion, which an inhabitant of this island would breathe, in such situations as the words he has to set, describe. And these indigenous expressions of passion Purcell had the power to enforce by the energy of modulation, which, on some occasions, was bold, affecting, and sublime.

These remarks are addressed to none but Englishmen: for the expression of words can be felt only by the natives of any country, who seldom extend their admiration of foreign vocal Music, farther than to the general effect of its melody and harmony on the ear: nor has it any other advantage over *instrumental*, than that of being executed by the human voice, like *Solfeggi*. And if the Italians themselves did not come hither to give us the true expression of their songs we should never discover it by study and practice.

It has been extremely unfortunate for our national taste and our national honour, that Orlando Gibbons, Pelham Humphrey, and Henry Purcell, our three best composers during the last century, were not blessed with sufficient longevity for their genius to expand in all its branches, or to form a school, which would have enabled us to proceed in the cultivation of Music without foreign assistance.

Orlando Gibbons died 1625, at forty-four.

Pelham Humphrey died 1674, at twenty-seven.

And Henry Purcell died 1695, at thirty-seven!

If these admirable composers had been blest with long life, we might have had a Music of our own, at least as good as that of France or Germany; which, without the assistance of the Italians, has long been admired and preferred to all other by the natives at large, though their princes have usually foreigners in their service. As it is, we have no school for composition, no well-digested method of study, nor, indeed, models of our own. Instrumental Music, therefore, has never gained much by our own abilities; for though some natives of England have had hands sufficient to execute the productions of the greatest masters on the continent, they have produced but little of their own that has been much esteemed.

SOURCE: Charles Burney, *A General History of Music from the Earliest Ages to the Present Period.* Vol. 2 (1789; reprint with critical and historical notes by Frank Mercer, New York: Harcourt, Brace, 1935): 404–405.

Ranieri Calzabigi (1714–1795), who worked as Gluck's librettist during the 1760s. Calzabigi's libretti were characterized by a direct and forceful use of language rather than the elevated poetry common to Metastasio's. In 1762, the team produced its first opera, *Orfeo ed Euridice*, a work that broke new ground in the integration of text and music and which set new dramatic standards that other composers would soon try to imitate. In *Orfeo* Gluck returned to the tale that had long spawned creativity in the operatic world, but he did so in a way that brought new insights to bear on how the tale should best be dramatized. Drawing much of his inspiration from French operatic traditions, he tried to integrate the chorus, spectacle, and dance into *Orfeo* and his subsequent productions. His compositional techniques blurred the gap that had long separated arias from spoken recitative. Further, in all respects of his production Gluck tried to balance the demands of the music

against the drama. In particular, Gluck banished the incessant ritornellos, or orchestral refrains, that had grown common in the Italian opera of his day. Instead he aimed for a seamless dramatic portrayal, in which music and words marched hand in hand to a common goal. The success of *Orfeo* in the 1760s and 1770s was followed by a number of similar works, most of which successfully achieved Gluck's reform-minded aims.

OTHER CHANGES IN OPERA. Although today Gluck is sometimes single-handedly portrayed as the great reformer of eighteenth-century opera, he was only one of several figures whose influence was transforming the genre at the time. In Stuttgart, another center of innovation, the Italian composer Nicoló Jommelli (1714–1774) was experimenting with similar changes in operatic production. And throughout Europe, the opera was acquiring a greatly expanded repertory of themes and plots. At this time the novel was acquiring great popularity as a literary form almost everywhere in Europe, providing a body of literature upon which librettists could draw for dramatizations. In addition, the theater itself was experiencing the birth of the form often referred to as "bourgeois drama," that is, works that treated themes from the everyday life of the European middle classes. In the decades between 1760 and the 1790s, these themes began to make their way into the operatic world as well. Among the works that made use of the fashion for "middle-class" themes were two of the greatest operas of the age: Mozart's *Le nozze di figaro* (The Marriage of Figaro) in 1786 and his *Cosi fan tutte* (The School for Lovers) in 1790.

SOURCES

Thomas Bauman and Marita Petzoldt McClymonds, eds., *Opera and the Enlightenment* (Cambridge, England: Cambridge University Press, 1995).

David Charlton, *French Opera, 1730–1830: Meaning and Media* (Aldershot, England: Ashgate, 2000).

Roger Parker, *The Oxford History of Opera* (Oxford: Oxford University Press, 1996).

Stanley Sadie, ed., *History of Opera* (Basingstoke, England: Macmillan, 1989).

THE RISE OF CLASSICISM AND ROMANTICISM

DEFINING THE PERIOD. The music of the later eighteenth century has often been described as "classical," a term that is problematic for several reasons. Like the composers of the later Renaissance and the early Baroque, the great commanding figures of this classical era, Josef Haydn, Wolfgang Amadeus Mozart, and the youthful Ludwig van Beethoven, did not imitate the music of classical Antiquity since little ancient music survived for them to emulate. Rather the use of the term "classical" to describe their music developed in the nineteenth century among those who saw in these composers a musical language that expressed harmony, balance, and an idealized sense of beauty, values that were at the time seen to be very different from the more emotional and rebellious spirit found in the works of the early Romantics, the movement that was long seen as replacing the "classical" style after 1800. The term "classical," in this sense, thus came to summarize the differences between the music of this brief era and the Baroque period that preceded it, as well as the Romantic era that soon followed it. Such an easy generalization has proven difficult to sustain on closer inspection, since more recent research has shown that many European composers in the later eighteenth century did not completely abandon the techniques and forms that Baroque composers had long relied upon. Nor did all adopt the elegant simplicity and balanced poise typical of the works of Mozart or Haydn. This classical style was common only among certain groups of composers, particularly those that lived and worked in and around the Austrian capital of Vienna at the end of the eighteenth century, and among artists who imitated their musical idiom throughout Europe. The designation of this period as "classical" proves similarly problematic, since even in the works of the two supreme examples of the classical style—Haydn and Mozart—elements are present that herald the more tempestuous Romanticism of the early nineteenth century. As a result, the term "classical" has in recent years come to be associated only with a particular kind of musical style popular among the Viennese composers and their imitators throughout Europe for a relatively brief period in the late eighteenth century.

THE EIGHTEENTH CENTURY AND THE NOTION OF MUSICAL "CLASSICS." The use of the term "classical" proves problematic, too, on other grounds. During the eighteenth century the modern phenomenon of a musical public for serious music emerged. Around 1700, those who attended concerts and operas, or who listened to music in church, expected to hear music that was new. Major public events at this time called for original music; those compositions might still be played for a few years, but new ones would soon replace them as listeners expected with popular music. In the opera houses of the time, too, few works survived in the repertory of most companies for more than a few years. Throughout the eighteenth century an important change was occurring in the ways in which people thought about and listened to music. First in England, then in other parts of Europe, many people came to value the great composers of the early eighteenth century and sought

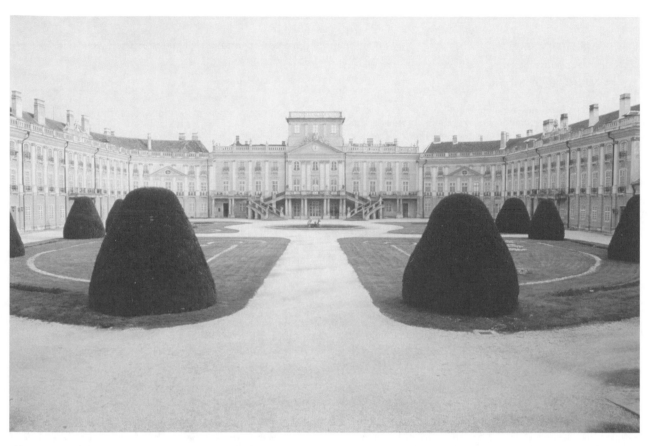

The Esterhàzy Palace near Fertod, Hungary. © VITTORIANO RASTELLI/CORBIS.

to continue to perform their works. The English society called the "Concert of Antient Music," founded in London in 1776, devoted itself to organizing concerts of earlier music, and in 1789, thirty years after Handel's death, they organized a festival to commemorate his music. This attitude toward music was similar in many ways to the reverence that was developing in eighteenth-century England for the works of Shakespeare, which were now hailed as literary embodiments of the genius of the English language. Like Handel's music, Shakespeare's works were quickly becoming a body of texts that was seen as canonical, literary classics that should be continually revived, performed, and celebrated in festivals. In the musical world this enthusiasm for older music soon spread elsewhere, as groups in Germany and other parts of Europe revived the music of Johann Sebastian Bach and other composers of the Baroque era. The advocates of these revivals believed that the music of these composers was not only beautiful, but also serious and learned. Its performance might uplift listeners, in contrast to popular songs of their day that they condemned as immoral and bawdy. The new conventions of these revival movements taught that the music of earlier times deserved special attention and that it should be listened to in silence and respect. As a result of these early efforts at revival, the notion of "classical music" as a serious art form was created. An assumption of the concert-going public as it developed at the end of the eighteenth century was that public performances of serious music should include not only new compositions, but also those composed many years earlier, including as far back as the later Baroque era.

EUROPE'S MUSICAL CENTERS. Since the eighteenth century fans of European serious music have relied upon the term "classical" in two ways; they have used it to refer to the entire body of composed music written in the Western tradition that merits serious listening in every era, even as they have also employed the word to describe the short period at the end of the eighteenth century that was dominated by the elegant, simple, and balanced works of figures like Haydn and Mozart. Both figures developed a specific musical language that has often been called "Viennese classicism." It is undeniable that the works of these composers were avidly studied and imitated throughout Europe, sponsoring the development of "Viennese classical" schools of composers as far away as Finland. Yet Vienna was only one of many important musical centers in late eighteenth-century Europe. Lon-

a PRIMARY SOURCE *document*

A MIRACLE OF MUSIC

INTRODUCTION: Just as painting and sculpture had taken center stage in the Renaissance, the extraordinary musical achievements of the eighteenth century led many commentators to wax poetic about the great strides being made in the art of music in their own day. An example of this can be seen in the English lawyer and antiquarian Daines Barrington's letter to the Royal Society in London during 1769, in which he described the prodigious feats of the young Mozart.

Sir,

If I was to send you a well attested account of a boy who measured seven feet in height, when he was not more than eight years of age, it might be considered as not undeserving the notice of the Royal Society. The instance which I now desire yon will communicate to that learned body, of as early an exertion of most extraordinary musical talents, seems perhaps equally to claim their attention.

Joannes Chrysostomus Wolfgangus Theophilus Mozart, was born at Saltzbourg, on the 17th [really the 27th] of January, 1756. I have been informed by a most able musician and composer that he frequently saw him at Vienna, when he was little more than four years old.

By this time he not only was capable of executing lessons on his favourite instrument, the harpsichord, but composed in an easy stile and taste, which were much approved of.

His extraordinary musical talents soon reached the ears of the present empress dowager, who used to place him upon her knees whilst he played on the harpsichord.

This notice taken of him by so great a personage, together with a certain consciousness of his most singular abilities, had much emboldened the little musician. Being therefore the next year at one of the German courts, where the elector encouraged him, by saying, that he had nothing to fear from his august presence, little Mozart immediately sat down with great confidence to his harpsichord, informing his highness that he had played before the empress.

At seven years of age his father carried him to Paris, where he so distinguished himself by his compositions that an engraving was made of him.

The father and sister who are introduced in this print are excessively like their portraits, as is also little Mozart, who is stiled "Compositeur et Maitre de Musique, age de sept ans."

After the name of the engraver, follows the date, which is in 1764: Mozart was therefore at this time in the eighth year of his age.

Upon leaving Paris, he came over to England, where he continued more than a year. As during this time I was witness of his most extraordinary abilities as a musician, both at some publick concerts, and likewise by having been

don and Paris, for example, had more vigorous and well-established traditions of public concert going than Vienna did, and both Haydn and Mozart were concerned throughout their careers to see that their music was played and known in these and other cities. Today the works of Haydn and Mozart have become so widely known that they have become in many people's minds synonymous with the entire concept of a late "eighteenth-century" sound. The enormous popularity of these works, though, tends to obscure the unprecedented compositional activity and experimentation that was occurring in many places throughout Europe in this period. The small city of Mannheim, for instance, was the capital of the southwestern German state of the Rhineland Palatinate, and despite its size was one of the great centers of musical innovation at the time. Mozart, Haydn, and other great Viennese composers kept abreast of the musical developments that occurred there, and they wrote works for the great virtuosi that were members of the city's fa-

mous orchestra. The city's composers, recognized already in the late eighteenth-century as a "Mannheim School," developed a musical idiom different from Viennese classicism. Among the most famous members of this group, Johann Stamitz (1717–1757) and his son Carl Stamitz (1734–1801), made use of rapid dynamic changes and contrasting themes, elements that showed off the brilliant playing of the Mannheim orchestra. Both Gluck and Haydn hailed another Mannheim-trained composer, Johann Martin Kraus (1756–1792), as a musical genius. Trained at Mannheim and active in Paris and Stockholm, Kraus's reputation has since the eighteenth century been eclipsed by his almost exact contemporary, Mozart. Beyond Vienna and Mannheim, Paris and a number of Italian cities nurtured composers and musicians that developed international reputations at this time.

HAYDN. By the final years of the eighteenth century, Vienna was already eclipsing these other centers, in large

alone with him for a considerable time at his father's house; I send you the following account, amazing and incredible almost as it may appear.

I carried him a manuscript duet, which was composed by an English gentleman to some favourite words in Metastasio's opera of *Demofoonte*.

The whole score was in five parts, viz. accompaniments for a first and second violin, the two vocal parts, and a bass.

My intention in carrying with me this manuscript composition was to have an irrefragable proof of his abilities, as a player at sight, it being absolutely impossible that he could have ever seen the music before.

The score was no sooner put upon his desk, than he began to play the symphony [i.e., the orchestral introduction] in a most masterly manner, as well as in the time and stile which corresponded with the intention of the composer.

I mention this circumstance, because the greatest masters often fail in these particulars on the first trial.

The symphony ended, he took the upper [vocal] part, leaving the under one to his father.

His voice in the tone of it was thin and infantine, but nothing could exceed the masterly manner in which he sung.

His father, who took the under part in this duet, was once or twice out, though the passages were not more difficult than those in the upper one; on which occasions the son looked back with some anger pointing out to him his mistakes, and setting him right.

He not only however did complete justice to the duet, by singing his own part in the truest taste, and with the greatest precision; he also threw in the accompaniments of the two violins, wherever they were most necessary, and produced the best effects.

It is well known that none but the most capital musicians are capable of accompanying in this superior stile. …

Witness as I was myself of most of these extraordinary facts, I must own that I could not help suspecting his father imposed with regard to the real age of the boy, though he had not only a most childish appearance, but likewise had all the actions of that stage of life.

For example, whilst he was playing to me, a favourite cat came in, upon which he immediately left his harpsichord, nor could we bring him back for a considerable time.

He would also sometimes run about the room with a stick between his legs by way of a horse.

SOURCE: Daines Barrington, "Account of a Very Remarkable Young Musician," in *Mozart: Die Documente seines Lebens.* Ed. O. E. Deutsch (Kassel: Bärenreiter, 1961): 86–90. Reproduced in *Music in the Western World: A History in Documents.* Eds. Piero Weiss and Richard Taruskin (New York: Schirmer, 1984): 308–310.

part because of the productivity of its most famous composers, Josef Haydn, Wolfgang Amadeus Mozart, and at the very end of the century, Ludwig van Beethoven, a citizen of the German city Bonn who took up residence in the city and studied for a time with Haydn. Vienna had many other musical figures of merit as well, some of who attracted international attention at the end of the eighteenth century. These included Carl Ditters von Dittersdorf (1739–1799), a composer of a number of opera and symphonies; Johann Albrechtsberger (1736–1809), a composer of sacred and keyboard music who often wrote fugues; and Joseph Eybler (1765–1846), a protégé of the great Haydn. Johann Nepomuk Hummel, Mozart's pupil, also came to maturity during the era of Viennese classicism, and continued to write music that reflected its values during the early nineteenth century. It was Josef Haydn, however, that helped to establish the conventions of many of the genres of orchestral and instrumental music in which the Viennese masters wrote.

These forms have continued to dominate much serious music until modern times. Haydn's influence was especially important in the development of the symphony, the string quartet, the sonata, and the piano trio. Born in humble circumstances, he was initially trained as a choirboy. Left without resources at the age of seventeen he followed a musical career. He began schooling himself in composition, largely by reading the major works of musical theory and by studying the scores of other major composers, including Carl Philipp Emanuel Bach. Soon he became an accompanist in the study of Nicola Porpora, one of the leading opera impresarios of the age and the voice teacher of such great singers as Farinelli and Caffarelli. Porpora offered whatever guidance he could as Haydn began to perfect his compositions, but Haydn developed a musical language that was distinctly his own even in his early years. During the 1750s and 1760s, the composer experimented with the latest styles, writing compositions in ways that made use of the tech-

Engraving of Franz Joseph Haydn. © HULTON-DEUTSCH COLLEC-
TION/CORBIS.

niques of the Galant and Sensitive Styles, and experimenting with ways to express *Sturm und Drang* emotions in his music toward the end of this period. The longest portion of the great composer's career was spent at the Esterhàzy court, one of the wealthiest and most cultivated aristocratic circles in Central Europe. The Esterhàzy employed one of the largest orchestras of the day, and within five years of Haydn's appointment in 1761, he had risen to become the director of this enviable musical establishment. He remained in this position full-time until 1790, although his duties often brought him to Vienna. In the Esterhàzy household, Haydn was required to produce music in all the genres then popular, and although he initially had some problems in getting along with the count, he gradually acquired great independence and through the publication of his works in Austria and abroad, he acquired a sizable fortune.

HAYDN'S WORKS AND HIS IMPACT ON THE SONATA FORM. Haydn was enormously prolific, although in the generations after his death a number of works were falsely attributed to him. Today his considerable output of new compositions is recognized to include 104 symphonies, 68 string quartets, 29 trios, 14 masses, and 20 operas. Haydn authored a number of concertos, piano

sonatas, and a host of smaller compositions as well. Although he produced masterpieces in almost every genre, it is for the glories contained in his symphonies and string quartets that he has most often been celebrated. Although Haydn did not create the symphony, he perfected its form and composed a body of symphonies that has consistently served as a source of inspiration to later composers. Among these, the Paris Symphonies (Numbers 82–87) are generally recognized as the first set of masterpieces of Haydn's mature style. They were commissioned for performance at a Masonic lodge in that city during 1785–1786, and they were enthusiastically accepted from their first hearing. Haydn's set of London symphonies (Numbers 93–104), completed while the composer was a resident of the English capital, represent his crowning achievement in the genre, and they continue to be among the most commonly played eighteenth-century orchestral works. Through his many compositional efforts, Haydn also helped to establish the popularity of the sonata form, a form that was increasingly used to organize the first movement of piano sonatas, concertos, and symphonies. The development of this form helped give composers standards to guide their work and ways to show off their skills and creative imagination. It gave members of the audience a sense of what to listen for, so that they could both enjoy the work and appreciate the ways a composer played with the form. Once it took its basic shape, composers used sonata form throughout the nineteenth century and into the twentieth. A movement in sonata form has two main parts. In the first part, called the "exposition," the composer first introduces a main musical theme in the work's main key, then a second theme in a related key. The second main part has two sections. The first of these is called the "development" because the composer plays with, or develops, the themes from the first section in a number of ways. In the second section, the "recapitulation," the composer goes back to the main themes again in ways that recall the exposition, though now the work stays in its main key. Some movements in sonata form may simply end with a cadence, a set of concluding chords, while others may add a coda, or concluding segment. This format is fairly simple and allows for a great deal of variation and creativity. Although he was not the only composer to make use of the form, Haydn's brilliant use of sonata form has consistently provided inspiration to composers since the eighteenth century who have relied upon it.

THE STRING QUARTET. At the end of the eighteenth century strings continued to hold the highest respect among musical instruments, second only to the voice in overall status. Groups of stringed instruments ranging in size (and therefore in pitch, from low to high) playing together had been common since the Renais-

Manuscript score of one of Wolfgang Amadeus Mozart's symphonies. © **ARCHIVO ICONOGRAFICO, S.A./CORBIS.**

sance. In the mid-eighteenth century, composers varied some of the works they had been writing for violins and continuo. They began to prefer a stringed instrument, usually the cello, for the lowest or continuo part, and to include a middle part for the viola. In this way the harpsichord, which had often served to play the continuo part, gradually disappeared from these ensembles, in favor of a new grouping that consisted only of strings. The resulting group of four voices—two violins, a viola, and a cello—became a standard group for composers and performers, known as the string quartet. Haydn's enormous output for these string ensembles helped to popularize the form of the string quartet, and to standardize the genre's form even more definitively than his orchestral works influenced the later writing of symphonies. Through his efforts the string quartet was largely established as a form that consisted of four movements, usually of fast opening and concluding pieces surrounding

two interior movements. One of these interior pieces was usually written as a slow movement, while the other was often a minuet. In his 68 quartets, the composer's continuous adaptation to the changing styles and tastes of the late eighteenth century become brilliantly apparent, as does the depth of his creative and lyrical genius. These works, like the composer's famous Paris and London symphonies, demonstrate the sense of balance, proportion, and idealized beauty, as well as the intellectual coherence and ready intelligibility that have often been noted as key features of the musical language of the Viennese classical era. During his brief life, Wolfgang Amadeus Mozart also composed 26 string quartets of incomparable beauty, although it still remains today largely a matter of taste which composer's works an individual listener prefers. Mozart freely admitted his great indebtedness to Haydn in perfecting his use of the form when he published his homage to the great mas-

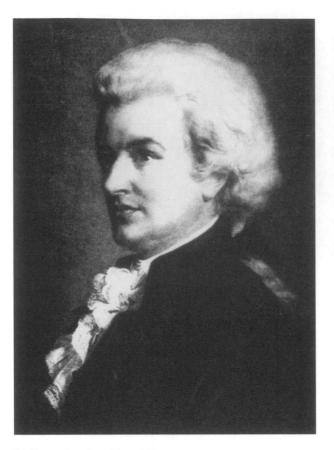

Wolfgang Amadeus Mozart. THE LIBRARY OF CONGRESS.

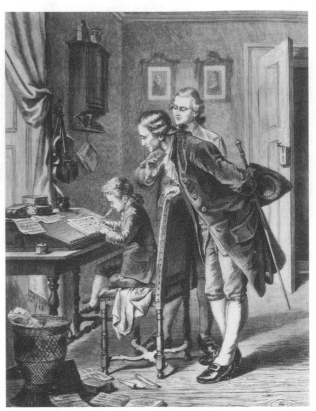

Engraving of *The Young Mozart Composing under the Watchful Eye of His Father.* © ARCHIVO ICONOGRAFICO, S.A./CORBIS.

ter, the "Six Haydn Quartets" in 1785. Both composers' quartets rank among the greatest achievements in the Western musical tradition, and long provided a fertile source of inspiration for the great masterful contributions that nineteenth-century composers like Beethoven, Schubert, and Brahms continued to make to the genre.

MOZART. While Haydn's great genius has long been recognized, his accomplishments have paled in the popular imagination to those of Wolfgang Amadeus Mozart, a figure who was recognized in his own lifetime in Austria and beyond as a divinely-inspired prodigy. Haydn wrote masterful compositions in many genres, but influenced later compositions primarily through his symphonies and string quartets. He also struggled with composition, laboring over his pieces until he got all the details just right. Mozart, by contrast, amassed a catalogue of works during his brief life that included masterpieces in every musical genre common in the later eighteenth century. He was, in other words, a great universal genius, as capable of setting church music and opera as he was of producing major works for the orchestra or the small ensemble. Unlike Haydn, he was reported not to have labored at all over his compositions, but to have

produced them while carrying on conversations with his family and friends. Trained by his father to assume the role of a musical director within the confines of a traditional court, the Archbishopric of Salzburg, Mozart made many significant contributions to church music early in his career, and continued to write sacred music throughout his life. His output of sacred music included fourteen masses; two oratorios and several sacred musical dramas; and 22 motets, besides his incomplete but masterful *Requiem*, one of only several masterpieces he worked on during the final months of his life. He produced fifteen operas, notably his great masterworks, *The Marriage of Figaro* in 1786 and *Don Giovanni* in 1787, as well as several other musical dramas, like *Cosi fan tutte*, *La Clemenza di Tito*, and *Idomeneo* that continue to inspire enormous admiration today. He wrote 56 symphonies and 23 piano concertos, as well as a host of incidental and dance music for orchestra, small ensembles, and keyboard. Such a brief description barely scratches the surface of Mozart's art and fails to do justice to the many small gems that the faithful listener can discover among his opus. It is impossible to summarize in brief the scope of such an achievement, an achievement that was compressed into the brief space of only 35

Interior of the Mozart family's house in Salzburg, Austria. © **WOLFGANG KAEHLER/CORBIS.**

years, although generations have consistently called attention to the composer's melodic invention, his rich harmonies and textures, his sense of elegant beauty, and his formal proportions. His achievement has long been accepted as the finest expression of the Viennese classical era. And yet, in the later stages of his career, particularly in the final years of his life, the composer also experimented with a new musical language that was to come to full flower only later in the Romantic era. His late works anticipated the more tempestuous Romantic musical language that Beethoven and other Viennese composers were to develop in the early nineteenth century.

THE RISE OF ROMANTICISM. In the final years of the eighteenth century, composers in Vienna and other European musical centers began to experiment with new sounds and styles, making use of a broader range of possibilities that the new large orchestras of the time offered. They also exploited the widespread popularity of small, intimate chamber ensembles like the string quartet. In Vienna and other European musical centers many composers began to experiment with new sounds and styles, and music began to change very quickly. These changes can be seen in the career of Ludwig van Beethoven, who studied with Haydn in Vienna in 1792. Although he was schooled

in the graceful elegance and rationality of Viennese classicism, Beethoven soon began to experiment with ways to enlarge that style's possibilities. Beethoven's career also coincided with an important change in the taste of European audiences and composers. By the end of the eighteenth century instrumental music was attracting more and more attention, a departure from sensibilities of the Renaissance and Baroque eras, which had held vocal music in highest esteem. The increasing importance of instrumental music was a result of new thinking about the arts. In particular, the literary movement known as Romanticism began to have its effect on the world of music as well as the other arts. Its advocates valued feelings and emotion over words and reason. Many of them argued that instrumental music, with its abstraction from both words and pictures, was the noblest and highest form of human expression. While early Romantic composers like Beethoven and Franz Schubert kept the basic rules of harmony and composition they inherited from the eighteenth century, they often departed from those rules or subtly modulated them to express their innermost feelings, and so to uplift the spirit of the audience. Thus advocates of Romanticism broke the connection between melody and word, the rhetorical pattern of thought that had inspired

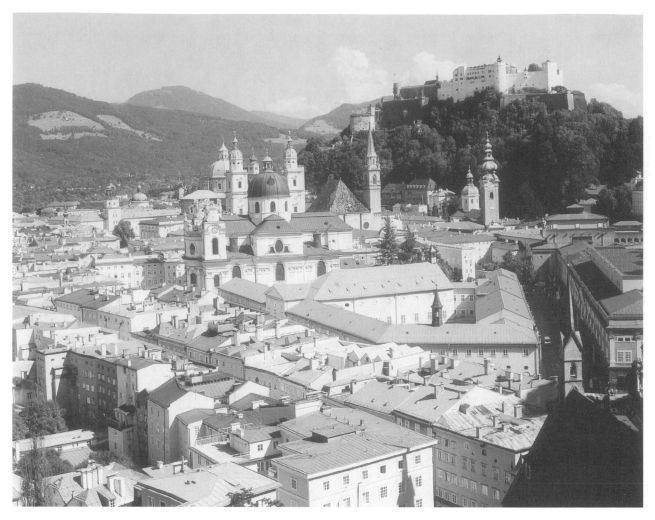

View of the city of Salzburg. TRAVELSITE/COLASANTI.

many of the musical innovations of the seventeenth and eighteenth centuries. Although it is usually true to say that the boundaries of decades or centuries are too artificial to mark the ends of artistic movements, it is reasonable to say that the years around 1800 marked an important change in European music. From this time forward a new Romanticism was to surpass in importance the long-standing sensibilities of the Baroque and classical eras.

SOURCES

John Irving, "Sonata Classical" in *The New Grove Dictionary of Music and Musicians.* Eds. S. Sadie and J. Tyrrell,. (London: Macmillan, 2001).

Sandra Mangsen, "Sonata Baroque" in *The New Grove Dictionary of Music and Musicians.* Eds. S. Sadie and J. Tyrrell. (London: Macmillan, 2001).

James Webster, "Sonata Form" in *The New Grove Dictionary of Music and Musicians.* Eds. S. Sadie and J. Tyrrell. (London: Macmillan, 2001).

Neal Zaslaw, ed., *The Classical Era: from the 1740s to the End of the 18th Century* (Englewood Cliffs, N.J.: Prentice Hall, 1989).

SIGNIFICANT PEOPLE
in Music

JOHANN SEBASTIAN BACH

1685–1750

Composer
Organist

EARLY YEARS. Johann Sebastian Bach, the greatest master of counterpoint and polyphony, was undoubt-

edly one of the greatest musical minds of the Western tradition. Unlike many composers who traveled extensively through Europe, Bach remained in the central and northern regions of the Holy Roman Empire for his whole life. He was born in Eisenach in central Germany, the eighth child of a family of musicians; both his parents died when he was nine, so he was sent to live for a few years with an older brother, an organist. Later he served as a choirboy. He excelled as an organist, and also played the violin. In 1703, he moved to the city of Arnstadt where he accepted his first professional post as an organist. His time there was not entirely happy. He did not get along well with the local musicians and criticized their lack of skill; he received four weeks of leave to travel to Lübeck so that he could listen to the great Baroque organist Dietrich Buxtehude, but he ended up staying away from his post for four months. Back in Arnstadt, locals complained that his music was too complicated for them to sing. It seems likely that Bach was developing musical ideas too complex for the abilities of the local performers. Bach was happy to accept another position as organist in Mühlhausen three years later; an early cantata, *Christ lag in Todesbanden* (Christ Lay in the Bonds of Death), as well as a guest performance as organist, helped him win this new post. He began to write more choral church music as well as organ compositions, including a number of cantatas. He also married his first wife, Maria Barbara. Soon Bach moved again, to a much more prominent position as organist for the duke of Weimar, and a few years later he was named the duke's concertmaster. At Weimar he had the first six of his twenty children, including the future composer Carl Philip Emanuel Bach. His friend, the composer Georg Philipp Telemann, who was even more famous in his lifetime than Bach, was the boy's godfather. Many of Bach's organ compositions date from this period, though he seems to have written few cantatas while at Weimar.

FROM CÖTHEN TO LEIPZIG.

In 1717, Bach was offered a position as *Kapellmeister* (chapel master) at the court of Prince Leopold at Cöthen. Out of personal animosity against the prince, the duke of Weimar refused to allow Bach to leave and even imprisoned him for a month, but Bach finally managed to move. Leopold loved music and played several instruments. Here Bach wrote mainly chamber and orchestral music, including his famous set of Brandenburg concertos. While traveling with the prince in 1720, Bach received the news that his wife had died. He considered leaving Cöthen, though the next year he married a singer at the court, Anna Magdalena Wilcke. Bach continued to consider

positions elsewhere, and found one at the church of St. Thomas in Leipzig, as cantor at its school and as music director for the city. Bach moved there in 1723 and remained there the rest of his life. The school supplied singers for four churches, and Bach was kept busy rehearsing them, conducting at least some of their performances, teaching students, and especially writing music for these groups to perform. During some of this time he wrote as much as one cantata every week, in addition to composing music for special occasions such as weddings, plus works for particular religious holidays. One major achievement of the first years in Leipzig was his composition of the famous *St Matthew Passion* in 1727 for performance during Holy Week. Bach was never happy with the non-musical tasks that the local schoolmasters often expected him to perform, which led to a number of disputes and a good deal of friction. A new director and some renovations helped improve matters, though only temporarily. Bach continued to keep his eyes open for new positions, or for secondary appointments to offer professional respite as well as financial support for his large family. He taught private students, tested organs in Leipzig and the surrounding area, and worked to make the best deals possible on the publication of his compositions.

NEW INTERESTS.

In 1729 Bach took over another group, the city's Collegium Musicum. This was a voluntary society composed of university students and professionals. The group gave weekly concerts in Leipzig, particularly at a local coffeehouse, which provided the subject for his "Coffee Cantata." The collegium gave Bach another venue and skilled musicians with whom to work, a place to perform secular compositions, and a forum for guest performances by visiting friends and colleagues. Bach ran the group for about ten years. During these years he also began work on a Mass (known as the Mass in B Minor), which he completed over ten years later. In 1733 he sent two sections, the Kyrie and Gloria, to the court of the elector of Saxony in Dresden. He was hoping to win the title of court composer; he was finally successful in 1736. His connections with Dresden became more important over time, especially since later directors of the Thomasschule had less interest in music.

LATER YEARS.

As Bach's older sons developed their own careers and accepted important appointments, his ties outside of Leipzig expanded still further. Carl Philip Emanuel Bach moved to the court of Prince Frederick, soon to become Frederick II (Frederick the Great), king of Prussia, at Berlin in 1738, and his father made several visits there. Frederick was an avid amateur musician

and excelled as a performer on the flute. In 1747 Frederick invited Bach to court to examine some of its new fortepianos and to perform. He also gave Bach a musical theme and asked him to improvise counterpoint upon it. Bach obliged, then promised to write a more substantial and effective composition when he returned home. The work he sent back to Frederick is now known as the *Musical Offering*, a set of thirteen pieces based on the theme and including an important part for the flute, the king's own instrument. During his later years, Bach joined a scholarly music society, the Society of Musical Sciences, and worked on revising a compendium called the *Art of Fugue* which remained unfinished at his death. His health began to fail, and cataracts affected his vision. An operation to repair his sight was unsuccessful, and he died shortly thereafter. His unpublished works were scattered among family members, and many of them were lost. Although his interest in the older "first practice" of contrapuntal Baroque music was no longer in fashion by the time of his death, his work remained highly regarded, and composers such as Mozart continued to study his works. The interest in the music of earlier times that had established itself in England eventually spread to Germany, and by the early nineteenth century interest in Bach was beginning to revive. Scholars and publishers did their best to collect, edit, and publish his works, and musical societies sponsored concerts and festivals in his honor and marking the centennials of many of his important works.

SOURCES

John Butt, ed., *The Cambridge Companion to Bach* (Cambridge, England: Cambridge University Press, 1997).

Barbara Schwendowius and Wolfgang Dömling, eds., *Johann Sebastian Bach: Life, Times, Influence* (New Haven; London: Yale University Press, 1984).

Peter Williams, *The Life of Bach* (Cambridge, England: Cambridge University Press, 2003).

Christoff Wolff, ed., *The New Grove Bach Family* (London: Macmillan, 1983).

GEORGE FRIDERIC HANDEL

1685–1759

Composer
Organist

FROM HALLE TO ITALY. One of England's greatest composers, George Frideric Handel was German by birth and upbringing. Born in Halle in the German territory of Saxony, he studied law as well as music. After a year as an organist at the Calvinist cathedral church, Handel left Halle for Hamburg with its opera house and greater possibilities. In Hamburg he played in the orchestra and wrote his first opera, *Almira*, in 1705. Here Handel already showed the mix of national styles he would continue to use in his later writings. The next year he traveled to Italy. Throughout the eighteenth century and into the next, northern European composers felt the need to spend time in Italy to study current Italian musical trends and to establish their reputations. Handel was no exception, and his efforts proved successful. He spent time in a number of cities, including Florence, Rome, Naples, and Venice. In Rome, a center especially of religious choral music, he wrote a number of motets, cantatas, and an oratorio. In Venice, his opera *Agrippina* was a great success. Handel met and befriended many of the Italian composers of his generation.

ENGLISH CAREER. When he returned north, he worked for a while as chapel master to the elector of Hanover, who was next in line to succeed to the English throne. The court granted him leaves of absence so that he could accept invitations to London. There he produced another opera, *Rinaldo*, again to great acclaim, and eventually Queen Anne awarded him an annual stipend. Upon her death in 1714 the crown passed to the elector of Hanover, who was crowned as George I. Except for a few visits to continental Europe, Handel spent the rest of his career in England. In 1727 he became a British citizen. Handel's long English career highlights many of the trends in the country's musical scene during those years. At times he worked directly for the king; he wrote the suites known as the *Water Music*, for example, for a royal procession by barge along the Thames River in the summer of 1717, a procession intended to give the new and foreign king greater visibility among his subjects. By 1719 he was working for a new private company called the Royal Academy of Music, formed to produce Italian-style opera in London, and he wrote a number of operas for them. The company survived ten years before having financial trouble, at which time Handel himself went into partnership with a colleague to carry on the project. A rival house competed with him, sometimes producing Handel's own operas. These professional rivalries, plus the problems of attracting the London public to performances of Italian operas when they could not understand the language of the libretto, limited the possibilities for Italian opera in England. Nonetheless, Handel continued to write successful operas even after his production ventures failed.

ORATORIOS. One solution to Handel's problems in popularizing Italian opera in England came in the form of the oratorio, a musical genre that Handel made distinctly his own. Handel, who had studied and written oratorios in Rome, revised an earlier composition into the oratorio *Esther* in 1732. With his oratorio *Saul*, Handel overcame the language problems of Italian-style opera by using an English text, and found a solid audience that he could continue to develop. Handel helped build up a tradition of performing oratorios, with their Biblical subjects, during the penitential season of Lent. He also played organ concertos at these performances. *Saul* was followed by *Israel in Egypt*. In answer to a request for a new work for a charity performance in Dublin for Easter in 1742, Handel wrote his oratorio *Messiah*, a work that was a resounding success from its first performances. Its Dublin debut was soon followed by London performances the following year, in which the work excited universal acclaim. Handel followed this commercial success with more oratorios, as well as his famous *Music for the Royal Fireworks,* written in 1748.

A MIX OF STYLES. Although English was only an adopted language to Handel, his vocal compositions captured English words and cadences so naturally that they can be seen to embody the Baroque era's preoccupation with textual expression as one of music's greatest goals. His writing for chorus is especially memorable, often alternating between homophonic sections and polyphony, and takes advantage of the natural ranges and strengths of vocal parts. Yet his instrumental music is also impressive. The Italian style dominates in most of his writings, but he made use of other regional and national styles as well. The French overture form, first developed by Jean-Baptiste Lully, and the precision and restraint of French court music generally figured prominently in many of Handel's works. Like many of his contemporaries, Handel was known for his ability to compose music quickly. The listening public wanted new works for major occasions, and Handel obliged, even if it meant borrowing heavily from earlier works. He was known for incorporating musical ideas from the works of others, reworking them into parts of his own compositions. Contemporaries viewed this practice more the way film directors do now, as a sort of "homage" to the other composer, rather than as a type of plagiarism.

LATER LIFE AND REPUTATION. Late in life, Handel's health began to fail. He had already suffered several strokes, but was able to recover and return to work. By the 1750s, however, his eyesight also began to fail. He continued to compose via dictation and to perform extemporaneously and from memory. By the time of his death, he had become a great English institution, and was buried in the Poets' Corner of Westminster Abbey with an imposing funeral. In 1784 Handel was honored with a commemorative festival by the Concert of Antient Music, an event that was attended by the royal family. This festival helped to solidify his important role in England's musical life, and inspired a fashion for works from earlier periods. Handel's posthumous reputation and its celebration in England were key features in the development of the notion of a European classical tradition of great music that deserved to be performed long after it was written.

SOURCES

Donald Burrows, ed., *The Cambridge Companion to Handel* (Cambridge; New York: Cambridge University Press, 1997).

Winton Dean, *The New Grove Handel* (London: Macmillan, 1982).

Christopher Hogwood, *Handel* (London: Thames and Hudson, 1984).

JOSEF HAYDN

1732–1809

Composer

EARLY YEARS. Josef Haydn's long life and career spanned the transition from the late Baroque to the Romantic era. Born into a modest family of artisans, his relatives were nonetheless musical. A local schoolteacher offered the young Haydn the opportunity to attend school, and within a few years he had been invited to become a choirboy at St. Stephan's Cathedral in Vienna, a post he accepted at the age of seven. Once his voice changed and he was forced to leave the choir, he spent several years as a freelance teacher, studying composition on his own, including the works of Carl Philipp Emanuel Bach. Mutual friends put him in contact with the composer Nicola Porpora, who hired him as an accompanist for his voice students, helped him with composition, and introduced him to prominent musicians and patrons. His "Missa brevis in F" dates from these early years, although many other works from this period do not survive.

THE ESTERHÁZY COURT. For a time Haydn secured employment in the household of Count Karl Morzin in Vienna and Bohemia. The year 1761 marked an important change, when he was offered a position in the court of Prince Paul Anton Esterházy, the head of a very powerful Hungarian family. Soon Paul Anton was succeeded by his brother Nicholas. The Esterhàzy's main

estate was at Eisenstadt, just south of Vienna, with a second home near Lake Neusiedl in Hungary, known as Esterháza. Nicholas was to build this home into a spectacular palace complete with two theaters and two music rooms. Haydn was put in charge of both musicians and compositions; he would remain many years with the court, and built his international reputation from this role as a court musician. He was required to compose at the prince's request, and the court retained rights to his works. By 1766 Haydn was also in charge of church music. He wrote a number of masses, among them his "Great" and "Little Organ Masses," and his noted "Stabat Mater" of 1767. He continued to visit Vienna often, and there eventually met and befriended the much younger composer Mozart.

INTERNATIONAL REPUTATION. The court featured frequent musical performances. During the 1760s, Haydn wrote over 25 symphonies for concerts there. Over time the Esterhàzys began to favor opera and musical theater over instrumental music, requiring more works than any single composer could provide. Haydn's operas, successful in their day, are seldom performed now, primarily because their libretti are not always up to the high standards of music that Haydn composed for them. By the late 1770s, Haydn seems to have been spending more time as an impresario, producing performances of the works of many others, than as composer of his own operatic works. He was able to renegotiate his agreement about rights to compositions and was now allowed to accept commissions from other patrons as well as to publish his works. Haydn's compositions were among the first publications of a new Viennese music press, Artaria. He quickly grew accustomed to the profitable and treacherous world of international music publishing. He tried to maximize his own profits in each country with a separate printing privilege, and also wrote more compositions specifically for the publishing market. These publishing ventures further extended his fame and the popularity of his works. He continued to receive a number of important international commissions. In 1784, for instance, the French Count d'Ogny asked him to write six symphonies for public performance in Paris, a commission that produced the famous Paris Symphonies. His services were also demanded to set a series of instrumental pieces on the theme of Christ's "Seven Last Words" for a Holy Week service in Cádiz in Spain. Despite the reputation of the performances at the Esterházy court, Prince Nicholas's son and successor Anton disbanded the court's orchestra in 1791. Haydn retained a pension but was free from his duties. He traveled to London, conducting and composing new works, including his famous London Symphonies. Hearing the works of Handel in England influenced the composition of his most famous oratorio, *The Creation*. The work has three parts; the first two treat the six days of creation itself, and the third focuses on Adam and Eve. When Prince Anton died in 1794, his successor Nicholas II invited Haydn back to the Esterházy court, which now resided primarily in Vienna. Haydn returned, by now widely celebrated as an international composer, and wrote an annual mass for the prince as well as works of his own choosing. He remained in Vienna until his death in 1809.

IMPORTANCE. Haydn is often referred to as the "father of the symphony" both because he wrote so many of them (104 in all), and because he was so influential in developing and establishing the form. His instrumentation usually depends on that of the group for which he wrote the work. His early symphonies used strings (the number available ranged from around 10 to 25), continuo, two oboes, and two horns. Some of these early symphonies were written in the three-movement style of the early sinfonia, that is fast-slow-fast. Yet before long he settled on the four-movement pattern that later became the norm: allegro, andante, minuet/trio, and allegro. He used sonata form for first movements, though less rigorously than later writers did. Bold contrasts of dynamics and changes of mood characterize many of the symphonies he wrote around 1770, often referred to as his "Sturm und Drang" period. Somewhat later, by the time he was receiving international commissions, he came to expect more from his audiences and performers alike. The later symphonies included a broad range of instruments and made greater demands, in other words, on both the listener and their performers. His London Symphonies included parts for clarinets, and both woodwind and brass parts had a more independent set of sounds. He selected themes that were fairly simple and could be broken apart and developed, and used a great harmonic range. In his later works, Haydn used the symphony as the arena for developing and presenting a composer's most creative ideas, and for serious, active listening and enjoyment on the part of the audience. These came to be the standards that were to prevail in European serious music of the nineteenth and twentieth centuries.

SOURCES

H. C. Robbins Landon and David Wyn Jones, *Haydn: His Life and Music* (Bloomington, Ind.: Indiana University Press, 1988).

Charles Rosen, *The Classical Style: Haydn, Mozart, Beethoven* (New York; London: W. W. Norton, 1997).

Elaine Sisman, ed., *Haydn and His World* (Princeton: Princeton University Press, 1997).

James Webster and Georg Feder, *The New Grove Haydn* (London: Grove, 2002).

David Wyn Jones, ed., *Haydn* (Oxford: Oxford University Press, 2002).

JEAN-BAPTISTE LULLY

1632–1687

Composer

ITALIAN ORIGINS. Lully, who came to epitomize both the French Baroque musical style and its musical scene, was born Giovanni Battista Lulli in Florence, the son of a miller. He began his musical studies there but moved to Paris as a tutor of Italian to Anne-Marie-Louise d'Orléans, the cousin of Louis XIV, in 1646. There he continued to study music and ballet, and rose quickly to the top of the musical profession. He was appointed composer of instrumental music to the king in 1652. The king, an excellent dancer, was known to appear on stage himself, and Lully's close relationship with Louis helped his career considerably. Lully was a violinist, and was put in charge of a group of sixteen players, the *petits violons* (the "small violins"). He wrote an early surviving work for this group, the masquerade, *La galanterie du temps*. Lully worked on their performance practice and discipline so successfully that by 1666, he also conducted the esteemed ensemble, the *24 violons du Roi* ("The Twenty-Four Violins of the King"), at performances of the court ballets. In 1662 he married Madeleine, daughter of the court composer Michel Lambert, and became a French subject.

OPERATIC COMPOSER. Lully's fame as a composer grew. His compositions would come to include several main types: ballets, *comédies-ballets*, operas, and sacred music. From 1664–1671 he worked with the great French playwright Molière in writing a number of comédies-ballets, among them *Le bourgeois gentilhomme* (The Bourgeois Gentleman) and *Les amants magnifiques* (The Magnificent Lovers). The *comédie-ballet* was a French genre that combined spoken or sung dialogue and dance. In writing the vocal music for these works, Lully worked to fit the music to the French language and its literary traditions, and he wrote some very popular arias. He developed a recitative style that he continued to use in his operas. Here the continuo supported the voice more than was normal in Italian recitative, while the lines themselves might vary in length. Lully insisted that the singers follow his notations exactly, unlike Italian styles that allowed freer interpretation by the performer. In 1672 Lully took an opportunity to purchase a royal privilege on academies for performing operas in France, and so he became director of the Royal Academy of Music. As he moved to write and produce operas, Lully continued to work very closely with his librettists, who were among France's most capable writers. Together composer and librettist developed plots in five acts, conforming to the ancient standards of writers like Aristotle. Lully also demanded effectively written lines that might be set attractively to music. The subjects of his operas came either from ancient mythology or modern romances.

INNOVATIONS AND LATER CAREER. Lully probably did not invent the form known as the French overture, but he did a great deal to popularize it by using it early and often in his dramatic works and elsewhere. He introduced new dances to the court ballet, such as the minuet. French operas typically included ballets, so Lully continued to write dance music even when he had become France's great operatic composer. Lully's career had blossomed thanks to the king's support, but he also found himself caught in some bitter and colorful rivalries with other composers and writers, one of whom he sued for having tried to poison him so that he could assume Lully's operatic privilege. His equally colorful private life also earned some disfavor with Louis XIV when late in his career he was accused of having seduced one of the king's pageboys. Although damaged by the incident personally, it seems to have had little effect on his professional standing. In addition to his music for the stage, Lully also composed a number of important works of religious music for combined voice and instruments, among them a *Miserere* and a *Te Deum*. It was his performance of the latter work that caused his fatal injury. In his role as conductor, he beat time (as was then traditional) by striking the floor with a large cane. The point pierced his toe; the toe became gangrenous, and Lully died after refusing its amputation. Although Lully had purchased the exclusive right to produce opera in France from the king, his skill as a composer and producer ensured his fame and the popularity of his works. Lully's innovations set the standards for those who followed him in French music, and his works were frequently revived in France throughout the eighteenth century. Lully's role in fashioning the second major regional style of the Baroque era, the French style, is indisputable as well. He helped establish performance practices, standards concerning ornamentation and embellishments, and musical forms like the French overture, and he ensured as well

the central role of dance and dance music in both operatic and instrumental music in France.

SOURCES

James R. Anthony, et al., eds., *French Baroque Masters: Lully, Charpentier, Lalande, Couperin, Rameau* (London: Macmillan, 1986).

John Hajdu Heyer, et al., eds., *Jean-Baptiste Lully and the Music of the French Baroque: Essays in Honor of James R. Anthony* (Cambridge, England: Cambridge University Press, 1989).

John Hajdu Heyer, ed., *Lully Studies* (New York: Cambridge University Press, 2000).

Joyce Newman, *Jean-Baptiste De Lully and His Tragédies Lyriques* (Epping, England: Bowker, 1979).

Caroline Wood, *Music and Drama in the Tragédie en Musique, 1673–1715: Jean-Baptiste Lully and His Successors* (New York; London: Garland, 1996).

WOLFGANG AMADEUS MOZART
1756–1791

Composer
Musician

EARLY GENIUS. Wolfgang Amadeus Mozart's father described him as "the miracle which God let be born in Salzburg." Leopold Mozart, a well-educated musician, devoted great energies to nurturing and promoting the talents of his son, whose musical genius manifested itself very early. Playing the harpsichord at the age of four and composing by the time he was five, Wolfgang quickly became a star attraction. His father took him on a three-year European performing tour, with his older sister Maria Anna that began when he was only seven. He excelled as an organist and violinist as well as at the harpsichord, and later would turn to the piano. The tour helped expose Mozart to the musical styles in all parts of Europe, and so aided the development of his own style as a composer. In 1764 at the age of eight, he performed before King Louis XV of France, and traveled with his father to London, where he composed his first symphonies, and published a set of violin sonatas. In London he also met Johann Christian Bach, the youngest son of Johann Sebastian Bach. After the family's return to Salzburg in 1766, Mozart made several trips to Vienna where he met the composer Josef Haydn. His father also took him to Italy in 1770, both to perform and to study. They returned once again to Salzburg, where both father and son held positions at court. Young Mozart continued to compose and develop his reputation as a composer, but increasingly he felt constrained by the provincial at-mosphere of Salzburg. He was unsuccessful, though, in winning a major position elsewhere, and so, he continued to make trips from Salzburg. Eventually, his requests for leave from his court position resulted in his dismissal, and in 1777 Mozart left on an extended tour of Germany and France with his mother. His mother died, though, not long after his arrival in Paris, and since Mozart was unsuccessful in securing a position in France, he returned again to Salzburg, where he once again received a contract from the Archbishop's court.

VIENNA. In 1781, after a stormy period in the employment of the archbishop, Mozart moved to Vienna to work independently as a freelance composer and performer. He found success quickly with the opera *The Abduction from the Seraglio*. The work has a German text and is written in the *Singspiel*, meaning it includes both arias, duets, and ensemble work together with spoken dialogue. Here Mozart evoked its Turkish setting not only with sets and costumes, but also with exotic-sounding instruments, such as the clarinet, and a range of percussion, and music intended to evoke Turkish styles. At about the same time he married Constanze Weber, and his relationship grew strained with his father, who had approved neither of the young Mozart's move or his marriage. A visit home in 1783 helped improve relations, and upon his return to Vienna Mozart enjoyed some of his greatest successes. He began to collaborate with the librettist Lorenzo da Ponte, a partnership that resulted in *The Marriage of Figaro* in 1786, *Don Giovanni* in 1787, and *Così fan tutte* in 1790. *Don Giovanni*, often accepted as the greatest musical achievement among the composer's twelve operas, balances the humor of its hero's romantic appeal and wandering eye with the eerie and dramatic spectacle of the statue of a wronged man coming to life and dragging him down to a well-deserved hellish damnation. *Così fan tutte* seems, on its surface, to be a mere light comedy, featuring devoted ladies whose sweethearts wager over whether they can be lured away to another lover in their absence. The story, with its confusion of identities and humor, accommodated some of Mozart's most charming writing. The conclusion, which muses on human weakness and begs for tolerance of mutual frailty, reveals the real depth of da Ponte's libretto as well as the thought behind Mozart's music. Despite his successes, Mozart had continued to seek financial stability, which he achieved with a court appointment in 1787. Mozart had always rebelled against a common tendency at courts to view musicians and composers as little more than skilled servants. He felt that he and his colleagues should be able to live affluently and to move freely in all kinds of society. His abil-

ity to manage money, though, did not keep pace with such pretensions, and so he and Constanze suffered chronically from financial troubles. The steady income of the new court position helped the composer to manage those troubles, although it did not end them.

LAST YEAR AND BEYOND. During the last year of Mozart's life, he completed another opera seria, *La clemenza di Tito,* as well as *The Magic Flute.* The latter opera is in German and with some spoken dialogue, but the plot has added themes not only from folk tales but also from the ideas of the Freemasons. Mozart had become a member of this society, and wrote a number of pieces for performances at its meetings. The opera's main figures, Tamino and Pamina, win both love and enlightenment amid a colorful and memorable collection of characters and dazzling arias that are graceful, amusing, or frightening as called for by the story line. In 1791 he began work on the famous *Requiem* Mass, which was commissioned anonymously by Count von Walsegg-Stuppach as a memorial to his wife. Mozart became ill with a fever and died before completing it. As was customary for persons of his station in Vienna at the time, he had a small funeral and was buried in a multiple grave. Constanze had his students and collaborators, Joseph Eybler and Franz Xaver Süssmayr, finish his *Requiem.* In the years that followed publishers began to put together collections of his works, while Constanze remarried and her second husband wrote a biography of Mozart.

IMPORTANCE. Mozart's enormous talents as a composer were more than a match for the continuously changing musical styles of the late eighteenth century. He did not invent new genres or forms, or create an entirely new style of composition. Rather, he used the new styles and forms that had already emerged in European music after 1750, making them his own and molding them into vehicles that were particularly expressive of his genius. His earliest writings relied not only on regional south German and Austrian styles but on Italian ones as well. An interest in counterpoint and careful, technical composition developed fairly early and remained with him. In Vienna, he discovered the music of Johann Sebastian Bach and he studied and arranged some of his compositions. Throughout his brief life he composed music in many different genres, so in each of these some similar developments of his talents and interests are evident. His melodies balance a sense of natural progression with surprise and innovation. His string quartets, especially those produced after his encounters with Haydn, seem to have mastered the ideal of four equal musical voices in dialogue or conversation with one another. His symphonies are demanding of the performers, feature complex devel-

opment of carefully worked themes, and combine the drama of recent styles with the complexities of counterpoint. His music became more complex over time, and a number of his later works gained a reputation among his contemporaries as being rewarding but difficult and challenging to listen to.

SOURCES

Cliff Eisen, *The New Grove Mozart* (London: Grove, 2002).

Robert W. Gutman, *Mozart: a Cultural Biography* (London: Secker & Warburg, 2000).

Konrad Küster, *Mozart: a Musical Biography.* Trans. Mary Whittall (Oxford: Clarendon Press, 1996).

Wolfgang Amadeus Mozart, *The Letters of Mozart and His Family.* Ed. and trans. Emily Anderson (London: Macmillan, 1985).

John Rosselli, *The Life of Mozart* (Cambridge, England: Cambridge University Press, 1998).

ANTONIO VIVALDI

1678–1741

Composer
Violinist

THE RED PRIEST. Vivaldi was both a prolific composer and a noted violinist. His father was a violinist at the ducal chapel of San Marco in Venice, and Antonio began his musical education at home. He was ordained a priest, though chronic respiratory problems (probably asthma) kept him from many clerical duties; due to his red hair he acquired the nickname *il prete rosso*, meaning "the red priest." In 1703 he accepted a position as violin teacher at a girls' orphanage and foundling home in Venice, the *Pio Ospedale della Pietà.* These orphanages provided musical training as part of their educational mission; the girls gave regular concerts, which attracted large audiences and garnered the institution an international reputation. Vivaldi was eventually promoted to concertmaster, and despite many years of travel during his career, he continued his association with the institution until 1740.

CONCERTOS. The frequent concerts at the *Ospedale* required a constant supply of new compositions, as audiences expected to hear new works. In 1723, for example, the institution asked Vivaldi to produce two concertos for them each month. Vivaldi continued to comply, and grew quite proud of his ability to compose not only well but quickly; he boasted that he could compose a concerto in all its parts faster than a copyist could transcribe

them. About 500 of his concertos survive. Vivaldi wrote them for a number of different solo instruments and combinations that reflect not only the popularity of various instruments, but also the variety of players over the years at the Ospedale. Nearly half are for a solo violin and orchestral strings. He also wrote for other solo instruments, such as flute, cello, oboe, and even mandolin. Others are double concertos for two soloists. Some use three soloists in the form of a concerto grosso, or in other combinations. Most of these works are in three movements, fast-slow-fast. Many fast movements use a form called *ritornello*, in which the larger orchestral group of strings plays a thematic section that returns several times in various keys, and alternates with freer sections for the soloist or soloists. This form allows for virtuoso writing and provides passages through which the soloist can display his or her skill. Often the soloist is allowed an improvisatory section near the final cadence of the movement, and because of its location such passages are called cadenzas. The slow movements of Vivaldi's concertos feature aria-like melodies. Vivaldi named many of his concertos. The names might refer to any number of features about the work, such as the original soloist, the person to whom it was dedicated, some technical aspect about the composition that was especially prominent, or a theme or subject that the music described, for example "Storm at Sea" or "The Hunt." For his famous "Four Seasons" concertos, he wrote a sonnet on the subject of each one and published them together with the compositions.

LATER LIFE. As he matured, Vivaldi also began to write operas, where his flair for the dramatic can also be seen. Some 21 works survive in whole or in part, though he wrote many more. At first, he produced them in Venice, but by 1718, he was invited to Mantua to present his current production. In the 1720s, he also spent several years in Rome, before returning to Venice, where he continued to produce operas and write instrumental compositions. But by the 1730s, he was traveling further afield. His last trip was to Vienna, where he died in 1741. Although he had made enormous sums of money during his lifetime, he spent just as extravagantly, and was given a pauper's burial in Vienna. Vivaldi's works were extremely popular for most of his career. Both the volume of his compositions and their high quality made them very influential. He published his works with care, dedicating them to prominent patrons and choosing presses with high-quality printing and good distribution. Etienne Roger of Amsterdam published his set of violin concertos, *L'estro armonico,* in 1711, dedicated to the Grand Duke of Tuscany. This choice both acknowledged

the interest of northern Europeans in Italian composers, and helped to continue to expand that market. His work influenced other major composers; Johann Sebastian Bach transcribed some of his works for the keyboard, and many other northern composers studied them with great interest. Vivaldi helped to standardize the writing of concertos, and to popularize the combination of virtuoso soloist with orchestra. Especially to those in northern Europe, he seemed to embody the best of Italian style in the later Baroque era. Some, however, were more impressed by his abilities as a fiery performer. The composers in the Galant and Sensitive styles that followed the later Baroque period singled out Vivaldi, criticizing him for having continued to write in an archaic style. They desired to separate themselves from elements of Vivaldi's style, including what they felt were an overemphasis on sheer virtuosity, display, and overly contrived passagework. Unlike other figures the Galant and Sensitive composers of the mid- and later eighteenth century criticized, Vivaldi had largely abandoned the contrapuntal style of Baroque composers. His influence on Bach later inspired a renewed interest in his works after his death, and his instrumental writings in particular continue to enjoy frequent performance and great popularity.

SOURCES

Denis Arnold, et al., eds., *Italian Baroque Masters: Monteverdi, Frescobaldi, Cavalli, Corelli, A. Scarlatti, Vivaldi, D. Scarlatti* (London: Macmillan, 1984).

H. C. Robbins Landon, *Vivaldi: Voice of the Baroque* (London: Flamingo, 1995).

Michael Talbot, *Venetian Music in the Age of Vivaldi* (Aldershot, England: Ashgate, 1999).

———, *Vivaldi* (London: Dent, 1978).

DOCUMENTARY SOURCES
in Music

Carl Philipp Emanuel Bach, *Essay on the True Art of Playing Keyboard Instruments* (1753—1762)—This treatise was the most important works concerning performance practice on the keyboard instruments written during the eighteenth century. Emanuel Bach, a great performer and a composer in his own right, provides even now a wealth of information to music historians anxious to understand the music of the later Baroque.

Charles Burney, *Memoirs of the Life and Writings of the Abate Metastasio*—Pietro Metastasio, (1698–1782) was one of the greatest librettists of the eighteenth century. He

composed the words for more than 25 operas as well as for a huge number of other sacred and secular works. Burney's edition helped to spread knowledge of the poet's achievements throughout Europe, Scandinavia, and Russia. Since then, more than 400 different composers have set Metastasio's texts to music.

Charles Burney, *Musical Tours in Europe* (1771–1773)— The great English music historian compiled this collection of observations on two tours undertaken through the Continent during 1771 and 1773. They provide an unparalleled insight into the ways in which music and its performers entered into the society of late eighteenth-century Europe.

Sir John Hawkins, *A General History of the Science and Practice of Music* (1776)—Hawkins wrote his music history after more than sixteen years of research in the British Museum in London. While warmly received at its publication, the work soon attracted controversy and intrigue. Supporters of Charles Burney, England's other ranking musicologist, subjected Hawkins' work to attacks in the British press. Over time, its erudition and importance has raised the work to one of the great monuments of music history and theory.

Franz Joseph Haydn, *Collected Correspondence and London Notebooks* (c. 1765(?)–1792)—This compilation of the composer's letters also includes selections from his London journals, kept while Haydn was writing his famous London Symphonies, one of the milestones in orchestral composition.

Johann Georg Leopold Mozart, *A Treatise on the Fundamental Principles of Violin Playing* (1756)—Written by Wolfgang Amadeus Mozart's father, this little book offers a window on the performance styles and techniques in which the young prodigy would have been trained in his childhood.

Wolfgang Amadeus Mozart, *Letters* (1756–1791)—The correspondence of the greatest musician of the eighteenth century inform us not only about the nature of musical society at the time but about the character of this undeniable genius.

Johann Joachim Quantz, *On Playing the Flute* (1752)—Written by one of the greatest German court musicians of the eighteenth century, this book's eighteen chapters treat far more than the art of playing the flute. Quantz's work is, in fact, a treasure trove concerning all the performance practices of the time and was widely read by all amateur musicians who hoped to improve their skills.

Jean-Philippe Rameau, *Theoretical Writings* (1722–1764)— Inspired by the principles of the Scientific Revolution, this French theorist hoped to grant a "scientific" foundation to music. Rameau's ideas provided one of the most influential theoretical foundations for the development of the eighteenth-century art, even as they contributed to a discussion of music's intellectual underpinning that had been occurring in Europe since the Renaissance.

Heinrich Schütz, *Letters and Documents* (c. 1670)—This collection catalogues the life of the first great Baroque composer of Germany. Schütz's career was long and illustrious and much of it coincided with a time of great trial, the Thirty Years' War (1618–1648), in German history. Despite these tribulations the composer placed his stamp on the formation of Baroque style in Central Europe.

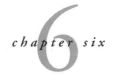

chapter six

PHILOSOPHY

Andrew E. Barnes

IMPORTANT EVENTS
in Philosophy

1596 René Descartes, who will try to raise philosophy into a science, is born near Tours, France.

1601 The French thinker Pierre Charron publishes his *De la sagesse* (On Wisdom), a work that argues, like Montaigne's Renaissance essays, that absolute knowledge of God cannot be established from human reason. It is an example of the skepticism in philosophy prevalent in early seventeenth-century Europe.

1609 The German astronomer Johannes Kepler publishes his *Astronomia Nova*. The work modifies Copernicus's heliocentric or sun-centered theory of the universe by showing that the planets move in elliptical, rather than circular orbits.

1610 Galileo's *The Starry Messenger* is published. The work tells of his recent observations of the heavens made with the aid of a telescope.

1620 Sir Francis Bacon's *Novum Organum* (The New Organon) defends inductive reasoning and empirical observation against the methods of traditional scholasticism. One year later Bacon will be exiled from his positions at the English court and forced to retire; from this vantage point he continues to conduct experiments and to write on scientific matters.

1625 The Dutch legal theorist and humanistic philosopher Hugo Grotius completes his *Three Books on the Law of War and Peace*, one of the first seventeenth-century treatises to rely on the concept of "natural law" to explain relationships between human beings. The work will influence the later writings of Thomas Hobbes and John Locke.

1633 The Italian astronomer Galileo Galilei is condemned to house arrest for the rest of his life for his defense of a sun-centered universe.

1637 René Descartes' *Discourse on Method* defends reason as the basis for progress and expansion of human knowledge.

1641 Descartes' *Meditations on the First Philosophy* appears. It includes the famous dictum, "I think, therefore I am."

1645 Baron Herbert of Cherbury's *The Layman's Religion* defends innate knowledge of God derived from nature. Later in the century, Cherbury's works will inspire English Deists to develop a religion that blends scientific and natural knowledge with traditional Christianity.

1651 Thomas Hobbes publishes *Leviathan*, a work that relies on a dismal view of human psychology to support the strong central authority of a sovereign over his subjects.

1655 Pierre Gassendi, a philosopher who has worked to revive Epicurean and skeptical ideas, dies.

1656 Baruch Spinoza is excommunicated by his Amsterdam synagogue.

1660 In England, Charles II is restored to the throne, and two years later he charters the Royal Society, an institution that will have great impact on British science and philosophy in the centuries to come.

1666 The French Academy of Sciences is founded in Paris.

1677 Spinoza dies in Holland, and his treatise *Ethics* is published by friends in the months following his death.

1679 The political philosopher Thomas Hobbes dies.

1680 The Cartesian philosopher Nicholas Malebranche publishes his *Treatise of Nature and Grace* to harmonize the notion of a benevolent God with the presence of evil in the world. The work also attempts to defend his previously published ideas, which conservatives find theologically unorthodox.

1687 Isaac Newton's *Principia* establishes a mathematical foundation for the theory of gravity.

1690 John Locke's *Two Treatises on Government* is published for the first time in England. The work sets out its author's philosophy of limited government.

1696 John Toland's *Christianity Not Mysterious* defends early Deist principles that God can be ascertained through the natural world.

1702 Pierre Bayle's vast *Historical and Critical Dictionary* is published for the first time. Although its author differs in many respects from later Enlightenment philosophers, his critical and searching intelligence will often be identified as one of the movement's sources of inspiration.

1714 Gottfried Wilhelm Leibniz's *Monadologia* appears. The work outlines its author's complex metaphysical philosophy that everything in nature is comprised of irreducible things called monads.

1722 The Baron de Montesquieu's *Persian Letters* holds a mirror up to European society, criticizing its government and conventions and sparking debates that lead to the deepening influence of the Enlightenment in France.

1734 George Berkeley is appointed Anglican bishop of Cloyne in Ireland. From this vantage point, he will try to stop the erosion in Christian belief in Great Britain.

Voltaire publishes his *Philosophical Letters*, observations on English customs and government gleaned while in exile there in the late 1720s.

1748 David Hume's *An Enquiry Concerning Human Understanding* denies the possibility of supernatural events since they would be violations of natural laws.

The Baron de Montesquieu publishes *The Spirit of Laws*, a treatise that illuminates the contrasting governments of states by examining their climate, history, and culture. The work sets forth a notion of the separation of the powers that will be influential in the later French and American revolutions.

1751 Denis Diderot and Jean d'Alembert begin compilation of their massive *Encylopédie*, a milestone of the French Enlightenment. When completed almost thirty years later, it will number 28 volumes of articles and illustrations.

1754 Étienne Bonnot de Condillac's *Treatise on Sensations* defends Lockian empiricism in France.

1762 Jean-Jacques Rousseau's *The Social Contract* defends constitutional government by strengthening a theory of the state of nature that is more pessimistic than his previous assessments.

1776 Thomas Paine's political tract, *Common Sense*, defends the developing American Revolution's campaign against Great Britain.

1781 Immanuel Kant's *Critique of Pure Reason* demonstrates that reality is ultimately unknowable on strictly rationalistic grounds.

1786 Moses Mendelssohn, a lifelong promoter of secularization and Enlightenment among the Jews of Central Europe, dies.

1787 The English historian and philosopher Edward Gibbon completes his monumental *The Decline and Fall of the Roman Empire*, a work that traces Rome's collapse to the rise of Christianity.

1789 Paul-Henri Thiry, more commonly known as the Baron d'Holbach, dies. He was an enthusiastic promoter of atheism.

In France, the *Declaration of the Rights of Man* assures many civil rights, achieving the goals of many French Enlightenment philosophers.

1792 Jeremy Bentham, an English utilitarian philosopher and social critic, is naturalized as a French citizen.

1793 The Reign of Terror, an effort on the part of radical leaders of the French Revolution to eliminate opposition, begins in Paris.

OVERVIEW
of Philosophy

THE LONG VIEW. In assessing the changes that occurred in philosophy in the Baroque period it is helpful to take a long view so that the depth and significance of the discipline's early-modern transformations stand out when contrasted against the traditional role that philosophy had long played in Europe's schools and universities. In the Middle Ages philosophy had developed in tandem with Europe's secondary schools and universities, the primary venues for higher education. To undertake advanced training in a university, students first completed a course of study in the liberal arts. The arts themselves were divided into two branches known as the *trivium* and the *quadrivium*. The trivium consisted of the areas of study that would today be called the "language arts" and included instruction in grammar, rhetoric (style), and dialectic (reasoned argumentation). In the quadrivium, by contrast, were consigned all those branches of knowledge that were mathematical in nature: arithmetic, music (because it was the science of sound and proportional harmony), geometry, and astronomy. Mastering these disciplines required a student to read, and frequently commit to memory, a number of already existing ancient and medieval texts that had treated these disciplines. Although today many of the texts that these students read would be considered philosophical in nature, philosophical study, in and of itself, was never an independent course of study either in the medieval secondary schools or in the university. Once students had completed this liberal arts course they enrolled in a university, where they entered into a faculty of law, medicine, or theology, the primary branches of study that existed in most medieval and Renaissance institutions. In these various faculties, students continued to study the works of ancient philosophers and medieval authorities that had written works that had implications for their discipline. In these three faculties, medieval academicians frequently wrote texts that expanded the body of knowledge, and which touched upon issues that can be identified as "philosophical." Great medieval theologians like Thomas Aquinas, for instance, ventured into subjects like epistemology, the science of establishing the truth of one's observations. Medical authorities considered questions about natural philosophy, a branch of ancient philosophy that was concerned with matter, even as ancient ethical questions continued to be treated by theologians and legal authorities as well. In this way, philosophy was an important handmaiden to the three main disciplines that co-existed within the medieval university, and students were forced to undertake study of many philosophical texts as part of the routine undertaking of mastering their profession. Yet philosophy as a branch of study pursued for its own ends and purposes did not exist in medieval Europe.

RENAISSANCE HUMANISM AND ITS IMPLICATIONS. In the three centuries following 1300, educated Europeans' understanding of the entire body of ancient philosophical works deepened through the impact of humanism. This intellectual movement—born in Italian cities—first arose independent of Europe's universities and cathedral schools, the primary venue in which higher education occurred during both the Middle Ages and Renaissance. The humanists' stated aims of returning to the sources (*ad fontes*) were not as new as might be supposed. In the twelfth and thirteenth centuries, for instance, theologians, physicians, and legal authorities working in Europe's universities had already begun to recover knowledge of Aristotle and other ancient philosophers' writings, a renewal that was often fed through contacts with Islamic and Jewish scholars. But as humanist scholars took on the task of understanding the entire body of ancient philosophical and scientific knowledge, they were concerned with examining these texts, not only for the insights that they might offer in theological, medical, or legal study, but for the moral and ethical insights they might offer for negotiating life in the new, more highly urbanized societies of their day. Humanists pioneered new techniques for studying texts—techniques like philology, which allowed students to explore the changes that had occurred in the uses of words and language over time. And they also established disciplined techniques for determining the veracity and authenticity of the many variant versions of ancient works that existed in Europe at the time. Still, humanist intellectuals were often very conservative in their ideas and methods. Like their medieval forbearers, they usually accepted the notion that the body of ancient philosophical and scientific works was a corpus of texts that might be profitably studied for the truths it contained on a number of subjects. They had, in other words, a fundamentally textual notion about truth. Instead of

subjecting the ideas that they found in many works to detailed examination, questioning, and experimentation, they often tried to harmonize the readily apparent incongruities that they found in these works, thus building new, ever-more complex intellectual systems. As humanists' studies of ancient texts revealed the enormous complexity of Antiquity's ideas about the body, for example, long-cherished theories of Galen and his four humors were combined, rejected, or replaced with new medical theories drawn from Platonic, Aristotelian, and other ancient sources, inspiring movements like sixteenth-century Paracelsianism with its challenging new intellectual formulations. The aim of humanist study, as it had often been in the medieval university, was the weighing of traditional authorities and the finding of a path of harmonization and synthesis through this evidence. Although they had initially resisted the new intellectual tools and knowledge humanism provided, most European universities had by the early sixteenth century come to accommodate this New Learning within their curricula. By the end of the sixteenth century, humanism and the by-then traditional methods of Aristotelian scholasticism persisted side-by-side in Europe's universities, and despite the great fissures that the Reformation and Counter Reformation had produced in Europe, the university training of intellectuals continued to be almost everywhere a conservative amalgam drawn from late-medieval exchanges between humanism and medieval scholastic methods. Philosophy, in this system, was still not an independent course of study or discipline, but was instead a tool that was in every country and university expected to uphold the fundamentally traditional and conservative demands of the Christian worldview.

EARLY-MODERN CHANGES. In the course of the seventeenth and eighteenth centuries this situation changed rather quickly, and philosophy as an intellectual discipline in and of itself began to emerge from the long role it had played as a handmaiden to theology, medicine, and the law. Three important transformations can be seen throughout the period. First, philosophy was persistently separated from theology as a series of thinkers in the period questioned the received wisdom their societies accepted from traditional Christian, medieval, and ancient authorities. Second, as it acquired a new independence from the longstanding concerns with supporting received opinion, philosophy moved closer and closer to modern science. And finally, as a new independent discipline of intellectual inquiry, philosophy flourished, not primarily in Europe's schools and universities where a conservative worldview inherited from

the medieval and Renaissance past made the new speculations seem dangerous. Rather this new discipline came to be a pastime practiced by a new professional intelligentsia that was concerned with influencing public opinion.

THE ATTACK ON RECEIVED WISDOM. During both the Middle Ages and the Renaissance, churchmen had insisted that all philosophical speculation reconcile itself to the truths of Christian faith. And although Protestant and Catholic leaders continued to try to uphold religious orthodoxy in the seventeenth century, they soon lost their ability to dictate the boundaries of permissible thought to those outside the clergy. As a result, intellectuals with increasingly secular, rather than religious views, began to jettison the long-standing effort to reconcile their thoughts with the teachings of the Christian churches. State authorities continued to monitor the materials being published, and some "freethinkers" or "libertines," as they were called, were incarcerated, and in some extreme instances, put to death. But across the seventeenth century, philosophers paid less and less attention to Christian sensibilities. For truth, philosophers turned instead to the Scientific Revolution. In the seventeenth century the Scientific Revolution was most associated with achievements in two areas, both involving applied mathematics. The invention of new instruments such as the telescope and the microscope, both of which represented the application of geometry to optics, allowed for the accumulation of far superior data concerning the natural world than most educated people had previously thought was possible. New mathematically derived theorems, such as Johannes Kepler's laws of planetary motion, and ultimately Isaac Newton's theory of gravity, helped make sense of the new data. Philosophers were enthralled with this new scientific wisdom and with the methods of scientists generally. The achievements of the latter, it was said, allowed "moderns" to see much further than the "ancients." In the fifteenth and sixteenth centuries, humanists had often led the assault on scholasticism and the monopoly on thought that churchmen alleged they maintained. Now seventeenth-century scientists assumed the leadership in this attack.

THE IMPACT OF THE PRESS. In this process the venues in which philosophical combat were waged also changed. In medieval Europe, universities and their lectures halls provided the only forums for the discussion of philosophical ideas. But in the early-modern period, universities were often closed off from the new scientific and philosophical debates because their intellectual discourse continued to be dominated by the demands of Christian theology. Seventeenth-century philosophers,

though, were heir to the invention of the printing press, a relatively new medium that humanists and reformers had already relied upon in the sixteenth century to promote their ideas. As they engaged in battle with traditional university scholasticism, scientists adopted the same tactics that Erasmus, Luther, and a host of others had used profitably in the sixteenth century. They took their ideas to the press, where they could sway a far larger group of readers without having to jockey for a place in a university lecture hall. The new role that the press attained as a vehicle for promoting the scientific and philosophical ideas of the time meant that by the eighteenth century universities had become marginal in many places to the process of intellectual discourse. The proliferation of newspapers and journals, combined with the emergence of a cultural tradition of learned debate in salons and coffeehouses, produced across Europe an extended community of reading, thinking individuals who collectively made up "public opinion." Intellectuals now appealed to this new court of "public opinion," and those intellectuals who dominated in the new commonwealth of printed letters were publicists as much as they were thinkers. The new intellectual figure of the eighteenth century was most brilliantly embodied in the figures of the French *philosophes*, men like Montesquieu, Voltaire, and Rousseau, who were brilliantly capable of shaping public attitudes and ideas because of their brilliant writing. These figures made their living by promoting their ideas to as large an audience as possible. And while governments did not always obey the dictates of the new court of "public opinion," they certainly kept track of its ideas and demands. The philosophers of Enlightenment thus indirectly influenced government actions by their successful attempts to mold public opinion.

THE RISE OF SCIENCE AND SHIFTING TOPICS IN PHILOSOPHY. The important role that philosophy played in seventeenth- and eighteenth-century societies can be seen in the many shifts that occurred in the discipline's discourse over the period. Science was at the heart of many of these disputes, as the philosophers of the period considered the role that the new natural knowledge played as a source of truth independent of the once traditional certainties of religion. The rise of science produced new philosophical movements like Deism, an English invention that eventually was espoused by many of the intellectuals of the French Enlightenment. Deism reconciled a belief in the existence of God with the new insights scientific inquiry had produced. It taught that the fundamental order and harmony revealed in the universe pointed to the existence of a higher being, yet at the same time it abandoned the

traditional theological teachings of Christianity. God may have created the universe, but in the world of the late seventeenth- or eighteenth-century Deist, he was now a far-off figure that had left man to his own devices to shape the world as man saw fit. Elsewhere the rise of the new science in the seventeenth century prompted bristling debates about the relative superiority of scientific and religious truth, even as it led to new attempts to chart the contours of society with methods similar to those the scientists had used to unlock gravity and the distant reaches of the solar system. By the middle of the eighteenth century, this intellectual ferment had helped to produce the Enlightenment, a cultural movement that celebrated the triumph of rationalism over what its proponents identified as the superstitions of the past. Although linked by certain affinities of topics, the movement was very different in the various national states in which it flourished. It had a profound impact, however, upon the birth of the modern notion of political philosophy, and the theories that still guide the modern disciplines of sociology, anthropology, political science, and economics can be traced to debates that originated during this era.

TOPICS
in Philosophy

BAROQUE PHILOSOPHICAL ROOTS

PROTESTANT VS. CATHOLIC SCIENCE. During the twentieth century historians often debated the question of the relationship between religion and the rise of science. Following the lead of the sociologist Max Weber, who had argued that there was a positive connection between Protestantism and the rise of capitalism in Europe, one group of historians made the case that Protestant culture was far more encouraging of scientific research than was Catholic culture. The problem with their case was that while England and Holland—the two examples most often cited in support of the argument—were Protestant, these were also states where the power of the state church was seriously constrained by the government. In Protestant states where the church and government shared the same cultural and religious agenda, such as the German Protestant states of the Central European Holy Roman Empire, scientific research was as absent as it was in Catholic states. An inability on the part of the state church to repress scientific research appears to have been more important than any positive encouragement given to science by Protestant churchmen.

Illustration of the Copernican world system. © STEFANO BIANCHETTI/CORBIS.

THE CRIME OF GALILEO. The story of Galileo has often been used to suggest that Catholicism was more hostile to science than Protestantism was. Galileo Galilei (1564–1642), known as the great Italian "natural philosopher," was a scientist who was forced by the Roman Inquisition to recant his arguments in support of the Copernican thesis that the earth revolves around the sun. Yet as Catholic apologists for the Inquisition have pointed out, Galileo was arguing for more than just the Copernican thesis, the notion that the sun rather than the earth was the center of the universe. His work presented a challenge to the church because he was promoting the notion that scientific pursuits should be free from moral and religious scrutiny. No seventeenth-century Christian church was, in fact, willing to grant that science should have such independence. Galileo's case for the autonomy of science, though, has long made him the starting point for any discussion of philosophy in the age of the Baroque. Galileo followed a string of Renaissance humanists who saw the "book of Nature" as an alternative to the teachings of medieval scholasticism. Tommaso Campanella (1568–1639), one of Galileo's contemporaries, went so far as to contrast the arid emptiness of traditional medieval scholasticism with its Aristotelian science, with nature as the true "living book of God." Galileo, though, was the first scientist to lend the weight of his achievements and observation to his argument. Although he was already well known for his discoveries of the physical properties of motion, Galileo had begun in 1609 to channel his considerable research talents into proving that the Copernican thesis was correct. After lifelong study, Nicolaus Copernicus published his

heliocentric theory in 1543, the same year in which he died. Like most Renaissance astronomers, his work was not based upon scientific observation or experimentation, but on his knowledge of texts, combined with his own subtle theorizing. Although his theory had circulated relatively freely in the sixteenth century, it did not become controversial until Galileo decided to confirm its observations with the use of a telescope. Galileo had read about this new invention, and he figured out how to build one himself. Then he wrote *The Starry Messenger* (1610) based upon the observations he made with it. Churchmen were fascinated with Galileo's new instrument; however, they did not follow him in his conclusion that the evidence it revealed refuted the Ptolemaic thesis that the sun revolved around the earth. In 1616, Galileo was called before the Inquisition and told to stop teaching that the Copernican thesis was true. He agreed, but then continued to try to convince churchmen and other intellectuals of the error of their ways. In 1623 he published another book, *The Assayer*, ostensibly a report of his observations on comets, but in fact an attack on the Ptolemaic thesis. Finally in 1632 he published his masterpiece, *Dialogue on the Two World Systems*, in which—in the context of a hypothetical debate between three learned men—he ridiculed the Ptolemaic thesis. It was the arguments in this *Dialogue* that the Inquisition forced Galileo to recant one year later.

GALILEO'S PHILOSOPHY OF SCIENCE. Galileo was the first thinker to insist that at the heart of the opposition between science and traditional scholastic Aristotelianism was a distinction between numbers and words. As Galileo observed in the *Assayer*, Philosophy (science) is written in "mathematical language and its characters are triangles, circles and other geometrical figures." Galileo rejected the insistence by Scholastics that science involved the constant reinterpretation of every newly discovered attribute of the physical world according to the explanations first offered by the ancient Greeks. For him, it had to be accepted that these new things could not be explained by the old teachings. In the *Assayer* he related the story of one of his Aristotelian colleagues who refused to look through his telescope for fear of seeing things he could not reconcile with his ideas, Galileo's point being that it was only through such ignorance that old beliefs might be maintained. Yet Galileo did not propose to replace the old speculations with new ones. For him, science was not about what might be speculated and then justified; it was about what could be seen and then demonstrated. Like Francis Bacon, Galileo argued for an inductive method of investigation that built from observation to theory and then through

experiment to validation of theory. But in a way that was different from Bacon, Galileo's method required that those rationalizations be expressed in mathematics. If a scientific theory is true, he reasoned, it can be demonstrated mathematically; if it cannot be demonstrated mathematically, it is not true. It is from this perspective that Galileo sought to free science from the oversight of religious authorities. Science, he argued, was about the physical world and, as such, its proofs had nothing to do with religion. In a letter addressed to the Grand Duchess Christina of Tuscany, Galileo argued that it is wrong to use the Bible as a guide to the natural world. In seeking to condemn the Copernican thesis, he complained, his enemies cited passages in the Bible where it states that the sun moves, and the earth stands still. But it is wrong to take the Bible literally, he argued, because the words of the Bible have layers of meaning, and the literal, obvious layer is there essentially to keep the common people, who are "rude and unlearned" happy. According to Galileo, the Bible and Nature, "proceed alike from the Divine Word, the former as the dictate of the Holy Spirit, the latter as the obedient executrix of God's commands." God's commands are the physical laws of the universe. Science, which could be defined as the effort to discover those laws, was thus only another form of Christian worship. Galileo argued, then, that the Copernican thesis was no challenge to the Bible's authority because it reflected a truer understanding of God's laws than did the traditional geocentric, or "earth-centered" theory. Its embrace signaled true Christian piety. But churchmen remained unmoved by Galileo's arguments. Defenders of the Catholic Church have long pointed out that, at the time Galileo was writing, there was no definitive proof of the validity of the Copernican thesis, and that the experiments that Galileo thought granted such proof have since been proven faulty. The issue in Galileo's censure, though, was not the quality of his science. The issue was whether or not an agency claiming moral authority, such as the Catholic Church, had the right to declare scientific investigation immoral. Galileo argued that it did not, but because he was a devout Catholic, he eventually acquiesced and submitted to the church's condemnation of his argument. Those who followed him, however, saw him as a martyr for the truth.

FRANCIS BACON AND THE RISE OF EXPERIMENTAL SCIENCE IN ENGLAND. Galileo's fate actually compared favorably with that of the other individual responsible for making the case for science to early seventeenth-century audiences. After a life in its own way as illustrious as Galileo's, Francis Bacon (1561–1626)

a PRIMARY SOURCE *document*

STARTING AFRESH

INTRODUCTION: Francis Bacon's *Novum Organum* has often been called the "manifesto" for the Scientific Revolution. In truth, that movement's origins were far more complex. But in his preface to the work, Bacon outlined his method. His emphasis on looking past received wisdom and setting natural inquiry on a firm footing of observation seem as modern today as they were refreshing to scientific minds in the seventeenth century.

Those who have taken upon them to lay down the law of nature as a thing already searched out and understood, whether they have spoken in simple assurance or professional affectation, have therein done philosophy and the sciences great injury. For as they have been successful in inducing belief, so they have been effective in quenching and stopping inquiry; and have done more harm by spoiling and putting an end to other men's efforts than good by their own. Those on the other hand who have taken a contrary course, and asserted that absolutely nothing can be known—whether it were from hatred of the ancient sophists, or from uncertainty and fluctuation of mind, or even from a kind of fullness of learning, that they fell upon this opinion,—have certainly advanced reasons for it that are not to be despised; but yet they have neither started from true principles nor rested in the just conclusion, zeal and affectation having carried them much too far. The more ancient of the Greeks (whose writings are lost) took up with better judgment a position between these two extremes,—between the presumption of pronouncing on everything, and the despair of comprehending anything; and though frequently and bitterly complaining of the difficulty of inquiry and the obscurity of things, and like impatient horses champing at the bit, they did not the less follow up their object and engage with Nature, thinking (it seems) that this very question,—viz., whether or not anything can be known,—was to be settled not by arguing, but by trying. And yet they too, trusting entirely to the force of their understanding, applied no rule, but made everything turn upon hard thinking and perpetual working and exercise of the mind.

Now my method, though hard to practice, is easy to explain; and it is this. I propose to establish progressive stages of certainty. The evidence of the sense, helped and guarded by a certain process of correction, I retain. But the mental operation which follows the act of sense I for the most part reject; and instead of it I open and lay out a new and certain path for the mind to proceed in, starting directly from the simple sensuous perception. The necessity of this was felt, no doubt, by those who attributed so much importance to logic, showing thereby that they were in search of helps for the understanding, and had no confidence in the native and spontaneous process of the mind. But this remedy comes too late to do any good, when the mind is already, through the daily intercourse and conversation of life, occupied with unsound doctrines and beset on all sides by vain imaginations. And therefore that art of Logic, coming (as I said) too late to the rescue, and no way able to set matters right again, has had the effect of fixing errors rather than disclosing truth. There remains but one course for the recovery of a sound and healthy condition,—namely, that the entire work of the understanding be commenced afresh, and the mind itself be from the very outset not left to take its own course, but guided at every step; and the business be done as if by machinery.

SOURCE: Francis Bacon, Preface to *Novum Organum*, in *The Works of Francis Bacon*. Vol. 4. Eds. James Spedding, Robert Leslie Ellis, and Douglas Denon Heath (London: Longmans, 1875): 39–40.

found himself equally humiliated and condemned. Under James I of England, Bacon had a political career that saw him rise to the office of Lord Chancellor of England with a seat in the English House of Lords, only to lose it all after a conviction for taking bribes. Exiled from any association with the royal court in 1621, Bacon spent the last five years of his life studying science and philosophy and initiating vast writing projects he never completed. Bacon's assault on scholastic Aristotelianism came from a different direction than that of Galileo. Both Bacon and Galileo followed the Italian philosopher Bernardino Telesio (1508–1588) in emphasizing that knowledge of nature, and therefore science, comes via sensory acquisition. Yet, while the five senses provided comparatively surer guides to the truth than the methods of intellectual conjecture preferred by the Scholastics, the senses are still prone to error. For Galileo, mathematical demonstration was the only fail-proof guide to the truth. For Bacon it was experimental demonstration. Bacon rejected an idea that would become the basis for the cognitive theories of his later countryman John Locke—the idea that the human mind is a "tabula rasa," a blank page waiting to be filled with knowledge via sensory experience—and postulated that the human mind was prone toward four sorts of problems in its reception of data. Bacon labeled these sorts of problems "idols" to suggest, following the ancient Epicurean meaning of that term, factors that promote de-

ception. As Bacon put it, these idols created "enchanted" or "crooked" mirrors that change and pervert reality. The first of these, "Idols of the Tribe," arose from features of human nature that clouded measured assessment of data, such as faulty or impaired senses or an instinct toward lumping versus one toward splitting. "Idols of the Cave" were the prejudices of individuals that obscured reasoned evaluation, such as a preference for one idea over another. "Idols of the Marketplace" had to do with the obstacles language places in the way of understanding. Here Bacon had in mind the fact that many of the qualitative terms that human beings use to describe phenomena in the physical world are, in fact, inadequate, incomplete, or overly general. Bacon cautioned against terms such as "moist" and "dry"—which were frequently used by natural philosophers of the period—for they lacked a precise character and therefore could not further scientific investigation. Bacon labeled the last sort of idols "Idols of the Theater" to denote the constructed, fictionalized character of intellectual theories. The pursuit of evidence to support theories, he argued, corrupted the evaluation of the results of experiments. Bacon advanced these arguments in his *Novum Organum* (New Organon; 1620), a work that has sometimes been called a "manifesto for the Scientific Revolution." It set out his new method of inductive investigation as a way to minimize the impact of the idols he identified. As Bacon saw it, the old deductive method used by Aristotelian scholasticism throughout the Middle Ages and the Renaissance jumped from the identification of particulars to the formation of general principles, and only then built up the theories that linked the particular to the general. It completed all these steps without any empirical validation. The absence of independent verification meant that the idols he had identified literally shaped what was accepted as true. His new method insisted upon a slow ascent from particulars through theories that were independently validated through observation to general principles. Key to his method is the idea that knowledge is derived via trial and error; experiments that fail to produce or generate an independent theory, he argued, should be discarded. Theories that could not be proven false had to be accepted as true.

BACON'S IDEA OF PROGRESS. For most of the twentieth century, historians emphasized the degree to which Bacon's inductive method had little to do with how scientists actually think. William Harvey, a contemporary of Bacon and the discoverer of the circulation of the blood, once quipped that Bacon pursued scientific research "like a Lord Chancellor," meaning that like a government official Bacon sought to mandate scien-

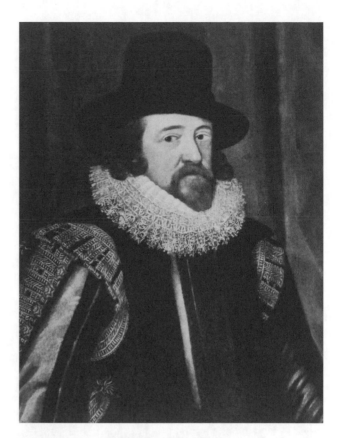

Portrait of Sir Francis Bacon. **PUBLIC DOMAIN.**

tific discoveries as opposed to accepting the leaps of imagination and deduction that so often lie behind scientific breakthroughs. Historians have built on this criticism, pointing out that a researcher following Bacon's method would discover him/herself in an endless loop of validating only minutely different experiments, and more importantly that Bacon's neglect of mathematics was a fatal flaw from which his method could not recover. More recent studies have sought to rehabilitate Bacon as a scientific forerunner, pointing out the inspiration, if not insight, he provided to many of the men who did participate in the Scientific Revolution. There is now also some appreciation of Bacon's role in the creation of the empirical methods favored by social scientists, especially his arguments that experiments should be designed to disprove rather than prove a theory. While Bacon's role in the actual production of science is the subject of debate and revision, his legacy as the first great advocate of science has always been acknowledged. It was Bacon who first made the case that knowledge is power and that the acquisition of knowledge enables states to become great. Significantly, what Bacon had in mind when he used the term "knowledge" was not "metaphysics," that is, ideas that explain the hidden or unseen

Frontispiece to Sir Francis Bacon's *Sylva Sylvarum*. **PUBLIC DOMAIN.**

tural explanations of various natural phenomena such as the cause of hiccups. The *New Atlantis*, perhaps the first piece of science fiction ever published, offered a utopian vision of a perfect society where, under the protective gaze of a wise ruler, a research institute called Solomon House continuously churned out inventions to make the lives of its citizens better. These four works were the most widely read of Bacon's works. None of them provided any scientific information of merit, yet the absence of scientific content is what allowed them to be appropriated by generations of intellectuals seeking justification for programs of cultural reform. Thus in the 1660s the founders of the Royal Academy of Science in England saw themselves as realizing the ideas Bacon put forth in his *New Atlantis*, while in the eighteenth century, the editors of the French Enlightenment *Encyclopédie* signaled their identification with Bacon's Great Instauration by placing his name on the first page of the first volume of their great work.

SOURCES

M. Biagioli, *Galileo, Courtier: The Practice of Science in the Culture of Absolutism* (Chicago: University of Chicago Press, 1993).

S. Drake, *Essays on Galileo and the History of Science* (Toronto: University of Toronto Press, 1999).

J. Henry, *Knowledge is Power: Francis Bacon and the Method of Science* (London: Icon Books, 2002).

P. Machamer, *The Cambridge Companion to Galileo* (New York: Cambridge University Press, 1998).

M. Peltonen, *The Cambridge Companion to Bacon* (Cambridge: Cambridge University Press, 1996).

A. Pérez-Ramos, *Francis Bacon's Idea of Science and the Maker's Knowledge Tradition* (Oxford: Clarendon Press, 1988).

Jean-Marie Pousseur, *Bacon, 1561–1626: inventer la science* (Paris: Bellin, 1988).

B. Price, ed., *Francis Bacon's New Atlantis* (Manchester, England: Manchester University Press, 2002).

G. Santanilla, *The Crime of Galileo* (Chicago: University of Chicago Press, 1955).

P. Urbach, *Francis Bacon's Philosophy of Science: An Account and a Reappraisal* (La Salle, Ill.: Open Court, 1987).

R. S. Westfall, *Essays on the Trial of Galileo* (Notre Dame, Ind.: University of Notre Dame Press, 1989).

sources of life and the universe. It was instead "physics," by which he had in mind a modern notion of nature and the technologies that can be used to exploit it. Bacon has also been correctly identified as the father of the "idea of progress," the idea that life on earth can be made better through advancements in technology.

THE GREAT INSTAURATION. The literary character of Bacon's writings allowed them to serve the scientific cause far more effectively than any piece of scientific research he did. In 1620 Bacon announced his plans to write a "Great Instauration," a six-part proposal for the effective establishment of civilization on a scientific footing. Bacon only completed the first two parts of his proposal: *The Advancement of Learning* (1623) and the *New Organon* (1620). After Bacon's untimely death in 1626, two of his other works were published together: the *Sylva Sylvarum* and the *New Atlantis* (1627). In the two parts of the Great Instauration he completed, Bacon presented his argument via a series of aphorisms, that is, pithy, witty, three- or four-sentence observations. The *Sylva Sylvarum* contained 100 "experiments," actually conjec-

THE SCIENTIFIC REVOLUTION AND PHILOSOPHICAL RATIONALISM

ISAAC NEWTON AND THE CONFIRMATION OF THE CASE FOR SCIENCE. Isaac Newton (1642–1727) was the first universally recognized scientific genius. In

his *Philosophiae Naturalis Principia Mathematica* (Mathematical Principles of Natural Philosophy), better known as the *Principia* (1687), he provided the mathematical demonstration necessary to prove his theory of gravity, and in doing so also lent irrefutable support to the Copernican thesis that the earth revolved around the sun. Beyond the *Principia*, Newton was also the discoverer (along with Gottfried Wilhelm Leibniz) of differential calculus, as well as the physical properties of light. He also invented the reflecting telescope. It was Newton who opened up the universe to scientific investigation by insisting that the physical laws that operate on Earth must also operate everywhere else, and that to discover what works on Earth is to discover what works in the universe. In making and announcing these discoveries Newton supplied the final push that turned European civilization toward the acceptance of science, not religion, as the basis of truth and knowledge. The contest between science and religion had been fiercely fought to a stalemate in the decades before Newton, with the defenders of religion, safe behind university walls, content to simply ignore the scientific challenge. The problem hindering the scientific assault was that advocates of science could not agree upon their own argument. The Copernican thesis was the cutting edge of the case being made for science, yet there was no consensus among the advocates of science that it was correct. Many of the arguments that Galileo advanced in favor of the thesis had been deeply flawed, and it is telling that Bacon chose to ignore the thesis in making his case for science. At the heart of the problem was an inability to explain scientifically the phenomenon that the accumulation of the data had revealed: the fact that the planets revolved around the sun in an elliptical rather than purely circular orbit. Newton's theory of gravity solved these problems by advancing the notion that the sun's pull on a planet was strongest when the planet was closest to it, and weakest when the planet was furthest away. His corollary development of the idea of centrifugal force—that at all times the pull of the sun on a planet was balanced by the pull of all other planets—definitively explained the phenomenon for which scientists had long been searching for an explanation. Newton's theory forced even churchmen to accept the veracity of the Copernican thesis. As Alexander Pope observed in a famous couplet from his "Epitaph intended for Sir Isaac Newton," "Nature and nature's laws lay hid in night; God said "Let Newton be!" and all was light." Contemporary Europeans embraced Newton—much as later twentieth-century Americans would celebrate Albert Einstein—as proof of the notion that through reasoned analysis it was possible to know nature, and, through nature, God. In his *Lettres philosophiques* (Philosophical Letters; 1734) Voltaire wrote with the aim of convincing Continental Europeans to follow the British cultural lead. Four of the twenty-four letters in the volume were devoted to explaining the work of Newton. Newton was a devout Christian who, it has been observed, wrote several million words of theology. Newton was also so deeply enamored of alchemy that the British economist John Maynard Keynes, who collected many of Newton's alchemical works, once characterized Newton as "the last of the magicians." Yet Voltaire correctly perceived that in the battle between science and religion, Newton was the ultimate weapon to defend science, and Voltaire passed on this awareness of the importance of Newton's discoveries to other Enlightenment thinkers. While the editors of the French Enlightenment *Encyclopédie* may have pointed out their indebtedness to Francis Bacon for their inspiration, Newton's new mechanistic universe was the justification for their work. His idea of a world held together by mathematical regularity, and by the opposing and counterbalancing forces of gravity and centrifugal force played a role in much of Enlightenment thought; this scientific model became, in other words, one of the dominant metaphors of the age, and its influence found its way into political theory, social criticism, and even the aesthetic writing of the period.

OPTICS AND THE SEARCH FOR A GEOMETRIC GOD. It was not coincidental that Galileo built his case for the Copernican thesis on the evidence he derived from his telescopic observations, or that when Bacon wanted to convey the idea of the cognitive blinders that inhibit human comprehension he adopted the metaphor of distorting mirrors. The seventeenth century was captivated by optics and all technology that derived from the use of glass lenses, much in the same way that the modern world is obsessed with the possibilities that computers offer. Glass lenses, like modern computer chips, are made from silicon. In both instances it is not silicon itself, but the way it has been mathematically configured that creates its utility for humans. The important role that mathematics played in grinding the lenses that were used in telescopes and microscopes inspired numerous attempts at the time to unearth a "geometric God." Seventeenth-century scientists still took as their departure point the premise that a supreme being had created the universe, and thus intellectuals thought that the geometric theorems that their technologies relied upon might be investigated to reveal the "secret" harmonies, proportions, and mathematical relationships God had used in His Creation. In this way geometry also became an important path of study for seventeenth-century

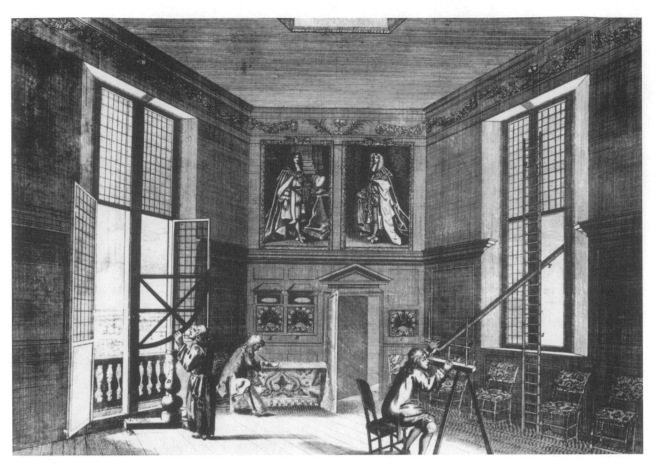

Engraving of astronomers in the Royal Observatory in Greenwich, England. The new astronomy of the seventeenth century led philosophers to challenge received wisdom. © BETTMANN/CORBIS.

philosophers, for, like scientists, they were convinced that it might reveal something about the attributes of the mind of God.

RATIONALISM AND MATHEMATICS. The chief exponents of the school of seventeenth-century philosophy known as rationalism were all in some way involved in the application of mathematical principles to technological problems. Both René Descartes (1596–1650) and Baruch Spinoza (1632–1677), the first two proponents of rationalism, had, in fact, made their living through lens grinding at one point or another in their careers. Rationalists like Descartes and Spinoza took as their starting point the notion that philosophy might follow a path to truth similar to that of mathematics, which derived its powerful theorems from axioms. In this way, rationalist philosophers became concerned with developing a way of working out the many logical implications of axiomatic statements concerning the nature of existence. To explain their method, one must first have a clear idea of how axioms and theorems function in mathematics. In geometry, for example, it is an axiom that a triangle is a two-dimensional figure or polygon composed by the intersection of three straight lines. All the theorems that have to do with different types of triangles follow from this axiom. In this sense, it can be said that these theorems are innate—that is, inherent in the axiom—and that it is the task of the mathematician to explicate them by logical deduction. Rationalists approached the study of God from this same perspective. Their goal was to demonstrate that God was the ultimate axiom from which all other axioms are logically derived. As a philosophical perspective, rationalism's origins were ancient, and could be traced back to the ancient Greek mathematician Pythagoras, who noted the mathematical correspondences that occur in nature and concluded as a result that "all is number." What was new in its reappearance in the seventeenth century was its application to the Christian intellectual tradition. To that point Christian thought took as a given that knowledge of God was revealed through the Bible or through visions and miracles. But rationalism rejected such revelation as a source of divine knowledge, and taught instead that true knowledge of God was innate within humans

"The Pascaline," an automatic calculating machine invented by the mathematician and philosopher Blaise Pascal. Seventeenth-century rationalists believed that mathematical principles could be used to solve philosophical problems. CORBIS-BETTMANN. REPRODUCED BY PERMISSION.

and could be deduced by the application of its rigorous intellectual method. Because they rejected the traditional role that divine revelation had long played in religious teaching, though, many rationalists were attacked as free thinkers and atheists.

RENÉ DESCARTES. The work of René Descartes has often been cited as the beginning of modern philosophy. At the time that Descartes began writing, skepticism had a pervasive influence over philosophical debate in Europe. Skepticism rejected the possibility of philosophical certainty. Its proponents argued that human beings were incapable of knowing truth and that they could only instead affirm through faith their own beliefs. Descartes sought to demonstrate that by following his rationalistic method, truth could be ascertained and known. His case for philosophical certainty was the starting point for every discussion of the topic during the Baroque and Enlightenment eras. Descartes was a first-rate mathematician,

though his impact is mostly forgotten today. He pioneered the methods followed in analytic geometry, which has to do with the utilization of algebraic procedures to resolve geometric problems and vice-versa. It was Descartes also who introduced the practice still followed in algebra of assigning the letters a, b, c, etc., to known quantities, and the letters x, y, z, etc., to unknown quantities. Descartes' religious sensibilities are the subject of some debate, and the stance taken in this debate dictates one's interpretation of his work. One school of biographers has long emphasized the depths of Descartes' Catholic faith, while another has charged that his display of religiosity was merely intended to ward off possible criticism. Untangling Descartes' religious convictions remains a perilous enterprise. By upbringing, he was a Catholic, and he went to great lengths in his work to show that he was not of a similar mind to Galileo. When he learned that the Roman Church had condemned

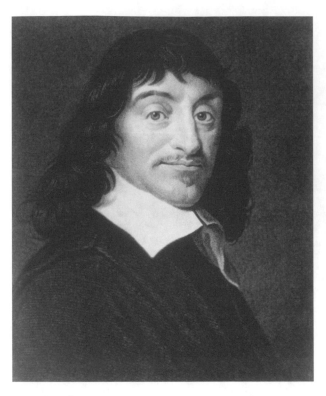

Engraving of René Descartes. THE LIBRARY OF CONGRESS.

the word "cogito" ("I think"), he had in mind a "clear and distinct" idea whose truth was self-evident in the way the truth of a mathematical axiom is self-evident. Importantly, one ramification of Descartes' notion was that it drew an absolute dichotomy between mind and body. Mind had to do exclusively with cognition, with thought. Body had nothing at all to do with thought. Thus, the mind could learn nothing of truth from the body, that is, through sensory perception and experience. The mind could only draw upon itself, upon the ideas that were innate within it. As a result the proof that Descartes fashioned for the existence of God stressed that since the human mind possessed an idea of perfection that idea must come from someone else. That someone else must be perfect, and since only God is perfect, He must have placed the idea of perfection in the human mind as proof of His existence.

SPINOZA. Descartes' ideas resonated among the intellectuals of his era, who were searching to find a way to prove God's existence through a seemingly scientific and ironclad rationalistic approach. While many intellectuals agreed with his starting point, some took exception to the path he suggested. Of those, the most important figure to articulate an alternative path to Descartes' rationalism was the Dutch Jewish thinker Baruch or Benedict Spinoza (1632–1677). Spinoza's case against Descartes derived from two observations. First, Spinoza insisted that Descartes had not pushed his ideas to their logical conclusions, and that second, humankind's spiritual freedom might be attained only if the logical conclusions of Descartes' system were embraced. Descartes, it must be remembered, often backed away from public presentations of arguments that might result in his censure from orthodox forces. By contrast, Spinoza's fate provides a powerful example of the consequences of making plain the theological implications that were inherent in a rationalist philosophical approach. As a young man Spinoza had been condemned and expelled from the Jewish community of Amsterdam. At this point he changed his name from Baruch to Benedict. Although a small group of thinkers recognized his achievements at the time of his death, for the most part Spinoza was reviled within the broader European intellectual community as an atheist. Modern commentators have emphasized that the characterization of Spinoza as an atheist is unfair. He had a strong faith in the Judeo-Christian deity; he just conceptualized that deity in a way that was distasteful to contemporary Jews and Christians. Key to Spinoza's argument for the reality of God was his pantheism, an idea he developed in his *Ethics*, a work completed in 1675 but not published until after

Galileo's works, he even withdrew a manuscript from his publisher in which he had supported the Copernican thesis. Still other evidence of his insincerity must be admitted. Although a Catholic, for instance, Descartes chose to spend a large portion of his adult life living in Protestant Holland, where he was free to pursue his philosophical work without being forced to practice his religion. Yet Descartes presented his philosophy all the same as a scientific case for the existence of God. Those who see his faith as real appreciated his work as a heartfelt if unsuccessful effort to use mathematics to confirm religion. Those who see his faith as insincere have treated his work as a camouflaged expression of atheism. Whatever the position taken on his religious sensibilities, all commentators agree that Descartes was sincere in his belief that mathematics and the rationalism it might foster provided an antidote to philosophical skepticism, the teaching that ultimate truths could not be established. In his *Discourse on Method* (1637), Descartes mapped out his objections to existing philosophical approaches. In his *Meditations on the First Philosophy: In Which the Existence of God and the Distinction Between Mind and Body are Demonstrated* (1641), by far his most influential work, he built his case against philosophical skepticism. In this work Descartes presents his most famous argument against doubt in the immortal words "cogito ergo sum" or "I think, therefore I am." For Descartes, when he used

his death in 1677. Spinoza modeled the *Ethics* on the ancient *Elements of Geometry* of Euclid, and in it, he sought to demonstrate that all that exists in the universe is God. While Descartes had postulated a dichotomy between mind and body, Spinoza rejected that dichotomy and argued instead that mind and body are parallel expressions of the same thing. The human mind, in other words, has within it an impression of the tree that is physically before its eyes. The tree itself exists as an "extension," a term that Descartes used to describe the physical and mathematical concreteness of things, but it exists all the same as a concept in the mind. In this sense mind and body are parts of the very same substance of which all existence is composed, and Spinoza identified that substance as God. In this way everything in the world is thus composed and contained within the deity.

THE CONTROVERSY OVER SPINOZA. The tragedy for Spinoza was that this argument could be interpreted in various contradictory ways. It could be taken, for instance, as an affirmation of an immanent deity who might be worshipped through his attributes, or it could be interpreted as a rationale for an atheistic materialism. Since God exists in all things, in other words, Spinoza could be seen as reducing God's importance to a superfluous detail. It was this latter interpretation of his work that dominated among the many contemporaries that attacked his ideas in the later seventeenth century. It has always been something of a puzzle as to why Spinoza was expelled from the Jewish community of Amsterdam so early in his life, but it remains plausible that perhaps this thinker's early precocious arguments against a providential God and the immortality of the soul may have had something to do with his excommunication. For Spinoza, beliefs in God's providence and the human soul's immortality were only ideas designed to make the deity appealing to humans. They stood in the way of the appreciation of God's human-dwarfing immensity, and it was only by appreciating this enormity that Spinoza believed humankind might find a path to spiritual freedom. In this regard his ideas concerning the human passions followed a similar logic. The passions made human beings and their affairs seem more important than they actually were when judged against the infinitude of God. Freeing oneself from the human passions was thus for Spinoza the only way to see God, and seeing God was the only way to ultimate freedom.

GOTTFRIED WILHELM LEIBNIZ. The last contributor of new ideas to the rationalist school of philosophy was Leibniz (1646–1716). The son of a professor, Leibniz earned a law degree by the age of twenty. Somewhat later he began a career in the employ of German princes,

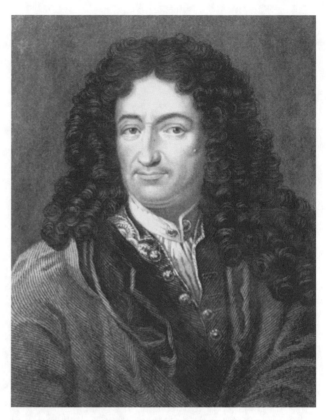

Engraving of the German Enlightenment philosopher Gottfried Wilhelm Leibniz. THE LIBRARY OF CONGRESS.

primarily the dukes of Hanover, serving among other things as a librarian, a diplomat, an engineer, and an educational reformer. Along the way Leibniz gained fame for his mathematical genius. Historians grant the honor of the discovery of differential calculus to Isaac Newton, but recognize that Leibniz made the discovery independent of the former. Leibniz also sought to reconcile rationalism with German Protestantism. Descartes had postulated an opposition between mind and body. Leibniz dismissed this opposition by rejecting the notion that the body had some reality beyond the mind. He also argued that time and space, the substance in which the body was captured for Descartes, was illusory. Leibniz reversed the philosophical inclination to define being as static or passive existence. For him, to be was to do, doing being equated with thinking. He could thus treat mind and body as the active and passive, immaterial and material parts of a whole. The idea that matter was composed of atoms was just then beginning to take hold in scientific discourse. Since he rejected the idea that matter has any existence outside the mind, Leibniz developed as an alternative to the idea of the atom, the idea of the monad. The idea of monads can be discerned evolving in Leibniz's work, reaching fruition in his

a PRIMARY SOURCE *document*

SIMPLE SUBSTANCES, COMPLEX THEORY

INTRODUCTION: As the debate over the nature of knowledge heightened in Europe around 1700, thinkers came upon new ways of defining epistemology, the science of mental knowledge. One response was George Berkeley's radical idealism, that is, the notion that the mind and senses shaped all knowledge of the outside world, and without perception, nothing existed. Gottfried Wilhelm Leibniz came to a different conclusion. To explain how the mind apprehended and comprehended the world, he relied on the concept of monads, a concept he himself invented. A monad was, as he observed, "nothing but a simple substance, which enters into compounds." The theory of knowledge that such a theory produced was complex, as this excerpt shows; it did not win many adherents.

1. The Monad, of which we shall here speak, is nothing but a simple substance, which enters into compounds. By 'simple' is meant "without parts." (Theod. 10)

2. And there must be simple substances, since there are compounds; for a compound is nothing but a collection or aggregatum of simple things.

3. Now where there are no parts, there can be neither extension nor form [figure] nor divisibility. These Monads are the real atoms of nature and, in a word, the elements of things.

4. No dissolution of these elements need be feared, and there is no conceivable way in which a simple substance can be destroyed by natural means. (Theod. 89)

5. For the same reason there is no conceivable way in which a simple substance can come into being by natural means, since it cannot be formed by the combination of parts [composition].

6. Thus it may be said that a Monad can only come into being or come to an end all at once; that is to say, it can come into being only by creation and come to an end only by annihilation, while that which is compound comes into being or comes to an end by parts.

7. Further, there is no way of explaining how a Monad can be altered in quality or internally changed by any other created thing; since it is impossible to change the place of anything in it or to conceive in it any internal motion which could be produced, directed, increased or diminished therein, although all this is possible in the case of compounds, in which there are changes among the parts. The Monads have no windows, through which anything could come in or go out. Accidents cannot separate themselves from substances nor go about outside of them, as the 'sensible species' of the Scholastics used to do. Thus neither substance nor accident can come into a Monad from outside.

8. Yet the Monads must have some qualities, otherwise they would not even be existing things. And if simple substances did not differ in quality, there would be absolutely no means of perceiving any change in things. For what is in the compound can come only from the simple elements it contains, and the Monads, if they had no qualities, would be indistinguishable from one another, since they do not differ in quantity. Consequently, space being a plenum, each part of space would always receive, in any motion, exactly the equivalent of what it already had, and no one state of things would be discernible from another.

9. Indeed, each Monad must be different from every other. For in nature there are never two beings which are perfectly alike and in which it is not possible to find an internal difference, or at least a difference founded upon an intrinsic quality [denomination].

10. I assume also as admitted that every created being, and consequently the created Monad, is subject to change, and further that this change is continuous in each.

11. It follows from what has just been said, that the natural changes of the Monads come from an internal principle, since an external cause can have no influence upon their inner being. (Theod. 396, 400)

12. But, besides the principle of the change, there must be a particular series of changes [un detail de ce qui change], which constitutes, so to speak, the specific nature and variety of the simple substances.

SOURCE: Gottfried Wilhelm von Leibniz, *The Monadology and Other Philosophical Writings.* Trans. Robert Latta (London: Oxford University Press, 1898; reprinted 1951): 217–223.

Monadologia (Monadology; 1714), published two years before his death. Monads were the irreducible, indivisible, and metaphysical "things" that made up the world.

As Leibniz characterized them, monads were complete concepts; they were self-contained and autonomous. Leibniz was extrapolating from mathematical reasoning

here. What he had in mind was a sentence such as "A is equal to A," a statement that would obviously remain true whatever the moment, whatever the situation. As Leibniz envisioned it, the set of valid predicates for each of these monads were some part immaterial, some part material in a hierarchical progression that stretched from the least active monads, such as those that took on the appearance of stone in the real world, to the most active, such as those that as a collectivity generated the appearance of the most sentient humans. The creator of all these monads was God, who remained the apex of the geometric pyramid favored by the rationalists, but who was now understood to be the monad for whom all other monads were predicates. Because he rejected the reality of material existence, Leibniz rejected the idea of causality, the idea that one thing in the material world caused another. Rather, he insisted that the predicates that exist for a given subject exist as a network of explanation from which it is possible to deduce the connection between events. For example, if one of the predicates for John is that he drives a car, and another of the predicates is that he is a careless driver, it is possible to deduce what Leibniz identified as the "sufficient reason" why John has a car accident. Applying this notion of sufficient reason to the world in which he lived, Leibniz argued that there was a rational explanation for all that occurred. It is in this sense that it is possible to extract from Leibniz's ideas the notion that we live in "the best of all possible worlds," the idea for which the French playwright Voltaire lampooned Leibniz in the figure of Doctor Pangloss, a central character in his satire *Candide*.

NICHOLAS MALEBRANCHE. Malebranche (1638–1715) was slightly senior in age to Leibniz, and his writings had their intellectual impact earlier than those of Leibniz. Like Leibniz, he was concerned with reconciling rationalism with Christianity, though in his case the Christianity in question was French Catholicism. He is often left out of discussions on Baroque philosophy because his contemporaries recognized him more as a disciple of Descartes than as the originator of new ideas. Yet in his role as a defender and reformer of the teachings of his master, he was perhaps the most influential of the rationalists after Descartes. Spinoza and Leibniz both used Descartes as the departure point for the development of their own systems of thought. Neither of these systems ever replaced that of Descartes as the definitive notion of rationalism. Malebranche rethought Descartes' ideas in light of the criticisms that had been directed at them in the last part of the seventeenth century. In the eighteenth century, when rival philosophers talked about rationalism, what they inevitably had in

mind was Descartes as amended by Malebranche. Malebranche's life and career followed a pattern that recurred often in early-modern French intellectual life. Born with a deformed spine and a sickly constitution, he preferred a life of seclusion and scholarship early on. In 1664 he was ordained a priest, though he never took on any pastoral duties. In the same year, after failed efforts to become a historian, then a biblical scholar, he discovered the writings of Descartes. Descartes' words caused his heart to "palpitate," and he spent the rest of his life studying and explaining Descartes' thoughts. Malebranche's major work on Descartes, *De la Recherche de la Verite* (The Search After Truth) appeared in three volumes published in 1674 and 1675. In this work he advanced two ideas that shaped the understanding of Cartesianism. First was the notion of "vision in God," the idea that all mental images or ideas exist only in God, and that at his discretion God allows man to see these things. Descartes had argued that ideas were innate within the human mind without working out how those ideas got there or how they were accessed on a moment-to-moment basis. For Descartes, it was sufficient to argue that God implanted ideas in the human mind at the moment of creation. Malebranche went beyond this and, fusing the ideas of Descartes with those of Saint Augustine, presented an image of an omnipresent God who continuously interacts with the human mind. Seemingly anticipating the assault on rationalist assumptions that was soon to come from empiricists, Malebranche rejected the argument that ideas came into the mind directly through the senses. The senses can reveal pain and pleasure. They cannot reveal what is causing pain or pleasure. Knowledge of what is outside the mind can only enter the mind through the representations placed there by God. What is perceived when one looks at a tree is not the tree as it really is, but the representation of the tree placed there by God. The second idea associated with Malebranche is "occasionalism," the argument that God is the ultimate cause of every action. To get a sense of what Malebranche was striving to express here, think of a soccer game where in the closing minutes a player gives the ball a kick that sends the ball through the goal for a winning score. As Malebranche would explain it, the player in question would be the occasional or incidental cause of the winning kick. The real source of the kick was God, who used the player as an instrument of his will.

SOURCES

A. Donagan, *Spinoza* (New York: Harvester, 1988).

L. Pearl, *Descartes* (Boston: Twayne, 1977).

D. Radner, *Malebranche: A Study of a Cartesian System* (Assen, Germany: Van Gorcum, 1978).

N. Rescher, *Leibniz* (Totowa, N.J.: Rowman and Littlefield, 1979).

W. R. Shea, *The Magic of Numbers and Motion: The Scientific Career of René Descartes* (Canton, Mass.: Scientific History Publications, 1991).

R. M. Silverman, *Baruch Spinoza: Outcast Jew, Universal Sage* (Northwood, England: Symposium Press, 1995).

R. S. Woolhouse, *Descartes, Spinoza, Leibniz: The Concept of Substance in Seventeenth-Century Metaphysics* (London: Routledge, 1993).

EMPIRICISM

PIERRE BAYLE. Not every seventeenth-century intellectual engaged in scientific research embraced rationalism. Some rejected it as presuming to use mathematics to do something mathematics could not do, that is, validate the existence of God. Of these, the most important was Blaise Pascal (1623–1662), the French genius whose Jansenist convictions prompted him to affirm that God is only knowable through the insights he offers as gifts of grace to individual humans. Those trained in the traditional concerns of humanism, with its emphasis on creating a philosophy that might inspire virtue, similarly failed to concede the high road to the rationalists. Many thinkers who could be placed in this category adopted a skeptical posture that questioned the value of any knowledge of human affairs derived from scientific methods of reasoning. Of these, the most influential was Pierre Bayle (1647–1706). Bayle was born and raised as a French Huguenot, those that followed the teachings of John Calvin. For a brief period he converted to Catholicism, although his re-conversion to Calvinism necessitated his flight from France. Ultimately, he settled as a free man in Rotterdam, but he did so with the knowledge that the French government had imprisoned his brothers as punishment for his writings. They would eventually die in jail. Even in Rotterdam, clerical authorities attacked Bayle for the apparent atheism articulated in his writings. The trials and tribulations Bayle experienced because of his religious views made him a bitter opponent of any and all dogmas— proclamations of truth—whether they be religious, scientific, or otherwise. As Voltaire later characterized him with some hyperbole, Bayle had the finest mind for the "art of reasoning"—that is, critical analysis—of any intellectual "who ever wrote." Bayle slowly examined any claim of truth and worked through its arguments to show the doubts about it every rational person had to recognize. One example of Bayle's method was his discussion of "identity." Since Descartes had based his proof of existence on consciousness, early-modern thinkers debated whether identity was continuous—whether a person has the same consciousness today that he or she had five days ago or five years ago. To a "learned theologian" who affirmed that consciousness is retained, Bayle posed the questions: "How do you know that, this morning, God did not let your soul fall back into nothing?" and "How do you know that God did not create another soul with the same modifications?" As Bayle concluded, "That new soul is the one you have now. Convince me to the contrary." Bayle's influence over philosophy stemmed from his *Dictionnaire historique et critique* (Historical and Critical Dictionary; 1702), a vast compendium of more than nine million words that was an international best-seller throughout much of eighteenth century. The articles in the dictionary were fairly straightforward. It was in his footnotes, though, that Bayle got into trouble. These were filled with the same relentless skepticism and questioning spirit that took no assumptions for granted that were found in all of Bayle's writings. While he insisted that he was a believing Christian, he nevertheless compiled a significant body of works that were questioned, even in his own lifetime, as a challenge to his own religion. Recent scholarship may have become more supportive of the idea that Bayle's confessions of faith were sincere, yet eighteenth-century philosophers who followed him were convinced of his questioning spirit and his use of human reason to undermine Christian teachings. Bayle's work was particularly important for its impact on rationalistic arguments. His writings successfully assaulted the rationalists' assumptions that mathematical reasoning could bring certainty to questions about human existence. In this way his work cleared the ground for the coming of empiricism, a school of philosophy that championed human observation and the insights it might offer.

EPICUREANISM. By the second half of the seventeenth century, philosophical thinking in Europe had come to an impasse. Outside of clerical circles the traditional methods of university scholasticism had almost no appeal. Humanism, too, with its emphasis on ancient textual and literary study, was incapable of making sense of the ongoing discoveries that were occurring in science and beyond Europe's boundaries in the journeys of exploration. Much of the new knowledge that was being amassed at the time, too, derived from new technologies like the telescope that extended the power of the human senses. For all these reasons, rationalism, with its rejection of the possibility of learning new things through the senses, left many people, but especially scientists, cold. In the works of Bayle can be seen some of the tensions of the age, and some scholars have long pointed to his

work as a prime example of a resurgence of skepticism in the era. At the same time, the rapid rise of empiricism, a movement that, in fact, grew from Bayle's very questioning cast of mind, cautions against an interpretation that points to a widespread resurgence of skepticism. It would be wrong to present the second half of the seventeenth century as waiting in anticipation of empiricism. Since modern philosophers continue to live in an intellectual universe where empiricist assumptions predominate and because they can look back and see this universe being born in the second half of the seventeenth century, it is useful to appreciate how empiricism fit with the European cultural sensibilities that were emerging in the seventeenth century in ways that no philosophical tradition has before, or since, been able to match. The key assumption of empiricism is the idea that knowledge comes through sensory experience. In contrast to rationalism's affirmation of innate ideas, empiricism insists that a reality exists outside and beyond the human mind, and that it is through the senses that humans gain an understanding of this reality. Like rationalism, empiricism's roots can be traced back to ancient Greek thought, specifically to the ideas of the Greek philosopher Epicurus (361–270 B.C.E.). Two of his conclusions were especially important to the later history of European empiricism. First, Epicurus recognized that the universe was made up of matter. From Democritus (460–370 B.C.E.) he derived a conception of the universe as a void or vacuum populated by atoms, which both figures understood to be irreducible, microscopic bits of matter. These atoms combined to create the macroscopic entities perceivable in the world. Epicurus added to Democritus the ideas that atoms have weight and thus naturally move in a downward direction, and that when atoms come together to form macroscopic entities, they coalesce in recognizable patterns that grant those entities discernible qualities such as the sweetness of honey or the whiteness of snow. It is worth stressing that the materialism implicit in Epicurus' notion of the universe also proved attractive to later seventeenth-century European thinkers. But Epicurus rejected the existence of a spiritual world. As noted before, many commentators recognize Francis Bacon's ideas as the source from which early-modern European scientists drew inspiration. This argument is true in the sense that Bacon's ideas provided a rationalization of scientific investigation upon which both scientists and the public could agree. On the epistemological level, however—that is, the level of the theory of knowledge—it was Epicurus who provided scientists with direction. His materialism, though, was an obstacle to the reconciliation of his ideas with Christianity. Many of the charges of atheism leveled at early-

modern scientists and philosophers can be traced back to their use of the ideas of Epicurus. The second idea of importance from Epicurus is that human understanding comes via the senses. The patterns in which atoms configured themselves grant them qualities discernible only through the five senses. Epicurus affirmed that the senses never lied. Any confusion concerning sensory input takes place in the human mind. Thus the way to knowledge is through using the senses to correct the mind.

GASSENDI AND BOYLE. For most of the twentieth century scholars recognized John Locke as the initiator of the empiricist movement. Over the past few decades, however, the significance of the ideas of Pierre Gassendi (1592–1655) and Robert Boyle (1627–1691) as shapers of Locke's thought has been increasingly appreciated. Gassendi suffered from physical infirmities like his contemporary Malebranche, and like Malebranche opted to enter the priesthood, though he never ministered a parish. Gassendi was the first person to record the orbital progression of a planet (Mercury), and thus provide evidence in support of Johannes Kepler's laws of planetary motion. He was also the first scientist to identify and name the Aurora Borealis. It is perhaps revealing of the degree to which mathematics had taken over the debate concerning astronomy that in 1645, when Gassendi was honored for his achievements, he received a chair in mathematics at the College Royal of France. Gassendi was recognized as a scientist in his own day. History has remembered him, however, first and foremost as the individual who reintroduced Western civilization to the thought of Epicurus. Gassendi was one of the men invited to write comments on the first edition of Descartes' *Meditations*. Gassendi took exception to Descartes' appropriation of the methods of geometry and their application to the human quest for truth. For him, Descartes' "cogito ergo sum" proved nothing. Rejecting Descartes' claim that the pathway to truth traveled through the layers of the mind, Gassendi turned to the writings of Epicurus for proof that truth was something humans could only approximate. According to Gassendi, truth was reached through an inherently opposing process by which the senses acted against the mind to misinterpret the knowledge to which they were exposed. Gassendi believed in a "voluntarist" versus an "intellectualist" God, in other words, a God who does not just make laws but who actively shapes and reshapes those laws as he sees fit. From this perspective, Gassendi attacked Descartes' argument that mathematical forms such as triangles are eternal. As Gassendi understood it, if triangles were eternal, they would then stand as something external to God and his creation, a possibility

Gassendi totally rejected. Triangles, therefore, must be part of the world God created. And as Gassendi cautioned, "Don't tell me if God destroyed it or established it otherwise, it would no longer be a Triangle." From this direction, Gassendi saw the atoms of Epicurus as serving God's command, and he sought to Christianize Epicurus, that is, to insert the Christian God as the animus or spirit in the materialistic universe that Epicurus had originally articulated. Thus whatever laws dictated the ways in which atoms came together, those laws had to be regarded as works in progress by God, who could and did, rework them over time according to his will. Gassendi's ideas were eagerly embraced in England by Robert Boyle, best remembered as the discoverer of the law that bears his name that summarizes the relationship between pressure and the volume of gases. A point of contention among seventeenth-century scientists was whether the universe consisted of a vacuum—a void—or a plenum—a filled space. Seeking to avoid a stand on the issue, Boyle labeled the irreducible bits of matter that make up the world "corpuscles," not atoms. But his corpuscles, like Gassendi's atoms, were God's building blocks. And while few people read Boyle for his corpuscular theory, the fact that Boyle explained his innumerable experiments based upon his corpuscular theory helped to diffuse his ideas among a broad readership.

JOHN LOCKE. Among the young men who helped Boyle with his many experiments was an aspiring medical student named John Locke (1632–1704). Although his skills as a medic were what brought Locke to the attention of his eventual patron, Lord Shaftesbury, Locke spent very little of his adult life practicing medicine. Eventually, his medical research provided him with qualifications for entering into the Royal Academy of Science, but Locke spent most of his time engaged in politics. Shaftesbury was a leader of the Whig party, which for most of the 1680s stood in opposition to King Charles II and his brother, who eventually took the throne as James II. Having failed in his effort to have the English Parliament exclude James from the succession to the English throne, Shaftesbury escaped England for exile in Holland in 1682, where he died less than a year later. As a close associate of Shaftesbury, Locke also felt it prudent to follow him into exile, and he remained in Holland until the Glorious Revolution of 1688 forced James from the throne. During the 1680s, while he was on the run from agents of the English crown, Locke composed *An Essay Concerning Human Understanding* (1690), the source text from which modern philosophical empiricism developed. In the Epistle or "Letter" that

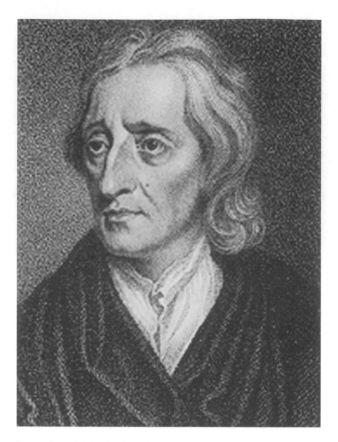

Engraving of John Locke. THE LIBRARY OF CONGRESS.

Locke provided as a prologue to this work, Locke treated his philosophy as deriving from the "scientific" ideas of figures like Boyle and Newton, the "master builders" he argued that had left "lasting monuments" for "posterity." His ideas were also shaped by the nature of the political-philosophical discourse that had occurred in England to this time. Although Thomas Hobbes's *Leviathan* (1651) remained fresh in the memory of English readers in Locke's day, this later philosopher came to far more optimistic conclusions than his predecessor had concerning the nature of humankind in a primitive state. His view of human psychology discarded the essential distrust and pessimism that had characterized Hobbes's earlier work. Locke portrayed his own work as an "under-laborer," inferior to the great achievements of Boyle and Newton. He was content, he wrote, to help "clear the ground" of some of the "rubbish that lies in the way of knowledge." In making this statement Locke expressed a sensibility that remains alive in the modern social sciences: the idea that the methods of investigation and analysis developed in the study of nature can be less loftily but still usefully applied to the task of clearing up some of the confusion or "rubbish" concerning humans and their behavior.

a PRIMARY SOURCE *document*

A BLANK SLATE

INTRODUCTION: In his *An Essay Concerning Human Understanding* of 1690, John Locke discounted the notion of innate ideas, and set forth the idea that the mind was a "blank slate," or *tabula rasa*, at birth, upon which experience wrote its teachings. The idea was to become tremendously influential during the Enlightenment and to spark a great eighteenth-century inquiry into the nature of empirical knowledge.

For, first, it is evident, that all children and idiots have not the least apprehension or thought of them [innate ideas]. And the want of that is enough to destroy that universal assent which must needs be the necessary concomitant of all innate truths: it seeming to me near a contradiction to say, that there are truths imprinted on the soul, which it perceives or understands not: imprinting, if it signify anything, being nothing else but the making certain truths to be perceived. For to imprint anything on the mind without the mind's perceiving it, seems to me hardly intelligible. If therefore children and idiots have souls, have minds, with those impressions upon them, they must unavoidably perceive them, and necessarily know and assent to these truths; which since they do not, it is evident that there are no such impressions. For if they are not notions naturally imprinted, how can they be innate? and if they are notions imprinted, how can they be unknown? To say a notion is imprinted on the mind, and yet at the same time to say, that the mind is ignorant of it, and never yet took notice of it, is to make this impression nothing. No proposition can be said to be in the mind which it never yet knew, which it was never yet conscious of. For if any one may, then, by the same reason, all propositions that are true, and the mind is capable ever of assenting to, may be said to be in the mind, and to be imprinted: since, if any one can be said to be in the mind, which it never yet knew, it must be only be-

cause it is capable of knowing it; and so the mind is of all truths it ever shall know. Nay, thus truths may be imprinted on the mind which it never did, nor ever shall know; for a man may live long, and die at last in ignorance of many truths which his mind was capable of knowing, and that with certainty. So that if the capacity of knowing be the natural impression contended for, all the truths a man ever comes to know will, by this account, be every one of them innate; and this great point will amount to no more, but only to a very improper way of speaking; which, whilst it pretends to assert the contrary, says nothing different from those who deny innate principles. For nobody, I think, ever denied that the mind was capable of knowing several truths. The capacity, they say, is innate; the knowledge acquired. But then to what end such contest for certain innate maxims? If truths can be imprinted on the understanding without being perceived, I can see no difference there can be between any truths the mind is capable of knowing in respect of their original: they must all be innate or all adventitious: in vain shall a man go about to distinguish them. He therefore that talks of innate notions in the understanding, cannot (if he intend thereby any distinct sort of truths) mean such truths to be in the understanding as it never perceived, and is yet wholly ignorant of. For if these words "to be in the understanding" have any propriety, they signify to be understood. So that to be in the understanding, and not to be understood; to be in the mind and never to be perceived, is all one as to say anything is and is not in the mind or understanding. If therefore these two propositions, "Whatsoever is, is," and "It is impossible for the same thing to be and not to be," are by nature imprinted, children cannot be ignorant of them: infants, and all that have souls, must necessarily have them in their understandings, know the truth of them, and assent to it.

SOURCE: John Locke, *An Essay Concerning Human Understanding* (London: Thomas Basset, 1690): 5–6.

SCOPE OF LOCKE'S ESSAY. The *Essay Concerning Human Understanding* is divided into four books. In the first book, Locke runs through the arguments for the existence of innate ideas in order to disprove them; he calls attention to the fact that children are not born knowing the rules of logic. The second book of the *Essay* is the most important, for it is here that Locke presents the empiricist model of human cognition still embraced today. Locke argues that all knowledge comes through ideas, ideas being defined as the "objects" about which humans think. Introducing a metaphor still much in use, Locke pictured the human mind as a "blank page" that

is filled through experience. There are two sorts of experience: "sensory," involving the acquisition of knowledge from the outside world, and "reflective," involving the manipulation within the mind of ideas already present. Likewise, there are two sorts of ideas: simple ideas having to do with the outside world that can only be received through the senses, and complex ideas that are the products of the mind's treatment and refinement of simple ideas. While humans cannot know the "essence" of things, they can come to an approximate understanding of them. Through the senses, humans can gain an idea of the primary qualities of things—their shapes,

their sizes—and also the secondary qualities of things—their smell, their taste, etc. Through reflection humans can then build complex notions about things humans can then test against further sensory experiences.

BERKELEY AND THE CHRISTIANIZATION OF EMPIRICISM. Although his ideas were sometimes perceived as an attack on the traditional Orthodox notion of the pervasiveness of Original Sin, Locke himself was a devout Christian who passed away while being read to from the Bible. Theologians attacked his *Essay*, but much of the venom of their criticism arose, not so much from Locke's work, but from the way in which his ideas were being used. In 1696, John Toland (1670–1722) published his *Christianity Not Mysterious.* Toland based many of his observations on the empiricist arguments in Locke's *Essay*, and used its reasoning to demonstrate that there was no validity at all in traditional revealed religion. Locke himself attempted to disown such a reading, but Edward Stillingfleet, the bishop of Worchester, argued after reading the *Essay* that it was a fair extrapolation. In a series of letters published between 1696 and 1702, Locke and Stillingfleet engaged in a polemic over whether the *Essay* undermined Christian faith. The point of contention was the distinction Locke insisted existed between knowledge, for which the criterion of truth had to be certainty, and faith, which by definition for Locke could only be accepted as probable. The demarcation of knowledge as something that could be only understood as true or untrue was the innovation for which Locke was being challenged. Locke was separating the understanding of the natural world and its societies from the understanding of God. As a result, he argued that the understanding of the world could be arrived at only by following empiricist procedures, while the understanding of God could never be arrived at with certainty following empiricist procedures. It was exactly upon this last point that George Berkeley (1685–1753), Anglican bishop of Cloyne in Ireland, also challenged Locke. Following Gassendi's reading of Epicurus, Locke had granted the material world a charter of independence from the spiritual world. The material world, Locke argued, could only be approached from a materialist perspective, an argument Berkeley rejected. Instead Berkeley denied the existence of a material world altogether, and denied the existence of any concrete realities outside the mind that human beings might attain some level of certainty in understanding. Whatever was out there existed solely as ideas and nothing more as they were brought within the compass of human understanding. Berkeley modified Descartes' "Cogito ergo sum" ("I think, therefore I am") to read, "Esse est percipi" ("to be is to perceive"), his point being that the one certainty humans can have is that the act of being empirical—the act of receiving information through the senses—is the validation of their conscious existence. Berkeley was a man of considerable intellectual powers. He had sufficient command of mathematics, in fact, to expose errors in Newton's calculus. It is thus significant that he turned away from science and back toward religion. His career both before and after his appointment as bishop of Cloyne can be characterized by his concern to stop what he took to be the erosion of collective belief. He identified philosophical materialism as the source of that erosion, and sought to make the case against its integrity. Berkeley's empiricism thus represented a break with the empiricism of his predecessors in that instead of attempting to free the scientific study of the physical universe from the oversight of theologians, he sought to demonstrate that whatever insights scientists gleaned about the physical universe were gifts from God. They were, in other words, signs of God's benevolence similar to the gifts the divinity had also given humankind through his revelation. In his youthful writings Berkeley had emphasized that insights about the physical universe came through the senses; now in his latter works, he articulated a Neo-Platonic position that allowed for some ideas to be innate in the human mind. Berkeley's efforts at Christianizing empiricism thus ended with a negation of the empiricist elements in his philosophy.

CONDILLAC AND SENSATIONISM. British empiricism had a powerful impact on intellectual thought everywhere in eighteenth-century Europe, but only one thinker on the continent made an original contribution to the empiricist school of thought. In 1688, William Molyneux, secretary to the Royal Irish Academy, sent a philosophical problem to John Locke that Molyneux hoped Locke would try his hand in solving. Suppose, Molyneux's problem began, a man born blind was trained to recognize a sphere and a cube by touch. Suppose then that this individual was granted sight. Would the individual then be able to identify a sphere and a cube by sight correctly without touching them? Locke concluded that the answer was "No." Later, when he took up the same problem, Berkeley reached the same conclusion. Both men saw this problem as turning on the issue of depth perception, and concluded, albeit with different justifications, that the circle and square that would confront the untrained eye would not immediately be recognized as a sphere and cube. Depth perception was not innate. The French empiricist Étienne Bonnot de Condillac (1714–1780), writing after Locke and Berkeley, suggested that Molyneux's problem was

a PRIMARY SOURCE *document*

THE SOURCES OF KNOWLEDGE

INTRODUCTION: In his *Treatise Concerning the Principles of Human Knowledge* the Anglo-Irish bishop George Berkeley examined the empirical basis of human understanding. Berkeley keenly sensed some of the problems inherent in John Locke's notion of the mind as a *tabula rasa*. In his *Treatise* he outlined a thorough-going idealism—all reality is defined in the mind working in tandem with the senses. But such a commonsensical idea also had its quizzical features in Berkeley's thought. He suggested that if objects were not perceived, then they did not exist.

25. All our ideas, sensations, notions, or the things which we perceive, by whatsoever names they may be distinguished, are visibly inactive—there is nothing of power or agency included in them. So that one idea or object of thought cannot produce or make any alteration in another. To be satisfied of the truth of this, there is nothing else requisite but a bare observation of our ideas. For, since they and every part of them exist only in the mind, it follows that there is nothing in them but what is perceived: but whoever shall attend to his ideas, whether of sense or reflexion, will not perceive in them any power or activity; there is, therefore, no such thing contained in them. A little attention will discover to us that the very being of an idea implies passiveness and inertness in it, insomuch that it is impossible for an idea to do anything, or, strictly speaking, to be the cause of anything: neither can it be the resemblance or pattern of any active being, as is evident from sect. 8. Whence it plainly follows that extension, figure, and motion cannot be the cause of our sensations. To say, therefore, that these are the effects of powers resulting from the configuration, number, motion, and size of corpuscles, must certainly be false.

26. We perceive a continual succession of ideas, some are anew excited, others are changed or totally disappear. There is therefore some cause of these ideas, whereon they depend, and which produces and changes them. That this cause cannot be any quality or idea or combination of ideas, is clear from the preceding section. I must therefore be a substance; but it has been shewn that there is no corporeal or material substance: it remains therefore that the cause of ideas is an incorporeal active substance or Spirit. …

28. I find I can excite ideas in my mind at pleasure, and vary and shift the scene as oft as I think fit. It is no more than willing, and straightway this or that idea arises in my fancy; and by the same power it is obliterated and makes way for another. This making and unmaking of ideas doth very properly denominate the mind active. Thus much is certain and grounded on experience; but when we think of unthinking agents or of exciting ideas exclusive of volition, we only amuse ourselves with words.

29. But, whatever power I may have over my own thoughts, I find the ideas actually perceived by Sense have not a like dependence on my will. When in broad daylight I open my eyes, it is not in my power to choose whether I shall see or no, or to determine what particular objects shall present themselves to my view; and so likewise as to the hearing and other senses; the ideas imprinted on them are not creatures of my will. There is therefore some other Will or Spirit that produces them.

SOURCE: George Berkeley, *A Treatise Concerning the Principles of Human Knowledge* (1710), in *The Works of George Berkeley*. Vol. 1. Ed. A. C. Fraser (Oxford: Clarendon, 1910): 51–53.

not about depth perception, but about the connections between the senses and the mind, and that Locke and Berkeley did not go far enough in their conclusions. To Condillac's mind, the question of depth perception took for granted that the mind was aware that there is a world outside the body where there are some things that are closer and some things that are further away. How did the mind, Condillac pondered, first come to realize that a world existed outside itself? Like Malebranche and Gassendi, Condillac was a sickly child who turned to scholarship and then to the priesthood. Condillac lived a much more varied life than either of these men, however. As a young man, he was part of an intellectual circle that included Jean-Jacques Rousseau and Denis Diderot. And for ten years of his life he served as the private tutor of the duke of Parma, the grandson of Louis XV (r. 1715–1774). Condillac's brand of empiricism has been labeled "sensationism." Sensationism moved beyond other forms of empiricism in insisting that all attributes of consciousness are the products of the senses. Whereas Locke's idea of empiricism maintained that ideas were derived from experiences, it took for granted that the mental processes through which experiences were turned into ideas were themselves innate. Condillac argued, by contrast, that mental processes were themselves the results of experience. In his *Treatise on Sensations* (1754) Condillac went Molyneux one better and asked his readers to imagine what would happen if an inanimate statue came to consciousness, acquiring the five senses either in isolation or in various sequences. As

Condillac saw it, the consciousness of the statue—that is, what it would know itself to be—would be a function of the combination of senses available to it. Condillac saw the human mind as passive and immobile. All it could do was react to the sensations, the impulses of data that flowed into it from the senses. Gradually, it learned to manipulate the data, to compare and contrast the latter, to arrange the latter in patterns, these acts signaling the acquisition of the mental processes earlier empiricists took as innate. As for the question of how the human mind first realized that a world existed outside itself, according to Condillac that discovery was a product of the sense of touch. Only after a human has touched an external object is it brought home to the mind that something exists that is not an extension of it.

HUME AND THE SECULARIZATION OF EMPIRICISM.

Meanwhile, back in Britain, Condillac's contemporary David Hume (1711–1776) was pushing empiricism in yet another direction. Like Locke, Hume was a thinker whose ideas have continued to influence the discussion of a number of topics. In the twentieth century Hume was celebrated by the philosophical naturalists, thinkers who argued that while science does not supply all the answers, its methods of investigation remain the best starting point for deriving answers. They recognized Hume as their distant forebear, an identification for which there is some justification. Hume saw himself as applying the "experimental method of reasoning" demonstrated by Newton to the "science of human nature." At the same time he has been seen as an important force that kept alive philosophical skepticism. Just as Hume reinforced the dichotomy Locke postulated between knowledge of the material world and belief in God, so Hume used Bayle's skepticism as a scalpel to slice away at the arguments through which the discussion of the physical universe had long been kept within a Christian intellectual framework. Whether Hume saw skepticism as an end in itself or merely as a tool to clear the way for his scientific philosophy remains an open question. Hume, though, more than any other figure in the empiricist movement, led the charge to secularize, that is, strip away the religious dimension from Europe's philosophical discourse. While he took up this mission in almost all his writings, the subject of all his thinking can be gleaned in his *Treatise on Human Nature* (1739–1740). Hume complained about the lack of public approval his treatise generated, remembering it later as having "fell dead-born from the press." So he spent the rest of his career re-packaging the ideas in the *Treatise*, and nowhere did he do so more effectively than in his *Enquiry Concerning Human Understanding* (1748). Hume recognized the twofold distinction

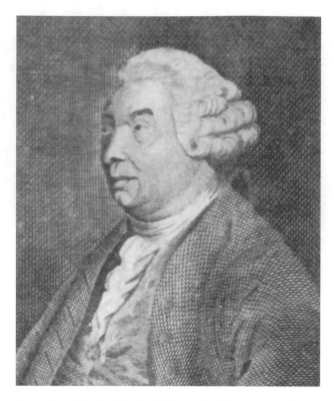

Engraving of the Scottish Enlightenment philosopher David Hume. THE LIBRARY OF CONGRESS.

that Locke had argued existed between sensory inputs and the mental representations they triggered. Hume labeled the former "impressions," the latter "ideas." Hume's first insight is that ideas are only "copies" of impressions. His second insight is what has been called his "liveliness" thesis: the notion that what separates ideas from impressions is the vividness of the copies. To use a modern analogy, if an image is photocopied, and then the photocopy is photocopied, each successive image will have less and less of the detail of the original. The difficulty with understanding Hume often resulted from his attacking and dismissing the "useless" ideas that he was trying to replace with his own theories. His attacks on traditional received wisdom, in other words, can be so vitriolic and entertaining that they sometimes cloud over what he had to say that was new. Using his two insights, Hume argued that all knowledge should be scrutinized to determine its factual versus its fictional character. The question concerning every idea that must be asked is "from what impression did it derive." If the source of the impression cannot be determined, Hume contends, it has no empirical validity. Hume skewered ideas concerning faith, miracles, and the supernatural because they possessed no empirical validation. Having dismissed the possibility of any spiritual basis for morality, Hume sought to establish

a PRIMARY SOURCE *document*

THE IMPOSSIBILITY OF MIRACLES

INTRODUCTION: In his *Enquiry Concerning Human Understanding* David Hume examined the long-standing claims of religion to be verified by miracles. He concluded that since miracles were violations of nature, and since experience taught that natural laws could not be violated, miracles were, in fact, impossible. His cool and detached reasoning displays one direction that Enlightenment philosophy took in the eighteenth century as it strove to prune away long-held superstitions.

A miracle is a violation of the laws of nature; and as a firm and unalterable experience has established these laws, the proof against a miracle, from the very nature of the fact, is as entire as any argument from experience can possibly be imagined. Why is it more than probable, that all men must die; that lead cannot, of itself, remain suspended in the air; that fire consumes wood, and is extinguished by water; unless it be, that these events are found agreeable to the laws of nature, and there is required a violation of these laws, or in other words, a miracle to prevent them? Nothing is esteemed a miracle, if it ever happen in the common course of nature. It is no miracle that a man, seemingly in good health, should die on a sudden: because such a kind of death, though more unusual than any other, has yet been frequently observed to happen. But it is a miracle, that a dead man should come to life; because that has never been observed in any age or country. There must, therefore, be a uniform experience against every miraculous event, otherwise the event would not merit that appellation; And as a uniform experience amounts to a proof, there is here a direct and full *proof* from the nature of the fact, against the existence of any miracle ...

The plain consequence is (and it is a general maxim worthy of our attention), 'That no testimony is sufficient to establish a miracle, unless the testimony be of such a kind, that its falsehood would be more miraculous, than the fact, which it endeavours to establish; and even in that case there is a mutual destruction of arguments, and the superior only gives us an assurance suitable to that degree of force, which remains after deducting the inferior.' When anyone tells me, that he saw a dead man restored to life, I immediately consider with myself, whether it be more probable, that this person should either deceive or be deceived, or that the fact, which he relates, should really have happened. I weigh the one miracle against the other; and according to the superiority, which I discover, I pronounce my decision, and always reject the greater miracle. If the falsehood of his testimony would be more miraculous, than the event which he relates; then, and not till then, can he pretend to command my belief or opinion.

In the foregoing reasoning we have supposed, that the testimony, upon which a miracle is founded, may possibly amount to an entire proof, and that the falsehood of that testimony would be a real prodigy: But it is easy to shew, that we have been a great deal too liberal in our concession, and that there never was a miraculous event established on so full an evidence.

SOURCE: David Hume, *An Enquiry Concerning Human Understanding* (Chicago: Open Court Publishing Co, 1926): 120–122.

an Epicurean notion of human ethical conduct: the pursuit of pleasure versus the avoidance of pain should be, he argued, the yardstick against which all human actions are judged. In this way, he helped to set the stage for philosophical utilitarianism in the nineteenth century.

SOURCES

M. W. Cranston, *John Locke: A Biography* (London: Longmans, 1966).

W. Doney, *Berkeley on Abstraction and Abstract Ideas* (Hamden, Conn.: Garland Science Publishing, 1989).

A. C. Grayling, *Berkeley: The Central Arguments* (London: Duckworth, 1986).

E. C. Mossner, *The Life of David Hume* (Oxford: Clarendon Press, 1979).

D. F. Norton, *The Cambridge Companion to Hume* (Cambridge: Cambridge University Press, 1993).

J. C. O'Neal, *The Authority of Experience: Sensationist Theory in the French Enlightenment* (University Park, Pa.: Pennsylvania State University Press, 1996).

———, *Changing Mind: The Shifting Perception of Culture in Eighteenth-Century France* (Newark, Del.: University of Delaware Press, 2002).

S. Priest, *The British Empiricists: Hobbes to Ayer* (London: Penguin, 1990).

S. Shapin, *Leviathan and the Air Pump: Hobbes, Boyle, and the Experimental Life* (Princeton, N.J.: Princeton University Press, 1985).

B. S. Tinsley, *Pierre Bayle's Reformation: Conscience and Criticism on the Eve of the Enlightenment* (Selinsgrove, Pa.: Susquehanna University Press, 2001).

R. Whelan, *The Anatomy of Superstition: A Study of the Historical Theory and Practice of Pierre Bayle* (Oxford: Voltaire Foundation, 1989).

THE ENLIGHTENMENT

THE BIG PICTURE. The Enlightenment was a broad and international movement in eighteenth-century Europe that aimed at placing science and knowledge derived through scientific methods of investigation at the heart of culture and civilization. It took its name from the idea that it represented: a process of bringing "the light of reason" to areas of darkness in human understanding. "Dare to know" was the banner call of the movement proclaimed by the German philosopher Immanuel Kant (1724–1804). Contemporaries understood this call as an invitation to hunt down and root out every instance of ignorance that continued to stand in the way of human progress. In many instances, certainly in most Catholic lands, religion in general and the state church in particular were identified as the prime sources of such ignorance. As such, the Enlightenment often took on a definite anti-religious cast in these regions. In terms of real people and real events this means that the Enlightenment can be seen as the sum of a series of organized efforts on the part of secular intellectuals to institute their ideas, usually as alternatives to those of the church. The Enlightenment was historically important in large part because these efforts proved to be successful over the long term. Enlightenment ideas, and the secular intellectuals who promoted these ideas, triumphed over existing social and cultural notions, most of which had long been dominated by traditional Christian orthodoxy. And while the idea that there was a positive value to cultural reforms based on science has not gone unchallenged in the modern era, those notions, born in the Enlightenment, have continued to be dominant in the West until contemporary times.

FOR GOOD OR FOR EVIL. Such a description of the Enlightenment, though, presents only the few points on which there is broad agreement among scholars. Everything else about the culture and philosophy of the movement has continued to remain disputed. In recent decades, the most agitated of these debates has been over the question of the social and cultural costs of the Enlightenment. Inspired primarily by the writings of the French thinker Michel Foucault (1926–1984), some scholars have argued that the Enlightenment simply substituted one sort of darkness with another. Science, they argue, became a justification for racism, sexism, and an entire host of other kinds of exploitation, just like religion had before it. Such criticism has not gone unchallenged, and others have countered that scientific investigation has, in fact, been a force for progress. While these figures readily admit that bad science has often been a dehumanizing force in the West, they have pointed out that its relentless pursuit of correct knowledge has been an overall positive force in the European tradition. Another debate, a debate that grew up in the Enlightenment itself, has also touched upon the moral consequences and costs of the movement itself. Critics approaching this problem from a religious perspective have pointed to the Enlightenment as the source for the rise of "secular humanism" and a moral relativism that it inspired. Champions of Enlightenment values, on the other hand, have pointed to Western society's traditionally repressive and intolerant nature before the eighteenth century. In this view, the Enlightenment has been seen as a force that helped to bring to an end centuries of religious hypocrisy in which only lip service had been paid to moral values. The Enlightenment may have fostered a moral relativism, they conclude, but it also allowed societies to recognize that humans are by nature different, and that they can be made to seem the same only through coercion.

PUBLIC OPINION. In recent years scholars have pushed their investigations of the origins of the Enlightenment backwards into the seventeenth century. They have begun to speak of the ideas of intellectuals like John Locke as the first wave of enlightened thought. The motivation behind this tendency is a desire to associate the Enlightenment with the development of empiricism. This desire has been prompted in large part by another trend of scholarship on the Enlightenment itself: a tendency to interpret that movement as an international phenomenon that followed very distinct paths in Europe's individual states. In this regard, the French Enlightenment has now been revealed to have been very different from its German and English cousins. But if the Enlightenment was different everywhere, then what can be said about it as a general historical phenomenon? When the Enlightenment is viewed as an outgrowth of empiricism, its common features become more obvious, although there is no direct and simple equation between empiricism and the later development of Enlightenment. While it is true that many Enlightenment thinkers were empiricists, and that empiricism was the philosophical foundation for most of the new intellectual disciplines that emerged during the Enlightenment, it is also true that the thoughts of many of the movement's thinkers deny easy categorization as "empirical." One of the links between these figures, though, was their willingness to affirm the existence of something that modern scholars call "public opinion," and their tendency to appeal to this new social arena of judgment for justification for the various sorts of reforms they advocated. Everywhere in eighteenth-century Europe, social reformers framed their ideas by reference to public welfare

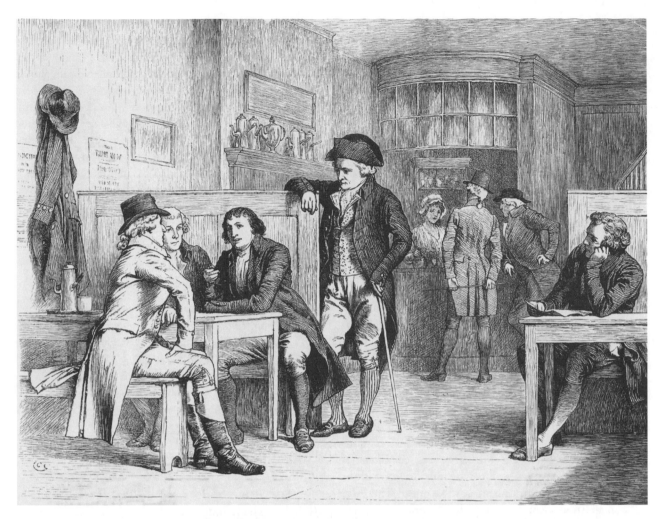

Engraving of an eighteenth-century English coffeehouse. BETTMANN/CORBIS.

or the common good, even as they branded those that opposed their ideas as "special interests" that were corrupt, intolerant, and fanatical. This common development is the best starting point for a discussion of the Enlightenment as a general phenomenon.

THE READING REVOLUTION. Behind the birth of "public opinion" was another cultural and social revolution that must be understood, a "reading revolution" that created new groups of readers and writers. In medieval Europe the "Republic of Letters"—the body of those that had used the written word to circulate their ideas—had an undeniably clerical cast. In the Renaissance, more and more lay people had acquired the ability to read and write, and they had begun communicating their ideas through the printed page. By the eighteenth century the vast majority of readers and writers were now lay people rather than clerics. This steady expansion in the number of society's readers inspired new genres of reading material, even as it also created new modes by which information

and news spread in society. The eighteenth-century reading public was now vast, but also complex and differentiated along lines of social class, education, and taste. To entertain and inform these various groups of readers, older types of printed communications, like the news broadsheet or the polemical pamphlet, now underwent a steady evolution, while at the same time new forms of reading matter, like the newspaper and the journal, developed. To supply the articles, stories, and thought pieces that went into these publications, a new occupation— that of the professional writer or "man of letters"— emerged. From individuals who made their living writing and publishing their own local newspaper, to internationally famous writers whose books were immediately translated into other languages, these individuals all made their living by saying in print what this new group of readers wanted to hear.

THE COFFEEHOUSE. In the largest sense, these new groups of readers constituted the public opinion to

which Enlightenment thinkers appealed, but much eighteenth-century writing was geared, not to all readers generally, but to a new category of bourgeois readers, in particular. This class became a common fixture of the economic landscape in most European countries around 1700. By this date, rising economic prosperity had forged a new middle class that often lived off the interest that their investments provided. With plenty of free time on their hands, members of this group spent their days in a new type of commercial establishment, the café or coffeehouse. There they sipped cups of the new beverages, coffee and tea, which were sweetened by sugar, the new wonder condiment, and smoked pipes filled with "sot weed" or tobacco. These new venues had begun to appear in London in the years around 1650, and within two generations they had spread to most European cities. In English, they were often called "penny universities," because for a mere penny men could be admitted into a society where others shared their concerns. For this modest cost of admission, men were able to read from an assortment of books, newspapers, and journals coffeehouses made available to their patrons. The idea of leisure time reading is key here because it helps explain the second social development that amplified the impact of Enlightenment thought. In the eighteenth century talking became a pastime in many of the ways it remains today. Enlightenment-era thinkers were conscious of themselves as having come up with not just new ideas, but new ways of communicating those ideas. The "art" of conversation—conversation that connoted the exchange of information via polite discourse—was the subject of essays and discussions. The concern was to find ways to move beyond the social hierarchy that had constrained oral communication in the past. The ideal was to create situations where individuals, no matter their social rank, could exchange ideas as intellectual equals. In the twenty-first century both radio and television offer a myriad of talk shows aimed at informing the public of news and ideas while also providing their listeners with a particular "spin" on news and ideas. The origins of this incessant commentary stretch back to the eighteenth-century Enlightenment world of the coffeehouse. In that world the art of conversation was practiced, and leisure reading provided a steady inspiration for the enrichment of discussion. In this way, the goal of much of the writing that appeared in the Enlightenment was to elicit conversation. The letter of one frustrated exile from the Paris salons to a friend voiced a sentiment shared by all those who were participating in the new world of the Enlightenment: "Reading alone, with no one to talk to, to discuss things with or be witty with, to listen to or to listen to me, is impossible." Enlightenment

thinkers framed what they had to say in ways they hoped would get people talking, and the measure of success of a piece of writing was its power as a conversation starter. Many of the men whose ideas inspired the coffeehouse chatter of the eighteenth century may not have spent much time themselves in the new cafés, but their eminence as "great" writers derived in large part because their works became the subject of the new kinds of debate that the Enlightenment helped to sanction. And while "public opinion" did not reside solely in the coffeehouse, it still constituted an important element of the audiences that Enlightenment thinkers hoped to influence.

SOURCES

P. Gay, *The Enlightenment; An Interpretation.* 2 vols. (New York: Knopf, 1995).

L. Goldmann, *The Philosophy of the Enlightenment* (Cambridge, Mass.: Harvard University Press, 1973).

J. V. Melton, *Cultures of Communication from Reformation to Enlightenment* (Burlington, Vt.: Ashgate, 2002).

———, *The Rise of the Public in Enlightenment Europe* (Cambridge: Cambridge University Press, 2001).

R. Porter, *English Society in the Eighteenth Century* (Harmondsworth, England: Penguin, 1982).

THE ENLIGHTENMENT IN FRANCE

THE ROLE OF PARIS. Paris was the home of the Enlightenment, and most discussions of the Enlightenment are actually discussions of its unfolding there. The French Enlightenment was characterized by the emergence of a group of thinkers, the *philosophes*, whose writings sought to give the Enlightenment everywhere both a rationale and an agenda. These philosophes met regularly in the afternoons at the homes of well-heeled patrons, where they would discuss events and ideas over elegant meals. These salons were the envy of European intellectual circles. The defining achievement of the French Enlightenment was the publication of the *Encyclopédie*, a multi-volume compendium of all useful knowledge that was to kick-start European civilization in the direction of progress. The philosophes were "men of letters," which, as Voltaire explained, meant that they were not scholars but explorers of all knowledge. This idea helps explain why so few of the philosophes offered original contributions to philosophy. Their ambition was not to come up with anything new in the way of ideas, but to put what was known to work in ways helpful to humankind. The archetype of the philosophe was Voltaire, who with some success tried his hand at almost every genre of writing. Philosophically, Voltaire

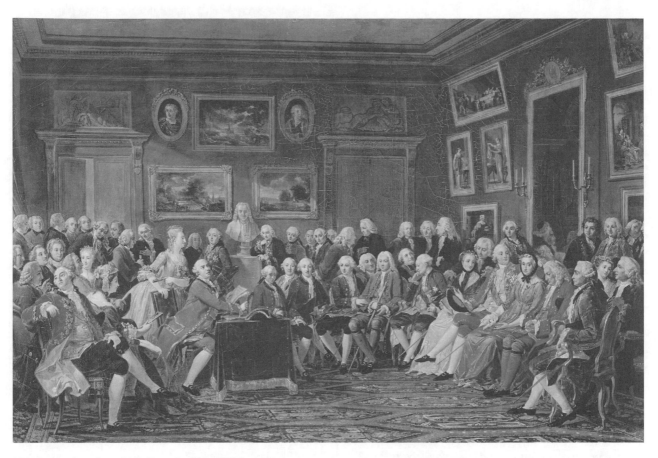

Meeting at the salon of Madame Geoffrin (1755). REUNION DES MUSEES NATIONAUX/ART RESOURCE, NY.

had little to say, but he did perform an important service for the Enlightenment through his efforts to introduce Continental intellectuals to English institutions and ideas. Exiled from Paris, Voltaire spent the years between 1726 and 1729 in London where he studied the writings of John Locke and attended the funeral of Isaac Newton. Later, Voltaire published a series of essays in the forms of letters, the *Letters on the English*, or, as it is also called, the *Philosophical Letters* (1734). These made the case that governments and societies on the Continent should imitate English examples. Still later, Voltaire wrote a study of the ideas of Newton and together with his mistress, Madame de Chatelet, he published a French translation of Newton's *Principia*. Because of his penchant for insulting powerful people, Voltaire actually spent very little of his adult life in Paris, and thus he partook little of the city's salon life. There were several different levels of these weekly dinner parties, almost all directed by women. But at the height of the Enlightenment during the 1760s four salons sat atop the social and intellectual pyramid in the city: two run by men and two by women. On Mondays, Madame

Geoffrin invited artists to her home to dine, while on Wednesdays she entertained writers. Tuesdays belonged to the philosophe Claude Adrien Helvetius (1715–1771). Thursdays and Sundays were the occasions for the salons held by another philosophe, the Baron D'Holbach (1723–1789), while Fridays were the days set aside for dinner at Madame Neckar's. Very few great intellectual moments may have taken place at these salons, but they did much to glamorize and romanticize the lives of intellectuals.

THE ENCYCLOPÉDIE. The men who wrote the *Encyclopédie* often congregated at Madame Geoffrin's house. This great project to summarize all science and wisdom in a single set of volumes was perhaps the greatest intellectual achievement of the French Enlightenment. Encyclopedic compendiums were certainly not new in the eighteenth century. Pierre Bayle's massive critical dictionary from around 1700, with its nine million words of text, had been just one of the many works that inspired the great French project that began in 1751. Originally, this new *Encyclopédie* had begun merely as a work to translate the *Cyclopedia, or an Universal Dictio-*

a PRIMARY SOURCE *document*

THE END OF THE NOSE

INTRODUCTION: Voltaire intended his *Philosophical Dictionary* (1764) to be a questioning work that would subject many cherished beliefs to close scrutiny. In it, he also exhibited a keen, and sometimes ironic sense of detachment. In the following entry on the "Limits of the Human Mind," he styles part of his short essay on Montaigne, the mildly skeptical figure of the later French Renaissance. To Montaigne's own question, "What do I know?", Voltaire answers trenchantly: the limits of human knowledge lay at the end of the nose, that is, at the point where the eye's gaze falls upon the world. He thus celebrates empirical observation, rather than metaphysical theorizing, as the true end of human intelligence.

Someone asked Newton one day why he walked when he wanted to, and how his arm and his hand moved at his will. He answered manfully that he had no idea. "But at least," his interlocutor said to him, "you who understand so well the gravitation of the planets will tell me why they turn in one direction rather than in another!" And he again confessed that he had no idea.

Those who taught that the ocean was salt for fear that it might become putrid, and that the tides were made to bring our ships into port (The Abbé Pluche in "The Spectacle of Nature"), were somewhat ashamed when the reply was made to them that the Mediterranean has ports and no ebb. Musschenbroeck himself fell into this inadvertence.

Has anyone ever been able to say precisely how a log is changed on the hearth into burning carbon, and by what mechanism lime is kindled by fresh water? Is the first principle of the movement of the heart in animals properly understood? does one know clearly how generation is accomplished? has one guessed what gives us sensations, ideas, memory? We do not understand the essence of matter any more than the children who touch its surface.

Who will teach us by what mechanism this grain of wheat that we throw into the ground rises again to produce a pipe laden with an ear of corn, and how the same soil produces an apple at the top of this tree, and a chestnut on its neighbour? Many teachers have said—"What do I not know?" Montaigne used to say—"What do I know?"

Ruthlessly trenchant fellow, wordy pedagogue, meddlesome theorist, you seek the limits of your mind. They are at the end of your nose.

SOURCE: Voltaire, *Philosophical Dictionary*. Trans. H. I. Woolf (1764; New York: Knopf, 1924): 194.

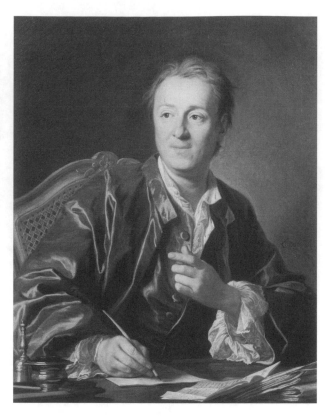

Portrait of Denis Diderot, one of the editors of the *Encyclopédie*. © **ARCHIVO ICONOGRAFICO, S.A./CORBIS.**

nary of Arts and Sciences (1728) by Ephraim Chambers. Eventually, the two editors of the French project, though, discarded the idea of a mere translation and began a massive work of compilation. What made the *Encyclopédie* a clear standout among the many such compendia published in the seventeenth and eighteenth centuries was that it was not written by experts, but by the philosophes. Eventually, the finished product totaled 28 volumes, as well as several supplements. Although such a large work did not present a single point of view, the editors Denis Diderot and Jean d'Alembert often chose like-minded intellectuals, and thus the tone of much of the writing was often distinctly anti-clerical and anti-religious, even as the text advocated reforms along the lines such Enlighteners favored. The text, too, was not aimed at a specialist, but a generalist reader, and thus it had a great impact in fashioning taste in later eighteenth-century Europe. The ultimate message of the project, though, was that which Francis Bacon had first expressed: human life could be made better through knowledge. By 1789, some 25,000 sets were in circulation across Europe, and the *Encyclopédie* had become one of the Enlightenment's great publishing success stories.

JEAN-JACQUES ROUSSEAU. Of the many individuals who wrote during the French Enlightenment, one

a PRIMARY SOURCE *document*

GOOD GOVERNMENT

INTRODUCTION: In book three of his *Social Contract* (1762), Jean-Jacques Rousseau explored the sources behind good government. In contrast to his earlier writing, Rousseau abandoned his faith in human goodness in the state of nature, even as he argued that governments must represent the general will of those that were governed, rather than the particular interests of a ruler or an aristocracy. The work scandalized many Europeans, even as it inspired many of the leaders of the French Revolution a generation later. It was subjected to censorship, although Rousseau was not punished. At the time he was already living in exile from his native France.

The question "What absolutely is the best government?" is unanswerable as well as indeterminate; or rather, there are as many good answers as there are possible combinations in the absolute and relative situations of all nations.

But if it is asked by what sign we may know that a given people is well or ill governed, that is another matter, and the question, being one of fact, admits of an answer.

It is not, however, answered, because everyone wants to answer it in his own way. Subjects extol public tranquility, citizens individual liberty; the one class prefers security of possessions, the other that of person; the one regards as the best government that which is most severe, the other maintains that the mildest is the best; the one wants crimes punished, the other wants them prevented; the one wants the State to be feared by its neighbours, the other prefers that it should be ignored; the one is content if money circulates, the other demands that the people shall have bread. Even if an agreement were come to on these and similar points, should we have got any further? As moral qualities do not admit of exact measurement, agreement about the mark does not mean agreement about the valuation.

For my part, I am continually astonished that a mark so simple is not recognised, or that men are of so bad faith as not to admit it. What is the end of political asso-

ciation? The preservation and prosperity of its members. And what is the surest mark of their preservation and prosperity? Their numbers and population. Seek then nowhere else this mark that is in dispute. The rest being equal, the government under which, without external aids, without naturalisation or colonies, the citizens increase and multiply most, is beyond question the best. The government under which a people wanes and diminishes is the worst. Calculators, it is left for you to count, to measure, to compare.

As the particular will acts constantly in opposition to the general will, the government continually exerts itself against the Sovereignty. The greater this exertion becomes, the more the constitution changes; and, as there is in this case no other corporate will to create an equilibrium by resisting the will of the prince, sooner or later the prince must inevitably suppress the Sovereign and break the social treaty. This is the unavoidable and inherent defect which, from the very birth of the body politic, tends ceaselessly to destroy it, as age and death end by destroying the human body.

There are two general courses by which government degenerates: i.e., when it undergoes contraction, or when the State is dissolved.

Government undergoes contraction when it passes from the many to the few, that is, from democracy to aristocracy, and from aristocracy to royalty. To do so is its natural propensity. If it took the backward course from the few to the many, it could be said that it was relaxed; but this inverse sequence is impossible.

Indeed, governments never change their form except when their energy is exhausted and leaves them too weak to keep what they have. If a government at once extended its sphere and relaxed its stringency, its force would become absolutely nil, and it would persist still less. It is therefore necessary to wind up the spring and tighten the hold as it gives way: or else the State it sustains will come to grief.

SOURCE: Jean-Jacques Rousseau, *The Social Contract and Discourses.* Trans. G. D. H. Cole (New York: Dutton, 1950): 82–86.

man stands out for the originality and force of his ideas. The work of Jean-Jacques Rousseau (1712–1778) defies compartmentalization. There is some debate among scholars in fact over the question of whether he should be considered an exponent of the Enlightenment or a harbinger of the Romantic Age that followed it. Rousseau himself was a deeply enigmatic figure, one that

seemed to march to a different drumbeat set by demons. The one thing known about his early life is that he was born in Geneva. The rest of the information about his youth has to culled from his autobiographical *Confessions* (1782–1789), written just before he died, which paints a Romantic picture of a young roustabout introduced to life, learning, and love by an older woman.

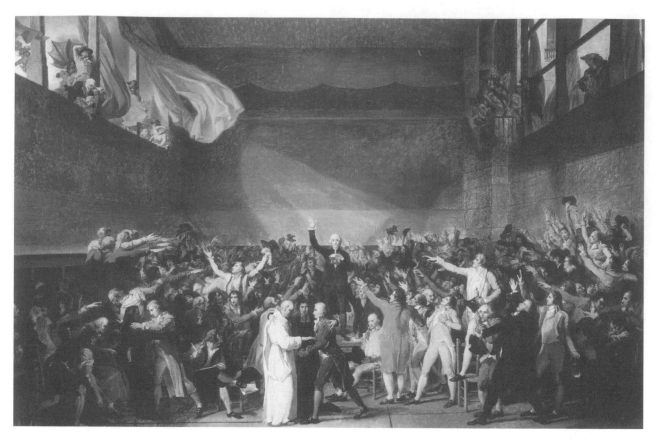

The Tennis Court Oath (1789) by Jacques-Louis David. The oath, one of the precipitating events of the French Revolution, asserted the sovereignty of the people over that of the king, a fundamental idea in the philosophy of Rousseau. THE ART ARCHIVE/MUSÉE CAR-NAVALET PARIS/DAGLI ORTI.

What is known for certain is that in 1742 Rousseau arrived in Paris hoping to make a name for himself as a musical theorist. He quickly became a friend of Denis Diderot and the circle of men writing the *Encyclopédie*; Rousseau wrote most of the articles in that work having to do with music. The first flashes of Rousseau's brilliance came in his debate with Jean-Philippe Rameau, the most powerful authority on music in France. The official topic of the debate was the relative merits of French versus Italian opera; below the surface the subject was really the superiority of rationality to emotion. In the context of this debate Rousseau put forward the idea that artistic creativity should take precedence over the forms in which it is expressed. In 1750 Rousseau won first prize in an essay contest sponsored by the Academy of Dijon for his *Discourse on the Sciences and the Arts*, in which he made the case that civilization has a corrupting influence on humankind. In 1755 Rousseau submitted another essay to the competition sponsored by the same academy, and his *Discourse on the Origins of Inequality* also won first prize. More importantly, it established him as a philosopher of merit. Taking up where the earlier essay had left off, this sec-

ond *Discourse* argued for the existence of two types of inequality: natural inequality, which has to do with the fact that one man is stronger or smarter than another, and artificial inequality, which was the inequality imposed between individuals by society. As Rousseau explained it, man in the state of nature was solitary but happy. The need to procreate turned the solitary individual toward village life and prompted the evolution toward civilization. Each step forward in the evolution of society, however, alienated the solitary individual from himself, the crucial step being the invention of private property, which triggered the development of law and government to protect the claims of owners, a development that ensured the continuation of artificial inequality over generations. "Man is born free, but everywhere he is in chains" is actually the opening line to *The Social Contract* (1762), the book Rousseau wrote to prescribe the way out of the situation described in *The Discourse on the Origins of Inequality*. As he outlined there, society must make explicit the pact or social contract that is implicit in communal living to find a way to salvation. Each society, each community has to be looked upon in the same way that an individual is examined—as the articu-

lator of a specific will. To the extent to which the members of a society can shape and share that will, then those members will come to know liberty because they will have control over their own destinies.

SOURCES

M. W. Cranston, *Philosophers and Pamphleteers: Political Theorists of the Enlightenment* (Oxford: Oxford University Press, 1984).

R. Darnton, *The Business of Enlightenment* (Cambridge, Mass.: Belknap Press, 1979).

N. Hampson, *A Cultural History of the Enlightenment* (New York: Pantheon, 1968).

M. Hulliung, *The Autocritique of Enlightenment: Rousseau and His Philosophes* (Cambridge, Mass.: Harvard University Press, 1994).

S. D. Kale, *French Salons: High Society and Political Sociability from the Old Regime to the Revolution of 1848* (Baltimore, Md.: Johns Hopkins University Press, 2004).

J. Simon, *Mass Enlightenment: Critical Studies in Rousseau and Diderot* (Albany, N.Y.: State University of New York Press, 1995).

SEE ALSO *Dance: The Enlightenment and Ballet; Literature: French Literature during the Enlightenment; Theater: The French Enlightenment in Drama*

THE ENLIGHTENMENT ELSEWHERE IN EUROPE

BRITAIN. The English and Scottish Enlightenments might be looked upon as complementary halves of a whole. English thinkers supplied very little philosophical importance to the Enlightenment, being mostly concerned with the development and application of technological and scientific ideas. Scottish thinkers, by contrast, made some of the most original and lasting contributions to philosophy in the eighteenth century. Unlike France, where the *philosophes* developed Paris into a center of literary ferment and glittering social life, the Enlightenment in England had no center, produced very little literature of note, and spawned a very different social venue for the exchange of ideas. Through their written works, the French Enlighteners hoped to encourage their country's government to adopt social reforms. In England, by contrast, Enlightenment thought concentrated on what could be done in the private sector to bring about progress. In France the Enlightenment was in the hands of "men of letters." In England it was busi-nessmen, industrialists and agricultural entrepreneurs who saw themselves as leading the charge toward the future. Significantly, English thinkers were always in the hunt for new things, "new things" being understood to mean innovations whose value could be measured by their impact on the profit margin, and the commercial cast of much eighteenth-century English political and social writing is undeniable when compared against the French philosophes. The one gathering that might pass as a salon in England was the Literary Club that the painter Joshua Reynolds organized in the 1760s in London around his friend Samuel Johnson. Otherwise, those interested in discussing progress and the future came together in scientific associations and literary and philosophical societies. These met on a weekly basis, with a lecture or demonstration serving as the starting point for conversation. The best known of the English associations was the Lunar Society of Birmingham, founded by the industrialist Matthew Boulton (1728–1809), famous then for the success of his tool and die factory but better known in history for supplying the capital that allowed James Watt to develop the steam engine. The Lunar Society met only on nights when the moon was full, so that there would be sufficient light for members to make their way home.

SCOTLAND. In France and England, the Enlightenment did not have much connection with the universities. In both states the universities remained the territory of the clergy, the group of thinkers most antithetical to Enlightenment thought. This was not the case in Scotland where, with the notable exception of David Hume (1711–1776) who was suspected of being an atheist, most of the leading thinkers of the Scottish Enlightenment held positions in the university. Glasgow was the university most open to Enlightenment thought. Adam Smith (1723–1790), the great eighteenth-century economic theorist, held a chair in Moral Philosophy there. Smith's tenure was followed by Thomas Reid (1710–1796), founder of the "Common Sense" school of Scottish philosophy, which challenged the skepticism of Hume. They argued that what humans need to know is obvious to them as common sense. Another Enlightenment figure that taught at Glasgow was the chemist Joseph Black (1728–1799), famous for first identifying the properties of carbon dioxide. During the 1780s, Edinburgh began to replace Glasgow as a center of Enlightenment thinking, especially after the founding of the Royal Society of Edinburgh in 1783. Much like the scientific societies in England, the Royal Society provided a venue in which visiting speakers could lecture and discuss their ideas with members. In this way, the

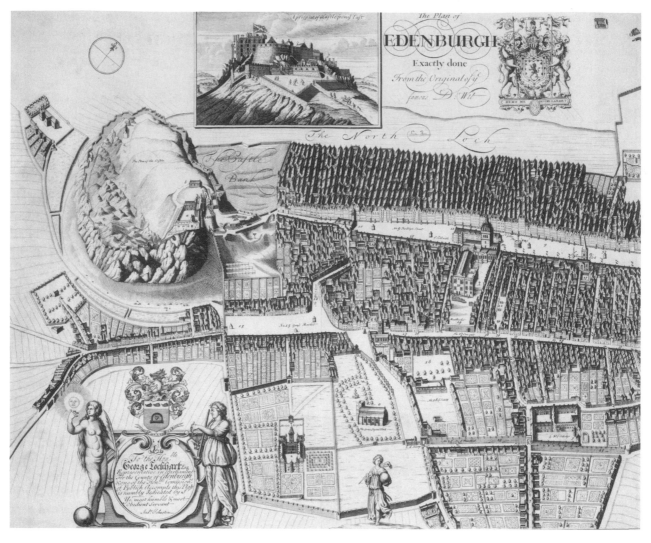

Engraved plan for Edinburgh's New Town, a mid-eighteenth-century settlement outside the city's medieval walls that became home to a number of Enlightenment philosophers. © HISTORICAL PICTURE ARCHIVE/CORBIS.

society brought the culture of the Enlightenment in Scotland into alignment with that in England.

THE ENLIGHTENMENT IN GERMANY. In both France and Britain the Enlightenment took place outside of government circles. In Germanic lands, by contrast, the *Aufklärung*, as the Enlightenment was known, became a reform movement that was, in fact, sponsored and directed by rulers. The reformist ideas of the French *philosophes* were not taken all that seriously by the government at Versailles, but in royal palaces in Berlin and Vienna, the capitals respectively of the kingdoms of Prussia and Austria, these ideas became the basis for the first serious efforts at social reform. In Berlin the Enlightenment occasioned a great outpouring of writings on culture and religion by German intellectuals. Immanuel Kant (1724–1804), whose impact on philosophy was not equaled by any of his contemporaries, was a product of

the Prussian Enlightenment. Still the Enlightenment in the Holy Roman Empire was made most vividly evident to ordinary Germans through the efforts of territorial rulers to modernize their societies through the application of ideas that emerged in France. The idea that the Enlightenment should be implemented from the top downward was the first and most important French idea embraced by the Germans. Voltaire had argued for it, and wrote a history of Louis XIV entitled *Le siécle de Louis XIV* (The Century of Louis XIV; 1751) to demonstrate the glory that might be acquired by a ruler who took the initiative to reform his realm. The notion first attracted an audience in Potsdam, where the summer palace of Frederick the Great, king of Prussia, was located. Frederick tried to expose the Prussian ruling class to the new ideas that were developing in France. In 1744, he revived the Berlin Academy of Science, which had

been established by Gottfried Wilhelm Leibniz in 1700, but which had fallen into neglect. At the suggestion of Voltaire, Frederick invited the French mathematician Pierre-Louis Moreau de Maupertuis (1698–1759) to serve as president of the Academy, and when Maupertuis stepped down, Frederick unsuccessfully sought to have Jean d'Alembert, one of the two original editors of the *Encyclopédie*, take the position. During Frederick's reign the publications of the Academy were all in French, but as an institution it still opened doors for German intellectuals. The most striking example of its fulfillment of this function came in 1763 when the Jewish intellectual Moses Mendelssohn won an Academy-sponsored essay contest on the nature of metaphysics. Frederick the Great was the first and greatest example of what historians have labeled an "enlightened despot," meaning a ruler who exercised absolute control over his state but who used this authority with a mind to improving the lives of his subjects. Perhaps the best illustrations of these instincts were Frederick's decree establishing religious toleration in his lands and his reforms of the Prussian judicial system. The second great eighteenth-century ruler to sponsor similar reforms was Joseph II of Austria (1741–1790), the eldest son of the empress Maria Theresa. He ruled with his mother from 1765 to 1780, and by himself from 1780 to 1790. Unlike Frederick the Great, Joseph imported French ideas, but he did not bother to bring French philosophes to his court. His most important reforms involved the state's relationships with the Catholic Church. He closed many monasteries and turned their revenues toward the founding of hospitals and other social welfare institutions. He sought to reform education also, on the one hand freeing the University of Vienna from clerical control, and on the other establishing a system of state-maintained seminaries for the training of priests. He granted freedom of worship to Protestants and Jews, and attempted to free the serfs. Although his ambitions for Austria were great, his enlightened reforms led to revolts across Austria and Hungary, and Joseph died a broken man.

IMMANUEL KANT. The greatest philosopher of the German Enlightenment was undoubtedly Immanuel Kant (1724–1804), a thinker whose ideas have long puzzled and perplexed his readers but who made a major contribution to the emergence of psychology as a discipline in the modern world. As a philosopher living in the early-modern era, Kant treated many issues that are now the preserve of psychologists. The topics that early-modern philosophers often treated—particularly their return over and over again to the subject of human epistemology and cognition—have now been explained scientifically, that is by cognitive research that has been validated by a stream of experiments. Early-modern philosophers lacked the ability to perform such tests, but even more importantly, they lacked the mindset that would seek to adjudicate a dispute by reference to quantitative data. They thought of explaining thinking only in terms of the logical analysis of thought. Or, to put the point in the terms that Kant would put it, they attempted to use a tool—in this case, the human mind—to explain the functioning of that tool. What made the work of Kant so important for the future was his insistence that instead of allowing the constraints to the operation of human consciousness to serve as obstacles to an understanding of such consciousness, it is better to identify those constraints and to seek to determine how they shape human consciousness. In this way Kant reconciled the major differences between rationalism and empiricism, and moved philosophical discussion to a new stage. Kant was the greatest Enlightenment figure to go against the grain of the ideals set down by the French philosophes. He was born in the Prussian city of Königsberg, and over the course of his eighty years never traveled more than sixty miles from it. He was reputedly so punctual in his habits that the town clock was set according to his daily routine. After many years of working as a private tutor for noble families, Kant was awarded a professorship at the University of Königsberg only in 1771. There he completed his most important work, including his *Critique of Pure Reason* (1781). In the text Kant shows how the dialectical opposition posed by the rationalists and empiricists could be resolved through a new synthesis. The substance of Kant's critique of the ideas of these two groups of philosophers treated what their questions about human thinking revealed about the character of thought. Take, for example, the question of the nature of the existence of time and space, of "extension" as René Descartes had formulated it. It is impossible for any human to grasp any phenomenon without mentally fixing that phenomenon in space and time. The rationalists identified time and space as innate features of human consciousness, while the empiricists saw them as developing as a result of experience. Kant argued that both approaches assumed that the mind was passive in its reception of phenomena, but he asserted that, in fact, the mind is an active participant in the framing of phenomena, and that time and space are transcendent categories that exist at a precognitive level. In other words, time and space are best understood, not as innate or learned phenomena, but as part of the very character of the mind as a tool. Said a third way, like the teeth of a saw or the tip of a screwdriver, time and space are attributes that help give the mind its identity as a tool. The mind has other characteristics, such as the

capacity to distinguish quality and quantity, features that aid its capacities to frame mentally the phenomena it engages. Understanding the mind, and what it brought to the process of understanding thus became for Kant the very goal of philosophy itself, although in the time since he wrote, his ideas have tended to become more and more the preserve of cognitive psychologists rather than philosophers.

PHILOSOPHY AND THE ENLIGHTENMENT. The lifespan of the Enlightenment is one of those topics upon which there is no consensus among historians. Older treatments of the subject were content to have the Enlightenment end just in time for the start of the French Revolution. More recently, as a result of the influence of the French philosopher Michel Foucault, many have come to see the Enlightenment as synonymous with the entire sweep of modern culture. Thus some have now depicted the Enlightenment as a thriving historical reality that has only in the later twentieth century been called into question by "Post-Modern" theory. Both these arguments for a "short" and a "long" Enlightenment associate the movement primarily with the rise and decline of the philosophes centered in Paris. While granting the importance of the Enlightenment as it happened in other locales, historians almost always come back to the salons of Paris. At the same time it must be admitted that the philosophes had very little to say in the great eighteenth-century philosophical debates that captivated Europe's intellectuals. In the heyday of the French Enlightenment, in the middle of the eighteenth century, very little philosophy emerged from Paris. Instead it was the ideas of figures like Hume and Kant, with their emphasis on problems of consciousness, that were to become the most relevant contributions to existing debates within philosophy. And while the ideas that Rousseau promoted in Paris in the 1750s and 1760s were a significant departure in philosophy that were to become more important in the decades that followed, those ideas had not been formulated in the Parisian milieu. Rousseau, in fact, was an émigré who developed his thought in relative isolation before coming to Paris. It seems fair to conclude, then, that the Enlightenment, as defined by historians, and philosophy were two ships that passed in the night. Such a conclusion, though, prompts three questions. The first is "What connections existed between the Enlightenment and philosophical discourse?" Primarily, the Enlightenment development of a culture of coffeehouses and salons broadened the audience for philosophical thought, although very few of the new "bourgeois" readers seems to have read Hume and Kant directly. Instead they learned of these debates through the writings of others who popularized their ideas, just as Sigmund Freud and Albert Einstein came to be known to most twentieth-century readers, not firsthand, but through the works of others who summarized their conclusions. A second question that arises is "Did the Enlightenment have any essential impact on the development of philosophy?" A better, though counterfactual, version of this question would be, "Would Hume and Kant have written their works even if the Enlightenment had not occurred?" The answer here must be yes, given the evidence of the ideas that went into the work of these two men. Even though the Enlightenment helped to popularize serious philosophy, it should be kept in mind that serious philosophy was propelled forward by an impetus only tangentially related to the concerns of the Enlightenment. A third question is "Did the Enlightenment have any lasting legacy on the development of philosophy?" Another way of putting this question would be, "Did the Enlightenment contribute anything to the mix that produced Rousseau's new departure?" Here also the answer must be yes. This answer requires some brief explanation. As much as Rousseau was a forerunner of Romanticism, he was equally a forerunner of the type of public figure readers demanded by the end of the eighteenth century. The Enlightenment's constant discussion of how society might be improved focused intellectual attention on the question of the role of government in directing society. The philosophes left the task of forcing the government to fulfill its obligation to lead to those in power. Rousseau made it squarely the task of the participants in civil society to hold government to its duties. As he argued, the path forward to liberty ran through collective effort. Rousseau synthesized the public reaction to the movement for political reform, a game at which French Enlightenment philosophes had been playing over the previous decades, and forge it into a new paradigm of political action. In that sense he was an ancestor to Tom Paine, Thomas Jefferson, and the other Americans who interpreted the Enlightenment primarily in terms of politics.

SOURCES

A. Broadie, *The Cambridge Companion to the Scottish Enlightenment* (Cambridge: Cambridge University Press, 2003).

D. Daiches, J. Jones, and P. Jones, eds., *A Hotbed of Genius: The Scottish Enlightenment, 1730–1790* (Edinburgh, Scotland: Edinburgh University Press, 1986).

F. Delekat, *Immanuel Kant* (Heidelberg, Germany: Quelle and Meyer, 1966).

Jean Guéhenno, *Jean Jacques Rousseau.* Trans. J. Weightman and D. Weightman (New York: Columbia University Press, 1966).

R. Porter, *English Society in the Eighteenth Century* (Harmondsworth, England: Penguin, 1982).

H. M. Scott, ed., *Enlightened Absolutism: Reforms and Reformers in Later Eighteenth-Century Europe* (Basingstoke, England: Macmillan, 1990).

SEE ALSO *Literature: The Enlightenment in Germany*

POLITICAL PHILOSOPHY

ABSOLUTISM. In Europe, political philosophy had come into its prime during the sixteenth century, prompted by the great political, military, and religious events of the period which inspired numerous treatises aimed at resolving the problems confronting rulers. The most significant problems rulers faced in the era arose from resistance to the state's ever-growing demand for revenue. By the sixteenth century the "Military Revolution" sparked by the introduction of guns and cannons was well underway. Princes either had to keep up with the latest military technology or risk becoming a victim of it. The only way to keep up with technological innovation was with money, and the only way to get money was through taxes. Raising taxes, however, angered taxpayers and risked rebellion. Princes thus faced a dilemma. They might tempt neighboring states by ignoring defense but keep their subjects happy. Or they could frighten off their neighbors but make their subjects unhappy through the imposition of unpopular taxes. Most chose the latter course, but in doing so, their subjects began to respond with increasing vehemence that kings were violating longstanding contractual notions of government. The religious problems of the age further complicated relationships between princes and their people, and religious turmoil often provided a further justification for rebellion. If the prince was Catholic and the subject Protestant, the argument went, the subject had a right to defend his "true" religion against the encroachments of the state.

DIVINE RIGHT OF KINGS. As a response to both kinds of arguments—those that opposed new taxes and those that sought to defend "true religion"—royal apologists of the day began to promote the doctrine of the "divine right of kings." Princes were, in the words of the English king James I (r. 1603–1625), "God's lieutenants on Earth." As such, subjects owed the same obedience to their king as they owed to God. Yet merely identifying a "divinely instituted" right to rule did not answer the bristling dilemmas that were raging all the same about just when and how a king might exercise his authority. To justify the increasingly enlarged view of royal power,

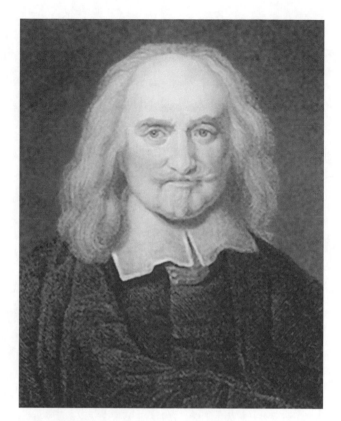

Engraving of Thomas Hobbes. ARCHIVE PHOTOS, INC. REPRODUCED BY PERMISSION.

sixteenth-century political theorists had turned to examine issues about sovereignty. They had argued that since the king had the final say in formulating laws, he, in fact, stood above the law, and was consequently the "absolute" authority in the nation. As James I again observed, "Kings were the authors and makers of the laws, and not the laws of the Kings." By the early seventeenth century, ideas of divine right, which asserted that the prince derived his authority from God, combined with these ideas of absolutism, thus producing new theories of divine right absolutism. In his *True Law of Free Monarchies* (1598), James I first gave expression to its key tenets. Sir Robert Filmer (1588–1653), an apologist for the absolutist ambitions of James and his descendents, wrote his *Patriarcha* (1680) to give such theories biblical support, although during the period of rising Puritan ascendancy in England he did not dare to publish his thoughts. *Patriarcha* appeared only after Filmer's death and the Restoration of the Stuarts to the English throne. Like many previous works, Filmer treated the state as a "family writ large," and the king as its father. But then he went on to trace a line of descent of princely fathers that started with Adam and ended with Charles I, the reigning monarch in England when he was writing. The greatest developer of such

a PRIMARY SOURCE document

NASTY, BRUTISH, AND SHORT

INTRODUCTION: Thomas Hobbes' *Leviathan* was the greatest work of political philosophy produced in seventeenth-century England. Hobbes' insights arose from a particularly dim view of humankind, and they caused him to support an authoritarian state that might rise above human egotism (the Leviathan mentioned in the work's title). In the famous passage below, he summarizes his view of human nature.

Again, men have no pleasure (but on the contrary a great deal of grief) in keeping company where there is no power able to overawe them all. For every man looketh that his companion should value him at the same rate he sets upon himself, and upon all signs of contempt or undervaluing naturally endeavours, as far as he dares (which amongst them that have no common power to keep them in quiet is far enough to make them destroy each other), to extort a greater value from his contemners, by damage; and from others, by the example.

So that in the nature of man, we find three principal causes of quarrel. First, competition; secondly, diffidence; thirdly, glory.

The first maketh men invade for gain; the second, for safety; and the third, for reputation. The first use violence, to make themselves masters of other men's persons, wives, children, and cattle; the second, to defend them; the third, for trifles, as a word, a smile, a different opinion, and any other sign of undervalue, either direct in their persons or by reflection in their kindred, their friends, their nation, their profession, or their name.

Hereby it is manifest that during the time men live without a common power to keep them all in awe, they are in that condition which is called war; and such a war as is of every man against every man. For war consisteth not in battle only, or the act of fighting, but in a tract of time, wherein the will to contend by battle is sufficiently known: and therefore the notion of time is to be considered in the nature of war, as it is in the nature of weather. For as the nature of foul weather lieth not in a shower or two of rain, but in an inclination thereto of many days together: so the nature of war consisteth not in actual fighting, but in the known disposition thereto during all the time there is no assurance to the contrary. All other time is peace.

Whatsoever therefore is consequent to a time of war, where every man is enemy to every man, the same consequent to the time wherein men live without other security than what their own strength and their own invention shall furnish them withal. In such condition there is no place for industry, because the fruit thereof is uncertain: and consequently no culture of the earth; no navigation, nor use of the commodities that may be imported by sea; no commodious building; no instruments of moving and removing such things as require much force; no knowledge of the face of the earth; no account of time; no arts; no letters; no society; and which is worst of all, continual fear, and danger of violent death; and the life of man, solitary, poor, nasty, brutish, and short.

SOURCE: Thomas Hobbes, *Leviathan* (London: Andrew Crooke, 1651): 61–62.

theories of divine right absolutism was Bishop Jacques-Bénigne Bossuet (1627–1704), perhaps the most influential churchman in France during the first half of Louis XIV's reign. As he argues in his posthumously published *Statecraft Drawn from the Very Words of the Holy Scripture* (1707) the person of the king is "sacred," and to attack him in any way is "sacrilege." It is through rulers, Boussuet explains, that God "exercises his empire." The power of the prince, he concludes, is "absolute," although he recommends that kings exercise this authority with humility. Against the enormous power of a prince, the people's only power exists in their own innocence.

LEVIATHAN. In *Leviathan* (1651), the work generally recognized as the first great text of modern political science, Thomas Hobbes (1588–1679) set out to make a case for absolutism that did not build upon such religious notions. Like his younger contemporary John Locke, Hobbes gained the patronage of a great aristocratic family very early in his career, and was drawn into politics from that family's vantage point. The Cooper family that employed Locke had republican sympathies, and Locke wrote in defense of constitutionalism. The Cavendish family that maintained Hobbes was royalist, and Hobbes' political writings all make the case for monarchy. As tutor to the second and third earls of Devonshire, Hobbes spent a good deal of his life traveling the Continent. During these tours he added to his outstanding command of Greek and Latin—the abilities that first brought him to the attention of the Cavendish family—an expertise in geometry and optics. These interests helped shape Hobbes' approach to writing about politics, furnishing him with a concern to establish first principles from which other arguments might be deduced. While Hobbes had this rationalist instinct, he

may also be viewed as an empiricist before the fact. Hobbes was among the first writers to advance a mechanistic explanation for the operations of the human mind, mapping the path sensations travel through thoughts to actions. In 1640, sensing the coming outbreak of civil war in England, Hobbes resettled in Paris, where, with the situation in England clearly in mind, he turned to writing about politics. Among the works he completed during his eleven-year stay in France the *Leviathan* (1651) stands out from the others, not for the uniqueness of its ideas—all Hobbes' political writings defend royal absolutism—but for the completeness of its case. Hobbes begins there with a discussion of human psychological motivations, focusing on the desire for pleasure and the fear of death as powerful stimuli in producing human actions. Hobbes then proceeds to discuss how different political systems accommodate these forces before he turns to consider the "state of nature" that exists wherever and whenever there is no common consent for a form of government. In such a state, where everyone acts out of pure self-interest, every human being will be at war, and because of this, human life will be "solitary, poor, nasty, brutish, and short." In this state of nature, human desires and motivations cannot possibly produce positive outcomes. Thus human society needs government to help human beings realize their own ambitions. Hobbes rejects, in other words, the idea that some human beings have been born with a "divine right" to rule over others. There are differences in strength and intelligence among individuals, but every individual has the capacity to kill every other. Hobbes' point is that government is by definition a result of mutual agreement. Behind every form of government there is at least an implicit compact or covenant that acknowledges the rights individuals give over in exchange for government protection. But the question that lingers for Hobbes is which form of government is the best? He concludes that in a state ruled by a constitution, there will always be disagreement over whose interpretation of the constitution takes priority. Thus in constitutional states an inescapable tendency toward war will exist. The best form of government is rather an absolutist monarchy where the ability of one individual to serve and protect the polity is not compromised by the self-interest of any other individual or group in the state.

ENGLISH CONSTITUTIONALISM. Hobbes attempted to put the argument in favor of absolutism on a "scientific" footing. In his *Two Treatises on Government* (1689), Locke made a similar effort for constitutionalism. Locke's two treatises are not just important as foundation texts of political science, however. They played a crucial role in restructuring the political debate in England after the Glo-

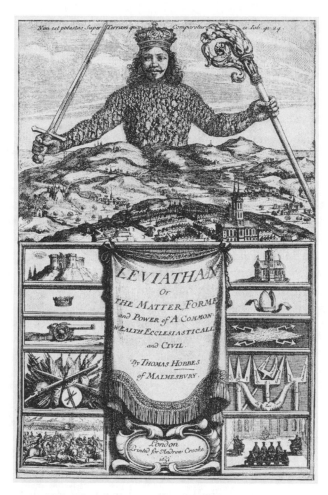

Title page from Thomas Hobbes' *Leviathan* (1651).
© BETTMANN/CORBIS.

rious Revolution of 1688. In seventeenth-century England the constitutional structures favored by the middle and laboring classes were different from that supported by the rich and powerful. Eventually, it was the constitutionalism this latter group supported that won the day, and Locke's arguments in his *Two Treatises* was used to justify this development. "When Adam delved and Eve spanned, Who was then a gentleman?" was the pithy phrase that had once been the rallying cry of English peasants during Wat Tyler's Rebellion in the 1380s. The phrase had reappeared around 1600, a fact that points to the challenges to the political status quo that were being mounted in England by the lower classes. Puritanism had helped to create a high level of literacy in England and had provided many ordinary people with the intellectual skills to participate in the great debate over absolutism versus constitutionalism. While the pamphlets written and read by ordinary folk made use of religious arguments, they also used historical arguments based in the "myth of the Norman Yoke." This notion alleged that monarchy

in England had only dated from the eleventh-century Norman Conquest. William the Conquerer, in other words, had done away with the simple democracy that had reigned in the country's Anglo-Saxon past, and had subjected English people to a tyranny of aristocracy and monarchy. During the English Civil Wars the Levelers, a movement of ordinary folk, tried to re-establish a democratic republic in the island. The Levelers captured a good deal of sympathy and support in the lower echelons of the New Model Army, the Puritan force that eventually defeated Royalists. As the English Civil Wars were drawing to a close in 1647, the Putney Debates took place. These were a series of debates that pitted the New Model Army's rank-and-file soldiers, who represented the "people" of England, against their superiors, who defended the interests of England's political and economic elite. During the course of the debates one soldier expressed the hope that "all inhabitants that have not lost their birthright should have an equal voice in Elections." To this, General Ireton, who represented the New Model Army's officers responded that only those who had a "permanent fixed interest in the country should be allowed to vote." Here Ireton was reaffirming the traditional practice that stipulated that only those men who paid an annual tax of 40 shillings should enjoy the franchise. Few of the Levelers were convinced, and it was only after violent repression that their movement fell apart.

LOCKE'S RESPONSE TO THE CALL FOR DEMOCRACY. Although the Leveler movement was eventually suppressed, the sentiments that its adherents expressed did not die out in later seventeenth-century England. In his *Two Treatises*, Locke addressed the lingering view that property qualification was a tool of oppression that had its origins in the "Norman Yoke." In Locke's constitutional theory he developed a notion of the state of nature that was very different from that of Hobbes's *Leviathan*. He argued that individuals extract from the environment valuable things by virtue of their hard work. Property arises from these efforts, and should therefore be protected by the state, along with life and liberty, as a fundamental, natural right. Government, he reasoned, came into existence through the efforts of property holders, who organized themselves under some form of authority to protect their interests. Thus Locke concluded there had never been a time when everyone had "an equal voice in Elections." Rather, from its very first existence, government had been concerned to protect the property of those with a "fixed permanent interest" in a state. Such arguments proved immensely popular in late seventeenth-century England, where the political instability caused by problems of the Stuart succession bred fears of a resurgent radicalism among the

country's political elites. Locke's constitutional ideas as expressed in the *Two Treatises* became cherished ideas among the aristocracy and gentry, people of vast interests in land. But they were also embraced by the growing class of merchants and commercial men, who were anxious to protect the wealth they were acquiring.

THE SPIRIT OF THE LAWS. At the end of the eighteenth century Europeans looked across the Atlantic and saw in the nascent state created out of Britain's former North American colonies a living testament to their own political ideas. It was obvious to all who had read Locke, for example, that the rights declared to be inalienable in the American *Declaration of Independence*—those that allowed for the search for "life, liberty and the pursuit of happiness"—had been inspired from Locke's *Two Treatises on Government* (with the anti-democratic word "property" changed to the less offensive "pursuit of happiness"). Those who had read Jean-Jacques Rousseau could recognize that the very way in which the political nation was conceptualized by the former colonists referred back to Rousseau's *The Social Contract*. It took a bit more learning, however, to appreciate that the boldest application of European political thought was to be discovered in the American Constitution, which articulated a principle first found in the Baron de Montesquieu's *The Spirit of the Laws* (1748): the idea that the power to rule must always be shared among competing governmental offices. Montesquieu's ideas are as fundamental to understanding the political philosophy of the eighteenth century as Adam Smith's *The Wealth of Nations* (1776) is to comprehending the age's economic theory. Charles-Louis de Secondat, Baron de Montesquieu (1689–1755), was an outstanding example of France's *noblesse de robe*, a category of bureaucratic nobles that received their titles for the services of administration they offered the crown. Montesquieu was trained as a lawyer, and then inherited the position of president of the Parlement of Bourdeaux, a regional court based in that city. He served in that capacity for eleven years before his fame as a writer made him a celebrity. That fame arose largely on the basis of his *Persian Letters*, a scathingly satirical critique of European society revealed through the imaginary letters of two Persian travelers in Europe. The profits generated from that work allowed Montesquieu to sell his office in the Parlement of Bourdeaux and to concentrate on his writing. Montesquieu brought the sensibilities of a working bureaucrat to the task of explaining how government works. Thus the point he seeks to drive home in *The Spirit of the Laws* is that the greatest danger confronting any government arises from the threat of despotism. He understands despotism as being the logical result of al-

lowing all discretionary authority to fall into the hands of any one official. The way to keep despotism in check, Montesquieu thus outlines in *The Spirit*, is to balance the discretionary power in the hands of one official with that of other officials in other parts of the government. In Montesquieu's view, the goal of government is not to protect property, as it was for Locke, but to maintain liberty, and he understands liberty to mean the freedom to do those things that do not harm others. It is a given, according to Montesquieu, that those who are endowed with power will ultimately abuse their authority and harm others. And so the best government is one that limits the opportunities for officials to exercise discretionary powers in this way. He identifies three different sources of government power that arise from decision-making powers in the executive, legislative, and judicial functions of governing. In the best government those who exercise any one of these functions will necessarily have to compete for authority against the other two offices, and thus this "balance of power" will cancel out the tendency for any one official to use his power indiscriminately.

IMPLICATIONS. The sophistication of Montesquieu's analysis reminds modern scholars of the impact that Europe's political theorists had in fashioning modern systems of democratic and constitutional rule. From the Renaissance, Europe's seventeenth-century political theorists had inherited a curiosity about the arts of government and the state of affairs that had existed in primitive societies. Political theory, too, had been catapulted into the center of Europe's intellectual discussions by the rise of divine right absolutism in many states around 1600, a controversial development that had produced both apologists and critics of the rising authority of monarchs and the state. While many royal apologists argued that such conditions were "natural" and divinely established, others like Thomas Hobbes built trenchant defenses for strong governmental authority by examining the "state of nature" that existed before governments arose. Although Hobbes supported strong monarchical authority, he also shifted the boundaries of discussions of political theory by basing his conclusions on seemingly scientific analysis, rather than biblical or religious precedents. His *Leviathan* ranks as one of the great intellectual contributions of the Age of Absolutism. Yet its chief arguments in favor of absolutism were soon superseded by the clamor of others like Locke, who argued in a more optimistic vein for greater political participation across the spectrum of a state's inhabitants. Those who followed Locke fashioned new ways of examining the powers of the state in an effort to try to unlock the secrets they hoped might allow good government and human liberty to co-exist. Montesquieu's *Spirit of the Laws*, then, stands as one mature expression of this attempt to fashion government that conforms to the needs of human society. That society, as the political philosophers of the Enlightenment were often convinced, was composed of a humankind that was fractious and wont to exercise despotic tyranny, but which was all the same charged with the intellectual powers and restraint necessary to exercise self-rule.

SOURCES

M. W. Cranston, *John Locke: A Biography* (London: Longmans, 1966).

J. Daly, *Sir Robert Filmer and English Political Thought* (Toronto: University of Toronto Press, 1979).

S. P. Gauthier, *The Logic of Leviathan: The Moral and Political Theory of Thomas Hobbes* (Oxford: Clarendon Press, 1979).

I. Hampsher-Monk, *A History of Modern Political Thought* (Oxford: Blackwell, 1990).

J. Meyer, *Bossuet* (Paris: Plon, 1993).

S. Priest, *The British Empiricists: Hobbes to Ayer* (London: Penguin, 1990).

SIGNIFICANT PEOPLE
in Philosophy

RENÉ DESCARTES
1596–1650
Philosopher

FATHER OF MODERN PHILOSOPHY. Because he was the first major seventeeth-century thinker to challenge the dominance of traditional Aristotelian scholasticism, René Descartes has long been called the "father of modern philosophy." Descartes' father was a member of the minor nobility, and although the region in which he was brought up was largely Protestant, his family was Catholic. In his youth he attended a Jesuit school in La Flèche, where he learned his Aristotle from the traditional scholastic texts that had long been in use. The curriculum of the Jesuit schools was also open to the influences of humanism, and Descartes would have been exposed to great literary works as a result of his education there. The training given there was intended to school young men to take up professions in the service of the state, although Descartes continued to the University of Poitiers, where he took a legal degree in 1616.

He soon departed for Holland, where he studied military architecture and mathematics, and for almost a decade following 1619 Descartes traveled extensively throughout Europe studying, as he later wrote, the book of nature.

REASON. In these years Descartes developed his method, which relied on deductive reasoning to adduce universal philosophical principles. He believed that the substance of his method might fruitfully be applied to all human endeavors, including the sciences. In this period of his life Descartes also was influenced by the Rosicrucian movement, an underground brotherhood of philosophers and Renaissance magi (practitioners of learned magic) that promoted the idea of a special wisdom. Like many followers of this abstruse movement, Descartes refused to marry and spent much of his time in seclusion. He also moved frequently, occupying in one two-decade period of his life eighteen separate residences. Much of Rosicrucian teaching, however, was mystical and often focused on magical and alchemical practices, something that Descartes eventually downplayed in favor of his rationalist philosophy. In 1620, he was enrolled in the Catholic army of the duke of Bavaria, although no evidence exists that Descartes was ever personally engaged in warfare. In 1628, when he returned to France he became rather quickly involved in a controversy when he claimed to be able to establish certainty in scientific endeavors. For his part in this controversy, the powerful reforming churchman Cardinal de Bérulle approached Descartes to try to recruit him in service of the Catholic cause. A few months later, though, the philosopher left France for the Netherlands, where he remained for most of the rest of his life. His own diverse religious and philosophical background likely prompted his move there. Born a Roman Catholic, he had grown up in a Protestant region, and later he had apparently dabbled in the ideas of Rosicrucianism before rejecting many of the movement's tenets. A champion of religious tolerance, Descartes seems to have found the relative openness of Dutch society to conflicting religious opinions a more congenial atmosphere than France.

PHILOSOPHICAL WORKS. Descartes continued to divide his time in his first few years in the Netherlands between his public profession as a military architect and his private concerns with philosophy. He traveled to Germany and Denmark to view fortifications, siege machines, and other implements of war, even as he spent meditative hours in his study writing his *Meditations*. In 1633, he prepared to publish *The World*, a work defending the Copernican theory, but he withdrew it from the printer when he learned that Galileo had been recently condemned for supporting the same ideas. His first major work to appear, then, was the *Discourse on Method* (1637), a work that set forth his idea that reason was innate within the human mind, and that everyone could be consequently trained to discern truth from falsehood. Importantly, Descartes wrote the *Discourse* in French rather than Latin, so that it might reach as broad an audience as possible. In the next years he published texts on optics, geometry, and meteorology before publishing his *Meditations on the First Philosophy* in 1641. Unlike his earlier *Discourse*, the *Meditations* were written in Latin, and addressed to the professors of the University of the Sorbonne in Paris. The work was revolutionary in that Descartes discounted all received wisdom, and instead insisted that philosophers must strive to prove their truths with certainty. To do so, Descartes argued that they must rely on the selfsame logical skills as were to be found in the world of mathematics. The *Meditations* also set forth and explained Descartes' famous dictum, *Cogito ergo sum*, or "I think, therefore I am." As he explained, the presence of clear and forceful ideas in the human mind pointed to the presence of an innate reason, a reason that must have been placed there by God. In this way Descartes' philosophy found a way out of the circle of philosophical skepticism that was common among some European intellectuals at the time. These skeptics argue that absolute philosophical truths could not be established with certainty, and had instead to be accepted on faith.

LATER YEARS AND IMPLICATIONS. Descartes continued to promote his rationalistic philosophy through a number of other published treatises that appeared in the decade before his death. He also returned to France on several occasions, and in the final years of his life he journeyed to Sweden in response to an invitation from Queen Christina. In the months in Sweden, his health deteriorated, in part from the punishing schedule that the queen imposed upon the philosopher. Anxious to learn the secrets of his rationalism, Christina made Descartes give her philosophy lessons every morning at five o'clock. He was also asked to develop military statutes for the country's army, and one day when delivering a draft of his proposals in the early morning air he caught pneumonia. He died a few days later. In the decades that followed, Descartes' philosophy attracted both supporters and detractors. Many of his works were on the Catholic Index of Prohibited Books by the 1660s. Questions had always swirled around his own religious convictions while he was alive, but by this time the Catholic Church had seen his clear defense of human reason as a serious challenge to orthodox teachings, which had by necessity to be supported by the testimony

of divine revelation. Despite the censoring of his works, Descartes' remains were transferred to Paris where they were placed within a prominent Catholic church in the city. In the years that followed his death, his philosophical works attracted thinkers like Baruch Spinoza and Gottfried Wilhelm Leibniz, who used them as a springboard to develop rationalistic philosophies that were even more radical than Descartes' own sources of inspiration. At the same time, thinkers like Pierre Gassendi and John Locke were to work to fashion an alternative to rationalism that emphasized the importance of human beings' empirical observation, rather than of an innate reason implanted at the mind at birth. Thus, although many of Descartes' ideas were jettisoned in the decades following his death, the very creativity his career inspired is testimony to his place as the "father of modern philosophy."

SOURCES

L. Pearl, *Descartes* (Boston: Twayne, 1977).

W. R. Shea, *The Magic of Numbers and Motion: The Scientific Career of René Descartes* (Canton, Mass.: Scientific History Publications, 1991).

J. R. Vrooman, *René Descartes: A Biography* (New York: Putnam, 1970).

R. S. Woolhouse, *Descartes, Spinoza, Leibniz: The Concept of Substance in Seventeenth-Century Metaphysics* (London: Routledge, 1993).

DAVID HUME

1711–1776

Philosopher

UPBRINGING. Hume grew up in the countryside of southern Scotland, not far from the English border, where his father, a minor lord, had an estate. His father died when he was three. Hume entered the University of Edinburgh when he was twelve and finished there about three years later, a course of study that was considered normal at the time. Although he was encouraged to study law after taking his degree, he soon put aside any ambitions for becoming an attorney. Instead he began to read voraciously, so voraciously that by the age of eighteen he suffered a nervous breakdown. After recovering, he worked in a merchant's office in Bristol in England for a time, but eventually set off to live in France for three years. While there, he wrote his *Treatise on Human Nature* (1739–1740), an enormous work that sets out the full scope of Hume's ideas and philosophy. Divided into three books, it treats issues in epistemology (the science of establishing certainty of knowledge), the passions and their relationship to human reason, and

moral philosophy. Later in life, Hume tried to disown the treatise, remarking that it was juvenile. But although it is longwinded and sometimes contrived and overly complex, it has continued to be read by philosophers, particularly for its first book on epistemology. In that section Hume advances a number of refinements in empirical philosophy, the dominant philosophical movement in England since the time of John Locke. The work was poorly received, but in the years that followed Hume began to achieve greater success.

CHARGES OF HERESY. In the mid-eighteenth century Edinburgh was quickly developing into one of the most important English-speaking centers of the Enlightenment. Sometimes referred to as the "Athens of the North," the city was undergoing a building boom and a general rise in its wealth and fortunes. At the same time Edinburgh was also a major center of Presbyterianism and of Scotland's national church. The tone of discourse in Edinburgh's university may have been enlightened, but Scotland was still a conservative country where Calvinist orthodoxy mattered. In 1744, Hume allowed his name to go forward for consideration of a chair in philosophy at Edinburgh's university. Conservatives attacked him as an atheist and materialist, and when he did not receive the appointment Hume left the city. For several years he wandered from job to job, becoming a tutor to a marquess and an assistant to a general. In this latter capacity he eventually traveled to Vienna as part of an ambassadorial mission. While these years distracted him from his philosophical pursuits, they were financially profitable, and Hume soon possessed the resources he needed to indulge his taste for study. In 1748, the wandering years came to an end, and Hume now began to publish a series of works that earned him a wide reputation. The first of these was eventually to become known as *An Enquiry Concerning Human Understanding*, a work that set out his famous attack on miracles. That section of the work, which soon earned Hume an even broader reputation for being an atheist, argued that since miracles were violations of nature and since experience taught that natural laws were never violated, miracles were an impossibility. In 1752, Hume applied for a second professorship, this time at the University of Glasgow, but he was rejected there also. In the year that followed, he became a librarian in Edinburgh, and used his institution's collection to write a *History of England*, a work that appeared in six volumes between 1754 and 1762. He also continued to write philosophy, including two works that treated his views on religion: his *Natural History of Religion* (1757) and his *Dialogues Concerning Natural Religion* (published posthumously in 1779). The second text could not be printed, because certain of its

denunciations of traditional religious doctrines excited controversy when Hume circulated the texts, and legal threats were made against Hume's publisher.

LATER TRAVELS. Despite the excitement and denunciations that Hume's attacks on religion precipitated, his reputation remained high in many quarters, and his general affability meant that he had many friends. In 1763, he was invited to accompany an English ambassadorial delegation to Paris, and on this trip he made the acquaintance of a number of French Enlightenment philosophers. Returning to Britain, he continued to nourish his contacts with other European philosophers, and when his friend Jean-Jacques Rousseau was expelled from his exile in Geneva in 1766, Hume invited him to England and saw to it that he was granted government support. A few years later, though, Rousseau grew suspicious of the English, and of Hume, in particular. He publicly attacked his former friend, accusing him of trying to ruin him. Hume took his case to the press, and was, in the public's mind, vindicated. In his later years, he returned to Edinburgh, where he spent his time reworking and editing earlier works and circulating in the city's intellectual high society.

SOURCES

P. Millican, ed., *Reading Hume on Human Understanding: Essays on the First Enquiry* (Oxford: Clarendon Press, 2002).

E. C. Mossner, *The Life of David Hume* (Oxford: Clarendon Press, 1997).

J. Passmore, *Hume's Intentions* (London: Duckworth, 1980).

S. Priest, *The British Empiricists: Hobbes to Ayer* (London: Penguin, 1990).

GOTTFRIED WILHELM LEIBNIZ

1646–1715

Philosopher

PIOUS UPBRINGING. Gottfried Wilhelm Leibniz was the son of a Lutheran pastor at Leipzig. Born at the very end of the devastation wrought by the Thirty Years' War, he was schooled outside the home, but seems to have found more inspiration for his learning in his father's large library. When he was fifteen he entered the University at Leipzig as a legal student, although learning about the new scientific breakthroughs that were becoming increasingly common in seventeenth-century Europe soon captivated him. He studied the works of René Descartes, Galileo, Francis Bacon, and Thomas Hobbes anxiously and began to develop a plan to har-

monize their works with the philosophies of Aristotle and other great minds from Antiquity. In 1663, he completed and defended his bachelor's thesis, *On the Principle of the Individual,* a work that contained already one of the ideas that was to grow in his thought. Leibniz reasoned there that the individual was not to be understood merely by his material entity alone, or by intellectual forms, but by the entire scope of his being. A few years later in his *De arte combinatoria,* he argued that all logic and human reasoning might be reduced to a combination of symbols, a theory that has sometimes been interpreted as anticipating the development of the computer in the modern world.

DEPARTURE FROM LEIPZIG. Although by 1666 Leibniz had completed the requisite course of study for the awarding of the doctoral degree in law, he was refused because he was too young to receive the degree. So he left Leipzig and never returned to his native city. He traveled first to Nuremberg's university city of Altdorf and took the doctoral degree, and was offered a professorship. He accepted instead a position with a local statesman, Johann Christian, Freiherr von Boyneburg, who introduced him at the court of the archbishop-elector of Mainz. He immediately found a place in the archbishop's service, who was worried at the time about the rise of Louis XIV to the west. To forestall a French invasion of the German-speaking territories, the elector hoped to divert Louis's attentions by involving him in a plan to stage a missionary expedition to Egypt. Leibniz offered his services to the elector by writing his *Catholic Demonstrations,* a work that developed a complex new theory about the soul's position in the body, and which expressed for the first time Leibniz's notion of "sufficient reason." He developed both of these concepts further in his mature philosophy, eventually producing his notion of the metaphysics of the soul known as "monadology" and the principle that nothing occurred in the world without a reason. In his years in the employment of the elector, he also examined certain problems in optics and physics, a common endeavor of the philosophers of the age. In 1672, Leibniz was sent on an ambassadorial mission to Paris and there he came in contact with Antoine Arnauld, leader of the Jansenist religious movement in the city. The deaths of his patrons the elector of Mainz and the Freiherr von Boyneburg left him for a time without employment, although bequests made to him in their wills left him free to pursue his studies without financial constraints. During 1673, he developed a computing machine which he took on his first visit to London in the same year, presenting it to the members of the Royal Society.

LIFE AT THE HANOVERIAN COURT. In the years following his journey to England, Leibniz continued his studies, and by 1675 he had come upon the breakthroughs that allowed him to advance the new mathematical discipline of integral and differential calculus. Isaac Newton had been at work on these problems in England, too, and the two figures came to relatively the same conclusions almost simultaneously. Although Newton has long been credited with pioneering this new science, it has long been recognized that Leibniz developed the same fundamental concepts in relative isolation from him. The following year Leibniz's experiments continued, and he pioneered the mechanical science of dynamics, a theory of movement based around the principles of kinetic energy. With his funds depleted by his period of independent study, he accepted a position at the court of Braunschweig-Lüneberg in 1676. Although this was a small territory in the German-speaking empire, it had recently become more important. In 1665, its ruler, Johann Frederick, had become duke of Hanover. At first, he was entrusted with the librarianship of the duke's enormous library, an institution that in the early-modern world was sometimes described as one of the "eight wonders" of the world. There, he continued to read voraciously, but he soon rose to a position of trust, being admitted into the duke's council. In the duchy Leibniz worked vigorously to establish a place for himself and his ideas. He formulated numerous plans to make the small duchy a model of technological and rationalist efficiency. When he was appointed to oversee the duke's famous library at Wolfenbüttel, he introduced the first catalogue and shelving system ever in a European library. He developed new kinds of windmills, water pumps, and hydraulic machinery, even as he advanced plans for the establishment of academies and schools. For a time, he even practiced mining engineering, an important industry in and around the Harz Mountains where the duchy was situated. All the while, Leibniz continued as well with his philosophical and mathematical work, although his ideas were beginning to become increasingly hostile to Descartes and his rationalism.

MONADOLOGY. Leibniz's indefatigable efforts in the employment of the Hanoverian dukes led him into numerous new discoveries, which he increasingly broadcasted through the publication of articles in scholarly and scientific journals by the 1690s. He made numerous plans for the foundation of scientific academies similar to the Royal Society in England, and in 1700 Sophia Charlotte, the first queen of Prussia and a daughter of his Hanoverian employer, responded to Leibniz's plans by founding the German Academy of Sciences in Berlin. Although Leibniz's mind ranged far and wide in these years over many intellectual dilemmas, his chief fascination of the later years of his life was in developing a philosophy based around his concept of monads. In contrast to the "atomistic" views of matter that were developing at the time in many parts of Europe, Leibniz's complex and sometimes baffling metaphysics contained in his late work, *Monadology* (1714), promoted the notion that matter itself was indivisible and that reality was an illusion. As Leibniz characterized them, monads were complete concepts that were entirely self-contained and independent; he characterized monads as moving in a steady hierarchy from those that were least active, like stones, to those that were most active, like the human organism. Because Leibniz considered reality to be illusory, he jettisoned the idea of causation, and instead substituted his concept of "sufficient reason." Applying this notion of sufficient reason to the world in which he lived, Leibniz argued that there was a rational explanation for everything that occurred. It is in this sense that it is possible to extract from Leibniz's ideas the notion that we live in "the best of all possible worlds," because as he argued everything in the world had been created by God with a purpose. It was for expressing this fundamentally optimistic idea that the later French Enlightenment philosopher Voltaire lampooned Leibniz in his *Candide* (1759).

SOURCES

R. M. Adams, *Leibniz: Determinist, Theist, Idealist* (Oxford: Oxford University Press, 1994).

N. Jolley, *The Cambridge Companion to Leibniz* (Cambridge: Cambridge University Press).

G. Macdonald Ross, *Leibniz* (Oxford: Oxford University Press, 1984).

D. Rutherford, *Leibniz and the Rational Order of Nature* (Cambridge: Cambridge University Press, 1995).

C. Wilson, *Leibniz's Metaphysics* (Princeton: Princeton University Press, 1989).

JOHN LOCKE

1632–1704

Political philosopher

EARLY YEARS. Although John Locke was born in a quiet corner of the English county of Somerset, his youth was shaped by the calamitous events of the English Civil Wars. His father was a solicitor who served in the Parliamentary Army. In 1652, during the chaotic years of the Puritan Commonwealth, Locke entered Oxford, where he appears to have been a diffident student. He was drawn at the time to the exciting ideas of René

Descartes, but the traditionalism of the English university of his day meant that Oxford's curriculum was still largely taught in the mold of Aristotelian scholasticism of previous centuries. As a result, Locke drifted, although he indulged his curiosity by undertaking medical and scientific studies outside his course of study, an endeavor that paved the way for his eventual election to the Royal Society in 1668. He may have considered a clerical career, but in 1659 he began to serve as a tutor in his college at Oxford. Despite this honor, Locke did not take an Oxford degree until 1674, when he was finally awarded a Bachelor of Medicine. In 1661, his father died, and Locke now had a small inheritance that provided him with the resources to continue his studies. In the years that followed he also made the acquaintance of Lord Ashley, who was later to become the earl of Shaftesbury and Locke's primary patron. By 1665, Locke had given up his post as a tutor at Oxford, and he began service on an ambassadorial mission to Germany. Although he might have continued in this career, he returned to scientific study and reading of philosophy. During these years he also worked with his close friends Robert Boyle and Thomas Sydenham on a number of scientific experiments.

SHAFTESBURY. Locke's association in these years with Lord Ashley also deepened, primarily as a result of a successful operation Locke performed to remove a liver cyst in 1668. Locke became a member of Ashley's household in London, where he fulfilled a number of roles, eventually advising him on matters of all kinds. As Ashley rose to become the earl of Shaftesbury in 1672, his political visibility increased. He was soon appointed Lord Chancellor, although his unpopular politics soon led to his downfall. Shaftesbury supported a strong Parliament as a counter to royal authority, a Protestant succession, and the economic expansion of England's colonies, all programs that were not favored by Charles II or his Royalist circle. Locke's association with Shaftesbury in these years largely freed him from the responsibilities of working, and he continued to devote a great deal of his time in the late 1660s and early 1670s to his private studies. He was also an enthusiastic participant in the activities of the Royal Society, an affiliation that kept him up to date on the most recent scientific advances that were occurring in the country. Eventually, Locke found that London's damp air worsened his asthma, and he returned to Oxford in 1675; a few months later, he set off on a four-year journey to France, where he lived for most of this period in Montpellier and Paris. In his years in France, Locke made the acquaintance of Pierre Gassendi, who at the time was developing a Christianized form of Epicureanism that might be a counter to René Descartes'

rationalism. Eventually, his work provided one of the foundations for Locke's own empirical philosophy.

RETURN TO ENGLAND AND EXILE. When Locke returned to England, he found that the political situation in the country had deteriorated as a result of the controversies over the succession. James, the duke of York, had in recent years made public his Catholicism, and the quarrels over the possibility of a Catholic king had resulted in the earl of Shaftesbury's imprisonment. Eventually, he was rehabilitated, but not without spending a year in the Tower of London. Shaftesbury's fortunes rose again, only to take a meteoric plunge in 1681, when he was unsuccessful in mediating the various conflicts between England's parliamentary factions. He was tried but set free, and soon fled the country for exile in Holland, dying there two years later. Because of his close association with Shaftesbury, Locke followed him into exile, and he remained there until the Glorious Revolution (1688) removed the Catholic James II from the throne and installed his daughter Mary and her husband William as co-regents.

WRITINGS. While in Holland, Locke had time to complete a number of important works that established his reputation as England's foremost political theorist. Before leaving Holland in 1689, Locke published his *Letter Concerning Toleration*, a work that argued for religious toleration of England's Protestant dissenters. He did not advocate the extension of toleration to Catholics or to Jews, although his program for Protestant nonconformists was essentially established in the early years of William and Mary's reign. Even as the *Letter Concerning Toleration* was appearing, though, Locke was preparing the way for his return to England, and in February 1689 he crossed in the same vessel that brought William and Mary to the country. In the years that followed he continued to publish a number of works that contributed to the political and intellectual ferment of the early Enlightenment in England. Later, their influence spread to Continental Europe, where in France particularly they encouraged the development of a vigorous tradition of political philosophy. In 1690, his *Two Treatises on Government* appeared. It set out a theory of limited constitutional monarchy—a theory that was, in large part, being realized in England at the time because of Parliament's triumph in the Glorious Revolution. Around this same time his *Essay Concerning Human Understanding* also appeared. In this, perhaps his most famous work, Locke outlined his theories concerning human knowledge and psychology by recourse to his theory of the mind as a "blank slate" at birth upon which experience writes impressions. His later years were spent

in a kind of quiet country isolation at Oates, where he was the guest of an English noblewoman, Lady Masham. Although he had largely retired from public involvement, his ideas were causing considerable ferment at the time, inspiring Deists like John Toland in his *Christianity Not Mysterious* to apply Locke's psychological insights to fashion a non-doctrinal religion. Locke, though, remained fundamentally orthodox and conservative in his own religious opinions. In the decades that followed continued debate of Locke's theories gave rise to a large school of English empirical philosophers, and some of these figures, men like George Berkeley and David Hume, refined Locke's initial observations. Locke continued to remain required reading, though, for any Englishman anxious to protect parliamentary prerogatives in the eighteenth century. His influence continued to resonate throughout the Enlightenment, helping to inspire the revolutionary developments and political settlements formulated during the French and American Revolutions.

SOURCES

M. W. Cranston, *John Locke; A Biography* (London: Longmans, 1966).

G. Fuller, R. Stecker, and J. P. Wright, eds., *John Locke: An Essay Concerning Human Understanding in Focus* (London: Routledge, 2000).

T. M. Lennon, *The Battle of the Gods and Giants: The Legacies of Descartes and Gassendi, 1655–1715* (Princeton, N.J.: Princeton University Press, 1993).

J. W. Yolton, *Locke; An Introduction* (Oxford: Blackwell, 1985).

BARON DE MONTESQUIEU
1689–1755

Political philosopher

ARISTOCRATIC BIRTH. Charles-Louis de Secondant, more familiarly known to history as the Baron de Montesquieu, was from an old military family in France that had been granted a noble title in the sixteenth century for its loyalty to the crown. Montesquieu's father had a relatively small fortune, although his mother's dowry brought great wealth to the family. Like many noble children, the young boy received much of his initial education in the home before going off to attend school at age eleven. When he was fourteen he enrolled in the University of Bordeaux, and he became a lawyer in 1708. In hopes of attaining more experience in his profession he soon moved to Paris, although when his father died five years later, he returned again to Bordeaux to manage the family's estates. Soon he married Jeanne de Lartigue, the daughter of a wealthy local Protestant, and her dowry brought Montesquieu the wealth that he needed to sustain his private studies. Although he continued to practice his profession as a lawyer, he turned over the management of his financial concerns to his wife, who appears to have been an astute businesswoman. She also gave Montesquieu two daughters and a son. In 1716, his fortunes were increased even further when he inherited the estates of his uncle, who died without a direct heir. He also secured an important position in the local Parlement of Bordeaux, a regional administrative court. Montesquieu now resolved to undertake major studies of Roman law, as well as to increase his understanding of science. He enrolled in the Academy of Bordeaux, the local body of scientific thinkers, in order to enhance his understanding of physics, geology, and biology, an influence that became evident in his later works of political philosophy.

CHANGING FASHIONS. Louis XIV, the chief designer of France's late seventeenth-century absolutist state system, had died in 1715, and his successor, Louis XV, had been at this time only five years old. In the intervening period of his regency, his uncle Philippe, the duke of Orléans, assumed chief power over the government of France. The period of Philippe's exercise of power was noted for a rather quick and dramatic change in fashions in Paris and throughout France. In architecture and art, a new Rococo style, lighter and less ponderous, began to replace the affection for the dark and somber tones of the Baroque. And in the theater and letters, the period began to see increasing ferment, and the emergence of many political salons in and around Paris. Montesquieu's first great work, *The Persian Letters* (1722), came as a surprise to the early Enlightenment culture that was just beginning to emerge in France as a result of these changes. In the vehicle of letters allegedly written by Persian travelers to Europe, Montesquieu undertook to criticize European institutions. The work poked fun at France's obsession with social class, its religious fanaticism and superstition, and its decadent sexual mores. It proved to be Montesquieu's entrée in the years that followed into the highest circles of intellectual discussion in the country. He now abandoned Bordeaux for the capital, and in the next few years, circulated in court circles. Eventually, life in Paris drained his financial resources, and Montesquieu, increasingly bored with his position in the Parlement of Bordeaux, sold his office. In the capital he was also making the acquaintance of prominent English aristocrats who lived in the city at the time, including the Viscount Bolingbroke, once a leading Tory politician in England and the duke of

Berwick. By 1728, though, Montesquieu had apparently grown tired of the high life in Paris, and he resolved to embark on a major continental tour, something that he had not done in his youth. He set off first to Vienna, then to Hungary, and somewhat later to Italy. In each place he indulged his vast interests, making the acquaintance of the Austrian general, Prince Eugene of Savoy, in Vienna; visiting mines and examining their use of technology in Hungary; and in Italy, developing his love of art. Eventually, he returned to Northern Europe, journeying through Germany, to Holland, and finally to England. In this his last stop, he was presented at court and circulated in the highest aristocratic circles, in part because of his friendships previously forged in Paris.

LITERARY CAREER. Although he had continued to indulge his taste for society along the route of his Grand Tour, the Baron de Montesquieu took a more serious tone following his return to France in 1731. He decided to pursue his writing as a career, and in 1734 he published *Reflections on the Causes of the Grandeur and Declension of the Romans*, a work that was his first foray into political philosophy. His taste for this kind of theory soon deepened, and Montesquieu embarked on a detailed program of study, intending to unearth the reasons for the greatness of some states and the relative weakness of others. He read voraciously, but also kept as many as six private secretaries busy on this endeavor, dictating to them his notes and using them to conduct his preliminary research. Much of the work for this project Montesquieu completed at his country home in Bordeaux, yet he continued to visit Paris in the 1730s and 1740s, circulating in its world of salons, reading in the king's library, and attending the meetings of the French Academy, to which he had been elected a member in 1728. By 1740, the outlines of his massive work of political philosophy had grown clearer, and Montesquieu set down to write his *Spirit of the Laws*, a work that eventually totaled almost 1,100 printed pages. The *Spirit* demonstrated a thorough comprehension of all the political philosophy that had been written to Montesquieu's time throughout Europe, yet it did not identify with any one particular set of assumptions. Some of his ideas have clearly not withstood the test of time. The *Spirit* argued, for instance, that climate was a major determinant of political systems. Yet he also subjected political systems to a searching eye, and his summaries of the differences in spirit that produce despotic, monarchical, and democratic political systems displays a wide reading and knowledge of history. Perhaps one of the most important influences that the work had was in its theory of the separation of powers. Montesquieu argued

that not only should the administrative, legislative, and judicial functions of a government be kept isolated from each other, but that these duties should be divided up between different groups that exercise their authority autonomously. In this regard, this part of his theory came to be widely discussed and applied in the French and American Revolutions.

LATER YEARS. Although Montesquieu continued to write in his later years, these works did not capture the imagination of his times the way that the *Spirit of the Laws* did. In the last years of his life, he continued to circulate in Parisian intellectual society, and he now found the circle of the Enlightenment much enlarged throughout the country and Europe. He corresponded with philosophers and political thinkers in England and throughout Continental Europe, and was widely admired for his kind and friendly manner.

SOURCES

P. V. Conroy, *Montesquieu Revisited* (New York: Twayne, 1992).

T. L. Pangle, *Montesquieu's Philosophy of Liberalism: A Commentary on the Spirit of the Laws* (Chicago: University of Chicago Press, 1973).

D. J. Schaub, *Erotic Liberalism: Women and Revolution in Montesquieu's Persian Letters* (Lanham, Md.: Rowman and Littlefield, 1995).

R. Shackleton, *Montesquieu: A Critical Biography* (London: Oxford University Press, 1963).

DOCUMENTARY SOURCES
in Philosophy

Francis Bacon, *Novum Organum* (The New Organon; 1620)—The first part of Bacon's planned *Great Instauration*, this work sets forth a method for discerning scientific truth that had a profound effect on the later thinkers of the Scientific Revolution. It consists of a series of aphorisms (short statements) in which Bacon outlines how truths about nature can be ascertained.

Pierre Bayle, *Historical and Critical Dictionary* (1702)—This enormous work totals over nine million words, and was a significant force in giving rise to the questioning spirit of the early Enlightenment. Its enormous scope was only outdone by the *Encyclopédie* of the French Enlightenment.

George Berkeley, *Treatise Concerning the Principles of Human Knowledge* (1710)—A major work of English empiri-

cism, this text includes the famous observation "to be is to be perceived" (*esse is percipi*).

Étienne Bonnot de Condillac, *Treatise on Sensation* (1754)—This important work of Continental eighteenth-century empiricism explored the effect that the senses have on producing human ideas.

René Descartes, *Meditations on the First Philosophy: In Which the Existence of God and the Distinction Between Mind and Body are Demonstrated* (1641)—By far Descartes most important work, this treatise includes his famous rationalist dictum *Cogito ergo sum*, "I think, therefore I am."

Thomas Hobbes, *Leviathan* (1651)—Although few modern political philosophers have agreed with its dismal assessment of the state of nature—that is, the character of society before political institutions—Hobbes' work still ranks as the heftiest work of political theory to appear in seventeenth-century England.

David Hume, *Enquiry Concerning Human Understanding* (1748)—Although it may not be his finest, this text is certainly David Hume's most famous philosophical work. In it, he argues that everything that does not fit with empirically established truth should be discounted as falsehood.

John Locke, *An Essay Concerning Human Understanding* (1690)—This major work of political theory helped to inspire many of the subsequent explorations of human societies and their institutions during the Enlightenment. Locke's empiricism argues that the mind is at birth a "blank slate" upon which experience leaves its writing.

Baron de Montesquieu, *Spirit of the Laws* (1748)—The product of a lifelong consideration of political institutions and history, this work produced major controversy in mid-eighteenth-century France. Its argument for a thorough separation of powers and personnel in government was later to be influential in the French and American revolutions.

Jean-Jacques Rousseau, *The Social Contract* (1762)—One of the most influential works from one of the most significant authors of the Enlightenment, this treatise outlines how human societies might regain their freedom from the aristocratic and monarchical systems into which governments had fallen over the centuries.

Baruch Spinoza, *Ethics* (1677)—Published after his death, this product of lifelong philosophical speculation embraced a thoroughgoing pantheism and discounted traditional revealed notions of religion. As a result it produced immediate and longstanding controversy.

Voltaire, *Philosophical Letters* (1734)—Produced after its author's return to France from exile in England, this set of ruminations recommended that Continental Europe emulate the virtues of English society and especially its political and scientific institutions.

chapter seven

7

RELIGION

Andrew E. Barnes

IMPORTANT EVENTS
in Religion

1598 The Edict of Nantes establishes a limited degree of religious toleration for Calvinist Huguenots in France.

1606 Jacob Arminius, a Dutch Calvinist theologian, rejects predestination and upholds free will in an address to his faculty at the University of Leiden. His ideas are considered heretical but his position, later known as Arminianism, begins to attract disciples.

1610 King Henri IV of France is murdered by the fanatical Catholic Ravaillac because of his policy of tolerance towards French Protestants. Henri's wife, Marie de' Medici will assume the throne over the coming years as regent.

1611 James I issues the Authorized Version of the Bible in English for use in the Churches of England and Scotland. The Bible will become known as the "King James Version."

1618 The Thirty Years' War begins in Central Europe. The conflict will be the bloodiest of all the religious wars of the sixteenth and seventeenth centuries.

1619 The Synod of Dordrecht meets in Holland to discuss the issues of predestination and free will. The meetings are attended by Calvinist theologians from throughout Europe, and the Synod's condemnation of free will is widely adopted throughout Calvinist churches.

1620 The Battle of White Mountain, staged on a hill outside Prague, destroys Czech Protestantism, and opens the door for the re-catholicization of Bohemia under the Austrian Habsburgs.

The Puritan Pilgrims land at Plymouth Rock in North America with the goal of establishing a society in which freedom of religion is an ideal.

1622 Pope Gregory XV creates the "Congregation for the Propagation of the Faith" at Rome, an organization that is charged with overseeing Catholic missions both in Europe and in the rest of the world.

1624 In the German diocesan capital of Bamberg, Bishop Gottfried Johann Georg II begins a persecution of supposed witches that will rage over the next three years and leave hundreds of inhabitants of the region dead.

1625 King Christian IV of Denmark invades Germany under the pretext of aiding Protestantism but in the hopes of expanding his territory. Four years later his expansionist campaign will be rebuffed and Denmark will no longer rank among the great European powers.

1630 Puritans establish the Massachusetts Bay Colony with its center in Boston.

1633 In England, Charles I names William Laud as archbishop of Canterbury. From this position, Laud will begin to persecute Puritans.

1640 The Dutch Catholic theologian Cornelius Jansen's *Augustinus* is published two years following the author's death. The work defends the theology of Augustine, and soon invigorates a devotional movement in France that supports Augustinianism against the perceived Pelagianism of the Jesuits.

In England the "Long Parliament" comes to power. Its Puritan measures will eventually result in the outbreak of civil war with the king and, following Parliament's victory, the country will be ruled as a Commonwealth under the leadership of Oliver Cromwell.

1642 The Puritan-dominated Long Parliament orders the closure of London's theaters because of their "godless immorality."

1645 William Laud, archbishop of Canterbury, is executed at London by Parliament. Over the previous decades his policies of persecution and his support of high church ritual had angered the Puritan party.

1648 The Treaty of Westphalia is signed at Münster in Germany, ending the dismal conflicts of the Thirty Years' War. The treaty recognizes Calvinism's legality but reasserts the sixteenth-century principle that German rulers have the right to choose which religion will be followed in their states.

1649 King Charles I is executed in England following a long period of civil war between Puritans and Cavaliers (supporters of the Crown).

1650 An English judge uses the term "Quaker" to describe George Fox and his followers. Fox is at the time on trial for his religious beliefs.

1653 Pope Innocent X condemns the teachings of Cornelius Jansen because they violate a papal prohibition against discussing the precise nature of free will and predestination and veer dangerously close to the extreme teachings of Calvinism concerning salvation.

1656 Blaise Pascal, a brilliant French mathematician and a Jansenist, begins to publish his *Provincial Letters*, a work that satirically attacks the lax morality of the Jesuits.

1660 The Stuart Prince of Wales is restored to the English throne as Charles II.

1662 Charles II issues a new *Book of Common Prayer* for the English church that is modeled in many respects upon that of Elizabeth I's reign.

1666 Philip Jakob Spener becomes head of the Lutheran church at Frankfurt am Main in Germany. He begins to found "schools of piety," small prayer and study groups. In the coming century this pattern of Pietist renewal in the church will spread to many places throughout Europe.

1678 In England the Puritan minister John Bunyan publishes his soon-to-be classic, *Pilgrim's Progress*.

1681 Charles II grants William Penn a large tract of land in colonial North America, on which he will found the colony of Pennsylvania as a haven for Quakers and other religious dissenters.

1682 The Four Gallican Articles are formulated at a meeting of bishops and royal officials held in France. The document will guide church and state relations between the French king and the pope for many years, but will also produce controversies when future popes refuse to affirm Louis XIV's appointments to Catholic posts in the country.

1685 King Louis XIV revokes the terms of the Edict of Nantes in France, forcing French Calvinists known as Huguenots either to convert to Catholicism or leave the country.

In Germany, a new dynasty assumes power in the Palatinate, an important state in the German southwest; working in tandem over the coming years with France, it begins to re-catholicize its Protestant territory, thus prompting many Calvinists in the region to emigrate. Many take up residence in the new English colony of Pennsylvania, a haven for dissenters of all kinds.

James II, a Catholic, ascends the English throne. Over the coming years, his pro-Catholic policies will irritate Parliament, eventually resulting in his exile from the country in 1688.

1688 In England, Parliament invites William of Orange and his wife Queen Mary, the daughter of the Catholic King James II, to assume the throne of England, thus accomplishing the country's Glorious

Revolution, a change in dynasty that ensures Protestantism in the country without bloodshed.

1689 John Locke publishes *A Letter Concerning Toleration*, arguing for the granting of religious tolerance to Protestant dissenters.

1690 The Parliamentary Act of Toleration ensures religious tolerance for English Protestant dissenters to worship, so long as they do so in licensed meeting houses.

1692 Witch trials begin in Salem in the North American colony of Massachusetts, eventually resulting in the execution of nineteen people. By this time, the witch craze has largely ceased in Europe.

1695 The German Pietist August Hermann Francke founds an orphanage and school at Halle for the training of the young. The schools of the Halle Pietists will, at their high point of development, serve 2,200 students and will become a major force on the educational horizon of northern Germany.

1696 In England, John Toland publishes his *Christianity Not Mysterious*, a work that argues that the Christian ethical revelations of the scripture can be understood through the intellect, and do not require a "leap of faith." The work will become an important manifesto for the Deist movement among intellectuals.

1701 Parliament's passage of the Act of Settlement in England ensures the monarchy's future Protestant succession.

1705 Philip Jacob Spener, the key thinker in the development of the German Pietist movement, dies.

1711 The Tory Party in Parliament passes the "Act of Occasional Conformity" to outlaw the common practice of English dissenters occasionally taking communion in the Church of England so that they can be eligible to hold public office. These measures will be repealed eight years later.

1714 The Tories in England's Parliament secure the passage of the "Schism Act," which aims to close those religious schools run by the country's dissenting churches. The Act will be repealed soon after Queen Anne's death.

1727 Count Nikolaus von Zinzendorf invites a remnant of the Bohemian Brethren, a Protestant group, to take up residence on his estates in Saxony. Over the coming years Zinzendorf will use his alliance with the group to found a Protestant ecumenical movement that spreads the teachings of Pietism throughout Europe.

1731 Anton von Firmian, archbishop of Salzburg, signs the Expulsion Pact, ordering that his territory's more than 20,000 professing Lutherans either convert to Catholicism or emigrate. Most refuse to convert and many take up residence in the English North American colony of Georgia.

1738 The Aldersgate Society is founded in London. Composed of members of the Moravian church and many English Pietists, the group will have a profound influence on the early development of Methodism in England.

The popular Calvinist revival preacher George Whitefield encourages John Wesley to begin to preach to the "unchurched" in England.

1741 Count Zinzendorf arrives in colonial North America where he establishes several congregations of the Moravian church. His actions anger populations of German Lutherans.

1743 In England, John Wesley publishes rules for the Methodist Societies that are steadily growing throughout the country.

1748 The Scottish Enlightenment philosopher David Hume denies the possibility of miracles in his *Essay Concerning Human Understanding."*

1751 In France the first volume of the *Encyclopédie* is published. The work will assert

a powerful influence on later eighteenth-century tastes, and its arguments for the development of a rational religion will eventually help to inspire the anticlericalism of the French Revolution.

1753 In Austria, Prince Kaunitz is appointed as one of the crown's chief ministers. In the forty years of his tenure, he will help to craft a number of measures designed to curb the power of the Roman church in the state.

1766 The first Methodist society is founded at New York in colonial North America.

1782 The Austrian King and Holy Roman Emperor Joseph II begins to abolish "superfluous" monasteries in Austria.

1783 Joseph II threatens to abolish the Catholic church in his state and to put a national church in its place while on a visit to Rome.

1790 In France, the National Assembly passes the Civil Constitution of the Clergy, abolishing the office of bishops and venerable clerical privileges and subjecting priests and monks to taxation.

1791 The remains of the French Enlightenment philosopher and deist Voltaire are moved to the Panthéon in Paris, a church once built by Louis XV to honor Saint Geneviéve, but now a monument to the great geniuses of French literature and philosophy.

1792 In England, the Methodist Church now includes more than 66,000 members.

1793 In France, the National Convention outlaws the worship of the Christian God.

1794 In Paris, the Cult of the Supreme Being is pronounced.

1803 Church property throughout much of continental Europe is secularized, that is, it is transferred to state ownership as a result of reforms promulgated by the French Emperor Napoleon Bonaparte.

OVERVIEW
of Religion

THE LONG VIEW. From the broad perspective of historical evolution, the history of religion in Europe during the seventeenth and eighteenth centuries is best appreciated as a long era of questioning, reappraisal, and transition. In the fourth century, Constantine the Great had converted the Roman Empire to Christianity, and from that date forward governments in Europe had supported the religion's claim to be the sole foundation for all culture, learning, and civilization. The sixteenth-century Protestant and Catholic Reformations had not challenged these underlying assumptions, but they had opened up the experience of Europeans to an ever-broader range of religious ideas and practices, which came to be subtly or profoundly affected by the decisions of states to sanction one set of religious beliefs and rituals against another. In the Age of the Baroque that began after 1600, new forces soon appeared that were to transform fundamentally Christianity's relationship to European culture. The rise of science provided educated men and women with new ways to explain the nature of the physical world without relying on the venerable mix of Christian theological and ancient philosophical ideas that had long explained matter and the universe. New political ideas, too, opened up the possibility of examining the nature of the state and its relationship to its subjects in ways that lay outside traditional Christian moral concerns. And in much of Europe, the ever-quickening tide of business and commerce created undreamed of wealth and eventually brought with it a consumer society that made Christianity's traditionally ascetic and world-renouncing teachings appear to many as outdated. As a result of these and other forces, the Christian religion was forced to compete against new forces that challenged its long-established authority. These changes did not occur overnight, and although the hegemony of religion came increasingly to be subjected to confrontations from new scientific ideas, political philosophies, and economic practices, Christianity's claims were still widely respected in many quarters of Europe at the end of the eighteenth century. Nevertheless, we can see both subtle and major alterations occurring in the roles that Christianity played in European society over the course of these two centuries. In short, religion's authority meant one thing at the beginning of the Age of Baroque, and quite another a century later at the onset of the Enlightenment, and still quite a different thing as the French Revolution approached in 1789. By that date, religion was for some but one ideology, a set of intellectually defined beliefs that existed in a world that was now awash with more compelling scientific, philosophical, and political ideas, a state of affairs that would have seemed strange and foreign to the men and women of the early seventeenth century.

THE STATE CHURCHES. Perhaps the most important religious development in the early modern world was the rise of the state church, a change that brought with it massive alterations in the ways in which people related to the clergy and Christian teaching. In 1500, all Europeans had been, by virtue of birth and baptism, members of the Roman church, an institution that was international in scope and which affected everyone's daily lives through its sacraments and rituals. To be sure, not every European had been devout; many had been strikingly indifferent to the disciplines that the Christian religion demanded of its adherents. But at the same time the concept of "Europe" was in people's minds largely synonymous with the notion of Christendom, a great international world made up of all Latin Christianity. Although a striking variety of opinions about Christianity's teachings had always flourished in Europe, upholding the unity of the church had long been seen to be fundamental to the health of society and secular governments. Religious heresy, it was often assumed, bred political disruption and disunity in its wake. At the same time European princes from the fourteenth century onward had become increasingly jealous of the revenues of the church, and of the powers that the pope and other high-ranking officials wielded within their kingdoms. A series of measures adopted in England, France, and other European states from this time forward had often tried to limit the power of Rome as well as that of bishops and archbishops. This trend toward state control over the church was to increase as a result of the controversies of the Reformation and Counter-Reformation. In the course of the sixteenth century as the Protestant Reformation gathered strength, the ideas of Martin Luther, John Calvin, and a host of other figures came to question and eventually jettison the old notion of Christian unity. And in the century after 1550, the proliferation of new Protestant and

Catholic reform movements touched off a series of costly and miserable religious wars that threatened to destroy all public order. It was not just religion that was at stake in these wars, but the integrity of the state to govern and control its subjects. As the conflicts worsened over time, they inspired ever-greater attempts to define the beliefs of subjects. While religious wars sometimes gave birth to limited degrees of religious toleration, as in the Edict of Nantes (1598) in France, more often they bred attempts to establish a single unitary faith, one that was now defined by kings and princes and which they labored to establish in their lands with new standards of discipline and mechanisms of control. In this process the secular state came to play a far greater role in its subjects' beliefs and everyday religious practices than it had previously.

ORTHODOXY, CONFORMITY, AND PERSECUTION.

The Ages of the Baroque and the Enlightenment overlapped with what has been called the "Age of Confessions," a period generally agreed to have occurred between 1550 and 1700. The term "Confessions" refers to the many written definitions of faith that were set down in print and circulated at this time in Europe's states. In these statements theologians tried to answer the claims of their religious opponents and set out in an orderly fashion just what beliefs were normative in their own church. Kings and princes sanctioned these attempts to define the religion of their realms, and they supported efforts to establish doctrinal purity and religious uniformity by requiring church attendance, censoring the book trade and the theater, and making catechism or the instruction of youth in their religion's tenets a legal requirement. Yet the very attempt to define Christianity with literate formula also bred its own problems, as theologians and state officials came to devote their attentions to defining with ever-greater precision theological concepts. These were now not just elements of Christian theology but important attributes of state policy. In contrast to the late-medieval world, where religion was often perceived as a set of rituals that people practiced in order to display their devotion, the religion of the seventeenth-century world was thus increasingly subjected to the written word, as theologians and princes tried with increasing discrimination to define just what it was acceptable to believe. Their efforts bred ever more definite attempts to indoctrinate the laity in those teachings the state accepted as normative. Issues that hinged around age-old debates concerning predestination and human free will came to dominate much of the theological debate of the time, and to prompt theologians to craft fine distinctions concerning their teach-

ings concerning salvation. Of course, these attempts to establish uniformity and define religious orthodoxy did not go unquestioned, and in many places the seventeenth century produced even more religious differences and competing positions than had the sixteenth before it. But for those who doubted the teachings of the new state-sanctioned cults, they were faced with a dilemma. They might bow to the power of the state; they might keep their own ideas secret; or they could immigrate to a place that offered a more congenial environment for their opinions. Those were, by and large, the alternatives offered to most Europeans in the seventeenth-century world.

WITCHCRAFT AND THE SUPERNATURAL.

While seventeenth-century state churches aimed to root out those who refused to conform to their beliefs, these institutions were even more determined to eliminate witchcraft and magic. In the century following 1550 the witch craze reached its height in Europe, its trajectory corresponding neatly with the Age of Confessions. In these years European states became obsessed with the idea that Satan was mounting a conspiracy to subvert Christianity and destroy the world. Such beliefs gave rise to brutal efforts in both Catholic and Protestant states to unearth and execute his minions, the witches. While the hunt to extirpate witches was one of the most dismal elements of life in early-modern Europe, its viciousness was short-lived. With the rise of the Scientific Revolution in the second half of the seventeenth century, beliefs in the supernatural began to wane among literate men and women and state officials. While belief in magic and the supernatural remained vital to many, particularly in the countryside, they were increasingly being driven underground.

THE RISE OF PIOUS SPIRITUALITY.

Even as Europe became an incubator for heightened intolerance and conformity in the seventeenth century, new forces were just beginning to become perceptible beneath the surface of the religious landscape that were eventually to transform the fundamental nature of Christianity. Beginning in the last quarter of the seventeenth century, waves of Pietist thinkers began to advocate a fundamental spiritual reformation of Christianity that would promote a deeper and more personal religion. This movement first became evident in Germany, where figures like Philip Jacob Spener (1635–1705) expressed distaste for the state-sanctioned religious orthodoxies that largely defined Lutheran Christianity at the time. Instead these figures reached into the past, finding in the religious mysticism of the later Middle Ages inspiration for their efforts to renew the spiritual life of the church. The new

Pietism was infectious, and its support of a rich and internal spiritual world found adherents in almost every European country, whether Protestant or Catholic. Not every group that flourished as a result of these growing sentiments was a threat to orthodoxy. Many were willing to assent to the theological teachings their states demanded, while others like the Quakers in England or the Moravians in Central Europe challenged key Christian teachings and became dissenters. As the eighteenth century progressed, the increasingly differentiated shape of public religious opinion was one factor that bred greater religious toleration. If the period gave rise to Deism—a broad intellectual movement to rationalize Christian beliefs—it also produced Methodism and a host of new Christian revivalist movements. These movements built upon the sentiments of Pietism and other spiritual movements of the late seventeenth century. The camp meeting appeared in those same societies where cultivated intellectuals aimed to curb the influence of Christian teachings, as intense piety crested side-by-side with religious disaffection. Thus the new churches and devotional movements that were born of eighteenth-century revivalism were to prove more than adequate wellsprings of Christian piety and they were eventually to lead a widespread renewal of the faith in the century that followed. Movements like Methodism, in other words, helped to create the modern Christian church as most people now know it, with its characteristic divisions into many privately supported houses of worship.

SCIENCE, ENLIGHTENMENT, AND REVOLUTION. As the history of Deism illustrates, the Scientific Revolution and the Enlightenment did not challenge Christianity so much as prompt its evolution in new directions. Science, deism taught, demonstrated both the ingenuity of the Christian God and the fact that he did not intervene in human affairs. Enlightenment thinkers like Voltaire embraced such a view and envisioned a reformed Christianity that might establish the religion's ethical teachings, while jettisoning its age-old glorification of miracles and superstition. Other Enlightenment thinkers, though, read the achievements of the Scientific Revolution as a sign that European governments and societies should abandon the Christian past altogether. They advocated secularism, that is, a reconstruction of European culture and civilization without recourse to traditional Christian thought, morality, and values. The high tide of their sentiments was to give birth to the French Revolution's 1793 attempt to "de-christianize" society and to establish a worship of the Supreme Being and human reason in place of traditional Christianity.

TOPICS
in Religion

THE STATE CHURCH IN EARLY-MODERN EUROPE

ORIGINS. By far the most important development in the history of European Christianity during the early modern age was the emergence of the state church. A series of measures pioneered in France, England, and Spain during the fourteenth and fifteenth centuries had anticipated its development. For much of the Middle Ages the Papacy in Rome had considered local churches as provinces in a Christian Empire under its control. The rising power of kings at the end of the period, though, brought Rome increasingly into conflict with the growing power of the secular state, and in the fourteenth and fifteenth centuries, national governments had begun to usurp authority the Pope had once claimed to exercise. In England, the Statute of Provisors (1351) attempted to limit the pope's authority to make appointments to English church offices, while the Statute of Praemunire passed two years later tried to prohibit the king's subjects from appealing their cases in the Roman church's courts by insisting that all such cases had to be submitted to the crown for approval before being referred to the papal judicial system. In France, the Pragmatic Sanction of Bourges (1438) and the Concordat of Bologna (1516) limited the pope's powers over the church in that country in ways that were similar, but even more thorough than in England. But it was in Spain where a truly national church began to develop at the end of the fifteenth century. As a result of their marriage, Ferdinand of Aragon and Isabella of Castille came to govern over a large part of the Iberian Peninsula, a European region with a wealthy and powerful church establishment. By 1485, the couple was already secure enough in their control of the Spanish church to found their own version of the Inquisition and they charged the office with eradicating the secret practice of Judaism and Islam among the *conversos*, those they had forced to convert to Christianity. This Spanish Inquisition, as it later came to be known over time, was staffed with members of the clergy, but it answered directly to King Ferdinand and Queen Isabella and not to the pope at Rome. It became in the sixteenth century a powerful weapon in the fight against heresy, and helps, in part, to explain the relatively limited appeal that Protestantism had in the country.

PROTESTANT INFLUENCES. During the sixteenth century the reforms advocated by Protestant leaders came

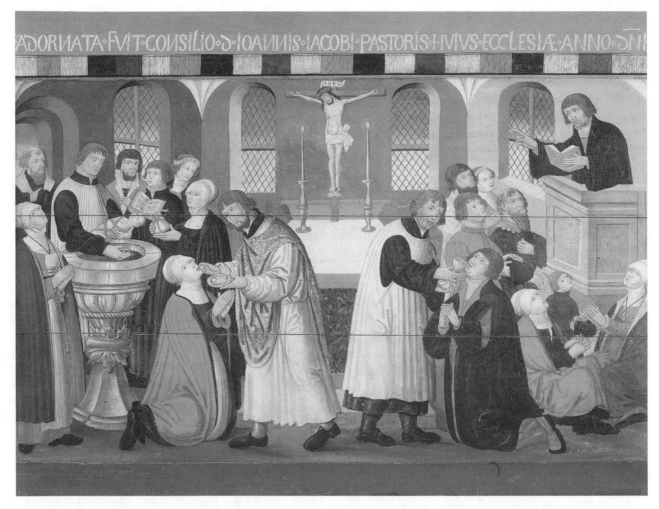

Danish seventeenth-century altarpiece celebrating the career of the German reformer Martin Luther. THE ART ARCHIVE/NATIONAL-MUSEET COPENHAGEN DENMARK/DAGLI ORTI.

alternately to support and discourage the increasing trend toward state control of religious institutions. In his *Address to the Christian Nobility of the German Nation* (1520) Martin Luther recommended that the German princes take up the cause of reforming the churches within their own territory, since he judged the contemporary clergy too entrenched and reactionary to oversee the job of eradicating abuses and corruption. In the first generations of the Protestant Reformation, Luther's appeal to state authority proved to be one of the attractive features of the developing Lutheran church, as German princes and kings in Scandinavia accepted the movement's evangelical teachings, in part, because of the greater degree of control that it afforded over their clergy and the church's wealth. In 1527, for example, Philip of Hesse became the first German prince outside Saxony to introduce a Lutheran-styled reform in his lands. Philip set a standard that was often repeated in Protestant countries during the years that followed. He dissolved the

monasteries and convents within his territory and sold off their possessions, reaping the benefits of the sale for his own government. His example was soon to be imitated in Scandinavia, and most decidedly in England where the Dissolution of the Monasteries during 1535 and 1536 resulted in a huge windfall for Henry VIII's treasury. Henry's move against the monasteries was merely the last in a series of measures resulting from his desire to secure a divorce from Catherine of Aragon and the legacy of that famous dispute was to establish his effective control over almost every aspect of the church's life in England. But if Protestant kings and princes often freely interfered and tinkered with the church, the attitude of Reformation theologians was not always as accepting of state control as Luther's had been. In Swiss Geneva, the French religious reformer John Calvin advocated for a very different pattern of church-state relations. Calvin insisted that the church's ministers and officials meeting in synods had the right to define church

practices and teachings, and that the state was responsible for enforcing the decrees and decisions of religious leaders. Calvin's ideas served as the basis for a great international movement, today known as Calvinism, which spread throughout Europe in the century after 1550. But it was only in Scotland where the movement came to fashion the national Presbyterian church that Calvinism became accepted as the basis for a state church. Elsewhere Calvinists succeeded only on a much smaller scale: their influence dominated in Holland, a country that was a loose confederation of cities and rural provinces; in the Swiss cantons, which were also ruled by urban governments; and in a few German principalities. Even in these small territories, princes often significantly altered Calvin's notions concerning the need for a Consistory, a committee of churchmen and lay elders, to regulate all issues having to do with church and state. The type of church control implemented in these small territories thus frequently came to mirror more that of Philip of Hesse than of the original Genevan model. In England and France, Calvinist disciples agitated for the establishment of their positions in England and France, but rulers in those countries long resisted their pleas. Thus while Calvinism was to remain a significant minority movement—the most significant minority movement in seventeenth-century Europe—its ideas about political authority and the relationship between church and state always proved to be stumbling blocks to its establishment as a national religion.

CATHOLIC INFLUENCES. It seems at first a paradox that the greatest impetus to the development of the state church came, not from within Protestantism, but from forces at work within the Roman Catholic church, an institution that had long resisted attempts to encroach upon its prerogatives. During the sixteenth century the rise of competing Protestant churches throughout Northern Europe had been a significant blow to the Roman church's prestige and authority. As a result the very multiplication of new churches throughout Europe meant that those who supported reform from inside the Catholic church were forced to rely on state power as never before to ensure that the task of internal reform was carried forward. In the years between 1545 and 1563 members of the church's hierarchy had met at Trent on the border of northern Italy to consider issues of church reform. Prompted by the attacks of Protestants the prescriptions they formulated at this Council of Trent resisted Protestant innovations but at the same time attempted to answer Protestant charges by supporting the elimination of abuses and corruption in the church and by fostering a new discipline among the clergy. At the council's con-

clusion, the church possessed a series of decrees that were a definitive rejoinder to Protestant teaching, but the church's officialdom also faced a dilemma. In order for the decrees to be established in the various countries of Europe that remained faithful to Rome, the Council's prescriptions had to be adopted and promulgated by kings and princes. Thus in the wake of the Council of Trent, Rome was forced to rely as never before on Europe's remaining Catholic princes, who came to promulgate the decrees and who also supported the establishment of Trent's program through rich financial subsidies. In this way the very complexity of the sixteenth-century religious situation helped to breed a new enhanced state control over the entire apparatus of the church's administrative and spiritual bureaucracy. In the years that followed Trent, the Catholic church was, in effect, to become ever more a department of state within those Western European kingdoms that retained their allegiance to the pope.

CHARACTER OF THE STATE CHURCH. By 1600, the legacy of the Reformation and Counter-Reformation and the ambitions of kings and princes meant that the development of the state church was well advanced in every major European state. These new institutions were officially sanctioned and publicly supported, but in most cases they retained the parish structure that had flourished in the medieval church. A parish was a geographical unit with boundaries, and every individual who lived within those boundaries was expected to worship within the parish's church. In the Roman church and the Church of England (often referred to merely as the Anglican church), parish priests administered the church and celebrated the sacraments. These priests were often called "curates," because they practiced the "cure of souls." In larger parishes, a curate might also have a vicar or a vice curate who assisted him. Catholic and Anglican priests were customarily addressed with the title "Father," while in Lutheran kingdoms and territories ministers served the congregation, rather than priests. The term "minister" had its origins in the reforms of sixteenth-century Protestant leaders like Martin Luther, who insisted that a special category of clergy was unnecessary to intercede between humankind and God. In Lutheran churches ministers were not considered a special legal caste, governed by their own laws and privileges. Instead the same laws that bound everyone in the state were also binding on Protestant ministers, although a great deal of prestige was still attached to being a member of the clergy and oftentimes the distinctions between a Lutheran minister and a Catholic or Anglican priest were minimal. Lutheran ministers were ad-

dressed as "Pastor" (*Pfarrer* in German). By contrast, Calvinist churches did not retain a parochial structure, but instead divided the faithful into congregations according to the place where they worshipped and not according to where people lived. Ministers or pastors were in charge of Calvinist congregations. To men and women of the time, the most visible difference between all the Protestant churches and the Roman Catholic church revolved around the issue of clerical celibacy. All Protestant churches allowed their clergy to marry, while Roman priests were expected to renounce all sexual activity. While these requirements were an ancient feature of Latin Christianity, priestly celibacy had often been lightly observed in many places in Europe throughout the Middle Ages. Many priests had kept concubines, and had merely paid annual fines to their bishops for breaking the church's laws. As a result of the reforms of the Council of Trent, clerical celibacy was becoming more strictly enforced in seventeenth-century Europe, although even then there were some regions in which concubinage (the keeping of mistresses) was common. By 1700, observance of clerical celibacy had grown to be the norm in Catholic lands, and concubinage had become very rare, a mark of the success of the program of the Catholic Reformation.

ENFORCING MORALITY. State churches served as the eyes and ears of the royal government. Priests and ministers kept records of births and deaths, as well as immigration into and emigration out of the communities under their supervision. It was among their responsibilities to note down the names of all individuals who did not appear at church services on Sunday morning. They also investigated and reported any deviant social or cultural activity. Priests and ministers passed on this information to state authorities, who sometimes, as in witchcraft investigations, interrogated entire villages based upon the information they received from the clergy. A key innovation of the new state churches that flourished in Europe at the time was the increased use of the Visitation, a type of inspection that had been more rarely practiced by bishops in the Middle Ages. The Visitation first became an element of state policy during the early years of the Lutheran Reformation in Saxony and Hesse, the two earliest states to convert their church establishments to Lutheran teaching. To assess the level of religious knowledge among their peoples, the Saxon and Hessian Visitors were charged with examining villagers and ministers. To do so, they were armed with a standard questionnaire with which they interrogated those in the countryside. While clerical officials conducted the visitations, the reports that these forays

in the countryside generated were given to princes and state officials, who formulated plans and responses to the generally low level of religious discipline and knowledge that these Visitations often revealed. Weekly catechism for the young was usually the most common prescription that arose from the Visitation and this practice of conducting schooling sessions in church doctrine came to be adopted, not only in Lutheran states, but in Catholic and Calvinist ones as well. In the Duchy of Bavaria, a large and powerful state within the Holy Roman Empire, these initiatives gave birth already in the 1570s to an institution known as the Clerical Council, a permanent body of the state that met regularly for more than 200 years in the Duchy's capital of Munich before being abolished. The Clerical Council regularly received reports about those who held dangerous religious opinions, about priests who were ineffective and poorly trained, and about parishes in which the level of religious knowledge seemed to be low. They responded by disciplining, reassigning, or removing ineffective priests and by requiring that efforts at indoctrinating the laity be redoubled in particular parishes. Eventually, they designed an ingenuous system in which priests gave out certificates to those who made their confessions, and then, each year lay people were responsible for presenting these tickets to state officials when they paid their taxes. The Bavarian Clerical Council was one of the earliest state offices to appear in Northern Europe that was charged with inspecting religion at the local level in ways that were similar to the Inquisition in Spain and Italy.

ALLEGIANCE TO THE STATE. The state churches that flourished in seventeenth-century Europe also played a major role in fostering new wellsprings of affection for national governments. At the local level, the minister or priest often served as the "king's man," a spokesman for the government. In the days before the development of radio, television, newspapers, or the Internet, it was consequently assumed that one of the duties of the clergy was to communicate to their parishioners news from the outside world as well as the king's proclamations and edicts. Patriotism is an anachronistic term when applied to the early-modern era. To the extent to which loyalty existed, it usually involved attachment to a ruler or a community, not a land or state. Early modern priests and ministers still can be credited, however, with building in the communities they served a nascent sense of patriotism for the state through the sermons they gave and the devotional activities they organized. Thousands of sermons survive from the period in which priests and ministers intoned the necessity of

Title page of John Cotton's *Spiritual Milk and Boston Babes in Either England*, a text published at Boston in 1646 that was intended to teach young chidren the truths of Puritan Christianity. **THE GRANGER COLLECTION.**

obedience to the reigning prince as a Christian virtue. In a more positive vein, the religious ideas of the period celebrated the benevolent, but effective king as "the father" of the national household. Just as an effective head of a house bred respect for his authority by chiding and chastening his recalcitrant children, so, too, was it the responsibility of the prince to discipline and supervise the activities of his subjects. Thus in this way, religious notions of authority tended ever more to sanction and buttress the rising power of kings and princes in the early-modern world.

THE ROLE OF PRINT AND EDUCATION. In the early-modern state church the practice of religious rituals also came to be more firmly fixed than previously. The seventeenth century was the great age of what the historian John Bossy has labeled "typographical tyranny." During this century state churches first gained the power to insist that congregations strictly observe the liturgy, the body of rites prescribed for public worship, as set in type in books of liturgical order such as the Roman Catholic missal, the Anglican *Book of Common Prayer,* and the Presbyterian *Book of Common Order.* In every state, on a given Sunday, every congregation across the land was quite literally on the same page in terms of the devotions it was performing. While the subjection of religious worship to this kind of formalism assaults modern sensibilities, the new typographical tyranny had its positive side: it was a boon to the spread of literacy. In order to make sure that members of congregations could read what was on the page, churches became committed to teaching members to read, if not necessarily to write. Universal public education systems did not exist in Europe until the nineteenth century. But even before this time, what schooling that did flourish did so largely under the supervision of churchmen. Typically, the priest or minister, or, in large churches, his assistant, would hold school for a few hours each day for local youth. The education in these schools was quite rudimentary. Its primary goal was to equip students with sufficient skill to read simple devotional works and most importantly to master their catechism, a manual that summarized the beliefs of a given creed. Only the brightest and usually the wealthiest students went on to grammar schools, and the "colleges" or secondary schools that were similar in many respects to modern American high schools. These schools were rarely maintained by the state church, but were "private" institutions funded by fees and maintained by churchmen who had no public responsibilities. In Catholicism, these secondary schools were often the preserve of the Jesuits, the most influential of the many religious orders that emerged from the Catholic Reformation. In Protestant lands many of the schools that first appeared during the Middle Ages to train clerics survived the Reformation to see new life as the training ground for lay people. This was the case with the English public schools. These institutions had originally been founded in the later Middle Ages under the auspices of the church and had been called "public" because the education occurred outside the homes of the nobility and gentry who sent their sons there. These "public schools" had long trained clergy for careers in the church, but in the seventeenth century institutions like Eton, Harrow, and Rugby became the training ground for more and more members of the elite anxious to participate in government.

THE STATE CHURCH AND COMPETITION. The priests and ministers in charge of state churches did a good deal of what today would be recognized as the state's work. In return they acquired an enormous amount of cultural power and influence. While churches became the eyes, the ears, and the voice of government, the state church's clergy regularly appealed to and encouraged their governments to beat back forces of religious competition. The state clergy made sure, in other words, that the government penalized those who, for whatever reason, chose not to attend the state church. Minority or "dissenting" churches existed in many parts of Europe, but usually these churches' members were granted only limited rights to worship, and these awards of limited religious toleration usually restricted dissenters' civil rights and fostered either subtle or overt patterns of religious persecution. The state clergy often vigorously lobbied for such injunctions, and they tried to protect their own religion's favored position against attempts to grant religious freedom to dissenters. Adherents of outlawed Christian movements, such as Anabaptists (those who rejected the validity of infant baptism, and thus practiced re-baptism as an adult as a necessary condition for participating in the church) were almost never allowed even a limited right to worship. Almost everywhere, Anabaptism was a crime punishable by death.

PROBLEMS OF ESTABLISHED RELIGIONS. While a tool of state domination and control, the established church in early-modern Europe satisfied the devotional and spiritual needs of the majority of Christians. Over time, however, as Europe's society and economy grew more complex and variegated, these institutions proved incapable of accommodating the increasingly diverse religious opinions that multiplied in society. During the seventeenth and eighteenth centuries, many parts of Europe were undergoing rapid urbanization and a transformation to a capitalist economy that would eventually spell the death knell for the old feudal order. In these cities commerce and merchant industries fostered new and increasingly divergent religious landscapes. On the one hand the new commercial economy often bred a dour and austere sense of discipline in many of the new "men of commerce," as Dutch traders, French artisans, or English industrialists came to evidence an almost "monkish" devotion to their pursuit of worldly wealth. Certainly, their seriousness did not preclude religious belief; in fact, it sent many in these groups in search of new forms of devotion that were more personally relevant in the context of their rapidly changing lives. For others, the new commercial economy, with the possibilities that it opened up for high standards of consump-

tion and leisure time made the traditional ideas of both Protestantism and Catholicism more and more irrelevant. Thus as the seventeenth century drew to a close, the state churches of Europe appeared to be increasingly assaulted from two directions. On the one hand, many felt that their religious and ritualistic formalism was inadequate and they searched for new religious movements that offered a more personal and internal spirituality. From the opposing direction, Europe's state-sanctioned religious establishments came as well to seem increasingly irrelevant to those who were less concerned with "storing up treasures in Heaven" than they were with enjoying them in the here and now. Among those who persisted as devout believers, the demand arose for a more vital and enthusiastic religious experience, a demand that was to give rise as a persistent chorus. And at the same time non-believers chafed to be free of the obligations of church attendance, catechism, and the other, often minimal requirements that the state church imposed upon its subjects. This dynamic—born of an increasingly pluralistic society in which religious beliefs were expressed in terms of personal relevance—was to make the state church seem more and more an outmoded relic of the European past as the eighteenth century progressed.

SOURCES

Thomas A. Brady, et al, *Handbook of European History, 1400–1600* (Leiden, Netherlands: E. J. Brill, 1994).

Euan Cameron, ed., *Early Modern Europe* (Oxford: Oxford University Press, 1999).

Jean Delumeau, *Catholicism between Luther and Voltaire* (Philadelphia: Westminster Press, 1977).

Richard S. Dunn, *The Age of Religious Wars, 1559–1715.* 2nd ed. (New York: Norton, 1979).

Ronnie Po-Chia Hsia, *Social Discipline in the Reformation: Central Europe, 1550–1750* (London: Routledge, 1989).

Gerald Strauss, *Luther's House of Learning. Indoctrination of the Young in the German Reformation* (Baltimore, Md.: Johns Hopkins University Press, 1978).

Williston Walker, et. al, *A History of the Christian Church.* 4th ed. (New York: Charles Scribner's Sons, 1985).

THE THIRTY YEARS' WAR AND ITS AFTERMATH

THE AGE OF RELIGIOUS WARS. As the development of the state church came to affect the lives of more and more Europeans in the seventeenth century, religious issues continued at the same time to dominate events in the political arena. In the century following 1550, Europe was convulsed by a series of religious wars

in which the lingering issues the Protestant and Catholic Reformations had raised prompted debate, civil strife, and military conflict. The Age of Religious Wars, the term that is often used to describe this period, is in many ways a misnomer. It implies that over a number of years Western European princes sustained organized military action to resolve the religious issues of the era. While military engagements caused a portion of the bloodletting in Europe in this century, the breakdown of public order—evidenced in the sporadic but deadly outbreak of religious violence in towns and villages—frequently proved to be far deadlier than military conflicts. Similarly, troop movements, rather than battles, killed far more peasants than soldiers, since as armies moved through the countryside they commandeered grain and other foodstuffs from local inhabitants, often leaving villages to starve in their wake. Armies, too, brought disease with them, touching off outbreaks of plague and other epidemics that proved to be more devastating than the casualties inflicted in battles. In the years between 1550 and 1600, these clashes were largely centered in France and the Netherlands and took on much of the character of civil wars. But the last and greatest of the religious wars, the Thirty Years' War (1618–1648) occurred in Central Europe, and its primary battleground was the loose confederation of states known as the Holy Roman Empire. Although it began as a localized dispute, the Thirty Years' War came soon to assume the character of a great international conflict, eventually involving France, Spain, the Scandinavian powers—indeed almost every major European state. Notable for its brutality, the length of its sieges, and the widespread depopulation and devastation that it wreaked on large portions of Central Europe, the war was a dismal climax to the great controversies that the Protestant and Catholic Reformations had bred in Europe since the early sixteenth century. The Treaty of Westphalia (1648) that drew the fighting to a close offered little new in the way of solutions to religious problems, but instead merely reiterated sixteenth-century precedents that upheld the right of a ruler to define the religion of his state. If any good thus came out of this massive bloodletting—the deadliest conflict in European history until the total wars of the twentieth century—it was by and large to discredit the arena of battle as a suitable forum for resolving religious differences. In the years that followed 1648, Europeans were to continue to fight one another, but it was increasingly to be territorial disputes, trade, and colonialism that inspired international wars, rather than religious issues.

CAUSES OF THE WAR. The causes of the Thirty Years' War were complex and lay in the long stalemate that had developed between Protestant and Catholic forces in the Holy Roman Empire following the Peace of Augsburg in 1555. At that time both Lutherans and Catholics had drawn a truce that upheld the legality of Lutheran teaching in the empire, so long as evangelical reforms were established through the actions of a prince or town council. The formula upon which the Peace of Augsburg had been based was *cujus regio, euius religio*, meaning roughly "He who rules, his religion." Like many of the truces drawn in the religious conflicts of the sixteenth century, no one ever really expected the Peace of Augsburg's solution to the Reformation crisis to stand. Like the Edict of Nantes (1598), which granted limited toleration to French Protestants some four decades later, it was thought of as a truce, a cessation in the conflict that Catholics and Protestants anxiously desired so that they might recover from the bloodletting of the previous generation. Most princes fully expected that at some time in the future a single religion would be re-established in the empire, but they were assured throughout much of the later sixteenth century that that moment was not about to come soon. By 1600 the majority of German princes and towns were Lutheran, while the emperor—always a member of the Austrian Habsburg dynasty—was Catholic. The election of a Catholic emperor was, in fact, assured by the very contours of the empire's constitution. Only seven electors within the German parliament, or Diet, possessed a say in electing a new emperor, and at this time four of the seven were Catholic. Thus religious issues in Germany had come to a stalemate: the emperor and the majority of the German electors were Catholic, but in the German territories and cities Lutheranism dominated. Both sides recognized that any attempt to establish their position as the "official" state religion was doomed to failure because of the very nature of the political landscape. Although this situation prevailed until the early seventeenth century, the religious complexion of the German lands was already beginning to change in the later sixteenth century as some states adopted Calvinist religious reforms. According to the terms of the Peace of Augsburg, Calvinism was an unrecognized, and therefore illegal, religion. Despite its prohibition, though, a number of powerful states adopted Calvinist church ordinances, including the Palatinate, Hesse, Nassau, and Anhalt. The Palatinate, in particular, was a wealthy state in the German Southwest that was in frequent contact with Calvinists elsewhere in Europe, particularly with the Huguenots in France. The Palatinate's ruler was also one of the Diet's seven electors, and in 1613, he was joined in his decision to practice Calvinism by the elector of Brandenburg-Prussia, a ruler of one of the largest territories in the

German northeast. Thus two of the three Protestant electors within the imperial Diet were now Calvinist, a situation that rankled the empire's Lutherans, and which raised Catholic concerns as well.

RESURGENCE OF CATHOLICISM. In the generation following the conclusion of the Council of Trent in 1563, Catholicism had begun as well to revive throughout Germany. The center for much of this renewal was the large and powerful Duchy of Bavaria in the southeast, where Duke Albrecht V (1550–1579) pioneered a state-directed pattern of Catholic reform that was to be copied in other Catholic territories throughout the empire. Princes like Albrecht were concerned to transform their states into model Catholic territories, but they also hoped to work a widespread re-catholicization of the empire itself. Their efforts laid the foundation for a renewed spirit in the Catholic leadership and inspired some state leaders to convert to Catholicism, touching off a renewal of spirit in the Catholic cause that was well underway by the second decade of the seventeenth century. By this time, the spokesman for the revival was the Austrian figure, Archduke Ferdinand. In 1617, Ferdinand secured his election as king of Bohemia, then, as now, a region with a Czech rather than German population. In his new office Ferdinand set about reforming the religion of his new subjects, outlawing the religious toleration that had recently been assured in the state and laying the foundation for the region's re-catholicization. His efforts soon inspired resistance, and only several months after coming to power, his nobles revolted, capturing Ferdinand's two most powerful Catholic ministers in Hradcany Castle at Prague and throwing them out the window. The men survived their fall, but this "defenestration of Prague," which occurred on 23 May 1618, touched off the entire complex series of events that soon made war inevitable. Emboldened by their show of resistance, Bohemia's nobles deposed their Catholic king and in his place elected the Calvinist, Elector Frederick III of the Palatinate. Thus their measures called into question the entire balance of power in the empire, since Bohemia was a territory that possessed an electoral vote in the German Diet, and if Frederick's claim to the throne had been upheld, Protestants would have possessed a majority of the seven votes. Instead the following year when the ailing Emperor Mathias died, the Protestant electors universally agreed that Ferdinand should be elected to replace him. But rather than exercising generosity to his Protestant compatriots, the new emperor raised an army that marched on Prague, defeating its Protestant nobles at the Battle of White Mountain just outside the city in 1620. With this victory Habsburg control over the territory was assured, thus touching off an ambitious program to reestablish Catholicism in Bohemia in the years that followed.

DANISH, SWEDISH, AND INTERNATIONAL PHASES. Although Ferdinand's victory in Bohemia might have ended the conflict, his buoying of the Catholic cause inspired the Lutheran King Christian IV of Denmark to enter the wars in 1625 in order to rally Protestant forces in the northern part of the empire. A series of stunning Danish defeats, though, caused the country to withdraw from Germany in 1629. In the months that followed, Denmark's archrival Sweden was drawn into the conflict as well, to serve as supporter of the Protestant cause. The entry of Sweden, a major European military power at the time, soon widened the conflict. Poland, Spain, the United Dutch Provinces, and eventually France came to participate in the wars, with Catholic France fighting on the side of Protestant forces in order to oppose its rival Spain. The worst years of the conflict occurred in the mid-1630s, when heavy fighting, famine, disease, and the pillaging of armies wreaked a heavy toll on large parts of Germany. In the German Southwest, the large and wealthy Lutheran territory of Württemberg saw its population decline by more than 75 percent. In many places the mortality rate soared to a level more than 30 percent higher than the birth rate. Travelers who visited the region at the time, like the English physician William Harvey who would later go on to discover the circulation of the blood, remarked that Germany was a country very much without a population. While attempts to halt the destruction continued throughout the later 1630s, the war was to grind on for another decade until a general peace conference was convened in the northern German town of Münster. The treaty that resulted from these deliberations, the Peace of Westphalia, accomplished little when compared against the massive destruction that had been wrought. The principle of *cujus regio, euius religio* was upheld, meaning that German princes were free to define the religion practiced in their territory. Calvinism, previously left out of the settlement of the Peace of Augsburg of 1555 was now recognized as a legal religion, and other developments that had long been established facts, like the independence of the Dutch Republic or of the Swiss Cantons, finally received legal recognition. The costs that the war had exacted in deaths, in human misery, and in a general cheapening of life throughout much of Central Europe scarcely justified such slight achievements. Yet on the positive side Continental Europeans were never again to stage such an enormous battle over religious issues. The specter of the Thirty Years' War, in which initial

religious zeal was quickly turned to baldly political ends, meant that the impulses that had fed religious conflicts had by 1648 largely come to be spent.

SOURCES

Ronald G. Asch, *The Thirty Years' War. The Holy Roman Empire and Europe, 1618–1648* (New York: St. Martin's Press, 1997).

Joseph Bergin, ed., *The Seventeenth Century* (Oxford: Oxford University Press, 2001).

Richard S. Dunn, *The Age of Religious Wars.* 2nd ed. (New York: Norton, 1979).

Geoffrey Parker, ed., *The Thirty Years' War* (London: Routledge, 1984).

C. V. Wedgwood, *The Thirty Years' War* (London: Methuen, 1981).

THE ENGLISH CIVIL WARS

RISING PURITAN DISSATISFACTION. Before the specter of religious conflict completely disappeared from Europe altogether, one final conflict, the English Civil Wars, was to answer questions that had long raged over the course that the state church should take in that island country. Since the later years of the reign of Elizabeth I (r. 1558–1603) English Puritans had been agitating for change in the rituals and doctrines of the Church of England. The Reformation settlement in England had been crafted, not by theological directives formulated by a Reformation leader like Martin Luther or John Calvin, but in response to political realities. Henry VIII had been pulled into the realm of Protestant states only gradually as a result of the circumstances arising from his famous divorce from Catherine of Aragon, but other than dissolving England's monasteries and taking a few tentative steps toward reforming the church establishment, Henry had left much of England's religion untouched. Under the reign of his son Edward VI (r. 1547–1552), the first English *Book of Common Prayer* had come into circulation, but it was carefully fashioned as a translation of the Sarum rite, a version of the Mass that had originated in England's Salisbury Cathedral and which had been in wide circulation throughout the country in the later Middle Ages. Although he was personally Protestant in his own religious ideas and he did invite a number of continental reformers to come to England—most notably the Strasbourg reformer Martin Bucer (1491–1551)— few definitive steps were taken to foster Reformation teachings throughout England until the year of Edward's death. At that time a new austere and definitively Protestant *Book of Common Prayer* was printed, but the king's premature demise prevented it from being circulated throughout the country. By contrast, Edward's successor, Mary Tudor (r. 1552–1558) tried valiantly to restore Catholicism in the island, putting to death more than 300 Protestants, and beginning tentative steps to re-establish English monasteries. But her early death, too, prevented these measures from being carried through. And while her half-sister Elizabeth I was a Protestant, she promised at the outset of her reign to make "no windows into men's souls." The church she thus fashioned continued to be a halfway house between outright Protestantism and traditional medieval practices. In 1559 she issued a new edition of the *Book of Common Prayer* more traditional in outlook than her brother Edward's second work, but more Protestant in its teachings than the first edition of 1549. And although she was to persecute some Catholics in the course of her reign, she generally tolerated a broad range of opinion, so long as she did not sense that it was a threat to her authority. The solutions that she crafted worked well for most of her reign, but by the 1580s and 1590s the Puritan movement had gathered increasing strength in Parliament. Puritanism, a theological and devotional movement that aimed to do away with vestiges of the Roman church's practices, had largely been inspired by the teachings of John Calvin (1509–1564) and the Scottish divine John Knox (1508–1572). The most extreme of English Puritans desired the abolition of the episcopate, and the substitution of a Presbyterian style of church government—something that Elizabeth and her successors steadfastly refused to do. In the Church of England, as elsewhere in Europe, the power of bishops served to buttress and support the power of the state. Both the Tudor and Stuart monarchs realized that to do away with these powerful links between state and church might subject the crown to powerful centrifugal forces it could not control. Not every Puritan, though, supported such radical measures. Others were content with more piecemeal measures to remove "popish" abuses and superstitions from the English prayer book and to curtail the elaborate ritualism of the state church.

JAMES I. Elizabeth resisted such innovations, and although she was largely able to forestall the growing Puritan demands of her later reign, she left the dilemmas that Puritanism raised as a legacy to her successors, James I (r. 1603–1625) and Charles I (r. 1625–1649), neither of whom evidenced the queen's same skill for managing the English Parliament. A central feature of Elizabeth's success had been her decision to call Parliament relatively infrequently, and to conduct a royal administration notable for its great economy. Despite these

measures she had left the crown heavily indebted at her death, and royal finances continued to worsen during the first decade of James I's reign. James soon learned, like Elizabeth before him, of the dangers of calling the English Parliament, who regularly required concessions in exchange for new taxes. In the first years of James's reign he came face-to-face with the religious issues that had also troubled the later years of Elizabeth's rule. As he made his way from Scotland to London, he was presented with the "Millenary Petition," supposedly signed by 1,000 English Puritans who desired a purified English church. News of these efforts soon reached the country's Catholics, a few of whom began to hatch a plan to tunnel under the houses of Parliament in Westminster and blow them up while the king was speaking there. This Gunpowder Plot, planned for November 1605, came to the attention of officials and, when thwarted, did a great deal to destroy the hopes of those who longed for a re-establishment of Catholicism as the state religion of England.

THE SITUATION WORSENS. Although James I may have been drawn to some of the theological conclusions of Calvinism, he had regularly battled with Scottish Presbyterians while king of Scotland. That experience continued to condition his reign as king of England. When he called a conference at Hampton Court palace outside London in 1604 to converse with Puritans, he was faced with the demand that he abolish the episcopate in England. His response, "No bishop, No king," alienated many in the movement. Still James did accede to their request for a new authorized translation of the Bible, the version that has since become known as the King James Version since its issuance in 1611. Yet in the years that followed, James instructed officials in the Church of England to reverse Elizabethan policies toward Dissenters, those who refused to attend Anglican services. Elizabeth had been relatively tolerant of those who refused to attend, but in the following years James's ecclesiastical establishment levied heavy punishments on those who refused to participate. Puritan dissatisfaction with his regime also grew when in 1618 James made clear his animus against the movement's custom of "keeping the sabbath." At that time he issued a proclamation that decided between a group of Puritans and Catholic-sympathizing members of the gentry. James's declaration made it legal to dance on Sundays, to go about "vaulting and leaping," to set up "May-poles," and to drink "Whitsun ales." James insisted further that the declaration be read from every pulpit in the land, but when the Puritan outcry was too great, he backed off from his plans.

WORSENING FISCAL AND POLITICAL CRISES. In the years that followed his initial encounters with the English Parliament, James decided, like Elizabeth before him, that it was better not to call the representative body to meeting. Still he was faced with an ever-increasing shortfall of funds, and during the second decade of his reign, he made up this shortfall through the sale of offices and the awarding of royal monopolies to trade in certain commodities. Elizabeth, too, had practiced such a policy, although her greater popularity had tended to stanch criticisms. James, by contrast, was not a popular figure. At the same time, he continued to uphold the Church of England while prudently promising persecution for Catholics who practiced their religion openly, a popular policy. In the final years of his reign, any goodwill that he had amassed through such policies was spent. In these years criticism mounted because of his tendency to fall prey to young favorites like George Villiers, the Duke of Buckingham, with whom James apparently nourished a long-term sexual obsession. In 1521, James secretly sent off his son and heir Charles with his favorite Buckingham to Madrid to arrange a marriage with the Spanish Infanta. When the scheme came to light it caused a scandal and had to be abandoned since an alliance with Spain had been particularly unpopular in England since the Spanish Armada of 1588. In that failed offensive Spain had launched an invasion force against the island with the intention of accomplishing its reconversion to Catholicism, and since that date most in England had turned a wary eye toward Spain. With the Spanish marriage discredited for his son Charles, James considered other possible marriage alliances. But his decision to wed his heir to Henrietta Maria, the sister of Louis XIII of France, was hardly a prudent choice. France, too, was a Catholic country that had long nourished a rivalry with England. Thus the last years of James's reign came to be particularly uncomfortable, especially when the dire financial situation of his government required the calling of Parliament to set England's finances aright. He now faced a chorus of criticism, particularly from his Puritan opponents who desired widespread reforms in exchange for new taxes.

CHARLES I. If James left his son a dangerously unstable situation, Charles I soon offended just about every faction in England. Quarrelsome and high-handed by nature, he came to alienate even his supporters. Early in his reign he dissolved two meetings of Parliament when members insisted that the king's ministers should be answerable to the body. By 1628 when he called his third meeting, he was forced to sign the Petition of Right, a document that outlawed many of his previous

Archbishop William Laud. THE LIBRARY OF CONGRESS.

revenue-raising schemes. Chastened by the defiance of Parliament, he resolved not to call the body again, and between 1629 and 1640 he ruled largely without any representative assembly, a decision that forced the king to rely on the sale of offices and other monopolistic practices that had long excited the outrage of Parliamentarians against him and his father James. At the same time, Charles's religious policies offended the sensibilities of many in England, who feared that his High Church formalism and support of pomp and ritual was a precursor to a restoration of Catholicism in the island. This strain of criticism only worsened, particularly after Charles installed William Laud (1573–1645) in 1633 as archbishop of Canterbury, the head of the church of England's establishment. Laud soon persecuted members of the Puritan party, including the popular London attorney William Prynne. Prynne, an avid opponent of the theater and a critic of the lax standards of morals evidenced at court, had for several years conducted a pamphlet campaign against the High Church party. Laud had Prynne seized and tried, but when Prynne began a term of imprisonment in 1633, he continued to write from his jail cell, having his works smuggled out of prison to be published and circulated secretly. King Charles and Laud continued to move Prynne about the country, hoping that they would find a spot secluded enough that he would be unable to work his intrigues. But in 1637 as

the prisoner continued to defy their orders, they had him seized, his earlobes shorn off and both his cheeks branded with the letters "SL" for "seditious libeller." Prynne, ever the showman, promoted his marks as "Stigmata Laudis," meaning literally, "the marks of Laud." Laud's other measures did little to quiet fears that a restoration of Catholicism was imminent in England and Scotland. He refused to engage in dialogue with Puritans and openly tried to offend the party. Between 1634 and 1637, the archbishop ordered Visitations of all English and Scottish dioceses, which turned up evidence of widespread Puritan practices. To counteract this threat, Laud insisted that observance of his policies was synonymous with loyalty to the king. Among the particularly despised measures he enacted were a revival of James I's measures against the "keeping of the Sabbath," a measure that now excited even more outrage in the 1630s than it had in 1618. Laud's measures re-installed the force of James I's proclamation allowing Sunday games and the opening of public houses. These measures were explained to the country in the so-called *Book of Sports* that King Charles issued in 1633. Laud's other directives sought to redecorate English churches with costly furnishings; in the past generations many of these churches had been whitewashed as Puritan ideas were in the ascendant. While his measures were popular among some quarters, they were greeted as "godless popery" among the Puritans, who generally were more organized in their opposition to state policies than moderates or the High Church party that supported such initiatives. By 1639, his efforts to establish an Anglican-style worship in Scotland produced the brief, but vicious "Bishop's War" in that country, a precursor to the great civil conflicts that were soon to come to England.

THE LONG PARLIAMENT. Matters of church and state were to clash in the years after 1640, when Charles I was forced once again to call Parliament in an effort to alleviate his chronic shortage of revenues. The first meeting that the king convened in the spring of the year, however, lasted only three weeks, when negotiations on both sides broke down and the king dismissed them. A few months later, though, Charles's financial situation had grown even more perilous and he summoned a second Parliament. This body was to become known as the Long Parliament because it continued to sit in some form or other until 1660. It eventually sentenced Archbishop Laud, Charles I, and other royalist supporters to death. In the months that followed its first deliberations, tensions between the Parliament and the king rose, thus necessitating Charles' departure from London in 1642. He raised an army, but in the capital the Puritan oppo-

Death warrant of King Charles I of England, dated 29 January 1649, and bearing the seals of the members of Parliament that signed it. © ADAM WOOLFITT/CORBIS.

sition began to exact its vengeance upon Charles's religious policy. Measures were enacted that did away with the office of the bishop and established a style of Presbyterian church government similar to that in Scotland. Late in 1644, the archbishop of Canterbury was imprisoned on a bill of attainder, a Parliamentary writ, and he was tried, convicted, and executed soon afterward. By this time forces of Parliament and the king were already skirmishing on battlefields in the north and west of England. In 1645, though, the conflict took a new direction when Parliament raised the New Model Army, an exemplary fighting force. In the months that followed, the leadership of the New Model army, particularly Oliver Cromwell, began to exert its influence over the religious situation. The king took up residence in Oxford not far from London, while the New Model Army laid siege to his outpost. Charles escaped for a time, but in 1647, the Scottish forces that controlled the retreat where he was hiding handed him over to Parliament. Yet again he escaped, and continued to lead a number of intrigues against the government. Finally, in August of 1648 the king was recaptured, tried, and on 30 January 1649, he was put to death. Thus the bitter rivalries over religious policies and political power that had characterized much of the reign of both of the Stuart kings seemed to come to an end. Until 1653, England continued to be ruled by the Long Parliament, but increasing disagreements and dissension in that body prepared the way for the rise of the Puritan leader and New Model Army hero Oliver

Cromwell, who served as Lord Protectorate of the English Commonwealth until his death in 1658. Social and religious unrest persisted under Cromwell's government, with ever more diverse groups of dissenters multiplying throughout the country. Some of the most famous groups that multiplied at the time were the Quakers (who recognized the lordship of the Holy Spirit and rejected Christian laws), the Levellers (who advocated the elimination of all elements of rank and social privilege), the Diggers (who supported the abolition of private property), the Ranters (who rejected all forms of religious ritual), and the Fifth Monarchy Men (an apocalyptic group who argued for the abolition of taxes). Most of these groups actively worked against the regime and, coupled with the actions of Puritan fanatics, the increasingly tangled religious and political situation came more and more to discredit the Commonwealth's rule. In truth it must be admitted the Cromwell showed the wisdom of an enlightened despot in dealing with English society at a very troublesome period. Despite his Puritan religious convictions, Cromwell was a friend to George Fox, founder of the Quakers, and he protected Quakers from outbreaks of sporadic violence. At the same time the tide of Puritan extremism and religious radicalism that rose in the years of the Protectorate, and which began to spiral out of control, meant that his regime eventually came to be painted with the same broad brush of despotism that had once tarnished Charles I. And in the two years following his death in

George Fox, founder of the Society of Friends. © ARCHIVE PHOTOS, INC. REPRODUCED BY PERMISSION.

1658, the vacuum of authority in England meant that even the generals of Cromwell's New Model Army began to realize that a return to the monarchy was preferable than the contemporary drift of affairs. Thus the way was prepared for the Restoration that occurred in 1660, an event that paved the way for the re-establishment of Anglicanism in England but at the same time did little to resolve the lingering issues of religious dissent in the country.

SOURCES

Edward C. E. Bourne, *The Anglicanism of William Laud* (London: Society for the Propagation of Christian Knowledge, 1947).

Charles Carlton, *Archbishop William Laud* (London: Routledge and Kegan Paul, 1987).

Christopher Hill, *Society and Puritanism in Pre-Revolutionary England* (New York: Schocken Books, 1967).

Peter Lake with Michael Questier, *The Antichrist's Lewd Hat: Protestants, Papists and Players in Post-Reformation England* (New Haven, Conn.: Yale University Press, 2002).

Nicholas Tyacke, *Anti-Calvinists: the Rise of English Arminianism, 1590–1640* (Oxford: Oxford University Press, 1987).

Michael Walzer, *The Revolution of the Saints* (Cambridge, Mass.: Harvard University Press, 1965).

SEE ALSO *Literature: English Literature in the Early Seventeenth Century*

THE RESTORATION SETTLEMENT IN ENGLAND

THE KING RETURNS. In 1660, Charles II (r. 1660–1685), son of the beheaded Charles I, was invited to return to England to claim his throne, and as part of the settlement that "restored" the monarchy, the Church of England was again established throughout the country. The legislation that in the Puritan years had established a Presbyterian style of church government was rescinded and English bishops were given back control over their dioceses. As part of the Restoration Settlement, those surviving members of the Long Parliament (1640–1660) were officially dismissed, and in their place a new body that became known as the "Cavalier" Parliament was summoned. Over the next few years it considered many questions about religion. In many of its pronouncements the Cavalier Parliament sought to turn back the clock as much as possible and re-establish the Church of England so that it resembled the church that had existed in the 1630s. Thus in 1662, a revised *Book of Common Prayer*, similar to that of Elizabeth I's reign, was reissued and made mandatory throughout England. As a result Puritans were forced to consider whether they could in good conscience remain in the Church of England, and deep splits emerged in the movement between those who accepted the restored prayer book, and those who rejected it. For those who rejected it, they were increasingly isolated into the same ranks of dissenters and sectarian groups that had flourished with such vigor and been so problematic to their movement during the period of Cromwell's Protectorate. All those who now rejected the national church—whether they were Puritan, Quaker, Baptist, or from any of a number of other dissenting groups—now came to be known as Nonconformists. This designation developed as a result of the "Act of Uniformity" of 1662 that restored the *Book of Common Prayer* to its hallowed place in the Church of England. Anyone who refused to conform to the requirements of the act—which included swearing allegiance to the monarch and taking communion according to the prayer book's ritual—was now considered a Nonconformist. In tandem, the stipulations of this measure and the Corporation Act that had preceded it one year earlier deprived Nonconformists of any role in English government, the

a PRIMARY SOURCE *document*

A LANDMARK OF CHRISTIAN DEVOTIONAL LITERATURE

INTRODUCTION: During the seventeenth century, Protestant societies in northern Europe witnessed an explosion of literary achievement. Prompted by the quiet introspection that Protestantism advocated, preachers, ministers, and lay Protestants began to produce devotional writings of unparalleled beauty and depth. John Bunyan (1628–1688), a Puritan who had fought in the English Civil Wars on the side of Parliament, was one of these great literary figures. With the Restoration of the Stuart monarchy, he was imprisoned for his religious dissent, but later freed. During his imprisonment he wrote his masterpiece, *Pilgrim's Progress*, which was first published in 1678. It became an immediate success. The work tells of the progress of the character Pilgrim through the trials of this world and his eventual reception into Heaven. In the present passage Bunyan styles the world as "Vanity Fair," the realm of the devil. Thus he repeats a central message Protestantism had propounded since the earliest days of the Reformation: that the human realm is controlled by Satan, and as the Christian travels through this depravity he can only be redeemed through God's grace. In recounting the woes of the world, or "Vanity Fair," Bunyan is careful to include England among the few countries that have stood up to the Devil's henchman, the pope, but he nevertheless insists that even the Protestant countries of Europe are controlled by Satan's minions. *Pilgrim's Progress* had an enormous impact on English literature, and in the nineteenth century, the great novelist William Makepeace Thackeray alluded to "Vanity Fair" in his famous novel of the same name.

Then I saw in my Dream, that when they were got out of the Wilderness, they presently saw a Town before them, and the name of that town is *Vanity*; and at the Town there is a fair kept, called *Vanity-Fair*. It is kept all the year long; it beareth the name of Vanity-Fair, because the Town where it is kept is lighter than Vanity, and also because all that is there sold, or that cometh thither, is *Vanity*. As is the saying of the wise, *"All that cometh is vanity."*

This Fair is no new-erected business, but a thing of ancient standing. I will show you the original of it.

Almost five thousand years agone, there were Pilgrims walking to the Celestial City, as these two honest persons are: and *Beelzebub, Apollyon,* and *Legion,* with their Companions, perceiving by the path that the Pilgrims made, that their way to the City lay through this *Town of Vanity,* they contrived here to set up a Fair; a Fair wherein should be sold *all sorts of Vanity,* and that it should last all the year long. Therefore, at this Fair are all such Merchandize sold as Houses, Lands, Trades, Places, Honors, Preferments, Titles, Countries, Kingdoms, Lusts, Pleasures; and Delights of all sorts, as Harlots, Wives, Husbands, Children, Masters, Servants, Lives, Blood, Bodies, Souls, Silver, Gold, Pearls, Precious Stones, and what not.

And moreover, at this Fair there is at all times to be seen Jugglings, Cheats, Games, Plays, Fools, Apes, Knaves, and Rogues, and that of every kind.

Here are to be seen, too, and that for nothing, Thefts, Murders, Adulteries, False-swearers, and that of a blood-red colour.

And, as in other Fairs of less moment, there are the several rows and Streets under their proper names, where such and such Wares are vended; so here, likewise, you have the proper places, Rows, Streets, (viz. Countries and Kingdoms,) where the Wares of this Fair are soonest to be found. Here is the *Britain* Row, the *French* Row, the *Italian* Row, the *Spanish* Row, the *German* Row, where several sorts of Vanities are to be sold. But, as in other Fairs, some one commodity is as the chief of all the Fair; so the Ware of Rome and her Merchandise is greatly promoted in this Fair; only our English nation, with some others, have taken a dislike thereat.

SOURCE: John Bunyan, *Pilgrim's Progress*. (London: Nathanael Ponder, 1681): 147–150.

church, and the universities. This legislation thus had a devastating effect on Nonconformists, as more than 1,900 clergymen refused to take the required oath and to receive communion according to the Anglican rite, and were ejected from their positions.

THE CLARENDON CODE. To make sure that these Nonconformist clergy did not begin to lead churches that would compete with the Church of England, the Cavalier Parliament passed two more statutes. The Conventicle Act (1664) prohibited all Nonconformist religious services, outlawing all religious assemblies of more

than five unrelated adults in which the *Book of Common Prayer* was not followed. Despite these measures Nonconformists continued to practice their religion, but as dissenters they came to be increasingly reliant on their neighbors, who often decided not to report their offenses, or on the tolerance of local authorities that might refuse to uphold the laws. To try to eliminate Nonconformism, Parliament pioneered new measures. In the Five Mile Act of 1665 the body aimed to sever any connection between Puritan preachers and their former congregations. This measure prohibited clergymen who

had been removed from a church for nonconformity from preaching anywhere within five miles of that church. And in the Second Conventicle Act of 1670 they adopted a page from the handbook of the medieval Inquisition. They lured Englishmen and women into informing on Nonconformists by promising them a share of the profits that accrued from the confiscation of dissenters' estates as well as those of anyone who was convicted of aiding them. In sum these measures came to be known collectively as the Clarendon Code, after the Earl of Clarendon, then Charles II's first minister, who had formulated them.

CHARLES II'S OPPOSITION. The chief opposition to the religious policies of the Cavalier Parliament came not from the ranks of defeated Nonconformists, but from King Charles II. How deep Charles' Catholic convictions ran has remained a subject of debate among historians for generations, but he does appear to have been determined to bring about some degree of toleration for Catholics, and in exchange for this, he was willing to offer some degree of toleration to Nonconformists. In 1660, before he was invited to return to England, Charles had issued a "Declaration" from his residence in the Dutch city of Breda, an outline of the agenda he might follow if restored to the monarchy. There he set out freedom of religion for "tender consciences" as one of the measures he would pursue. Throughout his reign he continued to return to Parliament regularly with a request for a general amnesty for Protestant dissenters as well as Catholics, but the body always turned down these measures. In 1672 Charles felt strongly enough on the matter to pronounce his own Declaration of Indulgence that rescinded the penal laws against Nonconformists, including Catholics. This Declaration of Indulgence allowed Catholics to worship privately at home, while insisting that Protestant Nonconformists acquire a license to hold public worship services. One notable beneficiary of Charles' initiative was the writer and Nonconformist minister John Bunyan, author of *Pilgrim's Progress*, the most profound and influential religious parable ever written in English. In 1672, Bunyan had already been in jail for twelve years for holding a service that was not in conformity with the rites of the Church of England. He was set free and permitted to purchase a license to preach. He then took over duties as the pastor of the separatist or Independent Church of Bedford. While the Declaration of Indulgence helped some Protestants like Bunyan, it was throughout the country as a ploy allowing for the outright practice of Catholicism, a suspicion that was confirmed for many in 1673 when the king's brother and heir, the future James II, publicly declared

himself a Catholic. When Parliament met again that same year, it declared that only it had the right to "suspend" penal statutes that touched on religious issues. Around the country attacks on Catholics increased, and so Charles II, correctly reading the political climate, canceled his Declaration. The most significant consequence of Charles' initiative was that from this point forward, various Protestant groups throughout England began to see that they had a common cause in keeping England free of Catholicism. In 1673, these perceptions were not yet strong enough to wipe away the great animosity that still existed between the Nonconformists and Anglicans, but they were to grow over the following decades. Besides moving against Charles II's toleration measures, the Parliament of 1673 also passed the Test Act, a law that required every individual holding government office to pass the test of receiving communion according to the Anglican rite. Another measure put forward in Parliament at this time, but never passed, sought to draw a distinction between Catholics and Protestant Dissenters by granting the latter limited toleration, while continuing to forbid the practices of the former.

THE SUCCESSION. From the moment he announced his decision to practice as a Catholic in 1673, James's religion became the central dispute in English politics. As a result of the Test Act, the future king had been deprived of a number of his political offices and in the last years of Charles' reign, Protestant fears about the prospective king reached historic proportions. Rising anxieties were capped by the "Popish Plot" of 1678, when two schemers announced that they had come across information about a plot concocted by some Jesuits to assassinate the king, foment rebellion in Ireland, and place a Catholic on the English throne. The identity of this Catholic claimant was not revealed, but there was little doubt in most people's minds that it was James. This "Popish Plot" has since been revealed as a complete fabrication, but that did not stop Parliament from embracing the story, and 35 people from being executed for complicity in the plot. In the aftermath of the Popish Plot, a movement began in the English Parliament to "exclude" James from the succession to the throne. England's first political parties, in fact, coalesced around this very issue. The "Whig" party developed at this time from its support of the exclusion of James from the succession. To garner popular support for their program, the Whigs announced that they were in favor of rights for Protestant dissenters. At about the same time the "Tory" party emerged to support James's right to the throne. For the Tories, the Whigs' attempts to exclude James evoked the specter of the Puritan Civil Wars and the

a PRIMARY SOURCE *document*

RELIGIOUS DIVERSITY AS A STRENGTH

INTRODUCTION: The French Enlightenment thinker Voltaire spent several years in England while exiled from France. When he returned to his native country, he published a series of letters on his experiences abroad. These letters helped to establish the Enlightenment's deep and abiding affection for English institutions and customs. In the sixth of these *Letters on England* Voltaire commented on the religious diversity of the country and he identified this plurality of religions as one of England's great strengths.

The Anglican religion only extends to England and Ireland. Presbyterianism is the dominant religion in Scotland. This Presbyterianism is nothing more than pure Calvinism as it was established in France and survives in Geneva. As the priests in this sect receive very small stipends from their churches, and so cannot live in the same luxury as bishops, they have taken the natural course of decrying honours they cannot attain.

Although the Episcopal and Presbyterian sects are the two dominant ones in Great Britain, all the others are perfectly acceptable and live quite harmoniously together, whilst most of their preachers hate each other with almost as much cordiality as a Jansenist damns a Jesuit.

Go into the London Stock Exchange—a more respectable place than many a court—and you will see representatives from all nations gathered together for the utility of men. Here Jew, Mohammedan and Christian deal with each other as though they were all of the same faith, and only apply the word infidel to people who go bankrupt. Here the Presbyterian trusts the Anabaptist and the Anglican accepts a promise from the Quaker. On leaving these peaceful and free assemblies some go to the Synagogue and others for a drink, this one goes to be baptized in a great bath in the name of Father, Son and Holy Ghost, that one has his son's foreskin cut and has some Hebrew words he doesn't understand mumbled over the child, others go to their church and await the inspiration of God with their hats on, and everybody is happy.

If there were only one religion in England there would be danger of despotism, if there were two they would cut each other's throats, but there are thirty, and they live in peace and happiness.

SOURCE: Voltaire, *Letters on England.* Trans. Leonard Tancock (Harmondsworth, England: Penguin Books, 1980): 40–41.

Commonwealth. The fear of revolution proved to be much greater among English elites than the fear of Catholicism. Charles was able to defeat the Whigs and those bills they put forward calling for exclusion of his brother from the throne. But for the first time in English history, a political group had sought the support of the Dissenters. In the years that followed those who hoped to shepherd their plans through Parliament were to realize the powerful support they might amass by playing to the issues that religious dissent posed.

A CATHOLIC KING. Charles II died in 1685, professing Catholicism on his deathbed. A nation of Protestants watched anxiously as the Catholic James II was crowned king. It became obvious that James was not willing to let things be, pushing whenever and wherever he could to grant legal rights to Catholics, and in the process, Protestant dissenters. After the disaster of the Declaration of the Indulgence, Charles' ministers had followed a strategy of focusing the attentions of Parliament and the nation on the past as well as on the presumed future dangers that Protestant dissenters posed. James reversed this strategy, and sought to make the case to Protestant dissenters that it was in their best interest to join forces with the Catholics. In line with this strategy,

he proposed in 1687 a new version of the Declaration of Indulgence, but this, like almost all of James's initiatives, served only to rally opposition against him. His efforts aimed to drive a wedge between Anglicans and Dissenters and prompted the Anglican clergy's protests. They insisted that they did not condemn the king's Declaration from "any want of tenderness" toward the Dissenters, but that they opposed it because they believed James did not have the authority to issue it. Despite this show of opposition, the Declaration was allowed to stand, since at the time, James was in his fifties and without an heir. Most members of England's political elite fully expected that the throne would soon pass to one of the king's Protestant daughters. Soon, though, it was announced that James's second wife, an Italian and Catholic, was expecting, and the thought of a Catholic heir was now too much for the English elite. In 1688, representatives of Parliament invited James's daughter Mary and her husband William, who was the stadtholder of Holland, to take the English throne. James escaped England and found safe haven at the court of Louis XIV in France. Back in England, the Convention Parliament that was called to sit in 1689 passed a Toleration Act. This act permitted Protestant dissenters the right to their own churches and ministers. Dissenters still were not allowed

civil rights, but they were no longer persecuted for their faith. Thus the long battles between Puritans, Anglicans, and Papists in England drew to a close.

SOURCES

Kenneth D. Brown, *A Social History of the Nonconformist Ministry in England and Wales* (Oxford: Oxford University Press, 1988).

Kenneth H. D. Haley, *Politics in the Reign of Charles II* (Oxford: Basil Blackwell, 1985).

James Rees Jones, *The First Whigs. The Politics of the Exclusion Crisis, 1678–1683* (London: Oxford University Press, 1961).

———, *The Restored Monarchy, 1660–1688* (Totowa, N.J.: Rowman and Littlefield, 1979).

James Munson, *The Nonconformists: In Search of a Lost Culture* (London: SPCK, 1991).

CATHOLIC CULTURE IN THE AGE OF THE BAROQUE

THE RISE OF EVANGELICAL FERVOR. During the later sixteenth century both Protestant and Catholic reformers had begun to redouble their efforts to indoctrinate their laity in the tenets of their religions, and by the first decades of the Baroque era, rising evangelical fervor was evident in the efforts of devout Calvinist, Lutheran, and Catholic writers, artists, and theologians. One key element of these new forces was that all tried to win over those who were relatively uncommitted to the cause of a particular religion so that they would take up its standard. From the first, the new propaganda that resulted from these efforts was composed of both positive and negative strains. On the one hand, the new European devout aimed to indoctrinate people against competing religious positions, and so they frequently condemned the ideas of their opponents, not just as wrong headed, but as a dangerous and subversive disease, or in their own words "heretical poison." On the other, the Protestant and Catholic devout sponsored new forms of art, architecture, and literature that were designed to propagate a positive image of their religion's teachings. Certainly, the negative efforts to "evangelize" Europe's population were most evident in the decades leading up to the Peace of Westphalia, that is, the period of the most intensive fighting in the continent over the issues the Protestant and Catholic Reformations generated. In these years a flood of polemical tracts, plays, and printed broadsides appeared condemning the ideas and actions of competitors. At the same time positive assessments of the strengths of each religion were also being generated

that left their mark on the visual arts, architecture, and literature of the age. As religious tensions gradually subsided in the years following the Peace of Westphalia, the heightened fervor evident in the early seventeenth century tended to lessen. At the same time the legacy of a Europe divided into opposing religious camps persisted, leaving its mark on the culture of Protestant and Catholic regions. One result of this continuing trend was that by 1700, one's identity and behavior were, in large part, shaped by whether one had grown up in a Lutheran, Calvinist, or Catholic state, for in each of these a different kind of culture now flourished.

ROME TRIUMPHANT. In the seventeenth century Roman Catholicism emerged triumphant in much of Europe, winning back lands, particularly in Central and Eastern Europe, where Calvinism and Lutheranism had acquired many adherents during the sixteenth and early seventeenth centuries. This trend continued in the later seventeenth and eighteenth centuries, as a number of princes in Germany and Central Europe re-converted to Catholicism, thus bringing their lands into the Roman orbit. While Scandinavia, much of Germany, parts of Switzerland, the United Dutch Provinces, England, and Scotland remained Protestant, the majority of Europe was now Catholic. Within this vast and diverse religious sphere, one of the most distinctive features of cultural and intellectual life was a cosmopolitan internationalism. As Rome began to revive as a great cultural center in the seventeenth century, artists and architects from throughout the Catholic world made their way to the ancient city, and the new patterns of Baroque painting and church building spread relatively quickly throughout Catholic regions. The traffic between Rome and the provinces of the Catholic world, though, also moved in the opposite direction. While Catholic artists like Peter Paul Rubens studied in Rome and returned to their own regions to promote the new dramatic intensity common to Baroque paintings, Italian artists were highly prized in Catholic courts and cities throughout Europe. The interconnectivity of the Catholic world in the seventeenth century thus became one of its most distinctive features. Throughout most of the seventeenth century Rome and Italian cities like Venice dominated style and fashions in art throughout the Catholic world, but gradually new centers emerged—particularly in France and Spain—that were to produce movements that spread quickly. The Jesuit order, with its systems of schools and seminaries in every reach of the Catholic continent, was also among the many important forces that nourished cultural connections and exchanges between different regions in this large world.

A Catholic religious procession in seventeenth-century Rome. **MARY EVANS PICTURE LIBRARY.**

THE AESTHETICS OF CATHOLIC DEVOTION. By far, the dominant aesthetic Baroque Catholicism favored was one in which the senses of sight and touch predominated and in which the Catholic devout concentrated on the symbols of the faith. Since the rise of the Catholic Reformation in the sixteenth century, devotional writers like St. Ignatius Loyola, founder of the Jesuit order, and St. Teresa of Avila, a Spanish mystic, had recommended the necessity of establishing mental discipline in prayer. In contrast to the relatively unregulated world of benedictions and meditations of the later Middle Ages, the Jesuit order, in particular, developed the idea of a spiritual retreat. By relying on St. Ignatius's *Spiritual Exercises*

they created the idea of a period of isolation in which the disciple could meditate and harness the imagination to avoid sin once he or she returned to society. In these sessions the participant learned how to parse out the hidden meanings behind things and events, and to rely on the senses of hearing, touch, and sight to draw closer to God. Catholics eagerly embraced the new devotions that flourished in this and similar veins in the seventeenth century, all of which emphasized in some way the powers of meditation. One devotion that flourished at this time was to the "Agonizing Death of Jesus Christ." Sponsored again by the Jesuits, it appeared in the mid-seventeenth century and quickly spread. By the end of

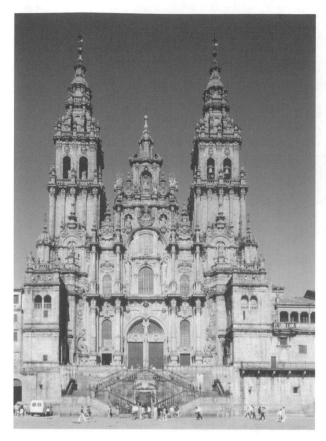

Front view of the Church of Santiago de Compostela in Spain, a site that remained an important pilgrimage in early-modern Europe. CORBIS. REPRODUCED BY PERMISSION.

the seventeenth century there were chapels dedicated to the devotion in parishes everywhere throughout Catholic Europe. The devotion centered around weekly or monthly periods of meditation during which participants contemplated how Christ died so as to prepare them for a "good" death. Like other new devotions, the devotion to the "Agonizing Death of Jesus Christ" was propagated through thin printed books that laid out the liturgy that was to be followed weekly. These texts demanded that the group spend a certain designated amount of time each week meditating on common themes before performing other good works. These good works, in turn, reinforced one of the symbolic themes that the group had meditated on in the days and weeks before.

ART AND ARCHITECTURE. The contours of much of Catholic devotional life in the seventeenth-century thus emphasized the importance of mental discipline and the use of the senses, particularly vision, to approach God. The importance of forming mental pictures of events like the Agonies of Christ helped to foster a climate in which artistic images and architecture played a vital role, for these arts were seen as helping to sustain

and deepen one's devotion. It is hardly surprising, then, that the seventeenth and early eighteenth centuries were great ages of church building and religious art in the Catholic world. The sheer number of church building and remodeling projects that were begun in these years still manages to astound the modern observer. In Catholic cities and parishes throughout the Continent, construction crews were in almost constant motion to refurbish older churches and build new monuments intended to satisfy and sustain the visual and sensual piety of the Catholic faithful. While the Jesuits and other religious orders commissioned and paid for a great deal of this art, the remodeling of parish churches was a task undertaken and financed at the local level by parishioners. Thus the sheer number of monuments points, in part, to the widespread popularity of Catholic Baroque piety. In Central Europe, the great resurgence in artistic production and church architectural projects was postponed for a generation or two longer than in Italy, Spain, and France because of the depression the Thirty Years' War produced. But when this resurgence began in the decades following the Peace of Westphalia (1648) it soon transformed the religious landscape of the region. In much of Central Europe, particularly in southern Germany, Catholics continued to live side-by-side with Protestant populations, and the building of dramatic Baroque churches thus became a direct counterattack on the sensibilities of Protestants, who worshiped in surroundings that were far more restrained, even dour. Throughout the region most churches were either reconstructed or refurbished in the Baroque style in the generations following the Thirty Years' War. While many projects were commissioned and paid for by religious orders, far more were financed at the local level. In this way the typical parish church in the region acquired the notable features of the Baroque: a sense of dramatic climax, a sumptuous and ornate ornamentation, and a plethora of religious images that expressed the rising popularity of modes of piety that aimed at mental discipline.

RITUAL AND DISPLAY. Another feature of Baroque piety that has long been noted by scholars was the rising affection for pilgrimages, processions, and other rituals that displayed and defended elements of Catholic teaching. During the sixteenth century the Protestant reformers had generally shared distaste for much of the ritual formalism of the medieval church, and they had often attacked displays of piety like processions and pilgrimages as vain and useless. As the Catholic resurgence began to heat up in Europe at the end of the sixteenth century, pilgrimage shrines began again to attract thousands of pilgrims in the Catholic world. While many

made the journey to great European centers of pilgrimage, like Rome or Santiago di Compostella in Spain, by far the most important centers of such devotion were local ones. Every Catholic region in Europe came in these years to possess a large number of local shrines: some quite large and attracting pilgrims from throughout the state, others considerably smaller and having only a regional following. One interesting feature of many of these seventeenth-century shrines was their attempts to copy and imitate developments from other parts of the Catholic world. In the sixteenth century one of the most popular devotions throughout Europe had been the pilgrimage to the Holy House at Loreto in northern Italy, a shrine that since the later Middle Ages had alleged to possess the dwelling in which Mary, Joseph, and the young Jesus had lived. During the mid-sixteenth century the Jesuit Peter Canisius had popularized this devotion throughout Europe by publishing the Laurentian Litany, a collection of prayers that had been found in the house and that alleged to have been written by the Virgin Mary. The popularity of the Litany sustained the Italian shrine as a place of popular devotion, but it also bred numerous "copies" of the Loreto chapel and its house throughout Europe, as pilgrims visited the site and wished to have a similar place of devotion nearby. Loreto was just one of many similar devotions that spread throughout the continent in this way, as Catholics in one region copied religious images, shrines, and other elements of Catholic devotion that had proven to be beneficial elsewhere. Journeys to these new centers of devotion were often undertaken in processions, with entire parishes making the trip to a local shrine on some mutually agreed day, usually in the summer months. But processions on saints' days or on major church feasts staged at home in the village, as well as other rituals like the blessing of animals and fields were common events throughout the Baroque Catholic world, too.

SOURCES

Louis Chatellier, *The Europe of the Devout* (Cambridge, England: Cambridge University Press, 1989).

Marc Forster, *Catholic Revival in the Age of the Baroque: Religious Identity in Southwestern Germany, 1550–1750* (Cambridge: England Cambridge University Press, 2001).

Ronnie Po-Chia Hsia, *The World of Catholic Renewal, 1540–1770* (New York: Cambridge University Press, 1998).

Hubert Jedin and John Dolan, eds., *The History of the Church in the Age of Absolutism and Enlightenment,* vol. 6 of *The History of the Church* (New York: Seabury Press, 1981).

Michael Mullett, *The Catholic Reformation* (London: Routledge, 1999).

John W. O'Malley, ed., *The Jesuits: Culture, Science, and the Arts, 1540–1773* (Toronto: University of Toronto Press, 1999).

SEE ALSO *Architecture: The Renaissance Inheritance and Catholic Renewal; Architecture: The Rise of the Baroque Style in Italy; Visual Arts: The Counter Reformation's Impact on Art*

PROTESTANT CULTURE IN THE SEVENTEENTH CENTURY

PROTESTANT AESTHETICS. While significant differences continued to exist between Calvinists, Lutherans, and Anglicans, Protestant notions about art and culture differed vastly from their Catholic counterparts. Protestants generally placed a higher emphasis on the word and the sense of hearing than they did on visual stimuli. These developments resulted, in part, from the Protestant churches' elevation of the sermon, scripture reading, and the study of devotional works over and against the rich ritual life of the late-medieval Church. Of all the Protestant religions, only Lutheranism kept some place, although in a drastically reduced form, for the commissioning of religious art in churches. In the Calvinist churches of Switzerland, Scotland, and the Netherlands, the frescoes of the Middle Ages were destroyed with coats of whitewash. Stained glass, sculptures, indeed all art that tried to represent the biblical story or the history of the church was removed. A similar situation prevailed throughout much of England, where Puritan influence dominated from the late sixteenth century onward. Archbishop Laud's reintroduction of rood screens in English churches in the 1630s was one exception to this general trend. These traditional screens had been richly decorated, covered with wood sculptures and had obscured the High Altar from the congregations' view. The general furor that Laud's actions caused meant that rood screens were to be definitively eliminated in the wake of the English Civil Wars. They survive today only as a rarity in English churches. Thus in place of the rich ritualistic and intensely visual experience that the church had fostered in the Middle Ages and which expanded during the Catholic Baroque, Protestant worshippers were presented with a situation that was undoubtedly severe. Yet at the same time it was not without its own aesthetics. Great churches were built in Protestant Europe during the seventeenth and eighteenth centuries. In the wake of the Great Fire of London in 1666, Sir Christopher Wren, a prominent mathematician and scientist, turned his attentions to architecture

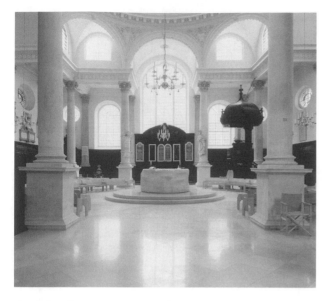

Sir Christopher Wren, interior of the church of St. Stephen Walbrook, London. © JOHN HESELTINE/CORBIS.

and planned an ambitious rebuilding of the city. Wren's own father had been a clergyman who had served the monarchy in the enviable position of Dean of Windsor, that is, he had been the administrator of one of the most important royal chapels in England. He understood that Protestant services called for interiors in which good acoustics allowed parishioners to hear the sermon and appreciate the service music. He rebuilt London's churches with clean sight lines, bathed them in light, and endowed these churches with spaces that provided a clear and unobstructed appreciation of the sermon, the central focal point of religious worship in these years. Wren's masterpiece, the great Cathedral of St. Paul's, was the largest church ever constructed in Protestant Europe and a truly noble building. If its interior today seems strangely unadorned—or in the words of Queen Victoria "dreary"—its aesthetic restraint attempted to remain faithful to one of the Reformation's central teachings: that the word of God, rather than human representations, should predominate in the life of the church. In many places where the new Protestant teachings were adopted, they gave birth to attempts like those of Wren. That is, Protestant architects labored to find ways to endow congregations with spaces of sufficient dignity that nevertheless held true to Reformation teachings.

THE SERMON. Still no one could argue that Protestantism's greatest achievements lay in the realms of art or architecture. Instead the monuments of the era were concentrated in literature, in sermons, and devotional works. The seventeenth century witnessed a great flowering of the sermon in both English and in German,

with this literary form reaching a level of complexity and sophistication from which it has consistently fallen since then. It became a common custom for devout Protestants to attend sermons almost every day of the week which were as much performed as they were spoken. Since they invariably involved disputes with other preachers, they resembled intellectual sporting contests. In Germany, the fashion for oratory gave birth to the custom in Lutheranism for elaborate funeral sermons, a genre that ministers in the church used to supplement their otherwise meager incomes. Governments regulated the fees that German ministers might charge to deliver a sermon at the funeral of a loved one, but the greatest of these literary productions were printed and circulated to mourners in the weeks after the funeral. They were collected and read in the months and years that followed. The most expensive kind of funeral sermon provided its listeners not only with a detailed exposition of biblical texts but also with a *Lebenslauf,* a summary of the deceased's life, which in many ways resembled a modern eulogy. Lutheran ministers used these short biographies moralistically to point out the pious virtues that the deceased had exhibited during his or her life. The surviving printed texts, of which more than 100,000 printed examples exist from the seventeenth century, points to the widespread popularity of sermons as a kind of entertainment, even if that entertainment occurred in the otherwise dark hours of a funeral.

HYMN SINGING. If the visual arts played a relatively minor role in Protestant churches during the seventeenth century, the era did witness an enormous flowering of religious music in those countries that adopted Reformation teachings. In German Lutheranism the age of the Baroque was also a great age of hymn writing, with thousands of hymns being written and regularly performed. In the course of the seventeenth century, these tunes, which were known then as chorales, grew steadily more complex in performance. Polyphony, orchestral accompaniments, and organ interludes were added to their performance in church, preparing the way for the still widely performed cantatas and chorales of figures like Johann Sebastian Bach (1685–1750). At the same time Calvinists rejected hymn singing and removed all instrumental music from religious ceremonies as a vestige of "popish" religion. To their minds, Christians only legitimately came together in order to pray and to listen to learned disputation on the Word of God. Although they might have wished that religious music completely disappear from the church, Calvinist ministers generally conceded some ground to its widespread popularity. They allowed the singing of the psalms set to simple tunes that were

a PRIMARY SOURCE *document*

OPPOSING TYRANNY

INTRODUCTION: Although the numbers of Calvinists in Europe remained small throughout the seventeenth century, their impact was far greater than the size of the movement. In later sixteenth-century French Calvinism, a theory of resistance to the state had already developed. In his *Vindicia contra tyrannos* (1579), Phillippe Duplessis-Mornay (1549–1623) had argued that the movement might oppose the actions of the king when royal authority violated true religion. Seventeenth-century Calvinists, as well as political theorists like John Locke, relied on the argument to counter the absolutist pretensions of kings. Duplessis-Mornay's work was reprinted in England during 1689 and used to justify the recent exile of the Catholic King James II (r. 1685–1688). This excerpt is from its later seventeenth-century English translations.

There was much danger to commit the custody of the church to one man alone, and therefore God did recommend, and put it in trust "to all the people." The king being raised to so slippery a place might easily be corrupted; for fear lest the church should stumble with him, God would have the people also to be respondents for it. In the covenant of which we speak, God, or (in His place) the High Priest are stipulators, the king and all the people, to wit, Israel, do jointly and voluntarily assume, promise, and oblige themselves for one and the same thing. The High Priest demands if they promise that the people shall be the people of God that God shall always have His

temple, His church amongst them, where He shall be purely served. The king is respondent, so also are the people (the whole body of the people representing, as it were, the office and place of one man) not severally, but jointly, as the words themselves make clear, being incontinent, and not by intermission or distance of time, the one after the other ...

It is then lawful for Israel to resist the king, who would overthrow the law of God and abolish His church; and not only so, but also they ought to know that in neglecting to perform this duty, they make themselves culpable of the same crime, and shall bear the like punishment with their king.

If their assaults be verbal, their defence must be likewise verbal; if the sword be drawn against them, they may also take arms, and fight either with tongue or hand, as occasion is: yea, if they be assailed by surprisals, they may make use both of ambuscades and countermines, there being no rule in lawful war that directs them for the manner, whether it be by open assailing their enemy, or by close surprising; provided always that they carefully distinguish between advantageous stratagems, and perfidious treason, which is always unlawful. ...

SOURCE: Phillippe Duplessis-Mornay, *Vindiciae Contra Tyrannos: A Defence of Liberty Against Tyranny or of the Lawful Power of the Prince over the People and of the People over the Prince.* Trans. Hubert Languet (London: Richard Baldwin, 1689; reprint, London: G. Bell and Sons, Ltd., 1924).

sung in unison. In the Church of England, Anglicans allowed music at both ends of the spectrum. In the simplest services influenced by Puritan sensibilities little or no music was performed. But at court and in London's greatest churches, elaborate service music often accompanied the celebration of worship.

DIARIES. The periods of quiet and introspection that seventeenth-century Protestantism afforded helped to inspire a new genre: the diary. The diary was particularly popular among Calvinists, whose church services and devotions were spare in the extreme and demanded that the faithful spend a great deal of time looking inward to examine their own consciences. Among Calvinists, diary writing fulfilled a role similar to that which it had played for figures like Saint Augustine. In his *Confessions* Augustine had pondered his spiritual autobiography, setting down his deepest and most inward thoughts to encourage readers to avoid his mistakes and to emulate whatever virtues he had achieved. By contrast, many Calvinist diaries were private affairs in which the writer

recapped his thoughts on a daily basis, setting down the spiritual trials he had faced and trying to see the hand of God in the events that he experienced that day. These diaries in turn became the source materials for the spiritual autobiographies that began to be published during this era. Aimed at inspiring others along the path of righteousness, these autobiographies narrated in minute detail the struggles of their authors with faith and its obligations. Modern sensibilities cannot grasp the spiritual edification Protestants received from these "play-by-play" accounts of another Christian's life. But over and over again, Protestants in the era recounted the "godly" inspiration that they derived from these accounts, contrasting this inspiration against the "popish" rituals of Catholics.

IMPACT OF CALVINISM. If the Jesuits dominated seventeenth-century Catholic piety, it was Calvinism that exercised the greatest force over the religion of seventeenth-century Protestants. While the number of territories in Europe that accepted Calvinism was quite

small and Calvinists found themselves at odds with kings and princes, the movement exerted an influence far greater than mere numbers suggest. Generally, Calvinism was a creed popular among the middling ranks of people in the city, those with incomes far above the poverty level, but who otherwise possessed little political power. In the countryside, the gentry and members of the minor nobility were often drawn to Calvinism. Even in Germany, where Calvinist influence was relatively minor, the appearance of Calvinist states prompted Lutherans to develop ways of imitating Calvinist piety for their parishioners to avoid disaffection. Peasants and urban workers were generally not drawn to the movement. At the same time, the men and women who embraced Calvinism were disciplined and focused, and thus the movement had an impact on society far greater than its numbers would suggest. The social character of Calvinism gave Protestantism a rebellious character on the international scene. Everywhere during the Age of the Baroque international Protestantism was the voice of political opposition, the voice of political challenge. It was a French Calvinist, Phillippe Duplessis-Mornay (1549–1623), who wrote the first political treatise that maintained subjects' rights to rebel. It was from Calvinists like Duplessis-Mornay that key seventeenth-century political theories were to be derived. In his *Vindiciae Contra Tyrannos* or *A Defense of Liberty against Tyrants* (1579) he argued that rulers entered into a contract with their subjects, and if a ruler did not live up to his contractual obligations then subjects might rebel. It was ideas like these that proved so troublesome to seventeenth-century kings, while at the same time these very Calvinist impulses helped to give birth to the ideas of figures like John Locke (1632–1704), who insisted that the contractual nature of government legitimated subjects' rights to rebel. Fueled with ideas like those of Duplessis-Mornay, Calvinist-inspired Puritans proved to be more than willing to sign the death warrant of King Charles I in England, and their criticisms of arbitrary government were only to grow in the decades that followed. The serious, sometimes dour piety of their most articulate leaders tended to spill out from their movement, helping to shape the religion and politics in all Protestant states at the time.

SOURCES

Richard S. Dunn, *The Age of Religious Wars, 1559–1715.* 2nd ed. (New York: Norton, 1979).

Paul C. Finney, ed., *Seeing Beyond the Word: Visual Arts in the Catholic Tradition* (Grand Rapids: Eerdmans, 1999).

Ronnie Po-Chia Hsia, *Social Discipline in the Reformation: Central Europe, 1550–1750* (London: Routledge, 1989).

Craig Koslofsky, *The Reformation of the Dead: Death and Ritual in Germany, 1450–1700* (New York: St. Martin's Press, 2000).

Larissa Taylor, ed., *Preachers and People in the Reformations and Early-Modern Periods* (Leiden, Netherlands: E. J. Brill, 2001).

SEE ALSO *Music: Oratorio and Cantata*

FREE WILL VERSUS PREDESTINATION IN THE DUTCH REPUBLIC

A COMMON PROBLEM. The establishment of state churches brought with it conflict and controversy among churchmen over official church doctrine. An issue that dominated the life of more than one church at the time was the question of the role of free will versus predestination in salvation. Proponents of free will insisted that individuals actively participated in their own salvation. Proponents of predestination argued on the contrary that salvation was a free gift from God and that individuals could do nothing to warrant it. Of concern for the promoters of free will was the responsibility of individual Christians for their salvation. If salvation came only from God, supporters of free will argued, then a Christian was under no obligation to live a righteous life. For their part, promoters of predestination countered that their doctrine was a logical one given the sovereignty of God over everything in Creation. To say that human beings had the capacity to earn salvation was heretical to them because it suggested that men and women had the power to dictate to God. This issue had been of major importance since the early years of the Reformation, and indeed it was an ancient dilemma in the history of the church, having produced bitter controversies in the later Roman Empire between St. Augustine, bishop of Hippo, and the Pelagians who were followers of the free will theologian Pelagius in the fifth century. Martin Luther, John Calvin, and other Protestant reformers had all upheld the Augustinian teaching of predestination and had outlawed any notion that works played a part in salvation. Yet the doctrine of predestination was a troubling one, and Protestant theologians continued to grapple with it in the seventeenth century, sometimes developing positions that were more akin to the notion of moral cooperation the Catholic church taught, i.e. the notion that Christians needed to participate in their salvation and perfect their faith through works. On the other side of the confessional divide, the issue was also of importance to Catholics, and in the seventeenth century many reached back to Augustine, finding in his doctrine of

a PRIMARY SOURCE *document*

REPORT ON THE STATE OF DUTCH CALVINIST CHURCHES

INTRODUCTION: In both the sixteenth and seventeenth centuries church and state officials relied on visitations, or inspection trips, to discern the level of religious knowledge and the condition of their local churches. In the early seventeenth-century United Provinces—that is, the modern Netherlands—these inspections revealed a low level of participation in many of the region's churches. Jakob Arminius and others who adopted his "free-will" point of view were responding to this situation, hoping to open up the Dutch church to greater numbers of people who felt alienated from the doctrines of Calvinism. As these documents make clear in the case of a visitation held in the city of Utrecht in 1606, many Dutch men and women were more drawn to the teachings and practices of Roman Catholicism than they were to Calvinism.

Rhenen. The minister there reported the reasonable condition of his church, though he complained that the services on Sunday were impeded by the buying and selling at the market, which was held then. Many of the children were not baptised in the church and since no one afterwards had any knowledge of the same baptism, great confusion might arise later. He also complained that some sort of private school was held in the monastery to the detriment of the Christian religion. He declared that he had not presented these complaints in order to invoke the help of their noble lordships, the States, but only to demonstrate the present condition of the church there, since he intended to seek such [assistance] from his own magistracy, who had also given him an undertaking to

remedy [matters] (which has also happened with other towns). …

Montfoort. The Minister reported the sorry state of the church there as a result of the manifold activities conducted by the Roman Church there; that there is still no organized church; that he administers the Supper twice a year, has few communicants, to wit only thirty in number; that previously 300 would attend (sometimes 500 or 600 on feast-days), but now only 100 because a certain priest, called *Heer* Hinderick, coming there from Utrecht, impedes the progress of the Gospel by holding mass, preaching baptising etc.; that the magistrate looks after poor relief, the school is middling: though the schoolmaster is of the Reformed religion, he uses books of all sorts.

Amerongen. The minister reported that his church was in a dismal state because (although a fair number attended, often between 100 and 150) there are few, indeed no communicants; that the church also, as regards its external condition, suffered from having been very badly ruined as a result of destruction inflicted by soldiers who had marched through. [He] complained that the congregation also leaves the church when baptism is administered before the public prayer and general blessing; that the superstitions associated with St Cunerus's Day are very detrimental to the religion; that the sexton only comes to church now and then; that he cannot lead the singing and also refuses to give any undertaking to do so; also believes that the schoolmaster teaches from books of all sorts, whatever comes to hand.

SOURCE: Alistair Duke, Gillian Lewis, and Andrew Pettegree, *Calvinism in Europe, 1540–1610: A Collection of Documents.* (Manchester: Manchester University Press, 1992): 196–197.

predestination an antidote to the teachings of the Jesuits and other orders of the Catholic Reformation who they felt had made the doctrines of human salvation too easy by overemphasizing human participation.

ARMINIANS VERSUS GOMARISTS. The first seventeenth-century confrontations about the nature of free will took place in the Calvinist churches of the Dutch Republic. On doctrinal issues, the Dutch Calvinist church, like all Calvinist churches, followed the lead of the church of Geneva, the church founded by John Calvin (1509–1564) himself. More than any other Protestant reformer, Calvin had made Augustine's teachings on predestination central to his theology and he had insisted upon a rigorous interpretation of the ancient theologian. For Calvin, it was essential for the Christian to understand that before the world itself existed, God had

chosen the souls that would see salvation, and also those that would be damned. There was nothing that any human being might do to alter these facts. What made Geneva unique among sixteenth-century European political entities was that it was ruled by a theocracy. The Consistory, the governing council of the Calvinist church of Geneva, was composed of both churchmen and lay elders. In meetings of the Consistory, churchmen had pride of place, and in general in Geneva temporal matters gave way to ecclesiastical concerns, not the other way around. But the exclusionary, anti-evangelical nature of the Calvinist message put off many Dutch Protestants. Likewise many lay Protestants took exception to the division between church and state advocated by the followers of Geneva. At the beginning of the seventeenth century, these groups found their spokesperson in Jacob Harmenszoon, who was known as Jacobus

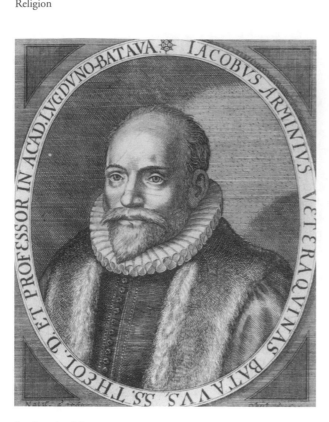

Jacobus Arminius. **MARY EVANS PICTURE LIBRARY.**

Arminius (1559–1609). Arminius was a theologian who taught at Amsterdam and Leiden. Arminius turned Calvin's formulation of the doctrine of predestination around, insisting that if God had created men and women to sin, a logical extension of Calvin's teachings on predestination, then God himself would have been the author of sin. Arminius sought to open up Dutch Protestantism to the idea of a broader, more inclusive church. He modified Genevan teaching on predestination by insisting that while salvation is a gift from God, that God only had foreknowledge of whether an individual would accept or reject his gift. He did not, in other words, determine that choice. Thus, in granting individuals the ability to embrace or ignore salvation, Arminius affirmed that individuals had free will. Arminius died in 1609, but the movement that coalesced around his ideas persisted, winning many adherents including Jan van Oldenbarneveldt (1547–1619), the civil leader of the Dutch Republic, and Hugo Grotius (1583–1645), perhaps the greatest legal scholar of the entire seventeenth century in Europe. Oldenbarneveldt and Grotius had been involved in negotiating the terms of peace with Spain, an effort that had drawn to them the enmity of Maurice of Nassau (1567–1625), military leader of the Republic. In 1610 Oldenbarneveldt, Grotius, and others published a "Remonstrance," a public defense of their views, and from that time onward supporters of the Arminian position became known as "Remonstrants."

THE OPPOSITION'S RESPONSE. To the opposition, the party led by Oldenbarneveldt and Grotius was a group of heretical Pelagians. Their ideas, in other words, marked a resurgence similar to those the great Augustine had condemned centuries before. The "Contra-Remonstrants," as the members of the opposing party were sometimes known, found their leader in the figure of Francisus Gomarus (1563–1641), so that they have often been called "Gomarists." On their side they enlisted the support of the powerful political leader Maurice of Nassau (1567–1625). Gomarus and Maurice upheld Calvinist principles of doctrine and church governance inherited from Geneva. Whether Maurice's defense of predestination and the authority of the church was prompted by spiritual concerns or by his desire for revenge against some Remonstrants has always been an open question. But he was a widely respected figure, and in July 1618 he used his army to suppress the Arminian party, arresting all public officials throughout the Dutch Republic who were known as Remonstrants, including Oldenbarneveldt and Grotius, and replacing them with Gomarists. As a result, the States General, the governing body of the Dutch Republic, was now purged of Arminians and it called for a synod, a general meeting of officials of the Dutch church, to decide the issue. The Synod of Dordrecht or Dordt met from November 1618 to May 1619. It was significant in that Calvinists from around Europe attended. Completely controlled by the Gomarists, the synod condemned Arminius' teachings as heresy and reaffirmed the teachings of the Genevan church, including those concerned with the separation of church and state. Maurice had Oldenbarneveldt convicted of treason and beheaded just after the conclusion of the synod. With the help of his wife, Grotius escaped from prison and went to live in Paris, where he entered the service of Sweden's king as an ambassador. Over the coming years Arminians were persecuted in the Dutch Republic or forced into exile. After Maurice's death in 1625, his brother and successor Frederick Henry pronounced a general amnesty. An Arminian church has continued to exist since that time in the Dutch Republic, but its influence on the national church ended with the Synod of Dordrecht.

SOURCES

Jacobus Arminius, *The Works of Jacob Arminius.* Trans. William and James Nichols (1853; Reprint, Grand Rapids, Mich.: Baker, 1986).

Carl Bangs, *Arminius: A Study in the Dutch Reformation* (Nashville: Abingdon Press, 1971).

Williston Walker, et al, *A History of the Christian Church.* 4th ed. (New York: Charles Scribner's Sons, 1985).

JANSENISM AND THE JESUITS IN FRANCE

CHARACTER OF THE JANSENIST MOVEMENT. The issue of free will and predestination also played a key role in the series of disputes that occurred between the Jansenists, followers of the Flemish Catholic theologian Cornelius Jansen (1585–1638) and members of the Jesuit order. In the Dutch Republic those who dissented from official church teachings had done so with the aim of broadening the national church, that is, they had desired to make it more inclusive and palatable to the laity by adopting the "free will" position. In France, by contrast, the dissenting Jansenists wished to narrow the possibilities of belief within the national church. In the Dutch Republic the plea had been for the national church to break free from the constraints of Calvinism's Augustinian position. But in France, the Jansenists aimed to embrace Augustinianism. The group was comprised of a self-consciously selected cadre of aristocratic elites and cultivated intellectuals centered around the prominent women's religious convent at Port Royal, on the southern fringes of Paris. From their homes in this section of the city, the Jansenists aimed to create a religious utopia, peopled with Catholics who held true to the teachings of Saint Augustine. Ultimately, this dream was brutally snuffed out when in 1709 Louis XIV sent troops to raze the abbey and remove every trace of its existence from the site. Yet while the dream was alive, Jansenism inspired French intellectual and artistic culture. The movement changed and developed over the course of the seventeenth century as it came to accommodate different groups of dissenters. In its original form, though, it aimed to undermine and destroy what its members felt was the Pelagianism of the Jesuit order.

INFLUENCE OF THE JESUITS IN FRANCE. In the first half of the seventeenth century, the French Catholic church was very much under the influence of the Jesuit religious order and its widely popular evangelization efforts. The Jesuit strategy was enormously successful in these years, but in the minds of many devout Catholics, Jesuit success came at the expense of key doctrines of the church. While opposition to the order arose for numerous reasons, the most controversial aspect of the Jesuits' work in the country had to do with their teaching concerning the sacraments of Confession and Communion. Since the thirteenth century the Roman church has required every believer to perform annually the confession of sins followed by the taking of communion. Although some devout Catholics participated in these sacraments more often than annually, most did not, and the requirement helped to give birth to the notion of "Easter Duties" among Catholics. The Jesuits desired to make the performance of Confession and the taking of Communion less of a psychological ordeal than it had been previously. They recommended frequent Confession and Communion, so that the sinner was not forced to recollect back over the course of the entire year to unearth his or her shortcomings. At the same time they applied concepts inherited from their founder St. Ignatius Loyola to teach that sin resulted from lapses in mental discipline. As spiritual advisers in the seventeenth century, the order frequently counseled the laity that lapses of sin were not tragic, but that they might be rectified by reapplying an even greater amount of mental discipline in the future. To their opponents, this approach to sin came with its own logical and theological problems. Sins, they argued, were not just mental lapses, but transgressions against God's laws and the teachings of the church. The Jesuits' critics thus accused the order of rationalizing away the spiritual and social consequences of sin so as to free the faithful from the stress of recognizing the magnitude of their wrongdoing. An even more important problem for Catholic theologians was the order's blatant disregard for the idea of predestination, a key traditional teaching of the church. In the Roman Catholic Church, as in the Protestant, predestination was considered an orthodox belief, although Catholics differed from Protestants in teaching on the matter since they insisted that those who were among the elect needed to make up for their sins by performing good works. The Jesuits went far beyond other Catholic movements of the day in characterizing the effort at mental discipline as, in and of itself, a pious good work that led to salvation, a belief that smacked to many of Pelagianism, the ancient heretical notion that human beings in effect saved themselves. In the early seventeenth century, Jesuit teachings concerning the sacraments and salvation were already exciting considerable controversy, yet each time prominent theologians and officials of the church complained to Rome, they were rebuffed. Powerful forces stood in defense of the Society of Jesus, and in 1611 Pope Paul V had declared any further discussion of the Jesuit teachings concerning predestination and salvation off limits. As he declared, both the Jesuit interpretation of predestination and that of their chief opponents were orthodox, and in the future the two sides were to refrain from accusing each other of heresy.

CORNELIUS JANSEN. Here matters were to rest until 1640, when the works of Cornelius Jansen came to

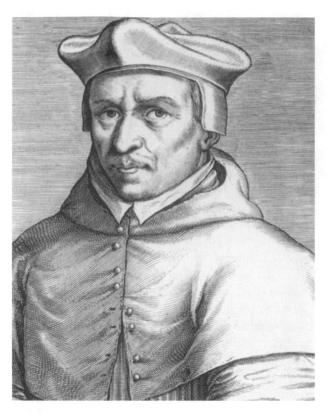

Engraving of Cornelius Jansen. **PUBLIC DOMAIN**.

be published. Jansen was an unusual figure to engender a theological revolution, for his entire life had been spent as a conscientious church official. In his youth he had been trained at the University of Louvain, a center of anti-Jesuit teaching and then he filled a variety of administrative posts in the church, dying in 1638 when he was the bishop of Ypres in what is now Belgium. Despite his position within the church establishment, he spent much of his spare time composing what he hoped was to be the ultimate proof of the Jesuits' heresies. Concerned with the papal order forbidding discussion of Jesuit teaching, and with what the Jesuits would do with his writings if they became public before he was finished, Jansen had a printing press installed in the episcopal palace in Ypres so he would not have to send copy out to have it set in press. Jansen did not complete his magnum opus until 1638, shortly before his death from the plague, and he left it to two of his assistants to see the work through final publication. The Jesuits heard about Jansen's work and sought to suppress it. But two years after Jansen's death his *Augustinus* nonetheless appeared. The work was composed in three books. In the first Jansen outlined the ideas of the heretical Pelagians and semi-Pelagians of the ancient church. In the second book, he presented the case for St. Augustine's teachings concerning predestination while arguing that the notion

of the freedom of the will was illusory. Like Augustine before him, and John Calvin in the sixteenth century, Jansen insisted that human beings' wills were enslaved to their sinful nature, and could hardly be considered to be free to choose salvation or damnation. In the third and final book, Jansen defended the concept of predestination by showing that it was not an illogical belief. He argued that God's power was so great that he might lead the will of the elect to salvation without the elect having any idea that they were being led. It was only in the work's appendix that Jansen compared the contemporary Jesuits to the ancient Pelagians. Jansen had taken the defense of predestination to an extreme, and because of the papal order forbidding discussion of the Jesuits' teachings concerning salvation, he left himself and anyone who read his book open to the charge of being "crypto-Calvinists." As the work soon became popular among the Jesuits' opponents, the Society responded by accusing Jansen's adherents of heresy.

SPREAD OF JANSENISM IN FRANCE. During his university days Jansen had made the acquaintance of a young French noble named Jean Duvergier de Hauranne (1581–1643), who has become known to history as the Abbé de Saint-Cyran, for the church office he held. The relationship between these two figures was lifelong and close, and their correspondence allows us to reconstruct the development of Jansen's ideas concerning Augustinian theology. By the 1630s Saint-Cyran had become one of France's greatest spiritual and devotional leaders, and he began to mount an attack on Jesuit teachings, primarily by developing an intensely austere devotional movement, which would only later become known as "Jansenism." Jansen had been concerned primarily with the Jesuits' theology, but Saint-Cyran had been trained in a Jesuit college as a youth and he understood that the problems with Jesuit teaching ran far deeper than just theological ideas. He thus labored to develop a piety that might counter the widely successful program of the Jesuits, with its emphasis on reassuring sinners and developing the practice of mental discipline. His austere devotions tried to eliminate any elements of psychological reassurance, and instead to build a Christian life that was a continual and prolonged cycle of penance and contemplation on one's wrongdoings. Where the Jesuits counseled frequent confession and the taking of communion so that eliminating sin became a routine affair, Saint-Cyran argued that the devout should prolong the cycle of penance that preceded taking communion as long as possible so that the sinner might concentrate on internal self-examination and ascetic rituals. In this way they might be adequately prepared to take communion.

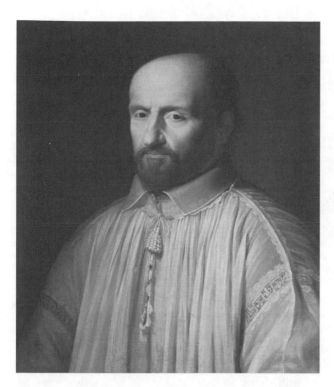

Portrait of the Abbé de Saint-Cyran. BRIDGEMAN ART LIBRARY.

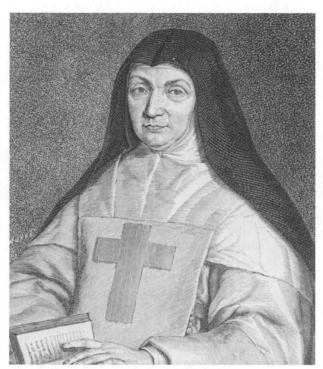

Portrait of the Jansenist abbess Jacqueline Marie-Angélique Arnauld, known simply as "Mère Angélique." MARY EVANS PICTURE LIBRARY.

Where the Jesuits' critics charged that the order cheapened the cycle of sin and forgiveness, Saint-Cyran and his developing movement in France aimed to make penance itself into a way of life. The teachings soon became widely admired for the austere discipline they inspired.

THE ARNAULD FAMILY. Before Saint-Cyran, the battle against the Jesuits had taken place primarily on an intellectual and academic plane. Saint-Cyran opened up a second front, providing Catholics who opposed the Jesuits with a devotional alternative. Three generations of one family, the Arnaulds, helped Saint-Cyran cement his religious ideas into a program for reform of the French Catholic Church. The Arnaulds had long been associated with the fight against the Jesuits. Antoine Arnauld (1569–1619), the patriarch of the family, was a lawyer who had successfully argued a case for the University of Paris against the Jesuits before King Henri IV, this case being, as it was joked in the seventeenth century, "the original sin of the Arnaulds." Antoine and his wife Catherine had twenty children, ten of whom survived to adulthood. Six of the ten were girls that became nuns in the abbey at Port Royal; two of them, Jacqueline Marie-Angélique Arnauld (1591–1661) and Jeanne-Catherine Agnès Arnauld (1593–1671), served as the monastery's most famous abbesses. One son, Robert Arnauld D'Andilly (1589–1674) eventually became a lobbyist for the Jansenist cause at French court. A second

son, Henri Arnauld (1597–1692), became the bishop of Angers and the most stalwart defender of the Jansenist cause among the clergy. A third son, Antoine Arnauld or "Arnauld le Grand" (1612–1694), as he is known in French history, introduced Saint-Cyran's devotional ideals to the broader French public through his book, *On Frequent Communion* (1643), one of the first works of theology to be written and published in French. *On Frequent Communion* attacked the Jesuit custom of encouraging frequent communion, and instead argued for a life engaged in penance preparatory to relatively infrequent communion. Three grandsons of the family— Antoine Le Maistre, Isaac-Louis Le Maistre de Sacy, and Le Maistre de Sacy—became "solitaires," or hermits who took over a country monastery that their aunt Marie-Angélique had deserted when she moved her convent to Port Royal in Paris. These three specialized in schooling, creating in their *Petits Ecoles*, or Little Schools, a celebrated alternative to Jesuit education. Saint-Cyran served as the spiritual guide to the entire Arnauld family, and channeled their considerable individual talents in the directions he thought best helped the cause. He began offering spiritual advice to Robert Arnauld D'Andilly in 1620, and through him he was introduced to Jacqueline Marie-Angélique, who was already known at the time as Mère Angélique, and was a woman of unconquerable

will who was determined to reform the relaxed life in her convent. When her sister published a tract in 1633, the monastery of Port Royal fell under suspicion of heresy, and Saint-Cyran sprang to its defense. From this date his relationship with Mère Angélique and Port Royal grew closer, and by 1636 Saint-Cyran had become the confessor and spiritual director of the institution. By this time, too, Saint-Cyran had already convinced Antoine Le Maistre, Mère Angélique's nephew, to become a hermit, and to devote himself to founding the "Little Schools."

THE MOVEMENT ATTRACTS SUSPICION. Cardinal Richelieu, chief minister of Louis XIII, realized the influence Saint-Cyran was having on the Arnauld family and, through the Arnaulds, on some of the best and brightest young minds in France. Saint-Cyran and Richelieu, in fact, had been good friends during their youth, so Richelieu sought to neutralize his old friend with the offer of a bishopric. When Saint-Cyran refused in 1638, Richelieu had him confined at the royal prison in Vincennes. Saint-Cyran remained there until Richelieu's death in 1643. Weakened by his five years of incarceration, he died a few weeks after being released. But even Saint-Cyran's imprisonment did not stop Port Royal from becoming a magnet for bright young Catholics serious about their devotional life. Jacqueline Pascal, sister of the famous mathematician Blaise Pascal (1623–1662), joined the nuns and her brother came to visit her in the convent frequently and was thus drawn into these circles. In 1653 Blaise had a religious conversion, a "night of fire" as he described it in his *Pensées* or *Thoughts*. He began to live in the countryside near the group's male hermitage as a result. Likewise, the painter Philippe de Champagne (1602–1674), who was ironically best known for his portrait of Cardinal Richelieu, came to share the group's convictions, and settled like Pascal near Le Maistre's hermits. Jean Racine (1639–1699), the great French dramatist and playwright of the day, also received his formal education in this group's "Little Schools." Later in life, Racine repudiated his past in order to build a career at court, but before his death in 1699 he requested to be buried in the cemetery near to the school he had attended in his youth.

PAPAL CONDEMNATION AND ROYAL SUPPRESSION. In France, Saint-Cyran's anti-Jesuit movement developed among French elites without any direct inspiration from Cornelius Jansen. Only through Saint-Cyran did Jansen help shape the French protest against the Jesuits, and Saint-Cyran's ideas were not so much derived from those of Jansen as nurtured by the two men's friendship and shared values. Nevertheless, the publication of the

Augustinus gave the Jesuits a target to hang on the back of their enemies, and from the time of that volume's first appearance, the movement in France became increasingly identified with Jansen's ideas and was consequently placed on the defensive. The *Augustinus* had appeared in September 1640, and by August of the following year, the Holy Office in Rome had already condemned it and prohibited Catholics from reading it. By June 1642, the actions of the Holy Office had been reinforced by the Papal bull, *In eminenti*, which likewise condemned the book and placed it off limits to Catholics. These pronouncements from Rome did nothing to stifle an ever more agitated debate about the ideas in the book in France, since papal decrees had no force in the country unless they were affirmed and promulgated by the king. Claiming that the *Augustinus*, not its ideas, had been condemned, Saint-Cyran's group, now openly referred to as Jansenists, continued to make their case, thus raising the ire of the Jesuits and the royal government. The matter was studied throughout the 1640s, and theologians in the service of the king picked apart the Jansenists' argument. They identified five propositions in the *Augustinus* they felt were heretical and sent the propositions to Rome for papal condemnation. A second papal decree of 1653 *Cum occasione* condemned the five propositions. Though this was a major defeat, the Jansenists refused to give up. Their leader at the time, Antoine Arnauld, counseled his followers to recognize that the five propositions were, in fact, heretical. Then in a piece of hair-splitting that bespoke his training in the law, he advised them to maintain that the five propositions could not be found in the *Augustinus* at all. While Jansenists satisfied themselves that they were free to continue to study and teach the *Augustinus*, their political support within France began to deteriorate. The royal government made clear its disapproval of the group, and insults and acts of persecution against them mounted.

PROVINCIAL LETTERS. Then, just when it looked as if all was lost, the brilliance of the group's polemicists, particularly Blaise Pascal (1623–1662), helped to create a widespread resurgence. Following his conversion, Pascal had sworn only to use his pen to defend the Jansenist cause. In 1656 Arnauld enlisted him to make the Jansenist case in a fashion that would appeal to the larger Catholic community. Pascal responded with the *Provincial Letters*, a series of nineteen letters, written in collaboration with Antoine Arnauld and Antoine Le Maistre, and published under a pseudonym over the course of the period 1656–1657. The letters alleged to be a description of actual Jesuit pastoral practices. In a satirical tone and in a style so elegant they shaped French prose writing for

decades, the letters skewered the Jesuits, going so far as to suggest that the Jesuits rationalized away murder for the convenience of their followers. The *Provincial Letters* were a resounding success. By the publication of the fifth letter, the press run had risen to 6,000 copies, an exceptionally large number at the time. In 1657 the complete editions of the *Provincial Letters* were published, helping to divert pressure away from the Jansenists and placing the Jesuits on the defensive. Written in French and invoking a French sense of ecclesiastical ethics, the *Provincial Letters* were also important in associating the Jansenist cause with Gallicanism, the concern among French Catholics for the independence of their church from Rome. From the 1660s onward, the term "Jansenist" came to be associated with other causes, causes that were now related to the growing distaste for the Jesuit order and the effort to produce a Catholicism in France that was in large part free of Roman influence. The *Provincial Letters* allowed for these developments.

SUPPRESSION AND REBIRTH. Although Antoine Arnauld had used sophisticated legal arguments to insist that the Jansenists were free to read and study the *Augustinus*, the actions of the royal government and the papacy increasingly placed that work off limits during the 1650s. In 1657, Cardinal Mazarin, then France's chief minister, called an Assembly of the Clergy to compose a formula of faith based upon recent papal pronouncements, and he required members of the French clergy to sign it. Jansenists, however, refused, and although the state and church persisted in their demands, the Jansenists' cause came to be aided by the complex nature of negotiations between Louis XIV and the papacy over the direction France's suppression of the movement should take. Matters ground to a halt until Pope Clement IX formulated a compromise in 1669. He permitted Jansenists to sign the royal government's formula of faith with the understanding that they might still maintain that the heretical propositions were not in the document, but that they would cease to argue about it for the good of the church. This Peace of Clement IX signaled the end of the first era of French Jansenism. When the battle over Jansenism flared up again in France during the first decade of the eighteenth century, the issue that predominated in the debate was not the presence of heretical doctrines in the writings of Jansen, but the ideas of the theologian Quesnel, who took over leadership of the Jansenists after Henri Arnauld died in 1692. Quesnel and the Jansenists who followed continued to see themselves as Augustinians fighting the influence of Jesuits. But the point of conflict for them was the issue of the rights of national churches vis-à-vis papal authority. In the eighteenth cen-

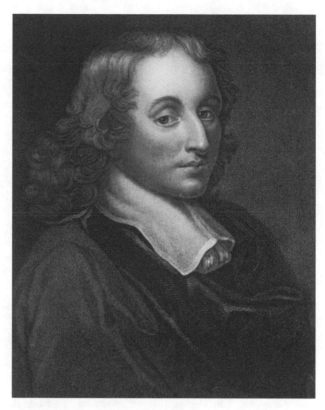

Blaise Pascal. THE LIBRARY OF CONGRESS.

tury Jansenism became an international movement as ecclesiastical nationalists in other states looked to French theologians for inspiration and arguments. The movement experienced its greatest victory in 1763, when by papal decree the Jesuit order was dissolved. But despite this victory, Jansenism never again coalesced as a movement with the force that it had in and around Paris in the mid-seventeenth century. That movement had presented the French church with a positive model for a Catholicism that was very different from that of the Jesuits and the reigning spirit of the Catholic Reformation.

SOURCES

William Doyle, *Jansenism: Catholic Resistance to Authority from the Reformation to the French Revolution* (New York: St. Martins Press, 2000).

Hubert Jedin and John Dolan, eds., *The History of the Church in the Age of Absolutism and Enlightenment,* vol. 6 of *The History of the Church* (New York: Seabury Press, 1981).

Alexander Sedgwick, *Jansenism in Seventeenth-Century France: Voices from the Wilderness* (Charlottesville, Va.: University Press of Virginia, 1977).

Dale Van Kley, *The Jansenists and the Expulsion of the Jesuits from France, 1757–1765* (New Haven, Conn.: Yale University Press, 1975).

F. Ellen Weaver, *The Evolution of the Reform of Port Royal* (Paris: Beauchesne, 1978).

MAGIC AND WITCHCRAFT

POPULAR MAGIC. In early-modern Europe state churches identified enemies among the missionaries of rival Christian churches, even as they also singled out promoters and participants of popular magic as targets. Early-modern Europeans, like their medieval ancestors, retained a strong belief in supernatural planes of existence that bounded the natural and visible world. Popular magic focused on the spirits who were believed to exist in these supernatural planes, and on how these spirits could be manipulated to serve the needs of humans. Knowing the denizens of the supernatural as well as how to invoke them and what they could do for you was the stated expertise of "wise men" and "cunning women." These were just two names for what anthropologists today call shamans, that is, diviners and healers who provided their clients with help and healing based upon the claim to expertise in accessing the supernatural world. Early-modern Europeans did not turn to shamans in every emergency. Shamans were usually called upon in those circumstances where the supernatural aid the church offered through prayers and recourse to the saints was judged either inadequate or inappropriate. In other words, when early-modern folk had need of a love or fertility potion, their first recourse was not to their priest or minister, but to the local shaman. By the same token, if witchcraft was suspected as the cause of an illness, Christian prayer was not deemed a strong enough counter-measure; a shaman was needed to cast a counter spell. The bodies of knowledge popular magic drew upon often reflected oral traditions from a host of pre-Christian religious traditions. By the early-modern period Christian supernatural entities had also been pressed into service to help humans with their problems. Angels, as well as demons, might be invoked to help find lost or stolen property. Saints, most especially the Virgin Mary, were beseeched for cures. Thus peasants trying to protect themselves from the vagaries of poor harvests, disease, infertility, and natural disasters had access to a rich supernatural world peopled with many different entities, all of whom might offer aid in particular circumstances. The church had long cast a jaundiced eye on these popular beliefs, having for centuries taught that it was appropriate to seek help through prayer to the saints, angels, and God himself. Europe's shamans, on the other hand, had no qualms about approaching any and all kinds of spiritual forces. They might even appeal to Satan himself in trying to resolve a thorny issue. Thus priests and ministers perceived shamans and the long-standing traditions of popular magic as sources of competition as well as a dangerous traffic with the evil spirits that peopled the supernatural order. They sought to have "wise men" and "cunning women" arrested and tried for these crimes as witches. During the first half of the seventeenth century religious and state officials stepped up their campaign against shamanism, helping to send longstanding traditions of popular magic into a decline. Magical beliefs and practices were now forced increasingly underground, where they were prized by some and feared by others. Popular magic's decline, then, was in part a result of the witch hunt, which had by the mid-seventeenth century made it extremely dangerous to practice any form of magic for fear of being identified as a witch.

LEARNED MAGIC. Popular magic stood in contrast to learned magic, a very different set of teachings that had similarly flourished for centuries. In early-modern Europe learned magic rarely involved the invocation of spirits, but rather it assumed that certain hidden connections existed between observable phenomena on earth and unseen phenomena in the universe, and that it was possible to discover these connections and exploit them to one's advantage. These assumptions are best demonstrated in astrology, perhaps the most avidly pursued branch of learned magic. The premise of astrology is that heavenly bodies determine the fortunes of humans on earth. Through the study of the heavenly bodies it is therefore possible for an individual both to anticipate and to take advantage of the events that will occur in the future. Astrology was a branch of learned magic that was widely practiced by medical personnel, since it was seen as bolstering the effectiveness of medicines and other types of cures that needed to be given at times when the stars' positions were most propitious for healing. Learned forms of magic like astrology progressed through the detailed study of texts. Its practitioners started from the intellectual assumption that scholars in the ancient world had discovered most if not all of the hidden connections between things, and that the task of contemporary scholars was thus to rediscover what the ancients had already known. Beginning in the twelfth century a flow of magical treatises from ancient Mesopotamia, Egypt, Greece, and Rome, preserved through the centuries by Muslim scholars, had begun to make its way into Western Europe. The reception of these texts gave rise to a new sort of intellectual figure, the *magus* (the plural form being known as "magi"), or the master of ancient magical knowledge. The status of the magus

was given a powerful boost by the Renaissance fascination with Platonism, which stressed the notion that things on earth were simply the signs for universal or higher heavenly forms that were beyond human comprehension. By the seventeenth century learned magic, like art and architecture, had gained patronage in many European courts and in the humanist circles in cities. Many of the first and second generations of thinkers we associate today with the Scientific Revolution were influenced by Europe's long traditions of learned magical speculation. Alchemy was the branch of these endeavors that drew the greatest support from princely and wealthy patrons throughout the continent. Students of alchemy started from the premise that minerals, like everything else on earth, were living things grown from seeds, and that different types of minerals were simply variants of the same mineral at different stages in the life cycle. If cultivated to their mature forms in an environment free of pollutants, alchemists reasoned, minerals might take on their noblest character, a form that alchemists saw as the element gold. Thus the aims of learned magic like alchemy were to learn how nature might be manipulated and bent to one's advantage, rather than to communicate with spirits to intercede in everyday problems.

MAGIC IN EUROPE'S VILLAGES. Accusations of witchcraft, by contrast, largely occurred in Europe's villages, far from the rarefied discussions of learned magic that intellectuals conducted in courts and cities. The distinction between magic and witchcraft in the minds of early-modern villagers is hard for the modern mind to grasp. For them, magic attempted to access and to influence the supernatural world. As such, for all of the moralizing of the churchmen, it was widely perceived in village society as a force that was never completely evil. Witchcraft, on the other hand, was feared as the use of the supernatural to prey upon one's neighbors, and was consequently the worst evil on earth. While plenty of individuals boasted of their ability to perform magic, no one admitted willingly to being a witch. Witchcraft was always imputed to individuals, and implicit in the charge was the idea that the witch was an "enemy of the human race," scheming to wreak havoc upon individuals and communities. While most Europeans did not believe that the use of magic was, in and of itself, criminal, they were largely agreed that witchcraft was an evil that needed to be utterly extirpated. It was normal, in other words, for townspeople and villagers to hate each other and sometimes to rely on magic to try to get back at one another. A successful piece of black magic aimed at an enemy probably did not upset many villagers, but what early seventeenth-century people feared were unexplained, ex-

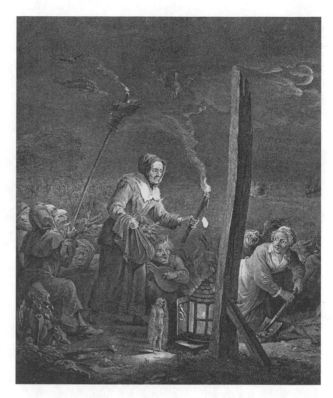

Engraving *Arrivee Au Sabat* (Witches' Sabbath) by J. Aliame after a drawing by David Teniers. © CHRISTEL GERSTENBERG/CORBIS.

cessive acts of vengeance. Such acts were signs of an individual out to hurt others. Modern readers of witch trial materials are appalled by the ease with which medieval and early-modern European villagers identified, tortured, and burned one or two of their number as the source of everything that had recently gone wrong in their village. Modern people, however, miss the reasoning that ran behind these trials. For early-modern communities, witches were social predators. They were an evil besetting the land, an evil that needed to be rooted out so that health might be restored to the community. The evidence of these trials suggests that an image of the witch—usually someone who was marginal to the community at large and who was widely feared and hated—prevailed as a powerful stereotype that prompted accusations and persecutions at the local level.

THE DIABOLIC PACT. When European villagers identified one of their own as a witch, their accusations were generally taken seriously by secular officials anxious to prosecute such charges. During the later Middle Ages the Inquisition, a formal office within the church charged with investigating heresy, had fed the persecution of witches by inspiring elaborate new theories of diabolism, that is, the science of demons. The Inquisition fashioned a view of witchcraft very different from that of village

a PRIMARY SOURCE document

A WITCH'S TRIAL

INTRODUCTION: The seventeenth-century witch hunts left behind many trial records that allow modern historians to reconstruct the belief in witches as well as the patterns of its persecution. In the account of the present case, the French woman Marie Cornu was accused of working a number of *maléfices* (evil deeds) against her husbands and neighbors. The records of her trial are typical of many such accounts.

This is a criminal trial held before us, Quintin Legambe, squire, lord of Autreulle, bailiff of the lands and lordships of Marchiennes, Fenain, etc., in the case of Marie Cornu, popularly called La Rousse, having been married three times and presently widow after her third marriage of the good Quintin de Ligny, charged and accused of being a *sorcière* [witch], and following the depositions which, by reason of this, have been made about her, informations following upon this and held by us about her reputation and general good name, by which we have found that for many long years she has been vehemently suspected of having exercised *sorcellerie* [witchcraft] and by this means has committed grave and enormous crimes. …

And to come to the crimes and *maléfices* committed and performed by her for the thirty-six years or thereabouts for which she has confessed to having been a *sorcière*, upon many persons and beasts, and of having been married three times and that her first husband, named Baltazar Bauduin, of whom she has confessed having murdered by putting a gray powder (which she said devil Belzebub delivered to her) into a tar of boiled milk which she then gave him to eat, and that she did this because the said husband gave more caresses in the household to a daughter of his named Julie Bauduin, presently the wife of Robert Menez, whom her late husband had had from a preceding marriage to another woman, than to her, who was his present wife. She has also confessed to having caused the death of Pierre Hélo, her second husband, having given to him a meal of pike prepared with butter, on which she had sprinkled the gray powder, because she said Hélo, her husband, treated a daughter of hers named Marguerite badly, a daughter she had had by her first husband, Baltazar Bauduin. Having also confessed to having killed her third husband, Quintin de Ligny, having put the same powder into a tart which she gave him to eat, because the said husband was always scolding … her. And she also, by *maléfice* caused the nose to fall off Anne Leurien, wife of Michel Richart, by having put a powder in her drink, because Anne had been the cause that she did not marry Adrien Leurien, father of the said Anne. In addition, she caused to languish a child of Jehan Herlin, having put some powder on a slice of bread because the said child had quarreled with her, when she was working in the house of the said Herlin, the child since having become lame. And she confessed to having killed a cow of the said Michel Richart by having put the powder near the soil of the stable, because the wife of the said Richart had refused to give her some milk.

SOURCE: "The Trial of Marie Cornu," in *Witchcraft in Europe, 400–1700.* Ed. Alan Kors and Edward Peters (Philadelphia: University of Pennsylvania Press, 2001): 346–347.

society. In place of the notion that witches were merely anti-social and predatory, the theories of witchcraft promoted by the Inquisition in the fourteenth and fifteenth centuries taught that witches were those who had allied themselves with Satan and were now seeking to destroy Christian society. By the seventeenth century this notion of a diabolic pact had achieved a general acceptance, not only among many churchmen, but among state officials who now rejected the divide that existed in the popular mind between benign magic and maleficent witchcraft. For these learned elites, there was no neutral way to manipulate magic. All power over the supernatural world derived either from God or from Satan, and every human being who used magic thus entered into a pact with the devil. The terms of witches' covenants with Satan demanded that they wage war against every aspect of Christian society. In the three centuries following 1400 C.E. an estimated 100,000 Europeans were tried, convicted, and put to death for the crime of witchcraft. The most vicious years of this persecution occurred in the century following 1550, that is, at the time when many secular officials became convinced, as had churchmen before them, of the Satanic nature of witchcraft and the dangers that it presented to their societies. Relying on elaborate theories of diabolism and witchcraft, secular and religious authorities persecuted witches in these years with increasing frequency, and the image of the witch as an ally of Satan came to traumatize the seventeenth-century world.

NATURE OF THE WITCH HUNT. The typical witchcraft trial was a local affair and was precipitated when one or several accusations against someone "everyone knew was a witch" were brought before secular officials. In questioning, secular judges began to ask these individuals to name their accomplices, and under torture, the accused often spewed forth as many names as were

a PRIMARY SOURCE *document*

A PLEA FOR BELIEF IN WITCHCRAFT

INTRODUCTION: By the later eighteenth century, belief in demons, witches, and in a supernatural world was definitely on the wane among intellectuals in Europe. The possibility of demonic influence on the earth, however, still troubled some highly educated thinkers. Joseph Glanvill (1636–1680), one of England's greatest seventeenth-century scholars, and his friend Henry More (1614–1687) were two of these who worried about this decline. Both conducted an active correspondence in which they informed each other about the most recent trials and tribulations worked on the world by demons and witches. In his later years, Glanvill published many of these accounts, together with impassioned pleas to his intellectual readers that they maintain their faith in the spirit world. His fullest expression of these ideas came in *Sadducismus Triumphatus* (Sadducism Triumphant), a work that compared the decline in witchcraft beliefs to the ancient Jewish sect known as the Sadducees that Jesus had encountered in the New Testament. In this work Glanvill included the following endorsement of the reality of witchcraft made by his friend, Dr. Henry More.

And forasmuch as such coarse-grained Philosophers, as those Hobbians [followers of Thomas Hobbes (1588–1679)] and Spinozians, [followers of the Dutch philosopher Baruch Spinoza (1632–1677)], and the rest of that Rabble, slight Religion and the Scriptures, because there is such express mention of Spirits and Angels in them, things that their dull Souls are so inclinable to conceit to be impossible—I look upon it as a special piece of Providence, that there are ever and anon such fresh Examples of Apparitions and Witchcraft as may rub up and awaken their benumbed and lethargic Minds into a suspicion at least, if not assurance that there are other intelligent Beings beside those that are clad in heavy Earth or Clay, in this I say, methinks the divine Providence does plainly outwit the Powers of the dark Kingdom, permitting wicked men and women, and vagrant Spirits of that Kingdom to make Leagues or Covenants one with another, the Confession of Witches against their own Lives being so palpable an Evidence, besides the miraculous Feats they play, that there are bad Spirits, which will necessarily open a door to the belief that there are good ones, and lastly that there is a God.

Wherefore let the small Philosophick Sir-Foplings of this present Age deride them as much as they will, those that lay out their pains in committing to writing certain well attested Stories of Witches and Apparitions, do real service to true Religion and sound Philosophy, and the most effectual and accommodate to the confound of Infidelity and Atheism, even in the Judgment of the Atheists themselves, who are as much afraid of the truth of those Stories as an Ape is of a Whip, and therefore force themselves with might and main to disbelieve them, by reason of the dreadful consequence of them as to themselves. The wicked fear where no fear is, but God is in the Generation of the Righteous, and he that fears God and has his Faith in Jesus Christ, need not fear how many Devils there be, nor be afraid of himself or of his Immortality, and therefore it is nothing but a foul dark Conscience within, or a very gross and dull constitution of Blood that makes Men so averse from these truths.

SOURCE: "Dr. H. M. [Henry More] his Letter with the Postscript to Mr. J. G." [Joseph Glanvill]," in Joseph Glanvill, *Sadducismus Triumphatus, or Full and plain evidence concerning witches and apparitions.* (London: S. Lowndes, 1689): 26–27. Text modernized by author.

needed to bring their suffering to an end. Judges then issued writs to have those accused arrested and tortured. In this way the size, length, and geographic scope of the trials grew. The high tide of these persecutions was also a time of civil war and sectarian conflict, of bad harvests, and of economic privation across Europe. The anxieties these problems generated thus helped to feed the efforts of judges and officials, many of whom argued that the collective misfortunes of contemporary society might be traced to cells of witches. The panic took different shapes in different areas. Germany was infamous for "chain reaction" trials. Judges received a list of names from one individual, and these individuals, in turn, generated their own new lists of accused under torture. These individuals then named others. Such trials might go on for years, claiming hundreds of lives. In Ellwangen in the German southwest, for example, more than 400 people met their deaths this way in the years between 1611–1618. In Bamberg, the capital of a bishopric in central Germany, more than 300 were executed for witchcraft between 1624 and 1631. In France, a series of cases involved nuns who were accused of being possessed by Satan and of appearing in the forms of priests. The best known of these, which took place at the Ursuline monastery at Loudon during 1636, became the subject of a famous novel, *The Devils of Loudon*, by Aldous Huxley in the twentieth century. In England, the panic prompted towns and villages to seek the services of professional "witchfinders," who traveled from place to place identifying witches for their neighbors to burn. Matthew Hopkins (d. 1647?) was the most famous of these. Sweden was the site for a relatively late (1660s–1670s) but

notorious trial in which the testimony of children about a mythical place known as Blakulla led to the execution of hundreds of individuals. In Blakulla, the children were alleged to have seen their friends and their friends' parents dancing and making merry with demons. In the midst of one of these panics, it was extremely dangerous to question the legitimacy of the threat. The assumption was that only a witch would try to dissuade the authorities from further interrogations. But when the accusations began to reach into the higher echelons of society, judges became a bit more scrupulous about the evidence they accepted to bring trials against those accused. As wives of mayors and other important officials came to be tarnished with accusations of practicing witchcraft, judges usually applied scrutiny to the evidence and in this way a particular witch-hunt ceased. In most places this process usually only took several weeks, and once a hunt had come to be discredited even those that had already been accused and condemned were often released.

THE DECLINE OF THE WITCH TRIALS. Witch trials continued through the 1670s, but by the 1680s they were beginning to be abandoned by royal governments throughout Europe. While recent historical research has emphasized the importance of the intellectual repudiation of witchcraft among governing elites, there is no consensus among historians about what caused this repudiation. Four interrelated changes in beliefs, however, clearly contributed. First, by the second half of the seventeenth century, the doom and gloom that had contributed to social anxiety and panic during the first half of the century had given way to intellectual optimism. Intellectuals began to express faith in the human ability to understand and control nature. In part this newfound faith was based on scientific breakthroughs such as Newton's discovery of the law of gravity, but it also arose from the technological and economic advances of the time that were then making Europe into the most prosperous region on earth. The results of this optimism were a turning away from the fear that had gripped governments and communities concerning the imminence of Satan's rule over the earth. Second, there was a general and growing skepticism on the part of many thinking people about the existence of any sort of supernatural world, heaven and hell included. During the 1680s some writers like Joseph Glanvill (1636–1680) made vain attempts to try to keep the belief in witches and demons alive. In his *Sadducismus Triumphatus* he warned that a Christian could not give up the belief in magic and witchcraft without relinquishing faith in God. But such arguments were increasingly out-of-date in a world in which intellectuals were looking with suspicion upon the traditional notion that an invisible or supernatural plane of existence intersected with the earthly world in which human beings lived. Third, the Christian churches throughout Europe began to alter their ideas concerning witchcraft. Over the course of the seventeenth century a number of Protestant and Catholic churchmen dismissed the reality of witchcraft and the theory of a satanic conspiracy. This skepticism grew over time, even as an increasing number of church leaders throughout Europe called attention to the deceit, greed, and corruption of the trials and to the fact that many innocent people were being put to death by false accusations. A fourth shift in belief was the turn by governments toward secularism. By the 1660s, there was a growing reluctance on the part of authorities to embrace any explanation of social and political problems built upon religious beliefs. No longer did governments accept that famine or the plague was a reflection of God's wrath or the devil's ambitions. Instead, officials now assumed that there was a rational explanation for every problem and that these causes might be solved with rational solutions. So the response to famine, they argued, should be the importation of grain, while the appropriate response to plague was quarantine. The elite abandonment of belief in the reality of witchcraft was not mirrored within the popular classes. Rural communities continued to seek relief from social anxieties by identifying and burning witches, but when they made accusations, villagers found their initiatives blocked by government authorities that now cast a skeptical eye on such prosecutions. Thus, by the eighteenth century belief in magic and witchcraft had become one of the boundaries that distinguished high and low culture in Europe. Intellectuals now mocked folk culture for its belief in witches, demons, and spirits, beliefs that had once been shared by learned and unlearned alike. The rich and luxuriant spiritual world of Europe that had given rise to the witch trials' bloodletting became reflective of an older archaic world of superstitious belief.

SOURCES

Bengt Ankarloo and Gustav Hennigsen, eds., *Early Modern Witchcraft: Centres and Peripheries* (Oxford: Clarendon Press, 1990).

Brian Levack, *The Witch Hunt in Early Modern Europe* (New York: Longman, 1987).

Darren Oldridge, ed., *The Witchcraft Reader* (New York: Routledge, 2002).

Edward Peters, *The Magician, The Witch, and the Law* (Philadelphia: University of Pennsylvania Press, 1978).

Lyndal Roper, *Oedipus and the Devil: Sexuality and Religion in Early Modern Europe* (London: Routledge, 1994).

G. Scarre, *Witchcraft and Magic in Sixteenth- and Seventeenth-Century Europe* (London: Macmillan, 1987).

Keith Thomas, *Religion and the Decline of Magic* (Oxford: Oxford University Press, 1971).

PIETISM

BACKGROUND. The transformation of churches into departments of state affected the religious experiences these institutions offered. The standardization of liturgy, the use of worship time for government business, the preoccupation of clergy with the services demanded of them by the state all contributed to emptying devotional activities of most of their enthusiasm and passion. This development was especially pronounced in the state churches of Lutheran Germany. Luther's idea of a church composed of a priesthood of all believers evolved into a collection of churches where the divisions between clergy and lay were almost as rigid as those in Catholicism. Medieval parish clergy had been noteworthy for their low level of education and lack of pastoral formation. To address this problem Luther (as did other Protestant and Catholic reformers) mandated that Lutheran clergy be trained in seminaries. Seminary training improved the educational level of the Lutheran clergy, but pastoral formation remained a problem. Parish clergy saw themselves as officeholders, and their main preoccupation was grabbing a bigger office, which in this case meant larger and more lucrative parishes. Education became identified in this way as the avenue to preferment: clergymen seeking to climb the ladder of success through theological treatises and published sermons. These pieces of writing could go to bizarre lengths in their efforts to show erudition; one sermon from the mid-seventeenth century focused on the biblical injunctions to keep one's hair neat and groomed. For lay parishioners, church life in this world was a weekly formality offering little spiritual reward. Church buildings were closed except for during times of public worship, and there simply was no idea of Christian outreach, that is, spiritual counseling and evangelism. The one outlet for emotional expression was hymn singing, and one measure of the Christian hunger for soul-satisfying religion was the growth in the size of hymnals across the seventeenth century. For example, the Dresden hymnal of 1622 had 276 hymns, while that of 1673 had 1,505; the Lüneberg hymnal of 1635 had 355 hymns, while that of 1695 had 2,055. Hymnals grew so large because their publishing was outside of the control of the clergy, thus hymn singing was free to reflect lay taste and sensibilities. The same dynamics were at work with devotional literature. While clergymen busied themselves writing arid tomes, publishers busied themselves translating and publishing devotional literature from elsewhere, especially Puritan England.

ARNDT. The most influential devotional work, however, was homegrown. Over the period 1605–1609, Johann Arndt, a controversial minister who spent his career moving from church to church, published his four-volume work, *True Christianity*. In much the same way that Saint-Cyran would call early modern Catholics back to a medieval ideal of the Christian penitent, so Arndt called early-modern Lutherans back to a medieval ideal of the Christian mystic. Arndt put an emphasis on the Christian life lived outside and beyond the parish church. His volumes were uneven collections of excerpts from the great mystics of the past, the excerpts chosen to show contemporary Christians they might recover the warmth and spirituality missing in church life through meditation. Arndt's writings generated much condemnation from Lutheran church officials, yet they were a popular success; between 1605 and 1740 there were 95 German editions of his work, as well as published translations in Bohemian, Dutch, Swedish, and Latin.

SPENER. Arndt's writings supported the development of an alternate religious experience to that taking place in the parish church. Phillip Jakob Spener (1635–1705) took Arndt's ideas and transformed them into the spiritual foundation for church reform. Spener's most important writing was his *Pia Desideria* or *Pious Desires* (1675), an outline for church reform he originally published as a preface to a posthumous edition of some of Arndt's sermons. In the *Pia Desideria* Spener reinforced Arndt's emphasis on the importance of meditation to devotion, but he indicted government officials and clergymen for their soulless management of the church. In particular, he called attention to the clergy's trend for self-aggrandizement at the expense of their flocks. He enjoined the laity to take the promotion of faith into its own hands. Spener looked back to Luther's original message and identified in it the still unachieved demand of the Reformation for a "priesthood of all believers." Spener understood Luther's idea, in other words, to be a call for Christian evangelism that might emerge from the Lutheran laity and be directed at fellow Lutherans. Even before the publication of the *Pia Desideria*, Spener was putting his ideas into practice. In 1666, he was awarded a major position in the Lutheran church in the city of Frankfurt, and by 1669 he had begun to exhort Lutherans at Frankfurt to replace their Sunday afternoons of drinking and card playing with Arndt-inspired discussions of devotional ideas. The next

Print of Philipp Jakob Spener, one of the founders of Lutheran Pietism. THE LIBRARY OF CONGRESS.

year a group of laymen in the city took up his challenge, approaching Spener and asking him to direct their weekly meetings of meditation and Christian fellowship. He agreed and thus was born the *collegia pietatis* or "schools of piety" that became the signature of Spener's movement for church reform. Conceived of as *ecclesiolae in ecclesia*, or "little churches inside the church," these meetings, or conventicles as they were labeled in contemporary discourse, were to become the building blocks of Pietism's church life. Participants found in them both the spiritual direction and rewards that they sensed were lacking in official church activities. Participants in the *collegia pietatis* soon became known as Pietists, and it was from them that the movement took its name. While class meetings were an immediate success among the Lutheran laity, these organizations and Spener soon became the objects of censure from the church establishment. Spener was accused of using class meetings to spread Donatism, an ancient heretical belief that taught that the state of a clergyman's soul determined the purity of the services he performed. In truth, many class meetings did in their enthusiasm come to condemn the laxity and lack of zeal of many of the clergy, a fact from which the charge of Donatism arose. To counter these tendencies, Spener wrote several treatises supporting the clerical establish-

ment. They had little effect, however, and, tired of the debate and controversy, in 1686 Spener accepted a position to serve as court chaplain for the elector of Saxony. The move only brought more conflict and opposition. Spener chastised the elector for public drunkenness publicly from his pulpit, a move to which the elector took exception. More important, Spener's presence in Saxony prompted students at the University of Leipzig, the local university, to revolt against their professors and to go out into the city where they set up class meetings among workers and ordinary citizens. These actions motivated the clerical establishment in Saxony to suppress Spener's movement. By 1691, though, the elector of Brandenburg invited Spener to his new capital city of Berlin. At the time the elector was eager to compete for spiritual leadership of the Lutheran church against Saxony, long home to the religion's most important educational institutions. To cement his claim to leadership, the elector of Brandenburg had recently founded a new university at Halle, and he asked Spener to join the theological faculty. The Pietist spent the rest of his life at Halle, making it the center of the Pietist movement in Germany.

FRANCKE. Just as Spener translated Arndt's devotional ideals into a program for church reform, so August Hermann Francke (1663–1727) turned Spener's program for church reform into an institutional reality. Francke had been one of the leaders of the student revolt at the University of Leipzig, the event that had helped to precipitate Spener's leaving Saxony. Leipzig, like other Lutheran universities of the time, focused its theological curriculum on the study of Aristotle, rather than on training in the Bible. In the years in which Spener had been in Leipzig, he encouraged the establishment of a *Collegium philobiblicum* at Leipzig. The *Collegium* was essentially a bible study movement in which older students helped younger ones to make up the deficiencies in their knowledge of the Bible. Francke turned this movement into a protest against the university's concentration on Aristotle, convincing 300 students to sell their philosophy texts and turn instead to the study of the apostle Paul. While still a student, Francke visited Spener and during one of these visits he underwent a conversion experience to Pietism. After Spener settled at the University of Halle, he arranged for Francke to join the faculty. Francke's realization of Spener's reform program did not alter the institutional structure of the Lutheran church as much as demonstrate how good works—that is, charity—could be effectively added to Lutheran devotional life. While serving as a faculty member, Francke simultaneously served as a pastor at a nearby church. Based upon his working sense of the real needs of a con-

a PRIMARY SOURCE *document*

THE FIRST BIBLE STUDIES

INTRODUCTION: In his *Pia Desideria*, or *Pious Desires*, the German Lutheran theologian Philipp Jakob Spener set out methods through which small groups of his co-religionists might deepen their faith. His prescriptions helped to fashion Pietism, the movement that spread out from Germany in the early eighteenth century and that eventually influenced such British groups as John Wesley's Methodists. In the current passage he describes a pattern of Bible or class study that is similar to that still practiced by many Protestant groups today.

It should therefore be considered whether the church would not be well advised to introduce the people to Scripture in still other ways than through the customary sermons on the appointed lessons.

This might be done, first of all, by diligent reading of the Holy Scriptures, especially of the New Testament. ...

Then a second thing would be desirable in order to encourage people to read privately, namely, that where the practice can be introduced the books of the Bible be read one after another, at specified times in the public service, without further comment (unless one wished to add brief summaries). This would be intended for the edification of all, but especially of those who cannot read at all, or cannot read easily or well, or of those who do not own a copy of the Bible.

For a third thing it would perhaps not be inexpedient (and I set this down for further and more mature reflection) to reintroduce the ancient and apostolic kind of church meetings. In addition to our customary services with preaching, other assemblies would also be held in the manner in which Paul describes them in I Corinthians 14:26–40. One person would not rise to preach (although this practice would be continued at other times), but others who have been blessed with gifts and knowledge would also speak and present their pious opinions on the proposed subject to the judgment of the rest, doing all this in such a way as to avoid disorder and strife. This might conveniently be done by having several ministers (in places where a number of them live in a town) meet together or by having several members of a congregation who have a fair knowledge of God or desire to increase their knowledge meet under the leadership of a minister, take up the Holy Scriptures, read aloud from them, and fraternally discuss each verse in order to discover its simple meaning and whatever may be useful for the edification of all. Anybody who is not satisfied with his understanding of a matter should be permitted to express his doubts and seek further explanation.

SOURCE: Philipp Jakob Spener, *Pia Desideria*. Trans. Theodore G. Tappert (Philadelphia: Fortress Press, 1964): 88–89.

gregation, he sought to equip future ministers with the pastoral skills needed to bring about spiritual renewal both in themselves and their parishioners. His teaching, while important, paled in significance compared to his charity work. At Halle, Francke developed a host of institutions that revolutionized the Lutheran approach to social services. He erected a three-tiered school system: the first tier being a free school popularly known as the "ragged school" for the children of the poor, the second tier being a day school for the fee-paying children of local bourgeoisie, and the third tier being an exclusive boarding school for the children of the Brandenburg nobility. On top of this, Francke maintained an orphanage. At the time of Francke's death in 1727, there were 2,200 students in the three schools and 134 children in the orphanage. In addition to the schools, Francke established teacher-training courses aimed at providing teachers for the countryside. He also founded a Bible Institute for the production and publication of inexpensive editions of the scriptures. To pay for his many enterprises, Francke developed a network of donors and supporters that stretched across Protestant Europe, and even into the German communities in the New World. And to these charitable donations he added the profits from his pioneering marketing of bottled medicines produced in his institute's dispensary. Francke's efforts at Christian outreach did not stop with German Lutherans. He provided and trained the first Lutheran missionaries to be sent to India, and during the eighteenth century, Halle sent some sixty missionaries to Asia. Francke's enterprises at Halle represented the high watermark of Pietism as a reform movement within German Lutheranism.

ZINZENDORF. Francke gave concrete expression to the Lutheran desire for faith to mean more than just church attendance, but at the same time, the movement was notable in that it did not challenge the position or authority of the state church. For all the complaints of the Lutheran establishment, Pietists never sought to create another church or replace the existing one, even though the Lutheran church's structure remained an obstacle to the Pietist celebration of the Christian spirit. In the next stage of its development under the direction

of Count Nikolaus von Zinzendorf (1700–1760), Pietism broke free of this restraint. Zinzendorf was among the students who studied at the Paedagogium, Francke's school for the offspring of the nobility. The school prepared students for government service, and, like his classmates, Zinzendorf had originally secured government employment following graduation. During his studies at Halle the nobleman had been struck by Pietism's religious message, and when he inherited family estates, he left government service to follow his religious calling. Soon Zinzendorf allowed religious refugees to settle on his lands. The most important of these refugees were members of the *Unitas Fratum*, or "Brethren of the Unity," a Bohemian religious group that traced its ancestry back to the fifteenth-century religious leader and heretic John Hus (1369–1415), but which also had a significant number of German-speaking adherents. In the wake of the re-catholicization of Bohemia that occurred during the Thirty Years' War, the *Unitas Fratum* was declared a heretical movement. The group faced intense persecution, barely surviving as an underground movement. Once granted lands on Zinzendorf's estates, however, the *Unitas Fratum* prospered again, attracting members. Most of these members were German speakers from Moravia, thus the group also became known as the Moravian church or the Moravian Brethren. Zinzendorf found himself progressively drawn into the affairs of the Moravians. At Herrnhut, the center of their German community on Zinzendorf's lands, the Moravians began to push for the establishment of a separate Moravian church. Zinzendorf, however, was determined to keep them within the limits of Lutheran orthodoxy, insisting that structures such as class meetings allowed the Moravians the freedom to seek the emotional experiences they found lacking in Lutheranism. Zinzendorf also sought to channel the energies of the Moravians in the direction of missions, and Moravian evangelists were sent out on missions as far away as the West Indies, Greenland, and Georgia in North America. Zinzendorf's efforts, though, did not placate the Moravians, who continued to petition government authorities for recognition as a separate church. Yet the innovative ways in which Zinzendorf made use of small groups or conventicles to allow for the expression of "heart religion" appealed to many Protestants, who began to flock to Moravian circles. In Germany, Lutheran state churches were now threatened by the Moravians' rapid rise in popularity, and officials complained to their governments. Austria, which controlled the territories from whence most of the Moravians had migrated, likewise complained to the government in Saxony, where Herrnhut was located. In 1736 the Saxon government banished Zinzendorf from

his lands, and he began a period of wandering during which he traveled through Europe and North America, preaching and establishing Moravian communities. His banishment was rescinded in 1747, but bankrupt from the costs associated with maintaining the Moravian church, Zinzendorf spent most of his remaining years preaching and writing abroad, primarily in England, where he lived from 1749–1755. Zinzendorf returned to Herrnhut in 1755, and died there five years later. Meanwhile the efforts on the part of the Moravians to have themselves recognized as a separate church bore fruit. In 1742 the government of Prussia granted their Moravian church full autonomy. In 1749, the English Parliament recognized the Moravian church as "an ancient Protestant Episcopal church." But in Saxony, the original German heartland of the movement, the Moravians had to be content to accept the Lutheran Augsburg Confession, in exchange for which they became a separate wing of the state church.

JOHN WESLEY. It took more than a century for the tension between enthusiasm and orthodoxy in German Lutheranism to give rise to a new church. In England a similar tension existed within the Anglican church, and thanks to the spark provided by the Moravians, it took only a few generations for the tensions between Pietism and religious orthodoxy to produce a new kind of church in England. The key figure in the establishment of the Methodist Church in England was John Wesley (1703–1791), who underwent a profound conversion experience in 1738 as a result of his contact with Moravian missionaries. Even before this time, Wesley had been actively preaching the gospel, but it was only after his conversion that he preached a message others seemed eager to follow. Wesley had been born the son of an Anglican priest, and both he and his brother Charles had attended Oxford with the intention of following in their father's footsteps. While at Oxford the Wesleys established a little organization known as the "Holy Club" which, like the Pietist class meetings Wesley would later admire and emulate, provided a vehicle for small groups to share spiritual experiences. Members of the Holy Club were roundly ridiculed by their contemporaries at Oxford, who called them "Methodists," a term of derision. Out of frustration in 1735 the Wesleys left to serve as missionaries in Georgia. Their efforts in Georgia were an embarrassing failure, but their tour was significant in that they made contact with the Moravians. Back in London in 1738, the Wesleys discovered a new direction for their ministry, again through the example and influence of the Moravians. As he recorded in his diary, it was while attending a Moravian meeting that John felt his heart

"strangely warmed" and knew that he had found the message he would preach for the rest of his days. The Wesleys were sufficiently moved by their experiences with the Moravians that they contemplated joining the Brethren. A trip to Germany to meet Zinzendorf, however, convinced them of the need to create their own movement. Still, the Wesleys adapted from the Moravians the key Pietist precepts that Christian devotions are best experienced in small groups and that these devotions must produce an emotional transformation within the Christian. Preaching this message in England was not easy. The Anglican establishment was no friendlier to Pietism than the Lutheran state churches had been in Germany. John Wesley went from parish church to parish church, requesting permission to preach before the congregation. Again and again he was turned down. Soon Wesley adopted the expedient of preaching, not in churches, but in open fields and town halls. Here he excelled, sometimes drawing thousands of listeners to his sermons, although the crowds were not always friendly; rocks and stones were sometimes thrown at his head. But most of his audiences were emotionally engaged, and the sense that Christianity could be about feelings, could be about emotions, gradually came to be accepted within English Protestantism. John Wesley cannot be granted sole credit for introducing the idea of the outdoor revival as a forum of Christian devotion in England. Credit for this development has to be shared with his good friend and competitor George Whitefield (1714–1770). Wesley and Whitefield met during their student days, when Whitefield joined the "Holy Club." Theological differences forced the two men to go their separate ways; Whitefield was a Calvinist, while Wesley was an Arminian. Whitefield is generally credited with being the greatest English preacher of his time, though few of his sermons have survived. Still, his open-air preaching, in tandem with that of Wesley, revolutionized Christian worship in England, providing thousands with a spiritually satisfying alternative to the dry formalism of parish devotional life.

METHODISM. John Wesley took the insights of the Pietists and applied them to the development of his movement. In his preaching and ministry Wesley targeted the poor and working classes—groups to his mind ignored by the Church of England. Raised by an Anglican priest to be an Anglican priest, Wesley's intention was to stay within the Church of England. With this ambition in mind, Wesley adapted the institution of the class meeting, which he relabeled the "band," to the tasks associated with evangelizing the poor and working classes within the context of the Anglican church. For Wesley,

Portrait of John Wesley. THE LIBRARY OF CONGRESS.

Christian salvation was the result of an active embrace of the obligations of faith and devotion. The duty of the "band" was to oversee the actions of church members to make sure that they fulfilled those obligations. Wesley issued "tickets" to church members that granted them three months of access to church services and activities. Every three months the actions and behavior of each member was assessed, and the tickets could be revoked for such things as swearing, fighting, drunkenness, and wife beating. Wesley went further and made these conventicles, or small group meetings, into the vehicle for positive development. To discipline church members to what was for many of them the new experience of participation in church upkeep, Wesley divided members into "classes" of twelve under a "class leader." Each member of a class was expected to put a penny each week toward church maintenance, the class leader being in charge of collection. Few members of the Anglican clergy followed Wesley out into the field. Thus in the beginning Wesley's movement suffered from a lack of ordained clergy. Wesley treated this dearth as an opportunity, opening up to lay people many positions reserved in the Anglican church for clerics. Laymen did much of the preaching that took place in the context of the "bands." Laymen were similarly called upon to serve as "stewards" to take care of church property, teachers in Methodists

a PRIMARY SOURCE *document*

AN EARLY ITINERANT PREACHER

INTRODUCTION: Influenced by the powerful example of the Moravians, John Wesley underwent a conversion experience and began to develop small groups of dedicated laymen within the Church of England, the nucleus that eventually formed the Methodist Church. Wesley was indefatigable in his efforts to spread the gospel, as his *Journals* make clear. His career helped to establish the patterns that modern Christians now associate with the itinerant revival preacher. Much like the twentieth-century evangelists Billy Sunday or Billy Graham, Wesley preached the gospel before thousands, many of whom proved willing to amend their lives and begin to follow the path outlined in Methodism. In the current passage he describes the difficulties that he had in adapting himself to this life, trained as he was to be a priest in the staid and formalistic Church of England. Wesley quickly overcame whatever reticence he felt, and began to preach to thousands.

Saturday, March 10, 1739: During my stay here, I was fully employed between our own society in Fetter Lane, and many others ... so that I had no thought of leaving London, when I received, after several others, a letter from Mr. Whitefield, and another from Mr. Stewart, entreating me, in the most pressing manner, to come to Bristol without delay ...

Wednesday, March 28, 1739: My journey was proposed to our society in Fetter Lane. But my brother Charles would scarce bear the mention of it. ... Our other brethren, however, continuing the dispute, without any probability of their coming to one conclusion, we at length all agree to decide it by lot. And by this it was determined I should go. ... In the evening I reached Bristol, and met Mr. Whitefield there. I could scarce reconcile myself at first to this strange way of preaching in the fields, of which he set me an example on Sunday; having been all my life (till very lately) so tenacious of every point relating to decency and order, that I should have thought the saving of souls almost a sin, if it had not been done in the church. ...

Wednesday, April 4, 1739: At Baptist Mills (a sort of suburb or village about half a mile from Bristol) I offered the grace of God to about fifteen hundred persons from these words, "I will heal their backsliding, I will love them freely."

In the evening three women agreed to meet together weekly with the same intention as those at London, viz., "to confess their faults one to another, and pray one for another, that they may be healed." At eight four young men agreed to meet, in pursuance of the same design. How dare any man deny this to be a means of grace, ordained by God? Unless he will affirm that St. James's Epistle is an epistle of straw. ...

Saturday, April 14, 1739: I preached at the poorhouse. Three or four hundred were within, and more than twice that number without; to whom I explained those comfortable words, "When they had nothing to pay, he frankly forgave them both."

Tuesday, April 17, 1739: At five in the afternoon I was at a little society in the Back Lane. The room in which we were was propped beneath, but the weight of people made the floor give way; so that in the beginning of the expounding, the post which propped it fell down with a great noise. But the floor sunk no farther; so that, after a little surprise at first, they quietly attended to the things that were spoken.

SOURCE: John Wesley, *John Wesley's Journal.* Ed. Nehemiah Curnock (New York: Philosophical Library, 1951): 65–67.

schools, and visitors of the sick. To supervise his growing movement, Wesley initially made the rounds by visiting each group in turn. When the movement grew too large for this, he established annual "Conferences" at which first preachers, and then other lay officials, met to discuss issues of church governance. To address the need for central direction, Wesley divided the local churches into "circuits" over which traveling preachers had jurisdiction. Later, superintendents were placed over the circuits. To educate lay officials to both the duties of their offices and the expectations of them as Christians, Wesley took another page from the German Pietist book, sponsoring the writing and publication of devotional literature developed specifically for his people. As much as possible Wesley sought to use the Anglican liturgy in his church services though, again reflecting the Pietist influence, he left space in his services for spontaneous outpourings of faith. Methodist church services also made extensive use of hymns; over the course of his career as his brother's right-hand man, Charles Wesley wrote almost 8,000 of them. Though the Anglican establishment constantly rebuffed his movement, John Wesley was determined to keep his groups within the confines of the Church of England. Still, when confronted with the reality of Anglican opposition, Wesley affirmed the independence of his movement. In 1784, after the conclusion of the American War of Independence, there was a need for Methodist ministers in North America. Wesley

a PRIMARY SOURCE document

GALILEO IN THE CROSSFIRE BETWEEN SCIENCE AND RELIGION

INTRODUCTION: One of the most famous of all the disputes between science and religion in the early-modern world involved Galileo's proofs for the heliocentric theory, the notion that the sun is at the center of the universe and that planets revolve around it. Galileo's work in this regard brought him before the Inquisition in Italy, and he was eventually forced to deny his ideas. Before that condemnation, the scientist wrote to Christina of Lorraine, the Grand Duchess of Tuscany, explaining his views and arguing that theologians should stay out of scientific matters, for which, he argued, they had little preparation. One year later, the Inquisition used his words in the proceedings mounted against him.

Let us grant then that theology is conversant with the loftiest divine contemplation, and occupies the regal throne among sciences by dignity. But acquiring the highest authority in this way, if she does not descend to the lower and humbler speculations of the subordinate sciences and has no regard for them because they are not concerned with blessedness, then her professors should not arrogate to themselves the authority to decide on controversies in professions which they have neither studied nor practiced.

Why, this would be as if an absolute despot, being neither a physician nor an architect but knowing himself free to command, should undertake to administer medicines and erect buildings according to his whim—at grave peril of his poor patients' lives, and the speedy collapse of his edifices.

Again, to command that the very professors of astronomy themselves see to the refutation of their own observations and proofs as mere fallacies and sophisms is to enjoin something that lies beyond any possibility of accomplishment. For this would amount to commanding that they must not see what they see and must not understand what they know, and that in searching they must find the opposite of what they actually encounter. Before this could be done they would have to be taught how to make one mental faculty command another, and the inferior powers the superior, so that the imagination and the will be forced to believe the opposite of what the intellect understands. I am referring at all times to merely physical propositions, and not to supernatural things which are matters of faith.

I entreat those wise and prudent Fathers to consider with great care the difference that exists between doctrines subject to proof and those subject to opinion.

SOURCE: Galileo, "Letter to Christina of Lorraine," in *The Seventeenth Century.* Ed. Andrew Lossky (New York: The Free Press, 1967): 89.

asked the bishop of London to ordain them. The bishop refused. Wesley was not a bishop and had no authority to ordain; yet in this instance he presumed the right to ordain the men in question, thus cementing Methodism's increasing independence from Anglicanism. Wesley died in 1791, and only four years later the Methodist movement had broken free of the Church of England and established itself as a separate church.

SOURCES

Mary Fulbrook, *Piety and Politics: Religion and the Rise of Absolutism in England, Württemberg, and Prussia* (Cambridge, England: Cambridge University Press, 1983).

Richard L. Gawthrop, *Pietism and the Making of Eighteenth-Century Prussia* (Cambridge, England: Cambridge University Press, 1993).

Roy Hattersley, *John Wesley: A Brand from the Burning* (London: Little Brown, 2002).

James Van Horn Melton, *Absolutism and the Origins of Compulsory Schooling in Prussia and Austria* (Cambridge, England: Cambridge University Press, 1988).

Johannes Wallmann, *Philip Jakob Spener und die Anfänge des Pietismus* (Tübingen, Germany: J. C. B. Mohr, 1986).

William Reginald Ward, *Christianity under the Ancien Regime, 1648–1789* (Cambridge, England: Cambridge University Press, 1999).

CHRISTIANITY, SCIENCE, AND THE ENLIGHTENMENT

THE SCIENTIFIC REVOLUTION. The seventeenth century was the moment when opposition to Christianity's cultural authority came to be located, not so much among scientists, but among intellectuals who championed science as an alternative to Christianity. Here "science" must be understood broadly as the new knowledge that resulted from scientific investigation, from technological advance, and from the empirical collection of data about new peoples and places. For anti-Christian intellectuals, science, technology, and empiricism (the observation and charting of the causes of natural phenomena) proved the Bible's inadequacy to explain the world and confirmed that Christian intellectuals were disconnected from reality. The jabs of these intellectuals, however, did only minor injury to the Christian cause. It was church

authorities that held Christianity up to ridicule by persecuting those scientists whose ideas they perceived as a threat and by insisting that the new science was a challenge to Christian authority. Many scientists—Galileo and Newton for example—remained practicing Christians. At the same time, many church authorities condemned science as heresy. The most spectacular demonstration of this process was the decision by the Catholic church to condemn the heliocentric theory, the theory that the earth and planets revolve around the sun. The Catholic church justified this decision with the argument that the Bible taught that the Lord had made the sun stop in the sky. Thus Christian orthodoxy necessarily had to affirm the geocentric argument, the theory that the sun and planets revolve around the earth. It was from this position that the Catholic church rationalized the conviction of the aged scientist Galileo (1564–1642) for heresy. Galileo was forced to recant his scientific findings and to proclaim publicly that the earth in fact remains stationary while the skies revolve around it. And yet, as Galileo is reported to have muttered under his breath after his public humiliation, "the earth does move." The trial of Galileo did not stop scientific investigation, but it did embarrass Christian intellectuals. The irony is that a good many Christian intellectuals actually embraced the new knowledge and sought to celebrate science as proof of the truth of Christianity. Calvin, in his *Institutes of the Christian Religion*, had insisted upon seeing the world as a "mirror" of God's greatness. The sort of arguments that began to appear in the seventeenth century emerged from the same inspiration, but went in a different direction. Fixated on the mathematical and mechanical attributes of the world that was revealed in scientific investigation, Christian writers insisted that the symmetry and the efficiency of Nature could not be coincidental; these things must be the designs of a divine hand. Thus everything from the webs of spiders to the law of gravity to human emotions was argued to be evidence for the existence of the Christian God. The intellectuals that promoted these sensibilities, though, rarely advanced into the upper echelons of Europe's state churches. Instead most of the men chosen to lead these institutions had an animus against science and they asserted that faith transcended scientific reality. As such, during the age of the Baroque and Enlightenment, Christianity never made its peace with science.

DEISM IN ENGLAND. In England, one group of Christian thinkers took the rationality of Nature as more than just evidence of the existence of the Christian deity; they took it as an indication of the character of the deity as well. Rejecting the image of the Christian god as an entity who constantly intervened in the natural world to reward his followers and punish his detractors, these thinkers celebrated an idea of the deity who was content to let the world He put in place operate according to the principles He had established. These Deists, as opponents labeled them, did not embrace a uniform set of beliefs. What united Deists were the targets of their attacks. Deists rejected the possibility of miracles, since miracles involved the suspension of the laws of nature and God himself had established the laws of nature, and therefore, would not suspend them. Secondly, Deists took aim at the clergy, whom they indicted for fostering superstitions as religion. For Deists, churchmen were little better than shamans; both groups hoodwinked a gullible public with lies about their ability to manipulate the supernatural, a concept they insisted did not exist since the entire natural order was subjected to the laws the Deity had established at Creation. Most Deists advocated morality as religion's most positive force. Living right and doing unto others as you would have them do unto you were the commandments Deists recognized as coming from God. In England, the great age of Deist thought occurred during the later years of the seventeenth century and the early years of the eighteenth when, in the relatively free climate created by the ascension of William and Mary and the passage of the Act of Toleration, Deists could publish their views with the anticipation that they were to spark controversy, but not excite government censure.

MAJOR DEISTS. Of the many thinkers during Deism's great age, five are worthy of note. John Toland (1670–1722) was the first Deist to attract public notice. In his *Christianity Not Mysterious* (1696) Toland argued that whatever is "repugnant" to the human mind as irrational should not be believed. He had in mind the many miracles that had traditionally been used to justify and support Christianity. Anthony Ashley Cooper (1671–1713), the Third Earl of Shaftesbury, did not consider himself a Deist, yet his work was most closely identified with the term by thinkers on the continent. Shaftesbury's work went in the opposite direction from the work of most Deists, away from challenging the "superstitions" manufactured by "priests" toward identifying the actions implied in living a moral religious life. Still, in his *Letter Concerning Enthusiasm* (1708) Shaftesbury found occasion to lambaste any and all forms of religious fervor as blasphemous. In his *Scripture Doctrine of the Trinity* (1712) Samuel Clarke, who was chaplain to Queen Anne, demonstrated that the doctrine of the Trinity could not be found in the New Testament. For his efforts, a conventicle of the Anglican clergy forced a public apology from him. Anthony Collins (1676–1729)

a PRIMARY SOURCE *document*

CHRISTIANITY NOT MYSTERIOUS

INTRODUCTION: The Irish-born Deist John Toland (1670–1722) had been raised Catholic, but converted to Protestantism at the age of sixteen. In his *Christianity Not Mysterious* (1696) Toland labored to reconcile Christian teaching with the new rationalism propounded by figures like John Locke. His central insistence that the realm of nature might reveal God rationally came to be accepted by other Deists, but also attracted charges of pantheism from more Orthodox quarters. In the current passage he makes one of the charges that was to garner criticism from the Church of England's clergy: that the mysteries of Christianity and its doctrines were created by the clergy so that they might have control over the explication of the Scriptures.

After having said so much of reason, I need not [laboriously] show what it is to be contrary to it; ... what is evidently repugnant to clear and distinct ideas, or to our common notions is contrary to reason. I go on therefore to prove the doctrines of the Gospel, if it be the Word of God, cannot be so. But if it be objected that very few maintain they are, I reply that no Christian I know of now (for we shall not disturb the ashes of the dead) expressly says reason and the gospel are contrary to one another. But ... very many affirm, that though the doctrines of the latter cannot in themselves be contradictory to the principles of the former, as proceeding both from God, yet that according to our conceptions of them, they may seem directly to clash; and that though we cannot reconcile them by reason of our corrupt and limited understandings, yet that from the authority of divine revelation, we are bound to believe and acquiesce in them; or as the fathers taught them to speak, to adore what we cannot comprehend. ...

In short, this doctrine is the known refuge of some men, when they are at a loss in explaining any passage of the word of God. Lest they should appear to others less knowing than they would be thought, they make nothing of fathering that upon the secret counsels of the Almighty, or the nature of the thing, which is indeed the effect of inaccurate reasoning, unskilfulness in the tongues, or ignorance of history. But more commonly it is the consequence of early impressions, which they dare seldom afterwards correct by more free and riper thoughts. So desiring to be teachers of the Law, and understanding neither what they say, nor those things which they affirm ... they obtrude upon us for doctrines, the commandments of men. ... And truly well they may; for if we once admit this principle, I know not what we can deny that is told us in the name of the Lord. This doctrine, I must remark it too, does highly concern us of the laity; for however it came to be first established, the clergy (always excepting such as deserve it) have not been since wanting to themselves, but improved it so far as not only to make the plainest, but the most trifling things in the world mysterious, that we might constantly depend upon them for the explication. And, nevertheless they must not, if they could, explain them to us without ruining their own design, let them never so fairly pretend it. But, overlooking all observations proper for this place, let us enter upon the immediate examen of the opinion it self.

SOURCE: John Toland, *Christianity Not Mysterious* (London: n.p., 1696): 23–27. Text modernized by author.

set his sights on disproving the "forgeries" of the clergy. In *An Historical and Critical Essay on the Thirty Nine Articles of the Church of England* (1724) he set out to invalidate the Church of England's claim of authority to resolve issues of faith. In *A Discourse on the Grounds and Reasons of the Christian Religion*, written in the same year, he worked out a chronology to demonstrate that Jesus could not have been the Messiah of the Old Testament prophecies. The final Deist figure that made a major mark on the religious ideas of the eighteenth century was Matthew Tindal (1653(?)–1733), who published a book in 1733 that has since become known as the Deist "Bible." The work, *Christianity as Old as the Creation, or the Gospel a Republication of the Religion of Nature* rejected the notion of Christianity as a "revealed" religion. All that was right and moral in Christianity, Tindal argued, might be reasoned from the laws of nature without recourse to Scripture and the fabulous stories it contained.

THE SPREAD OF DEISM. Deism in England has been pictured as a thinking man's recreation. It emerged simultaneously with the rise of the coffeehouse, where Englishmen frequently met to converse, smoke, and consume enormous amounts of the exotic new brew. Deist writers thus wrote in a style that was accessible and appealing to the coffeehouse crowd. Deism was not an organized force, but an amorphous and sometimes stylish philosophical and religious preoccupation of the time, but one that Orthodox churchmen in England took quite seriously and which they frequently decried. Tindal's *Christianity as Old as the Creation*, for example, prompted more than 150 learned rebuttals. Of the many Orthodox responses to Deism that appeared at the time,

the most important was that of the Anglican Bishop Joseph Butler (1692–1752), who in *The Analogy of Religion, Natural and Revealed, to the Constitution and Course of Nature* (1736) pointed out that Nature, which the Deists characterized as the embodiment of rationality, was as full of irrationalities and ambiguities as the Scriptures and, like the Scriptures, required faith to be comprehended. More influential among intellectuals outside the church were the various arguments advanced by the philosopher David Hume (1711–1776). Hume understood a point that apparently escaped most of the Deists: that skepticism can be turned back upon the arguments of skeptics. Hume asserted, in other words, that there was no way to prove logically that Nature provided any necessary clues to the intent or character of its Creator. Following the theological wisdom of the day, Deists affirmed that the first religion of humankind had been monotheism, a natural creed that had been subverted and corrupted by the clergy. Hume countered such arguments by insisting that the first humans had been polytheistic, and by showing that the monotheism Deism celebrated was, in fact, a later corruption of primitive polytheism. As a result of these and other critiques, interest in Deism began to wane in England in the 1730s, and the successful attacks of Butler and Hume meant that the movement was not revived later in the eighteenth century. Yet while Deism's importance declined to a position of relative insignificance in England, English Deist ideas sparked imitations that were more permanent in France and Germany. It is not surprising that continental thinkers imitated ideas that had been discarded in England. In that country churchmen had tried to use their influence with government to suppress the ideas of the movement, but to little avail, and secular-minded intellectuals in England had come to express their notions relatively free from clerical condemnation. Such relative freedom existed in France only later in the eighteenth century when the royal government relaxed its censorship. On the continent also, conservative Christian movements like Jansenism in France and Pietism in Germany guaranteed that secular-minded intellectuals had to develop some defense against the arguments of these movements' enthusiasts, and Deism thus provided a welcome alternative to the emotionalism of Pietism or the austere religiosity of Jansenism. In France, thanks to the popularity of things English, major English Deist thinkers were translated into French and published. Many of the *philosophes*, the intellectuals of the French Enlightenment, identified themselves as Deists. The philosopher Voltaire characterized God as "the great geometrician, the architect of the universe, the prime mover." And it was through these thinkers that Ameri-can intellectuals like Benjamin Franklin and Thomas Jefferson came to be exposed to Deist ideas. In the second half of the eighteenth century German Christians also assimilated and reproduced the by-then abandoned English ideas concerning the design of Nature as proof of God's existence. But it was only late in the eighteenth century, and then cautiously, that they began to consider Deism's others aims, such as the abolition of a doctrinal Christianity. In Germany, writers like Gotthold Ephraim Lessing (1729–1781) led this avant-garde movement. Lessing was the son of a Lutheran clergyman. During the years 1774–1778, he edited and published a selection of writings he entitled *Fragments*. These were excerpts from an "apology" for "rational worshippers of God"— a shorthand for Deists. Hermann Samuel Reimarus had originally written this defense of Deist principles, but he had been too fearful of persecution to publish his treatise while alive. The firestorm of criticism that Lessing's publication of the *Fragments* ignited validated Reimarus' fears. To defend himself, Lessing wrote *The Education of the Human Race* between 1777 and 1780, a treatise in which he argued that it was now permissible for humankind to leave revealed religion behind and progress forward to a rational understanding of faith. Lessing's most effective response to his critics, though, was his play *Nathan the Wise* (1779), a story that argued that the human pursuit of knowledge transcended religion.

CHRISTIANITY AND THE ENLIGHTENMENT. The Enlightenment as an intellectual movement was anti-Christian, but the nature and character of anti-Christian sentiment differed in different lands. The Enlightenment aimed to open up every aspect of life on earth to intellectual scrutiny and rational analysis. Taking the Scientific Revolution as an example of what the human mind could do when it applied itself, promoters of the Enlightenment promised that further dramatic discoveries were waiting to be made in the study of Nature and in the study of society, culture, and the arts. Enlightenment thinkers postulated an opposition between "religious" and "rational" modes of thought. Religious thought was superstitious and credulous. It was the darkness to which rationalism was the light. Texts by Enlightenment thinkers typically portrayed Christian churchmen as conservative and reactionary, and Christian churches as backward and intellectually stifling. Their attacks on religion were motivated by more than just a perspective that religious thinking violated human reason, however. Enlightenment thinkers were asserting that the nature of rational human knowledge was, in and of itself, different from that which Christian doctrine and theology had taught for centuries. The Enlightenment was a declaration of

a PRIMARY SOURCE document

AN ENLIGHTENMENT EXAMINATION OF AN OLD TESTAMENT MIRACLE

INTRODUCTION: Although Deism remained in fashion among English intellectuals for only a short while, the movement affected the Enlightenment in France and Germany during the later eighteenth century. German Enlightenment philosophers faced a generally more conservative public that resisted any attempts to modernize Christianity. In 1777, though, the philosopher and playwright Gotthold Ephraim Lessing (1729–1781) published the *Fragments* of Nikolaus Reimarus. These were philosophical musings that had been greatly influenced by deism. The furor they caused forced Lessing to defend himself from the charge of heresy in several subsequent works.

If we look at … the miracle of the passage through the Red Sea, its inner contradiction, its impossibility, is quite palpable. Six hundred thousand Israelites of military age leave Egypt, armed, and in battle order. They have with them their wives and their children and a good deal of rabble that had joined them. Now, we must count for each man of military age, four others at least; partly women, partly children, partly the aged, partly servants. The number of the emigrants, therefore, in proportion to those of military age, must be at least 3,000,000 souls. They take with them all their sheep and oxen, that is to say a large number of cattle. If we count only 300,000 heads of households, and give each of them one cow or ox, that would add up to 300,000 oxen and cows, and

600,000 sheep and goats. In addition, we must count on at least 1,000 wagon loads of hay or fodder; to say nothing of the many other wagons containing the golden and silver vessels which they had purloined, and piles of baggage and tents needed for such an enormous army—even if we count only 5,000 wagons, which is one wagon to sixty persons. At least they arrived at the Red Sea, and put down their camp near its shore. Pharaoh followed them, with 600 selected wagons and all the wagons left in Egypt, in addition to all the cavalry and infantry, and, as it was nightfall, he settled down not far from them. Josephus estimates this army at 50,000 cavalrymen and 200,000 infantry. It cannot have been small, for it was planning to confront any army of 600,000. But let us only count half of this—namely 25,000 cavalrymen, and 100,000 infantry, plus the wagons. During the night, the column of cloud and fire places itself between the Israelites and the Egyptians; God then sends a strong easterly wind which through the whole night pushes away the sea and makes the ground dry. Then the Israelites enter, dry of foot, and the Egyptians follow them, so that the former have crossed while the latter are in the middle of the sea. In the watch of the morning, God looks down upon the army of the Egyptians, allows the water to return so that it is restored to its full flood, and thus all the Egyptians drown, and not a one remains. It is this that the Biblical narrative partly tells us explicitly, partly compels us to infer.

SOURCE: Gotthold Ephraim Lessing, *Fragments*, in *Deism: An Anthology*. Ed. Peter Gay (Princeton, N.J.: D. Van Nostrand Co., 1968): 160–161.

independence for secularism, a proclamation of self-emancipation for those who wanted to investigate any and all subjects, free from considerations of religious truth and without fear of clerical reprisals. For centuries, Christian theologians and officialdom had characterized knowledge according to whether it aided or hindered human salvation. The thinkers of the Enlightenment abandoned such judgments. For them, knowledge was to be judged good if it served to validate experiences and phenomena that had been observed in the real world. In the course of the eighteenth century the Enlightenment took different paths and moved in very different directions in various European regions. It is the French Enlightenment that is best known and studied, and it was a movement that was vehemently anti-clerical. France was also the only Catholic land in which the Enlightenment grew deep roots. The French Catholic clergy provided the philosophes with examples to ridicule and condemn. France was also the one state where atheists made a point of publicly rejecting their belief in the Christian God. According to a long-standing anecdote, David Hume came face-to-face with this unprecedented rejection of Christianity while serving as a member of the British diplomatic corps in Paris. One evening at a dinner party hosted by the Enlightenment philosophe Paul Henry Thiry, the Baron d'Holbach (1723–1789), Hume remarked that he had never met an atheist. The Baron lamented Hume's bad luck, but then assured him that he was surrounded then by at least seventeen of them. The Deism of Voltaire, rather than the atheism of d'Holbach, is probably more reflective of the disposition of the French philosophes and their followers toward Christianity. Like Voltaire, most French who participated in the Enlightenment did not reject Christianity outright as much as they attacked the Catholic clergy and the cultural authority the church claimed. By contrast, Enlightenment thinkers in Britain had little to say on the subject of religion. Certainly David Hume

a PRIMARY SOURCE *document*

AN ENLIGHTENMENT ATTACK ON CHRISTIANITY

INTRODUCTION: Paul Henri Thiry, the Baron d'Holbach (1723–1789), was one of the French Enlightenment's most controversial figures. He vigorously attacked the Christian tradition and all religions as nothing more than edifices "in the air." In this excerpt from his *Common Sense*, published in 1772, d'Holbach praised atheism as the only sensible and rational choice for thinking men and women.

In a word, whoever will deign to consult common sense upon religious opinions, and bestow in this inquiry the attention that is commonly given to objects, we presume interesting, will easily perceive, that these opinions have no foundation; that all religion is an edifice in the air; that theology is only the ignorance of natural causes reduced to system; that it is a long tissue of chimeras and contradictions. That it represents, in every country, to the different nations of the earth, only romances void of probability, the hero of which is himself composed of qualities impossible to combine; that his name, exciting in all hearts respect and fear, is only a vague word, which men have continually in their mouths, without being able to affix to it ideas or qualities, which are not contradicted by facts, or evidently inconsistent with one another.

The idea of this being, of whom we have no idea, or rather, the word by which he is designated, would be an indifferent thing, did it not cause innumerable ravages in the world. Prepossessed with the opinion, that this phantom is an interesting reality, men, instead of concluding wisely from its incomprehensibility, that they are not bound to regard it; on the contrary infer, that they cannot sufficiently meditate upon it, that they must contemplate it without ceasing, reason upon it without end, and never lose sight of it. Their invincible ignorance, in this respect, far from discouraging them, irritates their curiosity; instead of putting them upon guard against their imagination, this ignorance renders them decisive, dogmatical, imperious, and even exasperates them against all, who oppose doubts to the reveries, which their brains have begotten.

SOURCE: Baron d'Holbach, *Common Sense*, in *The Portable Enlightenment Reader*. Ed. Isaac Kramnick (Harmondsworth, England: Penguin Books, 1995): 141.

made it the target of a good deal of his skeptical speculation. But the political economist Adam Smith was far more typical of the British Enlightenment, and Smith, as demonstrated in his classic, *The Wealth of Nations*, was concerned to identify the "natural" motivations for human behaviors. His focus, in other words, did not challenge alternative Christian explanations of human behaviors as much as ignore them. In Germany, the difficulties of thinkers like Lessing illustrate that one challenge of the Enlightenment in this region proved to be in getting any rationalist critique of Christianity into print. Yet it was in German-speaking Europe, more so than anywhere else in Continental Europe, that rulers looked to the works of Enlightenment thinkers popular elsewhere in Europe for hints at ways in which they might reform their state's churches. Prompted by the critiques of clerical authority that were common in the works of thinkers like Voltaire, Frederick the Great of Prussia and Joseph II of Austria both moved to reform the churches in their lands according to Enlightenment principles.

SOURCES

Peter Byrne, *Natural Religion and the Nature of Religion* (London: Routledge, 1989).

Gerald S. Cragg, *The Church and the Age of Reason, 1648–1789* (New York: Athenaeum, 1960).

Rosemary Z. Lauer, *The Mind of Voltaire* (Westminster, Md.: Newman Press, 1961).

Christopher Voigt, *Englische Deismus in Deutschland* (Tübingen, Germany: Mohr Siebeck, 2003).

CHRISTIANITY IN THE REVOLUTIONARY ERA

CHRISTIANITY AND ENLIGHTENED DESPOTISM. Frederick the Great (r. 1740–1786) of Prussia and Joseph II (r. 1765–1790) of Austria were among Europe's two most successful enlightened despots. They were rulers who applied the rationalistic and scientific approaches to their governments recommended by Enlightenment thinkers. Since the rise of the Enlightenment in the early eighteenth century, intellectuals had attacked the church as a bastion of privilege and irrational superstition. In both Prussia and Austria Frederick and Joseph pushed through reforms in the churches during the second half of the eighteenth century. Their attacks on the power and authority of the state church were not motivated by a desire to suppress Christianity, but to fit its practice into their rationalized schemes of government. By the second half of the eighteenth century most Protestant countries in Europe provided *de facto* forms of religious toleration, and although legal

codes did not always recognize freedom of religion, minority faiths practiced their religion in these places relatively freely. England had led the way in this regard since it had allowed dissenting forms of Protestantism to flourish from the 1690s and had also provided a space for the expansion and evolution of Methodism. The migration of Irish Catholics into the country in the eighteenth century added a new dimension to England's already pluralistic but mostly Protestant religious landscape, and the presence of Catholic workers in the country's thriving industrial factories by the later eighteenth century prompted government officials to relax their persecution of Catholicism. In 1753, the English Parliament also passed a Jewish Naturalization Act, though popular anti-Semitism later forced its repeal. These kinds of measures were quickly imitated elsewhere in Europe. In Prussia, Frederick the Great went even further than the English, and in his revision of the Prussian legal code, the *Allgemeine Landrecht*, published a year after his death, Prussia granted legally recognized religious toleration to all subjects in the country. For the first time in the history of Europe, citizenship was separated from religious considerations. While Prussian innovations in this regard were great, it was in Joseph II's Austria that the Enlightenment made its most spectacular mark. Since the grim days of the Thirty Years' War, Habsburg policies in Central Europe had freely used force to convert Protestant subjects to Catholicism. In 1781 Joseph II reversed more than 150 years of policy and declared that while public worship was to remain an exclusive right of the Catholic church, Protestant minorities might now practice their faith privately. Joseph also considered issues that were of importance for traditional Catholicism, and the measures he fostered were intended to strengthen local religious practice. He created more than 500 new parishes throughout his lands to accommodate recent population growth. Like most rulers influenced by Enlightenment ideas, Joseph aimed to curtail monasticism, which by this time was seen by most intellectuals as a wasteful, even parasitical, occupation. Governments concluded that religious orders should be eliminated and their wealth dedicated to the sorts of social improvements recommended by Enlightenment thinkers. In France during the 1760s, a royal commission closed 426 religious houses. In Sicily, a number of monasteries stayed open only by honoring the government's request that they provide free schooling for the poor. But Joseph II outdid these examples and closed between 700 and 750 monasteries in his lands. The enormous sum that the Crown netted from the sale of these institutions' properties funded Joseph's new parishes as well as new medical training facilities in Vienna. The Jesuit order suffered the most under these measures, since they had been singled out by many Enlightenment thinkers as the most manipulative of the Roman church's many groups of clerics. Already in 1758, Portugal had begun to pressure the Papacy to suppress the order, and an ever-growing chorus from other Catholic governments joined the call for the Jesuit's dissolution. In 1773, the Papacy surrendered to these demands and dissolved the Society of Jesus, the institution that had long played such a vital role in the missionizing efforts of Roman Catholicism. The Jesuits were to rise anew from this embarrassment several generations later, but never again was the order to play the key role in shaping political and governmental policies that it had in the early-modern world.

THE FRENCH REVOLUTION AND DECHRISTIANIZATION. Eighteenth-century enlightened despots like Frederick the Great or Joseph II had sought only to reform their state churches along lines advocated by Enlightenment philosophers. But the revolutionaries who came to power in the years following the outbreak of the French Revolution in 1789 frequently tried to destroy the church altogether. The French revolutionaries, in particular, have often been accused of taking the rationalism of the Enlightenment to its logical conclusions. These political leaders were not trying to accomplish some pre-existing political agenda, but were caught in reacting to the moment. Like many of the events of the revolutionary years that followed 1789, they were carried away by the course of events. The same pressure of revolutionary events that prompted France's revolutionaries to execute their king and queen also led them to disestablish the Catholic church. Several generations ago, historians coined the term "dechristianization" to describe the pervasive intellectual sentiments in France in the years leading up to the Revolution. Many scholars argued that there was a discernible decline in the practice of the Christian faith in these years among intellectuals. Unfortunately, the measures that were used to demonstrate this decline were problematic. Just as in England and other parts of the Continent, Christian sensibilities were changing in France on the eve of the French Revolution, but they were not disappearing. French Catholics, in fact, were not initially opposed to the Revolution, and members of the clergy formed the majority of delegates in the National Assembly, the revolutionary body that voted first to nationalize church lands and later to dissolve monasteries. But conflicts soon arose between the Revolution and Catholics concerning the Civil Constitution of 1790. This document made the church into a department of state, and significantly, required churchmen to swear an oath of loyalty to the

The Statue of Atheism is destroyed and replaced by that of Wisdom at the French Revolution Festival of the Supreme Being on 8 July 1794. **BRIDGEMAN ART LIBRARY**.

new government as state employees. The papacy, however, refused to permit the clergy to swear the oath, and churchmen were thus forced to decide whether their loyalties lay with the Revolution or with Rome. About half of France's clergy, including some initially sympathetic to the Revolution, refused to swear, and were soon persecuted as traitors. Devout Catholics soon rose to defend these "refractory" priests, creating an underground religious movement in France in which traditional Catholic rites were practiced in violation of the Revolution's dictates. This underground became the nucleus of opposition to the new government and thus condemned Catholicism in the minds of many revolutionaries as a reactionary force. As the movement's leaders saw it, the only way for France and the Revolution to go forward was to destroy any connection with the country's Catholic past, and thus a decided policy of active dechristianization took shape. Catholicism was jettisoned as the official faith of the French Republic; the government appropriated and sold churches and their furnishings. And in one of the most curious moves, the Revolution's leaders even abandoned the traditional Christian week and calendar. In 1793, "Year One" of

the Revolution, the week was reorganized into ten days known as "decadi" and the months were given new revolutionary names. Even more important than these measures were the Revolution's efforts to replace Christianity with the practice of a new Cult of Reason, a mixture of ideas and values drawn from science and history. To counter what he took to be the atheism implicit in this Cult of Reason, Maximilien Robespierre (1758–1794), the leader of the Revolution at the time, commandeered Paris' Cathedral of Notre Dame and staged an extraordinary ceremony during which he paid homage to a "Supreme Being," a projection of his own Deist sensibilities. The Cult of the Supreme Being did not catch on, nor did the Cult of Reason, and Catholicism continued to be practiced in France, albeit out of public view, until the historic relationship between France and Rome was reestablished by Napoleon in 1801.

TOWARD THE FUTURE. The French Revolution's spectacular attempts to escape the Christian past arose in part from the very controversial nature that the state church and its institutionalized religion had long played in early-modern Europe. While generally accepted and established as a force of state domination throughout

Europe for most of the seventeenth and eighteenth centuries, the state church was an institution that had never worn well on the sensibilities of many Europeans. As Europe had grown more religiously pluralistic in the course of these years, the established church had come to seem to both serious Christians and the religiously indifferent ever more like a relic of a distant past. But while France's revolutionaries hoped to build a new state divorced from traditional religious considerations, their deism and atheism proved to be largely out-of-step with a nation that still revered Christian teaching. In the century that followed, Christianity made a dramatic resurgence, not only in France, but also throughout Europe. The new realities of this revival meant that religion was forced to compete, as were any of a number of ideologies, for the hearts and minds of Europeans. The traditional systems of compulsion, intolerance, and indoctrination that had held such force in the states of early-modern Europe were now to have little impact in a world in which Europeans were free to believe or disbelieve as they chose.

SOURCES

Jack R. Censer and Lynn Hunt, *Liberty, Equality, and Fraternity: Exploring the French Revolution* (University Park, Pa.: Pennsylvania State University Press, 2001).

Timothy Tackett, *Religion, Revolution, and Regional Culture in Eighteenth-Century France* (Princeton: Princeton University Press, 1986).

Michele Vovelle, *Religion et Révolution* (Paris: Hatchette, 1976).

SIGNIFICANT PEOPLE
in Religion

JACOBUS ARMINIUS
1560–1609
Theologian

YOUTH IN A TEMPESTUOUS TIME. Jacob Harmenszoon, who later became known as the theologian Jacobus Arminius, was born in the town of Oudewater, near Leiden in the Netherlands. His father worked in the metal trades, either as a blacksmith or a forger of armor, but he died when Jacob was still a child. Throughout the child's youth the Netherlands were plagued with civil and religious wars, a result of the Dutch movement for independence from Spain. Following Jacob's father's death, a family friend, Jacob Aemilius, took the young

boy under his wing and paid for his primary and secondary education. When Aemilius died around the time Jacob Harmenszoon was fifteen, a Dutch-born professor at the University of Marburg in Germany, Rudolf Snellius, assumed the responsibility for Harmenszoon's education. Snellius paid Jacob Harmenszoon's fees at the University of Leiden, and in 1576, when the young student entered, he began to use the name "Arminius." After completing his studies there, Arminius won the support of the city of Amsterdam to study in Geneva, then the center of Calvinist theological education in Europe. Although usually temperate and mild-mannered, Arminius attracted controversy shortly after he arrived in Geneva when he defended the French mathematician, rhetorician, and Calvinist convert Peter Ramus, a figure he had admired since his school days in Leiden. During the St. Bartholomew's Day Massacres of 1572, Ramus was martyred, and in the decades that followed his works were widely reprinted and his fame spread throughout Europe. Ramus's Calvinist ideas were feared by some because he argued for a complete reorganization of universities and the elimination of Aristotelianism from the curriculum. At Geneva, Arminius's defense of Ramus seems to have ruffled some feathers, and in 1583, the young theologian left town to study in Basel. After some success there, he returned to Geneva where he seems to have ingratiated himself with Theodore Beza, then the leading theologian and successor of John Calvin in the city. In 1586, Arminius completed his studies in Geneva. He made a short trip to Italy and then returned to his native Netherlands, where he took a position as a minister in one of the churches of Amsterdam. He married and served for a time on the town council before being called in 1603 to a professorship at his alma mater, the University of Leiden.

CONTROVERSY. For most of his life Arminius seems to have lived the life of a quiet parson. But in his final years as a professor, the scholar became a lightning rod for controversy. Although he had originally believed in the Calvinist concept of predestination, he came to have doubts, and when he expressed them he became embroiled in a theological dispute that eventually erupted into a major controversy throughout the Dutch Calvinist church. Arminius rejected the teaching of "double predestination" that Calvin and other Genevan theologians had propounded. In this view, God not only had foreknowledge of who would and would not accept or reject his offer of salvation, he actively elected or chose those to receive his grace. Arminius rejected such a view and taught instead that God may have had foreknowledge of whether one was to be saved, but this knowledge did not

determine a human being's choice. One was free to accept God's offer of salvation or to reject it. In this way, Arminius's theology championed free will, a concept roundly rejected by Calvinist theologians of the day. At Leiden, Arminius's colleague Franciscus Gomarus led the charge against his views, developing a counter-party to the Arminians that became known as the Gomarists. Although he died only six years after accepting the post as professor of theology at Leiden, he attracted a significant following, and in the years following Arminius's death his concept of free will was taken up by a significant portion of the university's faculty and students, and was even embraced by Hugo Grotius, the greatest legal mind of the early seventeenth century. One year following his death, they issued the *Remonstrances*, a work that systematically defended his teachings and argued that they should be accepted by the Calvinist church in the Netherlands. From this time, the Arminian party in the Netherlands became known as Remonstrants. During the 1610s, the controversy continued to brew over Arminius's free-will theology, but in 1618, the Synod of Dordt, a meeting of the Dutch church's ministers and theologians roundly condemned his views as heretical. While a splinter group survived that adhered to his teachings, Dutch Calvinist orthodoxy continued to follow the vein of thinking on predestination that had first been set down by John Calvin in the sixteenth century. Arminius's views survived, however, and became even more significant in the eighteenth century, when they were adopted by John Wesley, the founder of the Methodist church.

SOURCES

Jacobus Arminius, *The Works of James Arminius*. Trans. William and James Nichols (1853; Reprint, Grand Rapids, Mich.: Baker, 1986).

Carl Bangs, *Arminius: A Study in the Dutch Reformation* (Nashville: Abingdon Press, 1971).

CORNELIUS JANSEN

1585–1638

Bishop
Theologian

EDUCATION AND THEOLOGICAL INFLUENCES. In 1602, Cornelius Jansen entered the University of Louvain, then in the southern Netherlands (today modern Belgium). From his earliest student days he was affected by the teaching of his professor, Jacques Janson, who taught a form of theology that had been developed in the later sixteenth century by the Flemish theologian,

Michel de Bay. De Bay's works taught that humankind was utterly wicked and could not hope to achieve salvation without an infusion of God's grace. In addition, his theology stressed divine election, the idea that God chose a small number of sinners to receive his gift of grace. Such teaching was part of the traditional orthodoxy of Roman Catholicism and stretched back to the writings of the ancient bishop and theologian St. Augustine (345–430). In the overheated world of Reformation and Counter-Reformation polemic, however, the Catholic church had come at the time to favor theories of salvation that stressed human participation. Although no papal pronouncements had outlawed ancient Augustinian teachings concerning the necessity of election and divine grace, the counter-reforming Jesuit order, in particular, favored teachings that stressed free will and voluntarism, the notion that human beings might choose or reject God's salvation. Many disputes had raged between the Jesuits and those who held to a more traditional Augustinianism, but in 1611, Pope Paul V had declared further discussions of these questions off limits. His pronouncement on the matter had stressed that the teachings of both the Jesuits and those who upheld the ideas of Augustine were orthodox. Although Jansen seems to have held to the Augustinian position throughout his life, he was cautious never to be drawn publicly into this dispute.

PARIS. After completing his studies at Louvain, Cornelius Jansen went on to the University of Paris, and there he met his lifelong friend, Jean Duvergier de Hauranne, who later became known as the Abbé de Saint-Cyran. The two decided to work to reform theology, a field of study they believed had become populated with errors and which had sunk into a dry and arid intellectualism. Under Duvergier de Hauranne's influence, Jansen became the head of a seminary in the family's hometown of Bayonne, and in the period between 1612 and 1614, both friends devoted themselves to the study of the works of the early church. Returning to Louvain a few years later, Jansen took over a seminary there, directing the theological study of a number of candidates for the priesthood. At this time, he devoted himself more thoroughly to the study of Augustine, and was said to have read the ancient Father's work at least ten times over the next few years. Through his study he became convinced that the contemporary teaching of the Jesuits were heretical and that they mirrored those of the ancient Pelagians, who had argued that human beings had the freedom to save themselves by choosing or rejecting God's gift of grace. Soon Jansen began to work on his monumental opus, the *Augustinus*, a work he intended

to defend the ancient teachings of Augustine and to condemn the Pelagianism of the contemporary Jesuit order. Powerful forces were arrayed in support of the Jesuits, though, and so Jansen worked for many years on his project secretly.

SUCCESS IN THE CHURCH. Despite the unconventionality of Jansen's religious ideas, he continued to rise in the church. His career was aided by the fact that he wrote several popular tracts critical of Protestantism. By 1635, he was appointed rector of the University of Louvain, and the following year, he was chosen bishop of Ypres. In this capacity he had a printing press installed in the bishop's palace so that he might supervise a secret printing of the *Augustinus.* Unfortunately, Jansen died only a few years later, in 1638, when an outbreak of plague struck Ypres. The publication of his famous book was undertaken by several of his friends, and in 1640, the *Augustinus* finally appeared. The character of the work was dense and learned, and it examined a number of technical points of Augustinian and Pelagian theology. It is hard to imagine now that it became a highly controversial work, but its violation of the papal decree forbidding discussion of the concepts of free will, predestination, and election meant that it was soon the center of a controversy. In France, the followers of Jansen's one-time friend, the Abbé de Saint-Cyran, saw in the work a theological underpinning for their disciplined and austere devotional movement, and they soon became known as "Jansenists." In this way, Jansen's severe Augustinian theology came to be identified with their reform movement, a movement that the Jesuits charged as being little more than a form of "crypto" or secret Calvinism within contemporary France.

SOURCES

William Doyle, *Jansenism: Catholic Resistance to Authority from the Reformation to the Revolution* (New York: St. Martin's Press, 2000).

Alexander Sedgwick, *Jansenism in Seventeenth-Century France* (Charlottesville, Va.: University Press of Virginia, 1977).

F. Ellen Weaver, *The Evolution of the Reform of Port Royal* (Paris: Beauchesne, 1978).

WILLIAM LAUD

1573–1645

Anglican Archbishop

EARLY CAREER. Born to prosperous parents in 1573, William Laud attended Oxford and pursued a career in the church and the university until his middle age. In 1608, Laud entered the service of the bishop of Rochester and from this point onward he received a number of church offices. As a priest in a royal chapel, he was noticed by James I, and soon became the confidant of the king's close friend, George Villiers, the Duke of Buckingham. He also served as Buckingham's priest. In these years his influence at court steadily rose, and his opposition to Puritanism came to be reflected increasingly in James I's policies. Following the king's death, his rise continued during the reign of Charles I. By 1627, he had been appointed to the privy council, the king's private administrative body, and soon he rose to become the bishop of London. In this capacity he pursued a policy directly aimed at countering Puritanism. He aimed to limit the use of sermons in Anglican worship, to reinstate communion rails, and to require forms of vestments like the surplice that fit with his formalism. He also enforced a strict adherence to the prescriptions of the *Book of Common Prayer.* In his years as London's bishop, though, he had not yet acquired the completely uncompromising nature that was to prove fatal in the years ahead. Realizing the strength of his opposition, he sometimes temporized and allowed Puritan elements of worship and piety to exist in the capital.

ARCHBISHOP OF CANTERBURY. In 1633, Laud became archbishop of Canterbury, and from this point onward he exercised the dominant voice at court concerning religious matters. In the next few years he ordered that all English diocese undertake a Visitation—that is, an official inspection—to determine the state of church property and religious knowledge. He aimed successive measures to combat Puritanism, legislating against sermons, opposing the Puritan custom of Sabbath-keeping, censoring the press, and even undertaking a very public battle against the Puritan propagandist William Prynne. Prynne, an outspoken opponent of religious formalism and ceremony and an avowed opponent of the theater, had published an enormous work critical of the king, the queen, and Laud's religious policy. As part of his punishment, Laud insisted that Prynne be maimed. Actions like these further alienated Puritans and moderates alike, and Laud found few ready allies, even in those court circles that were friendly to his ambitions. At the same time, Laud undertook to solve certain problems of church finance and raise the level of benefices, that is, the incomes that Anglican priests relied upon to support themselves. During the previous generations the economic ills of the church had grown to grave proportions, and although his efforts were well intentioned, they attracted criticism as proof

of his rapaciousness. By 1639, Laud's and King Charles's plans to make the English *Book of Common Prayer* obligatory in Presbyterian Scotland precipitated the "Bishop's War," as English troops were sent to the country to try to enforce the book's liturgy against widespread and frequently violent resistance.

CIVIL WAR AND CONDEMNATION. The convening of Parliament in 1640, a body that had not met since 1629, brought issues with Laud's control of the church to the boiling point in England as well. By 1643, King Charles had left the capital to rally an army in support of his cause. Soon Parliament moved against Laud, accusing him of high treason in 1644. He was imprisoned in the Tower of London before finally being tried before the body in proceedings that were managed by his one-time opponent, William Prynne. Although the House of Lords resisted attempts to sentence Laud for a time, the Commons eventually succeeded in obtaining his death sentence, and on 10 January 1645, Laud was beheaded. Since that time, the ill-fated archbishop has only rarely been seen as a sympathetic figure. His attempts to establish a rigorous formalism in the Church of England arose from his own deeply felt piety. He saw elaborate ritual, in other words, as the only fitting vehicle for the common worship of God. Like the Puritans, his own religious convictions were serious, uncompromising, and arose from reasoned thought, but they proved to be out-of-step with the more austere Protestant sentiments of many English men and women at the time.

SOURCES

Edward C. E. Bourne, *The Anglicanism of William Laud* (London: Society for the Propagation of Christian Knowledge, 1947).

Charles Carlton, *Archbishop William Laud* (London: Routledge and Kegan Paul, 1987).

Christopher Hill, *Economic Problems of the Church from Archbishop Whitgift to the Long Parliament* (Oxford: Clarendon Press, 1956).

H. R. Trevor Roper, *Archbishop Laud* (Hamdon, Conn.: Archon Books, 1962).

JOHN WESLEY

1703–1791

Anglican clergyman

UPBRINGING AND EDUCATION. John Wesley was born the son of an Anglican priest who had once been a member of a non-conforming sect. The fifteenth of nineteen children, his family's household was heroically run on slim resources by his mother, Susanna, a figure that John was later to immortalize as a paragon of Christian piety. In 1720, he entered Oxford and when he completed his degree several years later, he decided to pursue a career in the church. After assisting his father in his parish, he eventually was ordained in 1728. In these years he also had a fellowship at Oxford, and in 1729, he returned there to fulfill the requirements of that grant. John, his brother Charles, and several others formed the "Holy Club," a group that soon was mocked by other members of the Oxford community as "Methodists." John soon assumed the lead in the "Holy Club" and under his direction it steadily grew. Its members followed a pious regimen that included frequent partaking of communion as well as fasting, disciplines that had long fallen out of favor in Protestant England. Soon, the group also began to undertake social work, visiting prisoners in the local jail and aiding them in their efforts at rehabilitation. Eventually, they added ministries to the poor in the surrounding region and founded a school that aimed to teach the poor to read.

MINISTRY IN NORTH AMERICA. In 1735, John Wesley was asked to undertake a mission to the colonists and Indians of North America under the auspices of the Society for the Propagation of the Gospel, an Anglican missionary society. It was while he was on board the ship to Georgia that he made the acquaintance of a group of pious Moravians and was impressed by their demeanor and selflessness. His own efforts in the colonies, though, proved largely disastrous. At the time, Wesley's own religious convictions included a heavy dose of Anglican formalism, and his uncompromising ways irritated the locals. The unsuccessful courtship of a local woman proved his undoing, and by 1737, Wesley had returned to England. In London, he soon fell under the influence of the Moravians, who encouraged him to read Martin Luther and other classics from their tradition. He soon began attending the meetings of the Aldersgate Society, a group of Pietists that included many Moravians, but which fell under the supervision of the Church of England. At one of these meetings in 1738, he underwent a profound conversion experience, an experience prompted by Luther's commentary on the New Testament book of Romans. He became convinced of the reality of his faith and later reported that his heart was "strangely warmed" by the experience.

FAITH ALONE. In the months and years that followed Wesley's conversion he dedicated himself to preaching the gospel of "faith alone," the initial Reformation insight of Martin Luther that had produced

revolutionary religious changes in the sixteenth-century world. He traveled widely throughout England, visiting many religious groups and laboring to deepen their piety. One technique that he widely deployed was the adoption of the Moravian system of "bands," these were small groups of Christians of the same sex and station in life who might counsel and encourage one another in the pursuit of perfection. At first, Wesley tried to work through the established channels of the Church of England, but resistance to his efforts proved to be so great that he began to set up his own network of Methodist societies, taking the name of derision that had once been used against him at Oxford as an emblem of pride. To promote these societies, Wesley had to travel far and wide and he became one of the most successful itinerant preachers in the history of Christianity. Hundreds, even thousands, sometimes flocked to hear his sermons, and since he was largely barred from preaching in Anglican churches, he spoke in fields, streets, indeed anywhere where an audience might be assembled, giving rise to the development known as "field preaching." During his long life it is estimated that he may have traveled more than a quarter of a million miles and preached as many as 40,000 sermons. Both he and his brother Charles were also avid hymn writers, and while John's output did not match his brother's almost 8,000 hymns, he was nevertheless prolific. Wesley's example inspired many imitators, and numerous lay people took up the charge of preaching the gospel. In this way the English Methodist societies helped to establish one of the central aims that the Pietist movements had shared since the early eighteenth century: the desire to promote a true priesthood of all believers. Wesley's lay missionaries found their way to the North American colonies, and where he himself had been largely unsuccessful there, his Methodist Societies attracted huge numbers of Americans. During the American Revolution many of his preachers returned to England, and at the conclusion of the hostilities, Wesley faced many demands for ministers from his societies in the new United States. The bishop of London refused to ordain Methodist ministers to serve there, and so Wesley ordained the ministers himself. Such an action was not strictly legal according to the laws of the Church of England, but Wesley responded to criticism by pointing out that the Methodist Societies had always been independent of the Church of England.

FROM METHODIST SOCIETIES TO THE METHODIST CHURCH. In the final years of Wesley's life the increasing division between the Methodist Societies and the Church of England grew even more evident.

John Wesley, however, remained faithful in his mission as a priest of the Anglican church until his death in 1791. In the years immediately following, though, the Methodist Societies separated from the Church of England to form the Methodist church. From this vantage point, they continued to grow in the nineteenth century. Today there are some 300,000 Methodists in the United Kingdom, but worldwide the Methodist church numbers almost 70 million members and is thus almost as large as the Anglican Communion out of which it grew. In the United States the Methodist church is more than ten times larger than the Episcopal church, the descendant of the colonial Church of England. The sheer scale of Methodism success as a Pietist movement thus is ample proof of John Wesley's unique Christian vision for a church that might incorporate the message of salvation by faith, personal spirituality, and mechanisms for lay involvement.

SOURCES

Roy Hattersley, *John Wesley: A Brand from the Burning* (London: Little Brown, 2002).

John Pudney, *John Wesley and His World* (New York: Scribner, 1978).

Martin Schmidt, *John Wesley: A Theological Biography* (London: Epworth Press, 1962).

J. S. Simon, *John Wesley.* 5 vols. (London: Epworth Press, 1921–1934).

C. E. Vuliammy, *John Wesley* (New York: St. Martin's Press, 2000).

DOCUMENTARY SOURCES
in Religion

Antoine Arnauld, *On Frequent Communion* (1643)—This devotional work introduced the ideas of Cornelius Jansen and the Abbé de Saint-Cyran to a broader audience in seventeenth-century France and became one of the defining texts of the Jansenist movement in the country.

Johann Arndt, *True Christianity* (1605–1609)—This early seventeenth-century statement of devotional principles and practices became one of the primary sources of inspiration for the Pietist movement. In it, Arndt rejects the dull formalism of the Protestant church of his time and instead argues for the importance of meditation.

The Authorized Version of the Bible (1611)—This translation of the Scriptures has long been known simply as the "King James' Version," since its publication was approved

during the reign of the first Stuart king of England. The work is notable for the loftiness of its prose and for the profound influence it had on the development of seventeenth-century literary English.

Jakob Boehme, *Of True Repentance* (1622)—This mature statement of the author's faith became an important text in later seventeenth and early eighteenth-century Pietism. The author aimed to stir his readers to a true reformation of life and to instill the Lutheran church with an internal spirituality that might deepen the reform of doctrine that had occurred during the sixteenth-century Reformation.

John Bunyan, *Pilgrim's Progress* (1678)—Written while its author was imprisoned for his religious dissent during 1675, this work is the greatest spiritual allegory in English. It has remained a perennial classic, read by kings and princes and humble folk alike. It tells of the spiritual progress of a simple pilgrim, facing the trials of despondency, slough, and a host of other vices, yet emerging triumphant from these trials through the help of divine grace.

Charles I, king of England, *The Book of Sports* (1677)—Through this work Archbishop Laud and the Stuart king reinstated James I's 1618 proclamation allowing Sunday sport. The short book caused a furor by sanctioning recreation on the Puritan Sabbath. Like his father, Charles explained in the text that Sunday pastimes provided a release for the populace, avoiding the far greater evils the king sensed lay in their inactivity.

Samuel Clarke, *Scripture Doctrine of the Trinity* (1712)—This treatise demonstrated that the New Testament revealed nothing about the key Orthodox doctrine of the Trinity. As a result of its publication, the Deist Clarke was forced to answer charges of heresy from an Anglican conventicle that met to condemn his ideas.

George Fox, *Autobiography* (1694)—Compiled from the author's journals after his death, this work is one of the great spiritual autobiographies of the Western tradition. It also provides a wealth of insight into the founding of the Society of Friends, the Quakers, the movement of which Fox was the leader. The work includes a testimonial from William Penn, the Quaker founder of the English colony of Pennsylvania.

Joseph Glanvill, *Saducismus Triumphatus* (1681)—As the witch hunt drew to a close, this English theologian's work warned that the belief in witches and demons could not be relinquished without also giving up one's faith in God. The ideas of Glanvill proved to be increasingly outdated in a world in which intellectuals were quickly jettisoning the concept of the supernatural.

Jeanne-Marie Bouvier de la Motte-Guyon, *Life of Madame Guyon* (1712)—One of the great early-modern spiritual autobiographies, Madame Guyon's life tells of her mystical quest for union with God. The author was a member of the French Quietist movement that bore some similarities to English Quakerism. The Quietists sought to "wait upon the Spirit of the Lord," even at the expense of neglecting their own personal salvation. Madame Guyon, like other Quietists, fell afoul of the French state and was imprisoned for more than eight years. She spent her final years under house arrest.

Gotthold Ephraim Lessing, *The Education of the Human Race* (1780)—This treatise caused great controversy in Germany because of its argument that it was now permissible for the human race to leave revealed religion behind and progress forward to a rational understanding of faith.

John Milton, *Paradise Lost* (1667)—In this epic poem one of the greatest English poets of all time defended his Puritan religious beliefs. The work was published during the early years of the Restoration period, when Puritanism faced increasing persecution from Parliament and the Church of England.

Blaise Pascal, *Provincial Letters* (1656)—These fictional and highly satirical letters between a Jesuit and his overseer or "provincial" helped to revive the Jansenist movement in France during the second half of the seventeenth century. Their biting humor made them immediately popular and helped to tarnish the Jesuits with the reputation of being champions of intolerance.

Philip Jakob Spener, *Pia Desderia* (1675)—In this key work of Lutheran Pietism, the author stressed the importance of meditation as a part of Christian devotion and criticized Germany's government officials and clergy for their dry and arid management of the church.

Matthew Tindal, *Christianity as Old as the Creation, or the Gospel a Republication of the Religion of Nature* (1733)—This work has since the eighteenth century become known as the Deist "Bible." In it, Tindal rejected the notion of Christianity as a "revealed" religion and instead promoted the idea that everything that was moral in Christianity might be reasoned from the laws of nature alone. The book prompted more than 150 rebuttals in the years that followed its publication.

John Toland, *Christianity Not Mysterious* (1696)—One of the most important works of the early Deist movement in England, this book argued that whatever is "repugnant" to the human mind as reasonable should not be believed. Toland had in mind the many miracles that had traditionally been used to justify and support Christianity.

John Wesley, *Journal* (1735–1790)—The founder of the Methodists began this record of his spiritual quest in 1735, before his great conversion experience. He continued to keep his reflections up to date until the year before his death. The work provides an unparalleled view into the world of eighteenth-century Pietism as well as the opposition that these Christians faced to their message from more Orthodox quarters.

chapter eight

THEATER

Philip M. Soergel

IMPORTANT EVENTS
in Theater

1598 The Chamberlain's Men, the acting troupe of which William Shakespeare is an important member, takes up residence in the Globe Theatre in London.

King Philip II dies in Spain. During the reigns of his successors, Philip III (r. 1598–1621) and Philip IV (r. 1621–1665), a Golden Age of literature and theater will develop in the country.

1600 Pedro Calderón de la Barca, who will become one of Spain's greatest playwrights, is born in Spain.

1603 Queen Elizabeth I dies in England and is succeeded by King James of Scotland, who will continue to defend the theater against Puritan detractors who claim it is immoral.

The London acting troupe, the Chamberlain's Men, is taken under royal patronage and becomes the "King's Men."

1605 Ben Jonson and Inigo Jones stage the first of their many masques for the Stuart court, *The Masque of Blackness*. It is widely admired for the ingenuity of its costumes and stage design.

1606 Pierre Corneille, one of France's greatest playwrights, is born at Rouen.

Ben Jonson is brought before the London Consistory, a religious court of the Church of England, and forced to defend himself against charges that he is irreligious.

1611 William Shakespeare's *The Tempest*, the last of the great playwright's dramas, is first performed in London.

1616 William Shakespeare dies at his home in Stratford-upon-Avon.

1618 The Thirty Years' War breaks out in Central Europe. This conflict's devastation will have a dampening effect on the theater and other forms of cultural life in the region during much of the seventeenth century.

1622 The great comic dramatist Jean-Baptiste Molière is born at Paris.

1623 The first folio edition of Shakespeare's collected plays is published in London.

1635 Lope de Vega, author of some 1,800 plays and one of the greatest of all Spanish playwrights, dies at Madrid.

1637 Corneille's *Le Cid* is performed in Paris and causes controversy for its suggestion that romantic passion might be a human emotion as important as familial duty. Over the coming years, the popularity of this playwright's tragedies will establish inflexible canons for the genre in France and inspire a great age of tragic drama.

Ben Jonson, who was the greatest Jacobean playwright after Shakespeare, dies in London.

1639 Jean Racine, perhaps France's greatest seventeenth-century dramatist, is born.

1640 Aphra Behn, the first English woman to earn a living by writing for the stage, is born.

1642 London's theaters are closed as civil war breaks out in England between Puritans and Royalists.

1643 Jean-Baptiste Molière becomes a member of the *Illustre-Théâtre*, a dramatic troupe in Paris.

1647　The English Parliament reiterates its decrees against the theater, now promising swift punishment to anyone who performs or watches a drama.

1648　The Peace of Westphalia concludes the Thirty Years' War. In the second half of the seventeenth century, theater and the other arts will begin to revive in Central Europe.

The Puritan government in England repeats its ban on all theatrical performances. Despite these prohibitions an "underground" theater continues to flourish. Performances of itinerant "drolls," or comics, as well as dramas staged in the homes of England's nobles become particularly popular.

1658　Molière's play *The Amorous Doctor* is performed before King Louis XIV to great success. The author's star will soon rise at court, and in his later years, Molière will produce a number of successful comedies for the king.

1660　The Stuart monarchy is restored to power in England; a great age of theater will soon begin in the period known as the Restoration (1660–1688). For the first time in the country's history, women will be allowed to perform in theatrical productions.

1662　Molière's play *School for Wives* is performed for the first time in Paris and causes a scandal because of the author's amorality and willingness to satirize any and all situations.

1663　The Drury Lane Theatre opens in London under a royal charter from Charles II.

1664　Molière's play *Tartuffe* is performed for the first time, and engenders the wrath of France's clergy because of its attacks on clerical hypocrisy. The play is suppressed and thus begins a long period in which Molière is persecuted by the clergy.

1666　Nell Gwyn, the daughter of a madam, reigns as the greatest actress on the London stage. She will rise to become King Charles II's mistress.

The Great Fire destroys the vast majority of London's houses, commercial buildings, and public theaters.

1671　Aphra Behn's first play, *The Forced Marriage*, is staged in London.

1677　John Dryden's *All For Love* is staged in London. The work is a tragedy, a form not generally favored in the comedy-loving period of the Restoration.

1680　Louis XIV combines several theatrical companies to form the Comédie-Française in Paris. This venerable institution will become a Parisian dramatic landmark during the coming century.

1687　The actress and courtesan Nell Gwyn dies in London, and is buried at the Church of St. Martin-in-the-Fields.

1688　The Glorious Revolution sends the Stuart King James II into exile, and brings King William of Holland and Queen Mary, James's daughter, to power. The great age of Restoration drama soon draws to a close under the less supportive atmosphere of these rulers.

1689　The female playwright Aphra Behn dies in London.

1698　Jeremy Collier publishes *A Short View of the Immorality and Profaneness of the English Stage,* a work that criticizes the conventions of the Restoration theater that had flourished in the reigns of the later Stuart kings.

1700　John Dryden, the greatest poet and playwright of the Restoration era, dies.

1711　Georg Frideric Handel's first English opera, *Rinaldo*, is performed at the King's Theatre in Haymarket, London.

c. 1716 The first playhouse is established in British North America at Williamsburg.

1726 François-Marie Arouet, better known to history as Voltaire, is forced to spend more than two years in exile in London after having challenged a high-ranking noble to a duel. While there, he comes to admire the dramas of Shakespeare and of English playwrights in general.

1728 John Gay's *The Beggar's Opera* is first performed in London. The work uses spoken drama and musical ballads to communicate its action, and is the precursor to many modern British and American musicals.

1729 Gotthold Ephraim Lessing, a great German playwright and poet, is born in Saxony. Lessing's lively and realistic plays will help to develop the German theater, weaning it away from its long service to French and Italian models.

1730 The North American colonies' second playhouse is established at Charleston, South Carolina. In the coming years several theaters will also be established in New York.

1731 In London, George Lillo's *The London Merchant* deals with middle-class life, reflecting the mid-eighteenth century taste for bourgeois dramas.

1732 Voltaire completes his *Zaïre* and the play is performed in Paris. An heir to the tradition of French seventeenth-century classicism, Voltaire will expand the boundaries of traditional French genres by dealing with moralistic themes and exotic historical events that have not typically been treated by playwrights to this time.

1733 The great actor Charles Macklin makes his debut at the Drury Lane Theatre in London in the play *The Recruiting Officer*.

1737 The Licensing Act, an order of Parliament, is passed. The act is intended to establish more effective censorship over the London stage and to discourage the establishment of new theaters.

1743 Fernando Galli Bibiena, a noted Italian stage designer whose complex and imaginative stagings of productions influenced the Baroque theater throughout Europe, dies in Italy.

1746 Carlo Galli Bibiena, son of the great Fernando Galli Bibiena, moves to Germany. Over the next four decades he will travel throughout much of Europe, helping to popularize Italian stage design and settings throughout the continent.

1747 After approaching bankruptcy, the Drury Lane Theatre reopens under the capable direction of David Garrick.

1751 The publication of the *Encylopédie* begins in Paris under the editorship of Denis Diderot and Jean D'Alembert. The work will exercise a powerful influence on taste in drama and the arts in the second half of the eighteenth century, not only in Paris, but also throughout Europe.

1755 Lessing's play *Miss Sarah Sampson* is first performed in Germany. In this work Lessing tries to develop a uniquely German kind of tragedy that is not influenced by French examples.

1757 Denis Diderot's play *The Natural Son* is produced at Paris. In this work Diderot attempts to put into practice his theory of dramatic realism.

1769 Jacques-Ange Gabriel designs and supervises the building of a court theater for King Louis XV at Versailles.

David Garrick stages a jubilee celebration of the works of William Shakespeare in the dramatist's hometown of Stratford-upon-Avon.

1773 Oliver Goldsmith's brilliant comedy *She Stoops to Conquer* is first performed in London. The work is one of the only English plays from the eighteenth century still performed in modern times.

1776 The famous Teatro alla Scala is erected in Milan, Italy. The theater can accommodate 2,000 people and crowds flock to the site to see La Scala's operas, then the most popular kind of theatrical production in Italy.

1782 The great English actress Sarah Siddons scores her first major London success in a production of *The Fatal Marriage* at the Drury Lane Theatre.

1789 The great actor Charles Macklin retires from the stage in England.

1791 The city of Paris, once a theatrical backwater, now has more than 30 playhouses.

OVERVIEW
of Theater

RISE OF PROFESSIONAL THEATER. In the history of drama and the theater, the seventeenth century marked the gradual acceptance and solidification of trends that had begun in the later Renaissance. In the later Middle Ages most dramas had been religious in nature, and had often been performed in conjunction with the celebration of major church feasts and holidays. During the sixteenth century religious drama had come to be rejected in much of Northern Europe, as Protestants and reform-minded Catholics found the teachings and license of these productions increasingly unacceptable. The great rambling mystery plays of the later Middle Ages, which had often been staged over many days and weeks, were by the second half of the sixteenth century prohibited in both England and France. In the Protestant regions of Germany, too, the traditional dramas had ceased to be performed, and were now being replaced by a polemical theater that defended the cause of the Reformation. Only in Spain and in the Catholic regions of Central Europe were religious dramas similar to those of the later Middle Ages to survive with a measure of vitality in the seventeenth century. But as religious drama faded from the scene, a new professional theater, licensed by state governments and often heavily censored, was just beginning to take the place of the largely amateur and religiously-oriented productions that had provided popular entertainment in the later Middle Ages. Here audiences paid modest admission fees to see plays that dealt largely with secular themes, moral dilemmas, and historical subjects. The growth of this new commercial theater was by 1600 most advanced in England and Spain, where ranks of newly minted playwrights churned out a steady stream of comedies and tragedies intended to entertain a broad audience that stretched from the urban poor and middling classes to the educated elite. While not all the new works that were performed in London, Madrid, or Seville—the home of Europe's most precocious early seventeenth-century theaters—were of a high quality, the age gave birth to a number of authors of genius, including William Shakespeare (1564–1616) and Ben Jonson (1572–1635) in England; and Lope de Vega (1562–1635) and Pedro Calderón de la Barca (1600–1681) in Spain. The breadth of the new audience these figures addressed now seems remarkable. In London, for example, it is estimated that as much as ten percent of the city's population was in the theaters on any of the six weekdays on which performances were permitted. Many patrons attended the theater more than once each week, since the cost of admission to the pit, that is, the ground floor of London's theaters, was only a penny or two, the cheapest form of leisure entertainment available in the capital.

DEVELOPMENTS IN FRANCE. While the growth of a commercial stage was well advanced in London and the Spanish cities by the early seventeenth century, the emergence of a professional theater in France continued to lag behind these centers at the same time. As a result of the Wars of Religion (1562–1598), France entered the seventeenth century with a beleaguered economy and an embattled government and domestic scene that still faced considerable threats from religious disunity and civil conflict. During the first decade of the seventeenth century the measures of King Henri IV (r. 1594–1610) succeeded in re-establishing a modicum of order and stability throughout much of France, and a professional theater began to flourish in Paris. At the same time, royal monopolies awarded in the later Middle Ages to the Confraternity of the Passion, a group of young artisans who were junior members of the city's guild, still allowed for only one theater in the capital. When the confraternity's religious dramas were outlawed in 1548, the group began to stage farces and other secular fare at their theater in the Hôtel de Bourgogne, a relatively small indoor house that could accommodate far fewer patrons than the great outdoor arenas of London or Madrid. During the first decades of the seventeenth century the theater in the Hôtel de Bourgogne began to prosper, particularly so with the crowd-pleasing and often violent, bawdy works that the playwright Alexandre Hardy (c. 1569–1632 or 1633) created for the troupe that resided there. The size of the theatrical audience in Paris was always modest when compared against the age of Shakespeare in London or of Lope de Vega in Spain, although the influence that the Parisian stage exerted over European drama generally was far greater than the mere size suggests. Between 1630 and 1680 France produced several playwrights of great genius, and its classically inspired theater was widely imitated throughout Europe. It was Cardinal Richelieu (1585–1642), Louis XIII's chief minister, who first devoted significant attention to develop-

ing the theater in Paris. Eventually, Richelieu imported theatrical architects and stage designers from Italy, spawning a revolution in theater design in France that included such elements as moveable stage scenery and the small, horseshoe-shaped court theater; the intimate interiors of these enclosed spaces were notable for their improved capacities to carry the sound of actors' voices as well as their greatly enhanced sight lines. As French courtly culture came increasingly to be imitated throughout much of Northern Europe in later seventeenth-century states, the styles of theaters that were built in many European courts imitated these French and Italian examples. Richelieu was also an avid fan of the drama itself and he believed in the theater's power, not only to ennoble its audiences, but to support the absolute authority of the state. In the 1630s he patronized a group of French playwrights that followed this "party line," and although he died in 1642, his efforts were to be continued by those ministers who followed him.

CHARACTER OF THE SEVENTEENTH-CENTURY FRENCH STAGE. Among the most important of the figures that Richelieu supported was Pierre Corneille (1606–1684), a dramatist who perfected the use of the laws of unities that were then being discussed among French literary theorists and playwrights. The laws of unities were a set of canons derived from Italian humanist studies of Aristotle and they taught that all action in a play needed to be confined to a single plot that occurred on a single day in a single place. The theater that such notions fostered in France was austere and restrained, and not every dramatist that tried writing works in this style succeeded. In the careers of Pierre Corneille, Jean Racine (1639–1699), and Jean-Baptiste Molière (1622–1673), the French theater produced three figures that were more than equal to the challenge. The tragedies of Corneille and Racine and the brilliant but farcical comedies of Molière thus helped to fix the notion of classical unities in French drama as normative, and the rules, although sometimes questioned, survived in the French theater for much of the rest of the seventeenth and eighteenth centuries. While the brilliant works that France's triumvirate of masters produced had a wide impact on theatrical developments throughout Europe, the French theater of the seventeenth century was not a popular success, but an institution by and large patronized by the aristocracy. French drama was not a naturalistic mirror of the world, but a highly stylized and rigid theater where all action was conveyed through beautiful, but inflexible patterns of verse. The verse favored by most French playwrights was the twelve-syllable Alexandrine form, noted for the noble quality of the sounds it produced. Simi-

larly, the members of a French dramatic troupe were not expected to "act" their parts like modern actors, but to declaim or recite their verses in ways that heightened the audiences' understanding of the intellectual meanings of the lines. While such methods appealed to an audience that craved literary entertainment, they had little popular appeal. As the theater blossomed in Paris in the years between 1630 and 1680, no theatrical troupe in the city survived without rich grants from the crown; when King Louis' early love of the theater began to fade after 1680, the brilliant achievements of the age of Corneille, Racine, and Molière faded also. By 1700, only one theatrical troupe, the royally licensed Comédie-Française, still entertained Parisian audiences. The toll of France's involvement in international wars, the king's own increasing piety, and the rising popularity of opera in Paris resulted in a constriction of the brief, but brilliant episode of greatness that the French theater had experienced in the half century following 1630.

THE CLOSING OF THE THEATERS IN ENGLAND. Even as a new age of theatrical achievement gathered strength in France, developments were moving in an opposite direction in England. Since Elizabethan times, the stunning rise of the English theater on the London scene had proven worrisome to the country's small but growing faction of Puritans. Puritanism, a reform movement derived largely from the ideas of the French Protestant leader John Calvin, upheld a sobriety in life and aimed to rid the Church of England of all vestiges of Catholicism. Puritan ministers and writers well understood that the origins of drama lay in the religious theater that had been so common throughout the late-medieval church, and during the first decades of the seventeenth century, their distaste for the stage steadily increased, even as theater grew to be a more popular pastime in England's capital. By 1630 Puritan leaders were increasingly coming to loggerheads with a crown that avidly supported the development of the theater and which used lavish spectacles, filled with many theatrical elements, as forms of political propaganda. A little more than a decade later as the Puritan movement came to dominate England's Parliament, Puritans responded by ordering the closing of all London's theaters. Except for a few loopholes in Puritan regulations that allowed some private dramas to be staged in houses and schools, the theater largely disappeared from English life during the long years of the civil wars that followed. And in the Commonwealth period that followed the execution of Charles I in 1649, most of those who had been active on London's stage in the previous generation either fled the country or took up new occupations. Thus when Charles I's son, Charles II, returned to resume

the throne in 1660 and allowed the reopening of stages in London, the theater had to be largely created anew.

THE RESTORATION. In the first few years of the English Restoration period (1660–1688) the newly licensed theatrical troupes in London performed works drawn from the earlier English repertory, adapting them to the contemporary demands and tastes of audiences. In time, though, the Restoration stage acquired its own new dramatists, many of whom were courtiers and sophisticated amateurs well aware of the light style of Molière that was flourishing in France at the same time. Both the court and London playwrights came in these years to favor similar light comedies, but where the French Molière's works were merely suggestive or "naughty," Restoration tastes in England frequently evidenced an appetite for the bawdy, that is, for broad sexual humor. In time a new genre of "comedy of manners" developed in which the exploits and foibles of aristocratic society were mocked and satirized without ultimately being questioned. While many of those who wrote for the Restoration stage evidenced a sophisticated wit and a great mastery over the English language, only the works of John Dryden (1631–1700) have continued to be consistently studied since the time of the Restoration, although contemporary and ongoing research continues to unearth gems of comedy and tragedy that were written and performed in the period and then were soon forgotten. In at least one crucial aspect the legacy of the Restoration stage represented a loss for England. Prompted by the popularity of the new French- and Italian-styled theater buildings, the comedies of the period now came to be performed exclusively in smaller enclosed spaces, making the cost of admission beyond the reach of all but the wealthiest members of London's elite. Unlike the richly variegated audience that had existed for plays in both the Tudor and Stuart times, the theater of Restoration England was in many ways more similar to the institution that was flourishing at the same time in France: sophisticated fare performed before small, wealthy audiences. At the same time, Charles II's reestablishment of the theater departed from previous customs by allowing women to perform for the first time in England's history. Actresses like Nell Gwyn (1650–1687) captivated London's high society, and Gwyn herself capitalized upon her position to become the mistress to the king. Gwyn's actual theatrical career was short, but other women made the theater a lifelong profession; the personal lives of some did little to dispel the notion that the theater was immoral among those who opposed the institution. It was during the Restoration period, too, that the first female playwright, Aphra Behn (1640–1689), wrote professionally for the stage. Although Behn's controversial career did not immediately inspire droves of women to imitate her example, she nevertheless opened a door through which other women were to follow in the next decades.

RISE OF THE MIDDLE-CLASS DRAMA. The exile of Charles II's successor, James II, had far-reaching implications for the stage in England, although these implications were slow to be realized. James himself was a Catholic convert, and although he had upheld the Church of England's position in the country, he also set himself squarely behind the cause of Catholic toleration in England, introducing measures that irritated the country's Anglican nobles. In 1688, these powerful figures forced James into exile and invited his daughter Mary, a Protestant, and her husband the Dutch prince William of Orange to assume the throne. During the Restoration period (the reigns of Charles II and James II), bold sexual humor and coarse language had flourished on the London stage, but during the reigns of William and Mary and their successors, the Hanoverian monarchs, the theater grew more staid and conservative. Although the Puritan party had largely been discredited in England during the struggles of the English Civil Wars and Commonwealth, moralists in Britain continued to decry the lax morality of the theater. After 1700, a growing number of playwrights produced works on themes that upheld conventional morality. This trend continued throughout the eighteenth century in London as new measures to confine and censor the theater continued. As a result of the Licensing Act of 1737, for example, all new plays had to be submitted to the government for approval before being performed, and dramas were confined to only a few theaters in the capital. For a time, such measures, which were intended to combat criticism of the government, discouraged great authors from writing for the theater. By the mid-eighteenth century, an increasing number of playwrights had begun to write novels rather than dramas, as a new market in fiction steadily expanded throughout the country. The government's attempts to stamp out unsanctioned theaters, which were popping up throughout the capital, produced some unexpected results. Licensing requirements fed the development of England's "music hall" theaters —cheap venues for the production of song, dance, and short dramatic skits. And although the government attempted to censor content and limit the growth of the London theater, England's Hanoverian kings at the same time chartered a number of royal companies in the country's provincial cities. In this way, theater flourished, not just in London, but throughout England, Scotland,

Wales, and Ireland. The emergence of these provincial theaters provided a training ground, a recognized career path for actors and actresses interested in developing their craft before venturing to London, the still undisputed center of drama in England. The eighteenth century, it has often been said, was a great age of the novel, and not of drama. While few of the English plays written at the time stand up beside those of Shakespeare, Jonson, or Dryden, the period saw the birth of the phenomenon of the great actor. Figures like David Garrick, Charles Macklin, and Sarah Siddons captivated the imagination of the age, and attracted an ever-larger audience to the theater. While the quality of the contemporary plays that were being written may have been of a lesser standard, revivals of Shakespeare and other great English classics became in this period a permanent part of the theatrical scene, and audiences enjoyed the new high standard of naturalistic acting that the greatest of the eighteenth century's actors cultivated.

THE BOURGEOIS DRAMA ON THE CONTINENT. Theater in France may have fallen on a fallow period during the later years of Louis XIV's reign, but in the years that followed his death, the stage underwent a dramatic resurgence. During the first half of the reign of Louis XV (r. 1715–1774), the controversial Voltaire (1694–1778) dominated French developments in tragedy. Voltaire's verse style continued in the paths laid down by Corneille and Racine, and while he upheld the laws of the unities, he treated a greater range of exotic subjects, celebrating the role that human reason should play in society and calling into question traditional Christian morality. Subject to frequent imprisonment and eventually to exile from Paris, his controversial career emboldened other French Enlightenment thinkers to build upon his example. By mid-century an increasing number of Enlightenment philosophers in France were advocating the development of a new theater that might treat real-life situations and the concerns of the bourgeoisie, which now comprised a large portion of the audience in Parisian productions as well as those in the French provinces. Chief among the exponents of this new realistic theater was Denis Diderot (1713–1784), a playwright and critical theorist who exerted a profound influence on the second half of the eighteenth century in France, not so much by his heavy-handed dramas, but by his editorship of the *Encylopédie,* the massive, multi-volume project of Enlightenment thinkers that shaped tastes in the arts at the time. The Enlightenment's advocacy of a middle-class, or bourgeois, drama spread elsewhere in Europe, particularly in Germany where the great playwright Gotthold Ephraim

Lessing (1729–1781) used the new form to cultivate the development of a national theater. In France itself, a number of dramatists tried their hand at the new form in comedies and tragedies, but no one succeeded in producing a greater sensation with the new style than Pierre-Augustin Caron de Beaumarchais (1732–1799) with his wildly funny satires, *The Barber of Seville* (1775) and *The Marriage of Figaro* (1784). These dramas' mocking satire of aristocratic privilege, the church, and many of the institutions of eighteenth-century life exposed the revolutionary potential that might lie in theater to effect social change. Thus the ideas of the Enlightenment, with their emphasis on reform according to the dictates of human reason, addressed the rising demands of the middle classes for an art that was both relevant and entertaining. During the French Revolution that soon followed, the Enlightenment's championship of greater liberty produced massive changes in the theater of the late eighteenth century.

TOPICS
in Theater

THE COMMERCIAL THEATER IN EARLY SEVENTEENTH-CENTURY ENGLAND

THE RELIGIOUS LEGACY. In the final quarter of the sixteenth century commercial theater experienced a sudden rise in popularity in England's capital of London. The new theaters were run by professionals, an unprecedented development in the country, since all of the elaborate medieval religious dramas had been staged by amateur actors. By 1600, Londoners and visitors to the capital could take their pick of a number of daily performances, staged in both outdoor public playhouses as well as in new "private theaters" that catered to a more elite clientele. Although England's new commercial theaters staged plays that made use of religious symbols and imagery to convey their ideas, the themes treated in the many plays staged in the capital's theaters were secular, a fact that arose from the country's religious Reformation. Around 1500, the most popular dramatic performance in England had been the great mystery cycles, performed in conjunction with the celebration of religious holidays, as well as the morality plays, which also treated religious themes. Growing criticism of these forms of drama in the first half of the sixteenth century from religious reformers had eventually resulted in the suppression of religious drama by the mid-sixteenth

century. In the years that followed, the theater became a vehicle for religious propaganda, sometimes with undesirable results as audiences sometimes rioted in the wake of a particularly vigorous play that did not align with their own religious convictions. As a consequence, regulations enacted in 1590 stipulated that plays must not treat religious subjects or controversies. Such requirements were also a concession to the many Puritans who lived in and around London at the time who found the theater morally degenerate and its staging of biblical and religious themes particularly objectionable. Puritanism, a form of Protestantism inspired in England by the ideas of the French Reformer John Calvin, rejected theater for a number of reasons. First, the Puritans knew well that the origins of drama lay in the great mystery cycles that had been performed in conjunction with church festivals in the later Middle Ages. Thus they attacked the theater as an art form whose origins lay in "popery," the term the Puritans used to discredit all cultural features of medieval religion. Further, the Puritans advocated a sober and godly attitude toward everything in life and they came to detest the light comedies and other fare performed on London's stages as an affront to Christian living. A certain disreputability accrued to the theater as well, since to skirt London's regulations troupes often built their theaters at the edges of the city in quarters that were known to be haunts of thieves and prostitutes. Thus although Elizabeth I and her Stuart successors were to tolerate it, and in many cases to support its development, the theater remained controversial nonetheless in seventeenth-century England.

LEGACY OF THE RENAISSANCE. When compared to the types of theater that flourished in many other parts of Europe, England's brand of entertainment was unusual for a number of reasons. During the fifteenth century the cultivated Renaissance courts of Italy had tried to revive ancient drama, and a number of authors had begun to fashion their plays according to the five-act structure that had flourished in the comedies of the Latin writers Plautus and Terence. In the most sophisticated circles, study of the ancient masters had given rise to vigorous attempts to recreate the ancient theater, and playhouses modeled on ancient examples had been just one of the consequences of the new fascination with Antiquity. By the mid-sixteenth century the elite fascination with antique drama produced in Italy and somewhat later in France a number of experiments in writing and staging tragedies based on Greek models. The appeal of many of the plays that resulted from these experiments had always been quite limited since the complex allusions with which they were filled and the structures upon

which they were based were not fixed in native dramatic traditions but in historical cultures that were, by and large, foreign to most audiences. Thus these experiments in reviving ancient comedy and tragedy—which were largely influenced by the culture of Renaissance humanism —rarely flourished outside court circles and small groups of cultivated elites. England's relative isolation from these currents of theatrical production, as well as the financial realities of the London stage—which depended on ticket sales rather than royal patronage for financial stability—meant that the influences it derived from the culture of the Renaissance were always relatively slight. The greatest of England's Elizabethan and seventeenth-century dramatists were, to be sure, men of learning, and many were certainly aware of the experiments in dramatic productions that had occurred over the previous generations in Continental Europe. Yet the plays that they wrote in great profusion in the final decades of the sixteenth and early seventeenth centuries had to be pitched to a "middle-brow" audience. Thus rather than treating obscure subjects drawn from classical Antiquity or adopting the strict conventions of classical drama, England's playwrights chose themes that were well known to their audiences, or they wrote about subjects in ways that had a more universal appeal. This tendency can be seen in the great works of the eminent playwrights Christopher Marlowe (1564–1593) and William Shakespeare (1564–1616). Marlowe was one of the best educated of the late Tudor-era dramatists. He had taken the bachelor's and master's degrees at the University of Cambridge before embarking on his career as a writer for the London stage. In his great tragedy *Tamburlaine the Great,* Marlowe pioneered the use of blank, or unrhymed verse, a departure from the conventions of the day that relied on elaborate rhyme schemes. The use of blank verse allowed Marlowe's characters to speak with great naturalness and propelled the action of his drama forward in ways that held his audiences spellbound. In his slightly later *Dr. Faustus,* the dramatist treated elevated themes—the personal nature of evil, the quest for worldly success, and the damning consequences of pride—yet he did so in a way that could be understood by both the educated and uneducated classes. For instance, he relied on the traditional conventions of the late-medieval morality play rather than the more foreign structures of Greek tragedy. In this way his audiences found familiar signposts in his dramas that allowed them to follow themes and incidents that were nonetheless presented with considerable sophistication.

LEGAL REALITIES. Despite his ability to stage elevated themes and complex incidents in ways that did

not sacrifice intellectual depth, Christopher Marlowe's career as a writer for the London stage also exemplified the dangers that existed in this choice of profession. In the years immediately preceding his death, Marlow repeatedly answered charges of immorality and religious heresy, and his death in a barroom brawl was most likely a planned execution, brought on by his unpopular religious opinions as well as his prominence on the London theatrical scene. The sudden rise of the English commercial theater—a phenomenon made possible only in 1574 by the crown's decision to allow public, weekday performances in London—was undoubtedly popular, but controversial all the same. In the city of London, public officials feared the theater as a forum that might foment rebellion and immorality, and the town's growing cadre of Puritan ministers also detested the stage as a violation of Old Testament prohibitions against idolatry. The town's first public playhouses thus were situated, not inside the area of the city controlled by London's town government, but in fringe zones known as the "Liberties," where the municipal government held no authority. It was in these areas that dubious trades, prostitution, and other morally suspect enterprises had long flourished, and as the theater took up residence in these zones, it did little to dispel the dubious notoriety that already accrued to the entire dramatic enterprise. And while the crown tolerated London's stages, and even supported their cause against the municipal government, the monarchy promised censorship and persecution to those playwrights and actors who skirted too close to the edge of what was permissible. A distinguished lineage of playwrights in Tudor and Stuart times fell afoul of the law, including Ben Jonson (1572–1637), Thomas Nashe (1567–1601), Thomas Middleton (1580–1627), and Philip Massinger (1583–1640). Ben Jonson, the greatest London dramatist in the years after Shakespeare's retirement from writing for the theater, was imprisoned on a number of occasions; his association with the ill-fated production of *The Isle of the Dogs* (1597) landed Jonson in jail, and London's theaters were subsequently closed for a number of months. While Jonson was later released for his role in the "seditious" play, his partner in the enterprise, Thomas Nashe, fled to the Continent and died in exile. The whims of royal fancy and displeasure, which continued to blow hot and cold during the reign of the Stuarts, made play writing and acting hazardous, and the profession was often financially untenable. Once successful on the London stage, William Shakespeare invested in a brewery and other country enterprises to ensure that he had a safe and sustained income. He likely did so to prevent the very same problems suffered by his fellow professionals Jonson and Nashe, and to protect himself against any future theatrical closures.

OTHER PRACTICAL CONSIDERATIONS. By the time of James I's accession as king of England in 1603, the city of London's major commercial theaters were well established landmarks on the capital's scene, and despite sporadic problems with censorship and the imprisonment of playwrights, theater was flourishing quite vigorously. The first of London's commercial playhouses had been built in 1576 by a partnership of John Brayne and the actor James Burbage and was called merely the "Theater." Located in suburban Whitechapel, its stage consisted of three galleries superimposed on top of each other, an attempt to imitate the ancient Roman styles of stages that were becoming better known throughout Europe at the time as a result of humanistic research. Besides its covered stage, however, the Theater, like most of London's public playhouses, was exposed to the open air. Performances were thus held during daylight hours. The success of the Theater was soon followed by a string of new playhouses, including the Curtain founded one year later on a site close by the Theater, the Rose, the Swan, and finally, the famous Globe, a theater that was, in fact, moved from an earlier location north of the river Thames. These last three institutions were built, not to the northeast of the city of London in Whitechapel, but on the south bank of the River Thames, establishing a small theater district that persisted there for a number of years. At this early stage in the theater's development in England, men and young boys performed all roles since women were not allowed on the stage. London had several "boy troupes" at this time which were particularly popular among the audiences who visited London's "private theaters"—more expensive venues that were enclosed to the elements and consequently provided a smaller and more intimate setting for drama. These stages were candlelit, and thus performances could be held at night. There were eight of these private theaters in London before Puritan measures enacted in 1642 forced all the capital's theaters to close. The evidence suggests that, despite their higher price of admission, the private theaters became more popular and profitable than the large open-air public facilities throughout the reign of James I and Charles I. Although their patrons may have initially been drawn from higher echelons of society, the private theaters of London in this period were anything but luxurious. Poorly ventilated, and filled with bleacher-style seating, they afforded each patron a space only about eighteen inches wide on which to sit. The presence of hundreds of patrons in these cramped spaces, too, must have been particularly uncomfortable in the

summer months when the atmosphere within the private theaters was quite close and the ventilation inadequate. Despite these hardships, many seem to have preferred the smaller houses, and the old arena-styled theaters became associated in many people's minds with lower-class disorderliness. Like most theatrical venues in Europe, all of London's theaters at the time continued to be subject to periodic closures when epidemics struck or during periods of royal mourning.

TROUPES AND PLAYWRIGHTS. The new theaters were thoroughly commercial ventures, although many of the troupes augmented their incomes by performing at court. Actors founded some of the city's playhouses after receiving backing from an investor. In this type of arrangement, the profits of the venture were split between commercial backers and the actors of the troupe. In other arrangements the troupe owned its own props and venue, and the profits of a production were split between the troupe members. And in still a third kind of arrangement, many troupes took up residence in theaters that were owned by others, splitting the profits of their productions between the house and the performers. Licensing regulations in effect in England since the 1570s insisted that a troupe of actors had to be supervised by and affiliated with a member of the nobility, and the titles that acting troupes adopted thus honored their noble patrons. The patron of the Chamberlain's Men, the troupe of which Shakespeare was a member, was Queen Elizabeth's Lord Chamberlain Henry Carey. When the company came under the patronage of King James I in 1603, the troupe renamed itself the King's Men. In this way the titles of many troupes changed over time. Perhaps no company ever changed its name so frequently as that which began as the Lord Howard's Men around 1576. As Lord Howard was elevated to the position of Lord Admiral, the company became the "Lord Admiral's Men." But later in the early seventeenth century as the group came under different patrons, it became known as "Nottingham's Men," "Prince Henry's Men," and "Palsgrave's Men." Many of these troupes retained their own playwrights, who crafted the dramas and sometimes doubled as actors in the troupe itself. In this regard William Shakespeare's path to becoming a successful playwright was not unusual. He began as an actor in the company before beginning to write plays for the Chamberlain's Men around 1590. Thereafter, his success elevated him in the company until he had become its director in the early seventeenth century. While great milestones of English literature survive from the Tudor and Stuart period, most of the dramas that were produced at this time were considered ephemeral, that is, they were staged for a time and then put aside. The popularity of the theater meant that audiences craved new works, and playwrights often obliged by dramatizing incidents that had recently occurred in London and around Europe. The great works of Christopher Marlowe and William Shakespeare continue to fascinate audiences today with the depths of their psychological insight and their examination of characters' strengths and weaknesses, although it must be remembered that few of the hundreds of plays performed in London at this time rose to this level of greatness. Many were topical works, hurriedly written to take advantage of the interests of the day and then discarded when fashions shifted. London troupes were also jealous of their properties. Plays were not usually printed until well after they had been performed so that other troupes working in the capital could not pirate their productions. Such was the secrecy surrounding the script that most actors did not even receive an entire copy of the play they were performing, but were only given their own lines with appropriate cues so that they could not sell the play to another troupe. While plagiarism and artistic theft was a consistent problem between theaters, playwrights who wrote for the London scene were enthusiastic theatergoers, and they visited the plays written by their rivals for other houses. In his early days as a playwright, even William Shakespeare received accusations that he had plagiarized the works of other London writers. In truth, the practice of imitating successful works was as common then as it is among film producers in the modern world. Playwrights and troupes longed to exploit the themes and plots that had already proven to be successful with audiences, and over time plays treating similar themes and subjects were produced until the appetite for them was exhausted.

WILLIAM SHAKESPEARE. Despite commercial considerations and censorship, the achievements of early seventeenth-century drama in England still manages to astound modern observers. During the first years of the reign of James I (r. 1603–1625), the writing of William Shakespeare and a group of other accomplished playwrights reached a new level of maturity and finesse. During the 1590s, Shakespeare's plays had most often treated historical or comic themes, but in the first part of the seventeenth century, he conducted a number of experiments in genres that undermined and extended the traditional confines of popular Elizabethan forms, producing works that refashioned comedy, tragedy, and romance. The first signs of the author's growing mastery over his craft came in the series of "problem" plays that he produced just after 1600. In these works—*Measure for Measure, All's Well that Ends Well,* and *Troilus and*

Cressida—Shakespeare extended the boundaries of comedy by resolving his works in unexpected ways that undermined the neat moralistic formulas the genre had traditionally served. Characters in these dramas are forgiven their foibles and shortcomings even when they do not deserve to be forgiven, or the heroes of these dramas achieve success despite significant moral failings and personality flaws. Shakespeare continued in this vein of experimentation in the series of tragedies and historical dramas in the years that followed. In his *Othello* (1603), for instance, the author explored the psychological consequences of racism. The central character, Othello, is a Moor (a black African) who is married to a much younger and white Desdemona. When driven mad by the adulterous accusations brought against her by his treacherous friend, Iago, Othello murders her, and then realizes afterward that he must live with the consequences of his rush to judgment. Thus Othello is a fatally flawed tragic figure, but his flaw is curiously inexplicable given his status as the very model of propriety and good judgment prior to his rash act of murder. His willingness to believe the false accusations of Iago, though, results from his doubt about his interracial marriage. Iago, in other words, has been able to play upon Othello's own fears that a black man's marriage to a white woman is unnatural. In his *King Lear* (c. 1605), Shakespeare continued to examine his characters with great psychological insight. Like Othello, Lear is a flawed character who has unjustly banished his daughter Cordelia from his presence, but who is subsequently driven insane by the even greater injustice and monumental ingratitude of his two remaining daughters, Goneril and Regan. In his mad ravings he contemplates the nature of justice and the order of the universe, observations that are made more chillingly forceful because a seeming madman utters them. In the final of these late tragedies, *Macbeth,* Shakespeare explored the consequences of incivility, and, as in both *Othello* and *King Lear,* he brought major insights to bear on the dark emotions that produce enormous crimes.

HISTORICAL PLAYS AND LATER COMEDIES. Even as the great dramatist was at work on these masterpieces, he continued to produce historical plays and a series of brilliant romances. In contrast to the histories of comparatively recent English kings he had produced during the 1590s, the author turned to ancient Roman and Greek figures in the seventeenth century, finding in the relative obscurity and distance of Antiquity a vehicle for producing some of his great late masterworks, including his *Antony and Cleopatra* (c. 1606), perhaps his greatest historical work. Shakespeare produced some of his most insightful portraits of kingship and political power, not by concentrating on the kings of the near English past, but by examining the more remote universe of Antiquity. In this way the playwright circumvented the draconian censorship that James I's officials sometimes practiced in the theater. While these later ancient historical plays show a development of Shakespeare's art to a level of dramatic ease and fluency—a level that most critics agree has never been surpassed—the later comedies of this period also show a similar experimental spirit. These plays—*The Winter's Tale, Cymbeline,* and *The Tempest*—are alternately termed "romances" or "comedies." All three works are full of various kinds of entertainments, complex plots, and subplots, and their meanings have proven difficult to ascertain over the years. This favoring of a complex and highly sophisticated art may likely have been caused by commercial factors. In 1608, Shakespeare's troupe, the King's Men, took up winter quarters in the Blackfriars Theatre, a private theater located in an ancient London monastery that had been dissolved during the Reformation. The audience who frequented the Blackfriars was likely better educated and craved the elaborate concoctions that Shakespeare supplied them with in the years between 1608 and his retirement from the troupe after 1611. These productions were filled with dancing, singing, and "masques" that imitated the customs of courtly society, and their complex allusions and sophisticated poetry are very different from the world of the author's youth. Some critics have detected a strain of increasing self-doubt and critical self-examination in these works, a strain they have connected with the approach of the author's old age. Yet in 1611, when Shakespeare went into semi-retirement from his troupe, he was not yet fifty, and with his fortunes relatively established, he seems to have hoped to play the role of a country gentleman in his native Stratford-Upon-Avon. Although he probably returned to assist on one or several occasions, his increasing isolation meant that his company, the King's Men, turned to his associate John Fletcher for dramas. Fletcher ruled for many years as one of the most prolific of Jacobean playwrights, although the quality of authors who wrote for the stage in these years was generally very high.

BEN JONSON. While many of the details concerning the life of William Shakespeare continue to be debated, scholars are on far firmer ground in exploring the life and career of Ben Jonson (1572–1637), the figure who is today considered the second towering genius of the early seventeenth-century English stage. Jonson was probably a native Londoner, although his family hailed

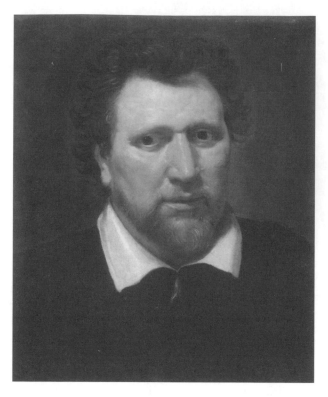

Ben Jonson. NATIONAL PORTRAIT GALLERY, LONDON. REPRODUCED
BY PERMISSION.

originally from Scotland. Educated at Westminster
School and later for a time at St. John's College in Cam-
bridge, he first pursued a career as a bricklayer before
becoming an English soldier in forces that were then
helping the Dutch achieve their independence from
Spain. When he returned to England, he became an ac-
tor, performing as a character in the Tudor dramatist
Thomas Kyd's *The Spanish Tragedy.* This was one of the
most popular plays of the late Elizabethan period, and
it was frequently revived in the decades that followed.
Jonson eventually wrote additional dialogue for the play,
as he seems to have done for other works performed dur-
ing the 1590s. By 1594, Jonson was successful enough
to marry, and he seems to have worked as an actor in
several London theaters, although he eventually joined
the troupe known as "Pembroke's Men." In 1597, he
wrote his first play for the group, and soon afterwards
he took part in the ill-fated *The Isle of Dogs,* the pro-
duction that landed him in jail. The play was considered
so seditious at the time that all copies of it were seized
and destroyed, and thus historians have long debated
about what its contents must have included. The title
refers to an island situated in the Thames just across from
the former site of the royal palace at Greenwich, but the
drama itself apparently mocked the intrigues of court.
Jonson was imprisoned for several months, and when

the London theaters reopened in 1598, he achieved his
first great success with the play *Every Man in His Hu-
mour,* a sophisticated comedy set in the urban world. It
made use of the notion of the then-reigning scientific
theory of the "four humors," the forces that were be-
lieved to govern health and the human psyche. During
1598, Jonson again fell afoul of the law when he killed
a fellow actor. While in prison for this offense, the play-
wright repented and converted to Catholicism, a deci-
sion that dogged him for the rest of his life. Upon his
release, Jonson returned to write for the theater, but by
1603, he had again fallen under suspicion, this time for
Catholicism and also for the treason that members of
Elizabeth I's Privy Council felt littered his recent play
Sejanus His Fall. In the years that followed, Jonson la-
bored to rehabilitate himself with King James I. At the
same time suspicions continued to hover around him,
and he was frequently detained for questioning because
of his Catholic beliefs and the fear that he was secretly
practicing his religion. He was imprisoned again in 1605,
this time for a play that seemed to mock the manners of
James I and his Scottish nobles, but he soon attained his
release. During the crisis of the Gunpowder Plot in the
same year—a foiled scheme to blow up the Houses of
Parliament in Westminster—Jonson again fell under sus-
picion, although he acquitted himself by giving evidence
against the conspirators.

JONSON'S RISING SUCCESS. Despite lingering
suspicions about his loyalties, Jonson's career flourished
in the years after 1605. In that year he began produc-
ing masques for the Stuart court in partnership with the
accomplished designer and architect Inigo Jones
(1573–1652). These imaginative productions were
widely admired, and the partnership spread across sev-
eral decades before the two parted company. In 1605,
he also wrote perhaps his most biting and satirical com-
edy *Volpone,* a work that showed little of his associate
Shakespeare's propensity for happy endings. *Volpone*
bristles with the firsthand knowledge that he had ac-
quired of the corruption that reposed in royal courts.
Prudently, though, Jonson set the play in Republican
Venice, but the deceit and trickery that he related might
just as easily have occurred in the Stuart halls of power.
In 1610, James I enacted a series of new measures di-
rected at English Recusants, that is, those that espoused
and practiced the Catholic religion, and in the wake of
these measures, Jonson renounced his Catholicism and
returned to the Church of England. Successes contin-
ued, and in the years that followed, the great playwright
entertained ever-greater notions of his success as a
scholar. For his efforts in entertaining the king, and his

achievements in the theater, he was granted a royal pension in 1616, the same year that William Shakespeare died. With Shakespeare's death, Jonson reaped even greater praise as England's greatest living writer. A folio edition of his work appeared in 1616, and by 1619, he was granted an honorary degree from the University of Oxford. This increasing fame, though, exacted a toll on his writing, and between 1616 and 1626 he produced no major works, although he did continue to produce masques for the court. One year following James I's death, Jonson produced his first play in a decade, *The Staple of News,* a work that, like several of the playwright's earlier pieces, satirized the growing tendency for trust to be generated in the business world and society merely by deceit and fast talking. The play was topical, since it was staged merely a year after the death of James I and seemed to mock the controversial Stuart practice of granting monopolies to trade in certain industries as well as problems in the new King Charles I's court. A few years following its production, Jonson suffered a stroke, although he was granted an office as London city historian soon afterwards. The king increased his pension, and he continued to write, completing an additional three comedies before his death in 1637. None of these, though, matched the success of his earlier works.

OTHER PLAYWRIGHTS. Ben Jonson and William Shakespeare were the great geniuses of early seventeenth-century English theater. Critics have long debated about the relative merits of each figure's works, some advocating that Jonson's plays show a greater range of learning and depth of examination than do those of the more famous Shakespeare. Certainly, Jonson was a more varied artist than Shakespeare. In addition to the dramas and poetry that he wrote, he also made significant contributions to English prose, and his interests were more wide-ranging and philosophical in nature than those of Shakespeare. It remains, however, a matter of taste as to which artist one prefers, and even if these two admittedly brilliant figures had never lived, the theatrical writing of the reign of King James I and Charles I might still appear particularly brilliant. Of the many capable dramatists who wrote in this period, Thomas Middleton (c. 1580–1627), Thomas Heywood (1573–1641), Thomas Dekker (c. 1570–1632), Francis Beaumont (c. 1584–1616), and John Fletcher (1579–1625) rank among the most prolific and accomplished, and they kept audiences entertained with a considerable outpouring of high-quality works. Thomas Middleton, for example, excelled in the genre of "city comedy" that was then very much in vogue. These witty and sophisticated comedies concentrated on the problems of court and city life. Middleton achieved dubious notoriety for one of these productions, *A Game at Chess* (1624), a biting satire that mocked the attempt by James I's son, Charles, to conclude a marital alliance with Spain. In particular, the work's most penetrating barbs were reserved for the then-serving Spanish ambassador to England. The work caused a sensation in London, earning an extraordinary sum of £1,000 in its nine consecutive days of performances, and inducing crowds to stand in long lines to purchase tickets. Middleton and his troupe recognized that the production was going to cause controversy, and they carefully timed their staging of *A Game at Chess* to coincide with the royal court's absence from London. But James I soon learned of the production and banned all future performances. In performing the work, Middleton and his actors played on popular anti-Spanish sentiment that had seethed below the surface of English society since the late sixteenth century. At the same time, the writer's attempts to capitalize on these sentiments helped to shape royal policy, as Charles turned eventually to France, and not to Spain, in search of a royal bride. This work also affected other plays, as most playwrights became more guarded, practicing self-censorship in the wake of the famous suppression. Middleton may be best known for his part in this famous scandal, but more recently, the structure of his poetry has been studied with the aid of digital technology. This research has shown that he collaborated with a number of early seventeenth-century authors and that the stamp of his prose is considerable in some of Shakespeare's works, including *Macbeth.* Such research reminds us that the concept of "authorship" was very different in the seventeenth-century world, and that many plays that we have long thought of as the works of a solitary genius like Shakespeare were actually hammered together from the efforts of more than one author. Thomas Dekker and Thomas Heywood were two such figures who produced their own works, but who also collaborated with a number of other playwrights. Heywood claimed to have written or have participated in the writing of more than 200 plays. Unfortunately, only a small portion of them—about thirty—survive. Thomas Dekker's stamp appears in about 50 works from the period, and the author was notable among playwrights of the time for his populist perspective as well as for the openly Puritan position he took in some of his plays. In contrast to the common stamp evident in Thomas Dekker's works, the theatrical writing team of Francis Beaumont and John Fletcher produced many dramas that focused on the values of the nobility and gentry. Their works were long thought to be merely an apology for the Stuart's political theory of the "divine right of kings." More recent

a PRIMARY SOURCE *document*

A ROYAL INVESTIGATION

INTRODUCTION: The staging of Thomas Middleton's play, *A Game at Chess,* was notable for the great furor it caused in London when performed in August of 1624. The play mocked the royal family and high-ranking officials, so the company known as the King's Players had timed their performance of it to occur when King James I was out of town. Word of the spectacle, however, soon came to the king, and he suppressed the performances of it. He also demanded that his officials conduct an investigation, the progress of which is reported in the following letter. A key point in the investigation hinged on just why the royal censor, the Master of Revels as he was known, had allowed the play to be performed in the first place.

… According to His Majesty's pleasure signified to this Board by your letter of the 12th of August touching the suppressing of a scandalous comedy, acting by the King's Players, we have called before us some of the principal actors and demanded of them by what licence and authority they have presumed to act the same: in answer whereunto they produced a book, being an original and perfect copy thereof (as they affirmed) seen and allowed by Sir Henry Herbert, Knight, Master of the Revels, under his own hand, and subscribed in the last page of the said book. We, demanding further whether there were no other parts or passages represented on the stage than those expressly contained in the book, they confidently protested they added or varied from the same nothing at all.

The poet, they tell us, is one Middleton who, shifting out of the way, and not attending the Board with the rest

as we expected we have given Warrant to a messenger for the apprehending of him.

To those that were before us we gave sound and sharp reproof, making them sensible of His Majesty's high displeasure therein, giving them straight charge and command that they presume not to act the said comedy any more, nor that they suffer any play or enterlude whatsoever to be acted by them, or any of their company, until His Majesty's pleasure be further known …

As for our certifying to His Majesty (as was intimated by your letter) what passages in the said comedy we should find to be offensive and scandalous, we have thought it our duties for His Majesty's clearer information to send herewithal the book itself, subscribed as aforesaid by the Master of the Revels, that so, either yourself, or some other whom His Majesty shall appoint to peruse the same, may see the passages themselves out of the original, and call Sir Henry Herbert before you to know a reason of his licensing thereof who (as we are given to understand) is now attending at court.

So, having done as much as we conceived agreeable with our duties in conformity with His Majesty's royal commandments, and that which we hope shall give him full satisfaction, we shall continue our humble prayers to Almighty God for his health and safety.

SOURCE: "A Letter from the Privy Council to the King's secretary reporting on the performances of A Game at Chess, 21 August 1624," in *English Professional Theatre, 1530–1660.* Ed. Glynne Wickham (Cambridge: Cambridge University Press, 2000): 127–128.

inspection, though, has shown that they worked a fairly sophisticated analysis of the concepts of kingship into their plays, and that they were even suspected of treason at one point in their careers for depicting the assassination of a monarch. After Beaumont's death in 1616, Fletcher continued to produce a number of works with other Jacobean-era authors.

THE CLOSING OF THE THEATERS. During the first quarter of the seventeenth century the popularity of the theater had been great in London. In the 1630s, however, the capital's theatrical landscape began to alter. At this time Puritans began to redouble their long-standing efforts to eradicate theatrical performances, and they engaged the Crown in a number of disputes over the religious policies the country should pursue. In 1633, William Prynne, a prominent Puritan lawyer in London, published one of the most vociferous of the movement's

many attacks on the theater, his *Histrio Mastix.* The almost 1,000 pages of this volume derided the stage and criticized the Crown for its support of the "popish" rituals of the theater. Although Prynne was soon imprisoned for his words, his example emboldened others, and the rising tide of Puritan sentiments in and around London meant that by the 1640 attendance was falling at London's theaters and the quality of their productions was in decline. In the years that followed, few great playwrights continued to write for the London stage, and when Puritan forces gained control of Parliament in the early 1640s, they soon outlawed the theater altogether. Their first measures of 1642 forced the capital's theaters to close, but clandestine performances continued to be mounted, prompting Parliament to pass an even tougher measure against all forms of drama in 1647. Those who participated in or who watched any performance were

a PRIMARY SOURCE *document*

PARLIAMENT CLOSES THE THEATERS

INTRODUCTION: In 1642, a Puritan-controlled Parliament issued an ordinance that ordered all stages closed in London on moral grounds. Although these measures were relatively clear, players continued to ignore them on occasion. In 1647, Parliament reiterated its demands that theaters be closed in England's capital, and in no uncertain terms it outlawed all attempts to evade the statute. The act notably termed those who defied it (i.e., actors who continued to perform) "rogues" and insisted that they and those who watched them would face swift punishments for defiance.

Whereas the Acts of Stage-Plays, Interludes, and common Plays, condemned by ancient Heathens, and much less to be tolerated amongst Professors of the Christian Religion, is the occasion of many and sundry great vices and disorders, tending to the high provocation of God's wrath and displeasure, which lies heavy upon this Kingdom, and to the disturbance of the peace thereof; in regard whereof the same hath been prohibited by Ordinance of this present Parliament, and yet is presumed to be practiced by divers in contempt thereof. Therefore for the better suppression of the said Stage-Plays, Interludes, and common Players, It is Ordered and Ordained by the Lords and Commons in this present Parliament Assembled, and by Authority of the same, That all Stage-Players, and Players of Interludes, and common Plays, are hereby declared to be, and are, and shall be taken to be Rogues, and punishable within the Statutes of the thirty-ninth year of the Reign of Queen Elizabeth, and the seventh year of the Reign of King James, and liable unto the pains and penalties therein contained, and proceeded against according to the said Statutes, whether they be wanderers or no, and notwithstanding any license whatsoever from the King or any person or persons to that purpose.

It is further Ordered and Ordained by the Authority aforesaid, That the Lord Mayor, Justices of the peace, and Sheriffs of the City of London and Westminster, and of the Counties of Middlesex and Surrey, or any two or more of them, shall, and may, and are hereby authorized and required to pull down and demolish, or cause or procure to be pulled down and demolished all Stage-Galleries, Seats, and Boxes, erected or used, or which shall be erected and used for the acting, or playing, or seeing acted or played, such Stage-Plays, Interludes, and Plays aforesaid, within the said City of London and Liberties thereof, and other places within their respective jurisdictions; and all such common Players, and Actors of such Plays and Interludes, as upon view of them, or any one of them, or by Oath of two Witnesses (which they are hereby authorized to administer) shall be proved before them, or any two of them to have Acted, or played such Plays and Interludes as aforesaid at any time hereafter, or within the space of two Months before the time of the said Conviction, by their Warrant or Warrants under their hands and seals, to cause to be apprehended, and openly and publicly whipped in some Market Town within their several Jurisdictions during the time of the said Market, and also to cause such Offender and Offenders to enter into Recognizance, or Recognizances, with two sufficient Sureties never to Act or play any Plays or Interludes any more, and shall return in the said Recognizance, or Recognizances, into the Sizes or Sessions to be then next beholden for the said Counties and Cities respectively; and to commit to the common Jail any such person and persons as aforesaid, as shall refuse to be bound, and find such Sureties as aforesaid, until he or they shall so become bound. And in case any such person or persons so Convicted of the said offence, shall after again offend in the same kind, that then the said person or persons so offending, shall be, and is hereby Declared to be, and be taken as an incorrigible Rogue, and shall be punished and dealt with as an incorrigible Rogue ought to be by the said Statutes.

SOURCE: Houses of Parliament, *An Ordinance For, The utter suppression and abolishing of all Stage-Playes and Interludes* (London: John Wright, 1647): 1–3. Text modernized by Philip M. Soergel.

now threatened with stiff penalties. The course of the English civil wars made these measures possible. In 1642, King Charles I had abandoned London altogether, as the capital had become too dangerous a place in which to reside. He retreated to the west of England and there raised a force that engaged with Puritan forces on battlefields throughout the British Isles. By 1647, royalist forces were in retreat, although the king continued to scheme against the rising power of Parliament. In August of 1648, Charles was finally captured, tried, and executed, thus giving rise to the period of the Puritan Commonwealth, which lasted until the restoration of the monarchy in 1660. During this period the theater largely ceased to exist in England, and when Charles I's son, Charles II, returned to England and soon restored the theater, very few of the great playwrights that had flourished on the London scene in the first half of the seventeenth century were still alive. Only two notable playwrights from Charles I's age—James Shirley (1596–1666) and William Davenant (1606–1668)—

were to live to see the stage revived during the Restoration of the monarchy that occurred after 1660. In those years, though, a new tradition, perhaps less brilliant but no less prolific, developed in London, and restored the commercial theater to its eminent position as a noteworthy art form in early-modern England.

SOURCES

Andrew Gurr, *The Shakespearean Playing Companies* (Oxford: Oxford University Press, 1996).

George K. Hunter, *English Drama, 1586–1642* (Oxford: Oxford University Press, 1997).

Glynne Wickham, Herbert Berry, and William Ingram, eds., *English Professional Theatre, 1530–1660* (Cambridge, England: Cambridge University Press, 2000).

Louis B. Wright, *Shakespeare's Theater and the Dramatic Tradition* (Washington, D.C.: Folger Shakespeare Library, 1963).

SEE ALSO *Dance: Social Dance in the Baroque; Music: Origins and Elements of the Baroque Style*

COURT SPECTACLE IN STUART ENGLAND

RISING SPLENDOR. Under the Stuart kings James I and Charles I the celebration of court entertainments and spectacles rose dramatically. The Tudor queen Elizabeth I had always been relatively restrained in the staging of court spectacles when compared to the grandiose continental standards of France, Italy, and Germany. To keep royal finances in check, Elizabeth had practiced a strict economy, and while the scale of the Tudor court was grand, it paled in comparison with that of France or of her later Stuart cousins. During the first years of James I's reign, the court's expenditure on clothing, food, and entertainment rose dramatically. James and Charles both admired masques, a complex entertainment that emphasized dancing and that had been introduced into England by Henry VIII in the early sixteenth century. The masques continued to be celebrated throughout the reign of Elizabeth I (1558–1603), particularly at Twelfth Night (that is, Epiphany, the final celebration of Christmas) and on Shrove Tuesday just before the beginning of Lent. Masques combined singing, poetry, and dancing, and they employed both members of the court as well as professional dancers, players, and acrobats. The core of these productions always lay in the masked dances that littered them, and oftentimes the choreographed figure dances that occurred in the staging of a masque lasted several hours. The masque was thus a hybrid theatrical

spectacle, and one that Elizabeth I's successor, James I, transformed into a major tool of royal glorification. His spectacles served important propagandistic purposes, both domestically and abroad, as the masques staged at court increasingly supported James's theory of the divine right of kings. In James's reign, the number of such productions rose steadily. In Tudor times the masques had been used primarily as a diversionary entertainment at Christmas and before the onset of Lent, but now they were performed at the conclusion of marital alliances, at royal births, and at the signing of treaties. Gaining entrance to one of the spectacular productions mounted at court was a highly sought honor among the foreign dignitaries who lived in England during James's reign. The texts and scenarios of many of these productions still survive, but the literary and dramatic impact of these spectacles always paled in comparison to their theatrical values. Inigo Jones, chief architect to both James I and Charles I, designed the scenery for many productions, and his great Banqueting Hall, constructed between 1619 and 1622 near Whitehall Palace in London, was built to provide a suitably grand venue in which to stage the court masques. To entertain his royal patrons, Jones kept abreast of the latest advances in theatrical machinery that had been developed in recent times in France and Italy, importing the tools of his trade from abroad or building anew machines from continental designs. Besides the many high-quality masques that Ben Jonson wrote and Inigo Jones staged for the court, a number of other Stuart playwrights also were commissioned to produce masques, including Thomas Middleton, George Chapman, and Francis Beaumont. As the tide of lavish productions rose in England during the first quarter of the seventeenth century, many playwrights, including Shakespeare, inserted smaller theatrical masques into their own plays. Thus in this way the fashion of the court for spectacle exerted an influence over the commercial theater.

THE MASQUE UNDER CHARLES I. The scale of royal productions of masques continued to rise during the reign of James I's son, Charles I (r. 1625–1649). Charles's wife, Henrietta Maria, was a daughter of King Henri IV and Queen Marie de' Medici of France, and as such she brought with her to the English court a taste for dance and elaborate spectacles. During the first few years of Charles's reign, a taste for new French styles of dance flourished in the court masques, and the cost and scale of these productions increased to new, unheard-of levels. At the same time, Puritan dissatisfaction with Charles's religious policies as well as those of his archbishop of Canterbury, William Laud, steadily mounted.

One of the most outspoken of these critics was William Prynne, who detested the lavish ceremonialism of the Church of England's rituals and was also a vociferous opponent of the theater generally and of court spectacle especially. Prynne's pamphleteering against these "popish," or Roman Catholic, influences began soon after Charles I's accession, and by 1527 he was already being tried for sedition. Trained in the law, Prynne beat these first charges on a technicality, but from 1630 onward he was under almost constant threat by the royal government for his opinions and publications. He continued to write, however, and in his *Histrio Mastix* (1633) he attacked the contemporary theater, dancing, and the court of Charles I as well as the king's wife, Queen Henrietta Maria. By any standard, Prynne's more than 1,000-page attack on theatrical spectacle was extreme, since it accused any woman who took part in dances and theatrical productions of whorishness. It was a daring charge since Prynne well knew that Henrietta Maria was an avid lover of both the theater and the dance. Yet Puritan distaste for these arts ran deep, and Prynne's onslaught against the stage continued even during the seven years he was imprisoned, and his determination encouraged others to speak out against the theater as well. Beside imprisoning Prynne, Charles I's reaction to the *Histrio Mastix* was swift and determined. Prynne had been a member of Lincoln's Inn, one of the four guilds of lawyers who practiced in London's courts. Charles immediately demanded that London's law guilds provide him with a suitably grand theatrical to demonstrate their loyalty to the crown. The members of the law guilds thus were required to stage *The Triumph of Peace,* a production that cost them more than £21,000 to mount—a prodigious sum when most Englanders survived on less than £100 per year. The production of this masque and the many hours of processions and pageantry that preceded it in the streets of London set new standards for profligate royal display and did little to heal the growing enmity between the Crown and Puritan Londoners. Thus the theater played a role in the rising sentiment that was to produce the Puritan Revolution in England, and ultimately result in King Charles I's execution in 1649.

SOURCES

David Bevington and Peter Holbrooks, eds., *The Politics of the Stuart Court Masque* (Cambridge, England: Cambridge University Press, 1998).

Skiles Howard, *The Politics of Courtly Dancing in Early Modern England* (Amherst, Mass.: University of Massachusetts Press, 1998).

David Lindley, ed., *The Court Masque* (Manchester, England: University of Manchester Press, 1984).

SEE ALSO *Dance: Dance in Court Spectacle*

THEATER IN GOLDEN-AGE SPAIN

A CENTURY OF GREATNESS. Although Spain suffered military and economic setbacks in the later sixteenth and early seventeenth centuries, this same period was one of brilliance in the arts and literature in the country. By 1600, the cities of Spain had already developed a vigorous theater that was in many ways even more vital than that of London. The origins of Spanish theater can be traced to the late-medieval dramas that were performed on solemn religious occasions. Like England, the Feast of Corpus Christi in late spring was an important occasion that was often celebrated with the staging of imposing religious dramas. Unlike many parts of Europe where Protestantism gradually restricted religious drama, such productions remained a vital part of urban piety in the seventeenth century, inspiring a new genre of *auto sacramentals*, or sacramental plays, that aimed to teach the Spanish the tenets of Counter-Reformation Catholicism. In particular, these sacramental plays focused on the theology of the Eucharist, and their series of scenes often demonstrated the biblical events that had produced the sacrifice of Jesus Christ as well as the rise of Christianity. Even as such religious theater remained a growing tradition in Spain's Golden Age, popular secular drama was undergoing a dramatic expansion, although its roots also lay in the religious institutions of the country. In the second half of the sixteenth century religious confraternities—brotherhoods of lay and clerical members—began to stage performances of secular dramas and comedies for paying audiences. Many of these brotherhoods cared for the sick and dying, and the profits of their dramatic performances were used to underwrite their charitable efforts. The typical Spanish theater of the time was known as a *corral*, a word that referred to the walled-in courtyards in which plays were performed. At one end of these corrals a raised stage provided the setting on which the dramas were performed. Usually these stages were two stories high, with an upper gallery that was decorated to suggest towers, houses, and other elements of urban architecture. The first two of these theaters—the *Corral de la Cruz* and the *Corral del Principe*—were constructed as makeshift affairs in the newly named Spanish capital of Madrid. Others developed there and at Seville, and by 1600, these two cities were home to the most vigorous theater life in Spain,

although other theatrical troupes thrived elsewhere in the country. By 1630, Madrid had seven theaters that accommodated crowds of around 2,000 people in each for daytime performances. As theatergoing became an increasingly popular pastime for Spaniards, the country's *corrales*—that is, its open-air playhouses—were often remodeled and roofed over to acquire a greater sense of permanence. Wealthy merchants and aristocratic patrons rented boxes in the galleries that stretched above the stage, while the poor were relegated to the ground from which they looked up at the stage. The staging used in these productions was still quite rudimentary since painted scenery and other elements of stage machinery did not become popular in Spain until later in the seventeenth century. The relatively modest production values aside, an incredible number of plays were written and performed in the period. No one has ever been able to ascertain the total number of dramas produced in this period, but estimates of the number of plays written in seventeenth-century Spain range from between 10,000 and 30,000. A list of Spanish playwrights compiled by a commentator in 1632, for instance, noted more than eighty authors then active in the province of Castile alone, and the most prolific of these figures produced hundreds of works during their lifetimes.

LINKS TO RENAISSANCE ITALY. Because of close ties in trade, culture, and language, Italy's influence upon Spain in the sixteenth century had been great. Renaissance humanism, with its emphasis on the study of classical Antiquity, had made many inroads in the country. As the new forms of secular drama became popular in Spanish society toward the end of the century, playwrights experimented with ways to adopt classical forms to the developing professional stage. In Italy, however, the comedies and tragedies of the Renaissance had frequently been performed in courts, where long hours might be devoted to watching elaborate stage productions that were frequently punctuated with imposing interludes known as *intermedi*. Comedies modeled on ancient examples had usually consisted of five acts, and when the full complement of accompanying interludes was figured into an Italian production, these plays might last for as long as six hours. The *corrales* of the Spanish Golden Age had no such luxury. Performed in the open air, dramas were required by law to be completed one hour before night fell. Thus a taste developed for shorter, three-act dramas known as *comedias*. Short verse preludes often preceded the beginning of the first act to set the mood for what followed. In between acts, comic skits or dances were usually performed. While the roots of the word *comedia* are similar to the English "comedy," the Spanish used the term to refer to any drama—serious, tragic, or comic—that was performed in verse. Much of the quality of poetic writing displayed in these plays was of a high artistic standard. Like the writing of Marlowe, Shakespeare, and Jonson, Spanish seventeenth-century playwrights labored mightily to please an audience that seems to have appreciated language in all its complex and difficult forms. The effect of many of these works is thus musical in nature since authors altered the verse structure throughout their works, relying on one rhyme and syllabic structure in a scene to suggest a certain mood and then changing it to fit another in other portions of the play. Commoners were frequently depicted using simpler, native rhyme structures, while noble characters were often portrayed with more complex meters drawn from Italian Renaissance examples.

CHARACTER OF THE COMEDIAS. In place of thorough character development and psychological exploration, Spanish audiences in the seventeenth century seem to have preferred fast-moving action. Cases of mistaken identity, deceits, and disguised characters abound in the plays from the era, and dramas were often punctuated with duels and other violence. The precise subjects of the dramas were drawn from other literary forms like short stories, medieval and Renaissance epics and romances, from history, and from the classics, but in many of these works the theme of honor figured prominently. Spanish playwrights did not consider this abstract human quality to be something associated merely with aristocratic status or wealth. Instead the tone of most dramas was highly moralistic, insisting that everyone in the social structure—from the highest noble grandee to the lowest peasant—shared a human dignity and a mission to fulfill, but this precise duty was peculiar to a character's specific station. Along the way to the conclusion of the *comedias,* characters' honor is frequently called into question and subjected to a test. But almost always, the conventional morality of the plays ensures that the wicked are punished and the good rewarded. For this reason the Spanish theater of the Golden Age has long been viewed as a force of social control and conformity. Unlike England where playwrights were constantly testing the boundaries of royal censorship, Spanish dramatists were often content to uphold the established social order, and seem to have infrequently cast a penetrating, critical gaze on established social realities. Instead their high-quality productions were notable for the artistry of their words and meter. At the same time, the enormous output of writers at this time reveal that in many works authors did examine critically elements of the Spanish character, making all easy generalizations about the lack

of social criticism in the Golden Age theater difficult to maintain. The continuing discovery of new works that have been forgotten for centuries means that the sheer variety and complexity of themes treated at this time will continue to be debated for many years to come.

LOPE DE VEGA. Of the many competent and even accomplished seventeenth-century dramatists active in Madrid, Seville, and other theatrical centers in Spain, two figures stand out as particularly brilliant: Felix Lope de Vega Carpio (1562–1635) and Pedro Calderón de la Barca (1600–1681). Lope de Vega was the son of an embroiderer; despite his humble origins, he learned to read and cultivated a rudimentary understanding of humanism through his broad exposure to noble circles in Madrid. By the 1580s he was already writing works for the stage in that city, but by the later part of the decade he was named in a libel case for verses he wrote against a local noblewoman who rebuffed his advances. Sent into exile from Madrid for eight years, he eventually overcame his legal troubles and returned to the capital. He ingratiated himself with several members of the nobility, lived in their houses, and served as a secretary to a duke until 1605. Lope also began to experiment with new dramatic forms, eventually establishing the *comedia* style that dominated the Spanish stage for much of the seventeenth century. A gifted writer of lyric poetry, the dramatist perfected his work during these years and thus began one of the most brilliant outpourings of dramas in history. Although the precise number of his plays cannot be definitely established, one of his admirers noted shortly after Lope's death that he had written at least 1,800 dramatic works. Of these, more than 300 survive today that appear to be definitely from his hand, while another almost 200 have long been attributed to him. Thus Lope seems to have written at least 500 *comedias* intended for the professional stage in Madrid, but he also wrote shorter dramatic works, as well as an enormous amount of poetry. Many of his most important dramatic works treated events from Spain's history, but the author was also well known for his comedies, which often included figures of wise peasants and servants as prominent characters. For his dramatization of the life and death of the ill-fated Mary Queen of Scots, Lope de Vega was awarded an honorary doctoral degree from the pope in 1627. While his enormous productivity continued throughout his life, numerous trials continued to punctuate his personal life. A string of mistresses brought the playwright a number of children, but the difficulties associated with these liaisons spurred him to take up the religious life around 1610. But after toying with several religious orders, Lope de Vega began another romance

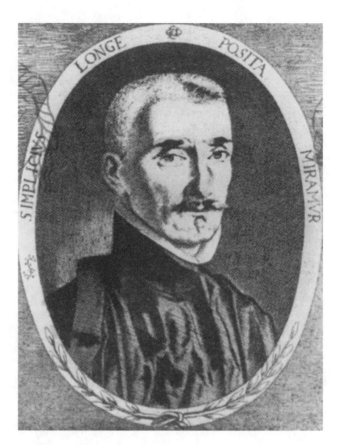

Engraving of Spanish playwright Felix Lope de Vega. **LIBRARY OF CONGRESS.**

and gave up all thoughts of becoming a member of a religious order. Somewhat later, he lost a treasured mistress, and two beloved children died under trying circumstances—circumstances that Lope de Vega commented upon in his poetry. When he died in 1635, his larger-than-life romantic exploits as well as his enormous productivity had already made him a hero in and around Madrid, and his death was mourned as a national tragedy in Spain.

PEDRO CALDERÓN DE LA BARCA. Pedro Calderón de la Barca, by contrast, was born into the minor nobility of Madrid and received his early education from the Jesuits. He intended to become a lawyer, but he eventually turned to writing plays in his twenties while serving the Constable of Castile. Like Lope de Vega, Calderón produced a number of sparkling comedies, writing the majority of his 120 works before he was in his mid-forties. Among the most famous of these, *El médico de su honra* (The Surgeon of His Honor) and *El pintor de su deshonra* (The Painter of His Own Dishonor) held up a mirror to Spanish society, examining its preoccupations with honor. In other works Calderón defended Catholicism and gently mocked the inequities

that noble privilege produced. While he flourished as a writer for Madrid's professional troupes until about 1640, Spain's worsening political crisis eventually led him to abandon his career as a professional dramatist. During the 1640s, revolts in Portugal and Catalonia resulted in the closure of Spanish theaters, and Calderón entered a religious order. In this new role, he authored Madrid's religious plays, or *autos sacramentales,* which were performed in conjunction with the celebration of the Feast of Corpus Christi and other major religious festivals. He also wrote plays and directed productions for the crown. Besides providing the dramas for these events, he continued to rework his own plays and to edit and rewrite those of others. His efforts helped finally to perfect the three-act *comedia* structure that Lope de Vega and others like Tirso de Molina (1584–1648) had developed. He is credited with developing the form to a high art that possessed considerable intellectual integrity as well as sensual poetry, but although the theater did not disappear in Spain, no author of similar genius arose to take his place following his death in 1681.

SOURCES

Melveena McKendrick, *Theatre in Spain, 1490–1700* (Cambridge, England: Cambridge University Press, 1989).

N. D. Shergold, *A History of the Spanish Stage from Medieval Times until the End of the Seventeenth Century* (Oxford: Oxford University Press, 1967).

Margaret Wilson, *Spanish Drama of the Golden Age* (Oxford: Oxford University Press, 1969).

THE FRENCH STAGE AT THE BEGINNING OF THE BAROQUE

CRISIS AND RECOVERY. The later sixteenth century in France had been punctuated by religious wars and economic and political instability. With the accession of Henri IV (r. 1594–1610) and his promulgation of the Edict of Nantes—a royal decree that granted a limited degree of religious toleration to French Calvinists—a new tenuous stability began to develop in the country. Although Henri IV was assassinated in 1610, France did not sink into civil war again as might have been expected. Instead under the regency of Henri's wife Marie de' Medici and the rule of her son, Louis XIII (r. 1610–1643), the country's political systems and economy gathered renewed strength and the way was prepared for France's rise to European dominance in the second half of the seventeenth century. Developments in the professional theater were very much affected by these trends as well. In 1600, Paris, which was by far

the country's largest city, possessed a theater that was little developed when compared against the high standards of professionalism being developed in England and Spain at the time. A half-century later, a new generation of playwrights was producing quality tragedies and comedies that were eventually to shape drama, not only in France, but throughout Europe as well. While the sudden rise of several generations of playwrights that included such geniuses as Pierre Corneille (1606–1684), Jean-Baptiste Molière (1622–1673), and Jean Racine (1639–1699), may appear meteoric, their successes nevertheless stemmed from the traditions of theater that had flourished in France before them.

THE SIXTEENTH-CENTURY THEATER. At the beginning of the sixteenth century, a variety of genres of drama were popular in France and were being performed by mostly amateur troupes of actors in the country's cities. As in other parts of Europe at the time, the popularity of religious drama was still strong, and mystery plays performed on important feast days often consumed the efforts of scores of actors in France's cities. Allegorical morality plays were also popular throughout the country, while for lighter fare, French audiences enjoyed silly farces and satirical dramas known as *soties.* In the second half of the century, however, the impact of humanism began to manifest itself in the writing of new kinds of comedies, tragicomedies, and tragedies inspired by the works of Antiquity. In comedy, the impact of the five-act form of the ancient writers Terence and Plautus began to produce subtle modulations around 1550 in French farces and comedies, as a group known as the Pleiades tried to adopt classical forms to the country's theater. This group took its name from the celestial constellation that, according to Greek mythology, had been formed out of the remains of seven prominent poets. The most prominent of these figures, Joachim du Bellay (c. 1522–1560) and Pierre de Ronsard (1524–1585), had studied classical forms with the intention of raising the standards of French drama to compete with the brilliance they saw in Italian humanist theater of the time. While many of the dramatic structures of ancient comedy came to be applied to the works of the Pleiades, much of the writing of the group continued to be faithful to French traditions of farce common in the later Middle Ages. As a group, the Pleiades still favored the octosyllabic, or eight-syllable, verse writing that had been commonly used in the writings of French comic farces to this date. They did not, in other words, emulate the use of prose that was common among Italian humanist dramatists of the day. At the same time many writers adopted plots that were drawn directly from Antiquity,

from the works of Terence and Plautus. Plays treating adulterous husbands and wives, scheming family members, and lovelorn students derived many of their plots from Antiquity, while continuing to be set in the urban world of the time. At about the same time that these experiments in new forms of comedy were appearing, French humanists also turned to the tragedies of Latin Antiquity for inspiration as well. Like Italian tragedies of the day, the many French tragedies that date from the second half of the sixteenth century evidenced the use of ancient canons of dramatic writing. A renewed interest in the Roman tragedies of Seneca and in the Greek works of Euripides was important in prompting French writers to emulate the ancient five-act structures of classical tragedy as well as to develop a role for the chorus. At the same time, many of the tragedies written in this period were not performed, but were primarily "closet dramas" intended to be read by educated elites. In this way ancient stories about figures like Julius Caesar, Medea, or Cleopatra often became a vehicle for commenting upon the grave circumstances of the French Wars of Religion (1562–1598). Writers saw in these ancient episodes events that might provide virtuous moral lessons for their contemporary readers, who were suffering through a time of uncertainty and political instability.

THE CONFRATERNITY OF THE PASSION. The sixteenth century also saw the rise of a nascent professional theater in Paris around the institution known as the Confraternity of the Passion. In 1402, this organization, which was comprised of young amateur performers who were usually apprentices and journeymen in Paris guilds, had been granted a royal monopoly over all dramatic productions in the city. This monopoly was to be upheld well into the seventeenth century before being formally abolished by Louis XIV, who began to charter new theaters in the city. For much of the later Middle Ages and the Renaissance the Confraternity of the Passion had been responsible for the annual staging of the city's mystery plays, religious dramas that accompanied the celebration of the Feast of Corpus Christi and other important religious holidays throughout the year. During the sixteenth century the Confraternity came under increasing criticism for the liberties that it took in producing religious dramas. Churchmen attacked the organization for including spurious material in their productions. French Protestants, in particular, detested the group's productions, fearing that the theater provided an entree into idolatry and immorality. By 1548, the Parlement of Paris, the local governing body, forbade the group from performing religious dramas in the city. At the same time, the Confraternity of the Passion

retained its rights to use the Hôtel de Bourgogne, a palatial residence that the group owned in the city. Deprived of their ability to perform religious dramas, the members of the Confraternity began to perform light farces and other kinds of secular fare in the Hôtel's theater, a large room outfitted with a simple two-story stage and bleachers. Over the following decades, though, the group gradually abandoned acting altogether and began to lease out their theater to professional troupes that performed their repertory there. Until 1600, no troupe, however, was able to achieve any modicum of financial success performing in the theater; at that time the company of Valleran le Conte set up shop in the Hôtel de Bourgogne, and its successful exploitation of the space as well as its populist-tinged dramas began to develop a professional theater in early seventeenth-century Paris. Le Conte had a highly successful relationship with the playwright Alexandre Hardy (c. 1575–1632), who in his relatively short life wrote hundreds of comedies, tragedies, tragicomedies, and pastorals. Unlike the cultivated dramas that Renaissance humanists were writing at the time, Hardy's works relied on a realistic mixture of coarse language, sexuality, and outright violence. His dramas were fast-paced and designed to please a broad spectrum of Paris' populace, filled as they were with a progression of short scenes and sudden plot turns. While highly cultivated French writers of the time labored to revive classical drama, Hardy gave his audiences a steady stream of crowd-pleasing sensations. Limbs were severed in duels, eyes were plucked out, and characters were beheaded in the many plays that he wrote for the Hôtel de Bourgogne. Eventually, Valleran's troupe took up permanent residence in the facility and hired Hardy from 1611 as their official playwright. The productions of the Conte de Valleran's troupe and Hardy were to have an undeniably important impact on French theater. While the quality of the dramas they produced may not have been particularly memorable, the sustained professionalism and high production values of their efforts helped to popularize theater in Paris.

OTHER GROUPS. Although the Hôtel de Bourgogne's monopoly over theatrical productions in Paris was not formally revoked until 1676, the growth of urban sprawl in Paris affected the theater there, just as it did in London at about the same time. In the English capital, Puritan ministers and city officials in late sixteenth- and early seventeenth-century London feared the disorder that accompanied the theaters. While many objected to drama, they also detested the theaters as the haunts of criminals and prostitutes. To skate the regulations of the city of London's officialdom, theater owners

in London had thus located their large public theaters in the areas known as the Liberties, places on the outskirts of the city where municipal regulations held no force. While the professional stage was not nearly so highly developed in Paris in 1600 as it was in London at the same time, Paris' growing urban sprawl provided a similar opportunity for professional troupes that were anxious to perform in the capital's vicinity. Around this date plays began to be performed at the fairs that were held in the suburban districts of Saint-Germain and Saint-Laurent in the spring and summer months. Thus these new temporary theaters developed alongside the monopolistic Hôtel de Bourgogne and flourished as venues for short dramas, dances, and song at the fairs on Paris' outskirts. In this way the dominance of the Confraternity of the Passion's control over the Parisian theater was gradually challenged. And as the royal government, too, acquired a taste for the theater in the 1630s and 1640s, new troupes were allowed to perform within the city's walls.

SOURCES

Karten Garscha, *Hardy als Barockdramatiker, eine stilistische Untersuchung* (Frankfurt am Main, Germany: Peter Lang, 1971).

Brian Jeffrey, *French Renaissance Comedy, 1552–1630* (Oxford: Oxford University Press, 1969).

Jillian Jondorf, *French Renaissance Tragedy: The Dramatic Word* (Cambridge, England: Cambridge University Press, 1990).

Donald Stone, *French Humanist Tragedy: A Reassessment* (Manchester, England: Manchester University Press, 1974).

NEOCLASSICISM IN SEVENTEENTH-CENTURY PARIS

A CENTURY OF GREATNESS. In 1600, no great playwrights comparable to the English Shakespeare or Jonson or the Spanish Lope de Vega or Calderón were active in France. Thirty years later, though, a great age of dramatic writing was just beginning to unfold in the country. As a result of the efforts of Pierre Corneille (1606–1684), Jean-Baptiste Molière (1622–1673), and Jean Racine (1639–1699), the theater played a major role in the country's aristocratic society, and its tastes and fashions influenced drama in many parts of Europe. As this new style of theater rose to popularity in mid-seventeenth-century Paris, it did so primarily in opposition to the salacious, crowd-pleasing spectacles that Alexandre Hardy and others had long provided the

Parisian audience. In contrast to the great popularity of the theater in Tudor and early Stuart England, or in Golden-Age Spain, the masterpieces that France's great seventeenth-century dramatists produced were aimed at a considerably narrower audience of courtiers and wealthy, educated Parisians. Elite tastes thus defined the new tragedies and comedies that flourished in the period, and the royal government was, in large part, responsible for the great flowering of the stage in Paris in the half-century that followed 1630. Louis XIII's chief minister, Cardinal Richelieu (1585–1642), carefully tended to the development of the theater, allowing new troupes of actors to take up residence in Paris, besides those that had traditionally resided at the Hôtel de Bourgogne. His efforts to develop a national stage that catered to aristocratic tastes coincided with the early career of Pierre Corneille, a writer of genius whose works may have had a limited appeal but nevertheless achieved a devoted following in Parisian high society. In painting, sculpture, and architecture, France's seventeenth-century theorists and artists became concerned to develop styles notable for their classicism, and they frequently turned to the works of High Renaissance masters like Michelangelo and Raphael for inspiration. So, too, in the theater the classical heritage in France produced plays that were very different from the histories, tragedies, and comedies of England or Spain. In both these countries, the commercial and popular nature of the theater had produced a flurry of works that frequently violated the canons that Renaissance writers of comedy and tragedy had advocated for the governing of drama. In his many vivid historical plays, for instance, William Shakespeare had ranged across decades, presenting incidents that frequently occurred years apart. To satisfy audiences in early seventeenth-century Spain, Lope de Vega and other writers of *comedias* tailored their works to appeal to a broad spectrum of urban society, and like those produced in England, their fast-paced dramas showed little indebtedness to the culture of Renaissance humanism. By contrast, the great outpouring of theatrical writing that occurred in seventeenth-century France proceeded from theoretical assumptions and certain intellectual premises that were traceable to the fascination with Antiquity, a fascination that played a large role in shaping all the arts in the country during the course of the seventeenth century.

THE CLASSICAL UNITIES. In contrast to the many theaters that were flourishing at the time in London or Madrid, Paris never acquired more than three principal playhouses during the seventeenth century. These houses were considerably smaller than many of the theaters of

London or Madrid. And while plays were performed in the English and Spanish capitals on weekdays, a theatrical troupe was only allowed to perform three times a week in Paris, thus limiting the commercial possibilities of the French stage. No Parisian theater was thus able to survive without the patronage of the king, and as a result court tastes defined French drama far more extensively than in other places. During the reign of Louis XIII (r. 1610–1643), it was Cardinal Richelieu, the king's chief minister, who helped to define the conventions of the French stage. During the 1630s he became an avid supporter of the theater, establishing a group of five playwrights who became known as "The Society of Five Authors." He regularly commissioned works from these dramatists, and one of the members of this group was Pierre Corneille, the figure who subsequently revolutionized French drama. At the time Richelieu was just beginning to patronize the theater, French drama critics and scholars were advocating the adoption of the notion of classical unities in theatrical writing. The notion of the unities traced its origins to sixteenth-century Italian commentators on Aristotle and ancient drama. From the mid-sixteenth century onward, the ideas of Aristotle had played an increasingly important role in defining taste in the arts in Italy, as scholars turned to the Greek philosopher's *Poetics* for inspiration in their attempt to reform the arts. Although their reading of Aristotle has long been shown to be problematic, Italian theorists derived a theory from the *Poetics* that stressed that all action in a drama should share unity of time, place, and action. In practice, these rules of the classical unities meant that all the action of a play should occur in the same place on the same day between sunrise and sunset, and that authors should not stray into subplots but should carefully outline all the implications of a single story. As French dramatists developed their craft in the mid-seventeenth century, the classical unities played a major defining role in shaping their writing. Fascination with these rules produced a number of stunning works that were undeniably great literary achievements. At the same time, the restrained classicism of the French theater and the strict subjection of drama to an oft-unbending set of rules held relatively less popular appeal than the great commercial successes typical of the English or Spanish stages. Where several thousand spectators had often crowded into London and Madrid's theaters to see a particularly popular play, at the high watermark of the theater's success in seventeenth-century Paris average attendance at the theater was around 400, and the most popular productions never drew more than 1,000 spectators. Most plays were only performed about a dozen times, while the greatest had no more than 30 to 40 performances.

THE THEATERS. Specialization was the rule among the five troupes that performed in the theaters of seventeenth-century Paris, with certain troupes performing tragedies and others specializing in lighter comedies. While the Confraternity of the Passion's monopoly over dramatic performances in the city was not abolished officially until 1676, new venues for theater had begun to flourish in the city long before that date. Besides the theater at the Hôtel de Bourgogne—home to the Comedians of the King—two new theaters developed in the mid-seventeenth century. In 1629, Cardinal Richelieu encouraged a company directed by the great actor Guillaume du Gilberts, who was also known as Montdory, to perform in the city, and Montdory's troupe soon scored a success with a production of Corneille's first comedy *Mélite* (1630). A few years later, Montdory's troupe renovated an indoor tennis court in the Marais, then a fashionable residential district in the city, for the performance of plays. By 1641, the last of Paris's seventeenth-century theaters began to take shape. It was built in the private residence of Cardinal Richelieu. The new theater made use of Italian innovations like the proscenium arch as well as other elements of stage machinery that to this time had been little known in France. When Richelieu died in 1642, his new state-of-the-art theater came into royal hands and became known as the Palais Royal, a venue that saw many great successes not only in drama, but also in opera and ballet. It remained a center for the performance of all three arts during the reign of Louis XIV and Louis XV. In the 1640s, Richelieu's successor as chief royal minister, Cardinal Mazarin, whose affections for the theater were considerably less developed than Richelieu's, did bring the great Italian stage designer Giacomo Torelli to Paris. Torelli remodeled the original theater to allow for easier changes of scenery, and he staged several productions in the theater that made use of these Italian innovations. Most often, though, scene changes were kept to a minimum in French theater. Given the prevailing rules about unities, most comedies had a set that suggested a single chamber usually outfitted with multiple doors. Tragedies were often performed in front of backdrops that suggested a royal palace or public setting. While the dramas staged in Paris's public theaters were notable for their spare production values, royal spectacles undertaken in Paris and Versailles at the same time were often quite elaborate and made use of complicated stage machinery. In 1660, for example, Louis XIV imported the Italian stage designer Gaspare Vigarani to supervise the building of the *Salles des*

Machines within the palace of the Louvre. This room was to this time the largest theater ever built in Europe and was more than 225 feet long. Its enormous stage, however, consumed more than half this space. The purpose of a grand theater like this was to stage royal spectacles—in this case, the festivities that were to celebrate Louis's impending marriage. Because of the highly literary nature of the art of theater in seventeenth-century France, the use of such spectacle and elaborate stage machinery was generally avoided in dramatic productions. The French theater of the seventeenth century was anything but naturalistic. Acting troupes and their playwrights did not strive for realism. Poetic lines were declaimed, that is, they were recited with an elaborate elocutionary style intended to heighten their effect. As each player recited his lines, he stepped forward to the front of the stage to deliver them, then moved back to allow another actor to speak his response. Such conventions were intended to heighten the dramatic effects of the words being spoken, but generally the style of performance suggests the great importance the theater attained in France as a vehicle for communicating an art that was perceived primarily as a literary form.

SOURCES

Georges Forrestier, *Passions Tragiques et Règles Classiques: Essai sur la Tragédie Française* (Paris: Presses Universitaires de France, 2003).

Robert McGridge, *Aspects of Seventeenth-Century French Drama and Thought* (Totowa, N.J.: Rowman and Littlefield, 1979).

Harriet Stone, *The Classical Model: Literature and Knowledge in Seventeenth-Century France* (Cambridge, England: Cambridge University Press, 1996).

SEE ALSO *Literature: French Literature in the Seventeenth Century*

THE LEGACY OF CORNEILLE, RACINE, AND MOLIÈRE

TRAGEDY. It was in tragedy that two of the three great dramatists of seventeenth-century France—Pierre Corneille (1606–1684) and Jean Racine (1639–1699)—excelled. Corneille was the son of a prominent Norman lawyer who was eventually ennobled by the king. Like the comic genius Molière, he was educated by the Jesuits, the great counter-reforming religious order that established an impressive network of schools throughout Catholic Europe during the later sixteenth century. Drama played a key role in Jesuit education, and instruction in the theater was seen as a way of inculcating

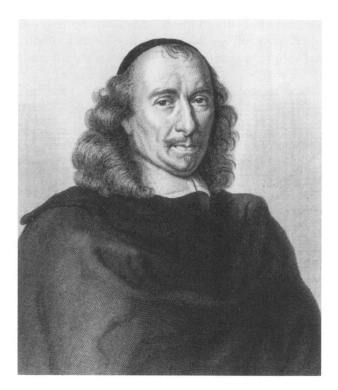

Engraving of playwright Pierre Corneille. © BETTMANN/CORBIS.

classical values. Although the Jesuit theater produced no lasting monuments of drama, the order experimented with all the latest production techniques, eventually adding dance and music to their productions so that many of the Jesuit school plays resembled operas more than drama. Corneille's art did not follow these paths; instead he became a great writer of tragedy and tragicomedy, a hybrid form that merged both comic and tragic elements. Finishing his education, he received a license to practice law and soon won a position as an administrator of royal forests and waterways, a position that he held well into his forties, while he continued to develop his career as a playwright. When he was just twenty he completed his first play, the comedy *Mélite,* which was performed at Rouen in 1629 and then staged in Paris. It caused great excitement and Corneille quickly became established in the 1630s as one of the chief authors for the Paris stage, receiving a number of commissions for plays from the king's minister Richelieu. His art continued to break new ground, but in 1636, the performance of his tragicomedy, *Le Cid,* caused controversy. While his previous plays had experimented with the laws of classical unities and with classical ways of expressing the emotions in a restrained fashion, Corneille broke from this path in *Le Cid.* Audiences were stunned by his representation of strong emotions and by the tale's plot, which involved a pair of star-crossed lovers kept

apart by a feud between their families that eventually resulted in the hero killing his lover's father. Corneille's tragedy thus highlighted the moral dilemma that arose from the questions of the relative importance of family honor or love, but Corneille did not neatly resolve this dilemma. Instead, his work insisted that either path—love or duty—might have been the correct one for the heroine to take. Several pamphlets soon appeared in Paris attacking his work as morally defective, and Richelieu himself found his young playwright's ending troubling. He submitted the play to the Académic Française, the Parisian academy Richelieu had recently founded and charged with establishing standards in French literature. The critics of the Academy found the play filled with much glorious poetry, but ultimately morally questionable, and so Richelieu suppressed its performance. Corneille eventually reworked his masterpiece, transforming it into a more thoroughly tragic piece, and in the plays that followed his *Cid* he became more conservative in his choice of subject material. Although it was feared when it first appeared, *Le Cid* has survived as one of the great literary landmarks of seventeenth-century French. Its encapsulation of the dilemmas of love and family duty and its glorious use of Alexandrine verse—a stately and extremely formal twelve-syllabic line—remains one of the great statements about the effect of the passions in the Western tradition.

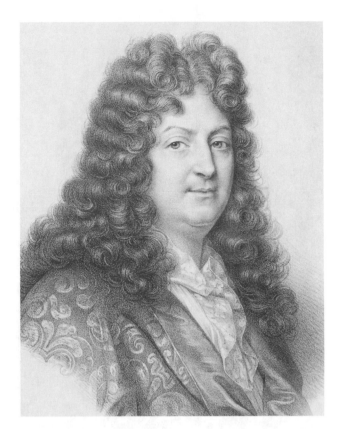

Engraving of French playwright Jean Racine. © MICHAEL NICHOLSON/CORBIS.

RACINE. In the years that followed, Corneille continued to write plays, although none of his tragedies was to be as ground breaking and controversial as *Le Cid.* He chose safer historical themes, usually setting his plays in ancient Rome and developing plots that set up dilemmas about patriotism, Christianity, and family honor. Avoiding controversy, Corneille's works often celebrated the deeds of kindly despotic kings in suppressing chaos or they celebrated the triumph of Christian morality over the human passions of romantic love, jealousy, and hate. Working in this vein, the quality of his plays gradually declined. By the 1660s, his place as France's greatest tragedian was ever more being subsumed by Jean Racine (1639–1699). Racine had been orphaned at a young age, and received his education in a convent school that was at the time heavily influenced by the pious Jansenist movement. The Jansenists, in contrast to the piety advocated by the Jesuit Order, fostered a deep sense of sinfulness and of humankind's inability to participate in their own salvation. Although Louis XIV eventually suppressed the movement because he feared it was a form of crypto-Protestantism, the fervent piety the Jansenists advocated left its stamp on the young Racine, as did the Jansenists' affection for classical literature. Racine eventually studied the law, but as he matured he sought royal patronage for his writing. He sent Louis XIV's chief minister Cardinal Mazarin a sonnet that praised his efforts in concluding a treaty with the Spanish, but received no royal appointment. Next, he tried to obtain a position in the church, but was again unsuccessful, and so he returned to Paris to try his hand at writing dramas. This course angered his Jansenist teachers, who found the theater to be a poor choice for someone of his pious nature who was possessed with gifts as a scholar. But in 1665, the young Racine's fortunes were assured with his production of *Alexandre le grand,* a play that meditated on the tragic shortcomings of the ancient conqueror Alexander the Great. His subsequent plays developed the Alexandrine verse that Corneille had immortalized in his tragedies, developing its possibilities to a high point of perfection. These works included *Andromaque* (1667), *Britannicus* (1669), *Bérenice* (1670), and his masterpiece *Phèdre* (1677). In these and other works Racine often set up his tragic dilemmas as conflicts between love, duty, and honor. When at the height of his powers as a dramatist, it is interesting to note that Racine's own sense of duty, and perhaps his piety, won out. At the age of only 37 he retired from the stage, and in the last quarter

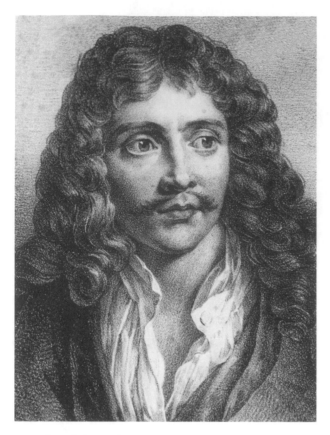

Engraving of playwright Jean-Baptiste Molière. © MICHAEL NICHOLSON/CORBIS.

century of his life he wrote only two biblical dramas that were performed in girls' schools. Even though his retirement robbed the French stage of the possibility of a number of great works of tragedy, his considerable output in his early years provided a storehouse of plays that stand as some of the greatest poetry in the French language.

MOLIÈRE. At the same time as the great tragedies of Corneille and Racine were fascinating audiences in Paris, Jean-Baptiste Poquelin, better known to history as Molière (1623–1673), was developing standards in comedy that were not to be equaled in the country for generations. Of the three great dramatic geniuses seventeenth-century France produced, Molière is today the most universally recognized. His works continue to be performed in France and throughout the world, and their mixture of slapstick humor, wit, and sophisticated urbanity is still widely admired. If Corneille and Racine rank as important figures in the development of literary French, Molière was at once a man who was at home in the theater from an early age. When he was just 21 he formed a troupe of actors at Paris, but Molière quickly went bankrupt. To support themselves, the band of actors left the city and spent twelve years traveling through the

French provinces. In this long apprenticeship as a playwright, Molière discovered firsthand just what kept audiences entertained, and when he returned to Paris, he was poised to make a major mark on the theater of the city. In 1658, King Louis XIV was in attendance at a performance of his comedy *The Affected Young Ladies.* From that date his importance as a writer of comedies for the Paris stage as well as entertainments for the king steadily rose. Louis XIV gave the playwright and his troupe use of the theater in the Palais Royal three days each week, and eventually conferred a small office in the royal household on the writer. Molière's royal favor irritated the clergy, powerful officials in Paris, and the other troupes that performed in the capital, and he claimed that he had to publish his plays so that these other companies did not pirate his works. Like Corneille, he had the benefit of a Jesuit education, with its exposure to the classics, but his family origins were considerably humbler, and without a family fortune or another profession to fall back upon like Corneille and Racine, he frequently had to scramble to produce his theatrical ventures. His plays satisfied the court's desire for light entertainments, and often had little in the way of literary pretensions. In most of these works he aimed to please rather than to educate or elevate his audience. At the same time his sense of comic timing, his undeniably keen observations of human nature, and the gentle mockery he directed at all categories of seventeenth-century people still manages to captivate modern audiences. Yet in Molière's own time his art was not always assessed as positively as it is today. His *Tartuffe* (1664) caused an immediate scandal among the clergy, who objected to the biting sarcasm the author directed against their hypocrisy. They succeeded in banning its performance for five years, and continued to harass the author for much of the rest of his life.

MOLIÈRE'S LATER TROUBLES AND THE DECLINE OF THE THEATER. The playwright refused to be worn down by these scandals. Instead he immediately responded by producing a new version of *Don Juan* in which the notorious Spanish lover meets his hellish fate, but only after entertaining the audience with his wit and amorous antics over the course of an evening. In the years that followed, Molière was frequently unable to find suitable plays for his company to perform, so he responded by taking on the task of writing a number of works for them. In the years between their return to Paris in 1658 and his death in 1673, he wrote about a third of the 95 plays his company produced. Although the king favored him, he still faced great trials in making a success of his company. In 1666, Louis' mother, Anne

a PRIMARY SOURCE *document*

AN OFFENSIVE COMEDY

INTRODUCTION: The great French dramatist Molière's comedy *Tartuffe* caused a furor when it first appeared in 1664 because of its mockery of clerical hypocrisy. The French clergy responded quickly by suppressing its performances. The following speech from a main character in the play, Cleante, is a biting example of what so offended the religious establishment.

I'm not the sole expounder of the doctrine,
And wisdom shall not die with me, good brother
But this I know, though it be all my knowledge,
That there's a difference 'twixt false and true.
And as I find no kind of hero more
To be admired than men of true religion,
Nothing more noble or more beautiful
Than is the holy zeal of true devoutness;
Just so I think there's naught more odious
Than whited sepulchres of outward unction,
Those bare-faced charlatans, those hireling zealots,
Whose sacrilegious, treacherous pretence
Deceives at will, and with impunity
Makes mockery of all that men hold sacred;
Men who, enslaved to selfish interests,
Make trade and merchandise of godliness,
And try to purchase influence and office
With false eye-rollings and affected raptures;
Those men, I say, who with uncommon zeal
Seek their own fortunes on the road to heaven;
Who, skilled in prayer, have always much to ask,
And live at court to preach retirement;
Who reconcile religion with their vices,
Are quick to anger, vengeful, faithless, tricky,
And, to destroy a man, will have the boldness

To call their private grudge the cause of heaven;
All the more dangerous, since in their anger
They use against us weapons men revere,
And since they make the world applaud their passion,
And seek to stab us with a sacred sword.
There are too many of this canting kind.
Still, the sincere are easy to distinguish;
And many splendid patterns may be found,
In our own time, before our very eyes.
Look at Ariston, Periandre, Oronte,
Alcidamas, Clitandre, and Polydore;
No one denies their claim to true religion;
Yet they're no braggadocios of virtue,
They do not make insufferable display,
And their religion's human, tractable;
They are not always judging all our actions,
They'd think such judgment savoured of presumption;
And, leaving pride of words to other men,
'Tis by their deeds alone they censure ours.
Evil appearances find little credit
With them; they even incline to think the best
Of others. No caballers, no intriguers,
They mind the business of their own right living.
They don't attack a sinner tooth and nail,
For sin's the only object of their hatred;
Nor are they over-zealous to attempt
Far more in heaven's behalf than heaven would have 'em.
That is my kind of man, that is true living,
That is the pattern we should set ourselves.
Your fellow was not fashioned on this model;
You're quite sincere in boasting of his zeal;
But you're deceived, I think, by false pretences.

SOURCE: Jean-Baptiste Molière, *Tartuffe, or The Hypocrite.* Trans. Curtis Hidden Page (New York: G. P. Putnam's Sons, 1908): 28–29.

of Austria died, and Paris's theaters were closed for more than two months as a time of national mourning. To make up for this great loss in revenue, Molière wrote five new works for his company to be performed after the playhouses reopened, even though he himself was in failing health. This tremendous output continued even though the author was also called upon to write a number of other entertainments for the royal course. The quality of these later works remained high, despite his health, but on 14 February 1673, Molière finally collapsed on stage while acting in one of his own plays. He died soon afterward. Because his death came so suddenly, the playwright and actor had not been able to take the Last Rites of the church. Thus he was unable to repent of the sinfulness that was believed to be inherent in the

profession of acting. As a result he was buried without fanfare, and in the months that followed his troupe struggled to survive. Eventually, it merged with the company that performed in the Théâtre Marais to become the Théâtre Guénégaud; in 1680, this group merged again with the troupe that continued to perform at the Hôtel de Bourgogne to form the Comédie-Française, which was the only surviving theatrical troupe in Paris performing French-language productions at the end of the seventeenth century. While the Comédie-Française survived and still exists as the oldest national theater in Europe, the merger of the various troupes that had performed in the city in the years between 1630 and 1680 points to a decline in the popularity of drama as an entertainment at this time. In the years after 1680

Louis XIV fell increasingly under the influence of his second wife, Madame de Maintenon, who nourished his piety, and he gave up his former taste for dramatic entertainments. In these years, the king became involved in a series of costly international wars as well, and was unable to maintain the lavish standards of royal patronage in the theater. The court in these years began to favor the opera rather than the drama. With the deaths of Molière in 1673 and Corneille in 1684 as well as Racine's premature retirement, no figure of similar genius appeared in Paris to continue the great experiments in drama these writers had nourished in earlier years.

SOURCES

David R. Clark, *Pierre Corneille: Poetics and Political Drama under Louis XIII* (Cambridge, England: Cambridge University Press, 1992).

George McCarthy, *The Theatres of Molière* (New York: Routledge, 2002).

Jacques Schérer, *Le théâtre de Corneille* (Paris: Nizet, 1984).

P. J. Yarrow, *Racine* (Totowa, N.J.: Rowman and Littlefield, 1978).

THEATER AND STAGECRAFT IN ITALY

INNOVATIONS OF THE LATE RENAISSANCE. The theatrical traditions of Italy had long played a role in shaping developments in theater far beyond the borders of the country. During the fifteenth and sixteenth centuries, Italian humanists had studied the dramatic literature and theater of Antiquity. In time, their efforts produced a great flowering of contemporary play writing in Italy, as writers as diverse as Niccolò Machiavelli and Torquato Tasso relied on ancient dramatic canons to shape their sixteenth-century dramas. A taste for comedies written in the style of the ancient Roman writers Plautus and Terence developed in the sophisticated courts of the peninsula, giving rise to new attempts to understand ancient theater in all its complexity. As the sixteenth century progressed, scholars and playwrights turned to tragedy and to the study of the pronouncement of Aristotle and other philosophers on aesthetics. There were few production values in many of these first attempts to revive ancient theater, and actors often performed before the barest of backdrops that merely suggested a place. Over time, painted scenery—often designed by accomplished artists—replaced these rudimentary elements, and as the sixteenth century progressed, architects and scholars became more concerned with recreating the look and feel of ancient theaters. The most famous of these efforts was Andrea Palladio's design for the Teatro Olimpico in Vicenza in northern Italy, a theater that still stands today. Palladio and his disciple, Vincenzo Scamozzi who eventually completed the project, created a structure that in many ways seems familiar to modern viewers, although the scenery with which the stage is outfitted was permanent and not moveable. It consisted of a two-story gallery, punctuated with doorways and archways. To the rear of this structure, street scenes were recreated in perspective so that the entire structure seems to recede to a vanishing point at the horizon. The ingenuity of this concept continued throughout the designs for the auditorium, where Palladio arranged curved, stepped-up bleachers in an ellipse around the stage, thus making it possible for all those in the audience to have at least a partial view of the action that was occurring before them. Palladio and Scamozzi's theater was completed in 1585, and it soon touched off a number of other experiments to find the perfect venue in which to perform the spectacles, dramas, operas, and ballets that were common entertainments in Italy's court. Of the many theaters constructed at this time, the one that had the broadest influence throughout Europe was the Teatro Farnese, a private theater constructed for the influential Farnese family in a palace outside the city of Parma in northern Italy during 1618–1619. Like the Teatro Olimpico, the Farnese had a proscenium arch stage, but one that now allowed for scene changes. The auditorium was also amazingly versatile, in part because a large arena separated the stage from the bleachers where the audience sat. This arena, which was similar to the orchestra level of many modern theaters, could be flooded to a level of two feet or, when dry, it served as a large stage for ballets, equestrian shows, balls, and diplomatic receptions. Because of its ability to be used in a variety of ways, many elements of the Farnese's design were duplicated in the court theaters that kings and princes constructed throughout Europe in the seventeenth century. The multiple uses of the orchestra-level floor was one particularly appealing feature of the Farnese's design, since throughout the seventeenth and eighteenth centuries court theaters continued to be used for ballets, balls, and other artistic productions in addition to their roles as venues for drama and opera.

A TASTE FOR SPECTACLE. The urbane and sophisticated court culture of the late Renaissance and early Baroque periods included a penchant for elaborate spectacles that glorified local princes and their dynasties. Throughout the sixteenth century the splendor of these events steadily grew, as Italy's noble houses competed against each other to mount ever more imposing testimonies to their wealth and prestige. Around 1500, ma-

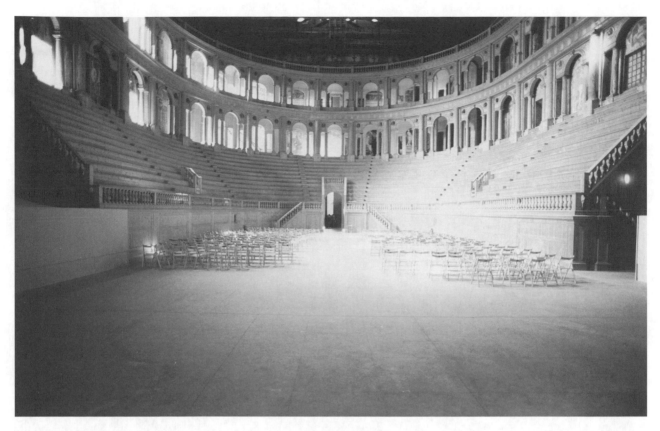

Interior of the Teatro Farnese in Parma, Italy. © RUGGERO VANNI/CORBIS.

jor architects and artists such as Leonardo da Vinci, Raphael Sanzio, Donato Bramante, and Michelangelo Buonarroti were already being commissioned to design scenery, costumes, and stage machinery for use in these festivities. Italy continued to provide Europe with a wealth of innovations in stagecraft throughout the Baroque period, and designers who had learned their craft in the peninsula's court theaters became a prized commodity in theaters throughout Europe until the end of the eighteenth century. Giacomo Torelli and the members of the Bibiena family were among the most prominent of the many accomplished production designers Italy produced, and the designs of these figures shaped tastes from Paris to Moscow. Giacomo Torelli (1608–1678) was a Venetian who began his career as a designer of theaters in that city before he devoted himself to solving problems of scenery changes. The designer pioneered a mechanism by which the scenery might be changed in a single operation. He attached the backdrops of his productions to rails that ran under the stage with a set of ropes and hung these drops from poles running above the stage. With the turn of a mechanism backstage, the entire set was quickly taken away and replaced by another. Until this innovation, the backdrops that had been used in the theater had merely suggested a time

and place in which the action was to have taken place. With the new method, scenes could be changed quickly and relatively effortlessly, and in the productions that Torelli designed after his innovation, he defined more precisely the places in which the play's action occurred. His productions thus fed a new taste for realism that was growing in the Italian theater and throughout Europe generally at the end of the seventeenth century.

THE BIBIENA FAMILY. This group of amazingly fertile artists became a dynasty of stage designers that influenced tastes in theatrical productions everywhere in eighteenth-century Europe. The family's rise to prominence began with Fernando Bibiena (1657–1743), who was the son of a painter from the city of Bologna. Fernando trained as an architect and painter before being appointed as a court artist in the ducal court at Parma. There he developed into a theatrical designer, relying on his knowledge of illusionistic painting to create sets that appeared more real than those that had previously been popular. Until this time, the backdrops used in most stage productions had sight lines that converged to a single vanishing point to simulate the recession of the horizon. Those who designed these scenic backdrops for court theaters were expected to take into account the

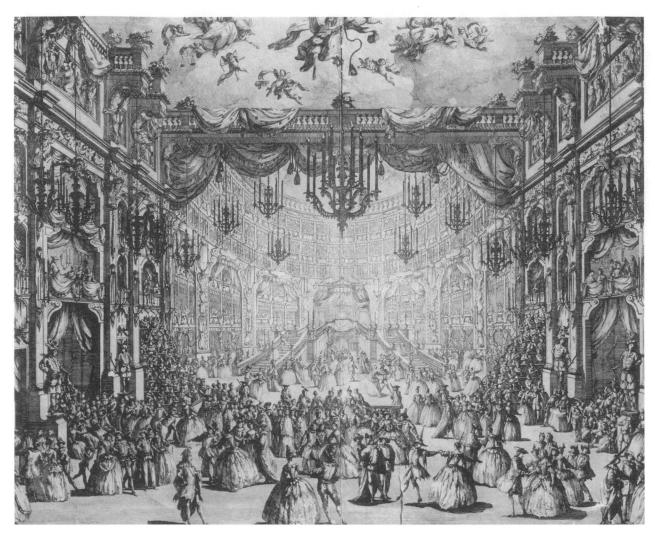

Stage design by Bibiena for an eighteenth-century ball. THE ART ARCHIVE/BIBLIOTECA COMUNALE IESI/DAGLI ORTI.

precise place in which the reigning prince sat in the auditorium, so that from his vantage point, the scenery appeared pleasing and correct to his eyes. Such techniques were commonly used in designs not only for the theater, but in Baroque garden and palace architecture as well. Fernando Bibiena, however, did away with such conventions, and instead relied upon his skills as an illusionistic painter to create spaces that appeared real to spectators on both sides of the theater, rather than just from the center. This innovation known as "scenes from angles" (*scena per angola*) made use of two horizontal vanishing points on both sides of the stage backdrop rather than in the center as designers had previously done. Fernando received aid in his efforts from several of his brothers, and a number of his sons carried on this tradition well into the eighteenth century in court theaters throughout the continent. Bibiena's sons, in particular, developed sumptuous production values, very

often staging scores of operas. As their fame spread and they received commissions and distinguished appointments throughout Europe, their designs were avidly imitated even in places where they never worked.

COMMEDIA DELL'ARTE. During the seventeenth century the sudden and meteoric rise of the opera in many Italian courts and cities threatened to eclipse the popularity of all other forms of theater. While spoken plays continued to be written and performed, it was the new musical dramas, with their complex and acrobatic ballets and other interludes, that attracted the greatest noble patronage throughout Italy. In some centers, notably Rome, plays continued to be performed alongside the new operas. But in the great developing centers of opera—cities like Venice, Milan, and Naples—opera dominated the theater. One older form of comedy inherited from the late Renaissance, the commedia dell'arte, still managed to sustain its popularity against the

sudden rise of the opera. The commedia's forms had largely been fixed by the end of the sixteenth century. These productions made use of a stock cast of characters that included a Venetian merchant, a Bolognese lawyer, two elderly men, one or several pairs of lovers, a retinue of servants, and four masked characters. Other conventions governed the commedia's performance. The lovers, for instance, always spoke in the distinguished Tuscan dialect—the language spoken in and around the city of Florence—while the servants spoke rougher colloquial Italian dialects drawn from less distinguished regions. The commedia had originally developed from the street and traveling troupes that were common in late Renaissance Italy, but even by the late sixteenth century the art form had already acquired a broad audience. Commedia troupes, for instance, performed at noble weddings, and they frequently provided entertainment at court. During the seventeenth century more than 35 of the troupes performed throughout the peninsula, and these numbers steadily mounted in the early eighteenth century. The commedia also spread far beyond Italy, and its influence was particularly vigorous in seventeenth-century France, where its conventions affected the comic writing of Molière and gave birth to the Comèdie-Italienne, a troupe of comic performers that staged works in its traditions. The commedia was by and large an improvised art form that nevertheless had specific characters that needed to be recreated anew in each performance. By the mid-eighteenth century commentators on the art criticized the commedia's decline into mere slapstick humor and its overt physicality and violence as a departure from the medium's early intentions. In 1750, the Italian dramatist and librettist Carlo Goldoni (1707–1793) announced his intention to reform the commedia dell'arte when he published a collection of sixteenth-century comedies at Venice. Goldoni relied on many of the conventions of the by-now well-established art, but at the same time he attempted to mold its comedy into a new form that was more credible and realistic. In place of the formerly improved art form, though, the new genre that he fashioned was a literary art form, with its plays being written down and performed from a text. His example of a comic theater that was based in real-life situations was immediately popular and produced a spate of similar comedies in Venice and eventually throughout Italy in the mid- and later eighteenth century.

SOURCES

Per Bjurström, *Giacomo Torelli and Baroque Stage Design* (Stockholm: Almquist and Wiksell, 1962).

Christopher Cairns, ed., *The Renaissance Theatre: Texts, Performance, Design* (Aledershot, England: Ashgate, 1999).

Deanna Lenzi, et al, eds., *I Bibiena: una Famiglia Europea* (Venice: Marsilio, 2000).

A. Hyatt Mayor, *The Bibiena Family* (New York: H. Bittner, 1945).

RESTORATION DRAMA IN ENGLAND

DRAMA DURING THE PURITAN COMMONWEALTH.

Despite a decree of the Parliament in 1642 that outlawed dramatic performances, the stage did not completely disappear from English life during the English Civil Wars and the subsequent Commonwealth. In the years between 1640 and 1660, English Puritans tried to refashion many elements of English life, government, and politics. Since the time of Queen Elizabeth I, the Puritans had battled against the theater, and the movement's most outspoken critics of the stage had long judged London's playhouses to be haunts of Satan. Puritan opposition to the theater arose, in part, from an astute understanding of the role that the medieval church had played in the development of drama, and the many figures that attacked the theater in the period realized that the custom of staging plays had arisen from the mystery and morality plays that had been common in the country before the rise of the Reformation. At the same time, Puritans shared an abiding distrust for all ritualized and theatrical displays, and they believed that evil lay at the heart of the pomp and magnificence of the stage as well as in the elaborate rituals of kingship and the Church of England. But while the parliamentary ordinances enacted in 1642 against the theater were clear, several loopholes in the law still allowed some minor forms of drama to flourish. During the period of the Puritan Commonwealth (1649–1660), it became a common custom for England's great noble families—many of whom had sided with the royalist cause—to stage plays and operas in their homes. Some of these productions were actually staged by professionals and performed for paying audiences. Short dramas, too, were sometimes performed furtively at fairs or in small towns on holidays; and the rise of drolls or traveling wits that toured the country entertaining crowds with short skits was yet another way in which theater survived in England during the 1650s. In the country's great public schools, institutions that had served to educate sons of nobles and gentlemen since the later Middle Ages, dramas continued to be used, as they were in Catholic Europe, to teach Latin and Greek as well as to expose students to ancient rhetoric and style. At the same time, while regulations against the theater were sometimes ignored, circumvented, or relaxed by the government during the Puritan period, the age was

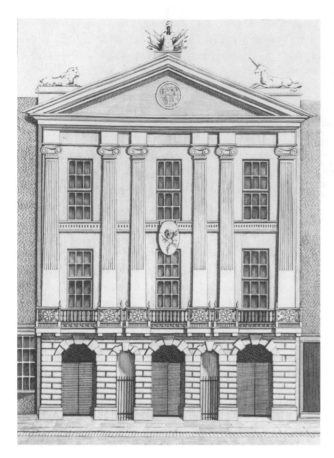

The exterior of the Drury Lane Theater, London. MARY EVANS PICTURE LIBRARY.

nevertheless a definitive break from the vigorous tradition of public drama that had flourished in England since the last quarter of the sixteenth century. Elizabeth I, James I, and Charles I had each thrown their support squarely behind the theater and had opposed Puritan efforts to rid the country of drama. As a result, most of London's actors, playwrights, and theater owners had been royalist supporters during the Civil War, and when their side was defeated, many were consequently forced into exile. Many of those who stayed in England took up other occupations. Very few who were active on the London stage in the years before 1642 lived to see the Restoration of the monarchy and the revival of the theater after 1660. Thus when Charles II returned to assume the throne in that year and permitted theatrical performances, the London theater by and large had to be created anew.

THE NEW THEATRES. During his exile from England, Charles I had been a guest of the royal court of France, and thus he had witnessed firsthand the cultivated courtly entertainments that were common in Paris at the time. One of his first measures upon returning to England was to license two acting troupes. The first became known as the King's Men and was directed by Sir Thomas Killigrew (1612–1683). Killigrew was a member of a royalist family from Cornwall, and had grown up in the court of Charles I. In the king's service he had played something of the role of a court wit and had published two tragicomedies before the closure of London's theaters. When the English Civil Wars had driven the Stuarts from England, Killigrew had remained loyal to the Stuart prince Charles and had followed him into exile. Charles granted the second license for a dramatic company to Sir William Davenant (1606–1668), a supporter who had received permission to found a theater shortly before the 1642 parliamentary measures that abolished the stage in London. Davenant had a colorful life. He may have been the godson of William Shakespeare, although court gossip in the seventeenth century sometimes alleged that he was the great playwright's illegitimate child. During the Civil Wars Davenant had served King Charles I by running supply ships from the continent to England, and in 1649, the king's widow had sent him on a mission to Maryland, expecting him to serve as governor. His ship was intercepted by Puritan forces, and he was imprisoned for five years. Shortly after his release he secured permission from Oliver Cromwell's Puritan government to stage a production of an early opera in the private home of an English noble. The performances were mounted before a paying audience, and thus circumvented Parliament's prohibitions against theatrical performances. When Charles II granted Davenant a license to start a theater, controversy soon erupted among other contenders for the honor. Sir William Herbert, another contender, sued in London's courts, charging that Davenant had been a Puritan sympathizer, and that he had used his influence with Oliver Cromwell's government to circumvent Puritan regulations against the stage. Despite these challenges, Charles' decision was upheld, and Davenant's company became known as the "Duke of York's Men." Killigrew and Davenant were both aware of the advantages that a smaller, French-styled theater offered, and so they established their theaters, not in the large outdoor arenas that had been popular in London at the turn of the seventeenth century, but in smaller more intimate settings. Like the Parisian theaters of the period, both Killigrew and Davenant initially converted indoor tennis courts into playhouses, before building new structures in which to perform. In 1663, Killigrew's company moved to a new theater specially constructed in Drury Lane near Covent Garden. Although this structure was eventually destroyed and replaced by several later structures, a theater still stands on the same spot in London today. Dav-

a PRIMARY SOURCE *document*

TENSE MOMENTS AT THE THEATER

INTRODUCTION: The English diarist Samuel Pepys (1633–1703) left one of the great records of life in the Restoration age. He attended the theater almost daily and recorded his thoughts about almost every play performed in London during the 1660s. In the entry he goes about his business during the day, attends the theater, and then goes back to work in the evening—a fairly typical pattern. The present entry from 20 February 1668, is notable because he remarks how that evening's play was intended to criticize the immorality of King Charles II, who was in attendance. Charles II, though, was fairly tolerant, and what might have caused the government to close a theater in an earlier period was now allowed to proceed relatively unhindered. It is interesting to note that Pepys refers to Nell (Nell Gwyn) speaking the prologue of the offending play, *The Duke of Lerma*. She herself was soon to become one of the king's mistresses.

Up, and to the office a while, and thence to White Hall by coach with Mr. Batelier with me, whom I took up in the street. I thence by water to Westminster Hall, and there with Lord Brouncker, Sir T. Harvy, Sir J. Minnes, did wait all the morning to speak to members about our business, thinking our business of tickets would come before the House to-day, but we did alter our minds about the petition to the House, sending in the paper to them. But the truth is we were in a great hurry, but it fell out that they were most of the morning upon the business of not prosecuting the first victory; which they have voted one of the greatest miscarriages of the whole war, though they cannot lay the fault anywhere yet, because Harman is not come home. This kept them all the morning, which I was glad of. So down to the Hall, where my wife by agreement stayed for me at Mrs. Michell's, and there was Mercer and the girl, and I took them to Wilkinson's the cook's in King Street (where I find the master of the house hath been dead for some time), and there dined, and thence by one o'clock to the King's house: a new play, "The Duke of Lerma," of Sir Robert Howard's: where the King and Court was; and Knepp and Nell spoke the prologue most excellently, especially Knepp, who spoke beyond any creature I ever heard. The play designed to reproach our King with his mistresses, that I was troubled for it, and expected it should be interrupted; but it ended all well, which salved all. The play a well-writ and good play, only its design I did not like of reproaching the King, but altogether a very good and most serious play. Thence home, and there a little to the office, and so home to supper, where Mercer with us, and sang, and then to bed.

SOURCE: Samuel Pepys, *The Diary of Samuel Pepys.* Vol. 2. Ed. Henry B. Wheatley (London: G. Bell and Sons, 1896): 330–331.

enant's company, the Duke's Men, moved from facility to facility throughout the 1660s, but by 1673 they had taken up residence in a theater designed for them in Dorset Gardens by the great architect Sir Christopher Wren. Both houses seem to have combined some of the latest French innovations in the theater with older English traditions. Although the stages were framed with a proscenium arch in the manner of Continental theaters, the stages curved and jutted outward so that players might act in close proximity to the audiences, as they had done in Elizabethan times. Changeable scenery was used, although each company had a relatively small supply of sets that suggested interiors and exteriors. Productions, in other words, were not designed anew, but relied on sets taken from the company's repertory of stock sets.

CHANGING TASTES. Despite the Restoration of the monarchy Puritan sentiments continued to flourish in late seventeenth-century London, and the theater consequently retained an "air of the forbidden" for many in the capital. The period's audience, while large, was drawn from more elite and cultivated circles than in Eliz-abethan or early Stuart times. In the first few years many of London's productions were adapted from earlier Tudor and Stuart plays, but soon the Restoration stage acquired its own stock of playwrights. While every genre of dramatic writing—from tragedy and history plays to glittering comedies—had flourished in the era of Shakespeare and Jonson, Restoration playwrights most often satisfied their cultivated and witty patrons with a long succession of satirical comedies of manners. This new genre made use of gossip, witty conversation, double entendre, and sardonic wit to mock the foibles and short-comings of all classes of English men and women, but it especially focused on the problems of high society. Molière was one very great influence on the comedy of manners, although the English genre outdid the French comedy of the time with its overt sexual humor. And like the moral ambiguity that lay at the heart of many of the works of Molière, many English playwrights of the time were unconcerned with drawing moralistic lessons from the events around which they based their comedies. George Etherege (c. 1635–c. 1692) helped to establish the conventions of comedy of manners with his 1664 production of *The Comical Revenge, or Love in a*

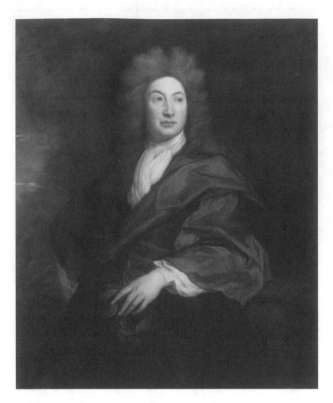

Portrait of John Dryden (1693) by Sir Godfrey Kneller. **NATIONAL POTRAIT GALLERY, LONDON.**

court produced. In 1680, he renounced his life of pleasure when he fell under the spell of the Puritan Countess of Drogheda, and the couple married. The countess soon died, however, and a dispute over her will left Wycherley penniless. King James II eventually rescued him from debtor's prison, awarding him a lifelong pension. By the time he died in 1716, he had reverted to Roman Catholicism once again.

JOHN DRYDEN. While he wrote brilliant comedies of manners, the greatest playwright of the period, John Dryden (1631–1700), is today best remembered for his tragedies, a type of play that was relatively undeveloped by Restoration dramatists. Dryden's family had sided with Parliament in the struggles against King Charles I, and in his early life, the future playwright attended the prominent Westminster School before obtaining a Bachelor of Arts from Trinity College in Cambridge. His first play, *The Wild Gallant,* was produced in 1663, and although it was notable for its bawdy language, it was not a great success. The following year he participated with Sir Robert Howard in writing the tragedy *The Indian Queen,* but it was not until he wrote a sequel to this play, *The Indian Emperour* (1665), that he scored his first definitive hit. Other successes followed, and by 1668 Thomas Killigrew retained the author to write plays to be performed solely by his company, the King's Men. The works he produced in these first years working with the King's Men were mostly comic farces and burlesques that featured a central hero's trials and tribulations set in exotic locales and filled with much blustering, onstage fighting, and larger-than-life antics. In 1672, he began to move away from this genre of heroic plays with his lively and witty comedy *Marriage a la Mode,* an urbane work in the comedy of manners vein. Perhaps his greatest achievement of these first years in the theater, though, was his tragedy, *All For Love* (1677), a play based on William Shakespeare's *Antony and Cleopatra,* which Dryden wrote in unrhymed or blank verse. In the following year the author severed his long-standing association with the "King's Men," which had fallen on hard times as a result of poor management, and he offered his services to their competitors, the "Duke of York's Men." During the 1680s the author concentrated more and more on his poetry, even as he also became embroiled in political controversy. A key issue of these years revolved around the question of the royal succession. Charles II's brother James was a Catholic, who supported greater religious toleration, not only for Roman Catholics, but for all dissenters generally. Although he stood in line to inherit the throne, an increasingly vocal faction in Parliament known as the Whigs favored the

Tub, which treated the exploits of the man of society Sir Frederick Frollick. At this point Etherege's dramas drew their style from older traditions, relying on verse rather than prose in their dialogue. In his *She Would, if She Could* (1668), Etherege jettisoned the traditional verse and instead adopted a more naturalistic prose style, something that he perfected in his last work, *The Man of Mode, or Sir Fopling Flutter* (1676). For these efforts the king knighted him in 1680. Like many of the Restoration dramatists, Etherege was a brilliant amateur. The writing of plays, in other words, was only one of many pastimes and avocations for this man of letters, who also served as an ambassador for the king. William Wycherley (1640–1716) was another figure who, like many of England's late seventeenth- and early eighteenth-century dramatists, combined a life of pleasure and educated pastimes with writing for the stage. Wycherley vacillated throughout his life between Roman Catholicism, Anglicanism, and Puritanism. While he was being educated in France as a young man, he converted to Roman Catholicism, but fell under Puritan influence when he returned to England. He came to the attention of Charles II's court, and he took up a life as a wit in its circles, writing a succession of plays that mocked the hypocrisy and foibles of aristocratic society. These works reveal the internal tensions that Wycherley's accommodation to

king's bastard son, the Duke of Monmouth. For his part in defending the opposing Tory party's views, Charles II named Dryden poet laureate, but when James did succeed to the throne and was soon forced into exile, Dryden lost the position to his Whig opponent, the playwright and poet Thomas Shadwell. Deprived of the income his royal pension provided, the poet returned to the theater in the final years of his life. His plays alternately succeeded and failed, and he began to write the dramatic librettos for some of Henry Purcell's operas in these years, too. At this time in his life, Dryden continued to write literary criticism and to translate classical works into English. When he died in 1700, he was considered the grand old man of English letters and he was buried in Westminster Abbey. Unlike many of the literary figures of the late seventeenth century, Dryden's reputation has consistently remained high over the centuries, and his works—although not of the high literary caliber of Shakespeare or Jonson—have continued to be studied, while the efforts of other Restoration dramatists have fallen in and out of favor or largely been ignored by subsequent generations.

WOMEN AND THE RESTORATION THEATRE. While the quality of many Restoration dramatists continues to be debated, the theater of this era was innovative in allowing women roles as actresses, stage managers, and playwrights. Charles II's reestablishment of the theater in the years after 1660 lifted the traditional bans against female performers, and in the years after 1660 the first female actresses began to attract considerable attention on the London scene. The great Nell Gwyn (1650–1687) was among the first to leave her mark on the English stage. Born the daughter of a bankrupt father and a mother who was a madam, Gwyn grew up tending bar in her mother's establishment. Later she sold oranges in the theater and became the lover of a prominent actor, which paved the way for her debut in 1665. During the years that followed, Gwyn reigned as the supreme actress of the Drury Lane Theater, notable for her abilities in comic roles. By 1669 she had come to the attention of Charles II and she soon became his mistress. The king provided well for Nell. She retired from the stage and lived in an elegant house Charles provided. Known for her extravagance, she played a key role at court by virtue of the elaborate parties she held. When the king died in 1685, Gwyn was heavily indebted, but Charles's brother James II settled her obligations and awarded her the enormous pension of £1,500 a year. She did not have long to enjoy her newfound stability. Apparently the victim of a stroke, she died in 1687. Her career was extraordinary among the women who made their way into

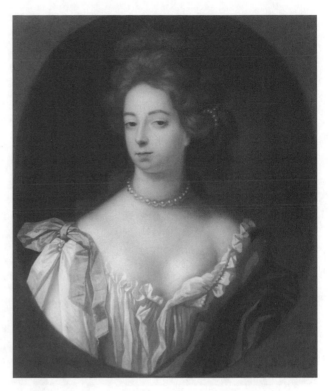

Portrait of Nell Gwyn (c. 1670) by Simon Verelst. **NATIONAL PORTRAIT GALLERY, LONDON.**

the theater in the later seventeenth century, and did much to earn the reputation that actresses were little more than prostitutes and courtesans. Gwyn's chief allure on the stage had consisted in her physical attributes as well as her sense of comic timing, but her actual dramatic career had been quite brief. Elizabeth Barry, who was the ward of the troupe director William Davenant, made her debut on the London stage in the late 1670s and continued to perform there until 1707. She was said to be a highly dramatic actress, widely admired for her tragic roles. Through her association with Davenant, she met John Wilmot, the Earl of Rochester, and the two were lovers for many years. The notoriety these famous women attracted helped to fix the dubious reputation that actresses had in the minds of many at the time, but not every woman connected with the theater moved in such illustrious and rarefied circles. In her youth Anne Bracegirdle (1671–1748) had been the ward of the actor and theatrical manager Thomas Betterton, who taught her acting and put her in his productions when she was only six years old. William Congreve and Nicholas Rowe wrote parts especially for her, and she probably secretly married Congreve. Widely admired for her piety and virtuous character, Bracegirdle, like Barry, retired in 1707, although she lived for an additional forty years. After her death in 1748 she was buried

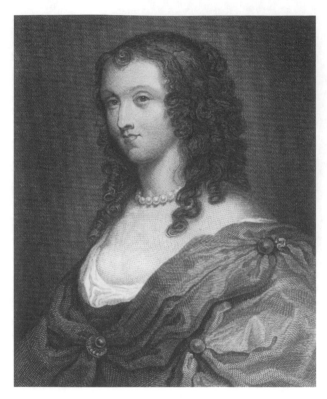

Engraving of Aphra Behn, the first professional woman playwright in seventeenth-century England. © MICHAEL NICHOLSON/CORBIS.

in Westminster Abbey, a testimony to the high regard in which she continued to be held. Barry and Bracegirdle's retirement from the stage prepared the way for Anne Oldfield (1683–1730) to reign supreme as the queen of London's theaters.

FEMALE PLAYWRIGHTS AND STAGE MANAGERS. Women participated in the late seventeenth- and eighteenth-century theater in London as playwrights and stage managers as well. During the 1670s and 1680s Aphra Behn (1640–1689) entertained audiences in the capital with a string of witty comedies of manners, thus becoming the first English-speaking woman to earn her livelihood by writing. Behn's life had all the components of high drama. Born in the countryside in Kent in southeast England, she traveled as a teenager to the Caribbean where she lived for a time in Dutch Guiana. This environment may have fostered her distaste for the commercial Dutch that peppers her later writing. She was apparently forced into an arranged and unhappy marriage from which her husband's death soon freed her. Coming to the attention of the royal court because of her intelligence and humor, Charles II entrusted her with the task of spying in the Netherlands. She was imprisoned for debts for a time when she returned to England,

and thus turned to writing to support herself. Her first play, *The Forced Marriage,* was a drama that attacked the conventions of arranged marriage. She followed this play with other serious works, but then turned to comedy. She scored a great success with *The Rover,* a two-part play staged in 1677 and 1681. The play still ranks as one of her most important contributions, although her fiction, including the colonial novel *Oroonoko,* tends to be more widely admired than her plays. She nevertheless established herself on the London stage as a powerful force. At the same time, her unconventional career subjected her to a great deal of criticism, and scandal circulated around her private life. Her career prepared the way for at least two other female dramatists—Susanna Centlivre (1667–1723) and Charlotte Charke (1713–c. 1760)—to follow her example in the eighteenth century. Both women were actresses who eventually turned to play writing, while Behn herself never performed on the stage. Nineteen works survive from Susanna Centlivre, mostly from the first two decades of the eighteenth century, but the author may have written a number of works far earlier under the pen name S. Carroll. Although her career has largely been forgotten today and her works did not rank as great art, they do nevertheless display a broad reading in French and Spanish theatrical traditions as well as those of the English masters. Charlotte Charke, by contrast, only wrote three plays during her tumultuous and scandal-ridden life, but she left behind a memoir of her time in the English theater, *A Narrative of the Life of Mrs. Charlotte Charke* (1755), that still makes for fascinating reading. The daughter of the accomplished actor and stage manager Colley Cibber, Charke's strong personality and unconventional behavior alienated her from her family. When her theatrical career soured, she took to dressing in male clothing and to working in men's professions. Eventually, she took up with another woman and the two traveled together as husband and wife, with Charke imitating the man. The careers of those women who served as stage managers in late seventeenth- and eighteenth-century England were more conventional than Charke's. Most gained a role in the theater through their husbands. Lady Henrietta Maria Davenant, the wife of the troupe manager and actor William Davenant, assumed control of her husband's troupe, the Duke's Men, following his death in 1668, eventually leading to successes and merging it with the failing King's Men, the other major London troupe of the day. This newly formed company worked under the direction of the actor Thomas Betterton (1635–1710), who had married the successful actress Mary Saunderson (d. 1712). Together the Bettertons shaped tastes in the London theater, and they also trained many promi-

nent actors and actresses, including the important actress Anne Bracegirdle.

SCOPE OF THE RESTORATION THEATER. Although the re-establishment of the English monarchy resulted in a great revival of the theater in later seventeenth-century London, the scale of the Restoration theater was by any standard far more modest than the great age of William Shakespeare and Ben Jonson that had preceded it. Audiences, although present in the Restoration playhouses, had shrunk, due in large part to the influence of Puritanism and other radical religious teachings that attacked the theater. These groups continued to have plenty of fodder for their criticisms in the amoral and often bawdy productions that were mounted in London under the reign of the later Stuart monarchs Charles II and James II. Nevertheless, royal favor was strongly behind the theater, although the receipts of the two London troupes, the Duke's Men and the King's Men, seem to have dwindled during the 1680s. Eventually, the King's Men was threatened with bankruptcy, and the two troupes concluded a merger and set up residence in the Drury Lane Theater in Covent Garden. Thus for a time, only one theater entertained London's audiences, a sign of the relatively limited appeal that many of the theatrical productions had in late seventeenth-century London. Where a vibrant popular theatrical tradition had flourished in Elizabethan and early Stuart England, the theater now served to entertain the sons of aristocrats and their stylish circles. The theater continued to cause controversy, and in the minds of many English men and women the Stuarts' support of the institution was consonant with their Catholic sympathies. When James II was forced into exile in 1688, tastes in the capital began to change rather quickly. The following year Parliament called the Dutch king William of Orange and his wife Queen Mary, who was James II's daughter, to assume the English throne, thus cementing the Whig party's control over the monarchy, an event that has long been referred to as England's Glorious Revolution. While William and Mary did not close London's theaters, they were less tolerant and permissive of the kind of bawdy humor and license that had prevailed under the later Stuarts. Thus as the eighteenth century approached, new standards that were more overtly moralistic governed taste on the London stage, and these mores left their imprint on the drama of the time.

SOURCES

Deborah Payne Fisk, ed., *The Cambridge Companion to English Restoration Theatre* (Cambridge, England: Cambridge University Press, 2000).

Frederick M. Link, *Aphra Behn* (New York: Twayne Publishers, 1978).

Fidelis Morgan, *The Female Wits: Women Playwrights on the London Stage, 1660–1720* (London: Virago, 1981).

Margaret Sherwood, *Dryden's Dramatic Theory and Practice* (New York: Haskell, 1965).

Montague Summers, *Restoration Theatre* (New York: Humanities Press, 1964).

THE HANOVERIAN THEATER

DEATH OF DRYDEN. From the perspective of hindsight the death of John Dryden in London in 1700 has often been seen as marking a pivotal change in the course of the English theater. While the passing of this influential playwright certainly affected English theater, moods were changing in England even before the great Dryden's death. In 1698, for instance, the fiery preacher Jeremy Collier published a bitter critique of the English stage entitled *A Short View of the Immorality and Profaneness of the English Stage,* a work in which he indicted the convention of Restoration drama. Collier attacked the rough language, indecent situations, and sense of license that had flourished under the later Stuart kings, and in particular, he singled out the works of George Etherege, Thomas Wycherly, and John Dryden for some of his bitterest attacks. Certainly Restoration tastes did not disappear overnight, and plays of the kind that had been performed in England over the previous four decades were staged in London during the first decades of the eighteenth century. Yet, at the same time, the resurgence of old puritanical attitudes, evident in the attacks of Collier, influenced dramatic writers of the time. A new sense of restraint sometimes referred to by historians of drama as "neoclassicism" began to flourish alongside the works of Sir John Vanbrugh (1664–1726) and others who remained faithful to Restoration traditions. None of the writers of the early eighteenth century rose to the level of Dryden's mastery over the English language and over verse. The tendency for amateurs to write for the stage continued alongside a generation of playwrights that were also actors and troupe managers in the by-now established tradition of figures like Shakespeare and Jonson. John Vanbrugh, who survived until the end of the first quarter of the century, was a figure who continued in the mold of amateur playwrights that had developed in the Restoration period. A member of Stuart court circles, he was a wit who entertained aristocrats with his charming mastery of the English language. He was also a cultivated amateur who not only wrote sparkling bawdy comedies for the London stage, but also

served as an architect to the country's nobles. His most famous buildings established a taste in England for elaborate and imposing Baroque structures, and among his most famous works were the imposing domed Castle Howard built in Yorkshire and Blenheim Palace, just outside Oxford. At the other end of the spectrum, the early eighteenth century produced the figure of Colley Cibber, the son of an accomplished sculptor, who made his way into the theater as an actor at the Drury Lane Theater around 1690. When his income from this profession proved inadequate to support his family, Cibber began to write and produce plays. Cibber's *Love's Last Shift* marked an important shift in comedy away from the light and seemingly amoral fare that had flourished in the previous years. It helped to found the new genre of "sentimental comedies" that dominated the English stage over the next century. The tone of the work was moralistic in contrast to those of the Restoration period and, in the years that followed, Cibber exerted a powerful influence over the London theater.

IMPRESARIOS. The father of the incendiary transvestite Charlotte Charke, Cibber became one of three managers of the Drury Lane Theatre around 1710 and, following the death of Queen Anne in 1714, he began to write political plays that supported the Whig party. For these efforts he was named England's Poet Laureate in 1730. Arrogant and difficult, he became a lightning rod for criticism, but his life illustrates the rise of a type that was to be an increasingly common figure in the eighteenth-century theater: the impresario, that is the showman who exerted powerful influence on tastes by controlling what, when, and where plays, operas, and ballets were produced. These larger-than-life figures that dominated the eighteenth-century stage were common, not only in England, but everywhere in Europe. Many controlled all aspects of production, presiding over the theaters they managed with what now seems like an indomitable will and dictatorial spirit. Of the many actors and troupe managers who filled this role, David Garrick (1717–1779) was the most famous English example. The son of an army captain, he first rose to prominence on the London stage as an actor, performing first in unlicensed theaters in the city and then rising to debut at the esteemed Drury Lane Theater. Garrick's new style of acting favored realistic portrayal rather than the artificial and rhetorical style then in use by most actors. After touring Ireland and directing a theater there, he assumed control over the Drury Lane when the institution fell on hard times. His astute sense of what audiences wanted revived the theater, so much so that when Garrick sold his share in the venture he earned the

princely sum of £35,000 for his stake. Garrick's choice of plays to be performed at the Drury Lane relied on by-then classical works drawn from the English tradition as well as new sentimental comedies popular at the time. In addition, the actor's own portrayal of Shakespearean roles and his staging of the first "Shakespeare Festival" in the bard's hometown of Stratford-Upon-Avon helped to raise the reputation of the great dramatist to the level of admiration he has enjoyed since the eighteenth century. Never again were Shakespeare's works to fall in and out of favor, for Garrick's astute productions of the poet's works—although not completely historically or textually correct by modern standards—helped to establish an abiding affection for the dramatist's achievement. At the time, England was quickly emerging as the dominant commercial and trading power of the Western world, and Garrick's influence even spread to the country's colonies. Although he never visited India, the great manager prepared the prompt books of Richard Sheridan's popular play *School for Scandal,* which were carried to India and used in the first Western production in Calcutta. While widely admired, particularly in aristocratic circles, his career as a theatrical producer was not without its setbacks. Not every production he staged in his tenure at the Drury Lane—which lasted for almost three decades following his assumption of its management in 1747—was a success. But in the cumulative effects of his productions, he shaped the experience of a generation of London theatergoers.

RESTRICTIONS ON THE THEATER. In the mid-eighteenth century one controversy dampened the development of the theater in London. In 1736, Henry Fielding's play, *Historical Register, For the Year 1736*, was staged at the Haymarket Theatre in the city; like Thomas Middleton's *A Game At Chess* of the previous century, it caused a sensation because of Fielding's open mockery of the prime minister Robert Walpole. Walpole responded by pushing a new measure through Parliament known as Walpole's Licensing Act in 1737. Under this law, all new dramatic productions were required to be submitted to the government for approval before being performed. In addition, the act stipulated that no productions could be performed outside the two then-existing theaters. The act produced unexpected consequences. At first it drove competent, even brilliant authors like Henry Fielding from writing for the theater for a number of years, and many of these figures turned to writing novels and other fiction, rather than drama. Thus began the great age of the English novel to which Fielding himself and other luminaries like Samuel Richardson were to contribute. They followed in the

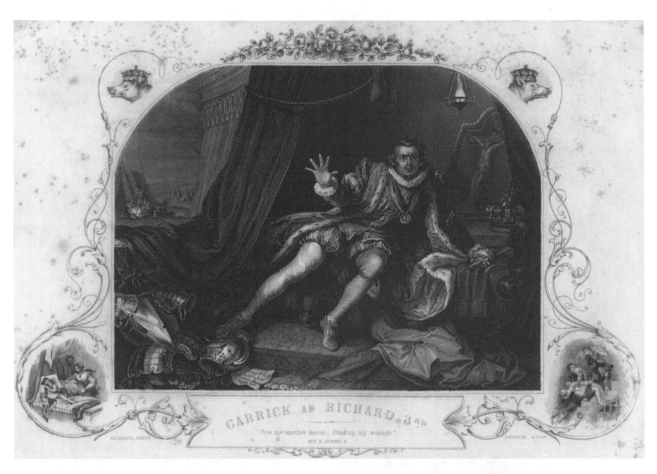

Print *David Garrick as Richard III* (1746) by William Hogarth. **MICHAEL NICHOLSON/CORBIS**.

paths that figures like Daniel Defoe and Jonathan Swift had already trod in the decades immediately preceding the passage of the Licensing Act. The publishing of novels, in fact, became a more profitable and a less risky venture than play writing since there was now no assurance that the government might license one's works to be performed. The government's restrictions aimed to limit the performances of drama to the two royally chartered theaters that existed in London at the time, but all sorts of ingenuous schemes developed to steer managers and actors around these requirements. Short dramas, skits, and other kinds of burlesques already popular in the capital at the time began to be performed in taverns and other ad hoc theaters. This music hall theater soon grew to be wildly popular, prompting the government to pass another measure directed at these institutions in 1751. The measures were ineffective since tavern owners merely formed private clubs with minimal admission requirements in order to entertain their clientele. Thus government measures actually helped speed the development of the English music hall, and by the nineteenth century there were hundreds of these institutions in the

capital. For a time in the mid-eighteenth century, though, government regulations did make it harder for serious actors to find work. As the two licensed theaters in London became the only outlet for drama, securing roles in dramatic plays became a far more difficult proposition for actors. At the same time, the crown was in these years actively chartering a number of theaters in the towns and cities in the British provinces, a development that provided work for London's actors, many of whom came to spend time, particularly in their early years, touring these cities. By the second half of the eighteenth century, working in a provincial company or touring with a traveling troupe had become a recognizable way for an actor to acquire the skills that were necessary to find role on the now more highly competitive London stage. Thus in an oblique way, the Licensing Act helped to raise the skills of those who performed in the city.

THE ACTOR AS STAR. If the quality of dramatic writing declined in the years immediately following Licensing Act, the damage that government regulation inflicted on the theater was neither permanent or long-

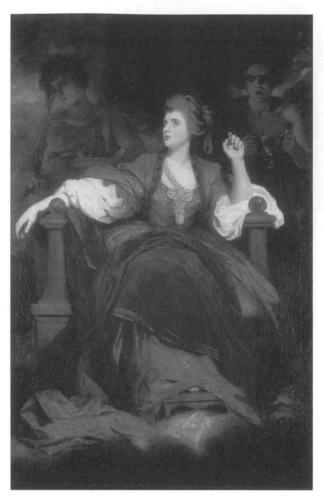

Sarah Siddons as the Tragic Music by Sir Joshua Reynolds.
© FRANCIS G. MAYER/CORBIS. REPRODUCED BY PERMISSION.

reer, although his personal life was far more turbulent than the gregarious Garrick. After an early career in the provinces, Macklin began to perform in London around 1725, and his career attracted great excitement over the coming decades. He played Shakespeare's famous character of Shylock in *The Merchant of Venice* with an altogether new twist. Instead of relying on the broad humor of the part, he transformed it into a tragic role. At the same time, Macklin's larger-than-life temper was always a problem. In 1735 he killed another actor when the two fought over a wig in the theater's Green Room. Although he was tried for manslaughter, he was never sentenced. For the rest of his life he was almost constantly involved in battles with other actors and legal cases, but his popularity as an actor was little diminished by these problems. By virtue of his incredibly long career, Macklin left an indelible imprint on the acting styles of the eighteenth century, but his success on the stage combined with his larger-than-life antics also garnered him celebrity status. Sarah Kemble Siddons (1755–1831), the greatest tragic actor of her generation, shared a similarly exalted position among the many competent, even accomplished performers of her time. The daughter of a theatrical family, she grew up touring the English provincial theaters and stepped onto the stage when she was just a child. When she threatened to marry another actor, her parents sent her off to become a servant in a noble household. They planned on her marrying a gentleman farmer, but Sarah eventually prevailed upon her parents and wed William Siddons while continuing to pursue a theatrical career. She came to the attention of David Garrick and was engaged for a performance at the Drury Lane Theatre, but when she failed to captivate audiences she returned for five years to provincial theaters. Several years later she returned to London, this time in a revival at the Drury Lane of Thomas Southerne's *Fatal Marriage*. The production was a huge success, and for the next thirty years she reigned as the unquestioned tragic actress of her generation. She also led a cultivated life as queen of the London stage until her retirement in 1812. Well educated by her parents, she was able to rise in London society. She is best remembered today from the portrait that Sir Joshua Reynolds painted of her entitled *Mrs. Siddons as the Tragic Muse*, although the artist painted the actress on other occasions, as did Thomas Gainsborough.

ROLE OF THE STAGE IN HANOVERIAN SOCIETY. Despite government attempts to restrict its performance and a decline in the quality of play writing, the theater in eighteenth-century England continued to play an important role in society. In fact, the evidence suggests that

lasting. Still, in contrast to the rich tradition of the Tudor and early Stuart stage or the Restoration Theatre, eighteenth-century England produced relatively fewer plays that have remained in the repertory until modern times. A few, such as Oliver Goldsmith's *She Stoops to Conquer* (1773) or Richard Sheridan's *School for Scandal* (1777) are still performed, but far more were ephemeral productions that were staged for a while and then quickly forgotten. Even as the quality of drama declined, though, the figure of the actor or actress became far more important on the London theater scene. David Garrick, the actor turned theatrical manager who guided the Drury Theatre to great financial success, was only one of many figures who acquired a star-like status at the time. Even as he fulfilled numerous roles in the theater, he continued to act in productions, often producing great excitement when he returned to the stage. Even before Garrick's fortunes had risen, Charles Macklin (1690/1699–1797) had already cultivated a similar ca-

a PRIMARY SOURCE *document*

OBSERVATIONS ON MRS. SIDDONS

INTRODUCTION: If the eighteenth-century English stage produced few works that continued to be performed in the modern world, it was an age notable for the emergence of great actors, whose careers were avidly followed in London and other theatrical capitals throughout Europe. One of the greatest of these figures was Sarah Siddons, who ruled over the English stage as the queen of tragedy. Leigh Hunt, a noted English critic of the day, made these observations about the acting of Siddons.

To write a criticism on Mrs. Siddons is to write a panegyric, and a panegyric of a very peculiar sort, for the praise will be true. Like her elder brother, she has a marked and noble countenance and a figure more dignified than graceful, and she is like him in all his good qualities, but not any of his bad ones. If Mr. Kemble studiously meditates a step or an attitude in the midst of passion, Mrs. Siddons never thinks about either, and therefore is always natural because on occasions of great feeling it is the passions should influence the actions. Attitudes are not to be studied, as old Havard [William Havard (1710–1778), actor] used to study them, between six looking glasses: feel the passion, and the action will follow. I know it has been denied that actors sympathise with the feelings they represent, and among other critics Dr. Johnson is supposed to have denied it. … It appears to me that the countenance cannot express a single passion perfectly unless the passion is first felt. It is easy to grin representations of joy and to pull down the muscles of the countenance as an imitation of sorrow, but a keen observer of human nature and its effects will easily detect the cheat. There are nerves and muscles requisite to expression that will not answer the will on common occasions. But to represent a passion with truth, every nerve and muscle should be in its proper action, or the representation becomes weak and confused: melancholy is mistaken for grief and pleasure for delight. It is from this feebleness of emotion so many dull actors endeavour to supply passion with vehemence of action and voice, as jugglers are talkative and bustling to beguile scrutiny. I have somewhere heard that Mrs. Siddons has talked of the real agitation which the performance of some of her characters has made her feel.

To see the bewildered melancholy of Lady Macbeth waling in her sleep, or the widow's mute stare of perfected misery by the corpse of the gamester Beverly, two of the sublimest pieces of acting on the English stage, would argue this point better than a thousand critics. Mrs. Siddons has the air of never being the actress; she seems unconscious that there is a motley crowd called a pit waiting to applaud her or that there are a dozen fiddlers waiting for her exit. This is always one of the marks of a great actor. The player who amuses himself by looking at the audience for admiration may be assured he never gets any. …

SOURCE: Leigh Hunt, *Dramatic Essays*. Ed. W. Archer and R. W. Lowe (London: Walter Scott, 1894): 11–14. Reprinted in David Thomas, ed., *Restoration and Georgian England, 1660–1788* (Cambridge: Cambridge University Press, 1989): 347–348.

the London stage in these years gradually acquired the popular audience that it had lacked during much of the Restoration period. An expanding economy in and around the city of London as well as increasing time for leisure meant that the audience that packed the city's few eighteenth-century theaters came from a broader range of society. The royal patronage that had been so key to the revival of the theater in the Restoration period was largely absent in London during the eighteenth century. The Hanoverian kings who ruled in the country during the period were not great supporters of the arts; instead they lived quietly, spending much of their time outside the capital in rural palaces and castles. The scope of royal patronage was altogether humbler in the England of the day than it was in France at the same time. Under these circumstances the English stage was a "paying proposition," but one that seems to have been enormously popular at the time. The emergence of provincial theaters in cities in England, Scotland, Wales, and Ireland also provided a training ground for actors and actresses to hone their craft. If the quality of many of the dramas performed in the period has not withstood the test of time, the celebrity status that performers achieved in this era has remained a fixture of the modern drama to the present day.

SOURCES

William Appleton, *Charles Macklin: An Actor's Life* (Cambridge, Mass.: Harvard University Press, 1960).

Phyllis T. Dircks, *David Garrick* (Boston: Twayne Publishers, 1985).

Robert D. Hume, ed., *The London Theatre World, 1660–1800* (Carbondale, Ill.: University of Southern Illinois Press, 1980).

Roger Manvell, *Sarah Siddons: Portrait of an Actress* (New York: Putnam, 1970).

CENTRAL EUROPE COMES OF AGE

SEVENTEENTH-CENTURY THEATER. In Central Europe the great and prolonged crisis of the Thirty Years' War (1618–1648) left this region desolate and economically depressed for much of the seventeenth century. This prolonged conflict eventually involved almost every European power, although the small states of the Holy Roman Empire were the primary battlefield for a conflict that grew to internecine proportions and which brought famine, disease, and depopulation in its wake. As a result of this devastation, the development of a secular, professionalized theater similar to that which had appeared in England, Spain, and France in the seventeenth century was delayed for several generations. At the same time, the performance of religious drama remained very much alive in seventeenth-century Central Europe. The Jesuit dramas performed in the order's schools followed much the same path of development that these productions took elsewhere in Catholic Europe. Reformation and Counter-Reformation polemical dramas, which satirized the positions of religious opponents or glorified the triumphs of Protestants or Catholics, was another dramatic tradition inherited from the sixteenth century that was very much alive in Central Europe generally, and in Catholic Germany and Austria in particular. Passion plays, the rural counterpart to the imposing Jesuit school dramas, also began to flourish in these years. The most famous of these productions is now the Oberammergau Passion Play, which was first staged in 1634 and has been staged at decade intervals since that time, but quite a few of the imposing, many-days long productions began to be performed in the seventeenth century. The Passion Play inherited much from the tradition of late-medieval mystery cycles, the imposing, often weeks-long productions that accompanied fairs or major religious holidays in the fifteenth century. At the same time, both the Jesuit drama and the Passion Play relied on newer staging techniques and a more compact and less rambling plot that often defended Catholic truth in line with the demands of the Counter-Reformation. Musical interludes, choral singing, and even choreographed dances were just a few of the other features that found their way into these plays. There was certainly a huge divide that separated the cultivated Jesuit school dramas from the rural Passion Play. Over time, the works of the Jesuit theater came, in fact, to more closely resemble operas than dramas. At the same time, both forms of theater—one popular, the other urbane—largely arose from the religious controversies of the period, and as these disputes grew less vicious toward the end of the seventeenth century, the works were performed less frequently.

ANDREAS GRYPHIUS. Despite the bleak condition of much of Germany's cultural life in the seventeenth century, every now and then there were notable bright spots on the horizon. Andreas Gryphius (1616–1664), the greatest German poet of the seventeenth century, was one of these. He had been a refugee as a child, having been forced to flee his native town in Silesia during the Thirty Years' War. As he moved from place to place he acquired a remarkably good education. Eventually, he received the patronage of a noble, who recognized his literary talents and financed his travels through Europe for several years. Returning to Silesia in 1647, he became a government official, and from this relative security he began to write a series of tragic masterpieces infused with a pessimistic, yet grand tone. Affected by ancient Stoicism, Gryphius' works treated Christian and heroic themes, intoning the necessity of martyrdom to defend religious principles and truths. The sense of resolute destiny is less pronounced in three comedies the poet wrote in the later years of his life, but a somber mood pervades most of the great author's verse and drama.

THE SMALL STATE. The rural character of much of Central Europe had a profound effect on theatrical traditions in the region. No city in Central Europe at the time was of a comparable size to the great urban centers of Western or Mediterranean Europe; to this day, most of the German-speaking peoples of Central Europe continue to live in towns that are much smaller than the great metropolises of France, the Netherlands, and England. While Germany may have had relatively few cities of any great size, it did have princely courts in great profusion. During the seventeenth century, the political disintegration of Central Europe accelerated, in large part as a consequence of the Thirty Years' War. The power of the Holy Roman Empire, the loose confederation of states in the region, became ever more fictional. At the same time in the individual states and territories of the empire, princes became ever more concerned with increasing their power and authority over their subjects in ways that were similar to the absolutist political innovations common to France and other great European states at the time. The support of the arts, music, drama, and literature became a hallmark of many of these princes' policies, since great achievements in the arts and humanities added luster to their reputations and international prestige. As the problems of the seventeenth century began to fade, scores of German princes began to support the development of court theaters on a pre-

viously unknown scale, importing Italian and French architects to build new elegant structures to serve as venues for the opera, the ballet and, to a lesser extent, drama. Thus if Germany failed to develop a single metropolitan capital similar to London or Paris, the circumstances of its court life brought about the flourishing of "high culture" in every corner of the country. This phenomenon was a direct result of the political situation that was bred in the German *Kleinstaat* or "small state," and the tendency to support the arts generously at the local level has persisted in the country until modern times. Even today, there is scarcely any town of middling size in Central Europe that is without its own opera and dramatic theater. Many of these institutions trace their origins back to the early-modern princes that founded them.

COURT THEATERS AND TRAVELING TROUPES. The economic realities of these small principalities meant that very few rulers could support performing groups on the same scale as Louis XIV and other great kings at the time. While a few of the German states like Austria and Brandenburg Prussia were of considerable size and wealth, most had far more limited economic resources. Despite their more modest resources, many German princes specialized in supporting the arts. One of the first positions that the great composer Johann Sebastian Bach (1685–1750) took after completing his education was as music master at the court of Cöthen, where a music-loving prince generally provided the resources Bach needed for his composition to flourish. Within a few years, though, his patron's tastes had changed, and his prince cut back on the music master's budgets. Bach soon moved on, finding work in other more congenial pastures. Similar patterns of patronage also affected the theater for much of the seventeenth and eighteenth centuries. While some princes favored the drama, most devoted their attentions to the opera and the ballet, the two most popular performing arts at the time. And while many courts had their own theater, it was most often given over to the performance of these arts, rather than to the production of plays. By contrast, in Germany's towns and cities dramas appear to have been popular, and from the early seventeenth century troupes of traveling performers are well recorded throughout the country. Audiences in German cities avidly supported the performances of Italian Commedia dell'arte troupes as well as the dramas staged by a number of English groups that toured the country. By the mid-seventeenth century many German-speaking actors had joined these English groups, and over time, they took over these companies altogether. But a traveling theater was ill suited to high standards of production, given the realities of German cultural life. The

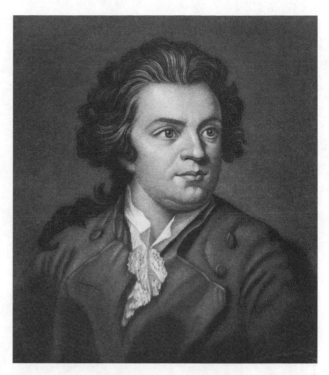

Portrait of Gotthold Ephraim Lessing. © BETTMANN/CORBIS.

country was badly divided by religious divisions, and troupes that traveled in both Protestant and Catholic areas needed to have different plays at hand to entertain audiences that were living under quite different social, political, and religious circumstances. At the same time, the great linguistic divisions in the country meant that dialogue needed to be carefully tailored to take account of the vast differences that separated north from south and east from west. Under these circumstances it was not uncommon for a troupe of traveling players to have as many as 100 plays in their repertoire, a situation that was not well suited to developing a great dramatic art.

EIGHTEENTH-CENTURY CHANGES. Toward the middle of the eighteenth century the drama began to develop in Germany in new ways as a talented group of writers produced works that spoke, not to the tastes of the court, but to the country's developing cities. The fashion of these new plays was shaped by bourgeois sensibilities, rather than by aristocratic pretensions. In this regard the theater of the time has long been termed "middle-class drama," since it was aimed not at court circles, but at well-to-do city dwellers who now had greater leisure time and disposable income to attend the theater. The rise of this new "middle-class" theater was not just a German phenomenon, but occurred in almost every country in Europe around the same time. Gotthold Ephraim Lessing (1729–1781), the first German author

a PRIMARY SOURCE *document*

ENGLISH DRAMA AND GERMAN TASTES

INTRODUCTION: The emergence of a national theater in Germany in the mid- and later eighteenth century was a subject that produced a great deal of debate among intellectuals in the country. While French models of theater had been popular in the court theaters of the later seventeenth and eighteenth centuries, the new "middle-class" or bourgeois writers of later years looked for inspiration to the English and the new breed of French dramatists of the Enlightenment. Of these playwrights, Gotthold Ephraim Lessing was the leader. In a letter he describes the stunting influence that the imitation of French playwrights Pierre Corneille and Jean Racine had had on the development of the German drama, and instead insisted on imitating the greatness of Shakespeare.

"Nobody," say the authors of the Bibliothek [a German encyclopedia of the day], "will deny that the German stage owes a great part of its first improvement to Professor Gottsched."

I am that nobody: I deny it outright. It would have been a good thing if Herr Gottsched had never meddled with the theatre. His supposed improvements either consist of unnecessary trivia or actually make matters worse.

When Frau Neuber was flourishing and a good many persons felt called upon to render both her and the stage a service, things did indeed look pretty wretched with our dramatic poesy. No one knew of any rules; no one cared for any models. Our *Staats- und Helden-Aktionen* [dramatic and heroic plots] were full of nonsense, fustian, filth and vulgar humour. Our comedies consisted of disguisings and tricks of magic; and their wittiest invention was a beating. It did not exactly take the subtlest and

greatest intellect to recognise this corrupt state of affairs. Nor was Herr Gottsched the first one to recognise it; he was only the first one with enough faith in his own powers to remedy it. And how did he go about it? He knew a little French and began to translate; he encouraged anybody who could rhyme and understand *Oui Monsieur* to translate as well; ... he laid his ban on improvisation; he had Harlequin solemnly drive from the stage, which was in itself the greatest harlequinade ever performed; in short, he wanted not so much to improve our old drama as to become the creator of an entirely new one. And what kind of a new one? A Frenchified one; without investigating whether this Frenchified drama was or was not suited to the German way of thinking.

He should have realised sufficiently from our old dramatic pieces which he banished that we incline more to the taste of the English than of the French; that we want to see and think about more in our tragedies than the timid French tragedy gives us to see and think about; that the great, the terrible, the melancholy has a better effect on us than the polite, the tender, the amorous; that excessive simplicity fatigues us more than excessive complication etc. So he should have remained on that track, and it would have taken him straight to the English theater. ...

If the masterpieces of Shakespeare had been translated with some minor changes for our Germans, I know for a certainty it would have been better consequences than having acquainted them with Corneille and Racine.

SOURCE: Gotthold Lessing, *Briefe, die neueste Litteratur betreffend (Letters Concerning the Most Recent Literature)*, in *German and Dutch Theatre, 1600–1848*. Ed. George W. Brandt (Cambridge: Cambridge University Press, 1993): 195–196.

to follow this path, was the son of a prominent Lutheran theologian, and although he never renounced his faith, he used his works to satirize religious hypocrisy and to mock those who blindly repeated received wisdom. Affected by the ideas of the Enlightenment, he had also read the works of many philosophers, and like the French playwright and encyclopedist Denis Diderot he aimed to capture "real-life" situations. In opposition to those who argued that the German theater should imitate the great but artificial tragedies of French figures like Racine and Corneille, Lessing supported a drama that was naturalistic. He began his career by producing several successful works for the Leipzig stage before his parents called him home and encouraged him to enroll in medical school. Although he eventually took his degree, he

returned to play writing soon afterwards, moving first to Berlin where he came into contact with an impressive circle of intellectuals. Over time, he served as an advisor to a group of private theatregoers in the city of Hamburg, who had decided in 1765 to found a theater in their town, the first such public venture in Central Europe. When this scheme soured in 1770, Lessing moved on to become court librarian in the relatively small state of Braunschweig-Wolfenbüttel. Despite its small size the state possessed in the small town of Wolfenbüttel one of the most impressive libraries in all Europe, and although Lessing was quite unhappy there, he used the time to write for the theater and to publish theoretical works on the drama. One of his most important plays, *Nathan the Wise* (1779), dates from these years, and argued in a dar-

ing fashion that the ethical impact of Judaism, Christianity, and Islam was largely similar. While *Nathan the Wise* was a profoundly serious work, many of Lessing's most notable plays were comedies, including the popular *Minna von Barnhelm*, a work that treats the concept of honor. The author's tragedy *Miss Sara Sampson*, too, is today considered among his most appealing works. It was Lessing's self-expressed intention throughout his life to establish a "national theater" in the German language. It was an ambitious goal, given the long tradition of regional particularity, political division, and linguistic differences that separated the German states from each other. At the same time, the playwright's ambitions were to be largely realized in the coming generation. In the last decades of the eighteenth century, an enormously talented group of dramatists, which included figures like Friedrich von Schiller (1759–1805) and Johann Wolfgang von Goethe (1749–1832), took up the challenge that Lessing had identified.

SOURCES

Stefanie Arend, *Rastlose Weltgestaltung: senecaische Kulturkritik in den Tragödien Gryphius' und Lohensteins* (Tübingen, Germany: Niemeyer, 2003).

Walter Bruford, *Theatre, Drama, and Audience in Goethe's Germany* (London: Routledge and Paul, 1950).

Gesa Dane, *Gotthold Ephraim Lessing* (Stuttgart, Germany: Philip Reclam, 2002).

Bruce Duncan, *Dark Comedy in Eighteenth-Century Germany* (Ithaca, N.Y.: Cornell University Press, 1970).

Gustav Sichelschmidt, *Lessing: der Mann und sein Werk* (Düsseldorf, Germany: Droste, 1989).

THE FRENCH ENLIGHTENMENT AND DRAMA

DECLINE OF THE THEATER. During most of the seventeenth century the theater in Paris had a relatively limited appeal, drawing its audience primarily from aristocratic and upper-class circles that were centered around the court. Often provincial theaters located in such cities as Lyons and Rouen had proven more innovative than the troupes of Paris, producing the plays that made their way to the capital after they had been successful in these smaller cities. While the years from 1630 to about 1680 had seen a great theater thrive in Paris, the size of the city's audience had always been relatively small when compared to the huge audiences for commercial productions that existed in early seventeenth-century London or Golden-Age Spain. The tragedies of Corneille and Racine or the comedies of Molière had been

great critical successes, and had been widely read and imitated throughout Europe, but keeping Paris's theaters afloat was always a risky financial venture. No theatrical troupe survived without the king's patronage, and even a gifted dramatist like Molière who received substantial support frequently had to struggle to make his productions clear a profit. While a number of sparkling successes had been staged in the years before 1680, royal patronage for the theater in the final two decades of the century actually shrank as Louis XIV became involved in a series of costly European wars and as the king fell under the influence of his pious second wife, Madame de Maintenon. One sign of the increasing disfavor in which the king held the theater was his expulsion in 1697 of the Comédie-Italienne, a troupe of Commedia dell'arte performers that had performed for a generation in the capital. Louis found the group's broad, sexual humor distasteful, and the troupe was not allowed to return to Paris until 1716, the year following the king's death. As the audience for the theater shrank, Paris for a time had only one public performing troupe, the Comédie-Française, which had been forged by the merger of Molière's troupe and two others.

REVIVAL AND GROWTH. This bleak state of affairs soon began to change in the years after 1715, as the theater entered upon a century of unprecedented expansion in Paris. By the end of the eighteenth century, the city had almost thirty theaters, making it the undisputed dramatic capital of Europe. A complex combination of factors produced the rise of this professional and commercial stage in Paris, but the expansionary trend became evident in the years immediately following Louis XIV's death. The king's successor, Louis XV, was only five years old when he assumed the throne, and thus his uncle Philip of Orléans served as his regent. Philip disliked the imposing spaces and lofty grandeur of Versailles, and between the years 1715 and 1723 he set up government in Paris rather than Versailles. As aristocrats streamed back to the city from the now abandoned royal retreat, they demanded entertainment that fit the changing tastes of the age. Drama, the opera, ballet, and the visual arts were all enriched by this brief period of Louis XV's regency, and when the king returned to set up government at Versailles several years later, many French nobles did not return to the country palace. Instead they stayed in Paris and prolonged the city's artistic revitalization. At the same time, the dramatic growth that the French theater witnessed in the course of the eighteenth century cannot be credited to aristocratic patronage alone. For the first time in France's history, a significant class of bourgeois patrons began to enter the ranks of

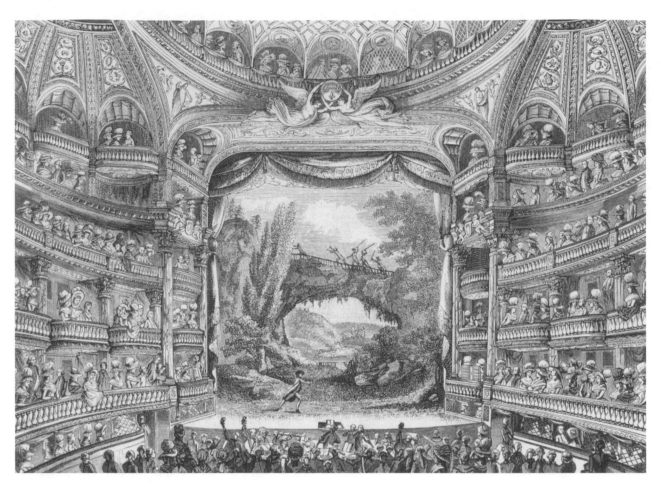

Performance at the Thêatre Française, Paris, in 1789. THE GRANGER COLLECTION.

theatergoers; they found in the drama, not only a source of leisure entertainment, but an elevated art form that appealed to their desire to be educated in the issues of the day. The ideas of the Enlightenment were to affect this new class of aristocratic and bourgeois patrons. Although the Enlightenment was an international movement, it attracted some of its largest numbers of adherents in France, particularly in Paris and the country's other major cities. In small circles known as salons the devotees of the movement discussed the necessity of change in France's social structure, even as they hoped to foster greater tolerance, liberty, and reason in everyday affairs. The theater was soon to be affected by these trends. The apex of the growing theatrical world in Paris was the Comédie-Française, the national theater that Louis XIV had chartered at the end of the seventeenth century and whose acting troupes were formed out of the merger of previously disparate groups in the city. This institution, a descendant of which still survives today, continued to produce elevated dramas in the tradition of Corneille and Racine. As a national institution

supported by the crown, the Comédie-Française often proved to be resistant to the winds of change that were beginning to sweep through France in the eighteenth century. But even in this aristocratic bastion of privilege, forces were at work that were questioning France's religious, social, and political order, and the works of Voltaire and other playwrights inspired by the Enlightenment came to be performed in the venerable institution. Beyond the Comédie-Française, an increasingly variegated theatrical scene began to take shape in the capital, and many far less prestigious venues for drama developed, particularly in the second half of the eighteenth century as a broader audience for entertainment emerged in Paris.

VOLTAIRE. The greatest, and frequently most controversial, French dramatist of the time was François-Marie Arouet (1694–1778) who has always been known by his pen name Voltaire. Despite being educated by the Jesuits like Molière and Corneille before him, Voltaire came to criticize organized religion; and although he mistrusted the French king Louis XV because he himself

had been persecuted by him, he was fundamentally a royalist who believed in enlightened despotism as a way to progress. When he had completed his education and served for a time as a diplomat, he made his way into Parisian society, establishing himself with his cultivated sense of satire. Exiled from Paris and then briefly imprisoned by the regent, the Duke of Orléans, on the suspicion of libel, he was released after a year, and produced his first great work *Oedipe* in 1717. In the wake of the success of *Oedipe* he was hailed as the successor to Racine and Corneille. Although he came to the attention of the royal court and for a time was admitted into high circles, he soon found himself in opposition to the regent again when he fell for a second time under the suspicion of libel and was taken into custody, placed in the Bastille, and then exiled from Paris. In the 1720s he rehabilitated himself with the Duke of Orléans and received a government pension. He became a spy for the crown, but once Orléans was dead, he soon fell from grace again by insulting a high-ranking noble in 1725. Again, he was imprisoned in the Bastille, beaten up, and promptly escorted to the port of Calais in northwestern France. From there, he made his way to England, where he spent more than two years in exile. English society and English theater captivated Voltaire, and he admired the greater freedom of life in the country and became in these years an admirer of Shakespeare, whom he credited with having a kind of barbarous energy. Upon his return to France, he began to try subtly to imitate the style of Shakespeare in his tragedies. These first few plays were not successful, but by 1732 Voltaire had scored a hit in the production of his *Zaïre.* In the years that followed, the playwright continued to write tragedies for the Comédie-Française, but he also turned to history and philosophy. Voltaire also rehabilitated himself at court, particularly with Louis XV's mistress Madame de Pompadour, although the king and many of his courtiers continued to distrust him. After making an indiscreet remark one evening at a party in which members of the court were in attendance, Voltaire was forced into hiding in 1747. The disfavor in which he was now held, the recent failures of some of his plays, and most importantly, the death of his long-term mistress Madame du Châtelet in 1749 left the artist exhausted and disoriented. According to his accounts, he seemed to suffer the equivalent of a nervous breakdown. To recover his composure, Voltaire accepted the invitation of his friend Frederick the Great to visit Prussia and he left for Berlin in 1750. Here initial enchantment between Frederick and Voltaire soon gave way to increasing disaffection. He quarreled with members of the Prussian nobility, was sued by a banker, and touched off controversy by pub-

Portrait of the French playwright and Enlightenment thinker Voltaire. © ARCHIVO ICONOGRAFICO, S.A./CORBIS.

lishing a poem attacking the president of the Prussian Academy of Sciences. The French dramatist tried to flee the country in 1753, but he was captured by Frederick's forces and imprisoned for a time before being allowed to continue. In the meantime he had received word from Louis XV that he was not to return to Paris and so after a year spent in the city of Colmar, he took refuge in Switzerland at Geneva.

VOLTAIRE'S LATER YEARS. Voltaire was at first hailed in Switzerland for his wit and sophistication as well as for the salon that he set up in his country retreat. Members of Swiss society streamed there to hear his views on religion and politics. Gradually, he excited controversy, particularly when he expressed doubts on key elements of Christian religious orthodoxy. By 1758, the situation had grown so uncomfortable in Switzerland that Voltaire was forced to flee, this time back to France, where he bought a country villa at Ferney directly on the French-Swiss border. Long experience had taught Voltaire that his ideas were inevitably going to be controversial, and in purchasing the house at Ferney he desired to be close to Switzerland for a quick escape across the border if he learned that the king's men were approaching. In these final twenty years of his life, Voltaire

a PRIMARY SOURCE document

VOLTAIRE ON COMEDY

INTRODUCTION: The French dramatist and Enlightenment thinker Voltaire (1694–1788) spent several years in England while in exile from his native France. There he became acquainted with a number of playwrights. While Voltaire admired the English stage's energy, he nevertheless detested its "barbarous" violation of the rules of drama. At the same time he came to be influenced by its conventions, some of which found their way into his later works. In his *Philosophical Letters*, Voltaire discussed the current English stage. While he believed that writers of tragedy were too deeply influenced by Shakespearean models, he admired English comic dramatists and discussed those who wrote for the late seventeenth- and early eighteenth-century stage.

The late Mr. Congreve raised the glory of comedy to a greater height than any English writer before or since his time. He wrote only a few plays, but they are all excellent in their kind. The laws of the drama are strictly observed in them; they abound with characters all which are shadowed with the utmost delicacy, and we don't meet with so much as one low or coarse jest. The language is everywhere that of men of honour, but their actions are those of knaves—a proof that he was perfectly well acquainted with human nature, and frequented what we call polite company. He was infirm and come to the verge of life when I knew him. Mr. Congreve had one defect, which was his entertaining too mean an idea of his first profession (that of a writer), though it was to this he owed his fame and fortune. He spoke of his works as of trifles that were beneath him; and hinted to me, in our first conversation, that I should visit him upon no other footing than that of a gentleman who led a life of plainness and simplicity. I answered, that had he been so unfortunate as to be a mere gentleman, I should never have come to see him; and I was very much disgusted at so unseasonable a piece of vanity.

Mr. Congreve's comedies are the most witty and regular, those of Sir John Vanbrugh most gay and humorous, and those of Mr. Wycherley have the greatest force and spirit. It may be proper to observe that these fine geniuses never spoke disadvantageously of Molière; and that none but the contemptible writers among the English have endeavoured to lessen the character of that great comic poet. Such Italian musicians as despise Lully are themselves persons of no character or ability; but a Buononcini esteems that great artist, and does justice to his merit.

The English have some other good comic writers living, such as Sir Richard Steele and Mr. Cibber, who is an excellent player, and also Poet Laureate—a title which, how ridiculous soever it may be thought, is yet worth a thousand crowns a year (besides some considerable privileges) to the person who enjoys it. Our illustrious Corneille had not so much.

To conclude. Don't desire me to descend to particulars with regard to these English comedies, which I am so fond of applauding; nor to give you a single smart saying or humorous stroke from Wycherley or Congreve. We don't laugh in reading a translation. If you have a mind to understand the English comedy, the only way to do this will be for you to go to England, to spend three years in London, to make yourself master of the English tongue, and to frequent the playhouse every night. I receive but little pleasure from the perusal of Aristophanes and Plautus, and for this reason because I am neither a Greek nor a Roman. The delicacy of the humour, the allusion, the *à propos*—all these are lost to a foreigner.

SOURCE: Voltaire, *Letters on the English*. Vol. 34 of *The Harvard Classics* (Cambridge, Mass.: Harvard University Press, 1909–1914): 139–140.

continued to write, and his correspondents grew to include an ever-larger number of European intellectuals. His house at Ferney also played a key role in furthering the ideas of the Enlightenment. There Voltaire set up a kind of intellectual court, and he was visited by many of the greatest thinkers and political figures of the age. Rich and secure from his writing as well as questionable business deals he had conducted earlier in his life, Voltaire finally achieved the peace and tranquility at Ferney that he had long desired. Although even then the irascible author continued to quarrel with the local peasants and religious leaders of the province. The themes of his work in these years persisted along the lines that he had long outlined: religious tolerance, the rule of human reason, and the establishment of a more humane and just society. Finally in the year in which he died, he was allowed to return to Paris, where a performance of his play *Irène* caused a sensation. Exhausted from the warm reception he received in the French capital, he soon grew ill and died on 30 May 1778.

DIDEROT AND MIDDLE-CLASS DRAMA. Despite the dubious notoriety that Voltaire achieved in many circles throughout his life, the author was recognized at the time as one of the great prose stylists and verse dramatists of the French language. Born at the time when the style of Racine tragedy held sway over the the-

ater in Paris, he never abandoned this form of drama in the works he completed for the theater. Although Voltaire exercised a powerful hold over the development of the Enlightenment in France, his dramatic ideas increasingly seemed old-fashioned to later generations of French dramatists. Admired and respected for the depth of his commitment to rational thought, Voltaire's plays, with their faithfulness to older forms of verse tragedy, seemed by the 1750s to be increasingly dated. The greatest exponent of a new kind of theater at this time was Denis Diderot (1713–1784). While Voltaire had often fashioned his dramas from ancient myths, classical history, and exotic tales, Diderot argued that the theater should represent bourgeois values and seek to present a realistic mirror of everyday life. Only two of his plays, *The Illegitimate Son* (1757) and *The Father of the Family* (1758), achieved anything above a level of moderate success, and they are rarely even read today. Diderot believed that the theater should not only hold up a mirror to bourgeois society, but that it might play a powerful role in teaching people the views of the Enlightenment. Thus some heavy-handed philosophizing often found its way into his works. While the quality of his dramas may not have been high, the playwright made a powerful impact on eighteenth-century taste by virtue of his role as the editor of the *Encyclopédie,* the massive multi-volume project of Enlightenment thinkers in France that was published between the 1750s and 1770s. As one of the editors of this project, Diderot chose writers to write entries about the theater whose views approximated his own. Besides his role in shaping the *Encylopédie*'s views on theater, he also continued in his later years to publish works on the theory of drama and acting. His opinions about acting, in particular, were influential, and tended to favor the naturalistic portrayal that was beginning to become the fashion at the time. This style of acting sought to represent the passions and emotions faithfully, in contrast to the artificial style of elaborately declaiming the text in the fashion that had held sway in seventeenth-century France. While his own works of drama may not have been so inspiring, he played a key role in establishing the "middle-class" drama of the later eighteenth century throughout Europe. In particular, his influence on the great German playwright Gotthold Ephraim Lessing was profound. In the years that followed his pronouncements on the subject, a more bourgeois set of sensibilities flourished in the French theater. The studied artificiality, grand gestures, and elevated verse that had once dominated the great works of Racine and his followers seemed increasingly outdated as a new theater that treated everyday life emerged.

BEAUMARCHAIS. The rise of bourgeois sentiments, and the problems that they might engender in an absolutist state like France, can be brilliantly witnessed in the works and career of Pierre Beaumarchais (1732–1799), who was the author of two brilliant comedies that long provided other artists with inspiration. The first of these, *The Barber of Seville,* was first staged in 1775, after having been prohibited for two years because of its anti-aristocratic tone. It was not an immediate success, since although a comedy, it was laden with heavy allusions to the author's own recent legal troubles. Beaumarchais revised the play—shortening it—and staged it once again. This time the comedy was a definitive success since it treated more neatly the comic exploits of a Spanish nobleman's servant. Through his wit, the servant is continually able to outsmart his lord, and thus Beaumarchais began to score success by criticizing the privileges of aristocrats. Despite his political stance, the author was very much a part of the "in-circle" of court and cultivated society in Paris. For a time he served on diplomatic missions in England, and was in part responsible for France's support of the American colonies during the Revolutionary War. Within a few years of *The Barber of Seville* Beaumarchais had written its even more famous sequel, *The Marriage of Figaro,* a work that immediately touched off a firestorm of controversy and which languished for many years without being performed. Although the light gaffs and jabs that the work makes against aristocratic privilege scarcely seem to raise an eyebrow today, the mood in France had changed dramatically from the time of the author's *Barber of Seville.* Reform programs aimed at curbing the powers and privileges of the nobility were now an imminent threat to France's large class of nobles. In order to secure the performance of his play, Beaumarchais was forced to intrigue at court so that he might secure a license for its staging, which was only granted after years of deliberation and a private performance before the royal court. When the play was finally performed before audiences in Paris, it caused a sensation and ran for a total of 75 performances, a huge number at the time. It attracted criticism from some as "godless" and "immoral," while at the same time acquiring many admirers. Beaumarchais long kept his silence against the attacks of his critics, but when he did finally respond to the accusation that his play was immoral, he was hastily imprisoned for a time in the Bastille. Such measures, though, did little to halt the play's rising popularity, not only in France, but throughout Europe as well. It is a testimony to how well Beaumarchais captured the brittle spirit of the times that in Austria the brilliant composer Mozart set to transforming the work into an opera only a little more than a year after it had been performed

and published in Paris. Admiration for Beaumarchais' wit and earthy wisdom persisted, so much so that the Italian composer Gioacchino Rossini used the dramatist's earlier *Barber of Seville* as late as 1816 to serve as the basis for the libretto of his famous opera of the same name. Despite Beaumarchais' attacks on aristocratic privilege, he himself was part of the court circle that was swept away by the tide of the French Revolution. The artist was imprisoned for a time during the 1790s because of his own aristocratic connections, but eventually released through the ministrations of a former lover. His dramatic efforts, although light-hearted and written in a spirit of satirical good fun, helped to realize the theater of bourgeois values in France that had been envisioned by such Enlightenment thinkers as Diderot.

SOURCES

Derek F. Connan, *Innovation and Renewal: A Study of the Theatrical Works of Diderot* (Oxford: The Alden Press, 1989).

Peter France, *Diderot* (Oxford: Oxford University Press, 1983).

William D. Howarth, *French Theatre in the Neo-Classical Era, 1550–1789* (New York: Cambridge University Press, 1997).

Haydn Mason, *Voltaire: A Biography* (Baltimore, Md.: Johns Hopkins University Press, 1981).

Peyton Richter and Ilona Ricardo, *Voltaire* (Boston: Twayne Publishers, 1980).

Jack Rochford Vrooman, *Voltaire's Theatre: The Cycle from Œdipe to Mérope* (Geneva: Institut et musée Voltaire, 1970).

Marie Wellington, *The Art of Voltaire's Theatre: An Exploration of Possibility* (New York: Lang, 1987).

SEE ALSO *Literature: French Literature during the Enlightenment; Philosophy: The Enlightenment in France*

THE RISE OF REVOLUTIONARY SENTIMENT IN FRANCE AND ITS IMPACT ON THE THEATER

THEATER AND PUBLIC OPINION. The sensation that Beaumarchais caused with his *Marriage of Figaro* was hardly the first or the last time the Parisian theater was to be the center of controversy. Yet his work was ultimately tolerated and performed in the Comédie-Française, the very heart of the theatrical establishment in France, which had been licensed and lavishly supported by the crown for more than a century at the time of *Figaro's* performance. During the high tide of the Enlightenment the Comédie-Française had frequently fulfilled a dual role. The theater was a medium for shaping public opinion and at the same time it was a barometer of those sentiments that allowed the crown to measure the popular mood. During the 1770s and 1780s criticism of France's entrenched social order, of the privileges of its clerics and nobles, and of the ineptitude of its royal government steadily rose. Although the country was one of the most prosperous and productive in Europe, the system of royal government that Louis XIV had developed in the later seventeenth century had been notable for its corruption and inefficient centralization. Louis' successor, his great-grandson Louis XV, had done little to lessen the sclerosis that lay at the heart of French government, and his involvement in numerous international wars had left the royal administration perilously drained of funds. When his grandson Louis XVI succeeded him in 1774, he was at first forced to embark on an ambitious program of reform, having no other choice but to increase the financial efficiency of his government. By the early 1780s, however, the plans of his reforming chief minister Jacques Necker were increasingly blocked by special interests. Rather than opposing those bastions of privilege that were preventing improvement in government, Louis capitulated to the enemies of Necker, and in the years following his dismissal, royal policy drifted, ever subject to increasing criticism. At first these great political trials played little role in the theatrical life of Paris' three official theaters: the Comédie-Française, Comédie-Italienne, and the Opera. Each institution had been founded with the express purpose of nourishing the theatrical arts of drama, ballet, and opera in France—a powerful mission at a time when French kings desired to use these media as tools for promoting national glory. In all three theaters ties to the court meant that the material performed in them was expected to uphold the values of the crown and the Catholic Church. Since the early eighteenth century onward, though, Voltaire and other playwrights had begun to produce dramas at the Comédie-Française that challenged these values either subtly or overtly. When a play excited too much controversy or seemed to challenge accepted mores or state policies too vigorously, it was often suppressed. As the tide of criticism of France's government and entrenched social order rose, however, patrons demanded new dramas that captured the political pulse of the age. The wild success of Beaumarchais' *Marriage of Figaro* thus demonstrates the appetite that existed just below the surface of French society for an art that addressed the major social topics of the day.

THE PARTERRE AND PUBLIC OPINION. At the same time, the theater began to be an important way to measure public opinion. As the audience for dramas expanded in Paris in the course of the eighteenth century, new classes of people began to fill the Comédie-Française's *parterre*, or ground floor. Admission to this section was far cheaper than in the balconies above where wealthy members of the Parisian aristocracy or bourgeoisie sat; while the cost of admission was still beyond the means of most of the laboring classes in the city, the parterre became the preserve of shopkeepers and skilled artisans—the middling and lower ranks of the bourgeoisie, that is the French middle classes. In the second half of the eighteenth century playwrights like Beaumarchais increasingly took up the challenge set by Enlightenment thinkers like Diderot, who had argued that the theater should favor contemporary themes and that its subjects should be portrayed realistically in ways that educated audiences about social issues. Beaumarchais's *Marriage of Figaro* was one such production, but there were others; in the 1770s and 1780s, audience response to these dramas was frequently the talk of Paris since the theatergoers of the parterre used the relative anonymity of the crowd to express vigorous reactions to the dramas they saw. The evidence suggests that in these years the parterre became increasingly opinionated, pronouncing its tastes on the acting styles of performers, booing or catcalling when something displeased them, and expressing support when the sentiments of the dramatist mirrored their own. Of course, this system was open to manipulation. Actors, stage managers, and dramatists often tried to pack the parterre with *claques*—that is, groups that were favorable to them—in order to ensure positive reviews from the crowd. Mounds of free tickets were often given away in attempts to manipulate audience's responses, so that the Comédie-Française became a venue in which two dramas were paradoxically being presented side by side: one on the stage, the other in the auditorium itself. At the same time, the sensation that a work like Beaumarchais' *Marriage of Figaro* produced in the mid-1780s points to the importance that the theater had attained in French society for presenting viewpoints on contemporary social issues and for testing the waters of public opinion. In that drama, the wealthy bourgeois Beaumarchais used his position of relative security at court to rail against aristocratic privilege, to mock the church and clergy, and to celebrate the homespun virtues of the working classes. Both the court and the Comédie-Française had debated about whether the play should be performed for years before finally giving in to widespread pressure to stage it. The favorable reactions the drama received from the parterre and the drama's unprece-dented run were but another proof positive of the widespread desire for reform, while the joyous reaction the parterre's crowds expressed at *Figaro's* performances ultimately protected the play from censure. The genie, in other words, had escaped from the bottle, and the French theater had emerged as a powerful vehicle both for shaping and expressing the public's sentiments.

RISE OF NEW THEATERS. In these same years new theaters were also emerging on the scene in Paris, institutions that were even more potentially volatile than the relatively conservative, state-supported Comédie-Française. Since Louis XIV's day, laws had forbidden dramas from being staged in Paris in any other venue except the officially recognized and licensed state theaters. As in England, though, attempts to regulate and confine the stage had always left some loopholes. In Paris, short dramas, for example, had long been tolerated in connection with the great suburban fairs that were celebrated on the city's fringes during the summer months. Actors and playwrights had used these events to supplement their incomes by participating in the carnival shows. A definite shift in the course of Paris's theatrical history occurred in 1759 when Jean-Baptiste Nicolet, a promoter of fair acts and short dramas, obtained permission to rent a building in the city's Temple district and to use it as a theater for variety acts. At the time, the Boulevard Temple was a hotbed of Parisian public life, a haunt visited by Enlightenment thinkers, prostitutes, and a broad swath of the city's society. Nicolet was a showman, not a politician, but to please his crowds he soon set about testing the boundaries of royal regulations forbidding the performance of dramas outside the state's theaters. Into his succession of vaudeville acts he built short dialogues that gradually grew longer until the management of the Comédie-Française began to complain to the authorities. Nicolet was questioned, imprisoned for a time, and fined, but then allowed to go about his business. After his release he grew more careful, but he continued to test the regulations. His example emboldened others, and by the end of the 1760s the Boulevard Temple and its surrounding area was populated with a number of variety theaters. Royal and municipal authorities at this time seemed to have thought of these institutions as little more than a nuisance, since the production values of most of these "boulevard theaters," as they became known, were crude and the theaters tended to cater to rowdy audiences. The typical Parisian boulevard theater at this time was thus similar to the emerging English music hall. Both, in other words, rose as a result of the practices of censorship, but each identified its audiences in the poorer segments of society who, because of their income levels,

were not able to attend the more expensive theaters in London and Paris. The Comédie-Française, with its older, more experienced, and well-trained troupe of actors, remained the venue *par excellence* for drama in the capital around 1770. The management of the three state theaters in Paris (that is, the Opera, the Comédie-Française, and the Comédie-Italienne) may have frequently complained to the authorities, but few educated Parisians thought that the boulevard theaters were going to replace or seriously threaten the dominance of these more venerable institutions.

THE TRIUMPH OF THE VARIÉTÉS. By the late 1770s, though, this situation had changed dramatically. At least two of the boulevard theaters, the *Variétés* and the *Associés,* had begun performing pirated versions of works that belonged to the Comédie-Française's repertory—a definite violation of the law. While the *Associés'* productions were thought to be crude and lacking in finesse, those of the *Variétés* were considerably more polished and were now attracting audiences from the Parisian upper classes. In 1781, a controversy over the building of new theaters for the state institutions brought to a head the long-standing enmity between the boulevard theaters and the Comédie-Française. In that year the theater used by the Paris Opera at the Palais-Royal burned, and Philip II, the Duke of Orléans, who owned the complex, began to build a new grand replacement for the company that might attract even more patrons to his burgeoning commercial development that adjoined the theater. The Palais-Royal was then the hub of street and café life in the city, buoyed by its ideal location in the very heart of ancient Paris, not far from the Cathedral of Notre Dame and the Palace of the Louvre. Philip spent an enormous sum constructing the new theater, but intrigues at court soon turned against him, and the duke's cousin, Louis XVI, decided to house the Opera, not in Philip's grand new theater, but in a far cheaper building that was hastily constructed at the far northern fringes of town along the Boulevard Saint-Martin. While Louis' decision may have pleased his courtiers, it rankled his cousin Philip as well as many of Paris' elite who were now forced to travel a far greater distance into an unfashionable quarter of town to attend the Opera. As a result, attendance at the new musical theater quickly declined, while Philip eventually scored a huge success with his grand new theater. The king's decision to relocate the Opera had left the duke holding a valuable piece of real estate, and to fill his expensive venture, he invited the *Variétés,* the most artistically successful of the boulevard theaters, to rent his space. With their new state-of-the-art theater in one of the most fashionable locations in the city, the *Variétés*

soon prospered and competed vigorously with the Comédie-Française, an institution that throughout the 1780s seemed to many of Paris's intellectuals to appear increasingly worn and tired. Even the installation of new stage lighting in 1784 and the controversial production of *The Marriage of Figaro* soon afterward did little to stem the relative decline of the venerable institution against the vanguard of the *Variétés.* As the decade progressed and the monarchy grew more unpopular, the Comédie-Française's status as a royal institution made it appear to many in Paris as a bastion of aristocratic reaction in a sea of change. The theater's relatively conservative choice of repertory as well as its managers' constant complaints to the king for redress against the boulevard theaters' violations of its monopoly did little to dispel such an opinion. For his part, Louis XVI's attentions were clearly diverted elsewhere in these years by the host of problems his government faced, and so he refused to uphold the Comédie-Française's rights. Thus the *Variétés* continued to challenge royal authority over drama.

THE BOULEVARD THEATERS GROW MORE RADICAL. The relocation of the *Variétés,* while an important event in helping to challenge royal control of the theater, was not, in and of itself, a factor in the growth of revolutionary sentiments in 1780s France. Throughout the seventeenth and eighteenth centuries, French actors and dramatists who achieved success on the Parisian stage had often been the most enthusiastic supporters of royal power. The example of figures like Voltaire, who had frequently been censored and imprisoned for his unpopular opinions, had inspired great caution in the theatrical community, and even Voltaire—though he questioned aspects of the exercise of royal authority in France—had been an enthusiastic supporter of despotic government. As the *Variétés* moved to its newfound highly respectable home around 1785, it tended to voice the same conservative political sentiments that had long flourished in the state theaters. At the same time, other forces were at work in the boulevard theaters, those institutions that remained along the streets and avenues of the capital that catered to a less elevated clientele. During the 1780s a radical press began to explode on the Parisian scene that was filled with satires and attacks on the monarchy. Queen Marie-Antoinette figured prominently in many of these works, some of which were boldly printed with their place of publication as "Peking," a joke intended to mock the inability of the French government to censor them. In these years the Austrian-born queen was singled out for the most violent abuse and accused of all kinds of sexual outrages,

from voracious lesbianism to orgiastic sex rituals, even as the popular press also heaped abuse on the king, his ministers, and the clergy. France's radical press was always more vicious in its criticisms than were the boulevard theaters that lined the cities' streets. After all, pamphlets could be published anonymously and it was difficult for the authorities to unearth just where, when, and by whom an offending work had been printed. The theater, by contrast, occurred in a public space, where police could seize an actor or easily trace the identity of the author of an offensive dramatic skit or the composer of a song. But as criticism of the crown mounted generally in the 1780s, Paris's neighborhood authorities seem to have grown increasingly lax about supervising the boulevard theaters, in part because they often approved of the anti-monarchical and anti-governmental sentiments that were being uttered in them.

THE REVOLUTION PROCEEDS. As the state of the government drifted perilously close to bankruptcy at the end of the 1780s, Louis XVI responded by calling a meeting of the Estates General, France's parliament, a body that had not been summoned since 1615. In the course of 1789 hopes for reform without drastic alterations to the government's constitution faded, and members of the third estate, or the commons, formed a new National Assembly. They formulated a new constitution for France that eliminated many noble and clerical privileges. The king swore allegiance to these documents, but as a result of the impending bankruptcy of his regime, he now faced greatly straitened circumstances. One result of these financial crises was that Louis XVI was forced to abandon patronage of Paris's royal theaters, and the city's government assumed control of the administration and supervision of these institutions. In 1791, the National Assembly deprived the Comédie-Française, Opera, and Comédie-Italienne of their monopolies, abandoning all pretenses that these were the only theaters legally sanctioned to perform in Paris. A key consequence of these measures was to make available to all the great repertory of French plays that had long been licensed as the sole preserve of the Comédie-Française. Since the 1770s the boulevard theaters had been encroaching upon this material by performing these plays in edited forms or by staging them under different titles, but now the new revolutionary government erased the long-standing privileges of the Comédie-Française, allowing the vast storehouse of works by Voltaire, Racine, Corneille, Molière, and all playwrights who were deceased to be performed by anyone who wished to stage a production. For a time the abolition of the old monopolies wreaked havoc on the Comédie-Française,

which searched for both new and old material to perform that might be suitable given the greatly altered political realities of the times. Disagreements within the troupe eventually caused an irreconcilable breach, and the company split in two. In their separate houses the two remnants of the Comédie had varied success, and even from their greatly reduced position, both houses continued to dominate the elite theater of the day. Most critics of the period agreed that the great French classics were best performed in the astute hands of the troupes that had grown out of the Comédie-Française. At the same time, scores of new theaters arose to compete with the older houses. Where they had been nine boulevard theaters in 1789, an additional twenty were founded by 1795. Not all of these new theaters succeeded, but everywhere in Paris the stage came to be increasingly subjected to heightened competition.

THE REVOLUTION GROWS MORE RADICAL. The National Assembly's decision in 1791 to eliminate the long-standing monopolies on the performance of opera, drama, and ballet in France soon were followed by new measures to control and censor the theater. As the Revolution progressed, the threats that it posed to royal authority grew more grave, and in June of 1791, Louis XVI and his family tried to flee the country to rally support from outside France to overthrow these threats. Caught at Varennes, Louis and Marie-Antoinette were brought back to Paris, where they now became virtual prisoners of the Revolution. In the months that followed calls for the abolition of the monarchy steadily rose, and the campaign of Republicans to rid the country of counter-revolutionary forces gave birth to the Reign of Terror. As a result, the National Assembly and Parisian city government began to sanction spectacles and dramas that glorified the cause of republicanism. Propagandistic plays that supported the Revolution became more common, but throughout most of the Revolution it was the classic French repertory as well as light contemporary comedies that continued to provide the most common fare in most of Paris' theaters. Theatrical managers, in fact, preferred these works because they were not controversial, and in the overheated political climate of the day they sensed that avoiding controversy was a good thing. By 1793, at the height of the Terror, the government took decisive measures to censor and control the theaters. The Directorate, the controlling committee within the National Assembly, stipulated that the theater must serve patriotic ends—that is, that it must defend and promote the Revolution and the cause of republican government. Thus for a time these directives altered the course of theater in Paris by prompting the writing and staging of

works that were overtly republican in nature. Yet even during the height of the Terror, when as many as 17,000 people were executed for counter-revolutionary deeds and sentiments, some of the most frequently performed works were those of Corneille, Molière, Voltaire, and Racine—works that by this time had achieved a "classic" status in French similar to Shakespeare's opus in English. These, it could be argued, met the Revolution's demands since they were masterpieces of the French language. During this dark period, many actors and playwrights who had served the monarchy fell under suspicion. Some fled to England or more congenial spots on the Continent. Others met their fate on the guillotine. But despite the suspicion that surrounded some actors and playwrights, there seems never to have been any shortage of performers willing to take their place. As greater stability and tranquility returned to the city at the end of the 1790s under the rule of the Emperor Napoleon Bonaparte, Paris now had more theaters than ever before in its history, and the city entered the nineteenth century as the undisputed European capital of both literary drama and popular vaudeville. Napoleon was to try, like the Bourbon kings before him, to restrain and censor the theater, introducing licensing and other censoring requirements in 1799 similar to those common under the Bourbon kings. But the sheer scale of the Parisian theatrical establishment made the institution increasingly difficult for state authorities to control. Thus the disputes and dilemmas that had become common in France in the last decades of the eighteenth century paved the way for the mass culture of theatrical entertainment that was to satisfy both popular and elite tastes in nineteenth-century Europe.

SOURCES

Gregory S. Brown, *A Field of Honor: Writers, Court Culture, and Public Theater in French Literary Life from Racine to the Revolution* (New York: Columbia University Press, 2002).

Robert Darnton, *The Literary Underground of the Old Regime* (Cambridge, Mass.: Harvard University Press, 1982).

William D. Howarth, *Beaumarchais and the Theatre* (New York: Routledge, 1995).

Emmet Kennedy, et al, *Theatre, Opera, and Audiences in Revolutionary Paris: Analysis and Repertory* (Westport, Conn.: Greenwood Press, 1996).

John Lough, *Paris Theatre Audiences in the Seventeenth and Eighteenth Centuries* (London: Oxford University Press, 1965).

Jeffrey S. Ravel, *The Contested Parterre: Public Theater and French Political Culture, 1680–1791* (Ithaca, N.Y.: Cornell University Press, 1999).

Michele Root-Bernstein, *Boulevard Theater and Revolution in Eighteenth-Century Paris* (Ann Arbor, Mich.: University of Michigan Press, 1984).

SEE ALSO *Dance: Ballet in an Age of Revolution*

SIGNIFICANT PEOPLE
in Theater

APHRA BEHN
1640–1689
Playwright

CLOUDED ORIGINS. The early years of Aphra Behn, the first Englishwoman to support herself by writing, are shrouded in some mystery. She was probably born in the village of Wye in the southeastern English county of Kent in 1640, but the identity of her parents is still not definitely known. Either when she was a teenager or slightly later in her early twenties she traveled to Surinam on the coast of South America. At the time, Surinam was an English trading colony, although it was later transferred to the Dutch. The experiences that Behn had while she was there formed the basis for her later novel, *Oroonoko* (1688). When she returned to London around 1664, she married Mr. Behn, a trader in the city whose family origins were Dutch and German. Her husband probably died about a year later, and in the years that followed she began to circulate in court circles where she was prized for her wit. Sometime around 1667, Aphra Behn went to Antwerp on a spy mission for Charles II; at this time, she amassed numerous debts in the king's service, and when she returned to England, she was imprisoned for them. She secured her release, but the king did not come to her aid. To pull herself out of her financial troubles, she began to write for the London stage, producing her first play, *The Forced Marriage*, in 1670. The play was staged by the Duke's Men and was a great success. In seventeenth-century England, it was generally customary for playwrights to receive box office proceeds for every third night that a play was performed. Since the theatergoing public in Restoration times was smaller than in Tudor or early Stuart times, most plays were staged for only a few nights. Behn's *The Forced Marriage* had six performances and its author consequently received the production's proceeds for two nights, a large sum that might keep a playwright sustained over months and even years.

SUCCESS AND FAILURE. In 1671, the company for which Behn wrote, the Duke's Men, moved into a handsome new theater designed for them by Sir Christopher Wren, and the author began to write plays at the rate of about one each year. Some of these (*The Rover* [1677] and *The Second Part of the Rover*) were successful, while a few others floundered and the author did not even receive one night's proceeds. Except for one tragedy and a tragicomedy, all her works were in the genre of "comedy of manners" that the Restoration theater favored. In particular, she often railed against the custom of arranged murders common in her day. Behn seems also to have been an astute judge of public tastes. In 1670, the wildly popular actress Nell Gwyn had retired from the stage after becoming the king's mistress; in 1677, Behn wrote the female lead in the comedy of manners play *The Rover* in an attempt to lure Gwyn out of her retirement and back to the stage. The actress obliged, helping to make the play a great hit. The following year, Behn wrote another work, *Sir Patient Fancy,* to include a role for the famous actress, and to honor her the playwright dedicated to Gwyn the publication of her work, *The Feigned Courtesans* in 1679. In these years Aphra Behn acquired her own dubious notoriety since her works were often filled with the bawdy humor and suggestions of sexual license that were favored at the time on London's stage. By the 1680s Behn's reputation as a dramatist of light comedies was well recognized, and her output of works was steadily increasing. Of all the Restoration dramatists, she ranked second only to John Dryden for the sheer number of her works. She produced three works, and another two in 1682. The last of these, *Like Father Like Son,* failed so miserably that the text was never published. In the prologue, too, she had included remarks that the censors found offensive, and she was arrested. While the outcome of her interrogation is not known, she was probably merely given a warning. But the incident, in tandem with the changing theatrical scene in London, seems to have discouraged Behn from writing for the theater for several years. Between 1682 and 1685, she apparently produced no works for the London stage. In the years leading up to her arrest, too, the company for which she wrote, the Duke's Men, entered on hard times, and by 1682 was forced to merge with The King's Men in order to survive. Behn's flagging productivity, then, may have been caused by these internal problems within London's theatrical companies. Whatever the reason, the author eventually returned to write for the theater, but only produced two more works for it in 1686 and 1687. Little is known about the circumstances of her early death in 1689, but she was immediately buried in Westminster Abbey, a sign of the high esteem in which she was held. This prestige and reputation persisted in many quarters, and two new plays were published after her death. Behn's plays were filled with sexual wit and bawdy humor, as were most of the works of Restoration playwrights. At the same time, reigning double standards meant that women were expected to exemplify higher moral standards than men. As a result, in the years following her death Aphra Behn had a dubious reputation for being a woman of loose morals and in the more restrained and conservative theatrical climate that developed in London after 1700, her works were rarely performed. Her career as a playwright, though, inspired a number of other women in the eighteenth century to imitate her example.

SOURCES

Derek Hughes, *The Theatre of Aphra Behn* (New York: Palgrave, 2000).

Frederick M. Link, *Aphra Behn* (New York: Twayne Publisher, 1968).

Jane Spencer, *Aphra Behn's Afterlife* (New York: Oxford University Press, 2000).

PEDRO CALDERÓN DE LA BARCA

1600–1681

Actor

DESTINED FOR THE CHURCH. Pedro Calderón de la Barca grew up in a strict household, an experience that left its mark on his later plays, many of which treat characters who disobey their dictatorial fathers. He was trained to take up a life in the church, but by his early twenties he was writing dramas for the court and serving in a noble household. Soon he became part of the small inner circle of confidantes to King Philip IV (r. 1621–1665), and he was eventually to be knighted in 1636. In these years his plays were performed, not only at court, but in the public theaters that were then popular in Madrid, Spain's capital. With the death of Felix Lope de Vega in 1635, Calderón came to be recognized as the greatest living Spanish dramatist. In 1640, he took up a military career when rebellion broke out among King Philip's Catalanese subjects, but when he was injured in the conflict, he retired from military service. In the years that followed he sired an illegitimate child, but a few years later decided to enter the priesthood. In 1651, he announced that he would write no longer for the stage. Although he largely held to this vow, refusing to write for the public theaters in Madrid, he did author plays for private performance in Spain's

royal court. For the remaining thirty years of his life he also authored each year *autos sacramentales,* or religious plays, for Madrid's celebrations of the Feast of Corpus Christi. In these years he also served as the priest to the king.

CHARACTER OF HIS WORKS. Calderón's career coincided with massive changes in Spain's political and cultural life. At the time of his birth Spain had recently suffered setbacks as a result of its conflicts with England and its prolonged involvements in the Dutch revolts. At the same time, the country possessed strong reserves of wealth and of intellectual life that continued to make it one of the most cultivated centers of learning in Europe. The Spanish public theater, which had begun to grow in Madrid and other cities throughout Iberia, had developed the form of the *comedia* in the first three decades of the seventeenth century into a high art form. At first, there was little difference between the dramas that were performed in the many *corrales* in towns like Madrid or Seville and those that entertained Spain's cultivated aristocrats, and the troupes that had performed in these theaters had often staged their productions before the king and court. The source of Spain's political and economic weaknesses were becoming increasingly evident in these years, however, as the monarchy failed to hold on to Holland and the other northern Dutch provinces and as it faced increasing resistance in Iberia itself. In 1640, Spain's theaters were closed when revolts in Catalonia and Portugal threatened public order. Even as Spain's domestic life grew more disordered and its economy more sluggish, Philip IV and his successors sponsored the development of an elite courtly theater for their own amusement. The *corrales* that had flourished in Madrid and other centers had been little more than ad hoc affairs remodeled out of existing courtyards that surrounded Spain's major monasteries. The country's religious confraternities had used public theaters as fund-raising opportunities to support their charitable endeavors. In 1533, though, Philip IV's new Madrid palace, the *Buen Retiro,* was completed, and among the new amenities it featured was a theater that made use of recent Italian innovations. The *Buen Retiro* provided for changes in scenery and other staging elements that raised the quality of court productions to the level of Baroque art. Calderón's decision to pursue a religious career, and his refusal to write for the public stage, then, must be evaluated against his subsequent activities at court. For in the years that followed his taking of priestly vows, the dramatist continued to write dramatic works for the court, and to contribute to the experimentation that was occurring at

the *Buen Retiro* in the development of a Spanish form of opera. In 1648, he wrote the first of his *zarzuelas,* a native Spanish art form that mixed spoken dialogue with songs in a two-act format. He followed up these experiments with the *zarzuela* format with other experimental works, and a few years later collaborated in the staging of the first Spanish opera. Like the drama that was being written at roughly the same time by Corneille and Racine in the French court, the works that Calderón prepared for the court were not realistic, but highly artificial. His dramatic productions, for instance, were not intended to be a naturalistic mirror of the world, but presented a highly formalized artistic vision of reality that might cause audiences to pause and ponder their underlying meanings.

DRAMATIC IMPACT. Much of the theater of seventeenth-century Spain had revolved around the question of honor, and in inane and silly comedies playwrights had often developed a formula in which the Spanish honor code was questioned, but yet emerged triumphant. In contrast to this trend, Calderón's art was subtler, and his reputation even at the time was considerably greater than the many craftsman-like dramatists that Spain produced. His most important works rise to the level of high art. In plays like *Life is a Dream,* Calderón explored perennial questions about the nature of free will and predestination, and he made major statements—as profound as those of William Shakespeare—about the nature of reality and the human psyche. In other works, like *The Painter of His Own Dishonor* and *The Surgeon of His Honor,* he relied on traditional formats like the comedy of intrigues, a venerable format in which various plots and subplots are hatched leading to a final climactic sequence of humorous events. At the same time he deployed the genre to reveal the inanity of certain Spanish customs, including practices like the isolation of young women. At other times, Calderón laid bare some of the underlying problems with the country's rigid code of honor. In sum, his works present testimony to an incredibly fertile mind that was fueled by a profound understanding of human capabilities and shortcomings.

SOURCES

Alexander Parker, *The Mind and Art of Calderón* (Cambridge, England: Cambridge University Press, 1988).

A. E. Sloman, *The Dramatic Craftsmanship of Calderón* (Oxford: Dolphin Books, 1958).

B. W. Wardropper, *Critical Essays on the Theatre of Calderón* (New York: New York University Press, 1965).

PIERRE CORNEILLE

1606–1684

French dramatist

EARLY SUCCESS. Pierre Corneille, the man who forged a reputation in French theater similar to Shakespeare in England, was born to an affluent family in Normandy and given an education in the classics by the Jesuits in his native Rouen. Eventually he took a law degree and entered into the king's service as an administrator of the royal forests and rivers. He continued to hold this post until his middle age, but in his early twenties he began to write dramas, the first of which was performed in Paris in 1530. The play, *Mélite*, became a hit on the Parisian stage, and Corneille continued to write dramas. Most of these early works were comedies, and in the years that followed the playwright came to the attention of Cardinal Richelieu, King Louis XIII's chief minister. Richelieu named the young playwright to his "Society of Five Authors," a group of dramatists from whom he regularly commissioned dramas for the Parisian scene. The cardinal stipulated which themes the authors were to take up and he even outlined their plots, and the members of the society were expected to write the drama collaboratively. Corneille chafed under such restrictions, although the theory of the classical unities that the group followed left its mark on his work. At the time, French literary theorists and dramatists were concerned about how the classical unities might be applied to the theater to foster literary greatness in the drama. The notion of the laws of unity had developed in Italy during the late Renaissance from a mistaken understanding of Aristotle's *Poetics*. Those playwrights who subjected their works to these canons were expected to confine their action to a single place on a single day and they were not to wander into subplots. Under Richelieu's powerful patronage, major dramatists in France began to subject their plays to these rules. At the same time, the unities imposed grave challenges on any playwright hoping to entertain an audience over the course of an evening. In his *Le Cid* (1637) Corneille resolved these challenges brilliantly, creating a tragedy that was immediately hailed as masterful and decried as morally defective. The subject for the drama was drawn from Spanish literature, and involved a romance between offspring of feuding families. In the first version of his dramatization, Corneille resolved this struggle in favor of the lovers, who marry despite the fact that the hero has killed the girl's father. Richelieu found the work offensive, and he instructed the Académie Française, an institution he had recently founded to foster greatness in French literature, to examine it. The members of the Académie diplomatically responded that the work was filled with much great poetry, but that its ending was unsuitable. The play as it stood was thus suppressed.

INCREASING CONSERVATISM. In the years that followed Corneille continued to write for the theater, at first under Richelieu's patronage, and then later under that of Cardinal Mazarin, Louis XIII and Louis XIV's chief minister. He married, and his brother Thomas, who also wrote for the theater, married Corneille's wife's sister. In the following years both brothers achieved great success in the theater, although Pierre Corneille's works have stood the test of time better than those of Thomas Corneille. While he continued to write tragedies, an increasingly conservative bent is discernible in these later works, one that after *Le Cid* rarely questioned social mores or standards. Many of his dramas, in other words, included subtexts that supported the absolutist monarchy and the Catholic religion, the two pillars of French society at the time. By 1643, the four finest of his tragedies were complete; these included *Le Cid* (1637), *Horace* (1640), *Cinna* (1641), and *Polyeucte* (1643). As his career as a playwright became more successful, he eventually moved from Rouen to Paris where he was admitted to the Académie Française. The failure of one of his plays in 1651 prompted Corneille to abandon writing for the theater for a number of years, although he continued to write poetry and to translate works into French. In 1659, he returned to drama and wrote plays until 1674, but his retirement from the theater in that year was prompted by the growing popularity of his rival, Jean Racine. For the remaining years of his life, Corneille wrote verse and lived to see some of his earlier dramas revived. While the quality of his dramas may not have risen to the high standard of Racine, he nevertheless helped to establish the canons by which the French stage was to flourish over the next century. His emphasis on drama as a literary force filled with beautiful poetry, often written in the twelve-syllable Alexandrine form, as well as his emphasis on the ennobling quality of tragedy were notions to which French playwrights returned time and again in the seventeenth and eighteenth centuries.

SOURCES

George Couton, *Corneille* (Paris: Hatier, 1958).

R. C. Knight, *Corneille's Tragedies: The Role of the Unexpected* (Cardiff, Wales: University of Cardiff Press, 1991).

P. J. Yarrow, *Corneille* (London: Macmillan, 1963).

NELL GWYN

1650–1687

Actress

AN UNFORTUNATE UPBRINGING. When she was just a child, Eleanor Gwyn lost her father, who likely died in a debtor's prison. The future great actress of the Restoration stage therefore grew up under the care of her mother, who ran a house of prostitution near Covent Garden, then in the western end of the city of London. In her childhood years she was a barmaid in her mother's establishment before becoming a fruit seller at the nearby Drury Lane Theater. She came to the attention of the theater's major actor, Charles Hart, and although only fifteen at the time she became his lover. Hart saw to it that she was given roles in productions and she continued in the company until 1669 when she became pregnant by the king. She returned to the theater for one production after the birth, but then soon retired to devote herself to her love, King Charles II. In the years that she had performed at the Drury Lane Theater, Gwyn premiered a number of roles in plays by John Dryden and James Howard. Although she acted in dramas, it was in comic roles that her talents were most evident. Observers noted that she had a quick and ready wit, and although illiterate, was able to charm even the most educated by the intelligence of her conversation. She was also considered to be an excellent singer and dancer, and she was admired for her abilities to recite the poetic prologues and epilogues that were common in the theater of the day. In her retirement the king granted her a house, where she entertained Charles and members of the aristocracy. She was twice coaxed back onto the stage during the 1670s, the first time to play the female lead in Aphra Behn's comedy of manners, *The Rover* (1677) and again in a role in the author's *Sir Patient Fancy* a year later. These productions were staged, not at her former establishment the Drury Lane Theater, but at the Dorset Gardens, the house belonging to the troupe known as "The King's Men."

AN EXTRAVAGANT LIFE. In the years after she became the king's lover, she devoted almost all of her energies to entertaining Charles and members of his court and to tending to her mother and children. Since she had the royal ear, she frequently became involved in intrigues at court, although she seems never to have tried to interfere in politics. Charles richly rewarded her with a generous allowance and a handsome house in the St. James' section of London so that she could be near the palace. He elevated the two sons she bore him to the nobility. With her newfound wealth, Gwyn provided a house for her mother in fashionable Chelsea, but her mother died in an accident in 1679 brought on by a bout of drunkenness. Despite the king's great largesse, Gwyn spent prodigiously and when Charles died in 1685, she was in danger of being sent to debtor's prison. Charles had commanded his brother King James II to look after "poor Nelly," and he quickly came to her rescue, dispensing with her debts and granting her a generous royal pension. For her part, the actress seems to have always been faithful to the king and to his memory; Charles, on the other hand, may have had two illegitimate children with Gwyn, but he produced a dozen more with other women, mostly from the nobility. Gwyn was the first great female "star" of the London stage, and her career both promoted and reinforced the notion that actresses were little more than prostitutes and courtesans. At the same time, Gwyn came to be widely admired throughout London because of her generosity of spirit, sense of fun, and ready wit. In this regard she stood in marked contrast to all of Charles II's other mistresses, many of whom were subjected to boos and catcalls as they moved about the streets of London. In particular, Charles' French mistress, the aristocratic and Catholic Louise de Kéroualle, the Duchess of Portsmouth, was particularly unpopular, and one day when Gwyn's carriage was moving through London's streets, the crowd mistook her for her French Catholic rival. Gwyn was said to have peered out of the carriage and shouted, "I am the Protestant whore!" It was this self-effacing quality that made the commoner Gwyn beloved among Londoners, and which made her death in 1687 following a stroke an event that elicited mourning from many of the capital's subjects.

SOURCES

Deborah Payne Fisk, ed., *The Cambridge Companion to English Restoration Theatre* (Cambridge, England: Cambridge University Press, 2000).

Derek Parker, *Nell Gwyn* (Stroud, England: Sutton, 2000).

John H. Wilson, *Nell Gwynn, Royal Mistress* (New York: Pellegrini and Cudahy, 1952).

DOCUMENTARY SOURCES
in Theater

Aphra Behn, *The Rover* (1677)—*The Rover* is the most successful and perhaps the greatest of the many plays that this female dramatist wrote for the London theater.

Charlotte Charke, *A Narrative of the Life of Mrs. Charlotte Charke* (1775)—In this memoir, the inimitable Char-

lotte Charke, an actress of the eighteenth-century London stage, tells of her exploits, which include a prolonged period of transvestism and the impersonation of a husband. Charke was the daughter of the noted actor, playwright, and English poet laureate Colly Cibber, and her adventures on the stage and off provide an unparalleled window onto the social history of the English stage in the eighteenth century.

Pierre Corneille, *Plays* (1630–1677)—Corneille's tragedies and comedies helped to establish a distinctive French art form characterized by formal verse and introspective concentration on the trials, triumphs, and failures of his heroes and heroines. Many translations are available in English.

Denis Diderot, *Discussion of the "Illegitimate Son"* (1757)—In this essay the great French Enlightenment thinker sets forth his ideas on the theater and reacts to his recent bourgeois drama, *The Natural Son*.

John Dryden, *Of Dramatic Poesie* (1668)—In this work the great Restoration dramatist defends the traditions of English drama against those of seventeenth-century French Neoclassicism and other European trends.

Ben Jonson, *The Works of Ben Jonson* (1616)—Although he relied on the same glorious verse forms and vocabulary as Shakespeare, Jonson developed a new genre of contemporary satirical comedy that was notable for its biting wit. His plays, *The Alchemist, Bartholomew Fair,* and *Volpone*, rank among the most accomplished of his prolific output.

Gotthold Ephraim Lessing, *Miss Sara Sampson* (1755)—This play was the first "bourgeois" drama to appear in Germany. It is a tragedy, based in part on Lessing's reading of English works about middle-class virtues, including the novels of Samuel Richardson. It was to have a profound effect on the development of a middle-class theater in Germany.

Jean-Baptiste Poqueline, or Molière, *Tartuffe or the Imposter* (1664)—The greatest comedy from one of France's premier dramatists, this play was to have a profound effect on the theater of the English Restoration.

Jean Racine, *Plays* (1633)—The author of this rich corpus of dramas perfected the verse form of tragedy first pioneered by Pierre Corneille. The works make use of the Alexandrine, or twelve-syllable, verse format and were notable for the influence they cast over many later French playwrights.

William Shakespeare, *Works* (1590–1616)—The works of perhaps the greatest dramatist of all time are available in many modern editions, some of which provide helpful annotation to illuminate their Elizabethan language.

Voltaire, *Irène* (1778)—In the year of his death the poet and dramatist was invited back to Paris to view a production of this play at the Comédie-Française. The excitement of his reception eventually resulted in the Enlightenment thinker's death.

VISUAL ARTS

Philip M. Soergel

1597 The Bolognese painter Annibale Carracci begins his ceiling frescoes at the Palazzo Farnese in Rome, a key work in inspiring a new monumental and heroic style of history painting during the Baroque era.

1600 The Italian painter Michelangelo Merisi, better known as Caravaggio, completes the *Calling of St. Matthew* for the Contarelli Chapel at the Church of S. Luigi dei Francesi. The work is widely admired for its realistic capturing of a crucial moment.

1606 Rembrandt van Rhijn, the greatest Dutch painter of the seventeenth century, is born in the city of Leiden in the Netherlands.

1613 Claude Lorrain, who will become France's greatest Baroque landscape painter, arrives in Rome to begin studying painting.

1618 The Thirty Years' War begins in Central Europe. The conflict will bring widespread devastation and disrupt noble patronage of the arts.

1621 The Italian painter Francesco Barbieri, better known as Guercino, begins his ceiling painting at Rome entitled *Aurora*.

Peter Paul Rubens, the greatest Flemish artist of the Baroque period, begins painting a series of monumental paintings for Marie de' Medici's residence, the Luxembourg Palace in Paris.

1623 The Italian Gianlorenzo Bernini sculpts his *David*, a work of dramatic tension that typifies the Baroque's taste for dynamic movement.

1625 The Italian artist Artemisia Gentileschi paints her famous *Judith with the Head of Holofernes*.

c. 1628 The French painter Nicholas Poussin completes his classically-inspired *The Inspiration of the Poet*.

c. 1630 The French artist Georges de la Tour paints his *Newborn,* an unprecedented work illuminated by the light of a candle.

1632 Jan Vermeer, who will become a great painter of scenes of everyday Dutch life, is born in the Netherlands.

1633 Bernini completes the huge canopy, or baldachino, that covers the high altar in the Church of St. Peter's at Rome.

1635 The great Flemish painter Anthony van Dyck paints *Charles I at the Hunt,* a work that is now in the Louvre in Paris.

c. 1636 Peter Paul Rubens completes his wildly energetic *Peasants Dancing*.

1639 The Italian fresco painter Pietro da Cortona finishes his monumental ceiling fresco in the Barberini Palace at Rome entitled *The Triumph of the Barberini*.

1640 Peter Paul Rubens dies after a long and productive career.

1641 Anthony van Dyck dies after a distinguished career in service to courts throughout Europe.

1642 The Italian painter Guido Reni, an important exponent of the early Bolognese style of Baroque painting, dies.

Rembrandt van Rhijn paints his masterpiece *The Night Watch*.

1648 The Peace of Westphalia draws the Thirty Years' War to a close in Central Europe. Over the next century a resurgence in church building and remodeling will leave

its mark on many of the Roman Catholic churches of the region, most of which will be elaborately decorated with murals and ceiling frescoes in the Baroque style.

The Royal Academy of Art is founded in Paris by Charles Le Brun.

1651 The sculptor Bernini's *Fountain of the Four Rivers* is completed in Piazza Navona at Rome. At the same time, the artist is at work on his famous Cornaro Chapel where he will immortalize Saint Theresa of Avila's life with his *Ecstasy of St. Theresa*.

1652 Artemisia Gentileschi, one of the first female artists to influence painting styles throughout Europe, dies at Naples.

1656 The Spaniard Diego Velázquez completes his *Las Meninas*, a group portrait of Spanish ladies in waiting and members of the Spanish royal family. The work is unprecedented for its great originality.

1662 At the suggestion of his minister Colbert, Louis XIV purchases the Gobelins factory at Paris to weave tapestries and produce decorative arts. Colbert hopes to wean French consumers away from consuming foreign imports. During the next three decades the Gobelins scheme will train a number of workers in the techniques of crafts that have until this time been unknown in France.

1665 The French classical painter Nicholas Poussin dies at Rome.

The Dutch painter Jan Vermeer completes his *Girl with Yellow Turban*.

1666 The accomplished Italian painter Guercino dies at Bologna after a distinguished career.

The French sculptor François Giraudon is given the commission for a monumental fountain of *Apollo Tended by the Nymphs* for the Gardens at Versailles.

1667 Rembrandt paints the last of his evocative *Self-Portraits*.

1669 Gianlorenzo Bernini begins terracotta studies for a monumental equestrian statue of Louis XIV that is never completed.

1671 Bernini begins construction of a tomb for Pope Alexander VII in the Basilica of St. Peter's at Rome.

1680 Bernini dies at Rome at the age of 82.

1685 The Hall of Mirrors is completed at Versailles and includes thirty ceiling paintings executed in a Baroque classical style by the artist Charles Le Brun and his studio.

1702 In England, Queen Anne ascends the throne. During her reign a great age in furniture and cabinet making will develop in England, setting simple, yet elegant design standards that spread throughout Northern Europe.

1710 The royal chapel is consecrated at Versailles near Paris with elegant ceiling frescoes by the French artist Antoine Coypel.

1715 The young boy Louis XV ascends the throne of France. During his long reign the Rococo decorative style will flourish and eventually be superseded by a new fondness for classicism.

1727 Thomas Gainsborough, destined to become one of England's greatest portraitists, is born.

1730 Josiah Wedgwood, founder of the great china company that bears his name and a major innovator in the manufacture of porcelain, is born at Burslem, Stoke, in England.

1732 The Trevi Fountain is begun at Rome. When complete thirty years later it will include an enormous mass of statues from the hands of four great eighteenth-century Italian artists.

1733 Cosmas and Egidius Asam complete their masterpiece, the Church of St. John Nepomuk at Munich. The church is notable for its integrated use of painted decoration and architecture.

1738 Germain Boffrand's Salon of the Princess is finished in the Hôtel de Soubise in Paris. The room reflects the reigning decorative spirit of the Rococo.

In Bavaria, François Cuvilliés begins assembling collections of Rococo decorative motifs. He publishes these and they begin to exert an important influence on the decorative arts.

1740 François Boucher paints the Rococo work, *The Triumph of Venus,* a painting now in the National Museum in Stockholm.

1741 Angelica Kauffmann, a woman destined to become one of Britain's premier portraitists, is born in Switzerland.

1747 The Venetian artist Giovanni Battista Piranesi settles in Rome. During the remaining decades of his life he will create about 2,000 engravings of ancient buildings and monuments that will be widely circulated throughout Europe and will help to inspire a new taste for Neoclassicism.

1750 The Italian painter Giovanni Battista Tiepolo begins his fresco decorations at the Residence in Würzburg, Germany.

1757 Louis XV and his mistress Madame de Pompadour found the Sèvres Porcelain Manufactory not far from Versailles. The aim is to reduce France's consumption of foreign porcelain and the factory has a tremendous influence on establishing tastes in the decorative arts during the later eighteenth century.

1763 Josiah Wedgwood patents his Queen's Ware, a beautiful cream-colored pottery born of his experiments in manufacturing.

1764 The English satirical painter Hogarth dies in London.

1765 The French painter Jean-Honoré Fragonard completes the painting *The Bathers.*

1767 The English architect Robert Adam begins construction of the Library at Kenwood House, his great decorative masterpiece. In the years that follow, the designer exerts a profound influence by popularizing the Neoclassical style throughout the English-speaking world.

1770 John Singleton Copley, North America's greatest colonial artist, finishes his famous portrait of the Boston silversmith Paul Revere.

1775 The Royal Copenhagen porcelain factory is founded in Denmark.

1784 The English portraitist Thomas Gainsborough paints his famous *Portrait of Mrs. Siddons as the Tragic Muse.*

The French artist Jacques-Louis David completes his *Oath of the Horatii,* a work that treats a legend from ancient Rome and expresses the political mood of the country.

1788 Elizabeth Vigée-Lebrun, one of France's foremost portraitists, paints the last of her portraits of Queen Marie-Antoinette.

1792 Sir Joshua Reynolds, one of England's greatest eighteenth-century masters, dies.

1793 Jacques-Louis David immortalizes the assassination of the famous French Revolutionary Marat with his *Death of Marat.* In the same year the Royal Academy of Painting and Sculpture is abolished in Paris.

OVERVIEW
of Visual Arts

A LEGACY OF TECHNICAL ACHIEVEMENT. Increasing technical mastery and experimentation in the visual arts had characterized the three centuries that preceded the rise of the Baroque style around 1600. During the Renaissance, artists had gradually perfected a number of techniques that allowed them to portray the natural world in ways that appeared more realistic than ever before. They had also studied the art of Antiquity, and by 1500 many Italian artists, in particular, worked in a fashion that was heavily influenced by their understanding of a classical harmony and proportion. New media, like oil paints, came to allow later Renaissance artists to portray the world in ways that were strikingly realistic. Thus as the Baroque age approached, Western painters and sculptors inherited several centuries of rising mastery over their craft. This trend provided them with the tools to portray nature and the human with a variety of techniques that increased art's verisimilitude, that is, its ability to mirror the natural world. During the brief period of the High Renaissance, roughly from 1490 to 1520, artists working in Rome and Florence had developed a classical language notable for its finesse, harmonious beauty, and monumental scale. For much of the rest of the sixteenth century, many artists in Italy and Northern Europe experimented with a less serene vision. In Italy, the new style was known as Mannerism, and it produced a highly intellectual and often self-consciously elegant art. In contrast to the standards of balanced and proportional design that High Renaissance masters had favored, Mannerist artists presented the human body in contorted poses with elongated forms. They dispersed the figures in their compositions to the edges of their panels and canvases, subverting the Renaissance tendency to create groupings of figures at the center of a picture. At the same time, the Mannerists evidenced a fashion for difficult to understand symbols and themes. The new style flourished most decidedly in Italy's courts, although the migrations of Italian artists into Northern Europe, and the journeys of artists from the Netherlands, Flanders, Germany, and Holland to Italy, helped popularize Mannerism elsewhere in Europe. Above all, this movement prized artistic creation as an artificial phenomenon, as Mannerist artists came to reject the long-standing Renaissance trend toward naturalism. Instead Mannerist artists and their patrons favored creations that were more beautiful and elegant than nature really was.

CRISIS AND RENEWAL. The sixteenth century, although a time of brilliant cultural achievements in all the arts, was also a troubled era in the arenas of politics, religion, and society. The Protestant Reformation was to tear asunder the more than one thousand years of Christian unity in Western Europe and to initiate more than a century of religious conflict and wars. The church response to this crisis was at first piecemeal but as the sixteenth century progressed, a broad Catholic Reformation gathered increasing strength. At the Council of Trent (1545–1563), Catholic leaders met to answer Protestant charges, and their response was to define the course of Catholicism until modern times. In the final days of the meeting, the church fathers considered the issue of religious art and the role that it should play in the life of the faithful. In contrast to many Protestant leaders who had aimed to curb its uses, the Catholic leadership reaffirmed religious art's powerful role as a textbook for the illiterate. At the same time, Trent's decrees insisted that bishops should carefully supervise the works displayed in churches to insure that they were readily intelligible to the masses. The Council did not formulate clear guidelines concerning what kinds of art were appropriate for use in the Roman Catholic Church, and its pronouncements on the matter were hurriedly crafted. But in the years that followed, two Catholic reformers and bishops, Charles Borromeo of Milan and Gabrielle Paleotti of Bologna, were to work for the reform of religious art in Italy and Europe. The writings of both figures were to have a major impact on the development of early Baroque art. In their writings on the subject, each figure took a slightly different tactic concerning religious art. Milan's bishop, Charles Borromeo (1538–1610), insisted that religious art must have a clear message and serve to educate people in the tenets of the faith. Beyond this, he stressed that paintings and sculpture should stir the emotions, moving the faithful to repentance. As bishop of Bologna and an influential member of the church's hierarchy, Gabrielle Paleotti (1522–1597) was to patronize a group of artists who led a reaction against Mannerism. He found this art overly intellectual and thus too difficult for the average Christian to understand. He insisted instead that religious art's meanings should be more thoroughly didactic, and the styles he favored were more nat-

uralistic and realistic than those generally in fashion in late sixteenth-century Italy. Although he patronized artists who shared his vision, Paleotti grew increasingly pessimistic in the later years of his life about the possibility of a true artistic reform. In the years immediately following his death, though, several artists working in Rome were to lay the groundwork for a new style, helping to fashion a visual language that in some ways mirrored Paleotti's pronouncements concerning art.

THE EMERGENCE OF THE BAROQUE STYLE. In the years around 1600, this extraordinary group of artists created a number of works that were to help to define the new Baroque style. No single path was evident in these works, but instead the art of the developing Baroque evidenced a great variety from the first. In the monumental ceiling frescoes of Annibale Carracci (1560–1609), for example, the new style took a highly dramatic and dynamic turn. Carracci's works were heavily influenced by the tense and muscled figures Michelangelo used to populate the Sistine Chapel ceiling and by the art of the Parman painter Correggio (1494–1534), a figure who had been widely overlooked by Mannerist artists during the sixteenth century. In his ceiling frescoes at the Palazzo Farnese in Rome, Carracci attempted to wed the fine draftsmanship that had been typical of Florentine and Central Italian Renaissance masters to the rich use of colors that had flourished in Northern Italy in such figures as Titian, Veronese, and Correggio. In place of the static, harmonious, and highly intellectual compositional strategies of Renaissance and Mannerist artists, Carracci's works suggested swift, dramatic movements and were notable for their appeal to the emotions. A drama of a somewhat different kind was typical of the art of Michelangelo Merisi da Caravaggio (1571–1610). Instead of presenting images of idealized beauty like Carracci, Caravaggio painted from life models, immortalizing the typical faces and gestures of the contemporary Roman street. The artist also relied on dramatic contrasts of light and dark in his paintings, using these to capture the excitement of the precise, crystallized moment in which a miracle or religious conversion occurred. In his famous painting of the *Conversion of St. Paul* (1601), for instance, he showed the exact moment when the apostle was thrown from his horse and blinded by a light from Heaven. Inspired by this unprecedented artistic insight, many Roman painters came to imitate his example, and in the first half of the seventeenth century, centers of Caravaggesque painting soon developed throughout Italy.

PAINTING IN NORTHERN EUROPE. The experiments of figures like Carracci and Caravaggio in Italy were also to inspire several generations of painters in Northern Europe, many of whom came to study in Rome in the first half of the seventeenth century. Among the figures that made the journey to the ancient capital were Peter Paul Rubens (1577–1640), Anthony Van Dyck (1599–1641), Georges de la Tour (1593–1653), Claude Lorrain (1604 or 1605–1682), and Nicolas Poussin (1594–1665). While a few of these masters ended up staying in Italy, most were to return to Northern Europe, where they were to produce stunning masterpieces that forged elements of their own native traditions with the dramatic intensity and monumental style that was becoming ever more pronounced in the Italian Baroque. Of the many masters who were affected by the example of Italian masters, Peter Paul Rubens was to rank among the greatest creative figures of the seventeenth century. Rubens, a Catholic convert from Antwerp, seems to have been initially affected by the art of the High Renaissance as well as the enormous scale typical of Carracci's works and the dramatic immediacy and lighting techniques of Caravaggio and his followers. Returning to his native city, Rubens made these elements his own, forging a style that appealed to the deeply pious churchmen and patrons in his native city. He soon won continental acclaim. Developing a highly successful studio, Rubens was to fill the halls of courtly palaces from Spain to Germany with enormous canvases that displayed a swift brushwork that suggested a hitherto unseen dramatic intensity and sense of movement. Despite Rubens' success in Catholic Antwerp, the artistic excitement his career inspired did not long outlast his death in 1640. Flanders, a region battered by the religious and economic changes of the era, was to fall into a profound and prolonged depression, as artistic innovation shifted northward to the now independent provinces of the northern Low Countries. In Holland, the largest of the counties in the new confederation known as the United Provinces, a commercial market in art was emerging in which art dealers purchased and traded in the works of many masters. Here art was becoming a venerable investment for the first time in European history. Holland and the other members of the United Provinces were Calvinist, and as such, artists working there were to produce few great religious works. During the late sixteenth century, most Dutch churches had been whitewashed and their religious paintings and sculptures had been removed. While some Dutch painters like Rembrandt van Rhijn (1606–1669) were to paint religious works for private consumption and for Catholic patrons elsewhere in Europe, most of the Dutch masters produced portraits, landscapes, and genre scenes of everyday life. Great variety characterized these works' styles, ranging from the

free, expressive brushwork and psychological insight of Rembrandt to the spiritualism and faithful realism of Jan Vermeer.

BERNINI AND CORTONA. As Holland's market in painting was heating up, the Baroque style continued to develop in Italy, entering upon a new phase of complexity and dramatic intensity by the mid-seventeenth century that art historians have long called the "High Baroque." The two greatest artists of this stylistic phase were Gianlorenzo Bernini (1598–1680), a universal genius similar to Michelangelo or Leonardo da Vinci, and the painter Pietro da Cortona (1597–1669). Bernini was a master of all the artistic media, but above all an architect and sculptor. With the election of his patron, the Cardinal Maffeo Barberini, as Pope Urban VIII in 1623, he began to rise to a favored position among all the artists of the city. From this vantage point, he left an indelible stamp on Rome's cityscape, designing numerous fountains and other public monuments that were to transform the town. The dramatic proportion and energy of these monuments was to be widely imitated, not only in Italy, but also throughout Europe during the remainder of the Baroque period. At the same time that Bernini was completing his many architectural and sculptural commissions, the great Northern Italian artist Pietro da Cortona was completing a series of works that were to inspire many artists over the coming centuries. Cortona's most imaginative creation was a new kind of ceiling fresco in which various scenes were combined into an entire complex whole that stretched across the broad spaces soaring above Baroque palaces. Like Bernini's sculptural creations, Cortona's style of ceiling frescoes found their way to many places beyond Rome, inspiring numerous imitators. Until the eighteenth century, no one came to surpass Cortona's sense of scale, complexity, dramatic energy, or ornamental beauty.

ROCOCO AND NEOCLASSICISM. The visual language that Baroque and High Baroque masters created dominated painting and sculpture in much of Europe until the early eighteenth century. The style was particularly popular among the many absolutist kings and princes of the era, since the new style's complexity, moralistic themes, and monumental scale could be infinitely adapted to rulers wishing to impress their subjects with images of their power and authority. Around 1700, though, a new, lighter fashion, eventually to be called Rococo, began to appear in France before spreading to other parts of the Continent. The Rococo resulted from a number of complex changes underway in French aristocratic society. In contrast to the grand receptions characteristic of the Baroque court, cultivated Parisian society now came to favor small, intimate gatherings held in exquisitely decorated salons. Patrons commissioned works that treated everyday pleasures for these bright spaces. Artists like Antoine Watteau (1684–1721), François Boucher (1703–1770), and Jean-Honoré Fragonard (1732–1806) epitomized the Rococo's search for an art that was deliberately elegant, light, and beautiful. All three masters were prolific draftsmen and the circulation of engraved copies of their works helped popularize the highly ornamental Rococo style throughout Europe. The imprint of these three artists, too, was to leave its mark on the decorative arts, as the patterns and drawings of each came to find their way onto everything from upholstery fabric to porcelains. Although the Rococo's rise and advance throughout Europe was rapid, it was also uneven. Italy and England proved relatively impermeable to the movement's decorative impulses, while Central Europe and Spain enthusiastically welcomed the new fashions.

NEOCLASSICISM. While the Rococo's spread throughout aristocratic societies in Europe had been swift, a new fashion for Neoclassicism would supplant its influences in the second half of the eighteenth century. The Rococo had arisen from a number of complex social changes that were transforming life in eighteenth-century Europe. So, too, Neoclassicism arose from a similarly multifaceted mixture of social and intellectual forces. During the 1730s and 1740s, the first systematic archeological excavations of ancient towns began at Pompeii and Herculaneum in southern Italy. These digs were to uncover a dramatically different picture of the art and architecture of Roman Antiquity than that which had been popular throughout Europe since the Renaissance. Through the undeniably beautiful engravings of artists like Giovanni Battista Piranesi (1720–1778), an appreciation for the standards of ancient design grew among contemporary artists and their patrons. By this time Rome had become the ultimate destination of the Grand Tour, an artistic and cultural pilgrimage that the sons and daughters of wealthy aristocrats, merchants, and gentlemen made as the culmination of their education. In Rome, these tourists came to collect ancient sculpture and decorative arts according to the growing fashion of the time, as well as to patronize the many classically influenced artists working there. Returning home, they continued to indulge their love of Antiquity, a fashion that also fit with the developing intellectual currents of the Enlightenment. In France, England, and Central Europe, the philosophers of this movement recommended the austere severity of ancient art, with its clear, readily intelligible principles of design, as most befitting to societies

that were striving to reform themselves according to the demands of human reason. Neoclassicism thus became synonymous in the imagination of the age with the attempt to clear away superstitions and to foster a more logical social order. The style was to leave its largest imprint on historical paintings, a genre that had flourished throughout the seventeenth and eighteenth centuries. In the works of figures like Jacques-Louise David (1748–1825), a new genre of moralistic history painting came to narrate ancient themes in ways that were a commentary on the ills of contemporary life. In the decades after 1760, Neoclassicism's influence came to reshape portraiture, sculpture, and the decorative arts. Yet like the rise of the Rococo, the pervasiveness of Neoclassicism was short-lived, as the faith the movement placed in human reason came to be questioned in response to the cataclysmic events of the French Revolution. Elements of Neoclassicism survived into the first decades of the nineteenth century, but a new fashion for a sentimental and emotional art, a movement that became known as Romanticism, was already beginning to become evident in the final years of the eighteenth century.

TOPICS
in Visual Arts

THE RENAISSANCE LEGACY

TECHNICAL BRILLIANCE. During the fifteenth and sixteenth centuries, painters and sculptors working in Italy and the Low Countries (modern Belgium and Holland) had perfected a number of techniques that allowed them to render nature and the human form more successfully than ever before. Chief among these developments had been the early fifteenth-century discovery of techniques of linear perspective. In the years following 1400 in Florence, the painter Masaccio and the sculptors Ghiberti and Brunelleschi had perfected a set of geometric rules for rendering three-dimensional space on a two-dimension picture plane. Somewhat later, the humanist and artist Leon Battista Alberti set these rules down in a treatise entitled *On the Art of Painting*. As this work circulated, artists came to master these techniques, and painting and sculpture throughout Italy took on a sense of depth and solidity as a result. While experimentation in perspective dominated the works of Italian artists, Flemish painters were developing new techniques in oil painting that allowed them to paint human beings and matter in a strikingly realistic way, us-ing rich palettes of vibrant hues. By 1500, this school of Flemish realism had perfected their observations of the natural world to such a high point that even today these works continue to present observers with images that seem to reach an almost photographic standard for their faithfulness to detail. As Flemish masters developed their realistic techniques, art in Italy entered a new phase of development at the end of the fifteenth century with the rise of the High Renaissance style. This brief, but brilliant period was to witness the achievements of three great masters: Leonardo da Vinci (1452–1519), Michelangelo Buonarroti (1475–1564), and Raphael Sanzio (1483–1520). These High Renaissance masters were to forge a style notable for its naturalism, its faithfulness to classical design standards, and its harmonious and idealized sense of proportion and beauty. While this great era of artistic achievement flourished, though, Italy's political situations grew ever more chaotic and troubled, and the High Renaissance vision of order and harmony came to be short-lived. By 1520, both Leonardo da Vinci and Raphael had died, and Michelangelo had begun to experiment with an altogether more tempestuous and turbulent style. By the time of the Sack of Rome in 1527, the artistic vision of the High Renaissance, with its emphasis on order, harmony, and balance, had begun to fade in favor of a new Mannerism. This new movement was notable from the first for its vivid palette, for its elongated and sinuous lines, as well as for its intellectualism, elegance, and purposeful violation of the rules of High Renaissance classicism.

MANNERIST COMPLEXITY. Not every center of Italian art proved susceptible to this Mannerist vision. In Venice and much of northern Italy, artists and patrons were largely resistant to the new design trends. Here the serene vision of High Renaissance classicism continued to shape visual expression throughout much of the sixteenth century. In Parma, the short-lived painter Antonio Correggio (1494–1534) produced a series of creations that made use of the High Renaissance sense of monumentality, although he endowed his works with a greater dramatic energy and sense of movement than was typical of the early years of the sixteenth century. His art, largely ignored throughout most of the sixteenth century, was to inspire the masters of the early Baroque, particularly Annibale Carracci. In Florence and Rome, though, it was the new Mannerist vision that predominated, and here a number of artists produced works that willfully played with and extended artistic possibilities by violating Renaissance standards of classicism. Instead of harmonious and staid symmetry typical of the late fifteenth and early sixteenth centuries, Mannerist artists

dispersed the figures in their paintings to the four corners of their pictures and created intricate, interwoven groups of human forms. They elongated the body, presenting it in lithe and elegant poses. Mannerist painters favored a heavily muscled, contorted vision of the human body under a new dramatic pressure that suggested energy. In other works, these artists presented the human figure—noblemen and aristocratic ladies, wealthy merchants, or the Virgin and the Christian saints—with a serene detachment. Parmigianino's *Madonna of the Long Neck* (begun in 1534) was typical of a strain of extreme elegance widespread among the Mannerist artists of the day. The venerable subject of the Virgin and Christ child had never been treated in medieval and Renaissance paintings in quite the way that Parmigianino imagined it. He stretched the Virgin's body and neck, perching the small, but extremely beautiful head of Mary atop an enormously lengthened form. Mary appears more like an aristocratic woman than as a traditional devotional figure; her hair is elegantly coifed and dressed with pearls. Similarly, the Christ child was shown, not as if he was an infant, but as if he had the body of a stripling, that is, a child eight or ten years old. Around this central composition, Parmigianino inserted a number of other characters whose precise relationship to the religious theme of the painting is not easily discernible. These figures were not positioned in the middle of the composition, as they might have been in a work of the High Renaissance. Rather, in the left foreground of the painting, Parmigianino placed a group of beautiful, angelic admirers. One of these figures presents an amphora, a large vase-like vessel, to the Virgin. To the right, the picture plane recedes into a deep space, where a prophet is shown unrolling a scroll. Merely decorative elements (a classical column that does not support a portico and a pulled back drapery) suggest that this is not a natural scene, but a posed and highly elegant reinterpretation of a traditional religious theme. The tendencies that the artist displays here, to distort and elongate the human body and to present traditional religious themes laden with a set of complex and not easily comprehensible symbols, were typically Mannerist elements.

INFLUENCE OF MICHELANGELO. For inspiration, many Mannerist artists also turned to the works of Michelangelo. The origins of the term Mannerism derived from the Italian words *a la maniera* (meaning "in the manner of"), used in the sixteenth century to refer to artists that imitated the great Michelangelo, who was recognized even at the time as the great Olympian genius of the day. Many agreed that his works had surpassed the examples of classical Antiquity, and conse-

quently, his creations were widely studied and imitated. In the later frescoes that he undertook in the Sistine Chapel at Rome around 1511 and 1512, the artist began to experiment with new compositional techniques. He presented the human body heavily muscled and placed under a dramatic tension that suggested heroic vigor and movement. In the years that followed Michelangelo left Rome and returned to Florence, where he continued to experiment and perfect this style. He also completed several architectural projects in Florence that were to have a widespread impact on buildings in the later sixteenth century. As Michelangelo matured, his artistic vision also became highly personal, even idiosyncratic, and his treatment of the human body reflected these changes. His forms grew more dramatic and elegantly elongated. The imitation of his style among Mannerist artists working in Rome and Central Italy became a recognizable feature of the artistic culture of the age.

FASHION FOR DIFFICULT THEMES. Another recognizable trend of the period was its fondness for difficult themes and complex iconographies. In the cultivated courtly circles that increasingly dominated the sixteenth-century Italian scene, a taste for allegory and literary references was reflected in patrons' choices of themes. Of the many abstruse and difficult-to-understand works that were painted at the time, perhaps none has ever surpassed Angelo Bronzino's *Exposure of Luxury*, a work that was once called *Venus, Cupid, Folly, and Time*. Painted around 1545 for the Medici duke in Florence, the image brilliantly captures the Mannerist movement's taste for exotic and puzzling subjects. At the top of the picture Father Time pulls back a curtain to reveal Cupid fondling Venus. The lovers are pelted with flowers by a *putto*, or cherub. In the background of the painting these subjects' alter egos, Envy and Fraud, appear. Envy tears her hair, while the beautiful figure of Fraud presents a honeycomb with her left hand. If we follow the lines of her body, however, we see that her form culminates in a griffin's tail. Discarded masks litter one side of the panel, while a dove, the symbol of Venus, trills and coos in the foreground. The allegorical meanings of this work have long been debated, even as they likely were by those who admired the painting in the cultivated circles that surrounded the Medici dukes. Mannerist paintings like Bronzino's were, in fact, similar to other widely practiced games and pastimes of the Italian courts. A fashion for emblems was one of the hallmarks of this kind of highly sophisticated society. Emblems were complex amalgamations of symbols that conveyed an allegorical meaning and they were printed in books, used on architectural decorations, and even painted onto dinner-

ware. They were the crossword puzzles of the age, since the symbols they presented were intended to stymie and perplex intellectuals, forcing them to comb through their memories to unlock the symbolic meanings that were hidden in these pictures. So, too, works like Bronzino's *Exposure of Luxury* were entertainment for an increasingly refined and educated circle of cultivated elites.

SHIFTS IN THE LATER SIXTEENTH CENTURY. By the later sixteenth century tastes began to shift away from the elaborate, sometimes contrived iconography and extreme refinement typical of the late phases of Mannerist art. While many Mannerist innovations continued to inform the world of the early Baroque period, the religious proscriptions of the Counter Reformation demanded a public art that was clear, forceful, and readily intelligible to viewers. Exotic iconographical confections like Bronzino's *Exposure of Luxury* continued to be commissioned for private consumption during the late sixteenth century, but the Mannerist propensity for veiled references and difficult themes was increasingly judged inappropriate for the arena of the church. The developing religious sensibilities of the Catholic Reformation sought out an art that was capable of inspiring the faithful to repentance and Christian perfection and at the same time able to defend the Catholic faith against Protestant criticisms. The first evidence of this renewal, however, arose in the architecture of the period. During the final decades of the sixteenth century, Michelangelo's great High Renaissance dome was to be completed at St. Peter's, and the Jesuit Order was to astound Rome with its monumental church, Il Gesù, providing the foundation upon which the early Baroque style in architecture was to develop. In the many churches that were to be built or remodeled as the Catholic renewal gathered steam in Rome, broad expanses were being prepared for the display of religious paintings and sculpture. Around 1600, an extraordinary group of painters came to flourish in Rome who developed a new visual language that was uniquely suited to the emerging demands of the Catholic Reformation.

SOURCES

Fritz Baumgart, *Renaissance und Kunst des Manierismus* (Köln, Germany: M. DuMont Schauberg, 1963).

W. Braungart, ed., *Manier und Manierismus* (Tübingen, Germany: M. Niemeyer, 2000).

Walter Friedländer, *Mannerism and Anti-Mannerism in Italian Painting* (New York: Columbia University Press, 1957).

John Shearman, *Mannerism* (Harmondsworth, England: Penguin Books, Ltd., 1967).

SEE ALSO *Architecture: The Renaissance Inheritance and Catholic Renewal*

THE COUNTER REFORMATION'S IMPACT ON ART

REACTION TO MANNERISM. The stylistic changes evident in the visual arts at the beginning of the Baroque period can in part be traced to historical developments that occurred in the wake of the Council of Trent (1545–1563), the church council that was to define the character of Roman Catholicism and its teachings until modern times. The Council's purpose was to debate and to answer the attacks Protestants had made against the church and to reform abuses in church practices and administration. During the final days of the session, the church's fathers met to discuss issues surrounding the invocation of relics and the use of statues and images in religious worship. Because the deliberations were hampered by time considerations, many questions were left unresolved at Trent, although the Council's decrees insisted on the value of religious art, a position that rejected the criticisms levied by some radical Protestant factions of the day that paintings and statues violated Old Testament prohibitions against "graven images." By contrast, the fathers at Trent reiterated the Catholic Church's long-standing support for religious art. Its purposes, they intoned, should be didactic, that is, it should serve to educate the unlettered masses in the truths of the church. While the Council insisted that bishops had a duty to eliminate works whose message was unclear or indistinct, their decrees provided few guidelines for establishing acceptable religious art. In the years that followed, the subject of religious art came to be debated vigorously throughout Italy, largely through the efforts of two Italian bishops: Charles Borromeo (1538–1584) of Milan and Gabrielle Paleotti (1522–1597) of Bologna. Both figures were widely influential in establishing guidelines for the creation of religious art, even as they came to vigorously oppose many designs and themes favored by Mannerist artists and their patrons. Borromeo, a major figure in many aspects of Catholic reform, published his treatise *Instructions for Builders and Decorators of Churches,* in 1577, and its 33 chapters considered such subjects as the proper church layout, design, and furnishings necessary for Christian worship. In one chapter, he discussed the ways in which artists should treat sacred themes. Borromeo argued that religious art should present its themes in a clear, readily intelligible way so that art might instruct viewers in Catholic teaching and encourage the faithful to repent. This work also pre-

scribed a system of fines for painters and sculptors who violated these guidelines.

BORROMEO'S INFLUENCE ON RELIGIOUS ART. While Borromeo aimed to censor religious art by outlawing the Mannerist tendency to veil meanings, the bishop was at the same time an enthusiastic promoter of religious images. The *Spiritual Exercises* of Saint Ignatius Loyola had very much shaped his own piety. In that work, the founder of the Jesuit Order had recommended that the faithful place before their mind's eye images of the Passion and the feats of the saints so that they might flee sin. Among the contemporary artists Borromeo admired were Jacopo Bassano, Antonio Campi, and the great Venetian Titian, and his private collection of images included several works by these masters. In public commissions for the Cathedral of Milan, Borromeo favored works by Antonio and Giulio Campi, brothers who were members of a prominent family of artists from nearby Cremona. Their works exemplified Borromeo's principles by being readily intelligible and treating their subjects in clear and forceful ways. The messages of their works were set off with artistic features that enhanced their emotional appeal. As the sixteenth century drew to a close, other artists came to study Borromeo's writings as well, and in this way, the circle of artistic innovators who were capable of expressing the new principles of Catholic reform broadened.

GABRIELLE PALEOTTI. Another force in the reform of religious art at the end of the sixteenth century was Cardinal Gabrielle Paleotti (1522–1597). Born in Bologna, Paleotti received a doctorate in canon law by the time he was 23, and eventually made his way to Rome, where he rose to become the judge of the *Sacra Rota*, a key court of appeals within the Vatican government. He was raised to the rank of a cardinal in 1565 and a year later was made bishop of Bologna. While much of his career was spent furthering the cause of church reform, he became fascinated with the subject of religious art in particular. Toward the end of the 1570s, he dedicated himself to writing a massive theological treatise on the correct uses of painting and sculpture within Catholicism. A friend of Borromeo, he took as his departure point the Milanese bishop's earlier work on church building and decoration, but he intended his *Discourses* to be a far more thorough examination of all the issues surrounding religious art. Like Borromeo, he insisted that religious art's messages must be clear and forcefully conveyed, but at the same time he recommended a return to the naturalism of the Renaissance and the fostering of a spirit of historical realism in painting. Paleotti was never able to complete his theological work on painting and sculpture, but even in its incomplete form his treatise was to have a major impact in defining the religious art of the later sixteenth century. At Bologna, his work encouraged a number of artists to abandon Mannerist conventions and to develop a clearer and more forceful presentational style in their religious works. Among the most prominent artists to study Paleotti's recommendations and to adopt them in their work were Annibale, Lodovico, and Agostino Carracci, key figures in expressing many of the design tenets that subsequently flourished during the early Baroque. Yet during the 1580s and 1590s, Paleotti's generally humane and moderate proposals for artistic reform went unheeded in the larger Italian artistic world. By the 1590s, the cardinal had returned to Rome to take up administrative duties within the church. Surveying the artistic scene in the church's capital, he grew increasingly pessimistic about the direction contemporary religious art was taking. During these years, he proposed that the church establish an office to censor religious images, an office that would be similar to the Index of Prohibited Books, an institution that, since 1559, had been charged with supervising and censoring book publication in Catholic countries. The plan was not adopted, and Paleotti died several years later. In the years immediately following his death, though, some of Paleotti's prescriptions for a historically accurate and naturalistic art came to fruition in the works of artists at Rome. At the same time, a new fashion for propagandistic works became evident, as leaders of the Catholic Reformation came to commission works that celebrated the triumph of the church in a grand and monumental fashion.

THE ROMAN JUBILEE OF 1600. Something of the sense of triumphal resurgence that was developing at Rome can be gleaned from the preparations that occurred in Rome to mark the Jubilee year 1600. Jubilee years had long been celebrated in the church's history to mark the passage of every quarter century, but during the sixteenth century, the rise of Protestantism had discouraged such events. To mark a departure from the recent dismal past, Pope Clement VIII planned to make the Jubilee Year 1600 into a major occasion that might promote the renewal that was underway in the church. During the Jubilee more than three million pilgrims visited the city to admire the many monuments that Clement and his immediate successors had built in preceding years. Among these were the Dome of St. Peter's, the Jesuit's Church of Il Gesù, major renovations to the Church of St. John Lateran, as well as a number of public monuments and squares. As the expectation for this event grew, many of Rome's religious institutions and

church officials came to commission a number of religious works from painters and sculptors. The works of the greatest of these artists came to express a new dramatic tension, a sense of movement, and realism that responded to the Catholic Reformation's demands for a clear and forceful art that might stir the hearts of the faithful. In this way Rome was to shape the development of the early Baroque style in the visual arts in a way that was similar to the role that it was acquiring as Europe's major center of architectural design.

SOURCES

The Age of Correggio and the Carracci, Exhibit Catalogue for the National Gallery of Art, Washington, D.C., 1986.

Paolo Prodi, *Il Cardinal Gabrielle Paleotti (1522–1597).* 2 vols. (Rome: Edizioni di storia e letteratura, 1959–1967).

E.C. Voelker, "Borromeo's Influence on Sacred Art and Architecture," in *San Carlo Borromeo: Catholic Reform and Ecclesiastical Politics in the Second Half of the Sixteenth Century.* Eds. J. M. Headley and J. B. Tomaro (Washington, D.C.: Folger Shakespeare Library, 1988).

Rudolf Wittkower and Irma B. Jaffe, eds., *Baroque Art: The Jesuit Contribution* (New York: Fordham University Press, 1972).

SEE ALSO *Religion: Catholic Culture in the Age of the Baroque*

ELEMENTS OF THE BAROQUE STYLE

INTERRELATED TRENDS. During the final quarter of the sixteenth century, the first gleanings of the paths that the seventeenth-century Baroque style was to take became evident in Bologna, the episcopal city administered by the Catholic reformer Gabrielle Paleotti. The leaders of this Bolognese school, Lodovico, Annibale, and Agostino Carracci, came to fashion a new kind of art that was in many ways opposed to the intellectual formalism and sophistication of the Mannerists. Their new style responded to the Catholic Reformation's demands for religious works that were clear and readily intelligible and which spoke to the hearts of the faithful. By virtue of the many students that the Carracci taught in Bologna, this new style emerged as a recognizable school of painting by the end of the century. Still great variety persisted on the Italian artistic scene, as many Mannerist masters continued to find a receptive audience willing to support them with commissions. With the arrival of Annibale Carracci in Rome in the late 1590s, though, Italy's foremost artistic center was presented with an artist who self-consciously aimed to revive many High Renaissance design principles. His works advocated a return to the naturalism and to the sense of order and harmonious balance that had marked the early sixteenth-century works of Michelangelo, Raphael, and Correggio. At the same time, a new dramatic sense of movement and even an ecstatic religious piety played a role in his work. Its appeal to the emotions, in other words, was far more profound than the intellectualism of the High Renaissance style. The efforts of Annibale Carracci and his Bolognese students who followed him to Rome were particularly important in establishing one feature of the visual arts in the Baroque: its attempt to harness emotions by impressing viewers with a sense of drama and a climactic whole that was greater than its parts. The Bolognese vision was only one part of the complex stylistic changes that were underway in Rome at the end of the sixteenth and the beginning of the seventeenth centuries. In these years the formidable talent Michelangelo Merisi da Caravaggio was carving out a different path in the Baroque's development. Caravaggio's works were notable for their realism. In contrast to the careful preliminary studies and drawings that Annibale Carracci and the Bolognese school made before painting, Caravaggio worked directly from life models, using this technique to capture the immediacy of the moments he narrated in his works. He clothed his models in contemporary costumes and relied on dramatic lighting to bathe his figures in contrasts of light and dark. As the examples of Caravaggio, the Carracci, and other Bolognese painters came to be appreciated on the Roman artistic scene, others came to experiment with the techniques these figures had demonstrated. Some known as "Caravaggisti" followed the path of Caravaggio's gritty realism, while others came to reflect the more classically inspired Bolognese values. Still others aimed to fuse both kinds of artistic visions. In general, though, none of the trends that are evident in the early Baroque in Rome—a return to High Renaissance classicism, the appearance of a sense of dynamic movement in paintings and sculptures, and the taste for portraying subjects in a way that was intensely realistic—was mutually exclusive. We frequently see artists in the first generations of the Baroque experimenting with all three of these elements to produce new kinds of artistic expression that spoke to the religious, social, and intellectual demands of their times.

THE CARRACCI. The city of Bologna was the northernmost outpost of the Papal States in Italy, the lands that the pope controlled as his own territory in the peninsula. During the 1580s, the brothers Annibale and Agostino Carracci and their cousin Lodovico Carracci

a PRIMARY SOURCE document

NEW DISCOVERIES

INTRODUCTION: The Baroque painters who came to maturity in the early seventeenth century were indefatigable students of art, traveling throughout Italy in search of inspiration. Most came to detest many Mannerist currents of art, and instead sought out older inspiration in Michelangelo or in other noted artists of the Renaissance. The great figure of Antonio da Correggio (1494–1534) was one of the artists that Annibale Carracci admired. Despite his short life, this artist left behind a number of important frescoes in and around the city of Parma. In 1580, Carracci wrote a letter to his cousin back in Bologna shortly after he had arrived in the city. He described his excitement at witnessing this great and relatively overlooked master's works. As Carracci developed his style he drew major inspiration from the swiftly moving forms of Correggio's High Renaissance art.

I do not know how many things I have seen this morning except the altarpiece showing St. Jerome and St. Catherine, and the painting of the Madonna with the Bowl on the Flight into Egypt. By Heaven, I would not want to exchange any of them for the St. Cecelia! Say yourself if the grace of St. Catherine who bows her head with such charm over the foot of that beautiful Christ Child is not more beautiful than Mary Magdalen? And that beautiful old man, St. Jerome, has he not more

grandeur and also more tenderness than has the St. Paul of Raphael, which at first seemed a miracle to me and now seems a completely wooden thing, hard and sharp? Moreover, can one not say so much that even your Parmegianino has to put up with these remarks, for I know now that he has attempted to imitate the grace in the pictures of this great man, but he is still far from having obtained it. The putti of Correggio breathe, live and laugh with such grace and truth that one must laugh and be gay with them.

I am writing my brother that it is absolutely necessary for him to come here, where he will see things which we never would have believed possible. For the love of God urge him to dispatch quickly those two tasks in order to come here at once. I shall assure him that we shall live together in peace. There will be no quarrelling between us. I shall let him say anything he wants and shall busy myself with sketching. Also I do not fear that he will not do the same and abandon talking and sophistry, all of which is a waste of time. I have also told him that I shall try to be at his service, and when I have come to be known somewhat I shall inquire and look for opportunities.

SOURCE: Annibale Carracci in A Documentary History of Art. Vol. II. Ed. Elizabeth G. Holt (Garden City, N.Y: Doubleday Books, 1958): 72–73.

had established a successful studio in Bologna that experimented with ways to revive High Renaissance classicism. They soon acquired a number of students, and their efforts, along with those of a number of other Bolognese artists, came to shift artistic commissions in Central Italy away from the then-dominant Mannerist movement. Of the three, it was Lodovico Carracci (1555–1619) who had the most pretensions of being a scholar, although Annibale was to carve out a niche as the most successful painter. Lodovico was the eldest of the three, and except for a brief visit to Rome and some travels in his youth, he spent almost all his career in provincial Bologna. While Lodovico tried to return to the High Renaissance classicism and naturalism, some Mannerist influences survived in his work. He was particularly drawn to the color of Venetian painting, and like all three Carracci, he greatly admired the works of Correggio (1489–1534), a painter from Parma, whose monumental ceiling frescoes in that city's cathedral were to inspire several generations of Baroque painters. Influential on the local scene in Bologna, Lodovico Carracci came to leave an even greater imprint on the art of the

age through his influence on his younger cousins as well as several of his students, the most important of these being Guido Reni, a prolific seventeenth-century master. Lodovico's early experiments in reviving a more naturalistic and classical style of depiction were soon superseded by his cousins Annibale and Agostino, although Lodovico helped set the mold for the Carracci's later success, in his efforts to join the Florentine tradition of draftsmanship (disegno) with Venetian and northern Italian coloristic techniques (colore). For much of the sixteenth century, artists and theorists had debated which of these two traditions was superior. Venetian and northern Italian artists, for instance, had long been recognized for the sophistication of their colors and their attempts to suggest mass and depth through the building up of rich layers of oils on canvases and panels. By contrast, the Florentine tradition of drawing a picture from studies and according to a rationally conceived program was seen as a very different tradition. The Carracci's famous studio at Bologna attempted to forge a union between these two distinctive traditions.

ANNIBALE CARRACCI AND THE PALAZZO FARNESE CEILING. The greatest of these three masters was Annibale

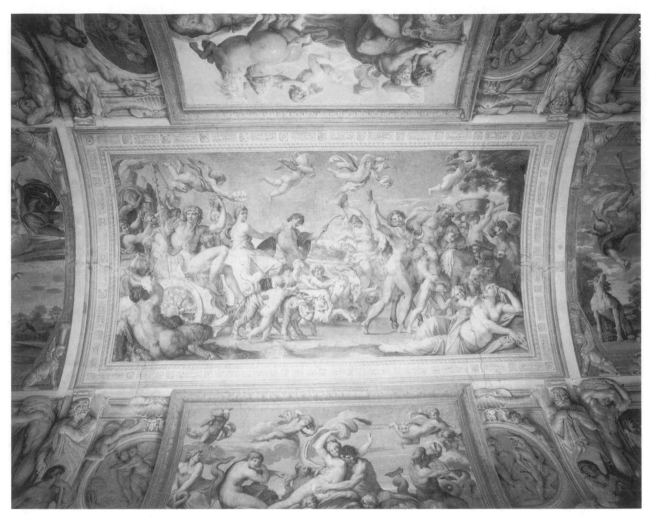

Triumph of Bacchus and Ariadne, ceiling fresco in the Palazzo Farnese, Rome, by Annibale Carracci. © **MASSIMO LISTRI/CORBIS. REPRO-DUCED BY PERMISSION.**

(1560–1609), who may have studied painting early on with his cousin Lodovico, but who was also influenced by the currents of Mannerism in Bologna during his youth. Even in his youthful works Annibale displayed an imaginative fusion between the many different painterly styles current in Central and Northern Italy. Like Lodovico, he was fascinated by the Florentine tradition of draftsman-like design, but equally captivated by the rich coloristic techniques of Venetian art. His works early on displayed a more thorough naturalism than that present in the artificial and highly elegant world of Mannerism, and he acquired many admirers, including Cardinal Odoardo Farnese, at the time a high-ranking member of the church's government. In 1595, Annibale came to Rome at Odoardo's insistence. Odoardo commissioned Annibale to paint a large gallery in the cardinal's palace. The work was one of the first defining masterpieces of the Baroque, and a composi-

tion that was widely admired soon after its completion in 1600. Carracci's creation was at the time seen to be of equal importance to Michelangelo's Sistine Chapel ceiling or the papal apartment frescoes that Raphael had executed at roughly the same time. Over the centuries such extravagant assessments of the Farnese Gallery have faded, yet it is nevertheless a brilliant achievement. The subject of the eleven major frescoes that Carracci painted in the hall was the loves of the pagan gods. Although the theme appears pre-Christian on its surface, the work actually manages to praise Christian virtues through the use of a number of hidden symbols and deeper meanings. Its use of an intellectually conceived program was to be a typical feature of Baroque ceilings, as was its use of many veiled and hidden meanings. At the same time, the work is accessible through its triumphant imagery, monumental scale, and impressive sense of dynamic movement. Stylistically, the ceiling made use of ideal-

ized human forms that were similar in feeling to those of the great Michelangelo's Sistine Chapel frescoes. To organize the design, Annibale Carracci divided the hall's barrel or rounded vault into a number of different images, each of which he framed with illusionistic devices so that they appeared to be set in individual frames. Between many of these, he placed classical nudes, again painted to appear as if they were sculptures and seeming to serve the role of *caryatids*, ancient statues that supported the porticos of temples. In its total effect the entire ceiling takes on the impression of being like the artistic gallery of a cultivated collector, filled as it is with images that suggest a collection of ancient art and sculptures. Throughout the work, Carracci also managed to wed the venerable traditions of draftsmanship to a Northern Italian sense of color. As a result of his example, he breathed new life into the fresco form, creating a style of composition that was to be widely imitated over the next two centuries in any number of monumental ceiling cycles executed by artists, both in Italy and abroad.

OTHER BOLOGNESE PAINTERS IN ROME. During the early years of the seventeenth century, a number of other painters from the Carracci studio made their way from Bologna to Rome, including Guido Reni (1575–1642), Domenichino (1581–1641), and Francesco Barbieri, better known as Guercino (1591–1666). Reni and Domenichino had trained in the studios of Agostino and Lodovico Carracci, while Guercino arrived there as a young painter and came to be influenced by their example. While the influence of the Carracci's style is evident in all their works, each of these figures developed a slightly different direction in their art. In 1601, Guido Reni was called to Rome by the papacy, and although he remained active there over the next decade and a half, he divided his time between the church's capital and Bologna. Often in disagreement with his papal patron, he was threatened for a time with arrest for his disrespect for papal authority. At home in Bologna, he developed a large and successful studio that executed many religious paintings in the new style for churches in Central and Northern Italy. About 250 of his works survive today, suggesting the fertility of his artistic imagination and the diligence with which he developed his studio. Reni painted a number of images of the Virgin Mary that were widely copied. Commercially, he was the most successful of the many painters who flourished in Italy at the time, and he was widely admired for his ability to present the religious sentiment of ecstasy in a way that appeared almost breathless. Personally, he was deeply religious, like many of the artists of the Bolog-

nese school, but at the same time he avoided praise and seems to have suffered from a conflicted sexual nature. It was his tendency to present religious sentiments in his work in ways that suggested the ethereal, which caused nineteenth-century art historians to discount his work as overly sentimental. His paintings have more recently been reassessed, and his impact on the artistic culture of the time has come to be better understood. By contrast, Domenichino's work was more thoroughly classical in spirit and organization. The artist produced a number of works on mythological and ancient themes, notable for the use of heroic figures set in landscapes that appear classical in origin. Domenichino's portrayal of the human emotions was more turbulent and less idealized than Reni's, a fact for which many artistic academicians criticized him in the later seventeenth century. Even during his life he had to defend himself against the charge that his works were derivative, since he frequently assembled many of his figures and landscapes from his knowledge of previous works of art. The long-lived figure of Guercino (a nickname that means "squinty-eyed") was also successful on the scene in Rome, where he caused a sensation with his creation of a ceiling fresco treating the myth of *Aurora* in a garden outbuilding at the Villa Ludovisi. Through his mastery of illusionistic techniques, he carried the lines of the room's structural architecture upward onto the ceiling and filled the vault with a narrow channel marked out by these false illusionary structures. Through this space Aurora's chariot careens with *putti* (small angelic figures), doves, and clouds being separated and dispersed in its wake. His style here, as it was elsewhere, was highly refined and given to luxurious display. Somewhat later, Guercino retired to his native Cento near Bologna, where he continued to preside over a successful studio. During the early 1530s, Queen Marie de' Medici of France considered hiring him for a time as her court painter but was unable to do so when she was forced into exile because of disputes with her son King Louis XIII. Although he traveled to complete commissions, Guercino continued to live in Cento until his death in 1666 at the age of seventy-five.

THE IMPORTANCE OF THE BOLOGNESE SCHOOL. The rise of a distinctive school of painting at Bologna came to have profound effects on the art of seventeenth-century Italy. The distinctive mix of naturalism, classical styling, and coloristic techniques that these Bolognese painters crafted was to begin to leave its mark on the city of Rome's artistic scene around 1600. The rise of other competing visions of the Baroque did not dampen the enthusiasm for the Bolognese masters, although they

came to be favored in some courts and cities while disregarded elsewhere. In the figure of Caravaggio (1573–1610), a second, even more dramatic vision of the new style developed. This altogether more turbulent and dynamic art came to appear on the Roman scene about the same time as Annibale Carracci was painting his famous frescoes in the Gallery of the Farnese Palace in Rome. Like the Carracci, Caravaggio's work was to attract many disciples, who saw in his strikingly realistic paintings, with their strong contrasts of light and shade, a suitable vehicle for conveying the religious themes of the age. These followers of Caravaggio were to become known as the "Caravaggeschi," a distinctive school of followers who imitated the lead of their inspiration, just as the Bolognese painters came to closely model their compositions on those of Lodovico, Annibale, and Agostino Carracci. This division of the painterly world in seventeenth-century Italy into rival camps is one of the distinctive features of the age. At the same time, it is possible to see that artists working in Rome came to derive inspiration from both schools of painting.

SOURCES

Dennis Mahon, *Studies in Seicento Art and Theory* (London: Warburg Institute, 1947).

Donald Posner, *Annibale Carracci*. 2 vols. (London: Phaidon Press, 1971).

Richard E. Spear, *Domenichino*. 2 vols. (New Haven, Conn.: Yale University Press, 1982).

Rudolf Wittkower, *Art and Architecture in Italy: 1600 to 1750*. 3rd ed. (Baltimore, Md.: Penguin Books, 1981).

———, *Studies in Italian Baroque* (London: Thames and Hudson, 1975).

SEE ALSO *Architecture: The Rise of the Baroque Style in Italy; Music: Origins and Elements of the Baroque Style*

REALISM AND EMOTIONAL EXPRESSIVITY

CARAVAGGIO. Michelangelo Merisi (1573–1610), who became known as "Caravaggio" after his family's native town, was a truly revolutionary painter. During the seventeenth century his influence spread throughout Italy and eventually Europe. Despite his short life, a school of painters in Italy known alternately as the "Caravaggeschi" or "Caravaggisti" carried on his legacy of dramatic realism. Elsewhere in Europe, many artists came to be affected by his art, including the great Rembrandt and Rubens. The young Michelangelo's father

was an official in the household of one of the Sforza, the ducal family that controlled Milan and surrounding Lombardy. In Caravaggio's youth the family seems to have moved back and forth frequently between their small, native village and the great city of Milan. When he was in his early twenties, he sold his share in the family's inheritance and left Lombardy, probably arriving in Rome around 1592. Early sources suggest that Caravaggio was a renegade and that he was involved in frequent brawls and quarrels. Even later, when his star had risen in Rome, he was often frequently caught up in court cases and a participant in brawls and eventually fled the city after killing a man in an argument. In temperament, the surviving sources paint a picture of a melancholic and incendiary spirit, prone to quick flashes of temper, but also to deep fits of depression. Upon his arrival in Rome, he was forced to take whatever positions he could find. He worked, for instance, in the household of a church official, churning out stock devotional images for use in his household. Then, he came to paint heads for a painter's studio, mastering the techniques of portraying the face so well that he was able to produce several works in a day. In these jobs, he was paid by the piece, although other painters soon recognized his skills and he rose to become a painter of half-length portraits in the then-reigning Mannerist style. After being kicked by a horse, he was forced to seek hospitalization in the ward of Santa Maria della Consolazione, and during the months of his convalescence, he produced a number of pictures for this institution. With his health restored, Caravaggio played a more independent role in the artistic life in Rome. For a time he lived in the household of Monsignor Fantigno Petrignani, a church official, and in this period his art began to take on a greater self-assurance. Next he seems to have been patronized by the Cavaliere D'Arpino, one of the reigning Mannerist painters in Rome. Around 1595, he painted a large number of pictures that show the influence of Northern Italian examples on his art. Among the most famous of these are the *Fortune Teller*, *The Cardsharps*, and *The Rest on the Flight into Egypt*. These canvases reveal a fascination with the properties of light, a feature that Caravaggio developed into a hallmark of his style. Their delicate and lyrical style, though, reveals little of the intense realism that Caravaggio was to develop as he matured over the next few years.

INCREASING STYLISTIC ASSURANCE. Caravaggio's increasing technical mastery and individualistic style came, in large part, as a result of his association with the Cardinal del Monte. By the mid-1590s, Caravag-

gio's art was attracting increasing attention in the Roman artistic scene, and the cardinal asked the artist to become a member of his household. At the time, del Monte was the Tuscan ambassador to the papal court, and he lived in one of the Medici family's palaces in Rome. Refined as a connoisseur of art and skilled as a musician, scientist and mathematician, del Monte's household was one of the most sophisticated in Rome at the time. The young Caravaggio was paid to paint pictures, and during his years there, he seems to have produced at least ten works for the cardinal. It was under the cardinal's influence, too, that the artist received the commission to execute a series of paintings for the Contarelli Chapel in the Church of San Luigi dei Francesi. The theme was the Life of St. Matthew, and Caravaggio painted three canvases for the chapel, the greatest of which was his *Calling of St. Matthew.* This subject had long been treated using the passage in Matthew 9 as a guide: "And as Jesus passed forth … he saw a man named Matthew, sitting at the receipt of custom: and he saith unto him, 'Follow me.' And he arose and followed him." In his rendering of this story, Caravaggio endowed the deceptively simple lines of the narrative with an understanding of the social dynamic in which Matthew's life-changing decision occurred. The gritty realism with which he immortalized the scene had never yet been seen in the world of Italian painting. Most previous treatments had sanitized the story, making it appear heroic through idealization. Caravaggio instead embraced the real meaning of the account, and in so doing he endowed Matthew's life-changing miracle with a sense of religious immediacy and drama that painters had not achieved to this point. Matthew, in fact, had been a Jewish publican (a collector of Roman tolls and taxes), an occupation that was detested in ancient Judea. In Caravaggio's rendition, he is shown sitting at a table in the tavern receiving payment from his minions. The boys and men that surround him are drawn with the typical local faces that Caravaggio had observed while a minor portraitist in Rome. The clothing and setting are typically Roman as well. In the background a window's panes are covered with the grimy oilcloth used in common people's homes and public houses. Light does not flow into the room from this source, however, but from above Christ's head. It cascades across the canvas to illuminate the faces of Matthew and his circle, throwing them into a harsh light that sets off patches of illumination against dramatic darkness. To the right, the head of Christ is barely visible behind the form of St. Peter, the savior's first disciple. With his outstretched arm, Christ motions to Matthew, just after he has spoken the words, "Follow

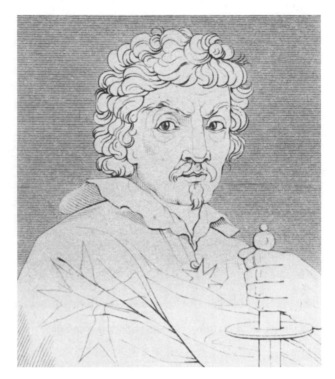

Engraving of Caravaggio from his self-portrait. **THE LIBRARY OF CONGRESS.**

me." Matthew turns his index finger toward his breast, as if to ask, "Me?" In this way Caravaggio was able to capture the pivotal moment of Matthew's life-changing conversion, the leap of faith that marked his transformation from a lover of worldly wealth to a follower of Christ. The realism that his image suggested achieved the kind of pious demands that figures like St. Charles Borromeo and Gabrielle Paleotti had argued in previous decades should invigorate the religious art of the Catholic Reformation.

LATER ACHIEVEMENTS. In the decade that followed the completion of the *Calling of St. Matthew,* Caravaggio painted a number of works notable for their dramatic intensity as well as for their sometimes coarse, even seamy presentation of religious themes. His success at the Contarelli Chapel was soon surpassed by the *Conversion of St. Paul.* As in the *Calling of Matthew,* the artist concentrated on the critical moment of conversion. Saul's transformation from a persecutor of Christians to the apostle Paul had often been treated in Renaissance art, and it remained a popular theme for painters in the Counter Reformation as well. In many previous treatments of the theme, Christ had been shown descending from the heavens surrounded by clouds and cherubs to speak the famous words, "Saul, Saul, Why persecutest thou me?" By contrast, Caravag-

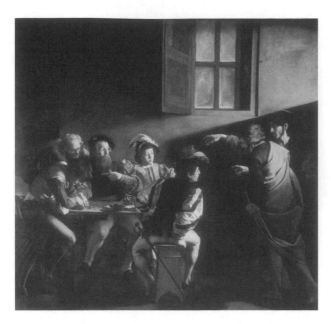

The Calling of St. Matthew by Caravaggio. © ARALDO DE LUCA/CORBIS.

gio dispensed with these saccharine trappings, and instead captured the instant at which Saul was thrown from his horse on the road to Damascus. He lies prostrate on the ground before us, his body dramatically foreshortened and appearing to project out from the picture plane into the viewer's space. In the background his horse has not even put down his front leg after rearing under the shock of the blinding light that has fallen from heaven. Saul throws out his arms toward the source of that light in the sky, while in the background his aged servant merely looks on, puzzled by his master's reactions. Engulfed in the darkness, the servant, in other words, has no clue to the great miracle that is occurring at this moment within Saul's soul. In this way Caravaggio depicted the event as a fully internal event, but one that occurred within the setting and trappings of everyday life. Beyond the ethereal light that streams into the canvas from the upper right to bathe Saul, no suggestion of the divine presence is made. Similar innovation marked several of Caravaggio's later paintings treating the life of the Virgin Mary. As the Mother of God, painters and their patrons had long taken great care to present Mary in ways that might spark reverence and admiration. Such a trend for idealized images of the Virgin continued in the seventeenth century and inspired the many ethereal presentations of artists like Guido Reni and his imitators. During 1604, Caravaggio painted an image of the *Madonna of Loreto* for the Church of San Agostino near the Piazza Navona in Rome. The previous winter, he had spent time in north-

ern Italy, not far from the shrine of the Holy House of Loreto, a place believed to house the actual childhood home of the boy Jesus. Returning to Rome, Caravaggio painted an image of the Virgin standing in her doorway like an Italian housewife, being admired by two pilgrims. Instead of idealizing Mary, Caravaggio painted his model faithfully, complete with dirt under her nails. Again, as in the *Conversion of St. Paul*, Caravaggio intended such homely portrayals to call attention to the way in which God worked through humble agents and to heighten his viewers' piety with the realization that those involved in the sacred dramas of scriptures had been ordinary men and women. Yet some felt at the time that his tendency to make the sacred profane was troubling, and the Madonna of Loreto immediately caused a controversy because of its homely portrayal of Mary. Similar criticisms were made, too, of the artist's *Death of the Virgin*, a painting that is now in the Louvre Museum in Paris. Typically, most artists had treated Mary's triumphant Assumption into Heaven, rather than focusing on the final hours of her life and death. Caravaggio, by contrast, showed the Virgin sick and bloated, just after the final throes of her suffering and with her bare legs outstretched as if in rigor mortis. When the painting was presented to the Roman monks who had commissioned it, they rejected it. Such a reaction to Caravaggio's work had become increasingly common at the time. But even as churchmen came to reject his works for public display, others clamored to purchase them for their private collections. In the case of the *Death of the Virgin*, many criticized the painting specifically for showing the Virgin's legs undraped, as well as for the artist's choice of a notorious local prostitute to serve as the model. Others attacked it for being too realistic, since there was no hint of Mary's triumphant journey to heaven. Instead the apostles and women who attended the woman seem struck by a grief so profound that there is no hope for release. Such works caused Caravaggio's art to be reviled, even as it was widely imitated by many later figures.

INCREASING TROUBLES. Even during the hightide of his success, Caravaggio's personal troubles were multiplying. Between 1600 and 1606, the artist had been accused of assault on an almost annual basis. In these years, he and his associate Orazio Gentileschi were also accused of libel, and a notorious case brought by the highly successful artist Giovanni Baglione granted the artist a dubious celebrity. In 1606, Caravaggio killed a man in a brawl that occurred after a tennis match, and he was forced to flee Rome for southern Italy. He traveled to Naples, then to Malta, and in these

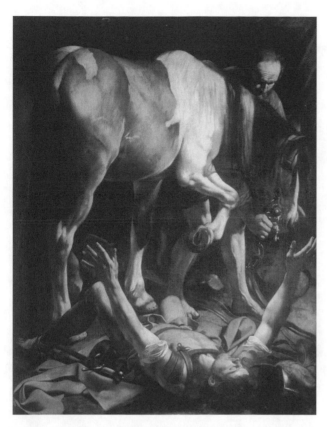

Conversion of St. Paul, Cerasi Chapel, Church of Santa Maria del Popolo, Rome, by Caravaggio. © ARALDO DE LUCA/CORBIS.

final years he continued to receive commissions. Wounded again in a fight, he spent several months convalescing at Naples before deciding to sail to Rome in 1610 after several intercessions gave him the impression that he might be pardoned if he returned there. As his boat was about to set sail, he was mistaken for another criminal, caught, and arrested. Although released a few days later, he developed pneumonia and died soon afterward.

INFLUENCE. Despite his short and stormy life, Caravaggio's output of paintings was enormous and his works were avidly traded in by artistic connoisseurs even in the early seventeenth century. The artist's travels in his later years from Rome to Naples to Malta left examples of his art in southern Italy, at that time a province of Habsburg Spain. From this vantage point they came to be studied by Italian and Spanish masters, and their highly dramatic imagery was widely imitated. Many Northern European artists who traveled in Italy were very much influenced by Caravaggio's example. Those who imitated Caravaggio's way of painting, in particular, adapted his use of *chiaroscuro* (the painting of light against dark spaces) to suggest drama. They also longed

to perfect his strikingly realistic style. In his technique, Caravaggio was an innovator, and throughout his later life he tried vigorously to guard the secrets of his working methods. Renaissance painters had usually made detailed studies for their compositions before beginning to work on their canvases and panels. Caravaggio, by contrast, painted without preparatory studies using live models. To achieve his effects of *chiaroscuro* he placed his models in a darkened room lit only with strong lighting placed high above their heads. His patron, the Cardinal del Monte, was very much interested in the science of optics, and reports survive that suggest that Caravaggio may have used lenses to project the outlines of his models and their setting onto his canvases. The attempt to capture nature faithfully was to be one of the preoccupations of the seventeenth century, and Caravaggio's example of a rough and dramatic realism was to inspire many who followed him.

SOURCES

Fritz Baumgart, *Caravaggio. Kunst und Wirklichkeit* (Berlin: Gebr. Mann, 1955).

Walter Friedlaender, *Caravaggio Studies* (Princeton: Princeton University Press, 1955).

Howard Hibbard, *Caravaggio* (London: Harper and Row, 1983).

Michael Kitson, *The Complete Paintings of Caravaggio* (New York: Harry N. Abrams, 1985).

A. Moir, *Caravaggio* (New York: H. N. Abrams, 1982).

THE CARAVAGGISTI

CARAVAGGIO'S FOLLOWERS IN ROME. During the final years of his life and for about two decades following his death, Caravaggio's example was avidly imitated by a number of painters at Rome. This trend developed in the years immediately following 1600, as the successes of the artist's works in the Cerasi and Contarelli chapels were recognized. The dark and brooding elements of his style soon appeared in a number of works by other artists, including those of Giovanni Baglione (1566–1643), Orazio Gentileschi (1576–1639), Tomasso Salini (1575–1625), and Bartolommeo Manfredi (1582–1622). While he lived, Caravaggio detested this trend, and he tried to protect the secrets of his working methods. Two of the earliest imitators, Giovanni Baglione (1566–1643) and Tomasso Salini (1575–1625), became his sworn enemies. In 1603, Baglione sued Caravaggio and his friend Orazio Gentileschi, charging them with libel. He believed that the two were responsible for writing verses

A DISH COOKED WITH NEW CONDIMENTS

INTRODUCTION: The painter Vincencio Carducho (1578–1637) was born in Florence, but soon moved to Spain where he eventually worked with his brother painting in the Escorial, Philip II's mammoth palace outside Madrid. Despite his Italian origins, the artist was schooled in the Spanish court and considered himself a Spaniard rather than an Italian. His *Dialogues on Painting* were one major contribution to art theory in seventeenth-century Spain. They were written in the form of a conversation between master and student. In the following excerpt, Carducho considers the art of the great Caravaggio and criticizes the widespread tendency of the time to imitate the artist. Carducho argues that, in the hands of lesser lights, Caravaggio's style soon degenerated into a pale reflection of the great master's art and that the rise of the Caravaggian style might soon destroy the careful traditions that painters had developed in previous centuries.

In our times, during the pontificate of Pope Clement VIII, Michelangelo Caravaggio rose in Rome. His new dish is cooked with such condiments, with so much flavor, appetite, and relish that he has surpassed everybody with such choice tid-bits and a license so great that I am afraid the others will suffer apoplexy in their true principles, because most painters follow him as if they were famished. They do not stop to reflect on the fire of his talent which is so forceful, nor whether they are able to digest such an impetuous, unheard of and incompatible technique, nor whether they possess Caravaggio's nimbleness of painting without preparation. Did anyone ever paint, and with as much success as this monster of genius and talent, almost without rules, without theory, without learning and meditation, solely by the power of his genius and the model in front of him which he simply copied so admirably? I heard a zealot of our profession say that the appearance of this man meant a foreboding of ruin and an end of painting, and how at the close of this visible world the Antichrist, pretending to be the real Christ, with false and strange miracles and monstrous deeds would carry with him to damnation a very large number of people by his [the Antichrist's] works which seemed so admirable (although they were in themselves deceptive, false and without truth or permanence).

Thus this Anti-Michelangelo [that is: Caravaggio] with his showy and external copying of nature, his admirable technique and liveliness has been able to persuade such a large number of all kinds of people that his is good painting and that his theory and practice are right, that they have turned their backs on the true manner of perpetuating themselves and on true knowledge in this matter.

SOURCE: Vincencio Carducho, *Diálogos de la pintura*, in *A Documentary History of Art*. Vol. II. Ed. Elizabeth G. Holt (Garden City, N.Y.: Doubleday Books, 1958): 209–210.

that accused him of being a plagiarist. Baglione's techniques were very different from those of Caravaggio and remained true to the Central Italian tradition of making major preparatory studies before beginning to paint. At the same time, his works did copy Caravaggio's dramatic *chiaroscuro* and he did try to cultivate the great master's sense of realism. While he later developed a style notably independent from Caravaggio, his works around the time of the famous libel case were, in fact, highly derived from Caravaggio's style. Baglione's close friend, Tomasso Salini, was also affected by the popularity of Caravaggism evident in Rome in the first quarter of the sixteenth century, although Salini's art continued to make use of many Mannerist design principles. While he derived inspiration from Caravaggio, Salini also became the artist's sworn enemy, in part because of the role that he came to play as a witness for Baglione in the 1603 legal case.

MANFREDI AND GENTILESCHI. Perhaps the two greatest Caravaggisti active in Rome at this time were Bartolommeo Manfredi and Orazio Gentileschi. Both managed to run successful studios and both were given a number of commissions, although their works followed two different paths. Manfredi treated many of the same themes in his paintings that Caravaggio had immortalized in his early career, including tavern scenes, concerts, and other genre paintings of daily life. At the same time, Manfredi was a successful painter of religious themes, although he rarely accepted public commissions. He was, in other words, primarily a painter patronized by wealthy Romans and churchmen, who bought his works to display in their private collections. His style was notable for its coarse realism, and his critics attacked it as vulgar. By contrast, Orazio Gentileschi's paintings derived a similar inspiration from Caravaggio, although this artist generally sanitized his works of the earthy, often lower class dimensions evident in the great master's immortal creations. During the artist's long years in Rome, he painted a number of religious and secular themes illuminated with the dramatic light typical of the earlier master. He usually

arranged the figures in his compositions close to the foreground and cast a white light from the right across them. While he attempted to capture Caravaggio's realism, his works sometimes showed a naiveté concerning anatomy. In contrast to the homely quality of Manfredi, Gentileschi's works abounded in rich brocades, tapestries, and other elegant trappings of aristocratic life. The artist managed to have a successful career in Rome, not only as a painter, but also as a decorator. He was responsible, in fact, for many of the decorative mosaic designs that adorn the interior of St. Peter's dome at the Vatican. Later in life, he left the city, and after travels to Genoa and Paris, he ended up as a painter in the court of Charles I in England.

DECLINE OF CARAVAGGISM AT ROME. While the movement reigned at Rome during the 1610s and early 1620s, its influence lessened after 1623. In that year, Cardinal Maffeo Barberini was elected Pope Urban VIII, and he was to reign until 1644. During his relatively long pontificate, he and his family were to commission a number of monuments and artistic works in Rome notable for their grand, triumphal style, rather than for their gritty realism. It was during the Barberini pontificate, for instance, that much of the interior decoration of the new St. Peter's Basilica was completed. The artist who spoke most vigorously to these new demands was Gianlorenzo Bernini, and his own design principles, revealed in the sculptures and architecture that he crafted for his Roman patrons, were to take a very different course from the brooding spirit of Caravaggio and his followers.

CARAVAGGISM IN NAPLES. It was in Italy's largest city, Naples, that Caravaggism exerted its greatest influence over artistic culture in the seventeenth century. Caravaggio had fled to Naples in 1607 after having killed a man in a brawl, and in southern Italy he had executed a number of commissions, often for some of the most influential families in the region. In Naples, he continued to experiment with new design techniques. In some of his paintings, he softened the intense realism typical of his most famous Roman pictures, although he continued to concentrate his attentions on a small number of figures placed in the extreme foreground of his pictures. The works that he produced soon acquired many admirers among the artists in Naples, and three Caravaggisti—Giovanni Battista Caracciolo (c. 1570–1637), Jusepe de Ribera (1591–1652), and Artemisia Gentileschi (1597–1652)—continued his experiments in realism there after his death in 1610. The style of Caravaggesque painting they helped to create in the city flourished in Naples far longer than in the rest

of Italy. All three artists demonstrated a taste for violent themes that were often gruesomely portrayed and which relied on elements of Caravaggio's *chiaroscuro.* The eldest of these figures, Caracciolo began to make his mark on the Neapolitan artistic scene around age thirty. During the early 1600s, his works show a steadily increasing sophistication of technique, enlivened toward 1610 by the experience of having seen Caravaggio's Neapolitan works. After a visit to Rome in 1614, his works acquired a greater finesse and certainty of technique, and during subsequent visits to Genoa, Rome, and Florence, he also came into contact with the idealized works of the Carracci school. In the years that followed he tried to forge a new style that united the insights that he had culled from this very different tradition to his longer standing Caravaggism. At the same time, Caracciolo was an avid painter of frescoes, a medium that few of the Caravaggisti practiced, and he left behind a legacy of numerous ceiling frescoes in Naples notable for their grand and heroic style. While many of the Caravaggisti were attacked even in the seventeenth century for their highly derivative and imitative style, Caracciolo managed to transform the great master's realism and lighting effects into a vehicle for presenting his own subtle psychological insights. The second member of the Neapolitan Caravaggisti, Jusepe de Ribera, was not an Italian, but a Spaniard. Born the son of a cobbler, he trained in Spain as a painter before moving to Rome around 1613. There he received a few commissions, and he forged a close relationship with the Utrecht Caravaggisti, a group of painters from the Dutch city of Utrecht that were active on the Roman scene at the time. These included Hendrick ter Brugghen, Dirck van Baburen, and Gerrit van Honthorst. In contrast to the life-painting the Roman Caravaggisti practiced at this time, precise draftsmanship and brushwork characterized the works of the Utrecht Caravaggisti, something that can be seen in the works of Ribera at this time, too. By 1616, Ribera had moved on to Naples, which was controlled then by the kingdom of Spain. Here he was to achieve great success as both a painter and engraver, completing many commissions for the Spanish officials and nobles that were flocking to southern Italy at the time. He continued to execute many works using the contrasting darks and lights of Caravaggism, but during the 1620s and 1630s he developed a second style, notable for greater lightness as well as swift and expressive brush strokes. By 1630, his reputation as a painter of the first rank had been established, and in that year Diego Velázquez visited him in Naples, and came to find inspiration in elements of Ribera's style. Thus the Caravaggism that was

so widespread in Naples was to leave its mark on the greatest painter of seventeenth-century Spain.

ARTEMISIA GENTILESCHI. Perhaps the most fascinating of all the followers of Caravaggio to emerge in seventeenth-century Italy was Artemisia Gentileschi, the daughter of the Roman painter Orazio Gentileschi. Trained by her father, she came to be the first female painter in European history to be celebrated throughout the Continent for the depth of her artistic insight. Unlike other female professional painters of the time she did not confine her work merely to still lifes and small devotional pictures, but instead took on large historical themes, which she came to endow with considerable depth of feeling. A precocious talent, she was painting in her father's studio by the time she was a teenager. Around this time Agostino Tassi, one of her painting teachers, raped her, and her father soon sued. As a result of the publicity the trial generated, Artemisia was quickly married off to a Florentine, and the couple moved immediately to Florence. It was in the period directly after her marriage that she painted one of her undeniable masterpieces, *Judith Beheading Holofernes*, a subject that Caravaggio had also treated. In this story from the Apocrypha, Judith triumphs over the Assyrian conqueror Holofernes and saves Judea by getting the general drunk in his tent. She then proceeds to behead him. Gentileschi's portrayal of the account is gruesomely realistic, so realistic that many people still find the picture difficult to view. Generations of connoisseurs, too, have seen in her account a psychological depth and rage arising from her unfortunate mishandling at the hands of men. Artemisia remained in Florence for a number of years and was admitted into the city's prestigious Academy of Design, the association of prominent painters in the city. She apparently developed a successful career in the city as a portraitist, although few examples of her works in this genre have survived over the centuries. By 1630, she had likely separated from her husband and had taken up residence in Naples. Her early works had often flouted convention by treating subjects that required her to paint female nudes. In Naples, though, her art took a more conservative turn, with the artist often painting religious subjects for Spanish patrons who lived and worked in the city. A trip to England to visit her ailing father in 1638 came to last three years, during which Artemisia finished some of the projects on which he had been at work during the final years of his life. She then returned to Naples, where she continued to support herself as a painter in the Caravaggistic tradition until her death in 1652. Widely admired and yet controversial in her time, she was one of the artists chiefly responsible for carrying Caravaggio's realism as well as his insights concerning light and shading to Florence and Northern Europe.

IMPACT OF CARAVAGGISM. The impact of Caravaggio's artistic vision came to spread, not only throughout Italy, but everywhere in Europe during the first half of the seventeenth century. Groups of Dutch artists, like the Utrecht Caravaggisti, were to bring with them the insights that they had obtained while observers on the Roman scene. At home, their dark and brooding musings on grim situations were admired for a time, before new movements arose to supplant their popularity. Still, the techniques that these Italian travelers had acquired while in Rome and other centers were not lost, but continued to affect painters like Van Dyck, Rubens, and Rembrandt in the years to come. In France and Spain, many artists came to be influenced by the fashion for Caravaggism as well. While the popularity of the movement persisted in few centers past 1650, Caravaggesque naturalism dramatically enriched the vocabulary of techniques available to artists in the later seventeenth century.

SOURCES

R. Ward Bissell, *Orazio Gentileschi and the Poetic Tradition in Caravaggesque Painting* (University Park, Pa.: Pennsylvania State University Press, 1981).

F. Benito Domenech, *Ribera, 1591–1652* (Madrid: Bancaja, 1991).

M. Garrard, *Artemisia Gentileschi* (Princeton, N.J.: Princeton University Press, 1989).

Alfred Moir, *Italian Followers of Caravaggio* (Cambridge, Mass.: Harvard University Press, 1967).

Benedict Nicolson, *Caravaggism in Europe* (Torino, Italy: U. Allemandi, 1989).

Arthur von Schneider, *Caravaggio und die Niederländer* (Marburg an der Lahn, Germany: Verlag des Kunstgeschichtliches Seminar, 1933).

Richard E. Spear, *Caravaggio and His Followers* (New York: Harper and Row, 1975).

SCULPTURE IN ITALY

GIANLORENZO BERNINI. The figure of Gianlorenzo Bernini (1598–1680) came to dominate the Baroque style in mid-seventeenth-century Italy. Although he is recognized today primarily as a sculptor, Bernini was a multitalented genius the likes of which had not been seen in Italy since the days of the High Renaissance. Trained as a sculptor in his father's Roman studio, he completed

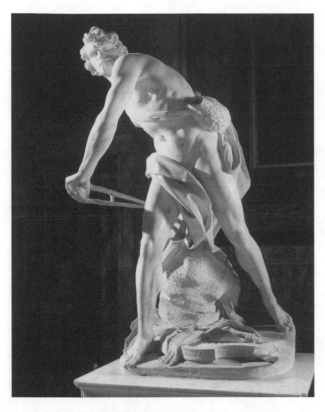

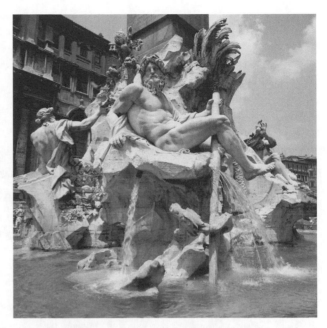

"The Ganges," *Fountain of the Four Rivers* by Gianlorenzo Bernini. © MIMMO JODICE/CORBIS. REPRODUCED BY PERMISSION.

David by Gianlorenzo Bernini. © GIANNI DAGLI ORTI/CORBIS.

his first sculptures by the time he was eleven years old. At this early age, he produced a small sculpture noticeable for its naturalness and delicacy for the Cardinal Scipione Borghese. While he continued to practice the art of sculpture his entire life, he also acquired great skills as a playwright, painter, draftsman, and composer. By the time he was twenty he had acquired a second prominent patron in the figure of Cardinal Maffeo Barberini, who eventually rose to become Pope Urban VIII (r. 1622–1644). Both Cardinal Borghese and Barberini managed to keep the young sculptor employed with a number of commissions. Even in this early period of his youth, Bernini produced a number of masterpieces that were hailed as unprecedented since the time of Michelangelo. Two of these early works, the *David* (1623) and *Apollo and Daphne* (1624), continued to shape the training of sculptors well into the nineteenth and early twentieth centuries. In contrast to Michelangelo's self-contained and assured *David*, Bernini's sculpture treating the same subject immortalized dramatic tension and movement. As in Caravaggio's painting, Bernini strives here to capture the moment: the exact instant when the young David is just about to propel the stone from his slingshot. The pose that Bernini captured in this marble was derived from one of the ancient figures contained in Annibale Carracci's ceiling at the Palazzo Farnese, but

the expression on the *David's* face was the artist's own. Oft-repeated anecdotes from the time told that Bernini spent a great deal of time looking at his own reflection in a mirror to capture the details of this strained expression, and that the future pope, Maffeo Barberini, even held the mirror for the artist several times while he was at work. A more fanciful creation can be seen in the young artist's *Apollo and Daphne*, completed one year after the *David*. Again, Bernini chose a climactic moment in the ancient myth: the point at which Daphne calls upon her own father for help and is turned into a laurel tree. As Bernini captures the legend, Daphne's hands and legs have already begun to be transformed into the tree, while behind the beautiful figure of Apollo rushes futilely to try to catch his love. These two sculptures helped proclaim the young artist's genius, and in the years to come he was to receive a cavalcade of commissions from his early patron Barberini, now Pope Urban VIII.

WORK AT ST. PETER'S. Even more than the work of the architect Carlo Maderno, Bernini's accomplishments in the interior and exterior of St. Peter's Basilica were to shape the experience of millions of visitors to the mammoth church for centuries to come. His first massive achievement there was the construction of the baldachino, a canopy almost ten stories above the high altar. Built between 1624 and 1633, the structure actually required the labor of a number of artists, although Bernini proved to be the guiding spirit behind its cre-

a PRIMARY SOURCE document

THE FOUR RIVERS

INTRODUCTION: Although the artist Gianlorenzo Bernini dominated the Roman artistic scene for a number of years, he did fall out of favor for a short period in the later 1640s, after the death of his long-time patron Pope Urban VIII. Urban's successor, Innocent X, cast a critical eye on the artist when two bell towers Bernini had designed for the façade of St. Peter's had to be torn down when it became clear that they were structurally unsound. In his *Life of Cavaliere Gianlorenzo Bernini*, the first biography of the artist, the Florentine Filippo Baldinucci (1624–1696) wrote of these problems, but also of how the artist redeemed himself through his ingenious creation of the plans for the Fountain of the Four Rivers in the Piazza Navona, one of the most charming monuments undertaken in Baroque Rome.

So strong was the sinister influence which the rivals of Bernini exercised on the mind of Innocent X that when he planned to set up in the Piazza Navona the great obelisk brought to Rome by the Emperor Antonino Caracalla, which had been buried for a long time at Capo di Bove, for the adornment of a magnificent fountain, the Pope had designs made by the leading architects of Rome without giving an order for one to Bernini. But how eloquently does true ability plead for its possessor, and how effectively does it speak for itself! Prince Niccolò Lodovisio, whose wife was a niece of the Pope and who was at that same time an influential friend of Bernini, persuaded the latter to prepare a model. In it Bernini represented the four principal rivers of the world, the Nile for Africa, the Danube for Europe, the Ganges for Asia, and the Rio della Plata for America, with a mass of broken rocks that supported the enormous obelisk. Bernini made the model and the Prince arranged for it to be carried to the Casa Pamfili in the Piazzo Navona and secretly installed there in a room through which the Pope, who was to dine there on a certain day, had to pass as he left the table. On that day, which was the day of the Annunciation, after the procession, the Pope appeared and when the meal was finished he went with Cardinal Pamfili and Donna Olimpia, his sister-in-law, through that room and, on seeing such a noble creation and the sketch for such a vast monument, stopped almost in ecstasy. Being a Prince of the keenest judgment and the loftiest ideas, after admiring and praising it for more than half an hour, he burst forth in the presence of the entire privy council, with the following words: "This is a trick of Prince Lodovisio. It will be necessary to employ Bernini in spite of those who do not wish it, for he who desires not to use Bernini's designs must take not to see them." He sent for Bernini immediately. With a thousand demonstrations of esteem and affection and in a majestic way, almost excusing himself, he explained the reasons and causes why Bernini had not been employed until that time. He gave Bernini the commission to make the fountain according to the model.

SOURCE: Filippo Baldinucci, *The Life of Cavaliere Gianlorenzo Bernini* in *A Documentary History of Art.* Vol. II. Ed. Elizabeth G. Holt (Garden City, N.Y.: Doubleday Books, 1958): 116–117.

ation. The most distinctive features of the baldachino are the four huge twisted spirals that serve to support the massive horizontal upper story and crown-like top above. Bernini adapted this design from descriptions of columns that had been in the original Constantinian basilica that had stood at the site until the early sixteenth century. These columns, in turn, were connected to the ancient Hebrew temple erected in Jerusalem during Solomonic times. Although the work is enormous, Bernini's baldachino proves to be one of the only structures within St. Peter's that is capable of suggesting the church's enormous scale. From the rear of the church the canopy appears small, yet as one approaches it and can grasp its massive proportions set against the even larger dome above, the true size of St. Peter's becomes evident. Throughout the interior of the building, too, Bernini oversaw a massive sculptural program that decorated the church's walls, holy water stoups, and massive piers and columns with statuary. Most of these statues are about one and a half times life size, but their scale is dwarfed within the confines of Christianity's largest church. As Bernini's labors progressed at the basilica, he also planned to build two massive bell towers on the other side of St. Peter's façade, though these structures eventually proved to be structurally unsound and had to be torn down. As a result his reputation as an artist, architect, and designer suffered for a brief time under the pontificate of Urban VIII's successor, Innocent X (r. 1644–1655). The artist's imprint on the church's exterior is most notable today through his design of the enormous square that lies outside the church's nave, as well as the statues he designed for this square's massive, encompassing colonnade (a forest of columns that is roofed over to provide protection from the elements). Three hundred simple Doric columns populate this curving colonnade, while on either side of the enclosed space Bernini placed two handsome bronze fountains. Atop the colonnade the statues Bernini designed portray the major saints of the church. In the center of the square he placed an ancient Egyptian

obelisk, a monument that signified the church's conversion of the heathen peoples and its subsuming of their cultures into Christianity. He imagined the entire structure, with its enfolding arms, as signifying Mother Church's embrace of the faithful, and despite its colossal size the square does manage to grant a sense of integrity and welcome to the massive structure that stands in its background. Generally, Bernini's decorative program at St. Peter's managed to endow the severe monumentality of the church with a sense of movement and dramatic climax, key features of the artistic sensibilities of both the visual arts and architecture in the Baroque. (See Architecture: The Rise of the Baroque in Italy)

BERNINI'S DECORATIVE PROGRAMS ELSEWHERE IN ROME. Although Bernini fell out of papal favor early in the pontificate of Innocent X, he soon came to be reinstated as the dominant artist of seventeenth-century Rome. For most of the century, he was the man that popes called upon to execute their ambitious plans. Scarcely a corner of the city escaped his touch. Since the Renaissance, Italian artists and architects had frequently envisioned handsome squares, broad avenues, and other urban monuments that might serve as focal points for urban life. Few of these grand plans had been executed, but in the seventeenth century Rome's popes redoubled efforts to endow their city with these grand monuments. As a result, Rome emerged as the model for the early-modern capital, and its handsome public spaces were to be imitated throughout the Continent. Bernini proved in every way to be equal to the challenge of creating noble public spaces. Throughout the city, he designed sculptures and fountains, and he placed ancient monuments within new frames that set off their noble features. The little obelisk that he placed in the square near the Church of Santa Maria Sopra Minerva was typical of one direction in which Bernini's decorative and humorous art flowed. He set the ancient monument atop the back of a fancifully sculpted elephant, suggesting the mode of transport that the artifact had likely taken on its way to Rome. Elsewhere his designs for urban squares were more dignified. Perhaps his most definitive achievement on the urban scene was the construction of the Fountain of the Four Rivers in the Piazza Navona. This long and narrow rectangular square had been the site of a Roman stadium, a staging point for chariot races in the ancient city. The monument was Bernini's first major commission undertaken for Pope Innocent X, after the setback that he had suffered as a result of St. Peter's ill-fated bell towers. Innocent stipulated that the square be decorated with a fountain as well as an ancient Egyptian obelisk that had been brought to Rome centuries before. Since the late six-

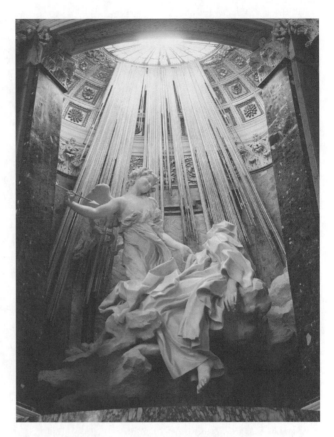

The Ecstasy of St. Teresa by Gianlorenzo Bernini. © MASSIMO LISTRI/CORBIS.

teenth century, the increase of the city's water supply had been an essential component of papal policy; ancient aqueducts had been repaired and new water sources developed. As these achievements occurred, successive popes came to celebrate Rome's new, secure sources of fresh water by commissioning fountains like Bernini's *Four Rivers*. The Roman fountain was above all a utilitarian object, for without running water in houses, this was how people received their water. Bernini's structure, though, came to outshine the many handsome, but largely utilitarian structures that had been built in the city to this point. Relying on his enormous ingenuity, Bernini built the obelisk into his fountain design, placing it atop a mountain of fake rock that appeared to be a natural pile of stone, but which in reality was carefully cut to refract light dramatically off its surfaces. At each of the four corners under the obelisk he designed a massive sculpture that personified the qualities of four of the world's most important rivers, including the Danube, Ganges, Nile, and the South American Plate. He encircled the sculptures with carved flora and fauna suggestive of the river's region and he relied on playful jets to dispense the fountain's water in dramatic spurts, dribbles, and jets of water. In this way

a PRIMARY SOURCE *document*

TERESA'S TRANSVERBERATION

INTRODUCTION: The sixteenth-century Catholic saint, Teresa of Avila (1515–1582), was one of the Christian tradition's greatest mystical writers. In her autobiography she described the many visions she had experienced, including that of the *transverberation*, a visitation by an angel who pricked her with a burning spear that left her alive with the love of God. This was the subject of Bernini's *Ecstasy of St. Teresa*, one of the most vividly emotional of all the Baroque's religious works. Teresa's life, like St. Ignatius Loyola's *Spiritual Exercises*, was widely read by the seventeenth-century devout, and the emphasis that both figures placed on the importance of forming a mental picture of the events of the Bible and the history of the church were a major impetus for the era's constant outpouring of new images and sculptures.

Our Lord was pleased that I should have at times a vision of his kind: I saw an angel close by me, on my left side, in bodily form. This I am not accustomed to see, unless very rarely. Though I have visions of angels frequently, yet I see them only by an intellectual vision, such as I have spoken of before. It was our Lord's will that in this vision I should see the angel in this wise. He was not large, but small of stature, and most beautiful—his face burning, as if he were one of the highest angels, who seem to be all of fire: they must be those whom we call cherubim. Their names they never tell me; but I see very well that there is in heaven so great a difference between one angel and another, and between these and the others, that I cannot explain it.

I saw in his hand a long spear of gold, and at the iron's point there seemed to be a little fire. He appeared to me to be thrusting it at times into my heart, and to pierce my very entrails; when he drew it out, he seemed to draw them out also, and to leave me all on fire with a great love of God. The pain was so great, that it made me moan; and yet so surpassing was the sweetness of this excessive pain, that I could not wish to be rid of it. The soul is satisfied now with nothing less than God. The pain is not bodily, but spiritual; though the body has its share in it, even a large one. It is a caressing of love so sweet which now takes place between the soul and God, that I pray God of His goodness to make him experience it who may think that I am lying.

During the days that this lasted, I went about as if beside myself. I wished to see, or speak with, no one, but only to cherish my pain, which was to me a greater bliss than all created things could give me.

I was in this state from time to time, whenever it was our Lord's pleasure to throw me into those deep trances, which I could not prevent even when I was in the company of others, and which, to my deep vexation, came to be publicly known. Since then, I do not feel that pain so much, but only that which I spoke of before—I do not remember the chapter—which is in many ways very different from it, and of greater worth. On the other hand, when this pain, of which I am now speaking, begins, our Lord seems to lay hold of the soul, and to throw it into a trance, so that there is no time for me to have any sense of pain or suffering, because fruition ensues at once. May He be blessed forever, who hath bestowed such great graces on one who has responded so ill to blessings so great!

SOURCE: *The Life of St. Teresa of Avila* (London: Thomas Baker, 1904): 255–257.

Bernini's fountain transformed an object that might have been a merely useful object on the Roman scene into a widely revered and playful monument.

THE CORNARO CHAPEL. Of Bernini's many Roman creations, the one that the artist himself most admired was his design for the Cornaro Chapel in the Church of Santa Maria della Vittoria, a work he executed between 1645 and 1652. The chapel's subject, *The Ecstasy of St. Teresa* immortalizes a famous incident in the life of this Spanish Counter-Reformation saint. In his plans for the chapel, Bernini designed a complete stage-like setting that reproduced the saint's miraculous visitation by an angelic messenger. During this incident, known alternately as her "Ecstasy" or "Transverberation," the angel pricked her with a burning arrow that left her alive with the love of God. Although the event had been painful, St. Teresa described it as so fulfilling and sweet that she never wanted it to end. To suggest this mixture of mingled pain and joy, Bernini relied on his already well-established language of flowing lines and polished drapery. The folds of St. Teresa's habit fall into elegant shapes that suggest movement and the inner turmoil and sweetness of her experience. The artist placed this sculpture, too, within an architectural frame that projects outward toward the viewer's space. Above, the pediment that crowns this group is broken and again moves outward toward the viewer. At either side he placed what appear to be theatrical boxes into which he put sculptures of members of the Cornaro family. Thus the patrons appear as witnesses to St. Teresa's great drama, and although sculpted in stone, they have before

them a perpetual image of the great Spanish saint's mysterious visitation. Since the onset of the Catholic Reformation in the sixteenth century, reformers like St. Ignatius of Loyola had recommended that the faithful practice daily meditations in which they kept before their eyes images of Christ's Passion as well as key events in the life of the Virgin and the saints. Bernini himself practiced similar pious regimens based, not upon St. Ignatius Loyola, but upon the devotions contained in Thomas à Kempis' late-medieval devotional classic, *The Imitation of Christ.* In his *Ecstasy of St. Teresa,* he showed the Cornaro family also taking part in this kind of visual meditation: they sit in a theatrical setting, as if pondering the miracle of Teresa's Transverberation, consuming it as one might a play. In this way Bernini's chapel made use of the widespread tendency to elevate images into a method for avoiding sin. To endow his entire creation with greater force, Bernini surrounded his entire chapel with richly colored marbles and touches of gilt, while in the space above he had painted a fresco that suggested the heavens. In its rich use of color, its dramatic sculptural imagery, and theatricality, Bernini's *Ecstasy* has long served as an emblematic image of the Catholic Reformation. It achieved, in other words, that dramatic mix of intense emotionalism and clear religious content that Catholic reformers had long recommended as the highest aims of religious art. While highly successful and often imitated, Bernini's Cornaro Chapel has more recently been invoked as the first of many complete artistic environments, a setting in which sculpture, painting, architecture, and the decorative arts all merge to provide a complete sensory experience to those who visit it.

SOURCES

Howard Hibbard, *Bernini* (Baltimore, Md.: Penguin Books, 1965).

John R. Martin, *Baroque* (New York: Harper and Row, 1977).

Rudolf Wittkower, *Gian Lorenzo Bernini. The Sculptor of the Roman Baroque.* 2nd ed. (Ithaca, N.Y.: Cornell University Press, 1981).

SEE ALSO *Architecture: The Achievements of Gianlorenzo Bernini*

THE BAROQUE MATURES IN ITALY

PIETRO DA CORTONA. Bernini, the great commanding figure of the seventeenth-century Baroque in Rome, was accomplished in almost all of the media available to a professional in his time. During his long life he came to dominate the development of public architecture and sculpture in the city, and although he may have painted as many as 150 paintings for his private pleasure, his influence was most definitive in the fountains, sculptures, and architectural commissions he undertook for the papacy. His great authority in artistic matters in the mid- and late seventeenth century, though, did not extend to the world of painting. Here the guiding figure that was to transform the experimentations of the Carracci and Caravaggio into a distinctively mature High Baroque style was Pietro Berrettini da Cortona (1599–1669). Born the son of a stonemason in the Tuscan town of Cortona, he was originally trained in his father's shop as a sculptor and stonecutter, a traditional avenue that often led into the practice of architecture. In painting, he was trained by a provincial artist in Cortona who had close ties to Florentine masters then active in Rome. When his teacher migrated to Rome in 1612, Cortona soon followed. Although he received many commissions during the years that followed, these demonstrate little of the finesse that appeared in his work after 1630. At that time, his art emerged as a mature synthesis fashioned out of the insights of the Bolognese painters of the previous generation, including the Carracci, Guido Reni, and Domenichino. At the same time, Cortona longed to unite the traditional concerns of Raphael, Michelangelo, and other Florentine High Renaissance masters with *disegno* or draftsmanship, with the rich coloristic tradition of Titian and the Venetians. His works around this period took on a greater finesse and surety of execution and were notable for their classical design, rich palette, and dramatic sense of movement and urgency. As a result of his rising status among the artists working in Rome at mid-century, he was given a number of important commissions, particularly from members of the Barberini family, whose son Maffeo then ruled as Pope Urban VIII.

PALAZZO BARBERINI. In 1633 Francesco Barberini commissioned Cortona to paint the ceiling of the Grand Salon of his palace in Rome, a massive project that became the artist's definitive masterpiece. The poet Francesco Bracciolini defined the iconography for this work, which was an allegorical treatment of Divine Providence. When completed six years later, the work astounded the Roman artistic world, and it set standards that later artists strove to attain during the remainder of the century. As an achievement it was not to be surpassed until the great frescoes that Giovanni Battista Tiepolo (1696–1770) created in the eighteenth century. Until Cortona's time, a ceiling as vast as that in the Barberini

Palace had usually been covered in smaller frescoes framed with illusionary architecture or frames to appear as if they were individual wall paintings transposed onto the ceiling. Michelangelo's Sistine Chapel Ceiling, completed between 1508 and 1512, consists of a series of narrative scenes that relate the biblical history from the Creation of Man to the Flood. Annibale Carracci's great achievement in the Palazzo Farnese, a cornerstone of the early Baroque style, had similarly been divided up into a series of individual works, unified by seeming to be a great artistic collection of antiquities and discrete works of art. It had, in other words, been unified as if it was a connoisseur's cabinet of pictures and sculptures housed in the Farnese's barrel vault. One of the reasons for working in this manner, known at the time as *quadri riportati* or "framed pictures," lay in the technical problems of the fresco medium. To undertake a commission of this monumental nature, artists were forced to divide up a fresco into many different sections, each corresponding to a day's work. In true fresco, for instance, plaster is applied to the wall and a section painted while the surface is still damp. In this way the pigments are fused into the surface and become a permanent part of the wall. It is consequently difficult, when working on a large surface such as the Palazzo Barberini's Grand Salon, to treat the entire area as a single composition, unless one has executed a brilliant series of plans. Of course, artists before Cortona had experimented with ways to unify a large ceiling painting as a single work of fresco. During the 1590s, the brothers Cherubino and Alessandro Alberti had painted a single fresco on the ceiling of the Salon of Clement in the Vatican Palace. And in his single ceiling fresco of *Aurora*, completed around 1615, the great artist Guercino had created a single fresco, but he had framed his work with illusionary paintings of architecture that projected upwards the lines of the room below. In this way the actual space the figural painting of Aurora took up on Guercino's ceiling was quite small. In the Grand Salon of the Barberini Palace, Cortona took a new, unprecedented tactic. He originally planned to create his work in a way similar to the Palazzo Farnese frescoes of Annibale Carracci, yet as his designs progressed he abandoned such a scheme. The final work appears at first glance as if it is a single gigantic fresco, but it is actually five scenes forged into a single compositional unity through a series of complex devices. The result is a breathtaking tour de force that manages to captivate viewers by its density. Out of this swirling mass of figures, an amazing comprehensive design is readily intelligible; at the same time, this unity invites viewers to decode the ceiling's many symbolic and allegorical messages. Like many grand Baroque projects, Cortona began with a literary program, one that was devised from the works of the poet Francesco Bracciolini. The shape of the ceiling is a coved, rather than barrel vault, meaning that it slants upwards on all four sides of the rectangular room. In these coves, Cortona painted mythological scenes that serve as allegories glorifying the great achievements of Pope Urban VIII, the most distinguished member of the Barberini clan at the time. Above, in the central space of the ceiling, the virtuous attributes of the Barberini family are immortalized, and the reign of the family's son as pope is celebrated as a sign of the gifts of God's providence. While its allegory sometimes appears contrived and overly difficult to understand, the entire composition holds an amazing degree of sensual force. On stepping into the room, in other words, it appears as if the very heavens have been opened up onto the space, and the rich colors of the ceiling present a kaleidoscopic effect that invites an observer merely to bask in the work as a purely ethereal confection.

CORTONA'S OTHER WORKS. Success at the Barberini Palace established Cortona as an artist of the highest rank in Rome, and he received a number of commissions as a result. Among the most important projects that he completed in the final years of his life was a series of decorations for the Grand Duke's apartment in the Pitti Palace in Florence. This particular commission was fraught with problems and setbacks, and although the artist began working there in 1642, he was still returning periodically to Florence to paint in the 1660s, and some rooms remained unfinished at his death. The press of his success at Rome insured that he, like Bernini, was always kept busy there with many projects, and his artistic example helped to establish the grand manner, drama, and dense compositional techniques that many Baroque artists came to favor in the second half of the seventeenth century.

OTHER ARTISTS IN ROME. At the same time, Cortona was only one of a large number of successful artists at Rome. Other figures who flourished during his lifetime included Andrea Sacchi (1599–1661), who also completed decorative frescoes in the Barberini Palace; Battista Gaulli who was known as Baciccio (1639–1709), and who decorated the huge barrel vault of the Jesuit's Church of Il Gesù; and Carlo Maratta (1625–1713), who painted a number of public religious pictures and ceilings in churches throughout the city. Maratta and Gaulli were a generation younger than Cortona and Scacchi, and they carried the High Baroque style into the early eighteenth century. During the later seventeenth century the fashion for Baroque ceiling frescoes increased everywhere throughout Rome, and many of the city's palaces and

churches were decorated by the city's extraordinarily fertile group of artists. Two of the greatest practitioners in the medium on the Roman scene were Andrea Pozzo and Luca Giordano. Pozzo's fresco, *The Entrance of St. Ignatius into Paradise*, completed in 1694 in the nave of the Church of St. Ignatius, was very much influenced by the early example of Guercino's *Aurora*. While hardly great art, his work is the most impressive example of the attempt to create an illusionary architectural framework for a ceiling fresco. The complete artifice of classical architecture that appears to surge upward from St. Ignatius's walls amazes and astounds viewers. Populated with a dense agglomeration of figures, however, Pozzo's fresco fails to sustain the visual interest of those of Guercino or Cortona. The art of Luca Giordano (1634–1705), a Neapolitan painter who studied with the great master Ribera in Naples, was quite different. The Caravaggism, not only of Ribera, but also of the accomplished Neapolitan painter Giovanni Lanfranco (1582–1647), influenced Giordano. He traveled to Rome where he acquired an understanding of the compositional techniques of Cortona as well. Then he embarked on a life of constant travel, spending time in Florence and a number of Italian centers before settling in Spain for a decade. He left behind him a trail of accomplished works that helped create a fashion for the grand manner of the Roman Baroque throughout the Italian and the Iberian peninsulas. An enormously prolific artist, he was discounted in the decades after his death as facile and lacking in depth. More recently, his art has been extensively re-evaluated, and in his light forms, gorgeous, brilliant coloration, and suggestions of swift movement, art historians have come to see echoes of the Rococo movement that was to flourish in the early eighteenth century.

SOURCES

M. Campbell, *Pietro da Cortona at the Pitti Palace* (Princeton: Princeton University Press, 1977).

Julius S. Held and Donald Posner, *Seventeenth and Eighteenth Century Art* (Englewood Cliffs, N.J.: Prentice Hall, 1971).

J. M. Merz, *Pietro da Cortona* (Tübingen, Germany: E. Wasmuth, 1991).

J. B. Scott, *Images of Nepotism: The Painted Ceilings of Palazzo Barberini* (Princeton: Princeton University Press, 1991).

BAROQUE CLASSICISM IN FRANCE

THE RECEPTION OF THE ITALIAN STYLE. The later sixteenth century had been a time of great turmoil in France. Between 1562 and 1598, a series of religious wars had erupted, leaving the country's political institutions, economy, and society badly battered. In the years after 1600, however, a tenuous stability returned to the country under King Henri IV (r. 1594–1610). Although Henri was eventually assassinated, civil war did not return to France, and during the long reign of Henri's son, Louis XIII (r. 1610–1643), a steady recovery in the country's fortunes continued. In the early years of his reign, Louis' mother, Marie de' Medici, served as regent. A connoisseur of the arts, she came to invite the great Flemish painter Peter Paul Rubens to court, and she supported a number of native artists as well. In the first quarter of the seventeenth century, too, many of the artists who were to contribute to the country's great flowering of the arts in the second half of the seventeenth century migrated southward to Italy, particularly to Rome. There they learned of the new styles of Caravaggio and the Carracci. Among these figures, Georges de la Tour (1593–1652), Nicholas Poussin (1593 or 1594–1665), and Claude Lorrain (1600–1682) were to build upon Italian examples, Northern European traditions, and their own native styles to fashion a resurgence of the arts in France. Each of these figures was shaped most definitively by their experience of the Roman Baroque. Georges de la Tour spent time there as a young man, while Poussin and Lorrain eventually emigrated to the city and remained there for the rest of their lives.

GEORGES DE LA TOUR. La Tour's career presents us with one case of the vagaries of reputation across the ages. He was an artist of considerable renown in his own times, but he soon fell out of favor after his death, and his place in seventeenth-century painting has only recently been restored. After a provincial upbringing in the province of Lorraine in the east of France, he traveled extensively in the Low Countries (modern Belgium and Holland) as well as in Italy. He arrived in Rome as the ferment of Caravaggio's new realism was erupting on the artistic scene. While affected by these currents, particularly in his use of *chiaroscuro*, La Tour was a strikingly original artist. As other Catholic artists of the time, he often painted religious subjects as if they occurred in his own time and place. Today, one of his most famous paintings is the *Newborn* (c. 1630), a canvas that shows his tendency to convey religious subjects realistically. The picture shows a mother inspecting her child by the light of a candle held by a midwife. Although the reverential feeling of the work suggests that it is a picture of the Virgin Mary and Christ child, no religious symbol, halo, or any other sign supports this assumption. Rather than the light emanating from the infant Jesus as in much traditional imagery,

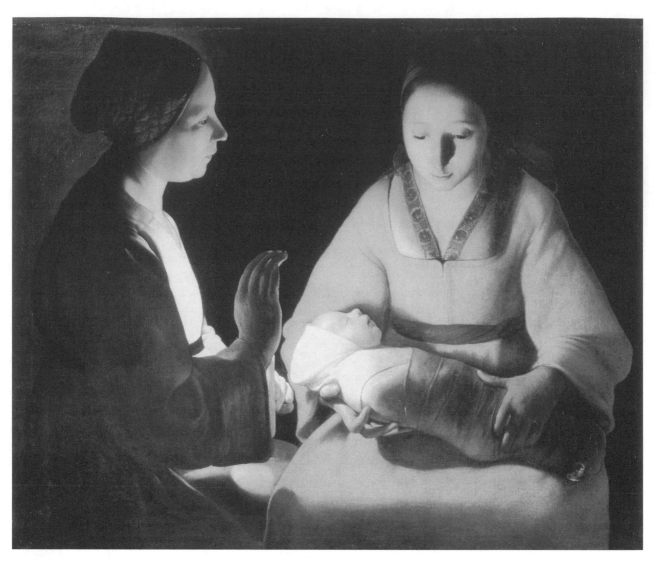

The Newborn by Georges de la Tour. **THE ART ARCHIVE/MUSÉE DES BEAUX ARTS RENNES/DAGLI ORTI.**

La Tour makes the illumination reflect across the picture surface to form patches of light and dark. Instead of the miraculous otherworldly light with which Caravaggio often cast on religious subjects like the Conversion of St. Paul, La Tour makes this light come from the natural source of a candle. Although we can surmise that the intensely reverential spirit of the work means that the subject is the Birth of Christ, La Tour seems to make here a statement about the wonder that accompanies all human birth. Most of the forty other images that can be attributed to the artist are, like this painting, executed on a small scale, a fact that suggests that La Tour carved out a niche for himself in the French provinces as a painter who worked for private patrons, rather than religious institutions. Of these works most treat religious subjects or are genre pieces, i.e., they treat subjects in everyday life. It is not always easy to tell into which category one of La

Tour's paintings falls, since he almost never included haloes or other recognizable religious symbols when he treated the saints or some other religious subject. He avoided placing the figures in his compositions in unnatural or stylized poses, as the Mannerist artists before him had done, and at the same time he did not display the dynamic sense of movement typical of Rubens and other Baroque painters of the time. He seems to have painted from life models, and he captured their natural poses in full- or half-length views. In most of his compositions, a quiet and still observation of human nature and human forms dominates, rather than the turbulent psychological realism of Caravaggio and the Caravaggeschi. His art does not recall the intensely sweeping motion of works like those from the hands of Cortona and his disciples. While he derived certain influences from all these great artists, La Tour's work is highly original

a PRIMARY SOURCE *document*

POUSSIN'S GREEK MODES

INTRODUCTION: As a French painter living in Rome, Nicholas Poussin (1594–1665) was deeply affected by the High Renaissance classicism of figures like Michelangelo as well as the grandeur of ancient Roman monuments. As a painter of historical themes, Poussin, too, formulated several consistent theories around which he built his art. In one set of writings, he developed the notion that painting should emulate the ancient Greek musical modes, an idea that he outlines in this letter to one of his patrons.

Our wise ancient Greeks, inventors of all beautiful things, found several Modes by means of which they produced marvellous effects.

This word "Mode" means actually the rule or the measure and form, which serves us in our productions. This rule constrains us not to exaggerate by making us act in all things with a certain restraint and moderation; and, consequently, this restraint and moderation is nothing more than a certain determined manner or order, and includes the procedure by which the object is preserved in its essence.

The Modes of the ancients were a combination of several things put together; from their variety was born a certain difference of Mode whereby one was able to understand that each one of them retained in itself a subtle variation; particularly when all the things which entered into combination were put together in such a proportion that it was made possible to arouse the soul of the spectator to various passions. Hence the fact that the ancient sages attributed to each style its own effects. Because of this they called the Dorian Mode stable, grave, and severe, and applied it to subjects which are grave and severe and full of wisdom.

And proceeding thence to pleasant and joyous things, they used the Phrygian Mode, in which there are more minute modulations than in any other mode, and a more clear-cut aspect. These two styles and no others were praised and approved of by Plato and Aristotle, who deemed the others superfluous, they considered this [Phrygian Mode] intense, vehement, violent, and very severe, and capable of astonishing people.

I hope, before another year is out, to paint a subject in this Phrygian Mode. The subject of frightful wars lends itself to this manner.

SOURCE: Nicolas Poussin, "Letter to Chantelou, November 24, 1647," in *A Documentary History of Art*. Vol. II. Ed. Elizabeth G. Holt (Garden City, N.Y.: Doubleday Books, 1958): 155–156.

and suggests the great variety that existed in seventeenth-century European painting.

POUSSIN. Perhaps the two greatest painters to appear in seventeenth-century France were Nicholas Poussin and Claude Lorrain (1600–1682), both of whom eventually settled in Rome. Like La Tour, both were also provincials; Poussin was from Normandy, while Lorrain was from the eastern French province of the same name. Poussin became perhaps the greatest painter of classical themes in the Western tradition. Unlike the heavily muscled classical images produced by Michelangelo in the sixteenth century or the swift-moving dynamism of Annibale Carracci, Poussin's works exude a quiet intellectualism. He did not labor to reproduce decisive moments from the scenes he painted as Caravaggio had done, but instead tried to retell ancient myths and legends faithfully, creating images that suggested their entire sweep and texture. While he also painted many religious scenes, he is best known for works on antique themes. An important artistic theorist as well, Poussin developed his own theory of aesthetics. He insisted that an artist must first have a clear understanding of the theme or story that he wanted to communicate before planning his composition. At the same time, an artist must execute his work so that it appears unlabored and natural. As his career progressed, the artist refined his aesthetics, and he tried to paint according to the system of modes once used in Greek music, perceiving in these abstract systems of tone an underlying sense of beauty that might communicate his ideas clearly to his audience. In his *Rape of the Sabines*, painted just after 1635, he relied on the Phrygian mode's organizing principles to create a work notable for its abstract principles of organization, in which the eye is carried around the canvas in a wheel-like rotation. Similarly, in his great masterpiece from around the same time, *The Dance to the Music of Time*, he explicitly relies on music to give life to the subject. Here the eternal cyclical rotation of the powers of poverty, labor, wealth, and pleasure are conceptualized in terms of being a great dance operating throughout history. In this, one of the greatest of his many pictures, the typical features of Poussin's design are clear, particularly his emphasis on creating an art notable for its balance of color, lighting, and forms. Unlike the dramatic and highly dynamic art popular in Rome at the time, Poussin's vision was altogether quieter and more cerebral. That he flourished in the same city remains a testimony to Baroque Rome's great and tolerant community of connoisseurs.

a PRIMARY SOURCE document

EXPRESSION AND THE PASSIONS

INTRODUCTION: A central dilemma of French painting in the seventeenth century revolved around how to capture the human emotions in a way that was still suitably grand and appropriate to the idealized format that large paintings provided. French artists and theorists debated just how much emotion was suitable in paintings, and the ways in which different emotions should be portrayed. The figure of Charles Le Brun (1619–1690) dominated art commissioned for the monarchy for much of the century, having been named by Louis XIII "Royal Painter" in 1638. He also served Louis' son, Louis XIV, and played a dominant role in the development of the French academies, the decoration of Versailles, as well as the Gobelins manufactory scheme. In this address to the members of the Royal Academy of Painting and Sculpture, he tries to define the relationship between human expressions and the interior passions or emotions. His remarks are interesting because of the almost clinical way in which he observes the various emotions' effects on the body.

Sirs:

At the last assembly you approved the plan which I adopted to discuss *expression* with you. It is therefore necessary first to know in what it consists.

Expression, in my opinion, is a naive and natural resemblance [true to nature] of the things which are to be represented. It is necessary and appears in all aspects of painting and a picture could not be perfect without expression. It is expression that marks the true character of each thing; by means of it is the nature of bodies discerned, the figures seem to have movement and all that is pretense appears to be truth.

Expression is present in color as well as in drawing; and it must also be present in the representation of landscapes and in the arrangement of figures.

It is this, Sirs, that I have tried to call to your attention in past lectures. Today I shall try to make you see that expression is also a part that shows the emotion of the soul and makes visible the effects of passion.

So many learned persons have discussed the passions that one can only say what they have already written. There I should not repeat their opinion on this subject

were it not that, in order to explain better what concerns our art, it seems necessary to me to touch upon several things for the benefit of young students of painting. This I will try to do as briefly as I can.

In the first place, passion is an emotion of the soul, which lies in the sensitive part [of the body]. It pursues what the soul thinks is good for it, or flees what it thinks bad for it; ordinarily whatever causes passion in the soul evokes action in the body.

Since, then, it is true that most of the passions of the soul produce bodily action, we should know which actions of the body express the passions and what those actions are ...

It would not therefore be inappropriate to say something of the nature of these passions in order to understand them better ... We shall begin with *admiration*.

Admiration is a surprise which causes the soul to consider attentively the objects which seem to it rare and extraordinary. This surprise is so powerful that it sometimes impels the spirit toward the site of the impression of the object and causes it to be so occupied in considering that impression that there are no more spirits passing into the muscles, so that the body becomes motionless as a statue ...

Anger. When anger takes possession of the soul, he who experiences this emotion has red and inflamed eyes, a wandering and sparkling pupil, both eyebrows now lowered, now raised, the forehead deeply creased, creases between the eyes, wide-open nostrils, lips pressed tightly together, and the lower lip pushed up over the upper, leaving the corners of the mouth a little open to form a cruel and disdainful laugh. He seems to grind his teeth, his mouth fills with saliva, his face is swollen, pale in spots and inflamed in others, the veins of his temples and forehead and neck are swollen and protruding, his hair bristling, and one who experiences this passion seems more to blow himself up rather than to breathe because the heart is oppressed by the abundance of blood which comes to its aid.

SOURCE: Charles Le Brun, "Concerning Expression In General and In Particular" (1667), in *A Documentary History of Art.* Vol. II. Ed. Elizabeth G. Holt (Garden City, N.Y.: Doubleday Books, 1958): 161–163.

CLAUDE LORRAIN. If Poussin was a great painter of historical themes, Claude Lorrain became the greatest French landscape artist of the seventeenth century. Poussin set his works in settings notable for their classical architecture, but his artistic vision always fell upon the human figure, and his choice of scale was determined to set off their forms and accentuate their actions. By contrast, Claude Lorrain included human forms in his many canvases, but almost always to establish the grandeur of the landscapes that he painted around them. These grand views of countryside and cityscapes were not forbidding or uninhabitable, but they were certainly immense in the

Louis XIV, King of France, Armed on Land and Sea, Hall of Mirrors at the Palace of Versailles, France, by Charles Le Brun. THE ART ARCHIVE/MUSEE D'ART ET D'HISTOIRE AUXERRE/GIANNI DAGLI ORTI. REPRODUCED BY PERMISSION.

prospects they offered to their viewers. These views are always idealized; they present, in other words, nature more inviting and beautiful than it is in actuality. In his *Marriage of Isaac and Rebecca*, completed around 1648, Lorrain retells the ancient biblical story in a countryside that resembles the area around Rome and the river that runs through the center of the image looks very much like the Tiber. Along the left of the painting an idealized classical portico and several other buildings allow the viewer to interpret the mammoth recession of space that occurs in the background, as does a large tree to the right. In the narrow but deep cavern of space that Lorrain carves out of this picture plane, the river rolls to the horizon as if it were the Mediterranean Sea, and once at its destination it disappears into the gorgeous yellowish glow of a late afternoon sun. The image points to a central underlying feature of Lorrain's art: its use of light as a way to grant unity and compositional integrity to his landscapes. Lorrain was not, to be sure, the inventor of the landscape form. It had begun to emerge in Venetian painting during the early sixteenth century. But his works opened up the genre's possibilities and the beauty with which he painted these scenes meant that he acquired many patrons. The Roman aristocracy came to commission many works from him in the more than forty years that he lived in their city. Unlike most artists, his mature style did not alter over time and he remained committed to the genre of ideal landscape into his old age.

THE AGE OF LOUIS XIV. The arts in France came to be dramatically affected by the reign of Louis XIV (r. 1643–1715). Louis came to power as a young boy, and in his youth his mother, Anne of Austria, served as regent. Anne was a great connoisseur of the arts, and in 1648 supported the foundation of the Royal Academy of Painting and Sculpture in Paris. During the 1660s Louis assumed the reins of government and a series of regulations attempted to regularize the teaching practices of this institution. Like most of the academies founded under Louis XIV, the Royal Academy of Painting and Sculpture was concerned with establishing canons of

classicism in the visual arts. Louis XIV was not a great connoisseur of art as his mother and her chief minister Cardinal Mazarin had been. Yet like many educated French men and women of the period he idealized the classical art of the Italian Renaissance, seeing in the art of Michelangelo and Raphael a high standard of excellence that students needed to study. The program of the Royal Academy was designed around instruction in the art of ancient Rome and Greece as well as these masters of the Renaissance. History painting, too, played a special role in the institution's goals, since no master was allowed to gain entrance into the Academy without having proved himself in this genre. To further these goals, Louis founded the French Academy in Rome, a place to which young painters and sculptors could travel in order to attain firsthand exposure to the great art of the ancient city. A state grant supported this institution, which was required to stage annual exhibitions of all its students. To create a market for the French Academy's instruction, moreover, the king granted the institution a monopoly over the teaching of life drawing. Thus if a student wanted to master the techniques of drawing with life models, he was forced to enroll in the Academy in Paris. To grant the institution greater cachet, Louis also insisted that he would award no commissions to any artist who was not a member. The king's state interventions in the art world were unprecedented in seventeenth-century Europe, and were not immediately imitated elsewhere. By the eighteenth century, however, a series of foundations of national academies elsewhere in Europe came to be closely modeled on the French example, and in this way, the European state acquired an important role in the training and support of artists. During Louis's time, however, royal support of the arts was evidenced primarily in a flurry of building. In architecture, the reign of the Sun King was a period of undeniable greatness that began with the completion of the East Façade of the Louvre in Paris. A number of designers, including François Mansart, Louis Le Vau, Claude Perrault, and Jules Hardouin-Mansart, developed a style notable for its Baroque monumentality and rigorous classicism. Louis XIV's age also became synonymous with the building of Versailles, an enormous project that displayed the king's grandiose ambitions. At Versailles the king favored Charles Le Brun (1609–1690), the most important member of the Royal Academy at the time. Le Brun's decoration of the Hall of Mirrors, the King's Bedroom, and other public spaces in the palace provided a suitably grand backdrop for the Sun King's pretensions. Somewhat later, Hyacinthe Rigaud (1659–1743) rose to prominence as the king's favorite, and Rigaud excelled primarily as a portraitist. He created the contours of a severe and grand royal portraiture that persisted throughout most of the eighteenth century. In sculpture, the dominant artist of the time was Antoine Coysevox (1640–1720), who created a number of busts and equestrian treatments for Versailles. Louis XIV's taste frequently ran toward the decorative, and during his reign the support that he gave to French industries was decisive in their development. Most prominent among Louis' actions in this regard was his acquisition of the Gobelins factory in Paris in 1661. He placed the factory under the direction of his minister Colbert, who further entrusted many of the details of its development to Charles Le Brun. Louis recruited a number of foreign craftsmen to come and teach the workers at the Gobelins the techniques of their trade. The Gobelins thus became a workshop for the creation of paintings, sculptures, tapestries, and furniture for all the royal households. It also played a key role in founding a number of decorative arts and complex trades in the country that had not previously been known to French masters. Gobelin-produced goods were not sold to the general public, but instead were produced directly for the consumption of the king and court. While this scheme flourished under Le Brun's direction, it fell into decline after the death of Colbert. The institution has survived, however, primarily as a tapestry factory until modern times. While commercially the scheme might be considered a failure, it played a tremendous role in extending knowledge of techniques in the decorative arts in and around the city of Paris.

SOURCES

Jean Coural, *Les Gobelins* (Paris: Nouvelles Editions latine, 1989).

Helen Langdon, *Claude Lorrain* (London: Phaidon, 1989).

Alain Mérot, *Nicholas Poussin* (New York: Abbeville Press, 1990).

Anne Reinbold, *Georges de la Tour* (Paris: Fayard, 1991).

PAINTING IN THE LOW COUNTRIES

THE MEDIEVAL AND RENAISSANCE INHERITANCE. The Low Countries consisted of the area that today comprises modern Belgium, the Netherlands, and Luxembourg. During the fifteenth and sixteenth centuries a sophisticated culture of artistic consumption emerged in this area, particularly in Flanders, the Dutch-speaking province that was at this time the dominant commercial center of the southern Netherlands. The development of Flemish painting had gone hand in hand with the meteoric rise of the Duchy of Burgundy to prominence in the region, as well as with the rapid urbanization of the area. As a commercial region, the inhabitants of the Low

Countries had been open to influences from throughout Europe, but cultural contacts were always closest with France and the commercial centers in Italy, the Flemish cities' most important trading partners. At the end of the fifteenth century, the Netherlands fell under the control of the Habsburgs, and as a result of the far-reaching marital policies of the dynasty, the region soon came within the orbit of Habsburg Spain. This relationship was always an uneasy one. By 1600, the inhabitants of the Low Countries were waging a brutal war of independence against Spain, the consequences of which were the eventual liberation of the northern Dutch counties from Habsburg control. The southern portion of the Netherlands, of which Flanders was the largest and wealthiest province, was to remain under Spanish domination. As war spread throughout the region, the wars became far more than a movement for political independence, acquiring the character of a widespread religious conflict. In the north, the severely puritanical doctrines of Calvinism dominated in the cities of the county of Holland, while Spanish control in the south buttressed Catholicism and persecuted the many Protestants and Jews who had once flourished in the area's cities. With the recognition of Dutch independence in the early seventeenth century, the culture of the northern and southern Netherlands began to diverge rather quickly and definitively. Although both regions still shared many common features of language and customs, the southern Netherlands (what is now Belgium) became a fervently Catholic bastion in which education and the arts were avidly supported by the Spanish nobility and its courts. In the north, in what is now modern Holland, a different course prevailed. It was now a predominantly Calvinist country, though minorities of Catholics, Jews, and many other religions came to be tolerated there in the course of the seventeenth century. In particular, numerous Jewish, Anabaptist, and Calvinist émigrés streamed there from Antwerp and other southern Netherlandish towns. As a result of the unprecedented climate of religious toleration that prevailed there, Holland witnessed incredible population growth and rising wealth. Further south, the ancient cities of Bruges and Ghent languished. Once-dynamic Antwerp, too, entered upon a long period of decline when its harbor was closed in 1648 as a consequence of the Peace of Westphalia. These divergences in religion, culture, and economic life came to affect the still vigorous market for painting that thrived in both regions throughout the seventeenth century.

FLEMISH PAINTING. The southern Netherlands, which has by long-standing, but incorrect practice been identified as "Flanders," had a long and distinguished tradition of achievements in the visual arts. During the fifteenth century, a string of masters beginning with Jan Van Eyck and Lucas van der Weyden had developed a tradition of Flemish realism that rivaled the great experiments in naturalism that were underway in Italy at the same time. Flemish innovations in oil painting were avidly studied and copied elsewhere in Europe, particularly in Venice and northern Italy, where the new techniques were quickly taken up in the course of the sixteenth century. An avid market for altarpieces, private devotional images, and portraits persisted in the region at the dawn of the Baroque era, and the craftsman-like tradition of painting born in the later Middle Ages flourished. Around 1600, though, the figure of Peter Paul Rubens (1577–1640) burst upon this scene. A figure as important in Northern Europe as Michelangelo had been in Italy during the sixteenth century, his artistic vision was to transform painting in the Low Countries and throughout northern Europe. Enormously prolific and fueled with a visionary's genius, his influence spread far beyond Antwerp, the city in which he spent most of his productive life. His art gave expression to certain key Baroque visual values, including the swift and dynamic sense of movement as well as the dramatic monumentality that many of the artists of the time longed to perfect. Rubens also built upon the values of the High Renaissance, merging insights from the art of its masters with his northern European love of realistic portrayal and landscape. Employing his understanding of the Italian masters as well as his own native traditions, Rubens provided an example emulated by Flemish and Dutch painters in the great century of artistic achievement that his career initiated.

RUBENS' LIFE AND EARLY WORK. Peter Paul Rubens was born, not in Flanders, but in Germany, where his Protestant family had taken refuge during the Wars of Religion in their native country. At age eleven he came to Antwerp, where he converted to Catholicism and entered Latin school to gain a thorough grounding in the Classics. Destined for a career as a diplomat, he was sent to serve as a page in the court of a nearby countess. At this time he also began to draw, and instead of pursuing his career as a diplomat—a profession he returned to later in life—he entered the painters' guild at Antwerp. Through his connections in Antwerp he won an appointment as a court painter to Vincenzo Gonzaga, the duke of Mantua. Although given a number of tasks in the ducal household, he was left largely free for a number of years to tour Italy. On these journeys he sharpened his understanding of the art of the High Renaissance, something he had known only via engravings to this point. By 1602, he had made his way to Rome, where

he received a series of three commissions from the Church of Santa Croce. At this time his art was very much influenced by the grand style of the Venetians, with its emphasis on gorgeous color and monumental scale. In Rome, however, he garnered a firsthand knowledge of many of the works of Raphael and Michelangelo, before being sent on a diplomatic mission to Spain the following year. When he returned to Italy, he worked for a time in Genoa, before returning to Rome. During this second trip, he studied more closely the works of Annibale Carracci, an important influence in his work that led him to develop a grand and swift sense of movement in his later works. In 1608, Rubens returned to Antwerp where he received a number of requests for paintings from the city's linen merchants and guild officers. He undertook many of these commissions for public settings. His famous *Descent from the Cross* (1612–1614) was completed for the city's Cathedral, and still hangs there today. This flurry of image commissioning was a move that at the time bore political and religious significance. In previous generations, Antwerp had been a religiously mixed city in which Catholics, Calvinists, and Anabaptists had all vied for advantage. During 1566, an outbreak of violent iconoclasm had resulted in the destruction of a good deal of religious art. Ten years later, mutineering Spanish soldiers had sacked the city, and in 1585 Spanish forces laid siege to the town, and it fell to Philip II. Soon after, Dutch forces had blockaded the Scheldt, Antwerp's link to the sea. In the aftermath of this long period of disorder, the town's population fell dramatically, decreasing from a high of around 100,000 in the mid-sixteenth century to around 40,000 in 1590. As a result of Antwerp's increasing instability, its Calvinists, Anabaptists, and a large number of its merchants migrated northward into Holland, or to Germany and France. Peter Paul Rubens' family had, in fact, been among these refugees. By 1610, however, Antwerp's Catholic future seemed assured, and those Catholic merchants and patricians who remained in the city now came to celebrate the triumph of their faith with a number of works of religious art intended to rehabilitate and refurbish churches that had fallen into disrepair in the previous two generations. Both Calvinists and Anabaptists opposed the use of religious images in churches as a violation of the Ten Commandments' prohibition of "graven images." To demonstrate Catholicism's greater receptivity and tolerance of religious art a flurry of new works were to be placed in the city's churches. Through his knowledge of the most recent innovations in Italian art, Rubens soon became the painter favored at Antwerp to give expression to the sense of Catholic resurgence.

RUBENS' HIGH BAROQUE STYLE. Rubens himself had been a member of an old and distinguished Antwerp family, and by virtue of his education and his travels in Italy, he soon emerged as the dominant artist on the local scene. In part, the early years back in his native Antwerp were filled with problems of readjusting to life in the conservative Catholic climate of his home city. The developing spirit of the Catholic Reformation called for the messages of religious art to be simple and forcefully portrayed. In Antwerp, however, patrons and religious institutions sometimes used these demands to cajole Rubens to return to the traditional, and to his mind, outmoded conventions of late-medieval art. They demanded, in other words, symbols and iconography that were clearly intelligible to the masses, so that meanings of his works were not misconstrued. In Italy, though, Rubens had been captivated by the art of Caravaggio, Annibale Carracci, and the Caravaggisti. Both Caravaggio and his followers had longed to present religious themes within settings that appeared like those of everyday life, while the heroic and idealized art of Carracci favored heavily muscled images of the human form, often naked or partially nude. During the 1610s, Rubens experimented with bringing these elements together in a way that might not offend local sensibilities, although the heroic dimensions he derived from Carracci and other Roman painters of the time were to gradually dominate his art. At the same time he strove to capture the drama inherent in Caravaggio's use of *chiaroscuro*, that is, the contrast of light and dark passages on the canvas. During these years the artist also took on many diplomatic missions for the provinces of the southern Low Countries, and in this capacity he moved freely in aristocratic circles. Always a man of learning and refinement, Rubens was forced to develop an almost industrial-like production system to complete the many commissions he received. His patrons insisted that his works be large, since many were intended for display in cathedral churches, monasteries, and other institutional settings. At the same time, the fashion for the age tended in all things toward the monumental. To cover these enormous panels and canvases, Rubens relied on an army of assistants who painted in the designs that he had sketched first. In many instances, he only returned to these works for the finishing brush strokes. Such a technique might seem merely facile today, yet as a method it worked brilliantly under the great artist's direction. Rubens was, in fact, a polymath, a master of many different arts and branches of knowledge. Visitors to his studio noted that someone might be reading a Latin history to the artist from one corner, while elsewhere he conducted a conversation with an intellectual in another.

a PRIMARY SOURCE *document*

THE ACQUISITIVE SPIRIT

INTRODUCTION: During the seventeenth century a definite commercial market in art and antiques began to emerge in Europe. Of all the centers of this new industry, it was in the Netherlands where the newly commercialized consumption of art was most precocious. Artists themselves took advantage of the new trend to deal in art as an investment. The two greatest artists in the region during the seventeenth century—Peter Paul Rubens and Rembrandt van Rhijn—both had enormous art collections. Rembrandt's collecting habits eventually destroyed his financial well being, while Rubens appears to have been a considerably more astute collector. In this letter he sent to the English ambassador to Holland in 1618, he sets in motion the process that will allow him to exchange some of his own canvases for Dudley's antiques. The letter shows what a shrewd and somewhat cagey bargainer Rubens was.

Most Excellent Sir:

By the advice of my agent, I have learnt that Your Excellency is much inclined to make some bargain with me about your antiques; and it has made me hope well of this business, to see that you go earnestly about it, having named to him the exact price that they cost you: in regard to this, I wish wholly to confide on your knightly word. I am also willing to believe you purchased them with perfect judgment and prudence; although persons of distinction are wont usually, in buying and selling, to have some disadvantage, because many persons are willing to calculate the price of the goods by the rank of the purchase, to which manner of proceeding I am most averse. Your Excellency may be well assured I shall put prices on my pictures, such as I should do were I treating for their sale in ready money; and in this I beg you will be pleased to confide on the word of an honest man. I have at present in my house the very flower of my pictorial stock, particularly some pictures which I have retained for my own enjoyment; nay, I have some re-purchased for more than I had sold them to others; but the whole shall be at the service of Your Excellency, because brief negotiations please me; each party giving and receiving his property at once; and, to speak the truth, I am so overwhelmed with works and commissions, both public and private, that for some years, I cannot dispose of myself. Nevertheless, in case we shall agree, as I anticipate, I will not fail to finish as soon as possible all those pictures that are not yet entirely completed, though named in the herewith annexed list, and those that are finished I would send immediately to Your Excellency. In short, if your Excellency will make up your mind to place the same reliance in me that I do in you, the thing is done. I am content to give Your Excellency of the pictures by my hand, enumerated below, to the value of six thousand florins, of the price current in ready money, for the whole of those antiques that are in Your Excellency's house, of which I have not yet seen the list, nor do I even know the number, but in everything I trust your word. Those pictures which are finished I will consign immediately to Your Excellence, and for the others that remain in my hand to finish, I will name good security to Your Excellency and will finish them as soon as possible. Meanwhile I submit myself to whatever Your Excellency shall conclude with Mr. Francis Pieterssen, my agent, and will await your determination, with recommending myself, in all sincerity to the good graces of Your Excellency, and with reverence I kiss your hands …

SOURCE: Peter Paul Rubens, "Letter to Sir Dudley Carleton, April 1618," in *A Documentary History of Art*. Vol. II. Ed. Elizabeth Gilmore Holt (Garden City, N.Y.: Doubleday Books, 1958): 190–191.

Before him he might be working on a canvas, while at the same time dictating a letter to his secretary. This enormously fertile mind and sense of energy shines through in almost all of his works.

SPIRIT OF HIS WORK. Although Rubens' early development and training had been in the tradition of Flemish realism that had flourished in the region since the fifteenth century, the spirit of his work is anything but Flemish in inspiration. It was his fortune to be able to forge together the currents of Italian art that had flourished in the peninsula's various centers over the previous generations. At the same time, he took these to a new level of synthesis and monumentality that spoke to the emerging tastes of Baroque patrons and rulers in Northern Europe. One of his most important commissions was for a series of paintings to decorate Queen Marie de' Medici's Luxembourg Palace in Paris. There were in all 21 of these massive canvases completed between 1621 and 1625 for the queen, who had served as regent for her son Louis XIII since 1610. In point of fact, Marie de' Medici's life had been marked by numerous failures punctuated with occasional political successes. Rubens perceived this enormous project, though, in ways that made use of his enormous classical learning. Throughout Marie is shown being protected by the Olympian gods. Of these works, one of the most polished is his *Henri IV Receiving the Portrait of Maria de' Medici*, a canvas almost 10' by 13' in dimension. Below, the figure of Henri IV is shown at the right inspecting an image of his future bride, Marie de' Medici, presented

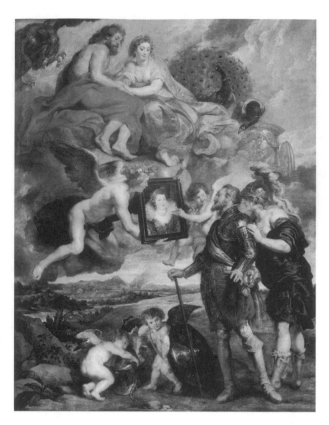

Henry IV Receiving the Portrait of Marie de Medici (c. 1622) by Peter Paul Rubens. ART RESOURCE.

to him by two angelic messengers. Behind the king, the goddess Minerva advises the aging king to accept Marie as his second wife, while above, Jupiter and Juno look down on the scene with the promise to bless the union. A gorgeously painted peacock, the goddess Juno's iconographic attribute, is set off against a tumultuous cloud-filled sky, while below, a limitless landscape stretches off to the horizon. Other gems abounded in Rubens' pictorial cycle, and the relationship that he developed with the queen as a result was long-standing. She desired to commission him to paint a second series that was to glorify, not her own life, but that of her deceased husband. But when problems over the payment of Rubens' fee for the first 21 canvases arose, he refused. When her son assumed the throne and relations between mother and son soured, Marie de' Medici was forced into exile. She sought out Rubens and lived with him for a time, a testimony to the close bond that had been forged by their professional association.

VAN DYCK. Peter Paul Rubens taught many students and had a number of apprentices in his Antwerp studio during his relatively long life. Many of these figures came to produce any number of craftsman-like works following his death, which kept alive, if albeit in

a less vivid way, the great artist's vision for a time. Of all the figures who came in contact with the master, Anthony Van Dyck (1599–1641) was the only member of Rubens' workshop to achieve universal acclaim and a broad European reputation. He did so despite his relatively short life. Like Rubens, Van Dyck moved in the cultivated and urbane circle of humanistically educated intellectuals that flourished in Antwerp in the early seventeenth century. He was very much affected by the Stoicism of the great philosopher of his time, Justus Lipsius, while many of his paintings, like those of Rubens, displayed a remarkable Catholic piety. Yet unlike his teacher, Van Dyck's talents shone most brilliantly when he was at work on small devotional pieces and portraits, rather than great public altarpieces and historical themes, although in this last genre he did make many significant contributions. Rubens had painted portraits only reluctantly, although toward the end of his career he came to undertake far more of these commissions. For most of his life, he had preferred the grand manner necessary to complete the enormous commissions his aristocratic and royal patrons stipulated. By contrast, Van Dyck reveled in portraiture and in his journeys through his native land, England, and Italy, he received numerous commissions for them. The differences in temperament between the student and his master are most evident when their portraits are compared. Rubens surrounded his subjects with the trappings of aristocratic grandeur and he came to endow their expressions and demeanor with attributes that suggested their intellect and dignity. Van Dyck, by contrast, preferred to present his subjects in landscapes or other more informal settings and he endowed them with aristocratic ease and self-assurance. An air of refinement, even delicacy permeates his most successful works. One of the most famous of these, *Charles I at the Hunt*, was painted around 1635, just after the artist had returned to London for what was to turn out to be a four-year residence shortly before the end of his life. The king stands atop a small hill, his arm extended with a walking stick planted on the ground as if to stake his claim to the hunting ground that stretches around him. Behind him a page tends to his horse while a tree shades the entire scene. Charles is shown without any of the typical attributes of royalty and his flowing locks and rakishly cocked hat suggest his reputation as the "Cavalier King," while at the same time pointing to his own well-recognized tendency toward indulgence and effeminacy. It is a curious pose for a royal who claimed, as Charles did, to rule by divine right. It portrays the Renaissance ideal of *sprezzatura* or "graceful ease" that Baldassare Castiglione and writers of English conduct books had come to recommend as valuable attributes for those

wishing to be successful at court. When compared to the dignified and imposing images of Louis XIV that were soon to express the French king's pretensions for absolute rule, Van Dyck's *Charles I at the Hunt* is a peculiar expression of royal power. Yet the artist's visual language was widely admired by the Italian and English aristocrats he painted, and he repeated the formula many times during his short career.

THE DECLINE OF FLEMISH PAINTING. Following the death of Rubens in 1640 and Van Dyck one year later, the leading Flemish artist was Jacob Jordaens (1593–1678). Both Rubens and Van Dyck had been recognized for their great achievements during their lifetime, both having been knighted in several of the courts in which they worked. By contrast, Jordaens only came to receive court commissions from small states in northern Europe after the deaths of Van Dyck and Rubens, and his art was completely ignored in France, England, Spain, and Italy. He came to carve out a niche for himself in a far less refined circle than that in which Van Dyck had moved. While he achieved great moments of compositional clarity and excitement in his art during the years immediately following Rubens' death, his works tended to fall into formulaic compositional strategies in his old age. He converted to Calvinism in 1656, and after this date was granted some commissions from territorial princes in Germany and from the house of Orange. The parochialism of his career, though, was symptomatic of the changes that were underway in Flanders, as that region was becoming steadily impoverished as a result of the great shifts that had occurred in trade, politics, and religious life throughout the Low Countries. Jordaens was not the last of a distinguished tradition of Flemish painters; the region's cities continued to produce a number of venerable artists throughout the later seventeenth century. Yet, like Jordaens, none of these figures was to attract the European-wide reputation, nor to display the same high level of imaginative genius of Rubens and Van Dyck.

PAINTING IN THE NORTHERN NETHERLANDS. To the north, in the provinces that had successfully waged war against Spanish rule, a great age of cultural and financial success was just beginning to unfold. Although war with Spain had broken out again in 1621, the threat from the Habsburgs steadily receded. By the time that the United Provinces' independence was formally recognized in 1648, Amsterdam and the other large cities of Holland, the largest of the country's seven provinces, had long enjoyed their independence and were by then Europe's premier trading centers. Here banking, shipping, industrial production, and new types of financial

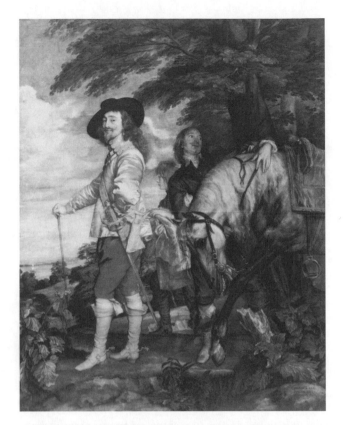

Charles I at the Hunt (1635) by Anthony van Dyck. MARY EVANS PICTURE LIBRARY.

services, like insurance and stock trading, were beginning to shape an undeniably modern economy. The relative tolerance of these towns meant that Anabaptists, Jews, Greek Orthodox, and a host of other religious groups streamed to the region. Art came to play a very different role in this new economy, since Calvinism prohibited religious art in churches. As a result, the great Dutch masters came to concentrate on landscape painting, portraits, and other genres that were of a mostly secular nature. Commissions from aristocrats and wealthy merchants were important to the many figures that painted in the Netherlands during the seventeenth and eighteenth centuries. Yet at the same time, an unprecedented phenomenon is evident in seventeenth-century Holland: the emergence of a public marketplace in art. To sustain themselves financially, Dutch artists came to sell their works to dealers who catered to these towns' many rich and middling ranks of merchants. Towns regulated these markets, but the evidence suggests that art came to enter into the commercial life of Holland and the other Dutch provinces in some very interesting ways. It was now a commodity with a value, and collecting and selling the works of a major master was one way that many increased their income. Art objects, too, were used

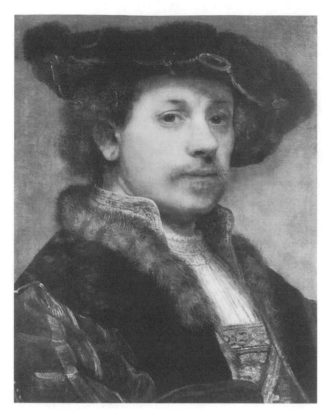

Self-Portrait by Rembrandt. © CORBIS-BETTMANN. REPRODUCED BY PERMISSION.

and other major Dutch cities faced an oversupply of paintings that drove the prices of art downward.

REMBRANDT. Rembrandt van Rhijn was born to a miller at Leiden, and was one of the younger of ten children. Although he came from a relatively humble set of circumstances, he attended Latin school in Leiden before entering its university at the age of fourteen. There he acquired the ambition to become a painter, and soon became the pupil of a local master, before setting off to Amsterdam to study for six months in 1624. The precise development of his art in these early years is difficult to gauge, although by 1625, he was back in Leiden, where his works soon began to be purchased by art dealers. It is notable that unlike Rubens and many of the great northern European masters of the time, Rembrandt never spent any time in Italy as a student or in later years. He was a genius produced exclusively on the local Dutch scene, and what knowledge he had of the art of the Renaissance and of Baroque Italy largely came to him through engraved copies. Even at an early date in his career, the distinctive features of his style were evident. He understood the distinctive coloristic possibilities of oil paints and he applied them in thick, built up passages known as *impasto*. At many points he was to experiment with the new techniques that other artists of the time were developing. At times, for instance, his works made use of Caravaggesque *chiaroscuro* to create drama and suggest turbulence. Yet in this and other regards, Rembrandt displayed a singular artistic vision that he developed through these techniques into his own inimitable visual language. The working techniques that Rembrandt developed in these early years were also notable, and show the increasing penetration of capitalist values into the Dutch art market. Rembrandt, for instance, forged an alliance with the artist Jan Lievens. Together, they hired life models, posed them, and painted their own individual visions of the same subject, thus cutting in half their expenses in producing a painting. Rembrandt turned his back on his early success in Leiden in 1631 and moved to nearby Amsterdam, the city that was quickly acquiring an identity as Holland's metropolis. He came to work for an art dealer, who found commissions for him as a portrait painter, and he soon married. In a few years he had developed a busy studio that served the thriving art market. His dealer, Hendrick van Uylenberg, catered to a large and diverse clientele, and he offered these consumers something in every conceivable price range. To satisfy this demand, Rembrandt developed a large studio, where painters copied his own and other Italian works popular at the time or in which they produced small scale works, or tronies. A tronie was a

to insure loans and to pay off obligations. A certain risk was present in this new market, as many who dabbled in it were to discover. The vagaries of taste and oversupply sometimes drove down the price of major works. Rembrandt, the greatest master Holland produced in the seventeenth century, was a prolific painter, but at the same time an avid collector and dealer in others' works. His expenditures in this regard led to bankruptcy, when he was unable to recoup his investments. Concern for the quality of great masterpieces came to breed some of the first legal cases concerning artistic forgery, as the high esteem in which certain artists were held became a bankable commodity. All this meant that the arts acquired a greater prestige in this newly urbanized society, and consequently, many more artists were trained and took up the profession than previously. The Netherlands at this time produced a host of small masters, many completely unknown today, others of high quality and reputation. Artists, too, came to specialize, with some producing images only of boats and harbor scenes, while others treated garden landscapes, drinking scenes, battles, and so forth. Paradoxically, as more and more artists competed against each other, the prices they could command for their works fell. By the mid-seventeenth century Amsterdam

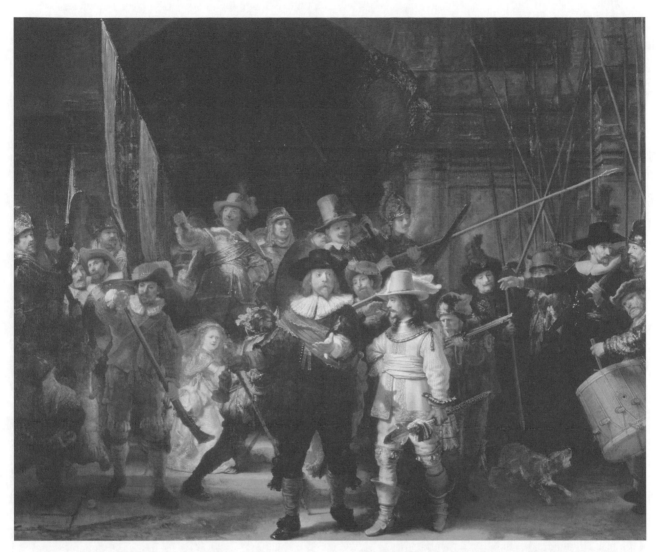

The Night Watch or *The Militia Company of Captain Frans Banning Cocq* by Rembrandt. © **ARCHIVO ICONOGRAFICO, S.A./CORBIS.**

particularly popular Dutch genre in which a portrait was undertaken of a sitter in an historical or mythological role. Rembrandt himself reserved his own attentions in the 1630s primarily for commissioned portraits, although he did paint a number of biblical scenes as well as traditional Catholic religious art commissioned by churches and religious institutions abroad. During this period he had little time to indulge his love of engraving, although later he was to realize the commercial possibilities inherent in this medium, since a single etching might be sold through dealers to hundreds of customers.

THE NIGHT WATCH. By 1642, Rembrandt's success was assured on the Amsterdam scene. In that year he devoted almost all his energies to finishing the great military portrait that has since become known as the *Night Watch*. The name is actually a misnomer. In the decades after it was painted, a heavy layer of varnish was applied

to the painting. When restorers removed this layer in 1975, they found that it had been painted to appear as if the scene was occurring in complete daylight. Political power in Dutch cities was frequently exercised in corporate bodies, and as a result the phenomenon of "group portraits" quickly developed in the seventeenth century to immortalize those councils, committees, and institutions that guided civic life. The *Night Watch* is one such portrait. It treats the civic militia that was charged with the defense of Amsterdam. Unlike most previous treatments of a group, Rembrandt's highly imaginative portrait set a new standard for such works. In the central foreground of the painting, Rembrandt depicted the figure of Captain Cocq, while around him he placed an amazingly active hubbub of drummers, standard bearers, and militia members. Thus in the confusion that inherently attends all military endeavors, Rembrandt found a

a PRIMARY SOURCE *document*

CONTRACTUAL ARRANGEMENTS

INTRODUCTION: Despite the high esteem in which painters were held in the seventeenth-century Netherlands, the new art market was an uncertain place. Rembrandt van Rhijn invested heavily in antiquities and art throughout most of his life, but in the mid-1650s his profligate spending caught up with him, and he was forced to declare bankruptcy. For a time he was imprisoned before regaining his freedom. Within a few years, Rembrandt's common-law wife Hendrickje Stoffels and his son Titus had worked out an arrangement through which the great artist became their employee. In this way he was able to circumvent his creditors and continue to paint, creating a way out of the family's financial crisis. The following agreement dated December 15, 1660, makes explicit the nature of the partnership between Titus and Hendrickje Stoffels.

On December 15, 1660, Titus, assisted by his father, [Rembrandt van Rhijn] and Hendrickje Stoffels, who is of age and is assisted by a guardian chosen by her for the purpose, declare that they agree to carry on a certain company and business, started two years before them, in paintings, pictures on paper, engravings, and woodcuts, the printings of these curiosities, and all pertaining thereto, until six years after the death of the aforementioned Rembrandt van Rhijn, under the following conditions:

Firstly, that Titus van Rhijn and Hendrickje Stoffels will carry on their housekeeping and all pertaining thereto at their joint expense, and having jointly paid for all their chattels, furniture, paintings, works of art, curiosities, tools, and the like, and also the rent and taxes, that they will continue to do so. Further, both parties have each

brought all they possess into the partnership, and Titus van Rhijn in particular has brought his baptismal gifts, his savings, his personal earnings, and other belongings he still possesses. All that either party earns in the future is to be held in common. According to this company's proceedings, each is to receive half of the profits and bear half of the losses; they shall remain true to one another in everything and as much as possible shall procure and increase the company's profit.

But as they require some help in their business, and as no one is more capable than the aforementioned Rembrandt van Rhijn, the contracting parties agree that he shall live with them and receive free board and lodging and be excused of housekeeping matters and rent on condition that he will, as much as possible, promote their interests and try to make profits for the company; to this he agrees and promises.

The aforementioned Rembrandt van Rhijn will, however, have no share in the business, nor has he any concern with the household effects, furniture, art, curiosities, tools and all that pertains to them, or whatsoever in days and years to come shall be in the house. So the contracting parties will have complete possession and are authorized against those who would make a case against the aforementioned Rembrandt van Rhijn. Therefore he will give all he has, or henceforth may acquire, to the contracting parties, now as well as then, and then as well as now, without having either the slightest claim, action, or title, or reserving anything under any pretext.

SOURCE: "Agreement Between Titus Van Rhijn and Hendrickje Stoffels," in *A Documentary History of Art*. Vol. II. Ed. Elizabeth G. Holt (Garden City, N.Y.: Doubleday Books, 1958): 204–206.

narrative purpose for the group portrait. Although legends have insisted through the centuries that Rembrandt's picture was not well received, it was, in fact, an immediate success. In the rising sophistication of Amsterdam as an artistic center, few seemed to have cared that the artist's swift-moving composition seemed to obscure the faces of some of those in the company. They admired instead the ingenuity with which Rembrandt had solved the problem of developing a seemingly natural setting in which to capture the militia.

LATER SETBACKS. Rembrandt's enormous successes at Amsterdam were soon to be followed by a series of setbacks during the final two decades of his life. Financially secure, the artist had begun to sink ever more of his wealth into the purchase of art and antiquities. These purchases cemented the artist's claim to gentlemanly status, some-

thing that he seems to have long desired. Although he used many of his acquisitions to help formulate his own artistic creations, he came at the same time to speculate widely in the art market, and to increasingly disastrous effect. In 1656, he declared bankruptcy, and his collection was largely liquidated to pay debts. This crisis came at a time when values on the art market in Amsterdam were suffering and many pieces in his vast collection were sold for a fraction of their worth. His house was soon sold off as well, and the artist and his children moved to a much more modest residence. In the years that followed, the artist was able to continue to paint under an unusual legal arrangement. His son and common-law wife formed a partnership while Rembrandt himself became their employee. This protected Rembrandt's creations from being seized to pay off his debts. A large number of commis-

sions undertaken at this time point to his continuing popularity in Amsterdam, and his fortunes rose once again. Another tactic that helped in the family's recovery of their fortunes was Rembrandt's decision to return to the medium of engraving. In these later years, despite the continuing press of commitments and financial and legal problems, Rembrandt also continued to paint his self-portrait, as he had done throughout his career. At his death he had completed almost seventy of these, as well as hundreds of drawings of himself, and many etchings. These provide a record of his maturation as an artist, even as they afford almost endless psychological insights into the master. In his religious and historical composition, too, a profound spiritual piety also came to manifest itself ever more vividly in his works in later life.

OTHER MASTERS. The brilliant period of Dutch painting in the seventeenth century produced what today appears as almost an endless cavalcade of landscapes, genre paintings, and portraits. In contrast to the monumental nature of many of Rembrandt's and Ruben's creations, much of the scale of Dutch painting was modest, geared to fit into relatively small Dutch townhouses. To treat all the distinguished Dutch artists who appeared at this time falls beyond the scope of the present volume. Among the most notable, though, are Jan Steen (1625/26–1679), Pieter Saenredam (1597–1665), Frans Hals (c. 1585–1666), and Jan Vermeer (1632–1675). Steen was particularly noted for his depictions of Dutch domestic life, showing crowded interiors filled with rollicking families. Amidst this hubbub, Steen included moralistic details that were intended to remind the viewers of his paintings of the transitory nature of human life. His fruit lies rotting on the table, a reminder of the consequences that comes from the overindulgence that his subjects are often engaged in. In Dutch, his art was to inspire the phrase "A Jan Steen household" to suggest domestic disorder. By contrast, Pieter Saenredam completed a number of realistic views of Dutch churches and civic halls. His works were incredibly carefully produced and although his output was rather small, his depictions show a striking attention to highly intellectual compositional techniques. Specializing in portraiture, Frans Hals was almost the equal of the great Rembrandt. Although his art does not contain the same depth of interior insight as the great master, his works range over the full scale of human emotions, from the genial, to the pensive, to the demonic. Perhaps the greatest of these "little masters" was Jan Vermeer, a painter who in his own time had little reputation for greatness, but who today points to the undeniable grandeur of Dutch seventeenth-century painting. Like Jan Van Eyck and earlier Flemish painters of

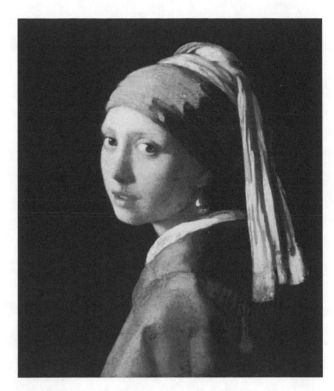

Girl With Yellow Turban by Jan Vermeer. © FRANCIS G. MAYER/CORBIS. REPRODUCED BY PERMISSION.

the fifteenth century, Vermeer had the ability to endow everyday human actions with quiet nobility. His experiments in light and realism appear startling today for their almost photographic clarity, yet at the same time they seem to convey a mystical intensity about the precious character of human life. To achieve his subtle optical effects, Vermeer most likely relied on a camera obscura, through which he peered in order to render the world more effectively. His output was small, perhaps no more than 60 paintings in all during his lifetime. Of these, only 35 survive today. Extensive research conducted on these works has shown that Vermeer frequently reworked and repainted his compositions, thus explaining his relatively small output. In contrast to many of the most prolific artists of the period, Vermeer probably produced only two to three works a year, in contrast to many of the "little masters" who painted hundreds, even thousands of works in their lifetimes. Yet what survives from Vermeer's hand points to the incredible sophistication of his artistic techniques as well as the variety of painterly visions that came to exist fruitfully side-by-side in the seventeenth-century Low Countries.

SOURCES

Daniel Arasse, *Vermeer: Faith in Painting* (Princeton: Princeton University Press, 1994).

Kerry Downes, *Rubens* (London: Jupiter Books, 1980).

Bob Haak, *The Golden Age.* Trans. Elisabeth Willems-Treeman (New York: H. N. Abrams, 1984).

Julius S. Held, *Rubens and His Circle* (Princeton: Princeton University Press, 1981).

John M. Nash, *The Age of Rembrandt and Vermeer* (Oxford: Phaidon, 1979).

Seymour Slive, *Frans Hals* (London: Phaidon, 1974).

Christopher White, *Peter Paul Rubens* (New Haven, Conn.: Yale University Press, 1987).

SPANISH PAINTING IN THE SEVENTEENTH CENTURY

A CENTURY OF ACHIEVEMENT. For most of the sixteenth century Spain was the dominant power in Europe, and its colonial empire insured that in the seventeenth the country retained an enormous importance on the European scene. At the same time Spain's wealth always rested on uncertain grounds. Despite huge influxes of capital from the New World colonies, Philip II (r. 1555–1598) was forced to declare bankruptcy twice during the second half of the sixteenth century, when the costs of his involvements in international wars perilously drained the state's treasury. Although engaged in costly wars in the Netherlands and faced with economic problems that were to increase over time, the first half of the seventeenth century was a period of cultural brilliance throughout Spain. The years after 1600 witnessed an enormous flowering of Spanish theater, literature, and the visual arts. While all forms of the visual arts—painting, sculpture, and engraving—flourished at the time, it was in painting that the Spanish made their most definitive contributions to European art. Here Spanish painters were at first indebted to the examples of Italy. Throughout the sixteenth century, the country's colonial and commercial outposts in the peninsula had kept Spanish painters abreast of the latest trends in painting. During the later sixteenth century the example of Venetian art, particularly of Titian, had captivated artists like Francisco Ribalta (1565–1628). Philip II had been an admirer of the great Venetian artist, and had had his portrait painted by him, and by the early seventeenth century Spain's royal collections contained a number of Venetian masterpieces. Most Spanish artists like Ribalta, though, had not come to learn of Venetian art by traveling to Venice or through studying the royal collections. They learned of these works through the many copies of Titian, Veronese, and Tintoretto's works that circulated in the country. The great painter El Greco (c. 1541–1614), a Greek who had trained in Venice, also exposed Spanish painters to the Venetian tradition. In 1577, the artist settled permanently in Toledo and produced a number of deeply religious works that inspired later Spanish artists. During the late sixteenth century Italian Mannerism had also played a role in shaping the art of Spain, but in the early seventeenth century it was primarily the example of Caravaggio that most influenced the rising generation of native artists who were to define tastes in the country for most of the rest of the seventeenth century. Three figures—Jusepe de Ribera (1591–1652), Francisco de Zurbarán (1598–1664), and Diego Velázquez (1599–1660)—were to found a highly original Spanish school of painting, notable at first for its indebtedness to Caravaggian models, but increasingly independent from this Italian tutelage over time. Although Jusepe de Ribera (1591–1652) was initially trained in the studio of the Spanish painter Francisco Ribalta, he soon made his way to Italy and never returned to Spain. In Rome he soon was affected by the popularity of Caravaggism, before moving on to Naples, a Spanish outpost. He spent most of his life working there, exploring the possibilities that lay within Caravaggio's and the Caravaggisti's techniques of realism, psychological immediacy, and *chiaroscuro*. Although his example was to shape the early art of Diego Velázquez, he was like Poussin and Lorrain as one of the émigré artists whose contributions belong more appropriately to the history of Italian, rather than Spanish, art. By contrast, Francisco de Zurbarán (1598–1664) and Diego Velázquez (1599–1660) trained exclusively in Spain, and developed successful careers there painting for the royal court, religious institutions, and the country's nobility.

FRANCISCO DE ZURBARÁN. Born in a provincial, mountainous region in southern Spain, Zurbarán came to settle in Seville at the age of fifteen, where he apprenticed himself to a local master. At the time, Diego Velázquez and a number of other artists who were to develop successful careers were also students in the city, and Zurbarán likely made their acquaintances at this time. He also seems to have become familiar with techniques for creating polychromed sculpture, an art form very much in fashion in Seville at the time. These works, carved from wood or stone, were painted with bright colors, and in Zurbarán's later paintings the treatment of many of his figures appears to be drawn from the genre of Spanish polychromed statues. With his apprenticeship completed, he returned to his native region, settling in Lierena, marrying, and setting up a studio in that town. About a decade later, he received a number of commissions from monasteries in Seville, and in 1629 the town council asked him to settle there. He did, and

a PRIMARY SOURCE *document*

THE SERVICE OF GOD

INTRODUCTION: The painter Francisco Pacheco (1564–1654) was a learned man as well as the teacher and father-in-law of Spain's greatest seventeenth-century artist, Diego Velázquez. Although he was fully aware of all the trends popular in the art world of his day, Pacheco spent most of his life completing commissions for Spain's powerful religious institutions. His statements in his theoretical work, *The Art of Painting*, show the effects of the deep Catholic piety for which Spain was famous in the seventeenth century.

The Aim of Painting is the Service of God. When dealing with the purpose of painting (as we have set out to do), it is necessary to make use of a distinction by the Church fathers which will clarify the matter: they say, one purpose is that of the work and another that of the worker. Following this teaching, I say that one aim is that of the painter and another that of painting. The object of the painter, merely as a craftsman, probably is by means of his art to gain wealth, fame or credit, to give enjoyment or to do a service to somebody else, or to work for his own pastime or for similar reasons. The purpose of painting (ordinarily) is probably to depict, through imitation, a certain object with all possible valor and propriety. This is called by some the soul of painting because it makes the painting seem alive, so that the beauty and va-

riety of the colors and the other embellishments are merely accessories. ... Considering, however, the object of the painter as a Christian craftsman (and it is he with whom we are here concerned), he might have two purposes, one main aim and the other one a secondary or consequent one. The latter, less important, purpose might be to ply his craft for gain or fame or for other reasons (as I have stated above), but which ought to be controlled by the proper circumstances, place, time and form, in such a way that nobody should be able to accuse him of exercising his talent reprehensibly or of working against the highest purpose. The main purpose will be—through the study and toil of this profession and being in the state of grace—to reach bliss and beatitude, because a Christian, born for holy things, is not satisfied in his actions to have his eyes set so low that he strives only for human reward and secular comfort. On the contrary, raising his eyes heavenward he is after a different aim, much greater and more exquisite, committed to eternal things. St. Paul often warned the serfs and all other men that when ministering to others they should remember that they did it chiefly for the sake of God. He said: "You who are slaves obey your masters on earth not out of duty or reflection but as servants of Christ who know that everyone will receive his reward from the Lord in accordance with his actions."

SOURCE: Francisco Pacheco, *El arte de la pintura*, in *A Documentary History of Art*. Vol. II. Ed. Elizabeth G. Holt (Garden City, N.Y.: Doubleday Books, 1958): 214–216.

from this point his commissions in the city steadily rose. The impact of Caravaggio on his style is evident from the first paintings that can be attributed to him. Like Velázquez, he had likely studied copies of the master's work while a student in Seville. Yet he went beyond this example to create highly spiritual and meditative paintings. Like other seventeenth-century masters working in Catholic societies, Zurbarán satisfied an almost insatiable appetite for devotional images, an appetite that had been bred by the Catholic Reformation and devotional classics like St. Ignatius Loyola's *Spiritual Exercises*. He was also prized as a painter of still-lifes and portraits. The images he created for Seville's monasteries, as well as the commissions he undertook in the 1630s for the royal court at Madrid, show a developing artistic sophistication. In the earliest works, for instance, rather naive treatments of the human form occur, while over time the artist acquired a surer skill in organizing his compositions. The intense piety of his works can best be seen in his paintings of the saints in meditation, works that he frequently provided to his monastic and aristocratic pa-

trons. Although his career flourished throughout the 1630s, the years after 1640 were troubled ones for the Spanish economy. To support his studio in Seville, the artist sold paintings to monasteries in the Americas. This traffic was particularly great in the years between 1648 and 1650, when the recession was worsened in Seville by an outbreak of plague. During these years Zurbarán's studio made large shipments to Mexico and the Andes where these works established a native Catholic Baroque style in Spain's colonies. During the 1650s Spain's economic fortunes rebounded somewhat, and by 1658 the artist had left Seville to work in the Spanish capital, Madrid. There he made contact with his old friend, Diego Velázquez, who may have helped him to compete successfully for commissions. In these later years of his life he seems primarily to have concentrated on producing devotional images for family and monastic chapels.

DIEGO VELÁZQUEZ. The undeniable giant of seventeenth-century Spanish painting, and one of the greatest European painters, was Diego Velázquez. Raised

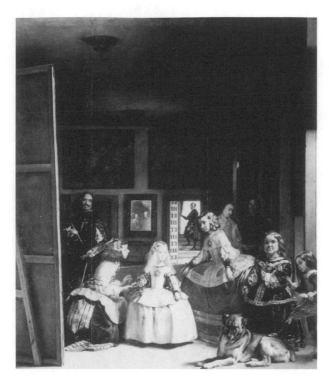

Las Meninas by Diego Velázquez. ERICH LESSING/ART RESOURCE, NY. REPRODUCED BY PERMISSION.

in Seville, he also trained there as an artist. Precocious at a young age, he entered into service at the royal court in 1523, becoming the principal painter to Philip IV (r. 1621–1665). He was to remain a member of the royal household until his death and was to be responsible for painting an astonishing number of portraits, notable for their great compositional originality and for their quick and expressive brushwork. Although he initially worked for members of the Spanish nobility in Madrid, the conditions of his court appointment soon made such private commissions impossible to execute. Velázquez was always very concerned with social rank and prestige, and tried throughout his life to establish that his family was of noble origins. Working solely at the command and whims of the king bolstered these claims in seventeenth-century Spain, where private commissions undertaken for solely monetary purposes were perceived to be crassly commercial. Velázquez soon put aside all thoughts of enrichment from his art and conformed to the necessity of producing works for the king's pleasure. Besides his training in Seville, his painting came to be affected by the visit of Peter Paul Rubens to Madrid in 1628, who came there on one of his diplomatic journeys undertaken for the provinces of the southern Low Countries. In addition, Velázquez acquired new influences in his art from two trips he took to Italy, the first from 1629–1631 and the second from 1649–1651. On the first of these jour-

neys, he traveled initially to Parma, Florence, and Venice, before heading on to Rome. He was particularly impressed with the art of the Venetians, having found already in the colorism and swift brushwork of Rubens a reason for admiring this tradition. At the same time, his Italian journeys brought him into contact with the Baroque style that was developing in Rome, even as he ended his journey in Naples, where the experiments of the Caravaggisti were to leave their impression on his later work. With these experiences in mind, he returned to Spain, and during the 1630s he was to integrate the many influences that he had come in contact with over the years. Although he continued to paint a large number of portraits for the royal family, he also undertook more historical and mythological themes at this time. Among these images, the *Surrender of Breda* is today one of the most famous. The painting memorializes a recent victory in Spain's ongoing wars against the Dutch. Velázquez had never traveled in northern Europe, and thus had no idea what the area around the Breda battlefield had looked like. To complete his vision of the concluding surrender ceremony, he relied on engravings and written accounts of the event. Yet despite his relative ignorance, the picture manages to rise to the level of realism that one might expect in journalism, rather than painting. Throughout the canvas the artist relies on a rapid, yet sure brushwork. At the right side of the painting, he shows the Spanish army standing elegant and self-assured, while to the left, the battle-worn and defeated Dutch forces appear considerably less confident. In the center, the commander of the Spanish forces leans downward to grasp and comfort his Dutch opponent, a gesture that suggests nobility of spirit, a quality with which Velázquez endowed the entire composition.

THE MAIDS OF HONOR. Of the many masterpieces the artist painted for the Spanish court, his mature *Las Meninas,* or the *Maids of Honor,* ranks as one of the most accomplished works of all time. The painting is, in fact, not an image of the court's ladies-in-waiting, but a portrait of the royal family. During the nineteenth century it acquired its present title, and at this time artists interpreted the puzzling picture much as if it had been a candid snapshot of the court captured within Velázquez's studio. The painting shows the young princess Margarita Maria surrounded by her ladies-in-waiting, while in the background to the left, the artist inserts himself at his easel painting a huge canvas. A mirror in the back of the room reflects back the image of the Spanish king and queen, showing that in reality, the portrait that Velázquez is engaged in painting is not of the young Spanish princess, but is, in fact, one of the king and queen themselves. The royal cou-

ple thus takes on a quixotic presence in the canvas, since they are at one and the same time viewing the actions in the room that Velázquez is painting and also serving as the artist's models. The precise meaning that the artist intended to portray through this brilliant compositional strategy has long been debated. Most likely, he was making a claim for the high intellectual nobility of the painter's art, and at the same time he was likely musing about the pervasive nature of royal power within the milieu in which he worked. Generations of connoisseurs and art historians have tried to unlock all the meanings that repose in the amazing canvas, but the work still continues to provide an almost inexhaustible number of interpretations. It has often been pronounced the "greatest painting of all time" by virtue of its nearly perfect compositional makeup, its mixture of light, color, and texture, as well as its numerous intellectual insights. Such assessments are always a matter of taste, but *Las Meninas* certainly does point to the high degree of finesse with which Velázquez had mastered his art. His successes were well recognized at the time, and in 1658 King Philip IV finally rewarded him with the knighthood that he had so long desired. Thus in the final years of his life, the artist took on a number of important ceremonial functions within the Spanish Habsburg's court, including the staging of the betrothal ceremonies between the Princess Maria Theresa and the young King Louis XIV of France. Velázquez's lifelong craving for the stamp of aristocratic approval is a potent reminder of the social confines in which seventeenth-century artists lived and worked.

SOURCES

Jonathan Brown, *Velázquez: Painter and Courtier* (New Haven, Conn.: Yale University Press, 1986).

——, *Zurbarán* (New York: H. N. Abrams, rev. ed., 1991).

J. Gállego and J. Guidiol, *Zurbarán, 1598–1664* (New York: Rizzoli, 1977).

J. S. Held and Donald Posner, *Seventeenth and Eighteenth Century Art* (Englewood Cliffs, N.J.: Prentice Hall, 1971).

THE ROCOCO

CHANGING TASTES. During the first decades of the eighteenth century, a new decorative style emerged in the visual arts in France, and soon spread to many other parts of Europe. Characterized by a lighter spirit, swirling lines, and a propensity for everyday themes of enjoyment, this style was to become known as the Rococo or *Rocaille*. The word derived from a plasterer's term to describe this craft's technique of imitating the forms of

rocks and boulders. Since the late Renaissance, plasterers had been employed throughout Europe creating fanciful grottoes in the gardens of the nobility. Around 1700, though, the techniques that the craft used to build up plaster came to be used in the interiors of royal residences and Parisian townhouses, and walls that were heavily encrusted with plaster designs suddenly became all the rage in France. These *rocaille* techniques later lent their name to the entire period of the early eighteenth century; like Baroque, the Rococo, or in French *Rocaille*, period became synonymous with heavily encrusted, even decadent decoration in the minds of the Neoclassical artists and authors of the later eighteenth century. In truth, the art of the early eighteenth century remained as varied as at any other time in European history, yet a shift in taste is undeniable in France during the last decades of the seventeenth century and in the early years of the eighteenth. The Baroque art favored throughout much of Louis XIV's reign displayed a haughty grandeur, evident in its monumental scale, mythological and historical themes, as well as its formal lines. As the century of the Sun King drew to a close, a new fondness for more informal paintings and sculptures flourished. While Versailles and other royal residences indulged the new tastes, it was in the homes of Paris's wealthy elites that this fondness for a sensual art that depicted the joys of everyday life developed most strongly. Although the new lighter art had begun to flourish in the final years of the reign of Louis XIV, its popularity increased dramatically in the years immediately following his death. The new king, Louis XV, was only five years old when he assumed the throne, and during the regency of his uncle, Philippe II, the duke of Orléans, the style made great inroads in Paris. The rise of the Rococo coincided with changes in French society, as quiet intimate gatherings became the norm, rather than the imposing formal receptions of the Baroque era. In Parisian architecture of the time, a new fashion developed for smaller, human-scaled rooms, in which families entertained small circles of friends. It was in these intimate salons that many of the gatherings of Enlightenment intellectuals and their disciples took place. In these rooms, richly decorative paintings treating the joys and entertainments of everyday living became common decorations, as French aristocratic society indulged a penchant for amusement and pleasure.

WATTEAU. The painter most notable for developing a distinctively Rococo style in painting was Antoine Watteau (1684–1721), who despite his short life shaped tastes in eighteenth-century France. He was born at Valenciennes, a town on the French-Flemish border, but otherwise not many details about his early life are known.

a PRIMARY SOURCE document

DIMPLED BEHINDS AND EXTRAVAGANCE

INTRODUCTION: The Enlightenment thinker Denis Diderot influenced tastes in France during the second half of the eighteenth century through the publication of the *Encyclopédie,* a major reference work, as well as his many writings on art. In 1763, Diderot reviewed the Royal Academy's annual *Salon,* an art show that had long been staged by the students and faculty of the institution to display their most recent creations. His scathing remarks on a painting by the artist François Boucher were important in helping to destroy the Rococo style.

Imagine in the background, a vase standing on a pedestal crowned with bundled branches. Place beneath it a shepherd, asleep with his head on the knees of his shepherdess. Scatter about them a shepherd's crook, a little hat filled with roses, a dog, some sheep, a bit of landscape, and Heaven knows how many more details, all piled on top of another; then paint the whole in the most brilliant colors, and you have the *Shepherd Scene* of Boucher.

What a waste of talent and of time! Half the effort would have produced twice the effect. The eye rambles among so many objects, all rendered with equal care; there is no sense of atmosphere, no quiet. Yet the shepherdess has the look of her kind, and the bit of landscape squeezed in near the vase has a surprising delicacy, freshness, and charm. But what does this vase and pedestal mean? What are these heavy branches which top it? Must a writer say all? Must a painter paint everything? Can't he leave anything at all to my imagination? But just try to suggest this to a man who has been spoiled by praise and who is obsessed by his talent: he'll shrug disdainfully, he'll ignore you, and we'll leave him to himself—he is condemned to love only himself and his works. It's a pity though.

For when this man had just returned from Italy he painted beautifully, his colors were strong and true, his compositions well thought out and yet full of intensity, his execution was broad and impressive. I know some of his earliest pictures which he now calls daubs and would like to buy back in order to burn them.

He has some old portfolios full of admirable works which he now despises. And he has some new ones, all dolled up with sheep and shepherds in the manner of Fontenelle, over which he gloats.

This man is the ruin of our young painting students. As soon as they are able to hold brush and palette, they begin to sweat over garlanded putti, to paint rosy and dimpled behinds, and to indulge in all sorts of extravagances, which are not saved by the warmth, originality, prettiness or magic of their model, but have all of its faults.

SOURCE: Denis Diderot in *Neoclassicism and Romanticism, 1750–1850.* Vol. I. Ed. Lorenz Eitner (Englewood Cliffs, N.J.: Prentice Hall, 1970): 56–57.

Around 1702, he came to Paris, and he began to move in a group of Flemish artists that painted in the capital at the time. He seems to have studied the art of Rubens and the Venetian masters, and the tradition of the Low Countries artists of the seventeenth century was particularly important in his development, too. During the late seventeenth century a taste for decoration in the Chinese style had begun to spread throughout Europe, and in this regard France was no exception. One of Watteau's early endeavors in Paris was to create *chinoiseries,* decorative designs that suggested Chinese themes. After 1704, the artist became associated with Claude Gillot, an engraver, illustrator, and painter who created elegant images of groups of satyrs and comedians. Gillot's work appears to have been important in shaping Watteau's own art during the 1710s, as the artist first produced a number of images of *commedia dell'arte* players, and then proceeded to develop a new style of *fête galantes.* The subject of these works was the fashionable pastimes of Paris' wealthy and aristocratic society, and in the years between 1714 and 1717 the artist painted a number of *fête galantes.* In some of these he posed his own fellow artists as if they were members of aristocratic society, while in others he painted aristocrats donning the clothing of peasants or of *commedia dell'arte* characters, two entertainments that were often practiced by aristocrats of the day in the countryside around Paris. Over the centuries, many have judged Watteau's work to be merely "pretty," yet a closer examination shows that he included subtle details intended to suggest deeper meanings. His landscapes are highly idealized, more beautiful than nature in reality is, but the statues that surround his characters or the musical instruments that his actors play convey a highly restrained language of emotion. The origins of this kind of art lay in the Dutch and Flemish genre paintings of the seventeenth century, although in Watteau's hands he elevated the genre of everyday entertainment and amusement into a cultivated, highly elegant art form.

BOUCHER AND FRAGONARD. It was François Boucher (1703–1770) and Jean-Honoré Fragonard (1732–1806)

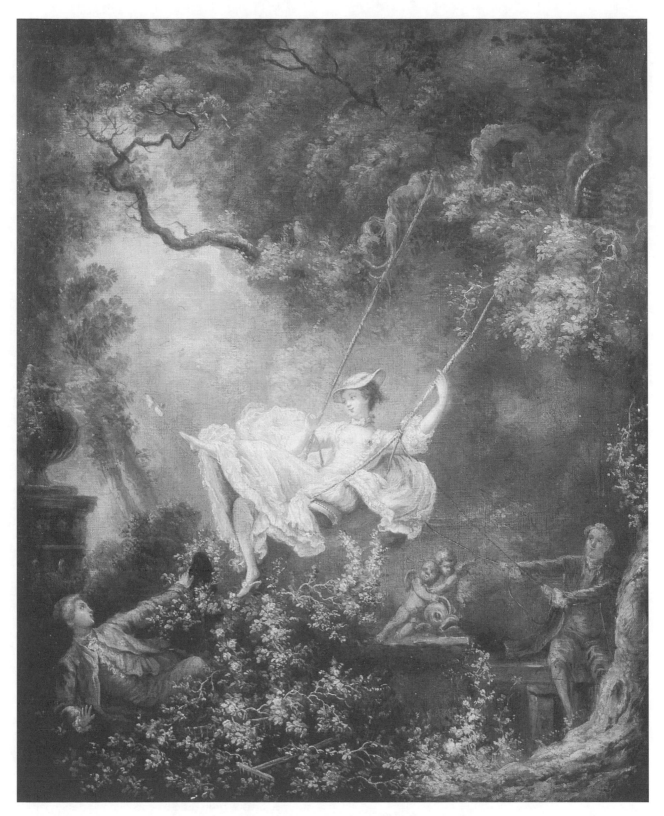

The Swing (1767) by Jean-Honoré Fragonard. THE ART ARCHIVE/MUSÉE DU LOUVRE PARIS/DAGLI ORTI.

who were to carry forward this elegant and refined style into the mid- and later eighteenth century. Boucher played a role as a designer, draftsman, and painter, and by virtue of his relatively long life, he came to leave a definite imprint on all the arts in eighteenth-century France. His art treated pastoral themes, but from the new dimension of sensuality that the Rococo enjoyed so limitlessly. His pictures were filled with images of the ancient gods, shepherds, lovers, and other rustics and they often suggested a frank and open sexuality. Their ready intelligibility and free decorative quality made Boucher's art a commodity that was readily adaptable to everything from porcelain to *toile du jouy*, a kind of cloth popular at the time that featured images of rural scenes. Boucher was an excellent draftsman; he was alleged to have made more than 10,000 drawings in his life. His style was light and free, and he was the first who tried to bring this draftsman's spirit into the art of painting. Although he was prolific throughout his life, Enlightenment thinkers like Diderot came to criticize his art in the second half of the century for its overt prettiness as well as the artist's propensity to show bare bottoms. Jean-Honoré Fragonard, by contrast, was an amazingly adaptable artist whose career long outlasted the popularity of Rococo decoration and design. Today, Fragonard is remembered best for images like *The Swing*, a picture showing an elegantly dressed aristocratic woman in free flight above two admirers. The artist's output was far more varied than this piece of Rococo elegance suggests. After an early career as a painter of historical themes, the genre advocated as the epitome of artistic expression by the Royal Academy in Paris, he came to paint genre scenes like *The Swing*. Later he concentrated increasingly on landscapes, especially after he won the French *Prix de Rome*, the Royal Academy's prize that underwrote a period of study in the ancient city. Like Boucher, Fragonard's reputation has long labored under the critique that he was merely a pretty artist. More recently, his work has come to be reassessed, and the depth of the artist's compositional and drafting skills have been more fully realized. As the founder of a family of artists who designed for the French decorative arts industry, Fragonard's influence was to last long after his death.

SOURCES

G. Brunel, *François Boucher* (New York: Vendome Press, 1986).

F. Moureau and M. M. Grasselli, eds., *Antoine Watteau (1684–1721): Le Peintre, son temps et sa légende* (Paris: Champion-Slatkine, 1987).

M. D. Sheriff, *Fragonard. Art and Eroticism* (Chicago: University of Chicago Press, 1990).

M. Vidal, *Watteau's Painted Conversations: Art, Literature, and Conversation in Seventeenth- and Eighteenth-Century France* (New Haven, Conn.: Yale University Press, 1992).

SEE ALSO *Architecture: The Rococo in the Eighteenth Century*

THE DECORATIVE ARTS IN EIGHTEENTH-CENTURY EUROPE

THE GROWTH OF INDUSTRY. In the eighteenth century the decorative arts—here understood as the production of upholstered furniture, cabinetmaking, and such household items as porcelains—experienced profound transformations. At the time, rising standards of living as well as declining costs of production brought more consumer goods to a broader spectrum of the population than at any time previously in human history. While this rise in consumption was to continue unabated in the nineteenth- and twentieth-century West, many of the design techniques and production methods that developed in the eighteenth-century world have continued to be followed in these industries until modern times. The modern assembly line has added a new dimension to the venerable techniques that cabinetmakers, porcelain manufacturers, and upholsterers pioneered during the course of the eighteenth century. Yet successful eighteenth-century producers might still recognize many of the processes that were pioneered and adopted in these industries in their own time. The rise in consumer goods was to affect tastes and habits in new and unexpected ways, insuring that the European gentry and middle classes were now able to emulate some of the refinement of aristocratic society. At the same time, the standards of consumption unleashed then have also continued to plague the West through the environmental damage that arises from a consumer society. However the rise of new consumer goods is assessed—as a positive element that brought with it rising standards of living, or as a negative phenomenon that bred a "keeping up with the Joneses mentality" and thus poisoned air and water—the ingenuity with which eighteenth-century decorative artists solved problems of production still ranks as a major development of the era. Consumer goods, often decorated with pictures and motifs from the hands of esteemed artists, brought elements of good design within the reach of broad strata of Europe's population.

PORCELAINS. In the later Renaissance, a fashion had developed in courts and wealthy urban society for maiolica dinnerware, a ceramic or earthenware product

that was decorated with intricate patterns and then glazed with tin before being fired. Perfected in Italy, the process had soon been copied in many places in Europe. In the great houses of Europe, nobles had sometimes commissioned noted painters to design the patterns that decorated these dinner services, but as the new products became available at the end of the sixteenth century in many European cities, they were increasingly stamped with stock patterns hastily applied by workers in factories. At the dawn of the seventeenth century, Portuguese and then Dutch traders began to import Chinese porcelains into Europe. These wares were widely prized for their workmanship, and they were at first incredibly expensive because of their greater strength and durability than simple earthenware. They were soon copied in factories in the Netherlands, most notably at Delft, where the typical blue and white "Delftware" that imitated Chinese designs soon became a commercial success. Its popularity increased dramatically at mid-century because the outbreak of civil war in China temporarily cut off the flow of porcelains to Europe. At the same time, the dominant economic theory that reigned in much of Europe in the later seventeenth and early eighteenth centuries was mercantilism. Mercantilist theory taught that for a country to prosper it had to limit imports and foster its own native industries in order to be self-sufficient. In this way, a country's own reserves of gold and silver were preserved. By 1700, most European kings and princes worried that the dependence on foreign imports of items like Chinese porcelains, silks, and other decorative items might bankrupt their states, and a flurry of schemes appeared throughout the continent that were designed to increase native production of these materials. Louis XIV's purchase of the Gobelins manufactory in Paris was only the most visible of these attempts. Through the efforts of his chief minister Jean-Baptiste Colbert, the king purchased this key industry, which had long woven tapestries and other fabrics for French aristocrats and wealthy city dwellers. Acquired in 1662, the factory flourished for the next two decades, becoming a center for the development of the decorative arts in and around Paris. Its output was not limited to tapestries, but under Louis' chief painter, Charles Le Brun, it educated many French craftsmen in decorative techniques used in furniture production, upholstery, cabinetmaking, and stonecutting. By the end of the century, the scheme had foundered, and the Gobelins confined its aims only to the production of tapestries. It nevertheless had by this date played a key role in advancing the skills of many French craftsmen, who continued to ply the trades they had learned in the eighteenth century. Around 1700, Europeans were still importing lavish amounts of Chinese

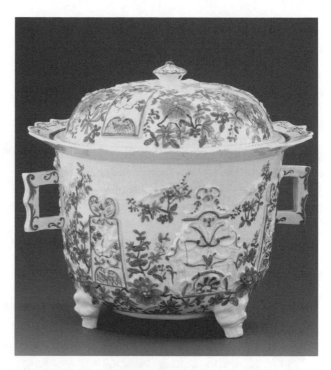

Meissen Ware soup tureen, footed with squared handles, eighteenth century. © ARTE & IMMAGINI SRL/CORBIS.

porcelains and other goods from Asia, all of which fed a taste for oriental decoration. But in the years that followed, new forms of porcelain manufacturing were to be developed in Europe that competed more effectively against imports from East Asia. Kings and princes founded most of the new schemes, while a few were privately financed.

MEISSEN. It was in the Saxon town of Meissen, not far from Dresden, that many of the technical problems that had hindered the development of a native porcelain industry in Europe were to be solved. Between 1700 and about 1750, the Saxon princes supported the development of this industry with great enthusiasm, carefully guarding the advances they made in the craft as state secrets. Around 1700, the Saxon court employed two notable alchemists, specialists in chemical compounds who frequently worked in the mining industry, to assist their efforts. Because of their knowledge of smelting and refining techniques, these specialists conducted a number of experiments concerning the vitrification of different mixtures of clay. By 1710, they had perfected a process for creating "hard-paste" porcelain. In this process, the specific mixture of clay resists melting to a very high temperature, and as a result, the materials with which the work is glazed are fused and become one with the fired clay itself. By 1710, the new Meissen factory was producing porcelain that was the equal, and in some cases

even superior to the East Asian variety. At first, the decorators at Meissen imitated designs that were available on silver and gold plate, but by 1720 a new designer at the factory was imitating Chinese designs, as well as developing the characteristic European flower patterns that have since figured on much porcelain. At Meissen, designs adapted from the works of such artists as Antoine Watteau, François Boucher, and native German artists became common, too. Much of the porcelain produced at the Saxon factory was not intended for public consumption, but was intended for display in the household of the Saxon Duke Friedrich-Augustus. His collection was so extensive that in 1717 he acquired a palace in the city of Dresden just to display his porcelains. Significant innovation and experimentation followed; Meissen figurines were being produced by the 1730s, and by the end of that decade the characteristic pattern known as "Blue Onion" had been produced. Over the coming years, it would compete successfully against Chinese wares and inspire numerous European imitators.

KNOWLEDGE SPREADS. Duke Friedrich-Augustus had tried to keep his discovery of "hard-paste" porcelain secret, but knowledge of the innovations that developed in his factory quickly spread to many other European centers. Soon one of his scientists established his own manufactory near Venice with Italian backers. Other factories soon followed in the region, but by 1750 the secrets mastered at Meissen had given rise to porcelain manufactories in Paris, Hamburg, Naples, Vienna, and Munich. By 1775, the famous "Royal Copenhagen" factory, too, carried the techniques of "hard-paste" porcelain into Scandinavia. Many of these early industries were state supported, and some, like Nymphenburg, were not commercially successful, although they produced a high quality product that tended to affect design techniques elsewhere. Similarly, the Sèvres factory near Versailles was a royal workshop created when Louis XV purchased a previously private factory in the region. Between 1756 and the outbreak of the French Revolution in 1789, the industry produced a number of stunning pieces, notable for their decorative Rococo qualities. The wares of the Sèvres factory relied on a "soft-paste" clay formula, in which the glazed objects were fired at lower temperatures than those executed using Meissen's techniques. As a result, "soft-paste" products were more porous than "hard-paste" varieties, but they were ivory colored, and presented more muted colors when decorated. Thus they came to be as prized as the wares produced at Meissen. Like Nymphenburg, the experiments undertaken at the royal factory at Sèvres were artistically and technically successful. Yet most of the wares produced there found

their way into the royal collections or onto the tables of wealthy aristocrats. The factory, in other words, was not a commercial, but rather an artistic success.

FURTHER PRODUCTION ENHANCEMENTS. Most of the porcelains produced in continental European factories in the first half of the eighteenth century were high quality, hand-produced products, requiring a painstaking attention to detail on the part of decorators. In England, new techniques of creating "bone china" had been discovered by 1750. In this method, the burned ash of animal bones was added to the clay. The resulting porcelain was harder than "soft-paste" porcelain, but not as hard as Meissen or other "hard-paste" varieties. By contrast, the great advantage of this new "bone china" was that it was more translucent and delicate than many of the porcelains then in production. The English porcelain industry by and large prospered without royal support. During the 1750s, Josiah Wedgwood and his partner Thomas Whieldon conducted a series of experiments that greatly reduced the costs of producing porcelain, while preserving a high quality product. At this early stage in the company's development, the porcelain was created, fired, and then sent out to be stamped with a design. Soon, Wedgwood and Whieldon perfected a new brilliant green glaze, the likes of which had not been seen before, and which could serve its own decorative purposes. In the years that followed, Wedgwood separated from Whieldon, and developed a new kind of earthenware product that could be used for ornamental items as well as for dinnerware. It had a creamy color and was able to withstand sudden changes in temperature without breaking. When Queen Charlotte purchased a set of the new product, it quickly became known as "Queen's Ware." Several years later, when Josiah Wedgwood supplied the queen with a beautifully executed tea service, she granted the potter the right to advertise himself as a supplier to the crown. From this point, the industrialist's fortunes were secured, and his Queen's Ware became one of Britain's most successful exports. To satisfy the demand from his customers, Wedgwood had to mechanize and further refine his production techniques. New lines of china followed, the most successful of these being the Jasper Ware that began production in the 1770s. The designs of Jasper Ware remain synonymous in many modern people's minds with the Wedgwood Company. Its great possibilities for decoration arose from the fact that it was formed and covered with a white glaze and then bas-relief decoration was applied in a variety of colors. Using this technique, Wedgwood was able to produce high quality, imitation cameo patterns, vases, and other decorative items. The rise to popularity of

Jasper Ware in England and throughout Europe coincided with the new Neoclassical fashions popular in the later eighteenth century. Wedgwood himself judged that his finest achievement was his successful copy of the Portland Vase, a beautiful Roman work from the first century C.E. that had found its way to England. Wedgwood executed his first copy around 1789, and one year later he began mass-producing the works and supplying them to those who had previously subscribed to the edition. In this way his production and marketing techniques anticipated the "limited editions" that were to become increasingly important among decorative arts collectors in the modern world. By this time Wedgwood's porcelain factory had already become highly mechanized. Engines now turned the lathes that produced the pottery, and sophisticated thermostats kept the temperature within the kilns constant to avoid over- or under-firing the pottery. In this way, Wedgwood's scientific experiments had laid the foundation for a product notable for its consistency. For these innovations, the potter was named a Fellow of Britain's Royal Society in 1783.

THE FACTORY MODEL. Although many of his works may not have been as beautiful or exquisitely crafted as those of the Sèvres or Meissen factories, Wedgwood's wares were more affordably priced, consistently produced, and appealed to contemporary tastes. His greatest achievements, like his Jasper Ware copies of ancient Roman vases, were eventually to be imitated by the great French and German porcelain factories. Elsewhere, the kinds of techniques that Josiah Wedgwood mastered to improve the production of porcelains were being adapted to other industries as well. Certainly, Britain was the leader in this industrialization of the decorative arts, and the country displayed an almost insatiable appetite to find ways of producing high quality consumer goods more cheaply and reliably than before. In the British Isles, new techniques allowed for the mass production of such items as flocked wallpapers, silverplate, and ormolu, a kind of decorative bronzework sometimes gilded to appear as if it was solid gold. These new items allowed the English gentry to decorate their homes in ways that imitated, albeit at considerably less cost, the costly brocades, damasks, and illusionary frescoes that had once lined aristocratic walls. These goods allowed merchants and members of the minor gentry to sip their tea in china cups, after filling them from imposing plated tea services, much like the aristocracy. And through the importing of cheaply gilded chair frames and other component parts from overseas, handsome furniture, too, came into the reach of these classes. While England stood at the forefront of this new "consumer revolution," everywhere in Europe a quickening appetite for goods was prompting producers to find ways to cheapen their costs, while retaining the generally high outward quality and appearance of goods. Mass production thus entered into the European economy to produce both monumental and subtle modulations in the ways in which people lived.

SOURCES

Anthony Burton, *Josiah Wedgwood* (New York: Stein and Day, 1976).

S. Eriksen and G. de Bellaigue, *Sèvres Porcelain: Vincennes and Sèvres, 1740–1800* (London: Faber and Faber, 1987).

Janet Gleeson, *The Arcanum: The Extraordinary True Story of the Invention of European Porcelain* (New York: Bantam Books, 1998).

Willi Goder, et al., *Johann Friedrich Böttger: Die Erfindung des europäischen Porzellans* (Stuttgart, Germany: Kohlhammer, 1982).

NEOCLASSICISM

SHIFTING VALUES. The Rococo movement that had developed in France and spread to other parts of Europe in the first half of the eighteenth century had reflected changes in the cultivated societies of patrons who commissioned art. The affection for lighter forms of depiction and for themes that treated pleasure and entertainment developed from a growing distaste for the imposing, monumental, and highly dramatic forms of the seventeenth-century Baroque. After 1750, styles in the visual arts changed rather quickly again as Neoclassicism influenced the artistic world. Neoclassicism, a movement that had musical, literary, and artistic dimensions, was inspired from the first by the advances that were underway in the eighteenth century in the study of Antiquity. During the 1730s and 1740s, the first systematic archeological excavations of ancient Roman towns began in Italy. At places like Pompeii and Herculaneum in southern Italy, artists viewed the frescoes and other interior decorative elements of Roman and Greek houses and public buildings. Figures like Giovanni Battista Piranesi (1720–1778) sketched these ruins and published engravings that were widely circulated throughout Europe, helping to feed the changing taste for classical images and design. Yet the undeniable shifts that occurred in mid-eighteenth century taste might not have occurred if cultivated consumers had not been prepared for them through the works of Enlightenment

philosophers. In their philosophical and literary works, these figures had extolled the virtues of ancient Rome and Greece, and they had argued that in Antiquity society had functioned in ways that were more attuned to the demands of rationality. Thus Neoclassicism, with its more austere lines and its readily intelligible standards of design, expressed the fervent desire of intellectuals and artistic patrons to create a new kind of society based upon the dictates of human reason. At the same time, the affectionate glance that Europeans cast upon the ancient world was frequently characterized by an almost religious reverence. Thus, although its admirers craved a revival of Antiquity that might express their faith in rationality and its attributes of clarity, harmony, and austerity, Neoclassicism was above all an emotional movement that inspired powerful sentimental love for all things ancient among its supporters, and as such, it carried within it the seeds of the Romanticism that began to supplant it as the dominant style in the arts at the end of the century.

BEGINNINGS OF NEOCLASSICISM. It was in Rome where the new spirit first began to take hold. Elites and artists from throughout Europe had long journeyed to the ancient city to complete their educations, and during the course of the eighteenth century Rome had persisted in importance as the ultimate destination of the Grand Tour. At the time, this circuit through Europe's major cultural capitals was becoming increasingly conventionalized. A Tour undertaken by members of the aristocracy, the landed gentry, or members of the wealthy commercial class in Europe's cities frequently lasted for two or even three years. On these journeys, wealthy patrons stocked their art collections, buying both contemporary and ancient works to line the halls of their homes. In Britain and elsewhere throughout Europe, a fashion for printed accounts of one's Grand Tour had grown throughout the eighteenth century. Tourists returning from their journeys published their journals, which recorded their impressions as well as the many fascinating sites that they had seen along the way. This taste for literary accounts of the Grand Tour came to be self-sustaining, as each new generation hoped to outdo the insights of the generation before. By the mid-eighteenth century, both wealthy patrons and artists became aware of the increased knowledge of the ancient world that archeological excavations were producing. As a result of the digs underway in Rome, Pompeii, Herculaneum and other Mediterranean sites, the connoisseur or artist no longer needed to comprehend Antiquity through the lens of the fifteenth- and sixteenth-century Renaissance. Through the many prints available for sale in Rome as well as the presence of nearby excavations, an intelligent tourist might witness ancient art and architecture first-hand. A rising appreciation of the classical world's design principles soon developed. Among the many forces that helped popularize the Neoclassical resurgence throughout Europe was the French Royal Academy in Rome. A talented group of architects, painters, and sculptors who lived and worked in Rome during the 1740s and 1750s were to carry the knowledge that they had acquired of Antiquity throughout Europe as they accepted positions in courts and worked as architects and designers in the second half of the eighteenth century. The presence in Rome of talented and accomplished students from every corner of the Continent also helped feed the Neoclassical appetite. Robert Adam, the great British architect and interior designer, was in Rome at the time that Giovanni Battista Piranesi's famous engravings of ancient monuments were being published and were helping to develop tastes for the noble architecture of Rome and Greece. By the end of the century, the distinguished list of Roman pilgrims included figures as diverse as the French painters Hubert Robert and Jacques-Louis David as well as the country's leading architect, Jean-Germain Soufflot; the noted German art historian and esthetic theorist, Johann Winckelmann; the Venetian sculptor Antonio Canova; and the Danish sculptor Bertel Thorvaldsen. Rome was thus the incubator of Neoclassicism, but the movement was broad and international in scope, with successive generations of artists, patrons, and scholars finding inspiration there before returning to their native lands to create forms of visual art that expressed the new fondness for Antiquity.

THE SEARCH FOR A CLASSICAL LANGUAGE IN THE VISUAL ARTS. From the first, most Neoclassical artists and their patrons looked with disdain upon the light and breezy styles of painting that had flourished in Europe during the Rococo period. Johann Winckelmann, the greatest theoretician of the new movement, came to exercise a profound influence on the ideas of both patrons and artists at the time with the publication of his works on ancient aesthetics. Winckelmann was a major figure, not only in the Neoclassical movement, but in the entire sweep of art history. Before his time, connoisseurs had often thought of the word "style" in terms of an individual artist's own way of expressing himself. Winckelmann, however, pioneered the use of the term to describe the entire underlying sense of beauty and compositional organization that was present in a chronological period. Thus it became possible to discuss the art of classical Antiquity in terms of being a coherent body of theory about aesthetics, that is the science of beauty, and

for Winckelmann, a disciple of classicism, the art of the ancient world represented the great high point of all world civilizations. Thus if contemporary artists were to emulate this achievement they might succeed in realizing, and perhaps even surpassing, the glories of the ancient world. Winckelmann thus championed imitation in his works as the supreme form of flattering the ancient styles. But he insisted that slavishly copying Antiquity was a dead end that could not lift art out of the merely decorative paths it had fallen into during the Rococo. The historical circumstances of the ancient past had been very different from those of the eighteenth century, and he cautioned that classical models needed to be adapted, rather than merely copied. Thus throughout the 1750s and 1760s, painters and sculptors searched for a new language that might express their reverence for the more austere, harmonious, and balanced design principles they admired in classicism.

HISTORICAL THEMES. It was in a revival of history painting that Neoclassicism's impact was to become clearly evident. The fashion for a genre of idealized works, their themes adapted from ancient history and mythology, first appeared at Rome, but it was to find its greatest exponent in the works of Jacques-Louis David (1748–1825), France's greatest history painter since Poussin. David was initially to draw more of his inspiration from the works of the great French master than he was from the painting of Antiquity. During the 1780s he created a series of monumental historical paintings that spoke to the rising affection for Antiquity as well as the political situation in France. Louis XVI was then struggling to avoid bankruptcy, while criticism of the state and the extravagance of its rulers and aristocrats steadily mounted. Two masterpieces from the period spoke directly to these crises: *Belisarius Begging for Alms* (1781) and *The Oath of the Horatii* (1784). In the first, David depicted the ancient story of Belisarius, a general in the Roman army, who was arbitrarily banished from the halls of power in the Byzantine Empire after the Emperor Justinian had him tried on trumped-up charges of corruption. The story had recently become popular in France through the publication in 1767 of Jean-François Marmontel's novel *Bélisaire*. It survived into the nineteenth and twentieth centuries as a popular theme, even prompting the great Italian composer Gaetano Donizetti to write an opera based upon it. For many in David's time, the incident had a special importance because it pointed to the damage that an arbitrary and high-handed ruler might wreak on the individual. David's painting of the theme emphasizes the great pathos of the general Belisarius, as he is forced to beg to survive. The artist's

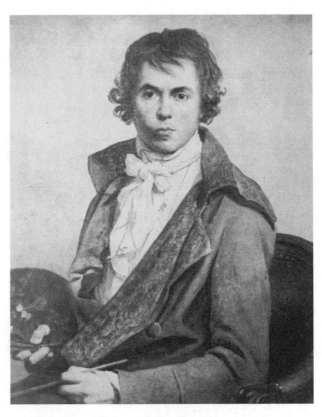

Portrait of Jacques-Louis David. **THE LIBRARY OF CONGRESS.**

rendering of the tale achieves a kind of drama similar to Poussin by capturing the moment at which Belisarius is recognized by former associates, and they become aware of the depths to which he has fallen through the emperor's injustice. In compositional style and feeling, this work resembles very much the great achievements of the seventeenth-century master. The work's dramatic rendering of the moral in its historical theme granted the artist great authority in 1780s France, as criticism of the injustices that a corrupt state fostered were on the rise. As a painter, David stood outside the academic establishment of the French Royal Academy at the time, yet despite his status as an outsider, his art was enthusiastically received in Paris.

THE OATH OF THE HORATII. Three years after the completion of the *Belisarius*, David was to present another striking moralistic painting to the Parisian audience: his *Oath of the Horatii*. By this time David's mastery of the Neoclassical language was more secure, and the painting ranks as one of the great masterpieces of the late eighteenth century. It shows a classical subject, the oath that three brothers make to their father before they go off to fight for Rome. The theme thus presented a moral very different from that of the corruption that the artist had stressed in his *Belisarius Begging*

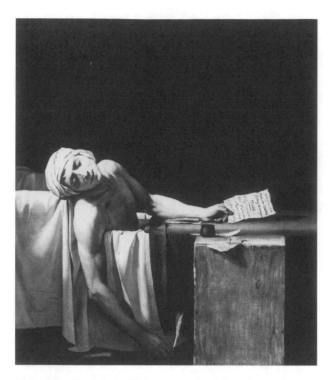

The Death of Marat (1793) by Jacques-Louis David. CORBIS-
BETTMANN. REPRODUCED BY PERMISSION.

for Alms. Here the individual must subjugate his own
aims and well-being to the greater service of the state.
The patriotism that the work reflects was a theme widely
discussed during the crises that France was experiencing
at the time, as Enlightenment philosophers and French
patriots recommended self-sacrifice as a way to alleviate
the country's fiscal and social dilemmas. With the dis-
play of this work, David's reputation as the greatest
painter in France was assured, and he acquired numer-
ous students in his studio. His career reached its high
point in 1793, when he painted *The Death of Marat,* an
image that became a force for the French revolutionar-
ies' identity. The subject was the assassination of one of
the Revolution's leaders in his bath. David immortalized
the event with a carefully executed vision of heroism
amidst pathos. The revolutionary assembly commis-
sioned David to paint an account of the event one day
after the famous assassination had taken place, and the
painting was publicly displayed to impress the image of
counter-revolutionary terror upon the minds of
Parisians. In effect, the work displays a number of reli-
gious qualities, and is comparable to images of the dead
Christ long popular throughout Europe. Through the
success of this and other images that David executed in
defense of the Revolution, his influence persisted into
the nineteenth century. The readily comprehensible in-
telligence of his rendering of historical themes survived

into the nineteenth century through the many artists he
had trained.

OTHER GENRES. Although Neoclassicism's effects
are most easily visible in historical painting, the move-
ment's design tenets also came to affect portraiture and
other artistic forms that treated everyday themes. David
and other French Neoclassical artists made major con-
tributions, not only to historical painting, but to the art
of portraiture. Instead of the highly elegant confections
popular among the artists of the Rococo, these neoclas-
sical images were notable for their greater naturalness
and relaxed atmosphere. The new style of portraiture
came to affect even the images of the royal family, long
resistant to change and innovation. Elisabeth Vigée-Lebrun
(1755–1842), the wife of a Parisian art dealer who rose
to great prominence in the 1780s, painted some of the
most striking and beautiful examples of this new, more
naturalistic style. Despite Vigée-Lebrun's humble ori-
gins, she painted thirty portraits of Marie-Antoinette,
many showing an increasing informality as the taste for
less restricting and ornamental clothing—a taste fostered
by Neoclassicism—influenced the highly formal French
court. Some at court complained that her portraits lacked
the suitable royal bearing and gravity that had long been
seen as essential components of images of the king and
queen. But Marie-Antoinette admired the artist and sup-
ported her nonetheless. Because of her proximity to the
crown, Vigée-Lebrun fled France for twelve years dur-
ing the Revolution, although she returned and carried
forward her career well into the mid-nineteenth century.
In England, the two greatest exponents of Neoclassical
portraiture were Sir Joshua Reynolds (1723–1792) and
Thomas Gainsborough (1727–1788). These two rival
artists influenced painting in England for much of the
eighteenth century. Of the two, Reynolds's influence was
greater in portraiture. The artist increased the range of
poses he used to render his subjects, adopting new com-
positional principles drawn from the art of the Renais-
sance and the seventeenth century as well as from antique
sculpture. Reynolds came from an urbane background;
his father had been an academic at Oxford. Highly ed-
ucated, he influenced British painting through his role
as director of London's Royal Academy. There he shaped
the education of many of the country's artists, and as
elsewhere in Europe, his tastes fostered a concern for the
classical heritage. By contrast, Thomas Gainsborough
sprang from much humbler roots: his father was a bank-
rupt cloth manufacturer. He spent most of his life in
provincial surroundings painting landscapes, historical
paintings, and portraits for the rural gentry and aristoc-
racy. He moved to London only around the time he

a PRIMARY SOURCE document

IMITATION OR IDEALIZATION?

INTRODUCTION: The rise of Neoclassicism in the second half of the eighteenth century produced a renewed interest in the subject of imitation. How should artists strive to emulate the art of antiquity as well as the great works of the European tradition? And more fundamentally, should they represent nature realistically or idealistically? Numerous artists and art historians addressed this issue. Sir Joshua Reynolds (1723–1792) was, by virtue of his learning and achievements, the greatest British painter of the age. In his *Seven Discourses on Art* the artist considered how painters should imitate the natural world. In place of realism, Reynolds recommended to students that they seek to present an idealized view of the world, one that might surpass the blemishes that exist in Creation.

The wish of the genuine painter must be more extensive; instead of endeavoring to amuse mankind with the minute neatness of his imitations, he must endeavor to improve them by the grandeur of his ideas; instead of seeking praise by deceiving the superficial sense of the spectator, he must strive for fame by captivating the imagination.

The principle now laid down, that the perfection of this art does not consist in mere imitation, is far from being new or singular. It is, indeed, supported by the general opinion of the enlightened part of mankind. The poets, orators, and rhetoricians of antiquity are continually enforcing this position, that all the arts receive their perfection from an ideal beauty, superior to what is to be found in individual nature. They are ever referring to the practice of the painters and sculptors of their times, particularly Phidias (the favorite artist of antiquity), to illustrate their assertions. As if they could not sufficiently express their admiration of his genius by what they knew, they have recourse to poetical enthusiasm. They call it inspiration, a gift from heaven. The artist is supposed to have ascended the celestial regions to furnish his mind with this perfect idea of beauty.

"He," says Proclus, "who takes for his model such forms as nature produces, and confines himself to an exact imitation of them, will never attain to what is perfectly beautiful. For the works of nature are full of disproportion, and fall very short of the true standard of beauty. So that Phidias, when he formed his Jupiter, did not copy any object ever present to his sight; but contemplated only that image which he had conceived in his mind from Homer's description." And thus Cicero, speaking of the same Phidias: "Neither did this artist," says he, "when he carved the image of Jupiter or Minerva, set before him any one human figure as a pattern, which he was to copy; but having a more perfect idea of beauty fixed in his mind, this he steadily contemplated, and to the imitation of this all his skill and labor were directed."

The Moderns are not less convinced than the Ancients of this superior power existing in the art; nor less conscious of its effects. Every language has adopted terms expressive of this excellence. The *gusto grande* of the Italians, the *beau ideal* of the French, and the *great style*, *genius*, and *taste* among the English, are but different appellations of the same thing. It is this intellectual dignity, they say, that ennobles the painter's art; that lays the line between him and the mere mechanic; and produces those great effects in an instant, which eloquence and poetry, by slow and repeated efforts, are scarcely able to attain.

Such is the warmth with which both the Ancients and Moderns speak of this divine principle of the art; but, as I have formerly observed, enthusiastic admiration seldom promotes knowledge. Though a student by such praise may have his attention roused, and a desire excited, of running in this great career, yet it is possible that what has been said to excite, may only serve to deter him. He examines his own mind, and perceives there nothing of that divine inspiration with which he is told so many others have been favored. He never traveled to heaven to gather new ideas; and he finds himself possessed of no other qualifications than what mere common observation and a plain understanding can confer. Thus he becomes gloomy amidst the splendor of figurative declamation, and thinks it hopeless to pursue an object which he supposes out of the reach of human industry.

SOURCE: Joshua Reynolds, *Seven Discourses on Art*, in *Neoclassicism and Romanticism, 1750–1850*. Ed. Lorenz Eitner (Englewood Cliffs, N.J.: Prentice Hall, 1970): 37–38.

turned fifty years old. Rumors have long circulated that Gainsborough was poorly educated, but more recent research has shown that he was intellectually voracious and that in his art he derived influences from an enormous variety of sources. In his career he avidly followed and integrated Neoclassical influences into his work. Toward the end of his life, in particular, he developed a visual language that was influenced by Neoclassicism's embrace of nature and of rustic settings.

SCULPTURE. Throughout the later seventeenth and eighteenth centuries, the art of sculpture had continued to be practiced by a number of craftsman-like figures. After Bernini, though, no great genius appeared who was to develop a European-wide reputation. In France, for

a PRIMARY SOURCE *document*

THE ABOLITION OF THE ACADEMY

INTRODUCTION: Despite his own success on the Parisian art scene, the neoclassical painter Jacques-Louis David (1748–1825) always chafed under the conventions of the Royal Academy of Painting and Sculpture. In the years following the outbreak of the French Revolution he and other artists who were won over to the side of republicanism worked for the institution's abolition. On 8 August 1793, they achieved their objective when the National Convention abolished the institution. Jacques-Louis David spoke to the assembly, and was effective in convincing the delegates to act. An excerpt from his speech follows.

If there is someone among you, citizens, who must still be convinced of the absolute necessity of destroying wholesale all the Academies, those last refuges of aristocracy, then let him give me his attention for a moment. I promise to dispel his doubts with a few words, and to make up his mind by appealing to his feelings. Let me demonstrate, to begin with, what damage the Academies do to art itself, how far they are from fulfilling the purpose which they have set themselves. Let me unmask the party spirit which guides them, the vile jealousies of their members, the cruel methods which they use to stifle nascent talent, and the monkish revenge which they wreak on the persecuted student to whom, by mischance, nature has given a talent which removes him from their tyrannical domination. ...

Oh, you talents lost to posterity! Great men left in neglect! I will placate your spirits, you shall be avenged: it was your misfortune, illustrious victims, to have lived under kings, ministers, Academicians!

I have said that I would demonstrate the damage Academies do to the art which they profess; I shall keep my word. I shall not bore you, citizens, with trifling details, with the bad methods of teaching used by the Academy of Painting and Sculpture. You will be easily persuaded when I tell you that twelve professors per year, in other words, one for every month (and every one of them tenured), compete with one another to destroy the fundamental principles which the young artist has received from the daily lessons of his master. Since every one of these twelve professors approves only of his own principles (as you can well imagine), the poor student, trying to please each one of them in turn, must change his manner of seeing and working twelve times a year. Having learned his art twelve times over, he ends up knowing nothing, since he does not know what to believe. But, supposing that by some rare gift from heaven he survives the poor teaching, then this child of so many fathers—on none of whom he can rely—calls down on himself the vile jealousy of all his masters who combine to ruin him. It is the policy of kings to maintain the balance of power; Academies maintain the balance of talent. Woe to the daring artist who steps across the forbidden line: he becomes an alien to the Academicians, his presence profanes the sacred, Druidical grove, and if he does not die on the spot he is driven off by chicanery.

SOURCE: Jacques-Louis David, "Speech before the National Convention, August 8, 1793," in *Enlightenment/Revolution*. Vol. I of *Neoclassicism and Romanticism, 1750–1850*. Ed. Lorenz Eitner (Englewood Cliffs, N.J.: Prentice Hall, 1970): 116–117.

example, the Gardens of the Palace of Versailles had been decorated with more than 1,400 sculptural fountains in the late seventeenth century. These had been designed and executed by an army of sculptors and stonecutters. In the first half of the eighteenth century, a competent group of craftsman-like artists continued to work at the palace and in Paris, including Jean-Louis Lemoyne and his brother Jean-Baptiste. The latter's son, again named Jean-Baptiste Lemoyne (1704–1778), was one of the first French sculptors to adopt the new Neoclassicism to his art, creating in the 1760s a series of classically-inspired portrait busts of several French aristocrats. One of Lemoyne's students, Jean-Antoine Houdon (1741–1828), was to carry the new Neoclassical idiom to a high point of development in France, creating not only classically-inspired portrait busts, but sculptural groupings based upon ancient themes. The history of sculpture in Italy was remarkably similar to that of France. Any number of competent programs continued to be undertaken in the decades following the death of Gianlorenzo Bernini, the great genius who dominated the art for much of the Baroque period. Great sculptural commissions continued to be executed throughout the eighteenth century. In Rome, the largest of these was the colossal Trevi Fountain, a project that required the thirty years after 1732 to complete. Its chief designer and executor, Pietro Bracci (1700–1773), was a competent, well-trained artist, and today the work continues to rank as one of the chief tourist attractions of Rome. The Neoclassical revival, however, bred a renewed interest in ancient sculpture, and in the figure of Antonio Canova (1757–1822) the movement produced an artist who ranked alongside Bernini in greatness. His works featured simpler design and clean lines, in contrast to the

Rococo fondness for florid elaboration. They also displayed the naturalistic and sometimes even severe presentation Neoclassicism advocated. During his long career, Canova was very much in demand as a portraitist with clients throughout Italy. Later in his career, he enjoyed a reputation as the greatest living European artist, and his skills as a portraitist in the Neoclassical tradition were sought out by many throughout Europe.

DECLINE OF NEOCLASSICISM. Although elements of the Neoclassical style survived into the nineteenth century, the cataclysmic events of the French Revolution called into question the faith in human reason that lay at the heart of the movement. During the 1790s, French Revolutionary leaders adopted the visual embodiments of Neoclassicism to express the ideals of their movement, including its faith in the perfectability of human society and the necessity of developing a set of social mores that were derived from nature, rather than tradition. The enormous bloodletting that occurred during the years following 1789, however, discredited the Enlightenment's worship of human reason in the minds of many. By the 1790s, in literature, music, and somewhat later in the visual arts a more tempestuous, less harmonious set of ideals and objectives that became known as Romanticism began to flourish. Besides the political problems of the late eighteenth century, rapid industrialization, burgeoning cities and economic problems were helping to destroy the Enlightenment's onetime faith in rationality. The new movement favored an open expression of human feelings and emotions, as well as privacy and inwardness, rather than a balanced and harmonious idealization of mankind's potentialities. At its foundation, though, the Neoclassical movement evidenced a nostalgic longing for the past, and the artists and patrons of the movement hoped to put aside the history of the seventeenth and eighteenth centuries. They longed to build a society, based not in the arbitrary symmetries of the Baroque or in its fondness for imposing monumentality, but on the principles of the natural world. As the movement progressed, the painters and sculptors of Neoclassicism evidenced an ever-greater attention to nature, endowing their subjects with an idealized beauty that suggested the idyllic harmony that might exist in a society untouched by the corruptions of their own age. The fondness for an informal treatment of nature was thus just one of the features that Neoclassicism shared with Romanticism. And while the new romantic spirit contrasted its own exertions in favor of the human emotions and an inward world of sentiment, the features that joined the two periods—Neoclassicism and Romanticism—were closer than their opposing rhetoric leads us on the surface to believe.

SOURCES

Walter Friedlaender, *From David to Delacroix* (Cambridge, Mass.: Harvard University Press, 1950).

Simon Lee, *David* (London: Phaidon, 1999).

Michael Levey, *Painting and Sculpture in France, 1700–1789* (Harmondsworth, England: Penguin Books, Ltd., 1992).

Anthony Potts, *Flesh and the Ideal: Winckelmann and the Origins of Art History* (New Haven, Conn.: Yale University Press, 1994).

SEE ALSO *Architecture: The Development of Neoclassicism*

SIGNIFICANT PEOPLE
in Visual Arts

MICHELANGELO MERISI DA CARAVAGGIO
1571–1610
Painter

A STORMY YOUTH IN LOMBARDY. The figure who was to revolutionize early Italian Baroque painting, Michelangelo Merisi da Caravaggio, was born near Milan in 1571. His father served as an official in the household of one of the Sforza, the dynasty that had long controlled the great Northern Italian city and its surrounding countryside, Lombardy. Many of the early details of the young Caravaggio's life are shrouded in uncertainty, but it is clear that by 1584 he was living in Milan, where he was apprenticed to a painter. When his father died some years later, Michelangelo Merisi sold his claim to his inheritance and moved to Rome, arriving there in 1592. The earliest biographers of the painter point to certain legal problems that may have prompted Caravaggio to leave Lombardy. One points to quarrels in which the artist may have been engaged, while another suggests that he was imprisoned shortly before his departure. No contemporary documents survive to establish whether these accounts are true, but Caravaggio's later tendency to become involved in scandals, brawls, and to assault his fellow artists suggests that the artist may have fled Milan with a cloud over his head.

ROME. The artist's first years in Rome were apparently filled with trials. He lived in the household of a churchman, where he did menial chores. Next, he worked

for several local artists, who produced paintings for the local market. Michelangelo Merisi painted heads on their canvases and he was paid by the piece. Sometime in these early years in the church's capital, the artist came to the attention of the Cavaliere D'Arpino, a prominent member of Roman society and a Mannerist painter. Caravaggio lived in the Cavaliere's household, a fact that suggests that the artist's talents were beginning to be recognized. Just what works the artist created under the influence of this successful Roman artist cannot be determined, but he probably painted still-life details onto the Cavaliere's works, or completed various works that this established artist then sold under his own name, a common custom of the time. This period of Merisi's life drew to a close, though, when he was kicked by a horse and forced to enter a local hospital in order to recover. With his health regained, the artist returned to work in Rome, soon finding lodging in the household of another official, the Monsignor Fantino Petrignani. It was during this period in Petrignani's house that Caravaggio's fortunes started to rise. The paintings he completed during this time show the artist's rising mastery over his medium, and this trend was to continue in the late 1590s as the artist came to the notice of a local connoisseur, the Cardinal del Monte. Del Monte was something of a polymath, that is, he was a master of all kinds of scientific and artistic endeavors, and after purchasing some of the artist's pictures, he invited Caravaggio to live in his house. The cardinal was at the time serving as the Tuscan ambassador to the Vatican, and his household was among the most sophisticated in the city. As a result of his time there, the young Caravaggio became known to the city's cultivated elite, and from this time forward, his fortunes were assured.

THE CONTARELLI AND CERASI CHAPELS. It was under del Monte's influence that Caravaggio was to receive the two greatest commissions of his career. In the first of these, the Contarelli family chapel in the Church of San Luis dei Francesi, the artist was to immortalize the life of St. Matthew in three works, the greatest of which was his *The Calling of St. Matthew*. The painting showed Christ entering an inn, where Matthew is counting the proceeds of his tax collection with a group of associates. Here Caravaggio painted from life and the models that he chose, dressed in contemporary Roman attire, mirrored the contemporary street. Christ is shaded in darkness and strong contrasts of light and dark characterize the painting, while a high light source, suggesting the miraculous nature of the incident, falls from the upper right hand side of the painting. The artist captures the moment when Christ has spoken the fateful

words, "Follow me," and Matthew has placed his hand at his breast as if to ask "Me?" In this way Caravaggio's dramatic, yet realistic portrayal heightens the miraculous nature of the incident. Through his portrayal of the event, Caravaggio makes Matthew's abandonment of his profession as a publican, or tax collector, stand out in greater relief, because the full consequences of his denial of the gritty actuality of his trade become evident to observers. It was just this kind of realism that the Catholic reforming Bishop Gabrielle Paleotti had recommended to artists as an antidote to the highly intellectualized and obscure meanings that had governed much Mannerist taste of the late sixteenth century. Caravaggio was to continue in this vein with perhaps his greatest masterpiece, the *Conversion of St. Paul,* a work completed several years later for the Cerasi family chapel at the Church of Santa Maria del Popolo. Here he captured the moment that a blinding light from heaven has just struck Saul, and he has been thrown from his horse in a catatonic fit. In the background Saul's servant looks on in incomprehension, while Paul's body lies prone, his arms outstretched toward the light source that again falls from above.

SUCCESS AND LATER TROUBLES. Caravaggio's triumphs in the Cerasi and Contarelli chapels established him as one of the greatest artists of his day and a group of "Caravaggisti," or imitators of his style, soon emerged who experimented with his light and dark contrasts (chiaroscuro) and dramatic realism. New commissions followed, but during the first decade of the seventeenth century many of his works came to be rejected by the religious institutions in Rome that commissioned them. This trend, however, scarcely affected the artist's reputation, since every time a monastery or church rejected his commission, a connoisseur appeared to purchase the work. Despite his success, these years were also plagued with legal troubles, as the artist accused others of plagiarizing his work, and he became embroiled in a libel suit. Accusations of assault, too, swirled around Caravaggio, and in 1606 he killed Ranuccio Tommasoni in a dispute following a tennis match. Forced to flee Rome, he went to Naples, receiving a number of commissions there and throughout southern Italy. His reputation had been little diminished by the controversies that swirled around his career, and the examples that he left behind in southern Italy inspired the development of a school of Caravaggeschi there that long outlasted his life. After travels in Malta and throughout southern Italy, he returned to Naples and prepared to journey to Rome. He had learned that he was to be pardoned for the Tommasoni murder, but when he boarded a boat for the city he was mistaken for another criminal and taken prisoner.

The mistake was realized, but in the meantime Caravaggio had contracted a fever and he died several days later. Despite his untimely death, the example of gritty realism that his works provided, with their models drawn directly from life, was to outlive him. Although his reputation was to suffer over the centuries, the genius of his achievement has in recent times been recognized. He has, in other words, been restored to his rightful place as one of the formative influences in the development of the Baroque, and his impact on artists of the period has come to be fully realized.

SOURCES

Walter Friedlaender, *Caravaggio Studies* (Princeton: Princeton University Press, 1955).

John Gash, *Caravaggio* (London: Jupiter Books, 1980).

Howard Hibbard, *Caravaggio* (New York: Harper and Row, 1983).

JACQUES-LOUIS DAVID

1748–1825

Painter

BEGINNINGS. The artist who was to revolutionize French painting in the later eighteenth century was born into a prosperous family that had long distinguished themselves as craftsmen and architects in Paris. The young David was related to the prominent painter François Boucher, and although his family wished David to be apprenticed to him, the elderly Boucher refused. Jacques-Louis came to learn his craft in the studio of Joseph-Marie Vien instead, and somewhat later he enrolled as a student at the Royal Academy. Each year, the institution held a competition for its prestigious Prix de Rome, an award that underwrote study in the ancient city, but David was to be rejected for the honor on three occasions, and as a result of the last rejection, he attempted suicide. On the fourth attempt, he finally won the prize and set off to Rome, but in the years that followed he came to harbor a vicious resentment of the artistic establishment in France. He arrived in Rome in 1775, and at the time was little impressed with the art of Antiquity. He struggled to find a way of reconciling his own interests as a painter with the growing popularity of the Neoclassical movement. But on this first journey to Rome, he seems to have spent more time studying the art of seventeenth-century Baroque painters than he did in the observation of antiquities. In particular, the art of the Italian master Guido Reni, as well as the historical paintings of the great French artist Nicholas

Poussin, interested him. These works caused him to reject the highly ornamental character of Rococo and instead strive to create works that were an idealized representation of the natural world. After completing several commissions in Rome, he returned to France in 1780 with the intention of becoming a member of the Royal Academy.

RISING FAME. As an institution affiliated with the crown, the Royal Academy had a long and venerable tradition of training artists, as well as establishing standards for those who worked for the king. When Louis XIV had founded the Academy in the second half of the seventeenth century, a special place had been given to the genre of historical painting, which French masters believed was the most difficult of all genres to capture in a suitably grand manner. To be accepted into the Academy, a painter had to demonstrate his abilities as an historical painter by undertaking a particularly difficult theme. To pass this test, Jacques-Louis David was to paint the subject of *Belisarius Begging for Alms*, a subject that had a special significance in the early 1780s. By this time the glory years of Louis XIV's reign were long gone, and France's government had by and large been bankrupted by a series of international wars. Its contemporary funding of the American Revolution, too, was another sore spot at the time, as royal finances seemed to be on an ever more perilous course. For decades, the thinkers of the French Enlightenment, the *philosophes*, had criticized the corruption of the monarchy and the arbitrary and capricious laws that governed the nation. The subject of *Belisarius* thus spoke to these dilemmas, for the story was about a prestigious ancient Byzantine general who had been destroyed through the corruption of the Emperor Justinian's state. Forced from the halls of power, he had been made to beg. Jacques-Louis David relied on his knowledge of Nicholas Poussin in the great work that he completed in 1781 to capture the moment when Belisarius is recognized by some of his former imperial associates. The painting has a simplicity and directness that was frequently missing in the academic art of the period, and the artist began to acquire a large stable of students, whom he was to keep busy on many large-scale projects over the coming years. Although *Belisarius* was a great painting, David's mastery over the genre of historical painting continued to grow, as can be seen in the *Oath of the Horatii*, a work completed in 1784. In the earlier *Belisarius*, David had intended to caution his viewers about the consequences of state corruption, while in this later canvas he presented a moral tale about the necessity of subverting one's individuality for the greater needs of the state. The painting depicts

the moment at which the three sons of the ancient Latin poet swear allegiance to their father before heading off to fight for Rome.

DAVID AS REVOLUTIONARY. With the onset of the French Revolution in 1789, the artist faced challenges as well as opportunities. Although he had long since been accepted into the Royal Academy, he had always bristled under its traditions and conventions, and with the rise of revolutionary sentiment he came to devote himself to the institution's abolition, an event that he and other artists were finally to achieve in 1793. He was not initially active as a revolutionary himself, but by 1790 he had joined the radical Jacobin club, and he soon painted the *Oath of the Tennis Court*, an image that immortalized the vow that members of the Third Estate had taken the year previously at Versailles after having been locked out of their assembly room. David's most influential Revolutionary picture, though, was his *Death of Marat*, a work that was immediately commissioned in the days that followed this revolutionary leader's assassination by Charlotte Corday in 1793. The work was publicly displayed and exercised a tremendously important emotional impact on the course of the Revolution during the height of terror. Often described as a "secular Pièta," David's *Death of Marat* remains one of the most powerful images of the Revolution. During these years, too, the artist played a major role by staging a number of revolutionary spectacles, and at the height of the Terror he was to provide history with a famous image of Queen Marie-Antoinette sketched on the tumbrel by which she approached the guillotine. As the Jacobins fell from favor, though, the artist was imprisoned on two separate occasions before being allowed to resume his life as an artist. As greater calm and stability returned to France, David's fortunes revived. He resumed his career as a painter and teacher, although some of his students now found his Neoclassicism out of touch with contemporary realities. He continued to receive many commissions, until the return of the Bourbon monarchy in 1815 forced him into exile in Belgium. He remained there for the rest of his life, continuing to paint the historical pictures and portraits for which he had long been famous.

SOURCES

Anita Brookner, *Jacques-Louis David* (London: Oxford University Press/British Academy, 1980).

Thomas E. Crow, *Painters and Public Life in Eighteenth-Century Paris* (New Haven, Conn.: Yale University Press, 1989).

Dorothy Johnson, *Jacques-Louis David: Art in Metamorphosis* (Princeton, N.J.: Princeton University Press, 1989).

Warren E. Roberts, *Jacques-Louis David, Revolutionary Artist* (Chapel Hill, N.C.: University of North Carolina Press, 1989).

ARTEMISIA GENTILESCHI
1592–c. 1652
Painter

AN ARTISTIC BACKGROUND. The young Artemisia Gentileschi, perhaps the first woman in Western history to exercise an influence as an artist over men in her field, grew up in Rome, where her precocious artistic development was to be shaped by her father, Orazio. The elder Gentileschi was also an artist, and who, although he was of an older generation, came to bear the characteristic imprint of Caravaggio in the first decades of the seventeenth century. His daughter was recognized as a prodigy early in her life, and she received most of her training in his studio. The great figure of Caravaggio, who dominated the artistic scene in Rome during the early seventeenth century, had worked by painting directly from live models, rather than through the painstaking process of preparatory studies that had flourished during the Italian Renaissance. The Gentileschi, too, adopted these techniques and their works show that they roughly sketched out the contours of the models they painted before rather quickly beginning to paint them. Such a method had inherent pitfalls, as seen in some of the works of Artemisia's father, where the rendering of arms and hands sometimes appears clumsy. But artists in the early Baroque were frequently concerned with capturing the immediacy of the moment, and the works of both Orazio and his daughter, though lacking sometimes in the finesse of High Renaissance masters, were more dramatic and realistic than those of sixteenth-century painters. In her youth Artemisia painted in her father's studio, and by the time she was nineteen she and her father were collaborating on the completion of commissions. Around this time her father hired the painter Agostino Tassi to refine her techniques in the painting of perspective. The artist, however, took advantage of his position and raped the young Artemisia. Incensed, her father sued in the Roman courts, an ordeal that subjected his daughter to the thumbscrews to ensure the veracity of her account of what had transpired. Because of the dubious notoriety the case achieved, Orazio soon arranged for the marriage of his daughter to a Florentine, Pietro Stiattesi, and the young couple headed off to Florence, where Artemisia continued to develop her skills as an artist.

ARTISTIC SUCCESS. In the years after her rape, Artemisia Gentileschi frequently painted the subject of *Judith and Holofernes,* an incident recorded in the Old Testament apocrypha. In this story, Judith saved the Jewish people by first seducing and then murdering the Assyrian general Holofernes. Gentileschi's treatment of the theme relied on the techniques of Caravaggian realism, and in her most vivid paintings of the subject, the anger that she directed at Holofernes is palpably real. It is still difficult today, even in an age that is relatively immune to the presentation of violence, for many to view Gentileschi's works on this subject. As a young married woman in Florence, Artemisia experienced a number of successes. She was the first woman ever to be admitted to the Florentine Academy of Design, the premier artistic association in a city that had long distinguished itself in the arts. In these years her art acquired a surer mastery, but her marriage seems eventually to have foundered. She left Florence and set up her studio in Naples, a city then ruled by the Spanish and which was falling under the sway of an intensely pious Catholicism. There Gentileschi changed her style, abandoning the daring spirit she had evidenced in her early years to satisfy a more conservative taste.

TRAVELS TO ENGLAND. Despite the more conservative bent that her artistic compositions took in Italy, Artemisia continued to be a successful artist in Naples. Her brother, Francesco, who was also an artist, came to take examples of her art with him as he traveled in Europe's courts. In 1638, Artemisia traveled to England to visit her father, now a court painter to King Charles I. There she found him in ailing health, and she assisted him in the completion of a number of works for the English crown. Although Orazio Gentileschi was to die a year after her arrival in London, Artemisia stayed in England for another two years, probably completing works that Orazio had begun. Her last years are shrouded in some mystery, but the evidence shows that she did return to Naples, where she continued to paint until her death sometime around 1652 or 1653. Despite the many trials and problems that she experienced throughout her career, her own painted works suggest that she was a major influence in the Italian art world of the early seventeenth century. When she arrived in Florence after 1610, artists began to imitate the Caravaggian style she had absorbed in Rome during her youth. Elsewhere her paintings were responsible for stirring a more thorough understanding of the great early seventeenth-century master, particularly in Genoa and Naples. By virtue of her gender, Gentileschi experienced numerous trials, but at the same time she was able to surmount these to exercise a major formative influence on the art of her generation.

SOURCES

R. Ward Bissell, *Artemisia Gentileschi* (University Park, Pa.: Pennsylvania State University Press, 1999).

Mary D. Garrard, *Artemisia Gentileschi* (Princeton: Princeton University Press, 1989).

Susanna Stolzenwold, *Artemisia Gentileschi* (Stuttgart, Germany: Belser, 1991).

REMBRANDT VAN RHIJN

1606–1669

Painter
Draftsman
Engraver

THE DUTCH GOLDEN AGE. The career of the great Dutch master Rembrandt coincided with the rise of Holland as Europe's most formidable commercial power. The artist lived during a great era of achievement in painting, but of all the masters that Holland was to produce in the seventeenth century, Rembrandt was universally acclaimed, even in his own time, as the supreme commanding figure. He came to acquire a reputation even in his own lifetime as an artist comparable to the great High Renaissance masters Michelangelo and Leonardo da Vinci. This achievement was all the more remarkable because of the artist's relatively humble origins. Unlike his great Flemish contemporary and patrician, Peter Paul Rubens, Rembrandt was the son of a miller from Leiden. He was, however, precocious and received Latin schooling before entering university. He never completed his degree, but instead apprenticed himself to a painter before going off to obtain additional training in Amsterdam. Of the greatest Northern European artists, he was one of the first to be completely schooled in his craft in his native country, for he never visited Italy and seems not to have traveled far from his native Netherlands during his life.

STYLISTIC MATURITY. Following the completion of his training at Amsterdam, the artist returned to Leiden and set up a studio there around 1626. In these early years, Rembrandt relied on engravings and his voluminous knowledge of the ways in which other painters had rendered subjects to create works that were already imaginative for their fusion of many different ideas and compositional techniques. At this time he also made contact with Hendrick van Uylenburgh, a successful art dealer in Amsterdam, who for many years was to sell the artist's works and to secure commissions for him. At Leiden,

Rembrandt shared a studio with the artist Jan Lievens, and the two developed an unusual relationship. They hired and posed models, each undertaking to paint his own version of the same subject at the same time, though they never seem to have worked on a canvas together. In the commercially overheated art market that was developing in the Netherlands at the time, such an arrangement had the advantage of cutting costs in half. By 1631, Rembrandt's career was already well established and he decided to move from Leiden to Amsterdam, which was then, as now, the busiest commercial center in the region. He took up residence at first in Hendrick van Uylenburgh's house, having invested money in the art dealer's business shortly before coming to Amsterdam. His reputation continued to grow, and he soon married Uylenburgh's niece Saskia, a love match that was to prove happy until his wife's death in 1640. The artist's fortunes rose, and eventually Rembrandt and his growing family were able to purchase a townhouse, an expensive commodity in the competitive Dutch economy of the day. During these early years in Amsterdam, the typical Rembrandt style became ever more pronounced, with the artist developing swift and bold brushwork that made use of built-up passages of paint known as *impasto*.

RISING SUCCESS. By the early 1640s, Rembrandt's success as an artist on the Amsterdam scene was assured, and shortly afterwards he was to paint one of the monumental works for which he has long been known, the so-called *Night Watch*. This painting is a group portrait of Captain Banning Cocq and his local militia regiment who were charged with defending Amsterdam. Long believed to have been painted by the master using night lighting, the art world was shocked in 1975 when the painting was cleaned. After removing layers of varnish that had been applied to the enormous canvas, it was revealed that Rembrandt had painted the picture using stark daylight. The work was notable at the time and widely admired for Rembrandt's ability to render the large company in a way that appeared completely natural. The artist arranged the members of the militia as if they had just been called to arms, and the swift movement and cacophony that his work suggests was widely admired at the time, even though some of those who appear in the work are partially obscured by the outbreak of the work's melee.

LATER TROUBLES. Even as Rembrandt's reputation continued to increase, problems in the artist's personal life worsened. In the years following the death of his wife, Rembrandt became personally involved with his son's nursemaid, a widow, and then dismissed her when another woman came into his life. In the furor that soon erupted, Rembrandt was forced to grant the widow an annuity. As the enmity between the two worsened, Rembrandt was to have the woman confined to a prison for defamation. Despite these personal problems, the artist's productivity remained prolific, and in these years he began to purchase extraordinary amounts of art. Commercial dealing in art, antiquities, and engravings was a popular pastime of the wealthy merchants of Amsterdam, and although Rembrandt seems to have wanted to indulge his own artistic interests as a collector and practicing artist, he also came to speculate on the art market as an investment. Another spur to his enormous collecting habits was his life-long search for acceptance and social respectability, since his enormous holdings conferred a status as a gentleman, something he had long craved. During the 1650s, his purchases grew to truly profligate levels, and he acquired a number of debts to sustain his collecting and speculation. By 1656, he was forced to declare bankruptcy, and was even imprisoned for a time before securing his release. Over the next few years, his possessions were auctioned off at a fraction of their cost, the market in art having become depressed. In the years that followed, the artist was allowed to enter into a commercial agreement with his family by which he became, in effect, their employee. This arrangement proved fruitful, allowing the artist to regain some of his former status. Besides completing a number of commissions in his final years, he also returned to engraving, a medium he had long enjoyed but had not had much time to practice during the 1640s and 1650s. In this late period, he came to realize the great commercial potential that his skills as an engraver provided. By the time of his death, the artist had apparently reinstated much of his fortune, since three locked storerooms filled high with art were found in his home after his funeral.

SOURCES

Marc Le Bot, *Rembrandt*. 2 vols. (New York: Crown Publishers, 1990).

Jakob Rosenberg, *Rembrandt*. 2 vols. (Cambridge, Mass.: Harvard University Press, 1948).

Christopher White, *Rembrandt* (New York: Thames and Hudson, 1984).

PETER PAUL RUBENS

1577–1640

Painter
Diplomat
Draftsman

CULTIVATED UPBRINGING. Peter Paul Rubens, the greatest seventeenth-century Flemish artist, came from

an important family in the port city of Antwerp. His father, however, was a Protestant and at the time of Peter Paul's birth, the family was living in exile in Germany. Rubens spent the first nine years of his life in Cologne and the small town of Siegen, before his father died and his mother returned with the family to Antwerp. At the time of the family's arrival there, war between the Netherlands' provinces and Spain was underway, and the family soon converted to Catholicism, since Antwerp was quickly becoming a bastion of Spanish power in the region. Antwerp, which had for much of the sixteenth century been one of Northern Europe's most important centers of trade, was just beginning to enter into a period of decline. Eventually, the Dutch provinces to the north were to cut off the city's access to the sea. But in Rubens' youth and for most of his life, the town still retained an aura of being one of the most brilliant humanistic centers in Europe. The artist was exposed to some of the greatest thinkers of the age, including the ideas of the philosopher Justus Lipsius as well as the intensely pious thinkers of the Catholic Reformation. As a member of the ruling class at Antwerp, he was schooled in the Classics and prepared for a life as a scholar and diplomat. He came to learn four languages (Dutch, French, Italian, and Latin) and was conversant in most of the philosophical, scientific, and theological issues of the day. He undertook artistic instruction, and in 1598 he was admitted into the city's painter's guild. By 1600, he had decided to travel to Italy, where he accepted employment as an artist in the court of the Gonzaga dukes at Mantua.

ITALIAN INSIGHTS. Rubens' Mantuan patron was very often away from his court, and thus the artist had relative freedom to travel throughout Italy, studying the art of the High Renaissance as well as the innovations that the peninsula's Baroque painters were making at the time. Mantua, too, had long had a distinguished history as a center of Renaissance art, and from there Rubens was to travel first in northern Italy, visiting Venice and then eventually making his way to Rome. In the ancient city, Rubens came to study the works of Michelangelo, and their heavily muscled forms were to leave a definite impression on his later works. In addition to the High Renaissance masters, Rubens also came to study classical sculpture. Returning to Mantua, Rubens' patron asked him to travel to Spain in 1603 on a diplomatic mission. While there, he painted several works that were to influence the development of later Spanish artists, most notably Velázquez. Eventually, he returned to Italy, where he stayed for another few years, traveling again to Rome and working for a time in Genoa. During this sec-

ond visit to the church's capital, he may have also seen the masterpieces of Caravaggio and Carracci that had recently been completed, although no direct evidence ties the artist to these works.

RETURN TO ANTWERP. Although Rome was the greatest artistic center of the age, Rubens was to return to his native Antwerp in 1608. There he was to undertake a number of religious commissions for churches in the city. During the previous decades, Antwerp's religious institutions had suffered attacks by Calvinists and Anabaptists interested in purging the town of its religious art. As the city's Catholic future seemed assured, Antwerp's citizens and religious institutions began to commission numerous altarpieces and religious paintings to restore luster to their religious buildings. Rubens responded to these demands by creating a style notable for its sense of drama, monumental scale, and swift brush strokes that suggested movement and emotional spirituality. By the 1620s, he presided over a large studio where numerous assistants executed works based upon his plans. Many of the paintings that today bear his name were only "finished" by the great master, but the artist's conception still manages to shine through even the most mundane of the works his studio turned out. Intensely restless and intellectually voracious, visitors to the artist's studio were often astonished at the way in which the artist conducted four or five tasks simultaneously. As a classically trained scholar and a member of the Antwerp elite, the artist moved relatively freely in courts throughout Europe. He painted works for King Charles I of England and for Philip III and Philip IV of Spain. All three of these kings conferred noble titles on Rubens. His most monumental courtly undertakings, though, were the series of enormous canvases he painted for Marie de' Medici of France. These paintings glorified the queen-regent's life in canvases that were larger than life. She so admired these works that she tried to convince Rubens to undertake a second cycle that might treat the life of her deceased husband, Henry IV. But Rubens, ever shrewd financially, refused because of previous problems with payments. The relationship between the artist and queen continued over the years to be cordial, and when Marie de' Medici was forced into exile in the 1630s, she spent time living as a member of Rubens' household. By this time, Rubens' fortunes were assured, and he now spent a great deal of his leisure at his two country estates. Highly intelligent and driven to work, the artist was also a family man whose two marriages were happy ones, as evidenced in the loving portraits that the artist made of both his wives.

SOURCES

Kerry Downes, *Rubens* (London: Jupiter Books, 1980).

Julius S. Held, *Rubens and His Circle* (Princeton: Princeton University Press, 1981).

Christopher White, *Peter Paul Rubens: Man and Artist* (New Haven, Conn.: Yale University Press, 1987).

DOCUMENTARY SOURCES
in Visual Arts

Giovanni Pietro Bellori, *The Lives of Modern Painters, Sculptors, and Architects* (1672)—An important source for the biographies of the Italian Baroque's most famous artists.

Vincenzo Carducho, *Dialogues on Painting* (1633)—Written in Spanish by a native Italian artist, this collection of dialogues between a master and his students argues for the high status of painting as one of the liberal arts.

Denis Diderot, *Essay on Painting* (1765)—One of the Enlightenment's most important thinker's musings about the nature of good art. The work is particularly critical of Rococo conventions popular at the time, and argues that good art must not violate the standards of humankind's common sense.

Charles Alphonse du Fresnoy, *The Art of Painting* (1667)—Although a painter, Du Fresnoy is best remembered for this influential treatise on aesthetics in which he argues that beauty must be the prime consideration of any painter hoping to produce profound art.

Charles Le Brun, *Concerning Expression in General and in Particular* (1667)—Originally given as lectures at the Royal Academy in Paris, Charles Le Brun's considerations of the way in which artists should render their subject came to have a major role in defining "good art" in late seventeenth-century France.

Francesco Pacheco, *The Art of Painting* (1649)—The author of this treatise on painting is better remembered today as an artistic theorist, than for his own works of art. This treatise ranks as perhaps the greatest Spanish contribution to the theory of art.

Roger de Piles, *The Principles of Painting* (1708)—A small manual written by one of France's most important Baroque art theorists. It summarizes in a practical way the skills necessary for an artist to produce the historical paintings common in France at the time.

Sir Joshua Reynolds, *Discourses* (1769–1790)—These fifteen lectures were given at the Royal Academy in London in the late eighteenth century. England's academy was a relative latecomer on the European scene, and the immensely talented Sir Joshua Reynolds came to have a formative influence upon it, in part through his writings and lectures.

Johann Winckelmann, *History of Ancient Art* (1764)—In this work, this formidable eighteenth-century art theorist argued that an underlying style could be identified in epochal periods. Many of his stylistic judgments about ancient art have been pervasive until modern times, especially the favorable light in which he cast the art of classical Greece when compared against the subsequent Hellenistic Age.

———, *Thoughts on the Imitation of Greek Art in Painting and Sculpture* (1755)—This work established Winckelmann's reputation as the leading theorist of Neoclassicism in mid-eighteenth-century Europe.

GLOSSARY

Absolutism: A political system and theory of government practiced in many seventeenth- and eighteenth-century European states in which the king or prince was envisioned as the sole authority from which all power issued in the land.

Act of Uniformity: A measure enacted by the English Parliament in 1662 requiring the use of the Book of Common Prayer in all churches in England.

Alexandrine Verse: A verse consisting of lines twelve syllables long that was popular in the French classical poetry and dramatic tragedies of the seventeenth century.

Allemande: A stately dance in duple time that was originally believed to be German in origin. After fading from popularity in the ballroom, its rhythms continued to appear in the many dance suites composers wrote during the Baroque era.

Anglicanism: The doctrines, ritual, and faith promoted by the Church of England and its offshoots throughout the world.

Aria: Italian for "air." Originally, a song within the early opera, the aria underwent steady development in the Baroque period to become lengthy and developed solos that displayed the skills of a particular singer. The most popular form was the aria da capo, which used an ABA format. Here an initial theme (A) was contrasted against a second or interior section (B), before the first theme (A) was repeated.

Aristotelianism: A philosophy developing out of the teachings of the ancient philosopher Aristotle that places a strong emphasis on matter, the physical universe, and the logical examination of ethical issues. Aristotelian scholasticism, a method of analyzing problems from this philosophical perspective, was particularly widespread in the universities of medieval and early-modern Europe.

Arminianism: A theology promoted by the Dutch Calvinist Jacob Harmenszoon who was known as "Arminius," that taught that human beings could accept or reject God's gift of salvation. It was declared heretical at the Synod of Dordrecht (or Dordt) in Holland in 1616.

Augustan Age: A term used to describe English life and literature from the late seventeenth century until about 1780. John Dryden, Alexander Pope, and Samuel Johnson were all key figures in developing the Augustan Age literary style, which was notable for a lucidity and restrained elegance that was judged to be a recreation of the literary greatness of the time of Caesar Augustus (first century B.C.E.) in Latin antiquity.

Augustinianism: Any Christian theology that traces its roots back to Augustine of Hippo, the fifth-century theologian that placed a strong emphasis on sinfulness and humankind's helplessness in the process of salvation. Jansenism, the seventeenth-century theology prominent in France, was one early-modern example.

Authorized Version of the Bible: The translation of the Bible undertaken in early-seventeenth-century England at the command of King James I. In North America, the Authorized Version is commonly called the "King James Version."

Autos Sacramentales: A religious play performed in late-medieval and early-modern Spain on important feast days of the church.

Ballet d'Action: An eighteenth-century dance that narrates a story. Ballets d'Action were the forerunners of nineteenth-century theatrical or classical ballets.

Ballet de Cours: An elaborate entertainment staged in the French court from the late sixteenth century to the early eighteenth century that combined dance, song, and poetry to narrate a story that often glorified the reigning monarch.

Basso Continuo: Meaning "continuous bass," this method of writing and performing the accompanying chords to music was common in the Baroque era. Composers usually stipulated the bottom-most note of the bass accompaniment and then through numbers or figures they showed the other notes that should be played with it, in this way, forming a continuous accompaniment that underpinned the melody. In performance, such practices could be modulated so that the accompaniment might be performed on the harpsichord, the organ, or by a mixture of instruments.

Battle of the Ancients and Moderns: A controversy that arose in the French Academy at the end of the seventeenth century over the relative merits of ancient and contemporary literature. The dispute produced a number of heated polemics, and spread to England and other parts of Continental Europe, where it prompted reassessment of the role of ancient literature in shaping and defining contemporary writing.

Book of Common Prayer: The printed order of services authorized for use in the Church of England. The first *Book of Common Prayer* appeared in 1549 in the reign of King Edward VI, and was followed by revised editions in 1552, 1559, and in 1662, at the Restoration of the Stuart monarchy.

Boulevard Theaters: Any of a number of theaters that lined the avenues of northern Paris in the years leading up to the French Revolution. Although officially illegal according to the terms of royal decrees, they came to be tolerated, and eventually to perform pirated versions of the great French classical repertory.

Cadenza: A brilliant solo passage reserved for a singer or instrumentalist to display their skills, usually before the conclusion of an aria or of a movement within a concerto.

Camera Obscura: An early forerunner of the modern camera, this apparatus allowed light to travel through a lens and be reflected by a mirror on a solid surface. The camera obscura was frequently used by scientists and painters in the seventeenth century.

Cantata: A musical form that developed in Rome in the early seventeenth century that shared certain similarities with early opera. Cantatas could be on any theme or subject, although its narration was provided solely through music. Unlike opera, that is, it was not acted, but merely sung. Among the most famous cantatas in the Western repertory are those of Johann Sebastian Bach, particularly his sacred cantatas that use themes based in German chorale tunes.

Caravaggisti: A group of seventeenth-century Italian and northern European painters that tried to imitate the dramatic lighting techniques and gritty realism displayed in the works of Michelangelo Caravaggio (1573–1610).

Cartesianism: The philosophy that developed from the works of the seventeenth-century French thinker René Descartes. Its teachings emphasized a duality between the mind and body and developed the notion that rational human thought shaped all knowledge of the world.

Catholic Reformation: The resurgence that began in the Roman Catholic Church in the sixteenth century, and which continued in many parts of Europe until the eighteenth. The Catholic Reformation witnessed the rise of many new religious orders, expansive missionary efforts in North and South America and the Far East, and the development of the Baroque style in art and architecture. It was accompanied as well by a popular resurgence in everyday Catholic piety among the peoples of Europe.

Cavalier Poets: A group of poets popular in England, particularly in the reign of Charles I. They treated everyday themes, often with a comical and light twist, in contrast to the elaborate conceits and emblematic symbols found in the "metaphysical" authors of the same period.

Clarendon Code: A series of measures passed in Parliament during the first years of Charles II's reign (1660–1685) that were intended to strengthen the position of the Church of England and discourage dissenters.

Comedia: The term used to describe the three-act plays performed in seventeenth-century Spain, whether they were comedies, dramas, or tragedies.

Comédie-Française: The state theater of France established in Paris by Louis XIV in 1680.

Comedy of Manners: A genre of plays that was particularly popular in the English Restoration. Comedies of manners satirized the foibles and conventions of life in aris-

tocratic society, and were favored by the elite audiences common in the period.

Commedia dell'Arte: A form of improvisational comedy that flourished in Italy from the sixteenth through the eighteenth centuries. Eventually, Commedia dell'Arte troupes became popular performers in cities throughout Europe.

Commonwealth: The term used to describe the system of parliamentary government that ruled England between the execution of Charles I in 1649 and the Restoration of Charles II in 1660.

Concerto: A work in which the playing of a solo instrument or group of instruments is contrasted against that of the accompanying ensemble. In the Baroque period, this form of instrumental music underwent a steady development, particularly in the works of the Italian composer Vivaldi, who wrote hundreds of these compositions.

Concerto Grosso: Meaning "great concerto." A popular form of instrumental music that featured alternating passages played by a small ensemble and a larger group. Bach's *Brandenburg Concertos* are among the most famous examples of the form.

Conduct Book: Any of a genre of books that attempted to prescribe the behavior in someone of a particular class or profession. Conduct books were particularly popular reading for early-modern aristocrats and members of the gentry and commercial classes.

Confession: A written statement of a particular Christian religion's doctrinal beliefs.

Confraternity of the Passion: A medieval religious organization originally composed of apprentices from the city of Paris' guilds that staged religious dramas in the fifteenth and sixteenth centuries. When religious plays were outlawed in Paris in 1548, the Confraternity continued to retain its monopoly over the staging of dramas in the city, and its theater in the Hôtel de Bourgogne became Paris' first commercial theater.

Consistory: A committee of the local clergy and laymen that often considered cases of moral and doctrinal infractions among early-modern Calvinists.

Constitutionalism: A political theory that advocates the operation of government through a set of written or clearly defined principles that outline the sharing of power between the various bodies that comprise a state's government.

Contredanse: A form of dancing first popular in early-modern England in which dancers were arranged in lines, circles, or squares and moved through a series of figures. Contredanse became widely popular in aristocratic France and Germany, where the rules of these dances became more formalized and complex in the seventeenth and eighteenth centuries.

Copernicanism: The theory that traces its roots to the sixteenth-century astronomer Nicholas Copernicus in which the sun, rather than the earth, was seen as the center of the universe.

Corral Theaters: The style of theatrical construction that developed in late sixteenth- and early seventeenth-century Spain. Corrales or "corrals" were courtyards enclosed on all sides by other buildings, and in the theaters that were built in these courtyards, rows and boxes of seats surrounded the stage on three sides.

Council of Trent: The church council convened in the northern Italian city of Trent between 1545 and 1563 to consider the charges brought against Catholicism by the Protestant Reformers. The Council formulated standards for the reform of the church, particularly its clergy, and outlined theological teachings that formed the basis for modern Roman Catholicism until the Second Vatican Council in the 1960s.

Counterpoint: In music, the juxtaposition of one or more melodic lines that are played together and thus create a single, overarching texture.

Courante: A lively dance written in triple time that often formed one of the movements within the Baroque dance suite.

Dance Suite: A Baroque instrumental composition that made use of the structures and rhythms of popular Renaissance and early-modern dances that were played as a series of individual movements. Although the dance suites of the Baroque era were highly varied, the most popular forms alternated slow and majestic dances like the allemande and sarabande against fast and lively rhythms like those of the courante and gigue.

Dechristianization: A largely discredited historical theory that argued that a widespread secularization and decline of traditional Christianity preceded the rise of the French Revolution in 1789.

Deism: A religious movement that developed in late seventeenth-century England. It discounted traditional theology and revelation and taught that God could be known through His works in nature. While its influence faded rather quickly in England, its teachings were also espoused by many of the thinkers of the French Enlightenment.

Diggers: Members of groups of agrarian radicals in England that advocated the common ownership of land during the English Civil Wars and Commonwealth.

Dissenters: Members of religious groups that opposed the Church of England in the seventeenth century.

Divine Right of Kings: The theory, particularly prevalent in seventeenth-century Europe, that kings are divinely chosen for their duties, and that their subjects thus owe them submission, even as they owe obedience to God.

Empiricism: A philosophy that denies the role of innate ideas and instead argues that the mind's interpretation of reality is based on sense experience and observation.

Encyclopédie: The great publishing project of the French Enlightenment edited by Denis Diderot and Roger d'Alembert. Begun in 1751, the project took more than 25 years to complete and when finished it included seventeen volumes of text and another eight volumes of illustrations. Its underlying arguments promoted the ideas of the Enlightenment and often attacked religion and received wisdom.

English Garden: Any of a number of gardens created in eighteenth-century Europe that made use of the more informal principles of organization current in contemporary Britain at the time, such as the famous English Garden of Munich begun in 1789.

Enlightened Despotism: A style of government adopted by a number of absolutist rulers in central Europe. These figures advocated reforms based on the rule of reason that were in harmony with Enlightenment principles.

Epicureanism: A philosophy based upon the ancient Greek thinker Epicurus that taught that pleasure and the desire to avoid pain were major human motivations. As a result, Epicurus tried to direct the human love of pleasure toward intellectual achievement. Epicureanism also promoted an atomistic view of matter, and was revived in seventeenth-century Europe by Pierre Gassendi (1590–1655).

Epistolary Novel: A genre of eighteenth-century fiction in which the action is told through letters, either those of a central character or through the exchange between a group of characters.

Extension: A philosophical principle of René Descartes that describes the physical and mathematical concreteness of matter in the world.

Fête Galantes: A genre of painting particularly popular in eighteenth-century France that depicted a celebration held in the outdoors.

French Academy: A royally chartered institution established by Cardinal Richelieu in 1635 with the intention of standardizing the French language. The Academy's first French dictionary was published in 1694, and has been revised continually since then.

French Overture: A form of instrumental music popular in the Baroque era that often began with a stately theme before proceeding into a faster section in which dotted, or lively, rhythms predominated. Toward the end of the piece the first slower theme often reappeared, and was summarized in a grand manner that led to the work's ultimate conclusion. The form was particularly popular as a form of overture to operas.

Fruit Bringing Society: A society founded in 1617 in the territory of Anhalt-Cöthen with the purpose of raising the literary standards of contemporary German. Its name in German was *Die Fruchtbringende Gesellschaft.*

Galant Style: A musical style that flourished in mid-eighteenth-century Europe that featured less complex melodies and which downplayed complex counterpoint. It was notable for its suave and refined characters.

Geocentrism: The theory that the earth is the center of the universe.

Gigue: A piece of lively dance music in which two themes are usually contrasted. Gigues were often used as one of the movements within Baroque dance suites. The English word for this form is "jig."

Gothic Revival: A resurgence of often romantic and fanciful architecture in mid-eighteenth-century England that harked back to the later Middle Ages.

Gunpowder Plot: A Catholic plan unearthed in November of 1605 to blow up the Houses of Parliament in London when the king and members were in attendance. The exposing of the plot made Catholicism widely unpopular in the country.

Hampton Court Conference: A conference convened at the royal palace of the same name in 1604 to debate the provisions outlined in the Puritans' Millenary Petition. Although James I refused to adopt most of those provisions, he did undertake a new translation of the Bible, as Puritans had advocated. The Authorized Version of 1611 was thus one of Hampton Court's chief achievements.

Heliocentric Theory: The theory advocated by Copernicus, Galileo, and many other seventeenth-century scientists that the sun was the center of the universe. Investigation of the theory led to Isaac Newton's discovery of the laws of gravity and centrifugal force.

High Church: A phrase used to describe the sensibilities of those in the Church of England that supported a strict performance of the Book of Common Prayer's rituals and who advocated maintaining its position in the land as the official church. Often the High Church party desired to uphold laws against nonconformists.

Humanism: An educational movement that developed in Renaissance Europe based around the *studia humanitatis* (humane studies), the precursor to the modern notion of the humanities. Humanists advocated the acquisition of a thorough knowledge of antiquity, its history, moral philosophy, and ethics, even as they supported rhetoric and study in the language arts as the disciplines most capable of ennobling humankind.

Iambic Pentameter: One of the meters particularly popular in early-modern English poetry. It consists of an un-rhymed line made up of five feet—that is a stressed syllable followed by an unstressed syllable. Besides its famous use in William Shakespeare's *Sonnets*, it was also widely employed by seventeenth-century German poets.

Impasto: In painting, any thick application of paint that makes the surface stand out in relief. The Dutch artist Rembrandt was especially known for the use of impasto passages.

Impresario: Prominent theatrical and operatic producers whose organization of public performances earned them widespread acclaim.

Intermedi: A dance or musical interlude between the acts of Italian dramas. Intermedi first appeared during the Renaissance and grew progressively more complex during the sixteenth century. They were often laden with spectacle, and as a result came to shape the production standards of early operas.

Jansenism: A theology popular in seventeenth-century France that traced its origins to the *Augustinus* of the Dutch theologian Cornelius Jansen (1585–1638). Jansenists stressed predestination and the necessity of an infusion of divine grace for salvation. Eventually declared heretical and persecuted by France's royal government, they had an important impact on French society through their foundation of schools and their opposition to the Jesuit Order.

Justaucorps: A tight-fitting coat that became popular at the French court in the 1670s. It was usually worn atop an interior waistcoat or vest and breeches, and was thus the eventual inspiration for the modern "three-piece" suit.

Levellers: A political party active during the English Civil Wars and Puritan Commonwealth that sought the establishment of a more egalitarian society. Their ideas were more popular and moderate than the Diggers, who advocated the abolition of private property.

Licensing Act (1737): A measure of the British Parliament that outlawed theatrical performances except those staged in theaters with a royal patent or license.

Licensing Act of 1662: This Act of Parliament charged the Stationers' Guild in London with examining the texts of books and granting licenses to publish. It was intended to stamp out opposition to the government. Eventually, the legislation bred great criticism of the guild for its high-handed and corrupt practices, and the act was allowed to lapse in 1695.

Literary Club: Originally called merely "the Club," this literary institution in later eighteenth-century London was founded by the painter Sir Joshua Reynolds and Samuel Johnson with the aim of discussing aesthetics and the principles of good writing. Its membership eventually included many of the great authors who lived in and around the capital.

Loggia: A covered walkway or arcade whose sides are open and whose roof is often supported by columns.

Mannerism: A late Renaissance stylistic movement that continued to attract adherents in the early seventeenth century. Its style imitated the willful and tempestuous creations of the later Michelangelo, and were often characterized by elongated, elegant, or distorted treatments of the human form.

Masques: A popular court entertainment in Tudor and Stuart England. Masques frequently featured songs, lengthy dances, and elaborate costumes and tableaux. Under the Stuarts, these entertainments grew to enormous lengths and their extravagant costs were a source of criticism to the government.

Meissen: The center of the Saxon porcelain industry, where in the early eighteenth century, the techniques of creating "hard-paste" porcelain were discovered. Meissen, too, is often used to describe the porcelain created in the town.

Mercantilism: The economic theory dominant in much of seventeenth-century Europe that held that states must preserve their supply of money by limiting imports and maximizing exports.

Metaphysical Poets: A group of poets in early seventeenth-century England that made use of elaborate conceits and a difficult style. John Donne and George Herbert were chief among the "Metaphysicals."

Millenary Petition: A petition formulated by English Puritans and presented to James I as he made his way from

Scotland to London to assume the English throne in 1603. The Millenary Petition requested reforms in the governance and ritual of the Church of England, and took its name from the fact that a thousand petitioners were said to have signed it.

Minuet: A dance that was French in origin and popular in the eighteenth-century ballroom. It was written in triple time, and it was often used in the Baroque dance suite. Later, it often figured prominently as the third movement of the classical-era symphony.

Neoclassicism: An artistic and architectural movement popular in mid-seventeenth and eighteenth-century Europe that was inspired by archeological excavations in Italy and Greece and which aimed to adopt classical forms to the needs of contemporary society.

Neo-Latin: The form of classically-inspired Latin revived by later fifteenth- and sixteenth-century humanists, and brought to a high point of expression in the work of figures like Desiderius Erasmus (1466–1536).

Neoplatonism: The philosophy that derived from Renaissance humanism's study of the works of Plato and his followers. Neoplatonism, or Renaissance Platonism as it is also called, became popular among intellectuals around 1500 through the research of Marsiglio Ficino (1433–1499) and other Platonic philosophers. These thinkers developed a difficult, and often metaphysical, philosophy that made use of learned magic, and which taught that there was an "ancient theology" shared by all religions. The movement's influence persisted in the early seventeenth century, and some thinkers influenced by this movement like Francis Bacon helped lay the foundations for the Scientific Revolution.

New Model Army: The most disciplined and effective of the fighting forces that Parliament raised during the 1640s English Civil Wars. Oliver Cromwell came to prominence as a general in this fighting force.

Nonconformist: A word that appeared during the Restoration period in England to describe those who would not "conform" to the attendance or communion requirements of the Church of England.

Opera Buffo: A form of comic opera popular, particularly in the later eighteenth century throughout Europe.

Opera Seria: One of the serious forms of musical drama that flourished in eighteenth-century Europe. Opera seria usually drew their subjects from classical or heroic themes.

Oratorios: A dramatic musical form that originally developed for performance during the Lenten season, when operas were thought too worldly to be performed. Oratorios, like cantatas, convey their stories through music alone, and often consist of a mixture of arias, recitatives, and choruses. Among the most famous of oratorios are the brilliant works of Georg Frederic Handel, particularly his *Messiah.*

Palladianism: A classical style of architecture that flourished in England in the seventeenth and eighteenth centuries, and which was influenced by the great Venetian Renaissance architect Andrea Palladio.

Passion Play: A religious play, often of considerable length. Passion plays were popular in the Catholic towns and villages of central Europe during the seventeenth and eighteenth centuries, and the most prominent of these, the Oberammergau Passion Play, is still performed in modern times.

Pastoral Literature: A genre of literature that developed in late Renaissance Italy that was particularly popular there and in Spain. Pastoral works featured conversations between shepherds, shepherdesses, nymphs, and satyrs in idyllic country settings. In the early history of opera many pastorals were set to music.

Peace of Westphalia: The treaty that ended hostilities in the Thirty Years' War, the great conflict that laid waste to much of central Europe between 1618 and 1648. The stipulations of the treaty recognized the legality of Calvinism, but reiterated the sixteenth-century principle, "He who rules, his religion," meaning that Germany's territorial rulers were once again free to define the religion of their subjects.

Pelagianism: A theology associated with the fifth-century monk Pelagius that denied the pervasive character of Original Sin and taught that human beings might save themselves by living sinless lives. In the seventeenth century, the French Jansenists attacked the Jesuits for teaching doctrines they alleged were derived from Pelagius.

Philosophes: The term used to describe the chief intellectuals and writers of the French Enlightenment. They were men of letters, not professional scholars or academicians, who desired to put the ideas of the Enlightenment, and its quest for the reform of society along reasoned ground before their readers to spur discussion.

Picaresque Novel: A genre of novel that developed in sixteenth-century Spain that featured a low-born hero and his adventures. Picaresque fiction often brilliantly mocked the social foibles and eccentricities of aristocracy and society's various orders. The genre was popular everywhere in early-modern Europe, prompting imitators

of this brand of Spanish fiction in France, England, and Germany.

Pietism: A religious movement that began in late seventeenth-century Lutheran Germany. The pietists advocated a "second Reformation" that would sponsor a sincere and heart-felt religion. Their influence came to be felt through educational institutions and their writings, which left their impact on religious thinkers in both Catholic and Protestant countries in the eighteenth century.

Polyphony: Music composed of many tones or "voices" that are played simultaneously to produce a single coherent texture.

Popish Plot: A fictional plot concocted in 1678 by the Anglican clergyman Titus Oates who alleged that the Jesuits were planning on assassinating King Charles II and installing his brother, the Catholic James, duke of York, as his successor. Although later revealed as a hoax, it gave rise to a general panic in which a number of English Catholics were tried and executed.

Port Royal: The Parisian convent that became a center of Jansenist teaching in the seventeenth century.

Puritanism: The religious ideology promoted by English followers of John Calvin and the Calvinists. The Puritans argued that the English Reformation had not gone far enough in establishing Protestant teachings and that the Church of England needed to be purified of its Roman elements.

Restoration: The re-establishment of the Stuart dynasty as rulers in England in 1660. The phrase "Restoration Period" is often used to refer to the period of the rule of the later Stuarts, Charles II and James II, and consequently occurs between the years 1660 and 1688.

Rococo: In architecture and the visual arts a highly decorative style that developed at the end of the Baroque era. The style took its name from the French word *rocaille*, which referred to rocklike plasterwork that frequently figured prominently on the ceilings and walls of Rococo interiors.

Roman à Clef: An early genre of novel in which prominent contemporary figures were depicted as ancient characters. Such fictions were particularly popular in seventeenth-century France, where Madame de Scudéry was one important author.

Romanticism: The movement that succeeded neoclassicism in the visual arts and literature at the end of eighteenth century. The romantic sensibility favored an exploration of the emotions and the power of nature, in contrast to the restrained and intellectually coherent values promoted in the classical period.

Rondeau: A sprightly dance form that has a repeating tune that is returned to several times, much like the refrain in a song. Rondeau figured prominently in the Baroque dance suites, and in classical-era symphonies it was often used as the concluding movement.

Royal Academy of Dance (Académie royale de danse): An institution chartered by Louis XIV in 1661 to foster the development of the art of dance in France. In time, the Academy maintained a school that trained many eighteenth-century ballet dancers.

Royal Academy of Music (Académie royale de musique): This institution, which became known merely as the Opera, was chartered by Louis XIV in 1669 to perform light musical entertainments. When Jean-Baptiste Lully assumed its directorship in 1672, it played a major role in promoting opera in France, and it continued to be an important musical force in the country until the Revolution.

Ruff: An elaborate collar in which pleats or ruffles are concocted out of starched white fabric or lace. The style, inherited from the late Renaissance, continued to be popular until the 1620s in many parts of Europe, before fading from the fashion scene.

Salon: A term that has at least three specific meanings in French culture. First, it described the small intimate public rooms of eighteenth-century palaces and townhouses. Second it refers to the important social gatherings that occurred in these spaces, gatherings that became venues for discussing and popularizing the ideas of the Enlightenment in France's elite society. Third, it was the title given to the annual exhibition held by the Royal Academy of Painting and Sculpture in France, an institution chartered by the king in 1648 for the advancement of the visual arts.

Scholasticism: A medieval academic method that placed great emphasis on the weighing of evidence from previous authorities. The scholastic method taught its students how to harmonize and respond to the conflicting opinions of ancient and medieval authorities concerning theological, legal, and medical issues. The method continued to live on in early-modern Europe, although it was widely criticized by seventeenth-century philosophers and eighteenth-century Enlighteners.

Scriblerus Club: A gathering of literary figures that occurred weekly in London during 1713–1714. Among those who attended were Jonathan Swift, Joseph Addison, Daniel Defoe, and Alexander Pope. The club's discussions left their imprint on the witty satires that these

figures published in the years following its dissolution, although since the members were Tories their meetings were curtailed with the rise of a Whig government in 1714.

Secularization: The process by which worldly, civic, or non-religious values gradually became more important in Europe than religious motivations or teachings. Secularization was often seen as an essential goal by some of the prominent thinkers of the Enlightenment.

Sensitive Style (*empfindsamer Stil*): A variant of the Galant Style in music that was particularly popular in northern Germany in the mid-eighteenth century. It aimed to express constant changes in mood and emotion. Its most famous exponent was Carl Philipp Emanuel Bach.

Sinfonia: Originally an Italian word that merely described the playing of various tones or instruments at once. By the early eighteenth century, the Italian sinfonia was developing into a recognized genre of instrumental music, usually intended for large ensembles. Its characteristic structure of either three themes or independent movements were played fast-slow-fast, in contrast to the French overture, which began with a slow and stately theme followed by a fast one. In time, sinfonias surpassed the French overture as a genre for operatic overtures, in large part, because of the great popularity of Italian opera in eighteenth-century Europe. From this vantage point, they contributed to the development of the classical-era symphony.

Skepticism: A philosophical movement particularly popular among some late sixteenth- and early seventeenth-century intellectuals that taught that absolute truth could never be established and that some ideas had consequently to be accepted on faith.

Sonata: A vast genre of early-modern instrumental music that featured one instrument or a group of instruments. Gradually, sonatas came to have three movements, usually a slow interior, songlike piece was preceded and followed by two other compositions that were fast.

Sonata Form: A musical form that is often used to organize the first movement of the classical-era symphony. It consists of three parts: an exposition that sets out one or several contrasting themes; a development in which those themes are explored; and a recapitulation, in which the themes are restated. Sometimes a coda, meaning "tail," concludes the piece. Sonata form became one of the most universally used musical organizational forms of European composers.

Spiritual Exercises: A devotional classic written by the Jesuit founder St. Ignatius of Loyola in the sixteenth century. The work's influence was felt in Baroque Catholic culture through its emphasis on meditations that were fueled by a powerful visualization of the dramas recorded in the scriptures.

Stationers' Guild: A medieval London guild that came to be entrusted in the sixteenth century with the office of censoring the press in England. It continued to fulfill this function until 1695, and in the eighteenth century it became the major organ for the awarding of copyright in Great Britain.

Sturm und Drang: Meaning literally "Storm and Stress," this German literary movement explored the force of the emotions, and provided a bridge to the developing sensibilities of the romantic movement. Its tempestuous and excitable style was also imitated by many of the musical composers of the era.

Sumptuary Laws: Legislation aimed at limiting consumption in clothes and in the celebration of marriages and funerals.

Symphony: An extended work for the orchestra that underwent a long period of development in the Baroque and classical eras. In the works of Josef Haydn the development of the classical symphony reached a high level of development, and consisted of four movements, opening and concluding pieces that were played fast and which framed a second aria-like composition, and a third movement written in a lively dance idiom. Despite the canonical status of Haydn's great symphonies today, though, the form was still undergoing major development at the end of the eighteenth century, although it was to become the most important genre of orchestral music for "serious" composers in the nineteenth and twentieth centuries.

Tabula Rasa: Meaning "blank slate." In his *Essay Concerning Human Understanding*, John Locke argued that this was the character of the mind before sense experience left its impressions upon it.

Tronie: A popular genre of painting in the seventeenth-century Netherlands in which patrons chose to be depicted wearing the costumes of ancient heroes, military figures, or emperors.

United Provinces: The confederation of counties that developed in the northern Netherlands in the period after they established their effective independence from Spanish Habsburg rule.

FURTHER REFERENCES

GENERAL

R. G. Asch, *The Thirty Years' War; The Holy Roman Empire and Europe, 1618–1648* (New York: St. Martin's Press, 1997).

J. Black, *Kings, Nobles, and Commoners: States and Societies in Early Modern Europe* (New York: Palgrave, 2004).

J. Bossy, *Christianity in the West, 1400–1700* (Oxford and New York: Oxford University Press, 1985).

Euan Cameron, ed., *Early Modern Europe, An Oxford History* (Oxford and New York: Oxford University Press, 1999).

C. Cook, et al., *The Longman Handbook to Early Modern Europe* (London and New York: Longman, 2001).

R. S. Dunn, *The Age of Religious Wars, 1559–1715* (New York: Norton, 1979).

H. G. Koenigsberger, *Early Modern Europe, 1500–1789* (London and New York: Longman, 1987).

L. Krieger, *Kings and Philosophers, 1689–1789* (New York: Norton, 1980).

The New Cambridge Modern History. Vols. 4–7 (Cambridge: Cambridge University Press, 1957).

G. Parker, *Empire, War, and Faith in Early Modern Europe* (London: Allen Lane, 2002).

T. K. Rabb, *The Struggle for Stability in Early Modern Europe* (London and New York: Oxford University Press, 1975).

J. Sweetman, *The Enlightenment and the Age of Revolution, 1700–1850* (London and New York: Addison, Wesley, Longman, 1998).

I. Woloch, *Eighteenth-Century Europe: Tradition and Progress, 1715–1789* (New York: Norton, 1986).

ARCHITECTURE

G. Beard, *The Work of Robert Adam* (New York: Arco, 1978).

R. W. Berger, *Versailles: The Château of Louis XIV* (University Park, Pa.: Pennsylvania State University Press, 1985).

A. Blunt, ed., *Baroque and Rococo: Architecture and Decoration* (New York: Icon Editions, 1982).

———, *Francesco Borromini* (Cambridge, Mass.: Harvard University Press, 1979).

———, *Roman Baroque* (London: Pallas Athene Arts, 2001).

K. Clark, *The Gothic Revival* (Middlesex, United Kingdom: Penguin Books, 1964).

J. Connors, *Borromini and the Roman Oratory* (Cambridge, Mass.: MIT Press, 1980).

K. Downes, *English Baroque Architecture* (London: Zwemmer, 1966).

R. D. Gray, *Christopher Wren and St. Paul's Cathedral* (Cambridge: Cambridge University Press, 1979).

E. Harris, *Robert Adam; The Genius of His Interiors* (New Haven, Conn.: Yale University Press, 2001).

J. Harris, *The Palladians* (New York: Rizzoli International Publications, 1982).

F. Hartt, *Art: A History of Painting, Sculpture, Architecture.* 3rd ed. (New York: H. N. Abrams, Inc., 1989).

J. S. Held and D. Posner, *Seventeenth and Eighteenth Century Art* (Englewood Cliffs, N.J.: Prentice Hall, 1971).

H. Hibbard, *Carlo Maderno and Roman Architecture, 1580–1630* (London: Zwemmer, 1971).

A. Hopkins, *Italian Architecture: From Michelangelo to Borromini* (London: Thames and Hudson, 2002).

———, *Santa Maria della Salute: Art and Ceremony in Baroque Venice* (Cambridge: Cambridge University Press, 2000).

P. M. Jones and T. Worcester, eds., *From Rome to Eternity: Catholicism and the Arts in Italy, ca. 1550–1650* (Leiden, Netherlands: E. J. Brill, 2002).

W. Kuyper, *Dutch Classicist Architecture* (Delft, Netherlands: Delft University Press, 1980).

I. Lavin, ed., *Gianlorenzo Bernini: New Aspects of His Life and Art* (University Park, Pa.: Pennsylvania State University Press, 1985).

J. M. Levine, *Between the Ancients and the Moderns: Baroque Culture in Restoration England* (New Haven, Conn.: Yale University Press, 1999).

W. Lotz, *Architecture in Italy, 1500–1600* (New Haven, Conn.: Yale University Press, 1996).

T. Magnuson, *Rome in the Age of Bernini* (Atlantic Highlands, N.J.: Humanities Press, 1982).

H. A. Meek, *Guarini Guarino and His Architecture* (New Haven, Conn.: Yale University Press, 1988).

V. H. Minor, *Baroque & Rococo: Art & Culture* (London: Laurence King Publishing, 1999).

P. Murray, *The Architecture of the Italian Renaissance* (London: Thames and Hudson, 1986).

J. Paul, *The City Churches of Sir Christopher Wren* (London: Hambledon Press, 1986).

N. Pevsner, ed., *The Picturesque Garden and Its Influence Outside the British Isles* (Washington: Dumbarton Oaks, 1977).

A. Picon, *French Architects and Engineers in the Age of Enlightenment.* Trans. Martin Thom (New York: Cambridge University Press, 1992).

P. Porteghesi, *Roma Barocca: The History of an Architectonic Culture.* Trans. Barbara La Penta (Boston: MIT Press, 1970).

N. Powell, *From Baroque to Rococo: An Introduction to Austrian and German Architecture, 1580–1790* (London: Faber, 1959).

C. N. Schulz, *Baroque Architecture* (New York: Rizzoli International Publications, 1986).

K. Scott, *The Rococo Interior: Decoration and Social Spaces in Early Eighteenth-Century Paris* (New Haven, Conn.: Yale University Press, 1995).

C. Scribner, III, *Gianlorenzo Bernini* (New York: H. N. Abrams, 1991).

D. Stillman, *English Neoclassical Architecture.* 2 vols. (London: A. Zwemmer, 1988).

J. Summerson, *Architecture in England, 1530–1830* (Harmondsworth, United Kingdom: Penguin, 1991).

W. von Kalnein, *Architecture in France in the Eighteenth Century.* Trans. David Britt (New Haven, Conn.: Yale University Press, 1996).

G. Walton, *Louis XIV's Versaille* (Harmondsworth, United Kingdom: Penguin, 1986).

D. Watkin, *The English Vision: The Picturesque in Architecture, Landscape, and Garden Design* (New York: Harper and Row, 1982).

D. Wiebenson, *The Picturesque Garden in France* (Princeton, N.J.: Princeton University Press, 1978).

R. Wittkower, *Art and Architecture in Italy, 1600–1750* (Harmondsworth, United Kingdom: Penguin, 1980).

———, *Palladio and English Palladians.* Comp. Margot Wittkower (London: Thames and Hudson, 1974).

A. Zega, *The Palaces of the Sun King* (New York: Rizzoli International, 2002).

DANCE

J. Cass, *Dancing Through History* (Englewood Cliffs, N.J.: Prentice Hall, 1993).

J. Chazin-Bennahum, *Dance in the Shadow of the Guillotine* (Carbondale, Ill.: Southern Illinois University, 1988).

I. K. Fletcher, S. J. Cohen, and R. Lonsdale, eds., *Famed for Dance: Essays on the Theory and Practice of Theatrical Dancing in England, 1660–1740* (New York: Books for Libraries, 1980).

S. L. Foster, *Choreography and Narrative; Ballet's Staging of Story and Desire* (Bloomington, Ind.: Indiana University Press, 1996).

Mark Franko, *Dance as Text: Ideologies of the Baroque Body* (Cambridge: Cambridge University Press, 1993).

I. Guest, *The Ballet of the Enlightenment* (London: Dance Books, 1996).

R. Harris-Warrick and C. G. Marsh, *Musical Theatre at the Court of Louis XIV* (Cambridge: Cambridge University Press, 1994).

W. Hilton, *Dance and Music of Court and Theater* (Stuyvesant, N.Y.: Pendragon Press, 1997).

S. Howard, *The Politics of Courtly Dancing in Early Modern England* (Amherst, Mass.: University of Massachusetts Press, 1988).

N. A. Jaffé, *Folk Dance of Europe* (Skipton, United Kingdom: Folk Dance Enterprises, 1990).

D. Lynham, *Chevalier Noverre, Father of Modern Ballet* (London: Sylvan Press, 1950).

S. McCleave, ed., *Dance and Music in French Baroque Theatre: Sources and Interpretations* (London: IAMS, 1998).

P. Migel, *The Ballerinas from the Court of Louis XIV to Pavlova* (New York: Macmillan, 1972).

S. Pitou, *The Paris Opéra: An Encyclopedia of Operas, Ballets, Composers, and Performers.* 2 vols. (Westport, Conn.: Greenwood Press, 1983–1985).

R. Ralph, *The Life and Works of John Weaver* (New York: Dance Horizons, 1988).

Roy Strong, *Splendor at Court: Renaissance Spectacle and the Theater of Power* (Boston: Houghton, Mifflin, 1973).

M. H. Winter, *The Pre-Romantic Ballet* (London: Pittman Publishing, 1974).

FASHION

F. E. Baldwin, *Sumptuary Legislation and Personal Regulation in England* (Baltimore, Md.: Johns Hopkins University Press, 1926).

A. Castelot, *Madame du Barry* (Paris: Perrin, 1989).

———, *Queen of France. A Biography of Marie Antoinette* (New York: Harper and Row, 1957).

M. Crosland, *Madame de Pompadour: Sex, Culture, and the Power Game* (London: Sutton, 2000).

E. P. DeLorme, *Joséphine: Napoléon's Incomparable Empress* (New York: H. N. Abrams, 2002).

M. Delpierre, *Dress in France in the Eighteenth Century* (New Haven, Conn.: Yale University Press, 1997).

J. P. Desprat, *Madame de Maintenon, 1635–1719* (Paris: Perrin, 2003).

A. Fraser, *Marie Antoinette* (London: Weidenfeld and Nicolson, 2001).

C. F. Haldane, *Madame de Maintenon. Uncrowned Queen of France* (Indianapolis, Ind.: Bobbs, Merrill, 1970).

J. Haslip, *Madame du Barry: The Wages of Beauty* (London: Weidenfeld and Nicolson, 1991).

A. Hunt, *Governance of the Consuming Passions; A History of Sumptuary Law* (London: Macmillan, 1996).

C. K. Killerby, *Sumptuary Law in Italy, 1200–1500* (Oxford: Clarendon Press, 2002).

D. L. Moore, *Fashion Through Fashion Plates, 1770–1970* (London: Ward Lock, 1971).

A. Ribeiro, *The Art of Dress: Fashion in England and France, 1750–1820* (New Haven, Conn.: Yale University Press, 1995).

———, *Dress in Eighteenth-Century Europe, 1715–1789* (London: B. T. Batsford Ltd., 1984).

D. Roche, *The Culture of Clothing* (Cambridge: Cambridge University Press, 1994).

O. Sronková, *Fashions Through the Centuries: Renaissance, Baroque, and Rococo.* Trans. Till Gottheimer (London: Spring Books, 1959).

J. Starobinski, *Revolution in Fashion: European Clothing, 1715–1815* (New York: Abbeville Press, 1989).

M. von Boehn, *Modes and Manners.* 4 vols. Trans. Joan Joshua (Philadelphia: J. B. Lippincott Co., 1932–1936).

C. L. White, *Women's Magazines, 1693–1968* (London: Joseph, 1970).

D. Yarwood, *English Costume* (New York: Scribner's, 1956).

LITERATURE

C. K. Abraham, *Enfin Malherbe: The Influence of Malherbe on French Lyric Prosody, 1605–1674* (Lexington, Ky.: University Press of Kentucky, 1971).

S. P. Atkins, *The Testament of Werther in Poetry and Drama* (Cambridge: Harvard University Press, 1949).

P. R. Backscheider, *Daniel Defoe: His Life* (Baltimore: Johns Hopkins University Press, 1989).

R. C. Bald, *John Donne: A Life* (New York: Oxford University Press, 1970).

R. Barbour, *Literature and Religious Culture in Seventeenth-Century England* (Cambridge: Cambridge University Press, 2002).

J. G. Basker, *Tobias Smollet, Critic and Journalist* (Newark, Del.: University of Delaware Press, 1988).

I. M. Battafarano, ed., *Georg Philipp Harsdörffer* (Berne: P. Lang, 1991).

H. Bekker, *Andreas Gryphius; Poet between Two Epochs* (Berne: P. Lang, 1973).

I. A. Bell, *Defoe's Fiction* (Totowa, N.J.: Barnes and Noble, 1985).

J. S. Bennett, *Reviving Liberty: Radical Christian Humanism in Milton's Great Poems* (Cambridge, Mass.: Harvard University Press, 1989).

H. Blamires, *Milton's Creation: A Guide through "Paradise Lost"* (London: Methuen, 1971).

D. D. Blond and W. R. McLeod, *Newsletters to Newspapers: Eighteenth-Century Journalism* (Morgantown, W.V.: West Virginia University Press, 1977).

P. Brewer, *Doctrine and Devotion in Seventeenth-Century Poetry: Studies in Donne, Herbert, Crashaw, and Vaughan* (Rochester, N.Y.: Brewer, 2000).

E. B. Brophy, *Samuel Richardson* (Boston: Twayne, 1987).

J. Carey, *John Donne: Life, Mind, and Art* (New York: Oxford University Press, 1981).

A. H. Cash, *Laurence Stern: The Early and Middle Years* (London: Methuen, 1975).

R. Critchfield and W. Koepke, *Eighteenth-Century German Authors and Their Aesthetic Theories* (Camden, S.C.: Camden House, 1988).

J. DeJean, *Libertine Strategies: Freedom and the Novel in Seventeenth-Century France* (Columbus: Ohio State University Press, 1981).

T. Eagleton, *The Rape of Clarissa* (Oxford: Oxford University Press, 1982).

P. Earle, *The World of Defoe* (New York: Athenaeum, 1977).

D. Fairer, *Pope's Imagination* (Manchester, England: Manchester University Press, 1984).

S. Fish, *Surprised by Sin: The Reader in Paradise Lost* (Cambridge, Mass.: Harvard University Press, 1998).

C. H. Flynn, *The Body in Swift and Defoe* (Cambridge: Cambridge University Press, 1990).

P. N. Furbank, *The Canonisation of Daniel Defoe* (New Haven, Conn.: Yale University Press, 1988).

F. Du Plessix Gray, *At Home with the Marquis de Sade* (New York: Simon and Schuster, 1998).

I. Grundy, *Samuel Johnson and the Scale of Greatness* (Leicester: Leicester University Press, 1986).

K. S. Guthke, *Gotthold Ephraim Lessing* (Stuttgart, Germany: Metzler, 1979).

I. Higgins, *Swift's Politics: A Study in Disaffection* (Cambridge: Cambridge University Press, 1994).

N. Hudson, *Samuel Johnson and Eighteenth-Century Thought* (Oxford: Oxford University Press, 1988).

F. Kermode, *John Donne* (London: Longman, 1957; reprint, 1971).

———, *The Poems of John Donne* (Cambridge: Cambridge University Press, 1968).

M. Kinkead-Weekes, *Samuel Richardson, Dramatic Novelist* (Ithaca, N.Y.: Cornell University Press, 1973).

J. M. Levine, *Between the Ancients and the Moderns: Baroque Culture in Restoration England* (New Haven, Conn.: Yale University Press, 1999).

C. Lougee, *Le Paradis des Femmes: Women, Salons, and Social Stratification in Seventeenth-Century France* (Princeton, N.J.: Princeton University Press, 1976).

G. Lukács, *Goethe and His Age* (New York: Grosset and Dunlap, 1969).

H. Mason, *Voltaire: A Biography* (Baltimore, Md.: Johns Hopkins University Press, 1981).

————, *Voltaire: Optimism Demolished* (New York: Twayne, 1992).

C. McIntosh, *The Evolution of English Prose, 1700–1800* (Cambridge: Cambridge University Press, 1998).

P. Milward, *A Commentary on the Holy Sonnets of John Donne* (London: Dance Books, 1996).

A. Nicolson, *God's Secretaries: The Making of the King James Bible* (New York: Harper Collins, 2003).

G. Parfitt, *English Poetry of the Seventeenth Century* (London: Longman, 1985).

G. Parry, *Seventeenth-Century Poetry: The Social Context* (London: Hutchinson, 1985).

J. J. Richetti, *Daniel Defoe* (Boston: Twayne, 1987).

P. Richter and I. Ricardo, *Voltaire* (Boston: Twayne Publishers, 1980).

W. Sale, *Samuel Richardson: Master Printer* (Ithaca, N.Y.: Cornell University Press, 1950).

D. J. Schaub, *Erotic Liberalism: Women and Revolution in Montesquieu's Persian Letters* (Lanham, Md.: Rowman and Littlefield, 1995).

B. L. Spahr, *Andreas Gryphius: A Modern Perspective* (Camden, S.C.: Camden House, 1993).

J. J. Stoudt, *Jakob Boehme: His Life and Thought* (New York: Seabury, 1968).

J. Sutherland, *Defoe* (London: Longmans, Green, 1956).

F. Van Ingen, *Philipp von Zesen* (Stuttgart, Germany: J. B. Metzler, 1970).

H. Vendler, *The Poetry of George Herbert* (Cambridge, Mass.: Harvard University Press, 1975).

R. Winegarten, *French Lyric Poetry in the Age of Malherbe* (Manchester, England: Manchester University Press, 1954).

J. A. Winn, *John Dryden and His World* (New Haven, Conn.: Yale University Press, 1987).

C. Wolff, *Samuel Richardson and the Eighteenth-Century Puritan Character* (Hamden, Conn.: Archon Books, 1972).

Music

G. Abraham, ed., *Concert Music, 1630–1750* (Oxford: Oxford University Press, 1986).

N. Anderson, *Baroque Music: From Monteverdi to Handel* (London: Thames & Hudson, 1994).

J. R. Anthony, *French Baroque Music: From Beaujoyeulx to Rameau* (New York: Norton, 1978).

D. Arnold, *The Oratorio in Venice* (London: Royal Musical Association, 1986).

T. Bauman and M. P. McClymonds, eds., *Opera and the Enlightenment* (Cambridge: Cambridge University Press, 1995).

D. D. Boyden, ed., *Violin Family* (London: Macmillan, 1989).

R. Brown, *The Early Flute: A Practical Guide* (Cambridge: Cambridge University Press, 2002).

D. Burrows, ed., *The Cambridge Companion to Handel* (Cambridge: Cambridge University Press, 1997).

J. Butt, ed., *The Cambridge Companion to Bach* (Cambridge: Cambridge University Press, 1997).

D. Charlton, *French Opera, 1730–1830: Meaning and Media* (Aldershot, United Kingdom: Ashgate, 2000).

T. Christensen, *Rameau and Musical Thought in the Enlightenment* (Cambridge: Cambridge University Press, 1993).

D. J. Grout and C. V. Palisca, *A History of Western Music.* 6th ed. (New York: W. W. Norton, 1996).

R. Harris-Warrick and C. G. Marsh, *Musical Theatre at the Court of Louis XIV* (Cambridge: Cambridge University Press, 1994).

B. Haynes, *The Eloquent Oboe: A History of the Hautboy, 1640–1760* (Oxford: Oxford University Press, 2001).

D. Heartz, *Music in European Capitals: The Galant Style, 1720–1780* (New York: W. W. Norton, 2003).

C. Hogwood, *Handel* (London: Thames and Hudson, 1984).

D. W. Jones, et al., *Haydn: His Life and Music* (Bloomington, Ind.: Indiana University Press, 1988).

E. Kennedy, et al., *Theatre, Opera, and Audiences in Revolutionary Paris: Analysis and Repertory* (Westport, Conn.: Greenwood Press, 1996).

D. R. B. Kimbell, *Italian Opera* (Cambridge: Cambridge University Press, 1991).

K. Komlós, *Fortepianos and Their Music: Germany, Austria, and England, 1760–1800* (Oxford: Clarendon Press, 1995).

K. Küster, *Mozart: A Musical Biography.* Trans. Mary Whittall (Oxford: Clarendon Press, 1996).

C. Lawson, *The Early Clarinet: A Practical Guide* (Cambridge: Cambridge University Press, 2000).

A. Lewis and N. Fortune, eds., *Opera and Church Music, 1630–1750* (London: Oxford University Press, 1975).

S. McCleave, ed., *Dance and Music in French Baroque Theatre: Sources and Interpretations* (London: IAMS, 1998).

J. Newman, *Jean-Baptiste De Lully and His Tragédies Lyriques* (Epping, United Kingdom: Bowker, 1979).

C. V. Palisca, *Baroque Music.* 3rd ed. (Englewood Cliffs, N.J.: Prentice Hall, 1991).

R. Parker, *The Oxford History of Opera* (Oxford: Oxford University Press, 1996).

S. Pitou, *The Paris Opéra: An Encyclopedia of Operas, Ballets, Composers, and Performers.* 2 vols. (Westport, Conn.: Greenwood Press, 1983–1985).

A. Powell, *The Flute* (New Haven, Conn.; London: Yale University Press, 2002).

A. R. Rice, *The Baroque Clarinet* (Oxford: Clarendon, 1992).

———, *Vivaldi: Voice of the Baroque* (London: Flamingo, 1995).

M. F. Robinson, *Opera Before Mozart* (London: Hutchinson, 1978).

E. Rosand, *Opera in Seventeenth Century Venice: The Creation of a Genre* (Berkeley, Calif.: University of California Press, 1991).

C. Rosen, *The Classical Style: Haydn, Mozart, Beethoven* (New York: W. W. Norton, 1997).

J. Rosselli, *The Life of Mozart* (Cambridge: Cambridge University Press, 1998).

S. Sadie, ed., *History of Opera* (Basingstoke, United Kingdom: Macmillan, 1989).

D. Schulenberg, *Music of the Baroque* (New York: Oxford University Press, 2001).

C. N. Schulz, *Baroque Architecture* (New York: Rizzoli International Publications, 1986).

E. Sisman, ed., *Haydn and His World* (Princeton, N.J.: Princeton University Press, 1997).

K. M. Stolba, *The Development of Western Music: A History* (Boston: McGraw Hill, 1998).

M. Talbot, *Venetian Music in the Age of Vivaldi* (Aldershot, United Kingdom: Ashgate, 1999).

———, *Vivaldi* (London: Dent, 1978).

W. Weber, *The Rise of Musical Classics in Eighteenth-Century England: A Study in Canon, Ritual, and Ideology* (Oxford: Oxford University Press, 1992).

P. Williams, *The Life of Bach* (Cambridge: Cambridge University Press, 2003).

PHILOSOPHY

M. Biagioli, *Galileo, Courtier: The Practice of Science in the Culture of Absolutism* (Chicago: University of Chicago Press, 1993).

B. Broadie, *The Cambridge Companion to the Scottish Enlightenment* (Cambridge: Cambridge University Press, 2003).

J. R. Censer and L. Hunt, *Liberty, Equality, and Fraternity: Exploring the French Revolution* (University Park, Pa.: Pennsylvania State University Press, 2001).

P. V. Conroy, *Montesquieu Revisited* (New York: Twayne, 1992).

M. W. Cranston, *John Locke; A Biography* (London: Longmans, 1966).

———, *Philosophers and Pamphleteers: Political Theorists of the Enlightenment* (Oxford: Oxford University Press, 1984).

D. Daiches, J. Jones, and P. Jones, eds., *A Hotbed of Genius: The Scottish Enlightenment, 1730–1790* (Edinburgh, Scotland: Edinburgh University Press, 1986).

R. Darnton, *The Business of Enlightenment* (Cambridge, Mass.: Belknap Press, 1979).

———, *The Literary Underground of the Old Regime* (Cambridge, Mass.: Harvard University Press, 1982).

F. Delekat, *Immanuel Kant* (Heidelberg: Quelle and Meyer, 1966).

S. Drake, *Essays on Galileo and the History of Science* (Toronto, Canada: University of Toronto Press, 1999).

P. France, *Diderot* (Oxford: Oxford University Press, 1983).

G. Fuller, R. Stecker, and J. P. Wright, eds., *John Locke: An Essay Concerning Human Understanding in Focus* (London: Routledge, 2000).

P. Gay, *The Enlightenment; An Interpretation.* 2 vols. (New York: Knopf, 1995).

L. Goldmann, *The Philosophy of the Enlightenment* (Cambridge, Mass.: Harvard University Press, 1973).

J. Guéhenno, *Jean Jacques Rousseau.* Trans. J. and D. Weightman. 2 vols. (New York: Columbia University Press, 1966).

N. Hampson, *A Cultural History of the Enlightenment* (New York: Pantheon, 1968).

J. Henry, *Knowledge is Power: Francis Bacon and the Method of Science* (London: Icon Books, 2002).

S. D. Kale, *French Salons: High Society and Political Sociability from the Old Regime to the Revolution of 1848* (Baltimore, Md.: Johns Hopkins University Press, 2004).

T. M. Lennon, *The Battle of the Gods and Giants: The Legacies of Descartes and Gassendi, 1655–1715* (Princeton, N.J.: Princeton University Press, 1993).

P. Machamer, *The Cambridge Companion to Galileo* (New York: Cambridge University Press, 1998).

H. Mason, *Voltaire: A Biography* (Baltimore, Md.: Johns Hopkins University Press, 1981).

————, *Voltaire: Optimism Demolished* (New York: Twayne, 1992).

J. V. H. Melton, *Absolutism and the Origins of Compulsory Schooling in Prussia and Austria* (Cambridge: Cambridge University Press, 1988).

————, *Cultures of Communication from Reformation to Enlightenment* (Burlington, Vermont: Ashgate, 2002).

————, *The Rise of the Public in Enlightenment Europe* (Cambridge: Cambridge University Press, 2001).

P. Millican, ed., *Reading Hume on Human Understanding: Essays on the First Enquiry* (Oxford: Clarendon Press, 2002).

E. C. Mossner, *The Life of David Hume* (Oxford: Clarendon Press, 1997).

D. F. Norton, *The Cambridge Companion to Hume* (Cambridge: Cambridge University Press, 1993).

J. C. O'Neal, *The Authority of Experience: Sensationist Theory in the French Enlightenment* (University Park, Pa.: Pennsylvania State University Press, 1996).

————, *Changing Mind: The Shifting Perception of Culture in Eighteenth-Century France* (Newark, Del.: University of Delaware Press, 2002).

T. L. Pangle, *Montesquieu's Philosophy of Liberalism: A Commentary on the Spirit of the Laws* (Chicago: University of Chicago Press, 1973).

J. Passmore, *Hume's Intentions* (London: Duckworth, 1980).

L. Pearl, *Descartes* (Boston: Twayne, 1977).

M. Peltonen, *The Cambridge Companion to Bacon* (Cambridge: Cambridge University Press, 1996).

A. Pérez-Ramos, *Francis Bacon's Idea of Science and the Maker's Knowledge Tradition* (Oxford: Clarendon Press, 1988).

B. Price, *Francis Bacon's New Atlantis* (Manchester, England: Manchester University Press, 2002).

S. Priest, *The British Empiricists: Hobbes to Ayer* (London: Penguin, 1990).

D. Radner, *Malebranche: A Study of a Cartesian System* (Assen, Netherlands: Van Gorcum, 1978).

N. Rescher, *Leibniz* (Totowa, N.J.: Rowman and Littlefield, 1979).

P. Richter and I. Ricardo, *Voltaire* (Boston: Twayne Publishers, 1980).

G. Santanilla, *The Crime of Galileo* (Chicago: University of Chicago Press, 1955).

H. M. Scott, ed., *Enlightened Absolutism: Reforms and Reformers in Later Eighteenth-Century Europe* (Basingstoke, United Kingdom: Macmillan, 1990).

R. Shackleton, *Montesquieu: A Critical Biography* (London: Oxford University Press, 1963).

S. Shapin, *Leviathan and the Air Pump: Hobbes, Boyle, and the Experimental Life* (Princeton, N.J.: Princeton University Press, 1985).

W. R. Shea, *The Magic of Numbers and Motion: The Scientific Career of René Descartes* (Canton, Mass.: Scientific History Publications, 1991).

R. M. Silverman, *Baruch Spinoza: Outcast Jew, Universal Sage* (Northwood, United Kingdom: Symposium Press, 1995).

J. Simon, *Mass Enlightenment: Critical Studies in Rousseau and Diderot* (Albany, N.Y.: State University of New York Press, 1995).

P. Urbach, *Francis Bacon's Philosophy of Science: An Account and a Reappraisal* (La Salle, Ill.: Open Court, 1987).

V. R. Vrooman, *René Descartes: A Biography* (New York: Putnam, 1970).

R. S. Westfall, *Essays on the Trial of Galileo* (Notre Dame, Ind.: University of Notre Dame Press, 1989).

R. Whelan, *The Anatomy of Superstition: A Study of the Historical Theory and Practice of Pierre Bayle* (Oxford: Voltaire Foundation, 1989).

J. W. Yolton, *Locke; An Introduction* (Oxford: Blackwell, 1985).

RELIGION

B. Ankarloo and G. Hennigsen, eds., *Early Modern Witchcraft: Centres and Peripheries* (Oxford: Clarendon Press, 1990).

R. G. Asch, *The Thirty Years' War: The Holy Roman Empire and Europe, 1618–1648* (New York: St. Martin's Press, 1997).

C. Bangs, *Arminius: A Study in the Dutch Reformation* (Nashville: Abingdon Press, 1971).

J. Bergin, *The Seventeenth Century* (Oxford: Oxford University Press, 2001).

E. C. E. Bourne, *The Anglicanism of William Laud* (London: Society for the Propagation of Christian Knowledge, 1947).

K. D. Brown, *A Social History of the Nonconformist Ministry in England and Wales* (Oxford: Oxford University Press, 1988).

P. Byrne, *Natural Religion and the Nature of Religion* (London: Routledge, 1989).

C. Carlton, *Archbishop William Laud* (London: Routledge and Kegan Paul, 1987).

L. Chatellier, *The Europe of the Devout* (Cambridge: Cambridge University Press, 1989).

G. S. Cragg, *The Church and the Age of Reason, 1648–1789* (New York: Athenaeum, 1960).

J. Delumeau, *Catholicism between Luther and Voltaire* (Philadelphia: Westminster Press, 1977).

W. Doyle, *Jansenism: Catholic Resistance to Authority from the Reformation to the French Revolution* (New York: St. Martin's Press, 2000).

R. S. Dunn, *The Age of Religious Wars, 1559–1715.* 2nd ed. (New York: Norton, 1979).

M. Forster, *Catholic Revival in the Age of the Baroque: Religious Identity in Southwestern Germany, 1550–1750* (Cambridge: Cambridge University Press, 2001).

M. Fulbrook, *Piety and Politics: Religion and the Rise of Absolutism in England, Württemberg, and Prussia* (Cambridge: Cambridge University Press, 1983).

R. L. Gawthrop, *Pietism and the Making of Eighteenth-Century Prussia* (Cambridge: Cambridge University Press, 1993).

K. H. D. Haley, *Politics in the Reign of Charles II* (Oxford: Basil Blackwell, 1985).

R. Hattersley, *John Wesley: A Brand from the Burning* (London: Little Brown, 2002).

C. Hill, *Economic Problems of the Church from Archbishop Whitgift to the Long Parliament* (Oxford: Clarendon Press, 1956).

R. Po-Chia Hsia, *Social Discipline in the Reformation: Central Europe, 1550–1750* (London: Routledge, 1989).

J. R. Jones, ed., *The First Whigs; The Politics of the Exclusion Crisis, 1678–1683* (London: Oxford University Press, 1961).

———, *The Restored Monarchy, 1660–1688* (Totowa, N.J.: Rowman and Littlefield, 1979).

C. Koslofsky, *The Reformation of the Dead: Death and Ritual in Germany, 1450–1700* (New York: St. Martin's Press, 2000).

S. Lehmberg, *Cathedrals Under Siege: Cathedrals in English Society, 1600–1700* (University Park, Pa.: Pennsylvania State University Press, 1996).

B. Levack, *The Witch Hunt in Early Modern Europe* (New York: Longman, 1987).

M. Mullett, *The Catholic Reformation* (London: Routledge, 1999).

J. Munson, *The Nonconformists: In Search of a Lost Culture* (London: Society for the Propagation of Christian Knowledge, 1991).

D. Oldridge, ed., *The Witchcraft Reader* (New York: Routledge, 2002).

J. W. O'Malley, ed., *The Jesuits: Culture, Science, and the Arts, 1540–1773* (Toronto, Canada: University of Toronto Press, 1999).

G. Parker, ed., *The Thirty Years' War* (London: Routledge, 1984).

E. Peters, *The Magician, The Witch, and the Law* (Philadelphia: University of Pennsylvania Press, 1978).

————, *The World of Catholic Renewal, 1540–1770* (New York: Cambridge University Press, 1998).

J. Pudney, *John Wesley and His World* (New York: Scribner, 1978).

D. Radner, *Malebranche: A Study of a Cartesian System* (Assen, Netherlands: Van Gorcum, 1978).

H. R. Trevor Roper, *Archbishop Laud* (Hamdon, Conn.: Archon Books, 1962).

L. Roper, *Oedipus and the Devil: Sexuality and Religion in Early Modern Europe* (London: Routledge, 1994).

G. Scarre, *Witchcraft and Magic in Sixteenth- and Seventeenth-Century Europe* (London: Macmillan, 1987).

M. Schmidt, *John Wesley: A Theological Biography* (London: Epworth Press, 1962).

A. Sedgwick, *Jansenism in Seventeenth-Century France: Voices from the Wilderness* (Charlottesville, Va.: University Press of Virginia, 1977).

J. S. Simon, *John Wesley.* 5 vols. (London: Epworth Press, 1921–1934).

G. Strauss, *Luther's House of Learning; Indoctrination of the Young in the German Reformation* (Baltimore, Md.: Johns Hopkins University Press, 1978).

T. Tackett, *Religion, Revolution, and Regional Culture in Eighteenth-Century France* (Princeton, N.J.: Princeton University Press, 1986).

L. Taylor, ed., *Preachers and People in the Reformations and Early-Modern Periods* (Leiden, Netherlands: E. J. Brill, 2001).

K. Thomas, *Religion and the Decline of Magic* (Oxford: Oxford University Press, 1971).

N. Tyacke, *Anti-Calvinists: The Rise of English Arminianism, 1590–1640* (Oxford: Oxford University Press, 1987).

D. Van Kley, *The Jansenists and the Expulsion of the Jesuits from France, 1757–1765* (New Haven, Conn.: Yale University Press, 1975).

C. E. Vuliammy, *John Wesley* (New York: St. Martin's Press, 2000).

W. Walker, et al., *A History of the Christian Church.* 4th ed. (New York: Charles Scribner's Sons, 1985).

M. Walzer, *The Revolution of the Saints* (Cambridge, Mass.: Harvard University Press, 1965).

W. R. Ward, *Christianity Under the Ancien Regime, 1648–1789* (Cambridge: Cambridge University Press, 1999).

C. V. Wedgwood, *The Thirty Years' War* (London: Methuen, 1981).

THEATER

W. Bruford, *Theatre, Drama, and Audience in Goethe's Germany* (London: Routledge and Paul, 1950).

W. D. Howarth, *Beaumarchais and the Theatre* (New York: Routledge, 1995).

————, *French Theatre in the Neo-Classical Era, 1550–1789* (New York: Cambridge University Press, 1997).

D. Hughes, *The Theatre of Aphra Behn* (New York: Palgrave, 2000).

R. D. Hume, ed., *The London Theatre World, 1660–1800* (Carbondale, Ill.: University of Southern Illinois Press, 1980).

G. K. Hunter, *English Drama, 1586–1642* (Oxford: Oxford University Press, 1997).

J. Jondorf, *French Renaissance Tragedy: The Dramatic Word* (Cambridge: Cambridge University Press, 1990).

E. Kennedy, *Theatre, Opera, and Audiences in Revolutionary Paris: Analysis and Repertory* (Westport, Conn.: Greenwood Press, 1996).

R. C. Knight, *Corneille's Tragedies: The Role of the Unexpected* (Cardiff, Wales: University of Cardiff Press, 1991).

R. Z. Lauer, *The Mind of Voltaire* (Westminster, Md.: Newman Press, 1961).

J. Laver, ed., *Costume of the Western World* (New York: Harper and Brothers, 1951).

D. Lindley, ed., *The Court Masque* (Manchester, United Kingdom: University of Manchester Press, 1984).

F. M. Link, *Aphra Behn* (New York: Twayne Publisher, 1968).

H. Mason, *Voltaire: A Biography* (Baltimore, Md.: Johns Hopkins University Press, 1981).

———, *Voltaire: Optimism Demolished* (New York: Twayne, 1992).

A. H. Mayor, *The Bibiena Family* (New York: H. Bittner, 1945).

G. McCarthy, *The Theatre of Molière* (New York: Routledge, 2002).

S. McCleave, ed., *Dance and Music in French Baroque Theatre: Sources and Interpretations* (London: IAMS, 1998).

R. McGridge, *Aspects of Seventeenth-Century French Drama and Thought* (Totowa, N.J.: Rowman and Littlefield, 1979).

M. McKendrick, *Theatre in Spain, 1490–1700* (Cambridge: Cambridge University Press, 1989).

D. Parker, *Nell Gwyn* (Stroud, United Kingdom: Sutton, 2000).

J. S. Ravel, *The Contested Parterre: Public Theater and French Political Culture, 1680–1791* (Ithaca, N.Y.: Cornell University Press, 1999).

M. Root-Bernstein, *Boulevard Theater and Revolution in Eighteenth-Century Paris* (Ann Arbor, Mich.: UMI Press, 1984).

M. Sherwood, *Dryden's Dramatic Theory and Practice* (New York: Haskell, 1965).

D. Stone, *French Humanist Tragedy: A Reassessment* (Manchester, United Kingdom: Manchester University Press, 1974).

H. Stone, *The Classical Model: Literature and Knowledge in Seventeenth-Century France* (Cambridge: Cambridge University Press, 1996).

M. Summers, *Restoration Theatre* (New York: Humanities Press, 1964).

VISUAL ARTS

D. Arasse, *Vermeer: Faith in Painting* (Princeton, N.J.: Princeton University Press, 1994).

R. W. Bissell, *Orazio Gentileschi and the Poetic Tradition in Caravaggesque Painting* (University Park, Pa.: Pennsylvania State University Press, 1981).

H. Blamires, *Milton's Creation: A Guide through "Paradise Lost"* (London: Methuen, 1971).

A. Blunt, ed., *Baroque and Rococo: Architecture and Decoration* (New York: Icon Editions, 1982).

———, *Francesco Borromini* (Cambridge, Mass.: Harvard University Press, 1979).

———, *Roman Baroque* (London: Pallas Athene Arts, 2001).

J. Brown, *Velàzquez: Painter and Courtier* (New Haven, Conn.: Yale University Press, 1986).

———, *Zurbáran*. Rev. ed. (New York: H. N. Abrams, 1991).

M. Campbell, *Pietro da Cortona at the Pitti Palace* (Princeton, N.J.: Princeton University Press, 1977).

F. B. Domenech, *Ribera, 1591–1652* (Madrid: Bancaja, 1991).

K. Downes, *Rubens* (London: Jupiter Books, 1980).

W. Friedländer, *Mannerism and Anti-Mannerism in Italian Painting* (New York: Columbia University Press, 1957).

F. Hartt, *Art. A History of Painting, Sculpture, Architecture*. 3rd ed. (New York: H. N. Abrams, Inc., 1989).

J. S. Held, *Rubens and His Circle* (Princeton, N.J.: Princeton University Press, 1981).

H. Hibbard, *Caravaggio* (London: Harper and Row, 1983).

M. Kitson, *The Complete Paintings of Caravaggio* (New York: Harry N. Abrams, 1985).

B. Nicolson, *Caravaggism in Europe* (Torino, Italy: U. Allemandi, 1989).

W. E. Roberts, *Jacques-Louis David, Revolutionary Artist* (Chapel Hill, N.C.: University of North Carolina Press, 1989).

M. D. Sheriff, *Fragonard; Art and Eroticism* (Chicago: University of Chicago Press, 1990).

S. Slive, *Frans Hals* (London: Phaidon, 1974).

R. E. Spear, *Caravaggio and His Followers* (New York: Harper and Row, 1975).

F. Warnke, *Versions of Baroque* (New Haven, Conn.: Yale University Press, 1972).

C. White, *Peter Paul Rubens: Man and Artist* (New Haven, Conn.: Yale University Press, 1987).

———, *Rembrandt* (New York: Thames and Hudson, 1984).

R. Wittkower, *Art and Architecture in Italy, 1600–1750* (Harmondsworth, United Kingdom: Penguin, 1980).

———, *Gian Lorenzo Bernini; The Sculptor of the Roman Baroque.* 2nd ed. (Ithaca, N.Y.: Cornell University Press, 1981).

———, *Studies in Italian Baroque* (London: Thames and Hudson, 1975).

A. Zega, *The Palaces of the Sun King* (New York: Rizzoli International, 2002).

MEDIA AND ONLINE SOURCES

GENERAL

Art of the Western World (1989)—Produced by WNET, New York, with funding from the Annenberg/CPB Project, this nine-part series treats the history of Western art from antiquity to modern times. Episodes five and six deal with the Baroque, Rococo, and neoclassicism.

Blaise Pascal (1971)—This film from famed Italian director Roberto Rossellini highlights the major events in the life of the great seventeenth-century mathematician and Jansenist supporter. Not rated, originally made for television.

Christian Classics Ethereal Library (http://www.ccel.org)—One of the oldest online databases of "public access" texts, this website is now a venerable mainstay of the academic community. Located at Wheaton College in Illinois it provides highly readable online versions of major classics in the Christian tradition. Its collection is particularly rich in works treating the early-modern centuries.

Project Gutenberg (http://promo.net/pg/)—This major online library of public domain texts is particularly rich in literature from the seventeenth and eighteenth centuries and includes many texts from the great philosophers of the Western tradition.

The Story of English (1986)—This nine-part PBS series explores the development of English from a tribal language to its dominant position in the world. The series places particular emphasis on the age of Shakespeare and the seventeenth century.

Versailles: The Visit (1999)—A comprehensive tour of the greatest Baroque palace of all conducted by the director of the Versailles' museums.

Voltaire Foundation (http://www.voltaire.ox.ac.uk/)—Located at Oxford University, this well-established scholarly society's website is a major source of information about the famous French philosopher, his work, and his times.

The Western Tradition (1989)—This massive 52-part historical series was originally produced by WGBH, Boston. It is noteworthy for its intelligent commentary by noted historian Eugen Weber, as well as its historical art illustrations. Episodes 31–35 treat the Baroque and Enlightenment periods.

ARCHITECTURE

Archinform (http://www.archinform.net/)—An international database of major architectural monuments from the European past. The website allows for searching, and includes photographs and brief summaries of the significance of each monument.

Bernini, Architect: The Great Problem Solver (1997)—This thirty-minute video from the "Masterpieces in Video" series summarizes the great Baroque artist's achievements as a builder in Rome.

Borromini: His Extraordinary Architecture (1996)—This thirty-minute video from the "Masterpieces in Video" series treats the great Roman architect's singular artistic vision and his major monuments in Rome.

Chateau de Versailles (http://www.chateauversailles.fr/)—The official website of Versailles provides a handsome virtual tour of Europe's largest Baroque palace as well as its gardens. This work of architecture is considered so important that it has been designated a "World Heritage" site, meaning it has been certified by UNESCO (United Nations Educational, Scientific, and Cultural Organization) as being so essential to the human heritage that it must be protected, not just by an individual state, but by all the peoples of the earth.

Great Buildings Online (http://www.artifice.com/gbc.html)—A commercial database of architectural images that provides multiple search engines for locating images and information about major monuments.

Renaissance and Baroque Architecture (http://www.lib .virginia.edu/dic/colls/arh102/)—An online collection of images of Renaissance and Baroque architectural monuments from the University of Virginia's Library.

Rome Revisited: The Renewal of Splendor (1995)—This video from the "Masterpieces in Video" series focuses especially on the renewal of Rome by Renaissance and Baroque architects.

Schloss Schönbrunn (http://www.schoenbrunn.at/de/ publicdir/)—The website of Schönbrunn, the second-largest palace of Baroque Europe, provides a great deal of information on this building outside Vienna. This work of architecture is considered so important that it has been designated a "World Heritage" site, meaning it has been certified by UNESCO (United Nations Educational, Scientific, and Cultural Organization) as being so essential to the human heritage that it must be protected, not just by an individual state, but by all the peoples of the earth.

Triumph of the Baroque (http://www.nga.gov/exhibitions/ 2000/baroque/splash.htm)—An online exhibition from the National Gallery of Art in Washington, D.C., summarizing the major achievements of the Baroque era in architecture and the arts.

Vitruvio.ch (http://www.vitruvio.ch/)—A database of major architectural monuments that is particularly strong in listings from early-modern Europe. The website includes photographs, brief bibliographies, and other information about the monuments. It also provides for searching of major architects and the buildings they designed.

DANCE

Danse royale: Music of the French Baroque Court and Theater—This compilation recording includes ballet music from France's Golden Age. Many of the pieces here are rarely recorded. Available on the Dorian label as recording number 90272.

Introduction to Baroque Dance—A two-part video series produced by Paige Whitley-Bauguess, a noted choreographer, instructing students in the steps of dances from the Baroque era. It is available for purchase online at http://www.baroquedance.com/.

How to Dance Through Time—Volume IV in this six-part video series teaches the social dance of the Baroque era, including the minuet, allemande, and contredanse. Available for purchase from the Dance Through Time society online at http://www.dancethroughtime.org/ home.html.

John Eliot Gardner and the English Baroque Soloists, *Don Juan*—Christoph Willibald von Gluck's ballet music for Gaspero Angiolini's ballet d'action is performed by one of the finest contemporary baroque ensembles. Available on the Elektra/Asylum label as recording number 89233.

Kevin Mallon and the Arcadia Baroque Ensemble, *Ballet Music for the Sun King*—This audio recording features ballet music from the operas of Jean-Baptiste Lully. Available on the Naxos label as recording number 554003.

Teatro alla Scala, Milan (http://lascala.milano.it/eng/ homepage.htm)—For more than 200 years the famous Teatro a la Scala in Milan, Italy, has been home to one of the world's great opera companies. Its ballet, too, has a long and distinguished history. The company's website includes insight into its venerable traditions.

Western Social Dance: An Overview of the Collection (http://memory.loc.gov/ammem/dihtml/diessay0.html) —This Library of Congress website reviews the dance instruction manuals published in Europe since the Renaissance. Of particular interest are the video clips of dance steps practiced during the Baroque period.

FASHION

The Affair of the Necklace (2001)—Loosely based on the story of Jeanne de la Motte-Valois, a woman who loses her claim to her title and property after she is orphaned. She schemes to regain her royal status in a series of events surrounding the "affair of the necklace," which is said to one of the contributing factors of the French Revolution. The film's images of late eighteenth-century aristocratic style are particularly good. Its relating of the circumstances of the famous affair of the diamond necklace, though, is less than convincing. Rated R.

The Costume Institute, Metropolitan Museum of Art, New York City (http://www.metmuseum.org/)—The collections of this great museum are particularly rich in costumes of the seventeenth and eighteenth centuries. The museum's website has a link to its costume department, the Costume Institute (http://www.metmuseum.org/Works_of_Art/department.asp?dep=8).

Museum of Costume, Bath, England (http://www.museumofcostume.co.uk/)—This museum of costume collections is particularly rich in eighteenth-century clothing, the period in which Bath was England's most fashionable resort. Its website provides a guide to its holdings as well as many special exhibitions mounted by the institution.

La Nuit de Varennes (The Night of Varennes, 1982)—This French period drama relates the circumstances surrounding the flight of Louis XVI and Marie-Antoinette from Paris in 1791. The film recreates French styles of the period in a way that is historically accurate. Rated R.

The Rise of Louis XIV (1966)—Produced by noted director Roberto Rossellini, this film catalogues Louis XIV's increasingly absolutist policies and shows the role that clothing played in the king's attempts to control his nobles. Rated G.

Vatel (2000)—Directed by Rolland Joffé and starring Gerard Depardieu and Uma Thurman, this film recreates the occasion of royal visit by Louis XIV to an important noble house. Its evocation of French costumes from the Age of the Baroque are particularly rich. Rated PG-13.

LITERATURE

The ARTFL Project (http://humanities.uchicago.edu/orgs/ARTFL/)—Located at the University of Chicago, this cooperative project between American and French scholars is making available the great French literary classics of the seventeenth and eighteenth centuries.

Clarissa (1992)—Although not without flaws, this PBS adaptation of the 1747–1748 Samuel Richardson novel has been the only attempt to dramatize the great English novel.

Cyrano de Bergerac (1990)—Starring Gerard Depardieu, this adaptation of the life of the famous seventeenth-century French author concentrates on de Bergerac's ability to use his skills in letter writing to woo his young love. Rated PG.

Dangerous Liaisons (1988)—Starring Glenn Close, this great adaptation of Pierre Choderlos de Laclos' great eighteenth-century novel of aristocratic trickery and deceit never fails to capture the imagination and to entertain the eye. Rated R.

The History and Misfortunes of Moll Flanders (1996)—Originally produced for Masterpiece Theater, this adaptation of Defoe's early novel does justice to the work's wit and satire.

Luminarium (http://www.luminarium.org/lumina.htm)—This unique anthology of English literary sources emphasizes the many accomplished authors of the early seventeenth century.

The Milton Society (http://www.urich.edu/~creamer/milton/)—The online presence of a venerable society is dedicated to the study of the English poet John Milton.

Tom Jones (1963)—Starring Albert Finney in the title role, this film from Tony Richardson captures the good fun of the original 1749 novel. Unrated.

Valmont (1989)—This second adaptation of Choderlos de Laclos's *Les liaisons dangereuses* was largely overshadowed by the more famous *Dangerous Liaisons* released one year before. It manages to treat certain themes left untouched by its more famous predecessor; the films stars Annette Bening and Colin Firth. Rated R.

The Voltaire Foundation (http://www.voltaire.ox.ac.uk/)—Located at Oxford University in England, this scholarly website provides up-to-date information on the great French Enlightenment author.

MUSIC

Classicalnet (http://www.classical.net)—This invaluable source for composers' biographies and information about the developments of musical forms and styles also includes thousands of reviews, many by noted authorities, on current recordings of classical music.

Complete Bach Edition (2000)—Produced on the Hännsler label, this set of 172 CDs is a milestone recording of all the surviving compositions of the great German master.

Complete Mozart Edition (1990–1992)—Produced by the recording industry giant Philips, this recorded edition of the great eighteenth-century composer's works totals 180 discs. Although minor criticisms have been made of the quality of some of its recordings, it remains the definitive source for recordings of Mozart's works.

Farinelli (1995)—This Belgian film chronicles the life of the greatest eighteenth-century castrato, Carlo Broschi, who was better known as Farinelli. Rated R.

George Frideric Handel (http://www.gfhandel.org)—This attractive site includes an up-to-date bibliography of the works of the famous German composer who had an important impact on England, his adopted country.

Hadyn Piano Trios, Complete (1997)—Recorded in the 1970s by the Beaux Arts Trio, this recording presents some of the most beautiful chamber music of the eighteenth century. It shows Haydn's styles developing from an early attachment to Galant and *Sturm und Drang* to the early romantic.

Haydn Symphonies, Complete (1987–2001)—In this milestone recording of the composer's 104 symphonies, the Austro-Hungarian Orchestra is conducted by Adam Fischer. The work is released under the Brilliant Classics label.

J. S. Bach Homepage (http://www.jsbach.org)—Among other attributes of this website is a copy of the complete listing of Bach's works.

The Magic Flute (1975)—This film from the great Swedish director Ingmar Bergman presents a lively performance of Mozart's great fantasy classic, *The Magic Flute*. Rated G.

The Mozart Project (http://www.mozartproject.org)—Besides its inclusion of a complete biography for the great composer, this website contains many essays on Mozart's music.

PHILOSOPHY

Blaise Pascal (1972)—This film, directed by famed Italian neo-realist Roberto Rossellini, portrays the intellectual and spiritual ferment that produced the ideas of the French philosopher and mathematician.

Civilisation (1969)—Edited by the art and cultural historian Kenneth Clark, this exploration of Western culture also includes much analysis of changing philosophical ideas.

Danton (1983)—Starring Roger Planchon and Gerard Depardieu, this film is set in Paris during the Reign of Terror, and portrays the consequences of the French Revolution's efforts to establish an Age of Reason advocated in the works of the Enlightenment. Rated PG.

Episteme.com (http://www.epistemelinks.com/)—This website is an online guide to philosophy resources available on the Internet.

Hume (1987)—Professor Bryan Magee and Hume expert John Passmore explore the life and ideas of the greatest philosopher of the Scottish Enlightenment.

The Internet Encyclopedia of Philosophy (http://www.iep.utm.edu/)—A venerable resource for articles concerning the major thinkers in the Western tradition.

Jean-Jacques Rousseau: Retreat to Romanticism (1991)—Although only a half-hour program, this English documentary manages to capture the most important aspects of the great French philosopher's career, including his friendship with the Scottish empiricist David Hume.

Locke and Berkeley (1987)—This BBC production features Professor Bryan Magee and Oxford philosopher Michael Ayers and treats the formulation and implications of the two great English empiricist philosophers of the late seventeenth and early eighteenth centuries.

The Stanford Encyclopedia of Philosophy (http://plato.stanford.edu/)—This website is a source of indispensable information concerning the philosophers of early-modern Europe.

Spinoza and Leibniz (1987)—Philosopher Anthony Quinton and Professor Bryan Magee treat the implications of two of the most important seventeenth-century rationalist philosophers in this video.

Voltaire and Jefferson: The Sage of Ferney and the Man from Monticello—This film treats Thomas Jefferson's lifelong admiration for Voltaire and his works. Filmed at Monticello and at Voltaire's estate at Ferney in southern France, it manages to capture the spirit of one of the most important associations of the Enlightenment.

RELIGION

Day of Wrath (1943)—An early Danish depiction of an early-modern witch trial brought against an adulterous wife from director Carl Theodor Dreyer. Rated PG-13.

The Devils (1971)—This film, directed by Ken Russell, is based upon the playwright John Whiting's theatrical adaptation of Aldous Huxley's 1952 novel of the same name. The subject is the 1634 case of a witch trial at Loudon in France, and the film adaptation is one of the most chilling works dealing with persecution and intolerance ever to be made. Rated R.

English Literature and Religion (http://www.english.umd.edu/englfac/WPeterson/ELR/elr.htm)—This website at the University of Maryland includes a database bibliography of more than 8,500 works treating the history of religion in England. It also includes links to online versions of major religious texts, including the various versions of the Anglican *Book of Common Prayer*.

Internet Modern History Sourcebook: Enlightenment (http://www.fordham.edu/halsall/mod/modsbook10

.html)—A voluminous collection of complete sources and excerpts from contemporary documents and writings that highlights the relationship between the Enlightenment and eighteenth-century religion.

Jesuits and the Sciences (http://www.luc.edu/libraries/science/jesuits/index.html)—This Loyola University site highlights the Jesuits' considerable contributions to the history of science, with particular emphasis on their early-modern involvement in the Scientific Revolution.

The Last Valley (1970)—Director James Clavell's recreation of the Holy Roman Empire during the Thirty Years' War has a frightening depiction of a witch trial and its aftermath. Rated PG.

Matthew Hopkins, Witchfinder General (1968)—A historic drama of the life of England's most famous professional witch hunter. Soon after this movie appeared, it inspired an entire genre of films treating witchcraft and magic, many of far lesser quality than this work. Unrated. Violence and sexual content.

Methodist Archives and Research Centre (http://rylibweb.man.ac.uk/data1/dg/text/method.html)—Located at the John Rylands Library of the University of Manchester in England, this archive of the Methodist movement provides invaluable documents concerning the early history of the movement. Its website also includes exhibits and links to other websites treating the history of Methodism and eighteenth-century England.

THEATER

The Aphra Behn Society Homepage (http://prometheus.cc.emory.edu/behn/)—The website of this academic society includes links to synopses of the great female playwright's life and analyses of her works. It also includes bibliographical information about recent studies of the dramatist.

Comédie-Française (http://www.comedie-francaise.fr/indexes/index.php)—This website informs about the contemporary productions of the oldest national theater in Europe, and also includes a brief section on the company's history.

The Complete Works of William Shakespeare (http://the-tech.mit.edu/Shakespeare/)—A venerable website from the Massachusetts Institute of Technology that includes all the texts of the great bard's plays. The site includes a set of links available to Shakespeare's works and criticism of them on the Internet.

Molière (1978)—Produced by noted French director Ariane Mnouchkine, this dramatization of the life of the famous seventeenth-century playwright is notable for its historical veracity. Unrated.

Much Ado About Nothing (1993)—Directed by Kenneth Branagh and starring Branagh and Emma Thompson, this adaptation of Shakespeare's late comedy is here set in eighteenth-century Italy, but the verse and spirit are that of the early seventeenth century. Rated PG-13.

Renascence Editions (http://darkwing.uoregon.edu/~rbear/ren.htm)—This website at the University of Oregon includes handsome electronic editions of seventeenth-century English works, including the masques of Ben Jonson, the plays of William Shakespeare, William Congreve, and a number of others, as well as a host of Continental sources first translated into English in the sixteenth and seventeenth centuries.

Restoration Stage: From Tennis Court to Playhouse (1993)—Written and produced by David Thomas for the University of Warwick's *Ancient Theatre and its Legacy* series, this film traces the conversion of London tennis courts into theaters during the reign of Charles II. The documentary then explores the ways in which the architects Sir Christopher Wren and Sir John Vanbrugh designed new playhouses for the London troupes in the later seventeenth century.

Shakespeare's Globe Theatre (http://www.shakespeares-globe.org/)—A site that informs about the current repertory of the Globe Theatre in London and this theater's attempts to recreate the drama of early seventeenth-century London in the twenty-first century world. There is also a virtual tour of the theater as well as an online exhibit treating the project's history and the history of the theater in the time of Shakespeare.

The Shakespeare Mystery (1989)—This *PBS-Frontline* documentary explores the controversy that surrounds the true identity of William Shakespeare.

VISUAL ARTS

The Louvre, Paris (http://www.louvre.fr/louvrea.htm)—A handsome website from one of the world's greatest art museums. The site features a virtual tour of the highlights of the collection as well as a history of the museum itself.

The Louvre: The Visit (1998)—A guided private tour through the wealth of the Louvre's collections.

The National Gallery, London (http://www.nationalgallery.org.uk/)—Another collection rich in the works of the Baroque and neoclassical periods.

The Rijksmuseum, Amsterdam (http://www.rijksmuseum .nl/)—The collections of this famous museum are a treasure trove of the "little" and "great masters" of the Dutch Golden Age. In addition, the museum's collections are strong in almost all periods of Western art before the twentieth century.

The Royal Museum of Fine Arts, Antwerp (http://museum .antwerpen.be/kmska/)—The website of this major Flemish museum highlights the major works in its collections, including its more than twenty paintings from Peter Paul Rubens.

The Vatican Museums, Rome (http://www.vatican.va/ museums/)—The Vatican Museum's collections are particularly rich in Baroque art, and the attractive website of this revered institution offers a glimpse of this great wealth.

ACKNOWLEDGMENTS

The editors wish to thank the copyright holders of the excerpted material included in this volume and the permissions managers of many book and magazine publishing companies for assisting us in securing reproduction rights. We are also grateful to the staffs of the Detroit Public Library, the Library of Congress, the University of Detroit Mercy Library, Wayne State University Purdy/Kresge Library Complex, and the University of Michigan Libraries for making their resources available to us. Following is a list of the copyright holders who have granted us permission to reproduce material in this publication. Every effort has been made to trace copyright, but if omissions have been made, please let us know.

COPYRIGHTED EXCERPTS IN ARTS AND HUMANITIES THROUGH THE ERAS: THE AGE OF BAROQUE AND THE ENLIGHTENMENT WERE REPRODUCED FROM THE FOLLOWING BOOKS:

Anonymous. From "Agreement Between Titus Van Rijn and Hendrickje Stoffels," in *A Documentary History of Art, Vol. II.* Edited by Elizabeth G. Holt. Princeton, 1958. Copyright © 1947, 1958 by Princeton University Press. Renewed 1986 by Elizabeth Gilmore Holt. All rights reserved. Reproduced by permission.—Anonymous. From "The Trial of Marie Cornu," in *Witchcraft in Europe, 400–1700.* Edited by Alan Kors and Edward Peters. University of Pennsylvania Press, 2001. Reproduced by permission.—Baldinucci, Filippo. From "The Life of Cavalier Giovanni Lorenzo Bernini," in *A Documentary History of Art, Vol. II.* Edited by Elizabeth Holt. Princeton, 1958. Copyright © 1947, 1958 by Princeton University Press. Renewed 1986 by Elizabeth

Gilmore Holt. All rights reserved. Reproduced by permission.—Barrington, Daines. From "Account of a Very Remarkable Young Musician," in *Music in the Western World.* Edited by Piero Weiss and Richard Taruskin. Schirmer, 1984. Copyright © 1984 by Schirmer Books, A Division of Macmillan, Inc. Reproduced by permission of the Gale Group.—Bellori, Giovanni P. From *A Documentary History of Art, Vol. II.* Edited by Elizabeth Holt. Princeton, 1958. Copyright © 1947, 1958 by Princeton University Press. Renewed 1986 by Elizabeth Gilmore Holt. All rights reserved. Reproduced by permission.—Carducho, Vincencio. From "Dialogues on Painting," in *A Documentary History of Art, Vol. II.* Edited by Elizabeth G. Holt. Princeton, 1958. Copyright © 1947, 1958 by Princeton University Press. Renewed 1986 by Elizabeth Gilmore Holt. All rights reserved. Reproduced by permission.—Carracci, Annibale. From *A Documentary History of Art, Vol. II.* Edited by Elizabeth G. Holt. Princeton, 1958. Copyright © 1947, 1958 by Princeton University Press. Renewed 1986 by Elizabeth Gilmore Holt. All rights reserved. Reproduced by permission.—Chambers, William. From "Designs for Chinese Buildings, Furniture, Dresses Machines, and Utensils," in *A Documentary History of Art, Vol. II.* Edited by Elizabeth Holt. Princeton, 1958. Copyright © 1947, 1958 by Princeton University Press. Renewed 1986 by Elizabeth Gilmore Holt. All rights reserved. Reproduced by permission.—David, Jacques–Louis. From "Speech before the National Convention, August 8, 1793," in *Neoclassicism and Romanticism, 1750–1850.* Edited by Lorenz Eitner. Prentice Hall, 1970. © 1970 by Prentice–Hall, Inc.

All rights reserved. Reproduced by permission of Lorenz Eitner.—Diderot, Denis. From "Francois Boucher, 'Shepherd Scene,' (Salon of 1763)," in *Neoclassicism and Romanticism, 1750–1850*. Edited by Lorenz Eitner. Prentice Hall, 1970. © 1970 by Prentice–Hall, Inc. All rights reserved. Reproduced by permission of Lorenz Eitner.—Galileo. From *Discoveries and Opinions of Galileo*. Translated by Stillman Drake. Doubleday, 1957. Copyright © 1957 by Doubleday, a division of Random House, Inc. Renewed 1985 by Stillman Drake. Used by permission of the publisher.—Le Brun, Charles. From "Concerning Expression in General and In Particular," in *A Documentary History of Art, Vol. II.* Edited by Elizabeth G. Holt. Princeton, 1958. Copyright © 1947, 1958 by Princeton University Press. Renewed 1986 by Elizabeth Gilmore Holt. All rights reserved. Reproduced by permission of Alfred A. Knopf, Inc., a division of Random House, Inc.—Lessing, Gotthold E. From "Briefe, die neueste Litteratur betreffend (Letters Concerning the Most Recent Literature)," in *Theatre in Europe: A Documentary History.* Edited by Glynne Wickham. Cambridge University Press, 1993. Reproduced by the permission of Cambridge University Press.—Mattheson, Johann. From "Der volkommene Capellmeister," in *Music in the Western World: A History in Documents.* Edited by Piero Weiss and Richard Taruskin. Schirmer, 1984. Copyright © 1984 by Schirmer Books, A Division of Macmillan, Inc. All rights reserved. Reproduced by permission of the Gale Group.—Minor, Vernon H. From *Baroque and Rococo Art & Culture.* Laurence King Publishing, 1999. Copyright © 1999 Calmann & King Ltd. All rights reserved. Reproduced by permission.—Pacheco, Francisco. From "The Art of Painting," in *A Documentary History of Art, Vol. II.* Edited by Elizabeth G. Holt. Princeton, 1958. Copyright © 1947, 1958 by Princeton University Press. Renewed 1986 by Elizabeth Gilmore Holt. All rights reserved. Reproduced by permission.—Poussin, Nicholas. From "Letter to Chantelou, November 24, 1647," in *A Documentary History of Art, Vol. II.* Edited by Elizabeth G. Holt. Princeton, 1958. Copyright © 1947, 1958 by Princeton University Press. All rights reserved. Reproduced by permission.—Rameau, Jean–Hilippe. From *Treatise on Harmony.* Translated by Philip Gossett. Dover, 1971. Copyright © 1971 by Dover Publications, Inc. Reproduced by permission.—Reynolds, Joshua. From "Seven Discourses on Art," in *Neoclassicism and Romanticism, 1750–1850.* Edited by Lorenz Eitner. Prentice Hall, 1970. Reproduced by permission of Lorenz Eitner.—Rubens, Peter P. From "To Sir Dudley Carleton," in *A Documentary History of Art, Vol. II.* Edited by Elizabeth G. Holt. Princeton, 1958. Copyright © 1947, 1958 by Princeton University Press. Renewed 1986 by Elizabeth Gilmore Holt. All rights reserved. Reproduced by permission.—Sevigne, Madame de. From *Selected Letters.* Translated by Leonard Tancock. Penguin, 1982. Copyright © Leonard Tancock, 1982. All rights reserved. Reproduced by permission of Penguin Books, Ltd.—Voltaire. From "On the Presbyterians," in *Letters on England.* Translated by Leonard Tancock. Penguin Books, 1980. Reproduced by permission of Penguin Books, Ltd.

INDEX

Arts and Humanities Through the Eras: The Age of the Baroque and Enlightenment (1600–1800)